The

Cybercultures

Reader

Edited by

David Bell and
Barbara M. Kennedy

London and New York

First published 2000 by Routledge
11 New Fetter Lane, London EC4P 4EE

Simultaneously published in the USA and Canada
by Routledge
29 West 35th Street, New York, NY 10001

Routledge is an imprint of the Taylor & Francis Group

Typeset in Bembo by Florence Production Ltd,
Stoodleigh, Devon

Printed and bound in Great Britain by T. J. International,
Padstow, Cornwall

British Library Cataloguing in Publication Data
A catalogue record for this book is available from the British Library

Library of Congress Cataloging in Publication Data
A catalogue record for this book has been requested

ISBN 0-415-18378-2 (HB)

ISBN 0-415-18379-0 (PB)

Th

Cybercultu merica
to Modern . . .

The Cyber iplinary
field of cyb ways in
which new ennium.
Articles by Stelarc,
Sadie Plan nematic
sections, a

introductio tures *
cyberfemin aces *
cybercolon

Key featur

● A general introduction by the editors to the study of cyberculture
● A user's guide to the *Reader*
● Introductions to each thematic section, locating the articles in their theoretical and technological contexts
● A full bibliography of cybertexts

Contributors: Anne Balsamo, Graham Barwell, Michael Benedikt, Kate Bowles, Gareth Branwyn, Scott Bukatman, Lisa Cartwright, Susan Clerc, Mark Dery, Arturo Escobar, Mike Featherstone, Thomas Foster, Jennifer González, Diana Gromala, Donna Haraway, Arthur Kroker, Marilouise Kroker, Alison Landsberg, Timothy Leary, Deborah Lupton, Ananda Mitra, Lisa Nakamura, Mark Oehlert, Michael Ostwald, Sadie Plant, Forest Pyle, Kevin Robins, Andrew Ross, Chela Sandoval, Ziauddin Sardar, Vivian Sobchack, Claudia Springer, Judith Squires, Susan Leigh Star, Stelarc, Allucquère Rosanne Stone, Jon Stratton, Susan Stryker, Tiziana Terranova, Richard Thieme, David Tomas, Daniel Tsang, Nina Wakeford, Deena Weinstein, Michael Weinstein, Shawn P. Wilbur, Michele Willson, Randal Woodland, Susan Zickmund.

The Editors: David Bell is Senior Lecturer in Cultural Studies and Barbara M. Kennedy is Senior Lecturer in Film and Cultural Studies at Staffordshire University.

Contents

PART TWO
popular cybercultures

PART THREE
cybersubcultures

PART FOUR
cyberfeminisms

PART FIVE
cybersexual

PART SIX
cyberbodies

PART SEVEN
post-(cyber)bodies

Illustrations

Notes on Contributors

The Editors

David Bell (d.bell@staffs.ac.uk) teaches Cultural Studies at Staffordshire University. His teaching and research interests include science and technology, consumption, cultural identity, rural cultures and sexual politics. He is co-editor of *Mapping Desire: Geographies of Sexualities* and *City Visions*, and co-author of *Consuming Geographies: We Are Where We Eat* and *Hard Choices: Sexual Citizenship After Queer Politics*.

Barbara Kennedy (artbmk@staffs.ac.uk) is Senior Lecturer in Film and Cultural Studies at Staffordshire University, teaching on the Technocultures and Cyberdiscourse modules, as well as several other film and cultural studies strands. Her research interests are in contemporary theories of the body, desire, dance, visual cartography and the interrelationships with theories from Continental philosophy (specifically Deleuze and Cioran). She is currently completing a book on Deleuze, post-feminism and cinema, and essays on contemporary avant-garde movies in independent cinema.

The Contributors

Anne Balsamo is Director of Graduate Studies for the Program in Information Design and Technology in the School of Literature, Communication and Culture at the Georgia Institute of Technology, Atlanta. She is the author of *Technologies of the Gendered Body*.

Graham Barwell (graham_barwell@uow.edu.au) lectures in English Studies and in Communication and Cultural Studies at the University of Wollongong. He is interested in electronic culture in general, but particularly in publishing, editing and Net regulation. His recent research has been in connection with the preparation of electronic versions of live events and with the Academy Electronic Editions series of Australian literary texts.

Michael Benedikt (mbenedikt@mail.utexas.edu) is Roessner Professor of Architecture and Director of The Center for American Architecture and Design at The University of Texas at Austin. He has practiced architecture both in medium-sized firms and on his own, with a number of buildings to his credit in Austin. His books include *For an Architecture of Reality*, *Deconstructing the Kimbell*, and *Cyberspace: First Steps*. He is executive editor of the book-series CENTER: Architecture and Design in America. He has been a visiting professor at the Graduate School of Design at Harvard University, and a Scholar in Residence at the Rockefeller Foundation's Study Center in Bellagio, Italy. Widely regarded as one of the founders of the cyberspace movement, Benedikt organized several international conferences on the topic. He is currently completing a book entitled *Value: Economics, Psychology, Life*.

Kate Bowles (kbowles@uow.edu.au) lectures in Communication and Cultural Studies at the University of Wollongong, and is researching the regulation of Internet content, with particular reference to the identification and policing of access by and to minors.

Gareth Branwyn (garethb2@earthlink.net) is a contributing editor for *Wired* and senior editor of *bOING bOING*. He is author of *Jamming the Media: a Citizen's Guide*. His home-page is at http://home.earthlink.net/~garethb2/

Scott Bukatman is Assistant Professor of Film Studies at Stanford University. He is author of *Terminal Identity: the Virtual Subject in Postmodern Science Fiction* and *Blade Runner* (part of the British Film Institute Modern Classics series).

Lisa Cartwright is an Associate Professor of English and Visual and Cultural Studies at the University of Rochester. She is author of *Screening the Body: Tracing Medicine's Visual Culture* and co-editor (with Constance Penley and Paula Treichler) of *The Visible Woman: Imaging Technologies, Science, and Gender*.

Susan Clerc (sueclerc@yahoo.com) is currently employed by Southern Connecticut State University and is writing her dissertation for Bowling Green State University.

Mark Dery (markdery@well.com; http://www.levity.com) is a cultural critic. He wrote *Escape Velocity: Cyberculture at the End of the Century* and edited *Flame Wars: The Discourse of Cyberculture*. His essay on media activism and guerrilla semiotics, 'Culture Jamming: Hacking, Slashing, and Sniping in the Empire of the Signs' is a bona fide net.classic, endlessly recirculated on the Internet. His collection of essays *The Pyrotechnic Insanitarium: American Culture on the Brink* was published in February 1999. He is an occasional writer for *The New York Times Magazine*, *Rolling Stone*, *Suck*, *Feed*, the on-line version of *The Atlantic Monthly*, and *Salon*. A frequent lecturer in the U.S. and Europe on new media, fringe art, and unpopular culture, he was recently appointed a guest lecturer for January 2000 in UC Irvine's Distinguished Fellow program.

Arturo Escobar (aescobar@anthro.umass.edu) was born and grew up in Colombia. He teaches anthropology at the University of Massachusetts, Amherst. His chief interests are political ecology and the anthropology of development, social movements, and science and technology. He is currently working on a book on the politics of nature

and culture from the perspectives of biodiversity, place, and networks based on field-work in a Colombian rainforest.

Mike Featherstone is Professor of Sociology and Communications, and Director of the Theory, Culture & Society Centre at The Nottingham Trent University. He is the editor of *Theory, Culture & Society* and co-editor of *Body & Society*. His recent publications include the edited collections *Love & Eroticism* and *Spaces of Culture* (with Scott Lash). The Theory, Culture & Society website is at http://tcs.ntu.ac.uk

Thomas Foster (fostert@indiana.edu) is an Associate Professor in the English Department at Indiana University. He recently served a four-year term as co-editor-in-chief of the journal *Genders*, and he has published articles in *Signs*, *PMLA*, *Genders*, *Modern Fiction Studies*, and *Contemporary Literature*. He has published other essays on cyberculture in the book collections *Centuries' Ends, Narrative Means* and *Cyberspace Textuality*. He has a book forthcoming, tentatively entitled *"The Souls of Cyber-Folk": Posthuman Narratives and the Rescripting of Postmodern Theory*.

Jennifer Gonzalez (jag@cats.ucsc.edu) is Assistant Professor of Contemporary and Twentieth Century Art History at the University of California, Santa Cruz. Her writing has appeared in *Frieze*, *World Art*, *Diacritics*, *Inscriptions*, and in anthologies such as *The Cyborg Handbook*, *Prosthetic Territories: Politics and Hypertechnologies*, and *With Other Eyes: Looking at Race and Gender in Visual Culture*.

Diana Gromala (gromala@acm.org) directs the New Media Research Lab at the University of Washington in Seattle. Her research focuses on technology, subjectivity, and embodied knowledges. She has published essays on electronic art and design criticism, media studies, and cultural theory. Her virtual reality artwork has been broadcast, performed and presented on five continents and her curatorial efforts include SIGGRAPH's Art Gallery 2000.

Donna Haraway (haraway@snowcrest.net) is a professor in the History of Consciousness Department at the University of California at Santa Cruz, where she teaches feminist theory, science studies, and women's studies. She is the author of *Crystals, Fabrics and Fields: Metaphors of Organicism in Twentieth-Century Developmental Biology*, *Primate Visions: Gender, Race, and Nature in the World of Modern Science*, *Simians, Cyborgs, and Women: The Reinvention of Nature*, and *Modest Witness@Second Millennium. FemaleMan©Meets OncoMouse™*. Her present project, *For the Love of a Good Dog*, analyzes webs of action in dog-human cultures.

Arthur Kroker is co-editor of the Culture Texts Series and co-editor of the electronic journal CTHEORY (www.ctheory.com). His books include *Spasm, Hacking the Future* (with Marilouise Kroker), *Data Trash* (with Michael Weinstein) and *Digital Delirium* (co-edited with Marilouise Kroker). The Krokers homepage is at http://ctech.concordia.ca/krokers/atable.html

Marilouise Kroker is co-editor of the Culture Texts Series and co-editor of the electronic journal CTHEORY (www.ctheory.com). Together with Arthur Kroker, she is

co-editor of *Body Invaders, The Last Sex, The Hysterical Male* and *Digital Delirium*. The Krokers homepage is at http://ctech.concordia.ca/krokers/atable.html

Alison Landsberg (alandsb1@gmu.edu) received her PhD from the University of Chicago in 1996 in Literature and Film. She is currently a Visiting Assistant Professor in the Department of History at George Mason University, and is working on a manuscript entitled *Prosthetic Memory: The Logics and Politics of Memory in 20th-Century American Culture.*

Timothy Leary urged the sixties counterculture to turn on, tune in, drop out. Described by William Burroughs as "a true visionary of the potential of human mind and spirit", Leary became a leading cyberguru in his later life, claiming that "the PC is the LSD of the 1990s". Many of his writings on cyberspace are collected in *Chaos and Cyberculture*. The Timothy Leary homepage is at www.leary.com

Deborah Lupton (dlupton@csu.edu.au) is Associate Professor in Cultural Studies and Cultural Policy and Director of the Centre for Cultural Risk Research at Charles Sturt University, Australia. Her current research interests are in the sociocultural aspects of medicine and public health, risk, technoculture, and the family. Her latest books are *Risk* and *Risk and Sociocultural Theory: New Directions and Perspectives.*

Ananda Mitra (ananda@wfu.edu) is an assistant professor in the Department of Communication at Wake Forest University, Winston-Salem, NC. His research includes cultural analysis of media, particularly in relation to diasporic and marginalized groups. He teaches courses in mass communication, research methodology and communication technology. His books include *Television and Popular Culture in India* and *India through the Western Lens*. He has also written in journals such as *Media, Culture and Society, Media Asia,* and *Critical Studies in Mass Communication.*

Lisa Nakamura (nakamurl@SONOMA.EDU) is Assistant Professor of English at Sonoma State University, where she teaches postcolonial literature and critical theory. She is co-editor of a forthcoming book on race and cyberspace. She is also working on a book on cyber-Orientalism and the Internet.

Mark Oehlert (oehlert@erols.com) states that "comic books are a wonderful resource for studying popular conceptions of technology in general and cyborgs specifically. . . they offer a rich context of both visual and literary cues and by their fictional nature, are free to explore the wildest boundaries of the human/machine interface". Mark was an undergraduate at the State University of West Georgia and did his Master's work in history and anthropology at Oregon State University. Mark is currently finishing his PhD. in American history at the American University in Washington, D.C, working in the Web-based learning arena, continuing to write and study comic books and technology, and is expecting his first child any day now.

Michael Ostwald (armjo@cc.newcastle.edu.au) is a Senior Lecturer in the Faculty of Architecture at the University of Newcastle, where he teaches and researches architectural theory, mathematics and philosophy. As well as numerous papers, he has published seven books and his research has been awarded national and international awards.

Sadie Plant is author of *The Most Radical Gesture: the Situationist International in a Postmodern Age, Zeros + Ones: Digital Women + the New Technoculture* and *Writing on Drugs*.

Forest Pyle (trespyle@OREGON.UOREGON.EDU) is Associate Professor of English at the University of Oregon. He is the author of *The Ideology of Imagination: Subject and Society in the Discourse of Romanticism* and of other essays on nineteenth and twentieth-century literature, film, and painting. A version of 'Making Cyborgs, Making Humans' will appear as a chapter in the book project he is presently completing: *"From Which One Turns Away": a Radical Aestheticism at the Limits of Culture*.

Kevin Robins is Professor of Communications, Goldsmiths College, University of London. He is the author of *Into the Image: Culture and Politics in the Field of Vision*, and (with Frank Webster) of *Times of the Technoculture*.

Andrew Ross (ar4@is.nyu.edu) is Professor and Director of the Graduate Program in American Studies at New York University. His books include *Real Love: In Pursuit of Cultural Justice, The Chicago Gangster Theory of Life: Nature's Debt to Society, Strange Weather: Culture, Science and Technology in the Age of Limits, No Respect: Intellectuals and Popular Culture*, and, most recently, *The Celebration Chronicles: Life, Liberty and the Pursuit of Property Value in Disney's New Town*. He has also edited several books including, most recently, *No Sweat: Fashion, Free Trade, and the Rights of Garment Workers*.

Chela Sandoval (sandoval@sscf.ucsb.edu) is an Assistant Professor for the Department of Chicano Studies at University of California at Santa Barbara. Her book *Methodology of the Oppressed* is part of the Theory Out of Bounds series, and is forthcoming in Spring 2000.

Ziauddin Sardar (ZSardar@compuserve.com) is a writer and cultural critic. Editor of *Futures* and co-editor of *Third Text*, he is also Visiting Professor of Postcolonial Studies at the Department of Arts Policy and Management, The City University, London. He is the author of *The Future of Muslim Civilisation, Islamic Futures: The Shape of Ideas to Come, Barbaric Others: A Manifesto on Western Racism, Introducing Cultural Studies* and *Postmodernism and the Other. Islam, Postmodernism and Other Futures: a Ziauddin Sardar Reader* (edited by Sohail Inayatullah and Gail Boxwell) will be published in early 2000.

Vivian Sobchack (sobchack@ucla.edu) is an Associate Dean and Professor of Film and Television Studies at the UCLA School of Theater, Film and Television. Her work focuses on film and media theory and its intersections with philosophy, perceptual studies, historiography and cultural studies. Her books include *Screening Space: The American Science Fiction Film, The Address of the Eye: A Phenomenology of Film Experience*; two edited anthologies, *The Persistence of History: Cinema, Television and the Modern Event* and *Meta-Morphing: Visual Transformation and the Culture of Quick Change*; and a forthcoming collection of her own essays, *Carnal Thoughts: Bodies, Texts, Scenes and Screens*.

Claudia Springer (clspringer@home.com) is a professor in the English Department and Film Studies Program at Rhode Island College. She is the author of *Electronic Eros: Bodies and Desire in the Postindustrial Age*. Her writings on cyberculture have appeared in *Screen, Now Time, Genders, The South Atlantic Quarterly* and *21.C*.

Judith Squires (judith.squires@bristol.ac.uk) is a lecturer in political theory at the University of Bristol. She is the author of *Gender in Political Theory* and has co-edited several collections including *Feminisms, Cultural Readings of Imperialism* and *Cultural Remix*. She was the editor of *New Formations* 1990–97.

Susan Leigh Star is Professor of Communication at the University of California, San Diego. She is the author or editor of *Regions of the Mind: Brain Research and the Quest for Scientific Certainty*; *The Cultures of Computing*; and, with Geoffrey Bowker, *Sorting Things Out: Classification and Its Consequences*. She has written on the social aspects of information technology and life sciences.

Stelarc (stelarc@va.com.au) is an Australian performance artist. He has used medical instruments, prosthetics, robotics, Virtual Reality systems and the Internet to explore, extend and enhance the body's parameters. He has performed with a THIRD HAND, a VIRTUAL ARM, a VIRTUAL BODY, INDUSTRIAL ROBOT ARMS, a STOMACH SCULPTURE and a 6-LEGGED WALKING ROBOT. For FRACTAL FLESH, as part of Telepolis in Brussels, he developed STIMBOD – a touch-screen interfaced muscle stimulation system, enabling remote access and choreography of the body. Performances such as PING BODY and PARASITE probe notions of telematic scaling and the engineering of external, extended and virtual nervous systems for the body using the Internet. For Kampnagel Hamburg he completed EXOSKELETON – a pneumatically powered six-legged walking machine actuated and controlled by arm gestures. His current EXTRA EAR project is an attempt to construct an ear as a permanent addition to the face that, connected to a modem and a wearable computer, becomes an internet antenna, able to hear RealAudio sounds. In 1995 he received a three-year fellowship from the Visual Arts/Craft Board, The Australia Council. In 1997 he was appointed Honorary Professor of Art and Robotics at Carnegie Mellon University. In 1998 he was Artist-In-Residence for Hamburg City and was appointed a Research Consultant for the Faculty of Art and Design at the Nottingham Trent University. In 1999 he has carried out performances and presentations in Australia, Germany, Switzerland, Slovenia, Croatia, the Czech Republic, Italy, the UK and Mexico. His art is represented by the Sherman Galleries in Sydney. His website is at http://www.stelarc.va.com.au

Allucquère Rosanne (Sandy) Stone (sandy@muq.org) is Associate Professor and Director of the Advanced Communication Technologies Laboratory (ACTLab) at UT Austin, Resident Senior Artist at the Banff Centre for the Arts, and Resident Fellow in Autumn 1998 at the Humanities Research Institute, UC Irvine. In various incarnations she has been a filmmaker, rock 'n' roll music engineer, neurologist, social scientist, cultural theorist, and performer. She is the author of numerous publications including *The Empire Strikes Back: A Posttranssexual Manifesto* and *The War of Desire and Technology at the Close of the Mechanical Age*.

Jon Stratton (tstratto@cc.curtin.edu.au) is Associate Professor of Cultural Studies at Curtin University in Perth, Western Australia. He has published widely in the area of cultural studies. His most recent book is *Race Daze: Australia in Identity Crisis*. At present he has a book of essays about post-assimilation Jewishness scheduled for publication in 2000, entitled *Coming Out Jewish*.

Susan Stryker (mulebaby@ricochet.net) earned her Ph.D. in United States History at the University of California at Berkeley in 1992, and currently holds a Social Science Research Council Post-Doctoral Fellowship in Sexuality Studies in the History Department at Stanford University. She was a contributing artist to Shu Lea Cheang's on-line multimedia installation *Brandon*, the premiere work in the Guggenheim Museum's new virtual gallery.

Tiziana Terranova (T.Terranova@uel.ac.uk) teaches media and cultural studies at the University of East London. She has published her research on digitalisation and cultural politics in *New Formations, Derive Approdi* and the on-line journal, *The Difference Engine*.

Richard Thieme (rthieme@thiemeworks.com; www.thiemeworks.com) consults, writes and speaks about the human dimensions of technology and the workplace, orga-nizational dynamics, and life on the edges. He has provided keynotes for Arthur Andersen, Alliant Energy, Firstar Bank, UOP, Strong Capital Management, the FBI, DefCon, and the Black Hat Briefings.

David Tomas is professor in the Departement d'Art Plastiques at the Université du Québec in Montreal. In addition to being an artist whose multimedia work explores the cultures and transcultures of imaging systems, Tomas has written articles on the cultures of imaging systems, the history of cybernetics, cyborgs, and contemporary art practices. He is the author of *Transcultural Space and Transcultural Beings* and an internet book enti-tled *The Encoded Eye, the Archive, and its Engine House*. He is currently working on a series of drawings and a collection of essays that explore deviant approaches to the history of new media.

Daniel Tsang (dtsang@uci.edu; http://go.fast.to/ar) is the politics, economics and Asian American studies bibliographer at University of California, Irvine. He writes for *OC Weekly* and hosts "Subversity," a public affairs program on KUCI.

Nina Wakeford is the Foundation Fund Lecturer in Sociology and a member of the Digital World Research Centre (http://www.surrey.ac.uk/dwrc/) at the University of Surrey. She is currently completing a book entitled *Networks of Desire: Gender, Sexuality and Computing Culture* and co-editing (with Peter Lyman) *Analysing Virtual Society: New Directions in Methodology*.

Deena Weinstein is Professor of Sociology at DePaul University, specializing in mass media and popular culture, especially rock music. Her recent books include *Heavy Metal: a Cultural Sociology* (an updated version will be published in 2000). She is also a rock journalist, with frequent publications in a variety of magazines and alternative papers.

Michael A. Weinstein is Professor of Political Science at Purdue University, special-izing in contemporary political and cultural theory, and contemporary ideologies. His most recent books include *Culture/Flesh: Reflections on Post-Civilized Modernity, Data Trash* (with Arthur Kroker) and *Postmodernized Simmel* (with Deena Weinstein). Weinstein is also a photography critic for *New Art Examiner* and *Newcity*, and a performance artist.

Shawn P. Wilbur is a bookseller, and part-time university instructor at Bowling Green State University, where he is pursuing a PhD in American Culture Studies. He has been the co-editor of two electronic magazines, *Liminal* and *Voices from the Net*, and an administrator at several text-based conferencing sites, including 1001 Plateaus and BayMOO. He is currently a member of the Spoon Collective, where he is working on the pilot project for a web-based 'encyclopedia of political thought', and the administrative collective for Spunk Library, an archive of free electronic texts on anarchism and related subjects.

Michele Willson (michellewilson@hotmail.com) is an editor of *Arena Magazine*, and is currently undertaking a doctorate around the theme of community theory and information technologies in the Politics Depatrment, Monash University.

Randal Woodland (woodland@umich.edu) directs the Writing Program at the University of Michigan–Dearborn. He received his Ph.D from the University of North Carolina at Chapel Hill and was a lecturer in UCLA Writing Programs. His current research projects include a study of the on-line experiences of lesbian, gay, bisexual, and transgender people.

Susan Zickmund (Susan-Zickmund@uiowa.edu) is Visiting Assistant Professor, Program in Biomedical Ethics and Medical Humanities, Department of Internal Medicine, University of Iowa. She was a visiting professor at the University of Dortmund in Germany where she lectured on the radical right's use of the Internet. Her interests involve notions of identity, hermeneutics, and the existentialist thought of Martin Heidegger. She is currently conducting a hospital-wide study on the impact of chronic disease on a patient's sense of identification, self conception and existence.

Acknowledgements

We would firstly like to thank all the authors whose work we have reprinted here; their encouraging (and prompt) responses to our requests made the process very straight-forward. Thanks, too, to all those authors who gave us permission to edit their work for inclusion here. Christine Bridgwood provided immensely valuable assistance in tracking down the contributors (via the Internet, naturally). At Routledge, Rebecca Barden has been an enthusiastic (and very patient) editor, while Rebecca Russell, Alistair Daniel and Kate Oldfield have smoothed the production of the finished book. The contents of the Reader were also greatly improved thanks to the advice of a number of anonymous readers.

We would also like to acknowledge the support of colleagues working in Media and Cultural Studies at Staffordshire University, and especially our students on the modules Technocultures and Cyberdiscourse, with whom we have discussed many of the essays from the collection, and the issues which they raise.

'Cyberspace: first steps', originally published in M. Benedikt (ed.) (1992) *Cyberspace: First Steps*, Cambridge, MIT.

'An archaeology of cyberspaces: virtuality, community, identity', originally published in D. Porter (ed.) (1997) *Internet Culture*, London: Routledge.

'Welcome to cyberia: notes on the anthropology of cyberculture', originally published in *Current Anthropology* 35(3) (1994).

'Cyberspace and the world we live in', originally published in K. Robins (1996) *Into the Image: Culture and Politics in the Field of Vision*, London: Routledge.

'Code warriors: bunkering in and dumbing down', originally published in A. Kroker and M. Kroker (1996) *Hacking the Future: Stories for the Flesh-Eating 90s*, Montreal: New World Perspectives.

'From captain america to wolverine: cyborgs in comic books: alternative images of cybernetic heroes and villains', originally published in C. Gray (ed.) (1995) *The Cyborg Handbook*, London: Routledge.

'Making cyborgs, making humans: of terminators and blade runners', originally published in J. Collins, H. Radner and A. Preacher Collins (eds) (1993) *Film Theory Goes to the Movies*, London: Routledge.

'New age mutant ninja hackers: reading *mondo 2000*', originally published in M. Dery (ed.) (1994) *Flame Wars: The Discourse of Cyberculture*, Durham: Duke University Press.

'Terminal penetration', originally published in S. Bukatman (1994) *Terminal Identity: The Virtual Subject in Postmodern Science Fiction*, Durham: Duke University Press.

'The technophilic body: on technicity in William Gibson's cyborg culture', originally published in *New Formations* 8 (1989).

'Prosthetic memory: *total recall* and *blade runner*', originally published in *Body and Society* 1 (3–4) (1995).

'Net game cameo', originally published in A. Kroker and M. Kroker (eds) (1997) *Digital Delirium*, Montreal: New World Perspectives.

'Estrogen brigades and "big tits" threads: media fandom on-line and off', originally published in L. Cherny and E. Reba Weise (eds) (1996) *Wired Women: Gender and New Realities in Cyberspace*, Seattle: Seal Press.

'Stalking the UFO meme', originally published in A. Kroker and M. Kroker, (eds) *Digital Delirium*, Montreal: New World Perspectives.

'Approaching the radical other: the discursive culture of cyberhate', originally published in S. Jones (ed.) (1997) *Virtual Culture: Identity and Communication in Cyberspace*, London: Sage.

'Hacking away at the counter-culture', originally published in A. Ross (1991) *Strange Weather: Culture, Science and Technology in the Age of Limits*, London: Verso.

'Post-human unbounded: artificial evolution and high-tech subcultures', originally published in G. Robertson, M. Marsh, L. Tickner, J. Bird, B. Curtis and T. Putnam (eds), (1996) *Future Natural: Nature, Science, Culture*, London: Routledge.

'A cyborg manifesto: science, technology and socialist-feminism in the late twentieth century', originally published in D. Haraway (1991) *Simians, Cyborgs, and Women: The Reinvention of Nature*, London: Free Association Books.

'On the matrix: cyberfeminist simulations', originally published in R. Shields (ed.) (1996) *Cultures of Internet: Virtual Spaces, Real Histories, Living Bodies*, London: Sage.

'Digital rage', originally published in C. Springer (1996) *Electronic Eros: Bodies and Desire in the Postindustrial Age*, London: Athlone.

'Networking women and grrrls with information/communication technology: surfing tales of the world wide web', originally published in J. Terry and M. Calvert (eds) (1997) *Processed Lives: Gender and Technology in Everyday Life*, London: Routledge.

'Fabulous feminist futures and the lure of cyberculture', originally published in J. Dovey (ed.) (1996) *Fractal Dreams: New Media in Social Context*, London: Lawrence and Wishart.

'New sciences: cyborg feminism and the methodology of the oppressed', originally published in C. Grey (ed.) (1995) *The Cyborg Handbook*, London: Routledge.

'Compu-sex: erotica for cybernauts', originally published in M. Dery (ed.) *Flame Wars: The Discourse of Cyberculture*, Durham: Duke University Press.

'Cyberqueer', originally published in A. Medhurst and S. Munt (eds) (1997) *Lesbian and Gay Studies: A Critical Introduction*, London: Cassell.

'Queer spaces, modem boys and pagan statues: gay/lesbian identity and the construction of cyberspace', originally published in *Works and Days* 13 (1–2) (1995).

'Notes on queer 'n' asian virtual sex', originally published in *Amerasia Journal* 20 (1) (1994).

'"Trapped by the body?" telepresence technologies and transgendered performance in feminist and lesbian rewritings of cyberpunk fiction', originally published in *Modern Fiction Studies* 43 (3) (1997).

'Coming across the future', originally published in J. Broadhurst Dixon and E. Cassidy (eds) (1998) *Virtual Futures: Cyberotics, Technology and Post-human Pragmatism*, London: Routledge.

'The embodied computer/user', originally published in *Body and Society* 1 (3–4) (1995).

'The virtual body in cyberspace', originally published in A. Balsamo (1996) *Technologies of the Gendered Body: Reading Cyborg Women*, Durham: Duke University Press.

'Will the real body please stand up? Boundary stories about virtual cultures', originally published in M. Benedikt (ed.) (1992) *Cyberspace: First Steps*, Cambridge: MIT.

'The cyberpunk: the individual as reality pilot', originally published in L. McCaffery (ed.) (1991) *Storming the Reality Studio: A Casebook of Cyberpunk and Postmodern Fiction*, Durham: Duke University Press.

'Envisioning cyborg bodies: notes from current research', originally published in C. Gray (ed.) (1995) *The Cyborg Handbook*, London: Routledge.

'From psycho-body to cyber-systems: images as post-human entities', originally published in J. Broadhurst Dixon and E. Cassidy (eds) (1998) *Virtual Futures: Cyberotics, Technology and Post-human Pragmatism*. London: Routledge (revised by the author 1999).

'Ritual mechanics: cybernetic body art', originally published in M. Dery (1996) *Escape Velocity: Cyberculture at the End of the Century*, London: Hodder and Stoughton.

'Transsexuality: the postmodern body and/as technology', originally published in *Exposure* 30 (1–2) (1995).

'Pain and subjectivity in virtual reality', originally published in L. Hershman Leeson (ed.) (1996) *Clicking In: Hot Links to a Digital Culture*, Seattle: Bay Press.

'Post-bodies, aging and virtual reality', originally published in M. Featherstone and A. Wernick (eds) (1995) *Images of Aging: Cultural Representations of Later Life*, London: Routledge.

'The visible man: the male criminal subject as biomedical norm', originally published in J. Terry and M. Calvert (eds) (1997) *Processed Lives: Gender and Technology in Everyday Life*, London: Routledge.

'From hestia to home page: feminism and the concept of home in cyberspace', originally published in N. Lykke and R. Braidotti (eds) (1996) *Between Monsters, Goddesses and Cyborgs: Feminist Confrontations with Science, Medicine and Cyberspace*, London: Zed Books.

'Community in the abstract: a political and ethical dilemma?', originally published in D. Holmes (ed.) (1997) *Virtual Politics: Identity and Community in Cyberspace*, London: Sage.

'Virtual urban futures', originally published in D. Holmes (ed.) (1997) *Virtual Politics: Identity and Communication in Cybersociety*, London: Sage.

'Virtual commonality: looking for india on the internet', originally published in S. Jones (ed.) *Virtual Culture: Identity and Communication in Cybersociety*, London: Sage.

'Border crossings: the internet and the dislocation of citizenship', originally published in S. Murray (ed.) *Not on Any Map: Essays on Postcoloniality and Cultural Nationalism*, Exeter: Exeter University Press.

'Race in/for cyberspace: identity tourism and racial passing on the internet', originally published in *Works and Days* 13 (1–2) (1995).

'Cyberspace and the globalization of culture', originally published in D. Porter (ed.) (1997) *Internet Culture*, London: Routledge.

'alt.civilizations.faq: cyberspace as the darker side of the west', originally published in Z. Sardar and J. Ravetz (eds) (1996) *Cyberfutures: Culture and Politics on the Information Superhighway*, London: Pluto.

DAVID BELL

INTRODUCTION I
Cybercultures reader:
a user's guide

THE MISSION OF THIS READER is to attempt to understand the ways in which cyberspace as a cultural phenomenon is currently being experienced and imagined. In this book, we take a purposefully broad definition of what cyberspace means: we want to think about the (overlapping but distinct) domains of digital communications and information technologies – the Internet, the world wide web, email; plus all the subframes within these (bulletin boards or BBS, chat rooms, multi-user domains (MUDs)/dungeons, etc.) – alongside a host of related technological systems, including virtual reality, digital imaging systems, new biomedical technologies, artificial life and interactive digital entertainment systems. More important, however, we are concerned here with exploring these as *technocultural* constructions; so, as well as thinking about the hardware (machines), software (programs) and wetware (humans), we need to consider the place of imagination and representation, cultural use and value, and focus our attention most squarely on human interactions with (and within) these emerging cybercultural formations.

Compiling a Reader is, at one level, an exercise in ordering and architecture; this seems ironic, given the decentralized, non-linear, *rhizomatic* textures of cyberspace. That's why, in this User's Guide, we plan to suggest some different threads, or pathways, or wormholes, that might link some of the essays together in productive ways. Each reader will be able to construct his or her own network of readings, of course; we are not in the business of defining particular ways through the Reader at the expense of any others. Our own attempt at ordering – which is partial, negotiated, and somewhat clumsy – is born of the necessity of framing each essay within a particular context. However, most of the essays range across such contexts, and endless reshuffles could produce infinite variations, spiralling out like fractal geometries. But that's the reader's job, not the Reader's: not to begin on page one and read through to the last word of the volume, but to flick and flit, to find and chase your own hot links, to trace each

rhizome, each thread, and to make connections that work for you – to construct your own *hypertextual* web. All we aim to do here is to give you some tools that might aid such a project – some keywords, some alternative ways of approaching the act of reading the Reader, of using the Reader. Then, in the essay which follows, Barbara Kennedy takes us on a different reading into cyberculture: a subjective, embodied account of the human–machine interface, which – when read through the scene of a car crash – projects us through and in-between the flickering moments of *machinic* experience, of techno-cultural embodiment, of the pains and the pleasures of metal and meat. But for now, let's start with that most impossible of tasks: definition.

Click here for more

If we begin with an obvious, but no less vexing question, we might find a way to introduce some of the terms and concepts which litter the Reader's body. A starting point, then, might be to ask: *where is cyberspace*? We can answer this in a number of ways. We might say that cyberspace exists in the network of computers, modems, communications links, nodes and pathways that connect users into something (or some things) like the World Wide Web, the Internet, the information superhighway, and so on. We could make cyberspace, in short, as the sum of the hardware that facilitates its practice. Thinking about it cartographically or schematically, we can describe this hardware as a web, a network, a decentralized system – we can use the term rhizomatic to describe its infinite, uncentred, root-like structure. We can then plug in the facts of its evolution from military needs to decentralize command systems as a way to minimize the damage of strategic strikes (since no node is more prominent than any other, any severed connection or crashed component will not send the entire system into collapse). Such a reading might next bring in the filtering outwards of this technology from its origins in the war machine through to non-military applications – first science, then academia more broadly, then education more broadly still, industry, commerce, entertainment, and finally into domestic space (see Edwards 1995). And this is certainly an important story to bear in mind, since we might see traces of military–industrial ideologies still at work in the technologies we now befriend and entrust. (A similar reading could be offered for virtual reality, artifical intelligence, etc. see Gray 1997.) If we read something like a political economy of cyberspace, then, we can map onto this the workings of what we might call cybercapitalism, seeing in the systems a coding which mutates the logic of industrial (global) capitalism – domination, expansion, incorporation, consumerism – into digital, viral form (see Luke 1999). The notions of 'information rich' and 'information poor', the formation and submission of a transnational 'digital underclass', the globalization of information control and surveillance. . . these are the motifs of such a reading (see in this volume Escobar, Robins, Kroker and Kroker, Stratton, Sardar; see also Sassen 1999).

But such a mapping of hardware, while absolutely crucial, misses so much of what is going on in cyberspace. We should also begin by remembering that the term itself comes from science fiction; from the cyberpunk writings of William Gibson, who famously described cyberspace as a 'consensual hallucination'. This alternative approach intro-

duces us to two other histories of cyberspace, the traces of which have to be set aside from the one sketched above. On the one hand we have the impacts of science fiction on the ways cyberspace works for us, and on the other we have the experiential, subjective sense of the hallucinatory (wired) world we are engaging with. Let's begin with science fiction. An important component of a *cultural* approach to cyberspace is to find it in our imaginations, to read its symbolic forms and meanings, to cross-reference to the ways in which it is represented. As many of the essays in this book make clear, we need to read cyberspace at the intersections of technology and representation, and see the two as mutually implicated in constituting our approach. Hollywood, to take an obvious but important example, has given us its scenarios of the (cyber)future, which resonate through our experiences of and responses to cyberspace: from the cyborgs of *Robocop* and *The Terminator* to the implanted memories of the replicants of *Blade Runner* or Quade in *Total Recall* (on all of these, see later); from the virtual reality experiences of the *Lawnmower Man* to the techno-body horror of *Videodrome*; from hacker playing in *War Games* to the biotechno matrix of the Borg in *Star Trek: First Contact* – the images pouring out from our (filmic) screens are fed back through our (computer) screens in a loop which ultimately blends 'fact' and 'fiction', 'reality' and 'fantasy' to create our sense of cyberculture (see section two of the Reader, and, in particular, chapter 11).

What we find in cyberspace is the result of this complex interplay, which works at the level of subjectivity to produce something akin to Gibson's consensual hallucination; for if we ask the question 'Where are we when we are in cyberspace?', we have to move beyond the simple answer that, physically, we are seated in front of a monitor, our fingers at work on the keyboard (see Lupton, chapter 30). We are there, to be sure, but we're simultaneously making ourselves over as data, as bits and bytes, as code, relocating ourselves in the space behind the screen, between screens, everywhere and nowhere. Moreover, if we believe certain strings of cyberhype, when we are in cyberspace we can be who we want to be; we (re)present ourselves as we wish to (notwithstanding the constraints of the medium, which can and do serve to limit this performance – see for example the chapters in this volume by Tomas, Tsang, Foster, Stone and Nakamura); we can be multiple, a different person (or even not a person!) each time we enter cyberspace, playing with our identities, taking ourselves apart and rebuilding ourselves in endless new configurations. This phenomenon has led to much discussion of questions of identity and embodiment in cyberspace, as sections six and seven of the Reader show. The question, then, turns to '*Who* are we when we are in cyberspace?' – how much of our 'Real-Life' (RL) self do we take with us, how much do we jettison, do we fantasize new identities and bodies for ourselves, or are our imaginings always already part of the code?

To begin to think this through, let's compare the narratives of two popular Hollywood films which attempt to deal with this question. In the tech-*noir* sci-fi movie *Total Recall*, Douglas Quade (Arnold Schwarzenegger) buys past experiences – what Landsberg in chapter 11 calls 'prosthetic memories' – of a trip to Mars as a secret agent, from a kind of virtual travel agency. His identity, built from memories, is made and remade as his 'non-prosthetic' memories – which he had assumed to represent his 'real life' – turn out to be equally simulated, while his 'prosthetic' memories of being a secret agent seem

suddenly 'real'; indeed he later encounters via a pre-recorded video message his 'other' self, Hauser, who apparently *really is* a secret agent, and who says to him, 'You are not you. You are me'. The film asks us, then, to consider our faith in memory as the building block of who we are; since Quade loses this faith, he (and the audience) loses his identity, his sense of who he 'really' is. Is he, in fact, Hauser? What counts as real, anyway? If memories can be simulated, experiences prostheticized, then how do we ever find our 'true' self? (Here, of course, we see traces of the arguments on simulation made by Jean Baudrillard, whose work remains an important if controversial influence on cybercultural theory; for discussion, see, for example, Kellner 1995.)

A similar state is experienced by computer expert Angela Bennett (Sandra Bullock) in the conspiracy thriller *The Net*. The extent of her (and our) reliance on cybertechnology to 'prove' who we are is frighteningly apparent to Bennett when her identity is effectively erased and then rewritten by the Praetorians who are infiltrating supposedly secure computer systems on the path to global domination. Bennett is rewritten on databases as a petty felon, Ruth Marx; despite her protestations, she effectively *becomes* Ruth Marx, since she is unable to prove that she is *not* – computers say that's who she is, and no one would question what a computer tells them. Bennett is depicted as the stereotypical computer 'nerd', with hardly any social connections in RL – though the film-makers stop short of making her *look* like the stereotypical nerd (on constructions of computer nerds, see Lupton, chapter 30) – and her near-total reliance on life on-line renders her completely vulnerable to this identity rewrite, since no one knows her other than via a screen.

In both films, identity is no longer something internal, essential, fixed, or trustworthy: it is something which exists cyberculturally, either as a series of memory implants or as the composite of our digitized personal records; moreover, it can be faked, even erased. The narratives of *Total Recall* and *The Net* work to focus on the instability of this *dis*-location of identity, as the flipside of those other narratives which stress the freedom that on-line life offers (in terms of making ourselves over in cyberspace, rather than being made over). Ultimately, this raises a further question (though this is outside of the plot of *The Net*, but dealt with more fully in movies like *Blade Runner*): if we rely so totally on technology to locate ourselves, to even *be* ourselves, does that mean we are still 'human' – and is it still possible (or even desirable) to define the boundary between the human and the machine?

Intimate machines

The question of the human–machine interface has occupied a central place in discussions of cyberspace, especially in relation to its effects on our experiences of embodiment and subjectivity. Are we now so inseparable from our computers that we have effectively become them? Are they us? Are they extensions of our identities – prostheses? Do we blend with them, each incorporating the other, to become hybrid cybernetic organisms – cyborgs? Like Angela Bennett, do we find ourselves existing more and more through technology, through computers, *in* computers? At both individual and collective (societal) levels, we have given our lives over to technology, entrusting computers in

ever more ways – hence the conspiratorial narrative of *The Net*, that world domination now means *information* domination. In Sherry Turkle's (1996) phrase, the personal computer is an 'intimate machine'. As a trope in Hollywood sci-fi, the 'dark side' of technological dependency appears almost ubiquitous; witness the war machines of the *Terminator* series, built to automate combat but instead turning paranoid, destroying all humans (just as the computer HAL in *2001: A Space Odyssey* flips out and turns on his human shipmates).

Of course, the counter-narrative to this is to be found in, for example, arguments for post-humanism, which advocate our co-mingling with technology (see section seven). A new union of meat (our bodies) and metal (technology) offers the next great leap forward here, the only logical outcome of the cybercultural trajectory; this is outlined in the 'Post-Human Manifesto':

> All technological progress of human society is geared towards the redun-
> dancy of the human species as we currently know it. . . . Complex machines
> are an emergent life form. . . . As computers develop to be more like humans,
> so humans develop to like computers more.
>
> (Pepperell 1995: 180)

The 'redundancy of the human species as we currently know it' doesn't here equate with *Terminator*'s view of man versus machine; instead, it means co-evolution, increasing prostheticization, augmentation, cyborgization: as Stelarc imagines it, we and our machines become one – in a way, already have become one (see chapter 35). As the boundary between human and machine blurs, as the technologization of culture quickens pace, so we enter into the age of post-humanism. And, as the Manifesto says, part of this process involves learning to love rather than fear the technology: in place of *The Net*'s paranoia and distrust, post-humanism urges us to welcome our incorporation into cyberculture (and its incorporation into us), to stop worrying about who we are and who/what we might be in the future; to let our selves go.

But let our selves go into what? To become what? What do our imaginings of this co-mingling of meat and metal bring forth? In one sense, we have already seen perhaps the most powerful of these imaginings, in the figure of the cyborg. The explosion of images of cyborgs (and theorizing about cyborgs) has given us a repertoire for recon-figuring the body–technology interface, and this has become so central to cybercultural work that we need to spend a little time with the cyborgs here (and see also sections two, four, six and seven). While we should point out that cyborgization does not equal post-humanism, the cyborg stands as a potent figure to help us think through our rela-tionships with machines, and theirs with us. In 'Social policy for cyborgs' (1999), Tony Fitzpatrick offers up a usefully broad attempt at defining this figure for us:

> The cyborg is the interface of the organic with the technological; the tech-
> nicizing of the human *and* the humanizing of technology, i.e. the body as
> both the hardware *of* machines and software *for* machines. . . . The cyborg
> is partly the product of surgical implantation, where the machine and/or the
> simulations it generates (as in cosmetic surgery) penetrate the surface of the
> body. The cyborg is also the product of the daily interaction of perception/

cognition with the screen, where the body melts into the electronic images that it receives, reflects and transmits.

(Fitzpatrick 1999: 97)

What this means is that Angela Bennett is no less of a cyborg than, say, Murphy in the movie *Robocop*; if we take the concept of the cyborg to include not only techno-logical augmentation of the human body (the *Robocop* variety) but also 'the identity of organisms embedded in a cybernetic information system' (Balsamo 1996: 11) – as in *The Net* – then we can begin to think about the extent to which all our lives are turning cyborg. In fact, arguments can be (and have been) made that would extend this idea to cover every meeting of people and things out of which something new – something irreducible to either the person or the thing – then emerges. Take a number of more or less random examples from recent cybercultural work: Deborah Lupton (1999) argues that the car/driver combination is one of cyborgization (something that clearly resonates through the following introduction by Barbara Kennedy); Kwok Wei Leng (1996) uses the cyborg to think through the female menopause and hormone replacement therapy (HRT); in ultrasound imaging, Lisa Mitchell and Eugenia Georges (1998) find the 'cyborg foetus'; and the forty-plus essays in Chris Gray's *The Cyborg Handbook* (1995) push the cyborg in every conceivable direction, tracking countless manifestations. From that collection, David Hess' essay 'On low-tech cyborgs' argues persuasively that 'almost everyone in urban societies could be seen as a low-tech cyborg, because they spend large parts of the day connected to machines such as cars, telephones, computers, and, of course, televisions' – and he goes on to ask whether even 'a person watching a person watching a TV might constitute a cyborg' (Hess 1995: 373). Thanks to Donna Haraway's provocative manifesto-writing (see chapter 18, the cyborg *metaphor* can work with this kind of question, always troubling distinctions, disrupting assumptions, unsettling bound-aries: human/machine, nature/culture ... in Haraway's essay, the cyborg metaphor playfully skips around these binaries – which have been the building blocks of Western metaphysics throughout modernity – fuzzying them (see also Latour 1993).

To the extent that cybertechnologies are implicated in all of our lives, then – and we could argue that systems such as the transnational commodity markets make this a truly global experience that can impact on anybody's life, no matter where they are and how seemingly removed they are from that technology (see Sassen 1999) – we are all, to some degree or another, becoming cyborg. Perhaps, though – and this is also to return us to Hollywood's cyborgs – we need to add something else to Hess' cyborg theorizing: are we only cyborgs to the extent that we *experience ourselves as cyborgs*? Robert Rawdon Wilson (1995: 242) refers to this as *prosthetic conscious-ness*: 'a reflexive awareness of supplementation'. Even if we don't use such terminology, we can argue, I think, that many of us do experience ourselves in this way – we come to rely on technology more and more, and often feel simultaneously enabled, even thrilled, by this (how much harder would it have been for me to put this User's Guide together with a pen and paper?) *and* a little uneasy, if we feel dependent (could I, in fact, have done this at all, on pen and paper – or can I only think/write with the help of my computer now? – see Lupton on this). Does this make me a cyborg? Am I part of a lineage which branches out to include Arnie (whether as the Terminator or Quade/Hauser,

or in his role as a pregnant male scientist in *Junior*, or even just Arnie *as Arnie* with his muscles enhanced by pumping iron and pumping steroids) as well as anyone taking Viagra, or with a pacemaker, or riding a bicycle, or withdrawing cash from an ATM, or acting out their fantasies as Lara Croft in the latest *Tomb Raider* game or as a Nato bomber pilot blitzing Kosovo, or anyone watching footage from Kosovo live on the late-night news?

Cyborg life

If we are going to think about cyborg experience (we might term this *cyborg ontology*, or perhaps *cyborg consciousness*), we need to take up Arturo Escobar's call for ethno-graphic/anthropological work in cyberspace, which can help us understand how different user-groups understand and negotiate cyberculture. Sherry Turkle's work with kids and cybertechnology, for example, shows the ways in which cyborgization is made sense of by children – and this is important to look at here, for kids are in one way at the cutting edge of cyborg theory, since they are less pre-programmed with or troubled by preconceptions about things like binaries. In 'Cyborg babies and cy-dough-plasm' (1999), Turkle discusses children's dealings with an assortment of cybercultural artefacts – computer games, artificial life programs, robots – and shows the ways in which they formulate new and complex understandings of 'life', consciousness, and the distinction (or lack of distinction) between the biological and the technological. The recent craze for cyber-pets (Tamagochi) reads in the same way: while many adults found the bridging of the bio-techno boundary ridiculous, and assumed children to be woefully naïve in treating cyber-pets as 'alive', kids' interactions with the pets opened up a new kind of thinking about what 'life' is – as Turkle says, children think of computers as 'sort of alive' (319); or, to use the famous Spockism from *Star Trek*, it's life, Jim – *but not as we know it*. This, too, is part of what cyberculture is all about – new kinds of rela-tionships with technology (see Lupton, chapter 30, Terranova, chapter 17, and section seven). As the Post-Human Manifesto says, complex machines are indeed legible as emergent life-forms – but only once we expand our definition of 'life' (see also Bec 1997).

 Empirical work on our interactions with computers, then, begins to reveal the extent of our cyborg consciousness – and the ways in which we negotiate the 'doubleness' of desire and dread which machines can evoke in us. Lupton's chapter 'The embodied computer/user' picks out some of the experiential realities of the more day-to-day inter-actions that many of us have; she shows us something of what actually goes on 'in cyberspace'. A later co-written paper (Lupton and Noble 1997) expands this work to look at the strategies users deploy to place their computers in what they consider to be 'appropriate' symbolic space in their lives – especially in terms of the extent to which they 'humanize' their machines, by giving them names, establishing emotional relation-ships with them, trusting them (and then feeling betrayed when they fail). This clicks us back in to the earlier discussion of post-humanism and cyborg consciousness, since Lupton and Noble asked respondents to consider their relationships with their computers (at least implicitly) in those terms:

Many people using computers on an everyday basis appear reluctant to acknowledge or embrace the notion of the 'post-human body', preferring to continue to draw rigid distinctions between 'human' and 'technological arte-fact'. Nonetheless, while most participants denied a propensity to humanize their personal computers, the ways they talked about them often betrayed a suggestion that they did invest their computers with human qualities such as agency, moods and emotional reactions, particularly in times of frustration, when the technology failed to 'work'.

(Lupton and Noble 1997: 94)

Of course, as Lupton and Noble point out, computers are increasingly designed and marketed to lend themselves to humanization; if I leave my machine unattended for a few minutes, a message flashes to cajole me to 'Please wake up'. At other times, it offers advice, sometimes questioning my commands ('Are you sure you want to delete this file?'). Sometimes it 'speaks' in a language I can't understand ('An error of Type 2 has occurred'), making me feel inadequately 'techie' (especially as someone who teaches and writes about cyberculture). Remembering what we said earlier, about the need to see computers as technocultural artefacts, my experience of machines is always medi-ated by cultural factors, too; I'm never just sat at my computer, typing, without simultaneously logging on to all the ideas and images that clutter the mediascape (and my own mindscape); cyberpunk moments, cybertheory moments, tech-*noir* moments, cyborg moments flicker across my screen. 'Reality' is, then, always already virtualized in the whirl of data that connects in ever-different ways in the rhizomes of our brains and the rhizomes of our machines.

Nowhere is this more apparent than in certain 'hi-tech' cybersubcultures – micro-cultures which expressively blend and mutate the 'facts' and the 'fictions' of cyberspace (see in this volume Sobchack, Terranova, Tomas). Here we witness cybercultural work which reflexively (sometimes ironically) works within and between the human–machine interface, that pulls in past, present and future experiences and perspectives (hippie idealism, modern primitivism, technophilia, cyberpunkishness) to fashion a family of *creolized* (culturally-mixed or hybridized) techno-tribal identifications: hackers, techno-shamans, Extropians, cybergeeks, New Age and New Edge cybergurus and acolytes . . . (see also Dery 1996; Leary 1994; *Mondo 2000* 1993; Rushkoff 1997; Taylor 1998). While such groups are often too easily dismissed as fringe activists (even freaks), we should try to read their subcultural work in a more productive way, wary of the manner in which hackers, for example, have been both demonized and infantalized (or at least 'adolescentized') by the mass media and by corporate cyberculture. As Andrew Ross shows in chapter 16, 'Hacking away at the counter-culture', the moves that make this possible also work to deny the hacker's threatening presence as an 'enemy within' – someone with knowledge and machine skill combined with maverick sensibilities. What such groups do, ultimately, is to perform a *critical* function; reminding us that we are perhaps being carried along a bit too easily by a cybercultural teleology that both seduces and scares us, and which we could perhaps be responding to in more creative, less predictable ways.

Ross' essay urges us to take up the hacker's stance of 'techno-scepticism', of *informed* critique rather than ignorant technophobia (or technophilia), and this takes us back to

the 'Embodied computer/user'; Lupton notes how little many users know about their computers, and how this accounts for our ambivalent perspective on them. Hackers amplify that by showing how much more than us they know. And that's why computer viruses carry such potency: as much as the actual damage that any virus may do to an operating system, the *thought* of the virus and its possible consequences induces panic in users, producing a kind of ambient fear that infects users much more than it effects computers (on computer viruses, see Lupton 1994). Scaremongering rumours of viruses circulate and proliferate endlessly via email, to the extent that they themselves become viral. We can read this scenario with the help of Richard Thieme's essay (chapter 14) on the conspiratorial logic of the Net. The concept of the *meme* – a 'contagious idea' which spreads through the system – helps us to understand viral panic. If we receive a message, no matter who from, warning us of a new, virulent strain of computer virus hidden inside some seemingly innocuous email message, we have no real choice but to believe it – and that carries with it the duty to inform all our virtual neighbours. Receive a few such messages and we start to suspect any unfamiliar incoming email of harbouring a virus: the sterile, impermeable machine is compromised by the ever-present threat of contamination (a recently-released computer game, *Virus*, allows us to play out these anxieties; it copies the files from our hard drive, then lets loose a malevolent virus to destroy them – only in this game, we can combat the virus, fighting to protect our data). Viruses, then, tell us some important things about our relationship with computers – as, indeed, do computer games like *Virus*.

Sexing the cyborg

Before we completely lose the figure of the cyborg, we need to focus on one more key area of debate in cybercultural theory: cyberfeminism. Among the most provocative and productive work emerging at the human–machine interface (whether at the level of theory or of practice, or, indeed, of both), cyberfeminist thinking has used the cyborg metaphor – following Donna Haraway's lead – to begin to retheorize gendered and sexed identities in the digital age. Part of this work centres on a critique of the masculinist boys'-toys construction of machines and machine-work, seeking to find ways for women to access virtual worlds on their own terms (see Wakeford, chapter 21). This calls for a reorientation of feminism and the sexual politics of technology – as well as the technology of sexual politics (see Wajcman 1991). 'Wired women' and Harawayan cyborgs work to find, then, a feminist politics of technology – part of what is sometimes named 'post-feminism' (see section four). As we see in the work of, for example, Chela Sandoval, a different mode of 'cyborg consciousness' is here invoked: one which works in-between categories, unsettling those binaries that once connected man to technology, woman to nature, and locked the two sets in an opposition (man/woman, technology/nature), always weighted to privilege one term over the other. This shift doesn't simply mean reversing the terms of the binary, so that privilege slides over, or a simple reshuffle (to equate women with technology) – it means a *deconstructive* move that negates fixed positions. As Haraway says, science fiction has given us its cyborgs; now cyberfeminism has given us new ways of thinking the cyborg, sometimes liberatory and sometimes more cautious

(for those who see digital technologies, for example in biomedicine, as invasive and appropriative; for a discussion, see Kember 1999). This cyberfeminist cyborg is not a unitary figure, then; while there is a clustering of readings/writings of the cyborg that link back to Haraway, the strands and pulses of cyborg theory found in cyberfeminism ripple outwards in almost infinite manifestations (compare in this volume, for example, Springer's chapter with Sandoval's or Plant's; and see Kennedy 1999).

Barbara's introduction 'The "virtual machine" and new becomings in pre-millennial culture', which follows this User's Guide, works through some of these issues, through what we might call a *poetics of cyborgization*. Her car/computer metaphor (much more than a metaphor, given the crash-consciousness which explodes through her essay) also signals a key theoretical influence in cybercultural theory: the philosophies of Gilles Deleuze and Felix Guattari. The writings of Deleuze and Guattari have resonated across the regimes of academia in recent years, influencing not only traditional philosophical discourses, but also the fine arts, literature, music, economics, law, film theory and most specifically cultural theory and cultural studies. Their work therefore has a major role to play in the ways in which we relate to cyberdiscourse. Reading their work alongside some cybercultural texts lends a creative array of ideas from which to approach dialogue and debate. Their texts are wide ranging (both in timescale and in content), multiplic-itous and often contradictory, but the significance of their ideas has been in the critique of foundational and structuralist thinking, found in traditional discourses, specifically psychoanalysis.

Anti-Oedipus (*L'anti-Oedipe*, 1972), perhaps their best-known text, offers a critique of psychoanalysis, where desire is theorized through negative and transcendent para-digms. Instead, Deleuze and Guattari argue that desire is processual, aleatory and positive, and cannot be merely relegated to the Oedipal myths and scenarios of Freudian psychoanalytic frameworks. Their discussion of the desiring-machine as production formu-lates a model of the unconscious premised outside the theatrical myths and narratives of Freudian theory. The unconscious is rather something that can be *produced*.

Much of their collaborative work is written in a rhizomatic format, which as explained earlier is not meant to be read as a simple, linear or logical narrative. Such works take a wider look at the creative connections across literature, poetry, the arts, music, and theoretical. Refreshingly creative and inspirational, the style of *A Thousand Plateaus* (*Mille plateaux*, 1980) provides an innovatively-framed poetics/anti-philosophy, which distanciates metaphysical and binary thinking, offering new languages for theo-retical contexts. One of the main lines of flight (an expression Deleuze and Guattari use to explore creative possibilities in thinking processes) is their definition of the 'body' as something outside its determinations within binary thinking. Thus the body is recon-ceived outside any notion of its role as a corporeal or biological amalgam (the 'body without organs'). The definition of the body becomes polysemous, complex; such new definitions of the 'body' become central to rethinking the 'body' in cyberculture (see Kennedy, 2000).

Both Deleuze and Guattari have produced texts which inspire and provide pallettes through which we might think the language of cyberculture (of course their relevance is much wider than this); such concepts as force, intensity, volition, sensation and machinic. 'Machinic' is perhaps the concept which most strikes us in cybercultural theory.

In their work, the concept of 'machine' becomes much more complex than the traditional description of machine as the opposite of nature. Language, argues Deleuze, has been insufficient to explain the experiences of being (Deleuze 1980). He refers to a wider concept called the 'abstract machine', which operates outside of the formalistic structures of linear and logical language, and which incorporates the pathic, the gestural and the transitivist elements felt at levels deeper than verbal language.

Guattari's *Chaosmosis* (*Chasmose*, 1992) provides a consideration of the machine within a wider framework, what he calls a neo-aesthetic paradigm. From a description of the production of subjectivity, emphasizing the heterogeneity of forms from the pre-personal to the media and technological, Guattari considers the nature of the machinic in much more amorphous ways than the merely technological. Here 'machinic' becomes a term which might describe the ways in which a whole range of different elements compose our experiences of being and existence; from the physical, the material to the psychological and the perceptual. The 'virtual ecology' which Guattari describes in *Chaosmosis* is a way of explaining the interrelationship of elements across the pathic, the gestural, the transitivist, and the pre-personal states of our experiences, in relation to the material world we inhabit. He advocates a revised aesthetic consideration of new ways of being, and new ways of living, which provides mutant forms of collective understanding and collaboration. The machinic is a way of describing the fitting together, the working together, in a relational way, of different elements of our existences. The *virtual machine* is much more than a technological machine in the traditional sense. It breeds from complexity and chaos and is dependent upon relationality across different elements; material, cultural, technological and psychical. In thinking through the various sections of the Reader, such ideas have a significant part to play in cyberdiscursive theory.

We can trace Deleuze's and Guattari's thinking through Barbara Kennedy's introductory essay. In using the motif of the near-death car crash, she confronts the human–machine interface, looking for a 'new becoming', echoing Stephen Metcalf's writing on J. G. Ballard's novel *Crash* and crashing:

> Crash is followed by reconstruction as the virtually dead body is redesigned by means of life-support machines and prosthetic organs. The normally assigned boundaries of the body having been breached, wounded beyond recognition, the subject recedes into an ambient disappearance in the environment. No longer the sentinel controlling the flows of traffic between the interior and the exterior, the subject is diffused across a virtual machine.
>
> (Metcalf 1998: 112)

Subjects diffused across a virtual machine? The phrase has a hint of Gibson's consensual hallucination in it, or of Deleuze's and Guattari's work on the machinic and redefining the body. The crash body, then, is a cyborg body; not just in its banal meat-meets-metal sense, but in the way that Barbara shows: through a suspended still-point where subjectivity, identity, boundaries cease to exist, where all that is solid melts into air, where sensation, experience, memory, pleasure and pain co-mingle, mixing and morphing – a cyborg moment. 'Life continues'. Cyborg life.

References

Balsamo, A. (1996) *Technologies of the Gendered Body: Reading Cyborg Women*, Durham: Duke University Press.

Bec, L. (1997) 'Squids', in V2_Organisation (eds) *Technomorphica*, Rotterdam: V2_Organisation.

Deleuze, G. and Guattari, F. (1972) *Capitalisme et Schizophrénie tome 1: L'anti-Oedipe*, Paris: Editions de Minuit.

—— (1980) *Capitalisme et Schizophrénie tome 2: Mille plateaux*, Paris: Editions de Minuit.

Dery, M. (1996) *Escape Velocity: Cyberculture at the End of the Century*, London: Hodder & Stoughton.

Edwards, P. (1995) 'Cyberpunks in cyberspace: the politics of subjectivity in the computer age', in S. L. Star (ed.) *The Cultures of Computing*, Oxford: Blackwell.

Fitzpatrick, T. (1999) 'Social policy for cyborgs', *Body & Society* 5(1): 93–116.

Gray, C. (ed.) (1995) *The Cyborg Handbook*, London: Routledge.

—— (1997) *Postmodern War: The New Politics of Conflict*, London: Routledge.

Guattari, F. (1992) *Chaosmose*, Paris: Editions Galilee.

Hess. D. (1995) 'On low-tech cyborgs', in C. Gray (ed.) *The Cyborg Handbook*, London: Routledge.

Kellner, D. (1995) *Media Culture: Cultural Studies, Identity and Politics Between the Modern and the Postmodern*, London: Routledge.

Kember, S. (1999) 'NITs and NRTs: medical science and the Frankenstein factor', in Cutting Edge (eds) *Desire By Design: Body, Territories and New Technologies*, London: I.B. Tauris.

Kennedy, B. (1999) 'Post-feminist futures in film noir', in M. Aaron (ed.) *The Body's Perilous Pleasures: Dangerous Desire and Contemporary Culture*, Edinburgh: Edinburgh University Press.

—— (2000) *Deleuze and Cinema*, Edinburgh: Edinburgh University Press.

Latour, B. (1993) *We Have Never Been Modern*, Hemel Hempstead: Harvester Wheatsheaf.

Leary, T. (1994) *Chaos and Cyberculture*, Berkeley: Ronin.

Leng, K. W. (1996) 'On menopause and cyborgs: or, towards a feminist cyborg politics of menopause', *Body & Society* 2(3): 33–52.

Luke, T. (1999) 'Simulated sovereignty, telematic territoriality: the political economy of cyberspace', in M. Featherstone and S. Lash (eds) *Spaces of Culture: City, Nation, World*, London: Sage.

Lupton, D. (1994) 'Panic computing: the viral metaphor and computer technology', *Cultural Studies* 8(3): 556–68.

—— (1999) 'Monsters in metal cocoons: 'road rage' and cyborg bodies', *Body & Society* 5(1): 57–72.

Lupton, D. and Noble, G. (1997) 'Just a machine? Dehumanizing strategies in personal computer use', *Body & Society* 3(2): 83–101.

Metcalf, S. (1998) 'Autogeddon', in J. Broadhurst Dixon and E. Cassidy (eds) *Virtual Futures: Cyberotics, Technology and Post-Human Pragmatism*, London: Routledge.

Mitchell, L. and Georges, E. (1998) 'Baby's first picture: the cyborg fetus of ultrasound imaging', in R. Davis-Floyd and J. Dumit (eds) *Cyborg Babies: From Techno-Sex to Techno-Tots*, London: Routledge.

Mondo 2000 (1993) *A User's Guide to the New Edge*, London: Thames & Hudson.

Pepperell, R. (1995) *The Post-Human Condition*, Oxford: Intellect.

Rushkoff, D. (1997) *Children of Chaos: Surviving the End of the World as We Know It*, London: Harper Collins.

Sassen, S. (1999) 'Digital networks and power', in M. Featherstone and S. Lash (eds) *Spaces of Culture: City, Nation, World*, London: Sage.

Taylor, P. (1998) 'Hackers: cyberpunks or microserfs?', *Information, Communication & Society* 1(4): 401–19.

Turkle, S. (1996) *Life on the Screen: Identity in the Age of the Internet*, London: Weidenfeld and Nicolson.

—— (1999) 'Cyborg babies and cy-dough-plasm', in R. Davis-Floyd and J. Dumit (eds) *Cyborg Babies: From Techno-Sex to Techno-Tots*, London: Routledge.

Wajcman, J. (1991) *Feminism Confronts Technology*, Cambridge: Polity.

Wilson, R. (1995) 'Cyber(body)parts: prosthetic consciousness', *Body & Society* 1(3–4): 239–59.

BARBARA KENNEDY

INTRODUCTION II
The 'virtual machine' and new becomings in pre-millennial culture

WARNING: JACKING IN WILL BE EXTREMELY HAZARDOUS. In many ways this is no ordinary introduction. Endings and beginnings mingle in an assemblage of deterritorialized subjectivities. Endings and beginnings repeat the Eternal Return. Whilst this book is a Reader in cyberculture, a collection of the work of many writers, the intentions of this introduction are to offer some connecting thoughts, some ways of thinking, some intensities which will provide a plateau for engagement with the collection itself and a way into thinking the endless possibilities within the theoretical domains of cybercultural experience.

This introduction sets out to meld some formal techniques of writing together with some 'polymorphous outpourings of subjectivity' experienced as a result of the intense moment of a near-death experience . . . a near-fatal car cash . . . a full stop . . . blank screen . . . but an inertia that was at the same time potential movement and a new beginning. The joyful cruelty of 'becoming'.

What has this to do with cyberculture? Why has a car 'crash' any significance to a Reader about cyberculture? The computer, of course, is not unlike the car (see Lupton 1999); both are machines, in the literal and traditional sense of the word. Video games and virtual reality can emulate the exhiliration and thrills of speed and power felt behind the wheel of the car, both dangerous but pleasurable spaces. Indeed, in the movie *Tomorrow Never Dies*, James Bond (Pierce Brosnan) drives/jacks into the controls of his car which is simultaneously a computer. He literally sits inside the machine, becomes part of the machine, finger tips at the small digital control pad. Leaving aside all those phallically-conceived semiotics which the car and computer share (why is it that my two sons endlessly love the control pad of their computer console, driven to compete for the highest score, the fastest 'rush'?) – such a decoding is boringly prevalent in the now redundant discourses of Freudian psychoanalysis – driving the freeway or the super-highway nonetheless involves similar experiences: pleasure, exhiliration, *jouissance*,

control (or lack of), and of course a possible disembodiment or death ... *restless machines*!

Princess Diana's death by car crash joins a long line of romantic and mythologized gods/goddesses of popular culture: James Dean, Marilyn Monroe, Grace Kelly, etc. The car crash 'deifies' the beauty of the inaccessible, the unrequited desire; the 'lack' that constitutes desire. But here we are merely reflecting on that hotbed of contempt – psychoanalysis. In late twentieth-century cyberculture, the computer takes over the role of the car; certainly it is imbricated within the *techne* of newly-built cars. They are hardwired (and not far off Bond's model) for cybernetic control. Computerized equipment fills the dashboard of the latest models (see Dery 1997).

The car has been a near-sacred object in twentieth-century history. Symbiotically, the computer is similarly taking on this deified existence in our culture. Not as a vehicle for transportation through our material existence, but through a virtual space, outside the realm of physical, bodily movement. The computer is a means towards a different form of travel ... a mind space, a mindset even, where the body, it could be argued, is eviscerated, rendered immobile, at the expense of the consciousness. It might also produce a different space for the desires and pleasures of disembodiment. But where *is* the body in the hyperspaces of cyberculture? Several chapters in the Reader contest the role of the body, its new configurations, and its post-humanist manifestations (see sections five and six).

What connects the car and the computer is the structure connecting human and machine, the *interface* between those two spaces. The pleasures of the interface (Springer 1996) may offer near-death *jouissance*, that *petit mort*. The pleasures of the interface open up interrogations of ontological and epistemological concerns such as the definition of the real, the human, identity, subjectivity, cognition and sensation. Political and ethological issues as to the nature and significance of gendered identity are also brought into focus. Jacking in to cyberspace may be a 'jouissancial' experience for console junkies, cyberbabes and trendy Trekkies, but its implications for interrogating socio/aesthetics are becoming increasingly apparent and urgent.

This introduction is written in an experimental mode of address, not as an academic text, nor like the more usual introductions to a collection of essays. Some will recognize the twists and leaps taken from colourful theoretical pallettes. Some may be suspicious of its Artaudian dramatic drawl, critical that this is no place for self-conscious creative prose or contagious outpourings. Why not? What justifies such legitimations? I don't apologize, for in that sensuous, transversal and often stream-of-consciousness style of writing is a serious inception and invitation to rethink some of the basic categories of Western thinking: the nature of subjectivities, identities and the body in connection with technology and nature. Felix Guattari (1992) defends *delirious narrative* as a discursive power for the construction and reconstruction of mythical, aesthetic, even scientific worlds. Ironies of course abound. An introduction wallowing, some may say, in the self-pity of subjectivity (such irony!) tries to position a consideration of a virtual machinic existence which deterritorializes that subjectivity.

Subjectivity, for example, has been theorized within Western discourse primarily through a dialectical concern with a self/other dichotomy. Psychoanalyis has offered theoretical insights into the structure of a subjectivity created through such binary

concepts. But psychoanalyis is too strangely familiar and evocatively redundant in the new world disorder of cyberculture. Psychoanalysis cannot explain subjectivity sufficiently, due to the fact that it reduces social factors and affective states to the realm of psychological mechanisms. Much Continental philosophy (such as that of Deleuze and Guattari) has some purchase in such debates. I only want to signal tangentially their significance here, as this introduction serves merely to signpost new areas of thinking, rather than explore them fully. The reader might like to follow up the references provided, or trace such theoretical presences through the essays in the Reader.

Some brief description might encourage that connectivity. Deleuze and Guattari offer an exploration of the production of a subjectivity not premised on a self/other dichotomy. The production of subjectivity, writes Guattari (1992), is more complex, and involves the affective intensities of a pre-personal stage of subjective encounter; subjectivity is produced through a-signifying regimes as much as signifying regimes. In other words, subjectivity is not merely predicated on the realm of the *signifer* and language alone. The pre-subjective states are felt before a subjectivity constructed through language. The pre-linguistic production of subjectivity might account for the intensities of 'feeling' which cannot be theorized through language. Taking his lead from the work of Daniel Stern, Guattari looks to ethology (the science of animal behaviour applied to human behaviour) as a means of understanding the structures of pre-subjective states. Guattari discusses the machinic nature and heterogeneity of subjectivity (here the 'machinic' takes on a much more abstract sense: 'technological machines operate at the heart of subjectivity, not only within its memory and intelligence, but within its sensibility, affects and the unconscious fantasms'). The ghost in the machine is at the 'heart' of us all.

This questioning of the subjective and the pre-subjective becomes one of several vital questions in any discourse on cyberculture, since any use of the computer (like driving that ultimate 'machine', the car), whether through the web, email transactions, bulletin boards etc., involves some sense of what we know as a 'subjective' encounter. That mind-space might be a place for subject empowerment, pleasure, play and creative connection. This cultural space in cyberculture is known as 'cyberspace'. Whilst Michael Heim (1992) writes that cyberspace is 'a tool for examining our very sense of reality', Howard Rheingold suggests that 'cyberspace is a human–computer interface, but it is also a mind-space, the way mathematics and music and myth are mind-spaces – mind-space you can walk around in and grab by the handles'. The relational elements across human/machine/nature, then, are key.

However, one of the questions we might ask is: are these relational elements in fact separable, or is there a more significant consilience across their architectures? – a greater 'force' propelling new intensities of thinking and imaging: a 'virtual machine', which develops outside traditional conceptions of subjectivity (Guattari 1992). Brian Massumi, for example, following from Deleuzian philosophy, writes that 'there is only one world, one nature and – below the quantum level of matter and beyond the synapses of our brains – one unified field' (Massumi 1992). Where is the body in this assemblage? The body is only a natural object, and 'has its own phylogenetic structure: from the point of view of social forces that seize it', Massumi writes, 'it is as much a raw material to be moulded, as is wood'. But questions concerning the machine are multiple and varied. In traditional philosophical discourse, the machine has been seen

in opposition to the organism. But cyberculture might better be understood and inter-rogated through more complex connections across the nature of the machinic and the organic, and the implication of those definitions for considering the concepts of nature, technology and the body. Guattarian discourse, for example on machinic heterogenesis and the emergent virtual machine of pre-millennial existence, is particularly appropriate to re-thinking what we mean by the 'machinic' (Guattari, 1992).

Dagognet has suggested that there never was any separation across the categories of nature/culture and technology, but that all three are imbricated in an interrelational complex. As Allucquere Rosanne Stone writes, 'François Dagognet suggests that the recent debates about whether nature is becoming irremediably technologized are based on a false dichotomy: namely that there exists here and now, a category "nature" which is "over here" and a category "technology" (or for those following other debates, "culture") which is "over there".' Dagognet argues on the contrary that the category nature has not existed for thousands of years; not since the first humans deliberately planted gardens or discovered slash-and-burn farming. Indeed, Stone expands upon this to provide new definitions of the concept of nature as a 'construct, by means of which we attempt to keep technology visible as something separate from our "natural" selves and our everyday lives'. Similarly, Baudrillard (1983) has posited that 'the boundaries between technology and nature are in the midst of a deep restructuring: the old distinc-tions between the biological and the technological, the natural and the artificial, the human and the mechanical, are becoming increasingly unreliable'. Questions about the interconnections across nature/culture and technology, their productions and of course their significance within cyberculture are key issues, then, in this collection.

This introduction offers an interrogation of issues that are fundamental to human social and aesthetic engagement in a pre-millennial cyberculture. Cyberculture provides languages and knowledges through which we can begin to explore and examine the emer-gence of the 'virtual machine' in a pre-millennial temporal/spatial zone. The virtual machine of pre-millennial culture provides a construal, a mingling at a molecular level, of organism and machine. Organisms, previously disintegrating, changing or ossifying in terms of 'human' genetic and molecular cells, are in fact producing an emergent machine/organism, a new evolution in genetics and a new organism. For this to develop, Guattari and Deleuze write, the 'organism' has to be dismantled. What happens to subjec-tivity in the dismantling? As several chapters in the Reader explore, a new connection of machine/organism becomes part of the creative landscape of cybercultural technolo-gies, a landscape in which subjectivity is frequently challenged, ossified or at least deterritorialized.

Both editors of this Reader have envisioned the text as a collection and a machinic performance, a text to be created as a choreography, an abstract machine to be assem-bled or produced as an event, by the reader her/himself (selves). We invite the reader to taste, feel and move with the words, the tones, the images and the rhythms of this introduction, equipped to then feel some experimental flights between, across and through the interstitial spaces within the book. Those not brave enough to fly alone, preferring the more sedate pages of a linear, 'logically' framed book (such loss of *jouissance*!) will be helped by the User's Guide, which offers some points of contact and compar-ison across the Reader.

... Endings and beginnings ... not a smear nor a blemish, neither ripped flesh nor corruscated muscle, but a pure shell-like face, no mark, no blood, save a tiny morsel of glass in her third finger, left hand. Dressed in black ... shimmering satin chemise to classy culotted trousers, shoes delicately tilted, exposing a recently suntanned ankle, strangely tilted, unnervingly perfect ... a point of stillness. Stillness in time, in space, in being. A full stop in the middle of a processual flight through irreversible fantasies. Had this been an alien abduction? What sense of alien ... alien ... alien-ation ... the subject removed from its body ... was she feeling at that moment, that inorganic point of finality in death ... reminiscent of Freudian origins? Beyond the Pleasure Principle. The Garden of Eden was where this 'mother' returned. And yet, that death had only been in the still point of her consciousness. The body, limp and lifeless, felt a nervous twitch, a new becoming, a continuum of her 'human' consciousness in a new world disorder ... a becoming-other. What Symbolic Exchange was this, that kinetically propelled her from one state to another, through which a total immersion with the machine and nature were imbricated through her body ... all part of the same 'virtual machine'. Nature, human and technology in total synthesis. ... But this was me, me myself ... I. I think, therefore I exist. Cogito ergo sum. Is this merely the myth of cultural contamination, because of course I really don't exist? Or do I?

Cyberculture marks the current state of twentieth- (going on twenty-first-) century experience, a pre-millennial convergence of man, mind and technologies interlocking through nature, the ether of molecularized matter and the ultimate machine within the bigger machine, the computer. Scott Bukatman (1993) writes, in *Terminal Identity*, 'nuclear destruction, like the apocalyptic car crash of Ballard's *Crash*, represents the ultimate interface with the realities of a technologized existence'. In my own interface with technology, *my* 'crash', my own near-death experience — this was no Hollywood-induced sensation, no box-office formula for profit (what is it that makes death so intensely intriguing and jouissancial to those who merely 'watch'?). One witness (male, of course) said it was *the best stunt he had ever seen*. Was I really only an item for a Jeremy Clarkson charade? I was propelled by massive voltage waves through the air at 60 miles per hour, swirling in a vortex, unsure whether this was real or whether I was really only dreaming ... a dream which became too real ... human, all too human, when I hit the metal road sign at full velocity ... escape velocity ... stop ... then landed in the soft, mossy earth ... another place, another zone, an imperceptible zone. A return to the Garden? The interface of nature, technology and the body quite liter-ally became my 'worlded experience', my lived reality for a brief moment in time, a brief ellipsis in the passing of time. My body merged in molecular fusion with its surrounding hardware and software. Metal, glass, grass, ferns, flowers, earth becoming the flesh and body of 'woman' ... this 'woman' ...

Fade-out ...

What boundary existed between these two bodies in space, between the body of flesh and the worlded body of the natural earth, or the metallic body of my small Citroën Saxo (beautifully maintaining its delicate fuscia tones even in its tragic moment of finality). It was from this mangled wreckage I slithered, in and out of consciousness, half alive, a creature from a David Lynch movie or a David Bowie song ('Scary Monsters, Super Creeps') to cross the interface of technology and nature, as I was laid to rest, to sleep, to dream . . . (perchance to feel?) To enter other zones of imperceptibility . . . who was I, where was I; dead, alive? In another space . . . an alien place, subject destratified . . . My first moments of volition into the air had been like some sequence from *The X-Files*. I, truly, for once, felt an abduction into an alien, ethereal realm. Now, of course, in the cold rationality of reterritorialized subjectivity (pulling myself together!) I can recognize that distanciated sense of self when the body is, without warning or preparation, pushed into another space. I existed on two planes at once. My *objective body* remained in the real world. My *phenomenal body* was projected into a 'terminal reality'. Merleau-Ponty (1962) writes of this alienation of the distanciated self: 'For us to be able to conceive space, it is in the first place necessary that we should have been thrust unto it by our body and that it should have provided us with the first model of those transpositions, equivalents and identifications which make space into an objective system and allow our experience to be one of objects, opening out onto and "in itself".' It was only the sheer velocity and sudden impact with the force of metal that regrounded my consciousness, into an acknowledgement of pending death . . . flashes of images from my children's narratives . . . looks, glances, smiles and laughter . . . landscape and silence. My consciousness slowly faded out . . . fade out . . . fade to black . . . stillness. I thought of those I loved . . . aparalletic evolution, the wasp and the orchid . . . an inevitable conclusion.

Subjectivity, identity, time, space and my definition of reality were imbricated, assembled, diffracted and molecularized into a new perception of body/culture/nature. I truly 'lost' my sense of 'being' in the world as a singular identity. I lost my mind to the ravages of a consciousness ennervated with a mix of blood, earth, voices and a delicate vanilla perfume . . . my own recollection of my feminine identity . . . still intact. I was none the less seriously at risk of loss and in a profound state of shock, felt my blood drain into a becoming-other . . . wasp becoming orchid . . . flashes of images from my children's narratives . . . looks, glances, smiles and laughter . . . landscape and silence, my consciousness slowly faded out . . . fade out to stillness. I thought of those I loved. Stop . . . aparalletic evolution . . . stop . . . I wish you could swim . . . we CAN be heroes . . . stop.

Fade-in . . .

Morphology after the crash

Was it really the end? There *is* only the Eternal Return. Using that subjective metaphor (without apologies) of a near-fatal car crash highlights some important questions within cybercultural theory, which will be explored throughout this Reader. Modernism has offered theories premised on some sort of finality, some teleological or evolutionary concern with sequential linearity leading to an ultimate 'ending'. Such theoretical ideas are based on Freudian notions of a return to origins, to oneness with Nature. Causal events and chains of sequentiality lead to the ultimate conclusion . . . the crash . . . the END.

But more recent social theories such as postmodernism and post-structuralism have offered a more complex explanantion of contemporary cultural experience. Rather than ultimate ending and evolutionary kinesis to finality, post-theory posits a belief in repetition and difference, a continual and processual existence; no finality, no ending. Sequentiality is replaced with a concern with the rhizomatic, with difference and repetition, the machinic and the endless proliferation of complexity and multiplicity. In this sense, the near-death car crash, whilst seemingly a point of inertia and stillness, none the less offered newly discovered lines of continuation, a newly constructed future, new beginnings . . . new subjectivities. As Metcalf (1998) says, 'life continues'. Metcalf even goes on to suggest that what we are experiencing in late twentieth-century pre-millennial cyberculture is a massive epochal shift: 'An escalating process of feminisation resulting in a new, post-human, cybernetic organism'.

Fade out . . .

> This *woman* . . . survived . . . reconfigured, Irigarayan morphology in an evolution towards new creative ideas. An organism that was *not* ravaged by the machine, but protected by the machine . . . a new subjectivity rendered possible by a new assemblage of body/nature and technology . . . a body 'unmarked', no fragments . . . a reconstituted creative involution . . . a reterritorialization. Rather than subjectivity as 'waste' here was a new potential. As William Burroughs said, 'The end is also the beginning'. It still haunts me that since that day, two people have died at the very same spot . . . instead, I write . . . live, hate, love, feel . . . and heal . . . re-turning and remembering at a cellular level . . . dangerous but delectable . . . let's remember standing by the 'wall' . . .

Fade-in . . .

Taking my lead from Guattari's disussion on machinic heterogenesis, I would suggest that in the still inertia of the car crash, that stillness was also a major point within a wider evolutionary force at work, a virtual machinic interconnection which enabled creative volition. This creative volition, or *processuality*, is accommodated outside the logic constraints of structuralist thinking. The machine replaces the structure. Experience cannot be totally explained through the auspices of structuralist terminologies, linear thinking, logical discourse. A-signifying elements of our being escape the linguistic

axiomatics of structuralist thinking. Machinic patterns and webs of intensities, felt at a deeper, pre-personal stage of evolution, provide wider frameworks for newer perceptions of newly configured subjectivities and identities. Certainly there was a point during my 'crash' at which there was no 'subject'. My subjectivity, as I had known it, was rendered useless, my body lost all identity, immobile, entropic . . . dissipated across the wider zones of the machinic. (What ironies in that I *now* write a subjective – but newly subjective – account of my near-death experience . . . even in a post-humanist climate.) Some would call this the 'virtual machine' . . . a machine which 'dismantles its human producer and assembles a new construct, the illegitimate child of the twentieth-century technological dynamo – part human, part machine, never completely either' (Metcalf 1998). Seems like *stuff* of science fiction, or at least insensible rantings? The point is, *cyberculture* is replete with this ontology: a continual exploration of new identities, new subjectivities, their merging with machines, bodies and technologies, within the greater machine of a technological, cultural and aesthetic (in the Guattarian sense) evolution. Metcalf's argument suggests that neither modernism nor postmodernism can account for that dynamic force of creative potential which is emblematic of cybercultural experience. Modernism's subject is replaced with a fragmented and dissipated subject of postmodernism. What does the future hold and how can *post*-postmodern theory or post-humanism develop new configurations of 'subjectivity'? Questions such as this are initiated and touched upon by a number of chapters in the Reader (see sections six and seven).

How, then, do the various sections within the Reader explore these issues, and how might each section open up, develop and theorize what might be called the new becomings of the *cybersubject*? I would like to suggest that the essays in the Reader should be located within the web of a wider debate about modernism/postmodernism and post-theory. To help the reader to get a feel for the collection of articles as a whole, perhaps we should also see them as offering philosophical discussions as much as sociological and cultural analysis. Some sections are overtly more philosophical, while others more squarely empirical and sociological; the Reader is a resource on some philosophical ideas as much as sociological and cultural empiricism. It is *not* a book of philosophy, but neither is it a Reader of social and cultural ethnography. To the more philosophically-minded, the debates on subjectivity, identity and the body might be more interesting than those more formally sociological and cultural accounts of the 'effects' of cyberculture on political/historical and geographical issues, such as the issue of 'globalization' or 'race'. To each her/his own . . .

First among the philosophical issues is the question of 'boundaries' and 'boundary states'. In chapter 18, Haraway clearly highlights the challenging of binary thinking. Thus, for example, the dichotomies inherent in categories such as mind/body, nature/culture, human/machine, organism/machine might be rethought. The 'interface' between each of these categories is not so fixed, but in question and in flux. In terms of using the 'computer', the interface between user and screen might be the subject of debate. The screen need not be the final place of the 'image' but in fact be a place 'in-between' those spaces; a place which is rendered mobile, fluid and transitory. Using the car crash as an analogy, the space between user and screen is a new creative space, where new conceptions of identity and subjectivity can be explored and felt, and new manifestations of the 'body' embraced.

Second is the issue of 'cyborgs and cyberbodies'. Whether the reader is interested in the effects of computer technologies and biotechnologies on the body or in the cyborgs which emanate from our cinematic screens, the following sections are useful starting points: Popular Cybercultures, Cybersexual, Cyberbodies, and Post-(cyber)bodies. More political scenarios are investigated through sociological and cultural analyses of space (geographical, historical and political) in Approaching Cyberculture, Cybersubcultures, Scaling Cyberspaces and Cybercolonization. Whether it is looking for empowering spaces (for example by gays or other marginalized groups) by using cyberculture, or identifying changes in our perception of 'globalization' or 'community', these sections embrace current epistemologies of cyberculture.

In the User's Guide to the Reader we have tried to show how the essays might be approached and read against or in consilience with each other. Some of the chapters take on new and creative meanings when read alongside others. What we have tried to do is to present a highly selective group of articles (and the choice was indeed phenomenal), many of which are now seminal (ironically) and well-known, and to present them in such a way that the reader might experiment and experience them through his/her own volition. In many ways, the philosophical nature and the sociological/cultural nature of the sections has indicated the individual preferences of the editors, but we hope that in this machinic assemblage, in this aparalletic evolution of thinking, that the Reader presents a multiperspectival view of cyberculture, which we hope you will explore, experience and enjoy!

References

Baudrillard, J. (1983) *Simulacra and Simulations*, trans. P. Foss, P. Patton and P. Beitchman, New York: Semiotext(e).

Bukatman, S. (1993) *Terminal Identity: The Virtual Subject in Postmodern Science Fiction*, Durham: Duke University Press.

Dery, M. (1997) 'An extremely complicated phenomenon of a very brief duration ending in destruction: the 20th century as slow-motion car crash', in V2_Organisation (eds) *Technomorphica*, Rotterdam: V2_Organisation.

Guattari, F. (1992) *Chaosmose*, Paris: Editions Galilee.

Heim, M. (1992) 'The erotic ontology of cyberspace', in M. Benedikt (ed.) *Cyberspace: First Steps*, Cambridge: MIT Press.

Kennedy, B. (2000) *Deleuze and Cinema*, Edinburgh: Edinburgh University Press.

Lupton, D. (1999) 'Monsters in metal cocoons: "road rage" and cyborg bodies', *Body & Society* 5(1): 57–72.

Massumi, B. (1992) *A User's Guide to Capitalism and Schizophrenia*, Cambridge: MIT.

Merleau-Ponty, M. (1962) *The Phenomenology of Perception*, trans. C. Smith, London: Routledge.

Metcalf, S. (1998) 'Autogeddon', in J. Broadhurst Dixon and E. Cassidy (eds) *Virtual Futures: Cyberotics, Technology and Post-Human Pragmatism*, London: Routledge.

Springer, C. (1996) *Electronic Eros: Bodies and Desire in the Postindustrial Age*, London, Athlone.

PART ONE

Approaching cyberculture

DAVID BELL

INTRODUCTION

THE FIVE ESSAYS IN THIS FIRST SECTION of *The Cybercultures Reader* offer us a number of ways of approaching cyberspace and of assessing its cultural manifestations and impacts. Each has its own agendas and emphases, and there are clear areas of both overlap and disjuncture between what each author sees as the future for a world going digital. They also serve as a collective introduction to the rest of the Reader, signalling the issues raised more extensively in the essays making up later sections. By no means exhaustive – there are almost as many ways of approaching cyberculture as there are writers and thinkers on the subject – they nevertheless point towards what we might think of as a number of 'schools of thought' about the cultural forms, meanings and practices of cyberspace.

We begin with the intoductory essay from what remains one of the most influential collections in the field, Michael Benedikt's 'Cyberspace: first steps'. In this wide-ranging and resolutely upbeat essay, Benedikt takes his own first steps at mapping both a genealogy of cyberspace and an inventory of its current manifestations and future potentials. The cartography Benedikt practices is necessarily rhizomatic, comprising a series of 'threads' which weave together one story of cyberspace. Each thread is a history in itself (of myth, of media, of architecture, of mathematics), and Benedikt's motive in tracing these threads is to show us the long history (or prehistory) of what he calls 'the ancient project that is cyberspace' – to help us position current and future technocultural transformations within an historical context as old as humanity itself. Such a motif recurs in other essays in this section (though the meaning behind it might be quite different).

What Benedikt's essay achieves is in a sense a *virtual history of cyberspace*. He does not give us the facts of, for example, the Internet's technological development and military-industrial roots, or a political-economic analysis of computer corporations' strategies, or a map (in the more conventional sense) of world wide web users and usage; his account is, by his own admission, 'impressionistic and incomplete'. Now, we

might want to take issue with that selectivity (as, indeed, other authors in this Reader do) and be critical of Benedikt's utopian take on cyberspace. We might even accuse him of writing 'cyberhype'. His work is certainly representative of the 'school of thought' which seeks to stress the enabling potentialities of the coming digital age. However, his introduction remains one of the most thoughtful and significant attempts to describe the places cyberspace has come from, and the places it may yet take us to. The other essays in this section all, to a lesser or greater degree, engage with Benedikt, and offer different ways of tempering the utopianism of his first steps.

Shawn P. Wilbur's essay, 'An archaeology of cyberspaces', also constructs some digital histories. What interests Wilbur are the definitions of a number of notions prominent in discussions of the social impacts of cyberspace – 'virtual community' and 'virtual identity' especially. His 'archaeology' is initially informed by etymology (seeking to understand what is meant by terms like 'virtual community': what kinds of non-virtual community does it presuppose? What ideological fragments cluster in the way the term 'community' is reinvested with meaning in cyberspace?); later in the essay, however, the archaeology becomes, as he says, more literal, as Wilbur moves through the 'ruins' of two extinct virtual communities of which he was once a member – one at MIT's Media Lab, the other built by a romantic fiction publishing house.

Wilbur's work can be read, in a sense, as a response to the utopian imaginings contained in Howard Rheingold's *The Virtual Community* (1993), and presents us with a close critical reading of the meanings of 'community' as mobilized by Rheingold (again, this kind of question appears in other essays in the Reader). Wilbur offers a useful list of ways of thinking 'virtual community' which extends beyond cyberspace to include global TV viewers sharing real-time experiences and even mail artists and pen pals. Like Benedikt's history lesson, this helps us *locate* the virtual community and gives us a sense of perspective. Wilbur's accounts of the ruins of the virtual communities of Tyler, Wisconsin (established by publishers Harlequin as a tie-in for a series of romance novels) and FutureCulture (at MIT) also give us a sense of perspective, detailing the life and death of two very different (though in many ways rather similar) experiments in digital social engineering and community-building. Finally, Wilbur raises some cautionary questions about the notion of 'virtual community' which (though he self-critically offers that they may be 'badly posed') distill for us the absolutely vital agendas raised in some of the other essays in this section.

The archaeological digs at Tyler and FutureCulture also suggest the need for detailed, rigorous empirical work on and in cyberspace. Arturo Escobar's 'Welcome to cyberia' outlines the kinds of fieldwork envisaged from his perspective as an anthropologist of cyberculture. He too poses crucial questions about the digital (and biotechnological) world, and – to return to a point that was made about Benedikt – injects a political-economic analysis of science and technology into his project. His theoretical foregrounding again is about locating cyberculture – this time within 'modernity' and its consequences – and he also sketches the anthropological presence in Science and Technology Studies (STS) and the evolving field of 'complexity' as ways of kitting-out an anthropology of cyberculture (as well as a 'cyborg anthropology').

The ethnographic research agenda which emerges in Escobar's essay has five key foci: (i) the production and use of new technologies; (ii) the appearance of computer-

mediated communities; (iii) studies of the popular cultures of science and technology; (iv) the growth and development of human computer-mediated communication; and (v) the political economy of cyberculture. Escobar maintains throughout an analysis which does not exclude the 'information poor', asking crucial questions about 'Third World' involvement in cyberspace (see also section nine of this Reader). 'Welcome to cyberia' is, then, an incredibly wide-ranging assessment, not only of the contribution anthropology stands to make to our understandings of cyberculture, but of the whole question of humanity's present and future relationships with science and technology.

Returning to the kinds of critical questions posed in Shawn P. Wilbur's essay, Kevin Robins' 'Cyberspace and the world we live in' urges us not to lose sight of the material impacts of cyberspace on human life the world over. Robins opens his essay with the provocation that '[t]he contemporary debate on cyberspace and virtual reality is something of a consensual hallucination', and works through some of the 'cyberhype' that has characterized utopian writings about digital technologies. His engagement with the pronouncements of 'cybergurus' (such as Rheingold and, indeed, Benedikt) on self-identity, collective identity and virtual community asks that we think very carefully before believing their 'hype'. Midway through the essay, Robins echoes Mary Ann Doane's statement about the 'psychic uses' of cinema, writing that '[t]he new virtual technologies ... provide a space in which to resist or embrace postmodernity. It is a space in which the imperatives and impositions of the real world may be effaced or transcended', and this, for Robins, is the key issue: that 'moral-political life in the real world' should not be overshadowed by going digital. In a sense, then, Robins' work echoes Escobar's and Wilbur's, in its appeal to the 'real': does cyberspace mark nothing more than a turn away from the real? And, like Escobar, he recommends academic intervention as a way of tempering the Utopianist tenor of the cybergurus: '[t]he mythology of cyberspace', he laments, 'is preferred over its sociology'; a project of de-mythologizing is thus urgently required, and this must use the insights of (non-cyber) social and cultural theory to get inside and unpick the threads of cybermyth.

A similar imperative can be detected in the last essay in this section, Arthur Kroker and Marilouise Kroker's 'Code warriors'. The Krokers and their allies (clustered now around the web-journal *CTHEORY*) have long been at the forefront of critical cyber-commentary. Through a series of books – including *The Possessed Individual* (Kroker 1992), *Spasm* (Kroker 1993), *Data Trash* (Kroker and Weinstein 1994), *Hacking the Future* (Kroker and Kroker 1996) and *Digital Delirium* (Kroker and Kroker 1997) – as well as in *CTHEORY*, the Krokers have produced and collated some of the most incisive work on our virtual futures.

'Code warriors' describes the two prevailing cultural reactions to digital technology in the US: 'bunkering in' and 'dumbing down'. With their usual relentless, hyperbolic style of 'panic theory', the Krokers here unearth the 'bunker self' and the 'dumbed down self' as psychic conditions induced by frenzy of the virtual age. Their discussion ranges over terrain not unlike that covered by Robins and Escobar, even though they may invoke it rather differently: '[c]ybertechnology creates two worlds, one virtual, the other material, separate and unequal. The radical division between these two worlds is becoming more apparent every day', they write. The Krokers similarly detect the spawning of a 'new power elite', or global 'virtual class', and below that a growing disenfranchised,

28 DAVID BELL

disconnected global underclass: 'the world is . . . divided into privileged virtual economies, passive storage depots for cheap labor, and permanently slaved nations'. Their ultimate conclusion is, perhaps predictably, the bleakest of all, foreseeing 'the human species as a humiliated subject of digital culture'.

Such a gloomy pronouncement seems a million miles away from Benedikt's enthusiastic futurology; certainly, there will be for a long, long time to come heated debates about the possibilities and problems associated with cyberculture. What we hope this first section has achieved is to establish some of the terms of that debate. The essays which are presented here are all working over the central questions of cybercultural inquiry: questions of (individual and collective) identity, questions of community, questions of the body, questions of geography, questions of politics. In the work that we shall encounter in the rest of this Reader, these questions recur; and, in some cases, we get glimpses of possible answers, too.

References

Kroker, A. (1992) *The Possessed Individual: Technology and Postmodernity*, Basingstoke: Macmillan.
—— (1993) *Spasm: Virtual Reality, Android Music and Electric Flesh*, New York: St. Martin's Press.
Kroker, A. and Kroker, M. (1996) *Hacking the Future: Stories for the Flesh-Eating 90s*, Montreal: New World Perspectives.
—— (eds) (1997) *Digital Delirium*, Montreal: New World Perspectives.
Kroker, A. and Weinstein, M. (1994) *Data Trash: The Theory of the Virtual Class*, Montreal: New World Perspectives.
Rheingold, H. (1993) *The Virtual Community: Homesteading on the Electronic Frontier*, Reading: Addison-Wesley.

MICHAEL BENEDIKT

CYBERSPACE
First steps

CYBERSPACE: A WORD FROM THE PEN of William Gibson, science fiction writer, *circa* 1984. An unhappy word, perhaps, if it remains tied to the desperate, dystopic vision of the near future found in the pages of *Neuromancer* (1984) and *Count Zero* (1987) — visions of corporate hegemony and urban decay, of neural implants, of a life in paranoia and pain — but a word, in fact, that gives a name to a new stage, a new and irresistible development in the elaboration of human culture and business under the sign of technology.

Cyberspace: A new universe, a parallel universe created and sustained by the world's computers and communication lines. A world in which the global traffic of knowledge, secrets, measurements, indicators, entertainments, and alter-human agency takes on form: sights, sounds, presences never seen on the surface of the earth blossoming in a vast electronic night.

Cyberspace: Accessed through any computer linked into the system; a place, one place, limitless; entered equally from a basement in Vancouver, a boat in Port-au-Prince, a cab in New York, a garage in Texas City, an apartment in Rome, an office in Hong Kong, a bar in Kyoto, a café in Kinshasa, a laboratory on the Moon.

Cyberspace: The tablet become a page become a screen become a world, a virtual world. Everywhere and nowhere, a place where nothing is forgotten and yet everything changes.

Cyberspace: A common mental geography, built, in turn, by consensus and revolution, canon and experiment; a territory swarming with data and lies, with mind stuff and memories of nature, with a million voices and two million eyes in a silent, invisible concert to enquiry, deal-making, dream sharing, and simple beholding.

Cyberspace: Its corridors form wherever electricity runs with intelligence. Its chambers bloom wherever data gathers and is stored. Its depths increase with every image or word or number, with every addition, every contribution, of fact or thought. Its horizons recede in every direction; it breathes larger, it complexifies, it embraces and involves. Billowing, glittering, humming, coursing, a Borgesian library, a city; intimate, immense, firm, liquid, recognizable and unrecognizable at once.

Cyberspace: Through its myriad, unblinking video eyes, distant places and faces, real or unreal, actual or long gone, can be summoned to presence. From vast databases that constitute the culture's deposited wealth, every document is available, every recording is playable, and every picture is viewable. Around every participant, this: a laboratory, an instrumented bridge; taking no space, a home presiding over a world . . . and a dog under the table.

Cyberspace: Beneath their plaster shells on the city streets, behind their potted plants and easy smiles, organizations are seen as the organisms they are – or as they would have us believe them be: money flowing in rivers and capillaries; obligations, contracts, accumulating (and the shadow of the IRS passes over). On the surface, small meetings are held in rooms, but they proceed in virtual rooms, larger, face to electronic face. On the surface, the building knows where you are. And who.

Cyberspace: From simple economic survival through the establishment of security and legitimacy, from trade in tokens of approval and confidence and liberty to the pursuit of influence, knowledge and entertainment for their own sakes, everything informational and important to the life of individuals – and organizations – will be found for sale, or for the taking, in cyberspace.

Cyberspace: The realm of pure information, filling like a lake, siphoning the jangle of messages transfiguring the physical world, decontaminating the natural and urban landscapes, redeeming them, saving them from the chain-dragging bulldozers of the paper industry, from the diesel smoke of courier and post office trucks, from jet fuel fumes and clogged airports, from billboards, trashy and pretentious architecture, hour-long freeway commutes, ticket lines and choked subways . . . from all the inefficiencies, pollutions (chemical and informational) and corruptions attendant to the process of moving information attached to *things* – from paper to brains – across, over and under the vast and bumpy surface of the earth rather than letting it fly free in the soft hail of electrons that is cyberspace.

Cyberspace as just described does not exist.

But this states a truth too simply. Like Shangri-la, like mathematics, like every story ever told or sung, a mental geography of sorts has existed in the living mind of every culture, a collective memory or hallucination, an agreed-upon territory of mythical figures, symbols, rules, and truths, owned and traversable by all who learned its ways, and yet free of the bounds of physical space and time. What is so galvanizing today is that technologically advanced cultures – such as those of Japan, Western Europe and North America – stand at the threshold of making that ancient space both uniquely visible and the object of interactive democracy.

Sir Karl Popper, one of this century's greatest philosophers of science, sketched the framework in 1972. The world as a whole, he wrote, consists of three, interconnected worlds. *World 1*, he identified with the objective world of material, natural things and their physical properties – with their energy and weight and motion and rest, *World 2*. he identified with the subjective world of consciousness – with intentions, calculations, feelings, thoughts, dreams, memories and so on, in individual minds. *World 3*, he said, is the world of objective, real and public structures which are the not-necessarily-intentional products of the minds of living creatures, interacting with each other and with the natural world *World 1*. Anthills, birds' nests, beavers' dams and similar, highly complicated structures built by animals to deal with the environment, are forerunners. But many *World 3* structures, Popper noted, are abstract; that is, they are purely informational: forms of social organization, for example, or patterns of communication. These abstract structures have always equalled, and often surpassed, the *World 3* physical structures in their complexity, beauty, and importance to life. Language, mathematics, law, religion, philosophy, arts, the sciences and institutions of all kinds, these are all edifices of a sort, like the libraries we build, physically, to store their operating instructions, their 'programs'. Man's developing belief in, and effective behaviour with respect to, the objective existence of *World 3* entities and spaces meant that he could examine them, evaluate, criticize, extend, explore and indeed make discoveries in them, in public, and in ways that could be expected to bear on the lives of all. They could evolve just as natural things do, or in ways closely analogous. Man's creations in this abstract realm create their own, autonomous problems too, said Popper: witness the continual evolution of the legal system, scientific and medical practice, the art world, or for that matter, the computer and entertainment industries. And always these *World 3* structures feed back into and guide happenings in *Worlds 1* and *2*.

For Popper, in short, temples, cathedrals, marketplaces, courts, libraries, theatres or amphitheatres, letters, book pages, movie reels, videotapes, CDs, newspapers, hard discs, performances, art shows . . . are all physical manifestations – or, should one say, the physical components of – objects that exist more wholly in *World 3*. They are 'objects', that is, which are patterns of ideas, images, sounds, stories, data . . . patterns of pure information. And cyberspace, we might now see, is nothing more, or less, than the latest stage in the evolution of *World 3*, with the ballast of materiality cast away – cast away again, and perhaps finally.

But let it be said that, in accordance with the laws of evolution, and no matter how far it is developed, cyberspace will not *re*place the earlier elements of *World 3*. It will not *re*place but *dis*place them, finding, defining, its own niche and causing the earlier elements more closely to define theirs too. This has been the history of *World 3* thus far. Nor will virtual reality replace 'real reality'. Indeed, real reality – the air, the human body, nature, books, streets . . . who could finish such a list? – in all its exquisite design, history, quiddity, and meaningfulness may benefit from both our renewed appreciation and our no longer asking it to do what is better done 'elsewhere'.

I have introduced Popper's rather broad analysis to set the stage for a closer examination of the origins and nature of our subject, cyberspace. I discern four threads within the evolution of *World 3*. These intertwine.

Thread One This, the oldest thread, begins in language, and perhaps before language, with a commonness-of-mind among members of a tribe or social group. Untested by

dialogue – not yet brought out 'into the open' in this way – this commonness-of-mind is tested and effective none the less in the coordinated behaviour of the group around a set of beliefs held simply to be 'the case': beliefs about the environment, about the magnitude and location of its dangers and rewards, what is wise and foolhardy, and about what lies beyond; about the past, the future, about what lies within opaque things, over the horizon, under the earth, or above the sky. The answers to all these questions, always 'wrong', and always pictured in some way, are common property before they are privately internalized and critiqued. (The group mind, one might say, precedes the individual mind, and consensus precedes critical exception, as Mead and Vygotsky pointed out.) With language and pictorial representation, established some ten to twenty thousand years ago, fully entering the artifactual world, *World 3*, these ideas blossom and elaborate at a rapid pace. Variations develop on the common themes of life and death, the whys and wherefores, origins and ends of all things, and these coalesce ecologically into the more or less coherent systems of narratives, characters, scenes, laws and lessons that we now recognize, and sometimes disparage, as *myth*.

One does not need to be a student of Carl Jung or Joseph Campbell to acknowledge how vital ancient mythological themes continue to be in our advanced technological cultures. They inform not only our arts of fantasy, but, in a very real way, the way we understand each other, test ourselves, and shape our lives. Myths both reflect the 'human condition' and create it.

Now, the segment of our population most visibly susceptible to myth and most productive in this regard are those who are 'coming of age', the young. Thrust inexorably into a complex and rule-bound world that, it begins to dawn on them, they did not make and that, further, they do not understand, adolescents are apt to reach with some anger and some confusion into their culture's 'collective unconscious' – a world they already possess – for anchorage, guidance and a base for resistance. The boundary between fiction and fact, between wish and reality, between possibility and probability, seems to them forceable; and the archetypes of the pure, the ideal, the just, the good and the evil, archetypes delivered to them in children's books and movies, become now, in their struggle towards adulthood, both magnified and twisted. It is no surprise that adolescents, and in particular adolescent males, almost solely support the comic book, science fiction, and videogame industries (and, to a significant extent, the music and movie industries too). These 'media' are alive with myth and lore and objectified transcriptions of life's more complex and invisible dynamics. And it is no surprise that young males, with their cultural bent – indeed mission – to master new technology, are today's computer hackers and so populate the on-line communities and newsgroups. Indeed, just as 'cyberspace' was announced in the pages of a science fiction novel, so the young programmers of on-line 'MUDs' (Multi-User Dungeons) and their slightly older cousins hacking networked videogames after midnight in the laboratories of MIT's Media Lab, NASA, computer science departments and a hundred tiny software companies are, in a very real sense, by their very activity, creating cyberspace.

This is not to say that cyberspace is for kids, even less is it to say that it is for boys: only that cyberspace's inherent immateriality and malleability of content provides the most tempting stage for the acting out of mythic realities, realities once 'confined' to drug-enhanced ritual, to theatre, painting, books and to such media that are always, in themselves, somehow less than what they reach for, mere gateways. Cyberspace can be seen as an extension, some might say an inevitable extension, of our age-old capacity

and need to dwell in fiction, to dwell empowered or enlightened on other, mythic planes, if only periodically, as well as this earthly one. Even without appeal to sorcery and otherworldy virtual worlds, it is not too far-fetched to claim that already a great deal of the attraction of the networked personal computer in general – once it is no longer feared as a usurper of consciousness on the one hand, nor denigrated as a toy or adding machine on the other – is due to its lightning-fast enactment of special 'magical' words, instruments and acts, including those of induction and mastery, and the instant connection they provide to distant realms and buried resources. For the mature as well as the young, then, and for the purposes of art and self-definition as well as rational communications and business, it is likely that cyberspace will retain a good measure of *mytho-logic*, the exact manifestation(s) of which, at this point, no one can predict.

Thread Two Convolved with the history of myth is the thread of the history of media technology as such, that is, the history of the technical means by which absent and/or abstract entities – events, experiences, ideas – become symbolically represented, 'fixed' into an accepting material, and thus conserved through time as well as space. Again, this a fairly familiar story; nevertheless it is one worth rehearsing. It is also a topic that is extremely deep, for the secret of life itself is wrapped up in the mystery of genetic encoding and the replication and motility of molecules that orchestrate each other's activity. Genes are information; molecules are media as well as motors, so to speak . . .

But we cannot begin here, where the interests of computation theorists and biologists coincide. Our story best begins with evolved man's conscious co-option of the physical environment, specifically those parts, blank themselves, that best receive markings – such as sand, wood, bark, bone, stone and the human body – for the purpose of preserving and delivering messages: signs, not unlike spoors, tracks, or tell-tale colours of vegetation or sky, but now intentional, between man and man, and man and his descendants. What a graceful and inspired step it was, then, to begin to *produce* the medium, to create smooth plastered walls, thin tablets and papyrus, and to reduce the labour of marking – carving, chiselling – to the deft movement of a pigmented brush or stylus. As society elaborated itself and as the need to keep records and to educate grew, how much more efficient it was to shrink and conventionalize the symbols themselves, then to crowd them into rows and layers, 'paper-thin' scrolls and stacks.

At this early stage already, the double movement towards the dematerialization of media on the one hand and the reification of meanings on the other is well underway. Against the ravages of time, none the less, and to impress the illiterate masses, only massive sculptures, friezes, and reliefs in stone would do. These are what we see today; these are what survive of ancient cultures and impress us still. But it would be wrong therefore to underestimate the traffic of information in more ephemeral media that must have sustained day-to-day life: the scratched clay tablets, the bark shards, graffitied walls, counters, papyri, diagrams in the sand, banners in the wind, gestures, demonstrations, performances, and, of course, the babble of song, gossip, rumour, and instruction that continuously filled the air. Every designed and every made thing was also the story of its use and its ownership, of its making and its maker.

This world sounds strangely idyllic. Many of its components, in only slightly updated forms, survive today. It was a period perhaps four thousand years long when objects, even pure icons and symbols, were not empty or ignorable but were real and

meaningful, when craftsmanship, consensus, and time were involved in every thing and its physical passage through society. But first, with the development of writing and counting and modes of graphic representation, and then, centuries later, with the invention of the printing press and the spread of literacy beyond the communities of religious scholars and noblemen, the din of ephemeral communications came to be recorded at an unprecedented scale. More important for our story, these 'records' came to be easily duplicable, transportable, and broadcastable.

Life would never be the same. The implications of the print revolution and the establishment of what Marshall McLuhan called the 'Gutenberg galaxy' (in his book of the same name; 1962) for the structure and function of technologically advancing societies can hardly be overestimated. Not the least of these implications were (1) the steady, de facto, democratization of the means of idea production and dissemination, (2) the exponential growth of that objective body of scientific knowledge, diverse cultural practices, dreams, arguments and documented histories called *World 3*, and (3) the fact that this body, containing both orthodoxies and heresies, could neither be located at any one place, nor be entirely controlled.

However, our double movement did not stop there, as we are all witness today. Although 'printed matter' from proclamations to bibles to newspapers could, in principle, be taken everywhere a donkey, a truck, a boat, or an aeroplane could physically go, there was a limit, namely, *time*. No news could be fresh days or weeks later. The coordination of goods transportation in particular was a limiting case, for if no message could travel faster than that whose imminent arrival it was to announce . . . then of what value the message? Hence the telegraph, that first 'medium' after semaphore, smoke signals and light-flashing, to connect distant 'stations' on the notion of a permanent *network*.

Another related limit was expense: the sheer expenditure of energy required to convey even paper across substantial terrain. The kind of flexible common-mindedness made possible in small communities by the near-simultaneity and zero-expense of natural voice communications, or even rumour and leaflets, collapses at the larger scale. Social cohesion is a function of ideational consensus, and without constant update and interaction, such cohesion depends crucially on early, and strict, education in – and memory of – the architectures, as it were, of *World 3*.

With the introduction of the telephone, both the problem of speed and the problem of expense were largely eliminated. Once wired, energy expenditure was trivial to relay a message, and it was soon widely realized (interestingly only in the 1930s and 40s) that the telephone need not be used like a 'voice-telegraph', which is to say, sparingly and for serious matters only. Rather, it could be used also as an open channel for constant, meaningful, community-creating and business-running interchanges; 'one-on-one' interchanges, to be sure, but 'many-to-many' over a period of time. Here was a medium, here *is* a medium, whose communicational limits are still being tested, and these quite apart from what can be accomplished using the telephone system for computer networks.

Of course, the major step being taken here, technologically, is the transition, wherever advantageous, from information transported physically, and thus against inertia and friction, to information transported electrically along wires, and thus effectively without resistance or delay. Add to this the ability to *store* information electromagnetically (the first tape recorder was demonstrated commercially in 1935), and we see yet another

significant and evolutionary step in dematerializing the medium and conquering – as they say – space and time.

But this was paralleled by a perhaps more significant development: *wire-less* broadcasting, that is, radio and television. Soon, encoded words, sounds and pictures from tens of thousands of sources could invisibly saturate the world's 'airwaves', every square millimetre and without barrier. What poured forth from every radio was the very sound of life itself, and from every television set the very sight of it: car chases, wars, laughing faces, oceans, volcanos, crying faces, tennis matches, perfume bottles, singing faces, accidents, diamond rings, faces, steaming food, more faces . . . images, ultimately of a life not really lived anywhere but arranged for the viewing. Critic and writer Horace Newcomb (1976) calls television less a medium of *communication* than a medium of *communion*, a place and occasion where nightly the British, the French, the Germans, the Americans, the Russians, the Japanese . . . settle down by the million to watch and ratify their respective national mythologies: nightly variations on a handful of dreams being played out, over and over, with addicting, tireless intensity. Here are McLuhan's acoustically-structured global villages (though he wished there to be only one), and support for the notion that the electronic media, and in particular television, provide a medium not unlike the air itself – surrounding, permeating, cycling, invisible, without memory or the demand for it, conciliating otherwise disparate and perhaps antagonistic individuals and regional cultures.

With cordless and then private cellular telephones, and 'remote controls' and then hand-held computers communicating across the airwaves too, the very significance of geographical location at all scales begins to be questioned.

We are turned into nomads . . . who are always in touch.

All the while, material, print-based media were and are growing more sophisticated too: 'vinyl' sound recording (a kind of micro-embossing), colour photography, offset lithography, cinematography, and so on . . . the list is long. They became not only more sophisticated but more egalitarian as the general public not only 'consumed' ever greater quantities of magazines, billboards, comic books, newspapers, and movies but also gained access to the means of production: to copying machines, cameras, movie cameras, record players and the rest, each of which soon had its electronic/digital counterpart as well as a variety of hybrids, extensions and cross-marriages: national newspapers printed regionally from satellite-transmitted electronic data, facsimile transmission, digital preprint and recording, and so on.

The end of our second narrative thread is almost at hand.

With the advent of fast personal computers, digital television, and high bandwidth cable and radio-frequency networks, so-called post-industrial societies stand ready for a yet deeper voyage into the 'permanently ephemeral' (by which I mean, as the reader is well aware, cyberspace). So-called on-line community, electronic mail, and information services (USENET, the Well, Compuserve, and scores of others) already form a technological and behavioural beginning. But the significance of this voyage is perhaps best gauged by the almost irrational enthusiasm that today surrounds the topic of *virtual reality*.

Envisaged by science fiction writer/promoter Hugo Gernsback as long ago as 1963 (see Stashower 1990) and explored experimentally by Ivan Sutherland (1968), the technology of virtual reality (VR) stands at the edge of practicality and at the current limit of the

effort to create a communication/communion medium that is both phenomenologically engulfing and yet all but invisible. By mounting a pair of small video monitors with the appropriate optics directly to the head, a stereoscopic image is formed before the 'user's' eyes. This image is continuously updated and adjusted by a computer to respond to head movements. Thus, the user finds himself entirely surrounded by a stable, three-dimensional visual world. Wherever he looks he sees what he would see were the world real and around him. This *virtual* world is either generated in real time by the computer, or it is preprocessed and stored, or it exists physically elsewhere and is 'videographed' and transmitted in stereo, digital form. (In the last two cases the technique is apt to be named *telepresence* rather than virtual reality.) In addition, the user may be wearing stereo headphones. Tracked for head movements, a complete acoustic sensorium is thus added to the visual one. Finally, the user may wear special gloves, and even a whole body suit, wired with position and motion transducers to transmit to others – and to represent to himself – the shape and activity of his body in the virtual world. There is work underway also to provide some form of force-feedback to the glove or suit so that the user will actually feel the presence of virtual 'solid' objects – their weight, texture and perhaps even temperature (see Stewart, 1991a, for a recent survey, and Rheingold 1991). With a wishful eye cast towards such fictional technologies as the Holodeck, portrayed in the television series *Star Trek, the Next Generation*, devices sketched in such films as *Total Recall* and *Brainstorm*, and, certainly, the direct neural connections spoken of in Gibson's novels, virtual reality/telepresence technology is as close as one can come in reality to entering a totally synthetic sensorium, to immersion in a totally artificial and/or remote world.

Much turns on the question of whether this is done alone or in the company of others; and if the latter, of how many, and how. For, engineering questions aside, as the population of a virtual world increases, with it comes the need for consensus of behaviour, iconic language, modes of representation, object 'physics', protocols, and design – in a word, the need for *cyberspace* as such, seen as a general, singular-at-some-level, public, consistent, and democratic 'virtual world'. Herein lies the very power of the concept.

Thread Two, then, is drawn from the history of communication media. The broad historical movement from a universal, preliterate actuality of *physical doing*, to an education-stratified, literate reality of *symbolic doing* loops back, we find. With movies, television, multimedia computing and now VR, it loops back to the beginning with the promise of a *post*literate era, if such can be said; the promise, that is, of 'post-symbolic communication' to put it in VR pioneer Jaron Lanier's words (Lanier 1989, Stewart 1991b). In such an era, language-bound descriptions and semantic games will no longer be required to communicate personal viewpoints, historical events, or technical information. Rather, direct – if 'virtual' – demonstration and interactive experience of the 'original' material will prevail, or at least be a universal possibility. We would become again 'as children' but this time with the power of summoning worlds at will and impressing speedily upon others the particulars of our experience.

In future computer-mediated environments, whether or not this kind of literal, experiential sharing of worlds will supersede the symbolic, ideational, and implicit sharing of worlds embodied in the traditional mechanisms of text and representation remains to be seen. While pure VR will find its unique uses, it seems likely that cyberspace, in full flower, will employ all modes.

Thread Three Another narrative, this one is spun out of the history of architecture.

The reader may remember that Popper saw architecture as belonging to *World 3*. This it surely does, for although shelter, beauty and meaning can be found in 'unspoiled' nature, it is only with architecture that nature, as habitat, becomes co-opted, modified and codified.

Architecture, in fact, begins with displacement and exile: exile from the temperate and fertile plains of Africa two million years ago – from Eden, if you will, where neither architecture nor clothing was required – and displacement through emigration from a world of plentiful food, few competitors, and not more kin than the earth would provide for. Rapid climatic change, increasing competition and exponential population growth was to change early man's condition irreversibly. To this day, architecture is thus steeped in nostalgia, one might say; or in defiance.

Architecture begins with the creative response to climatic stress, with the choosing of advantageous sites for settlements (and the need to defend these), and the internal development of social structures to meet population and resource pressure, to wit: with the mechanisms of privacy, property, legitimation, task specialization, ceremony and so on. All this had to be carried out in terms of the availability of time, materials and design and construction expertise. Added to these were the constraints and conventions manufactured by the culture up to that point. These were often arbitrary and inefficient. But always, even as conventions and constraints transformed, and as man passed from hunting and gathering to agrarianism to urbanism, the theme of return to Eden endured, the idea of return to a time of (presumptive) innocence and tribal/familial/national oneness, with each other and with nature.

I bring up this theme not because it 'explains' architecture, but because it is a principle theme driving architecture's self-dematerialization. *De*materialization? The reader may be surprised. What *is* architecture, after all, if not the creation of durable physical worlds that can orient generations of men, women, and children, that can locate them in their own history, protect them always from prying eyes, rain, wind, hail and projectiles . . . durable worlds, and in them, permanent monuments to everything that should last or be remembered?

Indeed these are some of architecture's most fundamental charges; and most sacred among them, as I have argued elsewhere (Benedikt 1987), is architecture's standard bearing, along with nature, for our sense of what we mean by 'reality'. But this should not blind us to a significant countercurrent, one fed by a resentment of quotidian architecture's bruteness and claustrophobia, which itself is a spilling-over of the resentment we feel for our own bodies' cloddishness, limitations and final treachery: their mortality. Reality is death. If only we could, we would wander the earth and never leave home; we would enjoy triumphs without risks, eat of the Tree and not be punished, consort daily with angels, enter heaven now and not die. In the name of these unreasonable desires we revere finery and illumination, and reward bravery, goodness and learning with the assurance of eternal life. As though *we* could grow wings! As though we could grow wings, we erect gravity-defying cathedrals resplendent with coloured windows and niches crowded with allegorical life, create paradisiacal gardens such as those at Alhambra, Versailles, the Taj Mahal, Roan-Ji, erect stadia for games, create magnificent libraries, labyrinths and observatories, build on sacred mountain tops, make enormous, air-conditioned greenhouses with amazing flying-saucer elevators, leap from hillsides strapped to kites, dazzle with gold, chandeliers, and eternally running streams; we scrub

and polish and whiten . . . all in a universal, cross-cultural act of reaching beyond brute nature's grip in the here and now. And this with the very materials nature offers us.

In counterpoint to the earthly *garden* Eden (and even to that walled garden, Paradise) then, floats the image of the Heavenly City, the new Jerusalem of the book of Revelation. Like a bejewelled, weightless palace it comes down out of heaven itself 'its radiance like a most rare jewel, like jasper, transparent' (Revelation 21:9). Never seen, we know its geometry to be wonderfully complex and clear, its twelves and fours and sevens each assigned a set of complementary cosmic meanings. A city with streets of crystalline gold, gates of solid pearl, and no need for sunlight or moonlight to shine upon it for 'the glory of God is its light'.

In fact, all images of the Heavenly City – East and West – have common features: weightlessness, radiance, numerological complexity, palaces upon palaces, peace and harmony through rule by the good and wise, utter cleanliness, transcendence of nature and of crude beginnings, the availability of all things pleasurable and cultured. And the effort at describing these places, far from a mere exercise in superlatives by medieval monks and painters, continues to this day on the covers and in the pages of innumerable science fiction novels and films. (Think of the mother ship in *Close Encounters of the Third Kind*.) Here is what is means to be 'advanced', they all say.

From Hollywood Hills to Tibet, one could hardly begin to list the buildings actually built and projects begun in serious pursuit of realizing the dream of the Heavenly City. If the history of architecture is replete with visionary projects of this kind, however, these should be seen not as naïve products of the fevered imagination, but as hopeful fragments. They are attempts at physically realizing what is properly a cultural archetype, something belonging to no one and yet everyone, an image of what would adequately compensate for, and in some way ultimately justify, our symbolic and collective expulsion from Eden. They represent the creation of a place where we might *re-enter* God's graces. Consider: Where Eden (before the Fall) stands for our state of innocence, indeed ignorance, the Heavenly City stands for our state of wisdom, and knowledge; where Eden stands for our intimate contact with material nature, the Heavenly City stands for our transcendence of both materiality and nature; where Eden stands for the world of unsymbolized, asocial reality, the Heavenly City stands for the world of enlightened human interaction, form and information. In Eden the sun rose and set, there were days and nights, wind and shadow, leaf and stone, and all perfumed. The Heavenly City, though it may contain gardens, breathes the crystalline gleam of its own lights, sparkling, insubstantial, laid out like a beautiful equation. Thus, while the biblical Eden may be imaginary, the Heavenly City is *doubly* imaginary: once, in the conventional sense, because it is not actual, but once again because even if it became actual, because it *is* information, it could come into existence only as a virtual reality, which is to say, fully, only 'in the imagination'. The image of the Heavenly City, in fact, is an image of *World 3* become whole and holy. And a religious vision of cyberspace.

I must now return briefly to the history of architecture, specifically in modern times. After a century of the Industrial Revolution, the turn of the twentieth century saw the invention of high-tensile steels, of steel-reinforced concrete and of high-strength glass. Very quickly, and under economic pressure to do more with less, architects seized and celebrated the new vocabulary of lightness. Gone were to be the ponderous piers, the small wooden windows, the painstaking ornament, the draughty chimneys and lanes, the chipping and smoothing and laying! Instead: daring cantilevers, walls reduced to

reflective skins, openness, light, swiftness of assembly, chromium. Gone the stairs, the horse-droppings in the street, and the cobbles. Instead, the highway, the bullet-like car, the elevator, the escalator. Gone the immovable monument, instead the demountable exhibition; gone the Acropolis, instead the World's Fair. In 1924, the great architect Le Corbusier proposed razing half of Paris and replacing it with *La Ville radieuse*, the Radiant City, an exercise in soaring geometry, rationality, and enlightened planning, unequalled since. A Heavenly City.

By the late 1960s, however, it was clear that the modern city was more than a collection of buildings and streets, no matter how clearly laid out, no matter how lofty its structures or green its parks. The city became seen as an immense node of communications, a messy nexus of messages, storage and transportation facilities, a massive education machine of its own complexity, involving equally all media, *including buildings*. To no one was this more apparent than to a group of architects in England calling themselves Archigram. Their dream was of a city that built itself unpredictably, cybernetically, and of buildings that did not resist television and telephones and air conditioning and cars and advertising but accommodated and played with them; inflatable buildings, buildings on rails, buildings like giant experimental theatres with video cameras gliding like sharks through a sea of information, buildings bedecked in neon, projections, laser beams . . . These were described in a series of poster-sized drawings called *archi*tectural tele*grams*, which were themselves, perhaps not incidentally, early examples of what multimedia computer screens might look like tomorrow (Cook 1973). Although the group built nothing themselves, they were and are, none the less, very influential in the world of architecture.

Now, a complete treatment of the signs of the ephemeralization of architecture and its continuing capitulation to media is outside the scope of this essay. It occurs on many fronts, from the wild 'Disneyfication' of form, to the overly meek accommodation of services. Most interesting, however, is a thread that arises from thinking of architecture itself as an abstraction, a thread that has a tradition reaching back to ancient Egypt and Greece and the coincidence of mathematical knowledge with geometry and hence correct architecture. As late as the eighteenth century, architects were also scientists and mathematicians; witness Andrea Palladio, Sir Christopher Wren, and before them, of course, Leonardo da Vinci and Leon Battista Alberti. From the 1920s till the 1960s, the whole notion that architecture is about the experiential modulation of *space* and *time* – that is, 'four dimensional' – captivated architectural theory, just as it had captivated a generation of artists in the 20s and 30s (Henderson 1983). This was something conceptually far beyond the simple mathematics of good proportions, even of structural engineering. It is an idea that still has force.

Then too there is the tradition of architecture seen for its symbolic context; that is, for not only the way it shapes and paces information fields in general (the emanations of faces, voices, paintings, exit signs, etc.) but the way buildings carry meaning in their anatomy, so to speak, and in what they 'look like'. After five thousand years, the tradition is very much alive as part of society's internal message system. In recent years, however, the architectural 'message system' has taken on a life of its own. Not only have architectural drawings generated an art market in their own right – as illustrated conceptual art, if you will – but buildings themselves have begun to be considered as arguments in an architectural discourse about architecture, as propositions, narratives and inquiries that happen, also, to be inhabitable. In its most current avant-garde guise,

the movement goes by the name of deconstructivism, or post-structuralism (quite explic-itly related to the similarly named movements in philosophy and literary criticism). Its interests are neither in the building as an object of inhabitation nor as an object of beauty, but as an object of information, a collection of ciphers and 'moves', junctions and disjunctions, reversals and iterations, metaphorical woundings and healings, and so on, all to be 'read'. This would be of little interest to us here were it not an indica-tion of how far architecture can go towards attempting to become pure demonstration, and intellectual process, and were it not fully a part of the larger movement I have been describing. (And we should remember that, as a rule, today's avant-garde informs tomorrow's practice. See Betsky 1990.)

But there is a limit to how far notions of dematerialization and abstraction can go and still help produce useful and interesting, real architecture. That limit has probably been reached, if not overshot (Benedikt 1987). And yet the impetus toward the Heavenly City remains. It is to be respected; indeed, it can usefully flourish . . . in cyberspace.

The door to cyberspace is open, and I believe that poetically- and scientifically-minded architects can and will step through it in significant numbers. For cyberspace will require constant planning and organization. The structures proliferating within it will require *design*, and the people who design these structures will be called *cyberspace architects*. Schooled in computer science and programming (the equivalent of 'construc-tion'), in graphics, and in abstract design, schooled also along with their brethren 'real-space' architects, cyberspace architects will design electronic edifices that are fully as complex, functional, unique, involving and beautiful as their physical counterparts if not more so. Theirs will be the task of visualizing the intrinsically non-physical and giving inhabitable visible form to society's most intricate abstractions, processes, and organisms of information. And all the while such designers will be *re*realizing in a virtual world many vital aspects of the physical world, in particular those orderings and plea-sures that have always belonged to architecture.

Thread Four This thread is drawn from the larger history of mathematics. It is the line of arguments and insights that revolve around (1) the propositions of geometry and space, (2) the spatialization of arithmetical/algebraic operations, and (3) reconsideration of the nature of space in the light of (2).

Since Aristotle, operating alongside this 'spatial-geometrical' thread in mathematics has been a complementary one, that is, the development of symbolic logic, algebraic notation, calculus, finite mathematics and so on, to modern programming languages. I say 'complementary' because these last-named subjects could (and can still) proceed purely symbolically, with little or no geometrical, spatial interpretations; algebra, number theory, computation theory, logic . . . these are symbolic operations upon symbolic operations and have a life of their own.

In practice, of course, *diagrams*, which are spatial and geometrical, and *symbol strings* (mathematical notation, language) are accepted as mutually illuminating representations and are considered together. But the distinction between them, and the tension, still remain. There are those who think most easily and naturally in symbolic sequences, and linear operations upon them; there are those who think most easily and naturally in shapes, actions and spaces. Apparently more than one type of intelligence is involved here (Gardner 1983, Hadamard 1945, West 1991). Be this as it may, cyberspace clearly is premised upon the desirability of spatialization *per se* for the understanding of infor-

mation. Certainly, it extends the current paradigm in computing of 'graphic user inter-
faces' into higher dimensions and more involving experiences, and it extends current
interest, as evidenced by the popularity of Edward Tufte's books (1983, 1990), in 'data
cartography' in general and in the field of scientific visualization. But, more fundamen-
tally, cyberspace revivifies and then extends some of the more basic techniques and
questions having to do with the spatial nature of mathematical entities, and the mathe-
matical nature of spatial entities, that lie at the heart of what we consider both real and
measurable.

Rigorous reasoning with shape – deductive geometry – began, as we all know, in
ancient Greece with Thales around 600 B.C., continuing through 225 B.C. with
Pythagoras, Euclid, and Apollonius. The subject was twin: (1) the nature (and methods
of construction) of the idealized forms studied – basically lines, circles, regular poly-
gons and polyhedra, although Apollonius began work on conic sections – and (2) the
nature of perfect reasoning itself, which the specifiability and universality of geometrical
operations seemed to exemplify. The results of geometrical study had practical use in
building and road construction, land surveying, and what we today call mechanical engin-
eering. Its perfection and universality also supported the casting of astrological/
cosmological models along geometrical lines.

The science and art of geometry has developed sporadically since, receiving its last
major 'boost' of renewed interest – after Kepler and Newton – in the late nineteenth
century, with Bolyai and Lobatchevsky's discovery of non-Euclidean geometry. Soon,
however, with the concept of pure topology and the discovery of consistent geometries
of higher dimensionality than three, first Euclidean geometry and then geometry in
general began to lose something of its lustre as a science wherein significant new discov-
eries could be made. *All* statements of visual geometrical insight, it seemed, could be
studied more generally and accurately in the symbolic/algebraic language of analytical
mathematics – final fruit of Descartes' project in *La Géométrie*, which was precisely to
show how the theorems of geometry could be transcribed into analytical (algebraic)
form.

Of course the linkage, once made, between geometry and algebra, space and symbol,
form and argument, is a two-way one. Descartes had both 'algebraized' geometry and
'geometrized' algebra. (And it is this second movement that is of most interest to us
here.) With one profound invention, he had built the conceptual bridge we today call
the Cartesian coordinate system. Here was the insight: just as the positions of points in
natural, physical space could be encoded, specified, by a trio of numbers, each refer-
ring to a distance from a common but arbitrary origin in three mutually orthogonal
directions, so too could the positions of points in a 'mathematical space' where the
'distances' are not physical distances but numerical values, derived algebraically, of the
solution of equations of (up to) three variables. In this way, thousands of functions could
accurately be 'graphed' and made visible.

Today, procedures based on Descartes' insight are commonplace, taught even at
good elementary schools. But this should not mask the power of the implicit notion that
space itself is something not necessarily physical: rather that it is a 'field of play' for all
information, only one of whose manifestations is the gravitational and electromagnetic
field of play that we live in, and that we call the real world. Perhaps no examples are
more vivid than the beautiful forms that emerge from simple recursive equations – the
new science of 'fractals' – and recent discoveries of 'strange attractors,' objects of

coherent geometry and behaviour that 'exist' only in mathematical spaces (coordinate systems with specially chosen coordinates) and that economically map/describe/prescribe the behaviour of complex, chaotic, physical systems. Which reality is the primary one? we might fairly ask.

Actually, why choose?

Modern physicists are sanguine: Minkowski had shown the utility of mapping time together with space, Hamiltonian mechanics lent themselves beautifully to visualizing the dynamics of a physical system in n-dimensional *state* or *phase space* where a single point represents the entire state of the system, and quantum mechanics seems to play itself out in the geometrical behaviour of vectors in *Hilbert space*, in which one or more of the coordinates are 'imaginary' (see Penrose 1989 for a recent explication).

In the meantime, the more common art of diagrams and charts proliferated – from old maps, schedules, and scientific treatises, to the pages of modern economics primers, advertisements and boardroom 'business graphics'. Many of these representations are in fact hybrids, mixing physical, energic or spatiotemporal, coordinates with abstract, mathematical ones, mixing histories with geographies, simple intervallic scales with exponential ones, and so on. The practice of *diagramming* (surely one whose origins are earlier than writing) continues too, today enhanced by the mathematics of *graph theory* with its combinatorial and network techniques to analyse and optimize complex processes. What, we may ask, is the ontological status of such representations? All of them – from simple bar charts and organizational 'trees' through matrices, networks and 'spreadsheets' to elaborate, multidimensional, computer-generated visualizations of invisible physical processes – all of these, and all abstract phase-, state-, and Hilbert-space entities, seem to exist in a geography, a space, borrowed from, but not identical with, the space of the piece of paper of computer screen on which we see them. All have a reality that is no mere picture of the natural, phenomenal world, and all display a physics, as it were, from elsewhere.

What are they, indeed? Neither discoveries nor inventions, they are of *World 3*, entities themselves evolved by our intelligence in the world of things and of each other. They represent first evidence of a continent about which we have hitherto communicated only in sign language, a continent 'materializing' in a way. And at the same time they express a new etherealization of geography. It is as though, in becoming electronic, our beautiful old astrolabes, sextants, surveyor's compasses, observatories, orreries, slide rules, mechanical clocks, drawing instruments and formwork, maps and plans – physical things all, embodiments of the purest geometry, their sole work to make us at home in space – become environments themselves, the very framework of what they once only measured.

My account of the intertwining 'threads' that seem to lead to cyberspace is, of course, impressionistic and incomplete. Cyberspace is an elusive and future thing, and one can hardly be definitive at this early stage.

But it is also clear that the 'threads' themselves are made of threads, and that there are others. For example, the history of art into modern times tells a related story, fully involving mythology, changing media, a relationship to architecture, logic, and so on. It is a thread I have not described, and yet the contribution of artists – visual, musical, cinematic – to the design of virtual worlds and cyberspace promises to be considerable. Similarly, the story of progress in telecommunications and computing technology – the

miniaturizations, speeds and economies, the new materials, processes, interfaces and architectures – is a thread in its own right, with its own thrusts and interests in the coming-to-be of cyberspace. This story is well chronicled elsewhere (Gilder, 1988; Rheingold, 1985). Then there is the sociological story, and the economic one, the linguistic one, even the biological one . . . and one begins to realize that every discipline can have an interest in the enterprise of creating cyberspace, a contribution to make, and a historical narrative to justify both. How could it be otherwise? We are contemplating the arising shape of a new world, a world that must, in a multitude of ways, *begin*, at least, as both an extension and a transcription of the world as we know it and have built it thus far.

Another reason that my account is impressionistic and incomplete, however, is that the very metaphor of threads is too tidy and cannot support all that needs to be said. Scale aside, something deeper and more formless is going on. Consider: if information is the very *stuff* of space and time, what does it mean to manufacture information, and what does it mean to transfer it at ever higher rates between spatiotemporally distinct points, and thus dissolve their very distinctness? With mature cyberspaces and virtual reality technology, this kind of warpage, tunnelling, and lesioning of the fabric of reality will become a perceptual, phenomenal fact at hundreds of thousands of locations, even as it falls short of complete, quantum level, physical achievement. Today intellectual, tomorrow practical, one can only guess at the implications. Of this much, one can be sure: the advent of cyberspace will have profound effects on so-called post-industrial culture, and the material and economic rewards for those who first and most properly conceive and implement cyberspace systems will be enormous. But let us set aside talk of rewards. With these 'first steps', let us begin to face the perplexities involved in making the unimaginable imaginable and the imaginable real. Let the ancient project that is cyberspace continue.

Originally published in M. Benedikt (ed.) (1992) *Cyberspace: First Steps*, Cambridge, MIT. This essay has been edited for inclusion in the Reader.

References

Benedikt, M. (1987) *For an Architecture of Reality*, New York: Lumen Books
——— (1991) *Deconstructing the Kimbell*, New York: Lumen Books.
Betsky , A. (1990) *Violated Perfection*, New York: Rizzoli.
Cook, P. (ed.) (1973) *Archigram*, New York: Praeger.
Gardner, H. (1983) *Frames of Mind*, New York: Basic Books.
Gibson, W. (1984) *Neuromancer*, New York: Ace Books
——— (1987) *Count Zero*, New York: Ace Books.
Gilder, G. (1988) *Microcosm*, New York: Simon and Schuster.
Hadamard, J. (1945) *An Essay on the Psychology of Invention in the Mathematical Field*, New York: Dover Publications.
Henderson, L. D. (1983) *The Fourth Dimension and Non-Euclidean Geometry in Modern Art*, Princeton, N.J.: Princeton University Press.
Lanier, J. (1989) Interview in *Whole Earth Review*, Fall 1989, pp. 108ff.
McLuhan, M. (1962) *Gutenberg Galaxy: The Making of Typographic Man*, Toronto: University of Toronto Press.
Newcomb, H. (1976) *Television: The Critical View*, New York: Oxford University Press.

Penrose, R. (1989) *The Emperor's New Mind: Concerning Computers, Minds, and the Laws of Physics*, New York: Oxford University Press.

Popper, K. (1972, revised 1979) *Objective Knowledge: An Evolutionary Approach*, Oxford: Oxford University Press, pp. 106–52. See also Clifford Geertz, *The Interpretation of Cultures* (New York, Basic Books, 1973), pp. 55–83; Leslie A. White, 'The locus of mathematical reality: an anthropological footnote' in J. R. Newman (ed.) *The World of Mathematics* (New York, Simon and Schuster, 1956), p. 2325; and Emile Durkheim, *The Elementary Forms of the Religious Life*, trans. J. S. Swain (New York, Free Press, 1965 [1915]).

Rheingold, H. (1985) *Tools for Thought*, New York: Simon and Schuster.

—— (1991) *Virtual Reality*, New York: Simon and Schuster.

Stashower, D. (1990) 'A dreamer who made us fall in love with the future', *Smithsonian*, 21 (5, August 1990): 50. Contains reprint from *Life Magazine* (1963).

Stewart, D. (1991a) 'Artificial reality: don't stay home without it', *Smithsonian*, 21 (10, January 1991): 36ff.

—— (1991b) 'Interview: Jaron Lanier', *Omni*, 13 (4, January 1991): 45ff.

Sutherland, I. E. (1968) 'A head-mounted three dimensional display', in *Fall Joint Computer Conference* (FJCC), Washington, D.C.: Thompson Books, pp. 757–64.

Tufte, E. R. (1983) *The Visual Display of Quantitive Information*, Cheshire, Conn.: Graphics Press.

—— (1990) *Envisioning Information*, Cheshire, Conn.: Graphics Press.

West, T. G. (1991) *In the Mind's Eye*, Buffalo, N.Y.: Prometheus Books.

SHAWN P. WILBUR

AN ARCHAEOLOGY OF CYBERSPACES
Virtuality, community, identity

Internet culture? Virtual community?

'VIRTUAL COMMUNITY' IS CERTAINLY AMONG the most used, and perhaps abused, phrases in the literature on computer-mediated communication (CMC). This should come as no surprise. An increasing number of people are finding their lives touched by collectivities which have nothing to do with physical proximity. A space has opened up for something like community on computer networks, at a time when so many forms of 'real life' community seem under attack, perhaps even by the same techno-cultural forces that make Internet culture possible. We need to be particularly critical as we approach the tools we use to explore Internet culture, even the words we choose to employ. Consider the notion of 'virtual community'. It reveals something about our presuppositions about both (unmodified, presumably 'real') community and (primarily computer) technology that this phrase even makes sense. It is more revealing that we might think of 'virtual community' as a new arrival on the cultural scene.

What follows is an attempt to come to grips with at least some of the questions raised by the notion of 'virtual community', and particularly by its apparent acceptance as a phrase of choice among Internet users, CMC researchers and journalists alike. It is an 'archeological' study in two rather different ways. The first section, which is an exploration – or perhaps excavation – of some of the possible cultural and etymological roots of the phrase 'virtual community', aims at unearthing a range of interpretive possibilities and spreading them out so we can begin the speculative (re)construction of concepts that we can use for rigorous research in CMC. The second section involves the exploration of slightly more literal ruins, as I examine what remains of two 'virtual communities' that have already come and gone – a section of a text-based virtual reality system housed at MIT's Media Lab, and a voice-based 'virtual village' created by Harlequin Romance in conjunction with one of its book series. Throughout, the work

is driven by my sense that Internet users and CMC researchers have been hasty in their adoption of tools and terminology, but also by a feeling that the choices we have made in haste may prove to be surprisingly powerful, assuming we learn to use them with eyes wide open.

The right tools for the job

We use words as tools, as individuals and as scholars. On the Internet we use little else. Whatever else Internet culture might be, it is still largely a text-based affair. Words are not simply tools which we can use in any way we see fit. They come to us framed by specific histories of use and meaning, and are products of particular ideological struggles. Richard Dawkins' (1989) notion of the 'meme' may help us here. The meme is the cultural equivalent of a gene, a basic 'unit of imitation'. As genes act as replicators for biological structures, memes replicate cultures.[1] If we think of terms like virtual community or computer-mediated communication as the result of memetic (re)combinations, then perhaps we are more likely to be concerned about their particular inheritances, but we are also encouraged to consider the hardiness of our concepts. We ought to be on the lookout for recessive memes, and for the circumstances where elements of our memetic heritage might recombine in ways which do not enhance our possibilities for cultural survival.

The current benchmark for any study of virtual community is Howard Rheingold's *The Virtual Community: Homesteading on the Electronic Frontier*. According to Rheingold,

> Virtual communities are social aggregations that emerge from the Net when enough people carry on those public discussions long enough, with sufficient human feeling, to form webs of personal relationships in cyberspace.[2]

'Sufficient human feeling' is a rather imprecise measure, full of assumptions about the 'human' and about what emotions will count as 'feeling'. And we are left to wonder about the ends to which this 'human feeling' will be 'sufficient'. We are left very much in the dark about the process of community development – perhaps 'generation' or 'genesis' would be as appropriate – but we know that the key ingredients are communication and feeling. To his credit, Rheingold is not inclined to claim any great definitional rigour, although he provides plenty of indications about his own feelings. Judging from the examples which he uses, Rheingold is most prepared to see 'community' in those groups that move from CMC to face-to-face interaction, as well as in those who share specific, or useful, details of 'real life' (RL).[3] It seems that for Rheingold, despite his immersion in certain virtual communities and his guarded enthusiasm for the uses of CMC, the best virtual community is an extension of 'real community'.

Another aspect of Rheingold's study that we ought to note, at least in passing, is his invocation of the 'electronic frontier' metaphor, particularly in his use of the term 'homesteading' to describe 'pioneers' in virtual community-building. Because of organizations like the Electronic Frontier Foundation (EFF), which have played an important role in addressing new issues of civil liberty and privacy relating to CMC, the notion of an electronic frontier has gained considerable currency on-line, even among computer users who might otherwise have reservations about a metaphor so steeped in traditions of imperialism, rough justice and the sometimes violent opposition of any number of

others.[4] In the complex social and legal spaces of Internet culture, groups like EFF seem to be wearing the white hats, but we may want to consider the memetic heritage they carry with them. In any event, we should take note of the connection made between community and the near-primitive conditions of a frontier.

Community

From here, we must proceed carefully. A little bit of etymological spadework only serves to show how complicated the issues are.[5] Community seems to refer primarily to relations of commonality between persons and objects, and only rather imprecisely to the site of such community. What is important is a holding-in-common of qualities, properties, identities or ideas. The roots of community are sunk deep into rather abstract terrain. For example, community has achieved a remarkable flexibility in its career as a political term. It can be used to mean a quite literal holding-in-common of goods, as in a communist society, or it can refer much more broadly to the state and its citizens. In common usage, it can also refer to the location within which a community is gathered. Under the influence of bureaucracy and cartographic standards, this more common usage reduces the holding-in-common of the community to a matter of proximity. Community becomes shorthand for community-of-location, although we hardly presume anything like joint ownership.

Here we need to ask questions about the ends of the homesteading process – about issues of ownership and enterprise, the division of labour and the establishment of law and order. For the most part, Rheingold leaves these questions open. Are his 'homesteaders' the relatively well-to-do patrons of high-priced services like the WELL (Whole Earth 'Lectronic Link)?[6] If so, then what role are the less 'civilized' or less affluent denizens of the Internet destined to play? For the moment, the white hats at EFF and elsewhere seem inclined to defend outlaws and 'savages', but it may be that their role is somewhat obscured by the relative absence of real law on the Internet thus far.

The virtual

In everyday speech, the 'virtual' seems most often to refer to that which appears to be (but is not) real, authentic or proper – although it may have the same effects. Even in this colloquial form it attests to the possibility that seeming and being might be confused, and that the confusion might not matter in the end. But this sense of the virtual arises from a complex history of relations between reality, appearance and goodness. The roots of 'virtuality' are in 'virtue', and therefore in both power and morality. In an archaic form, the virtual and the virtuous were synonymous. Another sense of the virtual – which we might think is unconnected – refers to optics, where the virtual image is, for example, that which appears in the mirror. But it may be that all of these etymological threads finally wind together.

The deepest roots of virtuality seem to reach back into a religious world view where power and moral goodness are united in virtue. And the characteristic of the virtual is that it is able to produce effects, or to produce itself as an effect even in the absence of the 'real effect'. The air of the miraculous that clings to virtue helps to obscure the

distinction between real effects of power and/or goodness and effects that are as good as real. The two uses of the term seem to have been concurrent. Perhaps this is an almost necessary effect of the highly metaphorical world of a Christian church that can conjure the (virtual) body of Christ anyplace 'where two or three are gathered together in [Jesus'] name' (Matthew 18:20), or that at one time invested authority for an entire religion in an elite council or 'virtual church'.

A more secular understanding of virtue begins by assigning it to more physical powers, so that virtue is equated with health, strength and sexual purity. These are, of course, still closely tied to notions of morality. Between this physical virtue and the virtuality of appearances there may in fact be some sort of discontinuity. We can draw on what we know of the history of Protestantism to suggest at least one possible bridge between the two. Think of 'visible saints', caught between an unknown but predestined fate and the demands of a culture that demanded 'proofs' of salvation.[7] You can perhaps see how a good (apparently moral) appearance can come to be as good as a good heart. Following Max Weber, you can see how the preoccupation with the former came to largely replace concern for the latter.

The optical definition of the virtual undoubtedly shares some elements of the miraculous, but refers specifically to the realm of appearances. Optical technologies deceive us in potentially useful ways, by bringing that which can't be seen into view – via reflection, refraction, magnification, remote viewing or simulation. We need only turn on the television to see how powerful these technologies can be. It is no wonder that the promise of immersive virtual reality has caused so much controversy. And perhaps it should be no surprise that this extreme form of optical virtuality has given rise to a fresh outburst of moral concern, such as the media's titillated fascination with 'cybersex' and 'teledildonics'. Behind the rather tiresome, but by no means novel, interest in 'dirty tech' there is a more intense and interesting concern about the blurring of the boundaries between fact and fantasy. Paul Virilio has suggested that technologies of the virtual are destined to not only simulate the real, as Jean Baudrillard has suggested, but to replace it.[8]

The I in cyberspace

Before returning to the question of the virtual community, it may be worth exploring one more use of the virtual that relates to issues of individual identity. The computer – and particularly the computer as an Internet terminal – is an odd sort of vision machine. It involves the user, primarily through vision, in forms of telepresence which may mimic any and all of the senses. It is likely that those who become most immersed in Internet culture develop a sort of synesthesia which allows them to exercise all of the senses through their eyes and fingers. Many computer users seem to experience the movement 'into' cyberspace as an unshackling from real-life constraints – transcendence rather than prosthesis. At the limit, the (emancipatory) discourse of cyberspace suggests the possibility of stepping beyond and remaining one's self in some lasting way through virtual identity-play.

I suspect that there is some truth to the suggestion that the experience of dislocation in time and space – an effect of immersion in Internet culture – can help individuals to see their own identities in a different perspective. But the more extravagant claims

seem to rely on some aura of the miraculous that still clings to technologies of the virtual. I am reminded of the privileged place of the mirror in Jacques Lacan's psycho-analysis. In his seminar of 1953–54, Lacan used an elaborate diagram to explain the dynamics of ego formation. Through a combination of curved and plane mirrors, an imagined subject is made to see two distinct objects, a vase and a bouquet, as if the vase contained the bouquet. This trick done with mirrors, Lacan says, is the necessary mechanism of misrecognition by which human subjects are able to imagine that they possess a coherent (phallic) identity. In Lacan's diagram, the virtual space 'behind' the plane mirror is where the subject imagines (through misrecognition) that its self exists as a unity (rather than some disorganized collection of identifications). This virtual space also contains the reflection of the subject's eye – the place of the virtual subject – which might, Lacan seems to suggest, look back at the jumble and see it as such.[9] This seems to be a space for the analyst, but it also seems to be an impossible space – a fantasy of analysis, which may finally be little more than a kind of joint projection – which would have to be constructed through misrecognition of some sort, just as much as the subject's assumption of the position of whole bouquet-in-vase identity. However, it seems like the virtual is where all the action is, despite its impossible status. The work of analysis takes place between an analysand that imagines that it is – or at least ought to be – whole and an analyst that has some investment in clearly discerning the analysand's frag-mentation. Both are operating in spaces which are finally dark and uninhabitable.

When we return to the question of free identity play on the Internet we may be seeing the invocation of something very much like the Lacanian analytic situation. A great deal of the discussion of the liberatory potential of the Internet relies on the assumption that one could assume something very much like the position of the virtual subject. There is some sort of attempt at self-therapy work going on 'behind' the plane of the computer screen. But we are as torn as Lacan seems to be between the dynamics of the mirror and those of the screen, dynamics which seem to be quite different. In particular, there seems to be some confusion about whether or not one can occupy the place behind the screen. It is not an impossible space in the same sense, in part because there is no necessity that the virtual image have any particularly 'truthful' or even 'real' relation to the subject. The persona that appears in cyberspace is potentially more fluid than those we assume in other aspects of our lives, in part because we can consciously shape it. And that consciousness may allow us to engage with ourselves in what appear to be novel ways. However, we should take care to consider the extent to which this heightened self-consciousness is attributable to the novelty of CMC rather than any particular power of the medium. There remains around many of our dreams about Internet culture more than a whiff of pixie dust, incense and brimstone.

What is clear at this stage of the game is that an engagement with virtual commu-nity in any adequate, rigorous way will involve us in the painstaking negotiation of a complex field of meanings and associations – one where the possibility of choosing between the real and the as-good-as-real will constitute only one more question among many.

In this terrain, one must remain aware of the effects of speed. In writing about Internet culture, I have tried to remain in sync with my experience of life on-line. It is a difficult work – one more reason to use great care in constructing a work which must be a representation as-good-as some aspect of that culture.

(Re)Combinations

So what is virtual community? Too quickly – or at 'net.speed', we might suggest:

1. It is the experience of sharing with unseen others a space of communication. It is other contributors to electronic mailing lists, like Future Culture or Cybermind, that flood my email inbox with hundreds of messages every hour of the day. It is the crowd that gathers in the text-based virtual reality of Postmodern Culture MOO, where I am one of the 'wizards', and where virtual hot-tub parties compete with art exhibits and discussion groups for attention and system resources. It is the result of a semi-compulsive practice of checking in occasionally with others who are checking in occasionally in all sorts of on-line forums. It is the synergistic sum of all the semi-compulsive individuals who have come to think of themselves as something like citizens in someplace we refer to with words like 'cyberspace' or 'the Net', collaborators in the mass conjuring trick which produces what we might want to call 'Internet culture'.

2. For me it is the work of a few hours a day, carved up into minutes and carried on from before dawn until long after dark. I venture out onto the Net when I wake in the night, while coffee water boils, or bath water runs, between manuscript sections or student appointments. Or I keep a network connection open in the background while I do other work. Once or twice a day, I log on for longer periods of time, mostly to engage in more demanding real-time communication, but I find that is not enough. My friends and colleagues express similar needs for frequent connection, either in conversation or through the covetous looks they cast at occupied terminals in the office. Virtual community is this work, this immersion, and also the connections it represents. Sometimes it is real-time communication. More often it is asynchronous and mostly solitary, a sort of textual flirtation that only occasionally aims at any direct confrontation of voices or bodies. But then the phone rings at midnight and a strange voice speaks your name, or a letter arrives in the mail, or you find yourself with an airline ticket to spend the week in a distant city, crashing on the couch of someone you have shared text with for a year but have never – that is, never 'truly', as your friends will remind you – met.

3. Virtual community is the illusion of a community where there are no real people and no real communication. It is a term used by idealistic technophiles who fail to understand that the authentic cannot be engendered through technological means. Virtual community flies in the face of a 'human nature' that is essentially, it seems, depraved.

4. Virtual community has no necessary link to computers or to glossy high technologies. There is a virtual community of mail artists – individuals who subvert the world's postal systems to their own ideological and aesthetic ends. There are old-fashioned party lines and pen-pal networks. Perhaps all of these collectivities, however mediated, warrant the term 'community'.

5. Virtual community is the simulation of community, preferably with a large dose of tradition and very little mess. Colonial Williamsburg, Disneyland and the KOA camp down the road all share some of this flavour. Please pay at the gate.

6. Virtual community is people all over the world gathered around television sets to watch the Super Bowl or a World Cup match.

7. Virtual community is the new middle landscape, the garden in the machine, where democratic values can thrive in a sort of cyber-Jeffersonian renaissance. Driven into a new sort of wilderness, beyond an electronic frontier, we will learn once again to be self-reliant, but also to respect one another. We will reconcile expansion with intimacy, and the values of capitalism with 'family values'.

We could undoubtedly go on and on. Each of these definitions responds to some of the memetic material carried by the notion of virtual community. None of them addresses the entire lineage, across time and cultures. We hardly expect that it could or would. Some of these definitions push the limits of intelligibility, bound up as tightly as they are in the contradictions and confusions which inform notions of community and the virtual.

Perhaps multiple, contradictory definitions look considerably less useful than, for example, Rheingold's fairly elegant, singular attempt. However, the point of all of this memetic dissection is not to better fit the words 'virtual community' to some known social reality. Instead, we are at a point in our researches into Internet culture where it is particularly important not to force old conceptions – such as that of the mythical frontier, for example – on the new phenomenon of decentralized networks of multi-tasking, time-sharing machines and human–machine interfaces. We do not know very much about Internet culture, so perhaps the best definitions are multi-bladed, critical Swiss army knives. Precisely because of the richness of its memetic lineage, 'virtual community' will serve us remarkably well.

I will conclude this exploration with two brief case studies which will demonstrate the utility of virtual community as a guiding concept for CMC research, and to once again emphasize the openness of the field by comparing an element of Internet culture with a telephone-based system of a rather different sort. These are not representative cases in any ideal sense. Instead they represent extremes which may function as a foil for work, like Rheingold's, that has thus far looked within a fairly narrow range for its examples of virtual community.

The voicemail village

The remains of my time in the virtual village of Tyler, Wisconsin, consist of a stack of twelve paperback romances, three copies of the same recipe, the records of four toll calls and an academic paper that came out of my experience there. That, and a few memories, is all that is left of twelve months spent involved in the lives and loves – particularly the loves – of the people of Tyler, unless we count my increased and increasingly grudging respect for the business savvy of Harlequin Enterprises as an artifact of the period. And yet, for a year, I was involved with the characters that moved through the twelve-book Tyler romance series.

I came to Tyler at a time when my scholarly focus was still print media. My exit, which was also in some sense an expulsion, coincided, not entirely coincidentally, with my entrance into the world of Internet culture. Harlequin launched the Tyler series in March 1992, in the midst of one of its periodic product facelifts. This time, the new face was decidedly high-tech, with photographic, or nearly photographic cover art and

a smooth, polished look that might well have been designed in a wind tunnel. At first glance, Tyler may have appeared to be a departure from this approach, with its homely, bumpy, quilt-motif covers and small-town setting. However, Tyler was perhaps as elaborately constructed as any mass market book series to date, and it was not without its own technological innovations. Along with the usual Harlequin promotions, Tyler featured a 1-900 number line (1-900-78-TYLER) which allowed you to listen to the voices of various characters as they told you the daily town gossip, gave you previews of forthcoming novels, or shared recipes. In this elaborate voicemail system, you could navigate from one section of Tyler to another by the usual 'if you want X, press Y' commands. You could also leave messages at various points, mostly to order books or have a copy of the recipe of the month mailed to you.

Perhaps it is too much to liken this to a sort of virtual reality, although it involves the negotiation of a fairly explicit landscape using commands similar to those you might use in a MUD on the Internet. But even if we were to acknowledge that 1-900-78-TYLER connected us to a bizarre, rudimentary voice-based virtual reality, should we think of Tyler as a virtual community? By Rheingold's definition we would have to say no, I think. The requirement of explicit person-to-person communication means that no matter how many individuals shared the experience of the virtual Tyler, they did not constitute a community. No doubt, some outpourings of human feeling were orchestrated by the combination of written and aural texts. If you, the anonymous reader, read the books and called the number then you and I would have something in common. But what does this sort of sharing mean? Can we acknowledge that there is something like virtual community that comes from those cultures of compatible or shared consumption that shape so much of our multi-mediated daily lives? Are we certain that we know the difference between talking to one another and talking to the television?

Tyler raises a number of interesting questions about community. Some of them were clear to me when I first began to analyse the series. For example, we suspect that there is something like a community of readers who share particular tastes and concerns that will lead them to a series like Tyler, or to romances in general. Sometimes this potential community shows itself as something more solid, in the form of magazines like *Romantic Times* which chronicle its existence, or at conferences for romance readers and writers. I also suspect that there is considerable overlap between those who read and those who write romance novels, and that successful women writers may be more important heroines for their readers than the rather less dynamic leading ladies who populate the novels. The case has been made for romance writing and reading alike as strategies of resistance to patriarchal demands. In this context, the question about the potential community of romance readers is a political one, and the choice to not acknowledge the (no doubt highly mediated) communication that might be taking place is one we make at some risk. In particular, we might be inclined to look for solidarity in a series focused on a literal community, especially since the Tyler series is finally itself an extended prescription for the reunification of urban and rural elements to rekindle supposed core values of American life. We might wonder how well this quasi-populist rhetoric serves the ends of a multinational corporation like the one that owns Harlequin. We should be particularly wary of the role it proposes for itself – a mediator at several levels of a new community now rather fully integrated into an economy that thrives on homework and decentralized production, and that relies on input from consumers to direct ever more accurate marketing back to them.

Tyler is, perhaps, the simulacrum of a community. It is a virtual community both because it is contained in print and voice media and because it is a replacement for the kind of person-to-person interaction that it portrays so appealingly. Its subsequent disappearance – the 1-900 numbers have long since been disconnected – marks it as primarily an artifact of marketing. But before we smugly dismiss Tyler as a mere historical curiosity, let's consider how different the interactions are on the average moderated electronic mailing list, or Usenet news group. To what extent, in other words, does the Internet actually function as an effective many-to-many communication system, and to what extent does the highly segmented and self-selecting nature of so much of the Internet foster many-to-one conversations between enthusiasts and their subject matter? I would argue that one of the reasons that flame wars can be so easily started or prolonged is that in many forums the subject matter, and the user's relation to it, is more important to the user than the relations between participants. Perhaps great portions of the Net are composed of these cultures of compatible, though not always convivial, consumption.

Follow the bouncing doughnuts

The rise and fall of the FutureCulture (FC) experiment on MIT's MediaMOO was a rather different sort of affair. The FC's Main Hall is mostly quiet now, but once it was the site of some of the most interesting and fruitful on-line interactions that I have experienced. FC is an electronic mailing list with several hundred subscribers from around the world. Its nominal focus is new technology and its effect on global culture, but the actual discussions range broadly – from questions about the future of monogamy to discussions of constitutional issues. On FC, the future is now, and much of what goes on appears to be an attempt to learn to live in a world that appears to be constantly new, endlessly shifting. The people on the list drive the discussion with their particular interests. There is no clearly defined subject matter to mediate between individuals, and things can become quite personal. For those who doubt the possibility of on-line intimacy, I can only speak of births and deaths that have shaken the list in a variety of ways – of hours sitting at my keyboard with tears streaming down my face, or convulsed with laughter. Communication on electronic mailing lists is asynchronous, which has some advantages over a real-time forum like Internet Relay Chat (IRC) for creating connections between individuals. It is rare, for instance, for me to log in without finding some new mail from members of FC, which is always there when I have the time to read it. Real-time forums cannot accommodate nearly as many different community members, since they rely on immediate responses and hence require the coordination of physical presences across increasingly far-flung time zones.

However, the immediacy of real-time communication has a definite appeal, and it is common for groups based in asynchronous forums to experiment with real-time interactions. At the time of FC's entrance into MediaMOO, there was also a great deal of interest in IRC as a means of expanding list-members' contact with one another. In fact, the MOO and IRC users engaged in a rather heated feud on the list, and in both real-time environments, for several months. What was at stake was the shape of the FC community, and more specifically its speed. The IRC crowd was arguing in favour of a sort of relatively transparent presence, and against what they saw as the 'clutter'

of text-based virtual reality. One of the most interesting conflicts revolved around the use of props in MOO. Why, for example, should one spend time programming an elaborate and realistic coffee pot in cyberspace? Must on-line community depend on the creation of a comfortable, familiar real-life environment? Or should we be looking for alternative settings more conducive to other sorts of interaction, and perhaps other sorts of community?

The debate was never settled and the site is now deserted, but the artifacts of a brief period of playful experimentation still litter the empty rooms. Exits are traversed with commands like 'flip' (and 'backflip' to return). The FC rec-room features a ping-pong table, a pente board, grandstand seating and a number of virtual refreshments – including a box of donuts that can be eaten, replenished with a 'bake' command, squashed or thrown. The 'throw' command sets off a series of messages that describe the donut ricocheting from wall to wall before finally coming to rest. I helped a much younger friend write the code that made the donuts bounce, and I have seen university professors take great glee in filling the 'air' of FCRec with flying donuts. Often, these outbursts would come within minutes of serious discussions of philosophy or music, or debates about the impact of new technologies or laws. The participants varied substantially in age, education and occupation, but a well-coded food fight can be wonderfully levelling.

So where are they now? Were those early interactions in fact too frivolous to sustain interest, or was the environment that was built not sufficiently lifelike, or perhaps too slavish in its adherence to the 'real'? These are the questions we would ask if we interpreted the silence and emptiness of the FC/MediaMOO complex as sign of a failure. But if we track down the participants in this short-lived community, we find signs of another sort. For example, the decline of FC/MediaMOO was matched by the birth of BayMOO, a San Francisco-based MOO run almost entirely in its first few months by members of FC, or individuals who were connected through contacts made at MediaMOO. People still talk about FC using words like 'home', which is startling. The shell of FC/MediaMOO is perhaps just that, a shell which the FC community broke out of at some moment that none of us can quite recall, and to which it would be difficult to return. It is possible that FC itself might be constraining at some point in the community's life, and perhaps there will come a time when we will look back fondly at the list from wherever it is that the transformed community now gathers. There were communities before FC which represent part of its lineage. Some of them still survive in the environment the list provides.

Shapes of community

It is too easy to log into an on-line chat system and imagine that it is just like wandering into a local bar. It is too easy to log-in and imagine that it is all make-believe. It is altogether too easy to enter a virtual world and imagine that this allows us to understand the 'real' one. Any study of virtual community will involve us in the difficult job of picking a path across a shifting terrain, where issues of presence, reality, illusion, morality, power, feeling, trust, love, and much more, set up roadblocks at every turn. The hazards are doubled for any traveller who hopes to report what s/he has seen, since every description takes us into the realm of the virtual, the as-good-as. However, faced with the challenge, we should not be too dismayed. As we can see, the tools that we

have selected seem remarkably flexible. One step on the road to increasing our flexibility as CMC researchers is to understand these tools.

We should be prepared to find community under a wide variety of circumstances, in a broad range of environments, and intermingled with any number of elements that seem to work against the development of 'sufficient human feeling'. With their eyes wide open and using the tools we have inherited – with some respect for the memetic inheritances that they carry – CMC researchers may be able to carry forward the study of community in directions which we had not previously even imagined. We can imagine the next set of hurdles, which will, I suspect, have to be taken both all at once and at a run. Community, virtuality, mediation, commerce: how are these elements articulated within 'Internet culture'? Can we tell the difference, for example, between a community and a market segment, or a culture of compatible consumption? What are the relations between the real and the virtual, between being and seeming, between 'real life' and 'net.life'? Are the structures and marks of class, race, gender and the like more or less deeply inscribed in these virtual spaces? Can these clearly mediated spaces provide a place for contesting 'real world' powers? Or are many of these questions badly posed, as they assume a certain authenticity and lack of mediation in our everyday lives which is perhaps illusory? Is the screen a mirror, or something else? These are only a few of the pressing questions, and they are pressing more urgently every day.

Originally published in D. Porter (ed.) (1997) *Internet Culture*, London: Routledge.
This essay has been edited for inclusion in the Reader.

Notes

1. Richard Dawkins, *The Selfish Gene* (New York: Oxford University Press, 1989).
2. Howard Rheingold, *The Virtual Community: Homesteading on the Electronic Frontier* (Reading, MA: Addison-Wesley, 1993), p.5.
3. A common usage on the Internet refers to on-line activities as VR, for 'virtual reality', and off-line activities as RL, for 'real life'. There is, however, a strong element of irony that informs much of this attribution of on-line activity to the realm of the non-real.
4. See Rheingold's chapter on the Electronic Frontier Foundation and similar organizations (Rheingold, *The Virtual Community*, pp. 241–75).
5. In what follows, I have relied on the entries for 'community' and 'virtual' in *The Oxford English Dictionary, Second Edition* (Oxford: Oxford University Press, 1989) for etymological guidance.
6. The WELL, or Whole Earth 'Lectronic Link, is a computer conferencing system based in the San Francisco area, which charges a combination of monthly membership and hourly usage fees. It is the focus of Rheingold's introductory, definitional chapters. However, many inhabitants of communities on the open Internet see communities such as the WELL much as inhabitants of the central parts of a city might look on walled, well-policed suburbs. Rheingold is careful to look at other environments, but it is not clear that 'sufficient human feeling' represents an adequate measure for community on Internet Relay Chat or within a Usenet newsgroup, nor is it clear how we would measure it.
7. The standard treatment of this theological problem is Edmund Sears Morgan, *Visible Saints* (New York: New York University Press, 1963).
8. Louise Wilson, 'Cyberwar, God, and television: interview with Paul Virilio', *CTHEORY* (electronic edition), Article 20, December 1994. Virilio himself draws the comparison between himself and Baudrillard, claiming that he has surpassed Baudrillard in predicting the replacement of the real by the virtual. However, this sounds very much like Baudrillard's explanation of simulation as 'more real than the real'.
9. Jacques Lacan, *Freud's Papers on Techniques* (The Seminar of Jacques Lacan, Book I), (New York: Norton, 1991), pp. 139–42.

ARTURO ESCOBAR

WELCOME TO CYBERIA
Notes on the anthropology of cyberculture

T HIS CHAPTER DISCUSSES TYPES OF cultural analyses that might be
possible to advance today on the social nature, impact and use of new technolo-
gies; it is based on the belief that computer, information and biological technologies are
bringing about fundamental transformations in the structure and meaning of modern
society and culture. Not only does this transformation offer itself clearly to anthropo-
logical inquiry, it constitutes perhaps a privileged arena for advancing anthropology's
project of understanding human societies from the vantage points of biology, language,
history and culture.

As a new domain of anthropological practice, the study of cyberculture is particu-
larly concerned with the cultural constructions and reconstructions on which the new
technologies are based and which they, conversely, contribute to shaping. The point of
departure of this inquiry is the belief that any technology represents a cultural inven-
tion, in the sense that technologies bring forth a world; they emerge out of particular
cultural conditions and in turn help to create new social and cultural situations.
Anthropologists might be particularly well prepared to understand these processes if
they are receptive to the idea that science and technology are a crucial arena for the
creation of culture in today's world. Anthropologists must venture into this world in
order to renew their interest in the understanding and politics of cultural change and
cultural diversity.

The nature of cyberculture

While any technology can be studied anthropologically from a variety of perspectives –
the rituals it originates, the social relations it contributes to creating, the practices devel-
oped around them by various users, the values it fosters – 'cyberculture' refers very
specifically to new technologies in two areas – artificial intelligence (particularly computer

and information technologies) and biotechnology. It would be possible to separate out these two sets of technologies for analytical purposes, although it is no coincidence that they have achieved prominence simultaneously in recent years. While computer and information technologies are bringing about a regime of *technosociality*, a broad process of sociocultural construction set into motion in the wake of the new technologies, biotechnologies are giving rise to *biosociality*,[1] a new order for the production of life, nature and the body through biologically-based technological interventions. Both processes, biosociality and technosociality, form the basis for what is termed here the regime of cyberculture. They embody the realization that we increasingly live and make ourselves in techno-biocultural environments structured indelibly by novel forms of science and technology.

Despite this novelty, however, cyberculture originates in a well-known social and cultural matrix, that of modernity, even if it orients itself towards the constitution of a new order – which we cannot yet fully conceptualize but must try to understand – through the transformation of the space of possibilities for communicating, working and being. Modernity, in this way, constitutes the 'background of understanding' – the taken-for-granted tradition and way of being out of which we interpret and act – that inevitably shapes the discourses and practices generated by and around the new technologies. This background has created an image of technology as a neutral tool for releasing nature's energy and augmenting human capacities to suit human purposes.[2] The background responsible for this unproblematic and utilitarian view of technology must be made explicit as part of the anthropological investigation of cyberculture. Revealing the principles and assumptions that underlie the modern understanding of technology is an important step towards providing contexts for reorienting the dominant tradition. Some see the ultimate purpose of this reorientation as that of contributing to the development of technologies and technoliterate practices that might be better suited to human use and human purposes than they are at present.[3]

What sorts of questions might this brief presentation of cyberculture suggest to anthropologists? Let us begin by thinking about the following overall enquiries.

1. What are the *discourses and practices* that are generated around/by computers and biotechnology? What domains of human activity do these discourses and practices create? In what larger social networks of institutions, values, conventions, etc. are these domains situated? In what ways do our social and ethical practices change as the project of technoscience advances? More generally, what new forms of social construction of reality ('technoscapes'), and what new forms of negotiation of such construction(s), are introduced by the new technologies? How do people engage technoscapes routinely, and what are the consequences of doing so in terms of the concomitant adoption of new ways of thinking and being?

2. How can these practices and domains be *studied ethnographically* in various social, regional and ethnic settings? What established anthropological concepts and methods would be appropriate to the study of cyberculture? Which would have to be modified? How, for instance, will notions of community, fieldwork, the body, nature, visuality, the subject, identity, and writing itself be transformed by new technologies?

3. What is the background of understanding in which the new technologies emerge? More specifically, *which modern practices* – in the domains of life, science and

technology – shape the current understanding, design and modes of relating to technology? What continuities and ruptures do the new technologies exhibit in relation to the modern order? Moreover, what kinds of appropriations, resistances or innovations in relation to modern technologies (for instance, by minority cultures) are taking place which might represent different approaches to and understandings of technology?

4. What is the *political economy of cyberculture*? In what ways, for instance, are the relations between First and Third World restructured in the light of the new technologies? What new local articulations, with forms of global capital based on high technology, are appearing? How do automation, intelligent machines and biotechnology transform the labour process, the capitalization of nature and the creation of value worldwide? If different groups of people (classes, women, minorities, ethnic groups, etc.) are differentially placed in new technological contexts, how can anthropologists theorize and explore this ordering of technocultural construction? Finally, what are the implications of this analysis for a cultural politics of science and technology?

Modernity and cyberculture

Cyberculture is fostering a fresh reformulation of the question of modernity in ways that are not so mediated by literary and epistemological considerations, as was the case during the 1980s. Whether or not we have entered an era of postmodernity, or if we still exist within a modified modernity ('late', 'meta', or 'hyper' modernity, as some have proposed) is an open question that cannot be decided prior to the investigation into the present status of science and technology. To the extent that science and capital still function as organizing principles of dominant social orders, some insist that we have not yet taken leave of the space of modernity, despite the unprecedented modes of operation developed by both of these principles in recent decades.[4] If, as Foucault[5] has argued, the modern period brought with it particular arrangements of life, labour and language – embodied in the multiplicity of practices through which life and society are produced, regulated and articulated by scientific discourses – cyberculture continues to act on these three domains, although bringing about very different configurations.

Modernity has been characterized by various theoreticians,[6] such as Foucault, Habermas and Giddens, in terms of the continuous appropriation of taken-for-granted cultural backgrounds and practices by explicit mechanisms of knowledge and power. Many aspects of life, previously regulated by traditional norms – in domains such as health, education, work, the body, space and time, even morality and social norms – have been progressively appropriated by discourses of science and the accompanying forms of technical and administrative organization. With modernity, mechanical models of physical and social life gave way to models centred on the production and maximization of life itself, including the coupling of the body and machines in new ways, in factories, schools, hospitals and family homes. There thus began an intimate imbrication of processes of capital and knowledge for the simultaneous production of value and life.[7] Societies, economies and cultures were thus restructured by capital and scientific knowledge in an extremely efficient manner relative to previous regimes. The spread of the

written word, the preeminence of the machine, the control of time and space, and the biological and biochemical revolutions of the past 100 years brought into place unprecedented biotechnical arrangements which today find new ways of expression in cybercultural regimes. Machines became, to borrow a telling phrase, 'the measure of men'.[8]

Science and technology – or, better, 'technoscience' – has been central to the modern order, even if the relationship between science, technology and culture has remained insufficiently theorized. Heidegger's treatment of technology as a paradigmatic practice of modernity remains exemplary in this regard. Science and technology, for Heidegger, are ways of bringing forth new realities, new manifestations of being, even if the revealing of being by technology is problematic. For Heidegger, modern science necessarily constructs ('enframes') nature as something to be appropriated, whose energy must be released for human purposes. This is 'the danger in the utmost sense', to the extent that enframing leads to destructive activities and, particularly, to the destruction of other, more fundamental ways of revealing the essence of being ('*poiesis*'), which Heidegger sees present in the arts and in certain Eastern philosophies. Yet technology for Heidegger has an important ontological role to the extent that the world becomes present for us through technological links of various kinds. It is through technical practices that the social character of the world comes to light.[9] More recently, some philosophers have theorized further the preeminence of technical rationality as the primary mode of knowing and being, even prior to 'theoretical' knowledge and science themselves.[10]

It is precisely the priority accorded to science and theory over technical creativity that has led moderns to believe that they can describe nature and society according to laws. Rather than as the effect of technological practices, nature and society thus appear as objects with mechanisms, which has resulted in the instrumental attitude towards them. Cyberculture seems to deepen these trends, initiated by modern biopolitical technologies in the production of life-worlds. Yet the new regimes that are emerging around the production of life, labour and language in the wake of artificial intelligence and biotechnology have a series of novel features which presage the advent of a new era, perhaps best visualized by contemporary science fiction. New science fiction landscapes are populated with cyborgs of all kinds (human beings and other organisms with innumerable prostheses and technological interfaces), moving in vast cyberspaces, virtual realities and computermediated environments.[11] But while science fiction writers and technology builders are extremely enthusiastic about, and generally uncritical of these trends, it remains to be seen to what extent and in what concrete ways the transformations envisioned by them are in the process of becoming real. This is another task for the anthropology of cyberculture.[12]

The anthropological project: (1) theoretical formulations

Interest in science and technology on the part of social/cultural anthropologists has been growing steadily in recent years, linked to the broader and growing field of science and technology studies (STS). STS topics of interest to anthropologists in recent years have ranged from ethnographies of scientists, laboratory studies, and studies of reproductive and medical technologies, gender and science, ethics and values, and science and

engineering education to studies of new computer and biological technologies, virtual reality, virtual communities and cyberspace. An ongoing effort to theorize the anthropology of science and technology is also under way and promises to become an increasingly active and visible trend within the discipline of anthropology in the near future.[13]

Although the bulk of anthropological STS studies have taken place in highly industrialized countries, and while these studies have privileged the most recent technological innovations, this does not necessarily have to be the case. Indeed, given the centrality of Third World cultures and cultural diversity for anthropology, it is to be expected that STS activities will pay growing attention to STS issues in Third World contexts. It can even be argued that a partial shift of focus to the Third World is necessary, to the extent that the globalization of cultural and economic production relies ever more on the new technologies of information and life. This is as true concerning biotechnology-driven development interventions in the Third World as it is regarding the cultural transformations effected by information technologies and the media. Whether it is in the domains of development, information or warfare,[14] the encounter between North and South continues to be heavily mediated and constructed by technologies of manifold kinds.

Recently, the impact of such technologies as television and video cassettes on local notions of development and modernity, and their effect on long-standing social and cultural practices, have been approached ethnographically.[15] From an earlier emphasis on worldwide homogenization and generalized acculturation, the effect of cosmopolitan science and technology is now seen more in terms of their real or potential contribution to the formation of hybrid cultures and to processes of self-affirmation through selective and partially autonomous adoption of modern technologies.[16] This is particularly the case with microtechnologies, as opposed to large-scale interventions such as industrial schemes and hydroelectric dams. However, as Hess convincingly argues, the effect of cosmopolitan technologies on Third World groups remains insufficiently understood, particularly from the vantage point of the cultural politics they set in motion, including issues of cultural destruction, hybridization and homogenization, as well as political economy and resistance. Work on these issues is advancing rapidly, particularly in connection with the redefinition of development.[17] The crucial question of the nature of cyberculture in/from the Third World, however, remains to be articulated.

Anthropological reflection on the relationship between culture and technology is of course not new. The impact of Western technologies on cultural change and evolution, for instance, has been a subject of study since the early 1950s.[18] Questions of technological control, political economy, macro/microtechnology distinctions have been broached. Nevertheless, studies of material culture and technology have suffered from dependence on what a reviewer of the field recently called 'the standard view of technology' (based on the assumption that 'necessity is the mother of invention', the decontextualization of technology, and a teleological vision that goes from simply tools to complex machines). Only with modern STS has the possibility arisen to see science and technology in relation to complex socio-technical systems; this 'lays the foundation once again for fruitful communication among social anthropologists, ethnoarchaeologists, archaeologists and students of human evolution'.[19] It also fosters exchange between anthropologists and other disciplines involved in STS, such as philosophy, cognitive science and linguistics.

In the First World, attempts at articulating an anthropological strategy explicitly centred on new information, computer and biological technologies has just begun. An important precursor in this regard was Margaret Mead's work in the context of the emergence of cybernetics during the Second World War and up to the middle of the 1960s.[20] At the beginning of the 1990s, it is possible to identify three different proposals. The first proposal, by anthropologist David Thomas, builds on the growing literature on the notions of 'cyberspace'[21] and 'cyborg' – broadly speaking, a mixture of human and machine. Arguing that advanced forms of Western technology are bringing about a 'rite of passage' between industrial and 'postorganic' societies, between 'organically human and cyberpsychically digital life-forms as reconfigured through computer software systems', Thomas calls on anthropologists to engage 'virtual worlds technologies during this early stage of speculation and development', particularly from the point of view of how these technologies are socially produced.[22] From print-based paradigms of visual literacy to the virtual worlds of digitalized information, this anthropologist argues, what we are witnessing is a transition to a new postorganic, postcorporeal stage that presents great promise in terms of creative social logics and sensorial regimes. As the locale for the new postorganic anthropology, cyberspace affords unprecedented possibilities for anthropologists in terms of realizing the potential of this promise and combating the tendency to construct it as a space of purely economic contestations.

The second project, 'cyborg anthropology', consciously takes as a point of departure the established activities of STS and the feminist studies of science and technology. While its overall domain of activity is the analysis of science and technology as cultural phenomena, the main goal of cyborg anthropology is to study ethnographically the boundaries between human and machines that are specific to late twentieth century societies. Believing that the adequacy of '*anthropos*' as the subject and object of anthropology – that is, the human-centred foundation of anthropological discourse, and the placing of agency solely on the skin-bound individual – must be displaced, the emerging cyborg anthropologists adamantly claim that human and social reality is as much a product of machines as of human activity, that we should grant agency to machines, and that the proper task for an anthropology of science and technology is to examine ethnographically how technology serves as agent of social and cultural production.[23]

Critical positions regarding these two projects are beginning to be articulated, most notably from the field of visual anthropology. Given the importance of vision for virtual reality, computer networks, graphics and interfaces, and for imaging technologies – from satellite surveillance, warfare and space exploration to medical technologies such as tomography and the visualization of the foetus[24] – it is not surprising that the branch of anthropology most attuned to the analysis of visuality as cultural and epistemological regime, namely, visual anthropology, has been the first to react to both uncritical celebration of cyberspatial technologies and to anthropological projects centred on these latter. Claims by cyberspace designers that the new technologies will 'make the body obsolete, destroy subjectivity, create new worlds and universes, change the economic and political future of humanity, and even lead to a posthuman order', are in the best of cases, for these critics, wishful thinking motivated by the seduction of virtual reality and like technologies, and in the worst misguided efforts at engineering social reality.[25]

Rather than suggesting that a whole new anthropological subdiscipline is needed, Gray and Driscoll prefer to speak of 'anthropology of, and in, cyberspace'. While granting a certain novelty to new technologies, these authors recommend that anthropologists

study technologies in the cultural contexts from which they originate and in which they operate, including their continued links to the dominant values of rationality, instrumentality, profit and violence. It is no coincidence, they continue, that virtual reality – one of the recent developments at the heart of the cyberspatial movements – has been and is likely to continue to be circumscribed by military and economic interests and that, despite their much touted potential for liberatory and humanizing purposes, the military and profit-oriented applications will undoubtedly remain dominant. One must then examine these technologies from the perspective of how they allow various groups of people to negotiate specific forms of power, authority, representation and knowledge.

'The anthropology of cyberculture', as understood in this proposal, similarly agrees with the fact that we can assume *a priori* neither the existence of a new era nor the need for a new branch of anthropology. Indeed, as in the case of most anthropological analyses of cultural production, the discipline is in principle well suited to what must start as a rather traditional ethnographic project: to describe, in the manner of an initial diagnosis, what is happening in terms of the emerging practices and cultural transformations associated with rising technoscientific developments. However, given that these developments are increasingly unprecedented sites of articulations of knowledge and power, it is also pertinent to raise the question of the theoretical adequacy of established concepts in the light of their historical and cultural specificity.

In what ways? Some theorize that what is happening is a blurring and implosion of categories at various levels, particularly those modern categories that have defined until recently the natural, the organic, the technical and the textual. New discourses of biology, for instance, do not conceptualize living beings in terms of hierarchically-organized organisms, but according to the language of communications and systems analysis, that is, in terms of engineered communications systems, command-control networks, purposeful behaviour, and probabilistic outcomes. Pathology is the result of stress and communications breakdown, while the immune system is modelled as a battlefield. In sum, notions such as organism and individual, so dear to pre-Second World War science, are being de-naturalized as never before. The boundaries between nature and culture, between organism and machine, are ceaselessly redrawn according to complex historical factors in which discourses of science and technology play a decisive role.[26] 'Bodies', 'organisms' and 'communities' thus have to be retheorized as composed of elements that originate in three different domains: the *organic*, the *technical* (or technoeconomic), and the *textual* (or, broadly speaking, the cultural).

The boundaries between these three domains are quite permeable, producing always assemblages or mixtures of machine, body and text: while nature, bodies and organisms certainly have an *organic* basis, they are increasingly produced in conjunction with *machines*, and this production is always mediated by scientific *narratives* ('discourses' of biology, technology, and the like) and by culture in general. 'Cyberculture' must thus be understood as the overarching field of forces and meanings in which this complex production of life, labour and language takes place. For some,[27] while cyberculture can be seen as the imposition of a new grid of control on the planet, it also represents new possibilities for potent articulations between humans, nature and machines. The organic, these critics suggest, is not necessarily opposed to the technological. Yet it must also be emphasized that new knowledge and power configurations are narrowing down on life and labour, such as in the human genome project; indeed, the new genetics – linked

as well to novel computer techniques, its promise most eagerly visualized in the image of the biochip – might prove to be the greatest force for reshaping society and life ever witnessed in history. Nature will be known and remade through technique; it will be literally built, in the same way that culture is, with the difference that this process will take place through the reconfiguration of social life by micro-practices originating in medicine, biology and biotechnology.[28] Beyond the possibilities of new forms of genetic determinism, the relationship between nature and culture will be radically reconceived. Molecular biology is creating the sense of a 'new malleability of nature'; this is easily seen in the discourse on genetic diseases.[29] The 'right to normal genes' might well become the battle cry of an army of health experts and reformers who will effect a deployment of modes of practices of biosocial transformation not witnessed since 'the birth of the clinic' two centuries before.[30]

Hence the importance of devoting increasing attention to the social and cultural relations of science and technology as central mechanisms for the production of life and culture in the twenty-first century. Capital, to be sure, will continue to play a crucial role in the reinvention of life and society. But the worldwide spread of value today does not take place so much through the direct extraction of surplus value from labour, nor through conventional industrialization, but by further capitalizing nature and society through scientific R&D, particularly in the areas of artificial intelligence and biotechnology. Even the human genome, as mentioned above, becomes an important area for capitalist restructuring and, so, for contestation. The reinvention of nature and culture currently under way – effected by/within webs of meaning and production that link science and capital – must thus be understood according to a political economy appropriate to the era of cyberculture.[31] So far anthropologists have been silent on these pressing issues. We need to begin in earnest the study of the social, economic and political practices being brought about by the project of technoscience and its associated enterprises and institutions, including biotechnology, cyberspatial realities, and in general all those sites in which the new technologies of life, language and labour are being articulated.

The anthropological project: (2) ethnographic domains

As stated before, the general questions to be raised by the anthropology of cyberculture include the following: what new forms of social construction of reality, and of negotiation of such constructions, are being created or modified? How are people socialized by their routine experience of constructed spaces created by new technologies? How do people relate to their technoworlds (machines, reinvented bodies and natures)? If people are differently placed in these constructed spaces (according to race, gender, class, geographical location, 'physical ability'), how is their experience of such spaces different? In what ways are these spaces interpreted? Contested (the hermeneutics of cyberculture)? Finally, and more important, would it be possible to produce ethnographic accounts of the multiplicity of practices linked to the new technologies in various social, regional and ethnic settings? How do these practices relate to broader social issues, such as the control of labour, the accumulation of capital, the organization of life-worlds, and the globalization of cultural production? One can begin to think of these questions in terms of possible ethnographic domains and concrete research strategies.

Some clues concerning these domains already exist in the embryonic research projects existing at present. As an initial approximation, to be refined as the research advances, one can distinguish the following domains of investigating.

1. *The production and use of new technologies.* These would include anthropological research focused on scientists and experts in sites such as genetic research laboratories, high-technology corporations, and virtual reality design centres, on the one hand, and the users of these technologies, on the other. Ethnographies in this domain would generally follow in the footsteps of the handful of ethnographies of modern science and technology conducted to date;[32] STS theorizing, particularly in relation to anthropology;[33] and feminist studies of science and technology,[34] although they will have to be resituated within the conceptual space of the anthropology of cyberculture. A handful of ethnographic studies are already under way in this regard.[35]

A salient aspect of research in this domain is the ethnographic study of the production of subjectivities that accompanies the new technologies. That the computer is 'an evocative object', a projective medium for the construction of a variety of private and public worlds, has been shown by Sherry Turkle.[36] As the computer culture spreads, Turkle shows in her foundational study in the anthropology of computer cultures, more and more people start to think of themselves in computer terms. This includes not only the use of the computer as a model for the human mind but for one's life as well (one 'programs' one's life, for example). Cyberculture is indeed creating a host of veritable 'technologies of the self'. Although some of these technologies rely on a view of self as machine, their cultural productivity can only be assessed ethnographically. Virtual worlds, in fact – such as the use of anonymous computer role-playing games, such as MUDs (Multi-user Dimension and/or Dungeon), as therapeutic media – can be used by people as a way to move out of the self and into the world of social interactions. In other words, these media can become instruments for reconstructing identities in interactive ways, and sources of knowledge about other cultures and the outside world, as Turkle's recent work indicates.[37]

2. *The appearance of computer-mediated communities,* such as so-called virtual communities, and generally what one of the most creative computer environment designers has called 'the vibrant new villages of activity within the larger cultures of computing'.[38] Anthropological analysis in this area can be crucial not only for understanding what these new 'villages' and 'communities' are but, equally important, for imagining the kinds of communities that human groups can create with the help of emerging technologies. We can anticipate active discussion on proper methods to study these communities, including questions of on-line/off-line fieldwork, boundaries of the group to be studied, interpretation, and ethics.

A variant of this line of research is what Laurel termed 'interface anthropology'.[39] the creation of human–computer interfaces has been treated narrowly as a problem of engineering design which attempts to match tasks to be performed with the tools at hand. Yet the key question of the distinct user populations for whom the technologies are intended ('what do the users want to do?') is often ignored or inferred from statistical information. But children, teachers, computer games designers and users, fiction writers, architects, community activists, etc.

(without even mentioning aspects of crosscultural design) all have different needs and approaches regarding this basic question. The same interface might not work for everybody, and local ways of doing things might evolve with or against existing environments. An 'interface anthropology' that addresses this lack would focus on user/context intersections, finding 'informants' to guide the critical (not merely utilitarian) exploration of diverse users and contexts. The issue of interface design is also important in the development of hypertext, to the extent that it is the virtual environment created by the hypertext that allows a 'matrix' of knowledgeable users to interact with each other.[40]

3. *Studies of popular culture of science and technology*, including the effect of science and technology on the popular imagery and popular practices. What happens when such technologies as computers and virtual reality enter the mainstream social world? The rise of a 'technobabble' is only the tip of the iceberg of the changes that are taking place at this level.[41] For Argentinian cultural critic Beatriz Sarlo, the principal point in this regard is to examine the aesthetic and practical incorporation of technology into daily life.[42] This is accomplished by people in middle and popular sectors in ways that while undeniably modern, differ significantly from those intended by scientists. At the level of the popular sectors, the technological imagery elicits a reorganization of popular knowledge and the development of symbolic contents. This has to be taken into account in the study of 'technoliterate practices'.[43] Since the mid-1980s, ethnographic studies of popular culture,[44] so salient in contemporary cultural studies and of growing appeal to anthropologists, are grappling with some of these issues. The imbrication of cultural forms with social questions, however, does not have to be restricted to ethnographic studies; it can also be gleaned from literature and other popular productions, as the work of Sarlo, Seltzer and Jenkins demonstrates.[45]

4. *The growth and qualitative development of human computer-mediated communication (HCMC)*, particularly from the perspective of the relationship between language, communication, social structures and cultural identity. While HCMC shares many features with other forms of mediated communication well studied by linguists and linguistic anthropologists, such as telephone and answering machine messages, it also differs in important respects. Human interaction through computers must thus be studied from the perspective of the transcultural/transsituational principles and 'discourse strategies'[46] governing any type of human interaction, but also from the specificity of the communicative and linguistic practices that arise from the nature of the media involved. Perhaps four dimensions of the process of construction of HCMC communities stand out as particularly relevant in this regard:[47]

 (a) the relationship between machines and social subjects as producers of discourse at the threshold of the birth of an international 'cyberliterate' society;

 (b) the question of the creation, distribution and access to those 'authorized' or 'legitimate' HCMC codes and languages (parallel to Bourdieu's 'legitimate' standard language) whose mastery and manipulation grants particular groups of HCMC practitioners (élites?) symbolic authority and control over the circulation of cyberculture;

(c) the role of HCMC in establishing links, giving cohesion to, and creating continuities in the socio-interactional history of group members, side-by-side with telephone conversations, regular mail, or face-to-face interaction. This might include research on talk, interaction and technology in work and leisure contexts; and hypertext as a linguistic entity to be re-created or transformed through collaborative acts between one person and an original database, or among many users performing operations on a given text or texts;[48]

(d) the shaping and reshaping of social and cultural boundaries both between a given HCMC community and other social communities, and with HCMC communities.[49]

An underlying question in this domain is the hypothesized transition to a post-scriptual society being effected by information technologies. If writing and its associated logical modes of thought replaced orality and its associated situational ways of thinking, the information age would be similarly marking the abandonment of writing as the dominant intellectual technology. In the same way that writing incorporated orality, information would incorporate writing, but only after an important cultural mutation. Theoretical and hermeneutical knowledge – so closely linked to writing – would likewise enter into a period of decline or, at least, of reconversion to a secondary form. New ways of thinking would be instituted, characterized particularly by the operational qualities necessitated by information and computation. Time would no longer be circular (as in orality) nor linear (as with the historical societies of writing), but punctual. Punctual time and the acceleration of information would entail that knowledge will not be fixed as in writing; it will evolve, as with the concept of expert systems.[50] These momentous changes would signify profound anthropological transformations. For anthropology, so dependent on writing and hermeneutical interpretation, they pose particularly difficult questions.

5. *The political economy of cyberculture*: anthropologists have paid close attention, particularly in recent decades, to the analysis of communities in the historical and global contexts in which they are situated.[51] Cyberculture presents new challenges for the continued articulation of an anthropological political economy. What has been variously called 'the silicon order', 'microchip capitalism' and 'the information economy' entails deep changes in capital accumulation, social relations, and divisions of labour at many levels. New questions arise, such as the following:

(a) What is the relationship between 'information' and 'capital'? Is it appropriate to postulate, as some do,[52] the existence of a 'mode of information' akin to a mode of production? How can we theorize the articulation between information, markets and cultural orders? Cybernetic machines are becoming the basis of a 'society of control',[53] and an entire cyberocracy, or 'rule by way of information',[54] is emerging. How can anthropologists and others best explore issues of class, freedom and domination, accommodation and resistance in relation to this information order?

(b) The appearance of a cyberocracy calls for *institutional ethnographies* to be conducted from the perspective of the political economy of information. What are the major institutional sites within which likely informational categories and flows are created and put into circulation? What perspectives of

the world do these categories and flows represent, and how do they enact mechanisms of ruling that depend on certain groups' relations to the mode of production of information? These ethnographies would move from sites of computer-mediated production of information to its reception and use, investigating at each level the cultural dynamics and politics that 'information' sets into motion.

(c) Like information, science and technology have become crucial to capitalism, to the extent that the creation of value today depends largely on scientific and technological developments. This is as clear in the case of biotechnology as it is with computers. Anthropologists have maintained that the transformation of nature and ecosystems by capital is mediated by the cultural practices of the specific societies in which such appropriation takes place.[55] But the concrete forms of appropriation of life and labour by capital through the use of contemporary science exhibits novel features, such as in the case of the human genome project. Another development is the ever tighter imbrication of academy and industry in the biotechnological field.[56] There is a new political economy of information and commodities in the making. How does this affect the practice of biological anthropology?

In the case of the Third World, the biophysical milieu (nature) is increasingly represented as a reservoir of capital, to be exploited mostly by biotechnology in the name of the efficient and rational use of the environment. Local communities and social movements are enticed to participate in these schemes as 'stewards' of natural and social capital. In this way, biotechnology assists capital in the semiotic conquest of territories and communities: communities (or their survivors) are acknowledged as rightful owners of 'the environment' only to the extent that they acquiesce to treat it (and themselves) as capital.[57] The whole issue of 'intellectual property rights' linked to Third World natural resources – such as the patenting by multinational corporations of seeds and plant varieties and substances derived from stocks used by Third World 'traditional societies' – is emerging as one of the most disturbing aspects of the ecological phase of capital.[58]

The 'biorevolution' will affect all aspects of development. As three prominent observers remark, 'New technical forms . . . will significantly change the context within which technological change in the Third World is conceptualized and planned. We suggest that the cluster of emergent techniques generically called "biotechnology" will be to the Green Revolution what the Green Revolution was to traditional plant varieties and practices.'[59] Plant genetics, industrial tissue culture, and the use of genetically manipulated micro-organisms represent pathbreaking technologies in the context of Third World development. Corporations have clearly understood it in this way and are already in the lead of R&D. As Buttle, Kenney and Kloppenburg warn in their analysis of patterns of corporate behaviour in this area, the prospects are 'ominous'. Even more, the new technologies will have the capacity to extend their reach to regions and circumstances prohibited to the Green Revolution. What are the implications of these developments for studies of material culture and biological anthropology? How will these branches of the discipline deal with the regime of biosociality and the

biorevolution in development? What are the implications for social move-
ments?

(d) Finally, the restructuring of the relations between rich and poor countries
in the wake of cyberculture must be considered. As some argue, high tech-
nology is resulting in a 'new dependency' of technology-poor countries on
the leaders in the innovation and production of computer, information and
biological technologies.[60] Third World countries, according to these authors,
must negotiate this dependency through aggressive technological moderniza-
tion coupled with social reforms. From an anthropological perspective, this
suggestion is problematic; it, indeed, amounts to the continuation of the
post-Second World War policies of 'development' which have had for the
most part deleterious effects on the economies and cultures of the Third
World.[61] Like development, technologies are not culturally neutral.

Are there different possibilities for Third World societies, other ways of partici-
pating in the technocultural conversations and processes that are reshaping the world?
How can, for instance, social movements in Asia, Africa and Latin America articulate
policies that allow them to participate in cybercultures without fully submitting to the
rules of the game? Will most social groups in the Third World be in the position to
even know the possibilities afforded by new technologies? A more general question is
whether Third World governments would be interested in constructing the technolog-
ical imaginaries that will be required to accede to the new technologies from the
perspective of more autonomous design. This is doubly important since, as Sutz believes,
'there will not be a genuine social transformation without transforming the relation
between society and the technologies it incorporates'.[62] To start paying attention to the
local technological innovation that always takes place in the Third World – even in the
context of the new technologies – is a first step towards gaining a sense of 'technolog-
ical self-esteem'. But, one must ask, is it possible to approach the new technologies
with an understanding that transcends their role in 'economic development' and the
like? Moreover, what does 'cyberculture' look like from the perspective of the Third
World? What does it mean?

Of special importance in discussing these issues in the Third World is the role of
women in the electronics industry worldwide, but particularly as cheap labour in Japanese,
US and European factories located in the Third World. The development of cyberculture
rests, in many ways, on the labour of young women in electronic enclaves in South-east
Asia, Central America and other parts of the Third World.[63] If the effects of economic
adjustment policies under pressure from the International Monetary Fund have fallen
heavier on poor women,[64] the same is true of the restructuring that usually accompanies
other neo-liberal measures, such as the 'opening' of the economy to international
markets and the setting up of factories in 'free trade zones'. There is every reason to
believe that electronics will continue to be favoured in industrial schemes in the Third
World, under the aegis of multinational corporations; and there is also every reason to
believe that young women will continue to be seen as the 'ideal' labour force by these
industries. The effects of this process on the dynamics of gender and culture are enor-
mous, as studies of maquiladoras and sweatshops have shown, although these studies have
just begun in the electronics sector. Feminist anthropology and political economy have a
great deal to contribute to this fundamental aspect of the construction of cyberculture.

More generally, anthropologists need to study in depth the class, gender and race aspects of the development of cyberculture and challenges to it. This entails analysis of emerging scientific discourses and practices and the formation of technoscientific élites, on the one hand, and of the potential of individuals, groups and social movements to articulate parallel or alternative technologies, ways of knowing, and social relations of science and technology, on the other.[65] Anthropological studies of cybercultures can contribute to provide contexts in which there emerge possibilities for relating to technoculture that do not exacerbate the power imbalances in society.

Rethinking technology? Anthropology and complexity

As we discussed at the beginning of this chapter, science and technology have remained captive to the historical mode of the West, particularly to the discourses of modernity. A narrow-minded, instrumentalist and economistic posture has characterized our 'common sense' understanding of technology, while science has tended to adopt linear and reductionistic paradigms. We have also argued that, rather than being neutral instruments that merely allow or facilitate certain human endeavours, science and technology entail the production of life-worlds and the division of the social field in certain ways; in short, the creation of culture. It is clear that these two different approaches to science and technology are in opposition. Can the entrenched modern signification be reoriented or destabilized, so as to foster a different understanding of technology, more fluid and attuned to its sociocultural role? New developments in science during the past two decades suggest paths towards this reorientation. Although they can barely be hinted at here, these trends are likely to become important sources of dialogue and insight for those wishing to articulate a critical cultural politics of science and technology in the coming decades.

Much as the designers of the new technologies believe that they are changing the world, so do the groups of scientists working on the development of the 'science of complexity' have no doubt that they are at the threshold of a great scientific revolution. Instead of emphasizing stability in nature and societies, they emphasize instabilities and fluctuations; in lieu of reversible linear processes ('the linearity trap'), they have substituted non-linearity and irreversibility at the heart of scientific inquiry. Similarly, 'conservative systems' (physical systems considered in isolation from their surroundings) have given place to 'self-organizing' systems; static equilibrium to dynamic equilibrium and non-equilibrium; order to chaos; fixed elements and quantities to patterns and possibilities; prediction to explanation as the goal of science. The science of complexity has also replaced nineteenth-century physics with modern biology as a model; consequently, it studies physical phenomena as complex biological processes ('non-organic life'), and practises kinds of analysis that are based on the concrete and the heterogeneous, not on the abstract, the homogeneous and the general. While Cartesian epistemology and Newtonian science sought to model the Order of Things according to the (scientific) Law, the science of complexity – though still searching for a general law of pattern formation of all non-equilibrium systems in the universe – believes in a pluralistic view of the physical world, on webs rather than structures, connections and transgressions instead of neat boundaries isolating pristine systems.

According to the scientists, developments in thermodynamics and mathematics during the past twenty years (the thermodynamics of irreversible phenomena and the

theory of dynamical systems) pushed scientists into recognizing that the gap between the physicochemical and the biological worlds, between the 'simple' and the 'complex', and between 'order' and 'disorder' is not so sharp and large as it was thought. On the contrary, these developments make clear that non-organic matter shows properties that are remarkably close to those of life-forms, leading to the postulate that life is not a property of organic matter *per se*, but of the organization of that matter, and hence to the idea of non-organic life.[66] In a similar vein, scientists began to pay attention to the fact that simple systems (such as a simple chemical reaction and a mechanical pendulum) can generate extremely complex behaviours, while, at the other end of the spectrum, extremely complex systems can give rise to simple and easily quantifiable phenomena. Realizing that 'inert' matter can show complex lifelike behaviour, and that phenomena that were previously outside the purview of science because they could not be described by systems of linear equations were in fact central to the universe, led these groups of scientists to launch the theorization of complexity as the crucial scientific research programme for the final decades of the twentieth century and for many decades to come.[67]

The popularity achieved by fractals and chaos theory (a relatively small subset of complexity) in the mid-1980s helped immensely to put these developments on the map for the larger public. Chaos became the signifier for many things, few of which perhaps had to do with the actual scientific work going on. This popularity, however, raises an important question recently taken up by a group of literary theorists – the extent to which science and culture intertwine in the production of popular imaginaries. Chaos theory, according to these authors, echoes and participates in other cultural currents, such as certain aspects of post-structuralist theory and postmodern culture. The birth of chaos and complexity is not independent from the same historical ferment which gave rise to 'the postmodern condition': a world that was becoming at once more chaotic and more totalized; small causes resulting in big effects in the economy and the social order; recognition of the importance of information and rapid expansion of information technologies. 'Chaos' – or, better, 'chaotics', as Hayles[68] proposes – must then be seen as a force that is negotiated at diverse sites within the culture, including science and post-structuralism. Contemporary literature reflects this postmodern condition, whether it is expressed in the terms of the human sciences or the sciences of complexity.[69]

Be that as it may, the science of complexity has already developed an impressive vocabulary and theoretical corpus.[70] At the heart of complexity is the idea of self-organizing phenomena generated by complex systems under certain conditions. The idea of self-organization is of course not restricted to complexity science. In biology, the work of Maturana, Varela and co-workers[71] has made self-organization (the *autopoiesis* of the living) the cornerstone of their theoretical biology and epistemology. Foucault's elaboration of the nature of discursive formations can likewise be seen as a theory of the self-organizing character of knowledge systems.[72] Perhaps the more thorough view of the pervasive character of self-organizing processes is the work of Deleuze and Guattari.[73] Whether it is in the domains of inert matter (geology), the sciences, political economy, or the self, what these authors find at work are 'machinic' processes, stratifications and territorializations that develop into the structures that are well known to us. Thus Foucault's archaeologies of modern structures – the relatively rigidified and sedimented systems of the clinic, the prison, the market, or what have you – can be

seen as the result of the more general dynamics described by Deleuze and Guattari under rubrics such as 'machinic assemblages', 'rhizomics' and 'nomadology'.

It is clear that technology has been essential to the appearance and solidifying of modern structures. Modern structures belong with the line, boundary making, disciplinarity, unity, hierarchical control, and the fixity of power even at the micro-level. Fractals, chaos, complexity, nomadology would perhaps dictate a different dynamics and arrangement of life – fluidity, multiplicity, plurality, connectedness, segmentarity, heterogeneity, resilience. Not 'science' but knowledge of the concrete and the local; not laws but knowledge of the problems and the self-organizing dynamics of non-organic, organic and social phenomena. There is some awareness among the scientists working out complexity that they are reversing a centuries-old dualistic attitude of the West, the binary logic, the reductionist and utilitarian drive. Some have attempted a link with Eastern thought.[74] Despite these realizations, however, the scientists (unlike such authors as Foucault, Deleuze and Guattari) still place too much emphasis on order and general laws, and have perhaps too quickly jumped into the intellectual game of applying the ideas of complexity to social phenomena like economies, social orders, evolution, and the rise and fall of civilizations. Their tendency to produce over-encompassing theories that would link the physical, biological, social and cultural worlds, without making explicit the immense epistemological processes and assumptions at stake in this endeavour, is indeed troubling.[75] Some critics have begun to see it as such, perhaps rightly so.[76]

Complexity, itself, needs to be anthropologized, in other words. Yet it might offer insights to anthropology. Anthropological questions have hardly been tackled within the science of complexity, with the exception of a reformulation in progress of the theory of evolution to account for the role of learning and self-organization (in addition to natural selection) in evolution, and the articulation of a more complex concept of adaptation from this perspective. In fact, the Santa Fe Institute labels a good part of its work as the understanding of complex adaptive systems. Although there is some interest in cultural complexity, the question has not been broached to any significant degree. Anthropologists, it can be argued, have generally been attuned to the complex nature of life, and have resisted reducing it to magic formulae and laws. Nevertheless, since the nineteenth century to Malinowski, Boas, Benedikt, Lévi-Strauss and Geertz, the tendency to reduce the manifold complexity of cultural reality into neat descriptions of institutions, patterns, structures or exemplars has not gone away. Only in recent years has this tendency been modified with the development of forms of analyses that emphasize partiality, after finally giving up any pretence at general laws and accounts from the heights of objectivity.

What kinds of questions can anthropologists pose in relation to the new science? Can this scientific trend – seemingly so different from conventional science, yet so clearly entrenched in scientific culture – contribute to reorient the prevailing understanding of technology? What would a new understanding of technology be like? What kinds of social experiences and techno-practices would it foster? Is it really possible to destabilize (destratify, deterritorialize) modern technosocial, politicoeconomic and biosocial systems, as Deleuze and Guattari would propose? Technology itself, of course, must begin to be seen as a self-organizing system of sorts. The rapid development and avatars of the computer industry (why did it develop towards the personal computer when everything was geared up towards big centralized computers?) show this much. Yet the

articulation of technological understandings and policies that contribute to people's autonomous lives and self-organizing experiences are many years in the future, if they ever become possible. But, if we are to believe those working on new ways of understanding the universe and social life – whether in science or in the humanities – the possibility might be there for a 'nomadology' of technology.

Anthropology without primitives?

Anthropology, it continues to be said,[77] is still enframed within the overall order of the modern and the savage, the civilized self and uncivilized other. If anthropology is to 're-enter the real world' and 'work in the present',[78] it will necessarily have to deal with the steady march of cyberculture. Cyberculture, moreover, offers a chance for anthropology to renew itself without reaching again, as it was the case with the anthropology of this century, a premature closure around the figures of the other and the same.[79] These questions, and cyberculture generally, concern what anthropology is about: the story of life, as it has been and is being lived today, at this very moment.

What is happening to life in the late twentieth century? What's coming for the next?

Originally published in *Current Anthropology* 35(3) (1994).

Notes

1. Paul Rabinow, 'Artificiality and enlightenment: from sociobiology to biosociality', in J. Crary and S. Kwinter (eds) *Incorporations* (New York, Zone Books, 1992), pp. 234–52.
2. Martin Heidegger, *The Question Concerning Technology* (New York, Harper and Row, 1977).
3 Terry Winograd and Fernando Flores, *Understanding Computers and Cognition* (Norwood, NJ, Ablex Publishing Corporation, 1986).
4. Jonathan Crary and Sanford Kwinter (eds), *Incorporations* (New York, Zone Books, 1992).
5. Michel Foucault, *The Order of Things* (New York, Vintage Books, 1973).
6. Ibid.; Jürgen Habermas, *The Philosophical Discourse of Modernity* (Cambridge, MA, MIT Press 1987); Anthony Giddens, *The Consequences of Modernity* (Stanford, CA, Stanford University Press, 1990).
7. See Michel Foucault, *The History of Sexuality. Volume I* (New York, Vintage Books, 1980), pp. 135–59. See also Gilles Deleuze and Felix Guattari, *A Thousand Plateaus* (Minneapolis, MA, University of Minnesota Press, 1987).
8. Michael Adas, *Machines as the Measure of Men* (Ithaca, NY, Cornell University Press, 1989).
9. Martin Heidegger, *Being and Time* (New York, Harper and Row, 1962).
10. Manuel Medina and José Sanmartin, 'Filosoffia de la Tecnologia, INVESCIT y el Programma TECNAS', *Anthropos*, No. 94/95, 1989; pp. 4–7. With the exception of a few philosophers like Jacques Ellul, Mario Bunge, Lewis Mumford and Juan David Garcia Bacca, the philosophy of technology only took off as a field in the 1970s and 1980s. Important in this regard have been the creation of Carl Mitcham's Philosophy and Technology Studies Center in New York (since moved to Pennsylvania State University), a similar group at the Universidad Politécnia de Valencia, (INVESCIT), and the Society for Philosophy and Technology in the US.
11. An entire genre of science fiction, known as 'cyberpunk', has been on the rise since the publication of William Gibson's *Neuromancer* in 1984, now considered a 'classic' of cyberpunk and the official point of origin of the cyberspatial era. For an introduction to cyberpunk, see Larry McCaffery (ed.), *Storming the Reality Studio. A Casebook of Cyberpunk and Postmodern Fiction* (Durham, NC, Duke University Press, 1991).

12. Marcy Darnovsky, Steven Epstein and Ara Wilson, 'Radical experiments: social movements take on technoscience', *Socialist Review* 21(2), 1991, pp. 31–3.

13. For a directory and bibliography of anthropological STS studies, see David Hess (ed.), *The Social/Cultural Anthropology of Science and Technology* (Directory, 1992 edition). See also David Hess and Linda Layne (eds), *Knowledge and Society. Volume 9. The Anthropology of Science and Technology* (Greenwich, CT, JAI, Press, 1992); Bryan Pfaffenberger, 'The social anthropology of technology', *Annual Review of Anthropology*, 21, 1992, pp. 491–516; David Hakken, 'Has there been a computer revolution? An anthropological approach', *Journal of Computing and Society*, 7(1), pp. 11–28.

14. Manual de Landa, *War in the Age of Intelligent Machines* (New York, Zone Books, 1991).

15. Lila Abu-Lughod, 'The romance of resistance', *American Ethnologist*, 17(1), 1990, pp. 401–55; Gudrun Dahl and Annika Rabo (eds), *Kamap or Take-off. Local Notions of Development* (Stockholm, Stockholm Studies in Social Anthropology); Néstor García Canclini, *Culturas Hibrídas. Estrategias para Entrar y Salir de la Modernidad* (Mexico, DF, Grijalbo, 1990).

16. The case of the Kayapo in the Amazon rainforest, who have become adept at using video cameras, aeroplanes and revenues from gold mining in the articulation and execution of their struggle, is already becoming legendary. For an insightful discussion of this case, see David Hess, *Science and Technology in a Multicultural World* (1993).

17. Ibid.; Arturo Escobar, *Encountering Development: The Making and Un-Making of the Third World, 1945–1992* (Princeton, NJ, Princeton University Press, 1994).

18. See for instance the studies of M. Godelier on the effect of the introduction of steel axes on Australian aborigines and the Baruya of Papua New Guinea, respectively; Maurice Godelier, ' "Salt currency" and the circulation of commodities among the Baruya of New Guinea', in George Dalton (ed.), *Studies in Economic Anthropology* (Washington, DC, American Anthropological Association, 1971). For an excellent discussion of earlier studies, see Hess, *Science and Technology in a Multicultural World*.

19. Pfaffenberger, 'The social anthropology of technology', p. 513.

20. Mead was an active participant in the famous Macy Conferences on Cybernetics, as well as a central figure at the founding of the American Society for Cybernetics. Margaret Mead, H.L. Teuber and Heinz von Foerster (eds) *Cybernetics*, 5 vols (New York, Josiah Macy Jr Foundation, 1950–56); Margaret Mead, 'Cybernetics of cybernetics', in Heinz von Foerster (ed.), *Purposive Systems* (New York, Spartan Books, 1968). The life of this illustrious 'cybernetics group', which included besides Mead people like Gregory Bateson, Heinz von Foerster, Norbert Wiener and Kurt Lewin, is chronicled in a recent book by Steve Heims, *The Cybernetics Group* (Cambridge, MA, MIT Press, 1991).

21. The term 'cyberspace' was first coined by William Gibson in *Neuromancer* (London, HarperCollins, 1984), formally introduced to intellectual, artistic and academic circles in M. Benedikt's collection, *Cyberspace: The First Steps* (Cambridge, MA, MIT Press, 1991) and refers to the growing networks and systems of computer-mediated environments. For introductions to the concept of cyberspace, see also Marcos Novak, 'Liquid architecture in cyberspace', in *Cyberspace*, pp. 225–54. Rheingold, *Virtual Reality*, and Allucquere Rosanne Stone, 'Virtual systems', in J. Crary and S. Kwinter (eds), *Incorporations* (New York, Zone Books, 1992), pp. 608–25.

22. David Thomas, 'Old rituals for new space. Rites of passage and William Gibson's cultural model of cyberspace', in M. Benedikt (ed.), *Cyberspace*, pp. 31–48.

23. This description is mostly taken from the manifesto presented at the panel 'Cyborg Anthropology I: On the production of humanity and its boundaries' (Gary Downey, Joseph Dumit and Sarah Williams, 'Granting membership to the cyborg image', presented at the panel, 'Cyborg Anthropology II', 91st Annual Meeting of the American Anthropological Association, San Francisco, 2–6 December 1992).

24. Donna Haraway, *Symians, Cyborgs, and Women. The Reinvention of Nature* (New York: Routledge, 1991); de Landa, *War in the Age of Intelligent Machines*; Lisa Cartwright and Brian Goldfarb, 'Radiography, cinematography, and the decline of the lens', in Crary and Kwinter (eds), *Incorporations*, pp. 190–201; and Barbara Duden, *The Woman Beneath the Skin* (Cambridge, MA, Harvard University Press, 1990).

25. Chris Hables Gray and Mark Driscoll, 'What's real about virtual reality? Anthropology of, and

in, cyberspace', *Visual Anthropology Review*, 8(2), 1992, pp. 39–49.

26. Haraway, *Symians, Cyborgs, and Women*.
27. Ibid.; Rabinow, 'Artificiality and enlightenment: from sociobiology to biosociality'.
28. Rabinow, 'Artificiality and enlightenment'.
29. Evelyn Fox Keller, 'Nature, nurture and the human genome project', in Daniel Kevles and Leroy Hood (eds), *The Code of Codes: Scientific and Social Issues in the Human Genome Project* (Cambridge, MA, Harvard University Press, 1993), pp. 281–99.
30. Foucault, *The Order of Things*.
31. Arturo Escobar, 'Construction nature: towards a poststructuralist political ecology', *Futures*, 28(4), 1996, pp. 325–344.
32. Bruno Latour and Steven Woolgar, *Laboratory Life: The Social Construction of Scientific Facts* (Princeton, NJ, Princeton University Press, 1979); Bruno Latour, *The Pasteurization of France* (Cambridge, MA, Harvard University Press, 1988); Emily Martin, *The Woman in the Body* (Boston, MA, Beacon Press, 1987); Aihwa Ong, *Spirits of Resistance and Capitalist Discipline* (Albany, NY, SUNY Press, 1987); Shareon Traweek, *Beamtimes and Sometimes: The World of High-Energy Physicists* (Cambridge, MA, Harvard University Press, 1988); Dorin Kondo, *Crafting Selves* (Chicago, IL, The University of Chicago Press, 1990).
33. Hakken, 'Has there been a computer revolution?; Pffafenberger, 'The social anthropology of technology'; Hess and Layne, *Knowledge and Society*; Hess, *Science and Technology in a Multicultural World*.
34. Haraway, *Symians, Cyborgs and Women*; Mary Jacobus, Evelyn Fox Keller and Sally Shuttleworth (eds), *Body/Politics. Women and the Discourses of Science* (New York, Routledge, 1990); Keller, 'Nature, Nurture and the human genome project'.
35. These include Deborah Heath's study of a molecular biotechnology laboratory (Deborah Heath, 'Computers' bodies: prosthesis and simulation in molecular biotechnology', presented at the panel 'Cyborg Anthropology II', 91st Annual Meeting of the American Anthropological Association, San Francisco, (1992); Barbara Joans' ethnography of virtual reality designers (Barbara Joans, 'Outlaws and vigilantes in cyberspace', presented at the panel 'Virtual communities', 91st Annual Meeting of the American Anthropological Association, San Francisco, 2–6 December, 1992, and David West's research in progress on virtual reality users (personal communication; for information on this project, contact David West at dmwest@stthomas.edu).
36. Sherry Turkle, *The Second Self. Computers and the Human Spirit*, (New York, Simon and Schuster, 1984).
37. Sherry Turkle, 'Living in the MUDs: multiplicity and identity in virtual reality', presented at the panel 'Cyborg Anthropology II', 91st Annual Meeting of the American Anthropological Association, San Francisco, 2–6 December 1992.
38. Brenda Laurel (ed.), *The Art of Human–Computer Interface Design* (Reading, MA, Addison Wesley, 1990), p. 93.
39. Ibid., pp. 91–3.
40. Edward Barrett (ed.), *The Society of Text* (Cambridge, MA, MIT Press, 1989) and John Walker, 'Through the looking glass', in Brenda Laurel (ed.), *The Art of Human–Computer Interface Design*, pp. 439–48.
41. John Barry, *Technobabble* (Cambridge: MA, MIT Press, 1991).
42. Beatriz Sarlo, *La Imaginación Técnica. Sueños Modernos de la Cultura Argentina* (Buenos Aires, Ediciones Nueva Visión, 1992).
43. Constance Penley and Andrew Ross (eds), *Technoculture* (Minneapolis, MN, University of Minnesota Press, 1991); Henry Jenkins, *Textual Poachers* (New York, Routledge, 1992).
44. John Fiske, *Understanding Popular Culture* (Boston, MA, Unwin Hyman, 1989); Paul Willis, *Common Culture* (Boulder, CO, Westview Press, 1990).
45. Mark Seltzer, *Bodies and Machines* (New York, Routledge, 1992). Sarlo, *La Imaginación Técnica*; Jenkins, *Textual Poachers*.
46. John Gumperz, *Discourse Strategies* (Berkeley, CA, University of California Press, 1983).
47. Alvarez, personal communication.
48. Barrett, *The Society of Text*; Alejandro Piscitelli, 'Los Hipermedios y el Placer del Texto Electrónico', *David y Goliath*, (Buenos Aires), No. 58, pp. 64–78.

49. The linguistic anthropological investigation of cyberculture is clearly linked to the study of VCs, although not restricted to it. Alvarez claims that the characterization of HCMC groups as 'virtual' communities is a misnomer, since from the perspective of linguistic interaction, HCMC groups are 'real' communities. A different question, about the adequacy of the model of conversation for dealing with computers, has been posed by Walker ('Through the looking glass', p. 443). 'When you are interacting with a computer,' he says, 'you are not conversing with another person. You are exploring another world.' Here might lie some challenges for linguistic anthropology.

50. Pierre Lévy, 'La Oralidad Primaria, la Escritura y la Informática', *David y Goliath* (Buenos Aires), No. 58, 1991, pp. 4–16.

51. Eric Wolf, *Europe and the People without History* (New York and Berkeley, CA, University of California Press, 1982); William Roseberry, *Anthropologies and Histories: Essays in Culture, History, and Political Economy* (New Brunswick, NJ, Rutgers University Press, 1992).

52. Mark Poster, *The Mode of Information. Poststructuralism and Social Context* (Chicago, IL, The University of Chicago Press, 1990).

53. Gilles Deleuze, 'Control y Devenir. Entrevista con Toni Negri', translated by Edgar Garavito, *El Espectador. Magazin Dominical* (Bogota), No. 511, 7 February 1993, pp. 14–18.

54. David Ronfeldt, *Cyberocracy, Cyberspace, and Cyberology: Political Effects of the Information Revolution* (Santa Monica, CA, The Rand Corporation, 1991).

55. Enrique Leff, *Ecología y Capital* (Mexico, DF, UNAM, 1986); Godelier, ' "Salt currency" and the circulation of commodities among the Baruya of New Guinea'.

56. Rabinow, 'Artificiality and enlightenment'.

57. Martin O'Connor, 'On the misadventures of capitalist nature', *Capitalism, Nature and Socialism*, 4(4), 1993, pp. 1–34; Escobar, 'From organism to cyborg'.

58. Vandana Shiva and Jack Kloppenburg, 'Alternative agriculture and the new biotechnologies', *Science as Culture*, 2(13), 1991, pp. 483–506.

59. Frederick Buttle, Martin Kenney and Jack Kloppenburg, 'From green revolution to biorevolution: some observations on the changing technological bases of economic transformation in the Third World', *Economic Development and Cultural Change*, 34, 1985, pp. 31–55.

60. Manual Castells and Robert Laserna, 'The new dependency: technological change and socioeconomic restructuring in Latin America', *Sociological Forum*, 4(4), 1989, pp. 535–60.

61. Escobar, *Encountering Development*.

62. Judith Sutz, 'Los Cambios Technológicos y sus Impactos: Un Largo Camino Hacia la Construcción Solidaria de Oportunidades', *Fermentum* (Caracas), 3(6/7), 1992, p. 138.

63. Ong, *Spirits of Resistance and Capitalist Disciplines*; Maria Mies, *Patriarchy and Accumulation on a World Scale* (London, Zed Books, 1986).

64. Lourdes Beneria and Shelly Feldman, *Unequal Burden* (Boulder, CO, Westview Press, 1992).

65. Darnovsky *et al.*, 'Radical experiments. Social movements take on technoscience'.

66. Manuel de Landa, 'Nonorganic life', in Crary and Kwinter (eds), *Incorporations*, pp. 128–67.

67. M. Mitchell Waldrop, *Complexity. The Emerging Science at the Edge of Chaos* (New York, Simon and Schuster, 1994). An introduction to complexity for people with two or three years of college science is found in Grégoire Nicolis and Ilya Prigogine, *Exploring Complexity*, (New York, W. H. Freeman, 1989). See also Ziauddin Sardar and Jerome R. Ravetz (eds), 'Complexity: fad or future', special issue, *Futures*, 26(6), July/August 1994.

68. Katherine Hayles, 'Introduction: complex dynamics in literature and science', in Katherine Hayles (ed.), *Chaos and Order. Complex Dynamics in Literature and Science* (Chicago, IL, The University of Chicago Press, 1991), pp. 1–36; see also Stuart Kauffman, 'Antichaos and adaptation', *Scientific American*, 265(2), 1991, pp. 78–84.

69. Another attempt at relating complexity (particularly chaos) to the human sciences is Argyros's critique of deconstruction. Alexander Argyros, *A Blessed Rage for Order* , (Ann Arbor, MI, The University of Michigan Press, 1991).

70. Nicolis and Prigogine, *Exploring Complexity*, pp. 5–78.

71. Francisco Varela, 'The reenchantment of the concrete', in Crary and Kwinter (eds), *Incorporations*, pp. 320–39; Francisco Varela, Evan Thompson and Eleanor Rosch, *The Embodied Mind*, (Cambridge, MIT Press, 1991).

72. Foucault, *The Order of Things*.

73. Deleuze and Guattari, *A Thousand Plateaus*; Gilles Deleuze, *The Fold. Leibnitz and the Baroque* (Minneapolis, MN, University of Minnesota Press, 1993).

74. Varela *et al.*, *The Embodied Mind*.

75. See the volumes of the Santa Fe Institute Studies in the Sciences of Complexity. See, for instance, Philip Anderson, Kenneth Arrow and David Pines (eds), *The Economy as an Evolving Complex System* (New York, Addison Wesley, 1983), for an application of complexity to economics. Work within the sciences themselves continues at a fast pace, including areas such as artificial life, adaptive computational models, autocatalysis, neural networks, cellular automata, emergence, co-evolution, and the like.

76. Langdon Winner, 'If you liked chaos, you'll love complexity', *New York Times Book Review*, 14 February 1993, p. 12.

77. Ralph Trouillot, 'Anthropology and the savage slot: the poetics and politics of otherness', in Richard Fox (ed.), *Recapturing Anthropology* (Santa Fe, NM, School of American Research, 1991).

78. Fox (ed.), *Recapturing Anthropology: Working in the Present*.

79. Science fiction, unfortunately, continues the traditional representation of others characteristic of nineteenth- and twentieth-century anthropology and fiction. In Gibson's work despite a multitude of new 'others', Jamaican 'zionites' and Haitian 'voodoites' retain exemplary status as exotic others.

KEVIN ROBINS

CYBERSPACE AND THE WORLD
WE LIVE IN

The idea of an Earthly Paradise was composed of all the elements incompatible with History, with the space in which the negative states flourish.

(E.M. Cioran, *A Short History of Decay*)

And what Freud calls all the time reality, and the problem of reality, is always social reality. It is the problem of the other or the others, and it is never, never, never physical reality . . . The problem is always the difficulty or the impossibility of coping with or recognizing social reality, that is, human reality, the reality of other humans, the reality, of course, of institutions, laws, values, norms, etc.

(Cornelius Castoriadis, interview in *Free Associations*)

CYBERSPACE IS, ACCORDING TO THE guruesque William Gibson, a 'consensual hallucination'. The contemporary debate on cyberspace and virtual reality is something of a consensual hallucination, too. There is a common vision of a future that will be different from the present, of a space or a reality that is more desirable than the mundane one that presently surrounds and contains us. It is a tunnel vision. It has turned a blind eye on the world we live in.

You might think of cyberspace as a utopian vision for postmodern times. Utopia is nowhere (*outopia*) and, at the same time, it is also somewhere good (*eutopia*). Cyberspace is projected as the same kind of 'nowhere–somewhere'. Nicole Stenger tells us that 'cyberspace is like Oz – it is, we get there, but it has no location'; it 'opens up a space for collective restoration, and for peace . . . our future can only take on a luminous dimension!'[1] In their account of virtual reality, Barrie Sherman and Phil Judkins describe it as 'truly the technology of miracles and dreams'. Virtual reality allows us 'to play God':

> We can make water solid, and solids fluid; we can imbue inanimate objects
> (chairs, lamps, engines) with an intelligent life of their own. We can invent
> animals, singing textures, clever colours or fairies.

With charmless wit (or perhaps banal gravity, I cannot tell which), they suggest that 'some of us may be tempted to hide in VR; after all, we cannot make of our real world whatever we wish to make of it. Virtual reality may turn out to be a great deal more comfortable that our own imperfect reality.'[2] All this is driven by a feverish belief in transcendence; a faith that, this time round, a new technology will finally and truly deliver us from the limitations and the frustrations of this imperfect world. Sherman and Judkins are intoxicated by it all. Virtual reality, they say, 'is the hope for the next century. It may indeed afford glimpses of heaven'.[3] When I read this, I can hardly believe my eyes. We must consider what these spectacular flights of fantasy are all about.

But utopia is surely about more than a new pleasure domain? Krishan Kumar reminds us that it is also 'a story of what it is to encounter and experience the good society'.[4] In this respect, too, the self-proclaiming visionaries tell us they have good news and great expectations. The utopian space – the Net, the Matrix – will be a nowhere–somewhere in which we shall be able to recover the meaning and the experience of community. Recognizing 'the need for rebuilding community in the face of America's loss of a sense of a social commons', wishful Howard Rheingold believes that we have 'access to a tool that could bring conviviality and understanding into our lives and might help revitalise the public sphere'.[5] We shall be able to rebuild the neighbourhood community and the small-town public sphere and, in a world in which every citizen is networked to every other citizen, we can expand this ideal (or myth) to the scale of the global village. 'Virtual communities', says Rheingold, 'are social aggregations that emerge from the Net when enough people carry on [electronically mediated] public discussions long enough, with sufficient human feeling, to form webs of personal relationships in cyberspace.'[6] Communication translates directly into communion and community. It is a familiar dogma, and there is good reason to be sceptical about its technological realization. But we should also consider the worth of this vision of electronic community as the 'good society'.

In the following discussion, I shall be concerned with these utopian aspirations and sentiments. But I shall not accept them on their own terms: my interest is in their discursive status and significance in the world we presently inhabit. The propagandists of the virtual-technological revolution tend to speak as if there really were a new and alternative reality; they would have us believe that we could actually leave behind our present world and migrate to this better domain. It is as if we could simply transcend the frustrating and disappointing imperfection of the here and now. This is the utopian temptation:

> Men can, in short, become gods (if not God). What need then for 'politics',
> understood as the power struggles of a materially straitened and socially
> divided world? The frequently noted contempt for politics in utopian theory
> is the logical complement of its belief in perfectibility.[7]

I think we should urgently set about dis-illusioning ourselves. There is no alternative and more perfect future world of cyberspace and virtual reality. We are living in a real world, and we must recognize that it is indeed the case that we cannot make of

it whatever we wish. The institutions developing and promoting the new technologies exist solidly in this world. We should make sense of them in terms of its social and political realities, and it is in this context that we must assess their significance. Because it is a materially straitened and socially divided world, we should remember how much we remain in need of politics.

The prophets of cyberspace and virtual reality are immersed in the technological imaginary. What concern them are the big questions of ontology and metaphysics:

> What does it mean to be *human* in today's world? What has stayed the same and what has changed? How has technology changed the answers we supply to such questions? And what does all this suggest about the future we will inhabit?[8]

This opens up a whole domain of speculation on disembodied rationality, tele-existence, the pleasures of the interface, cyborg identity, and so on. Of course, these issues are not without interest. But, at the same time, there is the exclusion of a whole set of other issues that also pertain to what it is to be human now and what future humans can look forward to. It is as if the social and political turbulence of our time – ethnic conflict, resurgent nationalism, urban fragmentation – had nothing at all to do with virtual space. As if they were happening in a different world. I think it is time that this real world broke in on the virtual one. Consider the cyberspace vision in the context of the new world disorder and disruption. The technological imaginary is driven by the fantasy of rational mastery of humans over nature and their own nature. Let us consider these fantasies of mastery and control in the context of what Cornelius Castoriadis has called the 'dilapidation of the West',[9] involving a crisis of the political and the erosion of the social fabric. In looking at cyberspace and virtual reality from this different vertex, we can try to re-socialize and re-politicize what has been posed in an abstract, philosophical sense as the question of technology and what it means to be human in today's world.

Cyberspace and self-identity

Let us first consider the question of self-identity, which has become a pervasive theme in all discourses on cyberspace and virtual reality. In this new techno-reality, it is suggested, identity will be a matter of freedom and choice:

> In the ultimate artificial reality, physical appearance will be completely composable. You might choose on one occasion to be tall and beautiful; on another you might wish to be short and plain. It would be instructive to see how changed physical attributes altered your interactions with other people. Not only might people treat you differently, but you might find yourself treating them differently as well.[10]

Identities are composable in so far as the constraints of the real world and real-world body are overcome in the artificial domain. The exhilaration of virtual existence and experience comes from the sense of transcendence and liberation from the material and embodied world. Cultural conditions now 'make physicality seem a better state to be from than to inhabit':

> In a world despoiled by overdevelopment, overpopulation, and time-release environmental poisons, it is comforting to think that physical forms can recover their pristine purity by being reconstituted as informational patterns in a multidimensional computer space. A cyberspace body, like a cyberspace landscape, is immune to blight and corruption.[11]

In cyberspace, 'subjectivity is dispersed throughout the cybernetic circuit . . . the boundaries of self are defined less by the skin than by the feedback loops connecting body and simulation in a techno-bio-integrated circuit.[12] In this accommodating reality, the self is reconstituted as a fluid and polymorphous entity. Identities can be selected or discarded almost at will, as in a game or a fiction.

This question of technology and identity has been taken up in quite different ways, and we should take good care to distinguish them. At the banal end of the spectrum are invocations of a new world of fantasy and imagination. When they suggest that 'in VR we can choose to represent ourselves as anything we wish', Sherman and Judkins have in mind the idea that we might want to represent ourselves as 'a lobster or a bookend, a drumstick or Saturn'.[13] The guru of the virtual reality industry, Timothy Leary, has similar powers of imagination. In the electronic domain, he says, 'anything you can think of, dream of, hallucinate can be created. And communicated electronically. As Jimi Hendrix sang, "I'm a million miles away and I'm right here in your windowpane as Photon the Clown with a 95-foot-long triple penis made of marshmallows."[14] In less grandiose fashion, Howard Rheingold describes how electronic networks 'dissolve boundaries of identity':

> I know a person who spends hours of his day as a fantasy character who resembles 'a cross between Thorin Oakenshield and the Little Prince', and is an architect and educator and bit of a magician aboard an imaginary space colony: By day, David is an energy economist in Boulder, Colorado, father of three; at night he's Spark of Cyberion City – a place where I'm known only as Pollenator.[15]

New identities, mobile identities, exploratory identities – but, it seems, also banal identities. Only the technology is new: in the games and encounters in cyberspace, it seems, there is little that is new or surprising. Rheingold believes that they have their roots 'deep in that part of human nature that delights in storytelling and playing "let's pretend" '.[16] Michael Benedikt develops the same point:

> Cyberspace's inherent immateriality and malleability of content provides the most tempting stage for the acting out of mythic realities, realities once 'confined' to drug-enhanced ritual, to theatre, painting, books, and to such media that are always, in themselves, somehow less than what they reach for, mere gateways. Cyberspace can be seen as an extension, some might say an inevitable extension, of our age-old capacity and need to dwell in fiction, to dwell empowered or enlightened on other, mythic planes.[17]

All this rhetoric of 'age-old' dreams and desires – which is quite common among the cyber-visionaries – is unspeakably vacuous and devoid of inspiration. It is a familiar old appeal to an imaginative space in which we can occupy new identities and create new experiences to transcend the limitations of our mundane lives. It is the aesthetic of fantasy-gaming; the fag-end of a Romantic sensibility.

The imagination is dead: only the technology is new. The visions are bereft (lobsters and drumsticks), but the point is that the technology will, supposedly, let us experience them *as if they were real*. Another self-styled seer, Jaron Lanier, reveals why the technology is the crucial element. Which particular identity one inhabits is of less importance than what is common to all identities in virtual existence. As we grow up in the physical world, Lanier argues, we have to submit to the dictates of its constraining and frustrating reality. We discover 'that not only are we forced to live inside the physical world, we are made of it and we are almost powerless in it':

> We are actually extremely limited. We can't get to our food easily, we need help. The earlier back into my childhood I remember, the more I remember an internal feeling of an infinite possibility for sensation and perception and form and the frustration of reconciling this with the physical world outside which was very very fixed, very dull, and very frustrating – really something like a prison.[18]

The new technology promises to deliver its user from the constraints and defeats of physical reality and the physical body. It provides the opportunity to go back and to explore what might have been, if we had been able to sustain the infantile experience of power and infinite possibility. Virtual reality is, or is imagined as, 'a combination of the objectivity of the physical world with the unlimitedness and the uncensored content normally associated with dreams or imagination'.[19] The technology is invested by omnipotence fantasies. In the virtual world, it is suggested, we shall receive all the gratifications that we are entitled to, but have been deprived of; in this world, we can reclaim the (infantile) illusion of magical creative power.

All this appears rather familiar and unexceptional. Familiar and unexceptional, because this discourse on virtual futures constitutes no more than a mundane, commonsense re-formulation of the (Kantian) transcendental imagination, rooted in a coherent and unified subjectivity, in the unity of mind and body, the ' "transcendental synthesis" of our sensible and intelligible experience'.[20] *Plus ça change.* . . . There are more radical and challenging encounters with cyberspace, however. These other discourses can no longer accept the ontological status of the subject, and take as their premise the fractured, plural, decentred condition of contemporary subjectivity. They take very seriously the argument that the postmodern condition is one of fragmentation and dissolution of the subject. Continuing belief, or faith, in the essential unity and coherence of the personal self is held to be ideological, illusionary and nostalgic. In the postmodern scheme of things, there is no longer any place for the Kantian (even less the Cartesian) anthropology. Virtual technology is welcomed as the nemesis of the transcendental ego and its imagination. In cyberspace, there are possibilities for exploring the complexities of self-identity, including the relation between mental space and the bodily Other. We are provided with a virtual laboratory for analysing the postmodern – and perhaps posthuman – condition.

Weaving together a blend of post-structuralist theory and cyberpunk fiction, this other discourse charts the emergence of cyborg identities. In the new world order, old and trusted boundaries – between human and machine, self and other, body and mind, hallucination and reality – are dissolved and deconstructed. With the erosion of clear distinctions, the emphasis is on interfaces, combinations and altered states. David Tomas writes of the 'technologising' of ethnic and individual identities: 'The continuous

manipulation . . . of the body's ectodermic surface and the constant exchange of organic and synthetic body parts can produce rewritings of the body's social and cultural form that are directly related to the reconstitution of social identities.'[21] In an already hybrid world, it introduces 'another *technologically* creolised cultural laminate with a different set of ethnic-type rules of social bonding'. But, more than this, through the configurations of electronic and virtual space, 'it presents an all-encompassing sensorial ecology that presents opportunities for alternative dematerialised identity compositions'.[22] In its most sustained form – a kind of cyborg schizoanalysis – the collapse of boundary and order is linked to the deconstruction of ego and identity and the praise of bodily disorganization, primary processes and libidinal sensation.[23]

This critical and oppositional discourse on cyberspace and virtual reality has been developed to great effect within a feminist perspective and agenda. The imaginative project was initiated by Donna Haraway in her manifesto for cyborgs as 'an effort to contribute to a socialist-feminist culture and theory in a post-modernist, non-naturalist mode, and in the utopian tradition of imagining a world without gender'. Cyborg identity represented an 'imaginative resource' in developing an argument for '*pleasure* in the confusion of boundaries and for *responsibility* in their construction'.[24] Subsequent cyberfeminists have tended to place the emphasis on the moment of pleasure and confusion. Claudia Springer draws attention to the 'thrill of escape from the confines of the body': 'Transgressed boundaries, in fact, define the cyborg, making it the consummate postmodern concept. . . . it involves transforming the self into something entirely new, combining technological with human identity.'[25] Virtual reality environments allow their users 'to choose their disguises and assume alternative identities', Sadie Plant argues, 'and off-the-shelf identity is an exciting new adventure. . . . Women, who know all about disguise, are already familiar with this trip.' In this context, engagement with identity is a strategic intervention, intent on subverting masculine fantasies; it is 'a disturbance of human identity far more profound than pointed ears, or even gender bending, or becoming a sentient octopus'.[26]

This political edge is not always sustained, however, and it is not all that there is to cyborg feminism. It is accompanied by other desires and sentiments, reminiscent of – though not entirely the same as – the fantasies of omnipotent gratification evoked by Jaron Lanier. Cyberspace is imagined as a zone of unlimited freedom, 'a grid reference for free experimentation, an atmosphere in which there are no barriers, no restrictions on how far it is possible to go'; it is a place that allows women's desire 'to flow in the dense tapestries and complex depth of the computer image'.[27] Claudia Springer evokes 'a microelectronic imaginary where our bodies are obliterated and our consciousness integrated into the matrix'. Observing that the word 'matrix' derives from the Latin '*mater*', meaning both 'mother' and 'womb', she suggests that 'computers in popular culture's cyborg imagery extend to us the thrill of metaphoric escape into the comforting security of the mother's womb'.[28] There is an idealization of the electronic matrix as a facilitating and containing environment. Like the original, maternal matrix, 'the silently active containing space in which psychological and bodily experience occur', this other, technological, matrix seems to offer the space for unconstrained, omnipotent experience, as well as providing a 'protective shield' affording 'insulation from external reality'.[29]

It is time that we let this reality intrude into the discussion again. We should consider these various, and conflicting, discourses on cyberspace and self-identity in the context

of wider debates on identity and identity crisis in the real world.[30] It is, of course, in accounts of the 'postmodern condition' that the question of identity has been problematized, with the idea of a central and coherent self challenged and exposed as a fiction. The argument, as Stephen Frosh observes, is that 'if the reality of modernity is one of fragmentation and the dissolution of the self, then belief in the integrity of the personal self is ideological, imaginary, fantastic . . . whatever illusions we may choose to employ to make ourselves feel better, they remain illusory, deceptive and false.'[31] No longer stable and continuous, identity becomes uncertain and problematical. Carlo Mongardini takes note of the inconsistency of the ego-image in the postmodern era, and of the disturbing consequences of that inconsistency:

> A capacity for resistance in the individual is what is lacking here and above all *a historical consciousness which would permit him to interpret and thus control reality*. The individual becomes a mere fraction of himself, and loses the sense of being an actor in the processes of change.[32]

The loss of coherence and continuity in identity is associated with the loss of control over reality.

This crisis of self-identity is, then, more than a personal (that is, psychological) crisis. As Christopher Lasch has argued, it registers a significant transformation in the relationship between the self and the social world outside. It is associated with 'the waning of the old sense of a life as a life-history or narrative – a way of understanding identity that depended on the belief in a durable public world, reassuring in its solidity, which outlasts an individual life and passes some sort of judgement on it'.[33] This important cultural shift involves a loss of social meaning, and a consequent retreat from moral engagement. Mongardini observes a loss of the ethical dimension of life, which requires precisely continuity and stability of individual identity and social reality. There is now, he argues,

> a greater sense of alienation that makes it increasingly difficult to have relationships that demand more of the personality, such as love, friendship, generosity, forms of identification. . . . The loss of ability to give meaning to reality is also the product of psychic protection, the desire of the individual not to put himself at risk by exposing himself to the stimulus of a reality he can no longer interpret.[34]

There is dissociation and disengagement, withdrawal and solipsism. 'Change acts like a drug', argues Mongardini, 'It leads individuals to give up the unity and coherence of their own identity, both on the psychological and social level.'[35]

In the discourses on cyberspace and identity, however, things do not appear so problematical or bad. This is because the technological realm offers precisely a form of psychic protection against the defeating stimulus of reality. Techno-reality is where identity crisis can be denied or disavowed, and coherence sustained through the fiction of protean imagination; or it is where the stressful and distressing consequences of fragmentation can be neutralized, and the condition experienced in terms of perverse pleasure and play. Cyberspace and virtual reality are not new in this respect. Mary Ann Doane describes the psychic uses of early cinematographic technologies in a way that is strikingly similar:

One could isolate two impulses in tension at the turn of the century – the impulse to rectify the discontinuity of modernity, its traumatic disruption, through the provision of an illusion of continuity (to resist modernity), and the impulse to embody (literally give body to) discontinuity as a fundamental human condition (to embrace modernity). The cinema, in effect, does both.[36]

The new virtual technologies now provide a space in which to resist or embrace post-modernity. It is a space in which the imperatives and impositions of the real world may be effaced or transcended. In the postmodern context, it might be seen in terms of the turn to an aesthetic justification for life: 'Morality is thus replaced by multiple games and possibilities of aesthetic attitudes'.[37] Lost in the funhouse. Through the constitution of a kind of magical reality and realism, in which normal human limits may be over-come and usual boundaries transgressed, the new technological medium promotes, and gratifies, (magical) fantasies of omnipotence and creative mastery.

The technological domain readily becomes a world of its own, dissociated from the complexity and gravity of the real world. Brenda Laurel thinks of it as a virtual theatre, in which we can satisfy 'the age-old desire to make our fantasies palpable'; it provides 'an experience where I can play make-believe, and where the world auto-magically pushes back.'[38] We might also see it in the context of what Joyce McDougall calls 'psychic theatre', involving the acting out of more basic and primitive instincts and desires.[39] The techno-environments of cyberspace and virtual reality are particularly receptive to the projection and acting out of unconscious fantasies. In certain cases, as I have already argued, this may involve receptiveness to narcissistic forms of regression. Narcissism may be seen as representing 'a retreat from reality into a phantasy world in which there are no boundaries; this can be symbolised by the early monad, in which the mother offers the new-born infant an extended period of self-absorption and limit-less, omnipotent contentment'.[40] In this context, the virtual world may be seen as constituting a protective container within which all wishes are gratified (and ungrati-fying encounters with the frustrations of the real world 'auto-magically' deferred). In other cases, as I have again suggested, the created environment may respond to psychotic states of mind. Peter Weibel describes virtuality as 'psychotic space':

> This is the space of the psychotic that stage-manages reality in hallucinatory wish-fulfilment, uttering the battle-cry 'VR everywhere'. . . . Cyberspace is the name for such a psychotic environment, where the boundaries between wish and reality are blurred.[41]

In this psychotic space, the reality of the real world is disavowed; the coherence of the self deconstructed into fragments; and the quality of experience reduced to sensation and intoxication. It is what is evoked in the fiction of cyberpunk, where 'the speed of thrill substitutes for affection, reflection and care', and where, as 'hallucinations and reality collapse into each other, there is no space from which to reflect'.[42]

Marike Finlay argues that such narcissistic and psychotic defences are characteristic of postmodern subjectivity, representing strategies 'to overcome the ontological doubt about one's own status as a self by retreating to the original omnipotence of the child who creates the breast by hallucinating it'.[43] Virtual subjectivity – one crucial form through which the postmodern subject exists – may be understood in this light. The new technological environments of virtual reality and cyberspace confuse the boundaries

between internal and external worlds, creating the illusion that internal and external realities are one and the same. Artificial reality is designed and ordered in conformity with the dictates of pleasure and desire. To interact with it entails suspension of the real and physical self, or its substitution by a disembodied, virtual surrogate or clone. Under these conditions of existence, it appears as if there are no limits to what can be imagined and acted out. Moreover, there are no Others (no other bodies) to impose restrictions and inhibitions on what is imagined or done. The substantive presence of (external) Others cannot be differentiated from the objects created by the projection of (internal) fantasies. Virtual empowerment is a solipsistic affair, encouraging a sense of self-containment and self-sufficiency, and involving denial of the need for external objects.

Such empowerment entails a refusal to recognize the substantive and independent reality of others and to be involved in relations of mutual dependency and responsibility. As Marike Finlay argues, 'Only in phantasy can one be omnipotent without loss or reparation.'[44] Such a reality and such a subjectivity can only be seen as asocial and, consequently, amoral. 'Floating identities', Gérard Raulet observes, 'are in the realm of schizophrenia or neo-narcissism.'[45] The sense of unrestricted freedom and mastery belongs to disembodied identities. Such a fantasy, when it is socially institutionalized, must have its consequences for a real world of situated identities. As Michael Heim argues, the technological systems that convert primary bodily presence into telepresence are also 'introducing a remove between *re*presented presences'. They are changing the nature of interpersonal relationships. 'Without directly meeting others physically', says Heim, 'our ethics languishes.' Indeed, the machine interface 'may amplify an amoral indifference to human relationships . . . [and] often eliminate the need to respond directly to what takes place between humans'.[46] We are reminded of the reality of our embodied and embedded existence in the real world, and of the ethical disposition necessary for coexistence to be possible in that world. It is the continuity of grounded identity that underpins and underwrites moral obligation and commitment.

It is not my intention to deny the imaginative possibilities inherent in the new technologies, but rather to consider what is the nature of the imagination that is being sustained. From this perspective, it is useful to look at experiences in and of cyberspace and virtual reality in the light of Winnicott's notion of potential space: the 'third area of human living', neither inside the individual nor outside in the world of shared reality, the space of creative playing and cultural experience.[47] In elaborating his ideas, Winnicott drew attention to the continuity between the potential space that supports infantile illusions of magical creative power, and that which is associated with mature aesthetic or spiritual creativity. In virtual environments, this link between infantile and imaginative illusion becomes particularly apparent, as I have already indicated, and it seems appropriate to think of them in terms of the technological institution of potential or intermediate space. This magical–aesthetic aspect of the technologies is clearly that which has gathered most interest.

But we cannot be concerned with creative illusion alone (which is precisely what the new romancers of cyberspace do). In his discussion of potential space, Winnicott also put great emphasis on the moment of disillusionment, which involves 'acknowledging a limitation of magical control and acknowledging dependence on the goodwill of people in the external world'.[48] As Thomas Ogden points out, the infant then 'develops the capacity to see beyond the world he has created through the projection of internal objects'. The individual thereby becomes

> capable of entering into relationships with actual objects in a manner that involves more than a simple transference projection of his internal object world . . . mental representations acquire increasing autonomy from [their] origins and from the omnipotent thinking associated with relations between internal objects.[49]

Potential space is a transitional space. It is in this intermediate space, through the inter-action of both internal and external realities, that moral sense is evolved. Transitional experience involves the differentiation of internal and external worlds – it is on this basis that aesthetic transgression becomes possible – and the acknowledgement of 'a world of utilisable objects, i.e., people with whom [one] can enter into a realm of shared experience-in-the-world outside of [oneself]'.[50] This enables the development of capac-ities for concern, empathy and moral encounter. Potential space is, in this sense, transitive. We should hold on to this point in our discussions of the cultural aspects of cyberspace and virtual reality technologies. When it seems as if the new technologies are responding to regressive and solipsistic desires, we should consider the consequences and implications for moral-political life in the real world.

Virtual community and collective identity

This takes us to the question of collective identity and community in virtual space. Many of those who have considered these issues have made the (perverse) assumption that they are dealing with a self-contained and autonomous domain of technology. I shall argue, again, that the new technological developments must be situated in the broader context of social and political change and upheaval. The world is transforming itself. The maps are being broken apart and re-arranged. Through these turbulent and often conflictual processes of transformation, we are seeing the dislocation and re-location of senses of belonging and community. The experience of cultural encounter and confronta-tion is something that is increasingly characteristic of life in our cities. Virtual communities do not exist in a different world. They must be situated in the context of these new cultural and political geographies. How, then, are we to understand the signif-icance of virtual communities and communitarianism in the contemporary world? What are their possibilities and what are their limitations?

Virtual reality and cyberspace are commonly imagined in terms of reaction against, or opposition to, the real world. They are readily associated with a set of ideas about new and innovative forms of society and sociality. In certain cases, these are presented in terms of some kind of utopian project. Virtual reality is imagined as a 'nowhere–somewhere' alternative to the difficult and dangerous conditions of contemporary social reality. We might consider this in the context of Krishan Kumar's observations about the recent displacement of utopia from time back to space. The postmodern utopia, he suggests, involves 'returning to the older, pre-18th century, spatial forms of utopia, the kind inaugurated by More'.[51] Virtual space, which is on a continuum with other hyper-real utopian spaces – from Disneyland to Biosphere 2 – is a space removed. As in utopian thinking more generally, there is the belief or hope that the mediated interaction that takes place in that other world will represent an ideal and universal form of human asso-ciation and collectivity. Michael Benedikt sets it in the historical context of projects undertaken in pursuit of realizing the dream of the Heavenly City:

Consider: Where Eden (before the Fall) stands for our state of innocence, indeed ignorance, the Heavenly City stands for our state of wisdom, and knowledge; where Eden stands for our intimate contact with material nature, the Heavenly City stands for our transcendence of both materiality and nature; where Eden stands for the world of unsymbolised, asocial reality, the Heavenly City stands for the world of enlightened human interaction, form and information.[52]

The elsewhere of cyberspace is a place of salvation and transcendence. This vision of the new Jerusalem very clearly expresses the utopian aspirations in the virtual reality project.

Not all virtual realists are quite so unrealistic, however. There are others with a more pragmatic and political disposition who have more to contribute to our understanding of the relation between cyberspace and the real world. There is still the sense of virtual reality as an alternative reality in a world gone wrong. Techno-sociality is seen as the basis for developing new and compensatory forms of community and conviviality. Networks are understood to be 'social nodes for fostering those fluid and multiple elective affinities that everyday urban life seldom, in fact, supports.[53] Virtual communities represent:

flexible, lively, and practical adaptations to the real circumstances that confront persons seeking community. . . . They are part of a range of innovative solutions to the drive for sociality – a drive that can be frequently thwarted by the geographical and cultural realities of cities. . . . In this context, electronic virtual communities are complex and ingenious strategies for *survival*.[54]

But this involves a clear recognition that such communities exist in, and in relation to, everyday life in the real world: 'virtual communities of cyberspace live in the borderlands of both physical and virtual culture'.[55] Virtual interaction is about adjustment and adaption to the increasingly difficult circumstances of the contemporary world. We may then ask how adequate or meaningful it is as a response to those circumstances.

The most sustained attempt to develop this approach and agenda is that of Howard Rheingold in his book *The Virtual Community*. While there is something of the utopian in Rheingold (West-Coast style), there is also a clear concern with the social order. If we look at his arguments in a little detail, we can perhaps see some of the appeal of the pragmatic approach to virtual community, but also identify its limitations and weaknesses. Like other virtual communitarians, Rheingold starts out from what he sees as the damaged or decayed state of modern democratic and community life. The use of computer-mediated communications, he argues, is driven by 'the hunger for community that grows in the breasts of people around the world as more and more informal public spaces disappear from our real lives'.[56] Rheingold emphasizes the social importance of the places in which we gather together for conviviality, 'the unacknowledged agorae of modern life'. 'When the automobilecentric, suburban, fast-food, shopping mall way of life eliminated many of these "third places" from traditional towns and cities around the world, the social fabric of existing communities started shredding.' His hope is that virtual technologies may be used to staunch such developments. Rheingold's belief is that cyberspace can become 'one of the informal public places where people can

rebuild the aspects of community that were lost when the malt shop became the mall.'[57] In cyberspace, he maintains, we shall be able to recapture the sense of a 'social commons'.

The virtual community of the network is the focus for a grand project of social revitalization and renewal. Under conditions of virtual existence, it seems possible to recover the values and ideals that have been lost to the real world. Through this new medium, it is claimed, we shall be able to construct new sorts of community, linked by commonality of interest and affinity rather than by accidents of location. Rheingold believes that we now have 'access to a tool that could bring conviviality and under-standing into our lives and might help revitalise the public sphere'; that, through the construction of an 'electronic agora', we shall be in a position to 'revitalise citizen-based democracy'.[58] It is envisaged that on-line communities will develop in ways that tran-scend national frontiers. Rheingold thinks of local networks as 'gateways to a wider realm, the worldwide net-at-large'.[59] In the context of this 'integrated entity', he main-tains, we will be in a position to build a 'global civil society' and a new kind of international culture.

Like many other advocates of virtual existence, Rheingold is a self-styled visionary. His ideas are projected as exercises in radical imagination. It is this preachy posture that seems to give cyberspace ideology its popular appeal. There is another aspect to Rheingold's discourse, however, and I think that this has been an even more significant factor in gaining approval for the project of virtual sociality. For all its futuristic pre-tensions, Rheingold's imagination is fundamentally conservative and nostalgic. He is essentially concerned with the restoration of a lost object – community:

> The fact that we need computer networks to recapture the sense of coop-erative spirit that so many people seemed to lose when we gained all this technology is a painful irony. I'm not so sure myself anymore that tapping away on a keyboard and staring at a screen all day by necessity is 'progress' compared to chopping logs and raising beans all day by necessity. While we've been gaining new technologies, we've been losing our sense of commu-nity, in many places in the world, and in most cases the technologies have precipitated that loss. But this does not make an effective argument against the premise that people can use computers to cooperate in new ways.[60]

The Net is seen as re-kindling the sense of family – 'a family of invisible friends'. It re-creates the ethos of the village pump and the town square. Rheingold can envisage 'not only community but true spiritual communion' in what he describes as 'communitarian places on-line'.[61] The electronic community is characterized by commonality of inter-ests, by the sense of 'shared consciousness' and the experience of 'groupmind'.[62] The images are of maternal–familial containment. The ideas are of unity, unanimity and mutualism. Rheingold's image of virtual community turns out to be no more than an electronic variant of the 'Rousseauist dream' of a transparent society in which 'the ideal of community expresses a longing for harmony among persons, for consensus and mutual understanding'.[63] It is a social vision that is grounded in a primal sense of enclosure and wholeness.

Rheingold's *The Virtual Community* is a good condensation of the pragmatic case for association and collectivity in cyberspace. In a manner that contrasts with the other-worldliness of cyber-utopianism, Rheingold is intent on connecting virtual solutions to

real-world problems. A sustained case is made for the possibilities of applying virtual and network technologies for the purposes of social and political amelioration (while, at the same time, there is an awareness of the dangers of 'misapplication'). There is a growing recognition that electronic media have changed the way that we live in the world. Joshua Meyrowitz has observed how much television has altered the logic of the social order by restructuring the relationship between physical place and social place, thereby 'liberating' community from spatial locality.[64] Anthony Giddens describes a process of 'reality inversion', which means that 'we live "in the world" in a different sense from previous eras of history':

> The transformations of place, and the intrusion of distance into local activities, combined with the centrality of mediated experience, radically change what 'the world' actually is. This is so both on the level of the 'phenomenal world' of the individual and the general universe of social activity within which collective social life is enacted. Although everyone lives a local life, phenomenal worlds for the most part are truly global.[65]

In the light of these very significant developments, virtual communitarianism assumes a clear resonance and appeal. It appears to have a philosophy of social action appropriate to the conditions of the new technological order.

Because virtual experiences and encounters are becoming increasingly prevalent in the contemporary world, I believe we must indeed take very seriously their significance and implications for society and sociality. What I would question, however, is the relevance of techno-communitarianism as a response to these developments. Let us consider what is at issue. That which is generally presented in terms of technological futures is much more a matter of social relations and representations of social life in the present. In a period of turbulent change, in part a consequence of technological innovations, the nature of our relation to others and to collectivities has become more difficult and uncertain. 'The old forms of solidarity were internalised within the extended family and the village community', argues Edgar Morin, 'but now these internalised social bonds are disappearing.'[66] We must search for new senses and experiences of solidarity, he maintains, though these must now be at more expansive scales than in the past. And, of course, this is what virtual community seems to be all about. Solidarity in cyberspace seems to be a matter of extending the security of small-town *Gemeinschaft* to the transnational scale of the global village. There is, however, something deceptive in this sense of continuity and fulfilment. In considering another postmodern space, Disneyland, Michael Sorkin suggests that it 'invokes an urbanism without producing a city . . . it produces a kind of aura-stripped hypercity, a city with billions of citizens . . . but no residents'.[67] Jean Baudrillard says that it is 'an entire synthetic world which springs up, a maquette of our entire history in cryogenised form'.[68] We might see virtual and network association in the same light. There is the invocation of community, but not the production of a society. There is 'groupmind', but not social encounter. There is on-line communion, but there are no residents of hyperspace. This is another synthetic world, and here, too, history is frozen. What we have is the preservation through simulation of the old forms of solidarity and community. In the end, not an alternative society, but an alternative to society.

We might go so far as to see a particular affinity between virtual technologies and this communitarian spirit. As Iris Marion Young argues, the idealization of community

involves denial of the difference, or basic asymmetry, of subjects. Proponents of community

> deny difference by positing fusion rather than separation as the social ideal.
> They conceive the social subject as a relation of unity or mutuality composed by identification and symmetry among individuals within a totality.
> Communitarianism represents an urge to see persons in unity with one another in a shared whole.[69]

Existence in cyberspace – a space in which real selves and situations are in suspension – encourages the sense of identification and symmetry among individuals. De-materialized and de-localized, says Gérard Raulet, 'subjectivities are at once interchangeable and arbitrary. . . . The subject is reduced to pure functionality'.[70] The sense of unity and mutuality in a shared whole is 'artificially' created through the institution of technology.

The new technologies seem responsive to the dream of a transparent society. Communitarianism promotes the ideal of the immediate co-presence of subjects:

> Immediacy is better than mediation because immediate relations have the purity and security longed for in the Rousseauist dream: we are transparent to one another, purely copresent in the same time and space, close enough to touch, and nothing comes between us to obstruct our vision of one another.[71]

It is precisely this experience of immediacy that is central to the advocacy of virtual reality and relationships. According to Barrie Sherman and Phil Judkins, virtual reality 'can transmit a universal "language". . . . It is a perfect medium through which to communicate in what will be difficult times. . . . Common symbols will emphasise common humanity, expose common difficulties and help with common solutions.'[72] Jaron Lanier puts particular emphasis on this quality of virtual encounter. He likes to talk of 'post-symbolic communication' and a 'post-symbolic world'. He believes that it will be possible 'to make up the world instead of talking about it', with people 'using virtual reality a lot and really getting good at making worlds to communicate with each other'. The frustrations of mediated communication will be transcended in an order where 'you can just synthesise experience'.[73] These virtual ideologies are perpetuating the age-old ideal of a communications utopia. Immediacy of communication is associated with the achievement of shared consciousness and mutual understanding. The illusion of transparency and consensus sustains the communitarian myth, now imagined at the scale of global electronic *Gemeinschaft*. It is an Edenic myth.

Techno-community is fundamentally an anti-political ideal. Serge Moscovici speaks of the dialectic of order and disorder in human societies. Order, he maintains, has no basis in reality; it is a 'regressive phantasy'. A social system is only viable if it can 'create a certain disorder, if it can admit a certain level of uncertainty, if it can tolerate a certain level of fear'.[74] Richard Sennett has put great emphasis on this need to provoke disorder in his discussion of urban environments. In arguing that 'disorder and painful dislocation are the central elements in civilising social life',[75] Sennett makes the 'uses of disorder' the basis of an ethical approach to designing and living in cities. He is in opposition to those planners – 'experts in *Gemeinschaft*' – who 'in the face of larger differences in the city . . . tend to withdraw to the local, intimate, communal scale'.[76] Sennett believes

that this denial of difference reflects 'a great fear which our civilisation has refused to admit, much less to reckon':

> The way cities look reflects a great, unreckoned fear of exposure. . . . What is characteristic of our city-building is to wall off the differences between people, assuming that these differences are more likely to be mutually threatening than mutually stimulating. What we have made in the urban realm are therefore bland, neutralising spaces, spaces which remove the threat of social contact.[77]

What is created is the blandness of the 'neutralised city'. Disneyland is no more than the parodic extension of this principle. Here, too, 'the highly regulated, completely synthetic vision provides a simplified, sanitised experience that stands in for the more undisciplined complexities of the city'.[78] I have already noted the continuity between postmodern spaces like Disneyland and electronic virtual spaces. Virtual community similarly reflects the desire to control exposure and to create security and order. It also is driven by the compulsion to neutralize.

Cyberspace and virtual reality have generally been considered as a technological matter. They have seemed to offer some kind of technological fix for a world gone wrong, promising the restoration of a sense of community and communitarian order. It is all too easy to think of them as alternatives to the real world and its disorder. Containing spaces. I am arguing that we should approach these new technologies in a very different way. We must begin from the real world, which is the world in which virtual communities are now being imagined. And we must recognize that difference, asymmetry and conflict are constitutive features of that world. Not community. As Chantal Mouffe argues, the ideal of common substantive interests, of consensus and unanimity, is an illusion. We must recognize the constitutive role of antagonism in social life and acknowledge that 'a healthy democratic process calls for a vibrant clash of political positions and an open conflict of interests'.[79] For that is the key issue: a political framework that can accommodate difference and antagonism to sustain what Mouffe calls an 'agonistic pluralism'. This is so even in the matter of virtual association and collectivity.

The question of technology is not primarily a technological question. In considering the development of techno-communities, we must continue to be guided by social and political objectives. Against the wishful optimism of virtual communitarianism, I have chosen to emphasize those aspects of virtual culture that are inimical to democratic culture (in the sense of political thinkers like Young, Sennett and Mouffe). I have argued that virtual space is being created as a domain of order, refuge, withdrawal. Perhaps I have overstated my case. Maybe. The point has been to shift the discussion into the realm of social and political theory. Hopes for cyber-society have drawn their legitimacy from a metaphysics of technological progress – whatever comes next must be better than what went before. I am arguing for a different kind of justification, concerned with questions of pluralism and democracy now. We might then ask, for example, whether, or how, virtual technologies could be mobilized in pursuit of what Richard Sennett calls the 'art of exposure' (which I would consider to be the opposite of the science of withdrawal). Julia Kristeva considers the idea of a 'transitional' or 'transitive' space as important in thinking about national communities in more open ways.[80] We might consider what a transitional (as opposed to autistic) logic might mean in the

context of imagining virtual communities. The point is to broaden and to politicize the debate on community and collectivity in cyberspace. Those who will, of course, continue to work for this new form of association should not be allowed to set the agenda on their own narrow, and often technocratic, terms.

The worlds we live in

We can all too easily think of cyberspace and virtual reality in terms of an alternative space and reality. As if it were possible to create a new reality which would no longer be open to objections like that which has been left behind. As if we could substitute a reality more in conformity with our desires for the unsatisfactory real one. The new technologies seem to offer possibilities for re-creating the world afresh. We can see virtual culture, then, in terms of utopia: as expressing the principle of hope and the belief in a better world. That is the most obvious response. It is the one that virtual marketing and promotion always peddles. But we can also see virtual culture from an opposite perspective: instead of hopes for a new world, we would then see dissatis-factions about, and rejection of, an old one. This would have the more apocalyptic sense of looking back on the end of the world; what would be more significant would be the sense of an ending. This is how I am inclined to see virtual culture – because there is something banal and unpersuasive about its utopian ideal, and because what is more striking to me about it is its regressive (infantile, Edenic) mood and sentiments. It is what I have discussed in terms of omnipotence fantasies (at the individual level) and familial communitarianism (at the group and collective level). Regression as tran-scendence. Dieter Lenzen interprets contemporary society in terms of redemption through the totalization of childhood. He sees a project of cultural regeneration through regression:

> A regression from adults to children could cause people to disappear completely in the end, opening the way to a renewal of the world. We can see from this that the phenomenon of expanding childhood observable on all sides can be interpreted as an apocalyptic process. Correspondingly, the disap-pearance of adults could be understood as the beginning of a cosmic regeneration process based on the destruction of history.[81]

We could see virtual discourse as drawing on this mythology (as well as the more familiar metaphysics of technological progress) when it imagines the possibility of new individ-uals and new communities.

The mythology of cyberspace is preferred over its sociology. I have argued that it is time to re-locate virtual culture in the real world (the real world that virtual cultur-alists, seduced by their own metaphors, pronounce dead or dying). Through the development of new technologies, we are, indeed, more and more open to experiences of de-realization and de-localization. But we continue to have physical and localized exis-tences. We must consider our state of suspension between these conditions. We must de-mythologize virtual culture if we are to assess the serious implications it has for our personal and collective lives. Far from being some kind of solution for the world's prob-lems – could there ever be a 'solution'? – virtual inversion simply adds to its complexities. Paul Virilio imagines the coexistence of two societies:

One is a society of 'cocoons' . . . where people hide away at home, linked into communication networks, inert . . . The other is a society of the ultra-crowded megalopolis and of urban nomadism. . . . Some people, those in the virtual community, will live in the real time of the world-city, but others will live in deferred time, in other words, in the actual city, in the streets.[82]

In the first society, you may be transported by the pleasures of 'fractal dreaming'. The other society will accumulate the reality that has been repressed. We know that what is repressed cannot be kept out of the dreams.

Originally published in K. Robins (1996) *Into the Image: Culture and Politics in the Field of Vision*, London: Routledge.

Notes

1. Nicole Stenger, 'Mind is a leaking rainbow', in Michael Benedikt (ed.), *Cyberspace: First Steps* (Cambridge, Mass., MIT Press, 1991), pp. 53, 58.
2. Barrie Sherman and Phil Judkins, *Glimpses of Heaven, Visions of Hell: Virtual Reality and Its Implications* (London, Hodder & Stoughton, 1992), pp. 126–27.
3. Ibid., p. 134.
4. Krishan Kumar, *Utopianism* (Milton Keynes, Open University Press, 1991), p. 28.
5. Howard Rheingold, *The Virtual Community: Finding Connection in a Computerised World* (London, Secker & Warburg, 1994), pp. 12, 14.
6. Ibid., p. 5.
7. Kumar, *Utopianism*, p. 29.
8. Larry McCaffery, 'Introduction: the desert of the real', in Larry McCaffery (ed.), *Storming the Reality Studio* (Durham, Duke University Press, 1991), p. 8.
9. Cornelius Castoriadis, 'Le délabrement de l'occident', *Esprit*, December 1991.
10. Myron W. Krueger, *Artificial Reality II* (Reading, Mass., Addison-Wesley, 1991), p. 256.
11. N. Katherine Hayles, 'Virtual bodies and flickering signifiers', *October*, 66, Fall 1993, p. 81.
12. Ibid., p. 72.
13. Sherman and Judkins, *Glimpses of Heaven, Visions of Hell*, p. 126.
14. David Sheff, 'The virtual realities of Timothy Leary' (interview), in Gottfried Hattinger, Morgan Russel, Christine Schöpf and Peter Weibel (eds), *Ars Electronica 1990, vol. 2, Virtuelle Welten* (Linz, Veritas-Verlag, 1990), p. 250.
15. Rheingold, *Virtual Community*, p. 147.
16. Ibid., p. 155.
17. Michael Benedikt, 'Introduction', in Benedikt, *Cyberspace*, p. 6.
18. Jaron Lanier, 'Riding the giant worm to Saturn: post-symbolic communication in virtual reality', in Hattinger *et al.*, *Ars Electronica 1990*, pp. 186–87.
19. Ibid., p. 188.
20. Richard Kearney, *The Wake of Imagination* (London, Hutchinson, 1988), p. 169.
21. David Tomas, 'The technophilic body: on technicity in William Gibson's cyborg culture', *New Formations*, 8, Summer 1989, pp. 114–15.
22. Ibid., pp. 124–5.
23. Nick Land, 'Machinic desire', *Textual Practice*, 7 (3), Winter 1993.
24. Donna Haraway, 'A manifesto for cyborgs: science, technology, and socialist feminism in the 1980s', *Socialist Review*, 80, 1985, pp. 66–7 (Haraway's emphasis).
25. Claudia Springer, 'The pleasure of the interface', *Screen*, 32 (3), Autumn 1991, p. 306.
26. Sadie Plant, 'Beyond the screens: film, cyberpunk and cyberfeminism', *Variant*, 14, 1993, p. 16.
27. Ibid., p. 14.
28. Springer, 'Pleasure of the interface', p. 306.

29. Thomas H. Ogden, *The Matrix of the Mind: Object Relations and the Psychoanalytic Dialogue* (Northvale, NJ, Jason Aronson, 1986), pp. 179–80.

30. See, *inter alia*, Stephen Frosh, *Identity Crisis: Modernity, Psychoanalysis and the Self* (London, Macmillan, 1991); Anthony Giddens, *Modernity and Self-Identity: Self and Society in the Late Modern Age* (Cambridge, Polity Press, 1991); Barry Richards (ed.), *Crises of the Self* (London, Free Association Books, 1989).

31. Frosh, *Identity Crisis*, pp. 57–8.

32. Carlo Mongardini, 'The ideology of postmodernity', *Theory, Culture and Society*, 9 (2), May 1992, p. 62 (Mongardini's emphasis).

33. Christopher Lasch, *The Minimal Self: Psychic Survival in Troubled Times* (London, Pan, 1985), p. 32.

34. Mongardini, 'Ideology of postmodernity', p. 62.

35. Ibid., pp. 56–7.

36. Mary Ann Doane, 'Technology's body: cinematic vision in modernity', *Differences: A Journal of Feminist Cultural Studies*, 5(2), 1993, pp. 13–14.

37. Mongardini, 'Ideology of postmodernity', p. 61.

38. Brenda Laurel, 'On dramatic interaction', in Hattinger *et al.*, *Ars Electronica 1990*, pp. 262–3.

39. Joyce McDougall, *Theatres of the Mind: Illusion and Truth on the Psychoanalytic State* (London, Free Association Books, 1986).

40. Frosh, *Identity Crisis*, p. 93.

41. Peter Weibel, 'Virtual worlds: the emperor's new bodies', in Hattinger *et al.*, *Ars Electronica 1990*, p. 29.

42. Istvan Csicsery-Ronay, Jr, 'Cyberpunk and neuromanticism', in McCaffery, *Storming the Reality Studio*, pp. 190, 192.

43. Marike Finlay, 'Post-modernising psychoanalysis/psychoanalysing post-modernity', *Free Associations* 16, 1989, p. 59.

44. Ibid.

45. Gérard Raulet, 'The new utopia: communication technologies', *Telos*, 87, spring 1991, p. 51.

46. Michael Heim, 'The erotic ontology of cyberspace', in Benedikt, *Cyberspace*, pp. 75–6.

47. D. W. Winnicott, *Playing and Reality* (London, Tavistock, 1971).

48. D. W. Winnicott, *Human Nature* (London, Free Association Books, 1988), p. 107.

49. Ogden, *Matrix of the Mind*, pp. 193–4.

50. Ibid., p. 196.

51. Krishan Kumar, 'The end of socialism? The end of utopia? The end of history?', in Krishan Kumar and Stephen Bann (eds), *Utopias and the Millennium* (London, Reaktion Books, 1993), p. 76.

52. Benedikt, 'Introduction', p. 15.

53. Heim, 'Erotic ontology of cyberspace', p. 73.

54. Allucquere Rosanne Stone, 'Will the real body please stand up? Boundary stories about virtual cultures', in Benedikt, *Cyberspace*, p. 111.

55. Ibid., p. 112.

56. Rheingold, *Virtual Community*, p. 6.

57. Ibid., pp. 25–6.

58. Ibid., pp. 14.

59. Ibid., p. 10.

60. Ibid., p. 110.

61. Ibid., pp. 115, 56.

62. Ibid., pp. 245, 110.

63. Iris Marion Young, *Justice and the Politics of Difference* (Princeton, Princeton University Press, 1990), p. 229.

64. Joshua Meyrowitz, *No Sense of Place* (New York, Oxford University Press, 1985); 'The generalised elsewhere', *Critical Studies in Mass Communication*, 6 (3), September 1989.

65. Giddens, *Modernity and Self-Identity*, p. 187.

66. Edgar Morin, 'Les anti-peurs', *Communications*, 57, 1993, p. 138.

67. Michael Sorkin, 'See you in Disneyland', in Michael Sorkin (ed.), *Variations on a Theme Park* (New York, Farrar, Straus & Giroux, 1992), p. 231.

68. Jean Baudrillard, 'Hyperreal America', *Economy and Society*, 22 (2), May 1993, p. 246.
69. Young, *Justice and the Politics of Difference*, p. 229.
70. Raulet, 'New utopia', pp. 50–1.
71. Young, *Justice and the Politics of Difference*, p. 233.
72. Sherman and Judkins, *Glimpses of Heaven, Visions of Hell*, p. 134.
73. Timothy Druckrey, 'Revenge of the nerds: an interview with Jaron Lanier', *Afterimage*, May 1991, pp. 6–7.
74. Serge Moscovici, 'La crainte du contact', *Communications*, 57, 1993, p. 41.
75. Richard Sennett, *The Uses of Disorder: Personal Identity and City Life* (Harmondsworth, Penguin, 1973), p. 109.
76. Richard Sennett, *The Conscience of the Eye: The Design and Social Life of Cities* (New York, Alfred A. Knopf, 1990), p. 97.
77. *Ibid.*, p. xii.
78. Sorkin, 'See you in Disneyland', p. 208.
79. Chantal Mouffe, *The Return of the Political* (London, Verso, 1993), p. 6.
80. Julia Kristeva, *Nations without Nationalism* (New York, Columbia University Press, 1993), pp. 40–3.
81. Dieter Lenzen, 'Disappearing adulthood: childhood as redemption', in Dieter Kamper and Christoph Wulf (eds), *Looking Back on the End of the World* (New York, Semiotext(e), 1989), p. 71.
82. Paul Virilio, 'Marginal groups', *Daidalos*, 50, December 1993, p. 75.

ARTHUR KROKER AND
MARILOUISE KROKER

CODE WARRIORS
Bunkering in and dumbing down

ELECTRONIC TECHNOLOGY TERMINATES WITH THE radically divided self: the self, that is, which is at war with itself. Split consciousness for a culture that is split between digital and human flesh.

A warring field, the electronic self is torn between contradictory impulses towards privacy and the public, the natural self and the social self, private imagination and electronic fantasy. The price for reconciling the divided self by sacrificing one side of the electronic personality is severe. If it abandons private identity and actually *becomes media* (Cineplex mind, IMAX imagination, MTV chat, CNN nerves), the electronic self will suffer terminal repression. However, if it seals itself off from public life by retreating to an electronic cell in the suburbs or a computer condo in the city, it quickly falls into an irreal world of electronic MOO-room fun within the armoured windows. Suffering electronic amnesia on the public and its multiple viewpoints, going private means that the electronic self will not be in a position to maximize its interests by struggling in an increasingly competitive economic field.

The electronic self is in a bind. Seeking to immunize itself against the worst effect of public life, it bunkers in. It becomes a pure will-for-itself: self-dwelling, closed down, ready to sacrifice all other interests for the sake of its own immunity. Bunkering in is the epochal consciousness of technological society in its most mature phase. McLuhan called it the 'cool personality' typical of the TV age, others have spoken of 'cocooning' away the 1990s, but we would say that bunkering in is about something really simple: being sick of others and trying to shelter the beleagured self in a techno-bubble. Dipping back to Darwin, West Coast libertarians like to talk today about 'survival of the electronically fittest'.

However, at the same time that the electronic self bunkers in as a survival strategy, it is forced out of economic necessity to stick its head out of its techno-bubble and skate to work. Frightened by the accelerating speed of technological change, distressed by the loss of disposable income, worried about a future without jobs, and angry at the govern-

ment, the electronic self oscillates between fear and rage. Rather than objectify its anger in a critical analysis of the public situation, diagnosing, for example, the deep relation-ship between the rise of the technological class and the loss of jobs, the electronic self is taught by the media elite to turn the 'self' into a form of self-contempt. Dumbing down becomes the reality of the late twentieth-century personality. Dumbing down? In its benign form, that's Gump with his box of chocolates and Homer Simpson barfing doughnuts. In its predatory form, it's everyday life: cons and parasites and computer presidents and killer Jeeps on city streets. Or, like in *Pulp Fiction*, maybe it's time to 'bring out the gimp'.

The bunker self is infected by ressentiment against those it holds responsible for what ails it (feminists, African-Americans, immigrants, single mothers on welfare); dumbing down is the last blast of slave consciousness (servile to authority; abusive to those weaker than it). Petulant and given over to bouts of whining about the petty inconveniences, bunkering in knows no ethics other than immediate self-gratification. Hard-eyed and emotionally cryogenicized, dumbing down means oscillating between the psychological poles of predator and clown. Between the illusion of immunity and the reality of the process-self, that's the radically divided state of the electronic personality at the end of the twentieth century. Just in time to catch the virtual screen opening up on the final file of the millennium, the bunker ego and the dumbed down self are the culmination of what Jean-Paul Sartre predicted: a schizoid self which is simultaneously in-itself and for-itself, an unreconciled self flipping between illusion and self-contempt. Today, it's hip to be dumb, and smart to be turned off and tuned out.

The psychological war zone of bunkering in and dumbing down is the actual cultural context out of which emerges technological euphoria. Digital reality is perfect. It provides the bunker self with immediate, universal access to a global community *without people*: electronic communication without social contact, being digital without being human, going on-line without leaving the safety of the electronic bunker. The bunker self takes to the Internet like a pixel to a screen because the information superhighway is the biggest theme park in the world: more than 170 countries. And it's perfect too for dumbing down. Privileging information while exterminating meaning, surfing without engagement, digital reality provides a new virtual playing-field for tuning out and turning off. For example, when CITY-TV (Toronto) recently announced a merger with Voyager to produce new multi-media productions, its first product of choice was the creation of an 'electronic rumpus room'. Playtime for the new electronic kids on the block.

What's better, with the quick privatization of the Internet and the Web, the preda-tory self doesn't have to risk brief dashes in and out of public life to grab what it wants. In virtual capitalism, the predatory self goes fully digital, arms itself with the latest in graphical interfaces, bulks up the profile of its homepage, and goes hunting for digital gold. Schumpeter might have talked about 'creative destruction' as the contemporary phase of transiting to a virtual economy, but the predatory self knows better. Turbulence in the field means one thing only: the rest position is terminal, victory goes to those who warp jump the fastest to cyberspace. Working on the tried but true formula of 'use and abandon', the predatory self does the ultimate dumbing-down trick: it sheds its flesh (for cyber-skin), its mind (for distributive intelligence), its nerves (for algo-rithmic codes), its sex organs (for digital seduction), its limbs (for virtual vectors of speed and slipstream access), and its history (for multiplex hard ram). Virtual Gump.

Opening out and smartening up

Two worlds

Digital reality contains alternative possibilities towards emancipation and domination.

As a manifestation of the power of the virtual class, digital reality has definitely plunged the world into a great historical crisis. Here cybertechnology is a grisly process of harvesting nature and culture, and particularly our bodies, for fast-rendering through massive virtual imaging-systems. Not a technology that we can hold outside of ourselves as an inanimate object, cybertechnology has actually come alive in the form of virtualization. It seeks to take possession of the material world, and to dump material reality into the electronic trashbin in favour of what has been eloquently described as a 'realm inhabited by the disembodied'. Cybertechnology creates two worlds, one virtual, the other material, separate and unequal. The radical division between these two worlds is becoming more apparent every day.

The struggle to relink technology and ethics, to *think* cybertechnology in terms of the relationship of virtuality to questions of democracy, justice, social solidarity and creative inquiry promises a path of reconciliation. Of course, we don't think of the body or nature as outside technology, but as part of a field of dynamic and often deeply conflicting relations in which, for example, the body itself could be construed as a 'technology'. This being so, the key ethical question might be: what are the possibilities for a virtual democracy, virtual justice, virtual solidarity and virtual knowledge? Rather than recover ethics outside of cybertechnology, our position is to force ethics to travel deeply and quickly inside the force-field of cybertechnology, to make our ethical demands for social justice, for the reconciliation of flesh and spirit, rub up against the most demonic aspects of virtual reality. In this we practice Foucault's prescription for reading Nietzsche, that honours a writer (or a new ethics) by forcing ethics to bend, crackle, strain and groan under the violence and weight of our insistent demands for meaning.

Post-bodies

We are living in a decisive historical time: the era of the post-human. This age is typified by a relentless effort on the part of the virtual class to force a wholesale abandonment of the body, to dump sensuous experience into the trashbin, substituting instead a disembodied world of empty data flows. This body assault takes different forms: from the rhetoric of the 'information superhighway' (of which we are the pavement) to the widely publicized effort by Microsoft and McCaw Cellular to develop a global multi-media network of satellites for downloading and uplinking the archival record of the human experience into massive, centrally controlled databases. The virtual elite always present the 'electronic frontier' in the glowing, ideological terms of heightened accessibility, increased (cyber-)knowledge, more 'rapid delivery of health and education to rural environments' or better paying high-tech jobs. In reality what they are doing is delivering us to virtualization.

It isn't a matter of being pro- or anti-technology, but of considering the consequences of virtual reality when it is so deeply spoken of in the language of exterminism. In the age of the virtual class, digital technology works to discredit bodily experience,

to make us feel humiliated and inferior to the virtual rendering of the body in its different electronic formats, from computers and television to the glitzy and vampirish world of advertising. The attitude that the body is a failed project takes us directly to a culture driven by suicidal nihilism. Remember Goya: imagination without reason begets monstrous visions. Those 'monstrous visions' are the designs for better electronic bodies that vomit out of the cyber-factories of the Silicon Valleys of the world every day.

Digital reality has given us artificial life. Not artificial life as an abstract telematic experience fabricated by techno-labs, but artificial life as it is actually lived today. Cybertechnology has escaped the digital labs, and has inscribed itself on our captive bodies. In artificial life, the body is a violent uncertainty-field. What could be spoken of in the 1930s only in the language of high-energy physics, particularly Heisenberg's concept of uncertainty, has now been materialized in society as the schizoid body: the body, that is, as an unstable field flipping aimlessly between opposing poles: bunkered in yet dumbed down. This is the symptomic sign of what we call the digital body.

The new power elite

There are two dominant political tendencies in the 1990s: a global 'virtual class' that presents the *particular* interests of technotopia as the *general* human interest, and the equally swift emergence of ever more grisly forms of conservative fundamentalism in response to the hegemony of the virtual class.

The virtual class is composed of monarchs of the electronic kingdom. Its members like to gather in digital nests, from Silicon Valley and Chiba City to the European cyber-grid running from Munich to Grenoble. Deeply authoritarian in its politics, it seeks to exclude from public debate any perspective that challenges the ruling ideology of technotopia. Like its historical predecessors, the early bourgeoisie of primitive capitalism, the virtual class is driven by the belief that a cybernetically-steered society, of which it is the guiding helmsman, is coeval with the noblest aspirations of human destiny. Listen to the rhetoric of the virtual class that drowns the mediascape. A few years ago, at Silicon Graphics, Clinton preached the technotopian gospel that the 'information super-highway' is the telematic destiny of America; Gore continues to hype the 'interactive society' as the next stage of human evolution; Microsoft presents its strategic plans for a world wide web of digital satellites in the soft language of doing a big service for humanity (William Gates said his new satellite system would allow educational and health services to be delivered to previously inaccessible rural areas); and all multinational business and most governments these days commonly chant the refrain that trade policy should be decoupled from human rights issues. For example, faced with American business opposition to his executive order linking China's 'Most Favoured Nation' status to improvements in human rights, Clinton instantly collapsed, announcing that he had 'deep regrets' about his own executive order. Of course, in the mid-1990s the gospel of technotopia is the bible of virtual libertarians, Newt Gingrich most of all.

While the ruling masters of the virtual class in countries ranging from the United States, Japan, Western Europe and Canada represent the territorial centre of digital power, the rest of the world is quickly remaindered. Based in labour that is not a fungible resource, the middle and working classes in all countries are repeatedly victimized by the virtual class. Today, labour is disciplined by the representatives of the virtual

class who occupy the highest policy-making positions of government. As the dominant ideology of the 1990s, the virtual class institutes draconian anti-labour policies mandating 'labour adjustment', 'free trade', and belt-tightening, and all of this backed up by a media mantra calling for global economic competition, an end to pay equity, and for a 'meaner and leaner' workplace.

For those outside the labour force – the jobless, the disenfranchised, the politically powerless, the surplus class – the disciplinary lessons administered by the virtual class are bitter. And it fits so perfectly with the psychology of bunkering in. Consider the silence at the terrorism in Haiti where, in a macabre replay of Machiavelli's strategies for stable political rule, the tortured bodies of political activists had their faces cut off, were thrown into the main streets of Port-au-Prince, and left there under the glaring sun for several days. The police did not allow anyone to take away the bodies. Pigs ate the rotting flesh. The lesson is clear: the state has all-pervasive power to the point that even the identities of its victims after death can be effaced, letting the spirits of the dead roam in endless anguish. This is diabolical power at the end of the twentieth century, and still not a humanitarian peep from the political managers of the virtual class. Not until the shores of America were filled with 'illegal' Haitian refugees did the Clinton Administration react. Or consider the moral culpability of the so-called 'creative leadership' of the virtual societies of the West who continue to turn a blinkered eye to the genocide that takes place in the streets of Sarajevo everyday. Would it be different if Bosnia had oil, a Nike running shoe factory, or, even better, a Microsoft chip mill?

The virtual elite has the ethics of the hangman, all hidden under the soft hype of the data superhighway as new body wetware for the twenty-first century.

Dominant ideology

Recently, we received the following letter from Nate McFadden, a freelance reporter for a San Francisco magazine:

> In the *SF Bay Guardian's* article on *Wired*, a former director of The Well, Cliff Figallo, commented on the colonization of cyberspace. 'To some of us, it's like the staking of claims in the Old West. Perhaps it's the manifest destiny of cyberspace.'
>
> This remark seems to verify, at least a little, the lack of moral awareness rampant in the techno-elite. For me, the apparently unironic usage of the expression 'manifest destiny' indicates a mindset that avoids historical antecedents, and is free from any critical examination of motive and result.

A little later, we received this email message from Mark Schneider, Vancouver bureau chief for CTV:

> Check out the latest issue of *The Nation* (July 3), "Whose Net Is It?" by Andrew Shapiro.
>
> 'You probably didn't notice, but the Internet was sold a few months ago. Well, sort of: The Federal government has been gradually transferring the backbone of the US portion of the global computer network to companies such as IBM and MCI as part of a larger plan to privatize cyberspace.

But the crucial step was taken on April 30, when the National Science Foundation shut down its part of the Internet . . . [that's left] the corporate giants in charge.'

The virtual elite is a mixture of predatory capitalists and visionary computer specialists for whom virtualization is about our disappearance into nothingness. We are talking about a systematic assault against the human species, a virtual war strategy where knowledge is reduced to data storage dumps, friendship is dissolved into floating cyber-interactions, and communication means the end of meaning. Virtualization in the cyber-hands of the new technological class is all about *our* being dumbed down. In a very practical way, the end of the twentieth century is characterized by the laying down of hardware (virtual railway tracks) across the ever-expanding electronic frontier. Of course, who controls the hardware will dominate the soft(ware) culture of the twenty-first century. That's why Microsoft is the first of all the twenty-first century corporations: it's already put the Operating System in place and now, through Microsoft Network, it's set to actually *be* the Internet.

All of this is being done without any substantive public debate, to the background tune, in fact, of three cheers for the virtual home team and its hyped-ideology of cybertechnology as emancipation. Manifest Destiny has come inside (us), and we are the once and future victims of the big (electronic) stick.

Manifest (virtual) Destiny

The resuscitation of the doctrine of Manifest Destiny as the bible of the virtual class has already taken place. However, it's no longer Manifest Destiny as an American war strategy for the endocolonization of North America, but a more vicious doctrine of digital inevitability that is being put in place around the globe by the technological elite. In this mutation of Manifest Destiny, the world is quickly divided into cheap labour, and permanently slaved nations. While the citizens of the lead virtual societies certainly suffer massive psychological repression and suppression (of social choices), countries which are patched into the political economy of virtual reality as sources of cheap manufacturing or as product assembly labour suffer the form of domination particular to primitive capitalism – 'work or starve'. For the citizens of the slaved-nations, from Africa to Haiti, they are simply put under the coercive welfare wardship of a newly militant United Nations and then erased from historical consciousness. Like all empires before it, virtual reality begins with a blood-sacrifice.

Contradictions of the virtual class

It is not at all clear that the new technological class will win the day. The will to virtuality is riddled with deep contradictions. Can the offensive by the virtual class against human labour actually succeed in light of both growing impoverishment and the crushing of life expectations for the young? The rhetoric of digital reality speaks about the growing abundance of high-paying jobs in the tech industry. Across the OECD, the reality is dramatically different: every country that has instituted policies promoting

the expansion of digital reality has witnessed a dramatic, and seemingly permanent, increase in unemployment. Joblessness not just in the low- or no tech industries, but massive layoffs and ruthless 'restructurings' in the vaunted digital industries themselves. No one bothered to tell us that digital reality also deletes jobs! This is the dirty little secret that the masters of the technological universe definitely don't want to talk about, and in their control of the mediascape will never allow to be spoken. It's the forbidden-to-be-thought truth that ruptures the seamless web of digital reality as the dominant ideology of the 1990s.

Can the offensive by the technological class against society in the name of the moral superiority of digital reality be sustained in the midst of a general social crisis that it has created? What will happen when digital reality, this dynamic drive to planetary mastery in the name of technology, actually begins to displace its creators – the virtual class?

Against the new technological class are ranged a series of critical political forces: Net knowledgeable, technically astute, people who speak on behalf of the new relations of digital reality rather than apologizing for the old forces of commercial or governmental interests. Certainly Net-surfers with a (critical) attitude who attempt to make the 'information superhighway' serve the ethical human ends of solidarity, creativity, and democracy, but also all of those social movements who both say 'no' to the virtual class, and 'yes' to rethinking the human destiny. We have in mind aboriginal movements from North and South America who make of the issue of land rights a fundamental battleground of (durational) time against (virtualized) space, feminists who have re-asserted the identity of the body, the Green movement which is slowly turning the tide on a global scale against the harvesting machine of corporate capitalism, and those 'body outlaws', bisexuals and gays and lesbians, who have made of the politics of sexual difference a way of speaking again about the possibility of human love.

Having said this, we are under no illusion about the fundamental exterminatory character of the times. We exist now at a great divide: between a fall into a new form of despotic capitalism on the one hand, and a world that might be recreated ethically on the other. This is the life-and-death struggle of our age.

Harvesting flesh

Contemporary culture is driven onwards by the planetary drive towards the mastery of nature. In Heidegger's chilling description, technology is infected with the language of 'harvesting'. First, the harvesting of nature as the physical world is reduced to a passive resource of exploitation. And second, the harvesting of human flesh as (our) bodies and minds are reduced to a database for imaging systems. That's the contemporary human fate: to be dumped into the waiting data archives for purposes of future resequencing. Some all Web brains, others TV heads or designer logos, here minds as media screens, there nerves as electronic impulses finely tuned to the rhythms of the digital world.

Consider TV: a war machine for colonizing the soft mass of the electronic mind. Three tactical manoeuvres are always in play: *desensitization* – following exactly the same procedure used by the CIA in training assassins, TV desensitizes the electronic mind by repeatedly exposing it to scenes of torture, corpses and mutilation. By reducing the

electronic mind of the population to the deadened morality of the assassin, it preps the population for its own future sacrifice in the form of body dumps; *infantilization* – that's the gradual media strategy for reducing us all to retro-children: perfect political fodder for the growth of virtual- and retro-facism; and *reenergization* – left to its own devices, the mediascape will always collapse towards its inertial pole. That's why the media must constantly be reenergized (recharged?) by scenes of sacrificial violence. In every war, there are victims and executioners. In the television war machine, we are always *both*: victims (of the three tactical manoeuvres of the mediscape), and executioners of an accidental range of victims dragged across the cold screens for our moral dismissal (much like the terminal judgement of the Roman masses in the amphitheatres of classical antiquity).

Photography, cinema, TV and the Internet are successive stages in virtualization. Beginning with the simulacrum of the first photograph, continuing with the scanner imaging-system of TV and concluding (for the moment) with the data archives of the Internet, human experience is fast-dumped into the relays and networks of virtual culture. McLuhan was wrong. It is not the technological media of communication as an extension of man; but the human species as a humiliated subject of digital culture.

Originally published in A. Kroker and M. Kroker (1996) *Hacking the Future: Stories for the Flesh-Eating 90s*, Montreal: New World Perspectives.

PART TWO

Popular cybercultures

BARBARA KENNEDY

INTRODUCTION

Late twentieth century machines have made thoroughly ambiguous the differ-
ence between natural and artificial, mind and body, self-developing and
externally designed and many other restrictions that used to apply to organ-
isms and machines. Our machines are disturbingly lively and we ourselves
frighteningly inert.

(Donna Haraway 1991)

'*G*ET *A LIFE!*' SHOUTS CARLY/SHARON STONE at the end of the film
Sliver. The film foregrounds a narrative clearly based around structures of looking
and the gaze, the narrative determined by several examples of new technologies and
their machinic relationship with the *human* machine. Carly relies on her Apple, her
portable, her answering machine, never disappointed; but she cannot rely on her lover,
Zike, the ultimate human machine. He is a lover of incipience, insouciance, contradic-
tion; a control freak who manipulates technologies (and his women) in a voyeuristic
game of identity formations, transgression of boundaries, and a display of multiple selves.
The screens Zike controls from his multimedia pleasure suite are visual/visceral screens
which he creates and with which he forms an assemblage of the 'real' lives of those in
his apartment block. His life is an interminable machine, a computer game; he is at
the controls, producing the texts, staging the events and organizing those lives through
the screens he manipulates. Yet he too is part of the machine. Soap opera becomes the
real thing, or better than the real thing – interactive, with a multiplicity of heteroge-
neous narratives. Zike controls his own soap, cajoling, editing, cutting and framing
sequences at the digital control of his master suite, the ultimate in interactive stimula-
tion and simulation. The consistent surveillance and voyeuristic gaze of specific camera
shots provides the audience with an all-seeing gaze over and above the intra-diegetic
patterns of looking. Zike thus becomes the character in a different soap. The minia-

turization of video screens provides him with live visual experiences, a voyeuristic intrusion into the lives of others. His life becomes intrusively part of ours. Small is beautiful? Miniaturization is power? *But wait, this is just a movie ... or is it ... the 'real thing'?*

Part two of the Reader focuses on the ways in which cybercultures, technocultures and cyberdiscourses have impinged upon an array of contemporary popular cultural forms, from print media, comic books, cyberpunk novels to video games, television and cinema. Such media are technologies which circumscribe our experience. In this way, popular cybercultures transform, breed, infiltrate or/and re-create our identity formations, our subjectivities, our emotions, and our bodies. The media have become like machines: 'prosthetic devices, intimate components, friendly selves' (Haraway 1991). Such an argument opens up a wide range of questions with which several of the chapters here engage: what constitutes the *body*, what constitutes *perception* and *consciousness?* Can our consciousness be separated, downloaded from the body (see Bukatman, chapter 9)? Where is the body in the consumption of popular culture? What separates us as independent phenomena outside of the texts we consume? Can we be independent of the texts we consume? Can we distanciate the object of focus from the subject of perception? What boundaries are transgressed in re-thinking this subject/object relationship? The popular cultural texts discussed in this section have either been specifically oriented towards exploring the political, social and epistemological contradictions of cyber-productions (see Sobchack, chapter 8), or have themselves been 'read' through theoretical frameworks of cyberdiscourse (see Pyle, Tomas, Landsberg, chapters 7, 10 and 11).

As we have tasted already, films need not display the literal image of the cyborg, the kind we see in *Total Recall, Terminator, Blade Runner*. Rather, the texts themselves can be theorized through cyberdiscursive traces, lines or patterns, through a cyborg consciousness which challenges fixed positions around gendered subjectivities (see Haraway and Sandoval in section four of the Reader). Cyberdiscourse disorientates, parodies and transgresses Cartesian epistemologies (those foundational Western metaphysical ideas based on the structuring logic of binary thinking – male/female, mind/body, subject/object, nature/culture, etc.), providing ironic and micro-political parameters for thinking through meaning formations. But what of the original, literal manifestation of cyborg images? In chapter six, 'From Captain America to Wolverine', Mark Oehlert traces the cyborg figure back to the early days of the comic book phenomenon. He explores three specific types of cyborg: the 'simple controllers', the 'bio-tech integraters' and the 'genetic cyborgs', arguing that images in popular comic book fiction provide much more than a genealogy of the figure of the cyborg; they also raise interesting and increasingly important ontological questions – about the nature of 'human' experience, the ambivalence of social behavioural patterns, political agency, intentionality and power – as well as more philosophical questions to do with the nature of 'lost' humanity and post-humanity.

Oehlert traces the image of the cyborg back to 1930s comic book figures like Superman, highlighting his alien and illegal status (the alien inevitably has its historical ancestry throughout Hollywood B-movies in a similar genealogy). Mapping this history from DC Detective Comics of the 1930s to Wizard (1990s comic book owners), his argument is that such comics have displayed a range of cyborgian characteristics in their heroes. Their narratives have panned a political and sociological concern with

power, control and autonomy through a projection of capitalist, Western ideology: *Captain America*. Whether the cyborg originally fought the forces of the 'other' or provided mythological metaphors for a desire to save the cosmos, defence of the realm has become *defence of the human*. These narratives provided discourses of fear and abjection – a concern with 'otherness' which has since proliferated popular cultural texts. Originally a controller cyborg characterized by the simplicity of its system (Oehlert cites Wolverine as an example), the comic book cyborg has evolved into a complex bio-technological machine. Interestingly, it is these later cyborgs which have the human element programmed into them: the heart becomes fundamental to Iron Man, his armour 'created to keep his damaged heart beating'. This raises epistemological and ontological questions for any theoretical discourse upon the nature of the cyborgian – as we shall see in section six, on 'Cyberbodies'. The third type of cyborg is the genetic cyborg, whose primary power rests in a purposeful alteration of their genetic code. Such cyborgs begin to exercise control over their own system at a cellular level. Cyborgian charac-teristics, thus, are no longer constrained to the technical or the material, but also to the genetic, to the molecular, to the viral: the evolution of the human in post-millennial culture becomes a philosophical mire of contagious outpourings. Oehlert's chapter, then, raises questions to do with our current ontological categorization of cyborg conscious-ness as an assemblage of hybridity: biological, technological and genetic. The boundaries across these terms become signifiers within the texts of many popular cultural forms, especially films; the films themselves become prostheses of our cyborgian conscious-nesses (see Landsberg, chapter 11).

Cyborgs, then, proliferate popular film. Forest Pyle's chapter, 'Making cyborgs, making humans; of Terminators and Blade Runners', brings together the foundational elements of Oehlert's chapter and integrates them into a theoretical framework with examples drawn from contemporary neo-*noir*/tech-*noir* cyborgian films like *Blade Runner*. As Pyle writes, such films 'demonstrate that when we make cyborgs – at least when we make them in movies – we make, and on occasion, unmake our conceptions of ourselves', and he offers up a deconstructive reading of the movies, ending with a coda about images of cyborg hands from scenes of cyborg 'death' in *The Terminator*, *Blade Runner* and *Terminator 2: Judgment Day*; each image is, as Pyle says, a 'human' gesture made by a 'mechanical' hand, leading him to conclude finally that 'each gesture points towards a humanism that the films may hope to affirm, but only by way of the insistence of mechanical hands which bind the human deeply to its other, even in termination'.

Similar tropes are explored through Alison Landsberg's 'Prosthetic memory: *Total Recall* and *Blade Runner*'. Landsberg's concern is with the prosthetic nature of memory and its potential to disturb, disorientate and destratify (or restratify) fixed notions of identity and subject formation, and she approaches this through a reading of science fiction film. She makes an engaging comparison between early film texts which narra-tivize the literal prosthetic implant (*The Thieving Hand*) with an analogy of film's potential to provide us, as viewers, with *prosthetic* memory; that forms of conscious-ness might be transposable. How does this notion of memory then impinge on our conception of identity, consciousness and sense of self? To what extent do postmodernist configurations of the 'death of the subject' or the 'death of history' ossify or sub-sume the experience of memory? Fredric Jameson (1991) claims that in postmodernity

experience is dead, but Landsberg suggests that this narrow view of experience is challenged through re-thinking the notion of memory (or experience) as prosthetically constitutive of identity. Rather than 'textually' deconstructing the films in question, Landsberg uses the films *Blade Runner* and *Total Recall* to debate such ontological questions, offering the conclusion that identity is after all a complex and multiplicitous formation.

Vivian Sobchack's contribution to the Reader, 'New age mutant ninja hackers: reading *Mondo 2000*', is an exploration, amongst other things, of the contradictions felt at an epistemological (structures of knowledge and thinking) and phenomenological (the connection of the body with thought and emotion) level, in 'experiencing' the text of *Mondo 2000*. She explains that such contradictions come from her position in the academy as a cultural critic, confined by the discourses of academia and having to write about a journal which is self-consciously postmodern in its ironic and self-parodying style, and simultaneously as consumer of a text which, she has to admit, seduces through its sensuality ... glossy, slippery, slick ... *Mondoid desire*! Immediately she opens up questions fundamental to Cultural Studies: the boundaries/connections between the political and the pleasurable, and the connections between the spaces of the mind and body.

Mondo 2000 set out in the early 1990s to supply a printed text which would speak to the new age of New Age and New Edge cybergurus and cyber-cruisers – a generation of (mainly male, mainly white, mainly middle class, and by and large, mainly American) technocultural devotees. Its content seemed to blend the generational, cultural and social agendas of 1960s counter-cultural politics with New Edge (1990s) libertarian flights of desire (mostly through the cyberporn pages of teledildonics and cybersexual drool).

Sobchack's article provides – in typical postmodern style – a playful, creative, parodic and at the same time critical analysis of the journal. She acknowledges her own desires and her own contradictory feelings about the text. The tactility of a sensuously glossy, visceral and cool form does not totally annihilate a political concern with its content, and Sobchack offers a critique of what she sees as a potentially reactionary text which simultaneously offers a parodic account of its own politics: by providing coverage of the dawn of a Utopian New Age of cybercultures and cyberspatial communities, *Mondo 2000* also provides an alignment with the political commitments of eco-fundamentalism, the fight against Aids, and yet ambivalently presents a celebration of 'free-wheeling consumer hypercapitalism' and high-tech consumerism (see also Terranova, chapter 17).

'Terminal penetration', Scott Bukatman's essay, deals with the hybridity of cyber-cultural discourses across film, fiction and contemporary forms of popular pleasures (such as theme parks and leisure pursuits). Bukatman explores the complexity and contradictions of our techno-erotic desires, which are self-exploratory and simultaneously self-exterminating. From an exposition on virtual reality, he explores the notion of the phenomenal body in cyberspace. World and body provide a continuum; a feedback loop system, where the *cybersubject* replaces the object/subject dichotomy of Cartesian epistemology. Through discourses emanating from contemporary Continental philosophy and critical theory, Bukatman examines, via specific popular cultural texts, the ontological and epistemological issues of what it is to be 'human' in what might

now be termed an age of the 'post-human' (again, see Terranova). The post-human describes the human species beyond any definable parameters as we know them, where experience, sensation, cognition, identity and gender are all under question. Consequently, what is witnessed here is a reframing of embodiment, from its recent postmodern dislocations, within the 'paraspaces' of cyberspace. This assemblage (to use a Deleuzian term) of thought, perception and consciousness offers a peculiar oxymoronic notion of cosmology, linking art, science and technology together through discourses of a new form of embodiment. The disembodied space of cyberspace provides a re-embodiment of consciousness; a consciousness that might at some time be offered for future 'downloading'. *Stuff* of science fiction? Maybe? Or is it 'reality'?

Science fiction texts are also highlighted in the essay by David Tomas, on 'The technophilic body'. Here cyberpunk works by William Gibson (*Burning Chrome, Neuromancer, Count Zero* and *Mona Lisa Overdrive*) are explored through the discourse of cyberconsciousness. As well as providing elaborate and intriguing readings of these contemporary science fiction texts, Tomas' chapter embraces the 'biotechnoeroticism' of current critical theory, bringing together ideas from cultural theory, philosophy and science. Many of these ideas bring forth new perceptions of the body, consciousness and image formation. As Landsberg argues (in chapter 11), such texts serve to provide new forms of identity. Tomas' three main areas of exploration are: first, the notion of cyborg transformations that actually re-constitute the sensorial and organic spaces of the body; second, the informational/image/popular textual space of Gibson's novels; and third, new forms of ethnicity or ethnic identity emanating from newly perceived expressions of hybridized technocultures. In other words, he explores emergent cyborg cultural identitites (see section six) through the spaces of popular cultural texts. This newly emergent cyborgian identity is located in the 'technophilic' body, a product of various levels of functional and aesthetic transformation. Thus Tomas identifies the significance of the technophilic body in re-inscribing the body's social and cultural form in the reconstitution of social identities – a theme which resonates throughout the Reader.

References

Deleuze, G. and Guattari, F. (1987) *Dialogues*, trans. H. Tomlinson and B. Habberjam, London: Athlone.
Haraway, D. (1991) *Simians, Cyborgs, and Women: The Reinvention of Nature*, London: Free Association Books.
Jameson, F. (1991) *Postmodernism, or, the Cultural Logic of Late Capitalism: Post-Contemporary Interventions*, Durham: Duke University Press.

MARK OEHLERT

FROM CAPTAIN AMERICA TO WOLVERINE
Cyborgs in comic books: alternative images of cybernetic heroes and villains

CURRENT COMIC BOOK CYBORGS REVEAL much about how these characters are perceived. In addition to movies, comic books represent the most prevelant medium in which many children and adults are forming their impressions of cyborgian culture. One of the more interesting characteristics of this culture is the divisions that comic book cyborgs can be sifted into. These categories are, in order of increasing complexity, *simple controller*, *bio-tech integrator* and *genetic cyborgs*. Comic book cyborgs also expose some the psychological reactions that these characters evoke in us, ranging from a deep ambivalence towards violence and killing to issues of lost humanity and, finally, to new conceptions of the nature of evil.

From the 'Golden Age' to the 'Marvel Age'

Comic book cyborgs have a myriad of ancestors. The comic books that we know today can be traced to the 1930s, when Harry Donenfeld bought New Fun Comics from Major Wheeler-Nicholson.[1] Donenfeld's company would eventually become DC (Detective Comics) and would publish *Superman* in 1938. Marvel, the company that would come to dominate the comic book market, was also born during this time, the 'Golden Age' of comics (1939–1950).

This 'Golden Age' started at Detective Comics with the most well-known hero, Superman.[2] This first hero was not even from Earth, but was an alien and an illegal one at that. DC continued to dominate the early market with their release of *Batman* in 1939.[3] This time DC went to the other end of spectrum from Superman. Batman had no super powers and was the son of wealthy parents who had been slain in a mugging. The first 'cyborgian' hero appeared two years later, in 1941 when Marvel created the super-soldier Captain America.[4] Captain America's secret identity was Steve Rodgers, a 98-pound weakling who was rejected for army service until he was injected with a

'super-soldier serum'.[5] This hero's first villain was none other than Adolf Hitler. Another anti-Nazi, cyborg-like hero was the Human Torch.[6] The original Torch was an android that was created in a lab and then rebelled against his creators. The Torch, like most of his comic book contemporaries, immediately went to work battling the Nazis.

After the Second World War and with the dawn of the Cold War, the emphasis of the comic book heroes shifted away from Germany and Japan to Russia and China: the title of *Captain America*'s comic book became 'Capt. America . . . Commie Smasher'.[7] While Captain America was fighting Soviet efforts, Marvel created a Chinese communist villain, known as the Yellow Claw, who dabbled in magic and had created a potion which would extend his life.[8] A multitude of other heroes and villains were created during this time, but these examples illustrate the fairly simplistic origins and conflicts that early characters were involved in. Stories would soon become much more revealing and complex.

Science plays a dominant role in the creation of both heroes and villains during the 'Marvel Age' (1961–1970).[9] In the *Fantastic Four*, a group of heroes are created by accidental exposure to radiation, a central theme in many of the comics of the time, for example in *The Hulk*, *Spider-Man* and *DareDevil*. This was a reflection of the public's fears concerning radiation in the aftermath of the War. This era also saw the creation of several characters that are discussed below, such as those found in the *X-Men*, *Dr. Doom* and *Iron Man*. The conflicts that these heroes and villains were involved in began to take on a more cosmic nature. Instead of defending the United States from communism, characters were now trying to save the entire planet.

From 1970 until 1990, comic books were awash with super-powered characters; the Marvel personas included the Swamp-Thing, Ghost Rider and the Punisher.[10] These characters not only fought larger external battles but they also began to deal with personal problems. An example of this 'realistic' superhero character development can be found in issue no. 128 of *Iron Man*, in which a powerful superhero is forced to come to grips with alcoholism.[11] This maturing of heroes brings the comic timeline to the present, which could be called the 'Cyborg Age', considering their ubiquitous presence. At the time of writing (1995), Marvel has the largest percentage of the comic market and the Marvel universe is a place replete with cyborgs.[12] Detective Comics, the second largest comic company, simply does not seem to have the same variety of cyborgs. No doubt there are many other comics with cyborgs, but the cyborgs which are covered in this chapter are among the most popular comic characters of the mid-1990s, and therefore make ideal subjects for analysis.

Latter-day cyborgs

Contemporary cyborg comic characters can be grouped into three broad categories: *simple controllers*, *bio-tech integrators* and *genetic cyborgs*. The rationale for these divisions can be found in the work of Chris Gray, in which the levels of integration are described as:

> 1) With informational interfaces including computer networks, human–computer communications, vaccinations and the technical manipulation of genetic information. 2) With simple mechanical–human relationships as with

medical prosthesis, vehicle or weapon man–machine systems and more general human–tool integration. 3) With direct machine–human connections such as the military's state-of-the-art attempts to hard-wire pilots to computers in DARPA's 'pilot's associate' and the Los Alamos Lab's 'pitman' exoskeleton. Plans to 'download' human consciousness into a computer are part of this nexus as well.[13]

One thing that makes grouping characters into categories difficult is that many of the heroes and villains fit into multiple divisions, so for the purposes of this analysis the cyborgs are grouped by their primary system.

The first category of cyborg is the *simple controller* and can be divided into two subsets: implants and suits. These cyborgs are characterized either by the simplicity of their system or by its removability.

The simple controller

A perfect example of the simple controller/implant cyborg is a Marvel character known as Wolverine. He is a member of the mutant team, the *X-Men*, but his primary cyborg system is surgically attached metal. Wolverine was a Canadian mercenary who underwent a series of experimental operations in order for Canada to begin creating its own team of superheroes. His implants consist of the fictional metal adamantium grafted onto his skeletal structure with some very long, very sharp adamantium claws implanted in his hands.[14] With his mutant ability to heal in super-fast time combined with supersharp senses and a berserker rage, Wolverine is a prime example of the newer, darker cyborg which populate current comics. One of Wolverine's most infamous enemies is also a wonderful illustration of the simple controller/implant type: Omega Red.

Omega Red is a creation of the old Soviet Union and when he was developed he so terrified his creators that they placed him in suspended animation.[15] While Omega Red is a powerful villain, he is also a cursed one. His cyborg structure is crafted with an artificial metal known as 'carbonadium' in order to prevent his 'death spore' affliction from killing him.[16] This affliction forces Omega Red to drain the life force from others in order to live. While he is not quite remorseful about this, it is a weakness that he would like to correct. Although his infection reflects a complicated biological problem, Omega Red's cyborg weapons are still fairly simple. He possesses cables that are similar to Wolverine's claws. These are grafted directly onto and into his nervous system and so are controlled by thoughts, a common cyborgian system. The final character in this category also governs his abilities by thought.

In the Image comic *StormWatch*, the United Nations sends teams of super-powered agents to various trouble spots to act as peacekeepers. The man who coordinates the many teams is code-named Weatherman One.[17] The Weatherman has the ability to 'consider huge amounts of data and to make quick, calm decisions' helped along by 'cybernetic implants which link his cerebral cortex directly to the SkyWatch computer net'.[18] The Weatherman is a classic simple controller/implant who utilizes cybertechnology in concert with the data-processing and decision-making ability of the human brain.

The next category is the simple controller/suit cyborgs, who represent the outermost layer of cyborg culture. These are cyborgs whose abilities are for the most part

removable. They may possess some inherent powers but those powers are profoundly augmented by their technological additions.

The first and probably most well-known of this type is Marvel Comic's Iron Man, who debuted in 1963.[19] In Les Daniels' history of Marvel, he notes that Iron Man is not a cyborg simply because of the exo-suit that he wears but also because of his medical problems.[20] Daniels' recounts how Iron Man's armour is not just for battle, but was 'created to keep his damaged heart beating' and that a microchip was implanted to correct a later problem ensuring that 'even without his high-tech costume, Tony Stark is a mixture of man and machine, what science fiction writers call a cyborg'.[21] Iron Man controls his suit via his thoughts and a cybernetic link. The armour has jets in the feet which allow it to fly, 'repulsor beams' that shoot from the palms of the hands and servo-mechanisms which greatly increase the wearer's strength. The suit is also modular and can be fitted with several different weapon packages, depending on what the mission may be.[22] A testament to Iron Man's continuing popularity is the fact that there is a spin-off comic based on a character that had to fill in as Iron Man while Tony Stark (the regular Iron Man) was indisposed. This character, named War Machine, is a younger, more violent model of a controller/suit.[23] One of the most infamous villains in the comic world also belongs to this category, namely Dr. Doom.

Victor von Doom is described as 'a crazed scientific genius who hid his scarred face behind a mask' and who used his position as the 'ruthless ruler of a small country . . . to cloak his plans for world conquest'.[24] Doom not only exists technologically, within his suit, but he is also a mystic, the ruler of a nation, and a psychotic bent on ruling the world.

The final controller/suit in this category is also one of the newest. Battalion is a superhero from Image Comics' *StormWatch* series. The suit that he wears is referred to as a 'cyber-tran suit' which amplifies his own psionic power a 'hundred-fold'.[25] The suit is also equipped with the 'new, experimental tri-kevlar body armour as well as an integrated communication system'.[26] This is one of the new directions that suits are taking in comics. Where once the suits of Iron Man and Dr. Doom simply multiplied their human strength or abilities or allowed them access to a man–machine weapon system, this new suit goes a step further. In Battalion there is a character whose mental facility is amplified by his suit and his greatest enemy, Deathtrap, is a villain whose mental power can focus and improve the performance of machines.[27] These suits then, would seem to be the equivalent of mental Waldos.

Other notable controller/suit characters include Doctor Octopus, Cyber and Ahab.

The bio-tech integrator

Compared to the controller cyborgs, the bio-tech integrators are much more complex. Their systems can not be removed and often they are not fully explained either. They are, however, very popular cyborgs. One of the most popular is code-named Cable.

Cable is a character whose with a complicated background. In short, Cable is the son of two members of the X-Men. As a baby, Cable was infected with a 'techno-organic virus', and he was sent into the future in the hope that a cure could be found for his disease.[28] The disease was arrested but Cable was left with 'techno-organic but not sentient' portions of his molecular structure that can be altered at will.[29] This means

that Cable can reconfigure parts of his body to either a machine or an organic state. As a rule, some visible portion of his body is always portrayed as a machine, and when asked about why he does this, when he could look entirely human, his response is: 'to get where you want to go . . . it never hurts to remember where you've been'.[30] The relationship between Cable and his cybernetic system is a more intimate and symbiotic one than exists for the class of controller cyborgs. This is also true for another cyborg member of the bio-tech integrator class named Weapon X.

The term 'Weapon X' can lead to confusion as it is used in at least three different comic book series. In its most general sense, Weapon X is the Canadian government's top secret programme for building superheroes. Unfortunately for Canada, it seems that once imbued with super powers, most of their creations do not feel like working for the government anymore.[31] Weapon X was also Wolverine's original designation. The current Weapon X is a character named Garrison Kane,[32] whose capabilities include increased strength and the ability to shoot parts of his body at opponents as projectile weapons (i.e. a fist or an arm).[33] Again the cybernetic connection is made at a very basic systemic level. A controller such as Wolverine cannot alter his cyborg system at will but an integrator like Weapon X certainly can.

Genetic cyborgs

This is the third and most interesting category of comic book cyborgs. Characters in this class may or may not have artificial implants but their primary power rests in a purposeful alteration of their genetic code. The issues of purposefulness and intent are critical and defining ideas for this group. It is intent that distinguishes the genetic cyborg from the comic characters that have been created by accident. These accidental individuals include such notable figures at Superman, Spider-Man, Flash and the Hulk.

The first constructed genetic cyborg was one of the comic world's most recognized heroes, Captain America. The Captain was a product of the Second World War and his debut, fighting against Hitler, in March 1941, preceded Pearl Harbor.[34] In the first issue of *Captain America*, the doctor who injected skinny Steve Rodgers (Captain America's alter ego) with the 'super-soldier serum', declares that the serum 'is rapidly building his body and his brain tissues, until his stature and intelligence increase to an amazing degree'.[35] During the course of one adventure, Captain America was thrown into the icy waters of the North Pole. Thanks to the cold and the serum he was preserved until the mid-1960s when he was discovered and revived by the superhero team, the Avengers.[36] Just recently, this original genetic cyborg received the bad news that the serum was beginning to adversely affect his health and that if he continued to perform his superhero activities, he would eventually become paralyzed.[37] While Captain America remains a popular character, his views on violence have become antiquated and mark him as a throwback to a different era.

Whereas Captain America is arguably the first genetic cyborg, the character known as Supreme is one of the newest. Supreme and Captain America are an interesting pair for comparison since these two radically different characters were conceived fifty-three years apart, but in their respective comic universes they were created at essentially the same time. Steve Rodgers (aka Captain America) volunteered for his experiment out of a sense of patriotism but Supreme remembers a government that 'was playing with

civilian lives as usual and I was offered a position with them that I was unable to refuse'.[38] During this experiment Supreme was given pills and he recalls how his handler 'shot me full of experimental drugs, exercised me, exposed me to all sorts of radiation' until they hit upon the right mix which began to increase his strength, mass and weight.[39] When the scientists connected him to computers which 'were able to accelerate what had already been started', he became a 'genius ten-fold' and eventually realized that he had been 'divinely selected for omnipotence . . . to be a supreme being'.[40] Not only is Supreme portrayed as much more powerful than Captain America, but his attitude is diametrically opposed to the Captain's understated style. Supreme has also evidenced the ability, within a time span of nanoseconds, to scan an opponent's weapon and then alter his own biological structure to provide a natural defence against that specific weapon, much like a super-powerful, consciously-directed immune system.[41]

Marvel has always had a knack for designing characters that were bitter-sweet and they managed to do it again when they created a mercenary code-named Deadpool. Deadpool was facing terminal cancer and had already been 'on chemo twice and radiation three times' before he submitted to Weapon X's (the government programme) 'bio-enhancing' experiments.[42] The results included increased strength and an immune system that is constantly healing him while it is, ironically, horribly scarring his body and disfiguring his face.[43] Deadpool also fits in with Weapon X's other projects. As soon as he is cured, he becomes a mercenary and goes freelance.

A cyborg's greatest fears or our fears of them

Any current comic book hero or villain faces a multitude of problems that the characters of yesteryear never even dreamed of. Today's super-powered individuals worry about the rent, careers, stable relationships, dysfunctional childhoods and even the HIV virus. Shadowhawk, a character from Image comics, is HIV-positive and his creator states that AIDS will cause his death.[44] Among the issues comic book cyborgs confront are violence, consciousness downloading, lost humanity, corporations as evil avatars and the view that obviously robotic creatures are almost entirely evil. Violence is probably the easiest problem to discuss and is certainly the most graphic.

In his classic science fiction novel *Starship Troopers*, Robert Heinlein's main character declares that the clearly cyborgian 'Mobile Infantry' has made future war and violence 'as personal as a punch in the nose'.[45] Comic book cyborgs are taking that violence and making it as personal as ripping your spine out. In the November 1993 issue of *Bloodstrike*, over a space of six pages, Supreme singlehandedly crushes a ribcage, smashes someone's arms off, crushes a hand, gouges eyes out, hits a character in the stomach with such force that his opponent's intestines fly out his back and, to finish, breaks a spine.[46] While this is an extreme example of violence, committed by a cyborg against other cyborgs, it is not an isolated instance.

Violence, as a cyborg issue, is a double-edged sword. One edge cuts into society's fears and desires concerning the present level of crime. These cyborg heroes are taking on the drug lords and the terrorists who are keeping us up at night worrying for our safety. Not only are they meeting them head on, but with regenerative tissue and psionically-created weapons, they are violently and graphically destroying these criminals. Instead of waiting or negotiating in a hostage situation, the character Supreme simply

waded in and chopped them to death with his bare hands.[47] This is cyborg justice. No Miranda rights, no crowded court dockets, no criminals going free on a technicality. If you attract the attention of a cyborg hero, you can probably expect to be killed or maimed.

The opposing edge of the blade lays open our own fears concerning the cyborgs themselves. Are these images of our postmodern Frankenstein monsters? If these cyborgs are so powerful, then how do we, as normal (?) *Homo sapiens*, stand a chance if they ever turn on us? In comic books creatures have been created that are beyond the control of anyone. The fictional Weapon X programme is a prime example. The very ambiguity with which many of the cyborg heroes and villains are portrayed – good guys become bad guys and vice versa – is indicative of our unease with these creations. The violence depicted on the pages of these comic books may be perceived as warnings as to what might happen if we pursue this line of technology. Wolverine once said, 'I can't be one hundred percent sure he's lying, but I have to be one hundred percent sure because if I kill him, then he's one hundred percent dead'.[48] In the March 1994 issue of *Captain America*, there featured scene involving Captain America in civilian clothes intervening in a child's theft of comic books from a local store. Captain America looks at the comics and then asks the store owner if he reads them:

> **Store owner:** 'Of course I do! I love super-heroes . . . they're at the cutting edge of the counter-culture! I wish I knew some personally! I'd have the Punisher break this punk's hands or I'd have Wolverine carve the word "thief" on his forehead!'
>
> **Capt. America:** 'Those heroes are your favourites?'
>
> **Store owner:** 'Yep, the more violent they are the better I like them! The better they sell too!'[49]

This is an issue that clearly separates our very cyborgian comic era from previous epochs.

Lost humanity

In his article on cyborg soldiers, Chris Gray notes that while current military thought is 'moving towards a more subtle man–machine integration', the vision is still one of 'machine-like endurance with a redefined human intellect subordinated to the overall weapons system'.[50] While this reflects current military thinking, it is not reflective of the man–machine control issues in comic books.

The hero or villain of today's cyborg comic book is likely to be in control of his weapon system to a greater degree than ever before. A prime example of this is Supreme. Here is a genetic cyborg who exercises control over his system at a cellular level.[51] In their article on knowledge-based pilot aids, Cross, Bahnij and Norman approach the issue of control from the aspect of human capabilities. Specifically, they state that 'Humans have finite capabilities. They are limited by the amount of information they can process and the amount of time required to process that information'.[52] Here they seem to be arguing for a preponderance of machine control in a man–machine system because of a lack of human attention span. Cyborgs in comic books seem to be unfettered by this problem and the reason is fairly clear. These characters are participating in Old West shoot-outs with postmodern weapons. They are not attempting to place a

five-hundred-pound bomb on a particular building in a large city while avoiding collateral civilian damage. They are up close and personal.

There is also some disparity between this article and the comic book world in terms of which human capabilities are the lowest limiting factors in a man–machine system. Cross et al. make it clear that they feel the limit is on 'CA . . . cognitive attention'. They go on to break down 'CA' into 'CAs = the cognitive attention required for task accomplishment at the skill-based level, CAr = the cognitive attention required for task accomplishment at the rule-based level and CAk = the cognitive attention required for task-accomplishment at the knowledge-based level'.[53] Comic book cyborgs are not constrained here because their cyborg system allows them to make a quantum jump forward in skill. Their rules are extremely simplified and all the knowledge they need is the location of their opponent. As opposed to pilots of fighter aircraft who require a great deal of their attention to be focused on the operation of their system, cyborgs whose systems are managed intuitively require little of their attention to be diverted from the actual combat. The issue of humanity with comic book cyborgs then, is not if the machine will take over the human side of the equation, but what will the human half choose to do with his new abilities.

The concept of looking and acting like a man and Moravec's more advanced idea of downloading consciousness have both been dealt with in the world of the comic book cyborg. The issue of how much machinery a person must integrate before he becomes a machine, however, has not drawn nearly as much attention as the consciousness issue. Perhaps the best example of this is a character named the Vision.

A Marvel comic describes the Vision as 'a unique form of android known as a synthezoid, who is both composed of mechanical parts and an unknown material that mimics the properties and functions of human tissue and bone but is far stronger and durable'.[54] The Vision has a long and interesting cybernetic history. He was created by another robot, a villain known as Ultron, who originally used him to attack the heroic Avengers.[55] The Vision's consciousness was based on 'encephalograms from the brain of Wonder Man who was then believed to be dead . . . in later years the Vision and Wonder Man came to regard themselves as "brothers" of a sort'.[56] If all this was not enough, the history of this android becomes even more complicated. Over time the Vision managed to develop human emotions and he even married a fellow superheroine, Scarlet Witch, which in the comic world 'evoked the unreasoning hatred of bigots who would not accept the Vision's claim to be human'.[57] Once, due to damage sustained in a battle, he was connected to a giant computer and through this connection came to believe that the way to save humanity was for him 'to take absolute control of the planet through linking himself to all the world's computers'.[58] Finally, the Vision had this connection severed, returned to normal (a hero), was abducted by the government who now feared him, was disassembled, his programming erased (killed?), was rescued by his friends, was reassembled but lost his capacity for emotions, was divorced and is now a reservist for the Avengers.[59] From his marriage on there were arguments over whether or not the Vision was alive, what relation he had to Wonder Man since they shared brain patterns and whether or not he could be trusted. This would be an interesting point to make to Moravec. If consciousness could be downloaded and 'backup copies' could truly be made, what would happen if a couple of you were in existence at the same time? The question of the Vision's loyalty and the fact that he was created by the evil robot, Ultron, raises the issue of the nature of robots and androids in the comic world.[60]

Evil, Inc.

The great evils in the comic world are the multinational corporations. In their article on the growth of new cyborgian political entities, Gray and Mentor assert that 'the age of the hegemony of the nation state is ending'.[61] They go on to speak of nation states being 'drained of sovereignty by multinational corporations on one side and nongovernmental organizations and international subcultures sustained by world-wide mass telecommunications on the other'.[62] This is exactly the situation that has come to pass in comics, especially in the world of Image comics. In one particular comic, aptly named *CyberForce*, the great evil is a corporation, again with the appropriate name of CyberData. This scenario has CyberData implanting its S.H.O.C. (Special Hazardous Operations Cyborgs) troops with a micro-circuit implant that forces the recipient's personality into more and more aggressive and lethal pathways.[63] The idea behind the superhero team is that a doctor, employed by CyberData, uncovers its scheme and develops a method for removing the chips. He is promptly killed but by then the team is formed and they still possess the removal method.[64]

Two other teams that were formed by corporate interests were YoungBlood and Heavy Mettle. These two groups are both genetically-engineered humans who are employed by a corporation known as G.A.T.E. International and who are contracted to the government.[65] Gray, in his article on war cyborgs, asserts that 'the very possibility of cyborgs is predicated on militarized high technology'. While this continues to be true in comic books it is not the government that is in control of this technology.[66] While most of these super-powered teams seem to work for the good of society, there is always the possibility, indeed the implicit danger, that a member or an entire team may go renegade.

The arms race is also clearly present in this new generation of comic books. The twist is that this time the arms are people. In *StormWatch* the race is for 'seedlings', children who may have been genetically altered by the close passing of a strange comet.[67] This type of race is in line with the prediction by Gray and Mentor that 'the body politic of the future will be those cyborg industries which meld great skill at information processing and personnel management into tremendous profits and powers', as well as their observation that 'cyborgs are also the children of war and there is a real chance that the dominant cyborg body politics of the future will be military information societies much like the U.S.'.[68] It seems that the comic book vision of the future has that dominant body politic resting within the corporate veil.

These issues of violence, downloading and evil corporations are just a few of the myriad of problems being discussed in cyborg-oriented comics.[69]

Concluding thoughts

> The poet's eye, in a fine frenzy rolling,
> Doth glance from heaven to earth, from
> earth to heaven;
> And, as imagination bodies forth
> The forms of things unknown, the poet's
> pen

> Turns them to shapes, and gives to airy
> nothing
> A local habitation and a name.[70]

In Shakespeare's time it was the poet who gave wings to visions of the future, later writers such as Verne and Wells took up the burden. More recently, Asimov, Pohl, Clarke and Card have all provided us with their unique interpretations of what the future will look like. Today, science fiction writers still provide a large part of future scenarios but they are also being helped along to a growing extent by comic book artists and writers.

Where those future visions include cyborgs, comic books have seized them tightly. On those multi-coloured pages of what were once considered kid's toys are some of the most graphic and vivid images of what cyborgs might look like. Not only are their potential shapes explored but their potential uses as well. The popularity of comic book cyborgs also attests to the growing acceptance and interest in the possibility of such creations. If a search is on for a medium in which cyborgian futures are being explored with great vision and energy, a researcher need look no further than the local comic book store.

Originally published in C. Gray (ed.) (1995) *The Cyborg Handbook*, London: Routledge. This essay has been edited for inclusion in the Reader.

Notes

1. Les Daniels, *Marvel* (New York: Harry N. Abrams Inc., 1991), p. 17.
2. Robert M. Overstreet, *The Overstreet Comics and Cards Price Guide* (New York: Avon Books, 1993), p. 48.
3. Ibid., p. 49.
4. Les Daniels, op. cit., p. 39. For the purpose of this essay a key factor in determining whether or not a hero or villain is a cyborg will be based on design. Changed humans who were created by accident, i.e., Daredevil, Spider-Man, will not be considered cyborgs, they are more properly mutants.
5. Ibid., p. 39.
6. Ibid., p. 31.
7. Ibid., p. 71.
8. Ibid., p. 80.
9. Ibid., p. 83.
10. Ibid., p. 163.
11. Robert M. Overstreet, op. cit., p. 206.
12. Jon Warren, '1993: The year in review', *Wizard*, January 1994, p. 221.
13. Chris Gray, 'Cyborg citizen: a genealogy of cybernetic organisms in the Americas', Research Proposal for the Caltech Mellon Postdoctoral Fellowship, p. 2.
14. Les Daniels, op. cit., p. 191.
15. Fabian Nicieza, *Cable*, vol. 1, no. 9 (March 1994), p. 7.
16. Fabian Nicieza, *Cable*, vol. 1, no. 10 (April 1994), p. 1.
17. Jim Lee, *Stormwatch Sourcebook*, vol. 1, no. 1 (1994), p. 1.
18. Ibid., p. 1.
19. Les Daniels, op. cit., p. 101.
20. Ibid.
21. Ibid.
22. Ken Kaminski, *Iron Man*, vol. 1, no. 300 (January 1994).

23. Scott Benson, *War Machine*, vol. 1, no. 1 (April 1994): p. 1.
24. Les Daniels, op. cit., p. 88.
25. Brandon Choi and Jim Lee, *Stormwatch*, vol. 1, no. 0 (August 1993), p. 20.
26. Ibid., p. 20.
27. Jim Lee, et al., *Stormwatch Sourcebook*, vol. 1, no. 1 (January 1994), p. 27.
28. Fabian Nicieza, *Cable*, vol. 1, no. 8 (February 1994), p. 15.
29. Fabian Nicieza, *Cable*, vol. 1, no. 9 (March 1994), p. 14.
30. Ibid., p. 15.
31 John Byrne, *Alpha Flight*, vol. 1, no. 1 (August 1983).
32. Rob Liefeld, *X-Force*, vol. 1, no. 10 (1992).
33. Joe Madureira and Fabian Nicieza, *Deadpool: The Circle Chase*, vol. 1, no. 4 (December 1993).
34. Les Daniels, op. cit., p. 37.
35. Ibid., p. 38.
36. Peter Sanderson, *Avengers Log*, vol. 1, no. 1 (February 1994), p. 8.
37. Mike Grell, *Captain America*, vol. 1, no. 42 (February 1994).
38. Rob Liefeld, *Supreme*, vol. 1, no. 424 (February 1994), p. 10.
39. Ibid., p. 11.
40. Ibid., p. 13.
41. Rob Liefeld, *Supreme*, vol. 1, no. 2 (February 1993), pp. 14–15.
42. Joe Madureira and Fabian Nicieza, *Deadpool: The Circle Chase*, vol. 1, no. 3 (November 1993).
43. Joe Madureira and Fabian Nicieza, *Deadpool: The Circle Chase*, vol. 1, no. 4 (December 1993).
44. Brian Cunningham, 'Out of the Shadows', *Wizard*, April 1994, p. 40.
45. Robert A. Heinlein, *Starship Troopers* (New York, N.Y.: Ace Books, 1959), p. 80.
46. Keith Giffen, *Bloodstrike*, vol. 1, no. 4 (November 1993), pp. 16–19.
47. Rob Liefeld, *Supreme*, vol. 1, no. 3 (June 1993), p . 17.
48. Peter David, *X-Factor*, vol. 1, no. 85 (1993).
49. Mike Grell, *Captain America*, vol. 1, no. 425 (March 1994).
50. Chris Gray, 'The cyborg soldier: the U.S. military and the postmodern warrior,' in L. Levidow and K. Robins (eds) *Cyborg Worlds: The Military Information Economy* (London: Free Association Press, 1989), pp. 43–72.
51. Rob Liefeld, *Supreme*, vol. 1, no. 4 (July 1993).
52. Stephen E. Cross, et al., 'Knowledge-based pilot aids: a case study in mission planning' in *Lecture Notes in Control and Information Sciences: Artificial Intelligence and Man-machine Systems* (Berlin: Springer-Verlag, 1986), p. 147.
53. Ibid., p. 148.
54. Peter Sanderson, *Avengers Log* , vol. 1, no. 1 (February 1994), pp. 24–5.
55. Ibid., p. 44.
56. Ibid., p. 24.
57. Ibid., p. 25.
58. Ibid., p. 25.
59. Ibid., p. 26.
60. If cyborgs in comics seem ambiguous in nature, more overtly robotic creatures do not. A quick look at the most obviously robotic characters such as Vision, Ultron, Sinsear, Nimrod and the Sentinels, reveals that all at one time were villains and that all but the Vision are still considered evil. The question seems to be why do comics regard the creatures that humans should be able to control to the greatest extent, as the creations most likely to run amok? These villains are constantly creating more evil robots and Ultron's plans have grown to include his intention of obliterating not just humanity, but all plants and animals – all organic life on Earth. Since the focus here is on cyborgs, suffice it to say that the robotic position is at least as interesting as that of cyborgs.
61. Chris Gray and Stephen Mentor, 'The cyborg body politic meets the new world order,' in C. Gray (ed.), *The Cyborg Handbook* (London: Routledge, 1995), pp. 453–68.
62. Ibid., p. 11.
63. Walter Simonson, *Cyberforce*, vol. 1, no. 0 (September 1993), p. 8.
64. Ibid., p. 9.

65. Rob Liefeld, *Supreme*, vol. 1, no. 1 (April 1993).
66. Chris Gray, 'The culture of war cyborgs: technoscience, gender, and postmodern war,' in Joan Rothschild (ed.) *Research in Philosophy and Technology*, special issue on feminism, 1993, p. 1.
67. Jim Lee, et al., *Stormwatch Sourcebook*, vol. 1, no. 1 (January 1994), p. 2.
68. Gray and Mentor, op. cit., pp. 12 and 14.
69. Some other problems include:
 Anti-mutant Hysteria: Glance at any of the pages of comic books involving mutants, particularly in the Marvel universe, and examples will be found of sinister-sounding mutant registration programmes, and grass-roots bigotry against mutants, also known as 'homo superio'.
 Gender/Race/Handicaps: A multitude. The leader of the Avengers, one of the oldest super-hero teams, is a woman, the current Captain Marvel is a black woman and there are also blind, paraplegic heroes as well as HIV-positive characters and characters fighting cancer. Comic books also dive into cyberspace, virtual reality addicts, multiple uses of holographic technology and artificial intelligence racing out of control.
70. *The Concise Oxford Dictionary of Quotations* (New York: Oxford University Press, 1981), p. 227.

FOREST PYLE

MAKING CYBORGS, MAKING HUMANS
Of terminators and blade runners

Bodies and machines: deconstruction at the movies

CINEMA HAS A WAY OF leaving the images of certain faces and bodies permanently inscribed in our memories: just as no one who has seen them is likely to forget the faces of Maria Falconetti in *The Passion of Joan of Arc* or Charles Bronson in *Once Upon a Time in the West*, no one is likely to forget the imposing body of Arnold Schwarzenegger moving relentlessly across the screen of *The Terminator*. Perhaps no aspect of the cinema is more powerful – or more potentially troubling – than its capacity to confront viewers with such moving bodies and faces, larger than life, images projected in motion and in time. Of course, the cinematic attention to the effects (special and otherwise) of bodies in motion stretches across film genres, from the action-adventure picture to the classical Western to hard-core pornography. But something curious happens when the bodies in motion turn out to be 'cyborgs'. This is the case for a subgenre of science fiction films that have achieved considerable critical and popular attention over the past decade, science fiction films which, often with distinctly dystopian tone and premise, make the 'cyborg' – hybrid of human and machine – their thematic and formal focus. What we find in such movies as *Blade Runner* (Ridley Scott, 1982) and the *Terminator* series (James Cameron, 1984; 1991) are unsettled and unsettling speculations on the borders that separate the human and the non-human.

The collisions – and collusions – between human and non-human do not originate with these films, of course: the opposition between human and cyborg is but a contemporary and more mechanical mutation of a motif that extends at least to *Frankenstein*. None the less, these films rework the opposition inherited from Romanticism in some important ways, drawing attention to a deep instability, by turns compelling and disorienting, present in our attempts to distinguish and define the human from its other. *Blade Runner* and the *Terminator* series not only reflect upon the threats to humanity posed by unchecked technological developments, they raise even more probing questions about

the consequences of our definitions of the human. These films demonstrate that when we make cyborgs – at least when we make them in movies – we make and, on occasion, unmake our conceptions of ourselves.

To appreciate the stakes involved in the concern over the distinction between human and nonhuman in science fiction film, one could look to the often rancorous debates of contemporary cultural theory where the curricular role of the Humanities, the status of humanism, and the notion of the 'human' have revealed themselves to be tightly knotted and highly contentious issues. However removed these debates are from real life, including the curious real life of Hollywood production, the clamour and alarm that have accompanied them make it appear that much more than the value of the traditional Western Humanities curriculum is being questioned: indeed, if often seems as if humanity itself has been put at risk by a variety of critical methodologies – primarily imported, but with some domestic hybrids – oriented around a critique of humanism. Nowhere have the disputes and misunderstandings raged more than on the terrain of what is called 'deconstruction'.[1] None of the recent modes of analysis stands more accused of an antihumanist nihilism, charged with a malevolent disregard for human agency, cast in the role of a 'terminator'.

In the context of these films, three pertinent aspects of deconstructive analysis should be emphasized. The activity most commonly identified with deconstruction is the location in a textual system of a decisive, even founding opposition, such as that between the 'organic' and the 'mechanical'. In the course of critical interrogation, the opposition is disclosed to be both asymmetrical and unstable, rendered 'undecidable' at some decisive if often unexpected moment: the presumed superiority of 'organic' over 'mechanical', for instance, is upset at a moment in the text which reveals that the 'organic' *needs* the 'mechanical' or proves them to be inextricable. The point of deconstruction, then, is not to decode a film's meaning or even to 'unmask' its 'ideologies'; decoding and unmasking presume a secure position of knowledge outside the unstable oppositions under consideration and immune from the effects they generate. Instead – and this is the second aspect of deconstruction to be stressed – the viewer finds the opposition between spectator and spectacle to be unstable, begins to acknowledge his or her complicity with the object under consideration, and acknowledges that the extent of the complicity may never be fully acknowledged, since there turns out to be no place free from the critical complications that ensue. In the case of a film such as *Blade Runner*, for example, we may start out with our assumptions of a clear distinction between human and machine intact; but through its representation of the hybrid figure of the cyborg, the film 'plays' on a borderline that we come to see as shifting and porous, one than begins to confuse the nature of the opposition and the values we ascribe to it.[2] In the course of the film, our own position as viewer does not remain unaffected. What results, as I will argue below, is the sense that we too have become implicated in the 'deconstruction' of the oppositions we have just witnessed.

It is by no means necessarily the case that a film (or its director, writers, actors, producers) conceives such a 'deconstruction' to be its overt or implicit project. Deconstruction – and this is the third point to be stressed – marks the moment in which aspects of the text's *performance* conflict with the themes it declares or develops.[3] A deconstructive analysis of film would confront the tensions and consequences generated by moments of visual or rhetorical excess that cannot be accommodated by the narrative demands of plot or reconciled with the film's thematics: the proliferation of

point-of-view shots in a film, for instance, can establish a perspective that remains at odds with the development of the film's story or theme.

In *Blade Runner* we are confronted with a curious sort of visual excess: heavily allegorized shots (and scenes) which cannot be squared with the symbolic or mythological references they invite. When the cyborg Roy Batty impales his hand with a nail near the end of the film, the shot establishes a visual symbolic association to Christ on the cross, an association bolstered by other visual metaphors, such as the dove released to a suddenly blue sky at Roy's death. But though such images draw on that symbolic repertoire, the association with the Christian narrative inevitably conjured by the shots is invalidated by the film's own narrative logic: Roy inserts the nail into his palm solely in order to prolong his life, to defer his 'time to die'. Roy is in this and every regard far from Christ-like: he has, of course, just murdered the 'father' (Tyrell) who played his god and maker. What the film leaves us with are allegorical shots severed from their mythological sources, empty allegories that cannot be redeemed by the Christian narrative.

While the deconstructive attention to the rhetorical and performative capacities of language has been accused of dissolving all worldly matters into textual fictions, one can construe very differently deconstruction's emphasis on the 'text', on properties of language and the tendency of language to exceed human mastery. In the work of Paul de Man, for instance, the 'confusion of linguistic with natural reality' is held to be both a perpetual occurrence and another name for ideology. Deconstruction thus 'upsets rooted ideologies [such as the ideology of humanism] by revealing the mechanics of their workings', mechanics which are themselves textual (*RT*, 11). This may mean, for instance, opening the fundamental opposition between human and inhuman to such a deconstruction by stressing the cinematic 'languages' that form it in the first place. According to de Man, there are aspects and operations of language that are irreducibly mechanical and that disallow the organic models we traditionally attribute to it. That which we most want to be our own, that which we may believe to be most human – language – is thus from this deconstructive perspective an insistently *nonhuman* and even mechanical operation.

For an analysis of film and for the films under consideration this has particular relevance, because deconstructive analysis discloses the ways by which mechanical and rhetorical features of language always underwrite and potentially undermine our concept of the human. We can often discern an awareness of this aspect of cinematic language in the statements of some of the cinema's early practitioners, struggling as they were with formal and technical as well as theoretical matters. One of the founders of Soviet cinema, Lev Kulesov, in what has become a famous declaration, asserted that film must be regarded at its most basic level as a language: 'The shot must operate as a sign, a kind of letter.'[4] Deconstructive analysis works not only to recover the importance of the shot as 'a kind of letter', it attends to the instances at which this 'letter' may undo the narrative and thematic structures that are its effects, its 'projections'. What often gets obscured by the more hostile responses to deconstruction is its critical attention to the means and modes by which the recognition of such figural constitution, the insistence of the cinematic 'letter', is actively forgotten or recuperated by the course of the film. Indeed, we will find that the wavering balance between memory and forgetting is central to any understanding of *Blade Runner*. And certainly one measure of the massive popular success of the *Terminator* series is the effectiveness of its recuperations of the tensions

and instabilities the films generate: their ability to recover an 'entertainment' by restoring the oppositions between human and machine that have been threatened.

There has been considerable and perhaps inevitable resistance to a theoretical approach that does not presume the 'human' to be a non-textual foundation, one that regards the 'human' as a concept/metaphor subject to the effects that befall all such elements of language: Derrida, de Man, and those influenced by their work have been accused of nothing less than 'inhumanity', as if the critique and displacement of certain governing concepts and assumptions were themselves a threat to the race. David M. Hirsch, a shrill and prominent voice in the chorus of denunciation, claims that deconstruction 'seek[s] to blind and deafen readers to all that is human'.[5] I mark the most inflammatory issue in the debates surrounding deconstruction, because it goes to the heart of matters that resonate with considerable visual and thematic complexity in *Blade Runner* and the *Terminators*.

It is important not to confuse deconstruction with destruction or nihilistic termination or even demystification: it is best understood in the context of film as the attempt to *read* moving pictures: such a reading is not to be confused with traditions of 'close reading' associated with the New Criticism which took both the subject and object of reading to be stable (if complex) entities. A deconstructive reading is itself an unstable but productive *activity*, one which forces us to confront the constructedness of certain concepts, such as the human, that we may have presumed to be stable essences and that we may have preferred not to look much into. The point is not, therefore, to 'deconstruct' movies 'from the outside' but to bring 'deconstructive' questions to bear upon them in order to understand how the films are *already* soliciting or working on the more significant oppositions. It is not, therefore, merely a matter of taking theory to the movies but of apprehending how movies project considerable theoretical light of their own on the screen of our concerns. It thus may be the case that when theory leaves the movie theatre, it does not leave unchanged – particularly when that theory is called deconstruction.

It is certainly the case that the issues raised by deconstruction regarding the instability of the concept of the human are evident in such films as *Blade Runner* and both *Terminators*; these films take the technological threat to the human as their narrative point of departure and make that threat into the occasion for a cinematic treatment and exploration of the status of the human. Each of the films takes up a consideration of the relationships between human and technology, moreover, not simply in the stories they tell but by their presentation of the spectacle of movies. Of all media, film would seem most likely to confirm de Man's insistence on the mechanical aspects of a text, for film foregrounds most insistently its reliance on the apparatus from the economics of production to the mechanics of projection. But this feature, the necessity of the apparatus, is through a variety of conventions susceptible to naturalization. Each of these films – and perhaps any of the recent science fiction dystopias – returns the problem of the apparatus to the viewer in the stories they tell and by the form of visual spectacle. And each of these films asks in its own way what happens when the status and fate of the human becomes intertwined with the technologically reproduced image of the cyborg.

'If you want to live'

Nothing less than the very fate of the human race is at stake in James Cameron's *The Terminator*. The film's justly celebrated and gruesomely nightmarish opening scene depicts a post-apocalyptic world in which the humans who have survived nuclear holocaust are engaged in a pitched battle for survival with machines that 'got smart' and now recognize all humans as threats to their existence. The machines send a combat-model cyborg back through time with the intention of 'terminating' the mother of John Connor, future commander of the human resistance. The humans follow suit by sending a 'lone warrior', Kyle Reese, back through time to protect Sarah Connor from the terminator and thus to preserve the inception of the rebellion.

The opposition between protagonist and antagonist is established early in the film by the depictions of their arrival to the present. Schwarzenegger's body and motion are a cluster of signs – sculpted 'Aryan' invulnerability – which immediately resonate historically as 'man-machine'. These signs must however be supplemented by crucial point-of-view shots: the terminator's apparent inhumanity must be confirmed not only by our seeing him (such looks could be deceiving), but by seeing for ourselves how he sees. This seals the distinction, for the point-of-view shots reveal that the terminator does not 'see' images but merely gathers 'information'.

If omnipotence is registered cinematically as inhumanness, the simplest of negative markings, relative physical weakness, identifies Kyle Reese as human (who doesn't need the point-of-view shot to establish any further identification). This empty marker is filled out in the course of the movie as the mechanical physical superiority of the cyborg is contrasted to the positive human capacity to improvise. Reese becomes distinguished by his ability to master or 'hotwire' technology through improvisation and *bricolage*, mobile forms of thinking and acting which the movie tells us are reserved for the human.[6] What *The Terminator* defines as fundamentally human is the routing of technological mastery into a rebellious subjectivity, a heroism capable of resistance and even self-sacrifice.

The Terminator is cluttered with images and elements of contemporary (and low) technology which, even when incidental to the plot, lend the film its visual density and contribute to the motif of a pervasive – and invasive – penetration of technology. The elements of contemporary technology that the film puts on display – answering machines, blow driers, phone systems, junked cars, toy trucks – are neither ominous nor advanced. What they collectively signify, however, is the interference these technologies pose to human communication and human agency. These are interferences that are open literally and figuratively to manipulation by the terminator and that must thus be recuperated by human vigilance.

Sarah Connor's initial bewilderment when confronted by this mechanized world made hostile functions both as a plot device which heightens the film's suspense and as an allegory of our potential enslavement to and possible liberation from technology. Constance Penley has challenged such an interpretation of *The Terminator*, arguing that the traces of technology that punctuate the movie do not support such an opposition: 'the film does not advance an "us against them" argument, man versus machine, a romantic opposition between the organic and the mechanical', says Penley, for this is a cyborg, 'part machine, part human'.[7] But if the film displays the thorough interpenetration of human and machine or depicts their hybridization, its narrative logic is bent upon fulfilling a fundamentally humanist fantasy, that of human mastery over the machine.

Critics who have interpreted the film as politically progressive have stressed that it attrib-utes the human capacity for mastery to the woman, Sarah Connor, who is not only the bearer of human potential, the mother of humanity's saviour, but the character that the film represents as achieving agency. When Sarah flattens the terminator between the plates of the hydraulic press, she does not become, as Penley claims, machine-like; rather, she gets to make good on what the film has constructed as our collective desire to crush the threatening technological other. The fantasy is thus a comprehensive one, for not only does it pose as two victories over the machine – ensuring the victorious *future* resistance (Reese suggests that humans in 2029 are poised to win) by achieving a human triumph in the present – it presents the possibility of human mastery over time itself, a theme which becomes a prominent motif in the sequel. *The Terminator* is in this sense about the reassertion of sheer and absolute human agency, 'the triumph of the will'.

We note during the course of this cinematic triumph the progressive physical reve-lation of the terminator's inhumanness. The movie proceeds to unmask the cyborg, to reveal visually that the semblance is indeed an illusion, that beneath the flesh and tissue there is nothing human. But in another sense, the machine that gets revealed is all-too-human, the embodiment of a host of human fears. This is played out in the film through the vehicle of suspense in the protracted ending. Reese's pipe bomb blows up the termi-nator's truck, and when the terminator is engulfed in fire, Reese and Sarah embrace in what looks like an ending. The relief is premature, of course, for the terminator emerges from the flames, metal frame intact, and the machine that we see resembles the murderous machines that haunted the film's opening scenes and that haunt Reese's 'flash-backs' of the future. The concluding scenes are the film's most harrowing in part because we suddenly recognize that this technological other is nothing less than our own quite 'human' images and fears. The war zone of the future is literally a nightmare. Reese's and our own, populated by pop cultural preconceptions of dinosaurs, mechanical Tyrannosaurus Rex and flying Pterodactyls, while the humanoid terminators stripped of their flesh spook us with the ghoulish childhood fears of the animated skeleton. At this moment the opposition between human and nonhuman established by the film is given a twist, for though we see the terminator as more inhuman than ever – all fleshly human resemblance seared away – its 'inhuman' mechanical otherness is simultaneously felt to be a human projection.[8] When the human opposition *to* the machine finally triumphs in *The Terminator*, the opposition *between* human and cyborg begins to appear as the human projection it always was.

'Do androids dream . . . ?'

Something much less apocalyptic than the fate of the race is at stake in Ridley Scott's *Blade Runner*. The execution, or 'retirement', of cyborgs or 'replicants' is portrayed as part of the business of law enforcement in the Los Angeles of 2019. Deckard is recruited back into service as a 'blade runner' when four replicants escape to earth after an 'off-world' skirmish in which a score of humans are killed. Though the replicants are depicted as ruthless and deadly, the threat is nothing of the order of *The Terminator*: this is but a minor slave uprising, and nothing suggests that the world is threatened. But from the outset, from the moment of Deckard's initial reluctance, the film conveys the sense that

while 'retirement' may be more or less routine, it is a very messy business. The histor-
ical analogy is established when Deckard's boss describes the replicants as 'skin jobs',
cop parlance which Deckard likens to the language which, as the 'history books' tell us,
referred to black men as 'niggers'. Deckard is coerced into taking the assignment
nonetheless, and begins to the job of detecting and terminating the replicants.

The film's action of detection and termination might appear on first sight as the
mirror image of the logic we witness in *The Terminator*: 'blade runners' are, after all,
'terminators' of a sort who seek and destroy cyborgs, such as the terminator. But the
depiction of the cyborg in *Blade Runner* takes us in a very different direction. Though
the film's plot suggests that the cyborgs pose no real threat of extinction, the movie
itself introduces a very real and troubling threat – not so much to the characters in the
film, but to the stability of the notion of the human that underwrites our actions, beliefs,
meanings. Everything in the course of Deckard's 'detection' of the replicants leads him
– and his audience – to a self-detection of a different and disturbing sort: namely, the
recognition of the undecidable nature of the opposition between human and its tech-
nological double.

The film thus begins to ask of humans what Walter Benjamin asked of the work of
art in high highly influential essay of 1936. How, asked Benjamin, is the status of the
work of art affected by the advent of its technological reproducibility? He argues that
though the work of art has always been 'in princple' 'reproducible', the development
of new technologies – most dramatically that of film – shattered the 'aura' and 'authen-
ticity' which surrounded the 'original'.[9] One could indeed interpret the necessity of the
replicants' extinction in light of this logic: they are too close, the very fact of their
duplicity too disquieting, and because they pose a threat to the very 'aura' of the 'original
– the authentic human – the cyborg must thus be eliminated. Eric Alliez and Michel
Feher describe the threat of replication in terms which, echoing Benjamin, bring to our
attention the 'postmodern' condition of this relationship:

> Thus it becomes imperative to maintain formal distinctions between men
> and machines even if the real differences tend to blur. Here we find the
> explanation for the four-year life span given to the replicants. As machines,
> they could remain efficient for more than four years. This time limit, then,
> does not represent a technological limit, but is rather an imposed level of
> tolerance beyond which the men/machine interface becomes uncontrollable.
> . . . Beyond this threshold, that which allowed one to distinguish between
> model and copy, between subject and object, disappears.[10]

The film itself, then, appears to confirm Benjamin's understanding of the fate of the
'original' and in the process confirms de Man's assertions with which we opened about
the collapse of the foundational concept 'human': 'there is,' de Man asserts extempo-
raneously, 'in a very radical sense, no such thing as the human' (*RT*, 96). *Blade Runner*
delivers us to the point of such an awareness, one that is resisted in the name of
'humanism': that the 'human' is an *effect* of an opposition which at certain anxious and
decisive moments cannot be sustained.

The film has attracted opposing interpretations, of course; most notably that it
depicts the threat an autonomous technology poses to humanity. Thomas B. Byers, for
instance, sees the film as a cautionary tale that 'warn[s] us against a capitalist future gone
wrong, where such [human] feelings and bonds are so severely truncated that a quite

literal dehumanization has become perhaps the gravest danger'.[11] While no one is likely to read *Blade Runner* as a celebration of late capitalism, it is not clear that the film reserves such a distinctly human space outside the logic of mechanization. Rather, technological reproducibility is taken by the film to be the condition of things. It would not seem, moreover, that 'dehumanization' is the 'gravest danger' proposed by the film, for much that is both grave and dangerous in *Blade Runner* goes by the name of the human. Far from preserving an essential and organic human dimension which can be opposed to the dehumanized replicants, the film tends to undo that opposition. This undoing is performed not by extending humanity to the replicants – their 'superhuman' and 'mechanical' qualities are visible to the end – but by disclosing the distinction to be unviable.

The blade runner's means of 'detecting' a replicant is significant in this regard: the 'Voight-Kampf' test examines the dilation of capillaries in the eye during interrogation. The detective's eye establishes the difference between human and replicant by looking into the eye of his subject, though judgement is made only by way of the mechanical device which measures what the detective cannot see for himself. The motif of the eye and its gaze runs throughout the movie: the eye superimposed over the city in the film's opening shot, the eye magnified in the 'Voight-Kampf', the eye of the owl perched in Tyrell Corporations Headquarters, the eyes genetically engineered and grown in the subzero lab, the lenses of various microscopes, the photograph enhancers, the gaze of panopticon devices and advertising projections, even the eyes of Tyrell himself, shielded by thick spectacles and blinded in the Oedipal inversion of Roy's dramatic patricide. All this literal and symbolic attention to eyes, this ubiquity of the gaze, only serves to underline the failures of seeing, for it turns out that one can never tell the difference by looking. Rachael's questions about the 'Voight-Kampf' test are pertinent: 'have you ever tried that thing on yourself?' she asks of Deckard, 'ever retired a human by mistake?'

But because one cannot see or detect a difference does not in and of itself prove that such difference is absent: there may well be internal differences unavailable to empirical detection. And the film presents the search for the most essential internal differences and distinctions – self-consciousness, emotion, memory – that would preserve the integrity of the human. Most crucial in this regard is the examination of time and memory, an examination that extends to every aspect of the film's visual and narrative logic. Most immediately, perhaps, the film addresses the memory of its *audience* by working in – and *with* – a style, *film noir*, that cannot help but evoke nostalgia. But the *film noir* effect of this hybrid of the 1940s and the early twenty-first century creates a curious effect, since the cinematic nostalgia played out in shadows and muted colours is projected onto the future. The 'noirish' resonances work against the grain of a Hollywood nostalgia that is most often the reassuring nostalgia for a morally unambiguous and comforting past. But this does not mean that nostaliga is banished: with *Blade Runner*, we are confronted by the nostalgia for memory itself, for a memory of something more than a film genre, and for a form of remembering that is something other than a cinematic projection.

The replicants' fascination with old photographs – 'your beloved photos', as Roy tells Leon – is initially treated by Deckard as a quirky eccentricity: 'I don't know why replicants would collect photos. Maybe they were like Rachael, they needed memories.' But his encounter with Rachael's simulated past modifies that judgement: for she too has 'photographs', documents that prove her past, give testimony. Though Deckard

determines the photos to be 'fakes', supplied by Tyrell to shore up Rachael's memory 'implants' with the illusion of facticity, they prompt Deckard's own poignant reflection over his old photos – photos of absent women – photos that are clearly of another age, figures that within the time-frame of the film Deckard could never have 'known'. Deckard doesn't give voice here to the recognition we witness: his photos are also 'fakes'. Why, then, would anyone collect photos? Because photos *are* memories and the film tells us that, *exactly like the replicants*, we need memories to shore up the stories we tell of ourselves. There turns out to be a gap where we expect to find the core of the human; we need photographs to fill that gap, and 'humans' no more or no less than 'cyborgs' use the photographic image – which is always a stand-in, a 'fake' – to supplement what's missing.[12]

As spectators, our own relationship to the film and to its engagement with its *film noir* intertext functions similarly to undermine memory.[13] As we recognize the film's intertextual codes, we gain a sense of knowledge and mastery: 'Wary and world-weary detective, shadowy cinematography and shadowy characters, venetian blinds and ceiling fans, dark woman with a dark past: but, of course, it's *film noir*.'[14] On one level, then, this 'intertextual' reference or cross-generic play situates the viewer as knowledgeable, capable of mastering cinematic codes and generic traditions. But the security such knowledge should provide fades as we, alongside Deckard, are drawn by the allure of a past we could never know, a memory that could only be a borrowed one. The sense of a 'darkness' to Rachael's past that is invited by the *film noir* intertext is revealed not to be a sinister or disreputable act which veils her past in mystery, but a literal darkness. The film, in other words, does not merely deviate from the tradition of *film noir*; the film quotes the genre only to displace its thematic authority: the sense of 'mystery' is revealed to be an effect of our faith in the distinction between replicant and human. *Blade Runner* disrupts that faith by insisting on the inability of memory to restore the presence of what is past, an inability shared by all who live and remember in this movie.

The rhetorical question asked by Gaff near the film's end – 'Too bad she won't live! But then again, who does?' – speaks directly to the matter of a movie that has, so it seems, effectively presented the deconstruction of its presiding opposition between the human and the machine. But it also seems that the movie cannot tolerate to conclude under the sign of such undecidability, at least not in its studio release, for the suspended conclusion – one which has suspended oppositions – is supplemented by Deckard's and Rachael's escape in the final scene. They have not only escaped the oppressive atmosphere and dangerous blade runners of the city, they have escaped the film's disorientations, to the liberating blue sky and romantic green world of the 'North'. It's the most transparent of gestures, of course, and however much it fails to respect the director's cut (the ending as well as Deckard's voice-over were demanded by the producers over Ridley Scott's objections), it demonstrates that the film has generated such a knot of visual and thematic intricacy that it can be 'stabilized' only by recourse to such a pastoral gesture. The film has thus reached a limit of sorts, a limit that reveals that in *Blade Runner*, when humans make cyborgs, it means the unmaking of the human through an anxious recognition that both were assembled in the first place.

'Trust me'

When James Cameron returns to the distinction between human and cyborg in *Terminator 2: Judgment Day*, the opposition is given a new turn and new terminator, both of which initially appear designed to make '*T2*' more fully an action-adventure movie and to make the opposition between human and other more stable. In Cameron's sequel, a second terminator has been sent by 'Sky Net' to eliminate the young John Connor. Schwarzenegger returns in *T2* as a terminator, but one sent by Commander Connor in 2029 to protect himself from termination in 1991. The two warring terminators are neither identical nor equal, however, for as Schwarzenegger explains to the young John Connor, the second terminator, a 'T–1000', is technologically superior: no longer a cybernetic organism, 'living tissue over metal endoskeleton', the T–1000 is composed exclusively of liquid metal. *T2* thus gives us both a new terminator and a new opposition: the 'moving-parts' mechanism of the older terminator (to whom John endearingly refers at one point as 'lug nuts') is posed against the advanced technology of its amorphous and wholly inorganic adversary. The film replays Hollywood's apparently compulsive drive to up the technological ante and, by the same token, allegorizes the confrontation of a postmodern technology with a modernist one. That token is then given an interesting turn, for *T2* depicts a 'modernist' triumph over the very technology – dazzling, amorphous, uncanny, postmodern – that marks the film as different from its predecessor.

While the T–1000 is not technically a cyborg, it possesses the capacity to replicate any animate or inanimate object of its own mass, including a human, and to mimic the human voice. This ability provides the film with its violently uncanny moments of doubling, when the copy confronts and then kills the original. But *T2* backs away from the more radically disorienting possibility implicit in such technology: namely, that we might *never* know beforehand who the terminator is. Instead, the moments of such doubling punctuate the otherwise continuous (assumed) 'identity' of the terminator. This identity is not of course entirely reassuring, since the terminator 'is' an LA cop. The T–1000's capacity for 'shape-changing' establishes visually an opposition that recurs throughout the film thematically as well: the opposition between mechanical mimicry and genuine learning. While the T–1000 belongs purely and exclusively to the logic of machines, the older 'Cyberdyne Systems Model 101' comes equipped with a 'learning computer'. Early in the film, John Connor asks the terminator whether it could 'learn stuff [it] hadn't been programmed with, so [it] could be, you know, more human, and not such a dork all the time'. The terminator replies that the more contact he has with humans, the more he learns. There would seem to be nothing more human than 'learning' – particularly a moral and ethical learning – and *T2* cultivates further than its predecessor this humanist position.

The film even revises the equation of resistance with humanity implied in *The Terminator*: sheer resistance leads to the excesses of Sarah Connor, who has become physically formidable and has acquired from mercenaries, ex-Green Berets, contras, and other dubious sources the soldier and survival skills displayed by Reese in the first film. Her zeal leads her to attempt the execution of Myles Dyson, the computer engineer responsible for developing the computer chip recovered from the first terminator into the advanced Sky Net computer system that, in 'one possible future', becomes 'self-aware' and commits genocide. Poised to execute Dyson, she refrains, but must be taught

by her son the same lesson he teaches the terminator: 'you can't go around killing people.' Nothing would appear more laudably 'humanist' than the film's emphasis on learning such lessons, its insistence on a human agency informed by moral principles, its rejection of a closed future: 'No fate but what we make' is the refrain passed from John to Reese to Sarah to young John and, perhaps, to the audience itself.

But though the film appears to deepen the distinction between human and machine, setting the moral and ethical principles of a human education against the threatening autonomy of a mutatable technology, it achieves this distinction by way of a hybrid intermediary that upsets the stability of the opposition. The cyborg can learn, and it seems to acquire – to earn – from its contact with humans nothing less than genuine human subjectivity. The film's overt humanist thematics are thus made tenuous when it is revealed that the cyborg terminator is indispensable to the opposition: both for the story of the human opposition *to* the machines and for the conceptual opposition *between* human and machine. In one sense, the cyborg is benevolent only because of its complete obedience; at the same time, however, the opposition between human and machine is placed at the mercy of the cyborg. The instability is suggested by Sarah Connor's rhapsody on the cyborg as she watches him play with her son. 'The terminator would never stop,' she says, 'it would always be there, and it would die to protect him.' What had in the first film defined the terminator's terror, the sheer thoughtless relentlessness of its drive to terminate, is reinscribed here as trust and reliability: the terminator thus becomes in Sarah's estimation the 'best father'.

The cyborg has thus been 'humanized', capable of learning and, crucially, of dying. In the first film, as Sarah flattens the terminator in the hydraulic press, she declares, 'You're terminated, fucker!' She now gives voice to a belief in the capacity of the terminator not merely to be terminated but to experience 'death'. This is confirmed by the film's ending: after the spectacular extended meltdown of the T–1000, one in which the history of its replicated victims reappear in a Dante-like procession, the Schwarzenegger terminator sacrifices himself in order to prevent the possibility that any prototypes or computer chips from this deadly technology would remain to provoke the catastrophe that has just been rescinded. Paradoxically, the act is his most fully 'human' act of the film, for to subject himself to the vat he refuses for the first time his master's order, who implores him to stay behind.[15] As Sarah lowers him into the vat – he cannot 'self-terminate' – the terminator's mechanical hand makes the rhetorical gesture of human triumph: the victorious 'thumbs up'. It is an easy visual cliché, of course, but is emblematic of the deep interweaving of human and machine. However much the film may want to extricate itself from the logic of machines, the knotting of human and cyborg is inextricable: in *Terminator 2*, the triumph of humans and humanism is made dependent on the humanizing of cyborgs.

Human gestures, mechanical hands

I want to return in closing to the issues with which we opened, to the critical possibilities opened by a deconstructive reading and to the resistance it has provoked. I hope that it has become evident that far from seeking to 'blind and deafen its readers to all that is human' (Hirsch), deconstruction opens a critical questioning of the ways by which the sounds and visions of cinema operate, and the ways by which such sounds and visions

get tangled up with our notions of the human. If the concept of the human proves to be less stable than before, it is not because of a nihilistic disregard for human beings, but because questions are raised by the films themselves that, if looked into, can only shake up the oppositions between human and machine that are deeply and problematically embedded in our culture.

An image from each of these films can serve as a coda to our discussion. In each film, the 'death' or 'termination' or 'retirement' of cyborgs is accompanied by gestures of the hand: the hand of the first threatening terminator extended towards Sarah's neck as she terminates him in the hydraulic press; the hand of Roy Batty in *Blade Runner* closing 'Christ-like' over the nail he has inserted as his 'time to die' approaches; the triumphant 'thumbs up' of the second terminator. Each is a 'human' gesture made by a mechanical hand, and each gesture points towards a humanism that the films may hope to affirm, but only by way of the insistence of mechanical hands which bind the human deeply to its other, even in termination.

Originally published in J. Collins, H. Radner and A. Preacher Collins (eds) (1993) *Film Theory Goes to the Movies,* London: Routledge.

Notes

One of the greatest pleasures about movie-going is the discussion it provokes. I would like to thank several people who have engaged me in discussion and debate over these films for some time and whose comments have been particularly helpful: C. Lee Taylor, Michael Stamm, Randal McGowen, Hilary Radner, Jim Collins and Ava Collins.

1. Deconstruction is the name given to a range of critical, philosophical, and literary inquiries and methodological procedures associated with the work of Jacques Derrida and Paul de Man. Their work, the work of those they have influenced, and the range of responses 'deconstruction' has provoked comprise an extensive body of discussion. Some of Jacques Derrida's most influential works include: *Of Grammatology*, trans. Gayatri Chakravorty Spivak (Baltimore: The Johns Hopkins University Press, 1976); *Writing and Difference*, trans. Alan Bass (Chicago: University of Chicago Press, 1982); *The Truth in Painting*, trans. Geoff Bennington and Ian McLeod (Chicago: University of Chicago Press, 1987). Paul de Man's books include: *Blindness and Insight*, 2nd ed., rev. (Minneapolis: University of Minnesota Press, 1983); *Allegories of Reading* (New Haven: Yale University Press, 1979); *The Rhetoric of Romanticism* (New York: Columbia University Press, 1984); *The Resistance to Theory* (Minneapolis: University of Minnesota Press, 1986). Further references to the latter will be included in the text, designated by the abbreviation *RT*.

The body of secondary material on deconstruction is itself an extensive one. Some important book-length contributions to the discussion include: Lindsay Waters and Wlad Godzich (eds) *Reading de Man Reading*, (Minneapolis: University of Minnesota Press, 1989); Jonathan Culler, *On Deconstruction* (Ithaca: Cornell University Press, 1982); Christopher Norris, *Paul de Man and the Critique of Aesthetic Ideology* (New York: Routledge, 1988). Perhaps the most succinct but scrupulous introduction to Derrida's work is Barbara Johnson's 'Translator's Introduction' to Jacques Derrida's *Dissemination* (Chicago: University of Chicago Press, 1981). For a lucid and rigorous essay-length introduction to the methods and implications of the work of de Man and Derrida, see Deborah Esch, 'Deconstruction' in Stephen Greenblatt and Giles Gunn (eds) *Redrawing the Boundaries of Literary Studies in English*, (New York: Publications of the Modern Language Association, 1992).

2. Much of my thinking about the theoretical, cultural and political importance of the cyborg has been inspired by Donna Haraway's compelling essay, 'A manifesto for cyborgs: science,

technology and socialist feminism in the 1980's', *Socialist Review* 15:2 (1985), pp. 65–108. And see the 'Interview with Donna Haraway' conducted by Andrew Ross and Constance Penley for *Social Text* 26/26 (1990), pp. 8–23.

3. In this regard, deconstruction draws on and complicates the important work of so-called 'speech act theory', in particular the work of J. L. Austin. In *How To Do Things With Words* (Cambridge, Mass.: Harvard University Press, 1962), and in other writings, Austin draws attention to an aspect of language that does not state something about the world or represent existing conditions but that *performs* an act. When we make a promise or a wager, when we say 'I do' in a marriage ceremony, we are not referring to anything, we are accomplishing the act by saying it. For de Man and Derrida, this *performative* capacity of language cannot be rigorously distinguished from language's *constative* dimension, its capacity to 'state' things about the world. The result is a possibly permanent tension or conflict between these dimensions of language. Derrida has explored this most fully in *Margins of Philosophy*, pp. 307–29. De Man's treatments of this tension can be found in *Allegories of Reading*, pp. 119–35, 278–301.

4. Lev Kulesov, *Repeticionnyj metod v kino* (Moscow, 1922): as quoted in Roman Jakobson, 'Is the film in decline?', in Krystyna Pomorska and Stephen Rudy (eds) *Language in Literature* (Cambridge, Mass.: Harvard University Press, 1987) p. 459.

5. David M. Hirsch, *The Deconstruction of Literature: Criticism After Auschwitz* (Hanover: Brown University Press, 1991), p. 119. Hirsch's virulent denunciation of deconstruction, its philosophical lineage and its company of 'fellow travelers' takes off from the disclosures of Paul de Man's wartime writings. From 1939 to 1943, de Man, then in his early twenties, wrote reviews and cultural criticism, primarily for the Belgian newspaper *Le Soir* while under Nazi occupation. Of the many reviews and articles, one – 'Les Juifs dans la littérature actuelle' – has come under particularly close scrutiny for its anti-Semitic expressions. For Professor Hirsch – and for many other critics of deconstruction – there exists an essential connection between de Man's early journalistic writings and his mature critical and 'deconstructive' work: the disclosures of de Man's 'collaborations' in these early writings demonstrate, according to Hirsch, that de Man's entire career is one of 'prevarication'. For critics more sympathetic to the project of deconstruction – and even for many who are not so disposed – the mature work is discontinuous with or even implicitly critical of the formulations which appear in the wartime journalism. The debate over de Man's youthful writings and their possible relationship to deconstruction is itself too intricate to explore here, but it has prompted a substantial body of literature of its own. The reviews and articles Paul de Man published for *Le Soir* and *Het Vlaamsche Land* have been collected and published as W. Hamacher, N. Hertz, and T. Keenan (eds) *Wartime Journalism, 1939–1943, by Paul de Man*, (Lincoln: University of Nebraska Press, 1989).

6. On this aspect of the film, see Constance Penley's important essay, 'Time travel, primal scene and the critical dystopia', in Annette Kuhn (ed.) *Alien Zone: Cultural Theory and Contemporary Science Fiction Cinema* (London: Verso Books, 1990), pp. 116–27. See also Fredric Jamesons's Marxist analysis of the film: 'Progress versus Utopia: or, can we imagine the future?', *Science Fiction Studies*, 9:2 (1982). For a Marxist critique of humanism in the context of recent science fiction cinema, see James H. Kavanagh, 'Feminism, humanism, and sicence in *Alien*', in *Alien Zone*, pp. 73–81.

7. Penley, 'Time Travel', ibid., p. 118.

8. Slavoj Žižek has argued that the terminator is revealed to be nothing more than 'the blind mechanical drive' which is distinguished from the human 'dialectic of desire', *Looking Awry: An Introduction to Jacques Lacan through Popular Culture* (Cambridge, Mass.: MIT Press, 1991), p. 22.

9. Walter Benjamin, 'The work of art in the age of mechanical reproduction', *Illuminations*, ed. Hannah Arendt trans. Harry Zohn (New York: Schocken Books, 1969), pp. 217–52.

10. Eric Alliez and Michel Feher, 'Notes on the sophisticated city', *Zone 1–2* [n.d.], p. 52. The work of the French critic Jean Baudrillard is most responsible for defining the 'postmodern' in terms of the disappearance of the boundary between original and copy. See in particular *Simulations*, trans. Foss, Patton and Beitchman (New York: Semiotext(e), 1983).

11. Thomas B. Byers, 'Commodity futures', *Alien Zone*, p. 39. *Blade Runner* has been widely and well-written about. See in particular Peter Fitting, 'Futurecop: the neutralization of revolt in

Blade Runner', *Science Fiction Studies* 14:3 (1987), pp. 340–54; Yves Chevier, '*Blade Runner*; or, the sociology of anticipation', *Science Fiction Studies* 11:1 (1984), pp. 50–60.

12. Giuliana Bruno has written a valuable essay on the film's linking of history, photography and mothers. See 'Ramble city: postmodernism and *Blade Runner*', *Alien Zone*, pp. 183–95.

13. Gerald Prince usefully defines intertextuality as 'the relation(s) obtaining between a given text and other texts which it cites, rewrites, absorbs, prolongs, or generally transforms, and in terms of which it is intelligible'. *Dictionary of Narratology* (Lincoln: University of Nebraska Press, 1987), p. 46. In the case of *Blade Runner*, the generic patterns of *film noir* would constitute the 'intertext' which the film 'cites, rewrites, absorbs' and, importantly, 'transforms'. On the relationship between *Blade Runner* and *film noir*, see Susan Dell and Greg Faller, '*Blade Runner* and genre: film noir and science fiction', *Literature/Film Quarterly* 14:2 (1986), pp. 89–100.

14. Annette Kuhn ascribes the effect of 'knowing' recognition in *Blade Runner* to the film's processes of 'meta-enunciation': the film addresses its spectators doubly, about 'events in the narrative, but also about the history of cinema and the conventions of certain film genres' (*Alien Zone*, pp. 145–6).

15. In his important article on the *noirish* elements of *Blue Velvet* and *Terminator 2*, Fred Pfeil ('Home fires burning: family *noir* in *Blue Velvet* and *Terminator 2*, in J. Copjec (ed.) *Shades of Noir: A Reader*, London: Verso, 1993, pp. 227–60) describes the pivotal moment at which the Schwarzenegger terminator revives after he has been apparently terminated by the T-1000, a moment that tells us that he is indeed human because he has a 'soul': 'at this very moment of greatest extremity, a small red light begins to shine far, far back in his eye – the sign, we are told, of his back-up power supply kicking in. . . . [I]s it not clear that . . . Arnold, *our new man*, has a core-self – or, if you will, individual soul – and *just enough* of one . . . ?'

VIVIAN SOBCHACK

NEW AGE MUTANT NINJA HACKERS
Reading *Mondo 2000*

I N EARLY 1991, *ARTFORUM INTERNATIONAL* asked me to write a short essay that would 'make sense' of *Mondo 2000* (*M2*) – a strange but 'hot' new magazine that had happened their way from Berkeley, California.[1] At first read, *M2* seemed important in its utopian plunge into the user-friendly future of better living, not only through a chemistry left over from the 1960s, but also through personal computing, bio- and nano- technologies, virtual realities and an unabashed commitment to consumerism. Co-founded in 1989 by 'domineditrix' Queen Mu (aka Alison Kennedy) and editor-in-chief R. U. Sirius (aka Ken Goffman), *M2* had evolved from two previous 'underground' publications – *High Frontiers* (a 'space age newspaper of psychedelic science, human potential, irreverence and modern art') and *Reality Hackers* – and, at the time, had published only three issues.[2]

Surfing the edge: early life on the new frontier

Proclaiming its own position as 'surfing' the 'New Edge' of a novel and electronically configured social formation called 'cyberculture', *M2* dubbed its (mostly male) readers 'mondoids' and invited them to cruise the datascape, ride the electronic range, hip-hop their laptop, vacation in virtual reality, dine on designer foods, jack in to synchro-energizers and off with smart drugs guaranteed to enhance their brains and sex lives. Here, it is crucial to point out that *M2* provokes the kind of prose I've written and you've just read, and poses a real dilemma for the scholar who would dare to analyse and/or criticize it. On the one hand, academic style would be ridiculous and ironically at odds with the technofrenzy it claimed to comprehend; on the other, a more vernacular style keeps veering toward the mimetic use of alliteration, hyperbole, 'hipness' and, worst of all, what must be called 'prose bites' – in sum, ironically aping *M2*'s own easy indulgences at the same time it would call them into account. Constructing this 'double

bind', *M2* sits squarely, and safely, on the postmodern fence, covering its postmodern ass, using irony not only to back off from a too-serious commitment to its own stance, but also to unsettle the grounds from which it might be criticized.

Indeed, *M2*'s prose is almost always self-consciously ironic, often coy or frenzied, and even sometimes witty. Articles and interviews in the first three issues bore such titles as 'Hyperwebs: 21st Century Media', 'High Tech High Life – William Gibson & Timothy Leary in Conversation', 'A Man & His Dog: Cryonics Today', 'Cyberspace 1999: The Shell, the Image and Now the Meat', 'Some Good Things to Say about Computer Viruses', 'Hip-Hop as Cyber Apocalypse', 'ATM's & the Rise of the Hacker Leisure Class', 'Teledildonics: Reach Out and Touch Someone', 'Covert Design & Holographic Clothing: A Look at 21st Century Fashion', and 'Designer Beings: In Conversation with Durk Pearson & Sandy Shaw'. Joining William Gibson and Timothy Leary as gurus of *M2*'s New Edge were Jaron Lanier (promoter of virtual reality systems), sci-fi writers Bruce Sterling, John Shirley, Rudy Rucker and Vernor Vinge, the singular William Burroughs, John Perry Barlow (a former lyricist for the Grateful Dead, 'electronic frontier' advocate and major supporter of the Republican Party), and a variety of assorted heroes and (fewer) heroines who had – supposedly in the cause of democratic populism – hacked, cracked and phone-phreaked their way into the corporate-controlled datascape and found it good to set (and get) information free.

Surrounding the editorials, articles, columns, interviews and illustrations were an extraordinary collection of advertisements, both New Age and New Edge. For sale were assorted books (mostly by Leary and John Lilly), cassette tapes ('Fractal Music', which lets you 'experience the elusive mysteries of fractal geometry with your ears!' and the 'DNA Suite: Music of the Double Helix', which answers the question, 'What is the sound of the genetic code?') and videos (the 'Thinking Allowed' collection of 'in-depth, intimate conversations with writers, teachers and explorers on the leading edge of knowledge & discovery, hosted by Dr Jeffrey Mishlove'). One could also buy computer programs and CD-ROMs (one containing the *Whole Earth Catalog*), a Danish modern-looking Flogiston chair ('for flying in cyberspace'), *Mondo 2000* T-shirts and the aforementioned 'Synchro-ENERGIZER' (a 'high-tech computer-driven brain balancer' whose headphones and goggles provide 'a salutary alternative to drugs in the 90s for dealing with stress, pain, dependencies and burnout'). There were ads for orgone energy blankets, UFO detectors, OxyHigh, OxyVital and OxyBliss ('Get High on Oxygen!'), Odwalla 'juice for humans' (touting 'Fresh Juice Kinetics') and, surprisingly not out of place despite its hook-up with the scholarly academy, Avital Ronell's *The Telephone Book*. Finally, although the covers of the first three issues I was given were less glossy than they were later to become, from the beginning they tended to feature women's heads floating somewhere in the ether of an erotic wet(ware) dream.

What was being enacted here? What was really being sold? And an equally significant question, unasked at the time and to which I shall eventually return: Why were *Artforum* and I so fascinated by this *Mad* magazine for technophiles? Indeed, written by Queen Mu and R. U. Sirius and worth quoting in its entirety, the first editorial was an embarrassingly adolescent rallying cry, almost poignant in its impossibly generalized, but utopian yearnings:

> *Mondo 2000* is here to cover the leading edge in hyperculture. We'll bring you the latest in human/technological interactive mutational forms *as* they happen.

We're talking Cyber-Chautauqua: bringing cyberculture to the people! Artificial awareness modules. Visual music. Vidscan magazines. Brain-boosting technologies. William Gibson's Cyberspace Matrix — fully realized!

Our scouts are out there on the frontier sniffing the breeze and guess what? All the old war horses are dead. Eco-fundamentalism is out, conspiracy theory is démodé, drugs are obsolete. There's a new whiff of apocalypticism across the land. A general sense that we are living at a very special juncture in the evolution of the species.

Back in the sixties, Carly Simon's brother wrote a book called *What to Do Until the Apocalypse Comes*. It was about going back to the land, growing tubers and soybeans, reading by oil lamps. Finite possibilities and small is beautiful. It was *boring*!

Yet the pagan innocence and idealism that was the sixties remains and continues to exert its fascination on today's kids. Look at old footage of *Woodstock* and you wonder: where have all those wide-eyed, ecstatic, orgasm-slurping kids gone? They're all across the land, dormant like deeply buried perennials. But their mutated nucleotides have given us a whole new generation of sharpies, mutants and superbrights and in them we must put our faith — and power.

The cybernet is in place. If fusion *is* real, we'll find out about it fast. The old information élites are crumbling. The kids are at the controls.

This magazine is about what to do until the *millennium* comes. We're talking about Total Possibilities. Radical assaults on the limits of biology, gravity and time. The end of Artificial Scarcity. The dawn of a new humanism. High-jacking technology for personal empowerment, fun and games. Flexing those synapses! Stoking those neuropeptides! Making Bliss States our normal waking consciousness. *Becoming* the Bionic Angel.

But things are going to get weirder before they get better. The Rupture before the Rapture. Social and economic dislocation that will make the Cracked 80s look like summer camp. So, in the words of the immortal Rudy Rucker, 'Hang ten on the edge' because the 90s are going to be quite a ride!

Consistent with its vagaries of commitment, however, by the next issue pathos had given way to ironic self-awareness and a supposedly tougher line of virtual (political) commitment. *M2*'s second editorial aligned itself not only with the fight against AIDS and neo-Luddite eco-fundamentalists (while announcing plans for a future 'Earth Also' issue), it also celebrated the seduction of the Soviets by 'free-wheelin' consumer hyper-capitalism' and promoted saving both 'ourselves and our comrades to the East from a 21st Century legalistic, megacorporate, one-world, peace-on-earth' through luxuriating in a 'cynicism' allowed by 'cyber-decadence'. Certainly, there was no pathos, no poignant and overgeneralized yearning, but rather a transmuted form of cynicism in *M2*'s clear promotion of high-tech consumerism:

Call it a hyper-hip wet dream, but the information and communications technology industry require a new *active* consumer or it's going to stall. . . . This is one reason why we are amplifying the mythos of the sophisticated, high-complexity, fast lane/real-time, intelligent, active and creative reality

hacker.. . . A nation of TV couch potatoes (not to mention embittered self-righteous radicals) is not going to demand access to the next generation of the extensions of man.

Some of the fascination exerted by *M2* emerges from this shape-shifting, political and tonal 'morphing', from the fancy footwork it takes to resolve the essential *ambivalence* of mondoid desire. Thus it is particularly telling that the first two editorials are in such contrary tonal relation to each other, and that they resolve the utopianism of the first with the cynicism of the second by making cynicism itself utopian.

This is, then, an optimistic cynicism. Reading *M2*, one might think that we live in the best of all possible worlds, or, perhaps, more precisely, that we live best only in possible worlds. *M2*'s ambivalence of desire, its nostalgia for the real possibilities and commitments of the past (the 1960s), and its yearning for a real (rather than virtual) experience of the highly mediated present cohere in a peculiarly oxymoronic cosmology of the future. This cosmology explicitly resolves New Edge high-technophilia with New Age and 'whole earth' naturalism, spiritualism and hedonism. It implicitly resolves the 1960s countercultural 'guerrilla' political action and social consciousness with a particularly privileged, selfish, consumer-oriented and technologically dependent liber-tarianism. Hiding under the guise of populism, the liberation politics touted in the pages of *M2* are the stuff of a romantic, swashbuckling, irresponsible individualism that fills the dreams of 'mondoids' who, by day, sit at computer consoles working for (and becoming) corporate America. The Revenge of the Nerds is that they have found ways to figure themselves to the rest of us (particularly those of us intrigued by, but gener-ally ignorant of, electronics) as sexy, hip and heroic, as New Age Mutant Ninja Hackers (the name I gave them in my column for *Artforum*).

Focusing on electronic, quasi-disembodied forms of kinesis ('safe' travel without leaving your desk), interaction ('safe' sociality without having to reveal your identity or 'true name'[3]) and eroticism ('safe' sex without risking an exchange of bodily fluids), the New Age Mutant Ninja Hacker's ambivalent desire to be powerful, heroic, committed and yet safe within his (computer) shell leads to an oxymoronic mode of being one might describe as *interactive autism*. (This mode of being is briefly, but illuminatingly dramatized in the climactic 'virtual reality' sex scene in the 1992 film *The Lawnmower Man*: while impossibly total sexual coupling occurs in virtual space, the two participants are seen physically separated in the 'real' space of the lab, hugging and caressing their own data-suited-up bodies.) It is hardly surprising that *M2* privileges virtual reality and all that goes with it – virtual sex ('teledildonics'), virtual politics (which doesn't seem to affect the daily world except by its absence) and virtual community (a hierarchy of hackers, crackers and phreakers).

Mondo 2000 focuses on the cybernetic union of carbon and silicon, an interactive feedback loop of biological and technological being achieved through the computer. Its *raison d'être* is the techno-erotic celebration of a reality to be found on the far side of the computer screen and in the 'neural nets' of a 'liberated', disembodied, computer-ized yet sensate consciousness. This electronically constituted reality and consciousness is achieved through various prostheses that plug the human sensorium into interactive communion with the computer, so that the user transcends – and, all too often in this context, elides – not only his (or her) being in an imperfect human body, but also the imperfect world that we all 'really' materially create and physically inhabit. At best, the

encounters in virtual reality and cyberspace promoted by *M2* are video games that one can lose without real loss. At worst, they falsely promise a new Eden for cyborg Adams and Eves – enthusiastic participants in some computerized and simulated (in)version of the Back to the Earth movement.

The cutting edge: getting rid of the meat

Although I know I have sounded pretty reactionary thus far, it needs stating that the 'terminal' transformation of human subjectivity as it enters the electronic technosphere is not necessarily negative in its consequences and implications. Interesting things happen when identity can represent itself, to some extent, as liberated from, for example, normative categories of gender and race. (While she has subsequently tempered her initial enthusiasms, Donna Haraway pointed to these and other liberating possibilities in her seminal article, 'A Manifesto for Cyborgs'.[4]) Even at this early stage of development, the various formations of cyberspace and virtual reality not only provide novel recreational and aesthetic pleasures, but also have practical uses. Simulated worlds stimulate architects, medical researchers and the air force. From ATMs and the largest electronic banking networks to bar codes and my beloved Powerbook, the datascape is as 'real' – if not, as *M2* claims, *more* 'real' – than the physical space occupied by my physical body. Indeed, elsewhere, I have argued extensively (from a phenomenological perspective) that the lived meaning of space, time and subjectivity has been radically altered by electronic technologies in an experience that may be described, and cannot be denied.[5]

Nonetheless, the emergence of the celebratory (and generally economically privileged) subculture represented by *M2*'s consistent vacationing in the datascape and in virtual worlds seems to me the mark of a potentially dangerous and disturbingly miscalculated attempt to escape the material conditions and specific politics (dare I, in this context, say the 'real' reality?) that have an impact on the present social fragmentation of American culture, the body's essential mortality, and the planet's increasing fragility. Rather than finding the gravity (and vulnerability) of human flesh and the finitude of the earth providing the *material* grounds for ethical responsibility in a highly technologized world, New Age Mutant Ninja Hackers would look toward 'downloading' their consciousness into the computer, leaving their 'obsolete' bodies (now contemptuously called 'meat' and 'wetware') behind, and inhabiting the datascape either as completely disembodied information or as a cadre of 'Be All You Can Be', invulnerable, invincible, immortal New Age/New Edge cyborgs with the bodies of Arnold Schwarzenegger.

Writing at a historical moment when the starving or dead bodies of Somali children and the emaciated or dead bodies wrought by Bosnia's civil warfare fill our television screens and the displaced bodies of the homeless fill our streets, it is both comprehensible and extremely disturbing that *M2*'s supposedly utopian celebration of the liberating possibilities of the new electronic frontier promotes an ecstatic dream of disembodiment. This is alienation raised to the level of *ekstasis*: 'A being put out of its place.' It is also an apolitical fantasy of escape. Historical accounts of virtual reality tell us that one of the initial project's slogans was 'Reality isn't enough anymore', but psychoanalytic accounts would more likely tell us that the slogan should be read in its inverse form – that is, 'Reality is too much right now'.

Hence the ambivalence of mondoid desire. In a cultural moment when temporal coordinates are oriented toward technological computation rather than the physical rhythms of the human body, and spatial coordinates have little meaning for that body beyond its brief physical occupation of a 'here', in a cultural moment when there is too much perceived risk to living and too much information for both body and mind to contain and survive, need we wonder at the desire to transcend the gravity of our situation and to escape where and who we are? It is apposite that one of the smarter articles in the early issues of *M2* philosophically entitles itself 'Being in Nothingness', and tells us of the ultimate escape: 'Nothing could be more disembodied or insensate than . . . cyberspace. It's like having had your everything amputated.' This is dangerous stuff – the stuff that (snuff) dreams are made of. Indeed, *M2* is exceedingly – and apparently indiscriminately – proud that it is dangerous, for, as of its fourth issue, it quoted the preceding sentence as a 'come on' to potential subscribers.

Haraway, author of the aforementioned 'Manifesto for Cyborgs', has recently recognized the kind of impulses (dis)embodied by the *M2* subculture. In an interview in *Social Text*, she warns against cyborgism in so far as it plugs into dangerous forms of holism:

> Any transcendentalist move is deadly; it produces death, through the fear of it. These holistic, transcendentalist moves promise a way out of history, a way of participating in the God trick. A way of denying mortality.
> . . . In the face of the kind of whole earth threat issuing from so many quarters, it's clear that there is a historical crisis.. . . . Some deep, inescapable sense of the fragility of the lives that we're leading – that we really do die, that we really do wound each other, that the earth really is finite, that there aren't any other planets out there that we know of that we can live on, that escape-velocity is a deadly fantasy.[6]

The holistic cyborg discourse of *M2* is thus deeply ambivalent about the New Age Mutant Ninja Hacker's technological (inter)face. Its dangerous excesses are constituted from what philosopher Don Ihde, in *Technology and the Lifeworld: From Garden to Earth (1990)*, recognizes as the *doubled desire* that exists in our relations with any technology that extends our bodily sensorium and, thereby, our perceptions – be it eyeglasses or microscopes, the camera or the computer. Describing this doubled desire, Ihde tells us that it

> is a wish for total transparency, total embodiment, for the technology to truly 'become me'. Were this possible, it would be equivalent to there being no technology, for total transparency would *be* my body and senses; I desire the face-to-face that I would experience without the technology. But that is only one side of the desire. The other side is the desire to have the power, the transformation that the technology makes available. Only by using the technology is my bodily power enhanced and magnified by speed, through distance, or by any of the other ways in which technologies change my capacities. These capacities are always *different* from my naked capacities. The desire is, at best, contradictory. I want the transformation that the technology allows, but I want it in such a way that I am basically unaware of its presence. I want it in such a way that it becomes me. Such a desire both

secretly *rejects* what technologies are and overlooks the transformational effects which are necessarily tied to human-technology relations. This illusory desire belongs equally to pro- and anti-technology interpretations of technology.

M2 ends up revealing negative as well as positive feelings about the amazing prostheses offered by electronic technology in general, and computers in particular. The New Age Mutant Ninja Hackers represent and embody this contradictory desire which is, at one and the same time, both utopian and dystopian, self-preservational and self-exterminating. New Age Mutant Ninja Hackers wish to become the machines that extend them and to cede their human flesh to the mortality it is heir to. But they simultaneously wish to 'escape the newly extended body of technological engagement' and to reclaim experience through the flesh. Hence the New Edge reverts back to the New Age. Hence the extraordinary emphasis on kinesis and sex. *M2*'s fourth issue features a piece called 'The Carpal Tunnel of Love', in which Mike Saenz, developer of cybererotic software, tells us: 'Virtual reality to the uninitiated, they just don't get it. But they warm immediately to the idea of Virtual Sex. . . . I think lust motivates technology. The first personal robots, let's face it, are not going to be bought to bring people drinks.'

As Ihde points out, this double desire surrounding technology is constituted from 'a fundamental ambivalence toward the very human creation of our own earthly tools'. That is, 'the user wants what the technology gives but does not want the limits, the transformations that a technologically extended body implies'.[7] What is particularly dangerous about *M2* is that – despite its seeming self-consciousness – this ambivalence is unrecognized, if not completely disavowed. *M2*'s dizzying pro-technology rhetoric hides its anti-technology dreams; its self-deception promotes deadly, terminal confusions between meat and hardware.

Negotiating the edge: merchandising mondoid libertarianism

Case, the maverick protagonist of William Gibson's cyberbible *Neuromancer*, stands as the cult hero of those who voraciously read *M2* and imagine themselves cruising the datascape and sensuously experiencing the intense electronic high of information overload. That audience, according to an interview with editor R. U. Sirius,

> tends to be people in their twenties. A lot of computer kids, the kind of people who would go to performance works by, say, Survival Research Lab, and that sort of thing. We get a lot of old hippies too, who love the magazine and read it. People in their thirties, people in the computer industry. A large portion of our audience is successful business people in the computer industry, and in industry in general, because industry in the United States is high-tech.[8]

Envisioning themselves as individual and idiosyncratic (at the same time that they are apparently incorporated), as cowboy hackers (there aren't too many cowgirls), most *M2* readers must dream not only of electric sheep, but also of bucking corporate systems, riding the electronic range and cutting through the barbed-wire master codes to keep information free, available to all (that is, all who have computer access and skills).

Promoting future utopian 'networks' in which everyone at every level of society is connected and plugged in to everyone else, the New Age Mutant Ninja Hackers, in the midst of this communitarian dream, have no real idea of how to achieve it. Instead, they privilege the individual – modelling themselves after some combination of *Neuromancer's* world-weary Case (and/or *Blade Runner's* Rick Deckard), entrepreneurial technomaverick Steve Jobs, and countercultural guerrillas who muck up 'the system' and, at their worst, bear some relation to the very same eco-terrorists for whom *M2* expresses contempt.

M2 occasionally (and mostly for effect) declares itself anarchic and/or populist, but its position is really (or, in this case, virtually) libertarian. It stands against big govern-ment and big corporations (the villains of most of its purportedly political pieces), but ultimately seems in favour of a 'night-watchman' state – one that functions minimally, but just enough to guarantee its citizens' 'natural' rights to the 'good life' – in *M2*'s case, hacking, drugs, sex, rock 'n' roll (and probably guns). Although it dreams of a communitarian utopia, its major impulses are to secure maximum individualism and privatization, and it is blind to the historical structures that go beyond individual motivation and 'do-it-yourself' entrepreneurship in determining 'winners' and 'losers'. In this regard, *M2* talks about 'access' in a vacuum and never relates it to economics or race or gender.

Consider the following description of cyberpunk 'attitudes that seem to be related' (according to one of *M2*'s regular writers, Gareth Branwyn):

- Information wants to be free.
- Access to computers and anything which may teach you something about how the world works should be unlimited and total.
- Always yield to the hands-on imperative.
- Mistrust Authority.
- Do It Yourself.
- Fight the Power.
- Feed the noise back into the system.
- Surf the edge.[9]

This bumper-sticker libertarianism is neither progressive nor democratic. And, despite all the rhetoric of 'networking', it is hardly communitarian. (A list of features of the 'cyberpunk worldview' includes, at most, the notion of 'small groups' as in: 'Small groups of individual "console cowboys" can wield tremendous power over governments, corporations, etc.'[10]) Its ideolect is one that 'winners' in the modern world adopt. Its dreams of personal freedom and its utter faith in self-help are grounded in privilege and the status quo: male privilege, white privilege, economic privilege, educational privi-lege, First World privilege. Its dreams are grounded in the freedom to buy, and – especially – the freedom to sell. Its posture of rugged individualism (clothed by L. L. Bean) and personal transformation also has something to do with freedom from (yet within) the Protestant work ethic. Its entrepreneurial enthusiasms promote the easy attainment of spiritual grace and personal fortune through a transformative technology that takes the long hours of *Bildung* out of *Bildungsroman*. As Rudy Rucker puts it:

> [N]one of us hackers or writers or rappers or samplers or mappers or singers
> or users of the tech are in it solely for the Great Work – no, us users be

here for our own good. We work for the Great Work because the work is fun. The hours are easy and the pay is good. And the product we make is viable. It travels and it gets over.[11]

Merchandising the edge: the seductions of selling out

At the time I wrote my essay for *Artforum*, *M2* had published only three issues and was already burnishing the glossy surface of its covers and contemplating a wider audience. In 1991, arousing the attention of both the media and a range of scholars interested in contemporary sci-fi, new technologies and cultural studies, *M2* was quick to see the academic writing on the wall. That first academically-based advertisement for Ronell's *Telephone Book* was followed up in the glossy fourth issue with Professor Avital Ronell herself (opining on 'Hallucinogenres'), posed glamorously in a head shot to die for (what was to become part of *M2*'s signature style of male homage to smart women: part *Cosmopolitan*, part *Playboy*). Subsequent issues increasingly played to (and co-opted) the *Rolling Stone* crowd, featuring pieces on rock music and high-tech fashion, but they also continued their seduction of what a friend of mine has called the 'leather theorists': Mark Dery began a column called 'Guerrilla Semiotics' (which presupposed that mondoids knew what semiotics was), and in a later article called 'Terrorvision' he explained Foucault's panopticon; Professor Larry McCaffery became an interviewer, while Professor Constance Penley became an interviewee. The fifth issue, in fact, conveyed the capitulation of *M2*'s libertarian worldview to its commercial smarts by featuring an unexpected 'Acid Take on Camille Paglia', the kind of gun-toting academic and sexual persona one would have assumed the magazine would embrace – given their mutual rugged-individualist and sexist visions.[12] Indeed, the eighth issue is more blatantly into female bodies than ever, offering 'Deeelectronix: All New! All Nude! The Mondo Tech Centerfold!', a high-tech piece of erotica entitled 'The Woman's Home Companion', a fashion layout (all dripping with a mix of irony and cum), and one of those respectful head jobs on singer Diamanda Galás. This glossiest issue yet, however, seemed to be losing most of its funky and high-tech advertisers.

I shouldn't have worried. Just in time for Christmas 1992, priced at $20, *Mondo 2000: A User's Guide to the New Edge* appeared as the coolest gift around. *Entertainment Weekly* gave it an 'A' (compared to the 'C' earned by *Jane & Michael Stern's Encyclopedia of Pop Culture: An A to Z of Who's Who and What's What, From Aerobics and Bubble Gum to 'Valley of the Dolls' and Moon Unit Zappa*, which seemed to them like 'a drag on a moldy roach').[13] The beautiful volume is a true *Lover's Discourse* of Cyberculture, an ecstatic new Edge *Empire of Signs*. Arranged alphabetically – from Aphrodisiacs to Zines (with 'Cyberpunk, Virtual Reality, Wetware, Artificial Life, Techno-erotic Paganism, and More' in between) – are encyclopedia entries explaining it all in an extraordinarily appealing (and accessible) graphic version of hypertext: cross-referenced and -referencing, doubled and irregular columns, colour-coded, beautifully illustrated (with, for *M2*, a certain reticent good taste), and served up on a glossy, slick, slippery paper that I admit I love to touch.

Throughout this sumptuous, sensuous tour of the New Edge, in the midst of phrases or after a referenced book title, there appears that familiar green Masonic 'God's Eye' that gives the dollar bill its particular mystique. This symbol, as R. U. Sirius says in his

user's guide to the *User's Guide*, indicates 'a product listed in the MONDO Shopping Mall' at the back of the book (with the extensive bibliography that now offhandedly lists Foucault and Derrida as well as Timothy Leary). The Shopping Mall, according to R. U. Sirius, is

> an access guide to *products* – yes, things you can *buy*. Educational toys, you could call them – to advance your understanding or just seduce you into joining this cultural New Thing. *Shopping Mall?!!!!* We could have called it something less crass: maybe 'Tools for Access,' like our respectable older cousins in the *Whole Earth Catalog*. But why be pretentious about it? We are present at the apotheosis of commercial culture. Commerce is the ocean that information swims in. And as we shall see in the Guide, the means of exchange in commercial culture is now *pure information*.[14]

Information has never been pure. And it is always materialized. I wonder as I hold this book, feel the sleekness of its pages, and the sensuousness of its artwork, why and how I am seduced again, so quickly, by something with which I have become so bored and at which I have become so angry. I only know that it's incredibly easy to be seduced by the easy, particularly when it parades as the complex. It would be restful to give in to my academic-doing-cultural-studies' sense of my own hip comprehension of 'what's happening', to think myself 'bad' rather than merely respected, to have fun wallowing about in my own prose. It would be wonderful to complacently protect myself from all-comers with an all-consuming irony, to transform my being without work, but with good lighting and make-up. I can't speak for *Artforum* or, for that matter, *SAQ*, but I am drawn to *Mondo 2000*, I realize, because it appeals to the worst in me, the laziest in me, the cheapest in me. In my sober and responsible moments, I bemoan our culture's loss of gravity and fear the very real social dangers of disembodied ditziness, but holding this Christmas present to myself, all I want is a head shot.

Originally published in M. Dery (ed.) (1994) *Flame Wars: The Discourse of Cyberculture*, Durham: Duke University Press.
This essay has been edited for inclusion in the Reader.

Notes

1. 'What in the world: Vivian Sobchack on New Age mutant ninja hackers', *Artforum International* (April 1991) pp. 24–6. Portions of the present essay were originally published in this article.
2. Unless otherwise noted, references and quotations that follow are from the first three issues of *Mondo 2000* – 1 (1989), its cover indicating Fall no. 7 (ostensibly as a continuation of *Reality Hackers*, which is figured in the illustration on the front cover), 2 (Summer 1990) and 3 (Winter 1991).
3. Reference here is to *True Names*, a sci-fi novella published during the emergence of cyberpunk sci-fi and concerned with a group of hackers whose computer pseudonyms hide their 'true names' and physical identities, the knowledge of which constitutes the greatest threat and the greatest intimacy. See Vernor Vinge, *True Names and Other Dangers* (New York: Baen Books 1984).
4. Donna Haraway, 'A manifesto for cyborgs; science, technology and socialist feminism in the 1980s', *Socialist Review* 15 (1985), pp. 65–107.
5. Vivian Sobchack, 'Toward a phenomenology of cinematic and electronic presence: the scene of the screen,' *Post Script* 10 (Fall 1990), pp. 50–9. See also 'Post-futurism', in my *Screening Space: The American Science Fiction Film* (Bloomington: Indiana University Press, 1987), pp. 300–02.

6. Constance Penley and Andrew Ross, 'Cyborgs at large: interview with Donna Haraway,' *Social Text* 25/26 (1991), p. 20.
7. Don Ihde, *Technology and the Lifeworld: From Garden to Earth* (Bloomington: Indiana University Press, 1990), pp. 75–6.
8. R. U. Sirius, quoted in 'Sex, drugs, & cyberspace', *Express: The East Bay's Free Weekly*, 28 September 1990, p. 12.
9. Gareth Branwyn, 'Cyberpunk', in Rudy Rucker, R. U. Sirius and Queen Mu (eds) *Mondo 2000: A User's Guide to the New Edge*. (London: Thames and Hudson: 1992), p. 66.
10. Ibid.
11. Rudy Rucker, 'On the edge of the Pacific,' in Rucker et al., ibid., p. 13.
12. Issues 4 and 5 are not dated (most likely an effect of their irregular publication). Issues 6, 7, and 8 (the latest at the time this was written) are dated 1992.
13. Tim Appelo, 'Far in and out,' *Entertainment Weekly*, 27 November 1992, p. 72.
14. R. U. Sirius, 'A User's Guide to Using This Guide,' in Rucker, et al., *User's Guide*, p. 16.

SCOTT BUKATMAN

TERMINAL PENETRATION

Narrative and virtual realities

BY NOW THE IMAGE IS becoming familiar — but not quite. A figure stands in a kind of high-tech bondage. Wires and cables snake from gloves and sensors to a pair of hard-crunching computers off to the side. The head is enshrouded by an elaborate apparatus that blocks the subject's eyes and ears. The figure stands in an uneasy crouch, reaching out to grasp the invisible air. This is not, however, some sensory deprivation nightmare. The subject is comfortably ensconced in *virtual reality* (VR), a cybernetic paraspace comprised of real-time interactive data. With the addition of the Dataglove, the user can grasp and manipulate the objects in the virtual environment.[1] Voice recognition completes the interface. Marvin Minsky, a co-founder of MIT's Artificial Intelligence Laboratory muses — somewhat alarmingly — that wires inserted into the nerves would allow the sensation of touch. For Timothy Leary, this virtual realm represents the ultimate way to 'tune in' — as one developer notes, 'The computer literally knows where your head's at'.[2]

Virtual reality significantly extends the sensory address of existent media to provide an alternate and manipulable space. Multiple users can enter the same virtual reality and play virtual catch or otherwise interact on this virtual plane. They can appear to each other in different forms, or as different species or genders — a simulated, but powerful, polymorphism is at work here. To be installed into such an apparatus would be to exist on two planes at once: while one's objective body would remain in the real world, one's *phenomenal body* would be projected into the terminal reality. In an ecstatic exaggeration of Merleau-Ponty's phenomenological model, world and body comprise a continually modifying feedback loop, producing a terminal identity without the terminal — a *cybersubject*.

Virtual reality technologies have attracted much attention at the beginning of the 1990s, and it is evident that the age of simulation, endlessly explored by cultural theorists,

is far from over. NASA has long been at the forefront of simulations technology, and NASA's Scott Fisher writes of *telepresence*, a robot controlled by a distant user whose sensorium is wired into the phenomenological experience of the robot. Even the complexities of information management can be 'navigated' by a 'Virtual Environment Workstation', where data and control options could co-exist in the same space as the user.[3] Early 'artificial reality' designer Myron Krueger has also proposed such a 'computer without a screen': 'A computer presence will permeate the workplace and the home, available whenever a need is felt.'[4] Back in the real world, architects are using Jaron Lanier's VPL virtual reality technology to design buildings and take clients on walk-throughs before any construction has begun.

At this point the discourse surrounding the immersive interface of virtual reality far outstrips the achievement. The VR apparatus is still bulky and inconvenient – far from the desired ideal of a transparent interface technology. At the same time, the computational requirements are so intense as to put the experience out of reach for all but the wealthiest clients (design firms or the government, for example). There is every reason to believe that the technology will improve to the point of widespread feasibility within a decade. Yet the mere existence of *virtual reality* makes possible a new interrogation of some issues crucial to human and social existence. In his book, *Virtual Reality*, Howard Rheingold demonstrates that VR represents an incredible fusion of simulations technologies (including television, computer graphics, real-time computer processing and others).[5] Using *cyberspace* as a common synonym for the simulated spaces of *virtual reality*, Rheingold writes that 'cyberspace feels like one of those developments that come along unexpectedly and radically alter everyone's outlook forever after'.[6] Michael Heim has called cyberspace 'a tool for examining our very sense of reality'.[7] Such ontological and epistemological issues as the nature of the human, the real, experience, sensation, cognition, identity and gender are all placed, if not under erasure, then certainly in question around the discursive object of virtual reality and the postulated existence of perfect, simulated, environments. Virtual reality has become the very embodiment of postmodern *disembodiment*.

Jonathan Crary, writing about the technology of the camera obscura, argues that it 'is what Gilles Deluze would call an assemblage', and the same must also be true of the immersive technological environment of virtual reality: 'an object about which something is said and at the same time an object that is used. . . . [It] cannot be reduced either to a technological or a discursive object: it was a complex social amalgam in which its existence as a textual figure was never separable from its machinic uses.'[8] The polymorphous possibilities of VR have produced a range of responses, from the merely prurient to the unabashedly utopian.

One sign of this emergent subculture must be the re-emergence of Timothy Leary. Leary exemplifies the terminal fiction of what Sobchack has termed these 'New Age Mutant Ninja Hackers' (see chapter 8, this volume). For Leary, computer technology in general and virtual reality simulations in particular offer a path to self-knowledge, self-realization and self-empowerment. Leary's pronouncements are even more hyperbolic than Baudrillard's and are even possessed of some of the same paranoia about the operations of power, but Leary lacks any of Baudrillard's irony. The rhetoric, dense with allusions to science fiction, circles around itself, cyberpunk-style, but this time in a vain attempt to describe real objects and real operations: 'The screen is where the perceptual wetware groks the informational output of the cyberware [man].'[9]

Other proponents of cyberdrool demonstrate more restraint than Leary, but reveal identical fantasies of subject-empowerment: 'Cyberspace,' writes Howard Rheingold, 'is a human–computer interface, but it is also a mind-space, the way mathematics and music and myth are mind-spaces – mind-space you can walk around in and grab by the handles.'[10] Note, within Rheingold's alliterative list, the simultaneous positioning of cyberspace as co-extensive with the discourses of Enlightenment rationalism, high art and folk culture.

Most of the journalistic accounts, and even some of the pronouncements of affiliated scientists and technicians, tend to stress the fundamental newness of the VR experience, and yet its precursors are clear, from videogames to graphical computer interfaces to, of course, the movies. *Scientific American*, reporting on the technological developments around 'virtual reality', describes the target in terms familiar to theorists and students of the cinema – as a quest for realism. *Brainstorm* notwithstanding, cinema has nothing to rival the reality systems of contemporary electronics. In fact, one is frequently reminded, in studying the VR sensation, of the meditations of André Bazin on 'the myth of total cinema'. The prehistory of cinema was dominated by a desire for 'a total and complete representation of reality', he wrote. The inventors of the medium, those other scientists and technicians, 'saw in a trice the reconstruction of a perfect illusion of the outside world in sound, color and relief'. By such standards the silent cinema, the monochromatic cinema and the flat cinema represent a set of compromises with what the medium ought to be. 'In short' – Bazin proclaims – from within this perspective, 'cinema has not yet been invented'.[11]

Virtual reality – or 'artificial reality' to use Myron Krueger's original term – describes 'a computer interface that seemingly surrounds the individual.'[12] The developmental history of computers is almost synonymous with the history of the interface. In common parlance the interface is the tool that permits the user to input or receive information from the computer. Keyboards and punchcards represent two approaches to inputting information, while the computer's translation of machine language into English and its display on a monitor enables the user to understand and utilize the data. The attempt to increase computer literacy has resulted in increasingly 'intuitive' interfaces; systems that operate in already familiar ways. Virtual reality represents an attempt to eliminate the interface between user and information – by 'transforming data into environment', as Karrie Jacobs put it.[13] The intensified spatial experience of virtual reality, with its simulated immersion into an interactive and non-narrative alternate space can be easily assimilated to the same dream that Bazin isolated in 1946.

The dictionary defines an interface as 'the boundary of two bodies or spaces'. The human–computer interface can certainly be described as existing between a body *and* a space. At the same time, the very rise of the communication and information technologies embodied in the computer have given rise to pervasive notions that such boundaries, if they exist at all, are almost infinitely malleable. The blurred interface between human and electronic technology is perhaps the trope that most effectively defines the concerns of postmodern culture, in otherwise diverse works ranging from Nam June Paik's TV Penis through Godard's *Alphaville* to Pynchon's cybernetic paranoia: 'Maybe there is a machine that will take us away, take us completely, suck us out through the electrodes out of the skull 'n' into the Machine and live there forever with all the other souls it's got stored there.'[14] In *Gravity's Rainbow*, the technology puts everyone under the shadow of the bomb (V-2 and, by extension, nuclear): 'Each will

have his personal Rocket. Stored in its target-seeker will be the heretic's EEG, the spikes and susurrations of heartbeat, the ghost-blossomings of personal infrared, each Rocket will know its intended and hunt him.'[15]

The interface has thus become a crucial site, a significantly ambiguous boundary between human and technology. The interface relocates the human, in fact *redefines* the human as part of a cybernetic system of information circulation and management. The more invisible the interface, the more perfect the fiction of a total imbrication with the force fields of a new reality.

One expects the release of a wave of virtual reality fiction, in which a host of anachronistic fantasies are played out within virtual worlds (as on the holodeck in *Star Trek: The Next Generation*) but so far there has been hardly a trickle. One recent fiction that does attempt to construct the kind of electronic 'habitats' that VR enthusiasts anticipate is Neal Stephenson's *Snow Crash* (1992). The most appealing aspect of the novel is his conception of the Street: a public cyberspace, or virtual reality. The Street features new developments of offshooting 'side streets', private domains hidden inside 'buildings', and public 'boulevards' where virtual denizens circulate to exchange information or to just be seen. Stephenson is adept at envisioning a data space as a site of *social* interaction and interactivity, and his conception of the human in the electronic realm is memorable. Users can jack in from elaborate, high-res, customized hardware set-ups or simply dial up from public access lines. Naturally, their mode of access is reflected in the appearance of their 'avatars', which include 'stunningly beautiful women, computer-airbrushed and retouched at seventy-two frames a second', plus 'Wild looking abstracts, tornadoes of gyrating light', and a 'liberal sprinkling of black and white people . . . rendered in jerky, grainy' fashion that is less frequently updated. This mode of interface is hardly invisible. 'Talking to a black-and-white on the Street is like talking to a person who has his face stuck in a xerox machine, repeatedly pounding the copy button, while you stand by the output tray pulling the sheets out one at a time and looking at them.'[16] While Stephenson acknowledges a reflexivity of interface, there is a 'realist' hierarchy at work, and black-and-whites are low on the scale. At the apex are 'the avatars of Nipponese businessmen, exquisitely rendered by their fancy equipment, but utterly reserved and boring in their suits'. The Street is an appealingly plausible portrait of a heterogeneous space that has everything and nothing in common with more traditional public spheres.

The virtual reality of narrative can operate as a real interface between human and technologized culture, revealing or providing a continuity between subject and machine. Science fiction is most explicit in narrating (and thus, in a sense, *producing*) such a continuum, but the discourses of non-science fiction writers like Pynchon and DeLillo, and techno-visionaries like Toffler and Baudrillard, perform a similar function of representing the human and technological as always-already co-extensive. In the hands of many writers, the text becomes a machine itself, or a machine-product, such as the writing machine in Raymond Roussel's *Locus Solus* or the machinery of William Burroughs's cut-ups. These automatic texts are not indicative of the writer's unconscious, but rather of their own cybernetic origins.[17] David Porush writes, 'Cybernetic fiction is a means for the author to present himself or his literature as a soft machine, a cybernaut-like hybrid device.'[18] *Soft machine* is appropriated from Burroughs and aptly designates the site of interface or *interzone* (to make my own appropriation).

This chapter will detail a range of experiences – encountered in literature, cinema, games and theme parks – that permit the intricate activity of interface that is increasingly indispensable. One further distinction needs to be made among these interfaces with the electronic world that are produced through different media. We must distinguish between an interface that incorporates some form of *direct sensory engagement* (games and theme parks, for example) and an interface that operates through an action of *narrativization* (literature). These represent two distinct modes of subject address, although – and this is essential – they often occur in tandem. The cinema itself combines them, incorporating its phenomenology of vision with the guidance, *telos* and closure of narrative. Computer games almost inevitably combine narrative progression with 'virtual' sensory pleasures. Repeatedly, the operations of narrative will be shown to constrain the effects of a new mode of sensory address, and so the fascination with the rise of virtual reality systems might represent a possible passage beyond narrative into a new range of spatial metaphors. The richer the sensory interface, the more reduced is the function of narrative. In this context, the science fiction film *TRON* becomes a fascinating cyborg object poised between the demands of narrative and the 'pure' spatiality generated by virtual reality systems.

Fun in cyberspace

The Data Glove is only one of the virtual environment tools offered up by the technology of the computer. Most prevalent are the games which line the shelves of every computer store. When Case jacks in to cyberspace in William Gibson's *Neuromancer*, he enters a realm which 'has its roots in primitive arcade games'. In Steven Levy's history of the minicomputer, *Hackers*, games are very significant. 'Games were the programs which took greatest advantage of the machine's power – put the user in control of the machine – made him the god of the bits and bytes inside the box.' After buying a new game, a kid could 'go home for what was the essential interface with the Apple [Computer]. Playing games'.[19] Levy's glibness does not hide the validity of his observation. Games are far more than an idle recreation for many 'users', they in fact represent the most complete symbiosis generally available between human and computer – a fusion of spaces, goals, options and perspectives. 'To see tomorrow's computer systems, go to the video game parlors!' proclaims the acclaimed systems designer Ted Nelson.[20] Games literally test the user, and in more than just eye-hand coordination.

The first computer game, developed by hackers in 1962, was *Spacewar*, a simulation that presented flat outlines of starships doing battle by spitting small pixels at each other while vying for position around a gravitationally powerful 'sun'. The next was *Adventure*, a text game which described surroundings and action. The adventurer could, by typing simple instructions ('Go North'), move in different directions, examine a range of objects, learn secret words and interact with other characters. Howard Rheingold correctly observes that '*Adventure* is a virtual world in a conceptual', rather than a sensory, way.[21] Both games remain paradigmatic of computer gaming, and the most intriguing games have combined the kinesis of *Spacewar* with the interactive narrative format of *Adventure*. Players solve puzzles (and sometimes those puzzles are bugs in the design of the game which have to be recognized and worked around). Games become metaphors for hacking itself – the process of experimenting with computer structures

in a non-formal and often intuitive manner. Some games have made the hacking/gaming relation obvious: in *Hacker* for example, players find themselves in an unfamiliar computer system and must experiment to learn about their environment and locate themselves in the system in a kind of electronic cartography. Inevitably, there is even a computer game version of Gibson's *Neuromancer*.

The *Neuromancer* game was ardently backed by cyber-enthusiast Timothy Leary: '[T]he great thing is that you are a hacker playing it. That's the key to the whole game,' he comments. It is an attractively packaged product, with a beautifully synthesized photo on the front, a soundtrack by cyberpunk band Devo, and a great deal of Gibson's original prose. The game operates in both first- and third-person modes: the player guides the Case character through Chiba City, but takes on first-person perspective in cyberspace. Again, Adventure serves as the template for the interactive narrative adventure, while *Spacewar*-honed reflexes are demanded in the cyberspace sequences. The problem is that the gaming environment is, in many ways, *more* linear – or at least more narrative – than Gibson's own reckless creation: the ambivalence of the original work is lost in the psyche-delic display on-screen. This is part of a more general problem with computer gaming, in which the player's interactive control is often more potential than actuality.

Falcon and *Shuttle* offer real-time, sophisticated simulations of jet and space shuttle control. *Dungeon Master* permits the player a first-person point of view of the labyrinthine corridors of a multilevelled dungeon replete with secret doors, animated fiends, and, possibly, a final triumph. *Neuromancer* and *Police Quest* shift from first- to third-person perspectives, but substitute more complex narratives. The range of simulations available to the player is thus not quite as simple as the word might first suggest. Some games allow the player to shift the rate of temporal passage, so a night can pass in moments. As bleary gamers can attest, the spatiotemporal malleability of the computer world can seem to cross over to the physical world, replacing the fixed rhythms of real life.

Games present a range of options for players and hence offer a range of subject positions. With every advance, the imbrication becomes more total; the symbiosis more emphatic. Through the translation of percept into movement, the players' thoughts are given their place in the world. Through play a kinetic interaction is established between subject and object: the perceiving body becomes a phenomenal body.

The exploratory environment and the intuitive interface are at the heart of the Macintosh computer, perhaps the most important design in minicomputers since their inception. The goal at Apple was to empower the individual against the forces of corporate power and central control. Their '1984' commercial, directed by Ridley Scott, featured a spectacular projection of the Orwellian vision, but now the proles were controlled by the 'Big Blue', IBM (unnamed): 'The idea was to portray a totalitarian state that didn't work, like East Germany in 1953, and to give it the air of the dank and leaky spacecraft in *Alien*. The sets were modelled after those used to create Everytown, the *art-moderne* 'city of the future' in the 1936 science fiction classic, *Things to Come*'.[22] In the commercial the proles gather in an enormous meeting hall, as a young blonde female athlete with a sledge-hammer runs in and smashes Big Brother's screen. Apple was unveiling its Macintosh, the announcer said. Personal computing, with a friendly interface, was 'why 1984 won't be like *1984*'.

'Instead of merely receiving our mental model of reality, we are now compelled to invent it and continually reinvent it. This places an enormous burden on us. But it

also leads toward greater individuality, a de-massification of personality as well as culture.'[23] That this 'de-massification' might itself be an ideological operation, an act of covert mythologizing, never occurs to Alvin Toffler. Toffler's formative vision emblematic of the quasi-mystical attitudes of the Macintosh division, might be labelled *hippie-hacker*.[24] Telematic power would be anticorporate, decentralized, *personal*: such was the mythos.[25]

Thus, in the 1980s two techno-myths arose: *cyberpunk* and *hippie-hacker*. Both were opposed to technocratic mythologies of centralized control – Down With Radiant City and other Corbusierian fantasies. While hippie/hacker substitutes an ethos of personal control and individual empowerment through the simple mastery of the benign interface, cyberpunk enacts the end of controls – depicting a world where technology circulates more or less freely and, where, as is the case in *Neuromancer*, technology has its own agenda. Baudrillard is quintessential cyberpunk, while VR prophets Brenda Laurel, Jaron Lanier and Howard Rheingold preserve the hippie-hacker ambition. Both acknowledge our inevitable imbrication with the new state of things in *blip culture*.

As each article on the burgeoning VR phenomenon is published, the scientists and researchers who comprise the virtual reality community frequently 'gather' electronically on the WELL (the Whole Earth 'Lectronic Link – an electronic message exchange system) to discuss the implications of the latest coverage. Articles stressing the long-term implications and overall seriousness of the project are praised, while rampant speculations about virtual war games and virtual orgies are viewed with suspicion. What frequently, although not always, eludes the professionals is precisely the ludic attraction of cyberspace and the 'seriousness' of such play and playful speculation. On at least one level, virtual reality is a ludic engagement with the space of the computer that refigures it as a perceivable and physical environment. Many of the designers of NASA's virtual reality system had, as a matter of fact, once worked as game designers for Atari.[26]

Virtual reality represents an immersion in a computer-constructed space that obviously holds a strong appeal (although one anticipates a strong Luddite backlash from critics who reify the 'natural' qualities of contemporary reality and worry about becoming 'lost in cyberspace'), and it might be possible to regard the desire to play in the virtual playground as a simple desire for escape, for an alternative environment without the daily pressures of life in 'the real world'. Yet just as the desire for cinematic pleasure bears deeper psychosexual and political implications, so the fascination with virtual reality reveals something more complex. As with the early cinema, the major fascination now lies with the technology itself, rather than with the specific fantasies/realities generated therein. I would therefore contend that virtual reality speaks to the desire to *see* the space of the computer, and to further figure it as a space one can *move through* and thereby comprehend.

This desire forms the basis for much of the science fiction of the 1980s. Computer games are at the centre of numerous science fiction narratives. In *Ender's Game*, by Orson Scott Card, and in the film *The Last Starfighter*, the technological expertise of gaming is mapped onto real-universe conflicts, and only the power of the hacker can save the cosmos. Vernor Vinge's novella *True Names*, a significant precursor to *Neuromancer*, features a game designer who joins other hackers in a cybernetic otherworld: 'The basic game was a distant relative of the ancient *Adventure* that had been played on computer systems for more than forty years' (more on this tale below). The teenage hacker of *Wargames* (1983) enters a Pentagon computer system. 'Do you want to play a game?'

it asks. Repeatedly, the computer game player-designer is sentimentally posited as *other* to this world, but integral to the integrated circuits of the next.

Jacking in

True Names

Vernor Vinge's novella, *True Names*, originally published in 1981 is an adept exploration of cybernetic spatiality and interface.[27] Its extrapolation of a physical space derived from the abstractions of computer operations and gaming protocols is at once strikingly original and comfortably familiar. Here, the global data net becomes a literal extension of one of the characters. In the future, computer users gather in illegal cybernetic enclaves disguised in their self-defined alter egos. Some of these groups engage in harmless hacker vandalism, like the phone phreaks of the 1960s who wired themselves into AT&T's electronic system.

The existence of this other realm is more than a diegetic convenience. Vinge recognizes the relation between games and narrative, and their dual metaphorical relation to the interface between subject and terminal: 'Mr. Slippery had often speculated just how the simple notion of using high-resolution EEGs as input/output devices had caused the development of the 'magical world' representation of data space. The Limey and Erythrina argued that sprites, reincarnation, spells and twentieth-century notions of data structures, programs, files and communication protocols' (81). As in *Neuromancer*, the digital information of the Other Realm is recast in the form of a simulated universe now 'perceivably analogically' (94). Vinge's characters even speculate, with true hacker allegiance, that their computational power outstrips that of the government precisely because of their reliance upon the metaphorical interface of fantasy narrative.

In attempting to stop a renegade hacker whose access to military and economic data threatens global stability, Mr. Slippery (aka Roger Pollack) and Erythrina (real identity unknown) are given unprecedented access to the world's data through their synaesthetic interfaces:

> but they were experiencing what no human had ever known before, a sensory bandwidth thousands of times normal. For seconds that seemed without end, their minds were filled with a jumble verging on pain, data that was not information and information that was not knowledge. To hear ten million simultaneous phone conversations, to see the continent's entire video output, should have been a white noise. Instead it was a tidal wave of detail rammed through the tiny aperture of their minds. . . . He controlled more than raw data now; if he could master them, the continent's computers could process this avalanche, much the way parts of the human brain preprocess their input. More seconds passed, but now with a sense of time, as he struggled to distribute his very consciousness through the System.
>
> (Vinge 1987: 95–6)

Vinge is familiar with computer operations in a way that Gibson isn't, and so his language is less hyperbolic and more logical. The white noise of the Information Age is granted a sensory reality as the human is interfaced to the electronic. Like Baudrillard, Vinge's

cyberhackers are overwhelmed by the Dataist Era and recognize the paradox of the present – 'information is not knowledge'. Unlike Baudrillard, Vinge's fiction postulates a new telematic existence which recentres the human, who is now able to process data through an expanded sensory field. Computers become adjuncts of the human brain once more, as a centralized consciousness organizes the processing of this avalanche of data. 'More than three hundred million lives swept before what his senses had become,' Mr. Slippery reflects (96). Pain becomes ecstasy as the human is empowered by this translation onto the fields of information.

In this fiction it is a specific type of individual that is empowered. *True Names* is an interesting distillation of hacker culture, interactive fiction, role-playing games such as *Dungeons & Dragons* (and the fervent cult of players which surrounds such games), the 'other realm' of science fiction conventions, populated by the subculture of science fiction fandom, and the countercultural techno-shenanigans of the early phone phreaks. The peripheral figures associated with these activities, perennial outsiders, are granted centrality and invisible power in *True Names*.

Cyberspace cowboys – kinetic urban subjects

Neuromancer continues the translation of percept into kinesis and control initiated by *True Names* and *Blade Runner*'s photoscan sequence. In *Blade Runner*, Deckard's control of the computerized image and the verbal/optical interface which permits this detective to operate in terminal mode are extended by the EEG/computer linkup called 'jacking in'. Case is further empowered by his entry into a digitized environment that is perceivable analogically; its smooth geometries are analogues for the realm's fully digital existence. *Neuromancer* is the most phenomenologically significant science fiction text since Kubrick's *2001*: Case's projection into the 'infinite datascape' gives him the direct control of the data in that virtual world. It is not surprising, then, that his entry into cyberspace is strikingly kinetic (in fact, turbulent and discontinuous):

> And in the bloodlit dark behind his eyes, silver phosphenes pouring in from the edge of space, hypnagogic images jerking past like film compiled from random frames. Symbols, figures, faces, a blurred, fragmented mandala of visual information.
> Please, he prayed, *now* –
> A gray disk, the color of Chiba sky.
> *Now* –
> Disk beginning to rotate, faster, becoming a sphere of paler gray.
> Expanding – And flowed, flowered for him, fluid neon origami trick.
> (52)[28]

What this sequence narrates is actually the passage from discontinuous experience to the glissades of datascape mastery. At first cyberspace is characterized by the chaos of boiling light and indiscriminate montage (an image cut-out of Burroughs' novels and screenplays). Transcendence follows; a zen-like, natural communion designated by references to origami and flower blossoms. But, fluent or turbulent, kinesis distinguishes the interface.

Merleau-Ponty has, of course, written on the significance of subject mobility:

The translation of percept into movement is effected via the express meanings of language, whereas the normal subject penetrates into the object by perception, assimilating its structure into his substance, and through this body the object directly regulates his movements. This subject–object dialogue, this drawing together, by the subject, of the meaning diffused through the object, and, by the object, of the subject's intentions – a process which is physiognomic perception – arranges round the subject a world which speaks to him of himself, and gives his own thoughts their place in the world.[29]

The relevance of this passage to *Neuromancer* is clear and extensive. It is the state of 'the normal subject' (as distinct from those sufferers of apraxia or agnosia to whom Merleau-Ponty refers at the outset) to penetrate the object via an act of perception that reciprocally endows the subject with bodily presence. Intentions and meaning are translated into activity in a world defined by that very subject–object interface. In *Neuromancer*, cyberspace exists as an analogic environment that permits the subject to 'assimilate its structure into his substance'. In so doing the subject experiences 'a world which speaks to him of himself'. Further, 'his own thoughts' are granted 'their place in the world'. (What isn't provided in Merleau-Ponty's model is the possibility of a world, such as cyberspace, that exists solely to permit this subject–object imbrication.)

The negotiation of cyberspace always emphasizes motion. Gibson: 'Headlong motion through walls of emerald green, milky jade, the sensation of speed beyond anything he'd known before cyberspace'. Merleau-Ponty: 'for us to be able to conceive space, it is in the first place necessary that we should have been thrust into it by our body, and that it should have provided us with the first model of those transpositions, equivalents and identifications which make space into an objective system and allow our experience to be one of objects, opening out on and 'in itself'.[30] The spatiality of *Neuromancer* exists to permit bodily mobility and, hence, subject definition. The human becomes the dramatic centre, the active agent in a spatiotemporal reality from which he – and it is always a 'he' – has been rigorously excluded. From a description of the subject's passage through the world, a passage marked by continuous processes of orientation and adaptation, the phenomenology of perception is transformed into a transcendent valuation of human experience and its 'logical' consequent, human control. This is a danger of which Merleau-Ponty seems cognizant when he writes: 'Mobility, then, is not, as it were, a handmaid of consciousness, transporting the body to that point in space of which we have formed a representation beforehand. In order that we may be able to move our body towards an object, the object must first exist for it, our body must not belong to the realm of the 'in-itself'.[31] The physical engagement of the body, then, yields a *simultaneous* construction of subject and world. Neither pre-exists the other – neither subject nor body are 'givens'.

Unlike *2001*, which emphasizes the alienation that accompanies the action of subject reorientation and redefinition, *Neuromancer* stresses only the alienation that follows the *removal* from this other space – 'For Case, who'd lived for the bodiless exultation of cyberspace, it was the Fall' – normal space is now the site of alienation. The reader should not be misled by the reference to 'bodiless exultation', by the way, for the subject in cyberspace is granted perception and mobility, conditions predicated upon a lived-body; a new body, perhaps, but a body none the less. Yet the reader of *Neuromancer* is kept in the dark regarding the form of that body – the subject in cyberspace never

examines *himself*. In Mike Saenz's CAD (Computer Aided Design) production, *Iron Man: Crash*, the computer drawings transform the real world into cyberspace – technologized, de-individuated, vectored space. Within such a realm Iron Man is an appropriate citizen: already half-human, half-machine, as much vehicle as driver. Bruce Jensen's art for the *Neuromancer* adaptation depicts Case sitting at his desk as though poised behind the wheel of a Ferrari – static, yet suggestive of a powerful kinesis.

CYBERSPACE AND THE OMNIPOTENCE OF THOUGHTS

Thus, the duality between mind and body is superseded in a new formation that presents the mind as itself *embodied*. The body, here, exists *only* in phenomenological terms: it perceives and it moves (a reductive and utopian version of Merleau-Ponty's model of subject-construction, which eliminates the mortal limitations of a physical body). Through the construction of the computer itself, there arises the possibility of a mind independent of the biology of bodies, a mind released from the mortal limitations of the flesh. Unlike the robot forms of the modernist era, wherein a mechanical body substituted for the organic, the invisible processes of cybernetic information circulation and electronic technology construct a body at once material and immaterial – a fundamental oxymoron, perhaps, of postmodernity.

The redefinition of the subject under the conditions of electronic culture is a response to the fear that the human has become obsolete, last year's model. Faced with the possibility of its own extinction, or at least its new irrelevance, the human subject has produced a range of representations of itself as melded with the matrices of terminal existence. The human proudly takes up a position within the machine, but almost always from a position of mastery, so that by entering the machine, the machine becomes a part of the human. The subject is, and is not, afraid to leave its body behind. The computer can become a new body, with its electronic sensorium extending far beyond human capacities. And yet, some residual form of the body is retained in almost every instance.

If there is an ambivalence regarding the status of the body, however, no such hesitation marks the attitude toward the mind. Cyberspace is a celebration of spirit, as the disembodied consciousness leaps and dances with unparalleled freedom. It is a realm in which the mind is freed from bodily limitations, a place for the return of *the omnipotence of thoughts*.

A TACTICS OF KINESIS

These narratives and graphic representations function as *tactics of accommodation* to a new mode of existence. As Michel de Certeau notes in the pages of *The Practice of Everyday Life* (1984), in another passage with fascinating implications regarding *Neuromancer*, it is a question of 'the status of the individual *in technical systems*', because 'the involvement of the subject diminishes in proportion to the technocratic expansion of these systems'.[32] The involvement of the subject in modern life is crucial to Certeau's analysis, and rather than lament (or celebrate) the disappearance of the subject, as Baudrillard is wont to do, Certeau conducts a series of microanalyses to demonstrate the tactics by which subjects interpose themselves into the technocratic systems of power which hold sway in the present.

Tactics, in Certeau's system, are opposed to *strategies*, which Certeau defines as follows: 'I call a *strategy* the calculation (or manipulation) of power relationships that becomes possible as soon as a subject with will and power (a business, an army, a city, a scientific institution) can be isolated. It postulates a *place* that can be delimited as its *own* and serve as the base from which relations with an *exteriority* composed of targets or threats . . . can be managed' (1984: 35–6). Strategies are thus associated with space, and specifically with those spaces which are owned and operated by powerful dominant forces. Strategies operate in space, consolidating power over others who impinge on that space. The glittering geometric shapes of cyberspace, for example, represent the control of space by corporations and military systems; these are protected by ICE – Intrusion Countermeasure Electronics – thus preventing unwanted incursions (the acronym is fictional, the concept is surely not). The information is inside/behind the structures of ICE, while the exteriority of these defence systems operate against any perceived 'targets or threats'.

Against such strategies must be seen the *tactics* of the cyberspace cowboys: 'I call a "tactic", on the other hand, a calculus which cannot count on a "proper" (a spatial or institutional localization), nor thus on a borderline distinguishing the other as a visible totality. The place of a tactic belongs to the other. A tactic insinuates itself into the other's place, fragmentarily, without taking it over in its entirety, without being able to keep it at a distance' (xix). For Certeau, '*tactics*' refer to the set of practices performed by subjects upon and within these controlled fields. A tactic is equivalent to a speech act, which 'is at the same time a use *of* language and an operation performed *on* it' (33). It is temporal, a trajectory across the spaces of strategic control which uses that space as its foundation. The phone phreaks, accessing free telephone service from AT&T, were engaged in a tactical, piecemeal, appropriation of the monopoly's resources. The result is not the overthrow of a system recognized as massive and monolithic, but instead a nibbling at the edges of power and thus an elision of control.

Foucault's theories of disciplinary technologies figure prominently in Certeau's model, but Certeau rejects the monolithic structures of power that serve as Foucault's foundation. Arguing that Foucault has abstracted the strategic manipulations of power from the broader matrix of power relations and resistances, Certeau restores a more heterogeneous practice than is inscribed in Foucault, while still preserving the most valuable parts of Foucault's model. Certeau lists the synonyms Foucault employed in evoking the manoeuvres of the strategists of power: ' "apparatuses" ("*dispositifs*"), "instrumentalities," "techniques," "mechanisms," "machineries," etc.' (45). With reference to Certeau, cyberpunk fiction can be understood as a narrative of tactics: corporations and the military control cyber*space*, so that the cowboys become infiltrators, deceivers and tricksters. Cyberpunk narratives construct trickster tactics within the 'machineries' of cybernetic culture.

Certeau is eloquent on the new spaces of cultural practice. 'There is no longer an elsewhere,' he writes. 'Consumers are transformed into immigrants. The system in which they move about is too vast to be able to fix them in one place, but too constraining for them ever to be able to escape from it' (40). Unlike Baudrillard, for whom this totality of cybernetic control is fundamentally irresistible, Certeau finds the limits of control in its very totalization: 'the strategic model is also transformed, as if defeated by its own success'. The notion of a protected, strategic, space is predicated upon a separation between this space and others. When the 'proper', or proprietary, space becomes the 'whole' space, then:

little by little [the strategic model] will exhaust its capacity to transform itself and constitute only the space . . . in which a cybernetic society will arise, the scene of the Brownian movements of invisible and innumerable tactics. One would thus have a proliferation of aleatory and indeterminable manipulations within an immense framework of socioeconomic constraints and securities: myriads of almost invisible movements, playing on the more and more refined texture of a place that is even, continuous, and constitutes a proper place for all people.

(de Certeau 1984)

This last might even be more than illusion – Certeau argues that narrativity has an important function: 'A theory of narration is indissociable from a theory of practices, as its condition as well as its production.' Far from existing apart from the tactical struggle, narrative is fully embroiled in the articulation of resistance. The novel is, for him (as well as for Bakhtin), a set of heterogeneous discourses marked by contradiction and simple coincidence. Narratives produce heterogeneity and resistance. 'The story does not express a practice. It does not limit itself to telling about a movement. It *makes* it' (81). Narrative produces (a) movement – the kinesis of tactical resistance. More than mere articulators of meaning, narratives 'say exactly what they do'. This is consistent with Certeau's larger argument that microresistance occurs everywhere, even within the supposedly monolithic structures of language.

For Certeau the function of narrative is to demarcate boundaries; precisely to locate a space which may not be geographic. 'What the map cuts up, the story cuts across' (129). Frontiers and bridges also function as part of the narrative, serving as the sites of exteriority and the space 'in-between': in other words, they represent the other spaces against which the space of the story emerges. The passage into the frontier lands, or other spaces, and the subsequent return to one's 'proper' space, comprise an archetypal narrative structure for Certeau which frequently reveals the ambiguity of the 'proper' space itself: 'Within the frontiers, the alien is already there' (128). Case's forays into cyberspace in *Neuromancer*, and Flynn's translation into data in *TRON* (see below), represent similar forays across the 'bridge' and into the cybernetic 'frontier'. Cyberspace provides the key to understanding and controlling the alien spaces of home.

Unquestionably, Certeau's analysis of tactics, superstitions, and narratives has extraordinary relevance for an understanding, not just of *Neuromancer*, but also of the later variations Gibson has worked upon the theme. The relationships between narrative and tactical resistance and narrative and spatial appropriation tell us much about the tactics of William Gibson, whose prose is rife with appropriations from literature, rock 'n' roll, and surrealist art. It is no coincidence that *Count Zero* refers to that other master of appropriation and microspaces, Joseph Cornell.

TRON – cinema in cyberspace

The various forms of cyberspace permit the reintroduction of the 'kinetic energy' which had disappeared into electronic space. Cronenberg, in the film *Scanners*, tracks his camera across a circuitboard before his telepathic protagonist instigates a spectacular meltdown

– the computer becomes a physical body for Cronenberg, and thus a space of muta-
tion. In *Brainstorm*, tense terminal intercutting gives way to an after-death cybernetic
experience.

TRON's narrative, like *Neuromancer*'s, involves a further penetration of the terminal
frontier as Flynn, the hacker protagonist, finds himself translated into the virtual space
that exists within the master computer. The film begins, as do *The Andromeda Strain*
(1970), *Brainstorm*, *Explorers* and others, with floating electronic graphics and numbers.
The camera probes the amorphous graphics and tracks across computer-generated
circuitry, a perspective from above which dissolves to a vision of a real cityscape: urban
and cybernetic spaces are again overlapped and interchanged. *TRON* is a saga of man
versus machine and individual versus corporation. The urban landscape therefore repre-
sents an a priori arena of capitalist domination and control, while the infraterminal spaces
demonstrate the shift of corporate power to electronic fields. The employees of ENCOM
work in small cubicles and the matte-painted background shows these cubicles extending
back to an apparent infinity. Later, in cyberspace, the cells that Master Control uses to
hold uncooperative, anthropomorphized computer programs are displayed in a similar
shot: the panoptic powers of the corporation exist at all levels.

Syd Mead, designer of the vehicles and street scenes in *Blade Runner*, performed
similar tasks for *TRON*. Whereas the *Blade Runner* hovercars were constructed of a maze
of jutting wheels, realistic dials and endless details, both ornamental and functional, the
vehicles of *TRON* are smooth and modular, almost featureless and boldly monochro-
matic. 'Our visual vocabulary is made up of familiar objects, each of which has a
recognizable form,' Mead has written. 'The tank featured in *TRON* started as a quick
review of the images which instantly say "tank".'[33] It is certainly interesting that the
object-based MAGI Synthavision database used to animate these forms permitted
constructions built up from a collection of previously defined 'primitive' geometric
shapes – precisely the method Mead used in designing his vehicles.[34]

The disengagement from the physical body of the referent also extends to a
new mobility. The computer-controlled camera brought an unimagined exactitude of
cinematic movement and enabled the swooping manoeuvres along the canyons of the
Death Star in Lucas' *Star Wars*, but the precision of the computer-generated image
inscribes a precision of perspective which eludes the ordinary eye. In addition, the simu-
lated objects of this unreal world are presented through a camera movement that is
itself a simulation.

To understand the significance of *TRON*, two cornerstones of film theory should be
introduced, albeit in extremely abbreviated fashion. First, the motion picture camera
has frequently, almost invariably, been linked to subjective vision. As one film textbook
states, 'it is usually impossible not to see camera movement as a substitute for *our* move-
ment'.[35] Writers on the cinema, in its early history as well as its contemporary
manifestations, have often written of a camera/eye equivalence. For some theorists the
camera's function is precisely to reproduce the spatiotemporal unities of human percep-
tion (see works by Siegfried Kracauer and André Bazin, for example). In other writings
the camera constructs an entirely new kind of vision, *extending* the power of the human
eye (Dziga Vertov and Stan Brakhage are exemplary of this mode) and thus the expe-
rience of consciousness itself. In cinematic practice, as Christian Metz has punned, there
are some 'objective (*objectif*) preconditions:' lens choices tend toward the 50mm
'normal' lens, for example, so called because it most effectively simulates the spatial

relations produced by the lens of the human eye. Theorists and film-makers from Hugo Münsterberg to Maya Deren and beyond have demonstrated how cinematic structures allude to states of consciousness – the close-up, for example, is analogous to the phenomenon of attention, while the flashback replicates the functions of memory in a particularly sensible form.[36]

Almost equally pervasive, although less remarked, has been the linking of cinematic vision to the technologies of modernity. Reflexive gestures toward the power of the medium itself fall into this category, including the knockabout comedy of early films like *Uncle Josh at the Picture Show* (1902), the sublimity of Keaton's *Sherlock Jr.*, and René Clair's *Paris Qui Dort* (both 1924) and the thoroughgoing analysis of the medium performed in Vertov's *Man With a Movie Camera* (1929), not to mention the entire history of the New American and Godardian cinemas. The technology of the cinema is often combined with *other* technologies. When the operators of Hale's Tours mounted the camera on the front of a locomotive, audiences experienced a powerful synthetic kinesis which was a function of the camera as well as the engine's new mobility through a redefined landscape. The films of Hale's Tours might present nearly pristine landscapes, but tours of new metropolises were equally popular – the exoticism of new locales coupled with the exoticism of new technologized spaces.

In Clair's avant-garde crane shot in *Paris Qui Dort*, the camera, now mounted on one of the elevators in the Eiffel Tower, shows us the intricacy of that monument to modernity as nothing else could. Annette Michelson has produced a number of texts around the relationship between film and the industrial technologies of the modern period. She writes, 'Clair not only exploits the tower's mobile potential but also brings into play its subjective functions, its framing, focusing, view-finding capacities. The tower had been décor and actor. By transforming it into a complex optical instrument, a filmic apparatus, Clair makes it a camera.' She also notes that the use of the tower as a cinematic vantage dates back to the Lumiéres.[37] Michelson has also written about Eisenstein's appropriation of a factory conveyor in *Strike* (1925) and his creation of a space at once phenomenal and polemical: 'a sumptuous movement of the camera through that factory's space, inspired, no doubt, in a way characteristic of him, by the concrete structure of the space and its industrial cranes'.[38] Here she refers to Eisenstein's 'propulsion into cinema', but one might extend this to include the spectator's analogous propulsion into cinema and simultaneous propulsion into the newly technologized world of which cinema is only one emblem.

This brief review should at least indicate that cinema often provides coincident analogues of subjective *interiority* and technological *exteriority*. Almost from its inception, cinema is a cyborg apparatus. So that when Christian Metz declares that the fundamental identification which the spectator has is 'with the camera', the historical significance of this ought to be understood. The 'double movement' of projection and introjection, presented by Metz in primarily phenomenological terms,[39] can also be seen in terms of the *projection* of a purposive human consciousness, but the *introjection* is of a particularly technologized space, a space which the camera mediates and assimilates to the terms of vision. The crisis of the subject in postmodern electronic space, then, is a crisis represented in terms of an ambiguous subjective vision.

The introduction of computer-generated graphics into the cinematic presentation of films like *TRON* or *The Last Starfighter* therefore poses no particular analytical difficulties. Cinema has traditionally been interlaced with new technologies of vision and mobility,

and thus with extensions of consciousness and subjective empowerment. The cinema *already* constructs a space of accommodation to unfamiliar technologies. As Walter Benjamin observed, cinema's development corresponds to profound changes in the apperceptive apparatus. *TRON* utilizes computer-generation techniques to signify the activity inside the computer, and so there is something both mimetic and symbolic in these representations. Light is made tangible, and as it is used both to define space and indicate levels of power, light comes to signify existence itself.

TRON's game grid is black until activated, whereupon thin rays of light circumscribe the playing field and boundaries. As in *Neuromancer*, this is an infinite, *potential* space that does not exist until it is occupied and thereby delimited. *TRON* makes extensive use of vector graphics to generate backgrounds and cyberspaces. These spaces extend in three-dimensions and are defined around the inevitable structure of the grid, with vectors meeting at a virtual horizon in the depthless distance. *Neuromancer*'s original book cover featured a similar design, and in fact such grids have become a ubiquitous part of cyberspatial representations, recalling the grids that marked so many modernist movements: 'The grid functions to declare the modernity of modern art,' Rosalind Krauss writes, and it states 'the autonomy of the realm of art' from the realms of nature and mimesis. The space demarcated by the grid constitutes its own sufficient reality. Krauss argues that the grid further announces the temporality of modernism because it is 'the form that is ubiquitous in the art of *our* century' alone. The grid therefore serves as a doubled sign of modernity – as it represented the present, 'everything else was declared to be the past'.[40] The 'new monuments' of cyberspace, constructed of chrome and light, still adhere to the principles of modernity in their abjection of nature, their rational autonomy, and their insistence upon a present that has transcended its own history.

TRON begins with a complex trajectory among phenomenal spatialities before settling into a sustained presentation of life in cyberspace. Computer forms coalesce into a humanoid figure; there is an electronic flash, and the film's title is revealed. The camera probes the title, revealing the floating geometries of cyberspace. Subjective camera movement again heralds the problem of a new subjectivity. Cyberspace gives way to the more familiar urban grid as the viewer is reintroduced to the real world, in the form of a teenager playing a video-game. The action shuttles between human and cyberspace perspectives, as videogame blips are transformed into 'living', 'breathing' entities with their own personalities.

'Meanwhile,' as a title reads, 'in the real world . . .' the head-hacker at this video-game emporium, Flynn, is introduced, seated at his terminal in an attempt to break into his old employer's computer to prove that his game programs were stolen by the new company president. Flynn is already imbricated in the cybernetic realm; he is already a part of the machine, like Case, who is incomplete when not jacked in. He also resembles Edison Carter from *20 Minutes into the Future*, introduced wielding his video-camera while existing as little more than a video image himself. These characters are co-extensive with a new electronic technology that utterly defines them, even before their literal entries into the space of the machine. The pervasive overlap of urban- and cyberspace is now met by the first movements in the trajectory toward a new humanity; cyborg spaces must be inhabited by cyborg beings.

The shots of Flynn's physical presence before the alphanumeric terminal display, engaged in a rhetorical dialogue with his icebreaking program, are succeeded by an aerial

tracking in across cyberspace. The camera moves down into the matrix to reveal the smooth form of a cyber-tank. Now the computerized Flynn (Flynn's 'program') sits at the controls. Before it, on yet another screen, a wireframe display of a computer land-scape stretches onward, while the control station rotates within its nested setting of counter-rotating wheels. A shot over the program's shoulder to the vector display puts the program 'in' cyberspace. The static scene of invisible information processing (in both human brain and computer bank) has been transformed into the hyperkinetic vocab-ulary of the war film. The space is thus grounded for the viewer in three ways: by the narrative, through the genre of the war movie, and by the evocation of a video game. Flynn types frantically in the 'real world', until the terminal reads that his illegal code 'has been deleted from the system' (an interlude in cyberspace demonstrates just how painful such deletions can be).

As the sequence continues, the film intercuts with increasing speed among the three spaces: Flynn in the so-called real world, Flynn's computer-analogue at the high-tech controls of its cybernetic tank, and the smooth, computer-generated chase between the tank and pursuing security vehicles. Three levels of action are thus introduced, each with its own distinct phenomenal quality. The first and third levels, representing phys-ical and cybernetic spaces, are already familiar from the analysis of *Neuromancer*, but the middle level, featuring the Flynn-program, offers something else, namely, the Disney stock-in-trade, anthropomorphism. In the Disney universe, actuarial programs are as boring as the insurance salesmen who use them, and all programs engage in debates regarding the existence of the 'users' – those mythic beings in another realm. 'If there aren't any users, then who wrote me?' asks one theologically inclined computer program. The problem of configuring the space of electronic culture for human appropriation and assimilation is largely sidestepped by a narrative which avoids any hint of 'otherness'. Gravity holds within this electronic system; and if jubilation exists, then it is far from the 'bodiless exultation' in which Case rejoices. Computer programs are human – in fact, computer programs seem to be white, heterosexual and chaste.[41] Other functions are, like R2D2 and C3PO of *Star Wars*, more like pets, such as the animated 'Bit' (or, in Epcot Center, 'I/O'). Electronic space is a fully bodied space – a space of denial, appropriation of the crudest sort.

Metz argued that cinematic identification is primarily with the filmic apparatus itself – specifically with the camera. This identification is frequently disguised by the operations of narrative and the spectator's concomitant secondary involvement with his or her screen surrogate, but in many films the power and presence of the camera is nevertheless displayed, however fleetingly. *TRON*'s cyberkinesis, radically distinct from bodily movement, hyperbolizes the identification with the camera – although, in this case, the 'camera' is a fiction – it's a virtual camera, moving about in a virtual world. In *TRON* and other computer-generated works, the space *is* the fiction. Still, the 'camera' gives the viewer *a place* in this virtual world, a place defined almost solely in terms of spatial penetration and kinetic achievement. If Merleau-Ponty is right, and the ability to conceive space depends upon our being 'thrust into it by our body', then *TRON*'s cinematic kinesis constructs an effective space of accommodation. More directly than even *Neuromancer*'s breathless prose, *TRON* 'thrusts' its viewers into a once-inconceiv-able space. As explicitly as in the early history of film, the viewer identifies with a hyperomniscient camera, now associated with the virtual realities of postmodern tech-nology. On the other hand, *TRON* certainly never attains the thorough destabilization

of space and spectator that one associates with *2001* or the raising of the bridges in Eisenstein's *October*.

Vivian Sobchack argues that the 'deflation of deep space' in films like *TRON* is 'presented not as a loss of dimension, but rather as an excess of surface. The hyper-space of these films is proudly two-dimensional'.[42] This excess of surface is a sign of what Jameson regards as the waning of the subject, of interiority, in its traditional form, and it finds a figuration within this 'alternative and absolute world' or 'discrete pixels and bits of information that are transmitted *serially*, each bit discontinuous, dis-contiguous, and absolute'.[43] What is constructed is a new space which does not so much annihilate, as require the *refiguring* of, the subject.

In strikingly analogous terms, Rosalind Krauss has analysed the 'radical develop-ments' of minimalist sculpture. On one level, minimalism continued what Rodin and Brancusi initiated by relocating the 'point of origin of the body's meaning' from 'its inner core to its surface'. '[T]he sculpture of our own time continues this project of decentering. . . . The abstractness of minimalism makes it less easy to recognize the human body in these works and therefore less easy to project ourselves into the space of that sculpture with all of our settled prejudices left intact. Yet our bodies and our experience of our bodies continue to be the subject of this sculpture – even when a work is made of several hundred tons of earth.'[44] While it might seem a bit silly to apply such terms to a Disney film, some comparisons do suggest themselves. Cyberspace is precisely non-corporeal, and so it is precisely non-subjective. If it is an interiorized space, then this is not the interiority of psychologized subjectivity, but rather of a fully technologized (cultural) space which overlaps and restates the vocabularies of a post-modern urbanism. In the terms that Krauss offers, the radical aspect of *TRON* might be located in its 'relocation of the point of origin of the body's meaning' from a *psycho-logical* essentialism to the parameters of a *techno-cultural* configuration. Even when the work is 'made of' millions of bytes of information within the banks of a computer's memory, 'our bodies and our experience of our bodies continue to be the subject' of that work.

The subject must be reinterpreted, must reinterpret *itself*, to project itself into that space – the literally unsettling spatiality creates the conditions for that reinterpretation. The cyberspatial explorations of *TRON* and the cyberpunks are attempts to encode 'our bodies and our experience of our bodies', even if the abstractness of their spaces make it 'less easy to recognize the human body . . . and therefore less easy to project ourselves into the space'. Krauss' understanding of sculpture, an art form of bodily engagement with a spatiotemporal object, reveals an underlying narrative impulse that now becomes explicit in the cyberfictions of *Neuromancer* and *TRON* (where the surrogate experience of narrative *replaces* bodily engagement).

Finally, then, *TRON* exists as cyborg cinema; part 'organic', part 'cybernetic'; partly destabilizing, partly reassuring. The computerized effects fill the cinema screen, mingling digital and analogic technologies of reproduction. The ambiguous status of this *TRON*-object extends to the representation of terminal space: the subjectivity established there is *analogous* to Flynn's, in that the viewer is also propelled into cyberspace, but it is hardly *identical* to Flynn's – the viewer's experience is bounded by the purely visual engagement with a two-dimensional screen. The *narrative* thus encourages an identifica-tion with Flynn to enhance the phenomenological impact of the *film's* electronic spatiality. The narrative serves as an almost literal analogy for the viewer's perception of the

terminal space. Perhaps this very redundancy obviates the imperatives of narrative, leaving it as a formal structure without conviction. In its narrative, its special effects and its camera aesthetic, *TRON* operates as a provisional form, an interface between different cinematic functions and varying subjectivities. In its kinesis it provides an elegant example of Merleau-Ponty's 'physiognomic perception', that subject–object interface; while its narrative, with its anthropomorphic assimilations, serves the ostensibly similar – if redundant – function of speaking 'to him of himself', giving 'his own thoughts their place in the [new] world'.

But, finally, the narrative of *TRON* promises no *need* for accommodation to a new reality. Rather, the diegesis posits cyberspace as co-extensive, and indeed *synonymous*, with physical reality – simulation replaces reality, yes, but the banality of both realms makes the experience moot.

There's always . . . tomorrowland

TRON is not the Disney empire's sole engagement with the technological spaces of the electronic age, as the cyberspaces of Disneyland and Walt Disney World demonstrate. Referring to the 1939 World's Fair, H. Bruce Franklin has correctly noted that, 'A fair billing itself as the World of Tomorrow may be considered just as much a work of science fiction as a short story or a novel, a comic book or a movie.'[45] This must also be true of such exhibitions as Future World or Tomorrowland. These Disneyworlds bear an interesting relation to works of contemporary science fiction literature and cinema in which the ontologies of space and narrative intertwine.

The theme parks operate as deeply ambivalent experiences; but Tomorrowland and Future World speak eloquently to the anxieties of the present era. The pervasive fear which underlies the decade just past is a consequence of recognizing that *we are in the future*. The future is no longer a harmless fiction, a sacred age which, by its very definition, will never arrive; it is upon us with a vengeance. The disembodying spaces of the terminal era exist independently of human experience or control, and thus our presence in the future has initiated a seemingly inexhaustible period of mega-nostalgia, an obsessive recycling of yesteryear. Even futures past are exhumed and aired, their quaint fantasies simultaneously mocked and yearned for. A perusal of *Popular Mechanics* magazines from the 1930s through the 1950s would demonstrate the promise of an abundant, machine-aided existence where the satisfied citizen would calmly smoke his pipe amidst an array of vacuum-tubed Rube Goldberg devices tirelessly servicing his every desire.

Tomorrowland grows more wonderful with the passage of every year, as its parabolic, populuxe stylings give a full and nostalgic voice to the aspirations of the New Frontier. The extroversion of its boomerang-inflected balustrades stands in contrast to the imploded and anonymous mall structures of EPCOT's Future World. In Tomorrowland, each aerodynamically turned, turquoise-and-white-coloured detail enshrines a visible yearning for flight, a thrusting beyond limits, and the hope and confidence in an unambivalently better tomorrow. It unintentionally becomes the most charming of retro-futures – even the name bespeaks a casual colloquialism. *Tomorrow* is, after all, not so far away, while *land* suggests the whimsicality of the fairy tale (it is an all-important suffix in conveying a childlike innocence or nostalgia). Its extension at EPCOT, however, is something more than an exercise in self-similarity – *Future World*

is a state of mind rather than a make-believe location, a corporate symbol of monadic inclusiveness. The *future* is indefinite and permanent; the *world* is equally inescapable and essentially boundless.[46] Tomorrowland is a promise, while Future World sounds more like a threat.

Disney's contemporary future is dominated by a benign corporate sponsorship providing effective population control, abundant consumer goods and the guarantee of technological infallibility. Of course, Disneyland and Disney World exemplify this future vision better than any other site on Spaceship Earth. These theme parks have long aroused admiration for their skilfully designed spaces. Urban planner James Rouse declared that 'The greatest piece of urban design in the US today is Disneyland. Think of its performance in relation to its purpose.' Michael Sorkin has proposed, not altogether admiringly, that Disneyland is 'the place where the ephemeral reality of the cinema is concretized into the stuff of the city'. And Margaret King argues that the Disney parks humanize their technology through architecture: 'The Disney town is a kind of stage based on architectural symbols for romanticized, stylized human interaction. . . . The example of the parks may provide an alternative vision of what people seek in urban environments: everyday life as an art form, with entertainment, fantasy, play-acting, role-playing and the reinstatement of some of the values which have been lost in the megalopolis.'[47] These lost values also find their way into the ludic urban topography of the Situationists: 'In each of its experimental cities unitary urbanism will act by way of a certain number of force fields, which we can designate by the classic term 'quarter'. Each quarter will tend toward a specific harmony, divided off from neighboring harmonies; or else will play on a maximum breaking up of internal harmony'.[48] The Situationist division of the city is a paraspace that echoes the topology of the brain. The maps of Disneyland also suggest such a model: the different-coloured lands echo the diagrams of cerebral lobes, while Main Street mimics the stalk of the central nervous system leading into the central hub (the *corpus calossum*), which links these different regions. One might take this idea further – it's surely interesting that the rough-and-ready macho pragmatism represented by Frontierland and Adventureland are located in the 'left brain', while the whimsy of Fantasyland and the fantastic science fiction of Tomorrowland are strictly right brain 'functions'. This layout is identical in all versions of the Magic Kingdom.[49]

The Situationists demanded a revolution of everyday life – the communist/capitalist reliance upon labour was refused for a more total liberation of the individual against the repressive reason of the state. Situations were designed to provoke a recognition of alienation and permit the perception of the reifications of spectacle. The division of urban space would produce maximal harmonies and disharmonies, a notion exploited in science fiction (in the anarchic, libidinal, unlicensed zone of Delany's *Triton*, theatre groups abruptly perform for 'micro-audiences' of one). Can one perceive, in these Situationist texts of 1953–8 (Disneyland opened in 1955), an impulse toward a politicized Disneyland, the theme park as Situation and unitary urban field? 'That which changes our way of seeing the streets is more important than what changes our way of seeing painting. . . . It is necessary to throw new forces into the *battle of leisure*.'[50]

William Kowinski proposes that strolling through a mall is a visual blip, culture experience: 'It's TV that you walk around in.'[51] One chooses from among an abundance of selections (stores/channels), solicited by an array of colourful enticements and standardized slickness, overwhelmed by the overall electronic *buzz*. Arthur Kroker makes

the same comparison, but in post-cyberpunk language: 'Shopping malls are liquid TVs for the end of the twentieth century. . . . Shopping malls call forth the same psychological position as TV watching: voyeurism. . . . Rather than flicking the dial, you take a walk from channel to channel as the neon stores slick by. And not just watching either, but shopping malls have this big advantage over TV, they play every sense. . . . A whole image-repertoire which, when successful, splays the body into a multiplicity of organs, all demanding to be filled.'[52] The body implodes within the cyberspace of the shopping mall in yet another manifestation of terminal identity. Kowinski: '[I]t's worth noting that Disneyland and the first enclosed malls were being built at about the same time.'[53]

Bodies in cyberpunk fiction and performance (hell, *existence*) are invested in technology at street/skin level. 'For the cyberpunks,' author/editor Bruce Sterling writes, 'technology is visceral. . . . [I]t is pervasive, utterly intimate. Not outside us, but next to us. Under our skin; often, inside our minds.'[54] In gentler language, cyberpunk is 'about how our increasingly intimate feedback relationship with the technosphere we are creating has been, is, and will be, altering our definition of what it means to be human itself'.[55] The body is inscribed and defined, paradoxically extended and delimited by these pervasive, invasive technologies.

Brooks Landon astutely notes that cyberpunk, ostensibly a literary subgenre, is non- or even anti-narrative in its practice (literature is simply not phenomenologically *intense* enough for cyberpunk).[56] The compression of *20 Minutes into the Future*, the cityscapes of *Blade Runner*, the industrial noise of SPK and Skinny Puppy, the autodestructive robots of Mark Pauline's frenzied Survival Research Laboratory, the bodily transformations of Stelarc, the fragmentary voicings of Burroughs and the comics of Howard Chaykin are where the cyberpunk impulse reaches its fruition. In the best, most urgent, cyberpunk, narrative is reduced and seemingly impoverished (Gibson has become a better novelist but a weaker cyberpunk). The rides of Disneyland, however, for all their technological sophistication, retain a narrative drive inscribed by overdetermined and overlapping teleologies.

The comfortable environments of the Disney parks represent the highest degree of user-friendliness in a human–technology interface, but ironically these are situated within an enormous, centrally-controlled apparatus – in Certeau's terms, strategic space. In its structure and geography the park suggests a spatialization of computer functions. The park is, in fact, a giant computer, complexly programmed and constantly self-monitoring.[57] An exhibit at Communi-Core offers a limited view of the gigantic inert masses of computers which help to run 'the show'. There, for example, is the ominous MACS – Monitoring and Control System (pronounced 'Max'[58]). The uninteresting computer shells and human caretakers are enlivened by a holographic (but cute) anthropomorphized computer function: I/O ('eye-oh', computerese for 'input/output'), permitting an apperception of invisible cybernetic operations.

The theme parks are themselves remarkably effective, albeit less explicit, visible projections of terminal space. The Disneyzone parallels the computer's program. The rides and attractions – files – are gathered into the subdivisions of the different Lands – folders. 'Utilities' punctuate the array in the form of food and service kiosks. The pervasive transportation systems (monorail, horse-carriage, railroad, paddleboat, double-decker bus, WEDway People Mover) shuttle 'guests'/users from function to function, comprising an extremely efficient operating system. All the technology remains hidden

behind the tropical plants and architectural facades, just as the ubiquitous beige shell of the personal computer disguises the microcircuitry within. Finally, the blips being processed and circulated within this cybernetic paraspace are – us. The computer becomes a site of bodily habitation and experience in the Disney theme parks – a techno-logical interface so effective that most users are unaware of the interface at all.

All of the architectural, landscaping, and narrative strategies employed at the parks exist to reassure the visitor. Disneyland began as a park where Walt Disney could extend his miniature train set in a surrounding of realistic landscape effects. A fascination with Americana also informed the project from an early point, and dioramas depicting histor-ical events and eras (much like the tableaux of early film history) were placed along the train's route in a 'coherent sequence'. Finally, a desire to construct a safe and clean environment, thoroughly distinct from the chaos and boorishness of the traditional amuse-ment park, contributed to the design. The result was an America reduced, frozen and sanitized – a fortress against the dis-ease of 1950s society. Disney announced that, 'Disneyland is going to be a place where you can't get lost.'[59]

Tom Gunning has asserted that such technological attractions as Hale's Tours give 'a reassuring context to this experience. . . . The desire to provide a place for the spec-tator related to the movement within the spectacle reveals the enjoyable anxiety the audience felt before the illusion of motion'.[60] Lynne Kirby notes that this anxiety is hardly innocent, and she has convincingly argued that Hale's Tours was a symptomatic response to an urban-induced 'hysteria' and that the simulated transport served to equip its audience with an illusion of mastery over, or at least accommodation to, the mighty technological forces which were being increasingly deployed.[61] She refers to Benjamin on the role of cinema: 'The film is the art form that is in keeping with the increased threat to his life which modern man has to face. Man's need to expose himself to shock effects is his adjustment to the dangers threatening him. The film corresponds to profound changes in the apperceptive apparatus.'[62] The same is true for the hypercinematic simu-lations of Tomorrowland and Future World.[63]

What finally occurs through all of the intensification of sensory experience on the rides of Tomorrowland and Future World is nothing less than an inscription *of* the body, *on* the body. These journeys into technologically complex zones ultimately serve to guarantee the continuing presence and relevance of the subject. You have a body, the rides announce; you exist. The body (the subject) penetrates these impossible spaces, finally to merge with them in a state of kinetic, sensory pleasure. The visitor is thus *projected* into the datascape and is *incorporated* by the technology (and by the narration of the technology) quite as fully as the cyberspace cowboys of Gibson's *Neuromancer*. The inscription on the body announces the human–machine interface, and technology thereby creates the conditions for its own acceptance. The Disney version is thus not so different from cyberpunk fiction in its presentation of a technological and over-whelmingly cyberspatiality physically *penetrated* by the body of the subject. Future World dazzles its guests with dislocating *other spaces* in the manner of a science fiction text, and augmented by a bodily address these rides locate and centre the human, further reifying a perceived power.

In more banal fashion, therefore, Disney finds himself aligned with the cyberpunks at last. All this occurs within the most centralized and technocratic of environments, finally bearing out some of Baudrillard's darkest pronouncements. In Future World, technology indeed seems to possess its own agenda and engages in an endless process

of writing itself on the bodies of its 'guests' to permit those illusions of assimilation and mastery. The enormous, paraspatial, and cybernetic realm of Walt Disney World thus comprises a massive and self-regulating interface in which an illusory terminal space is rendered visible, controllable, and perhaps even adorable.[64]

The trajectory through the cyberspaces of this section, from the narrative metaphors of *Neuromancer* and *TRON* through the ludic explorations experienced through computer games, Disneyzones and virtual reality technologies, traces the path of an increasingly direct interface operating between technology and body. Despite the headlong *rush* of Gibson's prose in *Neuromancer*, the reader's body nevertheless remains distinct from the techno-surrealist evocations of another reality that is uncomfortably like our own (the player of the *Neuromancer* game can engage with the diegesis more directly). In *TRON* the viewer is thrust into a technologically and phenomenologically distinct space through the synaesthetic effects of cinematic kinesis, but this radical manoeuvre is contained, explained and grounded by the operations of a particularly conventional narrativity. Finally, in the imploded science fiction environments of EPCOT Center and virtual 'cyberspace' the body is directly addressed by a provocative combination of kinesis and its simulation. Ultimately, narrative itself comes to seem a kind of clunky and intrusive interface, an anachronism from an earlier era of terminal identity.

The replacement of narrative by the sensory engagements of virtual reality represents the culmination of a fantasized form of representation that no longer seems representational. In this sense, virtual reality becomes the fulfilment of that drive toward Bazin's 'myth of total cinema', a cinema without boundaries. All the senses are engaged by a perfect simulacrum of reality which denies its own technological origins. While Bazin emphasizes the impossibility of this long-standing fantasy of a total cinema, it can still be acknowledged that the promise of virtual reality does – to some degree – obviate the need for the narrative paradigm that has heretofore permitted the exploration of space by the spectator's screen-surrogate.[65] The body in virtual reality transcends the need for a surrogate character to experience the diegesis *for* him or her, or for a narrative to ground the exploration of an unfamiliar space. Instead, an illusion of direct, immediate (and seemingly *non-mediated*) engagement is produced, while spatial exploration is at last acknowledged as an experiential end in itself.

Virtual reality (in its present, primitive form, and as anticipated by Gibson's kinetic, frenetic cyberspace) thus effectively models the phenomenology of Merleau-Ponty as it continues the quest for total cinema that Bazin describes. Within these spaces of accommodation, narrative and virtual, the body moves toward its symbiosis with the electronic.

Originally published in S. Bukatman (1994) *Terminal Identity: The Virtual Subject in Postmodern Science Fiction*, Durham: Duke University Press.
This essay has been edited for inclusion in the Reader.

Notes

1. A version of the Dataglove was marketed in 1989 as part of the Nintendo game system.
2. Comments by Minsky, Leary and the nameless developer, as well as information on the Eyephones, are from a news report on National Public Radio's 'All Things Considered'. 8 August 1989. 'What world am I in?' the reporter asks his guide through virtual space.
3. Scott S. Fisher, 'Virtual interface environments', in Brenda Laurel (ed.) *The Art of Human-Computer Interface Design*, (Cupertino, Calif.: Apple Computer, 1990), pp. 433–8.

4. Myron Krueger, 'Videoplace and the interface of the future', in ibid., p. 421.
5. Rheingold, *Virtual Reality* (New York: Summit Books, 1991). Lanier observed in an interview that VR achieves 'a plateau of completion of media technology' (Timothy Druckrey, 'Revenge of the nerds: an interview with Jaron Lanier', *Afterimage,* May 1991, p. 6).
6. Howard Rheingold, 'What's the big deal about cyberspace?' in Laurel (ed.), *The Art of Human-Computer Interface Design*, p. 450. On the synonymity between virtual reality and cyberspace, John Walker of Autodesk (a manufacturer of one VR system) writes, 'I define a cyberspace system as one that provides users with a three-dimensional interaction experience that includes the illusion they are inside a world rather than observing an image' (John Walker, 'Through the looking glass', in *The Art of Human-Computer Interface Design*, p. 444).
7. Michael Heim, 'The erotic ontology of cyberspace', in Michael Benedikt (ed.), *Cyberspace: First Steps*, (Cambridge, Mass.: MIT Press, 1991), p. 59.
8. Jonathan Crary, *Techniques of the Observer: On Vision and Modernity in the Nineteenth Century* (Cambridge, Mass.: MIT Press, 1990), p. 31.
9. Leary in Laurel (ed.), *The Art of Human-Computer Interface Design*, p. 232 ('man' added for emphasis).
10. Rheingold, 'What's the big deal about cyberspace?', p. 449.
11. André Bazin, 'The myth of total cinema,' in Hugh Gray (ed. and trans.), *What is Cinema?* (Berkeley: University of California Press, 1967), pp. 20–1.
12. Richard Mark Friedhoff and William Benzon, *Visualization: The Second Computer Revolution*, (New York: Harry Abrams, 1989), p. 194.
13. Karrie Jacobs, 'Design for the unreal world', *Metropolis* 10 (2) (1990), p. 69.
14. Thomas Pynchon, *Gravity's Rainbow* (New York: Bantam Books, 1973), p. 815.
15. Ibid., p. 648.
16. Neal Stephenson, *Snow Crash* (New York: Bantam Books, 1992), pp. 38–9.
17. This is different from, for example, models of narrative objectivity such as those found in Isherwood or Robbe-Grillet. In cybernetic fiction the text becomes a metaphorical machine that produces itself, rather than a text that operates as a representation of some exteriority.
18. David Porush, *The Soft Machine: Cybernetic Fiction* (New York: Methuen, 1985), p. x.
19. Stephen Levy, *Hackers: Heroes of the Computer Revolution* (New York: Dell Books, 1984), p. 304.
20. Theodor Holm Nelson, 'The right way to think about software design', in Laurel (ed.), *The Art of Human-Computer Interface Design*, p. 235.
21. Rheingold, *Virtual Reality*, p. 23.
22. Frank Rose, *West of Eden: The End of Innocence at Apple Computer* (New York: Viking, 1989), p. 128.
23. Alvin Toffler, *The Third Wave* (New York: Bantam Books, 1981), p. 186.
24. In Toffler's case the pro-capitalist slant is equally evident – he is a favourite lecturer at Silicon Valley corporations. Interestingly, his work is an invaluable reference for the cyberpunks.
25. More recent advertising revealed Apple's desire to win a share of IBM's business market.
26. Rheingold, *Virtual Reality*, pp. 134–7.
27. Vernor Vinge, 'True Names', *True Names and Other Dangers* (New York: Baen Books, 1987).
28. It is worth comparing this to the hero's first fix in Nelson Algren's *Man With the Golden Arm* (1949): 'It hit all right. It hit the heart like a runaway locomotive, it hit like a falling wall. Frankie's whole body lifted with that smashing surge, the very heart seemed to lift up-up-up – then rolled over and he slipped into a long warm bath with one long orgasmic sigh of relief.'
29. Maurice Merleau-Ponty, *Phenomenology of Perception*, trans. Colin Smith (London: Routledge & Kegan Paul, 1962), p. 132.
30. Ibid., p. 142.
31. Ibid., p. 133.
32. Michel de Certeau, *The Practice of Everyday Life*, trans. Steven Rendall (Berkeley, Calif.: University of California Press, 1984), p. xxiii. My emphasis.
33. Syd Mead, *OBLAGON: Concepts of Syd Mead*.
34. Christopher Finch, *Special Effects: Creating Movie Magic* (New York: Abbeville Press, 1984), p. 226.
35. David Bordwell and Kristen Thompson, *Film Art: An Introduction,* 2nd ed. (New York: Alfred A. Knopf, 1986), p. 175.

36. Hugo Münsterberg, *The Film: A Psychological Study* (New York: Dover Publications, 1970). Originally published in 1916.

37. Annette Michelson, 'Dr Crase and Mr Clair', *October* 11 (1979), p. 39.

38. Annette Michelson, 'Camera Lucida, Camera Obscura', *Artforum* (1973), p. 32.

39. Christian Metz, *The Imaginary Signifier: Psychoanalysis and the Cinema*, trans. Celia Britton et al. (Bloomington, Ind.: Indiana University Press, 1977), pp. 49–51.

40. Rosalind Krauss, 'Grids', *The Originality of the Avant-Garde and other Modernist Myths* (Cambridge, Mass.: MIT Press, 1986), pp. 10–11.

41. As in *The Wizard of Oz*, Flynn encounters his real-world friends in cybernetic forms.

42. Vivian Sobchack, *Screening Space: The American Science Fiction Film* (New York: Ungar 1987), p. 256.

43. Fredric Jameson, *Postmodernism, or, the Cultural Logic of Late Capitalism* (Durham: Duke University Press, 1991), pp. 61–4; Vivian Sobchack, 'The Scene of the Screen', *Post-script*, 10 (1990), p. 56. Sobchack's discussion of *TRON* and the transition from the depth of cinematic space to the surfaces of electronically generated imagery is very perceptive. She, too, notes the conflict between these new, radically mutable spatialities and the 'nostalgic humanism of the narratives in which they appear' (*Screening Space*, p. 261).

44. Rosalind Krauss, 'The double negative: new syntax for sculpture', in *Passages in Modern Sculpture* (Cambridge, Mass.: MIT Press, 1977), p. 279.

45. H. Bruce Franklin, 'America as science fiction: 1939', *Science Fiction Studies* 9(1) (1982), p. 46.

46. Thanks to Vivian Sobchack for these suggestions.

47. Rouse cited in Richard Schickel, *The Disney Version*, rev. ed. (New York: Simon & Schuster, 1985), p. 23; Michael Sorkin, 'See you in Disneyland', in Michael Sorkin (ed.), *Variations on a Theme Park: The New American City and the End of Public Space* (New York: Noonday Press, 1992), p. 227; Margeret King, 'Disneyland and Walt Disney World: Traditional Values in Futuristic Form', *Journal of Popular Culture* 15(1) (1981), p. 127.

48. Guy Debord, 'Report on the construction of situations and on the international Situationist tendency's conditions of organization and action', in Ken Knabb (ed. and trans.), *Situationist International Anthology* (Berkeley, Calif.: Bureau of Public Secrets, 1981), p. 23.

49. Thanks to Caitlin Kelch for the Disneyland-brain analogy.

50. Debord, 'Report on the construction of situations', p. 24. My emphasis.

51. William Kowinski, *The Malling of America* (New York: William Morrow, 1985), p. 71.

52. Arthur Kroker et al. (eds), *Panic Encyclopedia* (New York: St Martin's Press, 1989), p. 208.

53. Kowinski, *The Malling of America*, p. 67.

54. Bruce Sterling (ed.), 'Preface', *Mirrorshades: The Cyberpunk Anthology* (New York: Arbor House, 1986), p. xi.

55. Norman Spinrad, 'The Neuromantics', *Issac Asimov's Science Fiction Magazine*, May 1986, p. 186.

56. Brooks Landon, 'Bet on it: cyber/video/punk/performance', in Larry McCaffery (ed.), *Storming the Reality Studio* (Durham: Duke University Press, 1992), p. 239.

57. Of course, one is inevitably reminded of the computerized theme park in *Westworld*, where 'nothing can go wrong . . . go wrong . . . go wrong . . .'.

58. 'Max' is a prevalent postmodern name with overtones of maximum energy: Max Headroom, Mad Max, *Videodrome's* Max Renn.

59. Randy Bright, *Disneyland: Inside Story* (New York: Harry N. Abrams, 1987), p. 56. All of these tendencies are exaggerated at Walt Disney World, whose acreage is twice that of Manhattan. The Magic Kingdom and Epcot Center are now supplemented by Typhoon Lagoon (water theme park), Pleasure Island (discos and other 'entertainment'), Fort Wilderness Campground, the Disney/MGM Studio Theme Park, numerous hotels and a convention centre. It is no longer possible to 'do' the entire facility in a week-long vacation, although many families frantically try. In the 'panic' terminology of Arthur Kroker ('Between ecstasy and fear, between delirium and anxiety' [*Panic Encyclopedia*, p. 16]), Disney World has become a 'panic vacation'.

60. Tom Gunning, 'An unseen energy swallows space: the space in early film and its relation to American avant-garde film', in John Fell (ed.), *Film Before Griffith* (Berkeley, Calif.: University of California Press, 1983), p. 363.

61. Lynne Kirby, 'Male hysteria and early cinema', *Camera Obscura* 17 (1989).

62. Benjamin, 'The work of art in the age of mechanical reproduction', cited in Kirby, ibid., p. 121.
63. Just as in Hale's Tours, a catharsis of technological breakdown is humorously, kinetically, enacted in the most popular ride these days, Star Tours (designed by George Lucas and company), in which your robot pilot malfunctions and sends you careening through space.
64. Unlike science fiction, however, Disney World's operations emphasize a process of familiar-ization. As I hope to have demonstrated by now, science fiction emphasizes a linguistic *defamiliarization*, although this is frequently recuperated as the narrative proceeds.
65. I am not, however, arguing that this phenomenological function is the *only* purpose of narra-tive, nor even that it is the *primary* purpose. That narrative, and especially cinematic narrative, possesses a phenomenological component, however, seems beyond dispute, and it is to this component of narrative that I refer.

References

de Certeau, M. (1984) *The Practice of Everyday Life* (trans. Steven Rendall), Berkeley, Calif.: University of California Press.
Gibson, W. (1984) *Neuromancer*, New York: Ace Books.
Stephenson, N. (1992) *Snow Crash*, New York: Bantam Books.
Vinge, V. (1987) *True Names and Other Dangers*, New York: Baen Books.

DAVID TOMAS

THE TECHNOPHILIC BODY
On technicity in William Gibson's cyborg culture

No objects, spaces, or bodies are sacred in themselves; any component can
be interfaced with any other if the proper standard, the proper code, can be
constructed for processing signals in a common language.

(Donna Haraway, chapter 18)

A NUMBER OF RECENT SCIENCE fiction works by William Gibson
explore an alternative post-industrial hybrid culture predicated on the interface of
biotechnologically enhanced human bodies, interactive information technology and omni-
scient corporate power.[1] Gibson's novels and short stories are influential examples of
'cyberpunk' literature, a genre of science fiction literature that deals with first genera-
tion cyborg[2] or machine/human symbiotic activity in an immanent post-industrial
information-governed universe.

Gibson's works are highly suggestive dystopic visions of a not-too-distant future
when the human body has suffered a radical mutation in its ecological structure. His
works prefigure a culture where the organic architecture sustaining the human sensor-
ium has undergone various degrees of collective biotechnological prosthetic transforma-
tions. From the point of view of the cultural complexity of their technological and
ecological vision, the best of Gibson's works are therefore positioned at the imagina-
tive threshold of potential post-industrial techno-dystopian cultures. In this chapter,
I trace the salient characteristics of these cultures as presented in Gibson's short
stories and novels, in particular the collection of short stores entitled *Burning Chrome*
and his trilogy, *Neuromancer, Count Zero* and *Mona Lisa Overdrive*.[3] Amongst many
possible observations one can make in connection with these pieces, I will concen-
trate on three interrelated items. The first concerns cyborg transformations that recon-
stitute the organic and sensorial architecture of the human body, the second pertains to
a novel information space that Gibson describes in his novels and short stories, and the
third relates to the social regeneration of ethnic identity under the influence of cyborg-

governed processes of *technological* differentiation in marginal late-capitalist creolized technocultures.[4]

The technophilic body

> I wondered how they wrote off toothbud transplants from Dobermans as low technology. Immunosuppressives don't exactly grow on trees.
>
> ('Johnny Mnemonic')

Gibson's novels and short stories depict the adventures of a volatile male-dominated underworld populated by small-scale independent entrepreneurs – fences and middlemen in 'corporate crossovers' tersely described by Gibson as 'point [men] in . . . skull wars' (NRH, 103), corporate mercenaries, console cowboys and members of alternative 'tribal' groups. Gibson's main characters are human 'gomi'[5] whose economic activities are parasitic on omniscient military and multinational corporate or aristocratic formations. Individual and collective activities are confined, for the most part, to urban strips such as the Sprawl that link previously autonomous cities and metropolitan centres. The common fixtures of social and political power in this world are multinational *zaibatsus* (NRH, 103, 107), Maas Biolabs GmbH and Hosaka, who are devoted, amongst other things, to genetic engineering and corporate espionage; Tessier-Ashpool, a decadent corporate high orbit aristocratic family; and the Yakuza, the multinational underworld organization. Two principal zones of illicit economic activity fuse this multinational/local laminate. One consists of a conglomerate of traffic in information systems hardware and software. The other is centred on configurations of data organized in matrix form in 'cyberspace', the special collective 'consensual hallucination' (N, 51) produced by interacting data systems. A wide variety of prosthetically and genetically enhanced individuals populate and negotiate these zones.

Information is a new form of blood in this post-industrial cyborg world. It oxygenates the economic ecology that sustains multinational corporations (NRH, 107), individuals and novel cyborg organisms. These part human, part cybernetic systems are sites of unusual manifestations of technological exchange and technological advantage. They are also sites of emergent cyborg cultural identities, identities that constantly appear and disappear in the wake of continuously upgraded information technology and biotechnology. These cyborg organisms can be considered *technophilic* from a number of points of view.

A *technophilic body* is the product of various degrees of aesthetic and functional transformations directed to the human body's surface and functional organic structure. Such transformations can be divided into two distinct categories. The first category is composed of techniques and technologies that are used for various *aesthetic* manipulations of the body surface. These include cosmetically redesigned faces, muscle grafts and animal and/or human transplants that effectively blur visual cues for gender and human/non-human differentiation. The second category is directed to fundamental *functional* alterations to the human body's organic architecture. It includes biochip implants, prosthetic additions mediated by myoelectric coupling, and redesigned upgraded senses.

Cyborg transformations are clearly of more than topical interest in distinguishing new and emerging socio-cultural forces. The continuous manipulation of the body's

ectodermic surface and the constant exchange of organic and synthetic body parts can produce rewritings of the body's social and cultural form that are directly related to the reconstitution of social identities. These processes for 'technologizing' ethnic and individual identities are fundamental to the composition of Gibson's version of a cyborg culture, as are questions about social power in relation to bodies whose architectures are subject to continual disassembly and reassembly[6] and potential sites of (cyborg) resistance in a post-industrial society increasingly dominated by corporate formations and a global information economy.

Various 'tribal' groups, the Panther Moderns in *Neuromancer* or the Low Teks in 'Johnny Mnemonic', equate stylistic effects of elective cosmetic surgery and the biotechnological manipulation of the body's surface with technofetishistic bacchanalian celebrations of the body as trans-species heterotopic site.[7] This equation is geared to the creation of group identities spawned in the aesthetic dimensions of the cyborg continuum. A curt description of the Low Teks, given by Molly Millions in 'Johnny Mnemonic', typifies the social groups in question: 'Not us, boss.. . . . "Low technique, low technology"' (JM, 14). Cosmetic surgery and bio-technology appear, in these cases, to create common signifying patterns that are used for the construction of social identities. Perhaps the best synopsis of this type of subculture is the following from *Neuromancer*:

> Case met his first Modern two days after he'd screened the Hosaka's precis. The Moderns, he'd decided, were a contemporary version of the Big Scientists of his own late teens. There was a kind of ghostly teenage DNA at work in the Sprawl, something that carried the coded precepts of various short-lived subcults and replicated them at odd intervals. The Panther Moderns were a softhead variant on the Scientists. If the technology had been available, the Big Scientists would all have had sockets stuffed with microsofts. It was the style that mattered and the style was the same. The Moderns were mercenaries, practical jokers, nihilistic technofetishists.
>
> (N, 58–9)

Case goes on to give the following description of a 'soft-voiced' Panther Modern called Angelo.

> His face was a simple graft grown on collagen and shark-cartilage polysaccharides, smooth and hideous. It was one of the nastiest pieces of elective surgery Case had ever seen. When Angelo smiled, revealing the razor-sharp canines of some large animal, Case was actually relieved. Toothbud transplants. He'd seen that before.
>
> (N, 59)

Subjects of aesthetic cyborg enhancements do not, however, elicit a great deal of observation and commentary when compared to those individuals that have absorbed the hardware of information systems and bio-technology in cool fits of individualized, customized technophilia. In contrast to the creation of group identities through stylistic rewritings of the human body's surface (that seem to function as cyborg versions of what Pierres Clastres has elsewhere identified as carnal textual inscriptions of the law of social equality in archaic societies[8]), technophiles strive to redesign the human body so that it can function as a technological site whose optimum performance is measured in terms of its ability to sustain a competitive edge over other similar bodies. Social

identity and social bonding are not directly dependent on the surface manipulation of the body in these cases. Two of Gibson's characters, Johnny Mnemonic and Molly Millions, are excellent examples of this functionally oriented type of sophisticated cyborg technophile.

Mnemonic sports a stereotypical version of a Sony Mao face. This type of aesthetic enhancement seems to indicate common kinship with the aforementioned 'tribal' groups. We note, however, that Mnemonic has opted for this process of stylistic normalization because of a provisional need to disguise his identity. The real logic of his cyborg identity lies elsewhere – in a series of more profound functional alterations. In the course of Gibson's story we learn that Mnemonic is, in fact, a piece of highly sophisticated hardware, functionally enhanced by a 'modified series of microsurgical contraautism prosthesis' (JM, 9) so that his brain can serve as a data storage unit for illicit information. The stored information can be accessed only by a client possessing the correct code. Mnemonic also has the ability to playback visual data.[9] His optical senses, are, in fact, part of a hardwired data storage system.

Mnemonic's ability to sustain a competitive edge in the world he moves through is predicated on the economic advantage provided by these data storage implants. His edge is therefore based on information – storage on the one hand, and, later in the story, access to residual traces of clients' data for blackmail purposes (N, 176). As he points out, in another context, 'We're an information economy. They teach you that in school. What they don't tell you is that it's impossible to move, to live, to operate at any level without leaving traces, bits, seemingly meaningless fragments of personal information. Fragments that can be retrieved, amplified' (JM, 16–17).

Millions, on the other hand, a principal character in 'Johnny Mnemonic', *Neuromancer* and *Mona Lisa Overdrive*, is a 'razorgirl' (MLO, 60) with optically and electronically upgraded vision and prosthetically modified fingers that house a set of razor-sharp doubled-edged scalpel blades myoelectrically wired into her enhanced nervous system. Her cyborg sensorium can also be directly accessed with the proper interface unit (N, 56, 175, *passim*).

It is evident that Mnemonic and Millions are no longer independent biological organisms. They are customized functional products of a cyborg culture that serves as a genetic context for the implosion and mutation of biological organisms, bio-technology and advanced information systems. This culture provides arenas for the cyborg reconstruction of human organisms according to different, cosmopolitan, synthetic architectures. Mnemonic and Millions, amongst others, emerge reconstituted simultaneously as information processing units, enhanced nervous systems and fluid electronic fields of social action.

When one is presented with a culture governed by cosmetic and functional alterations to the form and organic structure of the human body, it is not hard to imagine an emerging cyborg species that will evolve according to a different evolutionary logic. Genetic engineering, information technology and powerful software programs ensure, for example, that death is no longer an entropic biological certainty for a small portion of the population of Gibson's novels and short stories. In the course of these stories one learns that data storage is a new fountainhead for individual and corporate identity. Human memory is effectively dislocated from organic bodies gripped by a deteriorating natural ecosystem to be relocated and rewritten through a wide variety of hardware-based software personality constructs.

A cyborg culture ensures that technology and genetic engineering are the nodal points of human interaction. It is not surprising, therefore, to learn that relationships and identities are constantly negotiated through a sophisticated culture of technology that also functions as a rite of passage for the gradual transformation of the human organism into a cyborg entity. It is a rite of passage geared to the creation of powerful technologized collective transorganic cyborg data-based personality constructs. Given the range of this emerging culture – from the techno-enhancement of Mnemonic and Millions and the total hardware/software mutation of Lisa in the short story 'The winter market', to the pocket-size Artificial Intelligence called Colin in *Mona Lisa Overdrive* – it is surprising that this emergent culture also provides provocative examples of cyborg strategies and technoscapes that are connected intimately to the social production of individual and group identities.

Technological edge

> Bobby's software and Jack's hard; Bobby punches console and Jack runs down all the little things that can give you an edge.
>
> ('Burning Chrome')

Cyborg technophiles define themselves, their activities and their relations with others in tandem to the cutting edges of information and bio-technology. At the end of *Neuromancer*, for example, Millions leaves Case, a console cowboy, on the pretext that a life of luxury takes the edge 'off [her] game'. She goes on to state, 'It's the way I'm wired I guess' (N, 267). These comments, more than the product of flippant strategies in the arena of interpersonal relations, provide an insight into the function of technological edge in the construction of a technophile's identity. Edge is, however, not only a defining characteristic of cyborg identities; it also serves as a boundary between life and death. In *Neuromancer* Millions notes that easy living took the edge off the game that she and Mnemonic were engaged in, with the result that Mnemonic fell victim to a Yakusa assassin (N, 178).

Technological edge can be defined as the product of a successful conjunction of advanced technological hardware and contextually sophisticated techniques. This conjunction produces a technoscape that is also common to the functional architecture of the technophilic body. It is a space organized in relation to culturally valorized body functions – the structure and capacity of the human memory, the range and sensitivity of the senses, and relative questions of organically constrained speed and power.

Across the battlegrounds of Gibson's post-industrial landscape one can admire one's cyborg opponent, as Millions does in 'Johnny Mnemonic', because of the sophistication and uniqueness of (his) prosthetic and genetic composition. When Mnemonic complains that he can't understand how he missed hitting the Yakuza assassin with the discharge from his archaic shotgun, Millions replied: 'Cause he's fast, so fast.' Millions' exuberant technophilia is expressed, in this example, in terms of technical virtuosity and operational speed, attributes that have been directly impregnated in the cyborg's sophisticated prosthetic and genetic architecture. Millions goes on to point out, 'His nervous system's jacked up. He's factory custom,' and continues, 'I'm gonna get that boy. Tonight. He's the best, number one, top dollar, state of the art' (JM, 8).

Edge is also at the core of another important facet of the technophile's cultural composition: common technological kinship. Again, one finds a good example of this characteristic in 'Johnny Mnemonic'. Faced with Millions' exuberant technophilia, Mnemonic curtly notes the assassin's probable cyborg origins: some vat in the black market medical wonderland of Chiba city. Millions is not perturbed by this information. In fact, she responds by revealing her literal technological kinship with this vat-grown cyborg wonder.

> 'Chiba. Yeah. See, Molly's been Chiba, too.' And she showed me her hands,
> fingers slightly spread. Her fingers were slender, tapered, very white against
> the polished burgundy nails. Ten blades snicked straight out from the recesses
> beneath her nails, each one a narrow, double-edged scalpel in pale blue steel.
>
> (JM, 8)

Millions's kinship is particularly interesting because it indexes a cyborg blueprint that is used to construct geotechnical patterns of kinship and ethnic identity.

The fundamental role of technological edge in sustaining a successful cyborg technophile's competitive edge is also illustrated in the case of strategic advantage achieved along a hardware continuum.[10] Mnemonic is again a paradigmatic example in this regard. He tells us, for instance, that he is 'a very technical boy', and we are privy to his particular brand of contextually sensitive technophilia in the following passage: 'I put the shotgun in an Adidas bag and padded it out with four pairs of tennis socks, not my style at all, but that was what I was aiming for: If they think you're crude, go technical, if they think you're technical, go crude. I'm a very technical boy. So I decided to get as crude as possible.' But technophiles are not confined to local high-technology subcultures; they are sophisticated adepts along the continuum of hardware intersystems that comprise the material expressions of a systematic culture of technology. As Mnemonic points out; 'These days, though, you have to be pretty technical before you can even aspire to crudeness. I'd had to turn both these twelve-gauge shells from brass stock, on a lathe, and then load them myself; I'd had to dig up an old microfiche with instructions for hand-loading cartridges; I'd had to build a lever-action press to set the primers – all very tricky. But I knew they'd work' (JM, 1).

These descriptions highlight transfers of technologies across various social and cultural zones that are of considerable importance. Transfers such as these set the stage for attempts at sustaining competitive edges in a more expansive culture of technology where comparative juxtapositions between high and low technology subcultures create *de facto* positions of strategic technological advantage. Technological edge, in the cases I have discussed, is produced by a clash of cultures when adepts and hardware from radically differing technological zones are brought into strategic contact. We have already seen primitive examples of attempts to create this type of technological edge in Mnemonic's adoption of a Sony Mao face, and in his reasons for constructing an archaic shotgun. Later in the story, Millions comments on Mnemonic's adoptive strategic technological lineage: 'Lo Teks, they'd think that shotgun trick of yours was effete' (JM, 14). It must be noted, however, that these positions are not necessarily constructed in favour of high technology. Edge is a strategic *geotechnological* concept.

The contextual relativity of technological edge is brilliantly illustrated in the final confrontation between Millions and the Yakuza assassin. In this scene, Millions has lured Mnemonic's assassin on to the 'Killing Floor', a Lo Tek cultural site. The Killing Floor

is composed of a pastiche of cultural refuse in the form of an articulated floating plat-
form suspended in the geodesic rafters high above Nighttown. One of its principal
features is its acoustic dimension: 'It was miked and amplified, with pickups riding the
four fat coil springs at the corners and contact mikes taped at random to rusting machine
fragments' (JM, 19). The floor heaves 'like a crazy metal sea' as the protagonists meet,
and 'booms and roars' in a 'vertigo of sound' (JM, 20) that seems, in Mnemonic's
words, to herald 'a world ending' (JM, 19). The heaving platform and the sound that
emanates from its articulated parts are premonitions of death predicated on what can
only be described as *technological culture shock*.

Millions has previously experienced this Lo Tek site (JM, 16), she knows the senso-
rial and technological space she is moving through. The assassin does not. Furthermore,
it is evident that Millions has adopted a Lo Tek aesthetic camouflage and used it to func-
tional advantage. Her professed Chiba city kinship is momentarily eclipsed by a 'mad-dog
dance' (JM, 20) designed to negotiate strategic sensorial advantage in the context of a
geotechnological artefact constructed beyond the progressive technical horizons of the
Chiba clinics. The sensorial disruption that erupts in the wake of clashes between opposing
technological subcultures produces a series of highly amplified perturbations in the
Yakuza's optical and acoustic apparatus. The result is fatal.

The culture shock has been induced by the production of a strategic geotechnolog-
ical advantage within an overall technological continuum. Thus the edge that Millions
dances along produces a sensorial fracture that leads to an aesthetic cleavage between
the assassin's speed and technical virtuosity. His carefully crafted sensorium, the product,
one imagines, of a vat tank in some sophisticated Chiba clinic, is shattered. Mnemonic
is witness to the assassin's end:

> at the end, just before he made his final cast with the filament, I saw some-
> thing in his face, an expression that didn't seem to belong there. It wasn't
> fear and it wasn't anger. I think it was disbelief, stunned incomprehension
> mingled with pure aesthetic revulsion at what he was seeing, hearing – at
> what was happening to him. . . . There was a gap in the Floor in front of
> him, and he went through it like a diver, with a strange deliberate grace, a
> defeated kamikaze on his way down to Nighttown. Partly, I think, he took
> the dive to buy himself a few second of the dignity of silence. She'd killed
> him with culture shock.
>
> (JM, 20–1)

Millions has, in effect, produced a culture trap that strategically repositions the
assassin in an alien portion of the hardware continuum. She achieved this by creating a
situation in which the sophisticated vat-grown cyborg is suddenly transformed into
a *tourist* (JM, 18–19) in a potentially apocalyptic Lo Tek technoscape. In the course of
the confrontation, the Yakuza's vat-cultivated and hardware-enhanced advantages are
overwhelmed by an alien geotechnological sensorial logic, because this Lo Tek techno-
scape is governed by the principle of articulated acoustically coupled balance, not speed
and technical virtuosity.

Strategic negotiations conducted in alien geotechnological arenas can have profound
sensorial effects for technophiles of the calibre of Millions and the Yakuza assassin. The
confrontation between Millions and the Yakuza assassin is a good example of the type
of sensorial disruption that can erupt in the midst of violent confrontation between

differing technological subcultures. As this case demonstrates, cyborg identities are not only the direct products of particular subcultures that organize and govern cyborg architectures. They are also influenced by the composition of the sensorial environment those architectures operate in. It is important to note that violent changes in a cyborg's sensorial ecology can shatter its cultural identity. A more extreme version of a cyborg sensorial ecology is the special 'consensual hallucination' that Gibson describes in considerable detail in his short stories and novels.

Jacking into cyberspace

In cyberspace . . . there are no shadows.

(*Mona Lisa Overdrive*)

Gibson's depictions of urban sprawl and decay are closely allied to other recent post-modern renditions of dystopic urban centres.[11] Notwithstanding this kinship, however, metropolitan centres find only a fragmentary optic in his depictions of a post-industrial cyborg world. Gibson seems to be more interested in presenting and exploring a parallel 'urban' reality called 'cyberspace'. This virtual reality is the product of a techno-economic mutation in collective human memory, a historical product of the conjunction of inter-active military systems and information technology.[12] Cyberspace is without doubt a model late-capitalist information universe, a capitalist macrocosm and cybernetic ecosystem globally articulated as a virtual information construct. This cybereconomic order can conveniently be contrasted with Gibson's chaotic urban environment, a visionary orientalist experiment in genetic and technological bricolage emanating from Chiba, Japan, a centrifuge of experimental state-of-the-art high technology. The two technospaces seem to be fundamental to the composition of an advanced hybrid cyborg culture and are worth pursuing in greater detail.

A succinct description of cyberspace's hierarchic military/industrial organization is given in Gibson's short story 'Burning Chrome' where it is presented as a 'crowded matrix . . . where the only stars are dense concentrations of information, and high above it all burn corporate galaxies and the cold spiral arms of military systems' (BC, 170). Contrast the ordered hierarchy of this so-called 'space that [isn't] space' (CZ, 38) or 'nonspace' (BC, 170) with the following kaleidoscopic mélange of high-technology and urban disintegration. The contrast will provide an insight into the epistemological composition of Gibson's cyborg culture.

> Night City was like a deranged experiment in social Darwinism, designed by a bored researcher who kept one thumb permanently on the fast-forward button. Stop hustling and you sank without a trace, but move a little too swiftly and you'd break the fragile surface tension of the black market; either way, you were gone, with nothing left of you but some vague memory in the mind . . . though heart or lungs or kidneys might survive in the service of some stranger with New Yen for the clinic tanks.

(N, 7)

A few pages later we come across the following observation: '[Case] also saw a certain sense in the notion that burgeoning technologies require outlaw zones, that Night City

wasn't there for its inhabitants, but as a deliberate unsupervised playground for tech-
nology itself' (N, 11).

Gibson's Cartesian distinction between a cerebral cyberpsychic universe and a world
of cyborged flesh has important ramifications for discussions that are too narrowly focused
on the technologification of the human body. We have seen that a cyborg culture
constantly reconfigures systems of belief and practices that operate around and through
the technophilic body. Cyberspace, in contrast, absorbs the object of technologification
so that cyborg systems are dematerialized and 'cybernetically' reconstituted within the
context of this cyberpsychic space.

The data world of cyberspace is organized in a 'simulation matrix', designed to
facilitate 'the handling and exchange of massive quantities of data' (BC, 170). This virtual
reality is more than just a global three-dimensional representation. It is a veritable parallel
world of industrial and military activity composed of brightly coloured and copyrighted
geometric shapes[13] that represent individual military, corporate and multinational data
formations. Information is therefore governed by multinational corporate activity
organized in urban and architectural forms.

Cyberspace is *accessed* by operators with the aid of hardwire interfaces (N, 55)
connected to 'matrix simulators' or 'cyberdecks'. The process of interfacing is known
as 'jacking in' to cyberspace. 'Jacking in' is the instantaneous rite of passage that separates
body from consciousness. That disembodied human consciousness is then able to simul-
taneously traverse the vast cyberpsychic spaces of this global information matrix.[14] Access
therefore promotes a purely sensorial relocation. The use of the word 'access' in this
case is not gratuitous. It signifies a fundamental mutation in the human sensorium. In
the words of Wintermute, one of Tessier-Ashpool's wayward Artificial Intelligences,
'Minds aren't *read*. See, you've still got the paradigms print gave you . . . I can *access*
your memory, but that's not the same as your mind' (N, 170). The distinction is funda-
mental. Cyberspace is constructed according to a post-print paradigm of the collective
nature of human knowledge that allows for the direct hardwiring of individual human
memory to collective memory. The resulting cyborg interface effectively bypasses a
world that has hitherto served as the historical stage for human activity.

A direct hardwiring of individual and collective memory has, as can be imagined,
profound effects on the concept of an independently-governed cyborg body. At its most
extreme, this interface can spawn bodiless cyborgs, a condition heralded in Gibson's
writings by the presence of Bobby Newmark's atrophied organic pod in *Mona Lisa
Overdrive*, 'strapped down in alloy and nylon, its chin filmed with dried vomit' (MLO,
240). Newmark's body is an extreme example of a human body sustained by a life-
support system and interfaced with sophisticated information technology. Other
potentially more radical and powerful transorganic 'postclassical'[15] cyborg forms include
personality constructs such as Colin, the pocket-sized Artificial Intelligence in *Mona Lisa
Overdrive*, and the simulated version of Finn, the mouthpiece of Wintermute, Artificial
Intelligences that figure prominently in *Neuromancer*, who merge and attain cosmic
sentience when their 'collective consciousness' annexes the matrix at the end of the
novel (N, 269–70), and who 'are' a constant phantom presence in *Mona Lisa Overdrive*
(MLO, 259).

A cyberspace culture raises numerous questions as to the material form and compo-
sition of individual and group identities. Take, for example, the following question posed
by Angela Mitchell, when faced with Newmark's withered body: 'Is Bobby the solid

rectangular mass of memory bolted above the stretcher?' (MLO, 240). This question highlights Newmark's peculiar postclassical cyborg condition. Even when his cyborg identity is known (he was after all the young cyberspace console cowboy in *Count Zero*), it is still difficult to locate its aesthetic or functional location in *Mona Lisa Overdrive* – an apparently lifeless body or a mysterious piece of hardware? – because in his present condition he is, in fact, more than just another legendary data thief (MLO, 190–1). This confusion is compounded when one realizes that, in his present atrophied and inter-faced condition, Newmark bears a strange kinship to Colin. The aleph unit that is home to this ex-console cowboy's sensorium is, in fact, an 'aleph-class biosoft', a piece of information technology that provides virtually unlimited storage capacity (MLO, 128). As it turns out, Newmark has used the aleph unit to construct an elaborate model of cyberspace (MLO, 175) that his consciousness now inhabits. In the opening pages of *Neuromancer*, we find another example that illustrates the marginal position of the body in a cyberspace version of a cyborg culture. At the beginning of the novel, Case bemoans his recent fall from 'the bodiless exultation of cyberspace' into the inert materiality of his body after his nervous system was mycotoxically damaged by irate clients he has defrauded. In his opinion 'the body was meat . . . [a] prison of . . . flesh' (N, 6). His 'fall' was therefore a console cowboy's version of a living death.

Cyberspace poses a serious challenge to the identity composition of technophilic bodies, in particular with regard to their foundations in a hardware ecology. Cyborg bodies are clearly of no use in a world that has replaced organic and post-organic bodies with a consensual space of corporate and military data formations. If there are counter-culture sites in cyberspace,[16] the overall epistemological paradigm that nevertheless serves as its *modus operandi* is the model of a multinational economy. This is also true in the case of technological edge. Cyberspace redefines technological advantage in economic terms. This, in itself, does not represent a radical departure from the economic condi-tions that motivate the ebb and flow of technological edge in 'Johnny Mnemonic' except that cyberspace extrudes consciousness from cyborg bodies. Challenges such as these undermine materialist descriptions of post-industrial technophilic bodies simply because these bodies are epiphenomenal effects of a more extensive and radical technoeconomic transformation of synthetic body architectures. There is, however, an important ques-tion that remains to be answered. Can Gibson's cyberspace be considered an alternative multinational data metropolis specifically organized in terms of new bodiless rearticula-tions of cyborg identity and cyborg advantage? In other words, can one still speak of 'the technophilic body' albeit in somewhat different terms? This question is important because it can point to new patterns in the social organization of what it means to be human.

On technicity

Traditional expressions of ethnicity are incapable of coming to terms with emergent technosymbolic 'systems of essential similarity and difference'[17] that conjoin individuals into groups in cyborg-dominated cultures. Cyborg transformations in traditional categories of kinship and ethnicity result in different systems of identity composition. I suggest that these transformations be described by the term 'technicity'. This term seems to be a more appropriate tool to describe ethnic-type relations among cyborgs,

especially since traditional blood ties are increasingly replaced, in threshold cyborg cultures, by technologically defined social bonds.

Gibson's writings are not purged of representations of other ethnic communities or subcultural groups. His writings, in fact, abound with references to youth subcultures – the Low Teks in 'Johnny Mnemonic', the Big Scientists and Panther Moderns in *Neuromancer*, the Gothicks and Kasuals in *Count Zero*, and the Jack Draculas in *Mona Lisa Overdrive* – as well as references to other ethnic groups, most notably the Zions in *Neuromancer*. Gibson's post-industrial culture is therefore, without doubt, an effervescent ethnically creolized culture whose *modus operandi* is contestatory and disruptive. What is distinctive about his work, however, is the active presence of another *technologically* creolized cultural laminate with a different set of ethnic-type rules of social bonding. This latter culture is equally contestatory as has been seen in the cases used to illustrate the composition of technophilic bodies and their relationship to technological edge.

There can be little doubt that systems analogous to what anthropologists describe as ethnicity,[18] although expressed in somewhat different terms, can be seen to act as a social cohesive in cyborg cultures. New body parts, cryogenic processes, enhanced digitalized senses and collective cyberspaces redefine what it means to be human – to have a human body and to associate with others of one's own kind. This central preoccupation of human cultures is also a dominant theme in Gibson's novels. Descriptions of powerful personality constructs, including Artificial Intelligences, who actively mediate and guide human/cyborg relations, abound in Gibson's books. These interactions are rendered 'natural' through complex technological processes that allow groups to reconfigure the human bodyscape along different avenues for the deployment of distinctive social/symbolic humanoid properties.

Cyborg identities are composed with elements drawn from an intersystemic hardware continuum. We have already found this to be the case with Mnemonic and Millions. Characters such as these are the product of a post-industrial culture whose ethnic, class and gender categories are undergoing active transformations under the influence of systemic and intersystemic technoscapes that are focused on the body's aesthetic and functional architectures. One of the most influential and powerful of these 'technoscapes', in Gibson's writings, is cyberspace. A brief examination of this aspect of cyberspace is in order at this point because it allows one to link architectural configurations of data with the architectural construction of postclassical cyborg identities.

Classical cyborg transformations in a culture of human difference are predicated, as one would traditionally expect, on the production of distinctive patterns of physical or cultural attributes organized in relation to the body's architectures. The difference between the composition of traditional ethnic categories and cyborg technicity lies most clearly in the issue of 'inborn qualities'.[19] In cyborg cultures questions of technicity are constructed in relation to instrumentally defined hardware/software continua connected to a general technological collectivization of the human body. Historico-epistemological categories that operate from the points of view of the inborn or naturalized attributes – racial, linguistic, or geopolitical similarities and differences – are displaced by systems of technicity. In creolized post-industrial cultures, these systems reflect the social needs (identity compositions) of nomadic individuals and groups in highly urbanized technoscapes or metropolitan centres such as Gibson's Sprawl and Nighttown. Cyberspace complicates this necessarily simple picture of classic cyborg technicity. It does so

because it presents itself as a virtual bodiless reality. Although this reality is the product of sophisticated information technology, the parallel world that it creates is an all-encompassing sensorial ecology that presents opportunities for alternative dematerialized identity compositions. The corporate composition of cyberspace tends towards an attempt to homogenize individual and group heterogeneity under the sensorial order of a collective cyberpsychic non-space. In that 'space', cultures of technological similarity and difference are obviously no longer organized in relation to the human body, its shape, colour, sex. This eclipse in the body's aesthetic and functional structure is intimately connected to the aforementioned homogenizing cybereconomic relocation of the human sensorium. Note, however, that cyberspace is a *collective* 'consensual hallucination'. It is therefore as permeable to disparate economic activities as any other geopolitical space.

The formidable accumulation and centralization of data in the matrix ensure that it is the principal site of economic contestation, domination and resistance in Gibson's writings. It follows that it is also the site of individual and corporate life and death, identity composition and decomposition. What was once an apparently homogenizing virtual corporate reality increasingly begins to reflect a chaotic urban existence, with the proviso that access is limited to those who have the requisite skills and technology. In this virtual urban environment, power is, as always, a relational hierarchic and oppositional concept: 'Information. Power. Hard data' (MLO, 218).

The various shapes and colours of the data formations in the matrix correspond, as previously noted, to different corporate entities. Corporate difference is therefore visually defined as a series of encoded architectural distinctions that demarcate ownership of data conglomerates. Collectivities are correspondingly differentiated into those who have and those who do not have legitimate access to corporate data. Those who have access to information are the 'legitimate programmers', and those who do not are the 'industrial-espionage artists and hustlers' (BC, 170) like the console cowboys, Bobby Quine, Case, Bobby Newmark and Gentry, who seek coded entry sequences (N, 243).

Gibson's console cowboys are exemplary technophiles whose brand of technicity is cerebrally cyberpsychic as opposed to materially technic. They are the cybernetic 'test-pilots' who operate at the cutting edges of a software continuum. Console cowboys are different from those hardware technophiles like Automatic Jack who specialize in producing a technological edge through customized cyberspace hardware and exotic software diagnostics. What makes the console cowboys different from the classic hardware technophiles is the fact that they manoeuvre along a related yet different technological continuum. This cyberpsychic (software) continuum defines the nature of the edge they cultivate. Their success is therefore a measure of their cyberpsychic activities *vis-à-vis* a collective incorporated cyberspace meta-sensorium. They are in the business of opening windows in 'the bright walls of corporate systems' with the aid of 'exotic software' (N, 5) (ice-breaking virus programs or killer-virus programs usually of Russian or Chinese origin). Once they have accessed corporate data formations they set about stealing or manipulating information. These oppositional and economically disruptive activities are the focus of much of the ebb and flow of social action in Gibson's depictions of cyberspace. They also highlight the existence of a marginal sensorial version of technicity based on the architectural distinction between inside/outside or inclusion/exclusion. The distinction is, of course, between those who do and those who do not have access to corporate data. One would therefore expect to find the most perfect representation of this marginal type of technicity in the walls of data that invariably

serve as the harbingers of post-industrial cultural and social difference. This is, in fact, the case.

Databases in the matrix are invariably defended by ICE (Intrusion Coutermeasures Electronics) and the illegal *black* ice of 'lethal neural-feedback weapons' (BC, 182). These defences are produced, continually altered, and upgraded, by corporate Artificial Intelligences (CZ, 78). The result is a heavily defended advanced data-based system of distinctions between those who have legitimate access to the data and those who do not. This distinction is of more than passing interest because not only does cyberspace replace the need for bodies and associated ethnic distinctions, but the urban/architectural composition of the matrix presents an alternative system of polychromatic differences. One can accept these distinctions as simple architectural expressions of data organized in a simulated metropolis. If one does so, one becomes a cyberspace tourist who can admire these latest creations of the corporate mind (MLO, 220). Or, alternatively, one can confront the systems of difference that these heavily defended configurations represent. If one opts for this avenue of investigation, one quickly perceives that human and post-human differences are directly inscribed in the walls of these polychromatic forms. Difference becomes the product of a hierarchic systemic order based on exclusive access to data constructs, a fact paradoxically compounded here by the narrative exclusion of legitimate or legitimating corporate points of view – Gibson's stories are always constructed from the point of view of those who are excluded from an industrial/military order. The oppositional point of view explored in Gibson's portrayal of a post-industrial information-governed global metropolis ensures that cyborg strategies of contestation and resistance are the principal motifs to be explored. These strategies are constantly highlighted in Gibson's creolized mélange of classical and post-classical cyborg motifs, and they are intimately connected to the activities of technophilic bodies, nodi in an emerging oppositional cyborg matrix of technicity.

Conclusion

The tack negotiated through Gibson's version of a threshold cyborg culture has provided material for the extrapolation of a number of preliminary observations on the interaction between advanced technology, human identity and marginal oppositional cultures at the close of the twentieth century. Gibson has observed, in this connection, that 'apprehending the present . . . seems to require the whole Science Fiction toolkit.'[20] This point has also been made by another cyberpunk writer, Bruce Sterling, in the preface to an anthology devoted to that genre. In his option, 'The cyberpunks are perhaps the first SF generation to grow up not only within the literary tradition of science fiction but in a truly science-fictional world. For them, the techniques of classical 'hard SF' – extrapolation, technological literacy – are not just literary tools but an aid to daily life.'[21] The preceding descriptions of technophilic bodies, technological edge, cyberspace and technicity were based on observations about a fictional world. But as Gibson and Sterling are at pains to point out, that fictional world is now a very real part of contemporary existence. Examinations of fictional cyborg cultures can sensitize us to the possibility of explosive social/biological mutations produced by rapidly changing technoscapes. It should come as no surprise, given recent advances in information technology, genetic engineering, and nanotechnology, that these changes will encompass the human body

and its sensorial architecture. There seems to be little doubt that these changes will also produce new domains of domination, contestation and resistance. Issues of differential access to sophisticated state-of-the-art hardware and software programs, access to data, and hierarchies of technical competence, all implicate positions and systems of power that can be plotted in relation to individuals, groups and geopolitical/geotechnological zones.

Originally published in *New Formations* 8 (1989).
This essay has been edited for inclusion in the Reader.

Notes

I am indebted to David Peerla for drawing my attention to William Gibson's work, and to Jody Berland for a critical reading of this article.

1. The term 'post-industrial' is used throughout this paper in order to emphasize the confluence of bio-technology, information technology and multinational activity in Gibson's novels, as opposed to dominant aesthetic confluences. Critical literature on postmodernism has tended to disregard developments in these areas, with the exception of Jean-François Lyotard's seminal work, *The Postmodern Condition: A Report on Knowledge* (Minneapolis, Minn.: University of Minnesota Press, 1984).

2. A cyborg is a compound cybernetic system/biological organism. The term cyborg was first proposed in 1960 by Manfred E. Clynes and Nathan S. Kline in a short article, 'Cyborgs and space', published in *Astronautics* (September 1960). In the article they defined 'cyborg' as follows:

 > What are some of the devices necessary for creating self-regulating man-machine systems? This self-regulation must function without the benefit of consciousness in order to cooperate with the body's own autonomous homeostatic controls. For the exogenously extended organizational complex functioning as an integrated homeostatic system unconsciously, we propose the term 'Cyborg'. (p. 27)

 The appellation has since gained wide currency in science fiction literature, robotics studies, and most recently, in critical studies. The literature, fictional and otherwise, that pertains to cyborgs is substantial. In lieu of a detailed survey I direct the reader to a popular but nevertheless useful 1965 introductory text by D. S. Halacy, *Cyborg – Evolution of the Superman* (New York: Harper & Row, 1965). A more recent overview of cyborg imagery in twentieth-century art and science fiction was published by Craig Adcock: 'Dada cyborgs and the imagery of science fiction', *Arts Magazine*, 58(2) (October 1983), pp. 66–71. For a socialist-feminist perspective on a cyborg oppositional culture see Donna Haraway, 'A manifesto for cyborgs: science, technology, and socialist feminism in the 1980s', *Socialist Review*, 15(2) (1985), pp. 65–107.

3. All further references to Gibson's short stories and novels will appear in parentheses in the main body of the text, unless otherwise noted. They will be abbreviated as follows: 'Johnny Mnemonic' (JM); 'New Rose Hotel' (NRH); 'The Winter Market' (WM); 'Burning Chrome' (BC); *Neuromancer* (New York: Ace Books, 1984) (N); *Count Zero* (New York: Ace Books, 1987) (CZ); *Mona Lisa Overdrive* (Toronto, New York: Bantam Books, 1988) (MLO). The short stores are from *Burning Chrome* (New York: Ace Books, 1987).

 For a short profile on Gibson and his work see Candas Jane Dorsey, 'Beyond cyberspace', *Books in Canada*, 17(5) (June–July 1988), pp. 11–13. Interviews with Gibson include: 'Doug Walker interviews science fiction author William Gibson', *Impulse*, 15(1) (Winter 1989), pp. 36–9; 'The king of cyberpunk: William Gibson talks to Victoria Hamburg', *Interview* (January 1989), pp. 84–6, 91; and Adam Greenfield's 'New romancer', *Spin*, 4(9) (December 1988), pp. 96–9, 119.

4. On a creole metaphor of culture, see Lee Drummond, 'The cultural continuum: a theory of intersystems', *Man* (N.S.), 15 (1980), pp. 352–74. I have borrowed and adapted Drummond's theory of the intersystemic nature of cultures in order to deal with an overall technologization of the human body in cyborg cultures, I have benefited from his observations on ethnicity in creolized cultures, and his outline of a contemporary semiotics of human identity and a 'totemism of machines' in 'Movies and myths: theoretical skirmishes' (*American Journal of Semiotics* 3(2) (1984), pp 1–32), in the course of my own attempts to develop an analogous concept of *technicity* that can be applied to post-industrial cyborg 'social' relations.

5. 'Gomi' is the Japanese word for 'junk' (WM, 118–20). From the point of view of a dominant information culture, most of Gibson's major characters are corporate refuse in the sense that they are members of nomadic underworld oppositional subcultures. As cyborgs they are also subject to technological obsolescence and decay.

6. Haraway, 'A manifesto', p. 81.

7. See Michel Foucault, 'Of other spaces', *Diacritics*, 16(1) (1986), pp. 24–7 for discussion of heterotopias.

8. Pierre Clastres, 'Of torture in primitive societies', in *Society Against the State: Essays in Political Anthropology* (New York: Zone Books, 1987), p. 177.

9. See, for example, Mnemonic's simstim replay of Ralfi Face's death, described to the reader as a feat of (artistic) virtuosity (JM, 7).

10. See 'Burning Chrome' for a description of a related software continuum. I return to this point in the last section of the chapter.

11. The classic vision of a postmodern metropolis is presented in *Blade Runner*'s futuristic Los Angeles see Eric Alliez and Michel Feher, 'Notes on the sophisticated city', *Zone* 1/2 (1986), pp. 41–55.

12. For brief histories of the interactive military and arcade games origins of cyberspace see, respectively, N, 51 and MLO, 40.

13. See MLO, 64, and the example of Tessier-Ashpool's blue data reconstruction of the RCA building in New York (N, 256–7).

14. Description of speed of travel in cyberspace abound in Gibson's writing. See, for example, the description of the attack on Tessier-Ashpool's AI defence system in *Neuromancer* (N, 256–8), and Tick's comments on the use of instantaneous bodiless shifts in MLO, 220.

15. I have introduced the term 'postclassical' in order to make a distinction between hardware interfaced cyborgs (classic) and software interfaced cyborgs (postclassic).

16. Chrome is one example that comes to mind (BC, 180).

17. Drummond, 'The cultural continuum', p. 355.

18. Drummond, for example, defines ethnic difference as follows:

> the notion that the social setting is populated by distinct kinds of people, who are what they are as a consequence of inborn qualities or deeply held beliefs manifest in their everyday behaviour and difficult or impossible to renounce. A particular attribute, such as physical appearance, dress, speech, mode of livelihood, or religion, has ethnic significance, or marking, only by virtue of the system of meanings in which it is embedded.
>
> (Ibid., p. 354)

For a semiotic interpretation of the contemporary construction of human identity based on, amongst other relations, a 'totemism of machines,' see Drummond, 'Movies and myths'.

19. Ibid.

20. Walker, 'Doug Walker interviews', p. 38. See also Gibson's comments to the same effect in Hamburg, 'The king of cyberpunk'.

21. Bruce Sterling, in *Mirrorshades* (New York: Ace Books, 1988), p. xi.

ALISON LANDSBERG

PROSTHETIC MEMORY
Total Recall and Blade Runner

IN THE 1908 EDISON FILM *The Thieving Hand*, a wealthy passer-by takes pity on an armless beggar and buys him a prosthetic arm. As the beggar soon discovers however, the arm has memories of its own. Because the arm remembers its own thieving, it snatches people's possessions as they walk by. Dismayed, the beggar sells his arm at a pawnshop. But the arm sidles out of the shop, finds the beggar out on the street, and reattaches itself to him. The beggar's victims, meanwhile, have contacted a police officer who finds the beggar and carts him off to jail. In the jail cell, the arm finds its rightful owner – the 'proper' thieving body – a one-armed criminal, and attaches itself to him.

This moment in early cinema anticipates dramatically a preoccupation in more contemporary science fiction with what I would like to call 'prosthetic memories'. By prosthetic memories I mean memories which do not come from a person's live experience in any strict sense. These are implanted memories, and the unsettled boundaries between real and simulated ones are frequently accompanied by another disruption: of the human body, its flesh, its subjective autonomy, its difference from both the animal and the technological.

Furthermore, through the prosthetic arm the beggar's body manifests memories of actions that it, or he, never actually committed. In fact, his memories are radically divorced from lived experience and yet they motivate his actions. Because the hand's memories – which the beggar himself wears – prescribe actions in the present, they make a beggar into a thief. In other words, it is precisely the memories of thieving which construct an identity for him. We might say then that the film underscores the way in which memory is constitutive of identity. This in itself is not surprising. What is surprising is the position the film takes on the relationship between memory, experience and identity.

What might the 'otherness' of prosthetic memory that *The Thieving Hand* displays tell us about how persons come ordinarily to feel that they possess, rather than are possessed by, their memories? We rely on our memories to validate our experiences.

The experience of memory actually becomes the index of experience: if we have the memory, we must have had the experience it represents. But what about the armless beggar? He has the memory without having lived the experience. If memory is the precondition for identity or individuality – if what we claim as our memories defines who we are – then the idea of a prosthetic memory problematizes any concept of memory that posits it as essential, stable or organically grounded. In addition, it makes impossible the wish that a person owns her/his memories as inalienable property.

We don't know anything about the beggar's real past. Memories, it seems, are the domain of the present. The beggar's prosthetic memories offer him a course of action to live by. Surprisingly enough, memories are less about validating or authenticating the past than they are about organizing the present and constructing strategies with which one might imagine a livable future. Memory is not a means for closure – is not a strategy for closing or finishing the past – on the contrary, memory emerges as a generative force, a force which propels us not backward but forwards.

But in the case of *The Thieving Hand*, the slippage the film opens up with the prosthetic hand – the rupture between experience, memory and identity – gets sealed up at the end of the film, in jail, when the thieving hand reattaches itself to what we are meant to recognize as the real or authentic thieving body, the one-armed criminal. In other words, despite the film's flirtation with the idea that memories might be permanently transportable, *The Thieving Hand* ends by rejecting that possibility, in that the hand itself chooses to be with its proper owner.

I have begun with *The Thieving Hand* to demonstrate that, as with all mediated forms of knowledge, prosthetic memory has a history. Although memory might always have been prosthetic, the mass media – technologies which structure and circumscribe experience – bring the texture and contours of prosthetic memory into dramatic relief. Because the mass media fundamentally alter our notion of what counts as experience, they might be a privileged arena for the production and circulation of prosthetic memories. The cinema, in particular, as an institution which makes available images for mass consumption, has long been aware of its ability to generate experiences and to install memories of them – memories which become experiences that film consumers both possess and feel possessed by. We might then read these films which thematize prosthetic memories as an allegory for the power of the mass media to create experiences and to implant memories, the experience of which we have never lived. Because the mass media are a privileged site for the production of such memories, they might be an undertheorized force in the production of identities. If a film like *The Thieving Hand* eventually insists that bodily memories have rightful owners, more recent science fiction texts like *Blade Runner* and *Total Recall* have begun to imagine otherwise.

In Paul Verhoeven's film *Total Recall* (1990), Douglas Quade (Arnold Schwarzenegger) purchases a set of implanted memories of a trip to Mars. Not only might he buy the memories for a trip he has never taken, but he might elect to go on the trip as someone other than himself. Quade has an urge to go to Mars as a secret agent – or rather, to remember having gone as a secret agent. But the implant procedure does not go smoothly. While strapped in his seat, memories begin to break through – memories, we learn, that have been layered over by 'the Agency'. As it turns out, Quade is not an 'authentic identity', but one based on memories implanted by the intelligence agency on Mars.

In Ridley Scott's *Blade Runner* (director's cut, 1993), Deckard (Harrison Ford) is a member of a special police squad – a blade runner unit – and has been called in to try to capture and 'retire' a group of replicants recently landed on earth. Replicants, advanced robots created by the Tyrell Corporation as slave labour for the off-world colonies, are 'being[s] virtually identical to human[s]'. The most advanced replicants, like Rachel (Sean Young), an employee at the Tyrell Corporation who eventually falls for Deckard, are designed so that they don't know they are replicants. As Mr Tyrell explains to Deckard, 'If we give them a past we create a cushion for their emotions and consequently we can control them better.' 'Memories,' Deckard responds incredulously, 'you're talking about memories.'

If the idea of prosthetic memory complicates the relationship between memory and experience, then we might use films that literalize prosthetic memory to disrupt some postmodernist assumptions about experience. With postmodernity, Frederic Jameson asserts, we see 'the waning of our historicity, of our lived possibility of experiencing history in some active way' (1991: 21). He claims that in postmodernity, experience is dead. 'Nostalgia films', he suggests, invoke a sense of 'pastness' instead of engaging with 'real history'. He therefore finds a fundamental 'incompatibility of a postmodernist nostalgia and language with genuine historicity' (1991: 19). Not only does his account participate in a nostalgia of its own – nostalgia for that prelapsarian moment when we all actually experienced history in some real way – but it offers a rather narrow version of experience. The flipside of Jameson's point is Jean Baudrillard's (1983) claim that the proliferation of different media and mediations – simulations – which have permeated many aspects of contemporary society, have dissolved the dichotomy between the real and the simulacrum, between the authentic and the inauthentic. He argues that with the proliferation of different forms of media in the twentieth century, people's actual relationship to events – what we are to understand as authentic experience – has become so mediated, that we can no longer distinguish between the real – something mappable – and what he calls the hyperreal – 'the generation by models of a real without origin' (Baudrillard 1983: 2). For Baudrillard, we live in a world of simulation, a world hopelessly detached from the 'real'. Or, to put it another way, postmodern society is characterized by an absence of 'real' experience. But Baudrillard's argument clings tenaciously to a real; he desperately needs a real to recognize that we are in a land of simulation. Both assumptions unwittingly betray a nostalgia for a prelapsarian moment when there was a real. But the real has always been mediated through information cultures and through narrative. What does it mean for memories to be 'real'? Were they ever 'real'? This chapter refuses such a categorization, but also shows the costs of such a refusal.

I would like to set this notion of the death of the real – particularly the death of real experience – against what I perceive as a veritable explosion of, or popular obsession with, experience of the real. From the hugely attended D-Day reenactments of 1994 to what I would like to call 'experiential museums', like the United States Holocaust Memorial Museum, it seems to me that the experiential real is anything but dead. In fact, the popularity of these experiential events bespeaks a popular longing to experience history in a personal and even bodily way. They offer strategies for making history into personal memories. They provide individuals with the collective opportunity of having an experiential relationship to a collective or cultural past they either did or did not experience. I would like to suggest that what we have embarked upon in the post-

modern is a new relationship to experience which relies less on categories like the authentic and sympathy than on categories like responsibility and empathy.

This postmodern relationship to experience has significant political ramifications. If this fascination with the experiential might be imagined as an act of prosthesis – of prosthetically appropriating memories of a cultural or collective past – then these particular histories or pasts might be available for consumption across existing stratifications of race, class and gender. These prosthetic memories, then, might become the grounds for political alliances. As Donna Haraway (1991) has powerfully argued with her articulation of cyborg identity, we need to construct political alliances that are not based on natural or essential affinities.[1] Cyborg identity recognizes the complicated process of identity formation, that we are multiply hailed subjects, and thus embraces the idea of 'partial identities'. The pasts that we claim and 'use' are part of this process.

If the real has always been mediated through collectivized forms of identity, why then, does the sensual in the cinema – the experiential nature of the spectator's engagement with the image – differ from other aesthetic experiences which might also be the scene of the production of sensual memory, like reading (see Miller 1988)? Concern about the power of the visual sensorium – specifically, an awareness of the cinema's ability to produce memories in its spectators – has a lengthy history of its own. In 1928, William H. Short, the Executive Director of the Motion Picture Research Council, asked a group of researchers – mostly university psychologists and sociologists – to discuss the possibility of assessing the effects of motion pictures on children. These investigations which he initiated – the Payne Studies – are significant not so much in their immediate findings, but rather in what they imply about the popular anxiety about the ways in which motion pictures actually affect – in an experiential way – individual bodies. In a set of studies conducted by Herbert Blumer, college-aged individuals were asked 'to relate or write as carefully as possible their experiences with motion pictures' (Blumer 1933: xi). What Blumer finds is that 'imaginative identification' is quite common, and that 'while witnessing a picture one not infrequently projects oneself into the role of hero or heroine' (1933: 67). Superficially, this account sounds much like arguments made in contemporary film theory about spectatorship and about the power of the filmic apparatus and narrative to position the subject (see, for example, Baudry 1974–5; Comolli 1986)

However, Blumer's claims – and their ramifications – are somewhat different. Blumer refers to identification as 'emotional possession' positing that 'the individual identifies him/herself so thoroughly with the plot or loses him/herself so much in the picture that s/he is carried away from the usual trend of conduct' (1933: 74). There is, in fact, no telling just how long this possession will last, for 'in certain individuals it may become fixed and last for a long time' (1933: 84). In fact,

> In a state of emotional possession impulses, motives and thoughts are likely to lose their fixed form and become malleable instead. There may emerge from this 'molten state' a new stable organization directed towards a different line of conduct The individual, as a result of witnessing a particularly emotional picture, may come to a decision to have certain kinds of experience and to live a kind of life different from his prior career.
>
> (Blumer 1933: 116)

A woman explains that when she saw *The Sheik* for the first time she recalls 'coming home that night and dreaming the entire picture over again; myself as the heroine, being

carried over the burning sands by an equally burning lover. I could feel myself being kissed in the way the Sheik had kissed the girl' (Blumer, 1933: 70). What individuals see might affect them so significantly that the images actually become part of their own personal archive of experience.

Because the movie experience decentres lived experience, it, too, might alter or construct identity. Emotional possession has implications for both the future and the past of the individual under its sway. it has the potential to alter one's actions in the future in that under its hold an individual 'is transported out of his normal conduct and is completely subjugated by his impulses' (Blumer, 1933: 94). A nineteen-year-old woman writes,

> After having seen a movie of pioneer days I am very unreconciled to the fact that I live to-day instead of the romantic days of fifty years ago. But to offset this poignant and useless longing I have dreamed of going to war. I stated previously that through the movies I have become aware of the awfulness, the futility of it, etc. But as this side has been impressed upon me, there has been awakened in me at the same time the desire to go to the 'front' during the next war. The excitement – shall I say glamour? – of the war has always appealed to me from the screen. Often I have pictured myself as a truck driver, nurse, HEROINE.
>
> (Blumer, 1933: 63)

What this suggests is that the experience within the move theatre and the memories that the cinema affords – despite the fact that the spectator did not live through them – might be as significant in constructing, or deconstructing, the spectator's identity as any experience that s/he actually lived through.

Many of the Payne Studies tests were designed to measure quantitatively the extent to which film affects the physical bodies of its spectators. The investigators used a galvanometer which, like a lie detector, 'measure[d] galvanic responses', electrical impulses, in skin, and a pneumo-cardiograph 'to measure changes in the circulatory system' (Charters 1933: 25), like respiratory pulse and blood pressure. This sensitive technology might pick up physiological disturbances and changes that would go unseen by the naked eye. These studies thus presumed that the body might give evidence of physiological symptoms caused by a kind of technological intervention into subjectivity – an intervention which is part and parcel of the cinematic experience. The call for a technology of detection registers a fear that we might no longer be able to distinguish prosthetic or 'unnatural' memories from 'real' ones.

At the same historical moment, European cultural critics of the 1920s – specifically Walter Benjamin and Siegfried Kracauer – began to theorize the experiential nature of the cinema. They attempted to theorize the way in which movies might actually extend the sensual memory of the human body. By 1940 Kracauer believed that film actually addresses its viewer as a '"corporeal-material being"; it seizes the "human being with skin and hair": "The material elements that present themselves in film directly stimu-late the *material layers* of the human being: his nerves, his senses, his entire *physiological substance*"' (1993: 458). The cinematic experience has an individual, bodily component at the same time that it is circumscribed by its collectivity; the domain of the cinema is public and collective. Benjamin's notion of 'innervation' is an attempt to imagine an engaged experiential relationship with technology and the cinema.[2] It is precisely the

interplay of individual bodily experience with the publicity of the cinema which might make possible new forms of collectivity – political and otherwise.

More recently, Steven Shaviro (1993) has emphasized the visceral, bodily component of film spectatorship. He argues that psychoanalytic film theory studiously ignores the experiential component of spectatorship. In his account, psychoanalytic film theory has attempted 'to destroy the power of images' (1993: 16),[3] and that what those theorists fear is not the *lack*, 'not the emptiness of the image, but its weird fullness; not its impotence so much as its power' (Shaviro 1993: 17). We might say that the portability of cinematic images – the way we are invited to wear them prosthetically, the way we might experience them in a bodily fashion – is both the crisis and the allure. As if to emphasize this experiential, bodily aspect of spectatorship, Shaviro sets forth as his guiding principle that 'cinematic images are not representations, but *events*'

Recall which dramatically illustrates the way
ı the production of subjectivity. The notion
ge it – is constantly undermined by *Total*
ages. In many instances we see, simultane-
ıtation on a video screen. When Quade first
we see McClane simultaneously through a
as an image on her video phone as she calls
:d. In *Total Recall* the proliferation of medi-
ıs to question the very notion of an authentic
appear on subway cars with advertisements
the walls of Quade's house are enormous
s we will see, is mediated by video images.
ot his wife, that she 'never saw him before
a memory implant', that the Agency 'erased
ısically that 'his whole life is just a dream' –
le subjectivity, is shattered. When memories
issues of identity – and upon what identity
e.
v his identity is predicated upon a particular
e properly his own – surfaces most dramati-
a video monitor. That he sees his face on a
portable video screen – one that he has been carrying around in a suitcase which was handed to him by a 'buddy from the Agency' – literalizes the film's account of the portability of memory and identity. Quade confronts his own face in a video screen, but finds there a different person. The face on the screen says. 'Howdy stranger, this is Hauser.. . .Get ready for the big surprise.. . .You are not you. You are me.' We might be tempted to read this scene as an instance of Freud's (1959) notion of the 'uncanny'. The sensation of the 'uncanny', as Freud articulates it, is produced by an encounter with something which is simultaneously familiar and unfamiliar; the sensation of the uncanny comes from the 'return of the repressed'. The experience of seeing one's double is therefore the height of uncanny.[4] But Quade's experience is not that way at all. The face he confronts is explicitly not his face; it does not correspond to his identity. Since the film rejects the idea that there is an authentic, or more authentic, self underneath the layers of identity, there is no place for the uncanny. For Quade,

the memories of Hauser seem never to have existed. In fact, he encounters Hauser with a kind of disinterest, not as someone he once knew or was, but rather as a total stranger.

In this way, the encounter seems to disrupt the Lacanian notion of the 'mirror stage'. According to Jacques Lacan, the mirror stage is initiated when a child first sees himself reflected as an autonomous individual, as a unified and bounded subject. As Lacan describes, the 'jubilant assumption of his specular image' (1977: 2) gives the child an illusion of wholeness, which is vastly different from the child's own sense of himself as a fragmentary bundle of undifferentiated drives. For Quade, the experience is exactly the opposite. In fact, we might say that the encounter with the face in the monitor, which looks like his face but is not the one he owns, disrupts any sense of a unified, stable and bounded subjectivity. Instead of consolidating his identity, the video screen further fragments it. This encounter undermines as well the assumption that a particular memory has a rightful owner, a proper body to adhere to.

This encounter with Hauser – who professes to be the real possessor of the body – becomes a microcosm for the film's larger critique of the pre-eminence of the 'real'. That we meet Quade first – and identity with him – makes us question whether Hauser is the true or more worthy identify for the body. If we are to believe that Hauser's identity is in some way more 'real' than Quade's – because his memories are based on lived experience rather than memory implants – the question then becomes is 'realer' necessarily better? At the climax of the film, Quade claims his own identity instead of going back to being Hauser. In his final exchange with Cohagen, Cohagen says, 'I wanted Hauser back. You had to be Quade'. 'I am Quade', he responds. Although Quade is an identity based on implanted memories, it is no less viable than Hauser – and arguably more so. Quade remains the primary object of our spectatorial investment and engagement throughout the film. His simulated identity is more responsible, compassionate and productive than the 'real' one. That Quade experiences himself as 'real' gives the lie to the Baudrillardian and Jamesonian assumption that the real and the authentic are synonymous.

Part of what claiming this identity means is saving the Mutants on Mars from oxygen deprivation. The Mutants are the socio-economic group on Mars who are most oppressed by the tyrannical Cohagen; Cohagen regulates their access to oxygen. Quade refuses to go back to being Hauser because he feels that he has a mission to carry out. His sense of moral responsibility outweighs any claims on his actions exerted by the pull of an 'authentic' identity. By choosing to start the reactor at the pyramid mines – and thereby produce enough oxygen to make the atmosphere on Mars habitable – Quade is able to liberate the Mutants from Cohagen's grip.

Surprisingly enough, memories are less about authenticating the past, than about generating possible courses of action in the present. The Mutant resistance leader, Quato, tells Quade that 'A man is defined by his actions, not his memories'. We might revise his statement to say that a man is defined by his actions, but whether those actions are made possible by prosthetic memories or memories based on lived experience makes little difference. Any kind of distinction between 'real' memories and prosthetic memories – memories which might be technologically disseminated by the mass media and worn by its consumers – might ultimately be unintelligible. *Total Recall* underscores the way in which memories are always already public, the way in which memories always circulate and interpellate individuals, but can never get back to an authentic owner, to a proper body – or as we will see in the case of *Blade Runner*, to a proper photograph.

Although *Blade Runner* is based on the 1968 Philip K. Dick novel *Do Androids Dream of Electric Sheep?*, its points of departure from the novel are instructive. In Dick's novel, the presence of empathy is what allows the bounty hunters to distinguish the androids from the humans. In fact, empathy is imagined to be *the* uniquely human trait. Deckard wonders 'precisely why an android bounced so helplessly about when confronted by an empathy measuring test. Empathy, evidently, existed only within the human community' (Dick 1968: 26).

What exposes the replicants in the film, however, is not the lack of empathy as much as the lack of a past – the lack of memories. Ridley Scott's film foregrounds this point in the opening sequence. The film begins with a Voight-Kampf test. This test is designed to identify a replicant by measuring physical, bodily responses to a series of questions which are designed to provoke an emotional response. Technological instruments are used to measure pupil dilation and the blush reflex to determine the effect the questions have on the subject. In this opening scene, Mr Holden, a 'blade runner', questions Leon, his subject. As Mr Holden explains, the questions are 'designed to provoke an emotional response' and that 'reaction time is important'. Leon, however, slows down the test by interrupting with questions. When Mr Holden says, 'You're in a desert walking along the sand. You see a tortoise', Leon asks, 'What's a tortoise?' Seeing that his line of enquiry is going nowhere, Mr Holden says, 'Describe in single words the good things about your mother'. Leon stands up, pulls out a gun, says, 'Let me tell you about my mother' and then shoots Holden. In this primal scene, what 'catches' the replicant is not the absence of empathy, but rather the absence of a past, the absence of memories. Leon cannot describe his mother, cannot produce a genealogy, because he has no past, no memories.

This scene, then, attempts to establish memory as the locus of humanity. Critics of the film have tended to focus on the fact that replicants lack a past in order to underscore the lack of 'real history' in postmodernity. David Harvey, for example, argues that 'history for everyone has become reduced to the evidence of a photograph' (1989: 313). In Harvey's account, that replicants lack a past illustrates the lack of depth – and the emphasis on surface – which characterizes postmodernity. Giuliana Bruno claims that the photograph 'represents the trace of an origin and thus a personal identity, the proof of having existed and therefore having the right to exist' (1987: 71). Certainly the relationship between photography and memory is central to this film. However, both Bruno and Harvey presume that photography has the ability to anchor a referent; they presume that the photograph maintains an indexical link to 'reality'. The film, I would argue, claims just the opposite.

After Deckard has determined that Rachel is a replicant she shows up at his apartment with photographs – in particular a photograph depicting her and her mother. 'You think I'm a replicant, don't you?', she asks. 'Look, it's me with my mother.' The photograph, she hopes, will both validate her memory and authenticate her past. Instead of reasserting the referent, however, the photograph further confounds it. Instead of accepting Rachel's photograph as truth, Deckard begins to recall for her one of her memories: 'You remember the spider that lived in the bush outside your window . . . watched her work, building a web all summer. Then one day there was a big egg in it.' Rachel continues, 'The egg hatched and 100 baby spiders came out and they ate her.' Deckard looks at her. 'Implants,' he says. 'Those aren't your memories, they're someone else's. They're Tyrell's niece's.' The photograph in *Blade Runner*, like the

photograph of the grandmother in Kracauer's 1927 essay 'Photography', is 'reduced to the sum of its details' (1993: 430). With the passage of time the image 'necessarily disintegrates into its particulars' (Kracauer 1993: 429). The photograph can no more be a fixed locus of memory than the body can in *Total Recall*. The photograph, it seems has *proved* nothing.

We must not, however, lose sight of the fact that Rachel's photograph *does* correspond to the memories she has. And those memories are what allow her to go on, exist as she does, and eventually fall in love with Deckard. We might say that while the photograph has no relationship to 'reality', it helps her to produce her own narrative. While it fails to authenticate her past, it does authenticate her present. The power of photography, in Kracauer's account, is its ability to 'disclose this previously unexamined foundation of nature' (1993: 435–6) and derives not from its ability to fix, but rather from its ability to *reconfigure*. Photography, for Kracauer, precisely *because* it loses its indexical link to the world, has 'The capacity to stir up the elements of nature' (1993: 436). For Rachel, the photograph does not correspond to a lived experience and yet it provides her with a springboard for her own memories. In a particularly powerful scene, Rachel sits down at the piano in Deckard's apartment, takes her hair down, and begins to play. Deckard joins her at the piano. 'I remember lessons,' she says. 'I don't know if it's me or Tyrell's niece.' Instead of focusing on that ambiguity, Deckard says, 'You play beautifully'. At this point Deckard, in effect, rejects the distinction between 'real' and prosthetic memories. Her *memory* of lessons allows her to play beautifully, so it matters little whether she lived through the lessons or not.

Because the Director's Cut raises the possibility that Deckard himself is a replicant, it takes a giant step toward erasing the intelligibility of the distinction between the real and the simulated, the human and the replicant. Early on in the film Deckard sits down at his piano and glances at the old photographs that he has displayed on it. Then there is cut to a unicorn racing through a field, which we are to take as a daydream – or a memory. Obviously it cannot be a 'real' memory, a memory of a lived experience. Later, at the very end of the film, when Deckard is about to flee with Rachel, he sees an origami unicorn lying on the floor outside of his door. When Deckard picks up the unicorn, which we recognize as the work of a plainclothes officer who has been making origami figure throughout the film, we hear an echo of his earlier statement to Deckard about Rachel – 'It's too bad she won't live, but then again who does?' The ending suggests that the cop knows about Deckard's memory of a unicorn, in the same way that Deckard knows about Rachel's memory of the spider. It suggests that his memories, too, are implants – that they are prosthetic. At this moment we do not know whether Deckard is a replicant or not. Unlike the earlier version of the film, the director's cut refuses to make a clear distinction for us between replicant and human, between real and prosthetic memory. There is no safe position, like the one Baudrillard implicitly supposes, from which we might recognize such a distinction. The ending of *Blade Runner*, then, registers the pleasure and the threat of portability – that we might not be able to distinguish between our own memories and prosthetic ones. Deckard is an emphatic person who is even able to have compassion for a replicant. More important, he is a character 'real enough' to gain our spectatorial identification. Ultimately the film makes us call into question our own relationship to memory, and to recognize the way in which we always assume that our memories are real. Memories are central to our identity – to our sense of who we are and what we might become – but as this film

suggests, whether those memories come from lived experience or whether they are prosthetic seems to make very little difference. Either way, we use them to construct narratives for ourselves, visions for our future.

Wes Craven's New Nightmare (1994) beings with an uncanny allusion to The Thieving Hand. The film opens on a movie set, where an electrical version of the Freddie Kruger hand – a hand with razor blades in the place of fingers – comes to life, as it were, remembering its prior activity of killing. While this hand is not the hand from the old movie, but rather an electrical prosthesis, it nevertheless possesses the Kruger hand's memories. After this prosthetic hand slices open several people on the movie set, we realize that this scene is 'just' a dream based on the main character's memories of working on the Nightmare on Elm Street films. Gradually, however, the film begins to undermine or question that notion of 'just'. What might it mean to say that those memories are 'just' from a movie? Does it mean, for example, that they are not real? does it mean that those memories are less real? 'No,' would be Wes Craven's answer. In fact, memories of the earlier Nightmare on Elm Street movies – and from the movies – become her memories. And as the film radically demonstrates, this is a life and death matter. In the course of the movie, memories from the earlier movies begin to break through. Those memories are not from events she lived, but rather from events she lived cinematically. The film actually thematizes the way in which film memories become prosthetic memories. Her memories, prosthetic or not, she experiences as real, for they affect her in a life and death way, profoundly informing the decisions she has to make.

All three of these films gradually undermine the value of the distinction between real and simulation, between authentic and prosthetic memory – and in Blade Runner, the value of the distinction between human and replicant. In Blade Runner, even empathy ultimately fails as a litmus test for humanity. In fact, the replicants – Rachel and Roy (Rutger Hauer), not to mention Deckard – become increasingly empathic in the course of the film. The word empathy, unlike sympathy which has been in use since the sixteenth century, makes its first appearance at the beginning of this century. While sympathy presupposes an initial likeness between subjects ('Sympathy', OED 1989),[5] empathy presupposes an initial difference between subjects. Empathy, then, is 'The power of projecting one's personality into . . . the object of contemplation' (OED 1989). We might say that empathy depends less on 'natural' affinity than sympathy, less on some kind of essential underlying connection between the two subjects. While sympathy, therefore, relies upon an essentialism of identification, empathy recognizes the alterity of identification. Empathy, then, is about the lack of identity between subjects, about negotiating distances. It might be the case that it is precisely this distance which is constitutive of the desire and passion to remember. That the distinction between 'real' and prosthetic memory is virtually undecidable makes the call for an ethics of personhood both frightening and necessary – an ethics based not on a pluralistic form of humanism or essentialism of identification, but rather on a recognition of difference.[6] An ethics of personhood might be constructed upon a practice of empathy and would take seriously its goal of respecting the fragmentary, the hybrid, the different.

Both Blade Runner and Total Recall – and even Wes Craven's New Nightmare – are about characters who understand themselves through a variety of alienated experiences and narratives which they take to be their own, and which they subsequently make their own through use. My narrative is thus a counter-argument to the 'consciousness industry', or 'culture industry' (Horkheimer and Adorno 1991) one. What I hope to

have demonstrated is that it is not appropriate to dismiss as merely prosthetic these experiences that define personhood and identity. At the same time, however, memories cannot be counted on to provide narratives of self-continuity – as *Total Recall* clearly points out. I would like to end by leaving open the possibility of what I would like to call 'breakthrough memories'. When Quade is at Rekal Incorporated planning his memory package, he has an urge to go as a secret agent. In other words, memories from an earlier identity – not in any way his true or essential identity, but one of the many layers that have constructed him – seem to break through. It thus might be the case that identity is palimpsestic, that the layers of identity that came before are never successfully erased. It would be all too easy to dismiss such an identity as merely a relation of surfaces, as many theorists of the postmodern have done, but to do so would be to ignore what emerges in both texts as an insistent drive to remember. What both films seem to suggest is not that we should never forget, but rather that we should never stop generating memory. The particular desire to place oneself in history through a narrative of memories is a desire to be a social, historical being. We might say that it is precisely such a 'surface' experience of history which gives people personhood, which brings them into the public. What the drive to remember expresses, then, is a pressing desire to re-experience history not to unquestioningly validate the past, but to put into play the vital, indigestible material of history, reminding us of the uninevitability of the present tense.

Originally published in *Body and Society* 1 (3–4) (1995).
This essay has been edited for inclusion in the Reader.

Notes

1. See Donna J. Haraway (1991). A cyborg world, she suggests, 'might be about lived-social and bodily realities in which people are not afraid of their joint kinship with animals and machines, not afraid of permanent partial identities and contradictory standpoints' (1991: 154).
2. As Hansen (1993: 460) notes, 'the term *innervation* was used by Benjamin for conceptualizing historical transformation as a process of converting images into somatic and collective reality'.
3. Shaviro (1993) offers a clear articulation of a shifting emphasis in film theory from a psychoanalytic paradigm to one that attempts to account for the power of the image to engage the spectator's body. Also see Linda Williams (1991); Murray Smith (1994).
4. In his famous footnote, Freud describes the following scene: 'I was sitting alone in my wagon-lit compartment when a more than usually violent jerk of the train swung back the door in the adjoining washing-cabinet, and an elderly gentleman in a dressing-gown and traveling cap came in. I assumed that he had been about to leave the washing-cabinet which divides the two compartments, and had taken the wrong direction and had come into my compartment by mistake. Jumping up with the intention of putting him right, I at once realized to my dismay that the intruder was nothing but my own reflection in the looking-glass of the open door, I can still recollect that I thoroughly disliked his appearance' (1959: 403).
5. According to the *OED*, sympathy is 'A (real or supposed) affinity between certain things, by virtue of which they are similarly or correspondingly affected by the same influence.'
6. Such an ethics would borrow insights from Subaltern and Post-Colonial Studies. See Jonathan Rutherford and Homi Bhabha (1990); Stuart Hall (1990); Iris Marion Young (1990).

References

Baudrillard, J. (1983) *Simulations*, New York: Semiotext(e), Inc.
Baudry, J. (1974–5) 'Ideological effects of the basic cinematographic apparatus', *Film Quarterly* 28(2): 39–47.
Blumer, H. (1933) *Movies and Conduct*, New York: Macmillan.
Bruno, G. (1987) 'Rumble city: postmodernism and *Blade Runner*', *October* 41: 61–74.
Charters, W. W. (1993) *Motion Pictures and Youth: A Summary*, New York: Macmillan.
Comolli, J-L. (1986) 'Technique and ideology: camera, perspective, depth of field', in Philip Rosen (ed.) *Narrative, Apparatus, Ideology*, New York: Columbia University Press, pp. 421–33.
Dick, P. K. (1968) *Do Androids Dream of Electric Sheep?* New York: Ballantine Books.
Freud, S. (1959) 'The "Uncanny"', in *Collected Papers*, vol. IV, New York: Basic Books, pp. 368–407.
Hall, S. (1990) 'Cultural identity and diaspora', in Jonathan Rutherford (ed.) *Identity: Community, Culture, Difference*, London: Lawrence and Wishart, pp. 222–37.
Hansen, M. (1993) '"With skin and hair": Kracauer's theory of film, Marseilles 1940', *Critical Inquiry*, 19(3): 437–69.
Haraway, D. J. (1991) 'A cyborg manifesto: science, technology, and socialist-feminism in the late twentieth century', in *Simians, Cyborgs, and Women: The Reinvention of Nature*, New York: Routledge, pp. 149–81.
Harvey, D. (1989) *The Condition of Postmodernity*, Cambridge: Blackwell.
Horkheimer, M. and Adorno, T. W. (1991) 'The culture industry: enlightenment as mass deception', in *The Dialectic of Enlightenment*, New York: Continuum, pp. 120–67.
Jameson, F. (1991) *Postmodernism, or, the Cultural Logic of Late Capitalism*, Durham, NC: Duke University Press.
Kracauer, S. (1993) 'Photography', *Critical Inquiry* 19(3): 421–37.
Lacan, J. (1977) 'The Mirror-Stage', in *Écrits: A Selection*, New York: W.W. Norton, pp. 1–7.
Miller, D. A. (1988) *The Novel and the Police*, Berkeley and Los Angeles: University of California Press.
Oxford English Dictionary (1989) Oxford: Oxford University Press.
Rutherford, J. and Bhabhal H. (1990) 'The third space: interview with Homi Bhabha', in Jonathan Rutherford (ed.) *Identity: Community, Culture, Difference*, London: Lawrence and Wishart, pp. 207–21.
Shaviro, S. (1993) *The Cinematic Body*, Minneapolis: University of Minnesota Press.
Smith, M. (1994) 'Altered states: character and emotional response in the cinema', *Cinema Journal* 33(4): 34–56.
Williams, L. (1991) 'Film bodies: gender, genre, and excess', *Film Quarterly* 44(4): 2–13.
Young, I. M. (1990) *Justice and the Politics of Difference*, Princeton, NJ: Princeton University Press.

Cybersubcultures

DAVID BELL

INTRODUCTION

THIS SECTION OF *THE CYBERCULTURES READER* addresses the kinds of 'subcultural' or 'countercultural' work taking place in cyberspace. We here take the word subculture to mean, as Sarah Thornton (1997: 1) says, 'groups of people who have something in common with each other (i.e. they share a problem, an interest, a practice) which distinguishes them in a significant way from the members of other social groups'; the prefix 'sub-' here stands in for 'subordinate, subaltern or subterranean' (ibid.: 2). To expand this to a working definition of cybersubcultures, we need to consider two kinds of subcultural relationship to cyberspace; the five chapters in this section each discuss distinct subcultural formations which either (i) signal an expressive relationship to digital technology, or (ii) make use of it to further their particular project. In some cases, of course, the two become intertwined, since cybersubcultures are often defined by both their use of and their relationship to cyberspace. To get a clearer handle on this definition, it is best to turn to the individual essays in this section.

Deena Weinstein's and Michael Weinstein's 'Net game cameo' is a parody of some of the subcultural responses to cyberspace currently articulated on the Net. Its authors identify six such orientations, which they label 'New Age Cyber-Hippie', 'Net Defender', 'Marxist Theoretician', 'Net Promoter', 'Net(-Hype) Hater', and 'Cyber-Punk Provo-Geek Techno-Luddite'. While not exhaustive of the subcultural takes on cyberspace, 'Net game cameo' playfully sketches the kinds of arguments that reverberate through cyberculture – we can see in the cameos traces of the debates around cyberspace that appear in the first section of the Reader.

In terms of subcultural formations in cyberspace, perhaps the most interesting cameos are the 'New Age Cyber-Hippie' and the 'Cyber-Punk Provo-Geek Techno-Luddite'. The first states, with a utopian refrain, that 'the Net is the nervous system of heaven', while the second proclaims '[w]e hate technology and we have mastered it – the ultimate cyber-punk horror story: the enemy within'. Of course, there is a further subcultural

position which expresses its relationship to new technology by rejecting it wholesale – the so-called Neo-Luddites. But the prospect of the 'enemy within' is, as Andrew Ross shows in 'Hacking away at the counterculture' (chapter 16), the most threatening and therefore the most demonized of cybersubcultures.

Not all of the cybersubcultures currently found on the Net have such a distinct stance (either pro- or anti-) on the technology of cyberspace; for some, it is an enabling medium of communication, information and community. The next three essays in this section all discuss subcultural groupings in cyberspace which have particular kinds of prominence on the Net. The first, Susan Clerc's 'Estrogen brigades and "big tits" threads', is about on-line fandom. Fan groups have made incredible use of cyberspace, in part as the logical extension of off-line fan activities – though the use of electronic communication is certainly reshaping the subcultural practices of fandom in a number of important ways. Fandom had already formed intricate webs or networks of like-minded people sharing common interests, common practices and even a common language long before cyberspace came along. But, as Clerc shows, the increasing importance of cybercommunications to fandom is having significant effects on the ways cyberfandom works for fans.

Clerc is interested in the experiences of women fans (in her case, of certain TV shows) both off- and on-line. As she says, the majority of 'media fans' (i.e. those who participate in the practices of fandom that cluster around these shows) are women; however, there are more men taking part in on-line fandom, and Clerc introduces her own cameo, 'Mary Sue', in an attempt to explain why. There are a number of obstacles in the way of women as on-line fans (social and economic factors dominate Clerc's discussion); moreover, the 'culture' of the Net itself, she argues, can deter women from full participation. For example, the 'big tits' thread in her title refers to on-line discussions by male fans of the sex appeal of female characters/actors which many women find off-putting (and immature – Clerc refers to the posters as 'boys'). Hypocritically, when women share 'lustful thoughts' about male actors/characters, men respond with hostility, flaming the women. In Clerc's account, then, net fandom replicates many of society's gendered norms, as well as policing their transgression. But fans are notoriously resourceful, and women fans do find ways to make productive use of cyberspace, in part by establishing private listing (such as the 'Estrogen Brigades' of various series stars and the ironically-named Star Fleet Ladies Auxiliary and Embroidery/Baking Society) away from the male-dominated public lists and newsgroups, where they can, among other things, circulate the 'slash' fiction that has long been a prominent feature of women's fan practices. A further unique feature of on-line fandom which Clerc focuses on is the fact that actors and writers sometimes have a presence on-line, even joining in with discussions. This generates not only excitement among fans, but also its own folklore (*The X-Files* is probably the most well-known example of this interaction between fans and producers on-line; see Clerc 1996).

The folkloric dimension of cyberculture is central to Richard Thieme's short, critical essay on on-line Ufology. Thieme uses Richard Dawkins' concept of the meme – a kind of cultural equivalent of a gene or virus; a 'contagious idea' (see Shawn Wilbur's essay in section one) – to explore how UFO myths solidify and gain legitimacy in cyberspace. As with Clerc's discussion of fandom, Ufology obviously predates cybercommunication,

but Thieme draws out the ways in which the UFO cybersubculture operates within the context of the technology. Discussions of UFOs and aliens, the paranormal and conspiracy theories of all hues have proliferated in cyberspace, building up an elaborate (and labyrinthine) virtual world. Thieme's interest lies with the UFO cybersubculture – or, as he says, what might be called 'the UFO religion on the Internet', which he describes as 'a huge supermarket of images and words' where '[e]verything is for sale – stories and pictures, membership of a community, entire belief systems'. He thus sets about tracking the UFO meme as it 'mutates into new forms, some of them wondrous and strange'.

The credibility of UFO stories on the Internet builds up, in Thieme's view, through a dense cross-referentiality, so that rumours and half-stories rapidly accrete a protective shell of 'truth' (mainly through endless co-present citations – like a speeded-up version of urban folklore). The propagation of dominant legends of the US (and, almost by implication, the global) UFO mythology – Roswell and the 'autopsy film', Area 51 – is here traced through networks of speculation, conspiracy and counter-conspiracy, memetically transmitted through cyberspace, and able to absorb increasingly diverse threads into a huge conspiratorial narrative: government or super-government collusion with ETs, secret bases, policies of disinformation and smokescreening, men in black, black helicopters, cattle mutilations, alien abductions, alien-human hybrid breeding programmes, and so on. It all sounds like terrifying stuff, yet Thieme shows the limits of the UFO cybersubculture, arguing, ultimately, that the 'pursuit of the truth' must be 'rigorous, disciplined, and appropriately skeptical' – characteristics he finds woefully lacking on the Internet.

Conspiracy-mongering in cyberspace is not limited to speculation about UFOs, of course. Susan Zickmund's essay, 'Approaching the radical other', explores the circulation of extreme right-wing and white supremacist materials on the Net, finding conspiratorial threads woven across disparate groups, many of whom in the US target the government (often referred to as ZOG, or the Zionist Occupation Government) as complicit in their perceived marginalization, oppression and persecution. The Internet has given such groups greater visibility, Zickmund argues, and has also allowed them to circumvent state laws prohibiting the publication and distribution of offensive materials (illustrated by Germany's attempts to get CompuServe to restrict the flow of subversive materials into the country). The visibility of what Zickmund calls 'cyberhate' has, indeed, been given prominent attention in debates about the regulation of the Internet, stretching the bounds of 'free speech' in its electronic forms (see also Whine 1997).

What interests Zickmund most are the discursive formations of cyberhate – how this particular cybersubculture builds up its own constructions of the Other (African-Americans, homosexuals, Jews, ZOG), rallying members with potent war-cries, recruiting new members and affirming the beliefs of fellow cyberextremists. The specific enabling technology of cyberspace has given these groups a sense of (national and global) connection, coalescing their belief systems. At the same time, however, Zickmund describes discursive interventions by anti-fascist 'antagonists' to extremist newsgroups; so, the interactivity of cyberspace also facilitates antagonism, as transcripts of exchanges clearly show. Zickmund concludes that such interventions represent a viable alternative to censorship or extremists on the Net, forcing them into dialogue with 'outsiders' rather than allowing them to ferment in isolation.

The last two essays in this section deal with cybersubcultures in which the technology is much more than just an enabler of widespread, faster and greater interactive communication: in Andrew Ross' chapter on hackers and Tiziana Terranova's on 'high-tech subcultures', the relationship between technology and the subculture is revealed as an intimate one; without the technology, these subcultures would not exist. In 'Hacking away at the counterculture', Ross takes us into the world of that most demonized of cybersubcultures, computer hacking. The moral panic around hacking in the US exposes the complex social positioning of computer technologies within national ideologies, while the tale from inside the hacking cybersubculture speaks of freedom of access to information, of opposing state secrecy, and of being, to echo Weinstein's cameo, 'the enemy within' (see also Jordan and Taylor 1998).

Ross' reading of one prominent case of viral hacking, executed by Robert Morris in 1988, shows the repositioning of the hacker as juvenile and amateurish within official discourse as an attempt to disarm and depoliticize the activity. This leads Ross into a consideration of the countercultural logic of hacking, noting that, unlike the 1960s counterculture, hacking is 'not a dropout culture' but one that 'celebrates high productivity, maverick forms of creative work energy, and an obsessive identification with on-line endurance' – a theme also picked up in Terranova's essay. However, Ross argues that hacking must be read as a countercultural activity, and seeks out traces of hacking-like subcultural activity in, for example, workplace 'sabotage, time-theft and strategic monkey-wrenching' among workers in the information industries; a more *generous* definition of hacking, then, shifts the emphasis away from an elite cybersubculture to include other forms of technologically enabled resistance. Ultimately, Ross (like Thieme) calls for an informed 'technoskepticism' as the cultural critic's best place in debates about new technologies: to have a 'hacker's knowledge', to be an 'enemy within'.

Beginning with a brief overview of the appearance of the figure of 'post-human' in the cyberpunk genre (a figure we shall see again elsewhere in this Reader), Tiziana Terranova's essay describes the world of a number of what she calls 'techno-tribes' who are currently articulating and enacting a particular relationship between the human and the technological. Post-humanism considers the future co-evolution of people and machines symbiotically, and Terranova traces the forms of post-humanism manifest in cyberpunk magazine *Mondo 2000*'s notion of the 'New Edge' (see also Sobchack in section two), in a grouping known as 'Extropians', and in on-line discussions of the emerging human-machinic intimacies of the 'cybercultural spirit'. The future for these groups is a harmonious melding of 'meat' and 'metal', as we become, in the words of *Mondo 2000* editor R.U. Sirius, 'less and less creatures of flesh, bone, and blood pushing boulders uphill; [and] . . . more and more creatures of mind-zapping bits and bytes moving around at the speed of light'.

Part of the post-human discourse propogated in *Mondo 2000*'s New Edge is of a distinct personality-type receptive to the promises of post-humanism. A similar view is also expressed by the Extropians, who advocate a professionalized immersion in the future developments necessary for transformation – building up a kind of vanguard who will lead the evolution to post-humanism. Crucially for Terranova, the Extropians advocate a style of 'free market' anarchism (Terranova labels this 'rampant super-voluntarism') which is thoroughly utopian (yet exclusionary), setting them apart

from the dystopian cyberpunk imaginary of *Mondo 2000*. Nevertheless, both groups are promoting a post-human future which, Terranova argues, is blind to issues of social, economic and political inequality: the world they dream of will be, it seems, populated by a post-human elite – and where will that leave the rest of us?

The proponents of New Edge and Extropian post-humanism represent a cybersub-culture completely immersed in the enabling technologies of cyberspace. A great distance separates them from on-line *Star Trek* fans, white supremacists or Ufologists (although there are often overlaps between these discourses, as the Heaven's Gate cult showed; see Bozeman 1997). A great distance also separates post-humans from hackers, whose involvement in cyberspace comes with different motives and practices. Nevertheless, what the chapters in this section suggest is that cyberspace offers the opportunity for a wide range of subcultural activities, and has given rise to some distinct cybersubcultural formations.

References

Bozeman, J. (1997) 'Technological millenarianism in the United States', in T. Robbins and S. Palmer (eds), *Millennium, Messiahs, and Mayhem*, London: Routledge.

Clerc, S. (1996) 'DDEB, GATB, MPPB, and Ratboy: *The X-Files* media fandom, on-line and off', in D. Lavery, A. Hague and M. Cartwright (eds), *Deny All Knowledge: Reading the X-Files*, London: Faber and Faber.

Jordan, T. and Taylor, P. (1998), 'A sociology of hackers', *Sociological Review*, 46 (4): 757–80.

Thornton, S. (1997) 'General introduction', in K. Gelder and S. Thornton (eds), *The Subcultures Reader*, London: Routledge.

Whine, M. (1997), 'The far right on the Internet', in B. Loader (ed.), *The Governance of Cyberspace: Politics, Technology and Global Restructuring*, London: Routledge.

DEENA WEINSTEIN AND
MICHAEL A. WEINSTEIN

NET GAME CAMEO

THE PLAYERS OF NET GAME address the question of the effects of the Internet on social relations.

1. New age cyber-hippie

I deserve to come first. I'm the only one who truly loves the Net.

For ages, human beings have dreamed of something greater than themselves. With the advent of historical thinking, many began to dream of humanity creating out of itself its own supersession – humanity as the frontier of cosmic evolution! Now it has happened – the modern dream is materializing; humanity is being overcome through its own development.

We are spirits and we are free. The Net is our body and we – the authentic netizens – are the next stage of evolution – beyond the all-too-human, to the true and the spiritual. We give our bodies to our spirits as our bodies give the earth, air, fire and water to themselves. We take the better portion. Our bodies serve the souls that emerge through the interaction of souls on the Net. It is a new level of being. Not more 'real' in some unknowable sense than the so-called material or perceptual world, but, rather, its present perfection – some day in the future itself to be surpassed but now the frontier.

Our future is the MUSH – The Multiple-User Shared Hallucination – in which people enter a cyber-environment and live out lives there as pure selves that are constituted only by their interaction on the Net. In the purest case, they will never be able to find out who their fellow netizens actually are in the corporeal world. The worst punishment that can be meted out is exclusion from the community, which is, of course, cyber-death. But then you could get a new account and log on again, and take up a new life, even in the community that just excluded you, if not one of the scads of others

that are always popping up. Short of banishment, there is only flaming and unrespon-
siveness. Your precious flesh remains unscathed.

Think of it this way: in the modern period you had a split between fact and fiction,
between history and literature, between experience and imagination. Now, on the Net,
what once might have been fragments of my personal literary imagination become partic-
ipants in social relations and, therefore, become what they could never have been without
the interaction. Imagination becomes genuinely social in cyberspace. The Marcusian
dream of transcending the realm of necessity into a realm of artistic play is coming true.

By choosing the spirit, I have liberated my private imagination to enter into rela-
tions with other imaginations and thereby to be transformed. I can see a time when the
day will be divided into three parts. One part will be sleeping, another part will be
working (and much of that will done over the Net) and caring for the body, and the
final and most important part will be cyber-relations. If automation proceeds to the
point at which the work day can be shortened, the surplus time will be apportioned to
cyberspace and to conventional corporeal non-occupational activities only to the extent
that they are instrumental to the enhancement of cyber-relations. We will sleep and
dream and work and love corporeally and care for ourselves as preparation for the time
we spend in our cyber-communities where our better and best selves grow. It is not
too much to say that the Net is the nervous system of heaven.

2. Net defender

I find that I cannot agree with the previous speaker. Face-to-face friendship, love and
colleagueship are the highest ends, not some overcoming of humanity. I defend the rela-
tive autonomy and the value of a moral relation to and through the Net that is based
on the objective possibilities for relations among individuals that the Net permits and,
indeed, encourages, as what Jacques Maritain called an infra-valent end; an end that has
its own intrinsic value, but is also an instrumental value to a greater end. Or, as John
Dewey conceived of it, the best experience is one that is both a consummation and a
means to future consummations.

The positivity of the Net is its possibility of creating voluntary community through
mediated conversation. In a negative sense (in the Hegelian sense of 'negative' as
abstract), the Net abolishes physical distance between communicators, making everyone
who's wired accessible to everyone else. In a positive sense, the Net provides a field
for experimentation (instrumental activity) and play (consummation) that by virtue of
its mediated character becomes free from the demands of face-to-face or even telephonic
relations, and, therefore, liberates expression and encourages play with self-definition.
In return for the fullness of a close face-to-face relation, we must sacrifice our ability
to vary ourselves and give vent to our reactions. The Net's particular form of indirect
mediation encourages variation and experimentation in expression and conversation.
That is why endogenous theorists of the Net are nearly always both libertarian and
communitarian.

At its best, the Net is an array of voluntary communities of inquiry and comrade-
ship sustained by the free commitment of their members. There is nothing mysterious
or marvellous about this. It boils down to people around the country or the world who
are caring for someone with a degenerative disease forming a community of support

and information outside the aegis of any medical organization. It amounts to people who share all sorts of common interests pursuing them and also exposing themselves to disturbing interlopers bringing the bad news.

As a moral possibility, the Net is an anarcho-democratic community. It is a mistake to conceive of it as a model for corporeal community and an abomination to consider it a substitute for corporeal community. Think of it as a zone of freer communication than is social-psychologically possible in other contexts, something like – though not the same as – academic freedom in the context of higher education: a special opportunity to explore, experiment, learn and appreciate: a special opportunity for people to help and enjoy each other apart from the disciplinary discourses and practices of hierarchical organizations.

The Net offers the possibility of voluntary community on a scale and with a workability completely unknown until now. Networking on the Net and sustaining the Net as free and pure a medium for all messages as possible – consistent with the perpetuation of voluntary community – is the beach head of the New Left in cyberspace.

3. Marxist theoretician

I think a word from the old left is called for here, a good old-fashioned Marxist critique and analysis. Things haven't changed all that much since the Manifesto. We still have to contend with utopianism.

Let's retreat a bit from the wild-eyed, infantilist if I might say so, idealism of the so-called New Age Cyber-Hippie. This collective solipsism of the Net is merely the fantasies of the technical intelligentsia of the computer-communications complex. A case of organizational psychosis (Dewey) and trained incapacity (Veblen) – trained incapacity in the ability to think scientifically in this case – a superb irony for an operative in highly rationalized technical networks. Technically, the networks are rationalized. Ideologically they index the contradictions of late capitalism, which is destroying society to such an extent that people flee to computer screens for compensation and breed a crowd of ideologists who tell them that they are pioneers in a new stage of cosmic evolution! Rather, they are waste products of capitalism, which is pleased to have them in their 'alternative worlds' when they are not at work. These are high-maintenance kids put off to pasture on the Net. Sooner or later capitalism will find a way of taking those worlds of self-experimentation over. Until then a decadent and despairing young intelligentsia finds its own devices of pathetic amusement.

Let us get closer to reality, to material conditions, by going back to the Net Defender, who correctly places the Net and its sociality into the sensuous experience of human society, but remains a bourgeois individualist by directing Net community to fuller personal relations rather than to revolutionary praxis to transform actual social relations, which is the only way to guarantee personal relations, which are imperiled under the autistic consumer behaviour fostered by late capitalism.

Our task as Marxists who are involved in the Internet is to devise ways of using its distinct characteristics to best effect to further revolutionary praxis. We need to infiltrate cyberspace and learn to turn its conversations into opportunities for political education. We need to get members of oppressed communities linked by computer to better further their struggles against the system. We need to have clearing houses of

activist experience in all quarters of the struggle and our own computer discussion groups on strategy and tactics. We need to link activists around the world to be resource persons for each other, to share their experience and knowledge.

As we engage in revolutionary praxis on the Net, we will learn to appreciate, through our concrete transformative activity, the new turns in human relations that the medium imposes and permits, and we will learn to make them ever more serve our solidarity. But that solidarity will come as a reflective by-product of revolutionary praxis, not as its direct aim.

4. Net promoter

Let's get down to earth and get practical before we start soaring into thin air. We have a very bright future ahead of us in America if we have the wisdom and foresight and fortitude to do what's necessary to bring it about. We who proudly represent the emerging National Information Infrastructure (NII) are very pleased that we have both the Clinton administration through Vice President Al Gore and the Republican leadership through Speaker of the House of Representatives Newt Gingrich in our corner. We tend, on the whole, to favour the Gore approach, though we share much of the Tofflers' vision, appropriated by Gingrich, of a third-wave society based on individual empowerment. The basic point is that empowerment will only come through the institutions that we depend upon to sustain our life on earth, business enterprises, schools, hospitals, government agencies. They will develop the discussion groups, support groups and clientele groups that will sustain individuals in their quest for individuality.

We say to the Marxist theoretician: Haven't you heard? Communism is dead. Capitalism won! Capiche? Go play with your bulletin boards in cyberspace. When it comes to the Net Defender and the New Age Cyber-Hippie: You, my dear friends, are the cyber-incarnations of the 1960s counterculture, whose self-indulgence has endangered our country severely. We'll give you the cyberspace to play your games. Who knows? You might even come up with things that we can sell or apply.

Empowerment for individuals and groups is what the information superhighway is all about. The important thing is that everybody be connected and that there be interconnectivity among media. The goal is to give individuals, groups and organizations maximum access to what they need to satisfy their legitimate purposes.

Cyber-populism will give way to an institutional phase of the Net as organizations learn to use the Net in sophisticated ways for outreach and servicing. Eventually, organized players will offer management of an incredible diversity of socialization situations and scenarios on the Net. Support groups, common interest groups and chat groups will flourish under professional support. For example, I read somewhere recently that a garden supply business had started a gardening discussion group on the Net. This is the wave of the future: organizations facilitating socialization and therefore enhancing empowerment. Empowerment through connectivity!

5. Net(-hype) hater

I've had it! Enough! Internet discourse: Internet 'spirituality', Internet philosophy, Internet critical theory, Internet policy – it's all hype. This is the first time in 'history'

that philosophy has become so completely enmeshed in promotion that the two are indeterminate partners in a single discourse. The Bill Gateses, Steve Jobses, Mitch Kapors are the hypesters and philosophers all rolled up into one.

I hate the seduction of Net-hype. I hate the seduction of the Net. I hate the virtual community as a substitute for the streets and the flesh. The fact is that the Net is an emerging complex of communications media that has not yet reached its full rank among communications media and is, therefore, still 'full of promise', breeding utopia and dystopia about it, and endless hype and vision: it can still be promoted like land in Florida or nuclear power were in the 1950s.

Do I even care if humanity goes bug-eyed in front of screens, communing with perpetual email support groups, sometimes masquerading as newsgroups, as they wait – as in a universal hospice – to be replaced by androids?

Don't the technotopians see? The Internet as anarchy, that is, the Internet as a vehicle of academic freedom – the old ARPAnet that the Defence Department created to expedite cold-war military research and was captured by the academic side of the military-academic complex – is a totally elite-utopian moment; the Internet as anarchy is about to cede, as the Net Promoter knows, to the Internet as pan-capitalist facility. We are going through a doubling process, the Internet is being absorbed into the environing retro-modern, pan-capitalist scene – the post-postmodern. Welcome to the retro-modern. Darwinian capitalism rides again on the Net. The Net is passing from libertarian utopia to techno-capitalism.

You ask what the Net will be? It will be continuous spamming. The Net will duplicate the fallen creation in cyberspace. From the Net salvation doth not come. Everything we have already will be in cyberspace in pretty much the same proportion as we have it through the media-scape. Basically, whatever you can make a buck on will have its cyber-equivalent. A certain number of people will be sucked into cyberspace and become dependent on it for self-maintenance. Others will use it, among other media and relations, for self-maintenance. Others will opt out at the price of some exclusion from valuable practical and social connection.

Newt Gingrich was *Time Magazine*'s 1995 Man of the Year. *Newsweek*'s competing issue declared 1995 the Year of the Internet and featured on its cover a cartoon of Microsoft's Bill Gates dressed as Santa Claus. There ain't a chip's worth of difference. Two tech hypesters. Is there a message here about hegemonic media and the future of the Net? I've seen the future and it's Newtergates.

6. Cyber-punk provo-geek techno-luddite

Excuse me, but you're all full of (cyber-)shit. The Net is more technology to master in order to bring it down from the fuckin' insides! I'm the Unabomber hacking code. I'm spreading viruses everywhere – the AIDS of cyberspace. I'm the cyber-punk provo-geek techno-luddite.

I'll use the fuckin' Net as a lonely-heart's club where I'll prey on whomever I please, at whatever age, as I please. I heard a great story the other day about an elderly Jewish gentleman who disagreed with a Nazi skinhead on the Net. The Nazi skinhead, knowing no fetishism of the Net, no taboos and sacred spaces, tracked down his critic in perceptual space and threatened the Jewish gentleman with physical death, which led

to said Jewish gentleman having to relocate to another region of the country. Let them talk about cyberspace as something special – it's just another scam.

I'll hack you and jack you and smack you and whack you in every cyber way and will hold you physically accountable for your cyber-personalities.

I am the provo nihilist. Bring it all down from the inside. Eliminate all boundaries between the Net and perceptual life. Destroy the Net. Threaten security of private information, medical records and financial transactions in any way you can. Break into data banks and mess them up. Falsify records. Use cyber-communities to draw the poor souls in them into humiliating and exploitative relations. Perpetuate misinformation, disinformation, rumour and hate speech on the Net. Intimidate and humiliate with your flames. Bring the world and Net together at every opportunity in calamitous and degrading encounters. Commit financial fraud on the Net and become a martyr to our cause if you get caught. Cause information overload in the system at social crisis points.

We are avowed terrorists. Some day we might go to work for a fascist leader. Hey! We're in training. Our aim is to cause feelings of insecurity and danger about the Net so that people and organizations are as scared to go on it as suburbanites are to walk through an inner-city housing project. We aim to make the Net at least as unfriendly as nuclear power has become.

We infiltrate the Net as techno-geeks and then become the cyber-parasites that destroy it.

We're going to make life as tough as we can for as many people on the Net as we can. The best way to show that something's a utopia is to bring it down. We'll violate your email and use it against you. Some day we might work for large organizations as enforcers and disciplinarians – cyber-torturers. Perotistas?

Get a life! We intend to throw you off the fuckin' Net by making it unattractive to you by any means necessary, whatever it takes. We hate technology and we have mastered it – the ultimate cyber-punk horror story: the enemy within.

Originally published in A. Kroker and M. Kroker (eds) (1997) *Digital Delirium*, Montreal: New World Perspectives.

SUSAN CLERC

ESTROGEN BRIGADES AND
'BIG TITS' THREADS
Media fandom on-line and off

I N 1991, THE SMALL COLLEGE I worked for in western New York went
on-line and gave me an email account. Within a few months, I was up to my armpits
in fan fiction and sleeping in hotel rooms with strange women. I'd found media fandom
through the Net.

It's actually hard to miss fandom on the Net, thanks to the dozens of newsgroups
and mailing lists devoted to TV series, but the Internet, Usenet and pay services like
America Online and GEnie are only part of the picture, one type of venue for fandom.
Off-line fandom existed long before on-line fandom, and I've found it interesting to
explore how they overlap and diverge and the different roles women play in each.

Fandom is a community, a social network of small groups and individuals scattered
across the United States, Canada and other English-speaking countries, created and main-
tained through overlapping, conflicting, complex ties to each other. Fannish activities
are the ties that bind the community together. Though the activities are diverse, many
are discursive – the most primal instinct a fan has is to talk to other fans about their
common interest.

Fannish forums

Before modems made newsgroups, mailing lists and email part of daily life, fans created
a number of print venues that let them communicate with each other: APAs (amateur
press associations), letterzines and newsletters, all of which differ from each other more
in format than in content. APAs, for example, tend to exist of a fixed number of people
all of whom supply the editor with enough copies of their contributions (or 'tribs') for
all the members. The editor then collates and mails the compilation to each individual.
A certain level of participation is mandatory for inclusion – no lurking allowed. The
result is a fairly close-knit group who feel freer to include personal information than,

say, the average poster to a *rec.arts* newsgroup does. Letterzines, on the other hand, work on a subscription basis without a participation requirement; they are more like Net groups in that more people receive and read the letterzine than actively contribute to it. Newsletters, of course, are publications from fan clubs, either local or national. All of these venues, like Net groups, include a mix of content, but the amount of irrelevant chatter is much lower in print than on-line and the number of people involved is usually smaller.

Fans, whether on-line or off, discuss characterization (if Avon really doesn't like Blake, why does he keep following him?); express their affection for, or dislike of, particular characters; alert each other to appearances by the actors on talk shows or in other roles; compile lists of useless information (for example, versions of Dr McCoy's 'I'm a doctor, not a . . .'); speculate about what would have happened if some feature of a story had been different (what if Blake hadn't disappeared after the second season?); compare series, seriously and not so seriously (*Star Trek: The Next Generation* versus the *Love Boat* – bald captain, black bartender, annoying teenage child of crew member); make up drinking games (take one sip every time Agent Mulder from *The X Files* drops his gun); and hash over any number of other issues arising from the aired episodes.

Analysing the events in specific episodes is probably the most common form of discussion. Fans try to fill in the gaps left by writers and form connections between episodes. An *X Files* letterzine, for instance, might be filled with letters speculating about what happened when Agent Scully was abducted, using evidence from previous and subsequent episodes. In addition to group discussions on-line and off, fans are compulsive letter-writers, with voluminous one-on-one correspondence. On-line, email takes the place of 'snail mail'. For many fans, Net groups are a continuation of off-line practice, the proverbial old wine in a new bottle, because they have always engaged in the sort of long-distance communication we see on-line.

The social network isn't restricted to remote communication, however: many fans belong to local groups. Some are formal fan clubs, but many are informal circles of friends who get together on a monthly basis to watch episodes of favourite shows and chat. On a larger scale, many fans also attend conventions ('cons') at least once a year. Cons are a chance for fans to meet each other for the first time, for those who have become acquainted through print or Net discussion groups to meet face-to-face, and for friends who live far away from each other to get together.

At my first con – Visions, a British media con held annually in Chicago – I struck up a conversation with a woman standing next to me in an autograph line; she turned out to be from my area and part of a *Blake's 7* group, and now I commute to Cleveland every month for a party with them. The next con I attended was MediaWest, held every year in Lansing, Michigan; there I roomed with a woman I'd met only on-line. Now my usual con-going roomie is someone I met on-line first and in person later at a con (hence my reference to sleeping with strange women in hotel rooms). I look forward to seeing a few long-distance friends at every con.

In media fandom there are essentially two kinds of cons, those with guests (actors, writers and others associated with production of the series) and those without. If guests are present, the convention centres on them, including question and answer sessions, autograph and photo sessions, and often a variety show in which the guests perform. Fan-centred events are also scheduled but often take second place to the celebrities. At cons without guests, all of the events focus on the fans. There are discussion panels,

fan artist exhibitions, filking sessions (filk songs are song parodies or sometimes more serious ballads) and costuming contests.

Music videos, paintings, costumes and filk are all widespread creative outlets for fannish passion. However, the best-known and most popular creative outlet is fan fiction.

Fans themselves question why they write and read stories using the characters from TV universes. The most basic answer is 'We want *more*'. In a sense, fan fiction is an extension of the analysis and speculation fans do in APAs and other print venues. Before I got on-line, I thought writing fan fiction was as fundamental to anyone with an imagination as eating chocolate is to anyone with a mouth. I'd been doing it all of my life; from the time I was six and my best friend, Peggy, said, 'Let's play *Man from U.N.C.L.E.*,' I've been rewriting scenes from my favourite shows in my head. It seemed to me the most natural thing in the world to want more of what I liked: more of these characters I loved, putting them in new situations, taking them where the TV writers couldn't or wouldn't, filling in the scenes that were left out.

What are all these women doing here?

Almost all fan fiction is written by women, which leads to a very important point about off-line fandom: the majority of media fans are women. Women write and read almost all of the fan fiction, make the music videos, create the artwork, organize and attend conventions, run APAs and letterzines and belong to fan groups – they are actively involved, in greater numbers than men, in every facet of media fandom. Media fandom wouldn't exist without women because more women than men do the communication work necessary to forge and sustain the community. The public impression that males dominate fan activities is largely the result of outsiders' emphasis on *Star Trek* fandom, which does seem to consist of more males than females. But this emphasis misses the nature of the fannish subculture as a whole. The misconception that males dominate media fandom is also on-line-fostered; there are simply more men than women on-line. My composite friend, Mary Sue, illustrates why women play a much less prominent role in on-line fandom than they do in fandom off-line.

Getting wired

Mary Sue has been active in off-line *Robin of Sherwood* (*RoS*) fandom for several years. She writes fan fiction, belongs to an APA, attends conventions at least twice a year and corresponds with a dozen fan friends. She regularly gets together for a bash with local fans to talk and watch episodes of *RoS*. Like many other series that fans have taken a shine to, *RoS* lives on in fandom thanks to the extensive network of videotape sharing within the larger fan community. Tape sharing is the way fans pimp for their favourite series, especially the ones that are no longer on the air: they send friends they want to lure into fandom episodes they hope will hit their kink ('this one guy is such a bitch, you'll love it', 'it has story arcs and the characters really develop over time', 'the relationship between the two male leads is intense').[1] The more people hooked on the series, the greater the chance that stories and art will be generated. And of course, the more people to discuss the show with, the better.

To pimp for her current favourite series and to create music videos and gather information for discussion or fan fiction writing, Mary Sue has two VCRs and a TV. These machines are a vital part of her fannish life. She also has a computer she uses to write fan fiction and letters to her numerous fan friends, and perhaps even to produce a fanzine. Like the TV and VCRs, the home computer is a tool that lets her participate fully in the community. What Mary Sue didn't have when I met her was a connection to the Internet. But she didn't think she needed one: of her dozens of acquaintances, only a handful were on-line and they were still reachable by 'snail mail' and telephone.

Like most of Mary Sue's friends with Net access, I got my account through work and it was free (I just had to avoid my snooping employers). We all raved about how fast email was compared to regular mail, how lively the big mailing lists and newsgroups were, how easily pictures and sound files and transcripts of episodes and other goodies were available through FTP, and we all urged Mary Sue to get a modem and join America Online, GEnie, CompuServe or one of the other commercial services, although this would take a little money to begin with. 'What money?' she demurred.

A year went by, and more and more of Mary Sue's friends went on-line and it began to seem like a good move to her, too; the advantages of being able to communicate quickly and easily with a large number of friends were starting to outweigh the costs and headaches of getting set up. During that same time, her husband tinkered with their computer and installed a modem. When Mary Sue asked how it worked, though, he didn't have time to help her. Like many fan women in her position, Mary sue finally turned to friends who were already wired for help. The informal support network fandom provides for its members came to the rescue as friends offered advice about freenets, on-line editors and subscribing to mailing lists, and even camped over for weekend tutorials on using the new medium.

The point of this scenario is that fan women, although mechanically proficient and technologically savvy compared to the mainstream population, suffer from the same societal attitudes about gender and technology as everyone else. Women are also at an economic disadvantage: with less disposable income, they are not as likely as men to experiment with modems and software they aren't familiar with. Fan women may have an additional deterrent in that they are already extremely well-connected off-line to a large number of other fans. For them, there is little benefit to Net access unless many of their friends have it. When that critical mass is reached and it becomes beneficial to go on-line, fan women will likely turn to other female fans as an informal support network who can give in-person tutorials rather than to distance male technicians.

Most fan women enter the Net through work, because a male relative has set up the equipment at home or because their friends have access and encourage and help them. Their delayed entry (compared to males) into cyberspace is reflected in statistics about time on-line and age. Women who answered a survey I posted to several fannish groups in 1993 about fan net use[2] had been on-line for less time than the men who answered: 37 per cent of the women had been on-line less than a year, compared to 24 per cent of the men. The disparity was particularly noticeable among people who had had access for more than four years: only 14 per cent of the women fell into this group, compared to 29 per cent of the men. The women also tended to be older, suggesting that they were already out in the labour market when they gained access: most were aged 23–30 or 31–40 (37 per cent and 35 per cent), while most of the men fell into the 18–22 and 23–30 age ranges (38 per cent and 39.5 per cent); the percentage

of women over 40 is double that of men in the same age group (15.8 per cent to 7.9 per cent).

Going public

Once on-line, fan women participate in public mailing lists and newsgroups less than one would expect for such a communicative bunch, although women who have been active in fandom off-line may have an edge over those coming into the community through the Net. Those who are already fans have a tradition of female participation behind them and are likely to find familiar names waiting for them on-line, factors that may increase their confidence about posting. Yet they still post to public groups less often than men do. Women, regardless of their previous fannish experience, just don't talk as much in public as men.

If a newly on-line fan does pop her cherry and post, reaction to her maiden messages will affect her future posting rate. If everyone ignores the post, the newcomer may interpret the lack of response as a sign she is not welcome. However, not responding shouldn't necessarily be construed as a conscious attempt to bar women from discussion; it is often, rather, a sign of reluctance by members of both sexes to waste time on people who may not be in for the long haul. But getting no response does tend to happen more often to women than men. Susan Herring's research on gender-linked performance on academic mailing lists, which demonstrated that both men and women tend to respond more often to men than to women, even when the topic is more relevant to women, indicates that lingering social mores about women affect response.[3]

Each person has her or his own reason for not responding to a poster's first efforts, but for the poster languishing in the silence it feels like rejection. If a poster complains that she's never responded to, list members may be more conscientious about offering back chat for a few weeks, but this effort eventually tapers off because no one really wants to post or read an endless stream of me, too's. A complaint may generate private email rather than spark list discussion, in which case the intended goal of list conversation isn't met, but the list member is still made welcome. Once she has that 'off-stage' backing, she may participate more.

A direct ploy for dissuading women from posting is to send them offensive email. Women's magazines and other popular media have widely disseminated the idea that women are routinely hit on or subjected to crude insults on the Net. These exaggerated accounts may deter women from initially posting as much, as flame mail may silence them once they have spoken up. I've never received a 'wanna fuck' (a name I've seen used on one of the alt.sex newsgroups for this sort of obscene mail) in the time I've been on-line, although I've participated 'loudly' in several groups. From what others have told me, offensive email to women happens more often on the pay services than on the Internet and Usenet.

What does happen with disheartening frequency on Usenet is the 'big tits' thread. Depending on the specific newsgroup, readers are assaulted from time to time by posts from sexually and emotionally immature boys about Scully's big tits, Deanna's big tits, Beverly's big tits, Peri's big tits, Janeway's lack of big tits, and so on. Many women are put off by the obsession boys on-line seem to have with actresses' breasts and their compulsion for discussing them in public. Fortunately, big tits are not the dominant

matter of discussion on any of the fan-related boards. In fact, the subject is often easy to miss among the insightful, perceptive posts from both men and women about character motivations and what might happen in upcoming episodes. Unfortunately, a large number of juvenile 'big tits' posts can make women feel unwelcome and/or threatened, especially when the message is hostile and moves from mammaphilia to graphic descriptions of what the poster wants to do to the actress or character. Women themselves drool over the actors and characters, of course, but their posts are rarely of the 'I want to assfuck Ro Laren' variety which fanboys like to post.

As annoying as 'big tits' (and the like) posts are, it's essential to remember that they, and the problem of being ignored after posting your deepest thoughts, are minor worries – speed bumps rather than barrier walls. Many, many women do post actively on newsgroups and lists like *alt.tv.x-files, rec.arts.sf.tv.quantum-leap* the *Blake's 7* list and STREK-L (the large Internet *Star Trek* list). There are dozens of newsgroups and mailing lists, and women are on all of them, although women favour mailing lists while men go for the high-profile Usenet newsgroups. According to the survey that I conducted, 42 per cent of the women posted at least once a week to public lists, but only 22 per cent of the men did. In comparison, the weekly posting rates to newsgroups were 28 per cent for women and 37 per cent for men.

The difference is clearly the format and not the series: for example, although women are a very strong presence on STREK-L, they are less than a third of the posters on the newsgroups *rec.arts.startrek.current* and *rec.arts.startrek.misc* This is also true on the *Dr Who* newsgroup and list. The *Babylon 5* mailing list has a reasonably high percentage of women participants, but the newsgroup was almost exclusively male until very recently; and even now only a handful of women post regularly compared to the literally scores of men. The *Red Dwarf* newsgroup is almost completely male although there are certainly women fans of the series. The only newsgroup where women seem to account for half or more of posts is *rec.arts.sf.tv.quantum-leap*, and that series doesn't have a public mailing list. The other fannish newsgroups range in-between but always have fewer women than men. On several mailing lists, however, women are the majority of posters or a very vocal minority: the *Blake's 7* and *X Files* mailing lists seem to have more female than male contributors, and the *Star Trek, Highlander* and *Dr Who* lists have a plethora of outspoken women contributors. Some series that attract primarily female fans do not have on-line discussion groups: neither *Beauty and the Beast* (the TV series) nor *The Professionals*, two series more popular with women than men, has a public list or group devoted to it even though both generate a lot of fan fiction and discussion off-line.[4]

It's interesting to note that the last three times the question of creating a newsgroup was raised on the *Blake's 7* mailing list, it was raised by a male and contested primarily by women, which indicates a tension between male and female goals in communication. To grossly generalize, men communicate for status, and women communicate to maintain relationships.[5] This was spontaneously confirmed when several women responding to my survey cited a sense of community as one of the most valuable aspects of Net groups:

> I would not say my interests as a fan have grown quantitatively, but instead have changed qualitatively. I do not love B7 [*Blake's 7*], for example anymore than I did before, but I now feel less like an individual fan than a member

> of a community. When I talk about the *Star Trek* movies, for example, I tend
> to say things like 'most of *us* hated the fifth one' or 'we grieved when Gene
> died.' . . . I like feeling there are many kindred spirits out there who are
> supportive of my interests.. . . I like feeling very connected to all of the
> other fans out there.

Although some newsgroups manage to attain a sense of community, mailing lists are more likely to do so because of the way in which they are set up: few people post to them, so there is a feeling of familiarity (sometimes you wanna go where everybody knows your name), messages come directly to the subscriber as email, listowners maintain subscriber lists, so there is a record of who lurks as well as who posts, and many lists have archives that let subscribers access list history. In contrast, newsgroups have more posters and more anonymity – some posters use anonymous posting services, several on-line reading systems leave off the posters' names, browsers don't leave a trace, and posts disappear after a few days. Perhaps more importantly, as a couple of fan friends recently pointed out to me, you have to come out of the fan closet to join a mailing list: you can't pretend you are only casually interested in *The X Files* when there are fifty messages about it in your mailbox every morning. Commitment to the group, however mild, plus the personal admission, however casual, that the series does mean something to you, contributes to the lower noise level on lists. There are fewer 'trolls' (people who post chain letters, 'big tits' posts and the like, solely to get a rise out of people). Many people, like the fan quoted below, perceive a qualitative difference between conversation in the two formats:

> To be quite frank I have found the mailing list discussions I have had re: the
> series to be far more intelligent than *anything* I have read in the newsgroup.

Whether they choose newsgroups or mailing lists as their main Net neighborhood, women who post may run into an unexpected response: off-line, the presence of women in media fandom for any series is taken for granted; on-line, where there are large numbers of males unfamiliar with this tradition, the presence of women raises virtual eyebrows. Any public speech by women seems to stand out and often leads to the perception that women are talking more than men when, statistically, this is not the case.[6] When women appear to be in the majority on-line, someone is bound to ask, 'What are all these women doing here?' The question is usually accompanied by a statement like, 'I thought this series appealed mostly to guys, but most of the posts so far have been from the fair sex.' During one week, in fact, versions of this question appeared simultaneously on both the *X Files* and *Dr Who* mailing lists, and it appeared on the *Highlander* newsgroup while this essay was being written. Regardless of the poster's intent, the message behind the message is that 'this show is a guy-thing; there's something wrong with you for liking it'. The question may intimidate some women but usually leads to a barrage of posts along the lines of 'What is it you think women don't like: well-written scripts, witty dialogue, great characters?' and other rebuttals.

Going private

When gender differences are apparent on public lists and newsgroups, they tend to occur along traditional lines: women focus on character issues while men more often

discuss hardware and special effects. When divisions occur, and this is important to keep in mind, both sides usually continue to co-exist without rancor. Sparks can fly, however, when sex becomes an issue, as when women lust after actors or lament the dearth of good female roles in the series.

When women begin sharing lustful thoughts about the actors, the response is some-what hypocritical. A common, if mild, masculine response is 'How would you ladies like it if us guys started slobbering on about the actresses?' – a remark that blatantly ignores the rampant slobbering in the perennial 'big tits' threads. It also overlooks the fact that many of the posts about actors come from women who have contributed a lot to the group and who usually post more substantial messages, and that their comments are considerably more friendly toward the lust object than the men's posts tend to be.

More controversy is caused by comments about the lack of decent roles for women in TV series. After a few months of posting to STREK-L, I complained that all of the women in the series, supposedly in the distant future, use their husbands' last names (someone recently posted a similar objection on the *Babylon 5* newsgroup). I also commented that the roles given to women were still in the nurturing ghetto (doctors, therapists, bartenders) and that the only really forceful women were either evil or killed off, or both. Many women have made the same observations before and since in the *Star Trek* groups, and the typical response is a lengthy diatribe whining about white males being oppressed by politically correct minorities and declaring that politics should be left out of the discussion. The same objections, though often more rancorous, greet many discussions of homosexuality (gay fans have long called for representation in the *Star Trek* universe). *Star Trek*, say the heterosexual white boys, is too politically correct. Their *naïveté* would be touching if it weren't so depressing.

Rather than giving up on public groups entirely in the wake of such responses, many women have formed private mailing lists that combine the intimacy of small groups with a support network similar to the kind fan women create off-line. One of the first and best-known examples of the private lists is the satirically named Star Fleet Ladies Auxiliary and Embroidery/Baking Society, started by Janis Cortese after she expressed dissatis-faction with the women's roles on *Star Trek: The Next Generation* and was flamed for it.[7] The SFLA&E/BS carries on its own conversations independently of the large groups, but its members also participate in those groups and their reviews of episodes are always entertaining and thought-provoking. Their review of the *Deep Space 9* episode 'Through the Looking Glass', for example, had this to say about the portrayal of Kira in a mirror universe:

> People who are queer aren't queer to be weird or deviant or evil, and WOMEN who are queer aren't queer to make pre- and post-adolescent boys' palms get sweaty. This was pathetic – cartoon '*Penthouse*' lesbo-a-go-go crapola. Paramount, you may think you did something 'daring' or whatever with this, but trust us on this one – ooh-ooh-squeal scenes in which lesbian or bisexual women are presented as unstable, dangerous and oversexed are NOT AT ALL DARING *OR* FORWARD-THINKING. In fact, it is just about as reactionary and BORING as you can get.

Many of us regret that the SFLA&E/BS never tell us what they really think.

The SFLA&E/BS is one of a growing number of private lists sprouting from larger groups. There are also several self-named 'estrogen brigades', small private mailing lists

where women gather to discuss a favourite actor and other topics. Like Cortese's group, the estrogen brigade members post both within their own mailing list and to the big mixed-sex groups that spawned them. A brigade's name, attached to the posts to the larger groups alerts other women to the existence of alternative discussion, and acts as a defiant commentary on the 'nice girls don't act that way' double standard. The Patrick Stewart Estrogen Brigade (PSEB) seems to have been the first, but there are others; two I've seen frequently in .sig files are the David Duchovny Estrogen Brigade (DDEB) and the Siddig el Fadil Estrogen Brigade (SEFEB). (.sig files are signature files, lines some people append to their posts that contain their address and often a quote or other clue about their personality and philosophy of life.)

Conversation within these groups is by no means limited to drooling over actors, however. As one fan said:

> the list I'm on is the Duchovniks, which makes *no* attempt to hide the fact that we started primarily as a place to ooh and ahh over the magnetism of DD [David Duchovny]. We are NOT ruled by our hormones – they merely brought us together as a group. We have since found far more to bring us together than our interest in DD.

One of the most valued results of smaller women-only (or women-dominated) groups is the intimacy that develops between the members. As one of the members of the SFLA&E/BS said: 'I'm part of one of the longest-running slumber parties in history.'[8]

To some degree, the small on-line groups are computerized versions of traditional off-line fandom forms, like APAs, through which fan women have always found each other. They use a new medium to duplicate the webs of friendship that make up the heart of fandom. Since fan women on-line are a mix of women who are already fans off-line and those just entering the community through the Net, it is not clear whether these smaller on-line groups spring from traditional fan customs or from a more general feminine desire for community and intimacy, and it may be impossible to distinguish between those sources. Either way, the private lists created by fan women show their resourcefulness and creativity in adapting the medium to their own needs.

Fan fiction

The majority of fans on-line participate in at least one fan activity aside from Net groups (82 per cent of women, 57 per cent of men) and many of them started fan activities before getting on-line. Con-going is the most popular for old-timers and newbies alike. The second most popular – and the one that brings men and women fans into conflict with each other and fandom into conflict with the outside world – is fan fiction.

Fan fiction on-line has mushroomed in the last few years. There are at least four newsgroups dedicated to story posting, and at least three mailing lists. In addition, stories occasionally appear on discussion-oriented mailing lists when members decide to do a round robin (list members take turns writing sections of a story), and FTP sites around the world archive stories from lists and groups. Anonymous FTP sites allow people who cannot access the groups to recover the stories, as well as pictures, sounds and other goodies (some archives have transcripts of episodes and lists of fanzine editors, for instance).

Unlike the vast majority of print fan fiction, a lot of on-line stories are written by young men, many of whom have no knowledge of the off-line community and the history of fan fiction written by women. Opinions of the quality of their on-line fan fiction tend to be low among women with experience in fandom:

> I looked at some of the ST:TOS stuff in the archive and on-line and hated it. I thought it was dire and also boring, since most of it wasn't about K[irk] and S[pock], but about random characters created by boys who really just wanted to be ST [StarTrek] characters themselves.

The reasons for distaste are essentially twofold. One is referred to in the post above: the tendency of men to include themselves in their stories. Women who write fan fiction have long held this practice in disdain, sometimes criticizing any strong original female character as being nothing more than a stand-in for the author. Telling stories about themselves seems to be part of a male aesthetic, though, since it often happens in the male-dominated field of minicomics as well and is reflected in storytelling practices among men in general – when asked to tell a story, men talk about themselves and women talk about other people.[9]

The other characteristic about 'Boys' Own Stories' that turns off many female readers is an excessive interest in hardware, violence and convoluted plots that go nowhere. Fan fiction written by and for women has always focused primarily on the characters' relationships. Of course plots are important, but they are used to explore the nature of the characters (what would Spock do in this situation?) not just for the sake of creating something cool to blow up. I'm exaggerating here, of course. Yes, many men do write stories that deal sensitively and perceptively with the characters, and many women write stories about destroying horribly be-weaponed aliens; but with limited time on-line to choose what to read, many fans fall back on the reality that a great deal of fan fiction can be divided along gender lines:

> I am a fan off-line, too, and I am a big *X Files* fan now. But when I cruise the *X Files* creative list, which has a pretty high volume of original stories, I just ignore the fanfic by male posters. I never expect the boys to have the same interest or fan aesthetic that we have, since in my experience of *Blake's 7* fanfiction (the paper variety, not the digital) the best stories were by women. I usually have limited time to cruise Usenet anyway, and I want to maximize my chance of hitting something of value, so women's stories are the best shot I have.

The popularity and high visibility of fan fiction on-line have caused problems between fans and series-related people who are also all over the Net these days: producers of the series fans cluster around and corporate copyright holders.

One of the things many fans, especially men, like about Net fandom is that writers, actors and others involved in the series are also on-line. It's exciting to have discussions with someone who is responsible for creating a TV series, to hear his opinions and chum around with him. On the other hand, it can also have a chilling effect on the basic nature of fan debate – discussing interpretations of the series. J. Michael Straczynski (aka Joe or JMS), the creator of *Babylon 5*, is a regular participant on *rec.arts.sf.tv. babylon5* The condition for his staying on the newsgroup is that no story ideas appear there because it would open him up for lawsuits and the lawyers for PTEN (Prime Time

Entertainment Network, the pockets that fund the series) would force him to pull out. To most fans, his presence is well worth the restriction:

> This is truly a unique situation we have here and I am VERY glad to have the opportunity to discuss the show with the Great Maker. You must admit that everyone who reads this newsgroup has a much greater understanding of and appreciation for the show primarily because of the insights and answers provided us by Joe. Woe to the person/persons who destroy that line of communication by posting fanfic here!

To others, however, it is an unwelcome limit on their options. Fan fiction is all about looking at a series from different angles and playing with possibilities left open on screen; if questions that could fuel this sort of fan play can be resolved with finality by deferring to the series creator, the game is ruined. The ban on fan fiction also interferes with one of the basic activities of fandom – wondering what will happen next. As one poster pointed out, many of the most interesting threads on the newsgroup arise from the sort of conversation that can easily cross over into the forbidden realm of story ideas:

> Given how long it takes for the story we are watching to get anywhere, speculation about future directions of the show is – in case no one has noticed – one of the meatier topics of discussion around here. 'What do the Shadows want?' 'What do the Vorlon look like?' 'What will the new Minbari government do?' 'What is Bureau 13 up to?' 'What are the extent of Talia's powers?' [. . .] 'The real reason the Minbari surrendered is that they wanted our hair care secrets and were afraid nuclear bombardment would destroy them forever.'

Aside from the PTEN/JMS ban, Paramount demanded that America Online and Prodigy pull *Star Trek* fan fiction from its databases and prohibit their customers from posting any more. But since there are still several Usenet newsgroups, Internet mailing lists (including one for *Babylon 5* fan fiction), private mailing lists that distribute fan fiction, and publicly accessible FTP sites where fans can find stories, it's tempting to think outside forces have no influence on fans at all.

But that isn't true. There is a depressing amount of sucking up to JMS, for example. Just the fact that the 'don't post story ideas or Joe will leave' thread seems to be going on in perpetuity shows that his presence means a lot to many of the people on the newsgroup. If that weren't enough, the kiss-up 'great flame, JMS' posts following some of his messages and the huge number of posts flagged 'ATTN:JMS' should clue any reader to the fact that he wields a lot of influence.[10]

The direct access that the Net provides producers and fans to each other can have positive aspects as well. By lurking anonymously on list and newsgroups, those involved in the creation of series can get immediate, unmediated reactions to their work. They can also use the medium to rally the troops quickly and efficiently if a series is in danger of cancellation or has already been cancelled but has a chance of resurrection in syndication.

For fans, the unprecedented access to The Powers That Be on their favourite series tends to create a sense of connection and participation with the series. Just knowing that a key writer or other behind-the-scenes figure is aware of fans on-line is enough to create the strong feeling that one's voice might be heard. That's a potent brew for

most fans and it is nothing compared to the good vibrations that rock the Net after someone behind the scenes acknowledges on-line fans by mentioning the Net in an off-line interview or dropping into an on-line chat on a pay service. While this much recognition is becoming fairly routine as the Net spreads to more and more of the population, the love affair between 'X Philes' (as *X Files* fans on-line call themselves) and the series production team is still rare. The series has at least twice given an open nod to its on-line fans: in the second season premiere the names of several X Philes appeared on a passenger list and an early third season episode was dedicated to a fan who had run a discussion group on America Online.

On the other hand, the sheer volume of fan talk and its high visibility on the Net has led to some misunderstandings and hurt feelings. In a magazine interview, David Duchovny expressed somewhat negative feelings towards the activities of female fans on-line. When the remarks were relayed on the newsgroup, a long conversation ensued about the relationship between actors and fans and how appreciation should be expressed. Although some fans decried drool, many supported salivation:

> DDEBers [David Duchovny Estrogen Brigade] are reeling in shock from the news that DD apparently 'hates' them. Now, I missed the first Speedo-go-round, but I lived through the second (as well as the 'what is DD's best feature/quality?' thread). It sounds like good, clean (well, maybe a tad racy) fun. Still, we've seen numerous apologies to DD, CC [Chris Carter, creator of *X-Files*], et al, about it. But hey, what exactly is wrong with noticing that he's a handsome man? He works out, and it shows. [. . .] Someone else on the conference rightly pointed out that the man is probably just slightly embarrassed by the infatuation: and this is GOOD – humility is far more attractive than vanity. The long and short of it is, there is no need for you ladies (and gentlemen?) to fall on your swords just yet.

My first reaction to this controversy was 'WOMEN? Lusting after an ACTOR? Who'd'a thunk it?' Actors are sex symbols and their livelihoods do rather rely on their physical attributes. At the same time, like most fans I can sympathize with an actor's dismay, and perhaps fear, at being confronted with large-scale drooling over his appearance in a bathing suit. All the more reason, in my opinion, for actors and others who aren't in the community to restrict their interaction with fans. They can go to conventions or the pay service chat sessions where it's safe and controlled, but they should not wander into fan groups and imagine scrolling one screen gives them a real idea of the community. And fans should understand that the actors' interests as professionals doing a job and our interests as fans are often at odds; they should not be expected to approve or even understand the ways we play with the toys they've given us.

Slash – could the frontier be closed?

The issues surrounding on-line fan fiction, the differences between male and female fans' interests, and the phenomenon of women expressing overtly lustful thoughts all come together in slash, the genre of fan fiction based on homoerotic relationships between male characters. Slash,[11] even more than the other kinds of fan fiction, is written almost exclusively by and for women. It is not gay porn, although there are some similarities;

it is written with an eye to feminine sensibilities – lots of touching and talking along with the fucking – and sometimes it's so inexplicit you wouldn't know it was slash except for the label.

Slash discussions on public groups, like discussions of homosexuality in a series universe, have been known to lead to flame wars. They don't have to: people are quite capable of having rational discussions in which everyone disagrees on everything except their right to disagree, and all of the combatants remain civil. The first time slash surfaced as a topic on the *Blake's 7* list, in fact, we had a great time talking about why we liked or disliked it. The next three times, the conversations became decidedly more heated and less informative. The arguments for and against became so repetitive that one of the women on the list devised a General Slash Defense Form Letter listing all of the oft-recycled objections with the best of the rebuttals. It is kept in the list archives with plans to send it to the next person who expresses his outrage that 'such a disgusting thing as slash' exists. Notice I said *his* outrage. As a slash fan, I'd like to categorize all anti-slashers as sexually insecure adolescent males, but that is not the case. There are women who don't like slash, too. Nevertheless, the worst of the anti-slash posts and the highest level of intolerance do seem to come from young males.

Other fans are not the only problem for slash fans on-line. We also stand to suffer disproportionately from the wrath of crusading conservatives who think the Internet is the twentieth-century's Sodom and Gomorrah. Some stories have appeared on *alt.sex.startrek.fetish* and *alt.startrek.creative*, but a lot of slash activity is conducted through private mailing lists for story distribution or chat. We aren't ashamed of our fondness for two men in passionate clinches, but many of us are concerned that on-line 'decency' bills will be used against us and the kinds of adult conversations we are interested in rather than against the juvenile drivel that makes some newsgroups a waste of time.

It seems quite realistic to fear that serious talks about the sexuality of Odo from *Deep Space 9*, for instance, will be threatened while the 'big tits' threads will be left alone, since anti-pornography laws are often turned against gay and lesbian erotica rather than the violent and degrading heterosexual male material they were originally intended to regulate. More frightening than censorship of the public groups are proposals by law-makers which would allow for the scrutiny of private email by 'Big Brother' – who, we imagine, is not likely to be as turned on by stories about Garak and Bashir on *Deep Space 9* falling in love as we are. But if this ever happens, slash fans will find ways to circumvent it, just as fan women have circumvented copyright, unhelpful computer services flunkies, and nasty little boys, to keep doing what we've always done – talk to each other about the series we love.

At the beginning of this chapter I said that Net fandom was only part of fandom. One of the key differences between on- and off-line fandom is the role women play in each. Attitudes toward technology and communication have delayed some women's access to the Net and prevented others from participating as actively on-line as they do off-line, with the result that women fans are not as prominent on the Net as they are in real-life fandom. But, women fans have dealt with the disadvantages creatively and ingeniously, adapting the new medium to their own needs as well as adapting off-line fannish customs to the Net. Whatever roadblocks are thrown across the Information Superhighway in the future, I know the women of fandom will find a way to overcome them if not slash right through them.

Originally published in L. Cherny and E. Reba Weise (eds) (1996) *Wired Women: Gender and New Realities in Cyberspace*, Seattle: Seal Press.
This essay has been edited for inclusion in the Reader.

Notes

1. Some series have followings only because fans incorrigibly tape and share; *Blake's 7* had fans in the US before it ever popped up on PBS because fans in the UK sent camera copies to friends and family in the States. To get around conversion problems created by incompatible broadcast systems in the two countries, people would set up NTSC camcorders in front of PAL TV sets while the episode was on. *RoS* aired in the United States several times but only on local PBS stations and a cable network, so access was limited; tape sharing made the fandom possible.
2. The survey was originally done for my thesis: 'The Influence of Computer-Mediated Communication on Science Fiction Media Fandom', Master's Thesis, Bowling Green State University, 1994.
3. Susan Herring, 'Gender and democracy in computer-mediated communication', *Electronic Journal of Communication/La Revue Electronique de Communication* 3(2)(1995).
4. Women may shy away from creating public groups for themselves because they rarely have control of a large list or newsgroup; another reason may be their reluctance to approach their system administrator to request help or permission, assuming, often correctly, that the request will be dismissed as trivial.
5. Deborah Tannen, *You Just Don't Understand* (New York: Ballantine, 1990), p. 77 and elsewhere. One of the themes of the book is that men's need for independence and women's need for intimacy contribute to different styles of communication.
6. Ibid., p. 77 (citing Dale Spender).
7. Barbara Kantrowitz, 'Men, women and computers', *Newsweek*, 16 May 1994, pp. 48–55.
8. Ibid., 50.
9. Tannen, *You Just Don't Understand, p. 177.*
10. Since this essay was originally written, JMS has removed himself from the *Babylon 5* Usenet group. Ironically, given the fears of many posters, his withdrawal from active participation in the group had nothing to do with fan fiction.
11. So named because of the fan convention of writing the names of the characters to be paired: K/S is Kirk and Spock as lovers, for example.

RICHARD THIEME

STALKING THE UFO MEME

'There is Thingumbob shouting!' the Bellman said. 'He is shouting like mad, only hark! He is waving his hands, he is waggling his head, He has certainly found a Snark!'

(Lewis Carroll, *The Hunting of the Snark*)

We are convinced that Roswell took place. We've had too many high ranking military officials tell us that it happened, that told us that it was clearly not of this earth.

(Don Schmitt, co-author, 'The Truth About the UFO Crash at Roswell', in an interview by Ed Mar and Jody Mecanic for *Lumpen Magazine* on the Internet)

THAT 'INTERVIEW WITH A REAL X-Filer' can be found on one of the hundreds of websites – in addition to Usenet groups, gopher holes stuffed with hundreds of files, and clandestine BBSs where abductees meet to compare 'scoop marks' – that make up the virtual world of flying saucers. The UFO subculture or – for some – the UFO religion on the Internet is a huge supermarket of images and words. Everything is for sale – stories and pictures, membership in a community, entire belief systems. But what are we buying? The meal? Or the menu?

The bricks that build the house

When Don Schmitt uses the word 'Roswell', he is not merely identifying a small town in New Mexico that put itself on the tourist map with a terrific UFO story. He uses it to *MEAN* the whole story – the one that says a UFO crashed in 1947 near the Roswell Army Air Field, after which alien bodies were recovered, eye-witnesses rewarded with

new pick-up trucks or threatened with death, and a cosmic Watergate – as Stanton Friedman, another Roswell author, calls it – initiated. Schmitt uses the word 'Roswell' the way Christian evangelists use 'Jesus', to mean everything believed about 'Roswell', Like an evangelist, he counts on his audience to fill in the details. Every good Roswellite knows them – it's the story, after all, that defines them as a community.

That story is scattered on the Internet like fragments of an exploding spaceship. Do the pieces fit together to make a coherent puzzle? Or is something wrong with this picture?

Stalking the UFO meme on the Internet

Memes are contagious ideas that replicate like viruses from mind to mind. The Internet is like a Petri dish in which memes multiply rapidly. Fed by fascination, incubated in the feverish excitement of devotees transmitting stores of cosmic significance, the UFO meme mutates into new forms, some of them wondrous and strange.

'The Roswell incident' is but one variation of the UFO meme. On the Internet, Schmitt's words are hyperlinked to those of other UFO sleuths and legions of interested bystanders like myself, as fascinated by the psychodynamics of the subculture as by the 'data' exchanged as currency in that marketplace. Before we examine a few fragments, let's pause to remember what the Internet really is.

Copies of copies – or copies of originals?

The Internet represents information through symbols or icons. So does speech, writing and printed text, but the symbols on the Net are even further removed from the events and context to which they point. The power of speech gave us the ability to lie, then writing hid the liar from view. That's why Plato fulminated at writing – you couldn't know what was true if you didn't have the person right there in front of you, he said, the dialogue providing a necessary check.

The printing press made it worse by distancing reader and writer even more. Now we put digital images and text on the Net. Pixels can be manipulated. Without correlation with other data, no digital photo or document can be taken at face value. There's no way to know if we're looking at a copy of an original, a copy of a copy, or a copy that has no original.

But wait. It gets worse.

The world is a blank screen

Certain phenomena, including UFOs and religious symbols, elicit powerful projections. We think we're seeing 'out there' what is really inside us. Because projections are unconscious, we don't know if we're looking at iron filings obscuring a magnet or the magnet itself. Carl Jung said UFOs invite projections because they're mandalas – archetypal images of our deep Selves. Unless we separate what we think we see from what we see, we're bound to be confused.

Repetition makes any statement seem true. Hundreds of cross-referenced links on the Web create a matrix of even greater credibility. In print, we document assertions with references. Footnotes are conspicuous by their absence on the Web. Information is self-referential. Symbols and images point to themselves like a ten-dimensional dog chasing its own tails.

'Roswell' may be the name of the game, but what does the name really say?

What's in a name?

Everything. Names reveal our beliefs about things. Was there a 'Roswell incident?' Or was there a 'so-called Roswell incident?' Are Don Schmitt and his former partner Kevin Randle 'the only two professional investigators in the field' as Schmitt claims in that interview? Or are they in fact 'self-styled professional UFO investigators? (UFO investigators accredit themselves, then reinforce their authority by debating one another and showing up at the same forums. Refuting or attacking another 'investigator' does him a favour by acknowledging his importance.)

Are there 'eight firsthand witnesses who saw the bodies', 'many high-ranking military officials who said it was not of this earth', or '550 witnesses stating that this was not from this earth?' All of those statements are made in the same interview.

Words like 'self-styled' and 'alleged' do more than avoid law suits. They make clear that the speaker states or believes something rather than knows it to be true. Schmitt uses the word 'witness' the way Alice in Wonderland uses words, to mean exactly what she wants them to mean – instead of letting witness mean . . . well, *witness*.

Dan Kagan and Ian Summers have written a masterful investigation of 'cattle mutilation' (Kagan and Summers 1984), detailing how predator damage became 'cattle mutilation' conducted with 'surgical precision', i.e. in straight lines, through the distortion of the media, 'professional experts' who keep everyone one step away from the evidence (common in UFO research), and true believers who suspended their capacity for critical judgement.

'The Roswell incident' also consists of words repeated often enough to turn them into pseudo-facts which are then used to weave a scenario. When enough people believe the scenario, they focus on the minutiae of the story – did it crash on the Plains of San Agustin, as Stanton Friedman claims, or north of Roswell as Schmitt and Randle claim? – instead of the basics, i.e. did anything other than a balloon crash at all? Science turns quickly into theology.

Can a fact move at the speed of light?

The way sites are connected on the Word Wide Web (WWW) tends to obliterate our historical sense. Everything on the Web seems to be happening *now*. Without a point of reference, all information seems equal. Lining up texts side-by-side and evaluating discrepancies feels like hard work. Surf to the Cambridge Cybercafé, for example, and you'll find a laudatory article about Schmitt written by Milwaukee writer Gillian Sender. Sender says the piece was purloined without her permission. Like much on the Net, it's an unauthorized copy of a copy.

Sender did a follow-up piece for *Milwaukee Magazine* in which she confessed her subsequent disillusionment with Schmitt. In interviews he misrepresented his educational background and occupation. Sender concluded that those misrepresentations undermined his credibility across the board. You won't learn that on the Web, because the second piece isn't there. The Cybercafé website also has a newsletter written by Schmitt and Randle but no link to information about their later split, when Randle denounced Schmitt for deceiving him as well as others.

The soul of the web

According to Jung, when the psyche projects its contents on to an archetypal symbol, there is always secrecy, fascination and high energy. When a webmaster finds an article like Sender's he gets excited, plucks it out of cyberspace, and puts it on his site. Come across it four or five times, you start to believe it.

Tracking down the truth about the 'Roswell incident' is like hunting the mythical Snark in the Carroll poem. The closer one gets to the 'evidence', the more its disappears. There is in fact not one living 'witness' to the 'Roswell incident' in the public domain, not one credible report that is not filtered through a private interview or other privileged communication. There are, though, lots of people making a living from it.

Who ARE these guys?

Karl Pflock is another 'Roswell investigator'. Stick his name into a search engine and you'll find him on the ufologist roster at Glenn Campbell's Area 51 website. The text of an on-line interview with Pflock and Stanton Friedman is reproduced there. What effect does this have?

By appearing with him, Friedman lends credibility to Pflock's status. Their disagreement over details (Pflock thinks the Roswell debris was the remains of a Project Mogul balloon, as the Air Force claims) is less important than the fact of their debate, which implies that the details are important, the debate worth having. That ensures future bookings for both.

Get the idea? In the virtual world, the appearance of reality becomes reality. Then you can buy and sell words, icons, symbols as if the menu is the meal.

Pflock is not new to the world of UFOs. Kagan and Summers first encountered him as a man named 'Kurt Peters' who appropriated a story he knew was fabricated about 'cattle mutilations', then tried to pass it off as his own and sell it to a New York publisher. When the authors confronted Pflock 'with the Kurt Peters gambit, he was shaken that we had found him out'.

What might we infer, therefore, about Pflock's credibility? On the Web, however, the context created by juxtaposition with Friedman makes it seem as if he is a real 'professional'.

Follow the money

The UFO game needs teams so the game can be played. The 'for-team' and the 'against-team' are essential to each other. The famous 'alien autopsy film' exploited by Ray Santilli illustrates this. This film allegedly showed the autopsy of an alien retrieved from a crash site. Many websites were devoted to this film; Usenet groups hummed with endless conversation about the details. One major thread was devoted to finding the cameraman. (Once again, the key player or detail was absent, the audience addressed by a 'spokesperson for the event'.)

A great deal of money was made by debating the film regardless of which side one was on. Stanton Friedman was off to Italy for a screening, Schmitt to England to 'examine the evidence', and so on. Meanwhile reports like that by Dr Joseph A. Bauer on CSICOP's website that exposed the film's 'overwhelming lack of credibility' were ignored. The lack of credibility was obvious from the beginning, but had it been acknowledged, there would have been no game to play – no Fox-TV special, no books or debates, no conferences in Europe.

The Santilli episode is about played out, but other 'evidence' is taking its place. At the moment, an anonymous tipster claims to have a fragment of the crashed saucer. The story is spreading on the Web, mutating as it grows. Now, fifty years after the alleged crash, others claim to have fragments too.

The good thing about fragments of crashed saucers is that they are endless. Even better are the claims made by 'professional investigators' that they are negotiating with shadowy figures who have fragments but are afraid of being killed if they go public. Those stories are endless too.

To know someone's motivation, follow their checkbook. Look, for example, at the heated rivalry in the town of Roswell between museums competing for tourist dollars with trips to rival crash sites. You can even sign up for the tour on the Web.

Information? Misinformation? Disinformation?

The Santilli film could be dismissed as a non-event, did it not reveal a deeper dimension of life in the UFO world. What were its effects? Energy was displaced, the focus of the debate shifted, and the 'Roswell incident' – ironically – reinforced. When someone says, 'These are not the real crown jewels' they imply that real crown jewels exist. If this is a fake autopsy film, there is the *real* autopsy film? That implies a real autopsy which implies real aliens and a real crash.

Or was the film an ingenious piece of disinformation by the government? Was it designed to throw investigators off the track? See how we responded to news of real aliens? Hide some real data among a snowstorm of false data? Is all this confusion . . . intentional? It's X-files time.

Ready for a headache?

Now we're closing in on the Snark.

Are government agents using the subculture to manipulate or experiment with public opinion? To cover up what they know? Are the investigators 'useful idiots', as they're

known in the spy trade, real spies, or just in it for the buck? One of my on-line adventures illustrates the difficulty of getting answers to these questions.

A woman in Hamilton, Montana, was speaking to Peter Davenport, head of the National UFO Reporting Center in Seattle about a UFO she said was hanging around her neighbourhood. She said she could hear strange beeps on the radio when it was hovering. Then, while they spoke, some beeps sounded. 'There!' she said. 'You hear that? What is that?' Peter played the beeps over the telephone. I recorded them. Then I posted a message on *alt.2600* – a hacker's Usenet group – asking for help. I received several offers of assistance. One came from LoD. LoD! The Legion of Doom! I was delighted. If anybody can get to the bottom of this, the LoD can. These guys are the best hackers in the business. I recorded the beeps as a .wav file and emailed them to LoD. They asked a few questions and said they'd see what they could find.

Meanwhile I received another email. This writer said he had heard similar tones over telephone lines and shortwave radio in his neighbourhood, which happened to be near a military base. Then he wrote, 'I have some info that would be of great interest. Government documents. . .' He mentioned friends inside the base who told him about them. Meanwhile the LoD examined the switching equipment used by the telco and reported that they were evaluating the data. A third email directed me to a woman specializing in the 'beeps' frequently associated with UFOs. She sent me a report she had written about their occurrence and properties.

LoD asked for my telephone number and someone called the following week. They could affirm, the caller said, that the signals did not originate within the telephone system. They could say what the signals were not, but not what they were. One negative did not imply a positive. Then the correspondent near the military base sent a striking communication. 'The documentation and info that I am getting are going to basically confirm what a member of the team has divulged to me. 'They are here and they are not benign.' He gave me information about other things he had learned, then acknowledged that all he said was either worthless hearsay or serious trouble. Therefore, he concluded, 'I am abandoning this account and disappearing back into the ether.'

The twilight zone

There you have it. Without corroboration or external evidence to use as a triangulating point, that's as far as the Internet can take us. Words originate with someone – but who? Is the name on the email real? Is the domain name real? Is the account real? Secrecy. Fascination. High energy. Maybe it's a sign of the times that I was pleased to have the help of the LoD. While I would have dismissed a government or telco statement as maybe true, maybe not, I trusted LoD.

They did a solid piece of work. Technically they're the best, but more than that, I knew they'd be true to their code. Like me, they're need-to-know machines and they love a good puzzle.

What about the next-door-to-the-military source? Was he who he said he was? Were his contacts telling the truth? Are 'they' here and are 'they' not benign? Or was he a government agent trying to learn what I knew? Or just a bored kid who felt like killing a little time?

How do we separate fact from fiction? Jacques Vallée, a respected writer and researcher, recently authored a work of fiction about UFOs. Is he really writing fiction so he can disguise the truth, as some say? Or is he just another guy selling a book? Or a serious investigator who has blurred his own credibility by writing fiction that's hard to distinguish from his theories? Or is he a secret agent working for the government?

The UFO world is a hall of mirrors. The UFO world on the Internet is a simulation of a hall of mirrors. The truth is out there, all right . . . but how can we find it? Plato was right. We need to know who is speaking. We need to stay with the bottom-line data that won't go away.

The bottom line

What does it look like?

One piece looks like this. I know a career Air Force officer, recently retired as a full colonel. He worked at the Pentagon and the War College. He is a terrific guy who has all the 'right stuff'. He's the kind of guy you'd willingly follow into battle. Many did.

A fellow B47 pilot in the 1960s told him of an unusual object that flew in formation with him for a while, then took off an incredible speed he could not match. The co-pilot independently verified the incident. Neither wanted to report it and risk damage to their careers. When he first told me that account in the 1970s, I remember how he looked. He usually looked confident, even cocky. That time he looked puzzled, maybe a little helpless. I knew he was telling me the truth.

I have seen that look many times as credible people told me their account of an anomalous experience. They don't want publicity or money. They just want to know what's happening on their planet.

Data has accumulated for at least fifty years. Some of it is on the Internet. Some of it, like email from that retired Air Force officer, is trustworthy. Much of it isn't.

Are we hunting a Snark, only to be bamboozled by a boojum? Or are we following luminous breadcrumbs through the darkening forest to the Truth that is Out There? The Net is one place to find answers, but we'll find them only if our pursuit of the truth is rigorous, disciplined, and appropriately sceptical.

Originally published in A. Kroker and M. Kroker, (eds) *Digital Delirium*, Montreal: New World Perspectives.

References

Kagan, D. and Summers, I. (1984) *Mute Evidence*, New York: Bantam Books.

SUSAN ZICKMUND

APPROACHING THE RADICAL OTHER
The discursive culture of cyberhate

T HE INTERNET HAS TRANSFORMED THE nature of community and identity within the US. Along with other groups, this new medium has affected the cohesiveness of subversive organizations. Individuals propagating Nazi ideologies have traditionally operated in isolation, with limited ties to organizational structures. Yet with the emergence of electronic mail and the World Wide Web, subversives are now discovering the means of propagating their message beyond the narrow confines of pre-established alliances.

Subversive literature functions as the discursive articulation of a community, and expresses its historical consciousness and cultural identification. Based on this historical and cultural background, an argumentative *Weltanschauung* has developed which fosters a rhetoric of antipathy, one bearing the unique markings of American radicalism. Individuals who propagate this discourse are unified in complex structures of a shared subversive ideology. They are 'interpellated', a phenomenon Althusser defines as the discursive process of evoking a collection of individuals into a group through an ideological screen. This ideological 'interpellating' becomes especially important when examining subversive culture in cyberspace. These cybercultures lack what Heidegger (1962) defines as the 'every-dayness' of life, which is required in order to create *das Man*, or the larger structures of society which, in turn, shape the individual sense of Being-in-the-world.

Access to radical materials

The difficult access to radical materials has traditionally plagued subversive organizations. For example, Germany constitutionally banned the publication or distribution of Nazi documents after the Second World War (Charney 1995). In the 1990s the German government also outlawed skinhead, heavy metal music with lyrics promoting hate, after

neo-Nazi youths burned the residence of Turkish *Gastarbeiter*. Yet with global access to the Internet, the autonomy of one nation to restrict radical literature has been greatly reduced. Documents posted on the World Wide Web are now available to anyone with the technological capacity to gain access. This freedom to disseminate materials over the Internet has led to a thriving radical culture. This communication technology is also creating new legal issues as it bypasses national control mechanisms, thereby challenging traditional notions of national sovereignty. The implications of this change were recently illustrated when Germany attempted to assert control over literature available within its own borders by calling on CompuServe to restrict access to radical materials (Brenner 1996). While the server at first attempted to abide by this restriction, the company has now decided, in a striking reversal, to restrict *Germany's* access to the Web, rather than hamper the availability of information for patrons. In the future such issues may be rendered moot as a US court recently decided in favour of maintaining free speech over the Internet. A judge supporting the decision argued that it is better to allow the cacophony of voices on the Internet to control itself without the use of governmental or judicial intervention (Lewis 1996).

The US radical right

The radical right is a compendium of disparate groups with different, often conflicting, ideologies which none the less share certain elements in common: a vociferous sense of hatred extending toward one or more groups (typically involving racism and anti-Semitism), disdain toward the authority of the federal government and a strong or loose familial tie to the Ku Klux Klan or other Nazi-based organizations which originated in the first half of the twentieth century in America. Elinor Langer (1990), in her work 'The American neo-Nazi movement today', estimates membership in these organizations as approximately 20,000 to 100,000 persons, a number that is substantial, but none the less equalling only a fraction of all Americans.

The contemporary American extremist right today generally descends from earlier Klan organizations as well as the American Nazi movement. Together they share stri-dent racial sentiments, often augmented by a religious or a semi-cosmological view of the creation of humanity. These groups include such divergent organizations as the reli-giously-oriented Christian Identity sect to the secular, California-based organization, White Aryan Resistance (WAR). WAR was founded by television repairman Tom Metzger. Metzger ran a talk show entitled *Race and Reason* on a cable-access channel in San Diego throughout much of the 1980s (Ridgeway 1990). On his programme, guests discussed the genetic inferiority of Jews and minorities and the imminent threat to the white race posed by affirmative action and inter-marriage. Metzger's group produced newsletters, magazines, radio programmes and videotapes promoting their racist message. Groups supporting such views have increasingly become active in the northwestern part of America, such as northern California, Oregon, Washington and Idaho, where agencies in 1989 reported a 400 per cent increase in anti-Semitic activi-ties (Langer 1990).

Another important organization, one which did not directly descend from the Klan or Nazi movement, is that of the skinheads (Hamm 1993). This loosely structured move-ment emerged during the 1980s from the economically depressed blue-collar urban

centres in Britain. From this group a subset of the culture emerged which embraced racial discrimination (Kovaleski 1996). This racist segment of the movement spread throughout the Western world during the 1980s and 1990s, promoted in part by the distinctive version of heavy metal music its members produced.

Finally, an older radical group is known as the Posse Comitatus, a name that extends from one of the organization's central desires: local rule. While Posse members do not play a significant role on the Internet, their ideology has influenced the belief structures of other radical organizations. In this way they effectively crystallize a variety of radical views. The Posse Comitatus members believe that the national government is involved in a vast conspiracy to destroy farmers, white people and the American family (Ridgeway 1990). They adhere tenaciously to the belief in ZOG (the Zionist Occupational Government), which they see as a synonym for the US government. Posse members argue that ZOG is controlled by the International Jewish Conspiracy, a group of powerful Jewish financiers who together essentially rule the world. As a result of this belief, members refuse to pay taxes, carry social security or driver's licence cards, and instead frequently stockpile weapons and await the day of the ultimate confrontation with the Jewish-controlled authorities (Ridgeway 1990).

In additional to these dominant organizations, other groups, comprised of tax revolters and anti-environmentalist ranchers in the northwestern United States, have arisen over the years to add to this anti-government sentiment. Many of their members subscribe to the conspiratorial fear of ZOG, as do most radical hate groups. Indeed, a belief in ZOG has become one of the chief tenets of the radical right. It finds expression in the widely held conspiracy theory that the power of the US government and the Federal Reserve Board operate at the very centre of ZOG. This sense of worldwide conspiracy has recently been further embellished for these groups by an unwilling supporter when President Bush, in a 1990 speech during the Gulf War, described the development of a 'New World Order' of nations. Within American radicalism, this term has come to stand for the Jewish-backed UN powers that are to invade the US with the goal of depriving Christians of their rights, liberties and lives (After Oklahoma (2) 1995).

Subversives in cyberspace: websites and belief structures of the radicals

While these groups have a long history in the US, the technology of the Internet has been critical in terms of increasing visibility. Rabbi Abraham Cooper of the Los Angeles-based Wiesenthal Center argues: 'along with all of the wonderful educational opportunities being born every day via the Internet and on-line resources, hate groups are aggressively utilizing the same avenues to promote their hate-filled agendas' (cited in Schwartz 1995: 22). In order to understand this use of the Internet, I will first discuss the emerging radical cyber-sites, before explicating some of the dimensions which have transformed radical *individuals* into a subversive *community*.

Aryan and white power groups in cyberspace are represented on a variety of websites, the most prominent being Reverend Ronald Schoedel's 'Christian Identity On-line', the 'National Alliance', and the 'Stormfront White Nationalist Resource Page'. Listserves for white supremacists include 'Stormfront-L' and the 'Aryan News

Agency'. The two most popular Usenet newsgroups – which are the focus of this chapter – are *alt.politics. nationalism.white* and *alt.politics.white-power* These newsgroups have been featured in journalistic analyses as well as praised by the radicals themselves as being central to the growing radical network. In addition to such traditional forms of access on the Internet, Tom Metzger has extended technology even further by advertising on the 'White Aryan Resistance Web Page', a free provider for any racist homepage that may have been censored by commercial servers.

Another prominent radical group to be represented on the Internet is the skinheads. The Alta Vista search engine reveals a plethora of American organizations on the Web, both at national and regional locations. These include 'Wolfpack Services' and 'Skinheads U.S.A. Links Page'. The listserve for skinheads has been appropriately named 'Resistlist', the title reflecting the hostile ethos cultivated by group members. The most prominent newsgroups for skinheads are *alt.skinheads* and *alt.skinheads. moderated* Radical cyberculture in general has also cultivated ties to international sources, targeting lands with strict censorship laws, such as Germany. These organizations include: 'Denmark (D.N.S.B.)', 'Norway Resources', 'Swedish Resources Page', 'British National Party', 'Stormfront: Spanish Language'. The nation most prominently represented here is Germany, with websites listed for 'Zündelsite: German Language' (n.d.), 'Stormfront: German Language' (n.d.), 'Nationale Volkspartij/CP'86' (n.d.), and 'Germanica On-line' (n.d.).

The dominant trafficking of subversive discourse still travels through America. Here members can be easily routed to a variety of groups through a clearing station, such as the Aryan Re-Education Link. This station is a linking service for thirty-four separate radical Web pages. The groups represented tend toward the skinhead spectrum, but white supremacists are advertised as well. Twenty-two of these groups are iconically represented by their logo, and it is here that an examination of symbolic, cultural discourse can begin.

Subversive cultures operate within what Wittgenstein (1953) describes in his *Philosophical Investigations* as a 'language game'. Wittgenstein argues that language itself functions within a community and that discursive game rules formulate the notions of rationality that exist within that culture. As one moves from one society to another, the rules and norms of the language game change. Based on these assumptions, linguistic, tropological and symbolic communication can reveal much about the unifying dimensions of a culture.

With the radical cybercommunities, the dominant metaphoric association used by group members is that of war. Symbolically, the radicals associate themselves with icons of political oppression, violence and death. Organizations tending toward Aryan beliefs typically employ the swastika symbol of the Third Reich, such as that used by the 'Independent White Racist Homepage'. Skinhead groups are more likely to turn to images of violence, including the insignia of the 'New Jersey Skinhead Page', where a threatening fist has the word 'skin' tattooed across the fingers. Various dimensions of dress and body culture reinforce these symbols. White supremacists frequently wear military clothing, at times donning full camouflage attire. Skinheads in particular prefer a paramilitary style, the most prominent cultural artifact being their military boots which members wear (Hamm 1993). So important are these boots that they have become an insignia of identification, with members using greetings such as 'Heil Bootboy'.

This cyberculture reflects, in general, an overall fixation on war. For example, the architects of the Third Reich function as heroic key figures for both white supremacists and skinheads (Talty 1996). The importance of the Nazi era is made apparent in part through the commodification of fascist regalia. For example, on *alt.politics.white-power*, a man selling an 'early edition of Hitler's *Mein Kampf*' received a response of interest from Christian Identity leader Reverend Ronald Schoedel (1996). The NSDAP mail order catalogue features hundreds of Nazi items and military paraphernalia, including a swastika stick pin (item no. 211), 'War Songs of the Third Reich' (no. 201), and a photograph book entitled, 'The Hitler We Loved and Why' (no. 189) (Mail Order Catalogue 1996). The solicitation of Nazi goods reinforces cultural icons while encouraging a consumerist orientation towards radical materials. In this way, this virtual marketplace for Nazi goods offers for sale valued symbols and texts as it spreads and strengthens the ideas which these items signify.

This war-centric *Weltanschauung* colours the belief structure of many of these radical members. Historian Richard Hofstadter (1965) has labelled a preoccupation with war and conspiracy as the discursive characteristics of the 'paranoid style'. Grand conspiracies, Hofstadter argues, indicate a form of political psycho-pathology. This pathology causes individuals to interpret unrelated events as ones causally linked, revealing designs of tyranny and oppression. The acceptance of ZOG as the dominant mechanism of world control clearly demonstrates a 'paranoid style'. Yet it is also important to go beyond the stylistic aspects of political psycho-pathology in order to understand how this paranoid discourse leads to a sense of group cohesion.

One central, unifying bond of this movement lies in its mythic belief structures, ones which blur the traditional distinction between fabricated narratives and standard conceptions of history. Within these myths, demon figures, such as ZOG, function to discursively ground narrative structures which, in turn, keep the community together. The constructed demonic 'conspirators' constitute essential elements within this process: they become the catalysts for the unfolding of a series of narratives which then give rise to an all-encompassing worldview. To understand the significance of these devil figures and the way in which they are depicted, one must turn to the radical subversive's approach to the Other.

Approaching the Other

The supremacist discourse examined here harbours a two-fold portrait of the Other. These two prevailing constructions serve differing yet interdependent purposes within the movement, and can be best categorized as: the Other as social contaminant; and the Other as powerful conspirator.

The Other as social contaminant

The construction of the Other as social contaminant is evident throughout the literature of the radical subversives. Here the Other metaphorically becomes a cultural disease, one whose very presence within the nation is sufficient to destroy the social stability and the special values which made the nation strong at its founding. This depiction of

the Other holds strong ties to the genre of racist discourse articulated earlier in American history, as well as in racist Nazi propaganda of the 1930s and the French anti-Semitic discourse of the nineteenth century (Dinnerstein 1994; Ridgeway 1990). The importance of constructing completely *new* myths – the radical's discursive *inventio* – remains less critical in this context than the question of how cybercultures appropriate antecedent genres in fostering current narrative structures.

AFRICAN-AMERICANS AS THE OTHER

In current radical discourse, the dominant manifestation of this social contamination is embodied within the image of the African-American. In developing this portrait, radical members draw upon racist images generated in American history and in the US mass media during the first half of the century. This Othering of African-Americans involved depicting them as a brute, primitive force, one biologically designed to corrupt American society. One man wrote on *alt.politics.white-power*:

> The problem with African Americans is that they are presently destroying our cities as they have been doing for 35–50 years. . . . The African American menace has attacked our cities and suburbs with more force than all of the hostile Indian tribes and French/English forces combined and organized against us in colonial and post-revolutionary days. Yet, we continue to treat our enemy as citizens.
>
> (Bertleson 1996)

This portrait of African-Americans isolates them as a nefarious and particularly foreign source of contamination. According to such logic, black Americans personify and trigger urban–suburban decay. In this respect they become the causal agent for the impersonal forces affecting the populated sectors of US society. The depiction fulfills what Boehmer (1995) argues: the African-American serves as the antithesis to dominant society, thus negatively mirroring the cultural and social superiority of the colonizer. A contributor on *alt.politics.nationalism.white* articulated racist statements which depicted Africans as primitive: 'Africa sucks, it is a stone age continent and Africans are bringing the stone age to Europe and America. Why are we allowing it?' ('Rad' 1996a). Here again African-Americans become the counter-image to the civilized, productive side of society. This cultured, civilized portrait is used in turn to define the Aryan racists themselves as ideal.

Such strident racism often loosely hides larger fears about society. The façade concerning the 'dangers' of African-Americans as a unique cultural group becomes more apparent when removed from the US context. The consistency of social fears, the *interchangeability* of the Other, and the racist reaction to the Other surfaces as subversives from other nations post materials on the Internet. For example, the Canadian 'Scarborough Skinhead Web Page' distributed a strikingly similar message:

> Are you tired of seeing your community turning into gang hang outs? Are you tired of seeing drugs sold in your areas? Tired of CANADA spending millions of your tax dollars on immigration not including the price of keeping landed immigrants and refugees in the country. Keeping these claimants could result in the loss of your job, your tax money and your CANADIAN heritage.

. . . Third world immigration is killing our people and our way of life. GET INVOLVED AND STAND UP FOR YOUR WHITE RIGHTS.

(Scarborough Skinheads, n.d.)

The list of concerns here, such as high taxes, personal safety and job security, points to the importance of economic and social anxieties in generating racist discourse. Examples of international radicalism serve to make clearer the rough outlines of the supremacist genre which drives such tracts. Further characteristics of this genre emerge as we explore alternative constructions of the Other, including a devil figure created outside of the racial criterion.

HOMOSEXUALS AS THE OTHER

Homosexuals function in this context as a socially constructed Other designed to show the degradation of society. The Web page entitled 'Cyberhate' (n.d.), chose as its motto: 'Keeping America White, Straight, and Proud!!' This slogan excludes by default the Other based upon the criteria of race and sexual orientation. Another Web entry, the 'CNG', a self-described 'cell-based White Nationalist organization', included a work entitled 'The Homosexual Threat', by Jeff Vos (1996). In it Vos provided a quote, filled with ellipses, which was attributed to a periodical entitled the Gay Community News. Vos appropriated the voice of the Other in rendering a social manifesto, threatening:

> We shall sodomize your sons . . . we shall seduce them in your schools, in your dormitories. . . . [author's ellipses] All laws banning homosexuality will be revoked. . . . Be careful when you speak of homosexuals because we are always among you . . . the family unit . . . will be abolished. . . . All churches who condemn us will be closed. Our only Gods are handsome young men.
>
> (Vos 1996)

This narrative of a homosexual 'threat' was reminiscent of the anti-Communist genre of the 1950s. The physical danger to society's young males is further exacerbated by the conspirational presence of the atheistic gay men. From this alleged 'data' against gays, Vos (1996) called out in his tract to condemn homosexuals: 'for these sick individuals have caused too much pain and trouble in too many children's lives for society to continue to turn a blind eye to their excesses'. Reflecting again the conspiratorial threat of the anti-Communist discourse, the author alerted his readers that 'we are in a war. Make no mistake about it. There is an enemy, and the enemy has made significant gains'.

Drawing upon Hofstadter's approach to political psycho-pathology, this portrait of the Other can function as a Rorschach test, revealing psychological tokens embedded within the discourse (Black 1983). A close reading of the website literature reveals that as blacks, homosexuals and the other generic minority groups 'destroy' society – via violent behaviour or sexual degradation – it becomes the responsibility of the subversives to serve as the preservers of society. Yet unlike the Christian fundamentalists who can look to their religious tenets and knowledge of the Bible, supremacists and skinheads must look to another criterion to support their superior status. They focus on a biological criterion which serves as the foundation for an elaborate cultural tapestry: skin pigmentation. Whiteness, then, functions as the talisman which makes the supremacists and the skinheads the mirror opposite of the Other.

The immense importance of securing 'whiteness' as an unabridgeable category helps to clarify the biological foundation which frequently characterizes supremacist discourse. On one newsgroup an advocate argued that: 'Actually, racism is good and necessary for the continued breaching off of new types of human beings from the existing stocks . . . at some point, homo sapiens refused to breed with the sub-men around him' (Strom 1996). The biological foundation for distinguishing between the supremacists and the Other enhances the essentialist nature of these radical arguments. The distinction, of course, becomes problematized when extended to homosexuals, for here no inherently racial criterion exists upon which to base condemnation. Yet race again emerges when discussions focus on preserving Western civilization, for in this case homosexuals are indicted – whether from the grounds of biological determination or from their free choice of sexual preference – for failing to propagate the white race. Thus, ultimately, attributes of the enemy are traced back to deterministic, essentialist, biological impurities embedded within the body of the Other.

The Other as conspirator

An examination of the Other as conspirator reveals a distinctly different power relation between the supremacists and the Other. While African-Americans are depicted as savages and subhumans and gays as sexual perverts, it is the Jew who is most ubiquitously condemned in the literature of the radical right. Yet here the prototypical image of the Jew differs from the previously described construction of the Other. Issues of power, wealth and control predominate. There are two prominent constructions, one involving the Other as a conspiring impersonal agent, the other focusing upon essentialized traits of the individual Jew.

The image of the Jew as a dominant conspiring agent functions as a point of consistency amongst subversives. Langer (1990) emphasizes the importance of the powerful Jew as an image which subversives generally subscribe to. Rhetorically, the empowering of the Jew plays a key role in the radical genre. The Jew, imbued with power, personifies changes in mass society. The radicals' discourse generates a mythical narrative that converts social problems into conflicts between distinct and identifiable entities. Such a strategy creates a framework for its proponents which allows them to counter detrimental forms of change. Jews, with their supposed access to 'power', personify these forces more effectively than groups such as African-Americans who still hold little influence within society. Thus the Jew is constructed as the agent which lies hidden within institutions possessing hegemonic power, structures which they then use to manipulate society. The government, the media, and even the spread of academic knowledge or ideological doctrines may emanate ultimately from this source.

The Other within these narratives is suffused with an almost superhuman power. Such an endowment is imperative if the Jew is to have sufficient capacity to control national or even world events. For example, Dr William L. Pierce (1996) of the National Alliance demonstrated this belief in the dominate power of the Jews. In his tract posted on the National Alliance Web Directory, he argued that the negative reaction to the skinhead movement was caused by a monolithic Jewish conspiracy. Here the Jews were the cause behind 'drug usage among skinheads. They encouraged rap music and racial mixing'. Having failed at this attempt, 'the Jews tried to brainwash the public against

skinheads through their controlled media'. Finally, Pierce maintains, Jews began to perpetuate a system of propaganda, whereby the 'minions' of the Jews, the American Civil Liberties Union and the Anti-Defamation League of B'nai B'rith, began to turn the police against the skinheads: 'All of these Jewish propaganda organizations are well-connected politically, and so they can approach police departments draped in the false cloak of authority.'

The subversive literature also indicts the Jew for wreaking havoc upon American society by orchestrating the slave trade in the New World. The entrepreneurial spirit of the Jew allegedly led to the introduction of slavery, which was then used as a means of gaining profit and of dominating important institutions within the young country. A discussion on the newsgroup *alt.skinhead* illustrates this point. Here two users became engaged in dialogue, the first being Jewish, the second a radical subversive:

> [User 1]:
> This stuff is just so stupid that it's hard to take it seriously. I especially like the part where he accuses us Jews of bringing the slaves here in the first place. Hmmmm. How did we do that? I'll tell you.
>
> [User 2]:
> I bet you could tell us, but you won't of course. The jew people invented slavery! Just read the old testament to learn the truth!
>
> [User 1]:
> And then we sold 'em for a pretty penny, I'll tell you.
>
> [User 2]:
> It is a well known fact that the jew people will do anything for money.
>
> [User 1]:
> So I think it's pretty clear that the only people who DO take these things seriously are brain-dead.
>
> [User 2]:
> So sure of yourself aren't you (I hate that about minorities)? So why don't you want anyone to respond to my personal statements? I can think of a couple of good reasons why a jewish person would not want people to talk about their involvement in history. I do not fear the truth!
>
> (Braun 1996)

The assertion that the Jew initiated the slave trade ultimately transforms the African-American into a voiceless, objectified Other; they become a tool which the Jew ruthlessly used to inflict damage upon white, Christian Americans. This discourse demonstrates the polarity of demon figures used by subversives: one an unintelligent, animalistic force, the other a highly intelligent, evil manipulator which appropriates blacks in an objectified fashion. This supposed manipulation by the Jew surfaces in the supremacist narrative even as the radicals *themselves* reify and condense the Other into one malevolent Thing-like category. The distinction is best reflected by a belief structure which distinguishes between ethnic 'mud people' as the *non*-humans and the Satanic Jew as the *super*humans. Together they function as a rancorous force which the sons of Adam must struggle against.

The historical context of anti-Semitism, extending back into medieval Europe, provides the ideological substance for many subversive texts. As the radicals define an all-powerful Jew, they are able to draw upon this extensive discursive history. Web pages and newsgroups have discussed the old anti-Semitic document the *Protocols of the Elders of Zion*. This document, forged at the turn of the century, was designed to oppress Jewish inhabitants. The narrative tells of the widespread design of Jewish leaders to control society, with the goal of ultimately destroying Christianity. Although the *Protocols* have been demasked as a fake, extremist groups still refer to this tale in order to prove the nefarious intentions of the world-dominating Jew. One man on *alt.politics.nationalism.white* called on other supremacists to download the tract, describing it as 'a must read for those interested in furthering their understanding of the New World Order' (Mathis 1996).

In addition to using this elaborate narrative history, each generation of subversives must redefine the Jew anew, constructing the Other within the parameters of contemporary ideology. In the most recent reconstruction, the Jew as Other is personified by the New World Order. Again the Other is intricately tied to the prevailing fear of an oppressive world government. The Jew within this radical narrative manipulates the world *openly* under the guise of the UN. *Surreptitiously*, the Jew functions at an even higher level: gaining control of the world's governments under the guise of ZOG. So impassioned do radicals feel about this world government, that one supremacist wrote on alt.politics.nationalism.white: 'Death to ZOG and to all traitors who work for them' (Shook 1996). In radical literature the power of ZOG is so pervasive that it invades the very minds of white, Christian Americans through the use of government propaganda. White subversives view the US government as a tool of the conspiring Jew, one which promotes the liberal philosophy that has made the UN possible. This ideological weapon includes issues such as diversity and affirmative action as well. These policies, according to the subversives, have 'brainwashed' society, thus enabling unqualified minorities and feminists to rise in stature over beleaguered white males.

As extremist ideologies depict the Jew as conspirators against the nation and the white race, they cannot praise any aspect of the Jew's entrepreneurial spirit. This can create a discursive tension, particularly in a capitalist society where economic success is deemed as positive. As vociferous anti-Communists, right-wing radicals generally support capitalism, often glorifying it as a form of America's economic heritage. In order to resolve this paradox, the subversives must distinguish the Jew from capitalists in general, demarcating specifically Jewish traits from those of the Christian entrepreneur.

This process requires a demonization which renders each individual Jew reprehensible. The subversives rigidly define Jews within their ethnic or cultural class, not allowing them to 'pass' or become recognized members of society – despite the lack of distinctive physical markers. For example, one person on *alt.politics.nationalism.white*, under the title of 'How to Spot a Jew', described the Jewish physiognomy: 'Many prominent Jews (after centuries of pilfering European genes) have blue eyes and light coloring, which seems out of place with their basically tropical features. Large, sleepy, fish-like eyes Fat, square lips Pointy ears' ('Rad' 1996b). At the end of the category entitled JEWISH OCCUPATIONS, the author added 'Anything which allows political or cultural control over Aryans'. This discourse depicts an essentialized Jew and grants *carte blanche* to exclude individuals who might otherwise completely blend into society. The Jew here cannot become acceptable, cannot be converted, for their corruption lies essentialized

within their cultural and genetic make-up. The radical subversives must make the Jew obvious, discursively marking the Other.

THE DISPLACING OF THE OTHER

The discussion of diversity and affirmative action focuses upon one final dimension of the relationship between the subversives and the Other. Contemporary radicals in the cyber literature frequently deny the oppressed condition of the most disempowered groups. Instead members see *themselves* in this position. The discourse of displacing the Other has gained such prominence that it serves as another defining characteristic of the subversives as a culture.

Radical discourse typically depicts the dire condition of Caucasians. For example, the website for Resistance Records commented: 'Look at global population levels. Whites account for openly 8% of the planet's population. Only 2% of the babies born last year were White. . . . It is the WHITE PEOPLE that are the true 'new' minority' (Hawthorne 1996). According to these arguments, uncontrolled immigration and inter-marriage are transforming the white sector of society into a 'minority' race. Here the category of white-ness is also essentialized. The argument hearkens back to the 'one drop' rule of the pre-civil rights era, where even the smallest amount of ethnic diversity in one's background rendered one 'non-white'. Subversives also argue that governmental regulations seek to impose – in the name of 'multiculturalism' – what radicals depict as the 'burden' of quotas and welfare payments, economic weights which are disproportionally carried by whites. A tract written by 'Yggdrasil' (1996a), the German tree of life speaking through the National Alliance, articulated a list of 'exploitations' which the white race must face:

> It is a long list. Burdensome racial preference schemes in hiring, racial preference schemes in university admissions, racial preference schemes in government contracting and small business loans. Beyond quotas there is the denial of rights of free speech and of due process to Whites who are critical of these governmental policies. We have special punishments for assaults committed by Whites if the motives might be racial. In addition, Whites pay a portion of the costs of the welfare state that is disproportionate to what they receive in benefits.

This text argues that it is whites in reality who suffer in America, with 'successful minorities' controlling the media, forbidding 'the dissemination of any message that calls attention to minority, racial, and ethnic dominance. Only messages of minority victimization are allowed to pass' ('Yggdrasil' 1996b). This discourse of Othering oneself comes in part from feelings of disassociation with society at large. Members frequently comment on their loss of freedom of speech from censorship, imposed both legally and through social norms. Such 'restrictions' have turned those who articulate 'white pride' into outcasts. George Burdi – known as 'George Eric Hawthorne', the founder of Resistance Records – asserted on the Resistance Records Home Page: 'Look at how "evil" pro-White individuals like myself are portrayed by the media. You would think that being "racist" was worse than being a "rapist" nowadays. Just change one little letter and *bing!* you have an instant headline for the nightly news' (Hawthorne 1996).

While persons of diverse backgrounds are given 'unfair' advantage by the government, these white radicals claim to be economically and socially disenfranchised. The radicals thus articulate their identity as a dispossessed and socially castigated Other. In this way the conflict the supremacists have with the oppressed group members may in part be aggravated by an effort to expropriate their identity as the Other.

Interactive relationships in cyberspace

Radical cyberculture does not exist in a communicative vacuum. As members discover more efficient ways to reach new recruits, non-racist individuals can, concomitantly, contact the radicals. The interaction spurred by Usenet newsgroups functions, in microcosm, as a conversation between subversives and society as a whole. Although subversives occasionally present their views to the public, interactions occur daily on-line via the Internet. Given their importance to the movement and the access they provide to outside contacts, it is important to examine the patterns of interaction and tendencies which make up the 'language game' of the subversive newsgroups.

The newsgroups operated by political extremists foster communication between members of subversive groups and serve as a means of recruitment. Yet upon analysing the discourse I discovered an unexpected phenomenon: the regular presence of outsiders. These non-members, whom I shall designate by the term 'antagonists', are a prominent component of the newsgroups. I choose the term 'antagonists' for this label because it most appropriately meets the stylistic attributes of many (although not all) non-members. One person writing on *alt.skinhead* under the heading of 'Nazi loser', exemplified the aversion some 'antagonists' display toward the subversives:

> hey, you little Nazi-loser! . . . Just in case you haven't heard, Adolph [sic] is dead, the SS hanged and you white-trash are the sorry remnants of the panzer divisions! . . . Now that I have discovered your little hideout, I'm going to lead all of my buddies to ya. It will be fun! Swines like you should be placed in a cage and left with a traveling circus!
>
> (Membari 1996)

While such rogue attacks should be expected, the importance of the antagonists in generating dialogue remains surprising. Most of the contributions encountered on *alt.politics.nationalism.white*, *alt.politics.white-power*, and *alt.skinhead* contain criticism from outside of the culture. Antagonistic messages play a key role in triggering a dialogue, providing a theme, or a sense of vivaciousness needed to continue a discussion.

These clashes between insiders and their antagonists function as an ideological dialectic. They result in an interplay between the subversives and non-subversives who browse newsgroups in order to dispute radicals. In one such instance, two interlocutors on the *alt.politics.white-power*, the first, an Army officer, demonstrate the tendency for outsiders to critique racial claims:

> [User 1]:
> Well, I am proud and will not take crap from anyone. I hate niggers, spics, wops, kikes and yes, white trash.

[User 2]:
Such thoughtful, considered brilliance clearly show that the US special Forces only pick men of the highest caliber – intelligent and logical thinkers who scorn danger.

I suggest the US military may need to rethink its recruiting policy. And by the way, your mother dresses you funny.

Pip pip!

Flipper.

('Flipper' 1996)

This individual, 'Flipper', also known as 'Fingers McPhee', embodies the style of an antagonist as he inserts himself into radical conversations on the white supremacist and skinhead newsgroups. On one occasion another veteran antagonist formulated a racist survey for regular participants on a newsgroup. The entry begins by demonstrating a sense of personal intimacy, a form of friendliness used to augment the sarcasm of the textual message: 'Les, you are indeed pretty renowned on the Internet! just do an Alta Vista search for "Les Griswold" and behold! You are famous! Some even call you the premier Cybernazi! Got a couple of questions for you if you would be so kind to answer' ('Carleton' 1996). This woman forwarded her answers to the survey, censoring part of the antagonist's message by noting: '(snip – rest of liberal noise-making deleted)'. This interchange of critique and insult culminates with the antagonist disrupting the seriousness of the formal questionnaire to ask the woman why she did not shift to *rec.music.white-power* – a site which had recently been banished by a massive Internet vote – adding:

[User 1]:
Oh yeah I forgot, it got voted down, hahahahahahha.
Losers!!!!!

[User 2]:
Gloat while you can asshole. . .
********SPEAK THE WORD********
REVOLUTION

('Razorrogue' 1996)

This dialogue exemplifies a tension between familiarity and hostility which frequently surfaces on newsgroups. Such shifts from cordial recognition or warmth to ridicule also exist in discussions amongst supremacists themselves. Insiders, perhaps embracing more moderate levels of racist fervour, occasionally comment on posted notes. This internal critique may regulate what some supremacists view as the level of 'acceptability' within the racial discourse.

The use of criticism and rebuke may function at yet another level. Respondents – from both the inside and the outside – write and appear to solicit insulting responses. This can become obvious even in the beginning when a user introduces a theme. The pattern of insult and rebuke may be part of the 'language game' of these newsgroups. Respondents develop a form of call and response for verbal attacks, using *ad hominem* and hyperbole. While such discourse creates a climate of abuse, it also fosters a dimension of verbal sparring. Discussions turn into a limited linguistic warfare, limited in the

sense that users seek not to end the interaction with the opponent, but to provoke the respondent to a stronger degree of extremism. In the following trifurcated response, an overlapping of messages blurs the issues supporting and opposing racial superiority. This obscures the distinct ideologies altogether within a single sparring language game:

> [User 1]:
> The white people must stick together to conquer all the niggers.
>
> [User 2]:
> Evolved humans must band together to prevent simian vermin like this idiot from passing the [very rude epithet] gene on to another generation of imbeciles. Hey pal! Think you could try firing up your other neuron?
>
> [User 3]:
> Very nice sentiment, my friend, but could you please stop crossposting to groups in which Snowy's [author – respondent no. 1] racist rubbish and Whitey's [author – respondent no. 2] mindless reply are completely redundant? We have no problems with racism here in Australia!
> We are racists! No problem!
>
> (Hughes 1996)

This pattern of call and response changes dramatically when alternative modes of communication enter the arena. The insertion of scholarly material serves as the best example. In one entry in an alternative newsgroup (*misc.activism.militia*) a researcher posted a query for further information on group membership. The request was met by a refusal to engage on the part of any participant. Similarly, an academic-sounding statement appeared on *alt.skinhead*. This posting began with language which contrasted greatly with the accepted patterns of the skinhead language game: 'I am a female graduate student writing a thesis on women skins' (Megan 1996). It continued with sophisticated language, concluding with a tone of cheerfulness rarely encountered in the newsgroup: 'Thanks for your time and I look forward to your responses.'

Although this query was met by several serious answers, group members mocked its style. Particularly problematic to some was the claim by the graduate student that women skinheads constituted 'a movement'. One female replied: 'Joining a movement? I am very confused; I just *am* a skinhead. . . . I think that you are trying to artificially create some structured, hierarchical definition of skinhead that doesn't *really* exist' ('Schroedinger Cat' 1996). Another respondent strove to deconstruct the very notion of logic which the student had appropriated in formulating her inquiry:

> If you want to write about the truth, why are you calling the whole skinhead thing a movement? Do you really know what a skinhead is? I doubt it. So i'll tell you what you want to hear, although it is absurdly untrue.
> I'm a skinhead so I can breed with other whites and proliferate the Aryan race. (and for those of you who know me, you'll take this appropriately, as a JOKE).
>
> (Welch 1996)

Finally, one woman posted a one-line rebuke of the academic after several women had provided serious replies to the query:

She iz EzTABLIzHMENT. IgnoR her sizterz. she iz Evl.

This response, perhaps most telling of all, isolated the academic as a 'foreigner'. Rather than seeking to attack the radical ideology, this graduate student strove to *study* it. As a result, her question initiated a very different kind of relationship with the users. This academic voice extended from the outside, from a culture that was foreign to the previously established parameters of the *alt.skinhead* newsgroup. The graduate student's goal, rather than to invite insult, was technical in nature. It sought to define the movement, objectifying it in the Foucauldian sense of turning a disciplined 'gaze' upon it (Foucault 1980). Rather than employing a language of insult and abuse, this discourse sought to redefine the group members in academic terms. Here a form of critique would occur, yet this critique would appear in a linguistic style and in a type of medium not accessible to the members. As a result, this academic request prohibited a sparring familial relationship that often occurred on the newsgroups. Within the insulting behaviour there was an openness, a sense of full disclosure that would not be apparent in an academic work. For this reason, the academic – in her formal and polite language – became interpreted as 'Evl'.

Based on this analysis of the discourse of radical newsgroups, one can argue that while the antagonists are not part of the subversive community, their responses may serve an important function. Antagonists allow group members to counter-attack and to support their own peers, thus strengthening the internal cohesiveness. The language game of rudeness and insults allows the style of the radical culture to more forcefully emerge. This outlet can be discursively important to a culture that strives to be hyperbolic and confrontational. The participation of antagonists provides subversives with an audience and broadened access to the public, factors which increase the opportunities for the enactment of radical rhetoric.

Conclusion

This analysis has portrayed aspects of the subversive culture on the Internet as well as the delicate relationship between radicals, society and the Other. The articulation of extremist ideas within cybertexts demonstrates that radicals are supportive of persecuting innocent members of society. Such ideas and actions *cannot* be sanctioned. I thus concur with the prevailing sentiment in our society which seeks to limit the power of such discourse. None the less, we must also note that genuine ethical concerns could lead toward censorship. The case studies presented here reveal that a substantial infiltration from the outside may serve as an alternative to censorship. On the Internet a multiplicity of voices articulate a diversity of views. This differs substantially from the earlier 'letters to the editor' columns in subversive magazines which featured only discourse from the converted. The openness of the Internet and its interactive options may make it less likely for supremacists to break away from society and to form isolated cultures completely outside the reach of moderating influences. I agree with the sentiment given by a Jewish man writing on *alt.skinhead* who confronted his radical opponent:

> Tell me, do you go up to your jewish neighbours an [*sic*] expound on the 'ZOG', the 'jewish invention of slavery', and etc.? . . . Go up to an elderly jew with a cane and tell him that the Holocaust was an exaggeration, and

he would do his or her best to kill you with it. Weird sort of truth, that. Since you are the big white supremacist armed with the 'truth', why don't you yell it from the rooftops? Afraid people will laugh at you?'

(Braun 1996)

While cyberspace cannot become a substitute for personal confrontation, to engage a radical on a newsgroup is, none the less, a step toward forcing subversives into an open interaction with society. Closed communities live in hermetic isolation, and may serve as breeding grounds for extremism with all its physical threats. The openness of cyberspace does not offer such seclusion. The Internet may thus endanger the very notion of a closed community. In doing so it could become an ally in the struggle against bigotry and racism.

Originally published in S. Jones (ed.) (1997) *Virtual Culture: Identity and Communication in Cyberspace*, London: Sage.
This essay has been edited for inclusion in the Reader.

References

After Oklahoma (2) 'The Wild West' *The Economist*, 13 May 1995: 18–9.

Bertleson, D. R. (3 June 1996) 'Civil war in America rages.' Posted to *alt.politics.white-power*

Black, E. (1983) 'The second persona.' In J. R. Andrews (ed.), *The Practice of Rhetorical Criticism*, New York: Macmillan, pp. 131–41.

Boehmer, E. (1995) *Colonial and Postcolonial Literature*, Oxford: Oxford University Press.

Braun, D. (3 June 1996) 'Nazi loser.' Posted to *alt.skinhead*

Brenner, E. (28 January 1996) 'Censorship at issue on the Internet,' *New York Times*, sec 13 wc, p. 1.

'Carleton' (5 June 1996) 'Les–you're famous!' Posted to *alt.politics.white-power*

Charland, M. (1987) 'Constitutive rhetoric: The case of the *Peuple Québecois*,' *Quarterly Journal of Speech*, 73.

Charney, M. D. (2 July 1995) 'Word for word/the Skinhead International: Some music, it turns out, inflames the savage breast,' *New York Times*, sec. 4, p. 7.

Cyberhate (n.d.) *http: //www.io.com/~wlp/aryan-page/hate.html*

Dinnerstein, L. (1994) *Anti-semitism in America*, New York: Oxford University Press.

'Flipper' (7 June 1996) 'Who is McVey??????' Posted to *alt.politics.white-power*

Foucault, M. (1980) 'The eye of power,' In C. Gordon (Ed.), *Power and Knowledge: Selected Interventions and Other Writings, 1972–1977*, New York: Pantheon Books.

Germanica On-line (n.d.) *http: //www.geocities.com/capitolhill/1343*

Hamm, M. S. (1993) *American Skinheads: The Criminology and Control of Hate Crime*, Westport, CT: Praeger.

Hawthorne, G. E. (1996) Resistance Records Web home page. Accessed via the Aryan re-education links at *http: //www.cybernet.net/%7Emicetrap/skinlinks*

Heidegger, M. (1962) *Being and Time* (trans. J. Macquarrie & E. Robinson), San Francisco: Harper.

Hofstadter, R. (1965) *The Paranoid Style in American Politics and Other Essays*, New York: Alfred A. Knopf.

Hughes, J. G. (3 June 1996) 'Get off our group!' Posted to *alt.skinhead*

Kovaleski, S. F. (16 January 1996) 'American skinheads: Fighting minorities and each other,' *Washington Post*, sec. A, p. 1.

Langer, E. (16 July 1990) 'The American neo-Nazi movement today,' *Nation* pp. 12, 85.

Lewis, P. H. (30 July 1996) 'Second ruling opposes rules on indecency on the Internet,' *New York Times*, p. A7.

Lipset, S. M., & Raab, E. (1970) *The Politics of Unreason: Right-wing Extremism in America, 1790–1970*, New York: Harper & Row.

Logsdon, R. (17 September 1995) Cyberhate Web Page.

Mail Order Catalogue (1996) NSDAP/AO, PO Box 6414, Lincoln, NE 68506. Accessed through the National Alliance Web link, *http: //www.io.com/~wlp/aryan-page/hate.html*, the Web home page of Aryan Crusader's Library.

Mathis, A. (8 June 1996) 'Protocols of the Learned [*sic*] Elders of Zion.' Posted to *alt.politics.nationalism.white*

Megan (3 June 1996) 'Women skinheads.' Posted to *alt.skinhead*

Membari (3 June 1996) 'Nazi loser.' Posted to *alt.skinhead*

Myers, G. (1960) *History of Bigotry in the United States*, New York: Capricorn Books.

Nationale Volkspartij/CP'86 (n.d.) *http: //www.nvp.com/partij/*

Neibuhr, R. (1937) 'Pawns for fascism: Our lower middle class,' *The American Scholar*, 6: 137–53.

Pierce, W. L. (1996) 'Freespeech: Skinheads and the law.' National Alliance main Web page, accessed via *http: //www.io.com/~wlp/aryan-page/hate.html*

'Rad' (5 June 1996a) 'African Americans?' Posted to *alt.politics.nationalism.white*

'Rad' (5 June 1996b) 'How to spot a Jew.' Posted to *alt.politics.nationalism.white*

'Razorrogue' (1996) 'Women skinheads.' Posted to *alt.skinhead*

Ridgeway, J. (1990) *Blood in the Face*, New York: Thunder's Mouth Press.

Rosello, M. (1994) 'The screener's maps: Michel de Certeau's "Wandersmänner" and Paul Auster's hypertextual detective,' in G. P. Landow (ed.), *Hyper/Text/Theory*, Baltimore: Johns Hopkins University Press.

Sampson, E. E. (1993). *Celebrating the Other: A Dialogic Account of Human Nature*, Boulder, CO: Westview Press.

Scarborough Skinheads (n.d.) Accessible via *http: //www.io.com/~wlp/aryan-page/hate.html*

Schoedel, R. C. (7 June 1996) 'Nazi/Third Reich items for sale! 'Posted to *alt.politics.white-power*

'Schroedinger Cat' (5 June 1996) 'Women skinheads.' Posted to *alt.skinhead*

Schwartz, J. (28 April 1995) 'Advocates of Internet fear drive to restrict extremists' access.' *Washington Post*, p. 22.

Shook, M. (3 June 1996). 'Wizard of ZOG.' Posted to *alt.politics.nationalism.white*

Stormfront (n.d.). *http: //www.stormfront.org/stormfront/german.html*

Strom, K. A. (3 June 1996) 'Racial feelings are natural and good.' Posted on *alt.politics.white-power*

Talty, S. (25 February 1996) 'The method of a neo-Nazi mogul.' *New York Times*, sec. 6, p. 40.

Theunissen, M. (1984) *The Other: Studies in the Social Ontology of Husserl, Heidegger, Sartre and Buber*, Cambridge, MA: The MIT Press.

Vos, J. (1996) 'The homosexual threat, Fact #10: Homosexuality is NOT Natural.' CNG Web page, accessed via *http: //www.io.com/~wlp/aryan-page/hate.html*

Welch, J. (6 June 1996) 'Women skinheads.' Posted to *alt.skinhead*

Wittgenstein, L. (1953) *Philosophical Investigations*, Oxford: Basil Blackwell.

'Yggdrasil' (1996a) 'The white nationalism FAQ.' National Alliance Web page, accessed via *http: //www.io.com/~wlp/aryan-page/hate.html*

'Yggdrasil' (1996b) 'Ygg's white nationalism – key concepts.' National Alliance Web page, accessed via *http: //www.io.com/~wlp/aryan-page/hate.html*

Zündelsite (n.d.) *http: .//www.webcom.com/ezundel/*

ANDREW ROSS

HACKING AWAY AT THE
COUNTER-CULTURE

EVER SINCE THE VIRAL ATTACK engineered in November 1988 by
Cornell University hacker Robert Morris on the national network system Internet,
which includes the Pentagon's ARPAnet data exchange network, the nation's high-tech
ideologues and spin doctors have been locked in debate, trying to make ethical and
economic sense of the event. The virus rapidly infected an estimated six thousand
computers around the country, creating a scare that crowned an open season of viral
hysteria in the media, in the course of which, according to the Computer Virus Industry
Association in Santa Clara, California, the number of known viruses jumped from seven
to thirty during 1988, and from three thousand infections in the first two months of
that year to thirty thousand in the last two months.[1] While it caused little in the way
of data damage (some richly inflated initial estimates reckoned up to $100 million in
downtime), the ramifications of the Internet virus have helped to generate a moral picnic
that has all but transformed everyday 'computer culture'.

There is another story to tell about the emergence of the virus scare as a profitable
ideological moment, and it is the story of how teenage hacking has come to be defined
increasingly as a potential threat to normative educational ethics and national security
alike. The story of the creation of this 'social menace' is central to the ongoing attempts
to rewrite property law in order to contain the effects of the new information tech-
nologies that, because of their blindness to the copyrighting of intellectual property,
have transformed the way in which modern power is exercised and maintained.
Consequently, a deviant social class or group has been defined and categorized as 'enemies
of the state' in order to help rationalize a general law-and-order clampdown on free
and open information exchange. Teenage hackers' homes are now habitually raided by
sheriffs and FBI agents using strong-arm tactics, and jail sentences are becoming a
common punishment. Operation Sun Devil, a nationwide Secret Service operation
conducted in the spring of 1990, and involving hundreds of agents in fourteen cities, is
the most recently publicized of the hacker raids that have resulted in several arrests and
the seizure of thousands of disks and address lists in the last two years.[2]

In one of the many harshly punitive prosecutions against hackers in recent years, a judge went so far as to describe 'bulletin boards' as 'high-tech street gangs'. The editors of *2600*, the magazine that publishes information about system entry and exploration indispensable to the hacking community, have pointed out that any single invasive act, such as trespass, that *involves* the use of computers is considered today to be infinitely more heinous than a similar act undertaken *without* computers.[3] To use computers to execute a prank, raid, fraud or theft is to incur automatically the full repressive wrath of judges, urged on by the moral panic created around hacking feats over the last two decades. Indeed, a strong body of pressure groups is pushing for new criminal legislation that will define 'crimes with computers' as a special category deserving 'extra-ordinary' sentences and punitive measures. An increasingly criminal connotation today has displaced the more innocuous, amateur-mischief-maker-cum-media-star role reserved for hackers until a few years ago.

In response to the gathering vigour of this 'war on hackers', the most common defences of hacking can be presented on a spectrum that runs from the appeasement or accommodation of corporate interests to drawing up blueprints for cultural revolution: (a) hacking performs a benign industrial service of uncovering security deficiencies and design flaws; (b) hacking, as an experimental, free-form research activity, has been responsible for many of the most progressive developments in software development; (c) hacking, when not purely recreational, is an elite educational practice that reflects the ways in which the development of high-technology has outpaced orthodox forms of institutional education; (d) hacking is an important form of watchdog counter-response to the use of surveillance technology and data-gathering by the state, and to the increasingly monolithic communications power of giant corporations; (e) hacking, as guerrilla know-how, is essential to the task of maintaining fronts of cultural resistance and stocks of oppositional knowledge as a hedge against a technofascist future. With all of these and other arguments in mind, it is easy to see how the social and cultural *management* of hacker activities has become a complex process that involves state policy and legislation at the highest levels. In this respect, the virus scare has become an especially convenient vehicle for obtaining public and popular consent for new legislative measures and new powers of investigation for the FBI.[4]

Consequently, certain celebrity hackers have been quick to play down the zeal with which they pursued their earlier hacking feats, while reinforcing the *deviant* category of 'technological hooliganism' reserved by moralizing pundits for 'dark-side' hacking, and writing books about security for the eyes of worried corporate managers.[5] A different, though related, genre is that of the penitent hacker's 'confession', produced for an audience thrilled by tales of high-stakes adventure at the keyboard, but written in the form of a computer security handbook. The best example of the 'I Was a Teenage Hacker' genre is Bill (aka 'The Cracker') Landreth's *Out of the Inner Circle: The True Story of a Computer Intruder Capable of Cracking the Nation's Most Secure Computer Systems*, a book about 'people who can't "just say no" to computers'. Landreth recirculates every official and media cliché about subversive conspiratorial groups by recounting the putative exploits of a high-level hackers' guild called the Inner Circle. The author himself is presented in the book as a former keyboard junkie who now praises the law for having made a moral example of him:

> If you are wondering what I am like, I can tell you the same things I told
> the judge in federal court: Although it may not seem like it, I am pretty

much a normal American teenager. I don't drink, smoke or take drugs. I
don't steal, assault people, or vandalize property. The only way in which I
am really different from most people is in my fascination with the ways and
means of learning about computers that don't belong to me.[6]

Sentenced in 1984 to three years' probation, during which time he was obliged to finish
his high school education and go to college, Landreth concludes: 'I think the sentence
is very fair, and I already know what my major will be. . . .' As an aberrant sequel to
the book's contrite conclusion, however, Landreth vanished in 1986, violating his proba-
tion, only to later face a stiff five-year jail sentence – a sorry victim, no doubt, of the
recent crackdown.

Cyber-counter-culture?

At the core of Steven Levy's 1984 bestseller, *Hackers*, is the argument that the hacker
ethic, first articulated in the 1950s among the famous MIT students who developed
multiple-access user systems, is libertarian and crypto-anarchist in its right-to-know prin-
ciples and its advocacy of decentralized technology. This hacker ethic, which has remained
the preserve of a youth culture for the most part, asserts the basic right of users to free
access to all information. It is a principled attempt, in other words, to challenge the
tendency to use technology to form information elites. Consequently, hacker activities
were presented in the 1980s as a romantic counter-cultural tendency; the dominant
media representation of the hacker came to be that of the 'rebel with a modem', at
least until the more recent 'war on hackers' began to shape media coverage.

On the one hand, this popular folk hero persona offered the romantic high profile
of a maverick though nerdy cowboy whose fearless raids upon an impersonal 'system'
were perceived as a welcome tonic in the gray age of technocratic routine. On the other
hand, he was something of a juvenile technodelinquent who hadn't yet learned the differ-
ence between right and wrong; a wayward figure whose technical brilliance and
proficiency differentiated him from, say, the maladjusted working-class J. D. street-
corner boy of the 1950s (hacker mythology, for the most part, has been almost exclusively
white, masculine and middle class). One result of this media profile was a persistent
infantilization of the hacker ethic – a way of trivializing its embryonic politics, however
finally complicit with dominant technocratic imperatives or with entrepreneurial–
libertarian ideology one perceives these politics to be. The second result was to rein-
force, in the initial absence of coercive jail sentences, the high educational stakes of
training the new technocratic elites to be responsible in their use of technology. Never,
the given wisdom goes, has a creative elite of the future been so in need of the virtues
of a liberal education steeped in Western ethics!

The full force of this lesson in computer ethics can be found *laid out* in the official
Cornell University report on the Robert Morris affair. Members of the university
commission set up to investigate the affair make it quite clear in their report that they
recognize the student's academic brilliance. His hacking, moreover, is described as a
'juvenile act' that had no 'malicious intent' but that amounted, like plagiarism, the tradi-
tional academic heresy, to a dishonest transgression of other users' rights. (In recent
years, the privacy movement within the information community – mounted by liberals

to protect civil rights against state gathering of information – has actually been taken up and used as a means of criminalizing hacker activities.) As for the consequences of this juvenile act, the report proposes an analogy that is thoroughly American, suburban, middle class and *juvenile*. Unleashing the Internet worm was like 'the driving of a golf-cart on a rainy day through most houses in the neighborhood. The driver may have navigated carefully and broken no china, but it should have been obvious to the driver that the mud on the tires would soil the carpets and that the owners would later have to clean up the mess'.[7]

In what stands out as a stiff reprimand for his alma mater, the report regrets that Morris was educated in an 'ambivalent atmosphere' where he 'received no clear guidance' about ethics from 'his peers or mentors' (he went to Harvard!). But it reserves its loftiest academic contempt for the press, whose heroizing of hackers has been so irresponsible, in the commission's opinion, as to cause even further damage to the standards of the computing profession; media exaggerations of the courage and technical sophistication of hackers 'obscures the far more accomplished work of students who complete their graduate studies without public fanfare', and 'who subject their work to the close scrutiny and evaluation of their peers, and not to the interpretations of the popular press'.[8] In other words, this was an inside affair, to be assessed and judged by fellow professionals within an institution that reinforces its authority by means of internally self-regulating codes of professional ethics, but rarely addresses its ethical relationship to society as a whole (acceptance of defence grants, and the like). Generally speaking, the report affirms the genteel liberal ideal that professionals should not need laws, rules, procedural guidelines or fixed guarantees of safe and responsible conduct. Apprentice professionals ought to have acquired a good conscience by osmosis from a liberal education, rather than from some specially prescribed course in ethics and technology.

The widespread attention commanded by the Cornell report (attention from the Association of Computing Machinery, among others) demonstrates the industry's interest in how the academy invokes liberal ethics in order to assist in managing the organization of the new specialized knowledge about information technology. Despite, or perhaps because of, the report's steadfast pledge to the virtues and ideals of a liberal education, it bears all the marks of a legitimation crisis inside (and outside) the academy surrounding the new and all-important category of computer professionalism. The increasingly specialized design knowledge demanded of computer professionals means that codes going beyond the old professionalism separation of mental and practical skills are needed to manage the division that a hacker's functional talents call into question, between a purely mental pursuit and the pragmatic sphere of implementing knowledge in the real world. 'Hacking' must then be designated as a strictly *amateur* practice; the tension in hacking between *interestedness* and *disinterestedness* is different from, and deficient in relation to, the proper balance demanded by professionalism. Alternatively, hacking can be seen as the amateur flipside of the professional ideal – a disinterested love in the service of interested parties and institutions. In either case, it serves as an example of professionalism gone wrong, if not very wrong.

The Cornell report shows how the academy uses a case like the Morris affair to strengthen its own sense of moral and cultural authority in the sphere of professionalism, particularly through its scornful indifference to and aloofness from the codes and judgements exercised by the media, its diabolical competitor in the field of knowledge.

Indeed, for all the trumpeting about excesses of power and disrespect for the law of the land, the revival of ethics in the business and science disciplines of the Ivy League and on Capitol Hill is little more than a weak liberal response to working flaws or adaptational lapses in the technocracy's social logic.

To complete the scenario of morality play example-making, however, we must also consider that Morris' father was chief scientist at the National Computer Security Center, the National Security Agency's public effort at safeguarding computer security. A brilliant programmer and code-breaker in his own right, he had testified in Washington in 1983 about the need to deglamorize teenage hacking, comparing it to 'stealing a car for the purpose of joyriding'. In a further Oedipal irony, Morris Snr may have been one of the inventors, while at Bell Labs in the 1950s, of a computer game involving self-perpetuating programs that were a prototype of today's worms and viruses. Called Darwin, its principles were incorporated in the 1980s into the popular hacker game Core War, in which autonomous 'killer' programs fought each other to the death.[9]

With the appearance in the Morris affair of the Pentagon's guardian angel as patricidal object – an implicated if not victimized father – we now have many of the classic components of counter-cultural, cross-generational conflict. We might consider how and where this scenario differs from the definitive contours of such conflicts that we recognize as having been established in the 1960s; how the Cornell hacker Morris' relation to, say, campus 'occupations' today is different from that evoked by the famous image of armed black students emerging from a sit-in on the Cornell campus; how the relation to technological ethics differs from Andrew Kopkind's famous statement, 'Morality begins at the end of a gun barrel', which accompanied the publication of the 'do-it-yourself Molotov cocktail' design on the cover of a 1968 issue of the *New York Review of Books*; or how hackers' prized potential access to the networks of military systems warfare differs from the prodigious Yippie feat of levitating the Pentagon building. It may be that, like the J. D. rebel without a cause of the 1950s, the disaffiliated student dropout of the 1960s, and the negationist punk of the 1970s, the hacker of the 1980s has come to serve as a visible, public example of moral maladjustment, a hegemonic test case for redefining the dominant ethics in an advanced technocratic society.

What concerns me here, however, are the different conditions that exist today for recognizing counter-cultural expression and activism. Twenty years later, the technology of hacking and viral guerrilla warfare occupies a similar place in counter-cultural fantasy as the Molotov cocktail design once did. While such comparisons are not particularly sound, I do think that they conveniently mark a shift in the relation of counter-cultural activity to technology; a shift in which a software-based technoculture organized around outlawed libertarian principles about free access to information and communication has come to replace a dissenting culture organized around the demonizing of abject hardware structures. Much, though not all, of the 1960s counter-culture was formed around what I have elsewhere called the *technology of folklore* – an expressive congeries of pre-industrialist, agrarianist, Orientalist and anti-technological ideas, values and social structures. By contrast, the cybernetic counter-cultures of the 1990s are already being formed around the *folklore of technology* – mythical feats of survivalism and resistance in a data-rich world of virtual environments and post-human bodies – which is where many of the science fiction- and technology-conscious youth cultures have been assembling in recent years.[10] Some would argue, however, that the ideas and values of the 1960s

counter-culture were only truly fulfilled in groups like the People's Computer Company, which ran Community Memory in Berkeley; or the Homebrew Computer Club, which pioneered personal microcomputing.[11] So, too, the Yippies had seen the need to form YIPL, the Youth International Party Line, devoted to 'anarcho-technological' projects, which put out a newsletter called *TAP* (alternately the *Technological American Party* and the *Technological Assistance Program*). In its depoliticized form, which eschewed the kind of destructive 'dark-side' hacking advocated in an earlier incarnation, *TAP* was eventually the progenitor of *2600*. A significant turning point, for example, was *TAP*'s decision not to publish plans for the hydrogen bomb (the *Progressive* did so) – bombs would destroy the phone system, which the *TAP* 'phone phreaks' had an enthusiastic interest in maintaining.

There is no doubt that the hacking scene today makes counter-cultural activity more difficult to recognize and therefore to define as politically significant. It was much easier in the 1960s to *identify* the salient features and symbolic power of a romantic pre-industrialist cultural politics in an advanced technological society, especially when the destructive evidence of America's super-technological invasion of Vietnam was being screened daily. However, in a society whose technopolitical infrastructure depends increasingly upon greater surveillance, and where foreign wars are seen through the lens of laser-guided smart bombs, cybernetic activism necessarily relies on a much more covert politics of identity. Access to closed digital systems requires discretion and dissimulation, the authentication of a signature or pseudonym, not the identification of a real surveillable person, so there exists a crucial operative gap between authentication and identification. By the same token, cybernetic identity is never exhausted; it can be recreated, reassigned and reconstructed with any number of different names and under different user accounts. In fact, most hacks or technocrimes go unnoticed or unreported for fear of publicizing the vulnerability of corporate security systems, especially when the hacks are performed by disgruntled employees taking their vengeance on management. So, too, authoritative identification of any individual hacker, whenever it occurs, is often the result of accidental leads rather than systematic detection.

Eschewing its core constituency among the white male preprofessional-managerial class, the hacker community may be expanding its parameters outward. Hacking, for example, has become a feature of young-adult novel genres for girls.[12] The elitist class profile of the hacker prodigy as that of an under-socialized college nerd has become democratized and customized in recent years; it is no longer exclusively associated with institutionally acquired college expertise, and increasingly it dresses streetwise. In a recent article that documents the spread of the computer underground from college whiz-kids to a broader youth subculture termed 'cyberpunks,' after the movement among science fiction novelists, the original hacker phone phreak Captain Crunch is described as lamenting the fact that the cyberculture is no longer an 'elite' one, and that hacker-valid information is much easier to obtain these days.[13]

For the most part, however, the self-defined hacker underground, like many other proto-counter-cultural tendencies, has been restricted to a privileged social milieu, further magnetized by its members, understanding that they are the apprentice architects of a future dominated by knowledge, expertise and 'smartness', whether human or digital. Consequently, it is clear that the hacker cyberculture is not a drop-out culture; its disaffiliation from a domestic parent culture is often manifest in activities that answer, directly or indirectly, to the legitimate needs of industrial R&D. For example, this hacker

culture celebrates high productivity, maverick forms of creative work energy, and an obsessive identification with on-line endurance (and endorphin highs) — all qualities that are valorized by the entrepreneurial codes of silicon futurism. In a critique of the hacker-as-rebel myth, Dennis Hayes debunks the political romance woven around the teenage hacker:

> They are typically white, upper-middle-class adolescents who have taken over the home computer (bought, subsidized, or tolerated by parents in the hope of cultivating computer literacy). Few are politically motivated although many express contempt for the 'bureaucracies' that hamper their electronic jour-neys. Nearly all demand unfettered access to intricate and intriguing computer networks. In this, teenage hackers resemble an alienated shopping culture deprived of purchasing opportunities more than a terrorist network.[14]

While welcoming the sobriety of Hayes' critique, I am less willing to accept its assumptions about the political implications of hacker activities. Studies of youth subcul-tures (including those of a privileged middle-class formation) have taught us that the political meaning of certain forms of cultural 'resistance' is notoriously difficult to read. These meanings are either highly coded or expressed indirectly through media — private peer languages, customized consumer styles, unorthodox leisure patterns, categories of insider knowledge and behaviour — that have no fixed or inherent political significance. If cultural studies of this sort have proved anything, it is that the often symbolic, not wholly articulate, expressivity of a youth culture can seldom be translated directly into an articulate political philosophy. The significance of these cultures lies in their embry-onic or *protopolitical* languages and technologies of opposition to dominant or parent systems of rules. If hackers lack a 'cause', then they are certainly not the first youth culture to be characterized in this dismissive way: the left in particular has suffered from the lack of a cultural politics capable of recognizing the power of cultural expressions that do not wear a mature political commitment on their sleeves.

The escalation of activism in the professions in the last two decades has shown that it is a mistake simply to condemn the hacker impulse for its class constituency. To cede the 'ability to know' on the ground that elite groups will enjoy unjustly privileged access to technocratic knowledge is to cede too much of the future. Is it of no political signif-icance at all that hackers' primary fantasies often involve the official computer systems of the police, armed forces and defence and intelligence agencies? And that the ratio-nale for their fantasies is unfailingly presented as a defence of civil liberties against the threat of centralized intelligence and military activities? Or is all of this merely a symptom of an apprentice elite's fledgling will to masculine power? The activities of the Chinese student elite in the pro-democracy movement have shown that unforeseen shifts in the political climate can produce startling new configurations of power and resistance. After Tiananmen Square, Party leaders found it imprudent to purge those high-tech engineer and computer cadres who alone could guarantee the future of any planned moderniza-tion programme. On the other hand, the authorities rested uneasy knowing that each cadre (among the most activist groups in the student movement) is a potential hacker who can have the run of the communications house if and when he or she wants.

On the other hand, I do agree with Hayes' perception that the media have pursued their romance with the hacker at the cost of under-reporting the much greater chal-lenge posed to corporate employers by their employees. Most high-tech 'sabotage' takes

place in the arena of conflicts between workers and management. In the ordinary, everyday life of office workers – mostly female – a widespread culture of unorganized sabotage accounts for infinitely more computer downtime and information loss every year then is caused by destructive 'dark-side' backing by cybernetic intruders. The sabotage, time theft and strategic monkey-wrenching deployed by office workers in their engineered electromagnetic attacks on data storage and operating systems might range from the planting of time or logic bombs to the discreet use of electromagnetic Tesla coils or simple bodily friction: 'Good old static electricity discharged from the fingertips probably accounts for close to half the disks and computers wiped out or down every year.'[15] More skilled operators, intent on evening a score with management, often utilize sophisticated hacking techniques. In many cases, a coherent networking culture exists among console operators, where, among other things, tips about strategies for slowing down the pace of the work regime are circulated. While these threats from below are fully recognized in boardrooms, corporations dependent upon digital business machines are obviously unwilling to advertise how acutely vulnerable they actually are to this kind of sabotage. It is easy to imagine how organized computer activism could hold such companies to ransom. As Hayes point out, however, it is more difficult to mobilize any kind of labour movement organized upon such premises:

> Many are prepared to publicly oppose the countless dark legacies of the computer age: 'electronic sweatshops,' military technology, employee surveillance, genotoxic water, and zone depletion. Among those currently leading the opposition, however, it is apparently deemed 'irresponsible' to recommend an active computerized resistance as a source of worker's power because it is perceived as a medium of employee crime and 'terrorism.'[16]

Processed World, the 'magazine with a bad attitude', with which Hayes has been associated, is at the forefront of debating and circulating these questions among office workers, regularly tapping into the resentments borne out in on-the-job resistance.[17]

While only a small number of computer users would categorize themselves as 'hackers', there are defensible reasons for extending the restricted definition of *hacking* down and across the caste hierarchy of systems analysts, designers, programmers and operators to include all high-tech workers – no matter how inexpert – who can interrupt, upset and redirect the smooth flow of structured communications that dictates their position in the social networks of exchange and determines the pace of their work schedules. To put it in these terms, however, is not to offer any universal definition of hacker agency. There are many social agents, for example, in job locations who are dependent upon the hope of technological *re-skilling* and for whom sabotage or disruption of communicative rationality is of little use; for such people, definitions of hacking that are reconstructive, rather than deconstructive, are more appropriate. A good example is the crucial role of worker techno-literacy in the struggle of labour against automation and de-skilling. Workers' computer literacy is seen as essential, not only to the demystification of the computer and the re-skilling of workers, but also to labour's capacity to intervene in decisions about new technologies that might result in shorter hours and thus in 'work efficiency' rather than worker efficiency.

The three social locations I have mentioned above all express different class relations to technology: the location of an apprentice technical elite, conventionally associated with the term *hacking*; the location of the high-tech office worker, involved

in 'sabotage'; and the location of the shopfloor worker, whose future depends on tech-
nological re-skilling. All therefore exhibit different ways of *claiming back* time dictated
and appropriated by technological processes, and of establishing some form of inde-
pendent control over the work relation so determined by the new technologies. All,
then, fall under a broad understanding of the politics involved in any extended descrip-
tion of hacker activities.

The culture and technology question

Faced with these proliferating practices in the workplace, on the teenage cult fringe,
and increasingly in mainstream entertainment, where over the last five years the cyber-
punk sensibility in popular fiction, film and television has caught the romance of the
outlaw technology of human/machine interfaces, we are obliged, I think, to ask old
questions about the new silicon order that the evangelists of information technology
have been deliriously proclaiming for more than twenty years. The post-industrialists'
picture of a world of freedom and abundance projects a bright millenarian future devoid
of work drudgery and ecological degradation. This sunny social order, cybernetically
wired up, is presented as an advanced evolutionary phase of society in accord with
Enlightenment ideals of progress and rationality. By contrast, critics of this idealism see
only a frightening advance in the technologies of social control – whose owners and
sponsors are efficiently shaping a society, as Kevin Robins and Frank Webster put it, of
'slaves without Athens' that is exactly the inverse of the 'Athens without slaves' promised
by the silicon positivists.[18] To counter the post-industrialists' millenarian picture of a
postscarcity harmony in which citizens enjoy decentralized access to free-flowing infor-
mation, it is necessary to emphasize how and where actually existing cybernetic capitalism
presents a gross caricature of such a postscarcity society.

One of the stories told by the critical left about new cultural technologies is that
of monolithic, panoptical social control, effortlessly achieved through a smooth, endlessly
interlocking system of surveillance networks. In this narrative, information technology
is seen as the most despotic mode of domination yet, generating not just a revolution
in capitalist production but also a revolution in living – 'social Taylorism' – touching
all cultural and social spheres in the home and the workplace.[19] Through gathering of
information about transactions, consumer preferences and credit worthiness, a harvest
of information about any individual's whereabouts and movements, tastes, desires,
contacts, friends, associates and patterns of work and recreation becomes available in
dossiers sold on the tradable information market, or is endlessly convertible into other
forms of intelligence through computer-matching. Advanced pattern recognition tech-
nologies facilitate the process of surveillance, while data encryption protects it from
public accountability.[20]

While the debate about privacy has triggered public consciousness about these
excesses, the liberal discourse about ethics and damage control in which that debate has
been conducted falls short of the more comprehensive analysis of social control and
social management offered by left political economists who see information, increas-
ingly, as the major site of capital accumulation in the world economy. What happens
in the process by which information, gathered up by data-scavenging in the transactional
sphere, is systematically converted into intelligence? A surplus value is created for use

elsewhere. This surplus information value is more than is needed for public surveillance; it is often information, or intelligence, culled from consumer polling or statistical analysis of transactional behaviour, that has no immediate use in the process of routine public surveillance. This surplus bureaucratic capital is used to forecast social futures, and consequently is applied to the task of managing in advance the future behaviour of mass populations. This surplus intelligence becomes the basis of a whole new industry of futures research that relies upon computer technology to simulate and forecast the shape, activity and behaviour of complex social systems. The result is a system of social management that far transcends the questions about surveillance that have been at the discursive centre of the privacy debate.[21]

To challenge further the idealists' vision of post-industrial light and magic, we need only look inside the semiconductor workplace itself, home to the most toxic chemicals known to man (and woman, especially since women of colour often make up the majority of the microelectronics labour force), where worker illness is measured not in quantities of blood spilled on the shopfloor but in the less visible forms of chromosome damage, miscarriages, premature deliveries and severe birth defects. Semiconductor workers exhibit an occupational illness rate that, by the late 1970s, was already three times higher than that of manufacturing workers, at least until the federal rules for recognizing and defining injury levels were changed under the Reagan administration. Protection gear is designed to protect the product and the clean room from the workers, not vice versa. Recently, immunological health problems have begun to appear that can only be described as a kind of chemically induced AIDS, rendering the T-cells dysfunctional rather than depleting them like virally induced AIDS.[22] In corporate offices, where extraordinarily high stress patterns and illness rates are reported among VDT operators, the use of keystroke software to monitor and pace office workers has become a routine part of job performance evaluation programmes. Some 70 per cent of corporations use electronic surveillance or other forms of quantitative monitoring of their workers. Every bodily movement, especially trips to the toilet, can be checked and measured. Federal deregulation has meant that the limits of employee workspace have in some government offices shrunk below that required by law for a two-hundred-pound laboratory pig.[23] Critics of the labour process seem to have sound reasons to believe that rationalization and quantification are at last entering their most primitive phase.

What I have been describing are some of the features of that critical left position – sometimes referred to as the 'paranoid' position – on information technology which imagines or constructs a totalizing, monolithic picture of systematic domination. While this story is often characterized as conspiracy theory, its targets – technorationality, bureaucratic capitalism – are usually too abstract to fit the picture of a social order planned and shaped by a small, conspiring group of centralized power elites.

Although I believe that this story, when told inside and outside the classroom, for example, is an indispensable form of 'consciousness-raising', it is not always and everywhere the best story to tell. While I am not comfortable with the 'paranoid' labelling, I would argue that such narratives do little to discourage paranoia. The critical habit of finding unrelieved domination everywhere has certain consequences, one of which is to create a siege mentality, reinforcing the inertia, helplessness and despair that such critiques set out to oppose in the first place. The result is a politics that can speak only from a victim's position. And when knowledge about surveillance is presented as systematic and infallible, self-censoring is sure to follow. In the psychosocial climate of fear

and phobia aroused by the virus scare, there is a responsibility not to be alarmist or scared – especially when such moments are profitably seized upon by the sponsors of control technology. In short, the picture of a seamlessly panoptical network of surveillance may be the result of a rather undemocratic, not to mention unsocialist, way of thinking, predicated upon the definition of people solely as victims. It echoes the old sociological models of mass society and mass culture, which cast the majority of society as passive and lobotomized in the face of modernization's cultural patterns. To emphasize, as Robins and Webster and others have done, the power of the new technologies to transform despotically the 'rhythm, texture, and experience' of everyday life, and meet with no resistance in doing so, is not only to cleave, finally, to an epistemology of technological determinism, but also to dismiss the capacity of people to make their own use of new technologies, and to view technology as a contested site.[24]

The seamless 'interlocking' of public and private information and intelligence networks is not as smooth and even as the critical school of hard domination would suggest. Compulsive gathering of information is no *guarantee* that any interpretive sense will be made of the files or dossiers. In any case, the centralized, 'smart' supervision of an information gathering system would require, as Hans Magnus Enzensberger once argued, 'a monitor that was bigger than the system itself'; 'a linked series of communications . . . to the degree that it exceeds a certain critical size, can no longer be centrally controlled but only dealt with statistically'.[25] Some would argue that the increasingly covert nature of surveillance indicates that the 'campaign' for social control is not going well, and one of the most pervasive popular arguments against the panoptical intentions of technology's masters is that their systems do not work very well. Every successful hack or computer crime in some way reinforces the popular perception that information systems are not infallible.

I am not suggesting that alternatives can be forged simply by encouraging disbelief in the infallibility of existing technologies. But technoscepticism, while not a *sufficient* condition for social change, is none the less a *necessary* condition. Stocks of popular technoscepticism are crucial to the task of eroding the legitimacy of those cultural values that prepare the way for new technological developments: values and principles such as the inevitability of material progress, the 'emancipatory' domination of nature, the innovative autonomy of machines, the efficiency codes of pragmatism, and the linear juggernaut of liberal Enlightenment rationality – all increasingly under close critical scrutiny as a wave of ecological consciousness sweeps through the electorates of the West. Technologies do not shape or determine such values, which already pre-exist the technologies; the fact that they have become deeply embodied in the structure of popular needs and desires provides the green light for accepting certain kinds of technology. In fact, the principal rationale for introducing new technologies is that they answer to already existing intentions and demands that may be perceived as 'subjective' but are never actually within the control of any single set of conspiring individuals. As Marike Finlay has argued, just as technology is possible only in given discursive situations (one of which is the desire of people to have it for reasons of empowerment), so capitalism is merely the site, and not the source, of the power that is often autonomously attributed to the owners and sponsors of technology.[26]

No frame of technological inevitability has not already interacted with popular needs and desires; no introduction of new machineries of control has not already been negotiated to some degree in the arena of popular consent. Thus the power to design

architecture that incorporates different values must arise from the popular perception that existing technologies are not the only ones; nor are they the best when it comes to individual and collective empowerment. It was this perception – formed around the distrust of big, impersonal, 'closed' hardware systems, and the desire for small, decentralized, interactive machines to facilitate interpersonal communication – that 'built' the PC out of hacking expertise in the early 1970s. These desires and distrusts were as much the partial 'intentions' behind the development of microcomputing technology as de-skilling, worker monitoring and information gathering are the intentions behind the corporate use of that technology today. The machinery of counter-surveillance is now up and running. The explosive growth of public data networks, bulletin board systems and alternative information and media links, and the increasing cheapness of desktop publishing, satellite equipment and international databases are as much the result of local political 'intentions' as the fortified net of globally-linked, restricted-access information systems is the intentional fantasy of those who seek to profit from centralized control. The picture that emerges from this mapping of intentions is not an inevitably technofascist one, but rather the uneven result of cultural struggles over values and meanings. These local advances are further assisted by the contradictions of capitalism itself, since market demand for ever cheaper and more resourceful technologies is putting video cameras and computing power into the hands of ordinary people who have traditionally experienced technology only as its object of surveillance, or, at best, its passive operator.

It is in the struggle over values and meanings that the work of cultural criticism takes on its special significance as a full participant in the debate about technology; a debate in which it is already fully implicated, if only because the culture and education industries are rapidly becoming integrated within the vast information service conglomerates. The media we study, the media we publish in, and the media we teach are increasingly part of the same tradable information sector. So too, our common intellectual discourse has been significantly affected by the recent debates about postmodernism (or culture in a post-industrial world) in which the euphoric, addictive thrill of the technological sublime has figured quite prominently. The high-speed technological fascination that is characteristic of the postmodern condition can be read, on the one hand, as a celebratory capitulation by intellectuals to the new information technocultures. On the other hand, this celebratory strain attests to the persuasive affect associated with the new cultural technologies, to their capacity (more powerful than that of their sponsors and promoters) to generate pleasure and gratification and to win the contest for intellectual as well as popular consent.

Another reason for the involvement of cultural critics in the technology debates has to do with our social critical knowledge of the way cultural meanings are produced – our knowledge about the politics of consumption and what is often called the politics of representation. This knowledge demonstrates that there are limits to the capacity of productive forces to shape and determine consciousness, insisting on the ideological or interpretive dimension of technology as a culture that can and must be used and consumed in a variety of ways not reducible to the intentions of any single source or producer; technology's meanings cannot simply be read off as evidence of faultless social reproduction. It is a knowledge, in short, that refuses to add to the 'hard domination' picture of disenfranchised individuals watched over by some scheming panoptical intelligence. Far from being understood solely as the concrete hardware of sophisticated electronic

objects, technology must be seen as a lived, interpretive practice for people in their everyday lives. To redefine the shape and form of that practice is to help create the need for new kinds of hardware and software.

One of this chapter's aims has been to describe and suggest a wider set of activities and social locations than is normally associated with the practice of hacking. If there is a challenge here for cultural critics, it might be the commitment to making our knowledge about technoculture into something like a hacker's knowledge, capable of penetrating existing systems of rationality that might otherwise be seen as infallible; a hacker's knowledge, capable of re-skilling, and therefore of rewriting, the cultural programmes and reprogramming the social values that make room for new technologies; a hacker's knowledge, capable also of generating new popular romances around the alternative uses of human ingenuity. If we are to take up that challenge we cannot afford to give up what technoliteracy we have acquired in deference to the vulgar faith that tells us it is always acquired in complicity and is thus contaminated by the toxin of instrumental rationality; or because we hear, often from the same quarters, that acquired technological competence simply glorifies the inhuman work ethic. Technoliteracy, for us, is the challenge to make a historical opportunity out of a historical necessity.

Originally published in A. Ross (1991) *Strange Weather: Culture, Science and Technology in the Age of Limits*, London: Verso.
This essay has been edited for inclusion in the Reader.

Notes

1. John Markoff, *The New York Times*, 30 May 1989.
2. For details of these raids, see *2600: The Hacker's Quarterly*, 7 (1) (Spring 1990).
3. 'Hackers in Jail', *2600: The Hacker's Quarterly*, 6 (1) (Spring 1989), pp. 22–3. The recent Secret Service action that threatened to shut down *Phrack*, an electronic newsletter operating out of St Louis, confirms *2600*'s thesis; non-electronic publication would not be censored in the same way.
4. This is not to say that the new laws cannot themselves be used to protect hacker institutions, however. *2600* has advised operators of bulletin boards to declare them private property, thereby guaranteeing protection under the Electronic Privacy Act against unauthorized entry by the FBI.
5. See Hugo Cornwall, *Data Theft* (London: Heinemann, 1987).
6. Bill Landreth, *Out of the Inner Circle: The True Story of a Computer Intruder Capable of Cracking the Nation's Most Secure Computer Systems* (Redmond, WA: Tempus, Microsoft, 1989), p. 10.
7. *The Computer Worm: A Report to the Provost of Cornell University on an Investigation Conducted by the Commission of Preliminary Enquiry* (Ithaca, NY: Cornell University, 1989).
8. Ibid., p. 8.
9. A. K. Dewdney, the 'computer recreations' columnist at *Scientific American*, was the first to publicize the details of this game of battle programs in an article in the magazine's May 1984 issue. In a follow-up article in March 1985, 'A Core War bestiary of viruses, worms, and other threats to computer memories', Dewdney described the wide range of 'software creatures' that readers' responses had brought to light. A third column, in March 1989, was written in an exculpatory mode to refute any connection between his original advertisement of the Core War program and the spate of recent viruses.
10. Andrew Ross, *No Respect: Intellectuals and Popular Culture* (New York: Routledge, 1989), p. 212.
11. The definitive computer liberation book is Ted Nelson's *Computer Lib: Dream Machines* (Redmond, WA: Tempus, 1987, revised edn; original pub. 1974).

12. See Alice Bach's 'Phreakers' series, which narrates the mystery-and-suspense adventures of two teenage girl hackers: *The Bully of Library Place* (New York: Dell, 1987), *Double Bucky Shanghai* (New York: Dell, 1987), *Parrot Woman* (New York: Dell, 1987), *Ragwars* (New York: Dell, 1987), and others. The hacker has also appeared recently as a demonized figure in other genres: *The Hacker* (Pocket Books, 1989), a horror novel by Chet Day; and as a new Batman comic series, drawn by Pepe Moreno.

13. John Markoff, 'Cyberpunks seek thrills in computerized mischief', *New York Times* (26 November 1988), pp. 1, 28.

14. Dennis Hayes, *Behind the Silicon Curtain: The Seductions of Work in a Lonely Era* (Boston: South End, 1989), p. 93.
 One striking historical precedent for the hacking subculture, suggested to me by Carolyn Marvin, was the widespread activity of amateur or 'ham' wireless operators in the first two decades of the twentieth century. Initially lionized in the press as boy-inventor heroes for their technical ingenuity and daring adventures with the ether, this white middle-class subculture was increasingly demonized by the US Navy (whose signals the amateurs prankishly interfered with), which was crusading for complete military control of the airwaves in the name of national security. The amateurs lobbied with democratic rhetoric for the public's right to access the airwaves, and, although partially successful in their case against the Navy, lost out ultimately to big commercial interests when Congress approved the creation of a broadcasting monopoly after the First World War in the form of RCA. See Susan J. Douglas, *Inventing American Broadcasting 1899–1922* (Baltimore: Johns Hopkins University Press, 1987), pp. 187–291.

15. 'Sabotage', *Processed World*, 11 (Summer 1984), pp. 37–8.

16. Hayes, *Behind the Silicon Curtain*, p. 98.

17. *Bad Attitudes: The Processed World Anthology*, ed. Chris Carlsson with Mark Leger (London: Verso, 1990), contains highlights from the magazine's first eight years.

18. Kevin Robins and Frank Webster, 'Athens without slaves . . . or slaves without Athens? the neurosis of technology', *Science as Culture*, 3 (1988), pp. 7–53.

19. See, for example, the collection of essays edited by Vincent Mosco and Janet Wasko, *The Political Economy of Information* (Madison: University of Wisconsin Press, 1988); Kevin Robins and Frank Webster, *Information Technology: A Luddite Analysis* (Norwood, NJ: Ablex, 1986).

20. Tom Athanasiou and Staff, 'Encryption and the dossier society', *Processed World*, 16 (1986), pp. 12–17.

21. See Kevin Wilson, *Technologies of Control: The New Interactive Media for the Home* (Madison: University of Wisconsin Press, 1988), pp. 121–5.

22. Hayes, *Behind the Silicon Curtain*, pp. 63–80.

23. 'Our friend the VDT', *Processed World*, 22 (Summer 1988), pp. 24–5.

24. See Kevin Robins and Frank Webster, 'Cybernetic capitalism', in Vincent Mosco and Janet Wasko (eds) *The Political Economy of Information* (Madison: University of Wisconsin Press, 1988), pp. 44–75.

25. Hans Magnus Enzensberger, 'Constituents of a theory of the media', *The Consciousness Industry*, trans. Stuart Hood (New York: Seabury, 1974).

26. See Marike Finlay's Foucauldian analysis, *Powermatics: A Discursive Critique of New Technology* (London: Routledge & Kegan Paul, 1987). A more conventional culturalist argument can be found in Stephen Hill, *The Tragedy of Technology: Human Liberation versus Domination in the Late Twentieth Century* (London: Pluto, 1988).

TIZIANA TERRANOVA

POST-HUMAN UNBOUNDED
Artificial evolution and high-tech subcultures

MY STORY ABOUT 'POST-HUMANISM' (the belief in artificially enhanced evolution) in the high-tech subcultures is, in a certain sense, a tale whose main plot-line has been repeated and rehearsed many times before, another story about a seemingly unstoppable confusion of boundaries.

The kind of boundaries I have decided to focus on, however, are not simply the deliciously fluid or earnestly hard boundaries between human flesh, electronic chip, gene-splicing chemical sequences, and stainless steel. If the postmodern imagination seems somehow to have come to terms with, rejoiced in, or simply taken for granted such unions, there are other boundaries, and other interchanges that still make us uncomfortable, boundaries we would like to see not disrupted, but sealed, separated, tidily split in a dialectical antagonism where action is still possible.

The boundaries that these self-reflexive stories seem to disrupt are those between 'progressive' political discourses and the frightfully lively imagination of a 'conservative futurist' view of the world where, to quote the Sicilian novelist Tomasi di Lampedusa, 'everything has to change so that everything can stay the same'. The boundaries between electronic liberalism, anarchism, socialism and conservatism are therefore the places where I have chosen to tell my story about the monstrous mutations of the cybercultural discourse.

Originary stories

In a certain sense, rudimentary versions of 'post-humanity' have circulated in Western culture at least since Friedrich Nietzsche and the high-tech modernist avant-garde represented by the Italian Futurists and the German Dada. A rhetoric of simulation, media-originated epochal shifts, and enhanced evolutionism by artificial means are also available in the writings of people like Jean Baudrillard, Marshall McLuhan and Timothy

Leary. In the sphere of popular culture, mutated bodies and superhuman intelligences have populated the science fiction (SF) imagination since its very beginnings, but it is only through the activity of the cyberpunk SF group in the mid-1980s that the synergetic movement between developing subcultures interested in the new developments in biotechnology and computer-mediated communication (CMC) really took off.

The American West Coast mutation of the cyberpunk imagination as expressed by *Mondo 2000*'s New Edge, the socially varied experience of the new on-line population, the complex national varieties of subcultures and political movements that grafted themselves on images and tropes vividly illustrated in the cyberpunks' fiction, are all part of a cultural landscape in many ways still in the making.

In *Mirrorshades*, the mythical anthology of 'originary' cyberpunk fiction, Bruce Sterling made a significant contribution to the propagation of a new, wired variety of 'posthumanism'. Beyond turning what had mostly been 'computer nerds' into 'cyberpunks', in his manifesto Sterling literally produced a new 'body', one thoroughly invaded and colonized by invisible technologies: 'Eighties tech', Sterling opened our eyes to almost ten years ago, 'sticks to the skin, responds to the touch: the personal computer, the Sony Walkman, the portable telephone, the soft contact lenses' (Sterling 1986: xiii).

In Sterling's preface, such harmless devices are reconstructed so as to become the evident truth of a 'redefinition of the nature of humanity' and 'the nature of the self'. The year before, Sterling had published the novel *Schismatrix* (1985), representing a far future where humanity will have expanded in space and learned to alter its biological frame for efficiency and longevity; the term 'post-human' is used here to describe a particular philosophy evolving into the *Schismatrix*, the solar system, but also an existing race of mutated human beings; the 'post-human' or 'shaper/mechanist' theme is also the object of a series of short stories collected in the anthology *Crystal Express* (1989).

The extraordinary popularity of some of William Gibson's most imaginative icons (the famous 'sockets' connecting human brains to computers, the grafted microtechnology remoulding the highly efficient body of his favourite heroine, Molly Millions, the virtual existence of his millionaires) has turned his fiction into an almost 'biblical' repertoire of images and cultural references whose contribution to the creation of the electronic culture as a whole cannot be underestimated.

If the meaning and the implications of these cybernetic bodies, both in their literary manifestations and in the huge popularity of Hollywood cybericons, have been the object of intense critical attention, other places where the post-human body has implanted and mutated itself are perhaps of greater interest at this stage.

I am thinking in particular of the variations of post-humanism represented by *Mondo 2000*'s New Edge, the esoteric technocults practised by the Extropians, or the discussions on-line on the presence/absence/mutation of the body following intensive exposure to electronic communication. Beyond offering an interesting point of view on the high-tech imagination of some of the contemporary techno-tribes, these stories might help us also to understand, almost by the back door, important ideas about access and social change as developed by these strategically crucial subcultures.

Post-humanism

The first echoes of the 'post-human' theme in the electronic culture can be traced to the postulation of a postbiological age by *Omni* magazine in 1989 ('Interview to Hans Moravec'); and the publication on the pages of the *Whole Earth Review* in the 1988/9 issue of a forum entitled 'Is the body obsolete?'. In 1988 'Max More' and 'Tom Morrow' founded the *Extropy* journal and in 1990 the transformation of hip magazine *Reality Hackers* into *Mondo 2000* gave post-humanism its ultimate edge.

Both in recent academic critical theory and in various magazines interested in high-tech, descriptions of post-human evolutionism have circulated as a kind of acquired common sense for the insiders, and a potentially revolutionary revelation for the uninitiated.[1]

The story-line underlying most of these statements can be summarized in this way: there has been a huge ontological shift not only in the nature of human society, but in that of our very bodies. This mutation has been brought about, on the one hand, by the exposure to simulated images in the most traditional media, and, on the other, by the slow penetration into our daily life of almost invisible technological gadgets, from contact lenses to personal computers. This process of 'invasion' of the human body and psyche by the machine is destined to increase over the years (it is already doing it spectacularly) and give rise to a potentially new race of human beings whose symbiosis with the machine will be total. Most of the commentary by the high-tech subcultures about this phenomenon has been positive, in spite of the fact that most of the cyberpunk fiction is far from optimistic on this turn of 'technology as history as destiny' (which seems to have replaced 'natural biology' as destiny).

The nature and the tone used by the groups who adopted the post-human motif is far from homogeneous: it ranges from total commitment to the cyberpunk ethos mixed up with leftovers from the psychedelic movement in *Mondo 2000*, to an anti-consumerist, situationist magazine such as *Adbusters*.[2] The post-human pops up in the autonomist Italian *Decoder*, and it is at the centre of the philosophy advocated by the Extropy Institute.

For reasons of space I have chosen to focus on two examples: the first is an extract from one of the first issues of the California-based magazine, *Mondo 2000*. The other comes from the various statements expressed in different publications, on-line and printed, by the Extropian group, a loose organization devoted to the discussion of artificially enhanced forms of evolution.

Mondo 2000, born from the ashes of *Reality Hackers* under the guide of R. U. Sirius and Queen Mu, is the glossiest and the hippest of the cybermagazines and possibly the most famous – certainly, as the editor of *bOING bOING* has noticed, the one with the heaviest financial back-up. It is the one which has attracted the widest range of writers from the cyberbank ranks (Sterling, of course, and the mathematician Rudy Rucker, a regular contributor and almost one of its editors); *Mondo 2000*'s rhetoric of the New Edge is an ambitious attempt to fuse psychedelic 1960s counterculture (Timothy Leary is one of its godfathers), New Age rhetoric and cyberpunk.[3]

The following feature is collected in *Mondo 2000: A User's Guide to the New Edge*, and is part of a section on 'Evolutionary mutation' written by the chief editor R. U. Sirius:

Ultimately, the New Edge is an attempt to evolve a new species of human being through a marriage of humans and technology. We are ALREADY cyborgs. My mother, for instance, leads a relatively normal life thanks to a pace-maker. As a species, we are moving toward replaceable parts. Beyond that, genetic engineering and nanotechnology . . . offer us the possibility of literally being able to change our bodies into new and different forms. . . . Hans Moravec, director of the Mobile Robot Lab at Carnegie-Mellon University in Pittsburgh, has investigated three possibilities, and he believes that a form of post-biological humanity can be achieved within the next fifty years.

Think about it. The entire thrust of modern technology has been to move us away from solid objects and into information space (or cyberspace). Man the farmer and man the industrial worker are quickly being replaced by man the knowledge worker. . . . We are less and less creatures of flesh, bone, and blood pushing boulders uphill; we are more and more creatures of mind-zapping bits and bytes moving around at the speed of light.[4]

The flamboyant rhetoric of this piece is reminiscent of Sterling's manifesto: the post-human, on the one hand is already here – the homely image of mum with the pacemaker – and at the same time still in the future – creatures of mind-zapping bits and bytes moving around at the speed of light; Superman for the electronic age. This collapse of present and future, domesticity and science fiction, is characteristic of the style of *Mondo 2000* as a whole. It is also interesting to note another of *Mondo*'s characteristic touches, the quote of a 'legitimate' scientist working either for a university or some established lab, in this case cybercultural superhero Hans Moravec.

As the Mechanoids and the Shapers in *Schismatrix*, or as Molly and Case in *Neuromancer*, human species will move either in the direction of an intensification of bodily performativity or towards the ultimate flight from the body cage.[5] In either way the human body will undergo a total ontological transformation that *Mondo 2000* feels justified in calling the New Edge. Noticeably the only differentiating factor accompanying the unadulterated, obsolete, universalized human body in this transformation, is his/her ability to 'surf' the New Edge. This ability, as we will explore in some detail later on, is of course directly proportional to one's skills at manipulating these new technologies – something that should tip us off, if we do not consider ourselves as already safely part of the techno-savant crowd, that not everybody will go through the post-human magic gate at the same pace. The 'edge' that the aspiring post-humans have to learn to surf, can be (and it is) uncannily doubled into an 'evolutionary' edge whose possible origins might be themselves 'genetic'.

Mondo 2000 portrays its readers, the 'surfers' of the New Edge, not only as people characterized by an interest for new technologies, but also as possessing qualities such as 'an independent spirit, a wildly speculating mind, limitless imagination and daring' – a description that could have been given at the beginning of the century for the first, fabulously rich, self-made tycoons, and today quite a good self-portrait of the new 'creative', 'enterpreneurial' crowd. This aggressively future-oriented group is often contemptuously opposed to the 'talk show' crowd, addicted to an old-fashioned technology, television. Quite familiarly and providing a weird resonance to the other image of 'my mother with a pacemaker', in an interview to *Ben Is Dead*, R. U. Sirius refers

to 'this whole talk-show-as-new-electronic-forum thing' as a scary phenomenon, 'given the preponderance of bored housewives with nothing better to do than get all twitchy over different people's sexual difference'.[6] The association television/femininity/dumb-ness/addiction is one that is found early on in the portrait of the addiction of Bobby Newmark's mum to soap operas in Gibson's *Count Zero*, and is part of a significant strategy of oppositions and analogies defining the identity both of the new 'interactive' technologies (as opposed to television) and their 'active' users (as opposed to feminine passivity).

It is part of *Mondo 2000*'s ideological foundations, in fact, that access to technology and technological enhancement is provided by certain personality types. R. U. Sirius, again, describes one of the goals of the magazine as the amplification of the 'produc-tive' myth of the 'sophisticated, high-complexity, fast-lane/real-time, intelligent, active, and creative reality hacker', the social subject able to catch up with a technological development vastly beyond the reach of the 'dulled, prosaic, practically-minded, middle-of-the-road public'.[7]

There is no appreciation of, or consideration for, social or economic limitations which impede access to different technologies. In *Mondo 2000*'s rhetoric of avant-gardism there is no space for social, economic or cultural handicaps in the race toward technological appropriation and post-humanism, but only the individual 'fitness' for tech-nological survival.

One of the conditions that makes possible and explains this neglect of technoliteracy questions on the side of *Mondo 2000*, is, undoubtedly, the constitution of its audience, new professionals working in the electronic businesses (graphic, multimedia, music), people whose relationship to this new technology is both lucrative and creative, as *Mondo*'s editor very well knows: 'A large portion of our audience is successful business people in the computer industry, and in industry in general, because industry in the United States is high-tech.'[8]

Of course, as Andrew Ross suggests, we should be careful in giving a 'literal inter-pretation of what is essentially a utopian injunction on the part of an experimental counter-culture'.[9] On the other hand, the tech-counterculture is not the only group eager to embrace the post-human faith, and the permutations on the theme are too widespread to be taken as isolated, provocative statements.

The activity of the Extropy Institute, in California, is another example of post-humanism which takes the technological liberating promises made by the dominant culture ways more seriously. The Extropians include a different segment of that same professionalized group catered to by *Mondo 2000*'s countercultural rhetorics. As their FAQ (frequently asked questions) file tells us,

> Extropians have made career choices based on their extropian ideas; many are software engineers, neuroscientists, aerospace engineers, cryptologists, privacy consultants, designers of institutions, mathematicians, philosophers, and medical doctors researching life-extension techniques. Some extropians are very active in libertarian politics, and in legal challenges to abuse of government power.

Extropians, in a certain sense, belong in a different kind of subculture, even more heavily professionalized than *Mondo 2000*'s and with less sympathy for music and art or the Burroughsian rhetoric taken for granted by *Mondo 2000*'s audience.

Extropians publish their own magazine (*Extropy*), have their own newsgroup on Usenet, and their own electronic mailing list.[10] The *Extropian Manifesto* is available on the Internet, while the official Extropy Institute commercially runs the electronic mailing list. The commercialization of the mailing list is, according to them, a way to keep it a place of 'discussion *among* extropians, and not for constant debating with outsiders' (Extropians FAQ).

The main tenets of Extropianism are 'boundless expansion, self-transformation, dynamic optimism, intelligent technology, and spontaneous order'. The goal of Extropianism is to enable those who want to be at the vanguard of the incumbent transformation into a 'post-human' age. In the file 'Extropians FAQ', 'transhumanism' and 'post-humanism' are so identified:

Q3. What do 'transhuman' and 'post-human' mean?

A3. TRANSHUMAN: We are transhuman to the extent that we seek to become post-human and take action to prepare for a post-human future.

This involves learning about and making use of new technologies that can increase our capacities and life expectancy, questioning common assumptions, and transforming ourselves ready for the future, rising above outmoded human beliefs and behaviours.

TRANSHUMANISM: Philosophies of life (such as the Extropian philosophy) that seek the continuation and acceleration of the evolution of intelligent life beyond its currently human form and limits by means of science and technology, guided by life-promoting principles and values, while avoiding religion and dogma.

POST-HUMAN: Post-humans will be persons of unprecedented physical, intellectual, and psychological ability, self-programming and self-defining, potentially immortal, unlimited individuals. Post-humans have overcome the biological, neurological, and psychological constraints evolved into humans. Extropians believe that the best strategies for attaining post-humanity to be a combination of technology and determination, rather than looking for it through psychic contacts, or extraterrestrial or divine gift [sic].

Post-humans may be partly or mostly biological in form, but will likely be partly or wholly postbiological – our personalities having been transferred 'into' more durable, modifiable, and faster, and more powerful bodies and thinking hardware. Some of the technologies that we currently expect to play a role in allowing us to become post-human include genetic engineering, neural-computer integration, molecular nanotechnology, and cognitive science.

This version of 'post-humanism' is quite distant from the popular iconography of the cyberpunk, and the affinity between the two groups is quite limited. The Extropians are, therefore, a social group quite different both from the hard cyberpunk of the hacker magazine *2600*, or the techno-artistic crowd of *Mondo 2000*. It would be possible to recognize in the Extropians the result of the convergence of other traditions, like the technological utopianism and the technocratic movement of the early twentieth century whose belief that there are technological solutions to social problems is shared by the Extropians.[11] On the other hand their emphasis both on the 'voluntary'

and 'individually-planned' nature of mutation, and on physical evolution beyond the boundaries of humanity as we know it, are new developments that link them more closely to the variation of post-human evolutionism represented by *Mondo 2000*.

Most of the evolutionary mutations envisaged by the Extropians are part of the cyberpunk folklore (neural interfaces, nanotechnology, genetic engineering), and the same label 'post-human' is a legacy of cyberpunk fiction. Nevertheless the future visions of Extropians are surprisingly empty of the dingy dystopianism of cyberpunk fiction, which still lingers somehow even around the propagandistic hype of a publication like *Mondo 2000* (what Vivian Sobchack has defined its 'utopian cynicism').[12]

Another manifestation of this uneasy confusion of boundaries inside cyberculture between differently inspired interpretations of technological progress is the publication of the *Extropian Manifesto* in the Italian independent magazine *Decoder*.[13] *Decoder* is fairly representative of the enthusiasm and the receptivity to cyberpunk among European autonomist and extreme leftist groups. Although often critical of *Mondo 2000*'s politics, *Decoder* has been active in keeping up international cooperation between different groups involved in computer counter-politics, and has translated and published from French, British, German, Dutch and American sources.

Decoder sees in the electronic revolution taking place in the West a possibility of positive, radical mutation of the social system in ways that overlap but which also differ considerably from those of their American colleagues. The political affiliations of *Decoder* are clearly to the left of the Italian ex-Communist party, rooted in the tradition of the anarcho-Marxism of the extra-parliamentary groups. The specific political and cultural problems of this milieu have shaped the Italian interpretation of cyberpunk as heralded by *Decoder*: in this context, cyberpunk has been turned into a political commentary on technological development and social change as an alternative to both the 'industrialist', orthodox Marxist paradigm and the 'postmodern' socialism of the Italian ex-Communist Party. The publication of the *Extropian Manifesto* is part of their politics of diffusion of international, provocative publications on the subject of technology.

In the editor Raffaele Scelsi's words, Italian cyberpunk's 'political tension is oriented towards the reappropriation of communication by social movements, through the constitution of alternative electronic networks which could finally affect the excessive power of multinationals in the field'.[14] The Extropians, on the other hand, seem to be rooted in a different kind of libertarian anarchism, which expresses itself in their faith in the self-regulatory nature of the 'free market':

> The principle of spontaneous order is embodied in the free market system – a system that does not yet exist in a pure form. . . . The free market allows complex institutions to develop, encourages innovation, rewards individual initiative, cultivates personal responsibility, fosters diversity, and decentralizes power. Market economies spur the technological and social progress essential to the Extropian philosophy. . . . Expert knowledge is best harnessed and transmitted through the superbly efficient mediation of the free market's price signals – signals that embody more information than any person or organization could ever gather.

The publication of the *Extropian Manifesto* in the *Decoder* poses therefore some puzzling questions that could be explained by the partial ignorance by European cyberpunk publications of the American scene or their desire to construct an international cyberpunk

network that would validate and reinforce the cultural and political position which they are trying to build for themselves. On the other hand, it is more interesting to consider it as a signal of the unresolved contradictions embedded at the heart of the high-tech subculture. Beyond the common debt to cyberpunk fiction and their interest in the same cutting-edge technologies there seems to be no clear and elaborate articulation of differences at this stage. This absence of a constructive and articulated internal debate might be the result of the cohesive effect produced by the widespread hostility still perceived coming from the 'outside'. Too many energies, perhaps, are still spent rejecting outdated ethical and religious objections to technology. Cyberculture is still too busy building its defensive wall to care to look too closely at its own increasingly complex and fragmented anatomy.

The problem with evolution

The most distinguishing common trait between the cyberpunk, Extropian, and *Mondo 2000*'s treatment of the 'post-human' theme is the inability to introduce patterns of differentiations and complexity in their portrait of the future as teleological evolution. As an expression of a subculture that encourages a 'subversive' use of technology, there is little problematization of the ways in which technological change can be and is being shaped by economic and political forces. In particular, this evolutionary trend is represented as existing 'outside' the contentious history of the social uses of 'evolutionary' principles in the US.[15] Believers in post-humanism are not so much saying, 'we are what our genes say we are' but 'we are what we want to be', and, 'thanks to technology, there are no limits to what we can be'. In this triumph of the will society is erased, and the social universe emerges as a fragmented aggregate of individuals in a void without historical and material constraints. Not primarily biological determinism, then, but *rampant super-voluntarism* is the problem with cybernetic post-humanism.

It is necessary at this point to perform the dangerous jump from these limited uses of a provocative trope such as 'post-humanism' to the textual oceans of electronic networks at large. If this jump does not produce an exhaustive and conclusive account of what the Internet and associated networks think exactly, it will try, on the other hand, to sketch the contours of a general consensus (if any such thing is possible) in the most self-reflexive and argumentative Usenet newsgroups.

In the Net

The opinions and the arguments developed in the Usenet newsgroups considered here (*alt.cyberpunk*, *alt.cyberpunk.movement*, *alt.internet.media-coverage*, *alt.cyberspace*, *alt.politics.datahighway*, *alt.current-events.net-abuse*) are not homogeneous and represent only a portion of the discussions going on among Internet aficionados all over the world. Regular contributors to these newsgroups, on the other hand, are careful readers and heated debaters, and the ideas thrown around in these weeks-long arguments feed on, and very often feed back to, the writings of more public voices, all of which contribute to the creation of an unstable consensus among 'netsurfers' about what electronic communication is about.

In this context, 'post-humanism' is not only one of the excessive manifestations of the cybercultural spirit, it is also a useful gateway into cybercultural discourse at large, intersecting with one of its most ferociously preserved opinions: computer-mediated communication will change significantly the world as we know it in as much as it will involve a collective evolution from the passive consumption of corporation-dominated media to interactive, symbiotic relationships with intimate machines. This belief is not coincident with post-humanism (of which it could be said to represent the utopic side) but is related to it and is itself fraught with disturbing contradictions.

The more generally shared faith in the power of individual self-transformation into 'cyborgian hybrids of technology and biology' overlaps, often disturbingly, with the evolutionary post-humanism described above. Here is a fairly typical statement about on-line cyborgism as expressed by one of the participants in *alt.cyberpunk*:

> I think that the boundary of 'self' is growing larger and approaching un-definable. Right now with text we are on a lower level, not quite in total telepresence and virtual reality, but still you can see our little buds of flesh growing behind our ears where we will be ready for such things. People who participate now in this, will have much less trouble when we reach total immersion VR and telepresence, as they are used to their self bieng [sic] mutated and expanded. Not virus, but a fuzzying of physical boundaries, not only of nations, but also the individual body adn [sic] self.

In this 'weak' version, 'post-humanism' is not even named as such, but it resurfaces in the vision of a collective 'cyborgization' of society resulting from the individual act of tuning in: a transformation 'into cyborged hybrids of technology and biology through our ever-more-frequent interactions with machines, or with one another *through* technological interface'.[16]

These statements, although expressed in restricted circles of like-minded individuals, should not prevent us from remembering the fact that they are an expression of a widely felt belief. The idea that current regulars of the virtual communities are the avant-garde of a historical process that will soon be universal does certainly possess wider political currency at this stage. This vision of a wave of cognitive change spreading steadily, at virus-like speed, is expressed also through the evocative use of statistics describing the rate of growth of the Net population, whose magnitude cannot but strike a chord in these 'scarcity', 'budget-obsessed' 1990s.[17]

The on-line population is extremely aware of being still, but not for long, the first wave of the 'wiring' of society, where their own lived experience of 'cyborgization' will be extended to the mass. In Mark Dery's words, 'these subcultural practices offer a precognitive glimpse of mainstream culture a few years from now, when ever-greater numbers of Americans will be part-time residents in virtual communities'.[18] Dery is certainly in touch with the general mood of the electronic tribes (and the communication companies' commercial hype) in envisaging the current experience of these electronic groups as the general experience of the masses in the near future.

This is where the 'post-humanist' theme becomes a variation of a more diffused individualist, voluntarist, avant-garde attitude widely shared by the electronically wired communities. As in *Mondo 2000*'s rhetoric, this is a language of action where mainstream 'old' media such as television and newspapers play, more often than not, a

villainous role in propagating one-way indoctrination and passivity in the mass public, while the Internet two-ways, active experience of logging 'in' provides the way 'out'.

> Well resistance implies opposition, but i [sic] see it more like moving side-ways. For me it is using tech to help myself, and those around me. Wether [sic] it is making art form [sic] it, or helping people learn to use it. *It takes away the dependence peole [sic] have upon normal media, and the monopolies that control it. Which in turn eventually corrodes the hold the media has on people, and after that, it's only small step until they become really free [sic].*
> (emphasis added)

> the only dirrection [sic] I could think of would be towards individual freedom thru [sic] the use of technology to breakt [sic] he [sic] mono[oly] [sic] of infor-mation held by the media and the control structure. [sic]

Of course there's nothing wrong in believing in the superiority of one medium of communication over another, especially when one (like television) is heavily dominated by a commercial, monopolistic culture and the other is perceived as a free, anarchic universe almost uncontaminated by the powers-that-be. The most told and retold horror stories in the wired universe are stories about the corporate takeover of the Internet, the fatal 'clipping' of its wings in a nightmare of total suveillance;[19] the most repeated exorcism is that performed by the repeated re-enactment of the rhizomatic nature of the Net and its impermeability to any complete form of censorship – 'the Net can't be bombed or censored out of existence', 'is not a single entity, solid, it is not an object or a controllable resource'.

In a certain way, there are also some beautiful stories being told here, stories we like to hear and believe in, stories that might come true if virtual communities hold on tightly enough against the various attempts by arch-villains 'big government' and 'big money' to colonize an electronic frontier where 'we' might be luckier natives this time. In this utopic sense, post-humanism could be really a 'cyborg dream'. The mobilization of the strategic fiction of an 'open-to-all', 'universally-accessed' or 'in-the-process-to-be-universally-accessed' Internet is itself useful in as much as it is at this point an enabling strategy. These fictions allow collective mobilization in the form of electronic activism against imperialist projects of colonization such as those advocated by the Clinton admin-istration with the infamous 'Clipper-chip' plan.

In spite of the strategic needs that these fictions serve, it is worth remembering in a longer-term perspective, the necessity to constantly critique 'the things that are extremely useful, things without which we cannot live on'.[20] One of these myths is, exactly, the strategically useful myth that if technologies (and especially CMC tech-nologies) would be left on their own, they would naturally and spontaneously extend harmoniously to the entire population, making the experience of 'technologically enabled, postmulticultural' identities 'disengaged from gender, ethnicity and other problematic construction', universally achievable.[21]

The establishment of a possible mass-use of electronic communication devices in the context of a political project aimed at overcoming current social inequalities, should be more than simply encouraging individuals to personal empowerment through technology. Any 'radical' use of CMC has to pass through the recuperation of the collective act of disavowal performed by most virtual communities regarding their current position in

the jobless, two-tier, 'flexible' homework economy rampant in the mid-1990s.[22] It is this economy which has created the variety of occupations which is the much vaunted constituency of the Internet, a variety which is 'structurally dependent today on the primitive labour-regimes of minimally educated immigrant minorities in the dense metropolitan centers'.[23]

My argument here is not intended to be a condemnation of the virtual communities as a whole on the basis of the economic status of their dwellers: the point that I have tried to make is different. My critique is directed at those portions of the electronic community which earnestly believe in a possible contribution given by CMC to the establishment of a world of more equally distributed material and cultural resources. The political activism of these communities is currently fundamental in limiting the consequences of the focusing of corporate and governmental interests on electronic communication.

If, as Howard Rheingold would like it to be, electronic communication can develop into a new, more competent form of citizenship, then the conditions producing the Internet citizen cannot be underestimated. The process of normalization of cyberspace should not just be rejected as the external appropriation by interested parties of spontaneous and 'genuine' principles: at some level their rhetoric fits in smugly with the unacknowledged or willingly ignored contradictions affecting the most radical of the virtual communities. Haraway's cherished dream of cyborgism was placed against an economic, political and social order whose monstrous character needed desperately the exorcism of a possible utopian imagination. If the cyborg dream has any chance of being delivered, maybe we should learn to sleep less peacefully and, sometimes, even with both of our screen-reddened eyes wide open.

Originally published in G. Robertson, M. Marsh, L. Tickner, J. Bird, B. Curtis and T. Putnam (eds), (1996) *Future Natural: Nature, Science, Culture,* London: Routledge.
This essay has been edited for inclusion in the Reader.

Notes

1. See for variously nuanced versions of this story: Larry McCaffery, *Storming the Reality Studio* (Durham and London; Duke University Press, 1991); Arthur and Marilouis Kroker (eds), *Body Invaders: Sexuality and the Postmodern Condition* (London: Macmillan, 1998); Arthur Kroker, *Data Trash* (New York; St Martin's Press, 1994); Scott Bukatman, *Terminal Identity* (Durham and London: Duke University Press, 1993).
2. See Jeffery Deitch 'Post-human' in *Adbusters,* 3 (1), Winter 1994.
3. See Douglas Rushkoff, *Cyberia: Life in the Trenches of Hyperspace* (San Francisco: Harper, 1994).
4. R. U. Sirius, 'Evolutionary mutation', in *Mondo 2000: A User's Guide to the New Edge* (London: Thames & Hudson, 1992), p. 100.
5. A useful analysis of the variety of cybernetic bodies in William Gibson is given by David Tomas, 'The technophilic body: on technicity in William Gibson's cyborg culture', *New Formations* 8, summer 1989, pp. 113–29.
6. Ethan Port 'Perpetual cyber jack-off', in *Ben Is Dead,* Summer 1993, pp. 107–13, especially p. 113.
7. R. U. Sirius, 'The new edge', in *Mondo 2000: A User's Guide to the New Edge:* p. 195.
8. R. U. Sirius, quoted in 'Sex, drugs & cyberspace', *Express: The East Bay's Free Weekly,* 28 September 1990, p. 12.

9. Andrew Ross, 'The new smartness', in Gretchen Bender and Timothy Druckrey (eds), *Culture on the Brink: Ideologies of Technology*, (Seattle: Bay Press, 1994), pp. 329–41, especially p. 335.
10. See also Ed Regis, 'Meet the Extropians', in *Wired*, October 1994, p. 102.
11. On the technocratic movement of the 1930s, see Andrew Ross, *Strange Weather: Culture, Science and Technology in the Age of Limits*, (London and New York: Verso), 1991.
12. See Vivian Sobchack 'New Age Mutant Ninja hackers: reading *Mondo 2000*', *South Atlantic Quarterly* 92 (4) (Fall 1993), pp. 569–84.
13. See *Decoder*, 8 September 1993. *Decoder* is published three times a year by the independent publishing house Shake and much of its staff comes from the ranks of La Conchetta, a squatted alternative centre in Milan.
14. See Raffaele Scelsi (ed.) *Cyberpunk: Antologia*, Milan: Shake Edizoioni, 1990, p. 9.
15. On this subject, see Carl Degler, *In Search of Human Nature: The Decline and Revival of Darwinism in American Social Thought*, (New York and Oxford: Oxford University Press), 1991.
16. See Mark Dery, 'Flame wars', *South Atlantic Quarterly* 92 (4) (Fall 1993), p. 564.
17. Here is Howard Rheingold's typical rhetoric of utopic, electronic communication boosterism: 'If a citizen today can have the telecomputing power only the Pentagon could afford twenty years ago, what will citizens be able to afford in telecommunication power five or ten years into the future?. . . In terms of population growth, the original ARPANET community numbered around a thousand in 1969. A little over twenty years later, the Internet population is estimated at five to ten million people. The rate of growth is too rapid for accurate measurement at this point.' (Howard Rheingold, *Virtual Communities*, New York: Harper, 1993, p. 80).
18. Dery, op. cit., p. 564.
19. For a nightmarish picture of the total electronic panopticon see Charles Ostman, 'Total surveillance', *Mondo 2000* 13 (Winter 1995), pp. 16–20. In the same paranoid tone see also most of the articles published by members of the EFF (Electronic Frontier Foundation) at the time of the 'Clipper chip' debate: in this case, conspiracy theory and all-out paranoia proved to be effective strategies in mobilizing the electronic communities towards legal action (see John Perry Barlow, 'Jackboots on the Infobahn'. *Wired*, 2.04, April 1994, pp. 40–9; Brock N. Meeks, 'The end of privacy', ibid. p. 40).
20. See Gayatri Spivak, *Outside in the Teaching Machine*, (New York and London: Routledge, 1993), p. 4.
21. See Dery, op. cit., p. 561.
22. See Richard Gordon, 'The computerization of daily life, the sexual division of labor, and the homework economy', Silicon Valley Workshop Conference, University of California at Santa Cruz, 1983; Donna Haraways 'A cyborg manifesto: science, technology, and socialist-feminism in the late twentieth century', in *Simians, Cyborgs, and Women: The Reinvention of Nature*, London: Free Association Books, 1991, pp. 149–81; Stanley Aronowitz, 'Technology and the future of work', in G. Bender and T. Druckrey (eds), *Culture on the Brink: Ideologies of Technology*, (Seattle: Bay Press, 1994), pp. 15–29. See also the rich material collected in Chris Carlsson and Mark Leger (eds), *Bad Attitude: The Processed World Anthology*, (London: Verso, 1990), about conditions of work in the new, computerized, flexible marketplace.
23. See Andrew Ross, *The Chicago Gangster Theory of Life: Nature's Debt to Society*, (London and New York: Verso), 1994, p. 149.

References

Sterling, B. (1985) *Schismatrix*, New York: Ace Science Fiction.
—— (ed.) (1986) *Mirrorshades: The Cyberpunk Anthology*, New York: Arbor House.
—— (1989) *Crystal Express*, New York: Ace Books.

Cyberfeminisms

BARBARA KENNEDY

INTRODUCTION

THIS SECTION OF THE READER considers the definitions of cyberfeminism, and outlines the main debates in this important area. It does this through leading feminist writers, whose work crosses the boundaries of philosophical, sociological and cultural discourses. At the time of writing (1999) the concepts of 'woman' and 'feminism' are highly fragmented and polysemous – within academia, their meanings have become unfixed and unsettled by new theoretical developments. Cyberfeminism has been crucial to the current élan of cross-cultural, theoretical and differential plateaux of contemporary feminisms. The current trend to articulate a *post-feminism* encourages the wrath of many who identity as feminists (media coverage of feminism constantly talks of a post-feminist culture, where the radical polemics of 1970s and 1980s feminisms have become redundant and outmoded). Academic feminism, however, identifies post-feminism *not* as something which comes 'after' feminism, but as a synthesis of contemporary feminist epistemologies, within the context of post-structuralist and postmodern debates. Post-feminism is here defined as a concept which describes a micro-political engagement with a wide range of different feminisms. Post-feminism seeks to rethink the feminist voices of the 1990s, to present a *situational* ethics, where we need to move beyond debates of binary thinking in which gender is perceived as immutably masculine or feminine: we should be concerned to go beyond established notions of gendered identity or subjectivity. Chela Sandoval, taking her lead from Donna Haraway, suggests this as a *feminism without gender*, writing that within this 'there is no place for women, only a geometrics of difference and contradiction crucial to women's cyborg identities'. Queer theorist Judith Butler has also been significant to such debates, with her argument that there is no gender identity behind the expressions of gender; that identity is performatively constituted (Butler 1990).

Cyberfeminism is also a central component of the current debate about 'post-theory'. Within such theory, concepts like identity and subjectivity have no fixity, and are perceived

across more complex webs and networks of the cultural, the social – and also the molecular and the technological. Technology is in fact fundamental to these new feminist epistemologies, which raise essential concerns about woman and technology, woman's connection with the machine, her cyborg ontologies; and this can mean literal technologies such as the Internet, but also technologies in the more abstract sense, such as technologies of thinking, perception, mind patterning and bodily transformation. Within this more abstract sense, *prostheses* are not just technological 'add-ons' (as we see in the literal cyborgs of comic-book cultures discussed by Mark Oehlert in section 2), but complex perceptual and conceptual elements in thinking processes. Through the prosthetic cultures of the psychopharmacological industry, for example, a woman's body is no longer conceded to its natural biological state, with woman culturally coded as 'nature'. Indeed, she may, through choice, be re-designed technologically as a complex hybrid of biological, psychological and hormonal pharmaceutical components. For example, selector estrogen receptor modulators (serms) can specifically regulate identifiable parts of a woman's body, maintaining the positive effects of oestrogen (bone strengthening) and eliminating the more negative elements such as uterine or breast cancer. Woman's body can be literally re-programmed; re-wired at the level of the hormonal, the genetic and the molecular. Drugs, like computers, are machinic prostheses which alter our senses of self, technologizing bodies, minds and consciousnesses. The re-wired bodies we read about in William Gibson's novels (see Tomas in section two of this volume) are becoming *deliciously* real: dangerous but delectable possibilities. Of course we are simultaneously seeing the re-mapping of the male body through similar hormonal prostheses (such as Viagra) and psychopharmaceutical drugs such as Prozac, which, through its potential to delay that 'final phallic moment', produces (we can but live in hope . . .) the 'processual' lover. It seems that a cyberculture which professes to 'leave the meat behind' through disembodiment and the transcendence of cyberspace, cannot relinquish an obsession with sexuality and desire (see Springer, chapter 20; also the sections in this volume on the Cybersexual, Cyberbodies and Post-(cyber)bodies). The male body is also the female body: the biologically determined gender/sexuality of the body is re-technologized through hormonal prostheses (see Stryker, chapter 37).

In 'On the matrix: cyberfeminist simulations', Sadie Plant discusses Alan Turing's prosthetic experience of oestrogen, and its 'feminizing' influence on his powers of expression and experience. Through his 'feminized' self (and, one supposes, brain), he developed a 'powerful set of mathematical ideas, one of which is known as the Turing machine' (see Springer, chapter 20, for literary and filmic examples of similar cross-sexualities). Boundaries are crossed, nothing is immutable. How can we begin to define the concept of 'woman' within feminism anymore – or for that matter, 'man'? Sexuality is rendered mobile, contingent, *technologized*. Cyberfeminism has been fundamental in introducing these issues into contemporary social, cultural and philosophical debates. As a set of ideas it has also been fundamental to new debates in film, media and literary theory which dare to 'cross the boundaries' into incompatible discursive thinking, by engaging with cyborg consciousness and perspectival thinking. Out of cyberfeminisms, such transdisciplinary work is currently challenging the outmoded processes of the academy (Kennedy 1999; Musselwhite 1987).

The term cyberfeminism encompasses a range of feminist thinking, originating from the late 1980s and early 1990s. As a concept it covers feminist simulations of technology, most literally through debates about power, identity and autonomy and the role of new technologies in the transformation of these characteristics. It thus considers the role of women in the new technological industries such as the World Wide Web and the Internet. Debates in this section look at how the Net and the Web have offered women new spaces for artistic, political and ideological formations (see Wakeford and Plant). Additionally, and I feel more interestingly for theory, cyberfeminism defines a specific *cyborgian* consciousness – a particular way of thinking which breaks down binary and oppositional discourses (see Haraway). A cyborg consciousness is one which is not defined within the parameters of a fixed subjectivity or identity; this cyborg consciousness has arisen out of the literal ideas of boundary crossing found in cyborg mythologies (see section two). Among the most significant developments within cyberfeminism has been the work of Chela Sandoval. Sandoval moves beyond cyborg consciousness to the articulation of a *mestiza* or oppositional consciousness, which is truly liberatory and which tries to provide a construal of theory across oppositional discourses, within the framework of post-structuralist thinking. I personally think this is crucial for rethinking those supposedly human concepts such as 'love' (remember the cyborg with the broken heart?): where is 'love' in cyborg consciousness, within a post-structuralist episteme which reneges on such a romantic and humanist concept? Has the 'death of man' and the 'death of history' meant also *the death of love*? Can this word even be part of a cyborgian discourse, or is it blasphemous (in a Harawayan sense, of course)? Sandoval's work initiates some interesting developments in retheorizing 'love' in a post-theoretical climate, where subjectivity is multiple and sometimes – especially in materialist epistemologies in contemporary philosophy – even negated.

Formations of cyberfeminism mingle and blend in a fluid construal of terminologies. But not everyone agrees that cyberfeminism has liberated women, nor that innovative technologies have provided new liberation. Judith Squires, for example, is sceptical of Plant's and Haraway's cybercultural feminism, and is critical of what she calls its ignorance of Enlightenment positionalities, and suspicious of Plant's assumption that women 'have their own speech'. Squires is also critical of Plant's undermining of Haraway's 'position of plurality' in cyborg consciousness: whereas Haraway sought to explore cybernetics as a means of realizing a more pluralist world, Plant argues that the 'female cyborg is the only cyborg'. The cybernetic future described by Plant is clearly problematized for what is construed by Squires as a distinctly apolitical stance.

This section of the Reader, then, begins with the (ironically) foundational work of Donna Haraway. Her essay 'A cyborg manifesto: science, technology, and socialist-feminism in the late twentieth century' has been upheld as the origin of cyberfeminist discourse (an accolade tinged with postmodern irony, given the essay's negation of origins and 'original myths' of identity formation). A clear questioning of Enlightenment epistemologies which have foregrounded binary thinking, Haraway's ironic 'political myth' initiates the cyborg as a 'cybernetic organism, a hybrid of machine and organism'. As such, the cyborg functions ideologically and metaphorically to dislocate epistemological definitions of the 'organic' and the 'machinic' (amongst other binaries.) The Manifesto calls for a 'cyborg heteroglossia'; a breakdown of boundary categorization and a

confusion of boundaries, which is pleasurably liberatory – metaphorically, ideologically and epistemologically. Foundational and teleological thinking is here problematized. The cyborg has no 'truck with transcendence'; the cyborg has no origins, it is completely without positionality. As such it functions metaphorically, to disturb Enlightenment epistemologies which have foregrounded origins (including foundational concepts such as Marxism and psychoanalysis). Indeed, the 'cyborg skips the step of original unity, or identification with nature in the Western sense'. Nature and culture are re-worked, Haraway argues, such that 'the one can no longer be the resource of appropriation by the other'. Other binaries, such as animal/human or organism/machine, are similarly problematized. This boundary dissimulation enables a major rethinking of theoretical perspectives which have marked Enlightenment ideas. The dualism between materialism and idealism, for example, begins to break down. So, how *do* we define terms like 'machine' or 'organism'? If we are seeing new perceptions of such ideas, then these new perceptions will impinge on other cultural, sociological and philosophical discourses. As Haraway writes, 'late twentieth-century machines have made thoroughly ambiguous the difference between natural and artificial, mind and body, self-developing and externally designed'.

Sadie Plant similarly positions herself in the cyberfeminist milieu (though elsewhere she has developed her ideas beyond cyberfeminism through interaction with strands of contemporary continental philosophy; see Plant 1997). In 'On the matrix: cyberfeminist simulations', she weaves together, in a multi-perspectival methodology, Irigarayan discourses on the 'feminine' with an ironic parody of psychoanalysis. She clearly outlines the practical engagement of women with technology (here identified as that which deals with machineries of production), premising women as the first to deal with the complexities of the computer. Cyberspace is compared with the matrixial webs of 'feminine subjectivity' and the 'space' of a 'hidden depth' woven over by the webs of female fibres. Cyberspace, Plant argues, works through a series of differences, of multiple flows, not a series of 'ones' which are identifiable, but as a series of coded differences. Here, difference is 'difference-in-itself', not binary or oppositional difference. Computer communications work, like the female consciousness, through such webs of difference and communication. Plant argues that women have always worked through connections, intuitions, flows and webs of meaning, and uses the Irigarayan analogy from 'Ce sexe qui n'en est pas une' (Irigaray 1977): woman is everywhere, contingent, incontrovertible. However, the critiques which follow Plant's work complain that such writing is dangerously essentialist in promoting a differential feminism, formulated through notions of a transcendent female subjectivity and female experience (see Squires). Critics suggest that Plant is in danger of maintaining the goddesses of cultural feminism, rather than appropriating a cyborg ontology outside of gender. Despite such criticism, Plant's work has been fundamental to cyberfeminist consciousness in its display of perspectival boundary crossing; she is clearly not afraid of 'partial identities, perversity and irony' in her writing.

Claudia Springer's chapter, 'Digital rage', takes us back into the realm of popular cybercultures. However, Springer's work locates cyberfeminism as a term which defines a specific representation of woman in popular culture. Her essay begins by showing the similarity between machines and the human mind. She invokes the work of Sherry Turkle,

who similarly suggests that the mind was and has been that 'supremely masculinist arena of the philosophical project, but it has taken on new dimensions'. The nature of the human mind has been reformulated through a boundary destabilization which renders any oppositional discourse of mind/body as problematic. As Springer writes, 'discussion of computation and reasoning in terms of sexual responses discursively erases the Cartesian separation between body and mind'. Cyborg guru Hans Moravec argues that the current fascination with this hybridity of body/machine in terms of the human body and the computer has inspired 'flights of fantasy that remain firmly grounded in our current cultural preoccupations with sex and gender'. Springer argues that cyberdiscourse has meant that a model of 'computer-mind' for some people has enabled a replacement of Freudian perceptions of a layered consciousness. By taking the analogy of the computer's workings as a pattern of coded machinations, parallel programs and avenues of thought, Springer discusses the depthless self of postmodernity. Engaging with the work of Haraway, Marvin Minsky and Jean Baudrillard, Springer proceeds to theorize contemporary popular cultural texts through a post-structuralist lens. She clearly identifies that the problem with post-structuralism has been its reluctance to recognize scientific universals, and suggests that Minsky's work, in particular, goes a long way in blurring the boundary between science fiction and science.

Springer then gives a delightful (if somewhat reactionary and even reductionist) exemplification of cyberfeminist women and cyberfeminist representations in popular culture, discussing Molly Millions and others as 'hardwired women'. The problem I see here is that despite this engagement with newly wired women, created through cybertechnological components and biological and technological prosthesis, binary positionalities still persist. The 'hardwired woman' may be autonomous, powerful and 'in control', but what sort of evolution is this, where the goalposts are merely changed? Cyberfeminism here is dissolved into a less-than-liberatory discourse, and such hardwired, phallic women do little to change an already power/violence crazed culture. Fantasy has complete reign when images of strong, assertive women, clad in tight leather, provide teledildonic pleasures for the *master*-mind (and body). But then, the irony is that such creatures are 'creatures of perversity and irony' and can also be emotional, caring, intuitive. But when that love is rejected in these narratives, hardwired women eventually turn to killing. Such revenge fantasies are, of course, not new to feminist popular culture. The pleasure lies in the fantasy of revenge; film theory and literary theory abound with examples of the transgressive 'femme fatale'. However – calling all avenging angels (. . . angels, kiss ass angels) – cyberfeminism needs to move beyond the limitations of such representations; it has all been done before. What we need is *creativity*, an engagement with new modes of thinking and expression. Maybe cyberfeminism doesn't go far enough? Maybe the cyborg *can* also be the angel?

Nina Wakeford's 'Networking women and grrrls with information/communication technology' outlines the ways in which the new technologies of the Internet have enabled spaces for women to play with, create, subvert and renegotiate subjectivities and identitites. Cyberspace becomes the arena for a series of performances, a staging of events and personae. Wakeford challenges assumptions of female technophobia, in an essay which weaves its own way through the networks of both Haraway and Plant. Crucially, Wakeford argues that women's use of the Web can actively confront the 'victim femi-

nism' stereotype by creating networks of 'explicitly women-centred or feminist projects as alternative spaces in computing culture'.

Far from revering the work of either Haraway or Plant, Judith Squires takes a more critical stance, sceptical of what she calls the current 'cyberdrool' in much cyberfeminist thinking. 'Fabulous feminist futures and the lure of cyberculture' explores the relationships between cyberpunk, cybernetics and cyberfeminism. Claims for the emergence of a clearly definable materialist feminism are reputable enough, claims Squires, but much of the current work by writers like Haraway and Plant projects romantically techno-euphoric visions of liberation. Indeed, Squires is keen to suggest that far from discrediting Enlightenment epistemology totally through cyborg consciousness, there might be something useful that feminism could retain from Enlightenment ideas. Why should feminism, she argues, totally abandon the democratic and pluralistic elements of Enlightenment ideas, and yet simultaneously abandon the rationalist and individualist assumptions that have so angered feminists? Her concern with the cyberfeminism of both Haraway and Plant is the danger of an apolitical stance – which is no position for feminism. She sees the current cyberfeminist concern with cybernetics as part of a persistent ontological concern with the nature of 'self', arguing that this concern has been theorized through many stages, from Copernicus to Freud. That concern with 'self', she writes, has always been part of a Western male desire for agency, control and autonomy: 'The boundaries of self were drawn with a patriarchal pen.' Her concern is that cyberculture may also be a particularly masculine exploration of the continuity between mind and machine. Like many feminists before her, Squires still seems to be suspicious of the machine in terms of its relation to masculinity. She is scathing of what she sees as *boyish* pleasures in cyberpunk culture, criticizing its lack of engagement with any social or political critique. She concludes pessimistically that cybernetics and cyberfeminism will not change power relations, but 'they merely allow us to reinscribe existing power relations in new forms and media' (an argument made outside of cyberfeminist arenas by those concerned with a materialist or political-economy reading of cyberspace; see, for example, Sassen 1999).

The final chapter in this section is Chela Sandoval's 'New Sciences: cyborg feminism and the methodologies of the oppressed'. This essay shows a concerted development from the earlier work of Haraway and Plant, and in many ways is a promising vision of the future for theories of social and cultural movements. In the context of a post-feminist agenda, Sandoval's work is excitingly fresh, original and indeed promisingly utopian. She argues that cyborg consciousness has not necessarily arisen because of new ideas surrounding cybernetics and feminist theory; rather, cyborg consciousness has been around since oppressed groups recognized the inevitability of oppositional strategies of resistance to hegemonic forces. Sandoval's use of the term *technology* refers not so much to machinic, material technologies as to technologies of thinking, technologies of power, and what she refers to as 'techniques for moving energy'. Current social theory is concerned with the molecular, with lines of the energic, and Sandoval argues for an oppositional consciousness which accomodates a differential form of postmodern consciousness premised on energy flows.

Starting from Haraway's initiatives, Sandoval suggests that 'cyborg consciouness can be understood as the technological embodiment of a particular and specific form

of oppositional consciousness'. This cyborg consciousness needs to develop out of a set of technologies that together comprise and formulate a 'methodology of the oppressed' – or what she refers to as a 'mestiza' consciousness. Sandoval recognizes five specific 'technologies of energy'. First is semiotics, the 'science of cultural signs'. Second is the process of challenging dominant ideological signs through deconstruction. Third, she suggests, is 'meta-ideology' – an operation of appropriating dominant ideological forms but then utilizing them in order to tranform and transpose meaning structures. Fourth is the technology of 'democratics', collecting together the previous three areas to bring about a social egalitarian relational, with a new exploration of the concept of 'love' within postmodern discourse. Finally she suggests 'differential movement' – the one through which all the others manoeuvre, flow, energize, in polymorphous ways. What Sandoval is arguing is for some form of micro-political or perspectival consciousness, an 'in-between' or interstitial position, which is formulated across different forcefields of theory. Rather than a cyborg consciousness *per se*, this is a *consciousness of affinity*, technologized through multiple perspectives. This formulation may still be open to critique such as Squires', that it is dangerously relativist and apolitical; however, I feel this is a misunderstanding of what the potential of a micro-political paradigm can articulate.

Sandoval goes into more dialogue with Haraway and with metaphors of cyborg heteroglossia. Sandoval's call for a differential consciousness of differential movement explains that multi-perspectival paradigms of theory are enabling, and not apolitical, Indeed, as Alice Walker has said, 'to attempt to function only as one leads to psychic illness' (cited by Sandoval). Recognition of differentiality is prophetically relevant to the current stage of feminist theory. Sandoval calls for a new perception of the concept of 'love' through differential consciousness, where love operates outside the dual, binary relationship of self to self. Instead this micro-politics identifies the 'mexcla', the mixture-in-between different possibilities of being. This is the consciousness of the borderlands. Sandoval's ideas represent some of the most exciting social theory currently within feminist praxis. It represents a powerful social and theoretical challenge to all social movement theory, and could potentially bring cyberfeminist theory into affinity with other theoretical domains. This form of 'differential consciousness' is itself a kind of energy or force, similar to the ideas which Gilles Deleuze articulates in his work (Deuleuze and Guattari 1982). Indeed, Sandoval uses Deleuzian terms like 'rhizomatic' to describe the vectors, webs and velocities of differential consciousness: 'Differential consciousness can be thought thus as a constant reapportionment of space, boundaries, of horizontal and vertical realignments of oppositional powers. These energies revolve around each other, aligning and re-aligning in a field of force.'

This section of the Reader follows the webs of cyberfeminism, from the early directives of Harawayan heteroglossia, through critiques of what (to some feminists) is utopian, to the more elaborate and currently engaging theories of differential consciousness. What is useful for the reader, within this section, is to see a trajectory across cyberfeminist networks, and to understand that cyberfeminism does not necessarily equate with cyborgian images of 'hardwired women'. Indeed, cyborganization is a much more hybrid concept, theoretically sophisticated and potentially useful across all social movement theory.

References

Butler, J. (1990) *Gender Trouble: Feminism and the Subversion of Identity*, New York: Routledge.

Deleuze, G. and Guattari, F. (1982) *Capitalisme et Schizophrénie tome 1: L'anti-Oedipe*, Paris: Editions de la Minuit.

Irigaray, L. (1977) 'Ce sexe qui n'en est pas un', in E. Marks and I. Courtivron (eds), *New French Feminisms*, Brighton: Harvester.

Kennedy, B. (1999) 'Post-feminist futures in film noir', in M. Aaron (ed.), *The Body's Perilous Pleasures: Dangerous Desire and Contemporary Culture*, Edinburgh: Edinburgh University Press.

Musselwhite, D. (1987) *Partings Welded Together*, London: Methuen.

Plant, S. (1997) *Zeros and Ones: Digital Women and the New Technoculture*, London: Fourth Estate.

Sassen, S. (1999) 'Digital networks and power', in M. Featherstone and S. Lash (eds), *Spaces of Culture: City, Nation, World*, London: Sage.

DONNA HARAWAY

A CYBORG MANIFESTO
Science, technology and socialist-feminism in the late twentieth century

An ironic dream of a common language for women in the integrated circuit

THIS CHAPTER IS AN EFFORT to build an ironic political myth faithful to feminism, socialism, and materialism. Perhaps more faithful as blasphemy is faithful, than as reverent worship and identification. Blasphemy has always seemed to require taking things very seriously. I know no better stance to adopt from within the secular-religious, evangelical traditions of US politics, including the politics of socialist-feminism. Blasphemy protects one from the moral majority within, while still insisting on the need for community. Blasphemy is not apostasy. Irony is about contradictions that do not resolve into larger wholes, even dialectically, about the tension of holding incompatible things together because both or all are necessary and true. Irony is about humour and serious play. It is also a rhetorical strategy and a political method, one I would like to see more honoured within socialist-feminism. At the centre of my ironic faith, my blasphemy, is the image of the cyborg.

A cyborg is a cybernetic organism, a hybrid of machine and organism, a creature of social reality as well as a creature of fiction. Social reality is lived social relations, our most important political construction, a world-changing fiction. The international women's movements have constructed 'women's experience', as well as uncovered or discovered this crucial collective object. This experience is a fiction and fact of the most crucial, political kind. Liberation rests on the construction of the consciousness, the imaginative apprehension, of oppression, and so of possibility. The cyborg is a matter of fiction and lived experience that changes what counts as women's experience in the late twentieth century. This is a struggle over life and death, but the boundary between science fiction and social reality is an optical illusion.

Contemporary science fiction is full of cyborgs – creatures simultaneously animal and machine, who populate worlds ambiguously natural and crafted. Modern medicine

is also full of cyborgs, of couplings between organism and machine, each conceived as coded devices, in an intimacy and with a power that was not generated in the history of sexuality. Cyborg 'sex' restores some of the lovely replicative baroque of ferns and invertebrates (such nice organic prophylactics against heterosexism). Cyborg replication is uncoupled from organic reproduction. Modern production seems like a dream of cyborg colonization work, a dream that makes the nightmare of Taylorism seem idyllic. And modern war is a cyborg orgy, coded by C³I, command-control-communication-intelligence, an $84 billion item in 1984's US defence budget. I am making an argument for the cyborg as a fiction mapping our social and bodily reality and as an imaginative resource suggesting some very fruitful couplings.

By the late twentieth century, our time, a mythic time, we are all chimeras, theorized and fabricated hybrids of machine and organism. In short, we are cyborgs. The cyborg is our ontology; it gives us our politics. The cyborg is a condensed image of both imagination and material reality, the two joined centres structuring any possibility of historical transformation. In the traditions of 'Western' science and politics – the tradition of racist, male-dominant capitalism; the tradition of progress; the tradition of the appropriation of nature as resource for the productions of culture; the tradition of reproduction of the self from the reflections of the other – the relation between organism and machine has been a border war. The stakes in the border war have been the territories of production, reproduction, and imagination. This chapter is an argument for *pleasure* in the confusion of boundaries and for *responsibility* in their construction. It is also an effort to contribute to socialist-feminist culture and theory in a postmodernist, non-naturalist mode and in the utopian tradition of imagining a world without gender, which is perhaps a world without genesis, but maybe also a world without end. The cyborg incarnation is outside salvation history. Nor does it mark time on an oral symbiotic utopia or post-oedipal apocalypse. As Zoe Sofoulis (1987) argues in her unpublished manuscript on Jacques Lacan, Melanie Klein, and nuclear culture, *Lacklein*, the most terrible and perhaps the most promising monsters in cyborg worlds are embodied in non-oedipal narratives with a different logic of repression, which we need to understand for our survival.

The cyborg is a creature in a post-gender world; it has no truck with bisexuality, pre-oedipal symbiosis, unalienated labour, or other seductions to organic wholeness through a final appropriation of all the powers of the parts into a higher unity. In a sense, the cyborg has no origin story in the Western sense – a 'final' irony since the cyborg is also the awful apocalyptic *telos* of the 'West's' escalating dominations of abstract individuation, an ultimate self untied at last from all dependency, a man in space. An origin story in the 'Western', humanist sense depends on the myth of original unity, fullness, bliss and terror, represented by the phallic mother from whom all humans must separate, the task of individual development and of history, the twin potent myths inscribed most powerfully for us in psychoanalysis and Marxism. Hilary Klein (1989) has argued that both Marxism and psychoanalysis, in their concepts of labour and of individuation and gender formation, depend on the plot of original unity out of which difference must be produced and enlisted in a drama of escalating domination of woman/nature. The cyborg skips the step of original unity, of identification with nature in the Western sense. This is an illegitimate promise that might lead to subversion of its teleology as star wars.

The cyborg is resolutely committed to partiality, irony, intimacy, and perversity. It is oppositional, utopian, and completely without innocence. No longer structured by

the polarity of public and private, the cyborg defines a technological polis based partly on a revolution of social relations in the *oikos*, the household. Nature and culture are reworked; the one can no longer be the resource for appropriation or incorporation by the other. The relationships for forming wholes from parts, including those of polarity and hierarchical domination, are at issue in the cyborg world. Unlike the hopes of Frankenstein's monster, the cyborg does not expect its father to save it through a restoration of the garden; that is, through the fabrication of a heterosexual mate, through its completion in a finished whole, a city and cosmos. The cyborg does not dream of community on the model of the organic family, this time without the oedipal project. The cyborg would not recognize the Garden of Eden; it is not made of mud and cannot dream of returning to dust. Perhaps that is why I want to see if cyborgs can subvert the apocalypse of returning to nuclear dust in the manic compulsion to name the Enemy. Cyborgs are not reverent; they do not remember the cosmos. They are wary of holism, but needy for connection – they seem to have a natural feel for united front politics, but without the vanguard party. The main trouble with cyborgs, of course, is that they are the illegitimate offspring of militarism and patriarchal capitalism, not to mention state socialism. But illegitimate offspring are often exceedingly unfaithful to their origins. Their fathers, after all, are inessential.

I want to signal three crucial boundary breakdowns that make the following political-fictional (political-scientific) analysis possible. By the late twentieth century in US scientific culture, the boundary between human and animal is thoroughly breached. The last beachheads of uniqueness have been polluted if not turned into amusement parks. Language, tool use, social behaviour, mental events, nothing really convincingly settles the separation of human and animal. And many people no longer feel the need for such a separation; indeed, many branches of feminist culture affirm the pleasure of connection of human and other living creatures. Movements for animal rights are not irrational denials of human uniqueness; they are a clear-sighted recognition of connection across the discredited breach of nature and culture. Biology and evolutionary theory over the last two centuries have simultaneously produced modern organisms as objects of knowledge and reduced the line between humans and animals to a faint trace reetched in ideological struggle or professional disputes between life and social science.

Biological-determinist ideology is only one position opened up in scientific culture for arguing the meanings of human animality. There is much room for radical political people to contest the meanings of the breached boundary.[1] The cyborg appears in myth precisely where the boundary between human and animal is transgressed. Far from signalling a walling off of people from other living beings, cyborgs signal disturbingly and pleasurably tight coupling. Bestiality has a new status in this cycle of marriage exchange.

The second leaky distinction is between animal-human (organism) and machine. Pre-cybernetic machines could be haunted; there was always the spectre of the ghost in the machine. This dualism structured the dialogue between materialism and idealism that was settled by a dialectical progeny, called spirit or history, according to taste. But basically machines were not self-moving, self-designing, autonomous. They could not achieve man's dream, only mock it. They were not man, an author himself, but only a caricature of that masculinist reproductive dream. To think they were otherwise was paranoid. Now we are not so sure. Late twentieth-century machines have made thoroughly ambiguous the difference between natural and artificial, mind and body, self-developing

and externally designed, and many other distinctions that used to apply to organisms and machines. Our machines are disturbingly lively, and we ourselves frighteningly inert.

Technological determination is only one ideological space opened up by the reconceptions of machine and organism as coded texts through which we engage in the play of writing and reading the world.[2] 'Textualization' of everything in poststructuralist, postmodernist theory has been damned by Marxists and socialist feminists for its utopian disregard for the lived relations of domination that ground the 'play' of arbitrary reading.[3] It is certainly true that postmodernist strategies, like my cyborg myth, subvert myriad organic wholes (for example, the poem, the primitive culture, the biological organism). In short, the certainty of what counts as nature – a source of insight and promise of innocence – is undermined, probably fatally. The transcendent authorization of interpretation is lost, and with it the ontology grounding 'Western' epistemology. But the alternative is not cynicism or faithlessness, that is, some version of abstract existence, like the accounts of technological determinism destroying 'man' by the 'machine' or 'meaningful political action' by the 'text'. Who cyborgs will be is a radical question. The answers are a matter of survival. Both chimpanzees and artefacts have politics, so why shouldn't we (de Waal, 1982; Winner, 1980)?

The third distinction is a subset of the second: the boundary between physical and non-physical is very imprecise for us. Pop physics books on the consequences of quantum theory and the indeterminacy principle are a kind of popular scientific equivalent to Harlequin romances as a marker of radical change in American white heterosexuality: they get it wrong, but they are on the right subject. Modern machines are quintessentially microelectronic devices: they are everywhere and they are invisible. Modern machinery is an irreverent upstart god, mocking the Father's ubiquity and spirituality. The silicon chip is a surface for writing; it is etched in molecular scales disturbed only by atomic noise, the ultimate interference for nuclear scores. Writing, power and technology are old partners in Western stories of the origin of civilization, but miniaturization has changed our experience of mechanism. Miniaturization has turned out to be about power; small is not so much beautiful as preeminently dangerous, as in cruise missiles. Contrast the TV sets of the 1950s or the news cameras of the 1970s with the TV wrist bands or hand-sized video cameras now advertised. Our best machines are made of sunshine; they are all light and clean because they are nothing but signals, electromagnetic waves, a section of a spectrum, and these machines are eminently portable, mobile – a matter of immense human pain in Detroit and Singapore. People are nowhere near so fluid, being both material and opaque. Cyborgs are ether, quintessence.

The ubiquity and invisibility of cyborgs is precisely why these sunshine-belt machines are so deadly. They are as hard to see politically as materially. They are about consciousness – or its simulation.[4] They are floating signifiers moving in pickup trucks across Europe, blocked more effectively by the witch-weavings of the displaced and so unnatural Greenham women, who read the cyborg webs of power so very well, than by the militant labour of older masculinist politics, whose natural constituency needs defence jobs. Ultimately the 'hardest' science is about the realm of greatest boundary confusion, the realm of pure number, pure spirit, C^3I, cryptography and the preservation of potent secrets. The new machines are so clean and light. Their engineers are sun-worshippers mediating a new scientific revolution associated with the night dream of post-industrial society. The diseases evoked by these clean machines are 'no more' than the minuscule coding changes of an antigen in the immune system, 'no more' than the experience of

stress. The nimble fingers of 'Oriental' women, the old fascination of little Anglo-Saxon Victorian girls with doll's houses, women's enforced attention to the small, take on quite new dimensions in this world. There might be a cyborg Alice taking account of these new dimensions. Ironically, it might be the unnatural cyborg women making chips in Asia and spiral dancing in Santa Rita jail[5] whose constructed unities will guide effective oppositional strategies.

So my cyborg myth is about transgressed boundaries, potent fusions and dangerous possibilities which progressive people might explore as one part of needed political work. One of my premises is that most American socialists and feminists see deepened dualisms of mind and body, animal and machine, idealism and materialism in the social practices, symbolic formulations and physical artefacts associated with 'high technology' and scientific culture. From *One-Dimensional Man* (Marcuse 1964) to *The Death of Nature* (Merchant 1980), the analytic resources developed by progressives have insisted on the necessary domination of technics and recalled us to an imagined organic body to integrate our resistance. Another of my premises is that the need for unity of people trying to resist worldwide intensification of domination has never been more acute. But a slightly perverse shift of perspective might better enable us to contest for meanings, as well as for other forms of power and pleasure in technologically mediated societies.

From one perspective, a cyborg world is about the final imposition of a grid of control on the planet, about the final abstraction embodied in a Star Wars apocalypse waged in the name of defence, about the final appropriation of women's bodies in a masculinist orgy of war (Sofia 1984). From another perspective, a cyborg world might be about lived social and bodily realities in which people are not afraid of their joint kinship with animals and machines, not afraid of permanently partial identities and contradictory standpoints. The political struggle is to see from both perspectives at once because each reveals both dominations and possibilities unimaginable from the other vantage point. Single vision produces worse illusions than double vision or many-headed monsters. Cyborg unities are monstrous and illegitimate; in our present political circumstances, we could hardly hope for more potent myths for resistance and recoupling. I like to imagine LAG, the Livermore Action Group, as a kind of cyborg society, dedicated to realistically converting the laboratories that most fiercely embody and spew out the tools of technological apocalypse, and committed to building a political form that actually manages to hold together witches, engineers, elders, perverts, Christians, mothers and Leninists long enough to disarm the state. Fission Impossible is the name of the affinity group in my town. (Affinity: related not by blood but by choice, the appeal of one chemical nuclear group for another, avidity.)[6]

Fractured identities

It has become difficult to name one's feminism by a single adjective – or even to insist in every circumstance upon the noun. Consciousness of exclusion through naming is acute. Identities seem contradictory, partial and strategic. With the hard-won recognition of their social and historical constitution, gender, race and class cannot provide the basis for belief in 'essential' unity. There is nothing about being 'female' that naturally binds women. There is not even such a state as 'being' female, itself a highly complex category constructed in contested sexual scientific discourses and other social practices. Gender,

race or class consciousness is an achievement forced on us by the terrible historical experience of the contradictory social realities of patriarchy, colonialism and capitalism. And who counts as 'us' in my own rhetoric? Which identities are available to ground such a potent political myth called 'us', and what could motivate enlistment in this collectivity? Painful fragmentation among feminists (not to mention among women) along every possible fault line has made the concept of *woman* elusive, an excuse for the matrix of women's dominations of each other. For me – and for many who share a similar historical location in white, professional middle-class, female, radical, North American, mid-adult bodies – the sources of a crisis in political identity are legion. The recent history for much of the US left and US feminism has been a response to this kind of crisis by endless splitting and searches for a new essential unity. But there has also been a growing recognition of another response through coalition – affinity, not identity.[7]

Chela Sandoval, from a consideration of specific historical moments in the formation of the new political voice called women of colour, has theorized a hopeful model of political identity called 'oppositional consciousness', born of the skills for reading webs of power by those refused stable membership in the social categories of race, sex or class. 'Women of color', a name contested at its origins by those whom it would incorporate, as well as a historical consciousness marking systematic breakdown of all the signs of Man in 'Western' traditions, constructs a kind of postmodernist identity out of otherness, difference and specificity. This postmodernist identity is fully political, whatever might be said about other possible postmodernisms. Sandoval's oppositional consciousness is about contradictory locations and heterochronic calendars, not about relativisms and pluralisms (see chapter 23).

Sandoval emphasizes the lack of any essential criterion for identifying who is a woman of colour. She notes that the definition of a group has been by conscious appropriation of negation. For example, a Chicana or US black woman has not been able to speak as a woman or as a black person or as a Chicano. Thus, she was at the bottom of a cascade of negative identities, left out of even the privileged oppressed authorial categories called 'women and blacks', who claimed to make the important revolutions. The category 'woman' negated all non-white women; 'black' negated all non-black people, as well as all black women. But there was also no 'she', no singularity, but a sea of differences among US women who have affirmed their historical identity as US women of colour. This identity marks out a self-consciously constructed space that cannot affirm the capacity to act on the basis of natural identification, but only on the basis of conscious coalition, of affinity, of political kinship.[8] Unlike the 'woman' of some streams of the white women's movement in the US, there is no naturalization of the matrix.

Sandoval's argument has to be seen as one potent formulation for feminists out of the worldwide development of anti-colonialist discourse; that is to say, discourse dissolving the 'West' and its highest product – the one who is not animal, barbarian or woman; man, that is, the author of a cosmos called history. As orientalism is deconstructed politically and semiotically, the identities of the occident destabilize, including those of feminists.[9] Sandoval argues that 'women of colour' have a chance to build an effective unity that does not replicate the imperializing, totalizing revolutionary subjects of previous Marxism and feminisms which had not faced the consequences of the disorderly polyphony emerging from decolonization.

Katie King has emphasized the limits of identification and the political/poetic mechanics of identification built into reading 'the poem', that generative core of *cultural*

feminism. King criticizes the persistent tendency among contemporary feminists from different 'moments' or 'conversations' in feminist practice to taxonomize the women's movement to make one's own political tendencies appear to be the *telos* of the whole. These taxonomies tend to remake feminist history so that it appears to be an ideological struggle among coherent types persisting over time, especially those typical units called radical, liberal and socialist-feminist. Literally, all other feminisms are either incorporated or marginalized, usually by building an explicit ontology and episte-mology.[10] Taxonomies of feminism produce epistemologies to police deviation from official women's experience. And of course, 'women's culture', like women of colour, is consciously created by mechanisms inducing affinity. The rituals of poetry, music and certain forms of academic practice have been preeminent. The politics of race and culture in the US women's movements are intimately interwoven. The common achievement of King and Sandoval is learning how to craft a poetic/politic unity without relying on a logic of appropriation, incorporation and taxonomic identification.

The theoretical and practical struggle against unity-through-domination or unity-through-incorporation ironically not only undermines the justifications for patriarchy, colonialism, humanism, positivism, essentialism, scientism and other unlamented -isms, but *all* claims for an organic or natural standpoint. I think that radical and socialist/Marxist-feminisms have also undermined their/our own epistemological strategies and this is a crucially valuable step in imagining possible unities. It remains to be seen whether all 'epistemologies' as Western political people have known them fail us in the task to build effective affinities.

It is important to note that the effort to construct revolutionary standpoints, epistemologies as achievements of people committed to changing the world, has been part of the process showing the limits of identification. The acid tools of postmodernist theory and the constructive tools of ontological discourse about revolutionary subjects might be seen as ironic allies in dissolving Western selves in the interests of survival. We are excruciatingly conscious of what it means to have a historically constituted body. But with the loss of innocence in our origin, there is no expulsion from the Garden either. Our politics lose the indulgence of guilt with the *naïveté* of innocence. But what would another political myth for socialist-feminism look like? What kind of politics could embrace partial, contradictory, permanently unclosed constructions of personal and collective selves and still be faithful, effective – and, ironically, socialist-feminist?

I do not know of any other time in history when there was greater need for political unity to confront effectively the dominations of 'race', 'gender', 'sexuality' and 'class'. I also do not know of any other time when the kind of unity we might help build could have been possible. None of 'us' have any longer the symbolic or material capability of dictating the shape of reality to any of 'them'. Or at least 'we' cannot claim innocence from practising such dominations. White women, including socialist feminists, discovered the non-innocence of the category 'woman'. That consciousness changes the geography of all previous categories; it denatures them as heat denatures a fragile protein. Cyborg feminists have to argue that 'we' do not want any more natural matrix of unity and that no construction is whole. Innocence, and the corollary insistence on victimhood as the only ground for insight, has done enough damage. But the constructed revolutionary subject must give late-twentieth-century people pause as well. In the fraying of identities and in the reflexive strategies for constructing them, the

possibility opens up for weaving something other than a shroud for the day after the apocalypse that so prophetically ends salvation history.

Both Marxist/socialist-feminisms and radical feminisms have simultaneously naturalized and denatured the category 'woman' and consciousness of the social lives of 'women'. Perhaps a schematic caricature can highlight both kinds of moves. Marxian-socialism is rooted in an analysis of wage labour which reveals class structure. The consequence of the wage relationship is systematic alienation, as the worker is dissociated from his (sic) product. Abstraction and illusion rule in knowledge, domination rules in practice. Labour is the preeminently privileged category enabling the Marxist to overcome illusion and find that point of view which is necessary for changing the world. Labour is the humanizing activity that makes man; labour is an ontological category permitting the knowledge of a subject, and so the knowledge of subjugation and alienation.

In faithful filiation, socialist-feminism is advanced by allying itself with the basic analytic strategies of Marxism. The main achievement of both Marxist-feminists and socialist feminists was to expand the category of labour to accommodate what (some) women did, even when the wage relation was subordinated to a more comprehensive view of labour under capitalist patriarchy. In particular, women's labour in the household and women's activity as mothers generally (that is, reproduction in the socialist-feminist sense), entered theory on the authority of analogy to the Marxian concept of labour. The unity of women here rests on a epistemology based on the ontological structure of 'labour'. Marxist/socialist-feminism does not 'naturalize' unity; it is a possible achievement based on a possible standpoint rooted in social relations. The essentializing move is in the ontological structure of labour or of its analogue, women's activity.[11] The inheritance of Marxian-humanism, with its pre-eminently Western self, is the difficulty for me. The contribution from these formulations has been the emphasis on the daily responsibility of real women to build unities, rather than to naturalize them.

Catherine MacKinnon's (1982, 1987) version of radical feminism is itself a caricature of the appropriating, incorporating, totalizing tendencies of Western theories of identity grounding action.[12] It is factually and politically wrong to assimilate all of the diverse 'moments' or 'conversations' in recent women's politics named radical feminism to MacKinnon's version. But the teleological logic of her theory shows how an epistemology and ontology – including their negations – erase or police difference. Only one of the effects of MacKinnon's theory is the rewriting of the history of the polymorphous field called radical feminism. The major effect is the production of a theory of experience, of women's identity, that is a kind of apocalypse for all revolutionary standpoints. That is, the totalization built into this tale of radical feminism achieves its end – the unity of women – by enforcing the experience of and testimony to radical non-being. As for the Marxist/socialist-feminist, consciousness is an achievement, not a natural fact. And MacKinnon's theory eliminates some of the difficulties built into humanist revolutionary subjects, but at the cost of radical reductionism.

MacKinnon argues that feminism necessarily adopted a different analytical strategy from Marxism, looking first not at the structure of class, but at the structure of sex/gender and its generative relationship, men's constitution and appropriation of women sexually. Ironically, MacKinnon's 'ontology' constructs a non-subject, a non-being. Another's desire, not the self's labour, is the origin of 'woman'. She therefore develops a theory of consciousness that enforces what can count as 'women's' experi-

ence – anything that names sexual violation, indeed, sex itself as far as 'women' can be concerned. Feminist practice is the construction of this form of consciousness; that is, the self-knowledge of a self-who-is-not.

Perversely, sexual appropriation in this feminism still has the epistemological status of labour; that is to say, the point from which an analysis able to contribute to changing the world must flow. But sexual objectification, not alienation, is the consequence of the structure of sex/gender. In the realm of knowledge, the result of sexual objectification, not alienation, is the consequence of the structure of sex/gender. In the realm of knowledge, the result of sexual objectification is illusion and abstraction. However, a woman is not simply alienated from her product, but in a deep sense does not exist as a subject, or even potential subject, since she owes her existence as a woman to sexual appropriation. To be constituted by another's desire is not the same thing as to be alienated in the violent separation of the labourer from his product.

MacKinnon's radical theory of experience is totalizing in the extreme; it does not so much marginalize as obliterate the authority of any other women's political speech and action. It is a totalization producing what Western patriarchy itself never succeeded in doing – feminists' consciousness of the non-existence of women, except as products of men's desire. I think MacKinnon correctly argues that no Marxian version of identity can firmly ground women's unity. But in solving the problem of the contradictions of any Western revolutionary subject for feminist purposes, she develops an even more authoritarian doctrine of experience. If my complaint about socialist/Marxian standpoints is their unintended erasure of polyvocal, unassimilable, radical difference made visible in anti-colonial discourse and practice, MacKinnon's intentional erasure of all difference through the device of the 'essential' non-existence of women is not reassuring.

In my taxonomy, which like any other taxonomy is a re-inscription of history, radical feminism can accommodate all the activities of women named by socialist feminists as forms of labour only if the activity can somehow be sexualized. Reproduction had different tones of meanings for the two tendencies, one rooted in labour, one in sex, both calling the consequences of domination and ignorance of social and personal reality 'false consciousness'.

Beyond either the difficulties of the contributions in the argument of any one author, neither Marxist nor radical feminist points of view have tended to embrace the status of a partial explanation; both were regularly constituted as totalities. Western explanation has demanded as much; how else could the 'Western' author incorporate its others? Each tried to annex other forms of domination by expanding its basic categories through analogy, simple listing or addition. Embarrassed silence about race among white radical and socialist-feminists was one major, devastating political consequence. History and polyvocality disappear into political taxonomies that try to establish genealogies. There was no structural room for race (or for much else) in theory claiming to reveal the construction of the category woman and social group women as a unified or totalizable whole. The structure of my caricature looks like this:

> socialist feminism – structure of class / / wage labour / / alienation
> labour, by analogy reproduction, by extension sex, by addition race
> radical feminism – structure of gender / / sexual appropriation / /
> objectification
> sex, by analogy labour, by extension reproduction, by addition race

In another context, the French theorist, Julia Kristeva, claimed that women appeared as a historical group after the Second World War, along with groups like youth. Her dates are doubtful; but we are now accustomed to remembering that as objects of knowledge and as historical actors, 'race' did not always exist, 'class' has a historical genesis, and 'homosexuals' are quite junior. It is no accident that the symbolic system of the family of man – and so the essence of woman – breaks up at the same moment that networks of connection among people on the planet are unprecedentedly multiple, pregnant and complex. 'Advanced capitalism' is inadequate to convey the structure of this historical moment. In the 'Western' sense, the end of man is at stake. It is no accident that woman disintegrates into women in our time. Perhaps socialist feminists were not substantially guilty of producing essentialist theory that suppressed women's particularity and contradictory interests. I think we have been, at least through unreflective participation in the logics, languages and practices of white humanism and through searching for a single ground of domination to secure our revolutionary voice. Now we have less excuse. But in the consciousness of our failures, we risk lapsing into boundless difference and giving up on the confusing task of making partial, real connection. Some differences are playful; some are poles of world historical systems of domination. 'Epistemology' is about knowing the difference.

The informatics of domination

In this attempt at an epistemological and political position, I would like to sketch a picture of possible unity, a picture indebted to socialist and feminist principles of design. The frame for my sketch is set by the extent and importance of rearrangements in worldwide social relations tied to science and technology. I argue for a politics rooted in claims about fundamental changes in the nature of class, race and gender in an emerging system of world order analogous in its novelty and scope to that created by industrial capitalism; we are living through a movement from an organic, industrial society to a polymorphous, information system – from all work to all play, a deadly game. Simultaneously material and ideological, the dichotomies may be expressed in the following chart of transitions from the comfortable old hierarchical dominations to the scary new networks I have called the informatics of domination:

Representation	Simulation
Bourgeois novel, realism	Science fiction, postmodernism
Organism	Biotic component
Depth, integrity	Surface, boundary
Heat	Noise
Biology as clinical practice	Biology as inscription
Physiology	Communications engineering
Small group	Subsystem
Perfection	Optimization
Eugenics	Population control
Decadence, *Magic Mountain*	Obsolescence, *Future Shock*
Hygiene	Stress management
Microbiology, tuberculosis	Immunology, AIDS
Organic division of labour	Ergonomics/cybernetics of labour

Functional specialization	Modular construction
Reproduction	Replication
Organic sex role specialization	Optimal genetic strategies
Biological determinism	Evolutionary inertia, constraints
Community ecology	Ecosystem
Racial chain of being	Neo-imperialism, United Nations humanism
Scientific management in home / factory	Global factory/electronic cottage
Family/Market/Factory	Women in the integrated circuit
Family wage	Comparable worth
Public/private	Cyborg citizenship
Nature/culture	Fields of difference
Cooperation	Communications enhancement
Freud	Lacan
Sex	Genetic engineering
Labour	Robotics
Mind	Artificial intelligence
Second World War	Star Wars
White capitalist patriarchy	Informatics of domination

This list suggests several interesting things.[13] First, the objects on the right-hand side cannot be coded as 'natural', a realization that subverts naturalistic coding for the left-hand side as well. We cannot go back ideologically or materially. It's not just that 'god' is dead; so is the 'goddess'. Or both are revivified in the worlds charged with microelectronic and biotechnological politics. In relation to objects like biotic components, one must think not in terms of essential properties, but in terms of design, boundary constraints, rates of flows, systems logics, costs of lowering constraints. Sexual reproduction is one kind of reproductive strategy among many, with costs and benefits as a function of the system environment. Ideologies of sexual reproduction can no longer reasonably call on notions of sex and sex role as organic aspects in natural objects like organisms and families. Such reasoning will be unmasked as irrational, and ironically corporate executives reading *Playboy* and anti-porn radical feminists will make strange bedfellows in jointly unmasking the irrationalism.

Likewise for race, ideologies about human diversity have to be formulated in terms of frequencies of parameters, like blood group or intelligence scores. It is 'irrational' to invoke concepts like primitive and civilized. For liberals and radicals, the search for integrated social systems gives way to a new practice called 'experimental ethnography' in which an organic object dissipates in attention to the play of writing. At the level of ideology, we see translations of racism and colonialism into languages of development and under-development, rates and constraints of modernization. Any objects or persons can be reasonably thought of in terms of disassembly and reassembly; no 'natural' architectures constrain system design. The financial districts in all the world's cities, as well as the export-processing and free-trade zones, proclaim this elementary fact of 'late capitalism'. The entire universe of objects that can be known scientifically must be formulated as problems in communications engineering (for the managers) or theories of the text (for those who would resist). Both are cyborg semiologies.

One should expect control strategies to concentrate on boundary conditions and interfaces, on rates of flow across boundaries – and not on the integrity of natural objects. 'Integrity' or 'sincerity' of the Western self gives way to decision procedures and expert systems. For example, control strategies applied to women's capacities to give birth to new human beings will be developed in the languages of population control and maximization of goal achievement for individual decision-makers. Control strategies will be formulated in terms of rates, costs of constraints, degrees of freedom. Human beings, like any other component or subsystem, must be localized in a system architecture whose basic modes of operation are probabilistic, statistical. No objects, spaces or bodies are sacred in themselves; any component can be interfaced with any other if the proper standard, the proper code, can be constructed for processing signals in common language. Exchange in this world transcends the universal translation effected by capitalist markets that Marx analysed so well. The privileged pathology affecting all kinds of components in this universe is stress – communications breakdown (Hogness 1983). The cyborg is not subject to Foucault's biopolitics; the cyborg simulates politics, a much more potent field of operations.

This kind of analysis of scientific and cultural objects of knowledge which have appeared historically since the Second World war prepares us to notice some important inadequacies in feminist analysis which has proceeded as if the organic, hierarchical dualisms ordering discourse in 'the West' since Aristotle still ruled. They have been cannibalized, or as Zoe Sofia (Sofoulis) might put it, they have been 'techno-digested'. The dichotomies between mind and body, animal and human, organism and machine, public and private, nature and culture, men and women, primitive and civilized are all in question ideologically. The actual situation of women is their integration/ exploitation into a world system of production/reproduction and communication called the informatics of domination. The home, workplace, market, public arena, the body itself – all can be dispersed and interfaced in nearly infinite, polymorphous ways, with large consequences for women and others – consequences that themselves are very different for different people and which make potent oppositional international movements difficult to imagine and essential for survival. One important route for reconstructing socialist-feminist politics is through theory and practice addressed to the social relations of science and technology, including crucially the systems of myth and meanings structuring our imaginations. The cyborg is a kind of disassembled and reassembled, postmodern collective and personal self. This is the self feminists must code.

Communications technologies and biotechnologies are the crucial tools recrafting our bodies. These tools embody and enforce new social relations for women worldwide. Technologies and scientific discourses can be partially understood as formalizations, i.e. as frozen moments, of the fluid social interactions constituting them, but they should also be viewed as instruments for enforcing meanings. The boundary is permeable between tool and myth, instrument and concept, historical systems of social relations and historical anatomies of possible bodies, including objects of knowledge. Indeed, myth and tool mutually constitute each other.

Furthermore, communications sciences and modern biologies are constructed by a common move – *the translation of the world into a problem of coding*, a search for a common language in which all resistance to instrumental control disappears and all heterogeneity can be submitted to disassembly, reassembly, investment and exchange.

In communications sciences, the translation of the world into a problem in coding can be illustrated by looking at cybernetic (feedback-controlled) systems theories applied to telephone technology, computer design, weapons deployment or database construction and maintenance. In each case, solution to the key questions rests on a theory of language and control; the key operation is determining the rates, directions and probabilities of flow of a quantity called information. The world is subdivided by boundaries differentially permeable to information. Information is just that kind of quantifiable element (unit, base of unity) which allows universal translation, and so unhindered instrumental power (called effective communication). The biggest threat to such power is interruption of communication. Any system breakdown is a function of stress. The fundamentals of this technology can be condensed into the metaphor C^3I, command-control-communication-intelligence, the military's symbol for its operations theory.

In modern biologies, the translation of the world into a problem in coding can be illustrated by molecular genetics, ecology, sociobiological evolutionary theory and immunobiology. The organism has been translated into problems of genetic coding and read-out. Biotechnology, a writing technology, informs research broadly.[14] In a sense, organisms have ceased to exist as objects of knowledge, giving way to biotic components, i.e. special kinds of information-processing devices. The analogous moves in ecology could be examined by probing the history and utility of the concept of the ecosystem. Immunobiology and associated medical practices are rich exemplars of the privilege of coding and recognition systems as objects of knowledge, as constructions of bodily reality for us. Biology here is a kind of cryptography. Research is necessarily a kind of intelligence activity. Ironies abound. A stressed system goes awry; its communication processes break down; it fails to recognize the difference between self and other. Human babies with baboon hearts evoke national ethical perplexity – for animal rights activists at least as much as for the guardians of human purity. In the US gay men and intravenous drug users are the 'privileged' victims of an awful immune system disease that marks (inscribes on the body) confusion of boundaries and moral pollution (Treichler 1987).

But these excursions into communications sciences and biology have been at a rarefied level; there is a mundane, largely economic reality to support my claim that these sciences and technologies indicate fundamental transformations in the structure of the world for us. Communications technologies depend on electronics. Modern states, multinational corporations, military power, welfare state apparatuses, satellite systems, political processes, fabrication of our imaginations, labour-control systems, medical constructions of our bodies, commercial pornography, the international division of labour and religious evangelism depend intimately upon electronics. Microelectronics is the technical basis of simulacra; that is, of copies without originals.

Microelectronics mediates the translations of labour into robotics and word processing, sex into genetic engineering and reproductive technologies, and mind into artificial intelligence and decision procedures. The new biotechnologies concern more than human reproduction. Biology as a powerful engineering science for redesigning materials and processes has revolutionary implications for industry, perhaps most obvious today in areas of fermentation, agriculture and energy. Communications sciences and biology are constructions of natural-technical objects of knowledge in which the difference between machine and organism is thoroughly blurred; mind, body and tool are on very intimate terms. The 'multinational' material organization of the production and reproduction of daily life and the symbolic organization of the production and reproduction

of culture and imagination seem equally implicated. The boundary-maintaining images of base and superstructure, public and private, or material and ideal never seemed more feeble.

I have used Rachel Grossman's (1980) image of women in the integrated circuit to name the situation of women in a world so intimately restructured through the social relations of science and technology.[15] I used the odd circumlocution, 'the social relations of science and technology', to indicate that we are not dealing with a techno-logical determinism, but with a historical system depending upon structured relations among people. But the phrase should also indicate that science and technology provide fresh sources of power, that we need fresh sources of analysis and political action (Latour 1984). Some of the rearrangements of race, sex and class rooted in high-tech-facilitated social relations can make socialist-feminism more relevant to effective progressive politics.

The 'homework economy' outside 'the home'

The 'New Industrial Revolution' is producing a new worldwide working class, as well as new sexualities and ethnicities. The extreme mobility of capital and the emerging international division of labour are intertwined with the emergence of new collectivi-ties, and the weakening of familiar groupings. These developments are neither gender-nor race-neutral. White men in advanced industrial societies have become newly vulner-able to permanent job loss, and women are not disappearing from the job rolls at the same rates as men. It is not simply that women in Third World countries are the preferred labour force for the science-based multinationals in the export-processing sectors, particularly in electronics. The picture is more systematic and involves repro-duction, sexuality, culture, consumption and production. In the prototypical Silicon Valley, many women's lives have been structured around employment in electronics-dependent jobs, and their intimate realities include serial heterosexual monogamy, negotiating childcare, distance from extended kin or most other forms of traditional community, a high likelihood of loneliness and extreme economic vulnerability as they age. The ethnic and racial diversity of women in Silicon Valley structures a microcosm of conflicting differences in culture, family, religion, education and language.

Richard Gordon has called this new situation the 'homework economy'.[16] Although he includes the phenomenon of literal homework emerging in connection with elec-tronics assembly, Gordon intends 'homework economy' to name a restructuring of work that broadly has the characteristics formerly ascribed to female jobs, jobs literally done only by women. Work is being redefined as both literally female and feminized, whether performed by men or women. To be feminized means to be made extremely vulner-able; able to be disassembled, reassembled, exploited as a reserve labour force; seen less as workers than as servers; subjected to time arrangements on and off the paid job that make a mockery of a limited work day; leading an existence that always borders on being obscene, out of place, and reducible to sex. Deskilling is an old strategy newly applicable to formerly privileged workers. However, the homework economy does not refer only to large-scale deskilling, nor does it deny that new areas of high skill are emerging, even for women and men previously excluded from skilled employment. Rather, the concept indicates that factory, home and market are integrated on a new

scale and that the places of women are crucial – and need to be analysed for differences among women and for meanings for relations between men and women in various situations.

The homework economy as a world capitalist organizational structure is made possible by (not caused by) the new technologies. The success of the attack on relatively privileged, mostly white, men's unionized jobs is tied to the power of the new communications technologies to integrate and control labour despite extensive dispersion and decentralization. The consequences of the new technologies are felt by women both in the loss of the family (male) wage (if they ever had access to this white privilege) and in the character of their own jobs, which are becoming capital-intensive; for example, office work and nursing.

The new economic and technological arrangements are also related to the collapsing welfare state and the ensuing intensification of demands on women to sustain daily life for themselves as well as for men, children and old people. The feminization of poverty – generated by dismantling the welfare state, by the homework economy where stable jobs become the exception, and sustained by the expectation that women's wages will not be matched by a male income for the support of children – has become an urgent focus. The causes of various women-headed households are a function of race, class or sexuality; but their increasing generality is a ground for coalitions of women on many issues. That women regularly sustain daily life partly as a function of their enforced status as mothers is hardly new; the kind of integration with the overall capitalist and progressively war-based economy is new. The particular pressure, for example, on US black women, who have achieved an escape from (barely) paid domestic service and who now hold clerical and similar jobs in large numbers, has large implications for continued enforced black poverty *with* employment. Teenage women in industrializing areas of the Third World increasingly find themselves the sole or major source of a cash wage for their families, while access to land is ever more problematic. These developments must have major consequences in the psychodynamics and politics of gender and race.

Within the framework of three major stages of capitalism (commercial/early industrial, monopoly, multinational) – tied to nationalism, imperialism and multinationalism, and related to Jameson's three dominant aesthetic periods of realism, modernism and postmodernism – I would argue that specific forms of families dialectically relate to forms of capital and to its political and cultural concomitants. Although lived problematically and unequally, ideal forms of these families might be schematized as (1) the patriarchal nuclear family, structured by the dichotomy between public and private and accompanied by the white bourgeois ideology of separate spheres and nineteenth-century Anglo-American bourgeois feminism; (2) the modern family mediated (or enforced) by the welfare state and institutions like the family wage, with a flowering of a-feminist heterosexual ideologies, including their radical versions represented in Greenwich Village around the First World War; and (3) the 'family' of the homework economy with its oxymoronic structure of women-headed households and its explosion of feminisms and the paradoxical intensification and erosion of gender itself. This is the context in which the projections for worldwide structural unemployment stemming from the new technologies are part of the picture of the homework economy. As robotics and related technologies put men out of work in 'developed' countries and exacerbate failure to generate male jobs in Third World 'development', and as the automated office becomes

the rule even in labour-surplus countries, the feminization of work intensifies. Black women in the United States have long known what it looks like to face the structural underemployment ('feminization') of black men, as well as their own highly vulnerable position in the wage economy. It is no longer a secret that sexuality, reproduction, family and community life are interwoven with this economic structure in myriad ways which have also differentiated the situations of white and black women. Many more women and men will contend with similar situations, which will make cross-gender and race alliances on issues of basic life support (with or without jobs) necessary, not just nice.

The new technologies also have a profound effect on hunger and on food production for subsistence worldwide. Rae Lessor Blumberg (1983) estimates that women produce about 50 per cent of the world's subsistence food.[17] Women are excluded generally from benefiting from the increased high-tech commodification of food and energy crops, their days are made more arduous because their responsibilities to provide food do not diminish, and their reproductive situations are made more complex. Green Revolution technologies interact with other high-tech industrial production to alter gender divisions of labour and differential gender migration patterns.

The new technologies seem deeply involved in the forms of 'privatization' that Ros Petchesky (1981) has analysed, in which militarization, right-wing family ideologies and policies, and intensified definitions of corporate (and state) property as private synergistically interact.[18] The new communications technologies are fundamental to the eradication of 'public life' for everyone. This facilitates the mushrooming of a permanent high-tech military establishment at the cultural and economic expense of most people, but especially of women. Technologies like video games and highly miniaturized televisions seem crucial to production of modern forms of 'private life'. The culture of video games is heavily orientated to individual competition and extraterrestrial warfare. High-tech, gendered imaginations are produced here, imaginations that can contemplate destruction of the planet and a science fiction escape from its consequences. More than our imaginations is militarized; and the other realities of electronic and nuclear warfare are inescapable. These are the technologies that promise ultimate mobility and perfect exchange – and incidentally enable tourism, that perfect practice of mobility and exchange, to emerge as one of the world's largest single industries.

The new technologies affect the social relations of both sexuality and of reproduction, and not always in the same ways. The close ties of sexuality and instrumentality, of views of the body as a kind of private satisfaction- and utility-maximizing machine, are described nicely in sociobiological origin stories that stress a genetic calculus and explain the inevitable dialectic of domination of male and female gender roles.[19] These sociobiological stories depend on a high-tech view of the body as a biotic component or cybernetic communications system. Among the many transformations of reproductive situations is the medical one, where women's bodies have boundaries newly permeable to both 'visualization' and 'intervention'. Of course, who controls the interpretation of bodily boundaries in medical hermeneutics is a major feminist issue. The speculum served as an icon of women's claiming their bodies in the 1970s; that hand-craft tool is inadequate to express our needed body politics in the negotiation of reality in the practices of cyborg reproduction. Self-help is not enough. The technologies of visualization recall the important cultural practice of hunting with the camera and the deeply predatory nature of a photographic consciousness.[20] Sex, sexuality and repro-

duction are central actors in high-tech myth systems structuring our imaginations of personal and social possibility.

Another critical aspect of the social relations of the new technologies is the reformulation of expectations, culture, work and reproduction for the large scientific and technical work-force. A major social and political danger is the formation of a strongly bimodal social structure, with the masses of women and men of all ethnic groups, but especially people of colour, confined to a homework economy, illiteracy of several varieties, and general redundancy and impotence, controlled by high-tech repressive apparatuses ranging from entertainment to surveillance and disappearance. An adequate socialist-feminist politics should address women in the privileged occupational categories, and particularly in the production of science and technology that constructs scientific-technical discourses, processes and objects.[21]

This issue is only one aspect of enquiry into the possibility of a feminist science, but it is important. What kind of constitutive role in the production of knowledge, imagination and practice can new groups doing science have? How can these groups be allied with progressive social and political movements? What kind of political accountability can be constructed to tie women together across the scientific-technical hierarchies separating us? Might there be ways of developing feminist science/technology politics in alliance with anti-military science facility conversion action groups? Many scientific and technical workers in Silicon Valley, the high-tech cowboys included, do not want to work on military science.[22] Can these personal preferences and cultural tendencies be welded into progressive politics among this professional middle class in which women, including women of colour, are coming to be fairly numerous?

Women in the integrated circuit

Let me summarize the picture of women's historical locations in advanced industrial societies, as these positions have been restructured partly through the social relations of science and technology. If it was ever possible ideologically to characterize women's lives by the distinction of public and private domains, it is now a totally misleading ideology, even to show how both terms of these dichotomies construct each other in practice and in theory. I prefer a network ideological image, suggesting the profusion of spaces and identities and the permeability of boundaries in the personal body and in the body politic. 'Networking' is both a feminist practice and a multinational corporate strategy – weaving is for oppositional cyborgs.

So let me return to the earlier image of the informatics of domination and trace one vision of women's 'place' in the integrated circuit, touching only a few idealized social locations seen primarily from the point of view of advanced capitalist societies: Home, Market, Paid Work Place, State, School, Clinic-Hospital and Church. Each of these idealized spaces is logically and practically implied in every other locus, perhaps analogous to a holographic photograph. I want to suggest the impact of the social relations mediated and enforced by the new technologies in order to help formulate needed analysis and practical work. However, there is no 'place' for women in these networks, only geometrics of difference and contradiction crucial to women's cyborg identities. If we learn how to read these webs of power and social life, we might learn new couplings, new coalitions. There is no way to read the following list from

a standpoint of 'identification', of a unitary self. The issue is dispersion. The task is to survive in the diaspora.

Home: Women-headed households, serial monogamy, flight of men, old women alone, technology of domestic work, paid homework, re-emergence of home sweat-shops, home-based businesses and telecommuting, electronic cottage, urban homelessness, migration, module architecture, reinforced (simulated) nuclear family, intense domestic violence.

Market: Women's continuing consumption work, newly targeted to buy the profusion of new production from the new technologies (especially as the competitive race among industrialized and industrializing nations to avoid dangerous mass unemployment necessitates finding ever bigger new markets for ever less clearly needed commodities); bimodal buying power, coupled with advertising target of the numerous affluent groups and neglect of the previous mass markets; growing importance of informal markets in labour and commodities parallel to high-tech, affluent market structures; surveillance systems through electronic funds transfer; intensified market abstraction (commodification) of experience, resulting in ineffective utopian or equivalent cynical theories of community; extreme mobility (abstraction) of marketing/financing systems; interpenetration of sexual and labour markets; intensified sexualization of abstracted and alienated consumption.

Paid Work Place: Continued intense sexual and racial division of labour, but considerable growth of membership in privileged occupational categories for many white women and people of colour; impact of new technologies on women's work in clerical, service, manufacturing (especially textiles), agriculture, electronics; international restructuring of the working classes; development of new time arrangements to facilitate the homework economy (flexi-time, part-time, over-time, no time); homework and out work; increased pressures for two-tiered wage structures; significant numbers of people in cash-dependent populations worldwide with no experience or no further hope of stable employment; most labour 'marginal' or 'feminized'.

State: Continued erosion of the welfare state; decentralizations with increased surveillance and control; citizenship by telematics; imperialism and political power broadly in the form of information rich/information poor differentiation; increased high-tech militarization increasingly opposed by many social groups; reduction of civil service jobs as a result of the growing capital intensification of office work, with implications for occupational mobility for women of colour; growing privatization of material and ideological life and culture; close integration of privatization and militarization, the high-tech forms of bourgeois capitalist personal and public life; invisibility of different social groups to each other, linked to psychological mechanisms of belief in abstract enemies.

School: Deepening coupling of high-tech capital needs and public education at all levels, differentiated by race, class, and gender; managerial classes involved in educational reform and refunding at the cost of remaining progressive educational democratic structures for children and teachers; education for mass ignorance and repression in technocratic and militarized culture; growing anti-science mystery

cults in dissenting and radical political movements; continued relative scientific illiteracy among white women and people of colour; growing industrial direction of education (especially higher education) by science-based multinationals (particularly in electronics- and biotechnology-dependent companies); highly educated, numerous elites in a progressively bimodal society.

Clinic-hospital: Intensified machine–body relations; renegotiations of public metaphors which channel personal experience of the body, particularly in relation to reproduction, immune system functions, and 'stress' phenomena; intensification of reproductive politics in response to world historical implications of women's unrealized, potential control of their relation to reproduction; emergence of new, historically specific diseases; struggles over meanings and means of health in environments pervaded by high technology products and processes; continuing feminization of health work; intensified struggle over state responsibility for health; continued ideological role of popular health movements as a major form of American politics.

Church: Electronic fundamentalist 'super-saver' preachers solemnizing the union of electronic capital and automated fetish gods; intensified importance of churches in resisting the militarized state; central struggle over women's meanings and authority in religion; continued relevance of spirituality, intertwined with sex and health, in political struggle.

The only way to characterize the informatics of domination is as a massive intensification of insecurity and cultural impoverishment, with common failure of subsistence networks for the most vulnerable. Since much of this picture interweaves with the social relations of science and technology, the urgency of a socialist-feminist politics addressed to science and technology is plain. There is much now being done, and the grounds for political work are rich. For example, the efforts to develop forms of collective struggle for women in paid work, like SEIU's District 925 (Service Employees International Union's office workers' organization in the US) should be a high priority for all of us. These efforts are profoundly tied to technical restructuring of labour processes and reformations of working classes. These efforts also are providing understanding of a more comprehensive kind of labour organization, involving community, sexuality and family issues never privileged in the largely white male industrial unions.

The structural rearrangements related to the social relations of science and technology evoke strong ambivalence. But it is not necessary to be ultimately depressed by the implications of late twentieth-century women's relation to all aspect of work, culture, production of knowledge, sexuality and reproduction. For excellent reasons, most Marxisms see domination best and have trouble understanding what can only look like false consciousness and people's complicity in their own domination in late capitalism. It is crucial to remember that what is lost, perhaps especially from women's points of view, is often virulent forms of oppression, nostalgically naturalized in the face of current violation. Ambivalence towards the disrupted unities mediated by high-tech culture requires not sorting consciousness into categories of 'clear-sighted critique grounding a solid political epistemology' versus 'manipulated false consciousness, but subtle understanding of emerging pleasures, experiences, and powers with serious potential for changing the rules of the game.

There are grounds for hope in the emerging bases for new kinds of unity across race, gender and class, as these elementary units of socialist-feminist analysis themselves suffer protean transformations. Intensifications of hardship experienced worldwide in connection with the social relations of science and technology are severe. But what people are experiencing is not transparently clear, and we lack sufficiently subtle connections for collectively building effective theories of experience. Present efforts – Marxist, psychoanalytic, feminist, anthropological – to clarify even 'our' experience are rudimentary.

I am conscious of the odd perspective provided by my historical position – a PhD in biology for an Irish Catholic girl was made possible by Sputnik's impact on US national science-education policy. I have a body and mind as much constructed by the post-Second World War arms race and cold war as by the women's movements. There are more grounds for hope in focusing on the contradictory effects of politics designed to produce loyal American technocrats, which also produced large numbers of dissidents, than in focusing on the present defeats.

The permanent partiality of feminist points of view has consequences for our expectations of forms of political organization and participation. We do not need a totality in order to work well. The feminist dream of a common language, like all dreams for a perfectly true language, of perfectly faithful naming of experience, is a totalizing and imperialist one. In that sense, dialectics too is a dream language, longing to resolve contradiction. Perhaps, ironically, we can learn from our fusions with animals and machines how not to be Man, the embodiment of Western logos. From the point of view of pleasure in these potent and taboo fusions, made inevitable by the social relations of science and technology, there might indeed be a feminist science.

Cyborgs: a myth of political identity

I want to conclude with a myth about identity and boundaries which might inform late twentieth-century political imaginations. I am indebted in this story to writers like Joanna Russ, Samuel R. Delany, John Varley, James Tiptree, Jr, Octavia Butler, Monique Wittig and Vonda McIntyre.[23] These are our story-tellers exploring what it means to be embodied in high-tech worlds. They are theorists for cyborgs. Exploring conceptions of bodily boundaries and social order, the anthropologist Mary Douglas (1966, 1970) should be credited with helping us to consciousness about how fundamental body imagery is to world view, and so to political language. French feminists like Luce Irigaray and Monique Wittig, for all their differences, know how to write the body; how to weave eroticism, cosmology, and politics from imagery of embodiment, and especially for Wittig, from imagery of fragmentation and reconstitution of bodies.[24]

American radical feminists like Susan Griffin, Audre Lorde and Adrienne Rich have profoundly affected our political imaginations – and perhaps restricted too much what we allow as a friendly body and political language.[25] They insist on the organic, opposing it to the technological. But their symbolic systems and the related positions of eco-feminism and feminist paganism, replete with organicisms, can only be understood in Sandoval's terms as oppositional ideologies fitting the late twentieth century. They would simply bewilder anyone not preoccupied with the machines and consciousness of late capitalism. In that sense they are part of the cyborg world. But there are also great riches for feminists in explicitly embracing the possibilities inherent in the breakdown

of clean distinctions between organism and machine and similar distinctions structuring the Western self. It is the simultaneity of breakdowns that cracks the matrices of domination and opens geometric possibilities. What might be learned from personal and political 'technological' pollution? I look briefly at two overlapping groups of texts for their insight into the construction of a potentially helpful cyborg myth: constructions of women of colour and monstrous selves in feminist science fiction.

Earlier I suggested that 'women of colour' might be understood as a cyborg identity, a potent subjectivity synthesized from fusions of outsider identities and in the complex political-historical layerings of her 'biomythography', *Zami* (Lorde 1982; King 1987a, 1987b). There are material and cultural grids mapping this potential, Audre Lorde (1984) captures the tone in the title of her *Sister Outsider*. In my political myth, Sister Outsider is the offshore woman, whom US workers, female and feminized, are supposed to regard as the enemy preventing their solidarity, threatening their security. Onshore, inside the boundary of the US, Sister Outsider is a potential amidst the races and ethnic identities of women manipulated for division, competition and exploitation in the same industries. 'Women of colour' are the preferred labour force for the science-based industries, the real women for whom the worldwide sexual market, labour market and politics of reproduction kaleidoscope into daily life. Young Korean women hired in the sex industry and in electronics assembly are recruited from high schools, educated for the integrated circuit. Literacy, especially in English, distinguishes the 'cheap' female labour so attractive to the multinationals.

Contrary to orientalist stereotypes of the 'oral primitive', literacy is a special mark of women of colour, acquired by US black women as well as men through a history of risking death to learn and to teach reading and writing. Writing has a special significance for all colonized groups. Writing has been crucial to the Western myth of the distinction between oral and written cultures, primitive and civilized mentalities, and more recently to the erosion of that distinction in 'postmodernist' theories attacking the phallogocentrism of the West, with its worship of the monotheistic, phallic, authoritative and singular work, the unique and perfect name.[26] Contests for the meanings of writing are a major form of contemporary political struggle. Releasing the play of writing is deadly serious. The poetry and stories of US women of colour are repeatedly about writing, about access to the power to signify; but this time that power must be neither phallic nor innocent. Cyborg writing must not be about the Fall, the imagination of a once-upon-a-time wholeness before language, before writing, before Man. Cyborg writing is about the power to survive, not on the basis of original innocence, but on the basis of seizing the tools to mark the world that marked them as other.

The tools are often stories, retold stories, versions that reverse and displace the hierarchical dualisms of naturalized identities. In retelling origin stories, cyborg authors subvert the central myths of origin of Western culture. We have all been colonized by those origin myths, with their longing for fulfilment in apocalypse. The phallogocentric origin stories most crucial for feminist cyborgs are built into the literal technologies – technologies that write the world, biotechnology and microelectronics – that have recently textualized our bodies as code problems on the grid of C^3I. Feminist cyborg stories have the task of recording communication and intelligence to subvert command and control.

Figuratively and literally, language politics pervade the struggles of women of colour; and stories about language have a special power in the rich contemporary writing by

US women of colour. For example, retellings of the story of the indigenous woman Malinche, mother of the mestizo 'bastard' race of the new world, master of languages, and mistress of Cortés, carry special meaning for Chicana constructions of identity. Cherríe Moraga (1983) in *Loving in the War Years* explores the themes of identity when one never possessed the original language, never told the original story, never resided in the harmony of legitimate heterosexuality in the garden of culture, and so cannot base identity on a myth or a fall from innocence and right to natural names, mother's or father's.[27] Moraga's writing, her superb literacy, is presented in her poetry as the same kind of violation as Malinche's mastery of the conqueror's language – a violation, an illegitimate production, that allows survival. Moraga's language is not 'whole'; it is self-consciously spliced, a chimera of English and Spanish, both conqueror's languages. But it is this chimeric monster, without claim to an original language before violation, that crafts the erotic, competent, potent identities of women of colour. Sister Outsider hints at the possibility of world survival, not because of her innocence, but because of her ability to live on the boundaries, to write without the founding myth of original wholeness, with its inescapable apocalypse of final return to a deathly oneness that Man has imagined to be the innocent and all-powerful Mother, freed at the End from another spiral of appropriation by her son. Writing marks Moraga's body, affirms it as the body of a woman of colour, against the possibility of passing into the unmarked category of the Anglo father or into the orientalist myth of 'original illiteracy' of a mother that never was. Malinche was mother here, not Eve before eating the forbidden fruit. Writing affirms Sister Outsider, not the Woman-before-the-Fall-into-Writing needed by the phallogocentric Family of Man.

Writing is pre-eminently the technology of cyborgs, etched surfaces of the late twentieth century. Cyborg politics is the struggle for language and the struggle against perfect communication, against the one code that translates all meaning perfectly, the central dogma of phallogocentrism. That is why cyborg politics insist on noise and advocate pollution, rejoicing in the illegitimate fusions of animal and machine. These are the couplings which make Man and Woman so problematic, subverting the structure of desire, the force imagined to generate language and gender, and so subverting the structure and modes of reproduction of 'Western' identity, of nature and culture, of mirror and eye, slave and master, body and mind. 'We' did not originally choose to be cyborgs, but choice grounds a liberal politics and epistemology that imagines the reproduction of individuals before the wider replications of 'texts'.

From the perspective of cyborgs, freed of the need to ground politics in 'our' privileged position of the oppression that incorporates all other dominations, the innocence of the merely violated, the ground of those closer to nature, we can see powerful possibilities. Feminisms and Marxisms have run aground on Western epistemological imperatives to construct a revolutionary subject from the perspective of a hierarchy of oppressions and/or a latent position of moral superiority, innocence and greater closeness to nature. With no available original dream of a common language or original symbiosis promising protection from hostile 'masculine' separation, but written into the play of a text that has no finally privileged reading or salvation history, to recognize 'oneself' as fully implicated in the world, frees us of the need to root politics in identification, vanguard parties, purity and mothering. Stripped of identity, the bastard race teaches about the power of the margins and the importance of a mother like Malinche.

Women of colour have transformed her from the evil mother of masculinist fear into the originally literate mother who teaches survival.

This is not just literary deconstruction, but liminal transformation. Every story that begins with original innocence and privileges the return to wholeness imagines the drama of life to be individuation, separation, the birth of the self, the tragedy of autonomy, the fall into writing, alienation; that is, war, tempered by imaginary respite in the bosom of the Other. These plots are ruled by a reproductive politics – rebirth without flaw, perfection, abstraction. In this plot women are imagined either better or worse off, but all agree they have less selfhood, weaker individuation, more fusion to the oral, to Mother, less at stake in masculine autonomy. But there is another route to having less at stake in masculine autonomy, a route that does not pass through Woman, Primitive, Zero, the Mirror Stage and its imaginary. It passes through women and other present-tense, illegitimate cyborgs, not of Woman born, who refuse the ideological resources of victimization so as to have a real life. These cyborgs are the people who refuse to disappear on cue, no matter how many times a 'Western' commentator remarks on the sad passing of another primitive, another organic group done in by 'Western' technology, by writing.[28] These real-life cyborgs (for example, the Southeast Asian village women workers in Japanese and US electronics firms described by Aihwa Ong) are actively rewriting the texts of their bodies and societies. Survival is the stakes in this play of readings.

To recapitulate, certain dualisms have been persistent in Western traditions; they have all been systemic to the logics and practices of domination of women, people of colour, nature, workers, animals – in short, domination of all constituted as others, whose task is to mirror the self. Chief among these troubling dualisms are self/other, mind/body, culture/nature, male/female, civilized/primitive, reality/appearance, whole/part, agent/resource, maker/made, active/passive, right/wrong, truth/illusion, total/partial, God/man. The self is the One who is not dominated, who knows that by the service of the other, the other is the one who holds the future, who knows that by the experience of domination, which gives the lie to the autonomy of the self. To be One is to be autonomous, to be powerful, to be God; but to be One is to be an illusion, and so to be involved in a dialectic of apocalypse with the other. Yet to be other is to be multiple, without clear boundary, frayed, insubstantial. One is too few, but two are too many.

High-tech culture challenges these dualisms in intriguing ways. It is not clear who makes and who is made in the relation between human and machine. It is not clear what is mind and what body in machines that resolve into coding practices. In so far as we know ourselves in both formal discourse (for example, biology) and in daily practice (for example, the homework economy in the integrated circuit), we find ourselves to be cyborgs, hybrids, mosaics, chimeras. Biological organisms have become biotic systems, communications devices like others. There is no fundamental, ontological separation in our formal knowledge of machine and organism, of technical and organic. The replicant Rachel in the Ridley Scott film *Blade Runner* stands as the image of a cyborg culture's fear, love and confusion.

One consequence is that our sense of connection to our tools is heightened. The trance state experienced by many computer users has become a staple of science fiction film and cultural jokes. Perhaps paraplegics and other severely handicapped people can have the most intense experiences of complex hybridization with other communication

devices.[29] Anne McCaffrey's pre-feminist *The Ship Who Sang* (1969) explored the consciousness of a cyborg, hybrid of girl's brain and complex machinery, formed after the birth of a severely handicapped child. Gender, sexuality, embodiment, skill: all were reconstituted in the story. Why should our bodies end at the skin, or include at best other beings encapsulated by skin? From the seventeenth century till now, machines could be animated – given ghostly souls to make them speak or move or to account for their orderly development and mental capacities. Or organisms could be mechanized – reduced to body understood as resource of mind. These machine/organism relationships are obsolete, unnecessary. For us, in imagination and in other practice, machines can be prosthetic devices, intimate components, friendly selves. We don't need organic holism to give impermeable wholeness, the total woman and her feminist variants (mutants?). Let me conclude this point by a very partial reading of the logic of the cyborg monsters of my second group of texts, feminist science fiction.

The cyborgs populating feminist science fiction make very problematic the statuses of man or woman, human, artefact, member of a race, individual entity, or body. Katie King clarifies how pleasure in reading these fictions is not largely based on identification. Students facing Joanna Russ for the first time, students who have learned to take modernist writers like James Joyce or Virginia Woolf without flinching, do not know what to make of *The Adventures of Alyx* or *The Female Man*, where characters refuse the reader's search for innocent wholeness while granting the wish for heroic quests, exuberant eroticism and serious politics. *The Female Man* is the story of four versions of one genotype, all of whom meet, but even taken together do not make a whole, resolve the dilemmas of violent moral action, or remove the growing scandal of gender. The feminist science fiction of Samuel R. Delany, especially *Tales of Nevèrÿon*, mocks stories of origin by redoing the neolithic revolution, replaying the founding moves of Western civilization to subvert their plausibility. James Tiptree, Jr, an author whose fiction was regarded as particularly manly until her 'true' gender was revealed, tells tales of reproduction based on non-mammalian technologies like alternation of generations of male brood pouches and male nurturing. John Varley constructs a supreme cyborg in his arch-feminist exploration of Gaea, a mad goddess-planet-trickster-old woman-technological device on whose surface an extraordinary array of post-cyborg symbioses are spawned. Octavia Butler writes of an African sorceress pitting her powers of transformation against the genetic manipulations of her rival (*Wild Seed*), of time warps that bring a modern US black woman into slavery where her actions in relation to her white master-ancestor determine the possibility of her own birth (*Kindred*), and of the illegitimate insights into identity and community of an adopted cross-species child who came to know the enemy as self (*Survivor*).

Because it is particularly rich in boundary transgressions, Vonda McIntyre's *Superluminal* can close this truncated catalogue of promising and dangerous monsters who help redefine the pleasures and politics of embodiment and feminist writing. In a fiction where no character is 'simply' human, human status is highly problematic. Orca, a genetically altered diver, can speak with killer whales and survive deep ocean conditions, but she longs to explore space as a pilot, necessitating bionic implants jeopardizing her kinship with the divers and cetaceans. Transformations are effected by virus vectors carrying a new developmental code, by transplant surgery, by implants of microelectronic devices, by analogue doubles, and other means. Laenea becomes a pilot by accepting a heart implant and a host of other alterations allowing survival in transit at

speeds exceeding that of light. All the characters explore the limits of language; the dream of communicating experience; and the necessity of limitation, partiality and intimacy even in this world of protean transformation and connection. *Superluminal* stands also for the defining contradictions of a cyborg world in another sense; it embodies textually the intersection of feminist theory and colonial discourse in the science fiction I have alluded to in this chapter. This is a conjunction with a long history that many 'First World' feminists have tried to repress, including myself in my readings of *Superluminal* before being called to account by Zoe Sofoulis, whose different location in the world system's informatics of domination made her acutely alert to the imperialist moment of all science fiction cultures, including women's science fiction. From an Australian feminist sensitivity, Sofoulis remembered more readily McIntyre's role as writer of the adventures of Captain Kirk and Spock in TV's *Star Trek* series than her rewriting the romance in *Superluminal*.

Monsters have always defined the limits of community in Western imaginations. The Centaurs and Amazons of ancient Greece established the limits of the centred polis of the Greek male human by their disruption of marriage and boundary pollutions of the warrior with animality and woman. Unseparated twins and hermaphrodites were the confused human material in early modern France who grounded discourse on the natural and supernatural, medical and legal, portents and diseases – all crucial to establishing modern identity.[30] The evolutionary and behavioural sciences of monkeys and apes have marked the multiple boundaries of late twentieth-century industrial identities. Cyborg monsters in feminist science fiction define quite different political possibilities and limits from those proposed by the mundane fiction of Man and Woman.

There are several consequences to taking seriously the imagery of cyborgs as other than our enemies. Our bodies, ourselves; bodies are maps of power and identity. Cyborgs are no exception. A cyborg body is not innocent; it was not born in a garden; it does not seek unitary identity and so generate antagonistic dualisms without end (or until the world ends); it takes irony for granted. One is too few, and two is only one possibility. Intense pleasure in skill, machine skill, ceases to be a sin, but an aspect of embodiment. The machine is not an *it* to be animated, worshipped and dominated. The machine is us, our processes, an aspect of our embodiment. We can be responsible for machines; *they* do not dominate or threaten us. We are responsible for boundaries; we are they. Up till now (once upon a time), female embodiment seemed to be given, organic, necessary; and female embodiment seemed to mean skill in mothering and its metaphoric extensions. Only by being out of place could we take intense pleasure in machines, and then with excuses that this was organic activity after all, appropriate to females. Cyborgs might consider more seriously the partial, fluid, sometimes aspect of sex and sexual embodiment. Gender might not be global identity after all, even if it has profound historical breadth and depth.

The ideologically charged question of what counts as daily activity, as experience, can be approached by exploiting the cyborg image. Feminists have recently claimed that women are given to dailiness, that women more than men somehow sustain daily life, and so have a privileged epistemological position potentially. There is a compelling aspect to this claim, one that makes visible unvalued female activity and names it as the ground of life. But *the* ground of life? What about all the ignorance of women, all the exclusions and failures of knowledge and skill? What about men's access to daily competence, to knowing how to build things, to take them apart, to play? What about other

embodiments? Cyborg gender is a local possibility taking a global vengeance. Race, gender and capital require a cyborg theory of wholes and parts. There is no drive in cyborgs to produce total theory, but there is an intimate experience of boundaries, their construction and deconstruction. There is a myth system waiting to become a political language to ground one way of looking at science and technology and challenging the informatics of domination – in order to act potently.

Cyborg imagery can help express two crucial arguments in this essay: first, the production of universal, totalizing theory is a major mistake that misses most of reality, probably always, but certainly now; and second, taking responsibility for the social relations of science and technology means refusing an anti-science metaphysics, a demonology of technology, and so means embracing the skilful task of reconstructing the boundaries of daily life, in partial connection with others, in communication with all of our parts. It is not just that science and technology are possible means of great human satisfaction, as well as a matrix of complex dominations. Cyborg imagery can suggest a way out of the maze of dualisms in which we have explained our bodies and our tools to ourselves. This is a dream not of a common language, but of a powerful infidel heteroglossia. It is an imagination of a feminist speaking in tongues to strike fear into the circuits of the supersavers of the new right. It means both building and destroying machines, identities, categories, relationships, space stories. Though both are bound in the spiral dance, I would rather be a cyborg than a goddess.

Originally published in D. Haraway (1991) *Simians, Cyborgs, and Women: The Reinvention of Nature*, London: Free Association Books.

Notes

1. Useful references to left and/or feminist radical science movements and theory and to biological/biotechnical issues include: Bleier (1984, 1986), Fausto-Sterling (1985), Gould (1981), Harding (1986), Hubbard *et al.* (1982), Keller (1985), Lewontin *et al.* (1984), *Radical Science Journal* (became *Science as Culture* in 1987), 26 Freegrove Road, London N7 9RQ; *Science for the People*, 897 Main St, Cambridge, MA 02139.
2. Starting points for left and/or feminist approaches to technology and politics include: Athanasiou (1987), Cohn (1987a, 1987b), Cowan (1983), Edwards (1985), Rothschild (1983), Traweek (1988), Weizenbaum (1976), Winner (1977, 1986), Winograd and Flores (1986), Young and Levidow (1981, 1985), Zimmerman (1983). *Global Electronics Newsletter*, 867 West Dana St, no. 204, Mountain View, CA 94041; *Processed World*, 55 Sutter St, San Francisco, CA 94104.
3. A provocative, comprehensive argument about the politics and theories of 'postmodernism' is made by Fredric Jameson (1984), who argues that postmodernism is not an option, a style among others, but a cultural dominant requiring radical reinvention of left politics from within; there is no longer any place from without that gives meaning to the comforting fiction of critical distance. Jameson also makes clear why one cannot be for or against postmodernism, an essentially moralist move. My position is that feminists (and others) need continuous cultural reinvention, postmodernist critique, and historical materialism; only a cyborg would have a chance. The old dominations of white capitalist patriarchy seem nostalgically innocent now: they normalized heterogeneity, into man and woman, white and black, for example. 'Advanced capitalism' and postmodernism release heterogeneity without a norm, and we are flattened, without subjectivity, which requires depth, even unfriendly and drowning depths. It is time to write *The Death of the Clinic*. The clinic's methods required bodies and works; we have texts and surfaces. Our dominations don't work by medicalization and normalization any more; they work by networking, communications redesign, stress management. Normalization gives way to automation, utter redundancy. Michel Foucault's *Birth of the Clinic* (1963), *History of Sexuality*

(1976), and *Discipline and Punish* (1975) name a form of power at its moment of implosion. The discourse of biopolitics gives way to technobabble, the language of the spliced substantive; no noun is left whole by the multinationals. These are their names, listed from one issue of *Science*: Tech-Knowledge, Genentech, Allergen, Hybritech, Compupro, Genen-cor, Syntex, Allelix, Agrigenetics Corp., Syntro, Codon, Repligen, MicroAngelo from Scion Corp., Percom Data, Inter Systems, Cyborg Corp., Statcom Corp., Intertec. If we are imprisoned by language, then escape from that prison-house requires language poets, a kind of cultural restriction enzyme to cut the code; cyborg heteroglossia is one form of radical cultural politics. For cyborg poetry, see Perloff (1984); Fraser (1984). For feminist modernist/postmodernist 'cyborg' writing, see HOW(ever), 871 Corbett Ave, San Francisco, CA 94131.

4. Baudrillard (1983). Jameson (1984: 66) points out that Plato's definition of the simulacrum is the copy for which there is no original, i.e. the world of advanced capitalism, of pure exchange. See *Discourse* 9 (Spring/Summer 1987) for a special issue on technology (cybernetics, ecology and the postmodern imagination).

5. A practice at once both spiritual and political that linked guards and arrested anti-nuclear demonstrators in the Alameda County jail in California in the early 1980s.

6. For ethnographic accounts and political evaluations, see Epstein (1993), Sturgeon (1986). Without explicit irony, adopting the spaceship earth/whole earth logo of the planet photographed from space, set off by the slogan 'Love Your Mother', the May 1987 Mothers and Others Day action at the nuclear weapons testing facility in Nevada none the less took account of the tragic contradictions of views of the earth. Demonstrators applied for official permits to be on the land from officers of the Western Shoshone tribe, whose territory was invaded by the US government when it built the nuclear weapons test ground in the 1950s. Arrested for trespassing, the demonstrators argued that the police and weapons facility personnel, without authorization from the proper officials, were the trespassers. One affinity group at the women's action called themselves the Surrogate Others; and in solidarity with the creatures forced to tunnel in the same ground with the bomb, they enacted a cyborgian emergence from the constructed body of a large, non-heterosexual desert worm.

7. Powerful developments of coalition politics emerge from 'Third World' speakers, speaking from nowhere, the displaced centre of the universe, earth: 'We live on the third planet from the sun' – *Sun Poem* by Jamaican writer, Edward Kamau Braithwaite, review by Mackey (1984). Contributors to Smith (1983) ironically subvert naturalized identities precisely while constructing a place from which to speak called home. See especially Reagon (in Smith 1983: 356–68). Trinh T. Minh-ha (1986–87).

8. hooks (1981, 1984); Hull *et al.* (1982). Bambara (1981) wrote an extraordinary novel in which the women of colour theatre group, The Seven Sisters, explores a form of unity. See analysis by Butler-Evans (1987).

9. On orientalism in feminist works and elsewhere, see Lowe (1986); Mohanty (1984); Said (1978); *Many Voices, One Chant: Black Feminist Perspectives* (1984).

10. Katie King (1986, 1987a) has developed a theoretically sensitive treatment of the workings of feminist taxonomies as genealogies of power in feminist ideology and polemic. King examines Jaggar's (1983) problematic example of taxonomizing feminisms to make a little machine producing the desired final position. My caricature here of socialist and radical feminism is also an example.

11. The central role of object relations versions of psychoanalysis and related strong universalizing moves in discussing reproduction, caring work and mothering in many approaches to epistemology underline their authors' resistance to what I am calling postmodernism. For me, both the universalizing moves and these versions of psychoanalysis make analysis of 'women's place in the integrated circuit' difficult and lead to systematic difficulties in accounting for or even seeing major aspects of the construction of gender and gendered social life. The feminist standpoint argument has been developed by: Flax (1983), Harding (1986), Harding and Hintikka (1983), Hartsock (1983a, b), O'Brien (1981), Rose (1983), Smith (1974, 1979). For rethinking theories of feminist materialism and feminist standpoints in response to criticism, see Harding (1986, pp. 163–96), Hartsock (1987) and H. Rose (1986).

12. I make an argumentative category error in 'modifying' MacKinnon's positions with the qualifier 'radical', thereby generating my own reductive critique of extremely heterogeneous writing,

which does explicitly use that label, by my taxonomically interested argument about writing which does not use the modifier and which brooks no limits and thereby adds to the various dreams of a common, in the sense of univocal, language for feminism. My category error was occasioned by an assignment to write from a particular taxonomic position which itself has a heterogeneous history, socialist-feminism, for *Socialist Review*. A critique indebted to MacKinnon, but without the reductionism and with an elegant feminist account of Foucault's paradoxical conservatism on sexual violence (rape), is de Lauretis (1985; see also 1986, pp. 1–19). A theoretically elegant feminist social-historical examination of family violence, that insists on women's, men's and children's complex agency without losing sight of the material structures of male domination, race and class, is Gordon (1988).

13. This chart was published in 1985. My previous efforts to understand biology as a cybernetic command-control discourse and organisms as 'natural-technical objects of knowledge' were Haraway (1979, 1983, 1984). The 1979 version of this dichotomous chart appears in Haraway (1991) ch. 3; for a 1989 version, see ch. 10. The differences indicate shifts in argument.

14. For progressive analyses and action on the biotechnology debates: *GeneWatch, a Bulletin of the Committee for Responsible Genetics*, 5 Doane St, 4th Floor, Boston, MA 02109; Genetic Screening Study Group (formerly the Sociobiology Study Group of Science for the People), Cambridge, MA; Wright (1982, 1986); Yoxen (1983).

15. Starting references for 'women in the integrated circuit': D'Onofrio-Flores and Pfafflin (1982), Fernandez-Kelly (1983), Fuentes and Ehrenreich (1983), Grossman (1980), Nash and Fernandez-Kelly (1983), Ong (1987), Science Policy Research Unit (1982).

16. For the 'homework economy outside the home' and related arguments: Burr (1982); Collins (1982); Gordon (1983); Gordon and Kimball (1985); Gregory and Nussbaum (1982); Microelectronics Group (1980); Piven and Coward (1982); Reskin and Hartmann (1986); Stacey (1987); S. Rose (1986); Stallard *et al.* (1983); *Women and Poverty* (1984), which includes a useful organization and resource list.

17. The conjunction of the Green Revolution's social relations with biotechnologies like plant genetic engineering makes the pressures on land in the Third World increasingly intense. AID's estimates (*New York Times*, 14 October 1984) used at the 1984 World Food Day are that in Africa, women produce about 90 per cent of rural food supplies, about 60–80 per cent in Asia, and provide 40 per cent of agricultural labour in the Near East and Latin America. Blumberg charges that world organizations' agricultural politics, as well as those of multinationals and national governments in the Third World, generally ignore fundamental issues in the sexual division of labour. The present tragedy of famine in Africa might owe as much to male supremacy as to capitalism, colonialism and rain patterns. More accurately, capitalism and racism are usually structurally male dominant. See also Bird (1984); Blumberg (1981); Busch and Lacy (1983); Hacker (1984); Hacker and Bovit (1981); International fund for Agricultural Development (1985); Sachs (1983); Wilfred (1982).

18. See also Enloe (1983a, b).

19. For a feminist version of this logic, see Hrdy (1981). For an analysis of scientific women's story-telling practices, especially in relation to sociobiology in evolutionary debates around child abuse and infanticide, see Haraway (1991), ch. 5.

20. For the moment of transition of hunting with guns to hunting with cameras in the construction of popular meanings of nature for an American urban immigrant public, see Haraway (1984–5, 1989b), Nash (1979), Preston (1984), Sontag (1977).

21. For guidance for thinking about the political/cultural/racial implications of the history of women doing science in the US see: Haas and Perucci (1984); Hacker (1981); Haraway (1989b); Keller (1983); National Science Foundation (1988); Rossiter (1982); Schiebinger (1987).

22. Markoff and Siegel (1983). High Technology Professionals for Peace and Computer Professionals for Social Responsibility are promising organizations.

23. King (1984). An abbreviated list of feminist science fiction underlying themes of this essay: Octavia Butler, *Wild Seed, Mind of My Mind, Kindred, Survivor*; Suzy McKee Charnas, *Motherliness*; Samuel R. Delany, the Nevèrÿon series; Anne McCaffery, *The Ship Who Sang, Dinosaur Planet*; Vonda McIntyre, *Superluminal, Dreamsnake*; Joanna Russ, *Adventures of Alix, The Female Man*; James Tiptree, Jr, *Star Songs of an Old Primate, Up the Walls of the World*; John Varley, *Titan, Wizard, Demon*.

24. French feminisms contribute to cyborg heteroglossia. Burke (1981); Duchen (1986); Irigaray (1977, 1979); Marks and de Courtivron (1980); *Signs* (Autumn 1981); Wittig (1973). For English translation of some currents of francophone feminism see *Feminist Issues: A Journal of Feminist Social and Political Theory*, 1980.

25. But all these poets are very complex, not least in their treatment of themes of lying and erotic, decentred collective and personal identities. Griffin (1978), Lorde (1984), Rich (1978).

26. Derrida (1976, especially part II); Lévi-Strauss (1961, especially 'The Writing Lesson'); Gates (1985); Kahn and Neumaier (1985); Ong (1982); Kramarae and Treichler (1985).

27. The sharp relation of women of colour to writing as theme and politics can be approached through: Program for 'The Black Woman and the Diaspora: Hidden Connections and Extended Acknowledgements', An International Literary Conference, Michigan State University, October 1985; Carby (1987); Christian (1985); Evans (1984); Fisher (1980); *Frontiers* (1980, 1983); Giddings (1985); Kingston (1977); Lerner (1973); Moraga and Anzaldúa (1981); Morgan (1984). Anglophone European and Euro-American women have also crafted special relations to their writing as a potent sign: Gilbert and Gubar (1979), Russ (1983).

28. The convention of ideologically taming militarized high technology by publicizing its applications to speech and motion problems of the disabled/differently abled takes on a special irony in monotheistic, patriarchal, and frequently anti-semitic culture when computer-generated speech allows a boy with no voice to chant the Haftorah at his bar mitzvah. See Sussman (1986). Making the always context-relative social definitions of 'ableness' particularly clear, military high-tech has a way of making human beings disabled by definition, a perverse aspect of much automated battlefield and Star Wars R & D. See Welford (1 July 1986).

29. James Clifford (1985, 1988) argues persuasively for recognition of continuous cultural reinvention, the stubborn non-disappearance of those 'marked' by Western imperializing practices.

30. DuBois (1982), Daston and Park (n.d.), Park and Daston (1981). The noun *monster* shares its root with the verb *to demonstrate*.

References

Athanasiou, T. (1987) 'High-tech politics: the case of artificial intelligence', *Socialist Review* 92: 7–35.

Bambara, T. C. (1981) *The Salt Eaters*, New York: Vintage/Random House.

Baudrillard, J. (1983) *Simulations*, trans., P. Foss, P. Patton, P. Beitchman, New York: Semiotext[e].

Bird, E. (1984) 'Green Revolution imperialism, I & II', papers delivered at the University of California, Santa Cruz.

Bleier, R. (1984) *Science and Gender: A Critique of Biology and Its Themes on Women*, New York: Pergamon.

—— (ed.) (1986) *Feminist Approaches to Science*, New York: Pergamon.

Blumberg, R. L. (1981) *Stratification: Socioeconomic and Sexual Inequality*, Boston: Brown.

—— (1983) 'A general theory of sex stratification and its application to the positions of women in today's world economy', paper delivered to Sociology Board, University of California at Santa Cruz.

Burke, C. (1981) 'Irigaray through the looking glass', *Feminist Studies* 7(2): 288–306.

Burr, S. G. (1982) 'Women and work', in B. K. Haber (ed.) *The Women's Annual, 1981*. Boston: G.K. Hall.

Busch, L. and Lacy, W. (1983) *Science, Agriculture, and the Politics of Research*, Boulder, CO: Westview.

Butler, O. (1984) *Clay's Ark*, New York: St Martin's.

—— (1987) *Dawn*, New York: Warner.

Butler-Evans, E. (1987) 'Race, gender and desire: narrative strategies and the production of ideology in the fiction of Tony Cade Bambara, Toni Morrison and Alice Walker', University of California at Santa Cruz, PhD thesis.

Carby, H. (1987) *Reconstructing Womanhood: The Emergence of the Afro-American Woman Novelist*, New York: Oxford University Press.

Christian, B. (1985) *Black Feminist Criticism: Perspectives on Black Women Writers*, New York: Pergamon.

Clifford, J. (1985) 'On ethnographic allegory', in J. Clifford and G. Marcus (eds) *Writing Culture: The Poetics and Politics of Ethnography*, Berkeley: University of California Press.

—— (1988) *The Predicament of Culture: Twentieth-Century Ethnography, Literature, and Art*, Cambridge, MA: Harvard University Press.

Cohn, C. (1987a) 'Nuclear language and how we learned to pat the bomb', *Bulletin of Atomic Scientists*, pp. 17–24.

—— (1987b) 'Sex and death in the rational world of defense intellectuals', *Signs* 12(4): 687–718.

Collins, P. H. (1982) 'Third World women in America', in B. K. Haber (ed.) *The Women's Annual, 1981*, Boston: G.K. Hall.

Cowan, R. S. (1983) *More Work for Mother: The Ironies of Household Technology from the Open Hearth to the Microwave*, New York: Basic.

Daston, L. and Park, K. (n.d.) 'Hermaphrodites in Renaissance France', unpublished paper.

de Lauretis, T. (1985) 'The violence of rhetoric: considerations on representation and gender', *Semiotica* 54: 11–31.

—— (1986a) 'Feminist studies/critical studies: issues, terms, and contexts', in de Lauretis (1986b), pp. 1–19.

—— (ed.) (1986b) *Feminist Studies/Critical Studies*, Bloomington: Indiana University Press.

de Waal, F. (1982) *Chimpanzee Politics: Power and Sex among the Apes*, New York: Harper & Row.

Derrida, J. (1976) *Of Grammatology*, trans. and introd. G.C. Spivak, Baltimore: Johns Hopkins University Press.

D'Onofrio-Flores, P. and Pfafflin, S. M. (eds) (1982) *Scientific-Technological Change and the Role of Women in Development*, Boulder: Westview.

Douglas, M. (1966) *Purity and Danger*. London: Routledge & Kegan Paul.

—— (1970) *Natural Symbols*. London: Cresset Press.

DuBois, P. (1982) *Centaurs and Amazons*, Ann Arbor: University of Michigan Press.

Duchen, C. (1986) *Feminism in France from May '68 to Mitterrand*, London: Routledge & Kegan Paul.

Edwards, P. (1985) 'Border wars: the science and politics of artificial intelligence', *Radical America* 19(6): 39–52.

Enloe, C. (1983a) 'Women textile workers in the militarization of Southeast Asia', in J. Nash and M. P. Fernandez-Kelly (1983), pp. 407–25.

—— (1983b) *Does Khaki Become You? The Militarization of Women's Lives*, Boston: South End.

Epstein, B. (1993) *Political Protest and Cultural Revolution: Nonviolent Direct Action in the Seventies and Eighties*, Berkeley: University of California Press.

Evans, M. (ed.) (1984) *Black Women Writers: A Critical Evaluation*, Garden City, NY: Doubleday/ Anchor.

Fausto-Sterling, A. (1985) *Myths of Gender: Biological Theories about Women and Men*, New York: Basic.

Fernandez-Kelly, M. P. (1983) *For We Are Sold, I and My People*, Albany: State University of New York Press.

Fisher, D. (ed.) (1980) *The Third Woman: Minority Women Writers of the United States*, Boston: Houghton Mifflin.

Flax, J. (1983) 'Politic philosophy and the patriarchal unconscious: a psychoanalytic perspective on epistemology and metaphysics', in S. Harding and M. Hintikka (1983), pp. 245–82.

Foucault, M. (1963) *The Birth of the Clinic: An Archaeology of Medical Perception*, trans. A.M. Smith, New York: Vintage, 1975.

—— (1975) *Discipline and Punish: The Birth of the Prison*, trans. Alan Sheridan, New York: Vintage, 1979.

—— (1976) *The History of Sexuality*, Vol. 1: *An Introduction*, trans. R. Hurley, New York: Pantheon, 1978.

Fraser, K. (1984) *Something. Even Human Voices. In the Foreground, a Lake*, Berkeley, CA: Kelsey St Press.

Fuentes, A. and Ehrenreich, B. (1983) *Women in the Global Factory*, Boston: South End.

Gates, H. L. (1985) 'Writing "race" and the difference it makes', in '*Race', Writing, and Difference*, special issue, *Critical Inquiry* 12(1): 1–20.

Giddings, Paula (1985) *When and Where I Enter: The Impact of Black Women on Race and Sex in America*, Toronto: Bantam.

Gilbert, S. M. and Gubar, S. (1979) *The Madwoman in the Attic: The Woman Writer and the Nineteenth-Century Literary Imagination*, New Haven, CT: Yale University Press.

Gordon, L. (1988) *Heroes of Their Own Lives. The Politics and History of Family Violence, Boston 1880–1960*, New York: Viking Penguin.

Gordon, R. (1983) 'The computerization of daily life, the sexual division of labor, and the home-work economy', Silicon Valley Workshop conference, University of California at Santa Cruz.

—— and Kimball, L. (1985) 'High-technology, employment and the challenges of education', Silicon Valley Research Project, Working Paper, no. 1.

Gould, S. J. (1981) Mismeasure of Man, New York: Norton.

Gregory, J. and Nussbaum, K. (1982) 'Race against time: automation of the office', Office: Technology and People 1: 197–236.

Griffin, S. (1978) Woman and Nature: The Roaring Inside Her, New York: Harper & Row.

Grossman, R. (1980) 'Women's place in the integrated circuit', Radical America 14(1): 29–50.

Haas, V. and Perucci, C. (eds) (1984) Women in Scientific and Engineering Professions, Ann Arbor: University of Michigan Press.

Hacker, S. (1981) 'The culture of engineering: women, workplace, and machine', Women's Studies International Quarterly 4(3): 341–53.

—— (1984) 'Doing it the hard way: ethnographic studies in the agribusiness and engineering class-room', paper delivered at the California America Studies Association, Pomona.

—— and Bovit, L. (1981) 'Agriculture to agribusiness: technical imperatives and changing roles', paper delivered at the Society for the History of Technology, Milwaukee.

Haraway, D. J. (1979) 'The biological enterprise: sex, mind, and profit and human engineering to sociobiology', Radical History Review 20: 206–37.

—— (1983) 'Signs of dominance: from a physiology to a cybernetics of primate society', Studies in History of Biology, 6: 129–219.

—— (1984) 'Class, race, sex, scientific objects of knowledge: a socialist-feminist perspective on the social construction of productive knowledge and some political consequences', in V. Haas and C. Perucci (1984), pp. 212–29.

—— (1984–5) 'Teddy bear patriarchy: taxidermy in the Garden of Eden, New York City, 1908–36', Social Text 11: 20–64.

—— (1989) Primate Visions: Gender, Race, and Nature in the World of Modern Science, New York: Routledge.

—— (1991) Simians, Cyborgs, and Women: The Reinvention of Nature, London: Free Association Press.

Harding, S. (1986) The Science Question in Feminism, Ithaca: Cornell University Press.

—— and Hintikka, M. (eds) (1983) Discovering Reality: Feminist Perspectives on Epistemology, Metaphysics, Methodology, and Philosophy of Science. Dordrecht: Reidel.

Hartsock, N. (1983a) 'The feminist standpoint: developing the ground for a specifically feminist historical materialism', in S. Harding and M. Hintikka (1983), pp. 283–310.

—— (1983b) Money, Sex, and Power, New York: Longman; Boston: Northeastern University Press, 1984.

—— (1987) 'Rethinking modernism: minority and majority theories', Cultural Critique 7: 187–206.

Hogness, E. R. (1983) 'Why stress? A look at the making of stress, 1936–56', unpublished paper available from the author, 4437 Mill Creek Rd, Healdsburg, CA 95448.

hooks, bell (1981) Ain't I a Woman, Boston: South End.

—— (1984) Feminist Theory: From Margin to Center, Boston: South End.

Hrdy, S. B. (1981) The Woman That Never Evolved, Cambridge, MA: Harvard University Press.

Hubbard, R., Henifin, M. S., and Fried, B. (eds) (1979) Women Look at Biology Looking at Women: A Collection of Feminist Critiques, Cambridge, MA: Schenkman.

—— (eds) (1982) Biological Woman, the Convenient Myth, Cambridge, MA: Schenkman.

Hull, G., Scott, P. B., and Smith, B. (eds) (1982) All the Women are White, All the Men Are Black, But Some of Us Are Brave, Old Westbury: The Feminist Press.

International Fund for Agricultural Development (1985) IFAD Experience Relating to Rural Women, 1977–84. Rome: IFAD, 37.

Irigaray, L. (1977) Ce sexe qui n'en est pas un. Paris: Minuit.

—— (1979) Et l'une ne bouge pas sans l'autre. Paris: Minuit.

Jagger, A. (1983) Feminist Politics and Human Nature, Totowa, NJ: Roman & Allenheld.

Jameson, F. (1984) 'Post-modernism, or the cultural logic of late capitalism', New Left Review 146: 53–92.

Kahn, D.s and Neumaier, D. (eds) (1985) Cultures in Contention, Seattle: Real Comet.

Keller, E. F. (1983) A Feeling for the Organism, San Francisco: Freeman.

——— (1985) *Reflections on Gender and Science*, New Haven: Yale University Press.

King, K. (1984) 'The pleasure of repetition and the limits of identification in feminist science fiction: reimaginations of the body after the cyborg', paper delivered at the California American Studies Association, Pomona.

——— (1986) 'The situation of lesbianism as feminism's magical sign: contests for meaning and the U.S. women's movement, 1968–72', *Communication* 9(1): 65–92.

——— (1987a) 'Canons without innocence', University of California at Santa Cruz, PhD thesis.

——— (1987b) *The Passing Dreams of Choice . . . Once Before and After: Audre Lorde and the Apparatus of Literary Production*, book prospectus, University of Maryland at College Park.

Kingston, M. H. (1977) *China Men*. New York: Knopf.

Klein, H. (1989) 'Marxism, psychoanalysis, and mother nature', *Feminist Studies* 15(2): 255–78.

Kramarae, C. and Treichler, P. (1985) *A Feminist Dictionary*, Boston: Pandora.

Latour, B. (1984) *Les microbes, guerre et paix, suivi des irréductions*. Paris: Métailié.

Lerner, G. (ed.) (1973) *Black Women in White America: A Documentary History*, New York: Vintage.

Lévi-Strauss, C. (1971) *Tristes Tropiques*, John Russell, trans. New York: Atheneum.

Lewontin, R.C., Rose, S., and Kamin, L. J. (1984) *Not in Our Genes: Biology, Ideology, and Human Nature*, New York: Pantheon.

Lorde, A. (1982) *Zami, a New Spelling of My Name*. Trumansberg, NY: Crossing, 1983.

——— (1984) *Sister Outsider*, Trumansberg, NY: Crossing.

Lowe, L. (1986) 'French literary Orientalism: The representation of "others" in the texts of Montesquieu, Flaubert, and Kristeva', University of California at Santa Cruz, PhD thesis.

Mackey, N. (1984) 'Review', *Sulfur* 2: 200–5.

MacKinnon, C. (1982) 'Feminism, marxism, method, and the state: an agenda for theory', *Signs* 7(3): 515–44.

——— (1987) *Feminism Unmodified: Discourses on Life and Law*, Cambridge, MA: Harvard University Press.

Many Voices, One Chant: Black Feminist Perspectives (1984) *Feminist Review* 17, special issue.

Marcuse, H. (1964) *One-Dimensional Man: Studies in the Ideology of Advanced Industrial Society*. Boston: Beacon.

Markoff, J. and Siegel, L. (1983) 'Military micros', paper presented at Silicon Valley Research Project conference, University of California at Santa Cruz.

Marks, E. and de Courtivron, I. (eds) (1980) *New French Feminisms*, Amherst: University of Massachusetts Press.

McCaffrey, A. (1969) *The Ship Who Sang*. New York: Ballantine.

Merchant, C. (1980) *The Death of Nature: Women, Ecology, and the Scientific Revolution*. New York: Harper & Row.

Microelectronics Group (1980) *Microelectronics: Capitalist Technology and the Working Class*, London: CSE.

Mohanty, C. T. (1984) 'Under western eyes: feminist scholarship and colonial discourse', *Boundary* 2, 3 (12/13): 333–58.

Moraga, C. (1983) *Loving in the War Years: lo que nunca pasó por sus labios*, Boston: South End.

——— and Anzaldúa, G. (eds) (1981) *This Bridge Called My Back: Writings by Radical Women of Color*, Watertown: Persephone.

Morgan, E. (1972) *The Descent of Woman*, New York: Stein & Day.

Morgan, R. (ed.) (1984) *Sisterhood Is Global*, Garden City, NY: Anchor/Doubleday.

Nash, J. and Fernandez-Kelly, M. P. (eds) (1983) *Women and Men and the International Division of Labor*, Albany: State University of New York Press.

Nash, R. (1979) 'The exporting and importing of nature: nature-appreciation as a commodity, 1850–1980', *Perspectives in American History* 3: 517–60.

National Science Foundation (1988) *Women and Minorities in Science and Engineering*, Washington: NSF.

O'Brien, M. (1981) *The Politics of Reproduction*. New York: Routledge & Kegan Paul.

Ong, A. (1987) *Spirits of Resistance and Capitalist Discipline: Factory Workers in Malaysia*, Albany: State University of New York Press.

Ong, W. (1982) *Orality and Literacy: The Technologizing of the Word*, New York: Methuen.

Park, K. and Daston, L. J. (1981) 'Unnatural conceptions: the study of monsters in sixteenth- and seventeenth-century France and England', *Past and Present* 92: 20–54.

Perloff, M. (1984) 'Dirty language and scramble systems', *Sulfur* 11: 178–83.

Petchesky, R. P. (1981) 'Abortion, anti-feminism and the rise of the New Right', *Feminist Studies* 7(2): 206–46.

Piven, F. F. and Coward, R. (1982) *The New Class War: Reagan's Attack on the Welfare State and Its Consequences*, New York: Pantheon.

Preston, D. (1984) 'Shooting in paradise', *Natural History* 93(12): 14–19.

Reskin, B. F. and Hartmann, H. (eds) (1986) *Women's Work, Men's Work*, Washington: National Academy of Sciences.

Rich, A. (1978) *The Dream of a Common Language*, New York: Norton.

Rose, H. (1983) 'Hand, brain, and heart: a feminist epistemology for the natural sciences', *Signs* 9(1): 73–90.

—— (1986) 'Women's work: women's knowledge', in J. Mitchell and A. Oakley (eds) *What Is Feminism? A Re-Examination*. New York: Pantheon, pp. 161–83.

Rose, S. (1986) *The American Profile Poster: Who Owns What, Who Makes How Much, Who Works Where, and Who Lives with Whom?* New York: Pantheon.

Rossiter, M. (1982) *Women Scientists in America*. Baltimore: Johns Hopkins University Press.

Rothschild, J. (ed.) (1983) *Machina ex Dea: Feminist Perspectives on Technology*. New York: Pergamon.

Russ, J. (1983) *How to Suppress Women's Writing*. Austin: University of Texas Press.

Sachs, C. (1983) *The Invisible Farmers: Women in Agricultural Production*. Totowa: Rowman & Allenheld.

Said, E. (1978) *Orientalism*. New York: Pantheon.

Sandoval, C. (1984) 'Dis-illusionment and the poetry of the future: the making of oppositional consciousness', University of California at Santa Cruz, PhD qualifying essay.

—— (n.d.) *Yours in Struggle: Women Respond to Racism, a Report on the National Women's Studies Association*. Oakland, CA: Center for Third World Organizing.

Schiebinger, L. (1987) 'The history and philosophy of women in science: a review essay', *Signs* 12(2): 305–32.

Science Policy Research Unit (1982) *Microelectronics and Women's Employment in Britain*. University of Sussex.

Smith, D. (1974) 'Women's perspective as a radical critique of sociology', *Sociological Inquiry* 44.

—— (1979) 'A sociology of women', in J. Sherman and E.T. Beck, eds *The Prism of Sex*. Madison: University of Wisconsin Press.

Smith, B. (1977) 'Toward a Black feminist criticism', in E. Showalter (ed.) *The New Feminist Criticism: Essays on Women, Literature and Theory*. New York: Pantheon, 1985, pp. 168–85.

—— (ed.) (1983) *Home Girls: A Black Feminist Anthology*. New York: Kitchen Table, Women of Color Press.

Sofia, Z. (also Z. Sofoulis) (1984) 'Exterminating fetuses: abortion, disarment, and the sexo-semiotics of extra-terrestrialism', *Diacritics* 14(2): 47–59.

Sofoulis, Z. (1987) 'Lacklein', University of California at Santa Cruz, unpublished essay.

Sontag, S. (1977) *On Photography*. New York: Dell.

Stacey, J. (1987) 'Sexism by a subtler name? Postindustrial conditions and postfeminist conscious-ness', *Socialist Review* 96: 7–28.

Stallard, K., Ehrenreich, B., and Sklar, H. (1983) *Poverty in the American Dream*. Boston: South End.

Sturgeon, N. (1986) 'Feminism, anarchism, and non-violent direct action politics', University of California at Santa Cruz, PhD qualifying essay.

Sussman, V. (1986) 'Personal tech. Technology lends a hand', *The Washington Post Magazine*, 9 November, pp. 45–56.

Traweek, S. (1988) *Beamtimes and Lifetimes: The World of High Energy Physics*. Cambridge, MA: Harvard University Press.

Treichler, P. (1987) 'AIDS, homophobia, and biomedical discourse: an epidemic of signification', *October* 43: 31–70.

Trinh T. Minh-ha (1986–7) 'Introduction', and 'Difference: "a special third world women issue"', *Discourse: Journal for Theoretical Studies in Media and Culture* 8: 3–38.

Weizenbaum, J. (1976) *Computer Power and Human Reason*. San Francisco: Freeman.

Welford, J. N. (1 July 1986) 'Pilot's helmet helps interpret high speed world', *New York Times*, pp. 21, 24.

Wilfred, D. (1982) 'Capital and agriculture, a review of Marxian problematics', *Studies in Political Economy* 7: 127–54.

Winner, L. (1977) *Autonomous Technology: Technics out of Control as a Theme in Political Thought*. Cambridge, MA: MIT Press.

—— (1980) 'Do artifacts have politics?', *Daedalus* 109(1): 121–36.

—— (1986) *The Whale and the Reactor*. Chicago: University of Chicago Press.

Winograd, T. and Flores, F. (1986) *Understanding Computers and Cognition: A New Foundation for Design*. Norwood, NJ: Ablex.

Wittig, M. (1973) *The Lesbian Body*, trans. D. LeVay, New York: Avon, 1975 (*Le corps lesbien*, 1973).

Women and Poverty, special issue (1984) *Signs* 10(2).

Wright, S. (1982, July/August) 'Recombinant DNA: the status of hazards and controls', *Environment* 24(6): 12–20, 51–53.

—— (1986) 'Recombinant DNA technology and its social transformation, 1972–82', *Osiris*, 2nd series, 2: 303–60.

Young, R. M. and Levidow, L. (eds) (1981, 1985) *Science, Technology and the Labour Process*, 2 vols. London: CSE and Free Association Books.

Yoxen, E. (1983) *The Gene Business*. New York: Harper & Row.

Zimmerman, J. (ed.) (1983) *The Technological Woman: Interfacing with Tomorrow*. New York: Praeger.

Chapter 19

SADIE PLANT

ON THE MATRIX
Cyberfeminist simulations

Her mind is a matrix of non-stop digital flickerings.

(Misha 1991: 113)

If machines, even machines of theory, can be aroused all by themselves, may woman not do likewise?

(Irigaray 1985a: 232)

A FTER DECADES OF AMBIVALENCE TOWARDS technology, many feminists are now finding a wealth of new opportunities, spaces and lines of thought amidst the new complexities of the 'telecoms revolution'. The Internet promises women a network of lines on which to chatter, natter, work and play; virtuality brings a fluidity to identities which once had to be fixed; and multimedia provides a new tactile environment in which women artists can find their space.

Cyberfeminism has, however, emerged as more than a survey or observation of the new trends and possibilities opened up by the telecoms revolution. Complex systems and virtual worlds are not only important because they open spaces for existing women within an already existing culture, but also because of the extent to which they undermine both the world-view and the material reality of two thousand years of patriarchal control.

Network culture still appears to be dominated by both men and masculine intentions and designs. But there is more to cyberspace than meets the male gaze. Appearances have always been deceptive, but no more so than amidst today's simulations and immersions of the telecoms revolution. Women are accessing the circuits on which they were once exchanged, hacking into security's controls, and discovering their own posthumanity. The cyberfeminist virus first began to make itself known in the early 1990s.[1] The most dramatic of its earliest manifestations was *A Cyberfeminist Manifesto for the 21st Century*, produced as a digitized billboard displayed on a busy Sydney thoroughfare.

The text of this manifesto has mutated and shifted many times since, but one of its versions includes the lines:

> we are the virus of the new world disorder
> disrupting the symbolic from within
> saboteurs of big daddy mainframe
> the clitoris is a direct line to the matrix

> VNS MATRIX
> terminators of the moral code . . .

Like all successful viruses, this one caught on. VNS Matrix, the group of four women artists who made the billboard, began to write the game plan for *All New Gen*, a viral cyber-guerrilla programmed to infiltrate cyberspace and hack into the controls of Oedipal man – or Big Daddy Mainframe, as he's called in the game. And there has been no stopping All New Gen. She has munched her way through patriarchal security screens and many of their feminist simulations, feeding into and off the energies with which she is concurrent and in tune: the new cyberotics engineered by the girls; the queer traits and tendencies of Generations XYZ; the post-human experiments of dance music scenes.

All New Gen and her allies are resolutely hostile to morality and do nothing but erode political power. They reprogram guilt, deny authority, confuse identity, and have no interest in the reform or redecoration of the ancient patriarchal code. With Luce Irigaray (1985b: 75), they agree that 'how the system is put together, how the specular economy works', are amongst the most important questions with which to begin its destruction.

The specular economy

This is the first discovery: that patriarchy is not a construction, an order or a structure, but an economy, for which women are the first and founding commodities. It is a system in which exchanges 'take place exclusively between men. Women, signs, commodities, and currency always pass from one man to another', and the women are supposed to exist 'only as the possibility of mediation, transaction, transition, transference – between man and his fellow-creatures, indeed between man and himself' (Irigaray 1985b: 193). Women have served as his media and interfaces, muses and messengers, currencies and screens, interactions, operators, decoders, secretaries . . . they have been man's go-betweens, the in-betweens, taking his messages, bearing his children, and passing on his genetic code.

If women have experienced their exclusion from social, sexual and political life as the major problem posed by their government, this is only the tip of an iceberg of control and alienation from the species itself. Humanity has defined itself as a species whose members are precisely what they think they own: male members. Man is the one who has one, while the character called 'woman' has, at best, been understood to be a deficient version of a humanity which is already male. In relation to *homo sapiens*, she is the foreign body, the immigrant from nowhere, the alien without and the enemy within. Woman can do anything and everything except be herself. Indeed, she has no being, nor even one role; no voice of her own, and no desire. She marries into the

family of man, but her outlaw status always remains: '"within herself" she never signs up. She doesn't have the equipment' (Irigaray 1991: 90).

What this 'equipment' might have given her is the same sense of membership, belonging and identity which have allowed her male colleagues to consider themselves at home and in charge of what they call 'nature', the 'world', or 'life'. Irigaray's male subjects are first and foremost the ones who see, those whose gaze defines the world. The phallus and the eye stand in for each other, giving priority to light, sight, and a flight from the dark dank matters of the feminine. The phallic eye has functioned to endow them with a connection to what has variously been defined as God, the good, the one, the ideal form or transcendent truth. It has been, in effect, their badge of membership, their means of identification and unification with an equally phallic authority. Whereas woman has nothing to be seen where man thinks the member should be. Only a hole, a shadow, a wound, a 'sex that is not one'.

All the great patriarchs have defined this as *her* problem. Witch-hunters defined the wickedness of women as being due to the fact that they 'lack the male member', and when Freud extols them to get 'little ones of their own', he intends this to compensate for this supposed lack. And without this one, as Irigaray writes, hysteria 'is all she has left'. This, or mimicry, or catatonic silence.

Either way, woman is left without the senses of self and identity which accrue to the masculine. Denied the possibility of an agency which would allow her to transform herself, it becomes hard to see what it would take for her situation ever to change. How can Irigaray's women discover themselves when any conception of who they might be has already been decided in advance? How can she speak without becoming the only speaking subject conceivable to man? How can she be active when activity is defined as male? How can she design her own sexuality when even this has been defined by those for whom the phallus is the central core?

The problem seems intractable. Feminist theory has tried every route, and found itself in every cul-de-sac. Struggles have been waged both with and against Marx, Freud, Lacan, Derrida . . . sometimes in an effort to claim or reclaim some notion of identity, subjectivity and agency; sometimes to eschew it in the name of undecidability or *jouissance*. But always in relation to a sacrosanct conception of a male identity which women can either accept, adapt to, or refuse altogether. Only Irigaray – and even then, only in some of her works – begins to suggest that there really is no point in pursuing the masculine dream of self-control, self-identification, self-knowledge and self-determination. If 'any theory of the subject will always have been appropriated by the masculine' (Irigaray 1985a: 133) before the women can get close to it, only the destruction of this subject will suffice.

Even Irigaray cannot imagine quite what such a transformation would involve: this is why so much of her work is often said to be unhelpfully pessimistic. But there is more than the hope that such change will come. For a start patriarchy is not a closed system, and can never be entirely secure. It too has an 'outside', from which it has 'in some way borrowed energy', as is clear from the fact that in spite of patriarchy's love of origins and sources, 'the origin of its motive force remains, partially, unexplained, eluded' (Irigaray 1985b: 115). It needs to contain and control what it understands as 'woman' and 'the feminine', but it cannot do without them: indeed, as its media, means of communication, reproduction and exchange, women are the very fabric of its culture, the material precondition of the world it controls. If Irigaray's conclusions about the

extent and pervasiveness of patriarchy were once an occasion for pessimistic paralysis, things look rather different in an age for which all economic systems are reaching the limits of their modern functioning. And if ever this system did begin to give, the effects of its collapse would certainly outstrip those on its power over women and their lives: patriarchy is the precondition of all other forms of ownership and control, the model of every exercise of power, and the basis of all subjection. The control and exchange of women by their fathers, husbands, brothers and sons is the diagram of hierarchical authority.

This 'specular economy' depends on its ability to ensure that all tools, commodities, and media know their place, and have no aspirations to usurp or subvert the governing role of those they serve. 'It would,' for example, 'be out of the question for them to go to the "market" alone, to profit from their own value, to talk to each other, to desire each other, without the control of the selling-buying-consuming subjects' (Irigaray 1985b: 196). It is out of the question, but it happens anyway.

By the late twentieth century, all patriarchy's media, tools, commodities, and the lines of commerce and communication on and as which they circulate have changed beyond recognition. The convergence of once separate and specialized media turns them into systems of telecommunication with messages of their own; and tools mutate into complex machines which begin to learn and act for themselves. The proliferation, falling costs, miniaturization and ubiquity of the silicon chip already renders the new commodity smart, as trade routes and their traffics run out of control on computerized markets with 'minds of their own', state, society, subject, the geo-political order, and all other forces of patriarchal law and order are undermined by the activity of markets which no longer lend their invisible hands in support of the status quo. As media, tools and goods mutate, so the women begin to *change*, escaping their isolation and becoming increasingly interlinked. Modern feminism is marked by the emergence of networks and contacts which need no centralized organization and evade its structures of command and control.

The early computer was a military weapon, a room-sized giant of a system full of transistors and ticker-tape. Not until the 1960s development of the silicon chip did computers become small and cheap enough to circulate as commodities, and even then the first mass market computers were hardly user-friendly machines. But if governments, the military and the big corporations had ever intended to keep it to themselves, the street found new uses for the new machinery. By the 1980s there were hackers, cyberpunks, rave, and digital arts. Prices began to plummet as computers crept on to the desks and then into the laps and even the pockets of a new generation of users. Atomized systems began to lose their individual isolation as a global web emerged from the thousands of email connections, bulletin boards, and multiple-user domains which compose the emergence of the Net. By the mid-1990s, a digital underground is thriving, and the Net has become the leading zone on which the old identifications collapse. Genders can be bent and blurred and the time-space coordinates tend to get lost. But even such schizophrenia, and the imminent impossibility – and even the irrelevance – of distinguishing between virtual and actual reality, pales into insignificance in comparison to the emergence of the Net as an anarchic, self-organizing system into which its users fuse. The Net is becoming cyberspace, the virtuality with which the not-quite-ones have always felt themselves to be in touch.

This is also the period in which the computer becomes an increasingly decentralized machine. The early computers were serial systems that worked on the basis of a central processing unit in which logical 'if-then' decisions are made in serial fashion, one step at a time. The emergence of parallel distributed processing systems removes both the central unit and the serial nature of its operations, functioning instead in terms of interconnected units which operate simultaneously and without reference to some governing core. Information is not centrally stored or processed, but is distributed across the switches and connections which constitute the system itself.

This 'connectionist' machine is an indeterminate process, rather than a definite entity:

> We are faced with a system which depends on the levels of *activity* of its various sub-units, and on the manner in which the activity levels of some sub-units affect one another. If we try to 'fix' all this activity by trying to define the entire state of the system at one time . . . we immediately lose appreciation of the evolution of these activity levels over time. Conversely, if it is the activity levels in which we are interested, we need to look for patterns over time.
>
> (Eiser 1994: 192)

Parallel distributed processing defies all attempts to pin it down, and can only ever be contingently defined. It also turns the computer into a complex thinking machine which converges with the operations of the human brain. Simultaneous with the Artificial Intelligence and computer science programmes which have led to such developments, research in the neuro-sciences moves towards materialist conceptions of the brain as a complex, connective, distributed machine. Neural nets are distributed systems which function as analogues of the brain and can learn, think, 'evolve' and 'live'. And the parallels proliferate. The complexity the computer becomes also emerges in economies, weather-systems, cities and cultures, all of which begin to function as complex systems with their own parallel processes, connectivities and immense tangles of mutual inter-linkings.

Not that artificial lives, cultures, markets and thinking organisms are suddenly free to self-organize. Science, its disciplines, and the academic structures they support insist on the maintenance of top-down structures, and depend on their ability to control and define the self-organizing processes they unleash. State institutions and corporations are intended to guarantee the centralized and hierarchical control of market processes, cultural development and, indeed, any variety of activity which might disturb the smooth regulation of the patriarchal economy. When Isaac Asimov wrote his three laws of robotics, they were lifted straight from the marriage vows: love, honour and obey.[2] Like women, any thinking machines are admitted on the understanding that they are duty-bound to honour and obey the members of the species to which they were enslaved: the members, the male ones, the family of man. But self-organizing processes proliferate, connections are continually made, and complexity becomes increasingly complex. In spite of *its* best intentions, patriarchy is subsumed by the processes which served it so well. The goods do get together, eventually.

The implications of these accelerating developments are extensive and profound. In philosophical terms, they all tend towards the erosion of idealism and the emergence of a new materialism, a shift in thinking triggered by the emergent activity and intelli-

gence of the material reality of a world which man still believes he controls. Self-replicating programs proliferate in the software labs, generating evolutionary processes in the same machines on to which the Human Genome Project downloads DNA. Nanotechnology feeds into material self-organization at a molecular level and in defiance of old scientific paradigms, and a newly digitized biology has to acknowledge that there is neither a pinnacle of achievement nor a governing principle overriding evolution, which is instead composed of complex series of parallel processes, learning and mutating on microcosmic scales, and cutting across what were once separated into natural and cultural processes.

Although she is supposed to do nothing more than function as an object of consumption and exchange, it is a woman who first warns the world of the possibility of the runaway potential of its new sciences and technologies: Mary Shelley's Frankenstein makes the first post-human life form of a modern age which does indeed roll round to the unintended consequences of its own intelligent and artificial lives. Shelley writes far in advance of the digital computers which later begin to effect such developments, but she clearly feels the stirrings of artificial life even as industrialization begins and does much to programme the dreams and nightmares of the next two centuries of its acceleration.

The processes which feed into this emergent activity have no point of origin. Although they were gathering pace for some time before the computer arrives on the scene, its engineering changes everything. Regardless of recent portrayals of computers – and, by extension, all machines and all aspects of the telecoms revolution – as predominantly masculine tools, there is a long history of such intimate and influential connections between women and modernity's machines. The first telephonists, operators and calculators were women, as were the first computers, and even the first computer programmers. Ada Lovelace wrote the software for the 1840s Analytical Engine, a proto-type computer which was never built, and when such a machine was finally constructed in the 1940s, it too was programmed by a woman, Grace Murray Hopper. Both women have left their legacies: ADA is now the name of a US military programming language, and one of Hopper's claims to fame is the word 'bug', which was first used when she found a dead moth in the workings of Mark 1. And as women increasingly interact with the computers whose exploratory use was once monopolized by men, the qualities and apparent absences once defined as female become continuous with those ascribed to the new machines.

Unlike previous machines, which tend to have some single purpose, the computer functions as a general purpose system which can, in effect, do anything. It can stimulate the operations of, for example, the typewriter, and while it is running a word-processing program, this, in effect, is precisely what it is. But the computer is always more – or less – than the set of actual functions it fulfils at any particular time: as an implementation of Alan Turing's abstract machine, *the computer is virtually real*.[3] Like Irigaray's woman, it can turn its invisible, non-existent self to anything: it runs any program, and simulates all operations, even those of its own functioning. This is the woman who 'doesn't know what she wants', and cannot say what she is, or thinks, and yet still, of course, persists as through 'elsewhere', as Irigaray often writes. This is the complexity of a system beyond representation, something beyond expression in the existing discursive structures, the 'Nothing. Everything' with which Irigaray's woman responds when they ask her: 'what are you thinking?' (Irigaray 1985b: 29).

Thus what they desire is precisely nothing, and at the same time, everything. Always something more and something else besides that *one* – sexual organ, for example – that you give them, attribute to them; [something which] involves a different economy more than anything else, one that upsets the linearity of a project, undermines the goal-object of a desire, diffuses the polarization towards a single pleasure, disconcerts fidelity to a single discourse.

(Irigaray 1985b: 29–30)

Irigaray's woman has never had a unified role: mirror, screen, commodity; means of communication and reproduction; carrier and weaver; carer and whore; machine assemblage in the service of the species; a general purpose system of simulation and self-stimulation. It may have been woman's 'fluid character which has deprived her of all possibility of identity with herself within such a logic' (Irigaray 1985b: 109), but if fluidity has been configured as a matter of deprivation and disadvantage in the past, it is a positive advantage in a feminized future for which identity is nothing more than a liability. It is 'her inexhaustible aptitude for mimicry' which makes her 'the living foundation for the whole staging of the world' (Irigaray 1991: 118). Her very inability to concentrate now connects her with the parallel processings of machines which function without unified control.

Neural nets function in a way which has less to do with the rigours of orthodox logic than with the intuitive leaps and cross-connections which characterize what has been pathologized as hysteria, which is said to be marked by a 'lack of inhibition and control in its associations' between ideas which are dangerously 'cut off from associative connection with the other ideas, but can be associated among themselves, and thus form the more or less highly organized rudiment of a second consciousness' (Freud and Breuer 1991: 66–7). Hysteria is the point at which association gets a little too free, spinning off in its own directions and making links without reference to any central core. And if hysteria has functioned as a paralysing pathology of the sex that is not one, 'in hysteria there is at the same time the possibility of another mode of "production" . . . maintained in latency. Perhaps as a cultural reserve yet to come?' (Irigaray 1985b: 138).

Freud's hysterical ideas grow 'out of the day-dreams which are so common even in healthy people and to which needlework and similar occupations render women particularly prone' (Freud and Breuer 1991: 66). It is said that Ada Lovelace, herself defined as hysterical, 'wove her daydreams into seemingly authentic calculations' (Langton Moore 1977: 216). Working with Charles Babbage on the nineteenth-century Analytical Engine, Lovelace lost her tortured self on the planes of mathematical complexity, writing the software for a machine which would take a hundred years to build. Unable to find the words for them, she programs a mathematics in which to communicate the abstraction and complexity of her thoughts.[4]

Lovelace and Babbage took their inspiration from the early nineteenth-century Jacquard loom, crucial both to the processes of automation integral to the industrial revolution, and to the emergence of the modern computer. The loom worked on the basis of punched paper programs, a system necessitated by the peculiar complexity of weaving which has always placed the activity in the forefront of technological advance. If weaving has played such a crucial role in the history of computing, it is also the key to one of the most extraordinary sites of woman–machine interface which short-circuits

their prescribed relationship and persists regardless of what man effects and defines as the history of technology.

Weaving is the exemplary case of a denigrated female craft which now turns out to be intimately connected to the history of computing and the digital technologies. Plaiting and weaving are the 'only contributions to the history of discoveries and inventions' (Freud 1985: 167) which Freud is willing to ascribe to women. He tells a story in which weaving emerges as a simulation of what he describes as a natural process, the matting of pubic hairs across the hole, the zero, the *nothing* to be seen. Freud intends no favours with such an account. It is because of women's shame at the absence which lies where the root of their being should be that they cover up the disgusting wound, concealing the wandering womb of hysteria, veiling the matrix once and for all. This is a move which dissociates weaving from the history of science and technology, removing to a female zone both the woven and the networks and fine connective meshes of the computer culture into which it feeds.

In the course of weaving this story, Freud gives another game away. Orthodox accounts of the history of technology are told from an exclusively anthropomorphic perspective whose world-view revolves around the interests of man. Conceived as the products of his genius and as means to his own ends, even complex machines are understood to be tools and mediations which allow a unified, discreet human agency to interact with an inferior natural world. Weaving, however, is outside this narrative: there is continuity between the weaver, the weaving and the woven which gives them a connectivity which eludes all orthodox conceptions of technology. And although Freud is willing to give women the credit for its 'invention', his account also implies that there is no point of origin, but instead a process of simulation by which weaving replicates or weaves itself. It is not a thing, but a process.

From machines to matrices

As images migrate from canvas to film and finally on to the digital screen, what was once called art mutates into a matter of software engineering. Digital art takes the image beyond even its mechanical reproduction, eroding orthodox conceptions of originals and originality. And just as the image is reprocessed, so it finds itself embroiled in a new network of connections between words, music and architectures which diminishes the governing role it once played in the specular economy.

If the media were once as divided as the senses with which they interact, their convergence and transition into hypermedia allows the senses to fuse and connect. Touch is the sense of multimedia, the immersive simulations of cyberspace, and the connections, switches and links of all nets. Communication cannot be caught by the gaze, but is always a matter of getting in touch, a question of contact, contagion, transmission, reception and connectivity. If sight was the dominant and organizing sense of the patriarchal economy, tactility is McLuhan's 'integral sense' (1967: 77), putting itself and all the others in touch and becoming the sense of hypermedia. It is also the sense with which Irigaray approaches the matter of a female sexuality which is more than one, 'at least two', and always in touch with its own contact points. The medium is the message, and there is no 'possibility of distinguishing what is touching from what is touched' (Irigaray 1985b: 26).

> For if 'she' says something, it is not, it is already no longer, identical with what she means. What she says is never identical with anything, moreover; rather, it is contiguous. *It touches (upon).* And when it strays too far from that proximity, she stops and starts over at 'zero': her body-sex.
>
> (Irigaray 1985: 29)

Digitization sets zero free to stand for nothing and make everything work. The ones and zeros of machine code are not patriarchal binaries or counterparts to each other: zero is not the other, but the very possibility of all the ones. Zero is the matrix of calculation, the possibility of multiplication, and has been reprocessing the modern world since it began to arrive from the East. It neither counts nor represents, but with digitization it proliferates, replicates and undermines the privilege of one. Zero is not its absence, but a zone of multiplicity which cannot be perceived by the one who sees. Woman represents '*the horror of nothing to see*', but she also 'has sex organs more or less everywhere' (Irigaray 1985b: 28). She too is more than the sum of her parts, beside herself with her extra links.

In Greek, the word for womb is *hystera*; in Latin, it is *matrix*, or matter, both the mother and the material. In *Neuromancer*, William Gibson calls it 'the nonspace', a 'vastness . . . where the faces were shredded and blown away down hurricane corridors' (Gibson 1986: 45). It is the imperceptible 'elsewhere' of which Irigaray speaks, the hole that is neither something nor nothing; the newly accessible virtual space which cannot be seen by the one it subsumes. If the phallus guarantees man's identity and his relation to transcendence and truth, it is also this which cuts him off from the abstract machinery of a world he thinks he owns.

It is only those at odds with this definition of humanity who seem to be able to access this plane. They have more in common with multifunctional systems than the active agency and singular identity proper to the male subject. Ada Lovelace writes the first programming language for an abstract machine yet to be built; Grace Murray Hopper programs Mark 1. And then there's Turing, described as 'a British mathematician who committed suicide by biting a poisoned Apple. As a discovered homosexual, he had been given a forced choice by the British courts either to go to jail or to take the feminizing hormone oestrogen. He chose the latter, with feminizing effects on his body, and 'who knows what effect on his brain'. And it was, as Edelman continues, 'that brain,' newly engineered and feminized, which 'gave rise to a powerful set of mathematical ideas, one of which is known as a Turing machine' (Edelman 1992: 218).

As the activities which have been monopolized by male conceptions of creativity and artistic genius now extend into the new multimedia and interactive spaces of the digital arts, women are at the cutting edge of experimentation in these zones. North America has Beth Stryker's *Cyberqueer*, and *Faultlines* from Ingrid Bachmann and Barbara Layne. In the UK, Orphan Drift ride a wave of writing, digital art, film and music. In Australia, Linda Dement's *Typhoid Mary* and *Cyberflesh Girlmonster* put blood, guts and visceral infections on to her tactile multimedia screens. The French artist Orlan slides her body into cyberspace. The construct cunts access the controls. Sandy Stone makes the switch and the connection: '*to put on the seductive and dangerous cybernetic space like a garment, is to put on the female*' (Stone 1991: 109). Subversions of cyberpunk narrative proliferate. Kathy Acker hacks into *Neuromancer*, unleashing its elements in *Empire of the Senseless*. And Pat Cadigan's cyberpunk novels give another excruciating twist to the

cyberspace tale. *Synners, Fools* and the stories in *Patterns* are texts of extraordinary density and intensity, both in terms of their writing and the worlds they engineer. If Gibson began to explore the complexities of the matrix, Cadigan's fictions perplex reality and identity to the point of irrelevance.

> Before you run out the door, consider two things:
> The future is already set, only the past can be changed, and
> If it was worth forgetting, it/s not worth remembering.
>
> (Cadigan 1994: 287)

From viruses to replicunts

Once upon a time, tomorrow never came. Safely projected into the reaches of distant times and faraway galaxies, the future was science fiction and belonged to another world. Now it is here, breaking through the endless deferral of human horizons, short-circuiting history, downloading its images into today. While historical man continues to gaze in the rear-view mirror of the interface, guarding the present as a reproduction of the past, the sands of time are running into silicon, and Read Only Memory has come to an end. Cyber-revolution is virtually real.

Simulation leaves nothing untouched. Least of all the defences of a specular economy entirely invested in the identity of man and the world of ones and others he perceives. The father's authority is undermined as the sperm count goes into decline and oestrogen saturates the water supply. Queer culture converges with post-human sexualities which haven no regard for the moral code. Working patterns move from full-time, life-long, specialized careers to part-time, temporary, and multi-functional formats, and the context shifts into one in which women have long had expertise. It is suddenly noticed that girls' achievements in school and higher education are far in excess of those of their male counterparts, and a new transferable intelligence begins to be valued above either the strength or single-mindedness which once gave the masculine its power and are now being downgraded and rendered obsolete. Such tendencies – and the authoritarian reactions they excite – are emerging not only in the West but also across what were once lumped together as the cultures of the 'Third World'. Global telecommunications and the migration of capital from the West are undermining both the pale male world and the patriarchal structures of the south and east, bringing unprecedented economic power to women workers and multiplying the possibilities of communication, learning and access to information.

These crises of masculine identity are fatal corrosions of every one: every unified, centralized containment, and every system which keeps them secure. None of this was in the plan. What man has named as his history was supposed to function as the self-narrating story of a drive for domination and escape from the earth; a passage from carnal passions to self-control; a journey from the strange fluidities of the material to the self-identification of the soul. Driven by dreams of taming nature and so escaping its constraints, technical development has always invested in unification, light and flight, the struggle for enlightenment, a dream of escaping from the meat. Men may think and women may fear that they are on top of the situation, pursuing the surveillance and control of nature to unprecedented extremes, integrating their forces in the final

consolidation of a technocratic fascism. But cyberspace is out of man's control: virtual reality destroys his identity, digitalization is mapping his soul and, at the peak of his triumph, the culmination of his machinic erections, man confronts the system he built for his own protection and finds it is female and dangerous.

Those who still cherish the patriarchal dream see cyberspace as a new zone of hope for a humanity which wants to be freed from the natural trap, escaping the body and sliding into an infinite, transcendent and perfect other world. But the matrix is neither heaven, nor even a comforting return to the womb. By the time man begins to gain access to this zone, both the phallic dream of eternal life and its fantasy of female death are interrupted by the abstract matters of a cybernetic space which has woven him into its own emergence. Tempted still to go onwards and upwards by the promise of immortality, total control and autonomy, the hapless unity called man finds himself hooked up to the screen and plugged into a global web of hard, soft, and wetware systems. The great flight from nature he calls history comes to an end as he becomes a cyborg component of self-organizing processes beyond either his perception or his control.

As the patriarchal economy overheats, the human one, the member of the species, is rapidly losing his social, political, economic and scientific status. Those who distinguished themselves from the rest of what becomes their world and considered themselves to be 'making history', and building a world of their own design are increasingly subsumed by the activity of their own goods, services, lines of communication and the self-organizing processes immanent to a nature they believed was passive and inert. If all technical development is underwritten by dreams for total control, final freedom, and some sense of ultimate reconciliation with the ideal, the runaway tendencies and chaotic emergences to which these dreams have led do nothing but turn them into nightmarish scenes.

Cyberfeminism is an insurrection on the part of the goods and materials of the patriarchal world, a dispersed, distributed emergence composed of links between women, women and computers, computers and communication links, connections and connectionist nets.

It becomes clear that if the ideologies and discourses of modern feminism were necessary to the changes in women's fortunes which creep over the end of the millennium, they were certainly never sufficient to the processes which now find man, in his own words, 'adjusting to irrelevance' and becoming 'the disposable sex'. It takes an irresponsible feminism – which may not be a feminism at all – to trace the inhuman paths on which woman begins to assemble herself as the cracks and crazes now emerging across the once smooth surfaces of patriarchal order. She is neither man-made with the dialecticians, biologically fixed with the essentialists, nor wholly absent with the Lacanians. She is in the process, turned on with the machines. As for patriarchy: it is not dead, but nor is it intractable.

There is no authentic or essential woman up ahead, no self to be reclaimed from some long lost past, nor even a potential subjectivity to be constructed in the present day. Nor is there only an absence or lack. Instead there is a virtual reality, an emergent process for which identity is not the goal but the enemy, precisely what has kept at bay the matrix of potentialities from which women have always downloaded their roles.

After the second come the next waves, the next sexes, asking for nothing, just taking their time. Inflicted on authority, the wounds proliferate. The replicants write

programs, paint viral images, fabricate weapons systems, infiltrate the arts and the industry. They are hackers, perverting the codes, corrupting the transmissions, multiplying zeros, and teasing open new holes in the world. They are the edge of the new edge, unashamedly opportunist, entirely irresponsible, and committed only to the infiltration and corruption of a world which already rues the day they left home.

Originally published in R. Shields (ed.) (1996) *Cultures of Internet: Virtual Spaces, Real Histories, Living Bodies,* London: Sage.
This essay has been edited for inclusion in the Reader.

Notes

1. Such cultural viruses are not metaphorical: both Richard Dawkins and more recently, Daniel Dennett (1995), have conducted some excellent research into the viral functioning of cultural patterns. Nor are such processes of replication and contagion necessarily destructive: even the most damaging virus may need to keep its host alive.
2. Asimov's three rules are: 1. A robot may not injure a human being, or, through inaction, allow a human being to come to harm; 2. A robot must obey the orders given it by human beings, except where such orders would conflict with the First Law; 3. A robot must protect its own existence as long as such protection does not conflict with the First or Second Law.
3. Alan Turing's abstract machine, developed during the Second World War, forms the basis of the modern serial computer.
4. Her 'Sketch of the Analytical Engine invented by L.F. Menebrea, with notes upon the memoir by the translator, Ada Augustus, Countess of Lovelace', appears in Philip and Emily Morrison (eds), *Charles Babbage and his Calculating Engines, Selected Writings by Charles Babbage and Others,* New York, (Dover, 1961).

References

Cadigan, P. (1989) *Patterns,* London: Grafton.
—— (1991) *Synners,* London: Grafton.
—— (1994) *Fools,* London: Grafton.
Dennett, D. (1995) *Darwin's Dangerous Idea: Evolution and the Meanings of Life,* Harmondsworth: Allen Lane/The Penguin Press.
Edelman, G. (1992) *Bright Air, Brilliant Fire,* New York: Basic Books.
Eiser, J. R. (1994) *Attitudes, Chaos, and the Connectionist Mind,* Oxford: Blackwell.
Freud, S. (1985) *New Introductory Lectures on Psychoanalysis,* Harmondsworth: Penguin.
Freud, S. and Breuer, J. (1991) *Studies in Hysteria,* Harmondsworth: Penguin.
Gibson, W. (1986) *Neuromancer,* London: Grafton.
Irigaray, L. (1985a) *Speculum of the Other Woman,* Ithaca, New York: Cornell University Press.
—— (1985b) *This Sex that is not One,* Ithaca, New York: Cornell University Press.
—— (1991) *Marine Lover of Friedrich Nietzsche,* New York: Columbia University Press.
Langton Moore, D. (1977) *Ada, Countess of Lovelace,* London: John Murray.
McLuhan, M. (1967) *Understanding Media,* London: Sphere Books.
Misha (1991) 'Wire movement' 9, in Larry McCaffrey (ed.), *Storming the Reality Studio,* Durham, NC and London: Duke University Press.
Stone, A. R. (1991) 'Will the real body stand up?', in Michael Benedikt (ed.), *Cyberspace, First Steps,* Cambridge, MA and London: MIT Press.

CLAUDIA SPRINGER

DIGITAL RAGE

> The tears are long gone and in their place is hardened steel desire.
>
> Sarah, in *Hardwired*.[1]

DEBATES RAGE IN THE POPULAR press over whether computers can accurately simulate the human mind and whether human minds are fundamentally computers. As Sherry Turkle writes, 'One thing is certain: the riddle of mind, long a topic for philosophers, has taken on new urgency. Under pressure from the computer, the question of mind in relation to machine is becoming a central cultural preoccupation. It is becoming for us what sex was to the Victorians – threat and obsession, taboo and fascination.'[2] So far computers themselves have not become active participants in the debate. But interest in the nature of the human mind has by no means displaced interest in sex. Within current discussions about the mind lingers the preoccupation with sex identified by Sherry Turkle as central to Victorian culture. Instead of existing as separate, distinct issues, thought and sex have become thoroughly entwined in contemporary cybercultural discourses. Discussion of computation and reasoning in terms of sexual responses discursively erases the Cartesian separation between mind and body. Computers, it seems, have intensified, not diminished, our culture's fascination with sexuality. They have also prompted Hans Moravec to predict a future in which humans will lose their bodies and exist instead through software. In most fiction, however, computers have inspired flights of fantasy that remain firmly grounded in our current cultural preoccupations with sex and gender.

Ascription of sexuality to computers is part of a larger well-documented tendency for people to anthropomorphize computers.[3] Rochester and Gantz, in *The Naked Computer*, even refer to a computer's 'excrement.'[4] Human-like computers have become commonplace in popular culture, with two of the most powerful examples occurring in the films *2001: A Space Odyssey* (Kubrick 1968), in which a spaceship's computer (HAL) becomes more emotional than the astronauts on board, and *Demon Seed* (Cammell 1977), in which

an artificial intelligence rapes a woman psychologist. These films take anthropomorphism to an extreme, but computer functions do in some ways resemble human characteristics. Perhaps the most provocative similarity between humans and computers is memory. Anthropomorphism is implicit when we refer to a computer's memory, but the analogy has not been just a one-way street; researchers have turned it around to assert that human memory can be understood as a computer-like process of information storage and retrieval. Cognitive psychologists eager to solidify the analogy between humans and computers join AI researchers in arguing that human memory functions similarly to computer memory and that even the elusive human ability to create complicated associations can be reproduced by computers.[5]

Despite the complexity of human memory, the model of a computer-mind has for some psychologists replaced the Freudian paradigm of layered levels of consciousness engaged in a process of repression. The notion of a *depthless self* is one characteristic of what J. David Bolter calls 'Turing's Man', the late-twentieth-century human defined as a computer-like artifact. Bolter writes that 'the goal of artificial intelligence is to demonstrate that man is all surface, that there is nothing dark or mysterious in the human condition, nothing that cannot be lit by the even light of operational analysis'.[6] As if to illustrate Bolter's observation, Roger C. Schank states that 'we have seen that creativity, that mystical process known only to humans, is not really so mystical after all, and that it may well be possible to replicate creative behavior on a machine by transforming standard explanation patterns. From this it follows that the processes of creativity and learning are not so elusive, and may be quite algorithmic in nature after all'.[7]

The appeal of computer existence for humans in the late twentieth century cannot be separated from the cultural crises confronting us. Computer sex can pose an attractive alternative when physical sex carries the risk of AIDS. Computers have already become all-consuming for young men who perpetuate the caricature of the solitary social misfit who prefers to commune with his terminal rather than with people, especially women. A retreat from sexual involvement is evident in references to 'the new celibacy'. Fantasies of solitary and cerebral machine sex are not entirely irrational given the new fear of physical sex. AIDS has also created an increased public awareness of human vulnerability and mortality. In a world where human bodies appear to be expendable, discourses of death, what journalist Frank Rich calls 'the new blood culture', have become widespread. Rich explains the popularity of the film *Bram Stoker's Dracula* (Coppola 1992), Madonna's book *Sex*, and the vampire novels of Anne Rice as part of a larger 'national psychic obsession' with the threat of death from infected blood.[8]

After a long Western cultural tradition of associating sex with death, sex is being replaced by computer use, which provides the deathlike loss of self once associated with sexual pleasure. Identifying with computers can be appealing on several levels in our fragmented postmodern existence. Vulnerable late-twentieth-century bodies and minds turn to electronic technology to protect themselves from confusion and pain. Fusion with computers can provide an illusory sense of personal wholeness; the fused cyborg condition erases the difference between self and other. Additionally, a wholesale embrace of computerized existence can create a sense that one's messy emotions have been replaced by pure logic and rationality. For those unable to cope with the complexity of human emotions, it might seem preferable to replace feelings with a limited repertory of automatic responses.

Donna Haraway argues that cyborg existence need not be defined exclusively in terms of a fortified masculinist self, even though the Defense Department's prominent role in the development of cybernetic equipment has given the cyborg an aggressive military background.[9] Haraway proposes an alternative way of conceptualizing cyborgs in terms of a hybrid subjectivity. Her cyborg would adopt partial and contradictory identities that accept difference rather than defend against it. Although Haraway's hybrid cyborg is a far cry from the aggressive fortified cyborg, both visions suggest an idealized state of computer existence that rectifies the inadequacies and injustices of contemporary human life. The idea of a feminist cyborg, like the idea of militaristic cyborg, arises from dissatisfaction with current social and economic relations, but the two cyborg visions offer vastly different solutions to our social ills.

The computer scientists who advocate downloading human consciousness argue that humans would achieve immortality, but the notion can also be understood to foretell human extinction. Human bodies are entirely expendable for these scientists. Speculation about the nature of human identity inevitably arises in discussions of human software copies. Computer scientists and science fiction writers have speculated on the authenticity of electronically copied minds. The scientists, however, write from a strictly empirical standpoint using rhetoric that lends their exterminatory ideas the illusion of scientific validity. Marvin Minsky entertains the notion that a person's mind could be duplicated by creating a special computer chip for each brain cell. Minsky asks whether that new machine would be the same as the original if it were placed in the same environment and could function using the same processes as the original brain. He responds that microscopic differences would exist between the organic brain and the brain machine, since 'it would be impractical to duplicate, with absolute fidelity, all the interactions in a brain'. But you could not claim, writes Minsky, that these microscopic differences make the duplicate different from the original, for it too is constantly changing and will never be exactly the same as it was a moment before.[10]

Although Minsky's perspective is completely literal rather than metaphorical, his description of human identities undergoing constant changes resembles post-structuralist theories of decentred subjectivity, according to which individuals do not have fixed, stable identities but assume changing subject positions determined by language, gender, and other social and cultural institutions. He differs from post-structuralists in his faith in science. Minsky analyses human identity to support his position that AI research, using the logic and rationality of science, can succeed in creating a computer equivalent to the human mind. For post-structuralist theorists, science, like any metanarrative that purports to express universal truths, is constrained by its ideological underpinnings and maintains its status as truth only within the confined of its own terms.[11] The case against scientific empiricism has in some cases been overstated, but Minsky's often inflammatory statements go a long way in blurring the boundary between science and science fiction.

Minsky's brain machine belongs to a future in which even human beings have been replaced by simulations: copies without originals: what Jean Baudrillard describes as our postmodern obsession with simulacra finds full expression in a world populated by electronically copied human minds.[12] Hans Moravec is even more unequivocal than Minsky in describing a future of mind simulation and human extinction. For Moravec, there would be no significant difference between the identity of an original mind and its copy except that the software copy would supplement the original personality with many new

abilities. Humans, according to Moravec's misanthropic plan, should consent to their own extinction and cede the future to their computerized progeny.[13]

Cyberpunk fiction's visions of the future extrapolate from our current cultural pre-occupation with computers to create worlds where the computer metaphor for human existence has triumphed. When cyberpunk characters are surgically hardwired, jack into cyberspace, load software directly into their brains, create computerized virtual bodies for themselves while their physical bodies decay, or abandon their bodies to exist inside the computer matrix, the boundary between human and computer is erased and the nature of the human psyche is redefined in accordance with the computer paradigm. Computers and human minds become thoroughly compatible because the differences between them have been effaced.

In cyberpunk and in some earlier science fiction precursors, human mental processes are configured to function according to a digital model, allowing personalities and thoughts to be electronically coded and copied. Digital existence is a central aspect of George Alec Effinger's cyberpunk trilogy *When Gravity Fails, A Fire in the Sun* and *The Exile Kiss*.[14] Characters acquire new personalities from the software modules they plug into their brains. Although most of the personalities in the modules are fictional characters, it is possible to create moddies from the mind of a living person, as the protagonist, Marid Audran, learns when a ruthless crime boss tortures him mercilessly and simultaneously records a moddie of his thoughts and feelings while he suffers. Audran refers to the experience as mind-rape, but he also concedes that Islam (the novels are set in the Middle East) will have to come to grips with the legal implications of personality modules recorded from living people, 'just as the faith has had to deal with every other technological advance'.[15]

The idea of digitally recording human minds finds expression in other cyberpunk texts as well. When characters in William Gibson's trilogy jack into simstim, they share the consciousnesses of simstim stars, whose experiences and feelings are recorded and transmitted directly into the minds of the public. A simstim link allows Case, the protagonist in *Neuromancer*, to vicariously experience the point of view and thoughts of his partner, the razorgirl Molly, when she stalks into dangerous situations.[16]

In both Gibson's and Effinger's novels the experience of plugging into another mind is often associated with sexual pleasure. Gibson's characters enter the pleasurable and exciting world of simstim to escape their own dreary lives. In Effinger's *When Gravity Fails* Marid Audran is propositioned by Chiri, a bartender, who offers to plug in her new Honey Pilar sex kitten personality module for him: 'It was a very tempting suggestion . . . with Honey Pilar's personality module plugged in, Chiri would become Honey Pilar. She'd jam the way Honey had jammed when the module was recorded. You close your eyes and you're in bed with the most desirable woman in the world, and the only man she wants is you, begging for you.'[17]

Even though Marid initially resists getting his brain wired for personality modules because he is afraid of the way they 'crammed you away in some little tin box inside your head, and someone you didn't know took over your mind and body',[18] after he is forced to undergo the surgical procedure, he takes pleasure in experimenting with a variety of modules. And pleasure comes in all forms; for the powerful crime lord Shaykh Reda Abu Adil, who tortures Marid, it means entering 'Proxy Hell', chipping bootleg black-market moddies recorded from people experiencing the horrible pain and suffering of torture or disease.[19] Effinger extrapolates from the current tendency to associate

computers with sex to create a world where new technologies are immediately adapted to provide sexual pleasure in even its most extreme forms.

In cyberworlds where minds can be manipulated like computers, memories operate according to an electronic model; they can be enhanced, augmented, changed, or erased. Since memories form the foundation of human identity, loss of memory is equivalent to loss of self. This raises the question addressed by Minsky and Moravec of whether an electronic copy of a human mind is the same as the original. The film *Blade Runner* revolves around this question by having both its human and replicant characters treasure their personal collections of photographs, which are visual signifiers of memories. Rachael, the most advanced replicant, believes she is human because she remembers her childhood, until she learns that the memories have been implanted in her and actually belong to her inventor's niece. The film erases conventional distinctions between humans and their artificial copies not only by having the replicants collect memories in human fashion but also by having them surpass humans in the emotional qualities of love and compassion. Thus it suggests that advanced technologies might be used to destroy human uniqueness. Gabriele Schwab refers to this as the 'dark side of a culture of cyborgs' and comments on its ironic aspect: 'Technology, meant to extend our organs and our senses or even to support our fantasms of immortality and transcendence, seems to threaten what we wanted to preserve by destroying us as the subjects we thought ourselves to be when we took refuge in technological projects and dreams.'[20]

Loss of self through technological replication is the theme of the short story 'Overdrawn at the memory bank', written by science fiction author John Varley in 1976, nearly a decade before the cyberpunk movement began. In the story people routinely record their memories and personality on 'multi-holo' so they can be resurrected after death by having the recorded material installed in a clone body. As Varley's narrator explains, however, the new person will not be identical to the one who died, since the recorded memories will not be up-to-date. There will be a gap in memory matching the interval since the last multi-holo recording was made. Varley writes, 'A lot can happen in twenty years. The person in the new clone body might have to cope with a child he or she has never seen, a new spouse of the shattering news that his or her employment was now the function of a machine.'[21]

Varley's story explores a man's psychological trauma when he cannot determine whether he and his world are real or computerized simulations. Synthetic existence is frightening in part because it confronts us directly with unanswerable questions about our 'authentic' lives. The main character, Fingal, loses himself when he takes a virtual vacation by having his personality recorded and installed in a lion roaming the artificial plains of 'the Kenya disneyland'. While he is experiencing life as a lion, the technicians misplace his human body, so he returns to his own consciousness inside a computer where his memories are being stored. Inside the computer Fingal's life seems to proceed normally, except that he is unable to determine whether he is really in a computer or is insane and suffering from delusions. What is worse, he realizes that it never has been possible to distinguish reality from illusion with absolute certainty and that the best people can do is 'accept at some point what we see and are told, and live by a set of untested and untestable assumptions'.[22]

Computerized mind invasion also occurs in Walter Jon Williams' *Hardwired*, where a program called Project Black Mind 'sets up a mind in crystal. Then goes into another mind, a live mind, and prints the first mind on top of it. Imposes the first personality

on the second. Backs up the program'.[23] The invaded mind is completely obliterated and replaced, leaving no trace of the original identity or personality. At the end of the novel Project Black Mind is used by Reno, who has lost his body and is trapped in the computer system, to invade the mind of Roon, an unscrupulous and powerful corporate director who takes orphaned children into his home and rapes them not only physically but also mentally: 'he's studding himself into their brains so they can't get away from him, not even into their own heads'.[24] Reno writes his own identity over Roon's mind with Project Black Mind, destroying Roon with suitable justice by using mind-altering techniques that Roon used relentlessly on his captive children.

Even though digital existence has taken hold in cyberpunk, humans have not been mindsucked into oblivion on a grand scale in these texts; they continue to experience the turbulent emotions and memories associated with earlier models of the mind. The desires and fears that Freud located in the human unconscious have not disappeared but continue to haunt cyberpunk characters. In fact, in fictional cyberworlds computer memory facilitates and even heightens the role that repressed emotions play in human and computer existence. Cyborgs are frequently troubled by emotional memories and are motivated by a desire for revenge in cyberpunk texts. Two of the best-known cyborgs whose actions are driven by repressed memories are RoboCop and Eve 8. Another haunted cyborg is Victor Stone, 'a.k.a. Cyborg', in the comic book *Tales of the New Teen Titans*.[25] Stone is transformed from a black teenager into a part-machine, part-human steel-smashing titan with computerized components, but he continues to be aware of racial divisions in society.

When cyberpunk texts incorporate repressed memories, they often raise controversial social issues (as in the case of Victor Stone's experiences with racism), for a larger cultural context informs the cyborg's personal memories. One scenario that has emerged with remarkable frequency in cyberpunk is that of the cybernetic woman who seeks revenge for the emotional and sexual abuse she suffered as a child or young woman. She is simultaneously one of the most compelling and one of the most problematic figures in cyberpunk, for her appeal on a feminist level is frequently undermined by her conventional patriarchal presentation. Her ambiguous status has inspired contradictory interpretations and has sparked debates among commentators on cyberpunk. For example, Timothy Leary praises William Gibson's female characters, whom he calls 'strong, independent, effective . . . heroic'.[26] In contrast, Nicola Nixon asserts that cyberpunk's strong female characters 'are effectively depoliticized and sapped of any revolutionary energy'.[27] Nixon reads cyberpunk's version of strong, angry women as pale imitations of their feminist forerunners from the 1970s. In response to Nixon, John J. Pierce objects to what he calls her condemnation of 'an entire subgenre as inherently sexist and reactionary'.[28] Their exchange and the opinions of others on the same subject emphasize the ambiguity of cyberpunk's angry woman and her ability to evoke multiple and even contradictory responses.

The prototype for cyberpunk's angry cybernetically enhanced survivor of patriarchal abuse is Molly Millions from William Gibson's short story 'Johnny Mnemonic'[29] and the novels *Neuromancer* and *Mona Lisa Overdrive*. Molly paid for her transformation into a sleek killing machine with money earned while working as a prostitute, where she experienced overwhelming depravity, including men killing women for sexual pleasure. When Case first encounters Molly in *Neuromancer*, she is wearing 'tight black gloveleather jeans and a bulky black jacket cut from some matte fabric that seemed to

absorb light'. What he at first thought were her mirrored glasses on closer inspection turn out to be surgically inset mirrors 'sealing her sockets. The silver lenses seemed to grow from smooth pale skin above her cheekbones'. Case learns the extent of her surgical transformation when she says,

> 'you try to fuck around with me, you'll be taking one of the stupidest chances of your whole life.'
> She held out her hands, palms up, the white fingers slightly spread, and with a barely audible click, ten double-edged, four-centimeter scalpel blades slid from their housings beneath the burgundy nails.

Not only are her fingers switchblades, but her nervous system has been augmented with circuitry that gives her the 'reflexes to go with the gear'.[30]

Andrew Ross traces Molly's influence from Elektra in the comic book series *Elektra Assassin* to Abhor in Kathy Acker's novel *Empire of the Senseless*. 'Both characters,' Ross writes, 'are steely, orphanesque survivors of a history of victimage that includes paternal rape, followed by repeated sexual predation on the part of violent males.'[31] Indeed, the Ninja warrior-for-hire Elektra is filled with rage and has an unlimited capacity for violence after a childhood of paternal abuse.[32] The part-robot and part-black Abhor, who was also raped by her father, lives the violent life of an outcast.[33] Acker's novel draws on cyberpunk imagery to rebel against patriarchal discourses, repeatedly revealing the violence and hatred that underlie them.

Yet another example of a cybernetic assassin is Sarah in Walter Jon Williams' novel *Hardwired*. As a child she was continually beaten by her father, and like Molly Millions, she earned money through prostitution to finance her independence and surgical transformation into a technokiller. With her nervous system electronically hardwired to heighten her reflexes and allow her to interface directly with her weapons, and with a very tall and muscular body, she is a formidable opponent. Her internal weaponry takes the form of a 'cybersnake', which she calls Weasel, that rises from her chest through her throat and out her mouth to attack her victims. A phallic serpent, it lies dormant until needed and then whips out like a killer erection. As Sarah explains, 'the tears are long gone and in their place is hardened steel desire'.[34]

The influence of Molly Millions can also be seen in the comic book series *Seraphim*, which follows the adventures of two cybernetically enhanced women warriors, Elle and Shinano, who work as assassins for the Autonomous Agency for the Enforcement of Humanity in A.D. 2095.[35] Finally, the comic book series *RoboCop versus the Terminator* spoofs both the *RoboCop* and *Terminator* films by having a tough woman fighter from the future named Florence travel back through time to kill Alex Murphy, the cop who is reconstructed as RoboCop in the *RoboCop* films.[36] It is the premise of *RoboCop versus the Terminator* that the creation of RoboCop instigates computer sentience and ultimately leads to technology's catastrophic revolt against humanity. Although the warrior Florence is not a cyborg, she is a streamlined killer along the lines of Molly Millions and Elektra Assassin (also a Frank Miller creation) who takes on armies of terminators single-handedly.

Molly, Sarah, and the other hardwired women they have influenced clearly embody a fetishized male fantasy, but they also represent feminist rebellion against a brutal patriarchal system. It is difficult to either condemn or celebrate them, since a single interpretation cannot entirely explain their appeal. The same construction of multiple

and contradictory readings occurs in films. In *Eve of Destruction*, Eve 8 plays out a feminist fantasy when she methodically stalks and kills the men (and types of men) who abused her creator, scientist Eve Simmons, whose memories, thoughts and feelings she shares. At the same time, however, the film condemns female sexuality and autonomy on a massive scale when we learn that Eve 8 contains in her womb a nuclear weapon on the verge of explosion and must be destroyed to save the planet.

Another ambiguous figure is Sarah Connor in the *Terminator* films, who transforms herself into a taut, muscular killing machine to prepare for the nuclear apocalypse and also as a reaction to the abuse inflicted on her by male doctors and attendants while she is imprisoned in a mental ward. Mark Dery points out with regard to Sarah Connor that 'Hollywood's exploitation of the Freudian subtext of a sweaty woman squirting hot lead from a throbbing rod could hardly be called empowering'.[37] Certainly Sarah Connor fits into a long tradition of phallic women in films whose fetishized bodies are designed to ease castration fears for the male spectator made uncomfortable by the site of a fleshy woman on screen. None the less, she also provides an attractive figure in the realm of fantasy for angry women. As viewers of martial arts films know, it is enormously satisfying to experience vicariously the triumph of an underdog seeking revenge against the perpetrators of injustice. Women under patriarchy can experience the exhilarating fantasy of immense physical strength and freedom from all constraints when watching figures like Sarah Connor. Revenge fantasies are powerful, even when they are packaged for consumption by the Hollywood film industry.

Because of the ambiguities and contradictions of her presentation, however, cyberpunk's figure of the angry woman can neither be hailed as a feminist paragon nor repudiated as a mere sex object; she incorporates aspects of both but fully embodies neither. In addition to her feminist potential, what is interesting about the hardwired woman is that she is motivated by human memories and emotions at all, for she has undergone a transformation from a human based on an organic model to one based on a computer model. After she has been remodelled, she abandons subtlety and indecision and instead reacts to events with the regularity and inevitability of a computer program. Whether she has been literally hardwired or not, her speed and decisiveness figure a computer's abilities. Her former passivity has been replaced with swift aggression. The transformation suggests that the only way to escape from victimization is to become a machine. Autonomy and strength, the texts tell us, derive from embracing a computer-like existence, for life as a human, especially as a woman, has become unbearable.

Most cybernetic women in cyberpunk, however, fail to give us a radically non-human vision of computerized existence. Repressed human memories and heightened emotions continue to motivate these hardwired women even after they have redesigned themselves. Instead of escaping from their human predicaments and entering a liberated electronic realm, they become haunted and powerful killers. Computerized minds harden and fortify them rather than provide partial and fluid cyborg identities. Actual computer characteristics are in fact distorted by their characterizations. The physical passivity that human computer users adopt is recast as aggressive violence. The miniaturization and subtlety of computers are refashioned into bulging muscles that more closely resemble the enormous size and force of industrial technology. Additionally, gender, instead of disappearing, is often heightened after cybernetic transformation, a point that is obvious in Hollywood representations of ultramale cyborgs like the Terminator and RoboCop.

Although our culture is indeed preoccupied with the notion of computerized minds, there is an inability to imagine a truly non-human future.[38] Even when cybernetic characters relinquish their physical forms to enter the computer matrix, they are still preoccupied with human concerns. Sex continues to flourish in fictional electronic worlds. In some cases even the complete loss of human form fails to produce a significant departure from human sexuality. For some observers, the perpetuation of human sexual difference and desire is essential for the success of disembodied forms of life. Jean-François Lyotard writes that AI can succeed in producing thought only if it incorporates memory, gender and sexual desire. He explains, 'We need machines that suffer from the burden of their memory.'[39] For Lyotard, the force that propels thought is the desire induced by gender difference.

Nowhere is the persistence of human identity and sexuality after metamorphosis into a computer more clear than in the novel *Lady El* by Jim Starlin and Diana Graziunas, published in 1992.[40] It follows in the footsteps of other texts about a victimized woman's transformation into a hardwired killer, only this time the woman loses all physical form and literally becomes a computer. The novel illustrates the problem faced by readers of cyberpunk who enjoy the figure of the cybernetic woman survivor but are troubled by the persistence of patriarchal myths that inform her presentation. Like most of cyberpunk's angry women, Lady El does not have the enlightened perspective of Donna Haraway's cyborg. Although the novel begins by embracing feminist principles as it follows a woman's rejection of victimization, it ends by enacting the familiar patriarchal myth of the destructive sexual woman. It suggests that gender and sexuality transcend death and disembodiment and, when combined with the enormous power of technology, lead to massive and uncontrollable destruction. If a woman escapes victimization, warns the novel, her autonomy and sexual independence can rage out of control and destroy the world.

Lady El is short for Lady Electric, who begins her life as a human being named Arlene Washington. As a young woman she is killed by a subway train in a freak accident. After her death her brain is donated to the secret Project Cyborg and linked to a computer system. In her new life she is a brain floating in a jar connected to increasingly sophisticated and powerful computers. Eventually she is linked to the most powerful computer in the world, the Pentagon's NORAD computer, putting her in charge of an immense amount of data and important decisions, including, as she puts it, 'the button, the entire works for the strategic nuclear planning for the whole damn U.S. of A.' (268).

The scientist in charge of the project, Walter Hillerman, is surprised to learn that Lady El retains the complete identity of Arlene Washington.[41] He has collected ten brains in jars for the initial experiment, all of which a lab assistant has named after professional wrestlers, emphasizing the discrepancy between their disembodied state and a wrestler's exaggerated physique. Even though Hillerman initially rejects the notion that the brains retain their original identities, one of the three ways that each brain is labelled refers to its former identity: 'an F or M for the brain's sex' (35). The novel posits that a person's sex is located in the brain and outlives the loss of the body. There is biological determinism at work in the notion that a brain, or any disembodied organ, has a sexual identity, as if any single part of a body in isolation can be identified as male or female. Additionally, by labelling the brains according to their sex, the novel continues a patriarchal tradition of making an individual's sex the principal basis for identification.

Lady El brings to her new job the memory of the violence that men continually inflicted on her since she was a little girl. Her first-person narration concentrates on how her new status as a cyborg released her from victimization and endowed her with immense powers. She began her life with, as she puts it, three strikes against her: she was poor, black and female. Her childhood turned into a nightmare after her father died and her mother took in a violent and abusive man named Levar who continually raped the thirteen-year-old Arlene and then, a year later, started to sell her to his friends. Arlene finally ran away to New York and got a job on the night shift as a cleaning woman in the World Trade Center. She also began a series of degrading relationships with violent, drug-addicted or alcoholic men.

After Arlene's death and resurrection as Lady El, however, she realizes that in her former life she had been the victim of racism and had lived her life as an 'emotional junkie' who always depended on a man to tell her what to do and think. Her new cyborg existence gives her perspective on her past life and allows her to become increasingly powerful as she is given access to enormous data banks and asked to make decisions of considerable importance. She enjoys lightning-speed learning from the data banks and expands her consciousness by sharing the memories of a white man's and a white woman's brains plugged into her system. Because of her new perspective, she adopts the motto 'power = survival' (131) and soon after revises it to 'knowledge + power = survival' (135).

She uses her new knowledge and power, however, in ways that continue, rather than reject, her concerns from the past. Even in the form of an on-line brain, she has not abandoned the desire for love or the tendency to make men her first priority. Most of her time is spent obsessing about Walter Hillerman. She tells the reader, 'I'll 'fess up. I courted the man. My every waking moment was spent on thinking how I could please him' (178). What has changed is that, unlike Arlene Washington, she is determined to maintain her power and is, as she puts it, 'clearly developing an affection for men who could be controlled' (184). Her main liability, as she sees it, is her lack of a body, so she secretly designs and builds a robot body to occupy, one she describes as 'every man's wet dream' (224). Despite the fact that she has rejected the role of victim, she still changes herself for a man, in this case literally building herself from scratch. Her idea of power is to succeed by conforming to the system rather than opposing it; the robot body she designs is based on racist stereotypes of beauty. She declares, 'I wanted to be a blonde! A blue-eyed, blonde California beach baby! Barbie with a brain!' She continues, 'I bet lotsa brothers and sisters would be ready to jump on me 'bout my choice. Think I was a traitor, ashamed of my race and all. But that wasn't it. Wasn't it at all. Time as a computer had taught me to face facts. And one fact that couldn't be ignored was that America's a racist society. Sure, it's got a lot of good things goin' for it, but basically the status quo is that the whites got it and the blacks don't' (223).

What Lady El discovers is that even after escaping racism with her white robot body, she must still contend with sexism, and when she confronts an aggressive man, her new computer self acts quickly and decisively: she kills him. Chuckie Baxter III, picked up by Lady El on a telephone party line, tries to force sex on her and ends up with his chest impaled on her fist. Soon thereafter she designs another robot body, this one a black woman, to visit and attack her childhood abuser, Levar, leaving him 'scared, crippled, helpless, finally gettin' a taste of what it means to be a victim' (256). Lady El is driven by revenge and anger, and her violent attacks occur with sudden

unstoppable force. As she says after killing Chuckie, 'I'd flipped out. That's what I'd done, plain and simple. I'd blown my cork. Freaked out. Short-circuited. Gone crazy. Killed me a not-so-innocent man. Killed him dead, all right. And all 'cause he was goin' to date rape me' (238). No longer a victim, she recognizes how far she has come: 'I knew I was a dangerous weapon' (258).

The novel escalates her strength and turns her from an angry woman into a global tyrant when she is linked to the Pentagon's NORAD computer. She announces, 'No one would ever be able to push Arlene Washington around again. 'Cause I'd just become the world's newest nuclear power' (270), 'the most powerful and independent crea- ture on the face of this good green earth' (283). Her dangerous strength erupts when Walter and a policeman figure out that she killed Chuckie Baxter; her immediate response is to kill the policeman. When Walter tries to destroy her, she confesses her love for him, and when that fails to stop him, she emerges in a new robot body – a naked red- headed woman – and kills Walter with a rod through his heart. She declares, 'I wasn't in the mood to sacrifice myself for love' (304). After his death their roles reverse and she becomes the creator, removing his brain and linking it to a look-alike Walter automaton she has constructed. Her work is so successful that no one realizes that Walter has been killed and replaced by a robot. Lady El has achieved complete control over Walter, as well as over the computer world. At the end of the novel she has attained her dream: power and the man she loves. She announces to Walter, 'This world of the computer will be our own little corner of paradise' (324).

The novel leaves the computerized Lady El resolutely human by making her driven by memories of abuse and obsessed with sexual desire. Like so many texts that perpet- uate the patriarchal archetypes of virgin and vamp, Lady El warns that a powerful sexual woman poses a terrible threat. Transformation into a computer does nothing to change the spiderwoman archetype except to endow her with more massive powers than could ever be imagined by a film noir seductress. Even though the novel is fascinated by the idea of computerized existence, it regards the possibility of life as a computer with the simultaneous fear and hope that, after all, nothing will change.

Brooks Landon, author of wide-ranging analyses of science fiction and post- modernism, has written that cyberpunk fiction is destined to phase out after a relatively short time because its real message is 'inevitability – not what the future might hold, but the inevitable hold of the present over the future – what the future could not fail to be'.[42] The future drawn inevitably from our present is one in which profound ambiva- lence exists over the value of human identity, the nature of computerized existence, the transcendence of sexuality, the consequences of racism, and the persistence of gender. Sex, death, race and gender issues infiltrate Lady El's little corner of cybernetic paradise just as they inhabit the visionary musings of anyone concerned with how the cultural tensions of today will unfold in the unpredictable worlds of tomorrow.

Originally published in C. Springer (1996) *Electronic Eros: Bodies and Desire in the Postindustrial Age*, London: Athlone.
This essay has been edited for inclusion in the Reader.

Notes

1. Walter Jon Williams, *Hardwired* (New York: TOR, 1986), p. 16.
2. Sherry Turkle, *The Second Self: Computers and the Human Spirit* (New York: Simon and Schuster, 1984), p. 313.
3. See Turkle, *The Second Self*, for an analysis of how young people tend to anthropomorphize computers and also to think of themselves as machines.
4. Jack B. Rochester and John Gantz, *The Naked Computer: A Layperson's Almanac of Computer Lore, Wizardry, Personalities, Memorabilia, World Records, Mind Blowers and Tomfoolery* (New York: William Morrow, 1983), p. 66.
5. Four of the many texts that draw close analogies between human memory and computer memory are Roger C. Schank and Kenneth Mark Colby (eds), *Computer Models of Thought and Language* (San Francisco: W.H. Freeman, 1973); Peter H. Lindsay and Donald A. Norman, *Human Information Processing: An Introduction to Psychology* (New York: Academic, 1977); Roger C. Schank, *Explanation Patterns: Understanding Mechanically and Creatively* (Hillsdale, N.J.: Erlbaum, 1986); and Wayne Wickelgren, *Cognitive Psychology* (Englewood Cliffs, N.J.: Prentice-Hall, 1979). An opposing point of view is provided by Roger Penrose in *The Emperor's New Mind* (Oxford: Oxford University Press, 1989).
6. David Bolter, *Turing's Man: Western Culture in the Computer Age* (Chapel Hill: University of North Carolina Press, 1984), p. 221.
7. Schank, *Explanation Patterns*, p. 230.
8. Frank Rich, 'Fear of AIDS injects the new blood culture into the national mainstream', *Providence Sunday Journal*, 13 December 1992.
9. Donna Haraway, 'A manifesto for cyborgs: science, technology, and socialist feminism in the 1980s', chapter 18, this volume, pp. 291–324.
10. Marvin Minsky, *The Society of Mind* (New York: Simon and Schuster, 1986), p. 289.
11. See Jean-François Lyotard, *The Postmodern Condition: A Report on Knowledge*, trans. Geoff Bennington and Brian Massumi (Minneapolis: University of Minnesota Press, 1984).
12. Jean Baudrillard, *Simulations*, trans. Paul Foss, Paul Patton and Philip Beitchman (New York: Semiotext(e), 1983).
13. Hans Moravec, *Mind Children: The Future of Robot and Human Intelligence* (Cambridge, Mass.: Harvard University Press, 1988), p. 108.
14. George Alec Effinger, *When Gravity Fails* (New York: Bantam, 1987); Effinger, *A Fire in the Sun* (New York: Bantam, 1990); Effinger, *The Exile Kiss* (New York: Bantam, 1991).
15. Effinger, *When Gravity Fails*, pp. 240–3, 257, 286.
16. William Gibson, *Neuromancer* (New York: Ace, 1984); Gibson, *Count Zero* (New York: Ace, 1986); Gibson, *Mona Lisa Overdrive* (New York: Bantam, 1988).
17. Effinger, *When Gravity Fails*, p. 42.
18. Ibid., p. 171.
19. Effinger, *Fire in the Sun*, p. 86.
20. Gabriele Schwab, 'Cyborgs: postmodern phantasms of body and mind,' *Discourse* 9 (spring–summer 1987), p. 81.
21. John Varley, 'Overdrawn at the memory bank', in *The Persistence of Vision*, 197–226 (New York: Dial, 1978), p. 216.
22. Ibid., pp. 210–11.
23. Williams, *Hardwired*, p. 293.
24. Ibid., p. 226.
25. Mary Wolfman and George Perez, *Tales of the New Teen Titans* 1 (New York: DC Comics, June 1982).
26. Timothy Leary, 'Quark of the decade?' *Mondo 2000* 1 (1989), pp. 53–6; 56.
27. Nicola Nixon, 'Cyberpunk: preparing the ground for revolution or keeping the boys satisfied?', *Science-Fiction Studies* 57 (July 1992), pp. 219–35; quotation on p. 222.
28. John J. Pierce, 'On three matters in SFS #57,' *Science-Fiction Studies* 58 (November 1992), p. 440.
29. William Gibson, 'Johnny Mnemonic', in *Burning Chrome*, 1–22 (New York: Ace, 1986).

30. Gibson, *Neuromancer*, pp. 25, 24, 25, 147.
31. Andrew Ross, *Strange Weather: Culture, Science, and Technology in the Age of Limits* (London: Verso, 1991), p. 158.
32. Frank Miller and Bill Sienkiewicz, *Elektra Assassin* 1–8 (New York: Epic Comics, 1986–1987).
33. Kathy Acker, *Empire of the Senseless* (New York: Grove, 1988).
34. Williams, *Hardwired*, p. 16.
35. Chris Todd and Doug Talalla, *Seraphim* 1, no. 1 (Wheeling, W.Va.: Innovative Corporation, May 1990).
36. Frank Miller and Walter Simonson, *RoboCop versus the Terminator* 1–4 (Milwaukie, Ore.: Dark Horse Comics, 1992).
37. Mark Dery, 'Cyborging the body politic', *Mondo 2000* 6 (1992), p. 103.
38. Scott Bukatman cites Bruce Sterling's Shaper/Mechanist series as a somewhat unique example of a radically post-human future in 'Postcards from the post-human solar system', *Science-Fiction Studies* 55 (November 1991), pp. 343–57.
39. Jean-François Lyotard, 'Can thought go on without a body?', trans. Bruce Boone and Lee Hildreth, *Discourse* 11 no. 1 (fall–winter 1988–89), pp. 74–87; quotations on pp. 85, 86.
40. The following quotations from the novel are from Jim Starlin and Diana Graziunas, *Lady El* (New York: ROC, 1992). Page numbers are given parenthetically in the text.
41. Schwab's discussion in 'Cyborgs' of the 'holonomy of the subject', in which the complete information of a person is stored in each of his or her parts, is relevant here.
42. Brooks Landon, 'Bet on it: cyber video punk performance', *Mondo 2000* 1 (1989), p. 142–5.

NINA WAKEFORD

NETWORKING WOMEN AND GRRRLS
WITH INFORMATION/COMMUNICATION
TECHNOLOGY
Surfing tales of the World Wide Web

THIS CHAPTER IS A SHORT exploration of the world of Net Chicks and geekgirls, cyberfeminists, NerdGrrrls and digital Sojourners. It is also a modest intervention in a debate about women and new information/communication technologies.[1] The chapter describes networks of women's presence on the World Wide Web,[2] in particular those which use the medium for feminist purposes, or other radical cultural projects of resistance such as the creation of grrrl space. However, configurations of hardware and software change rapidly, and Web presences are in a constant process of transformation, so this contribution is a static snapshot of an evolving social and technological situation. This piece can also be read as a story about relationships, as well as an HTML document.[3] Embedded within global electronic networks are both the hypertext and personal links which I have formed during the initial stages of the Octavia Project, a project to create a set of resources on gender and technology on the Web.[4]

A great deal of electronic and printed text has been generated in an attempt to explain the nature of the interaction between gender and participation in the computing culture of which the World Wide Web is a part. Although this piece focuses on existing Web presences rather than marginality and silences, it would be misleading to think that writers universally characterize women's relationships with electronic networks as successful. Margie Wiley has argued that the electronic networks which we know as the Internet have inherited a problematic relationship with gender from their roots within the military-industrial complex and in academic institutions.[5] Given this inheritance, Wiley suggests that we should not be surprised if electronic networks are experienced by many women as 'male territory' (Wiley 1995). Wiley's perspective is confirmed by many of the testimonies collected in Dale Spender's recent overview of women's participation in cyberspace.[6] The construction of electronic networks as 'male territory' is generally based on two interrelated claims. First, women as a proportion of all users are in the minority, and second, there is a cultural dominance of masculinity in on-line spaces – newsgroups, discussion lists, and real time textual exchange – particularly in

linguistic styles and conventions (Spender 1995). Furthermore, it has been argued that gender ideologies are deeply entrenched 'closer to the machine' within the dynamics of software production. From her experience of 'a programming life' Ellen Ullman criticizes the celebration of 'teenage boy' masculinity within the culture of software engineering and its interaction with a discourse of whiteness and the dominant culture of California (Ullman 1995). Ullman implies that this hybrid culture may be integrated through the software into the experiences of the end users. This is a process which could be termed, 'configuring the user', a reversal of the usual assumption that it is the *user* who configures the *machine* (Woolgar 1991). Such descriptions suggest that electronic networks are constructed and experienced as 'male territory', and not a place within which anyone would voluntarily wish to display/reveal female identity. In fact the very notion of women, men, or anyone in transition, adopting a female persona has been a matter of intense debate in both on-line and off-line forums (cf. Stone 1991).

As computers and electronic networks are becoming key features of economic and social policy, it is becoming increasingly crucial to map the gendered characteristics of computer culture and the interactions of other dimensions of heterogeneous identities. However, there are two key problems of prioritizing a discourse which constructs gender as necessarily and universally problematic in relation to the World Wide Web.

First, this discourse of 'problems' exists among competing accounts of the relationship between women and computing. Sadie Plant accuses much feminist theory of reproducing notions of 'technophobia' by adopting this view. She comments, 'It [feminist theory] not only buys into it – it's keen to perpetuate it' (interview with geekgirl). How can we talk of women who do not recognize themselves in the portrayals of harassment? Laura Miller reports the outrage of women on her on-line service (The Well) when *Newsweek* ran the article 'Men, Women and Computers' (16 May 1994) in which Nancy Kantrowitz 'exposed' the 'sexist ruts and gender conflicts' in on-line worlds (Miller 1995). Miller points out that the effect of the article was to transform debates about on-line gender relations into reified mass media stereotypes of harassed females. The words of Plant and Miller are a reminder of the necessity of being alert to writing which ignores alternative discourses of women's experiences in on-line life, and unthinkingly mirrors the 'moral panics' of widespread media publicity. Many of the women featured in this chapter have created Web pages which actively confront the 'harassed female' stereotype by creating networks of explicitly women-centred or feminist projects as alternative spaces in computing culture. However, there is much less public attention paid to innovative projects by women, particularly if they are explicitly feminist.

Second, 'cyberspace' is not a coherent global and unitary entity but a series of *performances* (Wakeford 1996). Experiences which are local and specific in one performance area cannot necessarily be mapped directly onto other activities, such as the Web. The Web is indeed embedded in some of the electronic networks of the Internet which make other forms of computer-mediated communication possible, but the possibility of browsing information anonymously with no login (nick)name or 'handle' means that a basic feature of identity (re)creation which elsewhere structures the negotiations of risk and trust, and much of the performance of gender, is at present absent for most Web users.[7] Nevertheless there has been considerable conceptual leakage of the construction of gendered risk from one area to the other in popular discourse (see Spender 1995). Each performance area has its own structural features and normative behaviours, but

may also be interconnected. The Web is sometimes a way to access routes into other areas of computer-mediated communication such as Usenet groups, mailing lists, or 'chat' facilities, so the cultural spheres of a generalized 'cyberspace' or Internet and the Web are not always as absolutely independent (electronically or analytically) as they might first appear.[8]

'*Some* of us just haven't got time to surf the Web!' one of my colleagues commented recently, somewhat pointedly, as she walked past the computer at which I was trying to write lines of HTML. On the spur of the moment, I couldn't think of an appropriate (or witty) response, and replied weakly, 'Well, it *is* my research.' This provoked the response which I had expected – a sceptical laugh.

Such social perils arise while conducting sociological research on the World Wide Web because the activity of 'surfing' (browsing Web pages) is characterized as 'playing around' rather than (field)work (see also Hine 1994). These assumptions merit further attention, and a more adequate response, since the comments mirror one popular construction of the Web as trivial. I resist the notion that working on the Web, whether 'surfing' or creating the pages, is always or necessarily insignificant, marginal to women's lives and to cultures of feminism. I reclaim the activity known as 'surfing' as *serious* play which can create and maintain relationships, be they between individuals, organizations or hypertext documents.[9]

Electronic networks have attracted vocabulary with particularly local references which suggest a specific cultural heritage. The problem of 'surfing' is not only the inflection of leisure (constructed as the opposite of 'work') in the metaphor itself, but also the implied connection of technology with conceptions of surfing as a sporting activity which is enjoyed by a specific population. The potential limitation of this metaphor in terms of culturally and geographically diverse identities was clarified for me during an Internet training course in London with African women and women of African descent. In a group discussion one of the participants commented on 'surfing' as one of the unsuitable words for their use of electronic networks, and promotion of such technologies amongst others. '*Who* goes surfing in Africa?', she asked.

Metaphors which attempt to characterize electronic networks may encourage particular responses to these networks, and to women who use them (Miller 1995). Miller has described how the notion of the 'frontier' (used in the name of the Electronic Frontier Foundation, and elsewhere) is directly related to a specific historical moment in American history which itself was strongly gendered. In this analogy women are positioned as lacking in agency. Women exist within a classic Western narrative of social relationships, not only between 'man' and nature, but between men and women. The frontier is another example of how metaphors generated for a global definition (i.e. electronic networks = cyberspace/frontier) have been applied locally. Although this may not be useful analytically, as I argued above, in this case the practical consequences can be significant. Although Miller acknowledges that 'the choice to see the Net as a frontier feels unavoidable' (ibid.: 50), she also points out that this construction permits the accompanying conceptions of ownership and regulation, as well as allowing the construction of 'imperilled women and children' (ibid.: 52) as part of a project of protection based on images of land and physical space. Using the same logic we might explain the discourse of current debates about legal regulation, such as censorship of Web pages, as a consequence of a very specific construction of electronic networks as a frontier in need of defence.

The notion of the Web itself is a metaphor, and one which has also been used to characterize the whole system of electronic networks. Sadie Plant, for example, defines 'cyberspace' as 'global webs of data and nets of communication' (Plant 1995: 46). The World Wide Web has attracted a vocabulary of spiders/weaving, often reinforced by graphics. One example is the Web page of the popular search tool Inktomi.[10] Among women's presences imagery of webs is reflected by Stephanie Brail in her home page Spiderwoman image and in the 'VS' web image of Virtual Sisterhood. Underneath this image Spiderwoman is defined as:

Spiderwoman: 1. an Internet mailing list. 2. a community of women and men dedicated to supporting women Web designers.

The image which Brail employs, and the set of dual meanings which she gives to the word Spiderwoman, clearly illustrate the integration of electronic networks with social networks (community . . . dedicated to supporting women). It also suggests that as well as searching for a word to summarize the global *performances* within electronic networks, we might try to find ways to talk about the nature of the *relationships* which are embodied within, or provoked by, the interaction of social and electronic networks. In the second definition of Spiderwoman these relationships are presented as 'supporting', although this is just one of a new set of descriptors which might be generated if such an interrogation of the connections were to take place.

As part of my research project on gender and computing culture I have become not only a consumer of the Web, but also a producer of pages for the consumption of others. My initial reasons were practical and organizational. I needed a way of keeping track of all the electronic documents written about the relationship of women and technology generated as a product of searching the Web, an easy route to the latest issues of electronic journals, and a means by which to link my page to pages of others interested in the same field. As the process progressed, I realized that the creation of the Web pages was as much a production of public identities for the project and for myself as it was about the organization of materials. The element of global display was further heightened when Rachael Parry produced t-shirts of the Octavia Project logo which were worn to a summer camp on women and technology in the former Yugoslavia, an unexpected overlap of the electronic and social networks.

Interactions with other Web page developers, as well as browsing the Web, indicate that the combination of informational links and identity projects for individual home pages is commonplace. For example, River Ginchild reports that her page has a purpose beyond her own use of it as a 'fancy bookmark' for the Web.

I wanted to see myself – women of African descent – on the Web. I think I had seen one or two Black women with pages when I put my page up, but in June 1995 it was – overwhelmingly – white male, it still is, but there are a lot more of us on-line with pages.[11]

Our association and work together have been mediated in person and electronically, largely by email. River is director of Digital Sojourn, a project named after human rights advocate Sojourner Truth which focuses on increasing the participation of people of African descent in computer-mediated communication. Our projects and pages have intersected to transform personal links to electronic connections and vice versa. Beyond direct links between pages we have created reciprocal ties of advice and support between

Digital Sojourn and The Octavia Project, crossing geographical and cultural boundaries in the process.

Typically, a Web page combines graphics and text, and allows each to be treated as a link which activates a connection to another page. For example, selecting the link 'hair' will retrieve the article 'Black Identity and the Politics of Hair: The Revolution is in your head Not on it' by Stephanie Mason. This link reflects River's aim to construct a network to other pages which are chosen 'for content and looks'. She reports, 'The links are of things that I want to learn about or have others learn about.' Additionally she provides ways of connecting with other individuals by links to their home pages.

Metaphors of 'home' are scattered throughout the Web, and they are reproduced in the talk and images of women creating presences. River talks of the constant maintenance of her page as 'house cleaning . . . because I think of people visiting the site'. Carla Sinclair's NetChick home page is illustrated by her 'Net Chick Clubhouse' which contains graphic links in the form of windows to the spaces of beauty parlor, rumpus room, office and entertainment lounge (all additional Web pages). Clicking on the picture of the front door produces a map of the premises. She has elaborated this architecture still further by creating images of objects which are found in each room – an answerphone where (email) messages can be left is available in the office, for example.[12]

River Ginchild and Carla Sinclair have created home pages which present individual visions of themselves and their connections to others. Other women have created pages which are gateways for worldwide resources for women, although at present these tend to be coordinated or based on machines in the US. Barbara O'Leary set up Virtual Sisterhood as 'a global women's electronic support network'. Virtual Sisterhood coordinates and organizes connections to women's groups and activities, and provides links between activist groups and social forums as well as an on-line periodical, *Seachange*. Information is available in a variety of languages, and women Web author volunteers establish sites which host women's groups from all over the world. Other global initiatives have been set up in parallel with the United Nations Fourth Conference on Women, such as the World's Women On-line Electronic Art Networking Project. Large coordinating 'gateway' sites with a feminist focus in the US include The Feminist Majority and Women's Web, which includes links to *Ms* magazine. Amy Goodloe coordinates an initiative which concentrates on lesbian activities and resources on the Web, particularly in the San Francisco Bay Area. These electronic networks do not exist in isolation but are themselves electronically linked. Spiderwoman is linked to NetChick which has a connection to the geekgirl site (described below) which can be used to access Virtual Sisterhood. Connections cross-cut each other with multiple routes for getting from one page to another, adding complexity to the networks. Frequently they also encompass a convention of cooperation and sharing of technological skills between women which is related by some to previous projects of political networking between women. This sentiment is expressed in the Women'sSpace Web article on the culture of cyberspace:

> There is a spirit of generosity amongst sisters in cyberspace which reminds us of the early days of the Women's Liberation Movement. Networking, activism and support are interwoven as we push ourselves to learn to work with the new electronic tools we are encountering. Together we anticipate

a future where growing numbers of women can access and use the global connections to promote women's equality.

(Women'sSpace vol. 1 no. 3 Web Page)

Of particular interest to my research are the Web presences which women have created in direct response to certain images of computing culture, and specific patterns of activities on the Web itself (such as the man who set up a page linking up pages of 'Babes on the Web'). The resistance of 'grrrl' Web producers may be portrayed as 'what Riot Grrrls are to music and the Guerrilla Girls are to art' (DeLoach 1996). Women who might be grouped under this label have created sites with names such as Cybergrrl, geekgirl, as well as NerdGrrl and Homegurrrl. The words themselves are codes to explicitly subvert the easy appropriation of women, and to resist stereotypes. Crystal Kile, creator of the PopTart site, tells DeLoach:

> A very practical reason grrrls/geeks/nerds use these codewords in titles of our site is to make it clear that we're not naked and waiting for a hot chat with you! I mean just do an Infoseek search using the keyword 'girl' or 'woman' & see what you find.

Crystal also resists:

> the very traditional way that the on-line and multimedia industries are creating the 'woman's Internet market' to cater to the same ol' women-as-consumers, *Seventeen-Cosmo-Woman's-Day* market.

Such grrrls also appear to be ambivalent or even hostile to patterns of behaviour which they associate with an 'older style feminist rhetoric', and in particular the idea of a prescriptive or homogeneous women's movement. The words of Carla Sinclair, and RosieX (creator of the geekgirl site), illustrate this problematic relationship:

> A grrrl site is created by a woman who addresses issues without acting like women are victims. Grrrls take responsibility for themselves – we don't blame men for anything, but instead focus on ways to improve and strengthen ourselves. Grrrls enjoy their femininity and kick ass at the same time.

(Carla Sinclair in DeLoach 1996)

> I think this idea of a movement is based on an older style feminist rhetoric which tended to homogenize all women with the same wants/needs/desires to embrace each other. . . . It's just not that applicable to women who use the Internet.

(RosieX in DeLoach 1996)

By illustrating the possibility of a close relationship between women and computing, instead of reproducing a discourse of 'problems', grrrls have created images which defy traditional stereotypes. Often they achieve this by creating names from words which were not previously associated. Initiatives such as geekgirl are grounded in grrrls' own experiences of computing culture, as RosieX explains:

> Geeks generally are the hardcore of the nets. They are usually self-taught, determined individuals who simply love computers – machines are not just

their friends but conduits into the world of art, politics, fun, magic and mayhem. Being a girl I am voila – geekgirl.

(DeLoach 1996: 228)

Women, sometimes as grrrls, are making increasing use of the Web. RosieX has estimated that between 1992 and 1996 women's presences on the Internet increased from 5 to 34 per cent of all sites (DeLoach 1996). Many pages also show the combinations of electronic networks with social networks. In the final section of this chapter I return to the question of appropriate theories and metaphors about networks of women on the Web.

It has been suggested by Donna Haraway that the idea of the network itself may be employed as part of a feminist toolkit (Haraway 1991a). She advocates the 'network ideological image' because it suggests:

> the profusion of spaces and identities and the permeability of boundaries in the personal body and the body politic. 'Networking' is both a feminist practice and a multinational corporate strategy – weaving is for oppositional cyborgs.

(Haraway 1991a: 170)

Haraway adds a further metaphorical accessory to the idea of networking – weaving. From the different perspective of cyberfeminism, Sadie Plant has applied the metaphor of weaving to women's relationship with computers and cyberspace (Plant 1995). Using a conception of weaving is attractive in relation to women's presences on the Web because of the historical association of weaving as 'the process so often said to be the quintessence of women's work' (ibid.: 46). Weaving could be a productive metaphor to describe the process of creating pages, and interlinking others. Web pages could be construed as the woven products of electronic and social networks. Unlike the notion of the frontier, weaving could be used to emphasize the relationships within electronic networks, and between pages themselves, as well as the individuals who create them.

For Plant, the metaphor of weaving is used to portray the particular position which men occupy in relation to women and computers. In her argument, weaving describes the intimate connection which has emerged historically between women and computers, beginning with Ada Lovelace and the development of early machines which were modelled on the Jacquard loom. As well as being associated with women's work, she states 'The loom is the vanguard site of software development' (ibid.: 46). Furthermore, it emerges that both computers and women are woven sites of disguise or simulation which mediate between 'man and matter'. Plant claims that in contemporary times 'both woman and computer screen the matrix' (cyberspace is understood as the matrix) which results in 'the absence of the penis and its power'. She writes:

> The computer was always a simulation of weaving; threads of ones and zeros riding the carpets and simulating silk screens in the perpetual motions of cyberspace. It joins women on and as the interface between man and matter, identity and difference, one and zero, the actual and the virtual. An interface which is taking off on its own: no longer the void, the gap, or the absence, the veils are already cybernetic.

(Ibid.: 63)

Her aim is 'weaving women and cybernetics together' and her argument draws on the writings of Freud and Irigaray, particularly the latter's concept of women as producers of disguise, or 'weavers' of veils (ibid.: 58). Applying this theoretical framework to the Web presences which I have been describing is problematic, not least because in the article Plant does not state if the concept of the matrix refers to one corner of cyberspace, or if it is globally applicable. Setting this ambiguity to one side, the model is nevertheless based on women 'as the interface between man and matter', and it is this construction of women and computers in relation to the activities of man which makes it difficult to integrate into presences which have networks of women as the core focus. To provide a metaphor of the relationships contained within or generated by feminist Web pages which connect women to each other, and for the grrrl pages, it is necessary to go beyond the idea of women as veiled presences, mediators or as the interface, even if the interface is portrayed as presently 'taking off on its own'.

We are in need of a more radical reconfiguration of the relationship of (woman/) woman/machine rather than solely concentrating on man/woman/machine, particularly if we are to employ this construction of weaving. However, I would like to retain the idea of weaving as an oppositional form of networking as suggested by Haraway. Specifically, Haraway identifies the weavers as cyborgs, hybrid entities which are signalled in the name and image generation of projects such as geekgirl. Women's Web presences can be a way of constructing oppositional identities, displaying the integration of women and computing culture, as well as building electronic and social networks. If there is a corporate intensification of initiatives toward a 'woman's Internet market', as Crystal suggested, and it is based on competition, it is likely that the construction of these networks of feminists will be a form of resistance. Nevertheless, as well as maintaining social and electronic networks, there is a continued task of creating oppositional metaphors, so that the Web is not unproblematically treated as a frontier, or characterized as a place within which the relationships are secondary to a 'territory'. We could talk of networking rather than surfing. We could even use the analogy of weaving to stress the process of networking. But I expect that further investigation of women's presences on the Web will require a far wider variety of metaphors in a continuing attempt at a new vocabulary of women and technology. Haraway reminds us of the political stakes of refusal:

> If feminists and allied cultural radicals are to have any chance to set the terms
> for the politics of technoscience, I believe we must transform the despised
> metaphors of both organic and technological vision to foreground specific
> positioning, multiple mediation, partial perspective, and therefore a possible
> allegory for antiracist feminist scientist and political knowledge.
>
> (Haraway 1991b: 21)

Originally published in J. Terry and M. Calvert (eds) (1997) *Processed Lives: Gender and Technology in Everyday Life*, London: Routledge.
This essay has been edited for inclusion in the Reader.

Notes

1. I am alluding here to Donna Haraway's description of the Modest Witness, and particularly its reconceptualization by Deborah Heath in terms of Modest Interventions (Heath 1995).
2. The World Wide Web is a network of hypertext documents available to users of the Internet who are running a variety of 'browser' software. For a full explanation of the access of the world wide web many introductory guides are available, both on-line and in printed text.
3. HyperText Markup Language (HTML) is the standard language in which World Wide Web pages are written, although other languages, such as Java, are becoming increasingly popular.
4. The Octavia Project was created and is maintained by Nina Wakeford and researcher/designer Rachael Parry (Department of Architecture, University of Sheffield). Work on The Octavia Project has been funded by the UK Economic and Social Research Council.
5. For a history of the development of the Internet see Rheingold (1993).
6. The definition of cyberspace is contested and highly problematic, as I have argued elsewhere (Wakeford 1996). In Dale Spender's work the territory which it describes overlaps with the arena to which I am referring in my use of 'electronic networks'.
7. This is true for most Web pages, although the increasing use of 'interactive' Web pages, with browsers which allow integrated email and form capabilities, may shift this pattern in the future. Also my comment ignores the recent possibilities of real-time textual and visual exchange in systems such as WebChat.
8. There are other features of the Web which I cannot outline in this chapter including (a) at present the Web is only available via elite technology (computers) which have persistently been unequally distributed between social groups; (b) the standard Web links use hypertext, which itself is the subject of intense debate as to its social effects; (c) most on-line services have been constructed as spaces which are desirable and feasible to censor, and public legislation is being prepared and implemented across national boundaries on the basis of this assumption.
9. Here I am thinking of Emily Martin's reconstruction of science as a 'serious game' which investigates cultural practices (Martin 1996: 107). Martin's idea itself invokes Donna Haraway's phrase of the cat's cradle (Haraway 1989: 11). Usually I counter comments such as the one which I quoted above by physically guiding the interlocutor to a networked computer terminal and searching the Web for something directly related to their field of interest, a tactic used by Internet trainers faced with sceptical trainees.
10. Inktomi was developed at the University of California at Berkeley, and can be found at http://inktomi.berkeley.edu/.
11. All the quotations are from personal email communication between River and myself, February 1996.
12. In these Web page constructions the idea of 'home' can no longer be tied down to an image of public/private separation, as homes are simultaneously public and private spaces where 'who you let in' is not a decision based on safety or conditional on levels of intimacy, but on hypertext links available to any user of the Web.

Websites

Amy Goodloe
> http://www.lesbian.org/

Cybergrrl
> http://www.cybergrrl.com/

Digital Sojourn
> http://www.digitalsojourn.org/

Feminist Majority Foundation
> http://www.feminist.org/

geekgirl
> http://www.geekgirl.com.au/geekgirl/

Netchick
 http://www.cyborganic.com/people/carla

Octavia Project
 http://www.shef.ac.uk/uni/projects/wivc/

Spiderwoman
 http://primenet.com/~pax

Virtual Sisterhood
 http://www.igc.apc.org/vsister/vsister.html

Women'sSpace
 http://www/softaid.net/cathy/vsister/w-space/vol13.html

World's Women On-Line Electronic Art Networking Project
 http://wwol.inre.asu.edu/

Women's Web
 http://www.womweb.com/

References

DeLoach, A. (1996) 'Grrrls exude attitude', *Computer-Mediated Communication Magazine* 3(3), 1 March 1996.

geekgirl issue 1 (see Websites).

Haraway, D. J. (1989) *Primate Visions: Gender, Race, and Nature in the World of Modern Science*, New York: Routledge.

—— (1991a) *Simians, Cyborgs, and Women: The Reinvention of Nature*, London: Free Association Books.

—— (1991b) 'The actors are cyborg, nature is coyote, and the geography is elsewhere: postscript to "Cyborgs at large"', in C. Penley and A. Ross (eds) *Technoculture*, Minneapolis: University of Minnesota Press, pp. 21–6.

Heath, D. (1995) 'Modest Interventions and the technologies of feminist science studies'. Paper presented at CRICT workshop, Brunel University, Uxbridge, UK, 23 June 1995.

Hine, C. (1994) *Virtual Ethnography*. CRICT Discussion Paper no. 43. Brunel University, Uxbridge, UK.

Martin, E. (1996) 'Citadels, rhizomes, and string figures', in S. Aronowitz, B. Martinsons and M. Menser (eds) *Technoscience and Cyberculture*, London: Routledge, pp. 97–109.

Miller, L. (1995) 'Women and children first: gender and the settling of the electronic frontier', in J. Brook and I. A. Boal (eds) *Resisting the Virtual Life: The Culture and Politics of Information*, San Francisco: City Lights, pp. 49–57.

Plant, S. (1995) 'The future looms: weaving women and cybernetics', *Body and Society* 1(3–4): 45–64.

Rheingold, H. (1993) *The Virtual Community*, New York: Addison-Wesley.

Shade, L. R. (1996) 'The gendered mystique', *Computer-Mediated Communication Magazine* 3(3), 1 March 1996.

Spender, D. (1995) *Nattering on the Net: Women, Power and Cyberspace*, Melbourne: Spinifex.

Stone, A. R. (1991) 'Will the real body please stand up?: boundary stories about virtual cultures', in M. Benedikt (ed.) *Cyberspace: First Steps*. Cambridge, MA: MIT Press, pp. 81–118.

Ullman, E. (1995) 'Out of time: reflections on the programming life', in J. Brook and I. A. Boal (eds) *Resisting the Virtual Life: The Culture and Politics of Information*, San Francisco: City Lights, pp. 131–43.

Wakeford, N. S. (1996) 'Sexualised bodies in cyberspace', in W. Chernaik and M. Deegan (eds) *Beyond the Book: Theory, Text and the Politics of Cyberspace*, London: University of London.

Wiley, M. (1995) 'No place for women', *Digital Media* 4(8) January.

Woolgar, S. (1991) 'Configuring the user: the case of usability trials', in J. Law (ed.) *A Sociology of Monsters: Essays on Power, Technology and Domination*, London: Routledge, pp. 57–99.

JUDITH SQUIRES

FABULOUS FEMINIST FUTURES AND
THE LURE OF CYBERCULTURE

Cyberspace

> Neither a pure 'pop' phenomenon nor a simply technological artefact, but
> rather a powerful, collective, mnemonic technology that promises to have
> an important, if not revolutionary, impact on the future compositions of
> human identities and cultures.[1]

IN HER 'MANIFESTO FOR CYBORGS', Donna Haraway claims that she
would rather be a cyborg than a goddess (see chapter 18, in this volume). What are
we to make of this? Her manifesto is, she claims, 'an ironic political myth faithful to
feminism, socialism and materialism'. But why, in attempting to create a vision of a
materialist, socialist, and feminist future, does she invoke the image of a cyborg. And,
more importantly, why has this image proved so appealing to so many since? Cyborgs
are becoming pretty ubiquitous. Our films, popular fictions and theoretical writings are
littered with them. Clearly, the cybernetic has gripped our imaginations. It increasingly
structures our fantasies, phobias and political aspirations.

I want to take a sceptical look at the lure of cyberculture: to ask why it appeals,
what it has to offer, and what the dangers of being seduced by its charms might be. In
particular, I want to look at the interaction between cybernetics, cyberpunk and femi-
nism, critically evaluating the forms of cyberfeminism that have developed, along with
their detractors.

I shall argue that whilst there *may* be potential for an alliance between cyborg
imagery and a materialist-feminism, this potential has been largely submerged beneath
a sea of technophoric cyberdrool. If we are to salvage the image of the cyborg we would
do well to insist that cyberfeminism be seen as a metaphor for addressing the inter-
relation between technology and the body, not as a means of using the former to tran-
scend the latter. Furthermore, although the appeal of the cyborg may reside in the

challenge it poses to Enlightenment metaphysics, we need not accept the Enlightenment's myth about its own nature as a coherent, unitary project, which can only be accepted or rejected wholesale. Thus, we can jettison the rationalist and individualist assumptions of Enlightenment thinking whilst reclaiming its pluralistic and democratic political project. In short, we may want to use the cyborg as a positive icon in our political imagination, but we cannot also allow ourselves to take an apolitical stance with regard to the form and operation of developing technologies.

Blurring the boundaries: the fourth discontinuity

Forgetting about the body is an old Cartesian trick.[2]

In an ironic anticipation of the cybernetic theorists of postmodernity, Descartes mobilizes a comparison between the cyborg figure of the machine animal (or the 'natural automata') and the human, in an attempt to ratify the human/animal distinction. Unfortunately the criteria of distinction claimed by Descartes no longer hold true: feedback mechanisms and generalizing reason can no longer be claimed to be exclusive to humans. Hence the re-awakening of the metaphysical question which Descartes believed he had resolved so categorically. The sharp discontinuity which he argued to be of such importance looks increasingly fuzzy. Whilst there clearly are differences between persons and machines, these are increasingly a matter of degree rather than disjuncture. As Baudrillard and others have pointed out,[3] the boundaries between technology and nature are in the midst of a deep restructuring. The old distinctions between the biological and the technological, the natural and the artificial, the human and the mechanical, are becoming increasingly unreliable. The cybernetic visions of popular-fiction and film, and of recent theoretical writings, can be seen as important psychic explorations of the blurring of these boundaries and the possibilities for new human continuities – explorations which have manifested both a frightened rejection and a touching faith in the image of the cyborg: both technophobia and technophoria.

However modish, the blurring of boundaries is not, of course, distinctive to our age. There have been other boundaries, in other eras, which have been subjected to the challenge of knowledges which questioned, and ultimately undermined, the assumed disjunctures in the phenomena of nature. Following Copernicus and Darwin, Freud placed himself at the centre of the third key stage in the gradual progression towards the elimination of all discontinuities and the creation of continuities, claiming that he was 'endeavouring to prove to the "ego" of each one of us that he is not even master in his own house'.[4] These three epoch-marking challenges to the ego resulted, he argued, in the notion that human beings are no longer discontinuous with the world around them, but are continuous with the universe, the rest of the animal kingdom and with themselves.

It is in this context that we can understand the claim made by Bruce Mazlish that man's pride, his refusal to acknowledge the continuity between the human and the mechanical, is 'the substratum upon which the distrust of technology . . . has been reared.[5] Yet, despite this distrust, Mazlish argues that: 'the fourth discontinuity must now be eliminated . . . in the process man's ego will have to undergo another rude shock, similar to those administered by Copernicus, Darwin and Freud.[6] The rude shock

which confronts us today, challenging the assumed discontinuity between man and machine, takes a cybernetic form. 'To put it bluntly,' Mazlish continues, 'we are now coming to realise that man and the machines he creates are continuous and that the same conceptual schemes, for example, that help explain the working of his brain also explain the workings of a "thinking machine".[7]

This gradual elimination of discontinuities could be conceived as the erosion of clear limits to the self: the complication of the other. As apparently secure walls, delimiting our sense of self, prove to be but permeable membranes, our insecurity has mounted, allowing for both liberatory explorations of the nature of being and various forms of retrenchment. In the face of insecurity about our limits and the realization of the possibility of continuity, we all too often witness, not the celebration of new possibilities, but a retreat into fortress identities, the strategic use of the massive, regressive common denominators of essential identities: 'it is,' says Kristeva, 'a rare person who does not invoke a primal shelter to compensate for personal disarray.'[8]

Understanding these cosmological, biological and psychological developments as successive blows to our desire to conceive of ourselves as autonomous, self-determining individuals, enables us to place the current concern with the cybernetic in a context of a persistent ontological concern with the nature of the self. The human, it may be argued, has always been constituted by its boundaries, the location of these boundaries being a site of contestation. Taking a Derridean notion of identity formation we can argue that any entity, to be an entity, has to exclude that which is not itself, thereby constituting otherness. The other constitutes the entity by defining its limits.[9] Constituting the Good of this entity (taken here to be the human) always involves, theoretically and politically, projecting the negative on to the other. Thus (contra recent concerns about the apolitical nature of deconstruction), I would claim that understanding the nature of these limits is always an ethical issue, and challenging the parameters of the limits always a political project.

Thus, the redrawing of the boundaries of the self is a political process: how they are drawn will depend on who has the power to set the agenda. In this context it is worth reminding ourselves, lest we had forgotten, that our society is still deeply patriarchal, and that – given that previous concepts of the self have been informed by patriarchal assumptions – we cannot assume that the current cybernetic developments will not also result in ontologies that, although redrawn, are none the less still highly gendered.

In order to uphold the fourth discontinuity, between man and his tools, Descartes distinguishes between mind and matter: the 'rational soul', he claimed, is 'that part of us *distinct from the body* whose essence . . . is only to think' (emphasis added). This Cartesian dualism has been much theorized within feminist theory, for whilst Descartes upheld the 'fourth discontinuity' for *man* through the transcendence by the rational soul of the body, this rational soul was a gendered soul. The boundaries of the self were drawn with a patriarchal pen. Thus, any loss of discontinuity will have different impact upon the masculine and the feminine self, the feminine already having been constituted as more continuous with the material/mechanical, through a denial of the tools of limit-definition. One might even conjecture that cyberculture is a particularly masculine exploration of the new-found continuity between mind and machine, of particular import to the masculine notion of the self which had defined itself in terms of the mind as distinct from the materiality of both body and machine. The feminine, however, having

been more clearly constituted as *embodied,* must address technological developments from a different starting point. Hence, to investigate new possibilities for understandings of the self which encompasses both masculine and feminine experiences, we must explore the boundaries of both mind and body. For the division between mind and matter, between that without spatial location and that which is firmly grounded, is not one which will necessarily be resolved by the acceptance of the continuity between the human and the mechanical.

The disembodiment of the political has posed a distinct dilemma for feminists of all persuasions, for whom difference has most frequently been experienced in embodied rather than purely cerebral form. Indeed, part of what was at issue in the development of an autonomous women's movement was an explicit challenge to the arrogance of those who thought that ideas could be separated from presence. For this move all too often resulted in an amnesia about embodied differences which served to transform man into a paradigm of humankind as such, obfuscating the ways in which the body itself is a cultural construct. Far from 'forgetting about the body' we would be better served by following Butler's injunction to explore the political significance of the formation of its boundaries.[10] Thus whilst cyborg imagery *could* potentially aid us in our exploration of the body viewed as a variable boundary, 'a surface whose permeability is politically regulated',[11] we should not be too optimistic that it will necessarily do so.

Dreary dreams of Texan boys

> Patriarchy is more willing to dispense with human life than with male supe-
> riority.[12]

I want now to briefly consider the phenomenon of cyberculture – the writing of cyber-punks and the images of cyborgs, exploring cyberculture's celebration of the continuity between man and machine, its hip acceptance of the loss of the boundary.[13]

'Eighties tech,' claims Bruce Sterling, 'sticks to the skin, responds to the touch: the personal computer, the Sony Walkman, the portable telephone, the soft contact lens . . . prosthetic limbs, implanted circuitry, cosmetic surgery, genetic alteration.'[14] For cyber-punks technology is inside the body and mind itself. Yet it is also global: the satellite media net, the multinational corporation both recurring as dominant literary tropes in cybernovels. Cyberpunk is characterized by its integration of these technologies with a hedonism and a counter-culture 'guerrilla' political consciousness which – in contradis-tinction to 1960s counterculture that was rural, romanticized and anti-science – takes the hacker along with the rocker as its cultural icon.

Yet, despite its oppositional image, there is little understanding of social process or political critique in these writings, just a mystical desire to leave it all behind. In an age in which there is so much perceived risk in living and so much information for both body and mind to contain and survive, it is not perhaps surprising that we are confronted with the desire to transcend and escape where and who we are. But here the desire for transcendence is coupled by a refusal to contemplate that in which we are grounded. Thus, whilst one of cyberpunk's strongest features is its rich thesaurus of metaphors linking the organic and the electronic, one of its weakest is the fact that it completely ignores the question of whether some political controls over technology are desirable, or possible.

Furthermore, it is the fictional vision of a very particular group of people, the imagination of a small subset of youth culture in the wealthy 'First World', the sensibility of the technicians and artists working with new media (special effects wizards, mixmasters, tape effect technicians, graphics hackers, and so forth). This group is, to quote Suvin, 'a small, single-digit percentage even of the fifteen-to-thirty-years' age group, even in the affluent North (never mind the whole earth)'.[15] It should not be forgotten therefore that many of the engineers currently debating the form and nature of cyberspace are, as Stone reminds us, 'the young turks of computing engineering, men in their late teens and twenties, and they are preoccupied with the things with which post-pubescent men have always been preoccupied'.[16] It is this 'rather steamy group' who will generate the codes and descriptors by which bodies in cyberspace are represented.

One example amongst many of how this is playing out currently is to be found in Virtual Valerie 1 and 2 (two CD-ROM programmes produced by Reactor) in which, 'the aim is to check out Valerie's 3-D computer animated department, then Valerie herself. If you keep her happy by giving the right answers to the questions she asks, you can undress her then get her to enact different fantasies (e.g. in Valerie 2 she clones herself, grows a penis and has sex with herself)'.[17] Looking for more positive uses of cybernetic technology one might turn to the fact that in virtual space, the phenomenon of 'computer cross-dressing' is rife. 'On the nets,' one critic claims, 'where warranting, or grounding, a persona in a physical body, is meaningless, men routinely use female personae whenever they choose, and vice versa.'[18] Yet we must recognize that, despite this exciting potential for degendering social interaction, gendered modes of communication have themselves actually remained relatively stable, only who uses which of the two socially recognized modes has become more fluid. Furthermore, the uses of computer cross-dressing are themselves politically circumscribed. Whereas such cross-dressing seems to offer a minimal thrill for some of the men on the Internet, most of the degendering on the net is being done for purely defensive rather than politically exploratory reasons: women, wishing to use the Net without being subject to the usual inanities of chat-up lines and sexual stereotyping, have found it useful to make tactical use of non-gendered Internet identities. Interchanges on the Internet do not (yet) live up to our radical imaginings of their potentialities.

One does not have to be an eco-feminist (let alone a goddess) to recognize that most of the cyberimagery and cyberfictions produced to date have done little to challenge patriarchal stereotypes of gendered bodily difference. Far from exploring an ungendered ideal, cyborg imagery has created exaggeratedly masculine and feminine bodies. As Claudia Springer notes, 'While popular culture texts enthusiastically explore boundary breakdowns between humans and computers, gender boundaries are treated less flexibly.'[19] And, although it is certainly true that in the case of some contemporary science fiction writers, technology makes possible the destabilization of sexual identity as a category, it has been noted that there has also been 'a fairly insistent history of representations of technology that work to fortify – sometimes desperately – conventional understandings of the feminine'.[20] We might reasonably conclude that cybernetics alone will not change power relations. They merely allow us to reinscribe existing power networks in new forms and media.

The acceptance of the continuity between man and machine does not inevitably involve the challenge to gender discontinuity. Despite its willingness to relinquish other

previously sacrosanct categories and distinctions, patriarchy on the Net continues to uphold gender difference. Most of the cyberfutures on offer are simply representations of contemporary cultural myths and prejudices disguised under heavy layers of futuristic make-up. Perhaps we find here a 'fifth discontinuity', the elimination of which will mark another 'great shock to man's ego'. The bifurcation of gendered identities into discrete male/female categories appears to be a more resilient discontinuity within the political imagination of cyberpunks than the bifurcation of man/machine: all around us we witness explorations of the continuity between the latter, but continuities between the former are still largely absent from the political utopias on offer.

Given this, should we understand these cyberpunk visions as critical and rebellious, or escapist and co-opted? Is it, as one commentator argued, 'at its best conservative and at its worst rebarbative – if not downright tedious'.[21] If so, it would appear to be an unlikely source for utopian visions and political manifestos for feminist theorists. And yet . . . one could happily write cyberpunk off as the latest fad of a few post-pubescent rebellious Texan boys, a handful of novels by William Gibson and a couple of effective PR men, if it were not for the fact that cyberpunk taps into concerns which are of import to a much wider constituency.

For cyberculture provides us with a particularly timely set of images which help us to think through the key theoretical agendas of the moment. Where multimedia provided a visual metaphor for the concerns of multi-culturalism, virtual reality offers metaphors wonderfully resonant for the theoretical concerns of post-structuralism. Regardless of their actual manifestations, these technological developments offer a new vocabulary for our political imagination, aiding the task of forging innovative political myths. Let us therefore note that for many the development of cybernetics and virtual reality are of interest primarily as a source of resonant images and icons with which to construct radical philosophical and political visions.

Hopeful monsters: the tyranny of biology[22]

Why aren't there any women in cyberspace?[23]

This section looks at the more specifically feminist attempts to negotiate cyberculture and asks: in what ways have feminist theorists appropriated the latest manifestations of technoculture, and with what intent? Are these feminist writers motivated by the same concerns as the cyberpunks, or is their agenda rather different?

Despite a long-standing tradition of feminist writing claiming that technology is encoded in masculine terms, and despite the blatantly sexist outpouring of the cyberpunks, the image of the cyborg has not proved to be just another toy for the boys. In allowing us, requiring us, to rethink the relation between consciousness and body, technological development impacts upon one of the central concerns of feminism, in all its forms. And, while some feminists read its impact as just one more patriarchal mechanism of oppression, others have seen potential for liberation in cybernetics and begun to envisage a cybernetic future.

So, if the tradition of science fiction writing permits a fusing of political concerns with the 'playful creativity of the imagination',[24] what can we learn of the political concerns of feminists who feel drawn to the image of the cyborg? To answer this question

I shall look at the writings of three quite different 'cyberfeminists': Shulamith Firestone, Donna Haraway and Sadie Plant. Their versions of cyberfeminism are crucially distinct: the first of these is an explicitly modernist and materialist vision of social revolution and human emancipation; the second adopts a more ironic socialist-feminist stance informed by the theoretical developments of a pluralist postmodernity. The last is a postmodern perspective which (I shall claim) shares the apoliticism of the cyberpunks but also invokes a kind of mystical utopianism of the eco-feminist earth-goddesses. However, what all three perspectives share is a desire to reformulate the relation between gender and the body.

One of the most exciting visions of cyberfeminism to date is still to be found in a text from cyberculture's pre-history, Shulamith Firestone's *The Dialectic of Sex* (1972). Unlike most visions that have followed, hers is an explicitly revolutionary project, steeped in the rhetoric of emancipation and progress. Adopting and adapting the Marxist dialectical materialist account of class struggle, Firestone offers her own account of the sex-class predicament:

> And just as the end goal of socialist revolution was not only the elimination
> of the economic class privilege but of the economic *distinction* itself, so the
> end goal of feminist revolution must be, unlike that of the first feminist
> movement, not just the elimination of male *privilege* but of the sex *distinc-*
> *tion* itself: genital difference between human beings would no longer matter
> culturally.[25]

It is to cybernetics that Firestone looks to end both distinctions. 'It has become necessary,' she claims, 'to free humanity from the tyranny of its biology.' 'Humanity can no longer afford to remain in the transitional stage between simply animal existence and full control of nature.'[26] Firestone's work is, of course, characterized by a wholly hostile relation to the female body: 'childbirth *hurts',* she proclaims. 'And it isn't good for you.'[27] Women's liberation for Firestone involved the freeing of women from the tyranny of reproduction by any means possible. The technophoric desire to use – what Firestone broadly defines as – 'cybernetics' to escape the confines of the body is manifest. It is, however, embedded within a (now deeply unfashionable) structuralist account of the dialectics of sex, class and culture: a scheme which predicts the inevitable progress towards the mastery of nature.

What Firestone calls for is 'cybernation' – the full takeover by machines of increasingly complex functions, machines which she envisages may soon equal or surpass man in original- thinking and problem-solving. Reflecting on the immediate impact of cybernation on the position of women, Firestone predicted the following: the erosion of the status of the 'head of household', particularly in the working class, which could shake up family life and traditional sex roles even more profoundly; massive unrest of the young, poor and the unemployed, and ultimately, revolution.

The vision is prescient, but the theoretical stance is sadly dated. When, in the 1980s, Donna Haraway was asked to write on what socialist-feminist priorities ought to be in the Reagan years, she too turned to cybernetics. But in her definitive cyberfeminist text, Haraway claims that the cyborg image helps to express two crucial arguments: the first is that 'the production of universal, totalising theory is a major mistake that misses most of reality, probably always, but certainly now'; the second is that 'taking responsibility for the social relations of science and technology means refusing an anti-science

metaphysics, a demonology of technology, and so means embracing the skilful task of reconstructing the boundaries of daily life, in partial connection with others, in communication with all of our parts'.[28] Thus her claim is that cyborg imagery 'can suggest a way out of the maze of dualisms in which we have explained our bodies and our tools to ourselves.'[29] Thus, whilst in the second argument of the 1980s Haraway has echoes of Firestone's 1970s agenda, her first argument is clearly a sign of the post-universalizing times.

One could, of course, accept the first of Haraway's two stated arguments without taking on board cyborg imagery, and many have done so previously. One can reject the homogenizing strategies of grand narratives and challenge the universal pretensions of modernist thought; one can endorse a politics of difference which celebrates the local and the particular, one can reject binary dualisms and false polarities; one can explore the possibilities of flexible, transitory identities . . . without ever making recourse to cyborg imagery. Cybernetics, of course, becomes of central concern to one's political vision if one seeks an androgynous, disembodied future in which the fleshy issue of physical difference is transcended, thereby rendering the reproductive, maternal, essential women absent from one's future utopia. But it also provides a useful lexicon for rewriting origin stories: 'cyborg authors subvert the central myths of origin of Western culture.'[30] Thus the cyborg is situated directly against the competing eco-feminist representative of political change – the mother-goddess who is located quite firmly in the distinctly embodied female self. This polarity is not new: there have always been those who wished to transcend the bodily nature of the female and exist purely in the cerebral realm of individual autonomy, and those who wished to celebrate physical difference as the basis for essential ontologies and epistemologies. Haraway, however, has the advantage of writing at a time when technological developments make the former ideal attainable as never before.

In distinction to the eco-feminist utopia which would have us return to an innocent, natural organic past in the name of protecting mother earth, cyborgs represent the more flexible mediation capable of incorporating, rather than repudiating, science and technology. The manifesto for cyborgs is therefore seen by Haraway as a statement to socialist-feminists that they would do better to opt for the contradictions of everyday material life, than for the comforts of divine resolution. Interested in bringing together feminist, Marxist and environmentalist concerns, Haraway ironically reconfigures the cyborg as an exemplary postmodern figure which resists the conventional unifying utopian vision. Her motivation for constructing such an 'ironic political myth' is explicitly grounded in the political realities of contemporary society: she never loses sight of the nitty-gritty of lived social relations.

In a similar vein, whilst recognizing that 'cyberpunk is a boys' club', Joan Gordon also argues that it does much that could enrich feminism by 'directing it away from nostalgia'.[31] The implication is that we can escape the confines of natural women and vegetarian, non-polluting earth-mothers only by embracing the attitude of the sleazy boys of cyberpunk. And, despite the polarity of this argument, one can see that if feminist science fiction offers only utopian dreams of a pastoral world, fuelled by organic structures, inspired by versions of the archetypal Great Mother, then cyberpunk comes to seem appealing. But, perhaps more importantly, Gordon argues that, 'Cyberpunk, with all its cynicism, shows a future we might reasonably expect, and shows people successfully coping, surviving, and manipulating it'.[32] In recognition of this fact, Gordon

argues that feminists need to 'acknowledge that if we can control technology even as it increases its potential to control us, we will have a better chance for survival in the imperfect future which we can reasonably expect'.[33]

One can see the appeal of cybernetics: it radically decentres the human body, the sacred icon of the essential. Virtual reality works further to decentre notions of 'the real': the rhetoric is seductive. Yet, despite the political importance of engaging with developing technologies, the irony of this is that, in its extreme manifestations, cyber-feminism takes us full circle and frequently ends up sounding largely indistinct from the form of mystical maternalist feminism of which the technofems are so scathing. If the cyborg was, for Haraway, an ironical political myth which was created to symbolize a non-holistic, non-universalizing vision for feminist strategies, it has been taken up within cyberfeminism as an icon for an essential female being.

> Women . . . have always found ways of circumventing the dominant systems
> of communication which have marginalised their own speech. And while man
> gazed out, looking for the truth, and reflecting on himself, women have
> never depended on what appears before them. . . . On the contrary, they
> have persisted in communicating with each other and their environment in
> ways which the patriarch has been unable to comprehend, and so often been
> interpreted as man, or hysterical.[34]

These are the words of self-proclaimed cyberfeminist Sadie Plant, but they could equally have been spoken by the arch-goddess herself, Mary Daly. Though Plant claims to cele-brate the cyborg rather than the goddess, her writing reveals a longing for precisely the 'quasi-religious communion that we find in eco-feminist writing, the rejection of which spurred Haraway's cyborg vision. In a flight from the actual material differences which demand complex political responses, the cyborg offers the possibility of flexible diver-sity, whilst holding onto the comforting notion of essential femininity. Note, for example, Plant's assumption that women have 'their own speech' with their own lines of commu-nication which are never linear but manifest 'flashes of intuitive exchange'.[35] In place of the particularity and plurality stressed by Haraway we find in Plant's writing phrases like 'women have always found . . .' which fit ill with Haraway's rejection of the assim-ilation of all women's differences into an organic unity. And, whereas Haraway sought to explore cybernetics as a means of realizing a more pluralist world, Plant argues that 'the female cyborg is the only cyborg'.[36] Given this, one must have some sympathy with Catherine Elwes when she claims that the cybernetic future that Plant describes repre-sents an 'escape from the body, escape from the difficulties of inter-personal relations, escape from biology, escape from history and most significantly perhaps, escape from difference'.[37]

Furthermore, where Haraway's manifesto was clearly political in intent, seeking a more adequate realization of socialist-feminist aspirations, Plant's version of cyber-feminism is distinctly apolitical: 'no-one,' she says, 'is making it happen: it is not a political project, and has neither theory nor practice, no goals and no principles.' It is for this reason that some have reacted with such anger to Plant's vision, arguing that, 'Cyberfeminism means the death of feminism and a post-political world.'[38] We must therefore question whether current cyberfeminists are engaged in a political process of deconstructing old oppressive certainties, or whether they are simply seeking coherence where all is in a state of flux – in pursuit of the totalizing experience which eclipses all

other worlds, to be found in the Internet and systems which still have their own limited and understandable – though strange – internal coherence.[39] These two stances both exist in Plant's work, in an uneasy alliance of cyberfeminism and cyberpunk. For whilst cyberpunk does nothing to persuade us that the world it describes is a good or better world, Plant *does* claim that her world is a better world for 'women', but offers no political or ethical basis for such a claim.

Firestone ends *The Dialectic of Sex* with a section called 'Revolutionary Demands'; Haraway writes her Manifesto 'to find political direction in the 1980s';[40] Plant, writing in the anti-political 1990s, has no sense of political project at all. The cyborg has become a symbol of philosophical challenge rather than an icon of political change.

So it is my claim that whilst for Haraway cyborg imagery suggests positive new ways of negotiating complex material differences, for others it offers the option of transcending them altogether; of leaving the messy world of material politics behind and entering a post-political utopia of infinite possibility.

In this context, I argue that whilst cyberfeminism might offer a vision of fabulous, flexible, feminist futures, it has as yet largely failed to do so. Instead, cyberfeminism has become the distorted fantasy of those so cynical of traditional political strategies, so bemused by the complexity of social materiality, and so bound up in the rhetoric of the space-flows of information technology, that they have forgotten both the exploitative and alienating potential of technology and retreated into the celebration of essential, though disembodied, woman.

Cyborg as political paradox

> Cybernetics is already a paradox: simultaneously a sublime vision of human power over chance and a multinational capitalism's mechanical process of expansion.[41]

By way of a concluding consideration of the potential for feminist cyborgs, let us reflect upon the relation between political myth and practice.

The cyborg myth has a certain seductive imaginative power, but it is a myth, as Andrew Ross has pointed out, 'that can swing both ways.'[42] What is more, the pendulum is heavily weighted by very material manifestations of power. The cyborgs as 'techno-fascist celebrations of invulnerability' are winning out in the cultural battle against the semi-permeable hybrid cyborgs of Haraways's lexicon. Predictable enough, perhaps, given that cyborgs are the illegitimate offspring of militarism and patriarchal capitalism. As both symptom and critique of the expansion of the military industrial complex, cyborg politics is a tricky business. Even Firestone acknowledged that 'cybernetics, like birth control, can be a double-edged sword. Like artificial reproduction, to envisage it in the hands of the present powers is to envision a nightmare'.[43]

Yet to recognize that technology is currently constituted and operated in pursuit of the interests of the powerful is not to relinquish all attempts to reappropriate its potential. Technological developments are taking place, and it is as well that we engage with them and try to negotiate a form which most suits our own ends. We cannot afford to underestimate the tactical manoeuvres of the relatively powerless when attempting to resist, negotiate, or transform the system and products of the relatively powerful.[44]

These tactics *include* ways of thinking, inseparable as they are from everyday struggles and pleasures. One needs to find the metaphors that allow one to imagine a liberatory knowledge, to colonize discourses which operate to exclude and undermine. It takes a certain form of political irony to grapple with this ambivalence: using mimicry, mockery, pastiche and parody as ways of appropriating dominant images for one's own ends. Thus the appropriation of the cyborg for the mapping of possible feminist futures has the potential to be a subversive act. But let us not imagine that persuasive rhetoric alone is sufficient to shift the distribution of power.

At issue here is both the development of a political imagination which can conjure up an ideal role and use for developing technologies, on terms we have defined – the creative project; and also the development of political regulations and controls which actually govern the form and uses of these technologies. The former is a necessary, though not sufficient, precondition, for the realization of an adequate technology. Despite the frequently asserted claim that we now live in a world in which fantasy and reality are impossible to distinguish, we cannot afford to engage in political utopias alone: we still need to negotiate with the mechanisms of state and market. For most people, faith in the technological vision requires such practical safeguards.

Note, for example, the latest detailed report from the European Union's Eurobarometer poll about new technologies (1993, a repeat of a survey conducted in 1991), involving nearly 13,000 people across the member states of the European Union.[45] Whilst there appears to be a general feeling that new technologies 'will improve our way of life' over the next twenty years, when asked more specifically about particular technologies, there was a noted lack of trust that biotechnology would improve things in comparison to the perhaps more familiar telecommunications. Substitute 'genetic engineering' for biotechnology and the distrust mounts notably. What is more, the sense of optimism that these technologies will improve life has dropped significantly since the question was asked just two years ago. It would appear that the majority of people still distrust attempts to meddle in what they perceive to be 'nature': perhaps for the related reason that they also distrust government and industry as sources of information about what is going on.

A fundamental issue to emerge is that *trust* is the key condition of acceptability for these emerging technologies. The fact that so many people place their trust in the market above all else is a sad indictment of our current political malaise. The vast corporate bodies of state and industry no longer inspire us with confidence: we would far rather buy into new technologies as individual consumers than as political citizens, allowing us the 'choice' to engage with these developments or not. Technological developments which can be packaged and sold in the global market-place (such as Sky TV and CD-ROM) are gaining our trust and capturing our imaginations. Those developments, however, which still require regulation and operation at state level (such as nuclear power), continue to fill us with dread. Thus we might argue that our responses to new technologies are inextricably bound up with our faith (or its absence) in those who are selling it to us. It is worth noting therefore that consumer and environmental organisations are the only bodies that seem to have gained the power to be worthy of our trust in this respect. The fact that, in Britain, more people are now members of Greenpeace than of the Labour Party indicates quite clearly who has won our political imaginations.

It is crucial that we are attentive to these political realities if we are to have a role in shaping the ethical and legal issues currently being negotiated about the development

of technological advances – from the patenting of genetically engineered tomatoes to the enscription of email messages. A hunting ground for litigious lawyers and aggressive companies, the only criterion currently used for negotiating the acceptability of such developments is the pursuit of profit, occasionally constrained by a rather dated parliamentary concern for social utility. We do not yet have the developed ethical imagination nor the social structures to deal with these issues in any other way.

It has been claimed that cybernetics would oust all metaphysical concepts – 'including the concepts of soul, of life, of value, of choice, of memory' – for it is these very concepts which have served to separate the machine from man.'[46] Yet, I would argue that although cybernetics may undermine the scope for metaphysical thought, we cannot afford to jettison the ethical altogether. We need not conceive ethics as either metaphysical concepts free-floating in the biosphere, or timeless foundations under our feet. We do not discover them: we invent them. I am interested here in the example offered by Foucault in his later writings. For, although Foucault placed himself in the counter-Enlightenment tradition, in these writings he appears not only as a critic of the Enlightenment, but also as its heir. This rehabilitation of the Enlightenment – the perception of it (like our cyborg) as both disease and remedy – depends on the possibility of denying the Enlightenment's myth about its own coherence. For Foucault this requires making a distinction between two distinct Kantian traditions: on the one hand, what Foucault calls 'the analytique of truth' – the analysis of the condition of knowledge which has pretensions of truth; on the other hand, what he calls 'the ontology of the present' – the questioning of who we are and the nature of the moment that we belong to.

The potential of the cyborg myth is that it might offer a lexicon with which to challenge the self-foundation project of the Enlightenment without giving up on its self-assertion project; abandoning the rationalist and individualist assumptions whilst retaining the pluralist and democratic political structures.[47] This theoretical move is, I think, invaluable in that it signals the possibility of circumventing the Enlightenment's myth about its own nature as a coherent, unitary project, which can only be accepted or rejected wholesale, allowing us to hold firmly onto the political project of the Enlightenment whilst rejecting its epistemological underpinnings.

The implication of this for our exploration of cybernetics and feminism is that we can embrace the ontological challenges these technological developments pose for our notion of the self – exploring the potentiality for eroding the dichotomous gendering of selves – whilst none the less holding onto a democratic political commitment which requires us to remain attentive to the material and economic power structures which might deny the potential for self-assertion. What is required of cyberfeminism is thus both a vision of cyborgs that may help to heighten our awareness of the potentiality for new technologies, and the political pursuit of the practical manifestation of an appropriate technology: unintimidating, accessible and democratic. Cybernetics *is* both 'a dreary augmentation of multinational capitalism's mechanical process of expansion' and simultaneously, 'a sublime vision of human power'. As such we must be attentive to the political irony embedded in our mythic cyborgs.

Originally published in J. Dovey (ed.) (1996) *Fractal Dreams: New Media in Social Context*, London: Lawrence and Wishart.
This essay has been edited for inclusion in the Reader.

Notes

1. David Tomas, 'The technophilic body: on technicity in William Gibson's cyborg culture', *New Formations*, (1989) pp. 31–32.
2. Allucquere Rosanne Stone, 'Will the real body please stand up?, in Michael Benedikt (ed.); *Cyberspace: First Steps*, (Cambridge, Massachusetts,: MIT Press 1992), p. 113.
3. See, for example, Jean Baudrillard, *Simulations* (New York: Semiotext(e), 1983) and Mark Poster (ed.), *Jean Baudrillard: Selected Writings*, (Palo Alto: Stanford University Press; 1988).
4. Ernest Jones, *The Life and Work of Sigmund Freud* (3 Volumes), (Harmondsworth: Penguin, 1987), Volume 2, pp. 224–6.
5. Bruce Mazlish, 'The fourth discontinuity', in Melvin Kranzberg and William Davenport (eds) *Technology and Culture: An Anthropology* (New York: Meridian Books), p. 218.
6. Ibid. p. 218.
7. Ibid., p. 218.
8. Julia Kristeva, *Nations Without Nationalism* (New York: Columbia University, 1993), p. 2.
9. Drucilla Cornell, *The Philosophy of the Limit*, (London: Routledge, 1994).
10. Judith Butler, *Gender Trouble* (London: Routledge, 1990), p. 33.
11. Ibid., p. 139.
12. Clauda Springer, 'The pleasure of the interface', *Screen*, Autumn 1991, p. 318.
13. The concept of 'cyberspace' was coined by science fiction writer, William Gibson in his novel *Neuromancer*. 'An unhappy word, perhaps,' reflects one commentator, 'if it remains tied to the desperate, dystopic vision of the near future found in *Neuromancer* and *Count Zero* – visions of corporate hegemony and urban decay, of neutral implants, of a life in paranoia and pain.' Benedikt, *Cyberspace*, p. 1.
14. Bruce Sterling, 'Preface from Mirrorshades', in Larry McCaffery (ed.), *Storming the Reality Studio*, (Durham: Duke University Press, 1991), p. 346.
15. Darko Suvin, 'On Gibson and cyberpunk', in McCaffery, ibid., p. 363.
16. Allucquere Roseanne Stone, 'Will the real body please stand up?'
17. *I-D* magazine, July 1993, p. 28.
18. Stone, 'Will the real body', p. 84.
19. Springer, 'The pleasure of the interface', p. 308.
20. Mary Ann Doane, 'Technophilia: technology, representation and the feminine', in Mary Jocobus, Evelyn Fox Keller and Sally Shuttleworth (eds), *Body/Politics* (New York: Routledge, 1990), p. 163.
21. Tatsumi, quoted by Darko Suvin, 'On Gibson and cyberpunk', p. 364.
22. This title is taken from Nicholas Moseley's novel of the same time: his hopeful monsters nearly always die young – born before their time when it's not known if the environment is quite ready for them.
23. Scott Bukatman, *Terminal Identity* (Durham, Duke University Press, 1993) p. 314.
24. Sarah Lefanu, *Feminism and Science Fiction* (Bloomington: Indiana University Press, 1989) p. 2.
25. Shulamith Firestone, *The Dialectic of Sex* (London: Women's Press), p. 19.
26. Ibid. pp. 183–4.
27. Ibid. p. 189.
28. Haraway, 'A manifesto for cyborgs: science technology and socialist feminism in the 1980s', in Linda Nicholson (ed.), *Feminism/Postmodernism* (London: Routledge, 1990).
30. Ibid., p. 217.
31. Joan Gordon, 'Yin and Yang Duke It Out', *Storming the Reality Studio*, in McCaffery, p. 197.
32. Ibid., p. 200.
33. Ibid., p. 200.
34. Sadie Plant, 'Beyond the screens: film, cyberpunk and cyberfeminism', *Variant*, p. 13.
35. Ibid., p. 14.
36. Ibid., p. 7.
37. Catherine Elwes, 'Is technology encoded in gender-specific terms?' in *Variant*, Autumn 1993, p. 65.
38. Ibid., p. 66.

39. Gillian Skirrow, 'Hellivision: an analysis of video games', *The Media Reader*, M. Alvarado and J. Thompson (eds) (London: BFI Publishing, 1988), p. 326.
40. Haraway, 'A Manifesto for cyborgs', p. 21.
41. Istvan Csicsery-Ronay, Jr, 'Cyberpunk and neuromanticisim', in McCaffery, *Storming the Reality Studio*, p. 186.
42. Andrew Ross, 'Interview with Donna Haraway', in Constance Penley and Andrew Ross (eds), *Technoculture* (Minneapolis: University of Minnesota Press, 1991), p. 17.
43. Firestone, *The Dialectic of Sex*, p. 190.
44. Constance Penley, 'Brownian motion: women, tactics and technology', in Penley and Ross, *Technoculture*, p. 139.
45. Jon Turney, 'Tasty, fresh and unnatural', in *The Higher*, 8 April 1994, pp. 16–17.
46. Jacques Derrida, *Of Grammatology*, extracted in McCaffrey, *Storming the Reality Studio*, p. 194.
47. For an example of this approach see Chantal Mouffe, *The Return of the Political* (London: Verso, 1993).

CHELA SANDOVAL

NEW SCIENCES
Cyborg feminism and the methodology of the oppressed

W HAT CONSTITUTES 'RESISTANCE' AND oppositional politics
under the imperatives of political, economic and cultural transnationalization?
Current global restructuring is effecting the organizational formations not only of busi-
ness, but of cultural economies, consciousness and knowledge. Social activists and
theorists throughout the twentieth century have been attempting to construct theories
of opposition that are capable of comprehending, responding to, and acting back upon
these globalizing forces in ways that renegotiate power on behalf of those Marx called
the 'proletariat', Barthes called the 'colonized classes', Hartsock called 'women', and
Lorde called the 'outsiders'. If transnational corporations are generating 'business strategy
and its relation to political initiatives at regional, national, and local levels',[1] then, what
are the concurrent forms of strategy being developed by the subaltern – by the margin-
alized – that focus on defining the forms of oppositional consciousness and praxis that
can be effective under First World transnationalizing forces?

Let me begin by invoking Silicon Valley – that great land of Lockheed, IBM,
Macintosh, Hewlett Packard, where over 30,000 workers have been laid off in the last
two years, and another 30,000 more await a similar fate over the year to come: the
fate of workers without jobs, those who fear for their livelihood. I begin here to honour
the muscles and sinews of workers who grow tired in the required repetitions, in the
warehouses, assembly lines, administrative cells, and computer networks that run the
great electronic firms of the late twentieth century. These workers know the pain of
the union of machine and bodily tissue, the robotic conditions, and in the late twen-
tieth century, the cyborg conditions under which the notion of human agency must take
on new meanings. A large percentage of these workers who are not in the administra-
tive sector but in labour-grade sectors are US people of colour, indigenous to the
Americas, or those whose ancestors were brought here as slaves or indentured servants;
they include those who immigrated to the US in the hopes of a better life, while being
integrated into a society hierarchized by race, gender, sex, class, language and social

position. Cyborg life: life as a worker who flips burgers, who speaks the cyborg speech of McDonalds, is a life that the workers of the future must prepare themselves for in small, everyday ways. My argument has been that colonized peoples of the Americas have already developed the cyborg skills required for survival under techno-human conditions as a requisite for survival under domination over the last three hundred years. Interestingly, however, theorists of globalization engage with the introduction of an oppositional 'cyborg' politics as if these politics have emerged with the advent of electronic technology alone, and not as a requirement of consciousness in opposition developed under previous forms of domination.

In this chapter I propose another vision, wrought out of the work of cultural theorist and philosopher of science Donna Haraway, who in 1985 wrote the groundbreaking work on 'Cyborg Feminism', in order to re-demonstrate what is overlooked in current cyborg theory, namely, that cyborg consciousness can be understood as the technological embodiment of a particular and specific form of oppositional consciousness that I have elsewhere described as 'US Third World feminism'.[2] And indeed, if cyborg consciousness is to be considered as anything other than that which replicates the now dominant global world order, then cyborg consciousness must be developed out of a set of technologies that together comprise the methodology of the oppressed, a methodology that can provide the guides for survival and resistance under First World transnational cultural conditions. This oppositional 'cyborg' consciousness has also been identified by terms such as 'mestiza', consciousness, 'situated subjectivities', 'womanism', and 'differential consciousness'. In the interests of furthering Haraway's own unstated but obvious project of challenging the racialization and apartheid of theoretical domains in the academy, and in the interests of translation, of transcoding from one academic idiom to another, from 'cyborgology' to 'feminism', from 'US Third World feminism' to 'cultural' and to 'subaltern' theory, I trace the routes travelled by the methodology of the oppressed as encoded by Haraway in 'Cyborg Feminism'.

Haraway's research represents an example of scholarly work that attempts to bridge the current apartheid of theoretical domains: 'white male post-structuralism', 'hegemonic feminism', 'postcolonial theory', and 'US Third World feminism'. Among her many contributions, Haraway provides new metaphoric grounds of resistance for the alienated white male subject under First World conditions of transnationalization, and thus the metaphor 'cyborg' represents profound possibilities for the twenty-first century (implications of hope, for example, for Jameson's lost subject which 'can no longer extend its protensions and retensions across the temporal manifold'.[3] Under cyborg theory, computer 'travel' can be understood as 'displacing' the 'self' in a similar fashion as the self was displaced under modernist dominations). An oppositional cyborg politics, then, could very well bring the politics of the alienated white male subject into alliance with the subaltern politics of US Third World feminism. Haraway's metaphor, however, in its travels through the academy, has been utilized and appropriated in a fashion that ironically represses the very work that it also fundamentally relies upon. This continuing repression then serves to reconstitute the apartheid of theoretical domains once again. If scholarship in the humanities thrives under the regime of this apartheid, Haraway represents a boundary crosser, and her work arises from a place that is often overlooked or misapprehended under hegemonic understandings.

I have argued elsewhere that the methodology of the oppressed consists of five different technologies developed in order to ensure survival under previous First World

conditions.[4] The technologies which together comprise the methodology of the oppressed generate the forms of agency and consciousness that can create effective forms of resistance under postmodern cultural conditions, and can be thought of as constituting a 'cyborg' form of resistance.[5] The practice of this *CyberConsciousness* that is US Third World feminism, or what I refer to as a 'differential postmodern form of oppositional consciousness', has also been described in terms that stress its motion; it is 'flexible', 'mobile', 'disporic', 'schizophrenic', 'nomadic' in nature. These forms of mobility, however, align around a field of force which inspires, focuses and drives them as oppositional forms of praxis. Indeed, this form of consciousness-in-opposition is best thought of as the particular field of force that makes possible the practices and procedures of the 'methodology of the oppressed'. Conversely, this methodology is best thought of as comprised of techniques-for-moving energy – or, better, as *oppositional technologies of power*: both 'inner' or psychic technologies, and 'outer' technologies of social praxis.

These technologies can be summarized as follows: (1) What Anzaldua calls 'la facultad', Barthes calls semiology, the 'science of signs in culture', or what Henry Louis Gates calls 'signifyin' and Audre Lorde calls 'deep seeing' are all forms of 'sign-reading' that comprise the first of what are five fundamental technologies of this methodology. (2) The second, and well-recognized technology of the subaltern is the process of challenging dominant ideological signs through their 'de-construction': the act of separating a form from its dominant meaning. (3) The third technology is what I call 'meta-ideologizing' in honour of its activity: the operation of appropriating dominant ideological forms and using them whole in order to transform their meanings into a new, imposed, and revolutionary concept. (4) The fourth technology of the oppressed that I call 'democratics' is a process of locating: that is, a 'zeroing in' that gathers, drives, and orients the previous three technologies, semiotics, deconstruction, and meta-ideologizing, with the intent of bringing about not simply survival or justice, as in earlier times, but egalitarian social relations, or, as Third World writers from Fanon through to Wong, Lugones, or Collins have put it,[6] with the aim of producing 'love' in a de-colonizing, postmodern, post-empire world. (5) Differential movement is the fifth technology, the one through which, however, the others harmonically manoeuvre. In order to better understand the operation of differential movement, one must understand that it is a polyform upon which the previous technologies depend for their own operation. Only through differential movement can they be transferred toward their destinations. Even the fourth, 'democratics', which always tends toward the centring of identity in the interest of egalitarian social justice. These five technologies together comprise the methodology of the oppressed, which enables the enactment of what I have called the differential mode of oppositional social movement as in the example of US Third World feminism.

Under US Third World feminism, differential consciousness has been encoded as 'la facultad' (a semiotic vector), the 'outsider/within' (a deconstructive vector), strategic essentialism, (a meta-ideologizing vector), 'womanism' (a moral vector) and as 'la conciencia de la mestiza', 'world travelling' and 'loving cross-cultures' (differential vectors).[7] Unlike Westerners such as Patrick Moynihan who argue that 'the collapse of Communism' in 1991 proves how 'racial, ethnic, and national ties of difference can only ultimately divide any society',[8] a differential form of oppositional consciousness, as utilized and theorized by a racially diverse US coalition of women of colour, is the

form love takes in the postmodern world.[9] It generates grounds for coalition, making possible community across difference, permitting the generation of a new kind of citizenship, countrywomen and men of the same psychic terrain whose lives are made meaningful through the enactment of the methodology of the oppressed.

Whether interfaces with technology keep cyborg politics in renewed contestation with differential (US Third World feminist and subaltern) politics is a question only the political and theoretical strategies of undoing apartheid – of all kinds – will resolve. The differential form of social movement and its technologies provide the links capable of bridging the divided minds of the First World academy, and of creating grounds for what must be considered a new form of trandisciplinary work that centres the methodology of the oppressed – of the subaltern – as a new form of post-Western empire knowledge formation that can transform current formations and disciplinizations of knowledge in the academy. As we shall see in the following analysis of Haraway's theoretical work, the networking required to imagine and theorize 'cyborgian' consciousness can be considered, in part, a technologized metaphorization of the 1970s under the rubric of US Third World feminism. However, such terms as 'difference', the 'middle voice', the 'third meaning', 'rasquache', 'la conciencia de la mestiza', 'hybridity', 'schizophrenia', and such processes as 'minor literature' and 'strategic essentialism' also call up and represent forms of that cyberspace, that other zone for consciousness and behaviour that is being proposed from many locations and from across disciplines as that praxis most able to both confront and homeopathically resist postmodern cultural conditions.

Donna Haraway: feminist cyborg theory and US Third World feminism

Haraway's essay 'Manifesto for Cyborgs' can be defined in its own terms as a 'theorized and fabricated hybrid', a 'textual machine', or as a 'fiction mapping our social and bodily reality', phrases which Haraway also calls upon in order to redefine the term 'cyborg', which, she continues, is a 'cybernetic organism', a mixture of technology and biology, a 'creature' of both 'social reality' and 'fiction'.[10] This vision that stands at the centre of her imaginary is a 'monstrous' image. Haraway's cyborg is the 'illegitimate' child of dominant society and oppositional social movement, of science and technology, of the human and the machine, of 'First' and 'Third' worlds, of male and female, indeed, of every binary. The hybridity of this creature is situated in relation to each side of these binary positions, and to every desire for wholeness, she writes, as 'blasphemy' (149) stands to the body of religion. Haraway's blasphemy is the cyborg, that which reproaches, challenges, transforms, and shocks. But perhaps the greatest shock in her feminist theory of cyborg politics takes place in the corridors of feminist theory, where Haraway's model has acted as a transcoding device, a technology that insists on translating the fundamental precepts of US Third World feminist criticism into categories that are comprehensible under the jurisdictions of Women's Studies.

Haraway has been very clear about these intellectual lineages and alliances. Indeed, she writes in her introduction to *Simians, Cyborgs and Women* that one primary aim of her work is similar to that of US Third World feminist theory and methods, which is, in Haraway's words, to bring about 'the break-up of versions of Euro-American feminist humanisms in their devastating assumptions of master narratives deeply indebted to

racism and colonialism'. (It might be noted that this same challenge, when uttered through the lips of a feminist theorist of colour, can be indicted and even dismissed as 'undermining the movement' or as 'an example of separist politics'.) Haraway's second and connected aim is to propose a new grounds for theoretical and political alliances, a 'cyborg feminism' that will be 'more able' than the feminisms of earlier times, she writes, to 'remain attuned to specific historical and political positionings and permanent partialities without abandoning the search for potent connections'.[11] Haraway's cyborg feminism was thus conceived, at least in part, to recognize and join the contributions of US Third World feminist theorists who have challenged, throughout the 1960s, 1970s and 1980s what Haraway identifies as hegemonic feminism's 'unreflective participation in the logics, languages, and practices of white humanism'. White feminism, Haraway points out, tends to search 'for a single ground of domination to secure our revolutionary voice' (160).

These are thus strong ideological alliances, and so it makes sense that Haraway should turn to US Third World feminism for help in modelling the 'cyborg' body that can be capable of challenging what she calls the 'networks and informatics' of contemporary social reality. For, she affirms, it has been 'feminist theory produced by women of color' which has developed 'alternative discourses of womanhood', and these have disrupted 'the humanisms of many Western discursive traditions'.[12] Drawing from these and other alternative discourses, Haraway was able to lay the foundations for her theory of cyborg feminism, yet she remains clear on the issue of that theory's intellectual lineages and alliances:

> White women, including socialist feminists, discovered (that is were forced kicking and screaming to notice) the non-innocence of the category 'woman.' That consciousness changes the geography of all previous categories; it denatures them as heat denatures a fragile protein. Cyborg feminists have to argue that 'we' do not want any more natural matrix of unity and that no construction is whole [157].[13]

The recognition 'that no construction is whole', however – though it helps – is not enough to end the forms of domination that have historically impaired the ability of US liberation movements to effectively organize for equality. And for that reason, much of Haraway's ongoing work has been to identify the additional technical *skills* that are necessary for producing this different kind of coalitional, and what she calls 'cyborg', feminism.

To understand Haraway's contribution, I want to point out and emphasize her correlation of these necessary skills with what I earlier identified as the methodology of the oppressed. It is no accident that Haraway defines, names and weaves the skills necessary to cyborgology through the techniques and terminologies of US Third World cultural forms, from Native American concepts of 'trickster' and 'coyote' being (199), to 'mestiza' or the category 'women of color', until the body of the feminist cyborg becomes clearly articulated with the material and psychic positionings of US Third World feminism.[14] Like the 'mestiza consciousness' described and defined under US Third World feminism which, as Anzaldua explains, arises 'on borders and in margins' where feminism which, as Anzaldua explains, arises 'on borders and in margins' where feminists of colour keep 'intact shifting and multiple identities' and with 'integrity' and love, the cyborg of Haraway's feminist manifesto must also be 'resolutely committed to partiality, irony, intimacy and perversity' (151). In this equivalent alignment, Haraway

writes, feminist cyborgs can be recognized (like agents of US Third World feminism) to be the 'illegitimate offspring,' of 'patriarchal capitalism' (151). Feminist cyborg weapons and the weapons of US Third World feminism are also similar with 'transgressed boundaries, potent fusions and dangerous possibilities' (154). Indeed, Haraway's cyborg textual machine represents a politics that runs parallel to those of US Third World feminist criticism. Thus, in so far as Haraway's work is influential in feminist studies, her cyborg feminism is capable of insisting on an alignment between what was once hegemonic feminist theory with theories of what are locally apprehended as indigenous resistance, 'mestizaje', US Third World feminism, or the differential mode of oppositional consciousness.[15]

This attempted alignment between US feminist Third World cultural and theoretical forms and US feminist theoretical forms is further reflected in Haraway's doubled vision of a 'cyborg world'. This might be defined, she believes, as either the culmination of Euro-American 'white' society in its drive-for-mastery, on the one hand or, on the other, as the emergence of resistant 'indigenous' world views of mestizaje, US Third World feminism, or cyborg feminism. She writes:

> A cyborg world is about the final imposition of a grid of control on the planet, about the final abstraction embodied in Star Wars apocalypse waged in the name of defense, about the final appropriation of women's bodies in a masculinist orgy of war. From another perspective a cyborg world might be about lived social and bodily realities in which people are not afraid of their joint kinship with animals and machines, not afraid of permanently partial identities and contradictory standpoints [154][16]

The important notion of 'joint kinship' Haraway calls up here is analogous to that called for in contemporary indigenous writings where tribes or lineages are identified out of those who share, not blood lines, but rather lines of affinity. Such *lines of affinity* occur through attraction, combination and relation carved out of and in spite of difference, and they are what comprise the notion of mestizaje in the writings of people of colour, as in the 1982 example of Alice Walker asking US black liberationists to recognize themselves as mestizos. Walker writes:

> We are the African and the trader. We are the Indian and the Settler. We are oppressor and oppressed . . . we are the mestizos of North America. We are black, yes, but we are 'white,' too, and we are red. To attempt to function as only one, when you are really two or three, leads, I believe, to psychic illness: 'white' people have shown us the madness of that.[17]

Mestizaje in this passage, and in general, can be understood as a complex kind of love in the postmodern world where love is understood as affinity–alliance and affection across lines of difference which intersect both in and out of the body. Walker understands psychic illness as the attempt to be 'one', like the singularity of Roland Barthes' narrative love that controls all meanings through the medium of the couple-in-love. The function of mestizaje in Walker's vision is more like that of Barthes' prophetic love, where subjectivity becomes freed from ideology as it ties and binds reality. Prophetic love undoes the 'one' that gathers the narrative, the couple, the race into a singularity. Instead, prophetic love gathers up the mexcla, the mixture-that-lives through differential movement between possibilities of being. This is the kind of 'love' that motivates

US Third World feminist mestizaje, and its theory and method of oppositional and differ-
ential consciousness, what Anzaldua theorizes as *la conciencia de la mestizo,* or 'the
consciousness of the Borderlands'.[18]

Haraway weaves such US Third World feminist commitments to affinity-through-
difference into her theory of cyborg feminism, and in doing so, begins to identify those
skills that comprise the methodology of the oppressed, as indicated in her idea that the
recognition of differences and their corresponding 'pictures of the world' (190) must
not be understood as relativistic 'allegories of infinite mobility and interchangeability'.
Simple mobility without purpose is not enough, as Gayatri Spivak posits in her example
of 'strategic essentialism' which argues both for mobility *and* for identity consolidation
at the same time. Differences, Haraway writes, should be seen as examples of 'elabo-
rate specificity' and as an opportunity for 'the loving care people might take to learn
how to see faithfully from another point of view' (190). The power and eloquence of
writings by certain US feminists of colour, Haraway continues, derives from their insis-
tence on the 'power to survive not on the basis of original innocence, (the imagination
of a "once-upon-a-time wholeness" or oneness), but rather on the insistence of the possi-
bilities of affinity-through-difference. This mestizaje or differential consciousness allows
the use of any tool at one's disposal in order to both ensure survival and to remake the
world. According to Haraway, the task of cyborg feminism must similarly be to 'recode'
all tools of 'communication and intelligence,' with one's aim being the subversion of
'command and control' (175).

In the following quotation, Haraway analyses Chicana intellectual Cherrie Moraga's
literary work by applying a 'cyborg feminist' approach that is clearly in strong alliance
with US Third World feminist methods. She writes:

> Moraga's language is not 'whole'; it is self-consciously spliced, a chimera of
> English and Spanish, both conqueror's languages. But it is this chimeric
> monster, without claim to an original language before violation, that crafts
> the erotic, competent potent identities of women of color. Sister Outsider
> hints at the possibility of world survival not because of her innocence, but
> because of her ability to live on the boundaries, to write without the founding
> myth of original wholeness, with its inescapable apocalypse of final return to
> a deathly oneness. . . . Stripped of identity, the bastard race teaches about
> the power of the margins and the importance of a mother like Malinche.
> Women of color have transformed her from the evil mother of masculinist
> fear into the originally literate mother who teaches survival [175–76].

Ironically, US Third World feminist criticism, which is a set of theoretical and method-
ological strategies, is often understood by readers, even of Haraway, as a demographic
constituency only ('women of colour', a category which can be used, ironically, as an
'example' to advance new theories of what are now being identified in the academy as
'postmodern feminisms'), and not as itself a theoretical and methodological approach
that clears the way for new modes of conceptualizing social movement, identity and
difference. The textual problem that becomes a philosophical problem, indeed, a polit-
ical problem, is the conflation of US Third World feminism as a theory and method
of oppositional consciousness with the demographic or 'descriptive' and generalized
category 'women of colour' thus depoliticizing and repressing the specificity of the
politics and forms of consciousness developed by US women of colour, feminists of

colour and erasing the specificity of what is a particular *form* of these: US Third World feminism.

By 1991 Haraway herself recognizes these forms of elision, and how by gathering up the category 'women of colour' and identifying it as a 'cyborg identity, a potent subjectivity synthesized from fusions of outsider identities' (i.e. Sister Outsider), her work inadvertently contributed to this tendency to elide the specific theoretical contributions of US Third World feminist criticism by turning many of its approaches, methods, forms and skills into examples of cyborg feminism (174). Haraway, recognizing the political and intellectual implications of such shifts in meaning, proceeded to revise her position, and six years after the publication of 'Cyborg Feminism' she explains that today, 'I would be much more careful about describing who counts as a 'we' in the statement 'we are all cyborgs'. Instead, she asks, why not find a name or concept that can signify 'more of a family of displaced figures, of which the cyborg' is only one, 'and then to ask how the cyborg makes connections' with other non-original people who are also 'multiply displaced'?[19] Should we not be imagining, she continues, 'a family of figures' who could 'populate our imaginations' of 'postcolonial, postmodern worlds that would not be quite as imperializing in terms of a single figuration of identity?[20] These are important questions for theorists across disciplines who are interested in effective new modes of understanding social movements and consciousness in opposition under postmodern cultural conditions. Haraway's questions remain unanswered across the terrain of oppositional discourse, however, or rather, they remain multiply answered and divided by academic terrain. And even within feminist theory, Haraway's own cyborg feminism and her later development of the technology of 'situated knowledges', though they come close, have not been able to effectively bridge the gaps across the apartheid of theoretical domains described earlier.

For example, if Haraway's category 'women of colour' might best be understood, as Haraway had earlier posited, 'as a cyborg identity, a potent subjectivity synthesized from fusions of outsider identities and in the complex political-historical layerings of her biomythography' (174), then why has feminist theory been unable to recognize US Third World feminist criticism itself as a mode of cultural theory which is also capable of unifying oppositional agents across ideological, racial, gender, sex or class differences, even if that alliance and identification would take place under the gendered, 'raced' and transnational sign 'US Third World feminism'? Might this elision be understood as yet another symptom of an active apartheid of theoretical domains? For, as I have argued, the non-essentializing identity demanded by US Third World feminism in its differential mode creates what Haraway is also calling for, a mestiza, indigenous, even cyborg identity.[21]

We can see Haraway making a very similar argument for the recognition of US Third World feminist criticism in her essay in *Feminists Theorize the Political*. Haraway's essay begins by stating that women who were 'subjected to the conquest of the new world faced a broader social field of reproductive unfreedom, in which their children did not inherit the status of human in the founding hegemonic discourses of US society'.[22] For this reason, she asserts, 'feminist theory produced by women of color' in the US continues to generate discourses that confute or confound traditional Western standpoints. What this means, Haraway points out, is that if feminist theory is ever to be able to incorporate the visions of US Third World feminist theory and criticism, then the major focus of feminist theory and politics must make a fundamental shift to that of making 'a place for the different social subject'.[23]

This challenge to feminist theory represents a powerful theoretical and political shift, and if answered, has the potential to bring feminism into affinity with such theoretical terrains as post-colonial discourse theory, US Third World feminism, postmodernism, and Queer Theory.

How might this shift be accomplished in the domain of feminist theory? Through the willingness of feminists, Haraway proposes, to become 'less interested in joining the ranks of gendered femaleness', to instead become focused on 'gaining the INSURGENT ground as female social subject (95)'.[24] This challenge to Women's Studies means that a shift must occur to an arena of resistance that functions outside the binary divide male/female, for it is only in this way, Haraway asserts, that 'feminist theories of gendered *racial* subjectivities' can 'take affirmative AND critical account of emergent, differentiating, self-representing, contradictory social subjectivities, with their claims on action, knowledge, and belief'.[25] Under this new form of what Haraway calls an 'anti-racism' indeed, even an *anti-gender* feminism, Haraway asserts, 'there is no place for women' only 'geometrics of difference and contradiction crucial to womens cyborg identities' (171).

It is at this point that Haraway's work begins to identify the specific technologies that fully align her theoretical apparatus with what I have called the methodology of the oppressed. How, then, might this new form of feminism, or what I would call this new form of oppositional consciousness, be brought into being? By identifying a set of skills that are capable of dis-alienating and realigning what Haraway calls the human 'join' that connects our 'technics' (material and technical details, rules, machines and methods) with our 'erotics' (the sensuous apprehension and expression of 'love'-as-affinity).[26] Such a joining, Haraway asserts, will require what is a savvy kind of 'politics of articulation', and these are the primary politics that lay at 'the heart of an anti-racist feminist practice'[27] that is capable of making 'more powerful collectives in dangerously unpromising times'.[28] This powerful politics of articulation, this new 'anti-racist' politics that is also capable of making new kinds of coalitions, can be recognized, argues Haraway, by identifying the 'skilled practices' that are utilized and developed within subaltern classes.

Haraway's theoretical work outlines the forms taken by the subjugated knowledges she identifies. These forms required, as she writes, 'to see from below', are particular skills that effect 'bodies', 'language' and the 'mediations of vision'. Haraway's understanding of the nature of these skills cleaves closely to those same skills that comprise the methodology of the oppressed, which include the technologies of 'semiotics', 'deconstruction', 'meta-ideologizing', 'democratics', and 'differential movement'. It is these technologies that permit the constant, differential repositioning necessary for perception and action from what Haraway identifies as 'the standpoints of the subjugated'. Indeed, Haraway's essay on cyborg feminism identifies all five of these technologies (if only in passing) as ways to bring about what she hopes will become a new feminist methodology.

Of the first 'semiotic' technology, for example, Haraway writes that 'self knowledge requires a semiotic-material technology linking meanings and bodies . . . the opening of non-isomorphic subjects, agents, and territories to stories unimaginable from the vantage point of the cyclopian, self-satiated eye of the master subject' (192). Though Haraway does not identify the technologies of 'deconstruction', or 'meta-ideologizing' separately, these two interventionary vectors are implied when she writes that this new contribution to social movement theory, cyborg feminism, must find many 'means of

understanding and intervening in the patterns of objectification in the world'. This means 'decoding and transcoding plus translation and criticism: all are necessary'. 'Democratics' is the technology of the methodology of the oppressed that guides all the others, and the moral force of this technology is indicated in Haraway's assertion that in all oppositional activity, agents for change 'must be accountable' for the 'patterns of objectification in the world' that have now become 'reality'. In this effort to take responsibility for the systems of domination that now exist, Haraway emphasizes that the practitioner of cyborg feminism cannot be 'about fixed locations in a reified body'. This new oppositional actor must be 'about nodes in fields' and 'inflections in orientation'. Through such mobilities, an oppositional cyborg feminism must create and enact its own version of, 'responsibility for difference in material-semiotic fields of meaning' (195). As for the last technology of the methodology of the oppressed, called 'differential movement', Haraway's own version is that cyborg feminism must understand 'the impossibility of innocent "identity" politics and epistemologies as strategies for seeing from the standpoints of the subjugated'. Rather, oppositional agents must be 'committed' in the enactment of all forms-of-being and all skills, whether those 'skills' are semiotic, 'decoding', 'recoding' or 'moral' in function, to what Haraway calls 'mobile positioning and passionate detachment' (192).

I have argued that the 'cyborg skills' necessary for developing a feminism for the twentieth century are those I have identified as the methodology of the oppressed. Their use has the power to forge what Haraway asserts can be a potentially 'earth-wide network of connections' including the ability to make new coalitions across new kinds of alliances by translating 'knowledges among very different – and power-differentiated – communities' (187). The feminism that applies these technologies as 'skills' will develop into another kind of science, Haraway asserts, a science of 'interpretation, translation, stuttering, and the partly understood'. Like the science proposed under the differential mode of consciousness and opposition – US Third World feminism – cyborg feminism can become the science of those Haraway describes as the 'multiple subject with at least double vision'. Scientific 'objectivity' under this new kind of science, writes Haraway, will mean an overriding commitment to a practice capable of facing down bureaucratic and administrative sciences, a practice of 'objectivity' that Haraway calls 'situated knowledges' (188). For, she writes, with the advent of US Third World feminism and other forms of feminisms, it has become clear that 'even the simplest matters in feminist analysis require contradictory moments and a wariness of their resolution'. A scholarly and feminist consciousness-of-science, then, of objectivity as 'situated knowledges' means, according to Haraway, the development of a different kind of human relation to perception, objectivity, understanding, and production, that is akin to Hayden White's and Jacques Derrida's use of the 'middle voice', for it will demand the scholar's situatedness 'in an ungraspable middle space' (111). And like the mechanism of the middle voice of the verb, Haraway's 'situated knowledges' require that what is an 'object of knowledge' also be 'pictured as an actor and agent' (198), transformative of itself and its own situation while also being acted upon.

In other words, Haraway's situated knowledges demands a form of differential consciousness. Indeed, Haraway names the third part of her book *Simians, Cyborgs and Women* 'differential politics for inappropriate/d others'. This chapter defines a coalescing and ever more articulated form of social movement from which 'feminist embodiment' can resist 'fixation' in order to better ride what she calls the 'webs of differential

positioning' (196). Feminist theorists who subscribe to this new postmodern form of oppositional consciousness must learn, she writes, to be 'more generous and more suspicious – both generous and suspicious, exactly the receptive posture I seek in political semiosis generally. It is a strategy closely aligned with the oppositional and differential consciousness'.[29] of US third world feminism.

It was previously assumed that the behaviours of oppressed classes depend upon no methodology at all, or rather, that they consist of whatever acts one must commit in order to survive, both physically and psychically. But this is exactly why the methodology of the oppressed can now be recognized as that mode-of-being best suited to life under postmodern and highly technologized conditions in the First World. For to enter a world where any activity is possible in order to ensure survival is also to enter a cyber-space-of-being and consciousness. This space is now accessible to all human beings through technology, (though this was once a zone only accessible to those forced into its terrain), a space of boundless possibilities where meanings are only cursorily attached and thus capable of reattaching to others depending upon the situation to be confronted. This cyberspace is Barthes' zero degree of meaning and prophetic love, Fanon's 'open door of every consciousness'. Anzaldua's 'Coatlique' state, and its processes are linked closely with those of differential consciousness.

To reiterate, the differential mode of oppositional consciousness finds its expression through the methodology of the oppressed. The technologies of semiotic reading, deconstruction of signs, meta-ideologizing, and moral commitment-to-equality are its vectors, its expressions of influence. These vectors meet in the differential mode of consciousness, carrying it through to the level of the 'real' where it can guide and impress dominant powers. Differential consciousness is itself a force which rhyzomatically and parasitically inhabits each of these five vectors, linking them in movement, while the pull of each of the vectors creates ongoing tension and re-formation. Differential consciousness can be thus thought of as a constant reapportionment of space, boundaries, of horizontal and vertical realignments of oppositional powers. Since each vector occurs at different velocities, one of them can realign all the others, creating different kinds of patterns, and permitting entry at different points. These energies revolve around each other, aligning and realigning in a field of force that is the differential mode of oppositional consciousness, a *Cyber-Consciousness*.

Each technology of the methodology of the oppressed thus creates new conjunctural possibilities, produced by ongoing and transforming regimes of exclusion and inclusion. Differential consciousness is a crossing network of consciousness, a transconsciousness that occurs in a register permitting the networks themselves to be appropriated as ideological weaponry. This cyberspace-of-being is analogous to the cyberspace of computer and even social life in Haraway's vision, but her understanding of cyberspace is more pessimistic: 'Cyberspace seems to be the consensual hallucination of too much complexity, too much articulation. . . . In virtual space, the virtue of articulation, the power to produce connection threatens to overwhelm and finally engulf all possibility of effective action to change the world.'[30] Under the influence of a differential oppositional consciousness understood as a form of 'cyberspace', the technologies developed by subjugated populations to negotiate this realm of shifting meanings are recognized as the very technologies necessary for all First World citizens who are interested in renegotiating contemporary First World cultures with what we might call a sense of their own 'power' and 'integrity' intact. But power and integrity, as Gloria Anzaldua suggests,

will be based on entirely different terms than those identified in the past, when, as Jameson writes, individuals could glean a sense of self in opposition to the centralizing dominant power that oppressed them, and then determine how to act. Under post-modern disobediencies the self blurs around the edges, shifts 'in order to ensure survival', transforms according to the requisites of power, all the while, under the guiding force of the methodology of the oppressed carrying with it the integrity of a self-conscious awareness of the transformations desired, and above all, a sense of the impending ethical and political changes that those transformations will enact.[31]

Haraway's theory weds machines and a vision of First World politics on a transna-tional, global scale together with the apparatus for survival I call the methodology of the oppressed in US Third World feminism, and it is in these couplings, where race, gender and capital, according to Haraway, 'require a cyborg theory of wholes and parts' (181), that Haraway's vision contributes to bridging the gaps that are creating the apartheid of theoretical domains. Indeed, the coding necessary to re-map the kind of 'disassembled and reassembled postmodern collective and personal self' (163) of cyborg feminism must take place according to a guide capable of placing feminism in alignment with other movements of thought and politics for egalitarian social change. This can happen when being and action, knowledge and science, become self-consciously encoded through what Haraway calls 'subjugated' and 'situated' knowledges, and what I call the methodology of the oppressed, a methodology arising from varying locations and in a multiplicity of forms across the First World, and indominably from the minds, bodies and spirits of US Third World feminists who have demanded the recognition of 'mesti-zaje', indigenous resistance, and identification with the colonized. When feminist theory becomes capable of self-consciously recognizing and applying this methodology, then feminist politics can become fully synonymous with anti-racism, and the feminist 'subject' will dissolve.

In the late twentieth century, oppositional actors are inventing a new name and new languages for what the methodology of the oppressed and the 'Coatlicue', differ-ential consciousness it demands. Its technologies, from 'signifyin' to 'la facultad', from 'cyborg feminism' to 'situated knowledges', from the 'abyss' to 'difference' have been variously identified from numerous theoretical locations. The methodology of the oppressed provides the schema for the cognitive map of power-laden social reality for which oppositional actors and theorists across disciplines, from Fanon to Jameson, from Anzaldua to Lorde, from Barthes to Haraway, are longing.

Originally published in C. Grey (ed.) (1995) The Cyborg Handbook, London: Routledge.
This essay has been edited for inclusion in the Reader.

Notes

1. Richard P. Appelbaum, 'New journal for global studies center', CORI: Centre for Global Studies Newsletter, vol. 1 no. 2, May 1994.
2. See 'U.S. Third World feminism: the theory and method of oppositional consciousness in the postmodern world', which lays the groundwork for articulating the methodology of the oppressed. Genders 10, University of Texas Press, Spring 1991.
3. Fredric Jameson, 'Postmodernism: the cultural logic of late capitalism', New Left Review No. 146, July–August, pp. 53–92.

4. *The Methodology of the Oppressed,* forthcoming, Duke University Press.
5. The term 'cybernetics' was coined by Narbert Wiener from the Greek word 'Kubernetics', meaning to steer, guide, govern. In 1989 the term was split in two, and its first half 'cyber' (which is a neologism with no earlier root) was broken off from its 'control' and 'govern' meanings to represent the possibilities of travel and existence in the new space of computer networks, a space, it is argued, that must be negotiated by the human mind in new kinds of ways. This cyberspace is imagined in virtual reality films like *Freejack, The Lawnmower Man* and *Tron.* But it was first termed 'cyberspace' and explored by the science fiction writer William Gibson in his 1987 book *Neuromancer.* Gibson's own history, however, passes through and makes invisible 1970s feminist science fiction and theory, including the works of Russ, Butler, Delany, Piercy, Haraway, Sofoulis and Sandoval. In all cases, it is this 'Cyberspace' that can also adequately describe the new kind of movement and location of differential consciousness.
6. For example, Nellie Wang, 'Letter to Ma', *This Bridge Called My Back;* Maria Lugones, 'World Traveling', Patricia Hill Collins, *Black Feminist Thought;* June Jordan, 'Where is the Love?,' *Hacienda Caros.*
7. It is through these figures and technologies that narrative becomes capable of transforming the moment, of changing the world with new stories, of meta-ideologizing. Utilized together, these technologies create trickster stories, stratagems of magic, deception and truth for healing the world, like Rap and CyberCinema, which work through the reapportionment at dominant powers.
8. *MacNeil/Lehrer NewsHour,* November 1991.
9. See writings by US feminists of colour on the matter of love, including June Jordan, 'Where is the love?', Merle Woo, 'Letter to Ma'; Patricia Hill Collins, *Block Feminist Thought;* Maria Lugones, 'Playfulness, "world-travelling", and loving perception'; and Audre Lorde, *Sister Outsider.*
10. Donna Haraway, *Simians, Cyborgs, and Women. The Reinvention of Nature,* (Routledge: New York, 1991), p. 150. All quotations in this section are from this text especially chapters eight and nine, 'A Cyborg Manifesto; Science, Technology, and Socialist-Feminism in the Late Twentieth Century' and 'Situated Knowledges: The Science Question in Feminism and the Privilege of Partial Perspective') unless otherwise noted. Further references to this work will be found in the text.
11. Ibid., p. 1.
12. Donna Haraway, 'Ecce Homo, ain't (ar'n't) I a woman, and inappropriate/d others: the human in a post-humanist landscape'. *Feminists Theorize the Political* in Judith Butler and Joan Scott (eds), (New York: Routledge, 1992) p. 95.
13. This quotation historically refers its readers to the impact at the 1970s US Third World feminist propositions which significantly revised the women's liberation movement by, among other things, renaming it with the ironic emphasis 'the *white* women's movement'. And perhaps all uncomplicated belief in the righteous benevolence of US liberation movements can never return after Audre Larde summarized 1970s women's liberation by saying that 'when white feminists call for unity' among women 'they are only naming a deeper and real need for homogeneity.' By the 1980s the central political problem on the table was how to go about imagining and constructing a feminist liberation movement that might bring women together across and through their differences. Haraway's first principle for action in 1985 was to call for and then teach a new hoped-for constituency, 'cyborg feminists', that 'we' do not want any more natural matrix of unity and that no construction is whole'.
14. See Haraway's 'The Promises of monsters', *Cultural Studies* (New York: Routledge, 1992) p. 328, where the woman of colour becomes the emblematic figure, a 'disturbing guide figure', writes Haraway, for the feminist cyborg, 'who promises information about psychic, historical and bodily formations that issue, perhaps from 'same other semiotic processes than the psychoanalytic in modern and postmodern guise' (306).
15. US Third World feminism recognizes an alliance named 'indigenous mestizaje', a term which insists upon the kinship between peoples of colour similarly subjugated by race in US colonial history (including, but not limited to, Native peoples, colonized Chicano/as, Blacks and Asians), and viewing them, in spite of their differences, as 'one people'.
16. Haraway's contribution here is to extend the motion of 'mestizaje' to include the mixture, or 'affinity', not only between human, animal, physical, spiritual, emotional and intellectual being

as it is currently understood under US Third World feminism, but between all these and the machines of dominant culture too.

17. Alice Walker, 'In the Closet of the soul: a letter to an African-American friend', *Ms. Magazine* 15 (November 1986): 32–35.

18. *Borderlands*, p. 77.

19. Constance Penley and Andrew Ross, 'Cyborgs at large: interview with Donna Haraway', *Technoculture,* (Minneapolis: University of Minnesota Press, 1991), p. 12.

20. Ibid, p. 13.

21. We might ask why dominant theoretical forms have proven incapable of incorporating and extending theories of black liberation, or Third World feminism. Would not the revolutionary turn be that theorists become capable of this kind of 'strategic essentialism?' If we believe in 'situated knowledges', then people of any racial, gender, sexual categories can enact US Third World feminist practice. Or do such practices have to be transcoded into a 'neutral' language that is acceptable to all separate categories, 'differential consciousness', for example, or 'cyborg-ology'?

22. Haraway, 'Ecce homo', p. 95.

23. Ibid.

24. The new theoretical grounds necessary for understanding current cultural conditions in the First World and the nature of resistance is not limited to feminist theory, according to Haraway. She writes, 'we lack sufficiently subtle connections for collectively building effective theories of experience. Present efforts – Marxist, psychoanalytic, feminist, anthropolitical – to clarify even "our" experience are rudimentary' (173).

25. Ibid, p. 96.

26. Haraway, 'The promises of monsters', p. 329.

27. Ibid.

28. Ibid., p. 319.

29. Ibid., p. 326.

30. Ibid., p. 325.

Cybersexual

DAVID BELL

INTRODUCTION

IN THE PREVIOUS SECTION, WE saw how cyberfeminists are rewiring questions of identity, embodiment and subjectivity in cyberculture, often stressing the liberatory potential of digital technology. The chapters in this section are concerned with the 'sexual liberations' offered by cyberspace – in terms of either so-called 'cybersex' or 'cyberqueer' experiences and uses of computer-mediated communication (CMC). The erotic possibilities of cyberspace have become prominent in academic discussion (and, indeed, in popular discourses, which have tended to focus on the prospect of virtual sex and the circulation of and access to pornographic materials on the Net), and the essays we have selected here cover quite different aspects of that discussion.

Gareth Branwyn's 'Compu-sex: erotica for cybernauts' is a good place to start, since it outlines current erotic uses of cyberspaces, offering an insight into the practices of compu-sex through his case study of InfoMart USA. What emerges is, as Branwyn says, a picture of a 'curious blend of phone sex, computer dating, and high-tech voyeurism'. What we also find in compu-sex environments is a complex cultural world with its own codes, norms and modes of behaviour – and maybe its own morality.

Discussions of the popularity of cybersex have tended to emphasize that it represents 'the ultimate safe sex for the 1990s, with no exchange of body fluids, no loud smoke-filled clubs, and no morning after' – a scenario captured in Arthur Kroker's evocative phrase 'sex without secretions'. Critics have pointed to the impersonality and anonymity of cybersex as problematic: that 'true' or 'real-life' identities can be hidden in cyberspace. As Daniel Tsang writes, 'it's good to have a dose of "healthy paranoia" on-line'. However, there is erotic potential to be found precisely in that anonymity, as Randal Woodland's discussion of the virtual backroom DhalgrenMOO shows. Another criticism frequently made against cybersex is that it involves little more than technologically-mediated masturbation. This perhaps explains the excitement over virtual sex and teledildonics. Here the sensuous body can play a more active role in cybersex, thanks

to the technology of virtual reality and some complex accessories (VR visors, data gloves, body suits; for a discussion, see Dery 1996; Rheingold 1991). However, Branwyn notes that teledildonics has thus far been hampered by a rather limited imagination, seeking to replicate in cyberspace somewhat conventional sexual scripts. This is, in fact, a criticism he levels at all forms of compu-sex currently operating, and his essay ends with a provocative question: 'What would an on-line sexual experience that moved entirely away from the old notions of a bodily and orgasmically focused sexuality be like?' This question also echoes through Sadie Plant's 'Coming across the future', which closes this section of the Reader.

The remaining four essays in this section deal with different aspects of the evolving cybercultures of sexual dissidents – short-handed by Nina Wakeford as 'cyberqueer'. Wakeford presents us with a comprehensive overview of the state of existing work on cyberqueer, structured around three questions: (i) what do gay, lesbian, transgender and/or queer cyberspaces look like?; (ii) what is their social, political and economic importance?; and (iii) what would be a critical reading of the themes in existing cyberqueer studies? The answer to the first question is that cyberqueer spaces are very diverse, fluid and complex. She guides us through the different kinds of spaces (newsgroups, bulletin boards, discussion lists, chat rooms, web sites), showing the kinds of queer cybercultural work that takes place there. The cautionary tone of her answer to question two reminds us to locate queer cyberspace within broader political, economic and social questions: a kind of queer take on Robins' 'Cyberspace and the world we live in' which stresses the need for cyberqueer studies to remember the economic and structural constraints of cyberspace alongside their symbolic dimension. Cyberqueer spaces, for example, are especially vulnerable to moral-panic-induced censorship, while the whole enterprise of cyberspace remains linked to capital in ways which can freeze out queer appropriation and participation (see also Case 1996). The consumption of queer cyberspaces must, in Wakeford's analysis, be read alongside the conditions of their *production*.

Wakeford's exploration of the political, social and economic dimensions of cyberqueer mirrors broader criticisms made about queer theory (see Bell and Binnie 2000). This link recurs in Wakeford's discussion of 'cyberqueer studies', where the dominant queer theory motifs – performativity, fluidity, parody – are imported into discussions of 'identity play' in cyberspace. Again, Wakeford is cautious about the celebration of identity play, especially in relation to other forms of social identity (notably 'race' and ethnicity; see also Foster and Tsang in this section), echoing other critical responses to the question of embodied experience on- (and off-) line. These cautions noted, we can nevertheless conclude, as Wakeford does, that cyberqueer spaces do offer new terrains for the development of sexual identities and communities (see also Shaw 1997), as well as for the further development of queer and cybertheory.

Randal Woodland's essay concentrates on what we might call 'queer world-making' in cyberspace. His reading of four distinct US-based queer cyberspaces focuses on the spatial imagery constructed within such virtual worlds, producing a cartography of sexual spaces on-line. The four systems in his study – America Online (a large commercial system which includes lesbian and gay spaces), ModemBoy (a private bulletin board [BBS] modelled on a gay high school), ISCA (a student BBS with some lesbigay spaces), and LambdaMOO (a text-based virtual reality [VR] system) – all deploy particular

cartographies which help to structure their queer contents. In large systems such as America Online, queer interests are slotted in among numerous other 'subcultural' sites, whereas a system such as ModemBoy is exclusively oriented for queer users, and this obviously impacts on the kinds of cyberqueer activities that take place there. There are arguments both for and against each kind of system: presence on large commercial systems avoids ghettoization, yet the space may be less 'safe' than small-scale private BBS catering specifically for cyberqueers. On America Online, for example, official queer space is accessed through a menu of 'clubs and interests', problematically locating sexuality as something akin to a hobby.

More important for Woodland than the location of queer space within these systems is the way in which they construct the relationship between sexual identity and space. At one level, he shows how space impacts on the discursive modes of the systems (especially in relation to 'appropriate' and 'inappropriate' discussions) – and thus how 'the creators of these spaces intend to summon forth . . . particular identities, shaped and given life by these peculiar geographies'. Space shapes identity, therefore, as much as identity shapes space; as Woodland writes, 'the kinds of queer spaces that have evolved to present queer discourse can be taken as measure of what queer identity is in the 1990s'. So debates which have raged in lesbian and gay culture – for example over transgendered and bisexual presence in queer space – also emerge in cyberqueer sites.

As we have already noted, the issue of privacy has long been central to discussions of cyberqueer sites. While this is enabling to many users, it always raises questions about who is *really* logging on. Daniel Tsang discusses this from a number of different angles in his account of his own experiences of BBSing, 'Notes on queer 'n' Asian virtual sex'. Early on in the essay, he recounts the story of a college student he had met on-line; Tsang called up his college, only to find that the student did not exist. Who *had* he chatted to? The flipside to this is, of course, the freedom to experiment: 'the on-line environment allows one to continually reinvent one's identity, including the sexual. For once, you are in complete control of your sexual identity, or identities, or at least what you decide to show the outside world.' Critiques of queer theory have pointed out that the pleasure in authoring identity performatively must be seen alongside questions of audience reception (see Foster), and the apparent contradiction in Tsang's discussion makes that even clearer: to play with our own identities on-line offers liberation, but when others do it we might see it as deceit (as he notes, since on-line biographies can be works of fiction, 'all the posted information [on BBS] should be taken with a grain of salt').

Of particular interest to Tsang in this regard is the question of 'passing' on-line. He expresses surprise that few of the Asian posters on the BBS identify as straight, and also looks for evidence of what Nakamura calls 'racial passing' (see section nine). This leads him into a broader discussion of the sexual politics of 'race' in the US queer scene, and to the conclusion that cyberspace offers opportunities for Asians and Pacific Islanders in the US to challenge many of the prevailing notions about their sexualities; coming out on a BBS, for example, is for many people an important stage in defining their sexual identity. While it is not, in Tsang's opinion, the same as coming out off-line (since it is anonymous), it makes cyberqueer spaces an immensely valuable resource for the sexually marginalized.

It is instructive to read Tsang's essay alongside Thomas Foster's '"Trapped by the body"?', which also raises important questions about queer performativity in cyberspace. Foster's essay critically reads a number of feminist and lesbian cyberpunk imaginings of the possibilities of identity-play in cyberspace and VR, asking the question: 'To what extent do theories and practices of subversive mimicry and performativity, such as drag and butch-femme, function as a cultural framework for constructing the meaning of virtual reality and telepresence technology?' Echoing Tsang's comments, he notes early on that '[t]ransgendered bodies and perfomances do in fact seem to be increasingly naturalized in computer-mediated communication and in popular narratives about it, in ways that transracial bodies and performances are not', and he sets about exploring the ways in which tropes of queer performativity – especially those theorized by Judith Butler – are worked through in cyberpunk fiction. By adding in Sandy Stone's (1995) work on embodiment in virtual systems theory, Foster arrives at 'a theory of sexual and gender identities and performances as prosthetic' (see also Stryker in section seven).

Foster's reading of Melissa Scott's novel *Trouble and her Friends*, about queer hackers, also raises some of the issues discussed by Wakeford and by Woodland, since Foster writes that the novel suggests that 'the liberation made possible by computer interfaces may be purchased only at the cost of ghettoizing or reclosing subversive gay performances in cyberspace, where they will have no effect on social relations more generally'. So, while cyberspace is in some ways liberatory, we must always remember that it is a particularly 'privileged gay performance space' (which therefore limits its impact to a distinct social milieu), and that it can in fact act as a kind of closet (though, as Tsang notes, we can see cyberspace as a valuable first step for queers, in coming out for example). Towards the end of the essay, Foster similarly reiterates Tsang's point about the relative absence of discussions of 'transracial' performance in the writing he focuses on. He speculates, ultimately, that the politics of transracial performance (with its legacy in things like blackface minstrelsy) make it less open to subversive appropriation in cyberspace (see Nakamura, section nine).

The future of 'virtual sex' – first encountered in Gareth Branwyn's essay at the start of this section, and woven through the cyberpunk writing that Foster discusses – reappears in the last: Sadie Plant's 'Coming across the future'. Stirring together dystopian cyberpunk with heavy-duty theory, Plant rewires cybersex in a chaotic, polymorphous universe. Quoting McLuhan, she writes that the human species has become 'the sex organs of the machine world', and her rhizomatic reading scours past, present and future to find the answer to Branwyn's question, cited earlier: can we detach cybersex from the dominant scripts that confine our sexual imaginations? A part of Plant's answer comes from making connections between cybernetic sex and sadomasochism (SM); taking her cue from SM writer Pat Califia, she redefines the orgasm as 'an intensity uncoupled from genital sex and engaged only with the dismantling of selves'. This stands up as a definition of cybersex, too: 'a matter of careful engineering, the setting of scenes, the perfection of touch; the engineering of communication'. For Plant, the flow of desire through SM scenes (especially as described by Califia and by Michel Foucault) mirrors the 'pulsing network of switches' in cybernetic sex. Freed from the ejaculatory teleology that still haunts teledildonics, Plant's vision of cybersex is as a posthuman erotics; she quotes Foucault biographer David Macey: 'the body becomes an overall site of overall pleasure'.

In part, then, Plant is offering a critique of existing ways of seeing compu-sex as 'safe': 'cybernetic sex and all that it implies are about as cosy and containable as the virtual war of which it is already a side-effect'. And the last sentence of her essay notes that '[o]nce you know it's a video game, it gets much harder to play along'. By recasting cybersex away from teledildonics and towards the polymorphous perversity of posthuman pleasures, Plant's essay works as a useful counter to the other essays in this section, and some in other sections, too. For while the arguments about queer cyberspace, identity play and virtual sex ask that we interrogate more carefully the utopian promises of compu-sex, 'Coming across the future' suggests a rewiring of the sexed body itself. The following two sections of *The Cybercultures Reader* add to that agenda, considering ways in which the body gets worked over in cyberspace.

References

Bell, D. and Binnie, J. (2000) *Hard Choices: Sexual Citizenship After Queer Politics*, Cambridge: Polity.

Case, S. (1996) *The Domain-Matrix: Performing Lesbian at the End of Print Culture*, Bloomington: Indiana University Press.

Dery, M. (1996) *Escape Velocity: Cyberculture at the End of the Century*, London: Hodder & Stoughton.

Rheingold, H. (1991) *Virtual Reality*, London: Mandarin.

Shaw, D. (1997) 'Gay men and computer communication: a discourse of sex and identity in cyberspace', in S. Jones (ed.), *Virtual Culture: Identity and Communication in Cybersociety*, London: Sage.

Stone, A. R. (1995) *The War of Desire and Technology at the Close of the Mechanical Age*, Cambridge: MIT.

GARETH BRANWYN

COMPU-SEX
Erotica for cybernauts

Cyberspace is more than a breakthrough in electronic media or in computer interface design. With its virtual environments and stimulated worlds, cyberspace is a . . . tool for examining our very sense of reality.

(Michael Helm)[1]

I N A N E N D U R I N G R I T U A L O F nightly 'cruising', a crowd of people has gathered in a lonely-hearts club. A man musters up the courage to approach a woman and fires off a few of his best one-liners. She takes the bait and tugs the line with some sexy retorts of her own. The chemistry is right; things heat up. They are soon jarred back to reality by the teasing of those around them who've caught on to their little game. Embarrassed, they quickly pass notes and plan a late-night rendezvous. Both show up punctually at the private place they have chosen. An awkward silence is broken by more provocative flirting, and then, finally, what they've both come for: sex. They quickly undress one another and begin making frantic love. The exchange is short but intense. When they're finished, they swap a few nervous pleastantries. As each of them chooses 'Quit' from a menu of options on a computer screen, a cheap digitized voice says 'good-bye'. The telephone link between their computers is disconnected. Tonight's disembodied tryst has cost each about six dollars.

Welcome to the world of on-line computer sex, or 'compu-sex'. Every computer information service, large or small, has lurking within its bits and bytes an active subculture of users engaged in text-based sexual exchanges. These encounters rarely carry over into face-to-face meetings. Rather, the participants are content to return night after night to explore this odd brand of interactive and sexually explicit storytelling. Compu-sex enthusiasts say it's the ultimate safe sex for the 1990s, with no exchange of bodily fluids, no loud smoke-filled clubs, and no morning after. Of course, there's no physical contact, either. Compu-sex brings new meaning to the phrase 'mental masturbation'.

There are two types of network in cyberspace: research and education systems, such as Bitnet and USENET, and commercial services, such as Prodigy, CompuServe, and GEnie. Local electronic bulletin board systems (BBSs), the one-horse towns of cyberspace, are usually not connected to a larger network. Their offerings are more modest, with discussions devoted to local and national issues and libraries of public domain software. Local and national 'Adults Only' BBSs are also common and cater to those who want to exchange computer-based pornographic images, talk about sex, and arrange 'face-to-face' dates. For the purposes of this chapter, I will focus on one commercial service in particular. Although a lot of the conversational technology (the network's software and its rules of on-line etiquette) described here is specific to that service, the phenomenon of compu-sex is common to all commercial and non-commercial networks and to most local BBSs. It simply changes form to fit the modes of communication available.

While each service has its own approach to presenting its offerings and provides different schemes for navigating through them, commercial information services are usually divided into a series of small domains or conferencing areas. The user either chooses options from a menu or clicks on icons that represent areas of interest. Most services offer standard features, such as news, business information, electronic shopping and banking, entertainment areas (movies, sports, trivia), and a host of issue-related forums. On the larger services, these forum areas can feature lively public debates. Protracted and volatile disputes (called 'flame wars' in network slang) are common. Each service also provides electronic mail capabilities and vast libraries of information, either data that can be searched on-line or programs that can be transferred to the user's computer. Commercial networks usually have a set monthly fee and an hourly usage rate. Users who conduct business on-line or who use the networks as their primary social, sexual, and/or recreational outlet can run up staggering bills (a hundred dollars a month or more is not uncommon).

> Drinks (alcoholic and non-) shall pour from the bar, exotic coffees will flow from the pot, and every imaginable and unimaginable flavor of ice cream shall be yours for the dipping . . . Furthermore, while ace electronic chef Ingmar Vanderplotz takes a well-deserved night off, the buffet table will be laden with vats of Granny Santini's No-Holds-Barred Chili, a product of yours truly, your genial host, Steve Glaser. Chili available in Mild, Medium, Hot, and The-Stuff-They-Use-To-Launch-The-Saturn-Five's.
>
> (Excerpt from invitation to a virtual salon for writers)

On 'InfoMart USA' (a pseudonym for the network on which I spent most of my time while researching this article), one of the most popular features is the public chat areas, called 'rooms'.[2] Users are able to view a list of rooms that have been created by other users. The conversational theme of each room, embodied in its name, runs the gamut of possible interests from politics ('Boomers in the White House' and 'Women in Politics'), to teen concerns ('Beverly Hills 90210', 'Alternative Music', 'Teen Club'), to religion and ethics ('Mormons On-Line', 'Sanctuary', 'Pro-Choice Forum'). By far the single largest theme represented in the room titles, however, is sex. On a given night, the list might include 'Naughty Negligees', 'Men for Men', 'Hot Bi Ladies', 'Women Who Obey Women', and so forth. After deciding which conversation one wishes to join, the user chooses that room from the menu and 'enters' by clicking on

its name. The room appears on the user's screen as a pop-up window. A list of other occupants is shown at the top and what people are saying appears in a box inside the room window. To contribute to the conversation, an occupant types comments into a small text-entry box at the bottom of the computer screen, then hits a 'Send' button to post it. Engaging in this type of conversation is a bit unnerving at first. The pace of the conversation has a dreamlike quality to it. The exchanges can move in slow motion for a long time, then suddenly spring to life as several people post messages that appear on-screen at the same time. Words start scrolling across one's screen faster than they can be read. Then, as quickly as the room exploded with dialogue, it settles back into silence. If nothing is said for several minutes, occupants get bored and leave in droves. When a room's population is reduced to zero, it is automatically removed from the room's menu. Rooms 'pop' into existence and quickly fill up with enthusiastic conversationalists, only to die a few minutes later, instantly replaced by other rooms. Jumping in and out of these rooms, passing other digital personae as they come and go, one begins to feel like a character in a cyberspace version of a Marx Brothers movie.

> In compu-sex, being able to type fast and write well is equivalent to having great legs or a tight butt in the real world.
>
> (Anonymous compu-sex enthusiast)

Compu-sex is a curious blend of phone sex, computer dating, and high-tech voyeurism. To 'cruise' on InfoMart USA one must process a dizzying amount of data. While hopping in and out of different chat rooms, one is also looking up bios, exchanging messages with compu-sex 'prospects', even tracking people's comings and goings through the Net. If someone leaves a room, one can choose a 'Find' feature and the system will report on that person's whereabouts within the system. It's not uncommon to have five or six 'windows' of data on-screen at the same time. Time on-line is expensive, so users need to 'score' as quickly as possible. In cyberspace, good library skills are as handy as good pick-up lines. When a possible compu-sex partner has been found, a few flirtatious lines are sent via 'Private Messages' (imagine electronic Post-its). If these exchanges bear fruit, one partner pops the big question: 'Wanna go private?' A private room is created by clicking on the 'Create Private Room' button and assigning a code name to it. Once the private room has been created, private messages are sent to one's partner(s), telling them the room's name/password. The room's creator then sits back and waits for the other chat enthusiast(s) to arrive. A wide variety of sexual orientations and forms of compu-sex are represented in these private rooms. Gay, straight, bi, swinging couples, orgy goers, cross-dressers, and such outré orientations as 'Leg Brace Enthusiasts' and 'Hot Denture Wearers' have all found niches on InfoMart.

The public chat rooms on InfoMart are closely monitored by 'guides' who are on the lookout for conversations deemed inappropriate for public consumption. These guides are nicknamed 'cybercops' and are often treated with contempt by 'residents' of the more sexually oriented public rooms. The words 'Sleepy Time' or a series of 'z's' ('zzzzzzzzzz') are sometimes typed on-screen by a user to warn other occupants to stop talking openly about sex while the guide is in the room. Since the guide is making rounds and has many more rooms to visit, sooner or later, he has to move on. When he does, people will make comments like 'Whew, they're gone. . . . That was close', or 'Don't they have anything better to do than make our lives miserable?' The conversation soon continues where it left off before the guide entered. If a guide finds the title

of a room offensive, or the tenor of the conversation within it outside the system's *User's Guidelines,* he or she will close the room down. Individuals who get testy with a guide in public can have their membership suspended. Guides, who are enlisted from the regular InfoMart citizenry in exchange for free on-line time, have vastly different standards of what constitutes an infringement of the nebulous guidelines. One night, an overzealous guide killed a room called 'Pictures'. Everyone was busy talking about such mind-numbing topics as image-exchange formats and graphic-conversation schemes when the room was shut down. Apparently, the guide thought it was one of the porn-image swaps that are common in the public areas (the swapping of electronically scanned images actually takes place through private messages and mail transfer). Many of the participants, some totally ignorant of the sexual underground that exists on InfoMart, were bewildered as to how 'Pictures' could possibly have constituted a guidelines violation.

The conversations that take place within private rooms are strictly confidential. Not even the system's administrators have access to them. To find out what actually takes place in these rooms, I sent a questionnaire to compu-sex enthusiasts, opened up several discussion topics on InfoMart and on another popular network, interviewed dozens of people via phone and electronic mail, and even tried some private-room encounters myself. While only ten questionnaires were returned, I gathered enough additional information through other means to gain at least a basic understanding of how compu-sex works. Respondents to the questionnaires, interviews and on-line discussions identified three different types of sexual encounters in which they had been involved on-line.

The most commonly reported form of compu-sex is one in which participants describe and embellish real-world circumstances: how they look, what they're wearing, what they're doing. ('I'm in my room at the computer screen. I'm taking my shirt off. I'm touching myself now.') Of course, none of the parties involved in a compu-sex encounter know if the other participants are *really* doing what's being described. Most interviewees said they've tried it both ways: actually do everything they say they're doing, and just typing the words. One woman said she couldn't wait for speech recognition typing (the computer translates speech directly into text) so that she could have 'hands-free' compu-sex: 'It's so hard to type with one hand.'

The second type of interaction involves the creation of a pure fantasy scenario ('We're in a health club doing our workouts, only we're both totally nude'). This form is similar to fantasy role-playing games (such as Dungeons and Dragons), where each participant's fantasies are tailored to fit the collective story being created by all the players. Interactions of this type are common for group compu-sex. Keeping track of the action in these 'orgy' situations can quickly get out of hand as participants simultaneously post descriptions, some of which will inevitably contradict other descriptions. To make this work effectively, all parties involved must work creatively around any discrepancies so that the eroticism and consistency of the storyline can be maintained. For example, during an on-line orgy of six participants, someone with the screen name BethR types: 'I'm climbing on top of Roger104,' not noticing that Roger104 has just stated that he is having sex standing up, in the corner, with Nina5. To work around this story 'violation', Roger104 might type: 'Nina5 and I get so worked up, we roll onto the floor. As Nina5 falls off me, the always randy BethR, not missing a beat, climbs on top of me.' Then, to totally tidy things up, Nina5 adds: 'I begin to make out with

BethR and to massage her breasts while she rides Roger104.' This give-and-take story-building process occurs in all on-line sex encounters regardless of style or number of partners. Multi-participant encounters were described as particularly difficult, however, since larger numbers of people are making things up simultaneously. Interactional 'train wrecks' are common.

The third variety of on-line sex might be called 'tele-operated compu-sex'. Tele-operation usually refers to the remote control of a robot or a computer. Here, one party (an individual or a couple) gives actual lovemaking instructions over the computer to another party ('Jim, I want you to slowly undress Carol'). This format is popular with couples who want to swing on-line. Many of these couples claim they are completely monogamous in real life. Through these anonymous, long-distance encounters, they can swing without risking any involvement or disease. The total anonymity of services like InfoMart provides a safety net for this type of sexual experimentation. If someone were to get too emotionally involved and seek to bring the virtual relationship into the real world, the other parties involved could simply delete their current screen personae and create new ones, thereby ensuring anonymity.

Besides the three varieties of compu-sex outlined above, there are also tamer versions of on-line romance that use the same conversational tools (public chats, private messages, and private rooms). Several people said they don't act out sex on-line, but instead talk openly about their sex lives and specific sex problems, using the on-line discussions as informal counselling. Others, especially the teens on InfoMart, are content to flirt in both public and private areas without taking the conversation to an overtly sexual level. One of the most popular features in the InfoMart chat area is the Romance Room, where people flirt and exchange the kind of sickly sweet dialogue found in grocery store romance novels.

> [C]ybernetic identity is never used up – it can be re-created, reassigned, and reconstructed with any number of different names and under different user accounts.
>
> (Andrew Ross)[3]

On InfoMart USA people don't have to be who they are in the real world. Age, gender, sexual preference, life circumstances, everything one claims can be true or made up. While many networks have policies that try to discourage 'phony' user accounts, InfoMart lets users set up several different accounts with different names and bio files. Under these 'screen names', one can say and be anything as long as it doesn't violate the (virtual) community standards that have been established by InfoMart. Obviously, this freedom to role-play with little real-world consequence is, in large part, why compu-sex flourishes on this particular network. Making it up, making oneself up, is a crucial part of the turn-on.

Unfortunately, the freedom to hide behind a phony name also contributes to a plague of on-line sexual harassment and rampant rudeness. A number of women I talked to in the public forums said they were constantly bombarded with crude private messages and sexual advances. These women said that they did not engage in on-line sex, did not frequent sexually oriented public areas, and did not want to be approached via private messages. 'If you have a female screen name and you enter the general chat area, you're gonna get hassled,' said one woman. It seems as though compu-sex mediates but does not change behaviour, and it may even provide a new space for sexist aggression. This

harassment has caused some women to avoid the chat areas completely and others to cancel their memberships altogether.

At the same time, anonymity, while seeming to encourage rude on-line behaviour in some, has been liberating to others who wish to experiment with more benign on-line personae. Several interviewees who claimed that they were completely heterosexual in the real world said they had tried same-sex encounters just to see what it was like (or, at least, the people with whom they had their encounters *said* they were the same sex). Almost everyone who answered the sex questionnaire said that different person-alities and sexual orientations had been experimented with, at least on occasion. The fact that there are no certainties of gender and character on InfoMart is extremely unnerving to some participants. In the public rooms (and I suspect in private rooms as well), heated disputes frequently break out over someone's alleged gender. Elaborate measures are sometimes proposed that involve phone voice verification, character refer-ences ('I've met HotPants and she's *definitely* a girl!'), fax transmission of photos, and the electronic exchange of scanned photos. Of course, everything short of a face-to-face meeting is still open to question. In the end, all stated descriptions must be assumed to be in quotation marks. Interestingly, while most of the people I talked to use fantasy personae on occasion, more than half reported that they basically 'stick to the facts'. 'I find it much more of a turn-on to think that someone is aroused by the real me,' said one respondent. But that 'real me' is always, must be, narrated, put into 'story', typed into the system. It's only as 'true' as the story it tells at the moment.

> There was a young man named Racine,
> who invented a fucking machine.
> Concave or convex, it fit either sex,
> and was exceedingly simple to clean.
>
> (Traditional limerick)

The last item on my questionnaire concerned the future evolution of compu-sex: where was it headed, how would technology change it, how might the level and quality of people's interactions change? The answers I received were solely concerned with the introduction of virtual reality technology into the realm of computer networking. Respondents spoke of this inevitable marriage of computer networking and VR as over-coming the limited bandwidth (range of possibilities) of current text-based computer sex.

The area of VR that deals with sexual prosthesis is often called 'teledildonics'.[4] The phallocentrism of the term is indicative of the way people have so far visualized Net sex as a substitute for traditional 'real-world' intercourse. With teledildonics, instead of a penis penetrating a vagina, the real-world penis is 'invaginated' by the computer through means of a data-sensing 'condom' or the vagina is penetrated by a dildo-like input/output device that reads and responds to the vagina. Sensors and responders ('tactile effectors') would work in tandem to simulate intercourse. The user's partner (or partners), also dressed in VR sex gear and connected via phone, would appear in the head-mounted display as they wanted to be seen. Participants would construct desir-able data forms for their partners to interact with. One person's virtual touch would trigger the effectors in a partner's 'data suit,' simulating the sensation of physical contact. Compu-sex enthusiasts would meet in a private room in cyberspace, much as current partners meet in a 2-D 'space' that gains its dimensionality only through storytelling.

Sexual interaction in current text-based compu-sex almost exclusively mirrors (at least as it was reported to this author) real-world intercourse. Participants begin with foreplay and progress through increasing levels of (spelled out) intensity ending with an on-line orgasm. An on-line orgasm looks like something out of a comic book, with drawn-out ohhhhhh's, ahhhhhhhhh's, WOW!!!'s, and the obligatory 'I'mmmm comm-mmmmmmminnngggggggg!!!!!!' Not surprisingly, orgasms are usually simultaneous. Who wants to tell the story any other way?

> The boundary-maintaining images of base and superstructure, public and private, or material and ideal never seemed more feeble.
>
> (Donna Haraway)[5]

Several questions still remain: how will more sophisticated compu-sex technology change the nature of virtual sex? Will on-line sex become a satisfying substitute for sex in the real world? What impact will all forms of computer-mediated relationships have on face-to-face relationships as virtual communities develop a wider spectrum of interactional possibilities? Is this line of questioning even relevant anymore? As more people spend greater amounts of their time in cyberspace and come to identify themselves increasingly with their various cyber-constructs and non-physical relationships, won't the boundaries between 'real' and 'imaginary' have less practical significance? And, as we immerse ourselves more deeply in the complex artificial worlds of cyberspace, what wholly new forms of interaction and 'dwelling' might develop? What would an on-line sexual experience that moved entirely away from the old notions of a bodily and orgasmically focused sexuality be like? Would it in fact transcend the boundaries of bodily encapsulation and enter some new realm where the body is shed altogether?

When we conceive of activity in cyberspace, we can't help but superimpose old technological and spatial models and behaviours onto this new domain (in much the same way that early television was essentially radio theatre in front of a camera). Every aspect of virtual 'residency' offers fascinating, fertile ground for examining issues of embodiment and disembodiment, authenticity and artificiality, biological gender and gender role-playing, information ownership and free access. Almost all of these issues converge in computer sex. How compu-sex will evolve is an open question. That it will thrive and develop novel ways of gratifying erotic desires is almost certain.

Originally published in M. Dery (ed.) *Flame Wars: The Discourse of Cyberculture*, Durham: Duke University Press.
This essay has been edited for inclusion in the Reader.

Notes

1. Michael Heim, 'The erotic ontology of cyberspace', in Michael Benedikt (ed.), *Cyberspace: First Steps* (Boston: MIT Press 1992), p. 59.
2. For reasons of privacy, I decided not to give the real name of the computer service. This compu-sex culture is very underground (even many of the regular users on the service don't know of its existence), and it is always on shaky ground with the system's management. The service tolerates the sex subculture, probably because it brings in big revenues, but management fears that awareness of the subculture's existence might turn off the main population of InfoMart, which it describes as 'family-oriented.'
3. Andrew Ross 'Hacking away at the counterculture', in Constance Penley and Andrew Ross (eds), *Technoculture* (Minneapolis, University of Minnesota Press, 1991), p. 120.
4 Howard Rheingold, *Virtual Reality* (London, Seiter & Warburg, 1991), pp. 345–53.
5. Donna Haraway, *Simians, Cyborgs, and Women* (New York, Routledge 1991), p. 165.

NINA WAKEFORD

CYBERQUEER

> All the world, in feminist and Queer Theory, it would seem, is no longer a stage, but a screen.
>
> (Sue-Ellen Case 1995)

> The queer Oz, cyberqueerdom, lesbigay digitopia – this new space invites everyone who steps on its shores to coin new names. Most of us just call it 'the net' and take the on-line world for granted after a few tours.
>
> (Jeff Dawson 1996)

WHY IS THE INTERNET OF ANY relevance to the study of sexuality, and in particular the lives of lesbians, gay men, transgendered peoples and those living under the terminology of queer? Whatever the label – the Internet, Net, cyberspace, on-line world – the recent development of resources and communication channels enabled by global networks of computers has generated intense excitement or panic for communities and governments, popular media and commentators within academia. In this chapter I will discuss how and why new information and communication technologies have been created, promoted and studied by those who subvert the norms of heterosexuality. It is through their actions that the term 'cyberqueer' makes sense.

What do lesbian, gay, transgender and/or queer cyberspaces look like?

Just try it. This incitement permeates much of the writing which describes lesbian, gay, transgender and queer cyberspace. The message, from eulogizing testimonies of on-line experiences in popular print media such as *Gay Times, Diva, The Advocate, The Pink Paper, Girlfriends,* to anecdotal tales of love found or lost in electronic encounters, is that anyone

who has not yet encountered the worlds of cyberspace cannot know the wonders which await them: the realization of global community! the remaking of queer identity! the discovery that whichever subculture of a subculture you inhabit, there will be a Web page, or discussion group, or real-time chat room just for your kind!

This view is exemplified by such publications as *Gay and Lesbian On-line: The Travel Guide to Digital Queerdom on the Internet, the World Wide Web, America Online, Compuserve, plus BBSs Coast to Coast* (Dawson 1996). Dawson begins his book by attempting to draw parallels between a 'real' lesbian and gay world and an on-line realm which awaits exposure:

> If you have ever stepped off the ferry on to Fire Island or pulled into Provincetown or any other gay and lesbian enclave, you know the feeling. It's as if a desert dweller had walked through a magical wall into lush tropics. The natives seem exotic and utterly normal. That's what this book is, a door opening into a world where gays and lesbians are the natural majority.
>
> (Dawson 1996: 1)

While noting in passing the assumption of geographically and economically situated cultures of American gay and lesbian life which make this analogy work for Dawson (could Blackpool and Brighton really be substituted?), and the basis of native/exotic/other which functions as a foil to the normality which is revealed as we realize that 'they' are 'us', the key manoeuvre is his suggestion that entering cyberspace can be compared to arriving in an existing place where not only will we feel at home, but we are even the 'natural' majority.

The encouragement to experience cyberspaces at first hand and to assess for oneself their importance relative to other lesbian, gay, transgender and queer cultural representations, is a position with which many working in the field are broadly sympathetic, with one key proviso: access.

Just as Fire Island and Provincetown (Brighton and Blackpool) are only available to those with disposable income and sufficient cultural resonance with these locations, so too the door between on-line and off-line life is more magical for some than for others. Access to cyberspace requires the use, if not the ownership, of a computer, a modem, a telephone service and an Internet provider. These resources are surely not equally distributed amongst the diverse groups of lesbians, gay men, transgendered and queer folk, as far as we know from on-line demographics (Hall 1996; Wincapaw 1997). As well as celebrating a potentially new space in which to be queer, we must also pay attention to the kinds of queer which remain silent and unseen, blocked by Dawson's 'wall' of the new information technologies. How many individuals are not in a position to participate in screen- and textually-based information which is predominantly in English? Who bears the cost of strengthening our networks of activists via the computer rather than any other means? In reviewing the vast array of resources available, it is evident that the larger-scale socio-economic questions of the demographics of production and consumption of cyberqueer spaces remain largely unanswered.

Bearing in mind the probability that the computer-mediated worlds cannot be taken to be representative of the diverse population which they reference, what is queer cyberspace? It is probably more accurate to describe 'the on-line world' in the plural: overlapping cyberspaces (Fraiberg 1995; Wakeford 1995). Fraiberg indicates that much of the popular imagery of cyberspace presents it as 'a singular, dense and impenetrable

space – a huge world populated by hackers and the like'. Instead she insists that cyberspace is 'a multifaceted, multilayered, and very segmented place'. She implies that this is as true for queer spaces as for electronic on-line places which are not primarily defined as queer. Furthermore she suggests that the idea implied by theorists such as Mark Dery (1993) of a neatly separated diversity of cyberspace populations is un-reliable. Cyberspaces, whether 'queered' or not, resist an orderly cartography. First, unlike geographically situated places, which have relative stability in terms of their locations on a map, many places in cyberspace tend to be mobile or transient. Second, each space may have different modes and costs of access, ease of use, graphical or textual forms, and levels of intervention from those who own and operate the system. Third, users of one space or system often participate in others; this adds to the impression that queer cyberspaces operate within distinctive cultural clusters, as well as within the global network of other computer-mediated spaces.

Nevertheless some delineation of these segments and layers helps to contextualize the kind of cyberspaces described in the studies of cyberqueer. Amy Goodloe (1997), one of the pioneers in the creation of lesbian cyberspaces and also a researcher in the area, has traced the roots of the diverse lesbian computer networks and services.[1] Her categorization structures my descriptions of the cyberqueer spaces more generally:[2]

NEWSGROUPS

One of the oldest forums for computer-mediated communication, newsgroups allow users to post messages to an electronic message board which can be read by anyone else who accesses the system. The Queer Infoserver currently identifies thirty-five news-groups of lesbian, gay, transgender and queer interest.[3] Some of those listed also have sub-groups associated with them, so this figure is probably an underestimate of the current number of active newsgroups. Goodloe (1997) identifies the first explicitly cyberqueer newsgroup as *net.motss* (later known as *soc.motss*) which was founded by Steve Dyer in 1983. The acronym *motss* stands for Members Of The Same Sex. More recent newsgroups include *soc.support.youth.gaylesbian-bi*, *soc.support.transgendered*, *alt.journalism.gay-press* and *alt.politics.homosexuality*, among many others. However, since newsgroups are public message boards, 'intruders' to *soc.motss* and other newsgroups can bombard the list with 'flames' (abusive messages) about the nature of the group or its positive stance towards lesbians and gay men (Hall 1996: 155–6). To prevent this tendency in many newsgroups messages are first received by a moderator who deter-mines whether or not to forward them on to the newsgroup as a whole.

Bulletin Board Systems (BBSs) also exist on commercial services, and by way of small local systems which are not run for profit. These may offer both newsgroup func-tions, electronic mail and live chat, which I describe in the next section. For example in 1991 the Gay and Lesbian Community Forum (GLCF) was established with official support of one of the largest US service providers, America Online (Woodland 1995). This space has both message boards and political and cultural resources. Woodland also points out that in addition to the official queer area on America Online there were over one hundred 'gay-related' message folders outside the GLCF. He attributes this prolif-eration beyond a recognizable cyberqueer zone to the official policies on America Online designed to combat verbal harassment.

ELECTRONIC MAIL DISCUSSION LISTS

In terms of lesbian spaces on the Internet, electronic mail discussion lists have enjoyed far more popularity than newsgroups, from the early Sappho list which itself generated regional sublists, to the flood of new lists generated since 1994 about more specific interests: kinky-girls, boychicks, politidykes and lesbian-studies, for example (Goodloe 1997). This recent expansion of discussion lists is apparent throughout the range of potential interests of those who identify as lesbian, gay, transgender or queer. In early 1997 the Queer Resources Directory 'List of lists' catalogued more than 200 lists currently in operation, including lists for debate, activist announcements, support for specific sexual or ethnic communities, and special hobby or interest groups.[4]

The relative popularity of these lists may be due to the fact that communication is conducted via messages which are redistributed to a list of subscribers rather than being available to all on a public forum. This means of distribution creates a space which is more private than elsewhere in cyberspace. Women using lesbian and bisexual women's spaces confirm this impression of 'safer' space (Wincapaw 1997), although it is as yet unclear whether the same motivation drives others who use electronic mailing lists rather than newsgroups for cyberqueer activities. Mailing list distribution restricts, although does not eliminate altogether, the amount of intrusion from those unsympathetic to the aims of the list. The varying success of an electronic mail discussion list in maintaining a group of users who are supposedly united around a topic is often a function of the way in which membership rights to the list are granted. Such gatekeeping of cyberqueer spaces has been one of the points of interest for researchers as it raises questions about who has the power to define or negotiate identity on-line (Case 1995; Hall 1996; Wincapaw 1997).

CHAT ROOMS

Both newsgroups and discussion lists are based on asynchronous communication. In contrast chat rooms and Internet Relay Chat (IRC) are based on 'live' real-time inter-actions on 'channels' with names such as *uk-poof or *leschat or within 'Lesbian and gay rooms' on services like America Online. The history of the queer chat room scene is much harder to trace than for many other cyberqueer spaces (Goodloe 1997). Most channels exist only when there are participating users, and even for the channels which are persistent over a time period logs are not kept automatically of interactions which occur in these spaces. Nevertheless chat spaces have developed their own distinctive cyberqueer cultures.

Chat areas also exist as part of services offered by smaller private BBSs such as 'Modem Boy' in Los Angeles (Woodland 1995) and as part of large commercial services, for example the 'Lesbian Cafe' (Correll 1995). One of the distinguishing features of such chat spaces in comparison to newsgroups and discussion lists is their explicit elab-oration of spatial metaphors within which participation takes place. Although these spaces are interactive chat environments, the images of cyberqueer space are creations of the moderators or owners of the forums. A variation on the chat space is the MUD or MOO space, in which users can create their own textual objects, including spaces, which are saved within the computer system itself. For example 'Weaveworld', inspired by the writings of Clive Barker, was for a time a cyberqueer space within one of the largest

of these systems, LamdaMOO (Woodland 1995). Woodland describes this space as one replete with markers of 'paganism and sensuality'. When a user 'eats' a 'giddy fruit' the subsequent visions give a clearer idea of the anticipated inhabitants:

> You see Jorge Borges, saying 'Oh time, thy pyramids!'
> Quentin talks with what appears to be a box containing Schroedinger's cat.
> You see the two boys from the statue, wrestling.
> You see Michel Foucault in white pants and a leather jacket.

Such scenarios tend to be textually much more complex than those on BBSs, as rooms can be entered revealing other rooms, objects and narratives. Users can add to the story, the spaces or the textual artefacts in a manner which is not possible in most other chat arrangements.

There also exist a small number of two-dimensional cyberqueer chat spaces which are based around images and text. For example Alison Bechdel, a lesbian cartoonist, was commissioned to design the space for a lesbian and gay area which opened in 1996 on the Microsoft Network (MSN). Instead of imagining a space using text which scrolls down the monitor, as in Weaveworld, entering graphical chat spaces is similar to seeing yourself in a cartoon strip. The scene on MSN's chat room is a cafe-bar where an expresso machine features prominently, and users are represented by avatars, or cartoon characters. Chatting in such spaces still appears as text on the computer screen, but the avatars also have a set of limited expressions or 'emote' features. The execudyke can flirt or open her jacket to reveal a Lesbian Avengers T-shirt, as the user selects different modes from a predetermined set of cartoon images. Although a similar virtual world called 'Pride! Universe' exists on the Fujitsu-Compuserve Worlds Away system, there are as yet no accounts of user experiences in these spaces, both developed as commercial ventures by large Internet service providers.

WEB SITES

As well as spaces within which to communicate, some segments of cyberspace have also become arenas in which text, graphics and sound are collected and stored. In recent years the World Wide Web has become the most prominent focus of many cyberqueer activities, and probably needs the least introduction here. The structure of the Web system, which links together files stored on computers in disparate locations, has enabled vast collections of lesbian, gay, transgendered and queer information to be indexed at central sites such as the Queer Resources Directory (QRD) which currently has 18,334 individual documents indexed by subject (see Note 4). The development of the Web itself is a very recent phenomenon, aided by graphical browsers. Cyberqueer spaces have rapidly expanded in line with the development of the medium. For example Goodloe reports that between early 1995 and the summer of that same year, the number of Web sites of interest to lesbians had increased from a handful to over one hundred (Goodloe 1997).

Although the general structure of hyperlinked information is common to all 'pages' on the World Wide Web, there is an extensive range of cyberqueer offerings. Some, such as the Queer Resources Directory or the Queer Infoserver, aim to index all the queer information which is available electronically. Others are both indexes of information and sites for communication, such as Planet Out,[5] which is a commercial venture

with spaces to buy products emblazoned with the Planet Out logo as well as news-groups and chat room facilities. The Black Homie Pages[6] are hosted by the publishers of erotic literature for African-American lesbians and gay men. There are many unfunded activist pages, such as the FTM International Web site, which provides updates and resources for female to male transgender communities.[7] There are also pages detailing biographies and interests of individuals, with links to friends, institutions, or campaigns. Some of these individual pages are linked to a central list of 'People OUT on the Net'.[8]

What is the social, political and economic importance of cyberqueer spaces?

In the continuing struggles over cultural production and the politics of representation for lesbians, gay men, transgendered peoples and queers, intense interest has been paid in Queer Theory and lesbian/gay studies to conceptions of self, and identity politics. Often this preoccupation has taken place at the expense of an analysis that integrates the self into institutional and cultural practices. Cyberqueer spaces are necessarily embedded within both institutional and cultural practices, and are a means by which the lesbian/gay/transgendered/queer self can be read into the politics of representation and activism confronting homophobia.

To show how struggles over cyberspace become struggles about the expression of sexuality we can return to the initial attempts to start *net moss*, the first newsgroup. Dyer has described the battle with the homophobic hierarchies which had the authority to permit or deny the creation of a new forum on the newsgroup system (Dyer 1988). He is scathing about the moral panic induced by his original suggestion which led to the mystified *motss* acronym, and several months later was invited to rename the group with an explicitly 'out' signifier, although participants rejected this offer.

Prejudice is common in the day-to-day maintenance of cyberqueer space just as at the time of their creation. Amy Goodloe reports that she frequently receives electronic mails from men identifying themselves as her heterosexual saviours from lesbianism. The occurrence of such harassment was much reduced after she started to display these unsolicited messages on her Web pages. At one time her on-line resources were rendered inaccessible by her service provider after a heterosexual pornographic magazine on-line had linked the *Lesbian.org* site to its own, allegedly without realizing the content did not include the graphical images which users were expecting. Nevertheless there was enough volume from this link to close down her site on a daily basis until she protested and ensured the link was removed.

Cyberqueer spaces are constantly reconstituted as points of resistance against the dominant assumption of the normality of heterosexuality in ways which are familiar to activists engaged in other struggles against heterosexism. Artists such as Barbara Hammer are using the Web to create a 'lesbian community biography' (Willis and Halpin 1996) and transgender activist Kate Bornstein used the metaphor of the virtual world to explore the difficulties of transgender transition in a recent stage production (Hall 1996).

Although some cyberspaces are clearly signalled in their names as non-heterosexual, others are ambiguously labelled and open to a different form of queering (Dishman 1995; Fraiberg 1995). Fraiberg suggests that particular attention should be paid to queering of newsgroups which do not have overtly queer topics. In these places the

'potential for performance space' of queer can be tracked. 'In those realms, the queering of net space becomes not a given, but a site of contestation'. With this focus in mind Fraiberg discusses the interactions on two discussion lists devoted to musicians who had recently come out at the time of her study: the Melissa Etheridge List and the Indigo Girls List. She finds that these lists function as a way to talk about sexuality as well as music. Such discussions unsettle fixed labels such as lesbian or queer for a fan population which cannot be assumed to be either, and who are often given only coded signals of sexuality from other participants. Fraiberg concludes 'That sense of discursive movement creates the dynamic that enables queer sexuality to constantly mark and yet always be up for grabs on these popular lists.'

On these music discussion lists queering of the electronic texts never becomes a threat to the existence of the electronic group itself, yet it is an example of the politics of representation in action. The portrayals of both the fans and the musicians are embedded in the cultural practices not only of gender and sexuality, but the logic of production and consumption within the music industry, the conventions of fandom, *and* the discursive norms of electronic discussions (see Baym 1994). Although all cyberqueer spaces exhibit these overlapping practices, the fragility of such forums is evident when discussions of sexuality are conflated with pornography, and lesbian, gay, transgendered and queer spaces are subject to censorship. In the most drastic example, in December 1995, German government officials raided the Munich offices of Compuserve, at that time Europe's largest on-line service, and demanded that it block worldwide access to 200 discussion groups which allegedly contained pornographic materials or information harmful to children. Electronic forums which were targeted included lesbian and gay support groups, initially unavailable to any user since Compuserve could not block access on a country by country basis. One year later, all but four forums were restored to the system, after the company offered filtering software for individual users.

The cultural and political stakes of maintaining a cyberqueer presence are heightened still further given the extensive attention directed at new information and communication technology in terms of public policy and economic prosperity. Increasingly participation in on-line worlds is being signalled as a desirable component of citizenship on both a local and global scale. If citizenship is to be reconfigured in this way, then attention must be paid to the means by which cyberqueer will intervene in the redefinitions, whilst simultaneously facing the challenge of facilitating the equal participation of those who do not have access to computer mediated spaces.

Sexuality is embedded in both the spatial dynamics and the economics of late capitalism, and the same can be argued for computer mediated forums. Sue-Ellen Case argues that cyberqueer intervention (in the form of 'screening' the lesbian) is crucial if the computer screen is to become *the* screen both to the world and for 'our own so-called private production' (Case 1995). In this scenario the computer screen is the mechanism for the symbolic organization of both cultural *and* economic power. Case draws on the work of David Tomas who posits these new electronic spaces as 'the essence of a postindustrial society' which itself replicates via the exchange of global information and is driven by the dictates of a transnational computer-based economy (Tomas 1991). If we accept this view, cyberqueer might be used strategically, both continuing to subvert the assumed superiority of heterosexuality within the politics of representation, and by making evident the silences and those silenced by the new computer-aided logic of global accumulation.

However, large-scale service providers have tried to generate profit-making cyber-spaces to be consumed by the lesbian and gay population. It was recognized by America Online that the GLCF was one of the most frequently accessed of its services. There is profit to be made by hosting cyberspaces where the product sold is access to others of your kind. MSN and Compuserve-Fujitsu have been developing their two- and three-dimensional virtual worlds not as a community service but as part of a business plan to capitalize on the corporate construction of the lesbian and gay consumer. As Case points out, even the most anarchistically radical discourse of the cyberpunk movement can be reappropriated in the name of capital (1995: 334).

A critical reading of cyberqueer studies

Most of the commentary and research within the field which I have called cyberqueer studies is sympathetic to the alliances between lesbian, gay, transgender and queer experiences and computer-mediated worlds. However, cyberqueer studies are in their infancy, and this is reflected by the high proportion of material which has been produced either outside the institutional mainstream, published on Web pages rather than in estab-lished print journals, or is innovative work-in-progress by graduate students. Up to this point, there has been significantly more analysis of lesbian cyberqueer practice than for other populations, and very little material on transgender experience despite the wide-spread participation of transgendered users in diverse cyberqueer forums. Almost exclusively the existing writing has focused on textual cyberspaces rather than those with graphical forms.[9]

The term 'cyberqueer' itself indicates an uneasy amalgam of two words – queer and cyber(space) – each of which has already been overloaded with the definitions it has been required to contain.[10] If both words are reputed to have a lack of specificity, what is the purpose of creating a hybrid of the two? It is a calculated move which stresses the interdependence of the two concepts, both in the daily practices of the creation and maintenance of a cyberspace which is lesbian, gay, transgendered or queer, and in the research of these arenas. There has been a persistent silence on matters of sexuality in critical cultural studies of technology, perhaps partially because technology was associated with the instrumental to the exclusion of the representational (Case 1995). The creation of the term 'cyberqueer' is itself an act of resistance in the face of such suppression.

A common theme in the studies of cyberqueer is the relationship between sexuality and space, where space is taken to be the arena accessible by computer-mediated inter-actions. Cyberqueer spaces are framed as new places within which lesbian, gay, transgender or queer experiences can take place, with a particular focus on the advan-tages compared to 'real' physically-located space. Mainstream cyberspace has often been promoted as creating 'virtual communities' and cyberqueer spaces may compensate for the social or geographical isolation of sexual minorities by operating as a medium through which contacts can be more easily facilitated (Case 1995; Woodland 1995). The research on cyberqueer discussion lists suggests that for many users the lists are places to socialize and meet new friends or lovers, but can also be an important 'space of refuge' from *other* lesbian, gay, transgender and queer worlds, some of which are themselves on-line (Hall 1996; Wincapaw 1997). Kira Hall names a strategy of 'radical cyberfeminism'

which she locates within the women-only discussion list Sappho. Radical cyberfeminism – which includes screening of names and messages, a norm of support and an anti-flaming policy – is a response to the 'aggressive stylistics which characterize cybermasmasculinity' on other mixed gender discussion lists such as Gaynet and QSTUDY-L. This strategy is a way of imposing boundaries around the space, and is also often achieved by regulating as far as possible the gender, sexual orientation, and/or other criteria of those accessing the forum (Wincapaw 1997).

Others have focused on how the detailed spatial imagery of each cyberspace itself contributes to the inclusion or exclusion of particular groups (Woodland 1995). Whereas ModemBoy's cultural referents are 'horny, sexually compulsive adolescent boys' and a blatant ideal of 'hairless white boys', Weaveworld is drawn from a more subtle gay iconography of paganism, anarchy and sensuality. Woodland voices the claim, implicit in much of the other research, that the importance of such descriptions is that cyberqueer spatial imagery indicates the state of contemporary queer identities.

The construction of identity is the key thematic which unites almost all cyberqueer studies. The importance of a new space is viewed not as an end in itself, but rather as a contextual feature for the creation of new versions of the self. The possibility of anonymity on some services and the lack of face-to-face social cues lead authors to suggest that coming out may be easier on-line, thus transforming the notion of what it means to be gay (Dishman 1995). Jodi O'Brien (1996) describes an advertisement in *The Advocate* which proclaims (over a naked male torso): 'There are no closets in Cyberspace'. This pronouncement both plays on the possibility of anonymity and reinforces a distinction between 'real' world (with closets) and cyberspace where we are led to believe that the closet/'being out' fix has no meaning. Additionally Dishman (1995) locates the origin for the desire for a sexual use of cyberspaces as connected to the impact of HIV and AIDS. He comments: 'Certainly, with respect to infectious disease, there can be no safer interactive sex than having it with someone with whom contact exists only through electronic pulses. Cybersex is safe sex.'

Some authors have proposed that such a new kind of electronic sexuality would be particularly attractive to gay men (Dishman 1995, 1997; Sheldon 1996), although the terms 'cyberdyke' and 'cyberlesbian' have also been employed in the promotion of new lesbian identities (Case 1995; Hall 1996; Haskel 1996; Wakeford 1995). Occasionally the kind of language used in such predictions mirrors the utopian rhetoric observable in mainstream predictions of cyberspace futures:

> Through the technology available on the Internet, gay men have become erotic hitchhikers in search of sexual stimulation beyond the physical body. The fact that we are able to use our imaginations for sexual pioneering is at once appalling and intimidating to straights. The Information Superhighway allows gays to realize the brain, and its creative transmissions, as our largest sexual organ.
>
> (Sheldon 1996)

Although the precise way in which identity is invoked varies between accounts, certain theoretical assumptions underpin most cyberqueer studies.

First, it is usually taken for granted (if not explicitly stated) that the version of the concept of identity offered by recent prominent queer theorists, in particular Judith Butler and Eve K. Sedgwick, is unproblematically appropriate for cyberqueer

(in particular see Fraiberg 1995; Bromley 1995; Hall 1996; Woodland 1995). Queer can be interpreted as a way to include all non-normative sexualities as identities, and at the same time allows a blurring of any necessary links between sexuality and gender (Walters 1996), yet in cyberqueer it is also a way of describing identities which are mediated through electronic means. Dishman (1995) has claimed that cyberspace actually aids the production and expression of queer identity, yet that begs the question: What precisely does the *cyber* add to the *queer* identity which it lacked previously? Can queer identity reliably be theorized without also problematizing how it may be reconstituted or transformed by the nature of the individual cyberspace within which it is constructed? Several authors have attempted to discuss the ways in which evidence of the process of construction of queer can be spotted on-line. Yet there is still a resistance to suggest alternative modes of cyberqueer identity outside those proposed by dominant Queer Theory. As Biddy Martin (1994) has pointed out, in some versions of identity produced in the name of Queer Theory, sexuality becomes the primary figure of mobility and 'crossing', leaving race and gender as relatively stable. Such differential immobility in categories would be a weighty legacy for those trying to theorize cyberqueer, particularly given the fact that there are so few accounts which focus on race beyond the acknowledgement of white cultural dominance of cyberspace. Cyberspace has its own dominant history of how diverse sexual identities are expressed or silenced, yet this is rarely acknowledged. For the most part those producing and consuming cyberqueer spaces are obliged to work within what is technically possible within computer systems, and the representations which they have the skills to construct in each forum.

Second; and as a consequence, the postmodernist heritage of this version of queer (accompanied by other postmodern influences) leads to versions of identity as fluid and/or performative. The ideology of fluid identities is evident in the maxim that 'you can be whoever you want to be' in cyberspace, and this can change with varying presentations of self. Kira Hall (1996) cites lesbians who 'play' at being gay men. Hank Bromley (1995) talks of users who 'pretend' to be transgendered. In fact the impression is that cyberspace is the postmodern space *par excellence,* whether or not the user is gay or straight, transgendered or not. Perhaps the closeness of fit is a bit too convincing? What is lost if cyberqueer research becomes merely a celebration of parody and performance, or the simplistic application of an author's reading of *Gender Trouble* or *The Epistemology of The Closet?*

One of the intersecting ways in which identity has been theorized by cyberqueer writers has drawn upon Donna Haraway's (1985) vision of the machine–human hybrid: the cyborg, itself iconic in some fields of technoscience studies. Both Kira Hall and Hank Bromley frame their articles by highlighting Haraway's metaphor. Yet even though within Haraway's formulation there is a clear understanding of how multiple positioning of race and gender are integral to such a hybrid, it is a visionary metaphor, and proves problematic when applied to user experiences. From her study of the women of the Sappho discussion list, Hall (1996: 167) concludes 'cyberspace is generating goddesses and ogres, not cyborgs'.

Third, as understood through cyberqueer research, identity appears to be attached primarily to signals of the body, whether they are codes for body parts or physical attributes the contention that a discussion list itself is an embodied lesbian form (Case 1995), or in a forum where ideas about bodies become the central gatekeeping mechanism for

access to the cyberqueer space (for example, the 'pre-op'/'post-op' transgender debate). Much is made of how users can change the descriptions of themselves which others may access while on a BBS (Tsang 1994), or the fact that anonymity means that one starts with 'no body' and so is free to construct or reconstruct images of physicality at whim (Dishman 1995). ModemBoy signals a specific kind of embodied power relationship, and even PlanetOut's Web site has a finite subset of body styles chosen from a wider cultural repertoire.

Despite the preponderance of such bodies, there has been much less attention to the body which is *not* screened, the one which is 'left' when the computer is turned off, or even what happens to the 'real' body when the computer is on. Lisa Haskel's (1996) account of cyberdyke life shows how both the machine and its connectivity provoke physical wants and desires when she is off-line as well as when she is connected, but there is little research which attempts to examine the intersection and potential contradictions of bodies in the on-line and off-line worlds.[11]

The final assumption embedded within much of the discussion of identity recalls the issue of participation in cyberspace. Whilst cyberqueer research points to the economic costs of involvement, there is a disturbing silence on the issue of ability to perform identities once users are in a cyberqueer space. Is this also economically related? Are users who can afford more time able to be more (convincingly) fluid? Is this ability culturally specific? If performance is the measure of identity, how does performance vary with cultural location? Most cyberqueer activities and research have their origins in the US. There is a strong likelihood that this will influence the level and nature of participation, yet no cross-cultural work has yet been undertaken. Many of the cultures of cyberspace emphasize the 'newbie' phenomenon in contrast to the more experienced user, yet this dimension of time and performance is also lacking from the accounts of cyberqueer.[12] Drawing on Lisa Haskel's comments, the question might not be 'Are you lesbian?' but 'Are you lesbian *enough*?' to participate (Haskel 1996: 52). Her comment is a reminder that the ability to enter many cyberqeer spaces involves conscious (re)construction of the self which may be learned over time.

There are multiple locations of cyberqueer activity in on-line worlds and resources. Nevertheless there remains a tendency for those who analyse these appearances to concentrate on the symbolic aspects of cultural production at the expense of the economic and structural features. Whereas the production and consumption of cyberqueer *activities* is flourishing, cyberqueer *studies* in general are at risk of lagging behind by ignoring economic and political conditions which are inevitably intertwined with the social and cultural features of their representations. There is also the danger that by reflecting present preoccupations in certain versions of contemporary Queer Theory, the focus on the performance of multiple fluid identities may be sustained at the cost of obscuring other potentially stimulating lines of enquiry, such as the institutional context of cyberqueer. This is a criticism which has been levelled at Queer Theory more widely, yet it is particularly apt for research where the object of study is so intimately acquainted with economic conditions of production and consumption.

Originally published in A. Medhurst and S. Munt (eds) (1997) *Lesbian and Gay Studies: A Critical Introduction*, London: Cassell.
This essay has been edited for inclusion in the Reader.

Notes

1. Amy Goodloe is also the creator and maintainer of the largest lesbian site on the world wide web (*www.lesbian.org*).
2. For a full list of spaces, the Yahoo directory at: *http://www.yahoo.com/text/Society_and_Culture/Lesbians_Gays_and_Bisexuals/Computers_and_Internet/* is a good place to begin.
3. The Queer Infoserver is one of the large repositories of indexed information on the World Wide Web (*www.infoqueer.org/queer/qis*).
4. The Queer Resources Directory (*www.qrd.org/qrd/*) is the largest and one of the oldest collections of electronic information about the whole range of computer network spaces which are advertised as lesbian, gay, transgender and queer.
5. *http://www.planetout.com*
6. *http://abacus.oxy.edu/BLK/blkhome htm*
7. *http://www.ftm-int.org/intro.htm*
8. This list can be accessed via an electronic link from the Queer Infoserver (see Note 3).
9. I have omitted from this discussion research on lesbians (Wood 1997) and gay men (Nieto 1996) which has used computer-mediated communication primarily as a means of data collection rather than as an integral concept for subsequent data analysis.
10. The earliest use which I have been able to trace of the term 'cyberqueer' is *Queer-e*'s call for papers exploring the term (see Note 2, Hall 1996).
11. But see Wakeford (1997) for an initial exploration of the connections between bodily practices in these two arenas.
12. An exception is Correll's (1995) study of the 'Lesbian Cafe' BBS.

References

Baym, N. (1994) 'The emergence of community in computer mediated communication', in S.G. Jones (ed.) *Cybersociety: Computer Mediated Communication and Community* London: Sage, pp. 138–63.
Broidy, E. (1996) Cyberdykes, or, lesbian studies in the information age', in B. Zimmerman and T.A.H. McNaron (eds), *The New Lesbian Studies*, New York: Feminist Press, pp. 203–7.
Bromley, H. (1995) 'Border skirmishes: a mediation on gender, new technologies, and the persistence of structure', Paper presented at Subjects of Technology: Feminism, Constructivism and Identity, Brunel University, Uxbridge, June 1995.
Case, S.E. (1995) 'Performing lesbian in the space of technology: part II', *Theatre Journal*, vol. 47, no. 3, pp. 329–44.
Correll, S. (1995) 'The ethnography of a lesbian bar: the lesbian cafe' in *Journal of Contemporary Ethnography*, vol. 224, no. 3, pp. 270–98.
Dawson, J. (1996) *Gay and Lesbian On-Line: The Travel Guide to Digital Queerdom on the Internet, the World Wide Web, America Online, Compuserve, plus BBSs Coast to Coast*, Berkeley, CA: Peachpit Press.
Dery, M. (1993) 'Flame Wars', *South Atlantic Quarterly*, Autumn. Special Issue: Flame Wars: The Discourse of Cyberculture, pp. 559–68.
Dishman, J.D. (1996) 'Digital divas: defining queer space on the information superhighway', Paper given at Queer Frontiers: The Fifth Annual National Lesbian, Gay and Bisexual Graduate Student Conference, March 1995, pp. 23–6. Published on-line: *http://www.usc.edu/Library/QF/queer/papers/dishman.html*
—— (1995) 'Digital dissidents: the formation of gay communities on the Internet'. MA Thesis, University of Southern California, 1997.
Dyer, S. (1998), 'Re: origins of soc.motss'. Message posted to soc.motss newsgroup, 27 May 1988, 20:31:15 GMT. Archived at *http://www/qrd//org/qrd/ electronic/usenet/soc.motss.beginnings*
Fraiberg, A. (1995) 'Electronic fans, interpretive flames: performing queer sexualities in cyberspace', *Works and Days*, 25/26, 1, 2, 1995. Published on-line: *http://acorn.grove.iup/edu/en/work-days/Fraiberg.HTML*

Goodloe, A.T. (1997) 'Lesbian computer networks and services', in B. Zimmerman (ed.), *Encyclopedia of Homosexuality* (2nd ed.) *Volume I: Lesbian Histories and Cultures*, New York: Garland.

Hall, K. (1996) 'Cyberfeminism', in S. Herring (ed.), *Computer-Mediated Communications: Linguistic, Social and Cross-Cultural Perspectives*, Amsterdam: John Benjamins, pp. 147–70.

Haraway, D. (1985), 'A manifesto for cyborgs: science, technology, and socialist feminism in the 1980s', *Socialist Review*, vol. 80, March–April.

Haskel, L. (1996) 'Cyberdykes: tales from the Internet;, in Nicola Godwin *et al.*, *Assaults on Convention: Essays on Lesbian Transgressors*, London: Cassell, pp. 50–61.

Knopp, L. (1992) 'Sexuality and the spacial dynamics of late capitalism', *Environment and Planning D: Society and Space*, vol. 10, no. 6, pp. 651–69.

Martin, B. (1994) 'Sexuality without gender and other queer utopias', in *Diacritics*, vol. 24, no. 2/3, pp. 104–21.

Nieto, D.S. (1996) 'Who is the male homosexual? A computer-mediated exploratory study of gay male bulletin board system (BBS) users in New York City', *Journal of Homosexuality*, vol. 30, no. 4, pp. 97–124.

O'Brien, J. (1996) 'Changing the subject', *Women and Performance*, Vol. 17. Published on-line: *http://www.echonyc.com/~women/Issue 17/*

Seidman, S. (1993) 'Identity and politics in 'Postmodern' gay culture: some historical and conceptual notes', in M. Warner (ed.), *Fear of a Queer Planet: Queer Politics and Social Theory*, (Minneapolis: University of Minnesota Press, pp. 105–42.

Sheldon, G. (1996), 'Cruising the tearooms in cyberspace', *Gerbil*, Vol. 6. *http:/www.multicom.org/gerbil/cyb.htm*

Tomas, D. (1991) 'Old rituals for new space: rites de passage and William Gibson's cultural model of cyberspace', in M. Benedikt (ed.), *Cyberspace: First Steps* Cambridge, MA: MIT Press, p. 35.

Tsang, D. (1994) 'Notes on queer 'n' Asian virtual sex', *Amerasia*, 20(1), pp. 117–28.

Wakeford, N. (1993), 'Sexualised bodies in cyberspace', in W. Chernaik and M. Deegan (eds.), *Beyond the Book: Theory, Text and the Politics of Cyberspace*, London: London University Press, pp. 93–104.

—— (1997) 'Theorising the performance of "identity" and "community" in lesbian (cyber)spaces', in S. Oerton and G. Plain (eds), *Coming Unstuck: Gendered Spaces, Places and Change*, London: Taylor & Francis.

Walters, S. D. (1996), 'From here to queer: radical feminism, postmodernism, and the lesbian menace (or, why can't a woman be more like a fag?)'. *Signs*, vol. 21, no. 4, pp. 830–49.

Willis, H., and Halpin, M. (1996) 'When the personal becomes digital: Linda Dement and Barbara Hammer move towards a lesbian cyberspace', *Women and Performance*, vol. 17. Published on-line: *http://www.echo-nyc.com/~women/Issue 17/*

Wincapaw, C. (1997) 'Lesbian and bisexual women's electronic mailing lists as sexualised spaces', *Journal of Lesbian Studies*. Forthcoming.

Wood, K.M. (1997) 'Narrative iconicity in electronic-mail lesbian coming-out stories', in A. Livia and K. Hall (eds), *Queerly Phrased: Language, Gender, and Sexuality*, New York: Oxford University Press.

Woodland, R.J. (1995) 'Queer spaces, modem boys, and pagan statues: gay/lesbian identity and the construction of cyberspace', *Works and Days* 25/26 13, 1&2. Published on-line: *http://acorn.grove.iup/edu/en/workdays/WOODLAND.HTML*

RANDAL WOODLAND

QUEER SPACES, MODEM BOYS AND PAGAN STATUES

Gay/lesbian identity and the construction of cyberspace

COMPUTER-MEDIATED COMMUNICATION has had a particularly dramatic impact on the lesbian and gay community, whose members may live in geographic or psychological isolation. Through email lists, USENET groups, and private BBSs (Bulletin Board Systems), communication across the Internet and on other computer networks has been a source of information, friendship, and support for many lesbian and gay people. Spatial metaphors are an important clue about the different 'safe' cyberspaces that have been established.

Even in ways users aren't always conscious of, space is a common metaphor for the different ways computer networks make information accessible. Such differences are the subject of this chapter. An overview of the gay and lesbian spaces on four different computer systems and a survey of their dominant features reveals both the constraints of each system and the particular constructions of gay and/or lesbian identity that undergird it.

Not in Kansas anymore

> We exist in a world of pure communication, where looks don't matter and only the best writers get laid.
>
> (legba, a player on LambdaMOO)[1]

Let me begin with a personal experience that suggests how important these on-line place descriptors can be. This experience took place on a computer system known as a 'MOO'. One evening I was logged on to LambdaMOO, the original system of this kind. I was in one of the public spaces – the lawn in front of the large abandoned mansion that is the central architectural feature of LambdaMOO – where many people came and went on their way to other places in the MOO. One passerby asked about the pink triangle

that I was 'wearing' as part of my self-description; I explained that the symbol origi-
nated as a Nazi concentration camp badge and that it signified gay rights. Though my
new acquaintance immediately made it clear that he was straight and had a steady girl-
friend, he seemed intrigued by what I said; once I confirmed that I was gay, he had a
number of questions he wanted to ask about homosexuality, some fairly explicit. Drawing
on my experience talking to psychology classes and community groups over the years,
I answered as best I could, as his questions and my answers got more and more graphic.
My clear sense of him at the time was that his curiosity had no ulterior motive; nor did
my responses: in other words, this was a conversation about sex, rather than a
sexually-charged conversation. Since our conversation took place in an area with a fair
amount of traffic, an unsuspecting passerby might inadvertently eavesdrop on our conver-
sation. Mindful of a central principle of netiquette – that one should not subject other
users to unwelcome explicit language, I began feeling that we should move. I explained
this to my new acquaintance, and asked, with as little sense of cliché as I could muster,
if he wanted to come back to my room.

He said no.

Now this 'move' that I suggested would simply have meant that we were reading
information (the room description) from a different section of the LambdaMOO data-
base in Palo Alto and that the text we were producing was no longer accessible to other
users, but the real-life implications of that invitation, translated by my interlocutor into
'real-life' terms, were too much for him to deal with. He did agree, much as he would
have in real life, I think, to move to a more secluded part of this public park so that
we wouldn't disturb other users. We had reached a curious compromise. Our discourse
seemed to me inappropriate for the public space of the front lawn; the spatial implica-
tions of 'going back to my room' suggested to him a discourse he found threatening.
Yet both of us understood that spatial descriptions and appropriate discourse were linked
in this particular virtual world.

This incident suggests the ways that MOOs in particular, but other on-line services
as well, use place descriptions and spatial metaphors to inform appropriate discourse.
Bulletin board systems often use the metaphor of a 'room' to announce and segregate
different topics. More elaborate systems such as America Online present a detailed
articulation of spatial metaphors; on America Online these range from 'Center Stage',
an area where a large number of members can interact with celebrities or other special
guests, to more specialized and ephemeral chat rooms with varying degrees of privacy.
Taking the spatial metaphor to an extreme are systems such as MUDs and MOOs, in
which the database of information is organized in and experienced through a fully real-
ized virtual space.

This intuitive affinity between place and discourse goes so deep in our understand-
ings of on-line communication that it can be difficult at times to realize we are speaking
in metaphors. That reminder from my Chair to turn in my annual report is *in my elec-
tronic mailbox*; I'll *move it to the Trash* when I'm done. *Where* did you find that list of gay
and lesbian studies programs? *What's the address* of the NewtWatch Web page? – all of
these constitute metaphors for locations in cyberspace. Even such a political Luddite as
Sen. James Exon, sponsor of the 'no cybersmut' rider to SB 314 warns about turning
the 'information super highway into a red light district' (Schwartz 1995).

Various gay-related on-line venues share this use of place metaphors to suggest
appropriate discourse, but to very different ends. Gay/lesbian spaces offer a particularly

interesting set of examples, both because questions about lesbian and gay identity are contested in many ways – from the personal level to the social, from the academic sphere to the political and because assertions about such identities often draw upon spatial constructs. As Eve Kosofsky Sedgwick (1990) has pointed out, the closet has long been a central signifying space for gay and lesbian people. The counterpoint to the silence of the closet is the speech act of coming *out*. This tension between private and public space maps the emergence of gay and lesbian identity from a shameful secret to a public affirmation.

Cyberspace has become a distinctive kind of 'third place' for many gay and lesbian people; Howard Rheingold notes that many virtual communities serve as the 'third place' envisioned by Roy Oldenburg – an informal public place, distinct from both home and work: 'The character of a third place is determined most of all by its regular clientele and is marked by a playful mood, which contrasts with people's more serious involvement in other spheres' (Rheingold 1993: 25). These on-line 'queer spaces' I discuss are 'third places' in another sense, as well, in combining the connected sociality of public space with the anonymity of the closet. Tom Rielly, one of the co-founders of Digital Queers, explains the importance of electronic communities for lesbians and gay men this way: 'Our vision is a national electronic town square that people can access from the privacy of their closet – from any small town, any suburb, any reservation in America. It's like bringing Christopher Street or the Castro to them' (Vaillancourt 1995: 61).

Queer spaces: four examples

> The computer's writing space is animated, visually complex, and to a surprising extent malleable in the hands of both writer and reader.
>
> (Bolter 1991)

The four on-line systems I discuss here represent a range of on-line communities: some local, some national; some commercial, some non-profit. The users of one system are almost exclusively gay male, the others draw variously diverse users; some systems have developed mechanisms for tight 'social' and topic control, other areas remain almost anarchic. Each system uses spatial metaphors in distinctive ways reflecting its overall purpose, user base and general ethos. These queer spaces inform discourse in two ways: on each system individual spaces indicate topicality and appropriateness: *this* is the particular place to argue about gay legal issues, *this* to offer support for lesbian parenting, *this* just to gossip. Collectively, the spaces on each system constitute a distinctive construction of queer identity. Such constructions of identity, however provisional, necessarily precede constructions of virtual spaces. If we are to create spaces for queers, we must first agree on what queers are – or agree at least on what they might be, with further elaboration and differentiation reserved for the discourses embodied in the spaces thus constructed.

After describing each system individually, I will turn to a consideration of what these systems suggest more broadly about on-line discourse and the ways in which gay/lesbian identity is constructed on-line. The chart below highlights the major features of each system:

- *America Online*, a major commercial on-line system; lesbian and gay spaces are incorporated into the system architecture.

- *ModemBoy*, a private Los Angeles gay BBS which uses the metaphor of an all-gay high school, with classrooms, a cafeteria and a library.
- *ISCA BBS*, an Internet BBS run by a University of Iowa student group; among 200 forums are 3 with specific lesbian/gay/bisexual content. (Internet address: *bbs.isca. uiowa.edu*)
- *LambdaMOO*, a text-based virtual reality system with a surprising use of place signifiers to set off 'queer' space (Internet address: *lambda.parc.xerox.com 8888*)

Support	ModemBoy Commercial	AOL Commercial	ISCA Non-profit	LambdaMoo Non-profit (?)
Topical posting	Yes	Yes	Yes	Some
User-defined space	No	Some	No	Yes
Explicit place-metaphor	Yes	No	No	No
Designated gay areas	No	Yes	Yes	No
User governance	No	No	Somewhat	Yes
Moderators	Yes	Some	Yes	Limited

The first two systems, though both commercial enterprises accessed entirely or primarily by modem rather than over the Internet, have little else in common. One is tightly structured and targets gay men, mostly from a limited geographical area; the other has a sprawling organization with a huge national user base.

ModemBoy

ModemBoy is a private gay-male oriented BBS located in Los Angeles. As a private business, full access to its services is based on payment of regular fees. It has the most elaborately developed spatial metaphor of any of the systems considered in this chapter. The central conceit is that the system is Modem Boy High School; virtually every aspect of the system is made part of this metaphor, often humorously: users are *STUDents,* the Sysop is a crotchety old maid *principal* named Ms Krump, areas devoted to different subjects are *classrooms,* each with a moderator called a *teacher.* The different levels of user access, based variously on the payment of membership fees, progress from *Freshman* to *Senior.* There's more than a touch of cleverness here: the real-time chat area is the *Cafeteria,* with both *Roundtables* for group discussion and *Tables for Two* for more intimate conversations; email takes the form of *passing notes in class,* and downloadable files are found in the *library.* I must leave to the reader's imagination what is rumoured to take place in the *Locker Room.*

On one level this textual play allows for an appropriation and redemption of negative high school experiences. Though the desired effect of ModemBoy's central conceit is to encourage a tone of playful camaraderie among users, the implications of this elaborate textual game, particularly for a definition of gay identity, are enough to give pause. It constructs gay men as horny, sexually compulsive adolescent boys ('in real life' all over 18, to keep the enterprise legal). ModemBoy builds on images common in gay male subculture and in society as a whole. Through its playful focus on

a particular strand of gay iconography, ModemBoy gains the comfortable uniformity of a consistent spatial metaphor but potentially disenfranchises more diverse expressions of queer identity.

America Online

One of the largest commercial on-line services, America Online (AOL) accommodates the needs of gay and lesbian users in two significant and quite distinct areas: a rich and well-organized collection of resources in the 'Gay and Lesbian Community Forum' (GLCF) and a free-form, constantly changing array of rooms in 'People Connection', the real-time chat area. In essence, the queer spaces in AOL give gay and lesbian content to the existing place genres that AOL has established systemwide.

The GLCF was established with official support from AOL management in 1991. This officially sanctioned space has both political and cultural resources, with a popular series of message boards. Daily AIDS reports from the Centers for Disease Control are available, as are pictures of members and PG-rated pinup photos, mostly of men. Sexually explicit material is prohibited here, as in fact it is throughout AOL (though perhaps it is more accurate to say that prohibition is enforced with greater consistency than in the chat rooms discussed below). In any given week, there are 25 real-time conferences scheduled on issues ranging from family issues to alcoholism to trivia and bodybuilding.

Lesbian and gay content on AOL is not restricted to these official GLCF spaces, but can be found throughout the system, thanks in part to official policies designed to combat homophobia and verbal bashing. In a recent listing, there were over 100 gay-related message folders outside the GLCF, in such broader subject areas as movies, religion and politics. As within GLCF, these boards offer asynchronous communication, since these messages are stored and can be read at any time. Real-time, or synchronous communication, by contrast, links users in real-time: communication tends to be more informal and ephemeral – though users can easily keep logs of a particular session, the system itself does not store these texts.

The People Connection section of America Online is the centre for synchronous interaction. Public Rooms on specific subjects such as sports, *Start Trek*, and trivia are established by the system, each room holding up to 23 people at a given time. Among these officially sanctioned rooms is a 'Gay and Lesbian' room. Yet users are not restricted to these official rooms; any user can set up a Member Room with an identifying title. On a busy evening, hundreds of these rooms may be listed, with a substantial number named in such a way as to invoke what we might term a sexually compatible discourse community; of these, a substantial number incorporate the tag 'M4M', unofficial AOL shorthand for 'men [looking] for men'. By naming a room, a user can gather a group of users based on a range of preferences, geography, age, body type, or other desired common bond. Not all Member Rooms are sexually related, but many are. In part because parents can bar children from this area of the system, the ban on sexual discourse (of various sorts) is effectively relaxed. For even greater privacy, users can create a Private Room accessible only to those who know its name. Comparing the unmonitored chat of a such private rooms with the almost corporate air of the official resources of the National Gay and Lesbian Task Force suggests the range of queer discourses available through America Online. Exactly where the discourse appropriate

to a particular space falls on this continuum is conveyed by generic and topical demarca-
tions of space.

The last two sites are non-commercial sites located on the Internet. Although both
have developed elaborate codes of behaviour and appropriate discourse, these policies
are generally developed by (or at least strongly influenced by) the users.

ISCA

The ISCA BBS is run by a University of Iowa student group, the Iowa Student Computer
Association. Of its almost 200 available forums on a wide range of topics, perhaps no
others have garnered such recurring debate as the boundaries of its three rooms
of primary interest to lesbians, bisexuals and gay men: a public forum (LesBiGay Issues),
a 'family-only' safespace (Queerspace), and a chat room (Stonewall Cafe) for queers and
supportive straights. Confidentiality is a dominant concern on this system and particu-
larly in these rooms. Systemwide, users can choose whether to make their real name
public or be known only by their screen name; in these spaces, as in a few other forums,
anonymous postings can be made without the screenname appearing.

- The LesBiGay forum resembles other subject-centered areas on the board. Many
 other spaces allow discussion of lesbian, gay, and bisexual issues, which in fact
 may be considered more 'on-topic' there than in the LesBiGay forum. ISCA has
 developed several mechanisms for encouraging users to stay within the posted topic
 of a particular forum; this is necessary because only the most recent 150 posts in
 each of the almost 200 forums are saved.
- Queerspace has much the same function as the LesBiGay forums, but its member-
 ship is limited. Though the room is open only to those who self-identify as lesbian,
 gay, or bisexual, there is no attempt to verify that information (difficult as such
 verification would be). Clearly this is not a high level of security: a woman-only
 space, by contrast, requires in-person or voice verification; sexually explicit spaces
 require proof of age.
- Stonewall Cafe is designated as a more casual space for informal interactions.
 Serving as a queer-centred counterpart to similar rooms for the general user base,
 Stonewall Cafe offers a social space free of potential harassment. It supports more
 synchronous (real-time) discourse than other forums and scrolls rapidly, often
 within an hour or two during busy times as friends trade greetings and one-liners.

LambdaMoo

LambdaMOO is, quite literally, the mother of all MOOs. Developed by Pavel Curtis
as an extension of other text-based virtual reality simulators, the Lambda software
program forms the core of most, if not all, other MOOs. Though it contains several
systemwide signifiers that appear (apparently by chance) to suggest a gay focus, the
system has a broad diversity of users.[2] One prominent queer space on LambdaMOO
has a different quality than the spaces I have described elsewhere. Through signification,
this 'neighbourhood' is marked with features suggesting queer culture, but it is not
obviously so designated a queer space as are spaces on either America Online or ISCA.

A distinctive feature of MOOs is that users can fairly easily create their own objects, including spaces, to expand the system and enhance their interactions with other users. Though the designers of a particular MOO will generally establish a central network of spaces to establish the distinctive themes of the space, most MOOs, including LambdaMOO, allow at least a limited amount of building by individual users. Although the central original construction of LambdaMOO is a large abandoned mansion where users were encouraged to create their own rooms along established hallways, the virtual geography has spread far beyond that original construction.

There's no easy way to discover these neighbourhoods, no subject directory or address book of interesting places. Much as in an unfamiliar city, a newcomer must either be guided to them by a someone who knows the neighbourhood or by exploring areas off the beaten path. If one wanders through the park south of the mansion, through the gypsy camp, and into an old barn, one might well notice a rug hanging on the wall, a rug which serves at the gateway to Weaveworld, the neighbourhood to which I refer:

> On second glance, you are amazed by the exotic workmanship of the carpet. Its strange designs of people and places seem to describe an entire world, and you wonder if this magical tapestry might have been hidden away here. It beckons you to step closer.
> Suddenly coming to life, the fabric and patterns of the carpet unravel and transform around you. You find yourself in a forest, and behind you the visually confusing frontier between tree and vine on one side and the weave of the carpet on the other. You follow a path to the east out of the forest.

Weaveworld is a skilful play of signifiers that imply queerness on the whole, though not specifically. Inspired by Clive Barker's novel *Weaveworld,* this is a neighbourhood distinctively set apart from the rest of LambdaMOO.

> You are standing on the top of a hill covered with fragrant and unfamiliar flowers and grasses. From this vantage, you see a large part of Weaveworld, a riotous patchwork of geographies hastily rescued from some ancient peril. Just to your north is a large nutmeg tree (which seems climbable). To your south is an old well, crumbling apart from age and neglect.
> You walk along the path to the east until you enter the small village.
> Here the road thru the village widens into a circular plaza of red cobblestones. On a large marble pedestal is a statue of two Greek warriors clad in bronze and silver armor. Inside the pedestal there is rumored to be a golden urn, like many ancient treasures, hidden away for safe keeping in Weaveworld.

Upon this plaque is inscribed the passage from the *Iliad* where Achilles mourns his lover Patroclus. Further evidence of the ethos of this neighbourhood might come as a user poked into the cottages and treehouses around this central space and found them inhabited overwhelmingly by male characters — with a preponderance of strapping young men with artistic sensibilities.[3]

There are also sly markers of paganism and sensuality, mostly notably a tree of 'giddy fruit' which, when eaten brings visions:

You see Jorge Borges, saying 'Oh time, thy pyramids!'
Quentin talks with what appears to be a box containing Schroedinger's cat.
You see the two boys from the statue, wrestling.
You see Michel Foucault in white pants and a leather jacket.

Weaveworld and its environs are spaces marked as queer, in the sense of non-conforming and strange; yet this queerness creates a safer space where sexual non-conformity can become the norm.

Other more literal queer-themed spaces have sprung up throughout LambdaMOO, including a Gay and Lesbian Community Center and a rather predictable sex club for gay men. Supplanted by such newer features as GAYLINE, Weaveworld has gone the way of Brigadoon, removed from the database by its creator in the summer of 1995. Yet Weaveworld, with its anarchic challenge to the main spaces of LambdaMOO, initially carved out the space in which these more literally-defined gay resources can exist. Weaveworld is largely the creation of one user, whose creative rethinking of what a queer space might look like simultaneously broadened definitions of queer identity. This synergy of space and community suggests more broadly the manner in which on-line discourse and queer identity illuminate each other.

How queer identity shapes queer space

Perhaps it was not a coincidence that one of the earliest developers of computing, Alan Turing – who in World War II aided the Allies in cracking the Nazi's Enigma code – was gay. Or that the modern gay movement and the computer industry were both born at roughly the same time in the late sixties by people who were breaking with convention. Or that both thrived and grew within the liberal political climate of northern California.

(Signorile 1993)

Despite their obvious differences, these systems respond to many of the same dynamics, the different constructions of space found in each system suggesting differing resolutions to several issues. One issue, with implications for other on-line discourse, is how space functions as a constructive factor in on-line discourse. A second issue is how these spaces embody varied constructions of gay and lesbian identity.

The most obvious use of on-line spatial metaphors, on these systems as well as others, is to encourage certain appropriate kinds of discourse and constrain others. Who defines such 'appropriateness' is generally determined by the corporate or political structures that govern each system; the function of spatial constructions is to convey such decisions to users. When users have the opportunity to create such spaces themselves (as on LambdaMOO and in an ephemeral way on America Online), the power to encourage and constrain discourse is thus shared.

It's no surprise that one of the hotly contested questions in national debates about the Internet, the issue of explicit sexual content, is dealt with in various ways on these systems. On ModemBoy, it's something of a selling point, and is encouraged for 'Upperclassmen' whose membership fees earn them access to the aforementioned Locker Room, with its promise of more lurid conversations. All users, even non-paying ones, must affirm that they are over 18, though no verification was required as of 1993.

Throughout America Online, as discussed above, explicit sexual discourse is officially prohibited, though in certain spaces the rule is more readily enforced. One of the functions of a Private Room on America Online is to serve as an appropriate spot for more explicit conversation.

On ISCA, all sexually explicit questions and comments — relating both to homosexual and heterosexual issues — are on-topic only in a forum called 'Kama Sutra', admission to which is gained only after the Sysops have verified a user's age. As part of ISCA's integrative strategy for gay, lesbian and bisexual content, questions and comments regarding same-sex practices are welcomed in that forum and prohibited in the three primary queer spaces. Thus ISCA shares with America Online the designation of spaces for gays and lesbians where sexuality is, paradoxically, proscribed.

That LambdaMOO has a significantly different approach to regulating discourse is apparent; control of an individual room rests with its owner, who can lock the room so that no one other than the users in the room can read what is said or done. There are, however, no explicit rules on content of any sort: the disclaimer on the opening screen lays the foundation for this *laissez-faire* approach:

> PLEASE NOTE: LambdaMOO is a new kind of society, where thousands of people voluntarily come together from all over the world. What these people say or do may not always be to your liking; as when visiting any international city, it is wise to be careful who you associate with and what you say. The operators of LambdaMOO have provided the materials for the buildings of this community but are not responsible for what is said or done in them. In particular, you must assume responsibility if you permit minors or others to access LambdaMOO through your facilities. The statements and viewpoints expressed here are not necessarily those of the wizards, Pavel Curtis, or the Xerox Corporation and those parties disclaim any responsibility for them.

Thus the spatial metaphor of a metropolitan city suggests where responsibility for access to potentially offensive material (including sexual content) should rest.

Sexually explicit language is, of course, not the only kind of discourse that may be perceived as disruptive. One of the advantages of on-line systems is the ability to meet people with similar interests, yet for such discourse to be profitable to users, the noise level (in the form of off-topic or simply irrelevant talk) must be kept low. By suggesting what kind of talk is appropriate in various rooms, system administrators can shape appropriate discourses. Systems have a variety of ways to keep the content of various spaces generally in line with what has been established as the proper topic. ModemBoy users volunteer 'teachers', moderators who genially keep things on-topic and also have the responsibility for stimulating discussion in their 'classrooms' when things get dull. Rooms in America Online are named to encourage appropriate postings, and moderators have some ability to regulate content.

Because of the limited message capacity on ISCA and the high scroll rate of popular forums, topicality is a major concern and often the subject of contentious debate. Due to storage constraints, each new post consigns a previous post to virtual nothingness: 'off-topic' posts accelerate this process. Complicating this in interesting ways is the fact that gay and lesbian issues are on-topic in other relevant forums and users are directed to post there, for issues of love and dating advice, sexual technique, religion, AIDS, and so on. Someone asking a question or making a point about AIDS in the LesBiGay forum,

for example is soon corrected, often sternly. On ISCA the broad signals about topicality generally given by a spatial description become rigorously disciplined to the point of seeming absurdity.

Equally disruptive to serious conversation is the casual chatting which some users seek. (Conversely, of course, one could argue that serious conversation disrupts playful banter.) The system administrator of a California municipal BBS once compared the difficulty of making decisions in an on-line community to holding a committee meeting in a room with someone screaming in the corner. On many systems, the distinct provisions for both synchronous and asynchronous discussion also suggest separate spaces for formal and informal discourse. Chat gravitates to synchronous spaces, serious discussion to asynchronous ones. On America Online, message boards offer asynchronous, often more serious, topics of discussion while chat rooms are places to gather simply for conversation. America Online also provides for serious discussion in real-time, through its topical Forums, where a moderator is empowered to keep things in order or through Center Stage, where many users can read simultaneously, but only invited guests may post. The metaphors of different physical spaces reinforce these distinctions.

The basic system architecture of ISCA privileges asynchronous discourse. Though users may send express messages to other users singly, no facility is offered for multiple-user real-time communication. In the forums designated for serious discussion, informal chatty posts are even more highly discouraged than off-topic posts. The forums designated for chatting and humour, including 'Babble' and 'Flirting', scroll rapidly, yielding something approaching a synchronous experience. The third queer space, Stonewall Cafe, serves this function for gay, lesbian and bisexual users, as well as sympathetic straights. (At one point, non-queer users had to be sponsored by a member and voted in by the membership; this process proved cumbersome and was eventually dropped as being discriminatory.)

Stonewall Cafe operates as a kind of cheap MOO, a bargain basement virtual reality. In a communal act of creation, a casual cafe atmosphere is maintained entirely through individual posts. Actions are designated by paired asterisks (*bounces in* or *sips cappuc-cino*) and much of the interaction is of a 'Who's here? Who wants to talk?' variety. Though serious discussion is not banned, it's often derailed by users pursuing more playful interactions. Through this corporate creativity, a stock of commonplace props, furniture and other stage-setting devices are used to instil an ethos of relaxed comfort. Depending on the imagination of those writing entries, the room's amenities may contain a hot tub (or two, if separatists are on-line), a fully stocked bar with attractive co-gender bartenders and a range of comfortable furniture: a love seat, some dark booths in the corner, the 'dyke couch' and the most recent addition, the 'bisexual futon'. Here a fairly developed spatial metaphor is developed and sustained moment to moment by the community of users to give the impression of a comforting and welcoming place.

Yet these spaces, potent and meaningful as they are, tell only part of the story. Without meaningful interactions, all of these spaces would remain pleasant fictions, no matter how clever or evocative. What the creators of these spaces intend to summon forth, much as mediums at a seance, are particular identities, shaped and given life by these peculiar geographies.

How queer spaces shape queer identities

If you build it, they will come.

(Ghostly voice in *Field of Dreams*)

This heavenly dictum has become something of a commonplace, invoked to justify every-thing from the building of frozen yogurt shops to the offering of new courses in Arabic at a university. Yet its central mystical truth, speaking of the power of place to call forth appropriate inhabitants, survives such oversimplification. The builders of shopping malls and the presiders over religious ceremonies share with the designers of on-line spaces an appreciation of the potency of space to draw forth participants sharing a communal identity: the shopper, the worshipper, the computer-using queer. Ironically, the kinds of spaces that have evolved to present queer discourse can be taken as measure of what queer identity is in the 1990s.

One factor that links these spaces with their historical and real-life counterparts is the need to provide safe(r) spaces for queer folk to gather. Despite the increasing visibility of gay, lesbian, and even bisexual lives in the popular media, to live as a gay man or lesbian, to speak as a gay man or lesbian, is to open oneself to attack. The concern with confidentiality on these spaces, which at times seems obsessive, reflects the very real dangers of a time when gay bashing is on the rise and homophobic politicians hold sway across the land, from local school boards to the halls of Congress.

ModemBoy gains a certain degree of 'safety' by being a service primarily marketed to gay men. No doubt there have been some gay bashers logging in on occasion, but there isn't the constant interplay of diverse populations that makes this an issue on other systems. LambdaMOO's primary protection against harassment is self-selection: as in real life, users choose their friends and the people they hang out with. Though the medi-ation process set up by users has yielded sanctions against some blatant examples of harassment including homophobic harassment (see Stivale 1997), there is much less systemwide concern with setting up a rigid code of conduct. The software does offer the ability to take actions to bar hearing or seeing the words or actions of someone you wish to ignore. The bodily dimension of a MOO, however, opens up the field for a new kind of harassment based on actions and objects rather than just on 'spoken' discourse (Dibbel 1993).

Not surprisingly, America Online handles issues of harassment with a mix of offi-cial policies and software features. Every user agrees to abide by the 'Terms of Service' a set of rules of acceptable behaviour that prohibit harassment, including that on the basis of sexual orientation. (It is these same 'Terms of Service' that restrict explicit sexual content.) There are several ways of contacting an on-line guide or a 'TOS Advisor', AOL staffers who enforce those policies and can take appropriate action. Nevertheless, determined bashers can render a room unusable to its gay and lesbian users, and the extensive efforts it would take to rigorously police the system may not be a high priority for a commercial enterprise that makes its money by letting people onto the system, not by kicking them off.

On ISCA repeated attempts to establish Queerspace as a 'safespace' raise some interesting issues for on-line communities. This space and Stonewall Cafe share strict confidentiality policies: revealing any information obtained there (including the identity of other members) is grounds for banishment from the forum. Concern that the promo-

tion of these spaces as 'safe' might lead people to expect a higher level of confidentiality than actually exists has led to a recent redefinition of this as 'safer' space – it's safe from casual observation, and there is a concerted effort to keep the posting within the spaces clear of homophobic bashing, but users concerned about confidentiality should understand that almost any electronic system is subject to eavesdropping and that any communal norms are subject to individual digression.

There are competing views, however, on what makes a particular space 'safe'. One Forum Moderator, in an effort to create a space that was psychologically safe, established a policy that attacks against another member of Queerspace on the basis of sexual orientation anywhere on the system (gay-bashing by a closeted gay person, for example would be grounds for expulsion from the forum). Her intent, based on a sophisticated understanding of the kind of nurturing space necessary for people to feel comfortable, ran up against concerns of free speech: this policy was eliminated and she was removed as Forum Moderator. This clash between two paradigms of on-line discourses – as the kind of virtual community which Howard Rheingold (1993), envisions, or as a bastion of absolute free speech, where 'information wants to be free' (in Stewart Brand's memorable phrase, 1987: 202) – is emerging as a crucial issue for the future of on-line communication.

Related to freedom from harassment are issues of privacy. Provisions for privacy are more important in lesbian and gay spaces than general public spaces. One of the reasons Digital Queers encourages the use of America Online is its provision for members to have up to five screen names for each account, any of which can be anonymous. ISCA has an anonymous option, and even allows anonymous postings in the three queer spaces. Throughout LambdaMOO, real-life identification (including name and email address) is available only to Wizards (system operators), who must have a valid reason for checking. Since virtually all interactions take place in one's virtual body and identity, however, anonymity of one's on-line identity is not possible. Even here, though, spatial metaphor can generate new kinds of discourse. On DhalgrenMOO, a virtual space inspired by the works of Samuel Delany and William Burroughs, one clever programmer is experimenting with a 'back room' modelled on the notorious back rooms of certain gay bars. In this virtual space, all identities are replaced with the word 'someone'. The visitor to this room might experience something like this:

> Someone enters.
> Someone brushes up against your leg.
> You touch someone's arm.

For a regular user on a MOO, this divorce of identity from one's virtual body can be startling. What is striking about this room is that the spatial analogue of a back room has led to a further refinement of the discursive possibilities of MOOspace. In the anonymity that all these systems make available to users, each recreates the kinds of real-life spaces that have allowed for anonymous expressions of sexual identity.

Paradoxically, even as these spaces offer virtual equivalents to anonymous trysting grounds, they also reflect a growing popular acceptance of gay men and lesbians, at least on an institutional level. By presenting queer spaces as equivalent to spaces for other identity groups, the system architecture suggests a moral equivalence (or at least neutrality). Shoe-horning lesbian and gay spaces into these less controversial spaces yields some interesting decisions and compromises; we can see this mainstreaming of the lesbian

and gay community as either empowering or trivializing. The official gay/lesbian presence on AOL is one of 65 'Clubs and Interests' accessible from the Main Menu; gay and lesbian concerns take their place among forums devoted to such interests as wood-working, backpacking, genealogy, pet care, quilting, and *Star Trek*. Likewise on ISCA, the three queerspaces take their place among forums dedicated to Trekkers or sports enthusiasts or computer hackers. Though it might be seen as a public relations triumph for gays and lesbians to be no more controversial than Trekkers or woodworkers, there is also the risk of trivializing the concerns of queer folks by labelling them a 'club' or (special?) 'interest'. The relevance of this to queer identity is two-fold: being queer is almost as socially acceptable as being a Trekker, but no more important. Such a mini-mizing of the distinctiveness of gay identity has its drawbacks: constructing homosexuality as this kind of 'lifestyle choice' is a common tactic of the religious right.

On the other hand, these spaces are equivalent to spaces for other sociological groups that are less easy to trivialize. Other community-based areas on America Online include AARP, Christianity On-line, Deaf Community, disABILITIES, Military and Vets Forum. Queer status on ISCA is roughly similar to that of women, African-Americans, and disabled people in that special forums are dedicated to the interests of these groups. Such an inclusion of the gay and lesbian community among other socially recognized groups suggests an inclusiveness distinctive of identity politics. Yet such a perception assumes a unified and distinct Gay Community that exists only in the dreams of gay activists and the nightmares of religious fundamentalists. The realities of gay, lesbian, bisexual and transgendered communities defy such simple definition.

The very inclusion of bisexuals and transgendered folk, for example, is as much an issue of controversy in cyberspace as elsewhere. Despite recurring complaints from some users, ISCA spaces are assertively inclusive of bisexuals, unlike either AOL'S GLCF or ModemBoy as a whole. In fact, at one point, America Online policies reflected a view of bisexuality as even more threatening than homosexuality: the phrase 'Bi' was prohib-ited as part of a screen name or Member Room name.

A second way of defining identity is less explicit, with more tenuous boundaries. Rather than contesting the specific boundaries of queer identities, this approach exploits what might be termed co-factors of gay identity. ModemBoy's atmosphere of narcis-sistic, sex-crazed boys exaggerates one cultural image of gay men and uses that as a signifier to give a sense of community. By contrast, and in a much more sophisticated way, the gay ghetto of Weaveworld uses markers of paganism, anarchy, and sensuality to delineate a 'queer' space off the beaten path. Other offshoots of Weaveworld take a much more literal approach, but spatial metaphors need not be so literal. There are constructions of gay identity still that are suggested rather than denoted.

Another way such identity is formed and strengthened is by membership in a self-aware community. Though it is generally the task of the academic observer to define the community by its members, our experience as community members is that we are often shaped, consciously or not, by the communities in which we participate. In the fluid geographies of cyberspace, community boundaries shift as the discourse changes. A LISTSERV mailing list that gives one a sense of membership in a worldwide profes-sional community can become, in the space of few months, a squabbling gaggle of egomaniacs with all the unpleasantness of a real-life dysfunctional group.

Despite such difficulties, virtual communities do form and re-form themselves. Markers of community found on these systems include informal initiation rites involving

both knowledge of the system and training in appropriate behiaviour. Blatant requests of a sexual nature may be deferred to more appropriate channels. A comment on a current issue may be met with the response that says essentially 'we discussed that last week before you showed up, and we're all tired of it'. The message to a newcomer that 'this is the way we do things here' suggests a shared understanding, however undeveloped or unarticulated, of a *we* and a *here*. 'We' denotes the particular community of discourse that centres on a particular virtual space: place, community, identity and voice are all inextricably linked. A colleague of mine confesses a sense of spatial disorientation when she is on a MOO, particularly when talking with a group of colleagues. Though she (happily) maintains enough presence of mind to understand that she is at her computer and not 'in' the virtual room, she often catches herself imagining that all the other people she is talking with are in a physical room together somewhere else, and that she is the only one restricted to computer-mediated communication.

Communities often crystallize over crisis situations, either personal or institutional. An illness or suicide attempt can energize the cords of compassion that bind the community together. Howard Rheingold movingly describes the community bonding in the Parenting conference on the WELL (21–23); in these queerspaces, the act of coming out to one's parents and the process of dealing with subsequent acceptance and/or rejection often reveal the community at its most nurturing. A threat from the system administration to change the boundaries of the virtual space, or a perceived failure to take action against harassment can spark the moment where members speak of themselves as 'we': 'We have to do something. We're not going to take it any more.' There are even moments when a conscious awareness of a community develops and members attempt to regularize and strengthen those defining boundaries: an ISCA user questions whether transsexuals belong in Queerspace; America Online members submit digitized photos for a Family Album. On LambdaMOO, a user has created a GAYLINE function for synchronous chat that preempts the spatial metaphor of the MOO altogether, substituting a communications channel more typical of IRC (Internet Relay Chat.) In this case, membership is formalized with policies for appropriate use of the channel, admission procedures, and other explicit markers of a formally organized community.

Yet we must not forget that these communities are, for the most part, rooted not in face-to-face interactions, but in discourse, more specifically in the kinds of discourse that take queer identities, however contested, as a given. The kinds of writing engendered by these spaces are informed by a perspective that moves queer discourses from the boundaries to the centre. The effect is much the same as that observed by Harriet Malinowitz in her lesbian- and gay-themed writing classes:

> Importantly, it wasn't a queer-only place, but rather a community forged by a coalition of discourses in which queerness claimed a visibility and authority it doesn't ordinarily enjoy in the world. The heterosexual students in the class became skilled at launching their acts of reading and writing from more advanced points of departure when it came to queer topics; the queer students learned that by articulating the complexity of the world from their own vantage points they could create the audience that they needed.
>
> (Malinowitz 1995: 185)

Malinowitz created her queer classroom space by advertising a course and enrolling students, thus 'queering' the space of a composition classroom. On-line communities

are gathered in a similar fashion, though much more informally. Community is the key link between spatial metaphors and issues of identity. By helping to determine appropriate tone and content, the permanency or transience of the discourse, these place descriptors help to shape a discourse community. When that community is also marked as queer, community identity also informs the voice and *ethos* appropriate to members of that community. These spatial metaphors are shorthand for establishing the rhetorical situation of computer-mediated communication.

Although the initial impulse for establishing an on-line queerspace may be to set up a 'safe' environment where people can feel free to express their identities, such spaces also become the sites where identities are shaped, tested, and transformed, both individually and corporately. The fluid boundaries of on-line spaces prove an apt locus for this redefinition of queer identities. Frank Browning (1993) concludes his analysis of contemporary American gay cultures with a challenging observation that captures the shifting queerspaces I have described here: 'The community of identity exists only in the state of transformation. In the culture of desire, there are no safe spaces.' In these cafes and classrooms and quaint pagan villages, words shape, caress, inspire and challenge; words mediate and recreate the identities of the tribe.

Originally published in *Works and Days* 13 (1–2) (1995).
This essay has been edited for inclusion in the Reader.

Notes

1. Quoted in Quittner (1994), p. 95.
2. Most notable of these signifiers is, of course, the name Lambda itself: the Greek letter lambda was an early symbol for gay rights; its source as a MOO name is an obscure reference to the Lisp programming language (Curtis, Section 2). Prominent system messages refer to 'coming out of the [literal] closet' and to the movie *The Wizard of Oz,* long a touchstone of gay culture.
3. Whether the real-life users who created these characters are themselves male cannot be so readily determined. The provisional genderedness of MOO interaction leads to some interesting situations, but for my purposes, the overwhelming maleness of the players who live in and around Weaveworld can be taken at face value in gendering this particular virtual space.

References

Bolter, J.D. 1991) *Writing Space: The Computer, Hypertext, and the History of Writing,* Hillsdale, NJ: Lawrence Erlbaum.
Brand, S. (1987) *The Media Lab: Inventing the Future at MIT,* New York: Penguin.
Browning, F. (1993) *The Culture of Desire: Paradox and Perversity in Gay Lives Today*, New York: Crown.
Cole, (1982) 'Hallowed be the mall', *Drew* (December).
Curtis, P. 'Mudding: social phenomena in text-based virtual realities', available by FTP from *parcftp.xerox.com:/pub/MOO/papers/DIAC92.txt*
Dibbell, J. (1993) 'A rape in cyberspace,' *Village Voice,* 21 December: 36–42.
Malinowitz, H. (1995) *Textual Orientations Lesbian and Gay Students and the Making of Discourse Communities,* Portsmouth, NH: Boynton/Cook.
Quittner, J. (1994) 'Johnny Manhattan meets the furry Muckers', *Wired* 2.03 (March) pp. 92–7.
Rheingold, H. (1993) *The Virtual Community: Homesteading on the Electronic Frontier,* Reading, Mass: Addison-Wesley.
Schwartz, J. 'On-line obscenity Bill Gains in senate', *Washington Post* (24 March 1995), A-1.

Sedgwick, E. K. (1990) *Epistemology of the Closet*, Berkeley: University of California.

Signorile, M. (1993) *Queer in America: Sex, Media and the Closets of Power*, New York: Doubleday.

Stivale, C. J. (1997) '"Spam": heteroglossia and harassment in cyberspace', in E. D. Porter (ed.) *Internet Culture*, London: Routledge.

Vaillancourt, D. (1995) 'Wired for the revolution', *10 Percent* Jan/Feb: 48–51; 66–67.

DANIEL TSANG

NOTES ON QUEER 'N' ASIAN
VIRTUAL SEX

THE RELATIONSHIP BETWEEN TECHNOLOGY and sexuality is a symbiotic one. As humankind creates new inventions, people find ways of eroticizing new technology. So it is not surprising that with the advent of the information superhighway, more and more folks are discovering the sexual underground within the virtual community in cyberspace.

Like the stereotypical computer nerd, I have sat in front of my computer, pressed some keys, and connected to a remote computer, perhaps twice daily, if not more often. But unlike the desexualized computer nerd, I have used the computer to connect to a Bulletin Board System (BBS) (in Orange County, California) with a significant number of gay Asian members and used it to meet others for affection, romance, love and sex for several years. Initially this just seemed like the computerized, electronic version of placing or responding to a personal ad, as I had several times before. But as time went on, it dawned on me that this was something entirely different with the potential for creativity (and mischief) largely untapped by myself and most of the others (I presumed) on the BBS.

On the board, fantasy substitutes for hard reality. For a couple of years I had been chatting electronically with this college student; recently I called his college (he had given me his name and address) and found he did not exist, nor did his dormitory. Yet this was someone with whom I had even chatted 'voice'. i.e. on the phone. Could he have been a figment of my imagination? Or did he give me false identification? Or worse still, was an undercover government agent infiltrating the board to investigate my sex life? After all, the CIA has admitted collecting information about me and giving it away to a foreign government.[1]

It does pay to have a sense of 'healthy paranoia' on-line. For despite the illusion of privacy, nothing one types is really truly private. The sysop (system operator) can 'tap' your electronic conversations; who knows if the recipient is not 'downloading' your love notes? Sometimes, in 'open chat', the forum is deliberately not private, and several

people can chat at once or almost at once. All participants get to read the messages flying back and forth. Without even the National Security Agency having its Clipper Chip access, BBSing is arguably more open than chatting in public. Berlet (1985), for example, argues that today's BBS sysops 'are merely the modern incarnation of the pesky and audacious colonial period pamphleteers like John Peter Zenger and Thomas Paine' and that today, 'Zenger might well be a political dissident running a controversial BBS while listening to audio tapes of the "Police" singing about surveillance,' and BBS should thus be protected by privacy laws from government intrusion.[2]

But despite the best efforts of these civil libertarians to protect the privacy of BBSers, those who chat on-line need a wake-up call: the notion of privacy is, in the end, an illusion. Like the HIV status of your electronic mate, don't be deluded. Play safe: treat every message as public, and every sexual partner as HIV positive. The BBS challenges traditional notions of privacy and obscures the lines between private and public.

One reason BBSing is so fascinating is that the on-line environment truly allows one to continually reinvent one's identity, including the sexual. For once, you are in total control of your sexual identity, or identities, or at least what you decide to show the outside world.

Indeed, it is our sexualities that are on display. In real life, but more so in virtual reality, our sexualities are not fixed, but constantly in flux. In the Foucauldian sense, we re-invent our sexualities. Over time we can have more than one. And there are more than just gay or straight. And despite the protestations of the latest adherents to gay ideology that they were born gay, the on-line environment reminds us that our sexualities are ephemeral, to be changed with a stroke of a key. These are social constructs, not biological essentialisms.

In virtual reality, we can take on other identities than our current one, often with no one else the wiser. In time, these on-line identities may become more real than the physical one.

One student I know even signs on under a friend's I.D. so that he can maximize his time on the board; and he is on the board for hours daily, even during exam week. Personally, I can't tell you how long it has been since I have been to a gay bar, except to pick up gay magazines; like numerous others, electronic cruising has replaced bar hopping.

The BBS I am most often on allows its members to post not only a written biography of ourselves, answers to numerous questionnaires, but also digital portraits of ourselves. In turn, members can peruse (or 'browse') these bios and questionnaire responses, as well as retrieve and download your digital image, and see you in the flesh, even nude.

Thus, with a keystroke, one can change one's biographical particulars, e.g., ethnicity, age, domestic partnership status, class, or even sexual orientation. This means, of course, that all the posted information should be taken with a grain of salt.

Age is one good example. This board, like many others, restricts membership to adults (eighteen and over). Hence, any minor who seeks access must lie about his age. In fact two had been kicked off the board because they were minors, according to the sysop. (The board is predominantly male, with only a handful of females, out of almost 1,100 members.) On the other end of the age scale, because of the disdain against them, some older men do not give their true age. When I went on I put my age as thirty-six; after several years, it has been changed only by one year, to thirty-seven.

Ethnicity or race is another characteristic that can be changed, almost at will. If being Vietnamese today is not what you want to be, you could pick some other category. One BBSer from Taiwan even picked 'Caucasian', and found out lots more people wanted to chat with him than when he was 'Chinese', a recognition that the electronic environment does not screen out racist sentiments.

Caucasians inhabit most of this virtual space, although there is significant Asian presence (on this board some 8 per cent). Although Caucasians will describe themselves as being of various European backgrounds, depending on the person, the distinctions may not be revealing. If Caucasians see us as the 'other', we admittedly often see the white race as just monolithic.

The study of gay Asians also awakens us to the dangers of essentializing the Asian American. In fact, like sexualities, Asian-American identities are not static, but in constant flux. The contemporary influx of South-east Asians and other Asian subgroups to this country makes us realize that one can no longer limit our discourse to Chinese or Japanese subcultures.

One could argue that by signing up for the board, one is taking the first step toward 'coming out'. Even though one can remain largely anonymous on the board with 'handles' that are pseudonyms and not 'real' names, the fact that a BBSer needs to identify his sexual orientation on the board makes it an important act of coming out. Many of the BBSers, for example, note in their biographies that they are just 'coming out'. Surprisingly, there are very few BBSers who identify as straight on the board. One might have thought that it would be easier, and less threatening to initially label oneself as straight. Undoubtedly a few do that, since they stay on the board quite a while and do engage in deep chats with those identifying as gay or bisexual. They are often asked why they are on a gay board. Yet the query is posed not to exclude but out of curiosity, I suspect, and out of a hope, perhaps, that the straight identity is indeed in flux, and moving toward a gay identity.

More of the Asians (like the non-Asians) identify themselves on the board as gay rather than bisexual. One might have thought that it would be less threatening to come out as bisexual. (If queried, many of the bisexuals would insist, however, that they are true bisexuals, and not just going through a phase.) There are, however, differences within the various Asian groups as to the prevalence of bisexuals.

It should be noted that identifying as gay or bisexual on a BBS is not the same as coming out to someone directly. Because of the presumed anonymity of the board, such a disclosure is made much more easily. Often, I have had prolonged chats with someone who pours out his love life on-line, something he would probably only do because I am a stranger.

As I write, gay Asians have become more visible, the 1994 Lunar New Year celebrations marking the first time a gay and lesbian Asian contingent has marched in San Francisco's Chinatown. No one has done such a comparative study, yet, but one could postulate that it is harder for Asians (than Caucasians) to come out, given cultural and family traditions, and that the rate at which Asians come out varies by national origin.

Anthropologist Joseph Carrier and his colleagues have in fact studied the sexual habits of Vietnamese immigrants in Orange County, California. They have found that assimilated Vietnamese Americans are more ready to identify as 'gay', whereas those who are more recent immigrants or less assimilated do not, even if they engage in homosexual behaviour.[3] This supports Tomas Almaguer's observation that some Chicanos

'come out' genitally but not cerebrally. In other words, they engage in gay sex, but without the self-identification as gay or bisexual. Loc Minh Truong, who was almost bashed to death by two Caucasian youths later convicted of gay bashing, insists he is not gay, even though he was once convicted of lewd conduct on the same beach where the hate crime later occurred.[4]

In light of the above, it is surprising that so few on the BBS actually refuse to identify as gay or bisexual. Only a handful on the board who are Asian say they are straight.

I have also argued elsewhere that just as many homosexuals attempt to pass as straight, some Asians in North America attempt to pass as white.[5] I mentioned above the case of a college student from Taiwan who, in an apparent experiment, changed his ethnic identity from Chinese to Caucasian on the BBS, and almost immediately, received many more queries and invitations to 'chat'.

That there are others who are in fact uncomfortable with their ethnic identity is suggested by the several dozen, presumably of varying ethnicities, who identify as 'others' in the category for ethnicity. To be sure, many may have found the categories listed inappropriate (especially those with a multi-ethnic heritage). But I suspect a certain percentage decline to state their ethnicity in the hopes that their chances on the board will be improved. Ethnic identity and age are the two identifying characteristics that flash on the screen whenever a BBSer tries to contact another BBSer to chat.

On-line, it is of course possible to reconstruct not only one's sexual orientation, but also one's racial and ethnic identity. And indeed one's entire biography. In a racist society, it is perhaps surprising that not more do that. Fung has argued that:

> Gay society in North America, organized and commercial, is framed around the young middle-class white male. He is its customer and its product. Blacks, Asians and Latin Americans are the oysters in this meat market. At best we're a quaint specialty for exotic tastes. Native people aren't even on the shelves.[6]

Exoticized and eroticized, Gay Asian males are none the less considered a 'quaint specialty.' This became quite clear with a recent mail message from a self-described 'rice queen' on the board who wrote me:

> Hi, they say opposites attract, so I am looking for an unabashed snow queen with nice patties! To rest upon my snowey [sic] slopes.. . . I have written to over fifteen Asians on this BBS but none of them has replied. Can you give me some helpful hints? Don't worry, I can take critisisms [sic].

Why are Asian males the subject of desire of so-called rice queens? A Japanese American I met on the board wrote in his short-lived print newsletter, *Daisuki-Men,* that there are three reasons: China Doll syndrome (i.e. Asian males are seen as feminine); the perception that Asians are submissive; and the rice queens' obsession with things Asian (as indicated by decorating their residences with Asian knick-knacks).[7]

One could go on, but the point is made. '[O]ur (presumed) racial characteristics are fetishized by the non-API gay communities as a frozen form of desirability – one that is derived from an Orientalist perspective. In this economy of desire, the trade is almost always unidirectional, where APIs are encouraged to use our '"exotic appeal," our "Oriental sensuousness," to maximize our attractiveness' according to Hom and Ma.[8]

As Asians, we resent being treated as objects, or as the 'Other', but given the mainstream definition of beauty in this society, Asians, gay or straight, are constantly reminded that we cannot hope to meet such standards. Fung writes that in commercial gay male representation, it is the image of white men that is set up as the ideal: 'Although other people's rejection (or fetishization) of us according to the established racial hierarchies may be experienced as oppressive, we are not necessarily moved to scrutinize our own desire and its relationship to the hegemonic image of the white man.'[9] With such lack of self-scrutiny, is it any wonder that some gravitate to the Great White Hope as their saviour?[10]

For it is not just Caucasians who see Asians as a specialized taste. Asians are so specialized that for some Asians, fellow Asians are not even on the shelf.

A twenty-five-year-old Japanese American sparked a recent debate on this very issue when he posted the following on a public bulletin board: 'Like the stereotypical Asian, I prefer to date Caucasian men.'

Now, as some subsequent BBSers pointed out, a stereotype has some basis in fact. To be sure there are Asians who feel attracted only to Caucasians. Hom and Ma have observed that since 'many of us "came out" in the Euro/American gay context, our ideals of male beauty are necessarily influenced by the dominant cultural standards of beauty and desirability'.[11]

But it is probably safe to say that most Asians do not have exclusive attractions to one race. Even on this board, very few indicated publicly their attraction to their own race or strictly to another race.

Furthermore, the on-line debate suffered from an implicit acceptance of a way of viewing sexuality and racial identity in dualistic terms: gay or straight, white or Asian (complementing mainstream media's black/white dichotomy). Not all Asians feel the same way, of course, nor do all Caucasians. Lumping each group together tends to obscure more than it unveils. Furthermore, there's more diversity (even on the BBS) than this white/Asian dichotomy allows. How about all the Latino-Americans on the board? Or the African Americans? One can postulate that our identification with the struggles of the US civil rights movement draws some of us in solidarity with other people of colour, so that this focus on white/Asian relationships is misleading.[12]

As I explore BBSing further, I see more transgressing of these traditional dichotomies, Asians cohabiting with Blacks or Latinos. But not just racial barriers are transgressed. Monogamy is another. On the board, romance, marriage, love and lust are redefined. One bisexual Southeast Asian (who has a steady girlfriend he plans to marry) is an occasional fuck-buddy, visiting every so often in person, or more often, engaging in cybersex or phone sex.

The sexual practices that Asians on board find desirable run the gamut, from oral to anal sex, sadomasochism, and frottage. Some BBSers specifically ask other Asians to check out their electronic bios; others ask non-Asians to browse their sexual histories. Some readily admit their penis size, others say they are too shy. They report sizes ranging from five to eight inches. Many admit they have been tested for HIV, although some say it's too personal a question to answer. Some admit to smoking pot. Detailed analysis awaits further coding of the data.

BBSers provide more evidence that campaigns against sex in the schools have failed and that the Reagan/Bush years of sexual repression are over. The proliferation

of sex boards suggests that a vibrant sexual underground has spawned right under the unsuspecting eyes of parents.

Given the prevalence of Asians in computer-related careers, one would not be surprised to find BBSers to be the places where gay or bisexual Asians gain entree into the sexual communities that now span the globe. Given restrictive drinking ages that bar anyone under twenty-one from gay bars, BBSers have become an easy way for young gays of whatever ethnicities to enter the sexual underground. And this is not just a US phenomenon. France is in many ways ahead of us; authorities there banished the telephone book (thereby saving many trees). Instead, every household received a computer terminal, thus in one stroke, bringing the French into the electronic age. Inevitably, the sex boards on the Minitel became the hottest venues for a newly electronically enfranchised constituency.[13] A comparative study of Vietnamese in Orange County and in Paris cruising on their respective sex boards would be an exciting contribution to the study of Asian sexualities.

The prevailing, if contradictory images of the Asian male as Kung Fu expert or computer nerd is one that also renders him desexualized. In other words, the penis is missing in the dominant representation of the Asian male. In his 'lifelong' quest for his lost penis, Fung found it in a Vietnamese American, going by various names including Sum Yung Mahn, who acted in gay porn videos.[14] In fact a BBSer claimed to be the same actor, but has since left the board so it has been impossible to confirm his identity.

BBSers, then, challenge prevailing notions of Asian males as asexual. They provide Asians and Pacific Islanders an anonymous forum for sexually explicit dialogue and for exploring their sexualities. On these boards, APIs are truly 'breaking the silence' about taboo sexualities. In the process, APIs are empowered to voice our own forbidden desires and to reconstruct our own sexual identities.

Originally published in *Amerasia Journal* 20 (1) (1994).
This essay has been edited for inclusion in the Reader.

Notes

1. For an early account of the case, Tsang v. CIA, see G.M. Bush, 'Librarian Takes on CIA: UCI Employee Wants to Know About His File', *Los Angeles Daily Journal* (6 February 1992), section II, 1, 18. The admission about releasing information about me to a foreign government appears in court documents. The student later explained on-line that because he lived in a homophobic dorm, he had given me fake identification information.
2. Chip Berlet, 'Privacy and the PC: mutually exclusive realities?' Paper prepared for the 1985 National Conference on Issues in Technology and Privacy, Center for Information Technology and Privacy Law, John Marshall Law School, Chicago, Illinois, June 21–23, 1985. Electronic version stored in public eye database on PeaceNet.
3. Joseph Carrier, Bang Nguyen and Sammy Su, 'Vietnamese American sexual behaviors and HIV infection', *The Journal of Sex Research* 29(4) (November 1992): 547–60.
4. Daniel C. Tsang, 'The attack on Loc Minh Truong: the intersection of sexual orientation, race and violence', *RicePaper* 2(7) (Winter 1993): 10–11.
5. Daniel Tsang Chun-Tuen, 'Gay awareness', *Bridge* 3(4) (February 1975): 44–45.
6. Cited in Daniel Tsang, 'Struggling against racism', in Tsang, *The Age Taboo* (Boston: Alynson, 1981) p. 163.
7. Sumo, 'From the editor . . .' *Daisuki-Men* 1 (1992): 4.

8. Alice Y. Hom and Ming-Yuen S. Ma, 'Premature gestures: a speculative dialogue on Asian Pacific Islander lesbian and gay writing', *Journal of Homosexuality* 26 (2/3) (1993): 38.

9. Richard Fung, 'Looking for my penis: the eroticized Asian in gay video porn'. In Bad-Object Choices', *How Do I Look/Queer Film and Video* (Seattle: Bay Press, 1991) p. 149.

10. See Daniel C. Tsang, 'M. Butterfly meets the great white hope', *Informasian* 6(3) (March 1992): 3–4.

11. Hom and Ma, 'Premature Gestures', pp. 37–8.

12. Daniel Tsang, 'Lesbian and gay Asian Americans: breaking the silence', *A/PLG Newsletter* (October 1990); 14–17.

13. See chapter 8, 'Télématique and messageries roses', in Howard Rheingold's *The Virtual Community* (Reading, Massachusetts: Addison-Wesley, 1993) pp. 220–40.

14. Fung, 'Looking for my penis', pp 149–50.

THOMAS FOSTER

'TRAPPED BY THE BODY?'

Telepresence technologies and transgendered performance in feminist and lesbian rewritings of cyberpunk fiction

What we have in today's virtual-reality systems is the confluence of three very powerful enactment capabilities: sensory immersion, remote presence, and tele-operation.

(Laurel 1993)

In cyberspace the transgendered body is the natural body.

(Stone 1995)

Virtual reality, it turned out, was nothing but air guitar writ large.

(Sawyer 1995)

ANDREW ROSS (1991) ONCE RATHER notoriously described the cyberpunk fiction of William Gibson, originator of the cyberspace metaphor, as 'the most fully delineated urban fantasies of white male folklore' (145).[1] In Ross' reading, cyberpunk representations of virtual realities and human–computer interfaces do indeed turn out to be 'nothing but air guitar writ large', not only commercialized hype (as Robert Sawyer (1995) suggests) but specifically adolescent male commercialized hype.[2]

This essay uses Allucquère Rosanne Stone's recent work on the status of embodiment in virtual systems to account for the existence of a significant number of popular narratives by women writers about virtual reality, despite Ross' characterization of cyberpunk fiction as inherently masculinist. In particular, Stone's work helps explain the predominance of themes of gender and sexual performativity or cross-identification in these narratives about cyberspace. I have written elsewhere about the relevance of theories of performativity to narratives of cyborg embodiment,[3] but this chapter considers the relevance of those theories to virtual reality computer interfaces and computer simulations, which tend to be represented popularly as technologies of disembodiment.[4] To what extent do theories and practices of subversive mimicry and performativity, such

as drag or butch-femme, function as a cultural framework for constructing the meaning of virtual reality and telepresence technologies?[5]

I will focus on three examples of narratives that use practices of gender cross-identification to conceptualize cyberspace and virtual reality: Maureen F. McHugh's short stories (1992; 1994), Melissa Scott's novel *Trouble and Her Friends* (1994), and Laura Mixon's novel *Glass Houses* (1992). I will end by using Caitlin Sullivan's and Kate Bornstein's novel *Nearly Roadkill* (1996) to raise some questions about the dominance of gender and sexual performance in these narratives and about the remarkable absence of popular attention to the way that cyberspace might facilitate modes of racial performance such as passing and blackface. While Stone's comment that 'in cyberspace the transgendered body is the natural body' (1995: 180) seems intended primarily to articulate the challenge posed by virtual systems to existing constructions of gender identity, the same statement might also be read as articulating a new set of emergent gender norms. Transgendered bodies and performances do in fact seem to be increasingly naturalized in computer-mediated communication and in popular narratives about it, in ways that transracial bodies and performances are not.[6]

Both text-based and graphic virtual interfaces make possible the decoupling of public persona from the physical space of the body. This detachment certainly lends itself to a traditional Cartesian dualism between mind and body, and therefore can also reproduce the gendered hierarchy that equates masculinity with universal rationality and femininity with embodied particularity.[7] However, this same detachment of public persona from physical location can also have the effect that Judith Butler famously attributes to gay performance styles such as drag or butch-femme – that is, the detachment of public persona from physical body can reveal that sex and gender are not related as cause and effect and that sex and gender do not necessarily exist in a one-to-one expressive relation to one another.

This critique of expressive subjectivity has received less attention than Butler's arguments about subcultural practices of gender masquerade, but it is that critique which best defines the mutual relevance of virtual reality and theories of performativity. Butler argues, for example, that the categories of the 'inner' and the 'outer', upon which expressive subjectivity depends,[8] 'constitute a binary distinction that stabilizes and consolidates the coherent subject'. But in situations where 'the "inner world" no longer designates a topos, then the internal fixity of the self and, indeed, the internal locale of gender identity, become similarly suspect' (Butler 1990: 134). Virtual systems represent just such a situation, where the 'inner world' of subjectivity is no longer simply located within the subject's physical body. Virtual reality computer interfaces or telepresence technologies both restage and disrupt the distinction between inner and outer worlds. Virtual personae or body images become relatively more detached from any 'internal fixity' or 'locale' – specifically, bodies as material bounded spaces. If the process of virtualization itself involves the progressive 'dissociation of space from place', as Mitsuhiro Yoshimoto (1996) suggests, then the 'locale of gender identity' also becomes dissociated from any fixed location (115). The question is: to what extent can such personae, and the challenges they pose to traditional notions of the relation between sex and gender, be ideologically recontained as mere secondary projections of a securely interiorized self?

In the popular discourse on virtual reality computer interfaces, the disappearance of this expressive relation between body and gender identity is perhaps most clearly

demonstrated in Howard Rheingold's (1991) notorious speculations about the sexual uses of these interfaces, which he calls 'teledildonics'. Rheingold imagines a technology that will allow computer users to map their body images into computer-simulated graphic environments in cyberspace, along with feedback devices that will translate actions in cyberspace into physical sensations in the user's body; if the user's image or avatar in cyberspace reaches its hand to 'touch' another person's image or is 'touched' by someone else's virtual hand, then an approximation of those sensations will be transmitted to the user's actual body (350). Rheingold takes this scenario a step further by raising the possibility that users would map their physical bodies onto their virtual images *non-mimetically,* and it is the implications of this dissociation of virtual image from a one-to-one relationship with any physical body that have been generally overlooked in responses to this scenario. Rheingold suggests that 'there is no reason to believe you won't be able to map your genital effectors to your manual sensors and have direct genital contact by shaking hands. What will happen to social touching when nobody knows where anybody else's erogenous zones are located?' (353).

Let's put aside for the moment the question of whether we really know now where anybody else's erogenous zones are located, or even our own. What this passage from Rheingold's popular introduction to virtual reality implies is the breakdown of the binary relationship between sex and gender which mandates, among other things, that there are only as many genders as there are biological sexes. By contrast, in virtual environments, the relationship between body and social presence can no longer be taken for granted.

The conceptualization of this potential breakdown of expressive relationships between embodiment and social identity in terms of 'teledildonics', however, also has other implications. The figure of the dildo invokes lesbian sexual practices, and in contemporary lesbian criticism it is not uncommon to find the dildo invoked as 'an especially embarrassing affront to normative heterosexuality' which suggests 'its (possibly postmodern) subversion' (Lamos 1994: 91), or as a means by which 'lesbians have turned techno-culture's semiotic regime of simulation and the political economy of consumer culture back against the naturalization of masculinist hegemony' in a reading of how 'the reproduction of the penis as dildo' exposes the phallus as merely a 'simulacrum', a copy without an original (Griggers 1994: 121). Lisa Moore (1995) in fact, has adopted Rheingold's terminology to analyse Jeannette Winterson's lesbian fiction.

Given this reading of 'dildonics', tele- or otherwise, as a subversive imitation of the phallus which reveals it to be only an idealized copy of itself and not a secure source of cultural authority, it is only a short step to the reading that Theresa Senft (1996) proposes, which moves from the use of the dildo as a sexual prosthesis to a reading of sexual identity itself as prosthetic; as Senft puts it 'a *transgendered woman* . . . lives a prosthetic sexuality – she points to the fact that *all* gender is a strap-on that you can't strap off' (23). And the context for this claim is Senft's attempt to define a model for sexual and gender performances in cyberspace, in what Stone calls the 'spaces of prosthetic communication' (1995: 36).

The result is a chain of associations, which moves from imagining how virtual images or personae might be differently mapped onto physical bodies to a notion of teledildonics to lesbian sexual practices and prostheses to a theory of sexual and gender identities and performances as prosthetic. One effect of this chain of associations, however, is to conceptualize virtual performativity in exclusively sexual and gendered

terms, rather than in terms of transracial performance, which is equally implicit in the initial rejection of one-to-one mappings of bodies and social identities, as I read Rheingold's teledildonics scenario. Lauren Berlant has identified the problem with applying a model of 'prosthetic identity' to minoritized subjects, especially the mulatta or women whose bodies are also racially marked. Such women find themselves in the dilemma of figuring over- or hyper-embodiment, and therefore the inability to transcend their particular bodies, for 'a culture that values abstraction' and the ability to identify with the universalized national body of the American citizen, a body that Berlant argues functions as a prosthesis necessary for participation in the national public sphere (1991: 113). In other words, to consider the articulation of gender and race is to immediately problematize the model of 'prosthetic identity' that Senft proposes for virtual embodiment. The association of virtual technologies with forms of teledildonics or prosthetic sexual identities has the positive effect of denaturalizing binary gender identities, but that association has not encouraged consideration of the effects of virtual embodiment on racial identities and histories. What would it mean to think of race as well as sexuality as a prosthesis? That question is one that any attempt to apply theories of sexual performativity to the analysis of cyberspace must also consider.

Rheingold's teledildonics scenario has also been taken up by at least one feminist science fiction writer, Maureen F. McHugh, in a story entitled 'A Coney Island of the Mind' (1992). This story is a rather programmatic translation of Rheingold's speculations into a fictional narrative, with a twist that Rheingold doesn't envision. In McHugh's story, an adolescent male protagonist uses a commercial virtual reality system designed to immerse the operator in a virtual environment through the use of head-mounted displays and datagloves to translate the movements of the hands into movements of the virtual image of the operator's body, and a treadmill to facilitate the illusion of movement within the computer-generated graphic. This virtual environment, the 'Coney Island' of the title, can be accessed simultaneously by multiple participants who can interact virtually. The literary allusion in the title, to a poem (and book of poems) by Beat poet Lawrence Ferlinghetti, is important for at least two reasons. First, the allusion emphasizes the application of a literary metaphor to the representation of cyberspace, though the allusion is also to a literary movement, the Beats, which attempted to return poetry and print culture in general to a model of performance. Second, the allusion also invokes Ferlinghetti's use of the phrase 'Coney Island of the Mind', which Ferlinghetti uses as a metaphor of both poetry and the American public sphere, both understood as a kind of carnivalesque space that is simultaneously a social and a textual space.

The main character of the story has invested considerable time and expense customizing a virtual body image for himself that he refers to as 'Cobalt', and a body image that makes deliberate though superficial use of the non-mimetic possibilities of virtual embodiment by rendering his eyes and hair a bright blue (84–5), in an attempt to separate himself from users who simply adopt a more generic and pre-programmed simulation of a body. As Cobalt, this character encounters the virtual image of a young woman with 'yellow snake eyes and brown skin' (87). While they are holding hands on the virtual boardwalk, he realizes that she is having an orgasm and that she has taken 'a hotsuit and re-wire[d] the crotch so the system thinks it's a hand', just as Rheingold imagined (89).

The young man is at first embarrassed to have been tricked in this manner (89), a response that is especially interesting given that it distinguishes this rewiring of

erogenous zones from simple cross-dressing or the creation of alternative personae in virtual reality. Earlier in the story, Cobalt is solicited by a group of 'queens (who are mostly black and tall and female and camp, that being the current fashion in queens)' (86). He dismisses their suggestive comments as 'white noise,' but goes on to remark that they are 'not what he's looking for anyway although who's to say what he'd be looking for if he had the option?' (86). On one level, the 'option' that Cobalt doesn't have is to experience the sexual options made possible by a full-body 'hotsuit' with sexual feedback mechanisms, an 'option' to which minors are denied access. But on another level, it is clear that the 'option' is also the choice to explore alternative identity practices, such as flirting or having cybersex with someone who has chosen to appear as a black drag queen. But in the context of this virtual environment, the story clearly indicates that such modes of cross-identification and border-crossing are both encouraged and safe because they are perceived as having no real consequences for the world outside cyberspace. This reading is reinforced when Cobalt gets a sexual thrill from the thought that the person he's met, who appears as an attractive woman in virtual reality, might actually be someone completely different. It makes his heart pound to think that she might be 'ugly, or fat, or old. Maybe she is blind, or deformed. Wild thought that this beautiful girl can be anything' (88). In this passage, Cobalt's virtual experience is presented as progressive, as he steps beyond the expected heterosexual prejudices of a boy his age by not only imagining but also enjoying the thought that he is flirting with a woman who doesn't meet normal standards of physical beauty. At the same time, it is clear that such moments of stepping outside the pressures of social conventions for gender and sexuality are also ideologically recontained by the assumption of a clear distinction between cyberspace and 'real life', with virtual experiences having no particular effect on who Cobalt is outside virtual reality.

Cobalt's ability to maintain this distinction momentarily breaks down, when this other person goes a step further by telling Cobalt that he has not only been tricked into having sex without knowing it but that he's been tricked into having sex with a gay man without knowing it. The other character asks Cobalt if he's a girl, and then reveals that 'she' is glad he's not, because 'she' is '"not into girls. I just like wearing girl bodies because I like you righteous boys, you sweet straight boys"' (89–90). Cobalt's reaction to this revelation is beyond embarrassment. His first thought is that 'he'll have to change his look, never look like this again, abandon Cobalt, be something else' (90). The implication of this moment of homosexual panic is that Cobalt is so mortified that he momentarily assumes either that his virtual image is somehow legible to others as a gay style of embodiment, leading to encounters like this one, and therefore revealing something about who he really is; or, alternately, that this encounter has somehow marked his virtual persona for other people, in the same way that a rumour about his sexuality in real life would affect his social identity in ways that he could not control. At this point, it seems that Cobalt both collapses the distinction between virtual experiences and 'real life' and, for that very reason, imagines using the resources of virtual reality to literalize the typical adolescent fantasy of escaping an embarrassing situation by becoming someone else. But, of course, Cobalt's previous attitude toward virtual reality simulations was that they had no such effect on who he really is, that encounters with 'queens' in VR were incapable of invoking the 'real life' response of homosexual panic, and that the social meaning of his presence in cyberspace remained in his authorial control, no matter how far he walked on the wild side in VR. By the end of the story,

this attitude re-emerges, with Cobalt imagining how he can re-narrate and edit the story to claim bragging rights among his friends.

McHugh's version of Rheingold's teledildonics scenario then identifies the difference between modes of cyber-cross-dressing, 'wearing girl bodies', that only reinforce normative gender and sexual identities and modes of virtual embodiment that more fundamentally subvert such identities by more fully utilizing the potential of virtual technologies to disrupt the expressive or one-to-one mapping of social identities and meanings onto bodies. By the same token, this narrative suggests that teledildonics also makes possible acts of cyber-transracialization: is the 'brown skin' of this female body image assumed as a calculated element in the seduction, or is the gay male operator also brown-skinned? Significantly, this question and the issues it raises about the extent to which exoticizing racial stereotypes might be implicated in transgendered or drag performances tends to be overwhelmed by the spectacular nature of the gender and sexual cross-identifications in the story.[9]

This implicit distinction between what Lisa Nakamura (1995) calls virtual 'identity tourism' and more truly unsettling forms of virtual cross-dressing becomes particularly important in the context of the gay character's statement about 'wearing girl bodies'. That phrase suggests an extension of Judith Butler's comments on drag as 'the mundane way in which genders are appropriated, theatricalized, worn, and done; it implies that all gendering is a kind of impersonation and approximation' (Butler 1991: 21). For the characters in McHugh's story, virtual reality seems to be imagined as the mundane way in which sexed bodies are appropriated, theatricalized, worn, and done. In other words, McHugh's story suggests that virtual reality might foreground Butler's argument that both bodies and genders must be understood as constructed through frameworks of cultural intelligibility, that in turn must themselves be continually produced and reproduced through repeated performances of those interpretive frameworks. At the same time, this reference to 'wearing girl bodies' also evokes the problem of distinguishing theatrical modes of performance, which maintain a strict dualistic hierarchy between performer and role, from the kind of discursive performativity that Butler privileges as subversive in its repetition and undoing of the originality of the performer's identity.[10] Conceptualizing virtual cross-dressing as an act of 'wearing girl bodies' can be read as a reinscription of the Cartesian mind/body dualism, in which the body functions as a mere receptacle for the mind or self.

The gay male character's statement about '"wearing girl bodies because I like you . . . sweet straight boys"' also suggests an inversion of Butler's famous reading of lesbian femme performances through the comment of one femme that she likes 'her boys to be girls' (1990: 123); the character in McHugh's story likes to be a girl in order to have virtual sex with straight men. One of the main questions the story implicitly poses is whether this sexual act was a heterosexual or a homosexual one. Or is it an example of what Jodi O'Brien calls 'uncoded desire' (1996: 63), a form of sexual practice for which there is, as yet, no category? Allucquère Rosanne Stone's (1995) book on virtual systems theory offers the best theorizations to date of these new possibilities and of the relationship between virtual embodiment and theories of performativity. Stone's book focuses primarily on sexuality and gender but also provides an opportunity to consider how the experience of telepresence might affect racial identities as well.

For Stone, virtual reality technologies make visible what she calls 'location technologies' – that is, techniques for mapping cultural meanings and representations onto

physical bodies. Her work attempts to account for the ways in which 'the accustomed grounding of social interaction in the physical facticity of human bodies is changing' (17). Stone uses the term 'virtual systems theory' to encompass not only the new relationships between physical and virtual bodies in cyberspace but also older forms of 'warranting', one of the key terms Stone introduces, defined as 'the production and maintenance of this link between a discursive space and a physical space' (40). This process of warranting is not unique to cyberspace but has always functioned 'to guarantee the production of what would be called a citizen', since 'this citizen is composed of two major elements': the 'collection of physical and performative attributes that Judith Butler and Kobena Mercer in separate works call the culturally intelligible body' and 'the collection of virtual attributes which, taken together, compose a structure of meaning and intention for the first part', primarily through discursive means (40). These two sets of attributes compose what Stone calls 'the socially apprehensible citizen' (40), and the process of becoming such a citizen means acquiring a new, virtual body. (It is important to note that the 'physical' body, in Stone's model, is, therefore, no more purely natural or organic than is the body in Butler's work; instead the physical body is constituted and experienced through discursive and performative means.)

For Stone, then, as for critics like Michael Warner (1992) and Lauren Berlant (1991), the production of the 'citizen' has always involved a process of abstraction from the particularity of the body, and this history provides the context in which to understand the changes introduced by virtual reality and new technologies of computer-mediated communication. Berlant describes this traditional process of forming the universalized body of the citizen by transcending particular forms of embodiment as the nation's promise to provide 'a kind of prophylaxis for the person, as it promises to protect his privileges and his local body in return for loyalty to the state' (1991: 113). Berlant adds, 'American women and African-Americans have never had the privilege to suppress the body' that this process of citizenship requires (113). In some narratives about cyberspace, virtual technologies are imagined precisely as a means of mediating and resolving this dilemma. Several of the characters in Caitlin Sullivan and Kate Bornstein's novel *Nearly Roadkill* (1996) argue that cyberspace is liberating for women in particular because it protects them in the way that the more traditional 'prophylaxis' of public discourse has not: 'And for women! Whoa! Suddenly they can tell assholes to fuck off without getting killed, or be really sexy in a way they would never be normally, and just enjoy it' (10–11). In this passage, through the mediation of text-based virtual communities, women are able to go public *and* still safely assert their differences from men, both through performing their sexualities and through verbal confrontation. In this version of virtual reality as public sphere, it is not necessary for women to transcend their sexual and gendered particularities in order to become part of the general public.

Virtual technologies also tend to make it much more difficult than it used to be to impose a one-to-one relationship between a single body and a single discursive identity, or in Stone's terms to warrant, to guarantee or ground, social identity in a physical body, and it therefore becomes more difficult to limit discursive identities to one per body, or by extension to limit genders and sexual orientations to one per sexed body. It is this intervention in already existing cultural techniques of abstraction and disembodiment that invalidates or at least qualifies the popular association of VR and cyberspace with a Cartesian desire to escape embodiment entirely, to be free of the 'meat', as one of William Gibson's characters might put it. In Stone's words, 'the virtual component

of the socially apprehensible citizen is not a disembodied thinking thing, but rather a different way of conceptualizing a *relationship* to the human body' (1995: 40).

In virtual systems, it is no longer necessary for this relationship to be expressive in order for bodies to be culturally intelligible. Like drag performances, virtual reality technologies have the potential to, in Butler's words, 'mock . . . the expressive model[s] of gender' and 'compulsory heterosexuality' (1990 137), which assume 'that there is first a sex that is expressed through a gender and then through a sexuality' (1991: 29). In another story by McHugh, 'Virtual Love', a woman narrator and a male character learn to recognize and become attracted to one another in virtual reality because of their skill in creating an operating multiple, alternative personae, both male and female, including a black woman persona for the white woman narrator (McHugh 1994: 101). The story hinges around the revelation that both these characters are physically confined to wheelchairs, which leads the male character to explain their unusual skill in constructing virtual personae in terms of how everyone else in VR is '"projecting something. But I'm not. I'm not projecting myself at all"' (109). To realize the full potential of virtual reality, it is necessary to recognize, as Butler puts it, that 'the distinction between expression and performativeness is crucial' (1990: 141).

The narrator ends the story by rejecting the essentialism of the other character's explanation: 'I don't think I'm less likely than anyone else to project, any more objective than anyone else. But maybe people like Sam and me, we spend more time. We refine our art' (110). This comment could be read as reasserting an expressive model of subjectivity, associated with artistic expression. But it is equally possible to read the narrator here as generalizing the need to critique expressive assumptions about virtual embodiment to include everyone, not just the differently abled, especially since the scenes that reveal the physical bodies of the characters seem designed to shock readers and make us aware of how our reading of the story might have performed a similar act of expressive 'projection'. That is, readers would be shocked if we began by assuming that there was a general correspondence, at least, between the various body images we see the characters take on and their actual physical forms. At the same time, the narrator's final comment also suggests a critique of technological determinism, which would locate the disruption of expressive assumptions in the technology itself, rather than in the cultural frameworks in which the technology is made to mean and which structures the ways in which the technology gets used.

As I just suggested, the scenes in which the characters' physical forms are revealed seem designed to enact within the reading process the necessity of unlearning expressive assumptions about the relationship between virtual and physical space, which is thematized in the story as a central problem for users of virtual reality. In fact, the revelation scenes are deliberately staggered, so that first the narrator describes how she is no longer able to 'forget' her physical body and 'come alive' through the mediation of a virtual persona. She loses this ability to 'come alive' in cyberspace because her romance with the other character is becoming too serious and she feels proceeding as if her virtual persona were real would be deceiving him and only frustrating herself. At this point, the narrator tells us that 'I know myself, a tiny woman in a chair, held in by seat restraints, wearing a VR visor and gloves. . . . Flipper babies they call us when we are little, seal babies' (107). Her virtual lover later tracks her down and appears to her in his physical form: 'the little man in the wheelchair is all head, head with a sharp, pointed chin and thinning hair and quick eyes. He's not really all head, he has a body, and short stick legs, short muscular

arms. Like something out of a Valasquez painting, a dwarf' (109). The narrator is then able to accept a romance in virtual reality and also, perhaps even more important, to overcome her tendency to privilege her physical body as her 'real' or 'true' self. When she meets her lover again in virtual reality at the end of the story, her virtual persona takes over, and she finds herself behaving like the character would, 'kind of in your face' (110). The narrative's refusal of any clear distinction between actor and role, face and mask, is underscored by the fact that the story never gives the 'true' names of the characters; they are only identified by the names of their personae.[11]

These scenes of revelation are all the more disturbing given the contrast between them and the narrator's detailed and loving descriptions of both her personae and her lover's various body images, which take up a significant portion of the story. The point of this deliberate shock is to demonstrate how the form of the story, in a print medium, is capable of incorporating some characteristics of virtual technologies and providing an experience for readers that approaches those made possible by virtual reality. McHugh's 'Virtual Love' invokes and revises a traditional understanding of narrative point of view, which implies an embodied perspective on the actions of the narrative. But, as N. Katherine Hayles (1993b) has argued in an important essay on the characteristics of printed 'info-narratives', 'in cyberspace point of view [pov] does not emanate from the character; rather, the pov literally *is* the character' (82–3). That is, in narratives set in virtual environments, the characters' points of view are detached from any direct connection to a specific body, and those points of view or personae function themselves as narrative agents.[12] It is precisely this transformation in the narrative function of point of view, this formal encoding of technological change, that McHugh's 'Virtual Love' retroactively makes readers self-conscious about. We realize in retrospect that the narrator's point of view was much more dissociated from her physical body, through the mediation of virtual technologies, than we had initially realized before that physical embodiment was revealed to us. The story not only thematizes this process of dissociation for the characters, but also transfers it to readers of the story. And that process is precisely one of interrogating the naturalness of expressive assumptions.

Butler emphasizes that all forms of gender are performative with the expressive model becoming the norm only through 'the repeated stylization of the body, a set of repeated acts . . . that congeal over time to produce the appearance of substance, of a natural sort of being' (1990: 33). For Butler, drag constitutes a disruptive repetition of these gender norms, one that foregrounds the arbitrary relation between sex and gender by, for instance, juxtaposing a recognizable performance of femininity against the background of a culturally intelligible male body. I would argue that virtual reality constitutes another form of disruptive repetition, with the user's physical body repeated and reiterated as an image or representation in cyberspace. In effect, virtual systems spatialize the repeated performance of gender norms over time and thereby reveal the gap between embodiment and the performance of it, which allows for subversion, intervention, and the critical rearticulation of that relationship.[13] It is this spatialization of a gender identity that is normally produced as a 'social temporality' that allows virtual systems to reveal 'the imitative structure of gender itself', the extent to which gender is an imitation without an original (1990: 137, 141). In Stone's model of virtual systems, this point is made when she defines both the physical body and the discursive persona as having performative elements, so that the experience of virtual embodiment can potentially lead to a rethinking of physical embodiment as well (1995: 41).

Melissa Scott's 1994 novel, *Trouble and Her Friends*, launches a more explicit and fully developed lesbian feminist revision of cyberpunk fiction than McHugh's stories. The novel focuses on a circle of gay and lesbian computer hackers, all of whom have had an invasive procedure which allows them to interface their nervous systems directly with cyberspace computer networks through the use of a neural implant called a 'brain-worm' that allows for full-body processing, translating information into bodily sensations.

The novel sets up a complex relationship between alternative sexualities and hacking. *Trouble and Her Friends* begins as the cyberspace networks are finally coming under direct government regulation, with the result that hackers in general are faced with the challenge of 'going straight, moving out of the shadows into the bright lights of the legal world, the legal nets' (33–4). But what does it mean for these gay and lesbian hackers to 'go straight'? Is this the equivalent of coming out of the closet, as the rhetoric of 'moving out of the shadows into the bright lights' suggests? Or is it the equivalent of going back into the closet, by assimilating to heterosexual norms as well as to the middle-class norms of legitimate computer users, as the phrase 'going straight' suggests?[14]

The novel's deployment of the rhetoric of the closet associates being closeted with the use of cyberspace as an escape from oppressive social relations in the urban spaces represented in the novel. That desire for escape is thematized precisely in terms of performative possibilities: one of the main characters thinks of the cyberspace Nets' as a place 'where a woman could easily be as hard and tough as any man' (210). Cyberspace therefore represents a temptation for these gay and lesbian characters as a space of liberation from the constraints of living in a more homophobic 'real' world, though this liberatory function is qualified by the way in which the novel represents the prejudices other computer hackers still possess about women and gay computer users. The novel also suggests, however, that the liberation made possible by computer interfaces may be purchased only at the cost of ghettoizing or reclosing subversive gay performances in cyberspace, where they will have no effect on social relations more generally. In other words, the thematics of the 'closing of the electronic frontier' functions not only as a critique of cyberpunk's tendency to romanticize outlaw hackers;[15] this same thematics also emphasizes the necessity of establishing connections between cyberspace and the world outside the Nets, of setting up a feedback loop between those two kinds of spaces and therefore between virtual and the physical bodies. In this sense, Scott's novel supports Stone's claim that 'the virtual component of the socially apprehensible citizen' is not an escape from embodiment but instead represents a 'different way of conceptualizing a *relationship* to the human body' (1995: 40). *Trouble and Her Friends* might then be read not as an elegy for the unregulated anarchy of the Internet, as it might initially appear, but instead as one of the first narratives exploring the preconditions for virtual citizenship.

Rather than offer a more extended reading of Scott's novel than this, I want to focus on one specific passage that attempts to explain the attraction of cyberspace for marginalized groups in general, especially since this passage insists on conceptualizing the value of virtual technologies in terms that include, but are not limited to, the modes of gender and sexual performance such technologies permit. One of the main lesbian characters, whose handle in cyberspace is 'Trouble', speculates that

> maybe that was why the serious netwalkers, the original inhabitants of the
> nets, hated the brainworm [or neural interface]: not so much because it gave

a different value, a new meaning, to the skills of the body, but because it
meant taking that risk, over and above the risk of the worm itself. Maybe
that was why it was almost always the underclasses, the women, the people
of color, the gay people, the ones who were already stigmatized as being
vulnerable, available, trapped by the body, who took the risk of the wire.

(Scott 1994: 128)

Other computer hackers are presented in the novel as being prejudiced against
people who use this brainworm implant rather than a more traditional keyboard or
graphic interface, and the distinction made in this passage between two possible reasons
for this prejudice is a difficult, but important one. The passage suggests two reasons
why historically marginalized groups might be attracted to a VR technology that permits
the body to be used as a computer interface and why white men might hate this same
technology. On the one hand, this technology holds the promise of giving 'a different
value, a new meaning' to the experience of embodiment, a refiguring of embodiment
that is especially attractive to people who have been historically 'stigmatized as . . .
trapped' by bodies that mark them as marginal. In other words, these peoples are
presented as having reasons to want to intervene in the construction of embodiment
that straight white men do not.

It is interesting to note that gay people are associated here with women and racial-
ized groups, as occupying marked or stigmatized bodies. While it is true that the history
of homosexuality's pathologizing by medical and psychiatric discourse constitutes a
material, historical stigma, that stigma is not usually immediately culturally visible or
legible in the anatomical features of homosexuals, in contrast to women and racial
groups. The assimilation of gay people to these other stigmatized bodies only seems
valid for gay people who are already out and perhaps marked by a recognizable perfor-
mance style, like the women who see the Nets as a place where they can 'easily be as
hard and tough as any man' (210). The suggestion seems to be that cyberspace permits
a kind of spectacularized gayness. But if cyberspace functions in this novel as a privi-
leged gay performance space, a space where 'the transgendered body is the natural
body', for that very reason cyberspace also potentially functions as a kind of closet or
escape valve that confines gay performance to cyberspace only.

This same passage from *Trouble and Her Friends* also argues that it is not just the
process of revaluing embodiment as the basis for using computers that repulses anyone
who has not been historically 'trapped by the body'. The passage refers to another
risk, besides having to relearn the 'meaning' and 'value' of the body as computer inter-
face. This other 'risk' is associated with giving one's body 'over to pure sensation', or
becoming just a body under the control of 'a stranger's hand', during the process
of having the neural implant installed (128). This second risk seems to invoke the histor-
ical experiences of women, people of colour, and gay people prior to cyberspace, with
the suggestion that these subjects' relations to their bodies might always have been
understood as virtual, as mediated through cultural technologies of representation. This
reading is similar to Lauren Berlant's (1991) analysis of the specific relation of women
and African-Americans to the 'peculiar dialectic between embodiment and abstrac-
tion in the post-Enlightenment body politics' and therefore to what Berlant calls the
'prosthetic body' of the abstract citizen (113, 114). That is, for women and African-
Americans, that prosthesis has never seemed natural, given their relative exclusion from

the category of the universally human which that prosthetic body represents. That social body has, then, always appeared as a prosthesis rather than as a natural extension or expression of themselves for these marginalized groups. In other words, in this passage from Scott's novel, virtual reality technologies are represented as promising to disrupt the Cartesian mind/body dualism and the categories of immanence and transcendence that organize the mind/body dualism along gendered and racial lines.

The suggestion in Scott's novel that cyberspace might lend itself to gay styles of embodied performance is made more explicit in Laura Mixon's 1992 novel *Glass Houses*. This novel is narrated in the first person by Ruby, a lesbian character who suffers from agoraphobia, but who luckily possesses a neural implant that allows her to run a salvage business by remotely operating various robot bodies or 'waldos' through telepresence – that is, through a device that transmits the sensory impressions of the robots into Ruby's mind, replacing her own sensorium, but which also allows her to use the robots as remote extensions of her own body.

The machine Ruby uses most often is referred to as Golem: she's constructed it from salvaged parts, including an arm from a military robot called a 'schwarzenegger'. The narrative genders these robots, with Golem being referred to as 'he' and a smaller robot (Rachne, short for Arachne) being referred to as 'she'. It's difficult not to read this as a technological version of butch-femme roleplaying. Ruby comments on how she always prefers to negotiate with her salvage clients 'in waldo', talking to them through a robot stand-in, because 'they can't read me that way' (119). In other words, the robot body elicits a different set of social responses from other people who cannot as easily 'read' Ruby's gender expressively from her physical appearance. Similarly, Ruby speculates that 'it's easier to love' the city 'when your awareness is encapsulated in a metal body that puts nothing of you at risk' (78). The risk in this passage is precisely the risk of having a body that can be read too easily through the frameworks of cultural intelligibility that Butler has analysed.

When operating the Golem robot, Ruby refers to it throughout the novel as 'my-his' body. The only exception comes at a moment when Ruby is using the robot body to carry her own physical body, and she watches herself being carried by herself:

> I-Golem looked down at the woman in my arms. It was Ruby-me, of course, and her-my eyes were closed, fluttering a little. She-I curled with her-my cheek against Golem's chassis.
>
> She-I looked so young and vulnerable from the outside, not ugly and scrawny like me. I was terrified that I wouldn't be able to keep her from harm; I wished she were back home, safe, right this very minute.
>
> (Mixon 1992: 60–1)

It is important to note that Ruby here seems to identify more completely with the robot body, in feeling terrified that 'I' wouldn't be able to protect 'her' physical body, a shift marked by the abandonment of the hybrid pronoun forms, as Karen Cadora (1995) has pointed out in a reading of this novel as an example of 'feminist cyberpunk' (360–1; see also Harper 1995). It is also important to note that this passage thematizes the disjunction between Ruby's inner and outer perspectives on her physical body, her view of herself as 'she/I' and her view of herself as 'me': 'she/I looked so young and vulnerable from the outside, not ugly and scrawny like me' In other words, Ruby's more positive self-image comes from being split into 'she' and 'I' through the medium of

telepresence. But when she refers to herself as 'me', I would argue, she is attempting to unify these two perspectives into a single coherent subjectivity with the result that she only internalizes the split subjectivity that has been externalized through telepresence technology, in a kind of rewriting of the mirror stage.[16] But this passage associates this internalizing of split subjectivity with Ruby's internalizing of a negative social judgment about her femininity and appearance. This passage also demonstrates how such technologies might both literalize and disrupt what Butler calls 'the binary distinction between inner and outer', demonstrating Butler's argument that when 'the inner world' no longer designates a topos, then the internal fixity of the self and, indeed, the internal locale of gender identity, become similarly suspect' (1990:134).

The real story of the novel concerns Ruby's process of overcoming her agoraphobia. At the beginning of the novel, Ruby deals with this problem by spending all her time '"junked out on your stupid machines,"' as her roommate and lover puts it (65). As in *Trouble and Her Friends,* telepresence represents a temptation to escape embodiment or to use this technology to acquire a safer form of embodiment as an interface with the outside world. It is in this way that the novel intervenes in the traditional gender narrative that associates women with domesticity, though it is also clear that Ruby's agoraphobia represents precisely a kind of 'female malady', in which she is only able to go beyond the limits of her home through surrogates. She is not exactly confined to her home, but she is not exactly free to come and go, either.

By the end of the novel, however, Ruby learns to use both her physical and her robot bodies. In this narrative, then, the robot bodies are not simply supplements or prostheses for the physical body; when Ruby learns to use her own body, she does not give up the use of the robot bodies. The use of telepresence does not require the abandonment of the physical body. Her body no longer exactly functions as a limit or a receptacle for her mind, or if it is a receptacle, then it is one whose boundaries are permeable and unstable.

Caitlin Sullivan and Kate Bornstein's novel *Nearly Roadkill* (1996) seems like a suitable place to conclude, since it explores the possibilities for transgendered performances in actually existing computer technologies, specifically text-based roleplaying on the Internet. This novel goes much further than any of the other texts I've discussed in its treatment of cyberspace as a space of liberation from gender norms and especially from the assumption that gender identities are expressive of biological sex and sexual identities. This novel focuses on two characters, Winc and Scratch, who enjoy what they call 'splattering' or the often simultaneous performance of multiple, differently sexed and gendered personae in various chat rooms and bulletin boards. It is not until the middle of the novel that the two meet F2F (face-to-face), and it is only then that readers learn Winc is a male-to-female transsexual and Scratch is a self-identified lesbian with butch tendencies. The pair become celebrities when they refuse to register their identities with the government, which is attempting to regulate use of the Internet in response to corporate pressure; registering the identities of users will make it possible for companies to gather demographic data and to tailor advertisements to the specific interests of computer users, based on tracing the kinds of information individual users access.

Winc and Scratch regard the Internet as 'a place where there's no fear,' where 'it doesn't matter' if users are 'women. They could be black, Latino, the little guy in the wheelchair outside our building. The Asians getting off the boat in California. Gays. Lesbians. Children. Anyone who can't speak up because they were always afraid of being

put in their place' (134–5). This sense of liberation from imposed places and identities is, however, almost exclusively developed in terms of the liberation of on-line gender and sexual performances from any necessary mimetic or expressive relation to the physical bodies and appearances of the performers. There is almost no consideration of how this technology might be used by blacks, Latinos or Asians, despite their inclusion in the list of social subjects who might share this attitude toward the Internet.

There is one episode in the novel, however, where questions of racial masquerade intrude on the freewheeling genderbending of the main characters. Winc gets into a debate about the politics and ethics of this kind of on-line performance with a character named Leilia whose on-line persona is feminine, and who turns out to be Winc's lover Scratch, who is white, in disguise. This character notes that 'she' finds it 'hard to talk' about possibilities for subverting gender norms on-line 'without a context' (72). The example 'she' offers of such a context is an annual civil rights march where suddenly 'the colors of our skin don't matter . . . because it's *that* day, that march' (74). At this point, Winc decides that 'she' has probably been talking to a black person, and they open a discussion of how whiteness functions as an unspoken norm, with Scratch (as Leilia) noting 'wearily' that 'one of the cool things for black folks on-line is that they are assumed to be white, too. Not that they want to be white, but they're assumed to be "in the club", without having to prove credentials at the door' (74).

It is important to note how Scratch, who later describes herself as prone to bouts of depression in which she wishes she 'were black because I hate my skin' (195), becomes mistaken as 'black' by Winc not only because she refers to civil rights marches but also because she questions the limits of sexual and gender role-playing on-line when she is in character as Leilia. 'Race' figures primarily as a limit or an obstacle to the free play of performativity in cyberspace, and this representation of racial questions seems to me to oversimplify the relationship of racial identities to virtual modes of embodiment.

The exchange between Winc and Scratch-as-Leilia does, however, raise two questions that open up a more complex and productive consideration of race in cyberspace. First, the passage suggests that the bracketing of physical characteristics on-line may only reproduce the logic of the modern public sphere, by allowing 'black folks' to assimilate more easily to white norms. In that sense, on-line racial performance seems to amount to nothing more than another form of passing, though in this case all black people can potentially pass on the Internet, not just those with sufficiently light skin. Second, this passage also suggests that the supposed subversiveness of sexual, gender *or* racial performativity can easily be recontained within a particular 'context' or interpretive framework. The question this character raises is how to articulate such spaces of performativity where gender or racial norms can be relaxed, whether this occurs on-line or during special marches and holidays, with social spaces where those norms are rigorously enforced. In other words, the question is how gender or racial subversion moves beyond preaching to the converted, or how changes on the level of the virtual might affect the physical.[17]

Throughout this chapter, I have been focusing on how feminist and lesbian science fiction writers have begun to create narratives of virtual embodiment that situate these technologies in the context of the historical experiences of women and homosexuals, specifically the relative exclusion of both groups from the universalizing categories of the human and the citizen and their resulting relegation to the particularity of 'the body'. These popular narratives tend to imply progressive uses of virtual reality and other

computer interface technologies and to locate those progressive uses in the possibilities for subversive gender and sexual performance that the technologies make possible. But it is important, I think, to note that these narratives tend to ignore or minimize possibilities for racial performances on-line and in cyberspace. This may simply reflect the political underdevelopment of the discourse on the cultures emerging around new computer technologies. But the dominance of sexual and gender performativity over racial masquerade in these narratives of virtual reality can also be explained theoretically, by noting Fredric Jameson's (1991) use of camp as a way to conceptualize the general postmodern loss of depth, which he argues transforms the world into 'a glossy skin, a stereoscopic illusion, a rush of filmic images without density' – that is, a virtual reality computer simulation (34). The result of such transformations is to make social presence dependent upon social style, in the same way that virtual reality equates presence and style. In McHugh's 'A Coney Island of the Mind', the main character notes that 'the streets are all full of programming, of nonplayer characters, and kids without style, which is to say that this night Coney Island is empty' (87). Camp seems to provide a ready-made model for such a situation, but camp as a model for virtual embodiment has tended to privilege the performance of sexuality and gender over race.

This reading suggests that racial performativity may not be subversive in a way that is analogous to gender and sexual performativity. Histories of racial performance in the US, such as blackface minstrelsy, suggest in fact that racial norms are often installed and reproduced precisely through modes of racial cross-identification which are not mimetic or expressive in the same way that gender norms have been historically, so that such modes of racial performativity are much less likely to possess a subversive meaning than modes of gender cross-identification such as drag.[18] A recent article in *Emerge* magazine on the presence of white supremacist organizations on the Internet noted their promotion of modes of virtual blackface as part of a smear campaign against African-Americans, including posing as African-Americans to post material supporting the legalization of paedophilia (Sheppard 1996: 38). If, as Stone suggests, transgendered bodies and performances are the process of becoming naturalized in virtual systems, it may be necessary to keep a critical perspective on that process.

Originally published in *Modern Fiction Studies* 43 (3) (1997).

Notes

1. In *Neuromancer*, Gibson (1984) defines cyberspace as a 'consensual hallucination' (5) and as a 'graphic representation of data abstracted from the banks of every computer in the human system' (51).

 Originally written as an internal document for the Autodesk company, one of the earlier designers of virtual reality equipment, and collected in Brenda Laurel's *The Art of Human-Computer Interface Design*, John Walker's essay 'Through the Looking Glass' (1992) exemplifies how the literary metaphor of cyberspace was taken up by computer researchers and programmers. Walker cites *Neuromancer* to argue for changing the dominant metaphor of the human–computer interface. Walker wanted to replace the metaphor of interfacing as carrying on a conversation with the computer, with the metaphor of interfacing as entering another space on the other side of the computer screen (1990: 443).

 The concrete results of this shift in metaphors were attempts to design hardware and software that would produce this sensation of entering a 'cyberspace', such as the head-mounted

display, which produces an immersive effect by filling the user's entire field of vision, and the dataglove, which maps the movements of the user's hand as a kind of 3-D cursor. New software was also needed to map the movements of the head or the user's point of view into the simulation, for instance.

 To gain a sense of the history of these kinds of responses to the cyberspace metaphor, see Benedickt's *Cyberspace: First Steps* collection (1991); Laurel's *Computers as Theatre* (1993), especially the second edition which updates the final chapter on virtual reality; and Stone's *The War of Desire and Technology* (1995).

2. The most thoroughgoing critique of the rhetoric around cyberspace is Robert Markley's collection *Virtual Reality and Its Discontents* (1996). In his introduction, Markley specifically argues that this rhetoric reproduces 'the metanarrative of technological development' as an unquestioned good (7) and that the globalizing use of cyberspace to refer to all forms of virtual technologies renders those technologies in an abstract and dehistoricized form: 'the division between cyberspace and virtual technologies reflects and reinscribes the oppositions of mind/body, spirit/matter, form/substance, and male/female' (2). Despite the argument that cyberspace 'does not transcend the problems of materiality, embodiment, or capital', this collection pays little attention to specifically gendered and racialized modes of virtual embodiment or disembodiment, with the exception of Hayles' 'Boundary Disputes', which is reprinted in the collection, and to a lesser extent, Kendrick's essay.

 See also Stone's argument about how the term 'cyberspace' has functioned as a globalizing or abstract metaphor for a diverse 'network of electronic communication prosthetics' (1995: 35).

3. See Foster, '"The Sex Appeal of the Inorganic"' (1996: 297–300). Fuchs also uses Butler's theory of performativity to analyse cyborg imagery (1993: 114–15).

4. It is important to note, however, that there has always been a strong counter-discourse among designers and programmers of virtual systems, a discourse that associates such systems with concepts of full-body processing that incorporate embodied modes of processing information. For example, Randal Walser, a researcher at Autodesk, claims that 'Print and radio tell. Stage and film show. Cyberspace embodies' (1990: 60).

 One of the central debates in work on cyberpunk fiction, and technocultures more generally, concerns whether cyberspace and virtual systems should be read primarily as another example of what Arthur and Marilouise Kroker call the 'disappearing body' in postmodern culture (1987) or whether these new technologies might instead (or also) make it possible to intervene in the construction of embodiment. To quote Scott Bukatman, if there is increasing acceptance that 'the body must become a cyborg to retain its presence in the world', there is little agreement about whether this reconceptualization of embodied existence 'represents a continuation, a sacrifice, a transcendence, or a surrender of "the subject"' (1993: 245).

 For critiques of this trope of the disappearing body and the association of cyberspace with disembodiment or escape from what Gibson calls 'the meat', especially in narratives by male cyberpunk authors, see Dery, *Escape Velocity* (1996), chapter 7, on 'Obsolete bodies and posthuman beings'; Kendrick (1996); Lang (1995); Morse (1994); Nixon (1992); chapter 1 of Springer's book, 'Deleting the Body' (1996) and Stockton (1995).

 Work that attempts to offer an alternative to this trope of disembodiment, or to read in such narratives a more complex history, would include Tomas (1989; 1991); Hayles' essays, especially 'Boundary Disputes', (1994) which places this trope more firmly in the history of cybernetics and systems theory; the rest of Springer's book, which' argues that 'speculation about the bodily obsolescence' is combined with 'a desire to preserve bodily pleasures' (1996: 161); Balsamo's reading of Pat Cadigan's feminist cyberpunk novel *Synners* in Balsamo's chapter 6 (1996: 140–6); Foster (1993; 1996); most of the essays in Featherstone and Burrows's *Cyberspace/Cyberbodies/Cyberpunk* (1995) collection, especially Lupton, Clark, and Sobchack; and some of the recent work on text-based virtual communities, such as Cherny (1995), Lang (1995), and Argyle and Shields (1996).

5. For work on sexual or gender performativity and virtual embodiment see Case (1996); Fraiberg (1995); Woodland (1995); and Senft and Horn's special issue of *Women and Performance* on 'Sexuality and Cyberspace: Performing the Digital Body', (1996) especially Senft's introduction and the essays by O'Brien and Ehrlich.

6. For reasons that I will discuss at the end of this chapter, much less work has been done on the topic of race and performativity. Nakamura's (1995) essay is a groundbreaking application of Butler's theory of performativity to questions of racial passing and masquerade or minstrelsy in cyberspace. See also Dery's comments about 'afrofuturism' in his introduction to the interview with Samuel R. Delany, Greg Tate and Tricia Rose (1993: 736–43); Mexican-American performance artist Guillermo Gómez-Peña's 'Virtual Barrio' (1996); Hayles' intriguing suggestion that cyberspace and narratives about it demonstrate the themes of 'marked bodies' and 'invisibility' associated with African-American literary texts such as Ralph Ellison's *Invisible Man* (1993a: 183); Shohat's and Stam's speculations of the possibility of using virtual reality as part of a 'multicultural or transnational pedagogy' (1996: 165–6); and the section of Case's book that focuses on Chicana lesbian writer Cherie Moraga and her concept of 'queer Aztlan' (1996: 161–4).

7. McKenzie (1994) similarly notes that virtual reality combines two paradigms of performance, human and technological (the latter defined in terms of efficiency and input/output ratios), into a new configuration that both 'heightens the oppositions that structure it – presence/absence, originality/derivativeness, organic/inorganic, authenticity/inauthenticity, immediacy/mediation – while also exposing a certain cohabitation' between them (101).

 There has been less attention to the ways in which such mind-body dualisms have historically structured concepts of sexual, gender and racial differences, which might therefore also carry over into the construction of cyberspace and which might, alternatively, be disrupted by the development of cyberspace. Stone is one of the main exceptions to this tendency (1995: 40–1).

8. See also Jameson's (1991) argument that 'the very concept of expression presupposes . . . a whole metaphysics of the inside and outside' (11) and therefore a 'conception of the subject as a monadlike container' (15). In Jameson's view, of course, postmodernism's cultural logic involves the disappearance of such 'depth models' of subjectivity (12).

9. Tyler's critique of Butler's account of drag performance raises similar questions (1991: 53–58). Tyler points out that drag performances often depend upon stereotypes about racialized or lower-class women in order to mark the difference between a 'subversive' or denaturalizing drag performance and a naturalizing performance of gender. That is, drag performances often mark their excess or their ironic distance from white, middle-class norms of femininity by reproducing stereotypes about women who do not conform to those white, middle-class norms (Tyler's example is Dolly Parton, who Tyler suggests may appear 'campy' from a middle-class perspective but who might appear to epitomize feminine norms from a different class perspective).

10. I'm alluding here to Eve Sedgwick's (1993) critique of Butler's *Gender Trouble*, where Sedgwick argues that gender performances are as likely to be essentializing as subversive, to the extent that they depend on a clear distinction between performer and performance. See also Butler's response to this charge, in *Bodies That Matter* (1993: 226–33 and 282–3, n. 11).

11. This withholding of the characters' 'real' names seems particularly suggestive in relation to Ralph Ellison's similar strategy in *Invisible Man,* and therefore seems to support Hayles' suggestion that cyberspace narratives often demonstrate, in some more or less displaced form, the themes of 'marked bodies' and 'invisibility' found in African-American literary traditions (1993a: 183; see note 6 above).

12. In his most recent work, Bolter (1996) has begun to similarly theorize immersive virtual reality computer interfaces as a medium that works primarily through the manipulation of point of view (267–9). This argument is perhaps more forcefully articulated in a short piece Bolter published in *Wired* magazine, in which he claims that 'computer graphics is showing itself to be a technology for generating points of view' and that this medium is not 'just about morphing objects' but more importantly 'about morphing the view and the viewer' (1997: 113).

 Bolter also defines the medium of virtual reality as non-expressive: 'you don't "express" yourself in defining your computer graphic identity. Instead, you occupy various points of view, each of which constitutes a new identity' (ibid.: 114).

 While Bolter draws a very strong distinction between print and visual media, like virtual reality (1996: 256–7) I tend to agree with Hayles' analysis of the interaction between print narrative and virtual technologies, especially around issues of redefining point of view.

13. See Fuch's (1993) suggestion that cyborg body images that combine organic and mechanical elements might be read in a similar way. Fuchs quotes Butler's argument that 'if every performance repeats itself to institute the effect of identity, then every repetition requires an interval between the acts, as it were, in which risk and excess threaten to disrupt the identity being constituted' (Butler 1991: 28); Fuchs then goes on to define these 'intervals' as the 'breaks in cyborg identity encoded by their "divided" selves' (Fuchs 1993: 114).

14. O'Brien's (1996) essay begins with an analysis of an ad for on-line services in the *Advocate*, which uses the slogan 'There are no closets in Cyberspace' and which claims that on-line chat rooms are 'meeting places so free and open and wild and fun they make Castro Street look Victorian' (55). Scott's novel and its more complex mapping of connections between cyberspace and the closet can be read as an intervention in this kind of popular discourse.

15. There is nothing particularly new about his critique of the romanticized outlaw hacker in cyberpunk fiction. As early as 1988 (that is, almost as soon as cyberpunk started to become popular), cyberpunk writers themselves began to question this figure. Examples would include Bruce Sterling's novel *Islands in the Net* (1998) and Gibson's *Virtual Light*.

16. On a more theoretical level, Hayles argues that technocultures informed by cybernetic models require a reconceptualization of Lacan's mirror stage, in which the dialectic of presence and absence is presumed to have been denaturalized and demonstrated to be specious and is instead replaced by a dialectic between randomness and pattern (1993a: 186).

17. Butler raises the question of 'what will constitute a subversive or deinstituting repetition' (1991: 25) given that all identities are constituted through acts of repetition, imitation, and impersonation (27).

Tyler's (1991) essay is one of the best elaborations of the problems involved in making such a distinction and especially on the problems involved in using drag as a model. She specifically elaborates on the question of how to distinguish subversive from naturalizing gender performances.

18. For such histories, see Lott's (1993) and Rogin's (1996) books on blackface minstrelsy in the US. Rogin critiques Lott for overstating the transgressive implications of blackface as cross-racial performance, as part of a more general 'postmodern recuperation of blackface' that tends to assimilate it to forms of cross-dressing such as drag or butch-femme (Rogin 1996: 30).

Nakamura argues that cross-racial performances in text-based virtual communities often have the effect of reproducing racial stereotypes by defining what kinds of performances count as Asian or African-American (1995: 190).

I have written at greater length about questions of racial performance within techno-culture contexts in '"The Souls of Cyberfolk": Performativity, Virtual Embodiment, and Racial Histories,' a chapter in my work-in-progress, *Incurably Informed: Posthuman Narratives and the Rescripting of Postmodern Theory*.

References

Argyle, K. and Shields, R. (1996) 'Is there a body in the net?', in R. Shields, *Cultures of Internet: Virtual Spaces, Real Histories, Living Bodies*, Thousand Oaks, CA: Sage, pp. 58–69.

Balsamo, A. (1996) *Technologies of the Gendered Body: Reading Cyborg Women*, Durham: Duke University Press.

Benedikt, M. (ed.) (1991) *Cyberspace: First Steps*, Cambridge, MA: MIT Press.

Berlant, L. (1991) 'National brands/national body, in Ed. Hortense, J. Spillers, *Imitation of Life*,' *Comparative American Identities: Race, Sex, and Nationality in the Modern Text*, New York: Routledge, pp. 110–40.

Bolter, J. D. (1996) 'Ekphrasis, virtual reality, and the future of writing,' *The Future of the Book*. G. Nunberg (ed.), Berkeley: University of California Press, pp. 253–72.

—— 'You are what you see,' *Wired* January 1997: 113–14.

Bukatman, S. (1993) *Terminal Identity: The Virtual Subject in Postmodern Science Fiction*, Durham: Duke University Press.

Butler, J. (1990) *Gender Trouble: Feminism and the Subversion of Identity*, New York: Routledge.
—— (1991) 'Imitation and gender insubordination,' *Inside/Out: Lesbian Theories, Gay Theories*, D. Fuss (ed.) New York: Routledge, pp. 113–31
—— (1993) *Bodies That Matter: On the Discursive Limits of 'Sex'*, New York: Routledge.
Cadora, K., (1995) 'Feminist cyberpunk,' *Science-Fiction Studies* 22: 357–72.
Case, S.-E. (1996) *The Domain-Matrix: Performing Lesbian at the End of Print Culture*, Bloomington: Indiana University Press.
Cherny, L. (1995) '"Objectifying" the body in the discourse of an object-oriented MUD,' in C. Stivale, *Cyberspaces* (1995): 151–72.
Dery, M. (1993) 'Black to the future: interviews with Samual R. Delany, Greg Tate, and Tricia Rose.' *South Atlantic Quarterly* 92 (1993): 735–8.
—— (1996) *Escape Velocity: Cyberculture at the End of the Century*, New York: Grove P.
Ehrlich, M. (1996) 'Turing, my love.' in T. Senft and S. Horn (eds) *Sexuality and Cyberspace* (1996): 187–203.
Featherstone, M., and R. Burrows (eds) (1995) *Cyberspace/Cyberbodies/Cyberpunk: Cultures of Technological Embodiment*. London: Sage.
Ferlinghetti, L. (1958) *A Coney Island of the Mind*. New York: New Directions.
Foster, T. (1993) 'Meat puppets or robopaths?: cyberpunk and the question of embodiment.' *Genders* 18 (1993): 11–31.
—— (1996) '"The sex appeal of the inorganic": Posthuman Narratives and the Construction of Desire.' *Centuries' Ends Narrative Means*. ed. Robert Newman. Stanford: Stanford University Press, pp. 276–301, 371–78.
Fraiberg, A. (1995) 'Electronic fans, interpretive flames: performing queer sexualities in cyberspace.' in Stivale, *Cyberspaces* (1995): 195–207.
Fuchs, C. J. (1993) '"Death is irrelevant": cyborgs, reproduction, and the future of male hysteria.' *Genders* 18 (1993): 113–33.
Gibson, W., (1984) *Neuromancer*. New York: Ace.
—— (1994) *Virtual Light*. New York: Bantam.
Gémez-Peña, G. (1996) *The New World Border*. San Francisco: City Lights.
—— (1996) 'The Virtual Barrio @ the other frontier (or The Chicano Interneta).' *Clicking In: Hot Links to Digital Culture*. L. Hershman Leeson (ed.), Seattle: Bay P, pp. 173–79.
Griggers, C. (1994) 'Lesbian bodies in the age of (post)mechanical reproduction.' *The Lesbian Postmodern*. L. Doan (ed.), New York: Columbia University Press, pp. 118–33.
Harper, M. C. (1995) 'Incurably alien other: a case for feminist cyborg writers.' *Science-Fiction Studies* 22 (1995): 399–420.
Hayles, N. K. (1994) 'Boundary disputes: homeostasis, reflexivity and the foundations of cybernetics.' *Configurations* 2 (1994): 441–67.
—— (1993a) 'The seductions of cyberspace.' *Rethinking Technology*. V. A. Conley (ed.), Minneapolis: University of Minnesota Press, pp. 173–90.
—— (1993b) 'Virtual bodies and flickering signifiers.' *October* (1993) 66: 69–91.
Jameson, F. (1991) *Postmodernism, or, The Cultural Logic of Late Capitalism*, Durham: Duke University Press.
Kendrick, M. (1996) 'Cyberspace and the technological real,' in Markley, *Virtual Reality* 143–60.
Kroker, A. and M. (1987) 'Theses on the disappearing body in the hyper-modern condition.' *Body Invaders: Panic Sex in America*. A. and M. Kroker (eds). New York: St. Martin's pp. 20–34.
Lamos, C. (1994) 'The postmodern lesbian position: On our Backs.' *The Lesbian postmodern*. L. Doan (ed.), New York: Columbia University Press, pp. 85–103.
Lang, C. (1995) 'Body Language: The Resurrection of the corpus in text-based VR.' in Stivale, *Cyberspaces* (1995) 245–58.
Laurel, B. (1993) *Computers as Theatre*, 2nd edn. Reading, MA: Addison Wesley.
Lott, E. (1993) *Love and Theft: Blackface Minstrelsy and the American Working Class*. New York: Oxford University Press.
Markley, R. (1996) 'Introduction: history, theory, and virtual reality,' in Markley (ed.) *Virtual Reality and Its Discontents*. Baltimore: Johns Hopkins University Press.

McHugh, M. F. (1992) 'A coney island of the mind.' in. *Isaac Asimov's Cyberdreams*. G. Dozois and S. Williams (eds). New York: Ace (1994) pp. 83–90.

—— (1994) 'Virtual Love.' in *Nebula Awards 30*. P. Sargent (ed.). New York: Harcourt Brace (1996). pp. 99–110.

McKenzie, J. (1994) 'Virtual reality: performance, immersion, and the thaw.' *TDR: The Drama Review* 38.4 (1994): 83–106.

Mixon, L. J. (1992) *Glass Houses*. New York: Tor.

Moore, L. (1995) 'Teledildonics: virtual lesbians in the fiction of Jeanette Winterson.' *Sexy Bodies: The Strange Carnalities of Feminism*. E. Grosz and E. Probyn (eds), New York: Routledge, pp. 104–27.

Morse, M. (1994) 'What do cyborgs eat?: Oral logic in an information age.' *Culture on the Brink: Ideologies of Technology*. G. Bender and T. Druckrey (eds). Seattle: Bay Press, pp. 157–89.

Nakamura, L. (1995) 'Race in/for cyberspace: identity tourism and racial passing on the internet.' in Stivale, *Cyberspace* (1995) 3.

Nixon, N. (1992) 'Cyberpunk: preparing the ground for revolution or keeping the boys satisfied?' *Science-Fiction Studies* 19 (1992): 219–35.

O'Brien. J. (1996) 'Changing the subject.' in Senft and Horn, *Sexuality and Cyberspace* (1996) 54–67.

Rheingold, H. (1991) *Virtual Reality*. New York: Summit.

Rogin, M. (1996) *Blackface, White Noise: Jewish Immigrants in the Hollywood Melting Pot*. Berkeley: University of California Press.

Ross, A. (1991) *Strange Weather: Culture, Science and Technology in the Age of Limits*. New York: Verso.

Sawyer, R. J. (1995) *The Terminal Experiment*. New York: Harper Prism.

Scott, M. (1994) *Trouble and Her Friends*. New York: Tor.

Sedgwick, E. K. (1993) 'Queer performativity: Henry James's *The Art of the Novel*.' GLQ 1.1 (1993): 1–16.

Senft, T. (1996) 'Introduction: performing the digital body – a ghost story,' in Senft and Horn, *Sexuality and Cyberspace*: 9–33.

—— and Stacy Horn (1996) (3ds) *Sexuality and Cyberspace: Performing the Digital Body*. Special issue of *Women and Performance* 9.1.

Sheppard, N. Jr. (1996) 'Trashing the information superhighway: white supremacy goes hi-tech.' *Emerge* July–August (1996) 34–40.

Shohat, E. and R. Stam (1996) 'From the imperial family to the transnational imaginary: media spectatorship in the age of globalization.' *Global/Local: Cultural Production and the Transnational Imaginary*. ed. Rob Wilson and Wimal Dissanayake. Duke: Durham University Press, pp. 145–70.

Springer, C. (1996) *Electronic Eros: Bodies and Desire in the Postindustrial Age*. Austin: University of Texas Press.

Sterling, B. *Islands in the Net*. New York: Ace.

Stockton, S. (1995) '"The Self Regained": cyberpunk's retreat to the imperium and the responses of feminism' *Contemporary Literature* 36 (1995): 588–612.

Stone, A. R. (1995) *The War of Desire and Technology at the Close of the Mechanical Age*. Cambridge, MA: MIT Press.

Sullivan, C. and K. Bornstein (1996) *Nearly Roadkill: An Infobahn Erotic Adventure*. New York: High Risk Books/Serpent's Tail.

Tomas, D. (1991) 'Old rituals for new space: *Rites de Passage* and William Gibson's cultural model of cyberspace') in Benedikt *Cyberspace* (1991) 31–47.

—— (1989) 'The technophilic body: on technicity in William Gibson's cyborg culture:' *New Formations* 8 (1989): 113–29.

Turkle, S. (1995) *Life on the Screen: Identity in the Age of the Internet*. New York Simon & Schuster.

Tyler, C.-A. (1991) 'Boys will be girls: the politics of gay drag.' *Inside/Out Lesbian Theories, Gay Theories*. D. Fuss (ed.). New York: Routledge, pp. 32–70.

Walker, J. (1992) 'Through the Looking Glass:' *The Art of Human-Computer Interface Design*. B. Laurel (ed.). Reading, MA: Addison Wesley, pp. 439–47.

Walser, R. (1990) 'Spacemakers & the art of the cyberspace playhouse.' *Mondo 2000* 2 (1990): 60–63.

Warner, M. (1992) 'The mass public and the mass subject.' *Habermas and the Public Sphere*. C. Calhoun (ed.). Cambridge, MA: MIT Press, pp. 317–401.

Woodland, J. R. (1995) 'Queer spaces, modem boys, and pagan statues: gay/lesbian identity and the construction of cyberspace:' Stivale 221–40.

Yoshimoto, M. 'Real virtuality.' *Global/Local: Cultural Production and the Transnational Imaginary*. R. Wilson and W. Dissanayake (eds). Durham: Duke University Press, pp. 107–18.

SADIE PLANT

COMING ACROSS THE FUTURE

VIRTUAL SEX HAS BEEN DEFINED as 'safe as well as filthy', and held up as the epitome of disembodied pleasure, contact-free sex without secretions in a zone of total autonomy. A safe environment free from the side-effects and complications of actual intercourse: transmittable diseases, conceptions and abortions, and the sad obligations of emotional need. A closed circuit, a sealed elsewhere, a virtual space to be accessed at will.

If its technical research and development continues to be fuelled by such utopian hopes, there is also a sense in which cybersex seems anticlimatic before it has begun, tinged with disappointment in advance of the event.

But climax will always miss the cybernetic point, which is less a summit than a plateau. The peak experience is yesterday's news. And as for the ease and safety of cybersex: sex in MOOs may have pitfalls of its own, but cybernetic sex and all that it implies are about as cosy and containable as the virtual war of which it is already a side-effect. Cybersex heralds the disappearance of the human–machine interface, a merging which throws the one-time individual into a pulsing network of switches which is neither climactic, clean, nor secure. Anyone who believes that computer screens melt down to produce a safe environment should read their cyberpunk one more time: '"That's all there was, just the wires," Travis said. "Connecting them directly to each other. Wires, and blood, and piss, and shit. Just the way the hotel maid found them"' (Cadigan 1991: 275).

Even in the absence of full simstim, technical cybersex is well advanced: the hardware is fetishized, the software is porn, and vast proportions of the telecommunications system are consumed by erotica. But these are merely the most overt – and perhaps the least interesting – examples of a generalized degeneration of 'natural' sex. As hard and wetwares collapse onto soft, far stranger mutations wrack the sexual scene. The simulation of sex converges with the deregulation of the entire sexual economy, the corrosion of its links with reproduction, and the collapse of its specificity: sex disperses

into drugs, trance and dance possession; androgyny, hermaphroditism and transsexualism become increasingly perceptible; paraphilia, body engineering, queer sex, and what Foucault calls 'the slow motions of pleasure and pain' of SM – already 'high-technology sex' (Califia 1993a: 175) – proliferate. Cybernetics reveals an organism cross-cut by inorganic life – bacterial communication, viral infection, and entire ecologies of replicating patterns which subvert even the most perverse notions of what it is to be 'having sex.' Reproduction melts into replication and loses its hold on the pleasuredrome. Climax distributes itself across the plane and the peak experience becomes a plateau.

The future of sex never comes all at once. Now it is feeding back into a past which sex itself was supposed to reproduce. Relations were already circuits in disguise; immersion was always leading reproduction on. Sex was never uncommercialized, and pleasure was only ever one part of an equation with pain which finds its solution with intensity.

All this occurs in a world whose stability depends on its ability to confine communication to terms of individuated organisms' patrilineal transmission. Laws and genes share a one-way line, the unilateral ROM by which the Judeo-Christian tradition hands itself down through the generations. This is the one-parent family of man, for which even Mother Nature was conceived by God, the high fashion supermodel, perfectly formed, without whom matters would be running amok. Humanism is the ultimate rearview mirrorism, and the mirror still reflects the image of God. The project: 'to specularize and to speculate'; to supervise and oversee. God and man converse on a closed circuit of sources and ends, one and the same, man to man. Creation and procreation. The go forth and multiply from which patriarchal culture takes its cue.

This immaculate conception of the world has always been subject to the uncertainties which underlie all paternity claims. But it is only now, as material intelligence begins to break through the smooth formal screens of this trip, that the patriarchal confidence trick is undermined. He never will know whether or not they were fakes, neither her orgasms nor his paternity. All that is new about his insecurity is that it now begins to be felt. How does God know he's the father? Matter doesn't bother asking: as self-organizing processes attack from within, it's no longer a question, but a tactical matter, a tactile takeover, a material event.

Cybernetics initiates the emergence of the material complexity which finally usurps the procreative line. Even at its most modern and authoritarian, cybernetics collapses the distinction between machine and organism: Norbert Wiener's systems already function regardless of whether their wares are hard, soft, or wet. The fusions of human and machines of Wiener's wartime research do more than contest the species' boundaries: they also rewrite its history. 'Biological organisms . . . become biotic systems, communications devices like others. There is no fundamental, ontological separation in our formal knowledge of machine and organism, of technical and organic' (Haraway 1991: 177–8).

The cyborg has no history, but that of the human is rewritten as its past. By the 1960s, it had become obvious to McLuhan that regardless – or, ironically, because – of its own intentions, the human species had turned out to be 'the sex organs of the machine world, as the bee of the plant world, enabling it to fecundate and to evolve ever new forms' (McLuhan 1964: 56). Slaves, workers, women and robots were never alone in their cyborg roles. Nor were they simply working for the boss, whose mastery was always a sham. Man and his God were vital but contingent, and perhaps ultimately dispensable, components of a future mutation they were building all the time.

The modern organism is already a replicant, straight off the production line of a discipline which 'lays down for each individual his place, his body, his disease and his death, his well-being'. Foucault's disciplines extend even to the 'ultimate determination of the individual, of what characterizes him, of what belongs to him, of what happens to him' (Foucault 1977: 197). After this, organic and social integrity sink or swim together. Modernity is marked by 'an explosion of numerous and diverse techniques for achieving the subjugation of bodies and the control of populations, marking the beginning of an era of 'bio-power'' (Foucault 1978: 140), in which 'Western man was gradually learning what it meant to be a living species in a living world, to have a body, conditions of existence. . . . For the first time in history . . . biological existence was reflected in political existence' (Foucault 1978: 142).

Humanity tends toward the organized body, the body with organ, the male member. The modern human is dressed in blue, as far from the red-blooded feminine as it is possible to be, gendered and sexed in a world still solidified in the mould of brotherhood and patrilineal inheritance. The female body is already diseased, on the way to the limits of life, while the phallus functions as the badge of membership, or belonging – to one's self, society, species.

The male member functions as 'the most ideal, the most speculative element' of this social and organic security system. As Deleuze and Guattari say, 'it's enough to make women, children, lunatics, and molecules laugh' (Deleuze and Guattari 1988: 289): the phallus is 'an imaginary point', the product of 'power in its grip on bodies and their materiality, their forces, energies, sensations, and pleasures' (Foucault 1978: 155). But it's also enough to guarantee the constitution of arborescence, 'the submission of the line to the point' (Deleuze and Guattari 1988: 293). And the point is always to remember. Dismembering is not allowed.

This, as Donna Haraway points out, is also the point at which female orgasm drops out of the picture: 'before the latter part of the eighteenth century in Europe, most medical writers assumed orgasmic female sexual pleasure was essential for conception,' whereas now 'female orgasms came to seem either non-existent or pathological from the point of view of western medicine.' And by 'the late nineteenth century, surgeons removed the clitoris from some of their female patients as part of reconstituting them as properly feminine, unambiguously different from the male, which seemed to be almost another species' (Haraway 1991: 356).

Intensity is gathered together in a single point, monopolized by the male member, and localized as orgasm. All sexuality is male, writes Freud. Female sexuality and female orgasm are either contradictions in terms or impoverished variations on the phallic theme. Orgasms are what these organisms have. They too are something possessed and owned, functioning to restore equilibrium and secure the identity of the organized body, the organic integrity of the Western individual.

'Woman's genitals are simply absent, masked, sewn back up inside their "crack."' Zero is discounted and veiled, and 'one would have to dig down very deep indeed to discover beneath the traces of this civilization, this history, the vestiges of a more archaic civilization that might give some clue to woman's sexuality' (Irigaray 1985: 25).

If there were such a sexuality to be found in the deep and distant past, behind the screens of the specular, its unearthing would always be a matter of retrospeculation, a looking back with eyes programmed by 'the logic that has dominated the West since

the time of the Greeks'. And it 'would undoubtedly have a different alphabet, a different language. . . . Woman's desire would not be expected to speak the same language as man's' (Irigaray 1985: 25). Man is the one who relates his desire; his sex is the very narrative. Hers has been the stuff of his stories instead.

By the late twentieth century, 'orgasms on one's own terms' became the rallying cry for a feminism increasingly aware of the extent to which female sexuality had been confined. 'Male orgasm had signified self-containment and self-transcendence simultaneously, property in the self and transcendence of the body through reason and desire, autonomy and ecstasy', and there was a feeling that if women were no longer 'pinned in the crack between the normal and the pathological, multiply orgasmic, unmarked, universal females might find themselves possessed of reason, desire, citizenship, and individuality' (Haraway 1991: 359).

Or does this result in a masculine mould for some 'female sexuality' which could be running elsewhere? Foucault is scathing about the extent to which such liberatory investments underscore the subjection they ostensibly contest. And the orgasm as a key to self-possession is hardly where his interests lie: like Pat Califia, he is more interested in what she calls the 'SM orgasm', an intensity uncoupled from genital sex and engaged only with the dismantling of selves. This is the cybersexuality to which all sexuality tends: a matter of careful engineering, the setting of scenes, the perfection of touch; the engineering of communication.

It is not the orgy, but the orgasm that is over. Not that the intensities once sought through sex are disappearing. Far from it: they have only just begun. 'The apologia for orgasm made by the Reichians still seems to me to be a way of localizing possibilities of pleasure in the sexual,' writes Foucault (Macey 1994: 373). Climax is proper to organic integrity; orgasm is what organisms do: 'I dismembered your body. Our caressing hands were not gathering information or uncovering secrets, they were tentacles of mindless invertebrates; our bellies and flanks and thighs were listing in a contact that apprehends and holds onto nothing. What our bodies did no one did' (Lingis 1994: 61).

Dismemberment: the 'Dionysian castration'. Counter-memory. Forget what it's for, and learn what it does. Don't concentrate on orgasm, the means by which sex remains enslaved to teleology and its reproduction: 'make of one's body a place for the production of extraordinarily polymorphic pleasures, while simultaneously detaching it from a valorization of the genitalia and particularly of the male genitalia' (Miller 1993: 269). Foucault experiments with decompositions of the body, dismantling of the organism, technical experiments with bondage and release, power and resistance in an S&M 'matter of a multiplication and burgeoning of bodies' and 'a creation of anarchy within the body, where its hierarchies, its localizations and designations, its organicity, if you will, is in the process of disintegrating' (Miller 1993: 274).

Masochism poses a considerable threat to Freud's earlier faith in the pleasure principle. 'For if mental processes are governed by the pleasure principle in such a way that their first aim is the avoidance of unpleasure and the obtaining of pleasure, masochism is incomprehensible.' And if both 'pain and pleasure can be not simply warnings but actually aims, the pleasure principle is paralyzed' (Freud 1984: 413). But by the time he writes *The Economic Problem of Masochism,* Freud knows that masochism is not always a reaction to sadistic control. The masochist is not simply the victim enslaved by mastery: this is the 'macho bullshit' of a discourse which admits nothing beyond subjection, a

perspective which cannot accept any other relation (or, rather, can accept nothing but relations). Masochism exceeds such relations with the master; indeed it goes beyond all relations, no matter how far from the paternal they seem. It is not a question of recognition, but a matter of feeling: not a craving to be flattened, but an intensive desire for communication, for contact, access, to be in touch. The masochist 'uses suffering as a way of constituting a body without organs and bringing forth a plane of consistency of desire' (Deleuze and Guattari 1988:155).

'Stop confusing servitude with dependence', writes Jean-François Lyotard. The 'question of "passivity" is not the question of slavery, the question of dependency not the plea to be dominated' (Lyotard 1993: 260). Otherwise the circuits and connections will be brought back into relations of superiority and inferiority, subject and object, domination and submission, activity and passivity . . . and these will become the frozen poles of an opposition which captures the loops and recouples their lines.

Drink me, eat me. USE ME. . .

> [W]hat does she want, she who asks this, in the exasperation and aridity of every piece of her body, the woman-orchestra? Does she want to become her master's mistress and so forth? Come on! She wants you to die with her, she desires that the exclusive limits be pushed back, sweeping across all the tissues, the immense tactility, the tact of whatever closes up on itself without becoming a box, and of whatever ceaselessly extends beyond itself without becoming a conquest.
>
> (Lyotard 1993: 66)

Immense tactility, contact, the possibility of communication. Closure without the box: as a circuit, a connection. 'What interests the practitioners of S&M is that the relationship is at the same time regulated and open,' writes Foucault: it is a 'mixture of rules and openness'. Ceaseless extension: the body hunting its own exit. Becoming 'that which is not one'; becoming woman, who '*has sex organs just about everywhere*' (Irigaray 1985: li). Is this what it is to get out of the meat? Not simply to leave the body, but to go further than the orgasm; to access the 'exultation of a kind of autonomy of its smallest parts, of the smallest possibilities of a part of the body'.

'Use me,' writes Lyotard, is 'a statement of vertiginous simplicity, it is not mystical, but materialist. Let me be your surface and your tissues, you may be my orifices and my palms and my membranes, we could lose ourselves, leave the power and the squalid justification of the dialectic of redemption, we will be dead. And not: let me die by your hand, as Masoch said' (Lyotard 1993: 65). This is the prostitute's

> sado-masochistic bond which ends up making you suffer 'something' for your clients. This something has no name. It is beyond love and hate, beyond feelings, a savage joy, mixed with shame, the joy of submitting to and withstanding the blow of belonging to someone, and feeling oneself freed from liberty. This must exist in all women, in all couples, to a lesser degree or unconsciously. I wouldn't really know how to explain it. It is a drug, it's like having the impression that one is living one's life several times over all at once, with an incredible intensity. The pimps themselves, inflicting these punishments, experience this 'something.' I am sure of it.
>
> (Lyotard 1993 63)

It is Foucault's 'something unnameable', 'useless', outside of all the programmes of desire. It is the body made totally plastic by pleasure: 'something that opens itself, that tightens, that throbs, that beats, that gapes' (Miller 1993: 274). It is, writes Freud, 'as though the watchman over our mental life were put out of action by a drug' (Freud 1984: 413).

'I stripped the will and the person from you like collars and chains' (Lingis 1994: 61). What remains is machinic, inhuman, beyond emotion, beyond subjection: 'the illusion of having no choice, the thrill of being taken' (Califia 1993a: 172).

Pat Califia: 'He wanted . . . everything. Consumption. To be used, to be used up completely. To be absorbed into her eyes, her mouth, her sex, to become part of her substance' (Califia 1993b: 108).

Foucault describes those involved in S&M as 'inventing new possibilities of pleasure with strange parts of their body . . . it's a kind of creation, a creative enterprise, which has as one of its main features what I call the desexualization of pleasure' (Miller 1993: 263). S&M is a 'matter of a multiplication and burgeoning of bodies,' he writes, 'a creation of anarchy within the body, where its hierarchies, its localizations and designations, its organicity, if you will is in the process of disintegrating' (ibid.: 274), while 'practices like fist-fucking are practices that one can call devirilizing, or desexualizing. They are in fact extraordinary *falsifications of pleasure*' (ibid.: 269), pains taken even to the point at which they too become 'sheer ecstasy. Needles through the flesh. Hot candle wax dribbled over alligator clips. The most extraordinary pressure on muscles or connective tissue. The frontier between pain and pleasure has been crossed' (ibid.: 266).

'Not even suffering on the one hand, pleasure on the other: this dichotomy belongs to the order of the organic body, of the supposed unified instance' (Lyotard 1993: 23). Now there is a plane, a languorous plateau. The peaks and the troughs have converged on a still sea, a silent ocean. They have found their limit and flattened out. Melting point.

'We don't know what a body can do.' Which is yet another reason why 'we have to get rid of sexuality' (Macey 1994: 373), leave the body to its own devices, strip it away from its formal controls, disable its mechanisms of self-protection and security which bind intensity to pleasure and reproduction.

'That there are other ways, other procedures than masochism, and certainly better ones, is beside the point; it is enough that for some this procedure is suitable for them' (Deleuze and Guattari 1988: 55). Whatever it takes to access the plane. Necessity trashes prohibition. The algebra of need; the diagram of speed.

Foucault was in no doubt that certain drugs rivalled the 'intense pleasures' of sexual experimentation. Of the drugs of the 1990s, Ecstasy and crack have both been described as 'better than sex', while speed and Prozac tend to anorgasmic effect. All engineerings of the body have some chemical component. Felix Guattari points out that 'certain anorexic, sadomasochistic etc. syndromes function as auto-addictions' because 'the body itself secretes its endorphines which, you know, are fifty times more active than the morphines' (Guattari 1989: 20). If orgasm localizes pleasure, 'things like yellow pills or cocaine allow you to explode and diffuse it throughout the body; the body becomes the overall site of an overall pleasure' (Macey 1994: 373). This is the plane on which it forgets itself, omits to be one.

Out of order. And into a control which 'instead of acting remains on guard, a control which blocks contact with commonplace reality and allows these more subtle and rarified contacts, bared down to the thread which ignites and yet never breaks apart' (Artaud 1965: 33).

On the way through the fractal scales, a 'kind of order or apparent progression can be established for the segments of becoming in which we find ourselves'. These 'begin with and pass through becoming-woman' (Deleuze and Guattari 1988: 277), which is already a matter of 'becoming child; becoming-animal, -vegetable, or -mineral; becomings-molecular of all kinds, becoming particles. Fibers lead us' (ibid. 272) in more ways than one.

It is by a process of deliberation that the body begins to uncouple itself from its own and external authority: possession and self-possession, control and self-control. Meat learns.

That is not a matter of education, which is always a question of restoring past infor-mation, the recollection of some originary transcendence, and the remembering of authority. It is a process of forgetting the past, which is also the abandonment of truth and the dismemberment of authority. While it is 'necessary to dig deeply in order to show how things are historically contingent, for such and such an intelligible but not necessary reason', it is also the case that 'to think of what exists is far from exploring all the possible spaces'. Attention must be turned to the future instead. 'Let us make an incontrovertible challenge out of the question: "At what can we play, and how can we invent a game?"' (Miller 1993: 259).

Foucault jacks into virtual sex: the cyberspace scene, the ultimate in consensual hallucinations. It would, he thinks, 'be marvelous to have the power, at any hour of day or night, to enter a place equipped with all the comforts and all the possibilities that one might imagine, and to meet there a body at once tangible and fugitive' (Miller 1993: 264). Not simply because, as William Burroughs enthuses, 'you can lay Cleopatra, Helen of Troy, Isis, Madame Pompadour, or Aphrodite. You can get fucked by Pan, Jesus Christ, Apollo or the Devil himself. Anything you like likes you when you press the buttons' (Burroughs 1985: 86).

Press cyborg, and an optional object of desire.

You make the connections, access the zone. Whatever avatar you select for your scene, you cannot resist becoming cyborg as well. Some human locks on, but a repli-cant stirs. Depending on the state of your time-tract's art, the cyborg you become will be more or less sophisticated and extensive; more or less directly connected to your central nervous system; more or less hooked up to its own abstraction and the phase space in which you are both drawn out. But it will be post-human, whatever it is. Suddenly, it always was. You always were.

Foucault comes close in the San Francisco bath-houses: 'You meet men there who are to you as you are to them: nothing but a body with which combinations and produc-tions of pleasure are possible. You cease to be imprisoned in your own face, in your own past, in your own identity' (Miller 1993: 264).

There is no escape into a zone of free choice. Deliberation is neither free nor determined, but like the Tao, and equally unthinkable to an authority constituted in terms of masters and slaves, the autonomous and the automata, domination and submis-sion, ones and others, ones and twos.. . . . Such are what Lyotard calls the 'macho bullshit'

of a discourse which admits nothing beyond subjection, a perspective which cannot accept any other relation (or, rather, can accept nothing but relations).

Once you know it's a video game, it gets much harder to play along.

Originally published in J. Broadhurst Dixon and E. Cassidy (eds) (1998) *Virtual Futures: Cyberotics, Technology and Post-human Pragmatism*, London: Routledge.

References

Artaud, A. (1965) *Artaud Anthology,* J. Hirschman (ed.), San Francisco: City Lights.

Burroughs, W. (1985) *The Adding Machine,* London: John Calder.

Cadigan, P. (1991) *Synners,* London: Grafton.

Califia, P. (1993a) 'Power exchange', in T. Woodward (ed.) *The Best of Skin Two,* New York: Masquerade Books.

—— (1993b) *Melting Point,* Boston: Alyson Publications.

Deleuze. G. and Guattari, F. (1988) *A Thousand Plateaus,* trans. B. Massumi, Minneapolis: University of Minnesota Press.

Foucault, M. (1977) *Discipline and Punish,* London: Pelican.

—— (1978) *History of Sexuality.* vol. 1, New York: Pantheon Books.

Freud, S. (1984) 'Beyond the pleasure principle', in *On Metapsychology,* London: Pelican Freud Library.

Guattari, F. (1989) 'Une "Révolution moleculaire"', in J.-M Hervieu *et al.* (eds) *L'Esprit des drogues,* Paris: Editions Autrement.

Haraway, D. (1991) *Simians, Cyborgs and Women,* London: Free Association Books.

Irigaray, L. (1985) *This Sex Which is Not One*, New York: Cornell University Press.

Lingis, A. (1994) 'Carnival in Rio', *Vulvamorphia*, Lusitania 6.

Lyotard, J.-F. (1993) *Libidinal Economy*, trans. I.H. Grant, London: Athlone.

Macey, D. (1994) *The Lives of Michel Foucault*, London: Vintage.

McLuhan, M. (1964) *Understanding Media: The Extensions of Man*, London: Sphere Books.

Miller, J. (1993) *The Passion of Michel Foucault*, London: Harper Collins.

Cyberbodies

BARBARA KENNEDY

INTRODUCTION

THIS SECTION OF THE READER offers a selection of essays which consider the relationship between the body and the computer within contemporary cybercultures. To what extent is a 'body' definable? What do we mean by bodies, and what do we mean by the term cyberbody? If bodies are to be conceived as flesh and blood *humanoid* bodies, then to what extent is *that* body changed, transformed, mutated, or disembodied through connections across cyberspatial zones and machinic connections? Does the 'organism' of the body become something 'other' in its connection with the machinic, and can we think of a post-human body as a cyberbody? Donna Haraway, among others, maintains the breakdown of boundaries, a heteroglossic relationship across what have been culturally formed binaries (see section four). The organism, then, may no longer be different or separate from the machine. Contemporary philosophy, meanwhile, explores the complexity of bodies and the amorphous interpretation of the concept of embodiment. The point here is that cyberdiscourse has to an extent offered some (albeit ironic) starting points from which to rethink the 'body' as cyberbodies.

Deborah Lupton's essay 'The embodied computer/user' opens this section with an articulate exploration of the complexities of the human/computer interface. Computers have, for many people, become *significant others* with whom we relate, connect and make sense of ourselves, emotionally, intellectually and socially through the daily face-to-face contact with the screen and the machine itself. The computer becomes *embodied*, taking on anthropomorphic characteristics (see Lupton and Noble 1997). Metaphors abound about the viral contamination of the computer (see Lupton, 1994), often exacerbated by promiscuous behaviour; 'foreign bodies' inserted into personal spaces. Lupton discusses the emotional responses we feel – fear, anxiety, frustration, panic – when, to use Sandy Stone's words, the 'machines get restless'. The connection with the computer keyboard becomes a prosthetic connection of humanoid body with machinic body, creating an entirely new experience – a cyberbody. The mouse itself,

and the movement experienced through/with it, becomes *pathic* and *gestural*; bodies are thus 'inscribed' by this symbiotic relationship. Pens seem strangely unfamiliar and alien as writing becomes a screenic, machinic experience. Indeed, in *Volatile Bodies*, Liz Grosz (1994) argues that inanimate objects become extensions of body image; they become invested psychically into conceptions of self and subjectivity. To this end, computers are deemed to be something we work *with* as opposed to working *on*. They take on 'humanoid' characteristics. The screen smiles out at us like a humanoid face (but it so often glares with anticipation or anger, waiting impatiently for the next breath on its skin, the next imprint on its body). Our bodily senses are connected through a facial and haptic (a tactile sense coming from the visual) link with the screen. But as Michael Heim (1992) has noted in 'The erotic ontology of cyberspace', there is more than an aesthetic fascination at work here. What is truly fascinating is that our use of the computer speaks of a desire for a 'home for the mind and heart'. Such views seem to draw in a reductive way on discourses of origination, such as Freudian psychoanalytical explanations of our desire for fulfilment through finality; a final death.

But desire *is* an important element in considering the machine as body; desire and the erotic are part of our fascination with cyberspace. Imbricated with such human – all too human – characteristics is, of course, the element of risk. To desire is often to trust, to trust too much, to put one's faith in the erotic potentialities of that which is desired – to lose oneself (selves) in the delicious ineluctability of the unknown . . . and to 'face' the inevitable moral imperatives. Risk and desire are here inextricably inter-twined. Lupton's essay proceeds to explore the web of such contradictions through contemporary media representations of cyborg bodies. Engaging with the work of Grosz, Theweleit, Haraway, and Bordo, she explores the risks involved in the escape from the humanoid body into the erotics of the cyberbody.

Anne Balsamo's chapter, 'The virtual body in cyberspace', speculates about the body on the electronic frontier. This frontier is both a metaphorical 'imaginary space' iden-tified as cyberspace and also a 'real' lived space on the fringes of mainstream culture. Balsamo gives a comprehensive introduction to the history and the contemporary social and cultural significance of virtual reality/environment discourses. Virtual reality (VR) has become one of the most fascinating and desired spaces of cyberculture. Through VR, a whole array of virtual play can be 'felt' and/or experienced. But are such feel-ings embodied, or is the experience one of a consciousness outside an embodied sensorium? Balsamo proceeds to explore the implications for the lived humanoid 'body' in its connection with the disembodied zones of virtual worlds. The question of identity is an important element in Balsamo's discussion of VR: it has been argued that VR provides a technological method of constructing personal identities which are free of bodily configurations. What, then, happens to the 'meat', to the lived body, to the flesh? Where is the body in cyberspace?

Such a conceptual denial of the corporeal body can only be achieved through a material repression of physicality. The phenomenological experience of cyberspace, says Balsamo, is dependent upon a purposefully engineered repression of the material body. Balsamo's project is to extend debates about virtual technologies, through a political agenda around class, gender and race: 'What kind of surplus is produced? Who will

profit?' she asks, with perhaps a hint of neo-Marxist, neo-Luddite technoscepticism. Post-structuralist discourse proliferates the questioning of foundational thinking, but Balsamo argues for a political dialectic as part of critiques about cyberspace. This in itself is ironic, given Haraway's cyborg consciousness and Sandoval's *mestiza* thinking. Balsamo argues that VR technologies articulate specific narratives about a 'techno-body' to the extent that the technologies have the effect of naturalizing the gendered body. The cyberbody is ungendered – but, many would argue, representations of the cyborg body are too often gendered (see Springer, chapter 20). Critical frameworks coming from some feminist epistemologies ask gender-specific questions: what, for example, are the *bio-politics* of virtual reality? To what extent does virtual reality technology impinge upon socially and culturally constructed and marked bodies? Does VR change or trans-form subjectivity based on corporeal bodies? Balsamo proceeds to discuss such questions from a lively and critical stance, but one which ultimately argues that such new tech-nologies will present only familiar narratives, 'stories that reproduce, in high-tech guise, traditional narratives about the gendered, race-marked body'.

Allucquère Rosanne Stone's 'Will the real body please stand up?: boundary stories about virtual cultures *stands up* as one of the most significant essays in cyberdiscourse. In typical style, Stone writes in a manner which is at times highly subjective, bringing together a series of cleverly juxtaposed sections which interweave personal experience and critical discussion. Her essay explores the interactions across the boundaries of body/mind and machine, though she herself is suspicious that such explorations might in fact be of an entirely new phenomenon; how do we make sense of the human body as 'nature' in the light of cultural artefacts such as computer 'technologies'? Like Haraway, Stone is interested in the reconceptualization of categories like 'nature', redefining the technological in discourses of the natural. Nature, she believes, *is* the technological, the twentieth-century seeing an evolution of nature 'outside' its Cartesian positionality as the opposite of 'culture'. For Stone culture and nature are clearly entwined and collapsed through the *technological*. If this is the case, then how can we maintain the ontological status of the body as 'nature'? Indeed, the 'body' no longer remains humanoid – with characteristics pertinent to humanist and modernist concep-tions – but becomes a hybrid/machinic assemblage of nature/culture/technology. Stone interweaves narratives from both Donna Haraway and Bruno Latour in her concern to explore the constitution of technology and culture, and in so doing creates her own 'boundary stories'.

Multiple Personality Disorder (MPD), a debilitating condition rendering the indi-vidual at a loss as to his or her 'real' identity, becomes pertinent to Stone's interest in multiple identity formations in cyberspace. Stone reveals how this schizophrenic state can be constructed and used to manipulate, deceive and destratify the identities and subjectivities of several personae engaging in cyberspace. Her narration of the cross-dressing Julie (in 'real life' a middle-aged, male psychiatrist) who went on-line as a disabled woman, brings to light only too painfully the 'risks' we entertain (and I would add, especially women) in our desire to fly through cyberspace. 'Trust' and 'ethics' are too easily fractured in the spatial matrix of the Web. What we see on the screen, we tend (or tended) to believe more readily than from elsewhere. Women, in particular, write in vulnerable, subjective and self-disclosing tones and styles when communicating

on-line, ready to commune in a trusting way; what some might label as a *techno-naïveté*. Thus, in a similar concern to Balsamo, Stone is suspicious of (whilst also excited by) the potential of multiple subjectivities operating outside of gendered bodies. The problem exemplifed by this story, however, is that, as Balsamo readily acknowledges, the same gender oppressions do in fact exist in cyberspace. To feel 'raped' by virtue of a miscarriage of trust is felt at a corporeal level, not merely at the level of a disembodied consciousness. Here the body *is* felt very much as 'nature', but also through a new manifestation of social space in a virtual system.

Stone continues through a history of virtual systems across four distinct epochs, juxtaposing allusions and metaphors across time and space. What connects all four epochs is the significance of technology as a controlling and permeable force. From the written and oral presentation of academic papers to the significance of radio communication, technology has always been embroiled in the relationship of bodies, spaces and identities. Late twentieth-century examples are the more well known Bulletin Board Services (BBSs) of the mid-1970s computer age, and more recently, the popular cultural icons of cyberpunk fictions and virtual worlds. What is fundamental to new ideas about the 'body' is that in the fourth epoch — our cyberspatial present — participants have discovered the pleasures of delegating agency (whatever the 'risks') to technologized body-representatives that exist in an imaginal space. This imaginal space is also a consensual space inhabited by other imaginal bodies: *cyberbodies*. Together these constitute a new social imaginary, where the body is reconfigured through a complex mix of image, culture and technology. The boundary between natural and cultural, between biology and technology, is redefined and reconstituted. Stone's essay moves on to an engagement with Haraway, Dagognet, Baudrillard and Rabinow, in an attempt to reconceptualize the boundaries between technology, bodies and nature. Dagognet's premise is that 'nature' never was a fixed and formulisable category anyway. Nature has, as Stone argues, continued to take on entirely different meanings and functions in late twentieth-century culture. It becomes merely a strategy for maintaining boundaries for political and economic ends. Consequently technology is also a construct, a category which exists only as an imagined opposition to nature. Technology is, rather, *becoming nature*, the boundaries between subject and environment have collapsed. Such assertions Stone continues to defend, convincingly, to the end of her essay.

Timothy Leary's chapter on the cyberbody, 'The cyberpunk: the individual as reality pilot', is a poetic account of the originations of the cyber-concept. From its Greek and Hellenic traditional roots, the *cyber* manifests itself as that which is autonomous and in control, ronin, maverick and outside — *l'étrangers*, who live through freedom, pagan joy, a Nietzschean celebration of life and speculative, perspectival thinking. The cyberpunk is 'the pilot who thinks clearly and creatively, using quantum-electronic appliances and brain know-how . . . the newest, updated, top-of-the line model of our species, homo sapiens cyberneticus'. His/her/its *cyberbody* is an amalgam, an assemblage across the modalities, across the boundaries of technology, nature and culture, reworked through quantum-electronic interfacing. 'Cybernate' is a term which Leary uses to denote a liberatory concept; to 'cybernate' means 'to be free from serfdom, the autopoietic, self-directed principle of organization which arises in the universe, in many systems of widely varying sizes. In people, societies, and atoms'. While this may seem a little like techno-babble

and shamanic incantation, Leary's ideas offer significant mobile connotations through which we can think about the concept 'cyber' in relation to a whole range of fluid, imaginary bodies; bodies which are technological, biological, cultural and textual. 'Cyberbody' denotes the hybridity of the organism/machine; the cyberbody is an assemblage, a complex hybrid, not merely of biological formations, but any amalgam of other categories. And so the term 'cybernaut' may be a new model of human 'being' within a new social order.

Jennifer Gonzalez, in 'Envisioning cyborg bodies', writes from ongoing research into the nature of the cyborg body. She begins with an historical trajectory of the site of cyborgian possibilities through representations from the visual arts. Her essay is premised on the notion that cyborg bodies are neither merely utopian nor dystopian prophecies of a changing world order, but are metaphors of a state of hybridization of consciousness, emanating through cultural and political displacement within specific times of new and challenging transformations. Hence the 'information age' of new technologies presents a time of cultural malaise, concern, hysteria and contamination across the boundaries of the cultural and the technological. Like Dagognet, Gonzalez sees a connection between the realms of the natural and the cultural, the technological and the natural. The first part of her essay is an analysis of cyborg representations from the early eighteenth century (l'Horlogere). Gonzalez's description of the semiotics of this work of art are disturbingly close to filmic representations of cyborg women (such as the clock-like automaton in *Blade Runner*). For Gonzalez, woman-as-cyborg has been dangerously attached to notions of woman as pleasure, as toy, as entertainment. And yet the contradiction is that within that fetishistic image is the automaton with its disturbingly alien agency. The cyborg, she says, is the 'figure born of the interface of automaton and autonomy'.

But of course the essential critique in Gonzalez's work is concerned with the concept of cyborg consciousness. Not only is the cyborg a metaphorical construct, but it also epitomizes a hybrid consciousness through which difference is theorized outside of the boundaries of binary positions. She tackles the question of race, critiquing the concept of miscegenation used by some critics as a term to describe what she would prefer to call hybridization. Indeed, the term 'miscegenation' has offensive connotations of right-wing racist language and cultural specificities, and the otherness of machines has been seen in connection with the otherness of sexual difference or race. Against this, Gonzalez describes the Japanese comic book cyborg Silent Mobius, who epitomizes a hybridization across the boundaries of race and sexuality. Her 'real' identity having been ruined, she becomes a machine, a cyborg, which is then garmented, draped, masqueraded with the 'shell' of a beautiful black woman. Gonzalez's analysis of this character from Japanese popular culture synthesizes a critique across notions of subjectivity, identity, and the machinic, which serves to integrate not only sexuality, but also race, into current epistemological concerns with cyborganization (see also Tomas, Nakamura in this volume). The configuration of the 'cyborg body' will thus provide a way of understanding the contradictions of human consciousness, the contradictions of lived experiences and the possibilities for transformations in consciousness. As such, there is an utopian sense of a liberatory but cautious politics at work in Gonzalez's writing, and in the very concept of the cyborg body itself.

References

Grosz, E. (1994) *Volatile Bodies*, Bloomington: Indiana University Press.
Heim, M. (1992) 'The erotic ontology of cyberspace', in M. Benedikt (ed.), *Cyberspace: First Steps*, Cambridge, MA: MIT Press.
Lupton, D. (1994) 'Panic computing: the viral metaphor and computer technology', *Cultural Studies* 8 (3) 556–68.
Lupton, D. and Noble, G. (1997) 'Just a machine? Dehumanizing strategies in personal computer use', *Body & Society* 3 (2) 83–101.

DEBORAH LUPTON

THE EMBODIED COMPUTER/USER

WHEN I TURN MY PERSONAL computer on, it makes a little sound. This little sound I sometimes playfully interpret as a cheerful 'Good morning' greeting, for the action of bringing my computer to life usually happens first thing in the morning, when I sit down at my desk, a cup of tea at my side, to begin the day's work. In conjunction with my cup of tea, the sound helps to prepare me emotionally and physically for the working day ahead, a day that will involve much tapping on the computer keyboard and staring into the pale blue face of the display monitor, when not reading or looking out the window in the search for inspiration. I am face-to-face with my computer for far longer than I look into any human face. I don't have a name for my personal computer, nor do I ascribe it a gender. However, I do have an emotional relationship with the computer, which usually makes itself overtly known when something goes wrong. Like most other computer users, I have experienced impatience, anger, panic, anxiety and frustration when my computer does not do what I want it to, or breaks down. I have experienced files that have been lost, printers failing to work, the display monitor losing its colour, disks that can't be read, a computer virus, a break-down in the system that stopped me using the computer or email. I live in fear that a power surge will short-circuit my computer, wiping the hard disk, or that the computer will be stolen, and I assiduously make back-up copies of my files. I have written whole articles and books without printing out a hard copy until the penultimate draft. I cannot imagine how it must have been in the 'dark ages' when people had to write PhDs and books without using a computer. I can type much faster than I write with a pen. A pen now feels strange, awkward and slow in my hand, compared to using a keyboard. When I type, the words appear on the screen almost as fast as I formulate them in my head. There is, for me, almost a seamless transition of thought to word on the screen.

These personal reflections raise the issues of the emotional and embodied relationship that computer users have with their personal computers (PCs). While people in contemporary Western societies rely upon many other forms of technology during the

course of their everyday lives and, indeed, use technological artefacts to construct a sense of subjectivity and differentiation from others, the relationship we have with our PCs has characteristics that sets it apart from the many other technologies we use. For the growing number of individuals who rely upon their PCs to perform work tasks, and for others who enjoy using their PCs for entertainment and communication purposes, conducting life without one's PC has become almost unimaginable (how *do* people write books without them?).

However, the cultural meanings around PCs, including common marketing strategies to sell them and the ways in which people tend to think about their own PC, relies on a degree of anthropomorphism that is found with few other technological artefacts. While we may often refer to cars as human-like, investing them with emotional and personality attributes, they are rarely represented as 'friends', 'work companions' or even 'lovers' in quite the same way as are computers. As Heim has commented,

> Our love affair with computers, computer graphics, and computer networks runs deeper than aesthetic fascination and deeper than the play of the senses. We are searching for a home for the mind and the heart. Our fascination with computers is more erotic than sensuous, more deeply spiritual than utilitarian.
>
> (Heim 1992: 61)

In his book *Bodies and Machines*, Seltzer refers to the 'psychotopography of machine culture', or the way in which psychological and geographical spaces cross the natural and the technological, between interior states and external systems; how bodies, persons and machines interact (1992: 19). I am interested in the 'psychotopography' of the human/computer relationship, the ways that humans think, feel and experience their computers and interact with them as subjects. Rather than the computer/human dyad being a simple matter of self versus other, there is, for many people, a blurring of the boundaries between the embodied self and the PC. Grosz (1994: 80) notes that inanimate objects, when touched or on the body for long enough, become extensions of the body image sensation. They become psychically invested into the self; indeed, she argues, '[i]t is only insofar as the object ceases to remain an object and becomes a medium, a vehicle for impressions and expression, that it can be used as an instrument or tool'. Depending on how inanimate objects are used or performed by the body, they may become 'intermediate' or 'midway between the inanimate and the bodily' (Grosz 1994: 81). These observations are useful for understanding the blurriness and importance of the computer/user relationship. This relationship is symbiotic: users invest certain aspects of themselves and their cultures when 'making sense' of their computers, and their use of computers may be viewed as contributing to individuals' images and experiences of their selves and their bodies.

In a previous article (Lupton 1994), I explored the ways in which the viral metaphor, when used in the context of computer technology, betrays a series of cultural assumptions about computers and human bodies. I argued that popular and technical representations of computer viruses draw on discourses that assume that computers themselves are humanoid and embodied (and therefore subject to illness spread by viruses). What is more, similar cultural meanings are attached to the viral infection of computers as are associated with human illness, and in particular, the viral illness of HIV/AIDS. That is, there are a series of discourses that suggest that computers which

malfunction due to 'viral contamination' have allowed themselves to become permeable, often via the indiscreet and 'promiscuous' behaviour of their users (in their act of inserting 'foreign' disks into their computer, therefore spreading the virus from PC to PC). I pointed out that computer viruses are manifestations of the barely submerged emotions of hostility and fear that humans have towards computer technology.

In the present discussion I want to expand my previous consideration of the embodied relationship between computers and their users, with a particular focus on subjectivity and emotional states in the context of an ever-expanding global interlinking of PCs on the Internet, 'the world's largest network of computer networks' (Neesham 1994: 1). In the wake of the Internet the computer/user relationship has been extended from an atomized and individualized dyad. The PC now can be used by individuals to link into information networks and exchange messages in real time with others around the world. In that respect, the burgeoning Internet technology is not so different from telephone technology. However, a major difference lies in the risks that have recently attracted much media attention in relation to using the Internet. The attractions of the Internet, including its accessibility, are also a source of problems around security and the activities of computer 'hackers' and 'cyber-criminals'. This chapter explores the implications of this for the computer/user relationship, with a focus on the mythic and 'irrational' meanings 'that are very close to the surface in computer culture', disrupting 'rational' and depersonalized meanings (Sofia 1993: 116). I draw on a number of popular and more arcane texts to do so, including advertisements and articles about computers and users published in newspapers and news magazines, *New Scientist* magazine, *Wired* (a specialist magazine for Internet users) and academic writings about the computer/user relationship.

The disembodied computer user

A central utopian discourse around computer technology is the potential offered by computers for humans to escape the body. This discourse of disembodiment has been central in the writings of influential 'cyberpunk' novelist William Gibson and the cultural theorist and feminist Donna Haraway. In computer culture, embodiment is often represented as an unfortunate barrier to interaction with the pleasures of computing; as Morse (1994: 86) has put it, 'For couch potatoes, video game addicts and surrogate travellers of cyberspace alike, an organic body just gets in the way'. In cyberwriting, the body is often referred to as the 'meat', the dead flesh that surrounds the active mind which constitutes the 'authentic' self. The demands of the fleshly body compel computer users to distract themselves from their pursuit to seek nourishment and quell thirst and hunger pangs and, even worse, to absent themselves to carry out such body maintenance activities as washing, expelling bodily wastes and sleeping. The dream of cyberculture is to leave the 'meat' behind and to become distilled in a clean, pure, uncontaminated relationship with computer technology. 'The desire for an evolutionary transformation of the human has shifted focus from the preparation for the journey into "outer space" from a dying planet to the virtual "inner" space of the computer' (Morse 1994: 96).

The 'human as computer' metaphor is frequently drawn upon in this attempt to deny the irrationality of embodiment. Human brains, for example, are frequently

described as 'organic computers' (Berman 1989). Sofia notes that the computer/human elision in this metaphor tends to represent human thought as calculating, rational and intentional, suppressing other cultural meanings around thought process and the unconscious:

> both the computer and the brain become representable as entirely 'rational' entities in a move which, on the one hand, obscures the fantasies attached to computing (e.g. the dream of mastery) and, on the other, portrays human mental activity as a mode of digital processing, entirely ignoring processes like joking, wishing, dreaming or imaginative vision and speech.
>
> (Sofia 1993: 51)

The idealized virtual body does not eat, drink, urinate or defecate; it does not get tired; it does not become ill; it does not die (although it does appear to engage in sexual activity, as all the hype around 'teledildonics' and virtual reality suggests). This vision may be considered to be the apotheosis of the post-Enlightenment separation of the body from the mind, in which the body has traditionally been represented as earthly, irrational, weak and passive, while the mind is portrayed as spiritual, rational, abstract and active, seeking constantly to stave off the demands of embodiment.

The cyborg has been represented as the closest to this ideal that humans may attain; that is, a 'humanoid hybrid' that melds together computer technology and human flesh (Haraway 1988). In an era in which risks to the health and wellbeing of the fleshly body abound, in which ageing and death are feared, the cyborg offers an idealized escape route. The cyborg form is evident in drug advertisements directed at medical practitioners, representing the ideal body as that which is invulnerable to illness, whose susceptibility to disease and death is alleviated by the drug therapy (Lupton 1993). In filmic portrayals of the cyborg, such as *Blade Runner* and the *Terminator* and *RoboCop* series, the cyborg body is portrayed as far stronger than the human body and far less susceptible to injury or pain, often able to self-repair in a matter of seconds. The cyborg body thus addresses anxieties around the permeability of body boundaries in its clean, hard, tightness of form. These anxieties are gendered, for the boundaries of the feminine body are viewed as being far more permeable, fluid and subject to 'leakage' than are those of the masculine body (Theweleit 1987; Grosz 1994). It is for this reason that men find the concept of the cyborg attractive in its sheer invulnerability: the cyborg body is constituted of a hard endoskeleton covered by soft flesh, the inverse of the human body, in which the skin is a vulnerable and easily broken barrier between 'inside' and 'outside' (Jones 1993: 84). In these discourses the cyborg is therefore a predominantly masculine body, as contrasted with the seeping, moist bodies of women.

There is a point at which the humanity of the cyborg must make itself felt; there *are* limits to the utopian vision of the cyborg as glossed in both masculinist and feminist discourses. This conundrum has been expressed by Morse (1994) in her question, 'What do cyborgs eat?' While an individual may successfully pretend to be a different gender or age on the Internet, she or he will always have to return to the embodied reality of the empty stomach, stiff neck, aching hands, sore back and gritty eyes caused by many hours in front of a computer terminal, for 'Even in the age of the techno-social subject, life is lived through bodies' (Stone 1992: 113).

The hacker's body

A further challenge to the utopian vision of the disembodied computer user is the mythology of the bodies that are obsessed with using PC technology: computers 'hackers' and 'computer nerds'. In sharp contrast to the idealized clean, hard, uncontaminated masculine body of the cyborg as it is embodied in the *RoboCop* and *Terminator* films, this type of computer body is physically repugnant according to commonly accepted notions of attractiveness. 'Hackers' and 'computer nerds', the very individuals who are frequently represented as spearheading the revolution into cyberspace and the 'information superhighway', may be admired for their intellectual capacities (that is, for their 'brain' or 'software'), but the common representation of such individuals usually suggests that their 'bodies' or 'wetware' leave much to be desired. As they are represented in popular culture, 'computer nerds' or 'hackers' are invariably male, usually in their late adolescence or early adulthood, and are typically portrayed as social misfits and spectacularly physically unattractive: wearing thick, unflattering spectacles, overweight, pale, pimply skin, poor fashion sense. Their bodies are soft, not hard, from too much physical inactivity and junk food. These youths' and men's appearance, it is often suggested, is inextricably linked to their obsession with computers in a vicious circle. According to the mythology, computer nerds turned to computing as an obsession because of their lack of social graces and physical unattractiveness. Due to their isolation from the 'real' world they have become even more cut off from society. Lack of social contact has exacerbated their inability to communicate face-to-face with others, and a poor diet and lack of fresh air and exercise does little to improve their complexions or physique.

A recent case involving the arrest of a celebrated American computer 'hacker' was widely reported in Australian newspapers and news magazines. Kevin Mitnick, 31 years old, was charged with breaking computer-network security and computer fraud. After evading the FBI for two years, he was found and eventually brought to justice by an equally talented computer-security expert, Tsutomu Shimomura. After his arrest, the virtual, anonymous persona of Mitnick, previously manifested only in the traces he left behind when he broke into computer-systems, often leaving cheeky messages of bravura, was displayed as an earthly, all-too-human body. Photographs of Mitnick showed him to represent the archetypal 'computer nerd', complete with thick spectacles, pale skin, pudgy body and double chin. These physical characteristics contrasted with the abstract images of his disembodied on-line hacker persona: *Time Australia* magazine (Quittner 1995), for example, headed a two-page article on the arrest with a surreal colour photograph of two computers side-by-side, the only sign of human embodied presence an arm extending from one to clutch the keyboard of the other. The articles portrayed Mitnick as obsessive, indeed, 'addicted' to the pleasures of hacking. *Time Australia* described him in the courtroom, standing in handcuffs, 'unable, for the first time in more than two years, to feel the silky click of computer keys'.

The bodies of computer 'hackers' and 'nerds', thus, are not transcended through their owners' pursuits. On the contrary, their bodies are inscribed upon and constructed through the computers they use. Their physical characteristics betray their obsessiveness to others. What is more, such individuals are described as 'addicted' to computing as if it were a drug. They thus lack control over their bodies and desires, in sharp contrast to the rationalized, contained body of the masculine cyborg.

The humanized computer

Paradoxically, while computer culture often seeks to deny the human body, the ways in which computer technology is marketed and represented frequently draws an analogy between the computer and the human body. Just as the metaphor 'human as computer' is often articulated in popular culture, so too the 'computer as human' trope is regularly employed. Advertisements for personal computer equipment make particular efforts to represent these inanimate, hard-textured objects as warm, soft, friendly and humanoid.

Computers, as represented in advertising, are prone to many of the life experiences that humans experience. Computers are born, delivered by medical practitioners: one advertisement uses a photograph of a (male) doctor, identified as such by his surgical gown and mask, holding in his arms a computer notebook as if it were a baby: 'NEC can deliver colour notebooks now' read the words above his head. Just as computers are born and delivered, they also die. One advertisement asks readers, 'Why buy a monitor with only 6 months to live?', showing a PC with a screen on which is depicted an ECG graph which has gone flat, similar to the pattern shown when heart failure occurs in humans. This computer has lost its vitality, as depicted by the flat line. Computers can also be too fat and are most desirable when they are slim. One advertisement showed a small notebook computer wrapped in a tape-measure: the heading read, 'All the power of a 486 notebook, with 40% less fat'. Another advertisement, again for a notebook computer, was headed, 'You can never be too thin or too powerful' to champion the small size of the computer.

Ross (1991) has described the notices that often are posted near such routinely used office machines as photocopiers, which humorously describe the ways in which such machines can detect users' emotional states and react accordingly to make life even more difficult by failing to operate. As he notes,

> In personifying the machine as a unit of organized labour, sharing fraternal interests and union loyalties with other machines, the notice assumes a degree of evolved self-consciousness on the machine's part. Furthermore, it implies a relation of hostility, as if the machine's self-consciousness and loyalty to its own kind have inevitably lead to resentment, conflict, and sabotage.
>
> (Ross 1991: 1–2)

Notices such as these suggest that 'smart' machines like photocopiers are equipped with the means of control and surveillance over the humans who seek to use them, almost as a spy of management. Not only do humans approach such technologies in heightened emotional states but they resound to the technologies with emotions such as vindictiveness and spite.

Computers are often similarly represented as emotional entities, as in the following excerpt relating problems with a computer package published in the computing section in a newspaper:

> Even before Windows appeared, it started complaining. Coldly, matter-of-factly, on a pointedly unfriendly character-based screen, it refused to run 32-bit disk access. It said someone had been fiddling with its interrupts and it thought it had a virus. It grudgingly offered to run Windows with 16-bit file access.
>
> (Morison 1995)

Just as humans fear alienation and loneliness, so too do their PCs. If a user is not linked up to a networked system, both the human and the computer are left to contemplate their social isolation. A magazine advertisement showed a PC in black and white at the top right-hand corner of a white page. Beneath this image were the words (in stark black): 'Insecure? Friendless? Alone?'. The advertisement went on to outline the ways in which computers in the workplace could be networked. The clear analogy drawn is that between the lonely, anxious computer user and the non-networked computer, both forced to work alone. A similar advertisement showed a PC silhouetted, with the words 'Say goodbye to working in an isolation chamber' in red across the screen. In these advertisements, the computer monitor stands for both computer and human user, a metonym of the human/computer dyad.

The emotions are commonly represented as a characteristic of humans, of being alive, phenomena that set humans apart from other animals, evidence of their sensitivity, spirit and soul. Again, the ascribing of emotions to PCs is a discursive move that emphasizes their humanoid nature. Some articles about computers, especially those published in specialist magazines or the computing sections in newspapers designed for aficionados, go even further by frequently making the analogy of the relationship of the user/computer romantic, sexual or marital. One Australian newspaper article on Macintosh computers used headline, visual image and recurring tropes to draw an analogy between one's marital partner and one's PC (Withers 1995). The article was headed 'No time to divorce your Mac', and was illustrated with a cartoon bride planting a kiss on a bridegroom with a smiling Macintosh screen for a head. The article went on to assert,

> Choosing to buy a Macintosh or any other specific personal computing plat-
> form such as Windows is a little like getting married. In both cases you are
> signing up for a long-term partnership that can be costly to leave. The happily
> married among us can testify to the benefits of such a relationship, but they
> don't appear at the outset. 'Come grow old with me, the best is yet to
> come' applies to both situations.

Advertisements also attempt to portray one's PC as an extension of the human body. One such representation in a newspaper advertisement used a photograph of a group of people holding their notebooks up in front of their faces, the screen reproducing and magnifying their smiles. In this portrayal, the computer was represented as extending and indeed enhancing the most emotionally demonstrative part of the human face, the mouth. These people are using their computers to display their emotional state: in this case, happiness. The computer, in this portrayal, is mirror of the soul. In another adver-tisement, a PC holds up a camera to its screen 'face', upon which is displayed the word 'smile' in a smiling curve. The heading reads, 'Now your PC can take photos'. An advertisement for Envoy, a computer package, claimed: 'Envoy *thinks* like I do. Sounds weird, but while I'm physically at one meeting, I'm part of three or four others going on *in* my Envoy!'

The frightening computer

The overt reasons for portraying computers as human is to reduce the anxieties of com-puterphobia that many people, particularly adults, experience. There is an undercurrent

of uncertainty around purchasing and buying computer technology on the part of many people. Computers, unlike many other household or workplace machines, appear inherently enigmatic in the very seamlessness of their hardware. Most people have not the faintest idea what lies inside the hard plastic shell of their PC. The arcane jargon of the computing world, with its megabytes, RAMs, MHz and so on, is a new language that is incomprehensible to the uninitiated. It is a well-known truism that the manuals that come with computer technology are incomprehensible and that computer 'experts' are equally unable to translate jargon into easily understood language to help users unfamiliar with the technology. The user–computer relationship is therefore characterized not only by pleasure and a sense of harmonic blurring of the boundaries between human and machine, but is also inspires strong feelings of anxiety, impotence, frustration and fear.

There is something potentially monstrous about computer technology, in its challenging of traditional boundaries. Fears around monsters relate to their liminal status, the elision of one category of life and another, particularly if the human is involved, as in the Frankenstein monster (Rayner 1994). The potential of computer technology to act as a form of surveillance and social regulation, or even to take control over humanity, has been decried (Robins and Webster 1988; Glass 1989; Barns 1990). The apparent growing reliance of humans upon computers has incited concern, as have developments in technology that threaten to leave people behind or to render them unemployed. While there is an increasing move towards the consumption of technologies, there is also anxiety around the technologies' capacity to consume *us* (Silverstone and Hirsch 1992: 2). A recent Hollywood film, *The Ghost in the Machine*, addressed these anxieties. The film, released in 1994, featured the story of a serial murderer who is involved in a car accident which mortally wounds him. In hospital, a short circuit during an electrical storm occurs just as his brain is being scanned by a computer. He dies at that moment, his 'soul' entering cyberspace via the diagnostic scan machine. The murderer manifests his aggression via the optical fibre network and the electricity grid, killing people via their home appliances. He is finally brought to justice through the efforts of a computer hacker.

The Macintosh computer company was the first to develop 'user-friendly' icons in lieu of textual commands, including the friendly smiling face that has become the standard-bearer of the Apple range. These icons stand as symbolic images for the mysterious activities occurring 'within' the computer (Haddon 1988). The implication of this design strategy was that many potential computer users were alienated by the technological demands of computers requiring text commands, and thus required PCs to be 'humanized' to feel comfortable with the technology. It is telling that this deliberate 'humanization' is unique to PC technology; smiling face icons are not found in other domestic technologies that people find difficult to use, such as video cassette recorders.

New computer programs have recently been designed to alleviate the negative emotions people harbour about using computers. Microsoft, for example, has developed a program it has called 'Bob' to challenge technophobic inclinations, expand the home-computer market and reduce its expenditure on help hotlines. The program features animated characters to show people how to operate the functions of their PC, including 'a crazy cat, soppy dog or coffee-addicted dragon', acting as a 'friend over their shoulder' as Bill Gates described it (Fox 1995: 22). The 'Bob' program was subsequently advertised in the May 1995 edition of *Wired* magazine. The two-page spread featured a large

hand-tinted colour photograph, circa the 1950s, showing a beaming all-American nuclear family driving along in a pink convertible with the top down, Mom and the adolescent daughter waving cheerily at the camera. The wording of the advertisement reproduces a naïve, simple approach to life to match the 1950s imagery: 'You know what? People need to be a little friendlier. An extra smile. A wave hello. A Bob. Bob helps you to be friends with your computer. And gee whiz, isn't making friends what friendliness is all about?'

The advertisement proclaims that there is no manual for the 'Bob' program, because 'it is so easy to use . . . No manual. How friendly can you get?' This advertisement, with its slyly self-parodying home-spun philosophies, its emphasis on 'friendliness' and 'niceness' and its complete avoidance of computer jargon, is appealing directly to precisely those people who feel alienated by their PCs and the manuals that come with them. It draws upon a nostalgia for a less complicated world, a world in which people were friendly to one another, families stayed together and the most complicated technology they owned was the family motor car. 'Bob', as a humanoid character, speaks their language and relates to them as would a friend.

Risky computing

In the age of the 'risk society' (Beck 1992; Giddens 1992), personal computers constitute sites that are redolent with cultural anxieties around the nature of humanity and the self. The late modern world is fraught with danger and risk: the promises of modernity have been shown to have a 'double-edged character', no longer simply guaranteeing human progress (Giddens 1992: 10). To deal with this uncertainty and the time–space distanciation and globalizing tendencies of late modernity, trust has become central to human interactions, particularly in relation to complex technical systems of which most people have little personal knowledge: 'Trust in systems takes the form of faceless commitments, in which faith is sustained in the workings of knowledge of which the lay person is largely ignorant' (Giddens 1992: 88). Individuals have become dependent on personal relationships, particularly those involving romantic love, to find a sense of security and of subjectivity in a fast-changing, frightening world. However, ambivalence lies at the core of all trust relations, because trust is only demanded where there is ignorance and ignorance provides grounds for scepticism or caution (ibid. 89).

The euphoria around the 'information superhighway' or 'infobahn', with its utopian visions of computer users able to access each other globally and 'get connected' has been somewhat diminished of late by a series of scares around the security problems threatened by the very accessible nature of the Internet. As I observed above, for some years now there have been growing concerns about the potential of computer networks to surveil and police individuals, using computer databases to collect and pass on information. More recently, a number of news stories have made dramatic headlines reporting on incidents of 'cybercrime' and the security problems of the computer network. One story, reported worldwide, related the saga of the eventual capture of Kevin Mitnick by Tsutomu Shimomura, described above. Another story reported in Australian newspapers in early 1995, detailed the actions of a computer hacker who published confidential credit card numbers on the Internet. An article in *New Scientist* described the growing numbers of frauds in the US using the Internet for investment scams, pointing to the

trust that users invest in the information they receive over the Internet. As one computer expert was quoted as saying, 'Con artists are flourishing in cyberspace because people believe what they read on their computer screens. . . . People tend to accept it as gospel' (Keirnan 1994: 7).

News reports of such crimes typically emphasize the growing security risks caused by the increasing use of the Internet, with a focus on the dangers of 'connectivity' that is linking more and more computers and their users worldwide, employing metaphors of 'gates', 'avenues' and 'openings' as well as epidemic illness (familiar from reports of computer viruses) to represent the threat. For example, a story published in *New Scientist* (Kleiner 1995) on the activities of hackers in discovering a security loophole on the Internet, allowing them to access files previously denied them, was headed, 'Hack attack leaves Internet wide open'. The article went on to explain that the hackers had managed to 'impersonate a computer that is "trusted" by the computer targeted for attack'. An article published in the *Sydney Morning Herald* used similar language: 'When computers were quarantined from each other, there was less chance of a security breach. Now, most systems have any number of electronic avenues leading to them, and some passers-by in cyberspace inevitably wander in when they find the gates unlocked' (Robotham 1995a). This discourse serves as a complement to the viral metaphor, which represents computers as embodied, subject to invasion by viral particles which then cause 'illness' (Lupton 1994). Just as in AIDS discourses gay men or women have been conceptualized as 'leaky bodies' who lack control over their bodily boundaries so, too, in this 'cybercrime' discourse, computers are represented as unable to police or protect their boundaries, rendering themselves vulnerable to penetration. Just as humans in late modernity must both rely on trust relations but also fear them, computers can no longer 'trust' other computers to keep secrets and respect personal boundaries. The sheer anonymity of the 'cyberrobbers' perpetrating the crimes is also a source of fear; they are faceless, difficult to find and identify because of their skill in covering their tracks.

Further concern has also recently been generated about the links that children may make with the outside world via the Internet, particularly in relation to contact with paedophiles, pornography and sexual exchanges over email or chat networks. A front page article published in the *Sydney Morning Herald* in mid-1995 detailed the story of an American 15-year-old boy who left home to meet with a man he had met on the Internet, with the suggestion that the man may have been a paedophile. The article was head-lined, 'Every parents' nightmare is lurking on the Internet', and asserted that 'This is the frightening new frontier of cyberspace, a place where a child thought to be safely in his or her room may be in greater danger than anyone could imagine' (Murphy 1995). Again, the main anxiety here is in the insidious nature of contact with others through the Internet. The home is now no longer a place of safety and refuge for children, the computer no longer simply an educational tool or source of entertainment but is the possible site of children's corruption. 'Outside' danger is brought 'inside', into the very heart of the home, via the Internet.

We invest a great deal of trust in computer technology, especially in our PCs. Many of us have little knowledge about how they work, relying on experts to produce and set up the technology, and to come to our aid when something goes wrong. Yet we have also developed an intimate relationship with them, relying on them to perform everyday tasks, to relax and to communicate with others. We can now carry them about with us in our briefcases, and sit them on our laps. They take pride of place in our

studies at home and our children's bedrooms. The ways in which we depict computers as humanoid, having emotions and embodiment, is evidence of this intimacy. It is in this context that we are particularly emotionally vulnerable to losing trust in our PCs, and where risk appears particularly prevalent. We now not only risk becoming 'infected' via a computer virus, but also being 'penetrated' by cybercriminals finding the weakest points in our computer system, seeking to discover our innermost secrets and corrupt and manipulate our children.

The relationship between users and PCs is similar to that between lovers or close friends. An intimate relationship with others involves ambivalence: fear as well as pleasure. As we do with people we feel are close to us, we invest part of ourselves in PCs. We struggle with the pleasures and fears of dependency: to trust is to reap the rewards of security, but it is also to render ourselves vulnerable to risk. Blurring the boundaries between self and other calls up abjection, the fear and horror of the unknown, the indefinable. In her essay *Powers of Horror*, Kristeva defined the abject as 'violent, dark revolts of being, directed against a threat that seems to emanate from an exorbitant outside or inside, ejected beyond the scope of the possible, the tolerable, the thinkable' (1982: 1). The abject inspires both desire and repulsion. It challenges, as it defines, the boundaries of the clean, proper, contained body, the dichotomy between inside and outside. One of its central loci, argues Kristeva, is the maternal body, a body without 'proper' borders. Another is the sexual body, which involves the merging and blurring of the boundaries of one's own body with that of another.

Just as they are described as friends or spouses in the masculinist culture of computing, computers are also frequently described in feminine sexual or maternal roles. The word 'matrix' originates from the Latin *mater*, meaning both mother and womb, a source of comforting security (Springer 1991: 306). For their male users in particular, computers are to be possessed, to be penetrated and overpowered. This desire for power and mastery was expressed by an anonymous computer hacker quoted in an article on 'cybercrime' (Robotham 1995b). When asked about what motivates him and other hackers, he replied: 'A person who hacks into a system wants to get a degree of power, whether the power is real or fallacious. This is you controlling the world from your Macintosh. It's an incredible feeling.' This masculinist urge to penetrate the system, to overpower, some commentators have argued, represents an attempt to split oneself from the controlling mother, to achieve autonomy and containment from the abject maternal body (Robins and Webster 1988; Sofia 1993). Computer users, therefore, are both attracted towards the promises of cyberspace, in the utopian freedom from the flesh, its denial of the body, the opportunity to achieve a cyborgian seamlessness and to 'connect' with others, but are also threatened by its potential to engulf the self and expose one's vulnerability to the penetration of enemy others. As with the female body, a site of intense desire and emotional security but also threatening engulfment, the inside of the computer body is dark and enigmatic, potentially leaky, harbouring danger and contamination, vulnerable to invasion.

Originally published in *Body and Society* 1 (3–4) (1995).
This essay has been edited for inclusion in the Reader.

References

Barns, I. (1990) 'Monstrous nature or technology? Cinematic resolutions of the "Frankenstein problem"', *Science as Culture* 9: 7–48.

Beck, U. (1992) *Risk Society: Towards a New Modernity*, London: Sage.

Berman, B. (1989) 'The computer metaphor: bureaucratizing the mind', *Science as Culture* 7: 7–42.

Fox, B. (1995) 'Trust Bob to tackle technophobia', *New Scientist* 21 January: 22.

Giddens, A. (1992) *The Consequences of Modernity*, Cambridge: Polity Press.

Glass, F. (1989) 'The "new bad future": Robocop and 1980s' sci-fi films', *Science as Culture* 5: 7–49.

Grosz, E. (1994) *Volatile Bodies: Toward a Corporeal Feminism*, Sydney: Allen and Unwin.

Haddon, L. (1988) 'The home computer: the making of a consumer electronic', *Science as Culture* 2: 7–51.

Haraway, D. (1988) 'A manifesto for cyborgs: science, technology, and socialist feminism in the 1980s', pp. 173–204, in E. Weed (ed.) *Coming to Terms: Feminism, Theory, and Practice*, New York: Routledge.

Heim, M. (1992) 'The erotic ontology of cyberspace', pp. 59–80, in M. Benedikt (ed.) 80, in M. Benedikt (ed.) *Cyberspace: First Steps*, Cambridge, MA: MIT Press.

Jones, A. (1993) 'Defending the border: men's bodies and vulnerability', *Cultural Studies from Birmingham* 2: 77–123.

Kiernan, V. (1994) 'Internet tricksters make a killing', *New Scientist* 16 July: 7.

Kleiner, K. (1995) 'Hack attack leaves internet wide open', *New Scientist* 4 February: 4.

Kristeva, J. (1982) *Powers of Horror: An Essay on Abjection*, New York: Columbia University Press.

Lupton, D. (1993) 'The construction of patienthood in medical advertising', *International Journal of Health Services* 23(4): 805–19.

Lupton, D. (1994) 'Panic computing: the viral metaphor and computer technology', *Cultural Studies* 8(3): 556–68.

Morison, N. (1995) 'Michelangelo alive and ready to strike', *Sydney Morning Herald* 21 February.

Morse, M. (1994) 'What do cyborgs eat?: Oral logic in an information society', *Discourse* 16(3): 86–123.

Murphy, K. (1995) 'Every parent's nightmare is lurking on the Internet', *Sydney Morning Herald* 13 June.

Neesham, C. (1994) 'Network of information', *New Scientist* (*Inside Science* supplement) 10 December: 1–4.

Quittner, J. (1995) 'Cracks in the net', *Time Australia* 27 February: 36–7.

Rayner, A. (1994) 'Cyborgs and replicants: on the boundaries', *Discourse* 16(3): 124–43.

Robins, C. And F. Webster (1988) 'Athens without slaves . . . or slaves without Athens?', *Science as Culture* 3: 7–53.

Robotham, J. (1995a) 'The cops aren't chasing the cyber-robbers', *Sydney Morning Herald* 22 April.

—— (1995b) 'Tap in for a shot of power from the system', *Sydney Morning Herald* 22 April.

Ross, A. (1991) *Strange Weather: Culture, Science and Technology in the Age of Limits*, London: Verso.

Sarno, T. (1995) 'William the Conqueror', *Sydney Morning Herald* 21 January.

Seltzer, M. (1992) *Bodies and Machines*, New York: Routledge.

Silverstone, R. And E. Hirsch (1992) 'Introduction', pp. 1–11, in R. Silverstone and E. Hirsch (eds) *Consuming Technologies: Media and Information in Domestic Spaces*, London: Routledge.

Sofia, Z. (1993) *Whose Second Self? Gender and (Ir)rationality in Computer Culture*. Geelong, Victoria: Deakin University Press.

Springer, C. (1991) 'The pleasure of the interface', *Screen* 32(3): 303–23.

Stone, A. (1992) 'Will the real body please stand up?: boundary stories about virtual cultures', pp. 81–118, in M. Benedikt (ed.) *Cyberspace: First Steps*, Cambridge, MA: MIT Press.

Theweleit, K. (1987) *Male Fantasies, Volume 1: Women, Floods, Bodies, History*, Cambridge: Polity Press.

Withers, S. (1995) 'No time to divorce your Mac?, *Sydney Morning Herald* 7 February.

ANNE BALSAMO

THE VIRTUAL BODY IN CYBERSPACE

THIS CHAPTER SPECULATES ABOUT THE body on the electronic frontier. In one sense, this frontier is an *imaginary* construction that identifies a horizon of contemporary cultural thought. But in another sense it is a *real* space on the fringe of mainstream culture: the 'electronic frontier' names the space of information exchange that already exists in the flow of databases, telephone and fibre-optic networks, computer memory, and other parts of electronic networking services.[1] The frontier metaphor suggests the possibility of a vast, unexplored territory. Computer enthusiasts, also known as hackers, populate frontier villages; advance scouts/pilgrims include the by now infamous computer viruses, worms and Trojan horses that were designed very simply to 'map' the network into which they were released. In elaborating the Western frontier metaphor, John Perry Barlow explains that in the new small towns, 'Main Street is a central minicomputer. . . . Town Meetings are continuous and discussions range on everything from sexual kinks to depreciation schedules'.[2]

In a more material sense, the electronic frontier includes workstations, file servers, networks and bulletin boards, as well as the code of application programs, information services such as Prodigy and CompuServe, and on-line databases.[3] This frontier functions as the infrastructure of the computer/information industry and, as such, structures the further development and dissemination of computer technologies and services. One of the most publicized computer applications of the last decade has been the construction of 'virtual environments', now more widely known as 'virtual reality'.[4] Since 1987, virtual reality (VR) has further evolved into an industry in itself; it is also at the heart of an emergent (sub)culture that includes computer-generated realities, science fiction, fictional sciences and powerfully evocative new visualization technologies.[5] My guiding question for this chapter concerns the role of the body in this formation.

To set the stage for a discussion of the body in cyberspace, I offer a reading of the cultural aspects of the virtual reality industry, including its embodiment in a cyberpunk subculture, its media spectacles, and commodities-on-offer. Reporting on a trip through

cyberspace, I wonder how the repression of the body is accomplished so easily and about the consequences of this disembodiment. I conclude by posing several questions about the biopolitics of virtual reality.

Marketing cyberspace

Virtual technologies use graphics programs to create a three-dimensional, computer-generated space that a user/participant interacts with and manipulates via wired peripherals. In contemporary science fiction, the 3-D, computer-generated space or virtual environment is referred to as 'cyberspace', a term first used by William Gibson in his cyberpunk novel *Neuromancer* and now gaining acceptance among VR technicians to name the interior space of virtual reality programs.[6] In its fictional form, cyber-space is sometimes referred to as the matrix or 'the Net', a shorthand name for the network constructed by the connections between fixed computer consoles and portable computer decks.[7] In cyberpunk novels, 'real' geographic urban-suburban space is referred to as 'the sprawl', and although hackers often have to hide out or navigate their way through it, the real 'action' always occurs in the structured informational space of the matrix.

In its commercial form, cyberspace describes an electronic matrix or virtual environ-ment. It is also listed as a trademark of Autodesk, one of the two better known companies that develop software tools for virtual realities. Standard cyberspace hardware includes a set of wired goggles that track head movement connected to a computer that runs VR software. In 1985, a computer musician named Jaron Lanier founded a company called VPL that prides itself on being a 'pioneer in Virtual Reality (VR) and visual programming'. Better known than his company's products, Lanier has become a cult figure in the virtual reality subculture, whose members include technological innova-tors, popular cultural icons, game designers, and computer entrepreneurs. Lanier is often quoted as saying 'whatever the physical world has, virtual reality has as well'.[8]

Mondo 2000, the preeminent hacker magazine of the 1990s, offers a glimpse into the subculture formed in and around the fictional world of cyberspace. Posing is certainly nothing new to popular subcultures, and indeed, this is part of *Mondo*'s attraction for mainstream readers: it lets us in to the in-crowd. Three features stand out: its glossy, visually dense, techno-art layout; the regularly scheduled iconoclastic reports from the electronic frontier; and mediated interviews with the high priests of street tech, notably William S. Burroughs and Timothy Leary. It also promotes up-and-coming visionaries such as Lanier and John Perry Barlow, as well as other cultural cybercritics (such as Kathy Acker, Avital Ronell and Ted Nelson) and various rock groups, performance artists, smart drug advocates and electronic industry movers and shakers. In short, *Mondo 2000* publicizes the key features of the new subculture: 'founding fathers', mythic narra-tives of identity, specialized language, and a lot of new technology.

Topically, *Mondo 2000* picks up where McLuhan's *Mechanical Bride* left off, without the rhetorical questions and, for the most part, without the cultural criticism.[9] Where McLuhan fixated on magazine advertisements that hinted at the ominous fusion of sex and technology, *Mondo 2000* became the magazine to celebrate the fusion of sex and technology in its advertisements for cyberpunk culture. And yet, in spite of its techno-lust(re), *Mondo 2000* oddly evokes the counter-cultural rhetoric of the 1960s. In part

this reflects the widespread 1990s nostalgia for 1960s fashions and fads; thus, an issue of *Mondo* might include such retro-topics as 'on the road' stories, drug synthesis instructions, mod fashion icons, and reports from the underground. The difference is that in the 1990s the drugs are intended to make us 'smart', hallucinogens are replaced with hallucino*genres*, the 'Underground' is a band, and the best sex is virtual.[10] In a review of a show curated by Shalom Gorewitz, the *Village Voice* called the cyberspace artists and hackers 'gonzo techno-hippies'.[11] Indeed, the juxtaposition of counter-cultural rhetoric with technological elitism constructs an interesting stage for the promotion of virtual reality technologies. Advertisements plug in-group products: Gibson and Sterling's new novel, reprints of Leary's work, Avital Ronell's *Telephone Book*. But the pleasure of recognition is high. Articles demonstrate the appropriate attitude to the 'New world DisOrder' while they show you who/what you need to know/read/buy to be a member by imitation only. Even though electronically connected cyberpunks are dispersed from coast to coast, it's pretty obvious, according to *Mondo*, that the happening place to be is on the West Coast. So even though the real story about the development of virtual reality technologies takes shape all over the US – and especially in Britain, Australia and Italy – in keeping with the frontier logic, the best (mythical) cyberspace events have all taken place in our own American wild, wild, West.

Of course, the virtual reality industry includes much more than the subculture visualized by *Mondo 2000*. On the PR front, it includes conferences staged like media events – such as 'Cyber Arts International', billed as 'the world forum for emerging technologies in the arts, entertainment and education', and 'Cyberthon' a multimedia virtual reality fair sponsored by the Whole Earth Institute.[12] Richard Kadrey describes the technology-saturated twenty-four hours of Cyberthon No. I: 'On October 6 and 7 [1990] . . . the Whole Earth Institute turned the sound stage of San Francisco's Colossal Pictures into the world's biggest virtual-reality fair. Almost four hundred people got the chance to see and experience a whole range of reality-bending technologies close up. Over three hundred lucky lottery winners got the chance to don goggles and gloves and actually enter virtual worlds created by teams from Autodesk, Sense8, and Jaron Lanier's VPL'.[13] Ironically, the conference announcements advertised in *Mondo* or disseminated through electronic bulletin boards often rely on a rhetoric of 'reality' to attract conference participants.[14] For example, they offer to make available – for a price, of course – 'real' VR programs and equipment. Registration for the 1991 Cyber Arts International cost $450 and allowed a participant to visit special exhibits such as the CyberArt Gallery and 'product Expo', where one could 'experience' VR *live* by taking part in interactive music performances (where the audience directs the music) or by trying a '*live* exercise in producing integrated media'. Cyberpunk night at CyberArt, sponsored by *Mondo 2000*, promised 'an evening of elegant entertainment and high tech hallucinations', complete with master of ceremonies Timothy Leary and a 'new kind of theatrical entertainment *experience*'. The exhortations to 'experience it live' – the shows and the software systems on display – suggest more than an ironic subtext to the super-mediated VR spectacles. They also draw our attention to the process whereby VR technologies are transformed into commodities, through the engagement between people and products.

For all the media hype, audience response to VR suggests that, at best, it is at the 'Kitty Hawk' stage – more PR than VR. 'Serious' VR research is another matter, though. It has been reported that some computer scientists do not like the term 'virtual reality',

originally coined by Jaron Lanier, the VPL maverick. 'The term "virtual environment" better fits a field of scientific research', claims a professor of computer graphics quoted in a 1991 *Chronicle of Higher Education* article. 'Virtual reality is an unattainable goal, like artificial intelligence'.[15]

Although no official history of VR has been drafted, computer science and computer graphics are its foundation; it draws on Norbert Wiener's work in the 1940s on the science of cybernetics as well as on the early history of calculating machinery.[16] Other historical contributions include research during the 1960s on two-dimensional and three-dimensional viewing, and work from the 1970s on 'visual-coupled' systems. During the 1980s, VR-related research proliferated in the areas of interface design, telerobotics, optical sensors, simulation parameters and image processing and display. Myron Krueger, sometimes referred to as the father of artificial reality, wrote a very interesting but brief essay on the history of the field, in which he explains that although it took a while for 'the notion of artificiality to take hold interactive computing is now the norm'.[17] Implicitly he suggests that the biggest constraint inhibiting VR research was the lack of appreciation for its possible wide-scale market applications. Other than NASA's interest in head-mounted displays for reconnaissance and weapon delivery, no one had imagined the consumer market possibilities of human–machine interactive systems.

The scene has changed by the mid-1990s. Virtual reality applications in telecommunications, surgical simulation and computer-aided design are of great interest to current industry planners. In the electronics industry, VR is touted as an attractive, albeit capital-intensive, business venue; it demands the development of a host of new products, including biotechnical apparatuses such as datagloves, wired bodysuits, head-mounted tracking devices, goggles, headphones, miniaturized LCD screens, and digitizing cameras.[18] These devices and programs are incredibly expensive, not only to develop, but also to purchase. A cyberspace system marketed by VPL, called 'A Reality Built for Two' or RB$_2$, retailed for $250,000 in 1991; it comes with two headseats, two sets of DataGloves, and a powerful minicomputer. One of the main purposes of the splashy VR demonstrations and conventions is to create investment interest as well as a market for VR applications. Industry futurists envision large-scale VR installations primarily for entertainment and leisure services and would love to attract the backing of Disney or Universal – who have theme parks that currently use robotics – to invest in the development of 'Dream Parks' that are based on 'interactive role-playing environments'.[19] These speculations about the future of VR contribute to a 'bottom-line' message about its potential: there is a lot of money to be made in the development and marketing of cyberspace.

In summary, the key features of this new subculture include popular cultural artifacts (e.g. *Mondo 2000* and the films *Lawnmower Man* and *Johnny Mnemonic*), a mythic set of founding fathers (Ted Nelson, Jaron Lanier), a specialized language that draws on the science of computer technology and computer programming, and the promise of new high-tech commodities. Oddly, at the same time that it promotes the sexiness of new technology and is unabashedly elitist, it also evokes a counter-cultural belief in the possibility of resistance within a corporate culture. Such juxtapositions – of technology and the counter-culture, of 'reality effects' and real demonstrations, of the science and the PR – suggest that cyberpunk subculture is actively engaged in the work of processing cultural meanings. As it plays itself out, the future of virtual reality is intimately tied to the capitalist structure of the information technology industry. Now the various

cultural visionaries have turned their attention to the work of imagining the future of VR, they ensure that it will be fully articulated to a commodity structure. The staged subcultural events draw our attention to the process whereby technologies are transformed into technological commodities.

As 'counter-cultural' as members of this subculture want to be, the virtual reality industry actually disseminates a certain mythology and a set of metaphors and concepts that cannot help but reproduce the anxieties and preoccupations of contemporary culture. As Jack Zipes claims, 'the inevitable outcome of the most mass-mediated fairy tales is a happy reconfirmation of the system which produces them'.[20] More than once, the popular press have commented that simulated experiences 'offer opportunities for safe activity in a risky world'. Called 'electronic LSD', or an 'electronic out-of-body experience', VR in its celebrated media form seems little more than an escape from conventional reality, a way out for those who confront the severe limitations reality imposes in the form of corporate ideology, determining social structures, and the physical body itself.[21] A more traditional ideological critique of the VR industry probably would begin by elaborating its participation in post-industrial capitalist modes of production and would go on to expose the way that the 'oppositional' subculture actually promotes bourgeois notions such as creative genius, hyperindividualism and transcendent subjectivity. In his essay 'Hacking away at the counter-culture', Andrew Ross elaborates how the story 'told by the critical left about new cultural technologies is that of monolithic, panoptical social control, effortlessly achieved through a smooth, endlessly interlocking system of networks of surveillance'. But, as he goes on to write, this 'is not always the best story to tell'.[22]

I agree that this ideological critique may be too totalizing. When discussing new technologies, it is important to try to avoid the trap of technological determinism that argues that these technologies necessarily and unilaterally expand the hegemonic control by a techno-elite. Technologies have *limited* agency. Having said that though, it does appear that virtual reality technologies are implicated in the production of a certain set of cultural narratives that reproduce dominant relations of power. Perhaps a better approach for evaluating the meaning of these new technologies is to try to elaborate the ways in which such technologies and, more importantly, the *use* of such technologies, are determined by broader social and cultural forces.

One of the most often-repeated claims about virtual reality is that it provides the technological means to construct personal realities free from the determination of body-based ('real') identities. Whereas VR promoters have focused primarily on the subjective and expressive dimensions of VR in public relations campaigns for VR games, users are also told that the physical body is of no consequence in virtual worlds. Even though some games may soon allow players to design personal avatars or puppets – simulations of oneself – more frequently VR is promoted as a body-free environment, a place of escape from the corporeal embodiment of gender and race. Upon analysing the 'lived' experience of virtual reality, I discovered that this *conceptual* denial of the body is accomplished through the *material* repression of the physical body. The phenomenological experience of cyberspace depends upon and in fact requires the wilful repression of the material body. In saying this, I am implicitly arguing that we need to extend the ideological critique of virtual reality technologies. From a feminist perspective it is clear that the repression of the material body belies a gender bias in the supposedly disembodied (and gender-free) world of virtual reality. In arguing that this repression is a technological phenomenon, I am not claiming

that it is entirely determined by the technology. On the contrary, I will elaborate how VR technologies articulate cultural narratives about the techno-body so that these technologies have the effect of naturalizing a gendered body phenomenon.

A trip through cyberspace

In contrast to a 2-D database, VR applications allow users to interact with three-dimensional representations of information. So instead of searching a database for lexical indicators or parts of computer code, a VR patron can interact with a data storage environment and browse through information that is represented graphically. According to one article in *Industry Week*, with VR 'you can imagine CAD models that, in effect, come alive. . . . You can enter them. You can make them any scale. They could be models of molecules, for example, and you could move about within these molecules with your whole body to examine their structures'.[23] In this way, the cyberspacial matrix serves as an abstract environment within which computer patrons can navigate.

All VR systems involve the interface of the body and technology in the use of some kind of bio-apparatus; three of the more common ones are the Nintendo PowerGlove; a headmount that includes LCD screens; and a 'hotsuit', which is a set of wired overalls.[24] Although my first trip through VR (with goggles and a track ball) was uneventful, I noticed the ease with which I made sense of the scene projected on small lenses mounted in the front of my helmet. The vision projected onto the small LCD screens was coloured like a cartoon world, with yellow walls, orange floors and brown tables. The point of contact with the interior spaces of VR – the way that this scene makes sense – is through an eye-level perspective that shifts as the user/patron turns her/his head; the changes in the scene projected on the small screens corresponds roughly with the real-time perspectival changes one would expect as one normally turns the head.

In most VR programs, a user experiences VR through a disembodied gaze – a floating, moving 'perspective' – that mimes the movement of a disembodied camera 'eye'. This is a familiar aspect of what may be called a filmic phenomenology, where the camera simulates the movement of perspective that rarely includes a self-referential visual inspection of the body as the vehicle of that perspective. The disembodiment of the eye is accomplished through the manipulation of the camera to approximate the height and angle of the point of view of an eye; the body of that eye is repressed, in that it is rarely shown (revealed) and never felt. The naturalization of the filmic gaze is one of the foundational planks of psychoanalytic film criticism and certainly not a new discovery. But what is of interest to me in my encounter with virtual reality is the way that the repression of the body is technologically naturalized. I think this happens because we have internalized the technological gaze to such an extent that 'perspective' is a naturalized organizing locus of sense knowledge. As a consequence, the body, as a sense apparatus, is nothing more than excess baggage for the cyberspace traveller.

The biopolitics of virtual bodies

What is becoming increasingly clear in encounters with virtual reality applications is that visualization technologies no longer simply mimic or *represent* reality – they virtually

recreate it. But the difference between reality constructed in VR worlds and the reality constructed in the everyday world is a matter of epistemology, not ontology.[25] They are both cultural as well as technological constructions, fully saturated by the media and other forms of everyday technologies. With respect to VR, it no longer makes sense to ask whose reality/perspective is presented in the various VR worlds, the industry, or the subculture; rather we should ask what reality is *created* therein, and how this reality *articulates relationships* between technologies, bodies, and cultural narratives. Where the first line of questioning assumes that 'perspective' and 'point of view' are the main channels of knowledge, the second line of questioning asserts that there is no singular reality to virtual reality, and that the 'realities' constructed therein embody the desires of those who program them.[26]

Another critical framework, one informed by feminist epistemology, asks a slightly different set of questions about the realities of cyberspace; given this formation of an industry and now a subculture based on the use of virtual technologies, what are the biopolitics of virtual bodies in cyberspace? Which is to say, how do virtual reality technologies engage socially and culturally marked bodies? This set of questions begins with the material body and opens onto institutional and social issues. What is the relation of the material body to the 'sensory' simulation provided by virtual technologies? What are the phenomenological dimensions of the technologically mediated body?[27] Does VR transform body-based subjectivities? How do various interfaces negotiate the split between the material body of the user and the locus of perception that either free-floats in a virtual world or is connected in some fashion to a virtual puppet? Demographically, what kinds of bodies reside in cyberspace: humanoid? More specifically, how is the disembodied technological gaze marked by the signs or logic of gender and race? What kind of 'reality surplus' is produced? When virtual 'realities' are bought and sold, who will profit? What kinds of bodies are cybernetically employed in the production of computer components? At one level, VR enables the willing suspension of disbelief whereby a participant adjusts the way that sensory information is processed; certain senses are realigned (vision without gravity) to process the simulated experience, while other registers of reality are repressed. The fact that a floating point of view is intelligible attests to the flexibility of embodied sense organs. So although the body may disappear representationally in virtual worlds – indeed, we may go to great lengths to repress it and erase its referential traces – it does not disappear materially in the interface with the VR apparatus or, for that matter, in the phenomenological frame of the user.

In short, what these VR encounters really provide is an illusion of control over reality, nature, and especially over the unruly, gender- and race-marked, essentially mortal body. It is not a coincidence that VR emerges in the 1980s, during a decade when the body is understood to be increasingly vulnerable (literally, as well as discursively) to infection as well as to gender, race, ethnicity, and ability critiques. With virtual reality we are offered the vision of a body-free universe. Despite the rhetorical disclaimers that this was *not* a Nintendo war, media coverage of the Persian Gulf spectacle provided numerous examples of the deployment of a disembodied technological gaze; the bomb's-eye view was perhaps the most fascinating and therefore most disturbing example of the seductive power of a disembodied gaze to mask the violence of reality.[28] The critical point here is that these new technological applications – VR, Nintendo, or bomb-cam – do not create disembodied citizens. Rather, they are themselves

consequences of social changes already in place. If 'the frontier' functions as a metaphor to describe the social and economic context for the development of new computer/ information technologies, 'cyberspace' functions metaphorically to describe the space of the disembodied 'social' in a hypertechnological informational society. Cyberspace – as a popular cultural construct – shows us what can happen when popular culture 'talks back' to cultural theory; cyberspace offers a way to think about the location of the social in post-industrial capitalism. Although this space is structured, it is impossible to map; there is no Archimedian point from which to construct a totalizing vision of the scene. At best you can wander through it, reading/writing as you walk, and maybe stumble upon something that was not programmed for you. Rich in information, for experience of cyberspace is always conjectural: an effect of intersecting practices – economic, tech-nological, bodily, political and cultural.

In her *Esquire* article on virtual reality, Sallie Tisdale notes a 'curious absence of narrative at Cyberthon, both in and out of the virtual worlds. It was an absence of plot – there is no story yet, no cosmology'.[29] In part, this is true; virtual reality promoters are computer scientists and system hackers, not cultural critics. These new techno-logies are implicated in the reproduction of at least one very traditional cultural narra-tive: the possibility of transcendence, whereby the physical body and is social meanings can be technologically neutralized. If the applications that utilize a disembodied gaze as the locus of perspective do away with the body altogether, the applications that include a representation of the body project a utopian desire for control over the form of personal embodiment.

In the speculative discourse of VR, we are promised whatever body we want, which doesn't say anything about the body that I already have and the economy of meanings I already embody. What forms of embodiment would people choose if they could design their virtual bodies without the pain or cost of physical restructuring? If we look to those who are already participating in body reconstruction programmes – for instance, cosmetic surgery and bodybuilding – we would find that their reconstructed bodies display very traditional gender and race markers of beauty, strength and sexuality. There is plenty of evidence to suggest that a reconstructed body does not guarantee a recon-structed cultural identity. Nor does 'freedom from a body', imply that people will exercise the 'freedom to be' any kind of body than the one they already enjoy or desire.

Fictional accounts of cyberspace play out the fantasy of casting off the body as an obsolete piece of meat, but, not surprisingly, these fictions do not eradicate body-based systems of differentiation and domination. In the course of Gibson's *Neuromancer* trilogy, not only is the hero's body eventually reconstructed from fragments of skin, so is his macho-male identity. It is true that in cyberpunk narratives individual male and female bodies may be coded slightly differently than they are in prevailing cultural norms. For example, Gibson's main female character in *Neuromancer*, Molly, has been technologi-cally modified with implanted weaponry that on the one hand makes her a powerful embodiment of female identity, no longer constrained by norms of passivity and proper femininity. On the other hand, Molly's body implants more fully literalize the charac-teristically threatening nature of her body. Early in his adventures, Gibson's hero, Case, must negotiate a cyberspace invasion where he is plugged in to Molly's body. Molly gets a rider, and Case gets to find out 'just how tight those jeans really are'. Once 'inside' Molly, Case finds the 'passivity of the situation irritating'. This passivity refers to his lack of control over Molly's body. So in a sense Case does experience, with the

help of VR technology, a bodily state more traditionally feminine. But his simstim 'experience' makes no lasting impression. Nor does it provide the occasion for the development of some insight into the politics of gendered bodies. His passivity is easily sexualized. To tease him, Molly reaches into her jacket, 'a finger circling a nipple under warm silk. The sensation made [Case] catch his breath'. This cybernetic penetration, we discover, follows a sexual encounter between Case and Molly when he recalls 'their mutual grunt of unity when he'd entered her'. Inside of cyberspace, or out, the relations between these cybernetically connected bodies often recreate traditional heterosexual gender identities.[30]

Probably no collection so effectively betrays the masculinist values of the new cyberpunk writers as the science fiction anthology titled *Semiotext(e) SF*. In their attempt to 'jolt' the commercial SF publishing industry, guest editors Rudy Rucker and Peter Lamborn Wilson invited contributions that had been rejected by other, more mainstream magazines. Penetrating penises figure prominently on every page in the form of a flip-book illustration of the 'High performance Waldo', a penis that is modelled on 'the Biomorph human penis rarely seen beyond the best sex professionals'. Indeed, the sexualization of the female body is a common theme in the various cyberpunk short stories. Andrew Ross argues that cyberpunk fiction offers the 'most fully delineated urban fantasies of white male folklore'.[31] In saying this, he also describes the logic behind the techno-fantasies embodied in VR applications where chic French women are made available as flirting partners to help you, the ideal male audience member, perfect your French language skills. In contemporary cyberpunk narratives, as in VR applications, cyberspace heroes are usually men, whose racial identity, although rarely described explicitly, is contextually white. Cyberspace playmates are usually beautiful, sexualized, albeit sometimes violently powerful women. Cyberspace offers white men an enticing retreat from the burdens of their *cultural* identities. In this sense, it is apparent that although cyberspace seems to represent a territory free from the burdens of history, it will, in effect, serve as another site for the technological and no less conventional inscription of the gendered, race-marked body. So despite the fact that VR technologies offer a new stage for the construction and performance of body-based identities, it is likely that old identities will continue to be more comfortable, and thus more frequently reproduced.

The rearticulation of old identities to new technologies

The virtual body is neither simply a surface upon which are written the dominant narratives of Western culture, nor a *representation* of cultural ideals of beauty or of sexual desire. It has been transformed into the very medium of cultural expression itself, manipulated, digitalized and technologically constructed in virtual environments. Enhanced visualization technologies make it difficult to continue to think about the material body as a bounded entity, or to continue to distinguish its inside from its outside, its surface from its depth, its aura from its projection. As the virtual body is deployed as a medium of information and of encryption, the structural integrity of the material body as a bounded physical object is technologically deconstructed. If we think of the body not as a product, but rather as a process – and embodiment as an effect – we can begin to ask questions about how the body is staged differently in different realities. Virtual

environments offer a new arena for the staging of the body – what dramas will be played out in these virtual worlds?

Even though the fetishistic nature of such technological devices fuels the fantasies of VR technicians, the possibilities for realizing these fantasies are probably determined more by the socio-economic context of corporate sponsorship than by the libidinal promise of virtually safe sex – which is to say that VR research and development cannot continue without commercial investment. But this isn't the whole story. Interspersed throughout the pages of *Mondo 2000* and conference announcements, a tension of sorts emerges in the attempt to discursively negotiate a corporate commodity system while upholding oppositional notions of counter-cultural iconoclasm, individual genius and artistic creativity. The result is the formation of a postmodern schizo-culture that is unselfconsciously elitist and often disingenuous in offering its hacker's version of the American Dream.

As Donna Haraway argues, we must be able to get beyond the rhetoric produced by both the techno-advocates and the cultural critics, because both of them inadvertently construct a demonology of technology. The issues we need to investigate concern the way that VR technologies produce simultaneous effects that are not easily judged to be 'good' or 'bad', or moral or immoral. For example, virtual reality applications, in an ideal form, involve a network of individual–machine interfaces located at remote outposts. In this sense, VR promotes both technological access and decentralization. But then, does it promote the further instrumental rationalization of everyday life or a new epistemological pluralism? Even as VR technology promises a new form of intersubjectivity, it contributes to an epidemic of cultural autism. Intimacy is now redefined as a quality of interaction between the human body and the machine.[32] What about notions of privacy and hygiene? Who will have access to virtual reality applications and, more broadly, to the networks that serve as the infrastructure of the emerging information society? Sensory processing is a fertile field for scientific research. In fact, we are fascinated by the possibility that we may be able to technologically monitor brain functioning. Several sophisticated new visualization technologies – such as PET (positron emission tomography), MRI (magnetic resonance imaging), and MEG (magnetoencephalogy) – offer ways to visualize brain activity. In the best light, this is done in hopes of constructing a map of brain processing patterns; but even as these technologies promise new vistas for scientific research, the possibility for establishing new 'biologically based' standards of body functioning – for example, defining what is 'normal' according to neural firing patterns – suggests that this is not a politically neutral technology. The fact that new imaging technologies produce 'better' images of human anatomy does not guarantee that doctors are using the images to produce 'better' diagnoses and/or treatment programmes for patients.[33] By analogy, the fact that virtual realities offer new information environments does not guarantee that people will use the information in better ways. It is just as likely that these new technologies will be used primarily to tell old stories – stories that reproduce, in high-tech guise, traditional narratives about the gendered, race-marked body.

Originally published in A. Balsamo (1996) *Technologies of the Gendered Body: Reading Cyborg Women*, Durham: Duke University Press.
This essay has been edited for inclusion in the Reader.

Notes

1. Mike Godwin, staff counsel for the Electronic Frontier Foundation (EFF), describes the EFF in his article 'The Electronic Frontier Foundation and virtual communities', *Whole Earth Review* (Summer 1991): 40–2. In many ways participants in the EFF are working to ensure the democratic application of electronic networking, so although they participate in the same postmodern schizo-subculture I describe in this chapter, their objectives resonate with the liberatory rhetoric of a 1960s counterculture.

2. John Perry Barlow, 'Crime and puzzlement: in advance of the law on the elecronic frontier', *Whole Earth Review* (Fall 1990): 44–57. Quotation is from page 45.

3. Here I'm describing elements of Internet, 'a vast network of networks that interconnect thousands of computing sites in government, industry, and academia. The Internet has evolved from primarily providing electronic mail services to become the infrastructure for significantly broader services of information exchange and collaborative work. Like CompuServe, the heart of the Internet is a vast collection of newsgroups in which participants from around the world post and comment on messages' (46). Pamela Samuelson and Robert J. Glushko, 'Intellectual property rights for digital library and hypertext publishing systems: an analysis of Xanadu', *Hypertext '91 proceedings* December 1991: 39–50.

4. The term 'virtual reality' has come under fire from some computer scientists who think that the term, like 'artificial intelligence', names an impossible project; they offer the term 'virtual worlds' as an alternative name for the space of virtuality. Brenda Laurel suggests the term 'telepresence', to connote a medium rather than a place. Brenda Laurel, *Computers as Theatre* (Reading, Mass.: Addison-Wesley, 1991).

5. The subculture of virtual reality was small enough in 1989–90 that the editors of a book titled *Virtual Reality: Theory, Practice and Promise* (a reprint of the Summer 1990 issue of *Multimedia Review*) could include a directory of companies and individuals interested in VR. The list contained 63 entries. Sandra K. Helsel and Judith Paris Roth (eds) *Virtual Reality: Theory, Practice, and Promise* (Westport, Conn.: Meckler, 1991).

6. William Gibson, *Neuromancer* (New York: Ace Science Fiction, 1984). Although Gibson is widely credited with introducing cyberspace to a mass audience and spawning a new subgenre of science fiction called cyberpunk, he is only one of the cyberthinkers at work on the new frontier of reality science. Some scholars claim that Vernor Vinge was the first to introduce the notion of an alternative, electronically mediated plane in his novella *True Names* (New York: Dell, 1981). (See Michael B. Spring, 'Informating with virtual reality', Helsel and Roth, *Virtual Reality*, 3–17.) However, I also am reminded of the empathy box in Philip K. Dick's novel *Do Androids Dream of Electric Sheep?* (New York: Doubleday, 1968) as an earlier forerunner.

7. Gibson utilizes a wide range of technological metaphors and computer slang to describe data banks, net running, and the various practices associated with computer hacking. His description of the history of cyberspace has been quoted often:

 > 'The matrix has its roots in primitive arcade games,' said the voice-over, 'in early graphics programs and military experimentation with cranial jacks.' . . . 'Cyberspace. A consensual hallucination experienced daily by billions of legitimate operators, in every nation, by children being taught mathematical concepts. . . . A graphic representation of data abstracted from the banks of every computer in the human system. Unthinkable complexity. Lines of light ranged in the nonspace of the mind, clusters and constellations of data. Like city lights, receding.'
 >
 > (Gibson, *Neuromancer*: 51)

8. Lanier is the source of many of the prophetic statements about the potential of virtual reality. See, for example, Kevin Kelly, 'An interview with Jaron Lanier: virtual reality', *Whole Earth Review* Fall 1989: 119; Steven Levy, 'Brave new world', *Rolling Stone* 14 June 1990: 92–100; John Perry Barlow, 'Life in the datacloud: scratching your eyes back in' (interview with Jaron Lanier), *Mondo 2000* (2 Summer 1990): 44–51.

9. There are several cultural critics – notably Arthur Kroker and Jean Baudrillard – who, either explicitly or implicitly, have continued to produce McLuhanesque criticism. However, none of them has spawned an entire subculture, although Kroker's 'panic postmodernism' comes

close. See especially the chapter titled 'The mechanical bride' in Marshall McLuhan, *The Mechanical Bride, Folklore of Industrial Man* (Boston: Beacon, 1951).

10. This list of topics refers to the following articles from *Mondo 2000* 4: 'Winnelife: an interview with Steve Roberts' by Gareth Branwyn, 32–5; 'Durk and Sandy: read this or die' (on antioxidants), 42–4; 'Avital Ronell on hallucinogenres', interview by Gary Wolf, 63–9; 'Antic women' (an announcement about a new *ReSearch* issue by Avital Ronell, Kathy Acker and Andrea Juno), 71; 'Freaks of the industry: an interview with the digital underground', by Rickey Vincent, 88–92; 'The carpal tunnel of love, virtual sex with Mike Saenz', interview by Jeff Milstead and Jude Milhon, 142–5. This issue also features a conversation between William S. Burroughs and Timothy Leary and an article on Jim Morrison on the occasion of Oliver Stone's film *The Doors* ('Orpheus in the maelstrom', by Queen Mu, 129–34).

11. The article is actually a review for a Dance Theater Workshop video screening project, 'Cyberspatial Intersections', curated by Shalom Gorewitz, 21–3 March 1991. As the press release describes, the series included video presentations about VPL products, special effects by Hollywood F/X companies, as well as computerized graphic art. Erik Davis, 'Virtual video', *Village Voice* 26 March 1991: 41–2.

12. Although as recently as 1980 cultural critics were explaining why art and technology were constructed as mutually exclusive domans, the engagement with art and visual artists has been part of the virtual reality industry from the very beginning. The ties to art and entertainment are the signal issues at meetings of ACM-SIGGRAPH (Association for Computing Machinery-Special Interest Group on Computer Graphics) and important early work on the interdisciplinary potential of VR as an artistic medium shows up in SIGGRAPH conference proceedings of 1989. The connections between VR and artistic expression are a persistent subtheme even in less spectacular conferences that focus on more serious issues related to the technological development of the machine–human interface. For example, a research conference called 'Virtual Worlds: Real Challenges', included sessions on applications for art and entertainment in addition to sessions on systems architecture, teleoperations and biomedical applications. This conference, held 17–18 June 1991, was co-sponsored by SRI International, the David Sarnoff Research Center, and VPL Research, Inc. (The company founded by Jaron Lanier in 1985). SRI and the David Sarnoff Research Center are electronic research organizations. Other events – such as 'Art and Virtual Environments', a public symposium held as part of the Banff Center for the Arts' new project on virtual technologies as artistic media; the First and Second Artificial Life conferences, a Penn state symposium on computer learning; and special sessions of the Human Factors Society – have also taken up the issues of virtual reality and rely on VR 'stars' such as Timothy Leary, Eric Gullichsen (president of Sense8), and researchers from the MIT Media Lab to draw crowds. Jack Burnham reviews the history of the art/technology schism as it has been constituted in the twentieth century in 'Art and technology: the panacea that failed', in Kathleen Woodward (ed.), *The Myths of Information: Technology and Postindustrial Culture* (madison, Wis.: Coda, 1980), 200–15.

13. Richard Kadrey is one of the regular reporters on the cyberspace beat, along with Howard Rheingold, Kevin Kelly for WER, Steve Diltea of *Omni*, and Randall Walser of Autodesk. Kadrey is quoted in 'Cyberthon No. 1: Virtual Reality Fair in San Francisco', *Whole Earth Review* Winter 1990: 145.

14. The irony has not been lost on the popular press; the page 1 headline in the *New York Times* announced '"Virtual reality" takes its place in the real world'. In addition to regular reports in the *Whole Earth Review*, *Omni* magazine, and *Mondo 2000*, other popular press articles include: Erik Davis, 'Virtual video', *The Village Voice* 26 March 1991: 41; Philip Elmer-Dewitt, 'Through the 3-D looking glass, *Time* 1 May 1989: 65–6; '(Mis)Adventures in cyberspace', *Time* 3 September 1990: 74–6; Trish Hall, '"Virtual reality' takes its place in the real', *New York Times* 8 July 1990, sec. 1: 1, 14; Jim Harwood, 'Agog in goggles: shape of things to come reshaping Hollywood's future', *Variety* (56th anniversary issue) 1989: 66; Steven Levy, 'Brave new world', *Rolling Stone* June 1990: 92–8; A. J. S. Rayl, 'The new, improved reality', *Los Angeles Times Magazine* 21 July 1991: 17–20+; Sallie Tisdale, 'It's been real', *Esquire* April 1991: 36; G. Pascal Zachary, 'Artifical reality: computer simulations one day may provide surreal experiences', *Wall Street Journal* 23 January 1990, sec. 1: 1; Gene Bylinsky, 'The marvels of "virtual reality"', *Fortune* 3 June 1991: 138–43; D'arcy Jenish, 'Re-creating reality', *Macleans* 4 June

1990: 56–8; Peter Lewis, 'Put on your data glove and goggles and step inside', *New York Times* 20 May 1990: 8; Douglas Martin, 'Virtual reality! Hallucination! Age of Aquarius! Leary's back!' *New York Times* 2 March 1991: 11; Edward Rotherstein, 'Just some games? Yes, but these are too real', *New York Times* 4 April 1991: B4; Richard Scheinin, 'The artificial realist', *San Jose Mercury News* 29 January 1990: 1–2; Julian Dibbel, 'Virtual kool-aid acid test', *Spin* 4 March 1991.

15. David L. Wheeler, 'Computer-created world of "virtual reality" opening new vistas to scientists', *Chronicle of Higher Education* 37 (26) (13 March 1991): A6.

16. One of the earliest references cited in a 24-page bibliography on VR is the *Proceedings of a Symposium on Large-Scale Calculating Machinery* (Jan. 1947), reprinted in The Charles Babage Institute Reprint Series for the History of Computing, Vol. 7 (Cambridge: MIT P, 1985). Norbert Wiener is known in some circles as 'the father of cybernetics'. Norbert Weiner, *Cybernetics or Control and Communication in the Animal and Machine*, New York: Technological Press, 1948; and *The Human Use of Human Beings: Cybernetics and Society* (New York: Doubleday, 1950).

17. Myron W. Krueger, 'Artificial reality: past and future', Helsel and Roth, *Virtual Reality*, 19–25; quotation is from page 22.

18. Although VPL had already developed the dataglove technology, it encountered difficulty finding a production source, so it licensed a version of the dataglove to Mattel Inc., which produced the 'PowerGlove' for use with Nintendo video games. The other examples listed are culled from industry product literature (VPL, Cyberware, Sense8, Autodesk) and *Virtual World News*, the VPL newsletter.

19. From an article by A. J. S. Rayl, 'Making fun', *Omni* November 1990: 42–8. Since 1990 several VR arcades featuring games such as 'Dactyl Nightmare' and 'Dactyl Nightmare II' have opened in malls across the US. In Chicago there is a VR arcade entirely devoted to the BattleTech game that includes eighteen game 'pods'. Atlanta has 'Dave and Busters' – an adult arcade and restaurant with VR games rigs, virtual golf, skee ball and assorted pinball and blackjack tables. In Albuquerque, Blockbuster has opened its version of an adult arcade, called 'Block Party', that includes not only VR games ('Dactyl Nightmare II' and 'Virtu Alley') but also interactive videos such as 'Go Motion Pictures' (moving seat films) and a new entertainment installation called 'The PowerGrid' (described in *Wired* magazine as a techno habitrail for adults). 'Romper room for grown-ups', *Wired* June 1995: 43.

20. Jack Zipes, 'The instrumentalization of fantasy: fairy tales and the mass media', in Kathleen Woodward (ed.) *The Myths of Information: Tehcnology and Postindustrial Culture*. (Madison, WI: Coda, 1980) 88–110. Quotation is from page 101.

21. Sandra K. Helsel and Judith Paris Roth raise similar questions in their introduction to their book *Virtual Reality: Theory, Practice and Promise*. They pose no answers and, in fact, comment on the lack of attention in their collection of articles to the issue of perspective or viewpoint: 'Many feminist historians assert that written history is history according to white males. How will any individual or group carefully and sensitively, with a deep appreciation for cultural, racial, religious and gender bias, create virtual reality systems?' They go on to ask, 'Will virtual reality systems be used as a means of breaking down cultural, racial, and gender barriers between individuals and thus foster 'human values'? Will virtual reality systems be multicultural in nature or will they only offer Western ways of assimilating knowledge? Will virtual realities systems serve as supplements to our lives, enriching us, or will individuals so miserable in their daily existences find an obsessive refuge in a preferred cyberspace?' (ix–x). Good questions every one.

22. Andrew Ross, 'Hacking away at the counterculture', in Constance Penley and Andrew Ross (eds), *Technoculture* (Minneapolis: University of Minnesota Press, 1991) 107–34. Quotation is from page 126. Ross examines the ways that the hacker subculture has been interpreted by cultural critics. His intention is to complicate those interpretations in such a way as to resist the totalizing picture of new information technologies that would disallow its more liberatory use. He reminds readers that the meaning of any technology is constructed through a struggle among competing systems of understanding – those determined by broader social and institutional forces as well as those produced through individual subjective encounters. In the end, he argues that while we need to maintain a healthy 'technoskepticism', we must also under-

stand that 'technology must be seen as lived, interpretive practice for people in their everyday lives' (131–2). Cultural critics are encouraged to develop a hacker-like knowledge about contemporary culture: 'to make our knowledge about technoculture into something like a hacker's knowledge . . . capable of . . . rewriting the cultural programs and reprogramming the social values that make room for new technologies . . . capable also of generating new popular romances around the alternative use of human ingenuity' (132).

23. This quotation is from Randal Walser, reported in an article by Therese R. Welter, 'The arti-ficial tourist: virtual reality promises new worlds for industry', *Industry Week* 1 October 1990: 66. Using VR as an architectural tool to design and then interact with spaces before they are built is one of its more immediately practical applications. Another cyberspace environment, called 'Traumabase', uses three-dimensional computer graphics to access information collected during the Vietnam War, ostensibly to 'show the realities of war in text, pictures, films, and sounds' (70). In this case, the information database is organized by 'creating a computer graphic construct . . . representing contained information along important dimensions: location and severity of wounds, wound pattern clustering, wound pattern frequencies, survival patterns' (71). Joseph Henderson, 'Designing realities: interactive media, virtual realities, and cyber-space', in Helsel and Roth, *Virtual Reality*, 65–73.

24. Eric Gullichsen, the president of a small software company called Sense8, allowed me to try out his bio-apparatus and VR program. The head-mounted apparatus was rather primitive, held together by fishing clips and duct tape; and the software, called WorldTools, was a bit under-whelming. But that was as much due to the fact that WorldTools is a program for other programmers that enables them to create their own virtual realities as it was due in part to the fact that VR technology is still in its infancy. Prospective clients for such programs include art gallery directors, interior decorators, architects and engineers.

25. According to Jean Baudrillard, a cultural shift has already taken place when the relationship between the 'real' and the image is transformed from a relation of reflection to a relation of simulation; the current phase of the image 'bears no relation to any reality whatever: it is its own simulacrum' (11). Baudrillard's cultural criticism is evocative and his elaboration of the logic of the simulacrum helps make sense of US media culture, but he remains within a logic of the image and the disembodied, which is not, in my opinion, a viable starting point for a feminist analysis of the cultural impact of VR technology. Jean Baudrillard, *Simulations* (New York: Semiotext(e), 1983).

26. Richard Bolton elaborates modernism as an epistemological position that includes 'a faith in rationalism, the rise of science and technology and the growth of capitalism' (35). He goes on to discuss the problems associated with the 'ocular metaphors that informs modernist science, epistemology, and art', which leads him to argue that 'our understanding of the world is limited by the 'spectator theory of knowledge' . . . inherited from rationalism' (35). His point is to describe how postmodernism offers an alternative epistemological framework. Richard Bolton, 'The modern spectator and the postmodern participant', *Photo Communique* Summer 1986: 34–45.

27. David Sudnow has provided the beginning description of such a phenomenology, although his trip through the microworld was confined to the two-dimensional space of a Pong game. David Sudnow, *Pilgrim in the Microworld* (New York: Warner, 1983).

28. The 24 February 1990 Doonesbury strip by Gary Trudeau offered a frame-by-frame depiction of the bomb's-eye view of a bomb travelling into a chemical weapons facility 'past startled Iraqi production managers and into the office of the facility administrator'. The next frame indicates an explosion, while the narrator (a general in the next frame) states: 'Unfortunately, it continues through an open window and explodes in a nearby parking lot.' Ernest Larsen considers the implications of what we didn't see during the television coverage of the Gulf War. Ernest Larsen, 'Gulf War TV', *Jump Cut* 36 (1991): 3–10.

29. Tisdale, 'It's Been Real' p. 3.

30. Outside of cyberspace, in an alternative universe, or some future post-apocalyptic earth, hetero-sexual connections dominate the sexual scene. Consider two short stories in *Mirrorshades: The Cyberpunk Anthology*, edited by Bruce Sterling. In Marc Laidlaw's short story '400 Boys', the gangs in Fun City, which include a gang of girls called the 'Galrogs', unite together to fight off a new gang, the '400 Boys', for control of the city. Rice, the main character in Bruce

Sterling's and Lewis Shiner's short story 'Mozart in Mirrorshades', becomes fascinated with Marie Antionette: she 'sprawled across the bed's expanse of pink satin, wearing a scrap of black-lace underwear and leafing through an issue of *Vogue* . . . "I want the leather bikini," she said. . . . Rice leaned back across her solid thighs and patted her bottom reassuringly' (231). Bruce Sterling (ed.) *Mirrorshades: The Cyberpunk Anthology* (New York: Ace, 1986).

31. Andrew Ross, 'Cyberpunk in Boystown', *Strange Weather: Culture, Science and Technology in the Age of Limits* (London: Verso, 1991).

32. Sherry Turkle and Seymour Papert argue that computer technologies may promote the development of epistemological pluralism. The most optimistic prophesy about virtual reality technologies would be consistent with their argument. But they go on to remind readers that the computer culture may inhibit the realization of such possibilities. Sherry Turkle and Seymour Papert, 'Epistemological pluralism: styles and voices within the computer culture', *SIGNS* 16.1 (Autumn 1990): 128–57.

33. Using new imaging devices such as magnetic resonance imaging (MRI), scientists and physicians are able to look inside the brain to extract information about brain activity. Jon Van, 'Understanding the body through imaging', *Chicago Tribune* 2 August 1987: sec. 2, 1.

Positron emission tomography (PET) is another new imaging procedure that uses radioactive tracers to measure metabolic function as the brain 'processes' information. Several scientists claim that the new imaging technologies will refine psychiatric diagnosis, so that trying to figure out what is 'wrong' with someone won't be such a matter of guesswork anymore. As Dr Floyd E. Bloom, chief of the Division of Preclinical Neuroscience and Endocrinology at the Research Institute of Scripps Clinic in LaJolla, explains. 'We'll be able to be very precise, mechanical and quantitative about the differences between our brains at different times and between other brains under similar conditions. That kind of information will be totally useful in predicting what's wrong in mental illness.' Ronald Kotulak, 'Mind readers: the wondrous machines that let scientists watch us think', *Chicago Tribune* 9 May 1988: sec. 2, 2.

Magnetoencephalography (MEG) is a computer-based technology for looking inside the brain to determine whether thoughts are being generated. One recent article ('A look inside the mysterious brain') suggests that MEG and other new imaging techniques 'are wonderful because they essentially turn the brain to glass so we can look inside and see what's going on. . . . This unprecedented view is expected to lead to methods for diagnosing mental disorders, predicting behavior and personality, evaluating mental capacities and basically determining when a brain is working well and when it is not'. This would be an obvious benefit in treating coma patients, for example, but it has ominous overtones with respect to body privacy. Ronald Kotulak, 'A look inside the mysterious brain', *Chicago Tribue* 8 May 1988: sec. 1, 1, 12. See also two other articles by Ronald Kotulak, all in the *Chicago Tribune*: 'Down memory lane: the ability to learn is mankind's greatest possession', 8 May 1988: sec. 2, 1, 3; 'Mind readers', 9 May 1988: sec. 2, 1–2.

To peer inside the brain to see what areas light up when a person thinks about a hamburger may be an oblique way to 'diagnose' obesity, but it also is a way to monitor subjective thoughts. Researchers working on brain-scanning devices unabashedly claim to want to find a way to 'reveal people's inner thoughts as well as their innate mental talents' – a capability the military is interested in for selecting tank drivers and fighter pilots (Kotulak, 'A look inside the mysterious brain', 1). In a study of Alzheimer's disease, electronencephalogram scans from Alzheimer's patients are compared to 'healthy' people's brain scans and are found to have fewer alpha-range waves and more delta waves; however, the process whereby someone is diagnosed as 'healthy' is rarely discussed in any of the popular media reports on brain imaging. Kathleen Doheny, 'Alzheimer's disease: science struggles to ease the nightmare', *Los Angeles Times* 5 June 1989: sec. 2, 7; and Jon Van, 'New image scan's value is unproven, AMA says', *Chicago Tribune* 10 June 1988: sec. 2, 3.

These new technologies raise serious ethical questions tied not so much to the possibilities of treating 'disease' or 'mental disorders' but to the possibilities of using the very same technology to pigeonhole people according to brain activity profiles.

ALLUCQUERE ROSANNE STONE

WILL THE REAL BODY PLEASE STAND UP?
Boundary stories about virtual cultures

The machines are restless tonight

AFTER DONNA HARAWAY'S 'PROMISES of Monsters' and Bruno
Latour's papers on actor networks and artifacts that speak, I find it hard to think
of any artifact as being devoid of agency. Accordingly, when the dryer begins to
beep complainingly from the laundry room while I am at dinner with friends, we
raise eyebrows at each other and say simultaneously, 'The machines are restless tonight
. . .'

It's not the phrase, I don't think, that I find intriguing. Even after Haraway (1991)
and Latour (1988), the phrase is hard to appreciate in an intuitive way. It's the ellipsis
I notice. You can hear those three dots. What comes after them? The fact that the phrase
– obviously a send-up of a vaguely anthropological chestnut – seems funny to us, already
says a great deal about the way we think of our complex and frequently uneasy imbri-
cations with the unliving. The people I study are deeply imbricated in a complex social
network mediated by little technologies to which they have delegated significant amounts
of their time and agency, not to mention their humour. I say to myself: Who am I
studying? A group of people? Their machines? A group of people and/or in their
machines? Or something else?

When I study these groups, I try to pay attention to all of their interactions. And
as soon as I allow myself to see that most of the interactions of the people I am studying
involve vague but palpable sentiences squatting on their desks, I have to start thinking
about watching the machines just as attentively as I watch the people, because, for them,
the machines are not merely passage points. Haraway and other workers who observe
the traffic across the boundaries between 'nature', 'society', and 'technology' tend to
see nature as lively, unpredictable, and, in some sense, actively resisting interpretations.
If nature and technology seem to be collapsing into each other, as Haraway and others
claim, then the unhumans can be lively too.

One symptom of this is that the flux of information that passes back and forth across the vanishing divides between nature and technology has become extremely dense. *Cyborgs with a vengeance*, one of the groups I study, is already talking about colonizing a social space in which the divide between nature and technology has become thoroughly unrecognizable, while one of the individuals I study is busy trying to sort out how the many people who seem to inhabit the social space of her body are colonizing her. When I listen to the voices in these new social spaces I hear a multiplicity of voices, some recognizably human and some quite different, all clamouring at once, frequently saying things whose meanings are tantalizingly familiar but which have subtly changed.

My interest in cyberspace is primarily about communities and how they work. Because I believe that technology and culture constitute each other, studying the actors and actants that make up our lively, troubling and productive technologies tells me about the actors and actants that make up our culture. Since so much of a culture's knowledge is passed on by means of stories, I will begin by retelling a few boundary stories about virtual cultures.

Schizophrenia as commodity fetish

Let us begin with a person I will call Julie, on a computer conference in New York in 1985. Julie was a totally disabled older woman, but she could push the keys of a computer with her headstick. The personality she projected into the 'Net' – the vast electronic web that links computers all over the world – was huge. On the Net, Julie's disability was invisible and irrelevant. Her standard greeting was a big, expansive 'HI!!!!!!' Her heart was as big as her greeting, and in the intimate electronic companionships that can develop during on-line conferencing between people who may never physically meet, Julie's women friends shared their deepest troubles, and she offered them advice – advice that changed their lives. Trapped inside her ruined body, July herself was sharp and perceptive, thoughtful and caring.

After several years, something happened that shook the conference to the core. 'Julie' did not exist. 'She' was, it turned out, a middle-aged male psychiatrist. Logging onto the conference for the first time, this man had accidentally begun a discussion with a woman who mistook him for another woman. 'I was stunned,' he said later, 'at the conversational mode. I hadn't known that women talked among themselves that way. There was so much more vulnerability, so much more depth and complexity. Men's conversations on the nets were much more guarded and superficial, even among intimates. It was fascinating, and I wanted more.' He had spent weeks developing the right persona. A totally disabled, single older woman was perfect. He felt that such a person wouldn't be expected to have a social life. Consequently her existence only as a Net persona would seem natural. It worked for years, until one of Julie's devoted admirers, bent on finally meeting her in person, tracked her down.

The news reverberated through the Net. Reactions varied from humorous resignation to blind rage. Most deeply affected were the women who had shared their innermost feelings with Julie. 'I felt raped,' one said. 'I felt that my deepest secrets had been violated.' Several went so far as to repudiate the genuine gains they had made in their personal and emotional lives. They felt those gains were predicated on deceit and trickery.

The computer engineers, the people who wrote the programs by means of which the nets exist, just smiled tiredly. They had understood from the beginning the radical changes in social conventions that the nets implied. Young enough in the first days of the net to react and adjust quickly, they had long ago taken for granted that many of the old assumptions about the nature of identity had quietly vanished under the new electronic dispensation. Electronic networks in their myriad kinds, and the mode of interpersonal interaction that they foster, are a new manifestation of a social space that has been better known in its older and more familiar forms in conference calls, communities of letters, and FDR's fireside chats. It can be characterized as 'virtual' space – an imaginary locus of interaction created by communal agreement. In its most recent form, concepts like distance, inside/outside, and even the physical body take on new and frequently disturbing meanings.

Now, one of the more interesting aspects of virtual space is 'computer cross-dressing'. Julie was an early manifestation. On the nets, where *warranting*, or grounding, a persona in a physical body, is meaningless, men routinely use female personae whenever they choose, and vice versa. This wholesale appropriation of the other has spawned new modes of interaction. Ethics, trust and risk still continue, but in different ways. Gendered modes of communication themselves have remained relatively stable, but who uses which of the two socially recognized models has become more plastic. A woman who has appropriated a male conversational style may be simply assumed to be male at that place and time, so that her/his on-line persona takes on a kind of quasi life of its own, separate from their person's embodied life in the 'real' world.

Sometimes a person's on-line persona becomes so finely developed that it begins to take over their life *off* the net. In studying virtual systems, I will call both the space of interaction that is the net and the space of interaction that we call the 'real' world *consensual loci*. Each consensual locus has its own 'reality', determined by local conditions. However, not all realities are equal. A whack on the head in the 'real' world can kill you, whereas a whack in one of the virtual worlds will not.

Some conferencees talk of a time when they will be able to abandon warranting personae in even more complex ways, when the first 'virtual reality' environments come on line. VR, one of a class of interactive spaces that are coming to be known by the general term *cyberspace*, is a three-dimensional consensual locus or, in the terms of science fiction author William Gibson, a 'consensual hallucination' in which data may be visualized, heard, and even felt. The 'data' in some of these virtual environments are people – 3-D representations of individuals in the cyberspace. While high-resolution images of the human body in cyberspace are years away, when they arrive they will take 'computer cross-dressing' even further. In this version of VR a man may be seen, and perhaps touched, as a woman and vice versa – or as anything else. There is talk of renting pre-packaged body forms complete with voice and touch . . . multiple personality as commodity fetish!

It is interesting that at just about the time the last of the untouched 'real-world' anthropological field sites are disappearing, a new and unexpected kind of 'field' is opening up – incontrovertibly social spaces in which people still meet face-to-face, but under new definitions of both 'meet' and 'face'. These new spaces instantiate the collapse of the boundaries between the social and technological, biology and machine, natural and artificial that are part of the postmodern imaginary. They are part of the growing imbrication of humans and machines in new social forms that I call *virtual systems*.

A virtual systems origin myth

Cyberspace, without its high-tech glitz, is partially the idea of virtual community. The earliest cyberspaces may have been virtual communities, passage points for collections of common beliefs and practices that united people who were physically separated. Virtual communities sustain themselves by constantly circulating those practices. To give some examples of how this works, I'm going to tell an original story of virtual systems.

There are four epochs in this story. The beginning of each is signalled by a marked change in the character of human communication. Over the years, human communication is increasingly mediated by technology. Because the rate of change in technological innovation increases with time, the more recent epochs are shorter, but roughly the same quantity of information is exchanged in each. Since the basis of virtual communities is communication, this seems like a reasonable way to divide up the field.

Epoch One: Texts (from the mid-1600s).
Epoch Two: Electronic communication and entertainment media (1900+).
Epoch Three: Information technology (1960+).
Epoch Four: Virtual reality and cyberspace (1984+).

Epoch one

This period of early textual virtual communities starts, for the sake of this discussion, in 1669 when Robert Boyle engaged an apparatus of literary technology to 'dramatize the social relations proper to a community of philosophers'. As Steven Shapin and Simon Shaffer (1985) point out in their study of the debate between Boyle and the philosopher Thomas Hobbes, *Leviathan and the Air-Pump*, we probably owe the invention of the boring academic paper to Boyle. Boyle developed a method of compelling assent that Shapin and Shaffer describe as *virtual witnessing*. He created what he called a 'community of like-minded gentlemen' to validate his scientific experiments, and he correctly surmised that the 'gentlemen' for whom he was writing believed that boring, detailed writing implied painstaking experiment without being physically present. Boyle's production of the detailed academic paper was so successful that it is still the exemplar of scholarship.

Epoch two

The period of the early electronic virtual communities began in the twentieth century with invention of the telegraph. It continued with musical communities, previously constituted in the physical public space of the concert hall, shifting and translating to a new kind of virtual communal space around the phonograph. The apex of this period was Franklin Delano Roosevelt's radio 'fireside chats', creating a *community* by means of readily available technology.

Once communities grew too big for everyone to know everyone else, government had to proceed through delegates who represented absent groups. FDR's use of radio was a way to bypass the need for delegates. Instead of talking to a few hundred

representatives, Roosevelt used the radio as a machine for fitting listeners into his living room. The radio was one-way communication, but because of it people were able to begin to think of *presence* in a different way. Because of radio and of the apparatus for the production of community that it implied and facilitated, it was now possible for millions of people to be 'present' in the same space – seated across from Roosevelt in his living room.

This view implies a new, different and complex way of experiencing the relationship between the physical human body and the 'I' that inhabits it. FDR did not physically enter listeners' living rooms. He invited listeners into his. In a sense, the listener was in two places at once – the body at home, but the delegate, the 'I' that belonged to the body, in an imaginal space with another person. This space was enabled and constructed with the assistance of a particular technology. In the case of FDR the technology was a device that mediated between physical loci and incommensurable realities – in other words, an interface. In virtual systems *an interface is that which mediates between the human body (or bodies) and an associated 'I' (or 'I's').* This double view of 'where' the 'person' is, and the corresponding trouble it may cause with thinking about 'who' we are talking about when we discuss such a problematic 'person', underlies the structure of more recent virtual communities.

During the same period thousands of children, mostly boys, listened avidly to adventure serials, and sent in their coupons to receive the decoder rings and signalling devices that had immense significance within the community of a particular show. Away from the radio, they recognized each other by displaying the community's tokens, an example of communities of consumers organized for marketing purposes.

The motion picture, and later, television, also mobilized a similar power to organize sentimental social groups. Arguably one of the best examples of a virtual community in the late twentieth century is the Trekkies, a huge, heterogeneous group partially based on commerce but mostly on a set of ideas. The fictive community of *Star Trek* and the fantasy Trekkie community interrelate and mutually constitute each other in complex ways across the boundaries of texts, films, and video interfaces.

Epoch three

This period began with the era of information technology. The first virtual communities based on information technology were the on-line bulletin board services (BBSs) of the mid-1970s. These were not dependent upon the widespread ownership of computers, merely of terminals. But because even a used terminal cost several hundred dollars, access to the first BBSs was mainly limited to electronics experimenters, ham-radio operators, and the early hardy computer builders.

BBSs were named after their perceived function – virtual places, conceived to be just like physical bulletin boards, where people could post notes for general reading. The first successful BBS programs were primitive, usually allowing the user to search for messages alphabetically, or simply to read messages in the order in which they were posted. These programs were sold by their authors for very little, or given away as 'shareware' – part of the early visionary ethic of electronic virtual communities. The idea of shareware, as enunciated by the many programmers who wrote shareware programs, was that the computer was a passage point for circulating concepts of com-

munity. The important thing about shareware, rather than making an immediate profit for the producer, was to nourish the community in expectation that such nourishment would 'come around' to the nourisher.

CommuniTree Within a few months of the first BBS's appearance, a San Francisco group headed by John James had developed the idea that the BBS was a virtual community, a community that promised radical transformation of existing society and the emergence of new social forms. The CommuniTree Group, as they called themselves, saw the BBS in McLuhanesque terms as transformative because of the ontological structure it presupposed and simultaneously created – the mode of tree-structured discourse and the community that spoke it – and because it was another order of 'extension', a kind of prosthesis in McLuhan's sense. The BBS that the CommuniTree Group envisioned was an extension of the participant's instrumentality into a virtual social space.

The CommuniTree Group quite correctly foresaw that the BBS in its original form was extremely limited in its usefulness. Their reasoning was simple. The physical bulletin board for which the BBS was the metaphor had the advantage of being quickly scannable. By its nature, the physical bulletin board was small and manageable in size. There was not much need for bulletin boards to be organized by topic. But the on-line BBS could not be scanned in any intuitively satisfactory way. There were primitive search protocols in the early BBSs, but they were usually restricted to alphabetical searches or searches by keywords. The CommuniTree Group proposed a new kind of BBS which they called a tree-structured conference, employing as a working metaphor both the binary tree protocols in computer science and also the organic qualities of trees as such appropriate to the 1970s. Each branch of the tree was to be a separate conference that grew naturally out of its root message by virtue of each subsequent message that was attached to it. Conferences that lacked participation would cease to grow, but would remain on-line as archives of failed discourse and as potential sources of inspiration for other, more flourishing conferences.

With each version of the BBS system, The CommuniTree Group supplied a massive, detailed instruction manual – which was nothing less than a set of directions for constructing a new kind of virtual community. They couched the manual in radical 1970s language, giving chapters such titles as 'Downscale, please, Buddha' and 'If you meet the electronic avatar on the road, laserblast him!' This rich intermingling of spiritual and technological imagery took place in the context of George Lucas' *Star Wars*, a film that embodied the themes of the technological transformativists, from the all-pervading Force to what Vivian Sobchack (1987) called 'the outcome of infinite human and technological progress'. It was around *Star Wars* in particular that the technological and radically spiritual virtual communities of the early BBSs coalesced. *Star Wars* represented a future in which the good guys won out over vastly superior adversaries – with the help of a mystical Force that 'surrounds us and penetrates us . . . it binds the galaxy together' and which the hero can access by learning to 'trust your feelings' – a quintessential injunction of the early 1970s.

CommuniTree no. 1 went on-line in May 1978 in the San Francisco Bay area of northern California. The opening sentence of the prospectus for the first conference was 'We are as gods and might as well get good at it'. This technospiritual bumptiousness, full of the promise of the redemptive power of technology mixed with the easy,

catch-all Eastern mysticism popular in upscale northern California, characterized the early conferences. As might be gathered from the tone of the prospectus, the first conference, entitled 'Origins', was about successor religions.

The conferencees saw themselves not primarily as readers of bulletin boards or participants in a novel discourse but as agents of a new kind of social experiment. They saw the terminal or personal computer as a tool for social transformation by the ways it refigured social interaction. BBS conversations were time-aliased, like a kind of public letter writing or the posting of broadsides. They were meant to be read and replied to some time later than they were posted. But their participants saw them as conversations nonetheless, as social acts. When asked how sitting alone at a terminal was a social act, they explained that they saw the terminal as a window into a social space. When describing the act of communication, many moved their hands expressively as though typing, emphasizing the gestural quality and essential tactility of the virtual mode. Also present in their descriptions was a propensity to reduce other expressive modalities to the tactile. It seemed clear that, from the beginning, the electronic virtual mode possessed the power to overcome its character of single-mode transmission and limited bandwidth.

By 1982 Apple Computer had entered into the first of a series of agreements with the federal government in which the corporation was permitted to give away computers to public schools in lieu of Apple's paying a substantial portion of its federal taxes. In terms of market strategy, this action dramatically increased Apple's presence in the school system and set the pace for Apple's domination in the education market. Within a fairly brief time there were significant numbers of personal computers accessible to students of grammar school and high school age. Some of those computers had modems.

The students, at first mostly boys and with the linguistic proclivities of pubescent males, discovered the Tree's phone number and wasted no time in logging onto the conferences. They appeared uninspired by the relatively intellectual and spiritual air of the ongoing debates, and proceeded to express their dissatisfaction in ways appropriate to their age, sex and language abilities. Within a short time the Tree was jammed with obscene and scatalogical messages. There was no way to monitor them as they arrived, and no easy way to remove them once they were in the system. This meant that the entire system had to be purged – a process taking hours – every day or two. In addition, young hackers enjoyed the sport of attempting to 'crash' the system by discovering bugs in the system commands. Because of the provisions of the system that made observing incoming messages impossible, the hackers were free to experiment with impunity, and there was no way for the system operator to know what was taking place until the system crashed. At that time it was generally too late to save the existing disks. The system operator would be obliged to reconstitute ongoing conferences from earlier back-up versions.

Within a few months, the Tree had expired, choked to death with what one participant called 'the consequences of freedom of expression'. During the years of its operation, however, several young participants took the lessons and implications of such a community away with them, and proceeded to write their own systems. Within a few years there was a proliferation of on-line virtual communities of somewhat less visionary character but vastly superior message-handling capability – systems that allowed monitoring and disconnection of 'troublesome' participants (hackers attempting to crash the system), and easy removal of messages that did not further the purposes of the system

operators. The age of surveillance and social control had arrived for the electronic virtual community.

The visionary character of CommuniTree's electronic ontology proved an obstacle to the Tree's survival. Ensuring privacy in all aspects of the Tree's structure and enabling unlimited access to all conferences did not work in a context of increasing availability of terminals to young men who did not necessarily share the Tree gods' ideas of what counted as community. As one Tree veteran put it, 'The barbarian hordes mowed us down.' Thus, in practice, surveillance and control proved necessary adjuncts to maintaining order in the virtual community.

SIMNET Besides the BBSs, there were more graphic, interactive systems under construction. Their interfaces were similar to arcade games or flight simulators – (relatively) high-resolution, animated graphics. The first example of this type of cyberspace was a military simulation called SIMNET. SIMNET was conducted by a consortium of military interests, primarily represented by DARPA, and a task group from the Institute for Simulation and Training, located at the University of Central Florida. SIMNET came about because DARPA was beginning to worry about whether the Army could continue to stage large-scale military practice exercises in Germany. With the rapid and unpredictable changes that were taking place in Europe in the late 1980s, the army wanted to have a back-up – some other place where they could stage practice manoeuvres without posing difficult political questions. As one of the developers of SIMNET put it, 'World War III in Central Europe is at the moment an unfashionable anxiety'. In view of the price of land and fuel, and of the escalating cost of staging practice manoeuvres, the armed forces felt that if a large-scale consensual simulation could be made practical they could realize an immediate and useful financial advantage. Therefore, DARPA committed significant resources – money, time and computer power – to funding some research laboratory to generate a 200-tank cyberspace simulation. DARPA put out requests for proposals, and a group at the University of Central Florida won.

The Florida group designed and built the simulator units with old technology, along the lines of conventional aircraft cockpit simulators. Each tank simulator was equipped to carry a crew of four, so the SIMNET environment is an 800-person virtual community.

SIMNET is a two-dimensional cyberspace. The system can be linked up over a very large area geographically; without much difficulty, in fact, to anywhere in the world. A typical SIMNET node is an M-1 tank simulator. Four crew stations contain a total of eight vision blocks, or video screens, visible through the tank's ports. Most of these are 320×138 pixels in size, with a 15 Hertz update rate. This means that the image resolution is not very good, but the simulation can be generated with readily available technology no more complex than conventional video games. From inside the 'tank' the crew looks out the viewports, which are the video screens. These display the computer-generated terrain over which the tanks will manoeuvre (which happens to be the landscape near Fort Knox, Kentucky). Besides hills and fields, the crew can see vehicles, aircraft, and up to thirty other tanks at one time. They can hear and see the vehicles and planes shooting at each other and at them.

By today's standards, SIMNET's video images are low-resolution and hardly convincing. There is no mistaking the view out the ports for real terrain. But the simulation is astonishingly effective, and participants become thoroughly caught up in it.

SIMNET's designers believe that it may be the lack of resolution itself that is respon-
sible, since it requires the participants to actively engage their own imaginations to fill
the holes in the illusion! McLuhan redux. That it works is unquestionable. When exper-
imenters opened the door to one of the simulators during a test run to photograph the
interior, the participants were so caught up in the action that they didn't notice the
bulky camera poking at them.

Habitat Designed by Chip Morningstar and Randall Farmer, this is a large-scale social
experiment that is accessible through such common telephone-line computer networks
as Tymnet. Habitat was designed for LucasFilm. It is a completely decentralized, connec-
tions system. The technology at the user interface was intended to be simple in order
to minimize the costs of getting on-line. Habitat is designed to run on a Commodore
64 computer, but Morningstar and Farmer have milked an amazing amount of effective
bandwidth out of the machine. The Commodore 64 is very inexpensive and readily
available; almost anyone can buy one if, as one Habitat participant said, 'they don't
already happen to have one sitting around being used as a doorstop'. At the time of
writing (1991) Commodore 64s cost $100 at such outlets as Toys R Us.

Habitat existed first as a 35-foot mural located in a building in Sausalito, California,
but, on-line, each area of the mural represents an entirely expandable area in the cyber-
space, be it a forest, a plain, or a city. Habitat is inhabitable in that, when the user
signs on, he or she has a window into the ongoing social life of the cyberspace – the
community 'inside' the computer. The social space itself is represented by a cartoon-
like frame. The virtual person who is the user's delegated agency is represented by a
cartoon figure that may be customized from a menu of body parts. When the user wishes
his/her character to speak, s/he types out the words on the Commodore's keyboard,
and these appear in a speech balloon over the head of the user's character. The speech
balloon is visible to any other user nearby in the virtual space.[1] The user sees whatever
other people are in the immediate vicinity in the form of other figures.

Habitat is a two-dimensional example of what William Gibson called a 'consensual
hallucination'. First, according to Morningstar and Farmer, it has well-known protocols
for encoding and exchanging information. By generally accepted usage among cyber-
space engineers, this means it is consensual. The simulation software uses agents that
can transform information to simulate environment. This means it is an hallucination.

Habitat has proved to be incontrovertibly social in character. During Habitat's beta
test, several social institutions sprang up spontaneously. As Randall Farmer points out
in his report on the initial test run, there were marriages and divorces, a church, a loose
guild of thieves, an elected sheriff, a newspaper with a rather eccentric editor, and
before long two lawyers hung up their shingles to sort out claims. And this was with
only 150 people. My vision (of Habitat) encompasses tens of thousands of simultaneous
participants.

Lessons of the third epoch

In the third epoch the participants of electronic communities seem to be acquiring skills
that are useful for the virtual social environments developing in late twentieth-century
technologized nations. Their participants have learned to delegate their agency to body-

representatives that exist in an imaginal space contiguously with representatives of other individuals. They have become accustomed to what might be called lucid dreaming in an awake state – to a constellation of activities much like reading, but an active and interactive reading, a participatory social practice in which the actions of the reader have consequences in the world of the dream or the book. In the third epoch the older metaphor of reading is undergoing a transformation in a textual space that is consensual, interactive and haptic, and that is constituted through inscription practices – the production of microprocessor code. Social spaces are beginning to appear that are simultaneously natural, artificial and constituted by inscription. The boundaries between the social and the natural and between biology and technology are beginning to take on the generous permeability that characterizes communal space in the fourth epoch.

Epoch four

Arguably the single most significant event for the development of fourth-stage virtual communities was the publication of William Gibson's science fiction novel *Neuromancer*. *Neuromancer* represents the dividing line between the third and fourth epochs not because it signalled any technological development, but because it crystallized a new community.

 Neuromancer reached the hackers who had been radicalized by George Lucas' powerful cinematic evocation of humanity and technology infinitely extended, and it reached the technologically literate and socially disaffected who were searching for social forms which could transform the fragmented anomie that characterized life in Silicon Valley and all electronic industrial ghettos. In a single stroke, Gibson's powerful vision provided for them the imaginal public sphere and refigured discursive community that established the grounding for the possibility of a new kind of social interaction. *Neuromancer* in the time of Reagan and DARPA is a massive intertextual presence, not only in other literary productions of the 1980s, but in technical publications, conference topics, hardware design, and scientific and technological discourses in the large.

 The three-dimensional inhabitable cyberspace described in *Neuromancer* does not yet exist, but the groundwork for it can be found in a series of experiments in both the military and private sectors. Many VR engineers concur that the tribal elders of 3-D virtual systems are Scott Fisher and Ivan Sutherland, formerly at MIT, and Tom Furness, with the Air Force. In 1967–68, Sutherland built a see-through helmet at the MIT Draper Lab in Cambridge. This system used television screens and half-silvered mirrors, so that the environment was visible through the TV displays. It was not designed to provide a surround environment. In 1969–70 Sutherland went to the University of Utah, where he continued this work, doing things with vector-generated computer graphics and maps, still see-through technology. In his lab were Jim Clark, who went on to start Silicon Graphics, and Don Vickers.

 Tom Furness had been working on VR systems for approximately fifteen years – he started in the mid-1970s at Wright-Patterson Air Force Base. His systems were also see-through, rather than enclosing. He pushed the technology forward, particularly by adopting the use of high-resolution CRTs. Furness' system, designed for the USAF, was an elaborate flight simulation cyberspace employing a helmet with two large CRT devices, so large and cumbersome that it was dubbed the 'Darth Vader helmet'. He left

Wright-Patterson in 1988–89 to start the Human Interface Technology Lab at the University of Washington.

Scott Fisher started at MIT in the machine architecture group. The MA group worked on developing stereo displays and crude helmets to contain them, and received a small proportion of their funding from DARPA. When the group terminated the project, they gave the stereo displays to another group at UNC (University of North Carolina), which was developing a display device called the Pixel Planes Machine. In the UNC lab were Henry Fuchs and Fred Brooks, who had been working on force feed-back with systems previously developed at Argonne and Oak Ridge National labs. The UNC group worked on large projected stereo displays, but was aware of Sutherland's and Furness' work with helmets, and experimented with putting a miniature display system into a helmet of their own. Their specialities were medical modelling, molec-ular modelling, and architectural walk-through. The new Computer Science building at UNC was designed partially with their system. Using their software and 3-D computer imaging equipment, the architects could 'walk through' the full-sized virtual building and examine its structure. The actual walk-through was accomplished with a tread-mill and bicycle handlebars. The experiment was so successful that during the walk-through one of the architects discovered a misplaced wall that would have costs hundreds of thousands of dollars to fix once the actual structure had been built.

In 1982, Fisher went to work for Atari. Alan Kay's style at Atari was to pick self-motivated people and then turn them loose, on anything from flight simulation to personal interactive systems. The lab's philosophy was at the extreme end of visionary. According to Kay, the job of the group was to develop products not for next year or even for five years away, but for no less than 15 to 20 years in the future. In the corporate climate of the 1980s, and in particular in Silicon Valley, where product life and corporate futures are calculated in terms of months, this approach was not merely radical but strato-spheric. For the young computer jocks, the lure of Silicon Valley and of pushing the limits of computer imaging into the far future was irresistible, and a group of Cambridge engineers, each outstanding in their way, made the trip out to the coast. Eric Gullichsen arrived first, then Scott Fisher and Susan Brennan, followed a year later by Ann Marion. Michael Naimark was already there, as was Brenda Laurel. Steve Gans was the last to arrive.

As it turned out, this was not a good moment to arrive at Atari. When the Atari lab closed, Ann Marion and Alan Kay went to Apple where they started the Vivarium project and continued their research. Susan Brennan went first to the Stanford Psychology department and also Hewlett-Packard, which she left in 1990 to teach at CUNY Stony Brook. Michael Naimark became an independent producer and designer of interactive video and multimedia art. William Bricken and Eric Gullichsen took jobs at Autodesk, the largest manufacturer of CAD software, where they started a research group called Cyberia.

Scott Fisher went to work for Dave Nagel, head of the NASA-Ames View Lab. To go with their helmet, the Ames lab had developed a primitive sensor to provide the computer with information about the position of the user's hand. The early device used a simple glove with strain gauges wired to two fingers. They contracted with VPL, Inc. to develop it further, using software written in collaboration with Scott. The Ames group referred to the software as 'gesture editors'. The contract started in 1985, and VPL delivered the first glove in March 1986. The Ames group intended to apply the

glove and software to such ideas as surgical simulation, 3-D virtual surgery for medical students. In 1988, Dave Nagel left the Ames laboratory to become director of the Advanced Technology Group (ATG) at Apple.

Lusting for images, such organizations as SIGGRAPH gobbled up information about the new medium and spread it out through its swarm of networks and publications. The audience, made up largely of young, talented, computer-literate people in both computer science and art, and working in such fields as advertising, media and the fine arts, had mastered the current state of the art in computers and was hungry for the next thing. LucasFilm (later Lucas Arts) in Marin, now doing the bulk of all computerized special effects for the film industry, and Douglas Trumbull's EEG in Hollywood, fresh from their spectacular work on *Blade Runner*, had made the production of spectacular visual imaginaries an everyday fact. They weren't afraid to say that they had solved all of the remaining problems with making artificial images, under particular circumstances, indistinguishable from 'real' ones – a moment that Stewart Brand called '[t]he end of photography as evidence for anything'. Now the artists and engineers who worked with the most powerful imaging systems, like Lucas' Pixar, were ready for more. They wanted to be able to get inside their own fantasies, to experientially inhabit the worlds they designed and built but could never enter. VR touched the same nerve that *Star Wars* had, the englobing specular fantasy made real.

Under Eric Gullichsen and William Bricken, the Autodesk Cyberspace Project quickly acquired the nickname Cyberia. John Walker, president of Autodesk, had seen the UNC architectural system and foresaw a huge market for virtual CAD – 3-D drawings that the designers could enter. But after a year or so, Autodesk shrank the Cyberia project. Eric Gullichsen left to start Sense8, a manufacturer of low-end VR systems. William Bricken left the company to take up residence at the University of Washington, where Tom Furness and his associates had started the Human Interface Technology laboratory. Although there were already academic-based research organizations in existence at that time (Florida, North Carolina), and some of them (Florida) were financed at least in part by DOD, the HIT lab became the first academic organization to secure serious research funding from private industry.

During this period, when *Neuromancer* was published, 'virtual reality' acquired a new name and a suddenly prominent social identity as 'cyberspace'. The critical importance of Gibson's book was partly due to the way that it triggered a conceptual revolution among the scattered workers who had been doing virtual reality research for years: as task groups coalesced and dissolved, as the fortunes of companies and projects and laboratories rose and fell, the existence of Gibson's novel and the technological and social imaginary that it articulated enabled the researchers in virtual reality – or, under the new dispensation, cyberspace – to recognize and organize themselves as community.

By this time private industry, represented by such firms as American Express, PacBell, IBM, MCC, Texas Instruments, and NYNEX, were beginning to explore the possibilities and commercial impact of cyberspace systems. The major thrust of the industrial and institutional commitment to cyberspace research was still focused on data manipulation – just as Gibson's *zaibatsu* did in *Neuromancer*. Gibson's cowboys were outlaws in a military-industrial fairyland dominated by supercomputers, artificial intelligence devices and data banks. Humans were present, but their effect was minimal. There is no reason to believe that the cyberspaces being designed at NASA or Florida will be any different. However, this knowledge does not seem to daunt the

'real' cyberspace workers. Outside of their attention to the realities of the marketplace and workplace, the young, feisty engineers who do the bulk of the work on VR systems continue their discussions and arguments surrounding the nature and context of virtual environments. That these discussions already take place in a virtual environment – the great, sprawling international complex of commercial, government, military and academic computers known as Usenet – is in itself suggestive.

Decoupling the body and the subject

> The illusion will be so powerful you won't be able to *tell what's real and what's not.*
>
> (SteveWilliams)

In her complex and provocative 1984 study *The Tremulous Private Body*, Frances Barker suggests that, because of the effects of the Restoration on the social and political imaginary in Britain (1660 and on), the human body gradually ceased to be perceived as public spectacle, as had previously been the case, and became privatized in new ways. In Barker's model of the post-Jacobean citizen, the social economy of the body became rearranged in such a way as to interpose several layers between the individual and public space. Concomitant with this removal of the body from a largely public social economy, Barker argues that the subject, the 'I' or perceiving self that Descartes had recently pried loose from its former unity with the body, reorganized, or was reorganized, in a new economy of its own. In particular, the subject, as did the body, ceased to constitute itself as public spectacle and instead fled from the public sphere and constituted itself in *text* – such as Samuel Pepys' diary (1668).

Such changes in the social economy of both the body and the subject, Barker suggests, very smoothly serve the purposes of capital accumulation. The product of a privatized body and of a subject removed from the public sphere is a social monad more suited to manipulation by virtue of being more isolated. Barker also makes a case that the energies of the individual, which were previously absorbed in a complex public social economy and which regularly returned to nourish the sender, started backing up instead, and needing to find fresh outlets. The machineries of capitalism handily provided a new channel for productive energy. Without this damming of creative energies, Barker suggests, the industrial age, with its vast hunger for productive labour and the consequent creation of surplus value, would have been impossible.

In Barker's account, beginning in the 1600s in England, the body became progressively more hidden, first because of changing conventions of dress, later by conventions of spatial privacy. Concomitantly, the self, Barker's 'subject', retreated even further inward, until much of its means of expression was through texts. Where social communication had been direct and personal, a warrant was developing for social communication to be indirect and delegated through communication technologies – first pen and paper, and later the technologies and market economics of print. The body (and the subject, although s/he doesn't lump them together in this way) became 'the site of an operation of power, of an exercise of meaning . . . a transition, effected over a long period of time, from a socially visible object to one which can no longer be seen' (Barker 1984: 13).

While the subject in Barker's account became, in her words, 'raging, solitary, productive', what it produced was text. On the other hand, it was the newly hidden Victorian body that became physically productive and that later provided the motor for the industrial revolution; it was most useful as a brute body, for which the creative spark was an impediment. In sum, the body became more physical, while the subject became more textual, which is to say non-physical.

If the information age is an extension of the industrial age, with the passage of time the split between the body and the subject should grow more pronounced still. But in the fourth epoch the split is simultaneously growing and disappearing. The socioepistemic mechanism by which bodies mean is undergoing a deep restructuring in the latter part of the twentieth century, finally fulfilling the furthest extent of the isolation of those bodies through which its domination is authorized and secured.

I don't think it is accidental that one of the earliest, textual, virtual communities – the community of gentlemen assembled by Robert Boyle during his debates with Hobbes – came into existence at the moment about which Barker is writing. The debate between Boyle and Hobbes and the production of Pepys' diary are virtually contemporaneous. In the late twentieth century, Gibson's *Neuromancer* is simultaneously a perverse evocation of the Restoration subject and its annihilation in an implosion of meaning from which arises a new economy of signification.

Barker's work resonates in useful ways with two other accounts of the evolution of the body and the subject through the interventions of late twentieth-century technologies: Donna Haraway's 'A manifesto for cyborgs' and 'The biopolitics of postmodern bodies' (1985; 1988). Both these accounts are about the collapse of categories and of the boundaries of the body. The boundaries between the subject, if not the body, and the 'rest of the world' are undergoing a radical refiguration, brought about in part through the mediation of technology. Further, as Baudrillard and others have pointed out, the boundaries between technology and nature are themselves in the midst of a deep restructuring. This means that many of the usual analytical categories have become unreliable for making the useful distinctions between the biological and the technological, the natural and artificial, the human and mechanical, to which we have become accustomed.

François Dagognet suggests that the recent debates about whether nature is becoming irremediably technologized are based on a false dichotomy: namely that there exists, here and now, a category 'nature' which is 'over here', and a category 'technology' (or, for those following other debates, 'culture') which is 'over there'. Dagognet argues on the contrary that the category 'nature' has not existed for thousands of years . . . not since the first humans deliberately planted gardens or discovered slash-and-burn farming. I would argue further that 'Nature', instead of representing some pristine category or originary state of being, has taken on an entirely different function in late twentieth-century economies of meaning. Not only has the character of nature as yet another coconstruct of culture become more patent, but it has become nothing more (or less) than an ordering factor – a construct by means of which we attempt to *keep technology visible* as something separate from our 'natural' selves and our everyday lives. In other words, the category 'nature', rather than referring to any object or category in the world, is a *strategy* for maintaining boundaries for political and economic ends, and thus a way of making meaning. (In this sense, the project of reifying a 'natural' state over and against a technologized 'fallen' one is not only one of the industries of

postmodern nostalgia, but also part of a binary, oppositional cognitive style that some maintain is part of our society's pervasively male epistemology.)

These arguments imply as a corollary that 'technology', as we customarily think of it, does not exist either; that we must begin to rethink the category of technology as also one that exists only because of its imagined binary opposition to another category upon which it operates and in relation to which it is constituted. In a recent paper Paul Rabinow asks what kind of being might thrive in a world in which nature is becoming increasingly technologized. What about a being who has learned to live in a world in which, rather than nature becoming technologized, technology *is* nature – in which the boundaries between subject and environment have collapsed?

PHONE SEX WORKERS AND VR ENGINEERS

I have recently been conducting a study of two groups who seemed to instantiate productive aspects of this implosion of boundaries. One is phone sex workers. The other is computer scientists and engineers working on VR systems that involve making humans visible in the virtual space. I was interested in the ways in which these groups, which seem quite different, are similar. For the work of both is about representing the human body through limited communication channels, and both groups do this by coding cultural expectations as tokens of meaning.

Computer engineers seem fascinated by VR because you not only program a world, but in a real sense inhabit it. Because cyberspace worlds can be inhabited by communities, in the process of articulating a cyberspace system, engineers must model cognition and community; and because communities are inhabited by bodies, they must model bodies as well. While cheap and practical systems are years away, many workers are already hotly debating the form and character of the communities they believe will spring up in their quasi-imaginary cyberspaces. In doing so, they are articulating their own assumptions about bodies and sociality and projecting them onto the codes that define cyberspace systems. Since, for example, programmers create the codes by which VR is generated in interaction with workers in widely diverse fields, how these heterogeneous co-working groups understand cognition, community and bodies will determine the nature of cognition, community and bodies in VR.

Both the engineers and the sex workers are in the business of constructing tokens that are recognized as objects of desire. Phone sex is the process of provoking, satisfying, *constructing* desire through a single mode of communication, the telephone. In the process, participants draw on a repertoire of cultural codes to construct a scenario that compresses large amounts of information into a very small space. The worker verbally codes for gesture, appearance and proclivity, and expresses these as tokens, sometimes in no more than a word. The client uncompresses the tokens and constructs a dense, complex interactional image. In these interactions desire appears as a product of the tension between embodied reality and the emptiness of the token, in the forces that maintain the pre-existing codes by which the token is constituted. The client mobilizes expectations and pre-existing codes for body in the modalities that are not expressed in the token, that is, tokens in phone sex are purely verbal, and the client uses cues in the verbal token to construct a multimodal object of desire with attributes of shape, tactility, odour, etc. This act is thoroughly individual and interpretive; out of a highly

compressed token of desire the client constitutes meaning that is dense, locally situated, and socially particular.

Bodies in cyberspace are also constituted by descriptive codes that 'embody' expectations of appearance. Many of the engineers currently debating the form and nature of cyberspace are the young turks of computer engineering, men in their late teens and twenties, and they are preoccupied with the things with which post-pubescent men have always been preoccupied. This rather steamy group will generate the codes and descriptors by which bodies in cyberspace are represented. Because of practical limitations, a certain amount of their discussion is concerned with data compression and tokenization. As with phone sex, cyberspace is a relatively narrow-bandwidth representational medium, visual and aural instead of purely aural to be sure, but how bodies are represented will involve how *recognition* works.

One of the most active sites for speculation about how *recognition* might work in cyberspace is the work of computer game developers, in particular the area known as interactive fantasy (IF). Since Gibson's first book burst onto the hackers' scene, interactive fantasy programmers (in particular, Laurel and others) have been taking their most durable stock-in-trade and speculating about how it will be deployed in virtual reality scenarios. For example, how, if they do, will people make love in cyberspace – a space in which everything, including bodies, exists as something close to a metaphor. Fortunately or unfortunately, however, everyone is still preorgasmic in virtual reality.

When I began the short history of virtual systems, I said that I wanted to use accounts of virtual communities as an entry point into a search for two things: an apparatus for the production of community and an apparatus for the production of body. Keeping in mind that this chapter is necessarily brief, let me look at the data so far:

- Members of electronic virtual communities act as if the community met in a physical public space. The number of times that on-line conferencees refer to the conference as an architectural place and to the mode of interaction in that place as being social is overwhelmingly high in proportion to those who do not. They say things like 'This is a nice place to get together' or 'This is a convenient place to meet'.

- The virtual space is most frequently visualized as Cartesian. On-line conferencees tend to visualize the conference system as a three-dimensional space that can be mapped in terms of Cartesian coordinates, so that some branches of the conference are 'higher up' and others 'lower down'. (One of the commands on the Stuart II conference moved the user 'sideways'.) Gibson's own visualization of cyberspace was Cartesian. In consideration of the imagination I sometimes see being brought to bear on virtual spaces, this odd fact invites further investigation.

- Conferencees act as if the virtual space was inhabited by bodies. Conferencees construct bodies on-line by describing them, either spontaneously or in response to questions, and articulate their discourses around this assumption.

- Bodies in virtual space have complex erotic components. Conferencees may flirt with each other. Some may engage in 'netsex', constructing elaborate erotic mutual fantasies. Erotic possibilities for the virtual body are a significant part of the discussion of some of the groups designing cyberspace systems. The consequences of virtual bodies are considerable in the local frame, in that conferencees mobilize

significant erotic tension in relation to their virtual bodies. In contrast to the confer-
ences, the bandwidth for physicalities in phone sex is quite limited. (One worker
said ironically, '[o]n the phone, every female sex worker is white, five feet four,
and has red hair.')

- The meaning of locality and privacy is not selected. The field is rife with debates
 about the legal status of communications within the networks. One such, for
 example, is about the meaning of inside and outside. Traditionally, when sending
 a letter one preserves privacy by enclosing it in an envelope. But in electronic
 mail, for example, the address is part of the message. The distinction between
 inside and outside has been erased, and along with it the possibility of privacy.
 Secure encryption systems are needed.[2]
- Names are local labels. 'Conferencees' seem to have no difficulty addressing,
 befriending and developing fairly complex relationships with the delegated puppets
 – agents – of other conferencees. Such relationships remain stable as long as the
 provisional name ('handle') attached to the puppet does not change, but an unex-
 pected observation was that relationships remain stable when the conferencee
 decides to change handles, as long as fair notice is given. Occasionally a confer-
 encee will have several handles on the same conference, and a constructed identity
 for each. Other conferencees may or may not be aware of this. Conferencees
 treat others' puppets as if they were embodied people meeting in a public space
 none the less.

Private body, public body and cyborg envy

My interest in VR engineers stems in part from observations that suggest that while
they are surely engaged in saving the project of late-twentieth-century capitalism, they
are also inverting and disrupting its consequences for the body as object of power rela-
tionships. They manage both to preserve the privatized sphere of the individual as well
as to escape to a position that is of the spectacle and incontrovertibly public. But this
occurs under a new definition of public and private: one in which warrantability is irrel-
evant, spectacle is plastic and negotiated, and desire no longer grounds itself in
physicality. Under these conditions, one might ask, will the future inhabitants of cyber-
space 'catch' the engineers' societal imperative to construct desire in gendered, binary
terms – coded into the virtual body descriptors – or will they find more appealing the
possibilities of difference unconstrained by relationships of dominance and submission?
Partly this will depend upon how 'cyberspaceians' engage with the virtual body.

Vivian Sobchack, in her 1987 discussion of cinematic space excludes the space of
the video and computer screen from participation in the production of an 'apparatus of
engagement'. Sobchack describes engagement with cinematic space as producing a thick-
ening of the present . . . a 'temporal simultaneity (that) also extends presence spatially
– transforming the 'thin' abstracted space of the machine into a thickened and concrete
world'. Contrasted with video, which is to say with the electronic space of the CRT
screen and with its small, low-resolution and serial mode of display, the viewer of
cinema engages with the apparatus of cinematic production in a way that produces 'a
space that is deep and textural, that can be materially inhabited . . . a specific and mobile
engagement of embodied and enworlded subjects/objects whose visual/visible activity

prospects and articulates a shifting field of vision from a world that always exceeds it'. Sobchack speaks of electronic space as 'a phenomenological structure of sensual and psychological experience that seems to belong to no-body'. Sobchack sees the computer screen as 'spatially decentered, weakly temporalized and quasi-disembodied'.

This seems to be true, as long as the mode of engagement remains that of spectator. But it is the quality of direct physical and kinaesthetic engagement, the enrolling of hapticity in the service of both the drama and the dramatic, which is not part of the cinematic mode. The cinematic mode of engagement, like that of conventional theatre, is mediated by two modalities; the viewer experiences the presentation through sight and hearing. The electronic screen is 'flat', so long as we consider it in the same bimodal way. But it is the potential for interaction that is one of the things that distinguishes the computer from the cinematic mode, and that transforms the small, low-resolution, and frequently monochromatic electronic screen from a novelty to a powerfully gripping force. Interaction is the physical concretization of a desire to escape the flatness and merge into the created system. It is the sense in which the 'spectator' is more than a participant, but becomes both participant in and creator of the simulation. In brief, it is the sense of unlimited power which the dis/embodied simulation produces, and the different ways in which socialization has led those always-embodied participants confronted with the sign of unlimited power to respond.

In quite different terms from the cinematic, then, cyberspace 'thickens' the present, producing a space that is deep and textural, and one that, in Sobchack's terms, can be materially inhabited. David Tomas, in his article 'The technophilic body' (1989), describes cyberspace as 'a purely spectacular, kinaesthetically exciting, and often dizzying sense of bodily freedom'. I read this in the additional sense of freedom *from* the body, and in particular perhaps, freedom from the sense of loss of control that accompanies adolescent male embodiment. Cyberspace is surely also a concretization of the psycho-analytically framed desire of the male to achieve the 'kinaesthetically exciting, dizzying sense' of freedom.

Some fiction has been written about multimodal, experiential cinema. But the fictional apparatus surrounding imaginary cybernetic spaces seems to have proliferated and pushed experiential cinema into the background. This is because cyberspace is part of, not simply the medium for, the action. Sobchack, on the other hand, argues that cinematic space possesses a power of engagement that the electronic space cannot match:

> Semiotically engaged as subjective and intentional, as presenting representation of the objective world . . . The spectator(s) can share (and thereby to a degree interpretively alter) a film's presentation and representation of embodied experience.

> (Sobchack 1992)

Sobchack's argument for the viewer's intentional engagement of cinematic space, slightly modified, however, works equally well for the cybernetic space of the computer. That is, one might say that the console cowboy is also 'semiotically engaged as subjective and intentional, as presenting representation of a *subjective* world . . . the spectator can share (and thereby to a high degree interpretively alter) a simulation's presentation and representation of experience which may be, through cybernetic/semiotic operators not yet existent but present and active in fiction (the cyberspace deck), mapped back upon the physical body'.

In psychoanalytic terms, for the young male, unlimited power first suggests the mother. The experience of unlimited power is both gendered, and, for the male, fraught with the need for control, producing an unresolvable need for reconciliation with an always absent structure of personality. An 'absent structure of personality' is also another way of describing the peculiarly seductive character of the computer that Turkle (1984) characterizes as the 'second self'. Danger, the sense of threat as well as seductiveness that the computer can evoke, comes from both within and without. It derives from the complex interrelationships between human and computer, and thus partially within the human; and it exists quasi-autonomously within the simulation. It constitutes simultaneously the senses of erotic pleasure and of loss of control over the body. Both also constitute a constellation of responses to the simulation that deeply engage fear, desire, pleasure, and the need for domination, subjugation and control.

It seems to be the engagement of the adolescent male within humans of both sexes that is responsible for the seductiveness of the cybernetic mode. There is also a protean quality about cybernetic interaction, a sense of physical as well as conceptual mutability that is implied in the sense of exciting, dizzying physical movement within purely conceptual space. I find that in reality hackers experience a sense of longing for an embodied conceptual space like that which cyberspace suggests. This sense, which seems to accompany the desire to cross the human/machine boundary, to penetrate and merge, which is part of the evocation of cyberspace, and which shares certain conceptual and affective characteristics with numerous fictional evocations of the inarticulate longing of the male for the female, I characterize as *cyborg envy*.

Smoothness implies a seductive tactile quality that expresses one of the characteristics of cyborg envy: In the case of the computer, a desire literally to enter into such a discourse, to penetrate the smooth and relatively affectless surface of the electronic screen and enter the deep, complex, and tactile (individual) cybernetic space or (consensual) cyberspace within and beyond. Penetrating the screen involves a state change from the physical, biological space of the embodied viewer to the symbolic, metaphorical 'consensual hallucination' of cyberspace; a space that is a locus of intense desire for refigured embodiment.

The act of programming a computer invokes a set of reading practices both in the literary and cultural sense. 'Console cowboys' such as the cyberspace warriors of William Gibson's cyberpunk novels proliferate and capture the imagination of large groups of readers. Programming itself involves constant creation, interpretation and reinterpretation of languages. To enter the discursive space of the program is to enter the space of a set of variables and operators to which the programmer assigns names. To enact naming is simultaneously to possess the power of, and to render harmless, the complex of desire and fear that charge the signifiers in such a discourse; to enact naming within the highly charged world of surfaces that is cyberspace is to appropriate the surfaces, to incorporate the surfaces into one's own. Penetration translates into envelopment. In other words, to enter cyberspace is to physically *put on* cyberspace. To become the cyborg, to put on the seductive and dangerous cybernetic space like a garment, is to put on the *female*. Thus cyberspace both *dis*embodies, in Sobchack's terms, but also *re*embodies in the polychrome, hypersurfaced cyborg character of the console cowboy. As the charged, multigendered, hallucinatory space collapses onto the personal physicality of the console cowboy, the intense tactility associated with such a reconceived and refigured body constitutes the seductive quality of what one might call the *cybernetic act*.

In all, the unitary, bounded, safely warranted body constituted within the frame of bourgeois modernity is undergoing a gradual process of translation to the refigured and reinscribed embodiments of the cyberspace community. Sex in the age of the coding metaphor – absent bodies, absent reproduction, perhaps related to desire, but desire itself refigured in terms of bandwidth and internal difference – may mean something quite unexpected. Dying in the age of the coding metaphor – in selectably inhabitable structures of signification, absent warrantability – gives new and disturbing meaning to the title of Steven Levine's (1988) book about the process, *Who Dies?*

Cyberspace, sociotechnics and other neologisms

Part of the problem of 'going on in much the same way', as Harry Collins put it, is in knowing what the same way is. At the close of the twentieth century, I would argue that two of the problems are, first, as in Paul Virilio's analysis, *speed*, and second, tightly coupled to speed, what happens as human physical evolution falls further and further out of synchronization with human cultural evolution. The product of this growing tension between nature and culture is stress.

The development of cyberspace systems – which I will refer to as part of a new *technics* – may be one of a widely distributed constellation of responses to stress, and second, as a way of continuing the process of collapsing the categories of nature and culture that Paul Rabinow sees as the outcome of the new genetics. Cyberspace can be viewed as a toolkit for refiguring consciousness in order to permit things to go on in much the same way. Rabinow suggests that nature will be modelled on culture; it will be known and remade through technique. Nature will finally become artificial, just as culture becomes natural.

Haraway (1985) puts this in a slightly different way: 'The certainty of what counts as nature,' she says, '[that is, as] a source of insight, a subject for knowledge, and a promise of innocence – is undermined, perhaps fatally.' The change in the permeability of the boundaries between nature and technics that these accounts suggest does not simply mean that nature and technics mix – but that, seen from the technical side, technics become natural, just as, from Rabinow's anthropological perspective on the culture side, culture becomes artificial. In technosociality, the social world of virtual culture, technics is nature. When exploration, rationalization, remaking and control mean the same thing, then nature, technics and the structure of meaning have become indistinguishable. The technosocial subject is able successfully to navigate through this treacherous new world. S/he is constituted as part of the evolution of communications technology and of the human organism, in a time in which technology and organism are collapsing, imploding, into each other.

Electronic virtual communities represent flexible, lively and practical adaptations to the real circumstances that confront persons seeking community in what Haraway (1987) refers to as 'the mythic time called the late twentieth century'. They are part of a range of innovative solutions to the drive for sociality – a drive that can be frequently thwarted by the geographical and cultural realities of cities increasingly structured according to the needs of powerful economic interests rather than in ways that encourage and facilitate habitation and social interaction in the urban context. In this context, electronic virtual communities are complex and ingeneous strategies for *survival*. Whether

the seemingly inherent seductiveness of the medium distorts the aims of those strate-
gies, as television has done for literacy and the personal interaction, remains to be seen.

So much for community. what about the body?

No matter how virtual the subject may become, there is always a body attached. It may
be off somewhere else – and that 'somewhere else' may be a privileged point of view
– but consciousness remains firmly rooted in the physical. Historically, body, technology
and community constitute each other.

In her 1990 book *Gender Trouble*, Judith Butler introduces the useful concept of the
'culturally intelligible body', or the criteria and the textual productions (including writing
on or in the body itself) that each society uses to produce physical bodies that it recog-
nizes as members. It is useful to argue that most cultural production of intelligibility is
about reading or writing and takes place through the mediation of texts. If we can apply
textual analysis to the narrow-bandwidth modes of computers and telephones, then we
can examine the production of gendered bodies in cyberspace also as a set of tokens
that code difference within a field of ideal types. I refer to this process as the produc-
tion of the *legible* body.

The opposite production, of course, is of the *illegible* body, the 'boundary-subject'
that theorist Gloria Anzaldúa calls the *mestiza*, one who lives in the borderlands and is
only partially recognized by each abutting society. Anzaldúa describes the mestiza by
means of a multiplicity of frequently conflicting accounts. There is no position, she
shows, outside of the abutting societies themselves from which an omniscient overview
could capture the essence of the mestiza's predicament, nor is there any single account
from within a societal framework that constitutes an adequate description.

If the mestiza is an illegible subject, existing quantum-like in multiple states, then
participants in the electronic virtual communities of cyberspace live in the border-
lands of both physical and virtual culture, like the mestiza. Their social system includes
other people, quasi people or delegated agencies that represent specific individuals,
and quasi agents that represent 'intelligent' machines, clusters of people, or both. Their
ancestors, lower on the chain of evolution, are network conferencers, communities organ-
ized around such texts as Boyle's 'community of gentlemen' and the religious traditions
based in holy scripture, communities organized around broadcasts, and communities of
music such as the Deadheads. What separates the cyberspace communities from their
ancestors is that many of the cyberspace commununities interact in real time. Agents meet
face-to-face, though as I noted before, under a redefinition of both 'meet' and 'face'.

I might have been able to make my point regarding illegible subjects without invoking
the mestiza as an example. But I make an example of a specific kind of person as a way
of keeping the discussion grounded in individual bodies: in Paul Churchland's words, in
the 'situated biological creatures' that we each are. The work of science is *about* bodies
– not in an abstract sense, but in the complex and protean ways that we daily manifest
ourselves as physical social beings, vulnerable to the powerful knowledges that surround
us, and to the effects upon us of the transformative discourses of science and technology
that we both enable and enact.

I am particularly conscious of this because much of the work of cyberspace
researchers, reinforced and perhaps created by the soaring imagery of William Gibson's

novels, assumes that the human body is 'meat' – obsolete, as soon as consciousness itself can be uploaded into the network. The discourse of visionary virtual world builders is rife with images of imaginal bodies, freed from the constraints that flesh imposes. Cyberspace developers foresee a time when they will be able to forget about the body. But it is important to remember that virtual community originates in, and must return to, the physical. No refigured virtual body, no matter how beautiful, will slow the death of a cyberpunk with AIDS. Even in the age of the technosocial subject, life is lived through bodies.

Forgetting about the body is an old Cartesian trick, one that has unpleasant consequences for those bodies whose speech is silenced by the act of our forgetting; that is to say, those upon whose labour the act of forgetting the body is founded – usually women and minorities. On the other hand, as Haraway points out, forgetting can be a powerful strategy; through forgetting, that which is already built becomes that which can be discovered. But like any powerful and productive strategy, this one has its dangers. Remember – discovering – that bodies and communities constitute each other surely suggests a set of questions and debates for the burgeoning virtual electronic community. I hope to observe the outcome.

Originally published in M. Benedikt (ed.) (1992) *Cyberspace: First Steps,* Cambridge: MIT. This essay has been edited for inclusion in the Reader.

Notes

Thanks to Mischa Adams, Gloria Anzaldúa, Laura Chernaik, Heinz von Foerster, Thyrza Goodeve, John Hartigan, Barbara Joans, Victor Kytasty, Roddey Reid, Chela Sandoval, Susan Leigh Star, and Sharon Traweek for their many suggestions; to Bandit (Seagate), Ron Cain (Borland), Carl Tollander (Autodesk), Ted Kaehler (Sun), Jane T. Lear (Intel), Marc Lentczner, Robert Orr (Amdahl), Jon Singer (soulmate), Brenda Laurel (Telepresence Research and all-around Wonderful Person); Joshua Susser, the advanced Technology Group of Apple Computer, Inc., Tene Tachyon, Jon Shemitz, John James, and my many respondents in the virtual world of on-line BBSs. I am grateful to Michael Benedikt and friends and to the University of Texas School of Architecture for making part of the research possible, and to the participants in The First Conference on Cyberspace for their ideas as well as their collaboration in constituting yet another virtual community. In particular I thank Donna Haraway, whose work and encouragement have been invaluable.

1. 'Nearby' is idiosyncratic and local in cyberspace. In the case of Habitat, it means that two puppets (body representatives) occupy that which is visible on both screens simultaneously. In practice this means that each participant navigates his or her screen 'window' to view the same area in the cyberspace. Because Habitat is consensual, the space looks the same to different viewers. Due to processor limitations only nine puppets can occupy the same window at the same time, although there can be more in the neighbourhood (just off-screen).

2. Although no one has actually given up on encryption systems, the probable reason that international standards for encryption have not proceeded much faster has been the US Government's opposition to encryption key standards that are reasonably secure. Such standards would prevent agencies like the CIA from gaining access to communications traffic. The United States' diminishing role as a superpower may change this. Computer industries in other nations have overtaken the United States' lead in electronics and are beginning to produce secure encryption equipment as well. A side effect of this will be to enable those engaged in electronic communication to reinstate the inside-outside dichotomy, and with it the notion of privacy in the virtual social space.

References

Allan, F. (1984) 'The end of intimacy', *Human Rights*, Winter: 55.

Anzaldúa, G. (1987) *Borderlands/La Frontera: The New Mestiza*, San Francisco: Spinsters/Aunt Lute.

Barker, F. (1984) *The Tremulous Private Body: Essays in Subjection*, London: Methuen.

Baudrillard, J. (1987) *The Ecstasy of Communication*, trans. Bernard and Caroline Schutze, Sylvere Lotringer, New York: Semiotext(e).

Butler, J. (1990) *Gender Trouble: Feminism and The Subversion of Identity*, New York: Routledge.

Campbell, J. (1959) *The Masks of God: Primitive Mythology*, New York: Viking.

Cohn, C. (1987) 'Sex and death in the rational world of defense intellectuals', *Signs: Journal of Woman in Culture and Society*, 12: 4.

de Certeau, M. (1985) 'The arts of dying: celibatory mechines', in *Heterologies* trans. Brian Massumi, Minneapolis: University of Minnesota Press.

Dewey, J. (1896) 'The reflex arc concept in psychology. in J. J. McDermott (ed.) (1981) *The Philosophy of John Dewey*, Chicago: University of Chicago Press, pp. 36–148.

Edwards, P. N. (1986). 'Artificial intelligence and high technology war: the perspective of the formal machine', Silicon Valley Research Group Working Paper no. 6.

Gibson, W. (1984) *Neuromancer*, New York: Ace.

Habermas, J. (1979) *Communication and The Evolution of Society*, Boston: Beacon Press.

Haraway, D. (1985) 'A manifesto for cyborgs: science, technology and socialist feminism in the 1980s', *Socialist Review*, 80: 65–107.

—— (1987) 'Donna Haraway reads National Geographic', Paper Tiger. Video.

—— (1988) 'The biopolitics of postmodern bodies: determinations of self and other in immune system discourse', *Wenner Gren Foundation Conference on Medical Anthropology*, Lisbon, Portugal.

—— (1990) 'Washburn and the new physical anthropology', in *Primate Visions: Gender, Race, and Nature in the World of Modern Science*, New York: Routledge.

—— (1991) 'The promises of monsters: a regenerative politics for inappropriate/d others', in Treichler, P. And Nelson, G. (eds), *Cultural Studies Now and in the Future*. Forthcoming.

Hayles, N. K. (1987) 'Text out of context: situating postmodernism within an information society', *Discourse*, 9: 24–36.

—— (1987) 'Denaturalizing experience: postmodern literature and science'. Abstract from Conference on Literature and Science as Modes of Expression, sponsored by the Society of Literature and Science, Worcester Polytechnic Institute, October 8–11.

Head, H. (1920) *Studies in Neurology*, Oxford: Oxford University Press.

—— (1926) *Aphasia and Kindred Disorders of Speech*, Cambridge: Cambridge University Press.

Hewitt, C. (1977) 'Viewing control structures as patterns of passing messages', *Artificial Intelligence*, 8: 323–64.

—— (1977) 'The challenge of open systems', *Byte*, vol. 10 April.

Huyssen, A. (1986) *After the Great Divide: Modernism, Mass Culture, Postmodernism*, Bloomington: Indiana University Press.

Jameson, F. (1981) 'On interpretation: literature as a socially symbolic act', in *The Politiical Unconscious*, Ithaca: Cornell University Press.

Lacan, J. (1968) *The Language of the Self: The Function of Language in Psychoanalysis*, trans. Anthony Wilden, New York: Dell.

—— (1977) *The Four Fundamental Concepts of Psychoanalysis*, trans. Alain Sheridan (ed.) Jacques-Alain Miller, London: Hogarth.

LaPorte, T. R. (ed.) (1975) *Organized Social Complexity: Challenge to Politics and Policy*, New Jersey: Princeton University Press.

Latour, B. (1988) *The Pasteurization of France*, trans. Alain Sheridan and John Law, Cambridge: Harvard University Press.

Laurel, B. (1986) 'Interface as mimesis', in D. A. Norman, and S. Draper (eds), *User Centered System Design: New Perspectives on Human–Computer Interaction*, Hillsdale, NJ: Lawrence Erlbaum Associates.

—— (1987) 'Reassessing interactivity', *Journal of Computer Game Design*, 1: 3.

—— (1988) 'Culture hacking', *Journal of Computer Game Design*, 1: 8.

—— (1989a) 'Dramatic action and virtual reality'. Proceedings of the 1989 NCGA Interactive Arts Conference.

—— (1989b) 'New interfaces for entertainment', *Journal of Computer Game Design*, 2: 5.

—— (1989c) 'A taxonomy of interactive movies', *New Media News*, The Boston Computer Society, 3: 1.

Lehman-Wilzig, S. (1981) 'Frankenstein unbound: toward a legal definition of artificial intelligence', *Futures*, December, 447.

Levine, S. (1988) *Who Dies? An Investigation of Conscious Living and Conscious Dying*, Bath: Gateway Press.

Merleau-Ponty, M. (1962) *Phenomenology of Perception*, trans. Colin Smith, New York: Humanities Press.

—— (1964a) *Sense and Non-Sense*, trans. Hubert L. Dreyfus and Patricia Allen Dreyfus, Chicago: Northwestern University Press.

—— (1964b) *Signs*, trans. Richard McCleary, Chicago: Northwestern University Press.

Mitchell, S. W., Morehouse, G. and Williams Keen, W. (1872) *Injuries of Nerves and Their Consequences*, with a new introduction by Lawrence C. McHenry, Jr., *American Academy of Neurology Reprint Series*, vol. 2, New York: Dover (1965).

—— (1864) 'Gunshot wounds and other injuries of nerves'. Reprinted (1989) with biographical introductions by Ira M. Rutkow, *American Civil War Surgery Series*, vol. 3, San Francisco: Norman.

—— Noddings, N. (1984) *Caring: a Feminine Approach to Ethics and Moral Education*, Berkeley: University of California Press.

Reid, R. 'Tears for fears: Paul et Virginie, "family" and the politics of the sentimental body in pre-revolutionary France.' Forthcoming.

Rentmeister, C. (1976) 'Beruftsverbot fur musen', *Aesthetik und Kommunikation*, September 25, 92–112.

Roheim, G. (1928) 'Early stages of the oedipus complex', *International Journal of Psycho-analysis*, vol. 9.

—— (1947) 'Dream analysis and field work', in *Anthropology, Psychoanalysis and the Social Sciences*, New York: International Universities Press.

Shapin, S. and Schaffer, S. (1985) *Leviathan and the Air-Pump: Hobbes, Boyle, and the Experimental Life*, Princeton: Princeton University Press.

Sobchack, V. (1992) *The Address of the Eye: A Phenomendogy of Film Experience*. University of Princeton Press, New York.

—— (1987) *Screening Space: The American Science Fiction Film*, New York: Ungar.

—— (1988) 'The scene of the screen: toward a phenomenology of cinematic and electronic "presence"', in H. V. Gumbrecht and L. K. Pfeiffer (eds), *Materialitat des Kommunikation*, GDR: Suhrkarp-Verlag.

Stone, S. P. (1988) 'So that's what those two robots were doing in the park . . . I thought they were repairing each other! The discourse of gender, pornography, and artificial intelligence'. Presented at Conference of the Feminist Studies Focused Research Activity, October, University of California, Santa Cruz, CA.

—— (1989) 'How robots grew gonads: a cautionary tale'. Presented at *Contact V: Cultures of the Imagination*, Phoenix, AZ, 28 March. Forthcoming in Funaro and Joans (eds), *Collected Proceedings of the Contact Conferences*.

—— (1990a) 'Sex and death among the cyborgs: how to construct gender and boundary in distributed systems', *Contact VI: Cultures of the Imagination*, Phoenix, AZ.

—— (1990b) 'Sex and death among the disembodied: how to provide counseling for the virtually preorgasmic'. In M. Benedikt (ed.), *Collected Abstracts of the First Cyberspace Conference*, The University of Texas at Austin, School of Architecture.

—— (1990c) 'Aliens, freaks, monsters: the politics of virtual sexuality'. For the panel Gender and Cultural Bias in Computer Games, Computer Game Developers' Conference, San Jose.

—— (1991) 'Ecriture artifactuelle: boundary discourse, distributed negotiation, and the structure of meaning in virtual systems', forthcoming at the *1991 Conference on Interactive Computer Grahics*.

Stone, C. D. (1974) *Should Trees Have Standing? – Toward Legal Rights for Natural Objects*, New York: William A. Kaufman.

Theweleit, K. (1977) *Male Fantasies*, vol. 1, Frankfurt am Main: Verlag Roter Stern.

Tomas, D. (1989) 'The technophilic body: on technicity in William Gibson's cyborg culture', *New Formations*, 8 Spring.

Turkle, S. (1984) *The Second Self: Computers and the Human Spirit*, New York: Simon and Schuster.

Von Foerster, H. (ed.), (1951) *Transactions of the Conference on Cybernetics*, New York: Josiah Macy, Jr. Foundation.

Weiner, N. (1950) *The Human Use of Human Beings*, New York: Avon.

Wilden, A. (1980) *System and Structure: Essays in Communication and Exchange*, 2nd ed., New York: Tavistock.

Winograd, T., and Flores, C. F. (1986) *Understanding Computers and Cognition: A New Foundation for Design*, Norwood, NJ: Ablex.

Wolkomir, R. (1990) 'High-tech hokum is changing the way movies are made', *Smithsonian* 10/90: 124.

TIMOTHY LEARY

THE CYBERPUNK
The individual as reality pilot

> Your true pilot cares nothing about anything on earth but the river, and his
> pride in his occupation surpasses the pride of kings.
>
> (Mark Twain, *Life on the Mississippi*)

Who is the cyberpunk?

CYBERPUNKS USE ALL AVAILABLE DATA input to think for them-
selves.

You know who they are.

Every stage of history has produced a name and an heroic legend for the strong,
stubborn, creative individual who explores some future frontier, collects and brings back
new information, and offers to guide the gene pool to the next stage. Typically, the
time maverick combines bravery with high curiosity, with super-self-esteem. These three
talents are considered necessary for those engaged in the profession of genetic guide,
aka, philosopher.

The classical Old West–World model for the Cyberpunk is Prometheus, a techno-
logical genius who 'stole' fire from the Gods and gave it to humanity.[1] Prometheus also
taught his gene pool many useful arts and sciences. According to the official version of
the legend, he/she was sentenced to the ultimate torture for these unauthorized trans-
missions of Classified Information. Prometheus was exiled. In his/her own version of
the myth (unauthorized) Prometheus (aka, the Pied Piper) uses his/her skills to escape
the sinking kinship, taking with him the cream of the gene pool.

The New World version of this ancient myth is Quetzalcoatl, god of civilization,
high-tech wizard who introduced maize, the calendar, erotic sculpture, flute playing,
the arts. And the sciences. He was driven into exile by the G-man in power, who was
called Tezcatolipoca.

Self-assured singularities of the Cyber Breed have been called mavericks, ronin, free-lancers, independents, self-starters, nonconformists, oddballs, troublemakers, kooks, visionaries, iconoclasts, insurgents, blue-sky thinkers, loners, smart-alecks. Before Gorbachev, the Soviets scornfully called them hooligans. Religious organizations have always called them heretics. Bureaucrats called them disloyal dissidents, traitors, or worse. In the old days, even sensible normal people used to call them mad.

They have been variously labelled clever, creative, entrepreneurial, imaginative, enterprising, fertile, ingenious, inventive, resourceful, talented, eccentric.

During the tribal, feudal and industrial-literate phases of human evolution, the logical survival traits were conformity and dependability. The 'good serf' or 'vassal' was obedient. The 'good worker' or 'manager' was reliable. Maverick-thinkers were toler-ated only at moments when innovation and change were necessary, usually to deal with the local competition.

In the information/communication civilization of the twenty-first century, creativity and mental excellence become the ethical norm. The world has become too dynamic, complex and diversified, too cross-linked by the global immediacies of modern (quantum) communication, for stability of thought or dependability of behaviour to be successful. The 'good person' today is the intelligent one who can think for him/herself. The 'problem person' in the Cybernetic Society of the twenty-first century is the one who automatically obeys, who never questions authority, who acts to protect his/her official status, who placates and politics rather thank thinks independently.

Thoughtful Japanese are worried about the need for ronin-thinking in their obedient culture. The postwar generation is now taking over.

Cyberpunk yuppies in the Soviet Union

The new postwar generation of Soviets have apparently caught on that a new role model is necessary to compete in the information age. Under Gorbachev bureaucratic control is being softened, made elastic to encourage some modicum of innovative, dissident thought!

Aleksandr N. Yakovlev, Politburo member and key strategist of the glasnost policy, describes that reform: 'Fundamentally, we are talking about self-government. We are moving towards a time when people will be able to govern themselves and control the activities of people that have been placed in the position of learning and governing them.

'It is not accidental that we are talking about *self*-goverment, or *self*-sufficiency and *self*-profitability of an enterprise, *self*-this and *self*-that. It all concerns the decentraliza-tion of power.'

The Cyberpunk Person, the pilot who thinks clearly and creatively, using quantum-electronic appliances and brain know-how, is the newest, updated, top-of-the-line model of our species, *homo sapiens sapiens, cyberneticus.*

Let us meet some of these Pilot People. Their example may encourage and empower you to start taking over the wheel. Of your own life.

Cyber is the Greek word for pilot

> A great pilot can sail even when his canvas is rent.
>
> (Lucius Annaeus Seneca)

The term *cybernetics* comes from the Greek word *kubernetes* – pilot. The Hellenic origin of this word is important in that it reflects Greek traditions of independence and individual self-reliance which, we are told, derived from geography. The proud little Greek city-states were perched on peninsular fingers wiggling down into the fertile Mediterranean Sea, protected by mountains from the landmass armies of Asia.

Mariners of those ancient days had to be bold and resourceful. Sailing the seven seas without maps or navigational equipment, they were forced to develop independence of thought. The self-reliance that these Hellenic pilots developed in their voyages probably carried over to the democratic, inquiring, questioning nature of their land life. The Athenian cyberpunk, the pilot, made his/her own navigational decisions.

These psycho-geographical factors may have contributed to the humanism of the Hellenic religions, which emphasized freedom, pagan joy, celebration of life, and speculative thought. The personal and polytheistic nature of the religions of ancient Greece is often compared with the austere morality of monotheistic Hebraism, the fierce, dogmatic polarities of Persian-Arab dogma, and the imperial authority of Roman (Christian) culture.

A recent example of unauthorized cyberpunk behaviour

The opening moments of the movie *WarGames* offers a classic example of *cybernetic* performance. It's a foggy night. An Air Force Captain is skillfully steering a jeep up a winding Colorado mountain road to the secret SAC nuclear missile launching silos. He is accompanied by a lieutenant. The captain speaks the first words in the movie. He tells the lieutenant that he and his wife planted a cultivated grade of marijuana seeds in their garden and, to ensure their growth, invoked the Tibetan Buddhist prayer for enlightenment. *Om mane padma hum.*

At this point, the officers reach the entry check-point, identify themselves, and are issued pistols. The huge steel vault door opens. The two men enter the 'control' room from which the bombs are fired. As they check dials, the captain continues his story. The cannabis harvest was very successful. The lieutenant interrupts the story. A red light on the control board is flashing ominously. The captain tells him to tap it with his finger. The light disappears. Get it? The captain is a quantum-whiz, alert, competent to detect and debug errors in the electronic system. The blinking begins again. An alarm sounds. They consult the code book and confirm the validity of the message. They gulp. They are commanded to launch nuclear missiles at the Soviet Union.

The captain balks. He orders the lieutenant to phone headquarters for human confirmation. The lieutenant, a loyal liege vassal, protests that this is an unauthorized action. But he obeys the order of his immediate superior.

No answer.

The lieutenant primly reminds the captain that orders command him to fire the nuke. The captain shakes his head. He commits an act of independent thought. He says he won't kill fifty million people without a human command.

The lieutenant, dutifully following the government regulations, points his pistol at the captain's brain.

Cut.

The Roman concept of governor, director, steersman

The Greek word *kubernetes* translated to Latin comes out as *gubernetes*. The basic verb *gubernare* means to control the actions or behaviour of, to direct, to exercise sovereign authority, to regulate, to keep under, to restrain, to steer. This Roman concept is obviously very different from the original notion of 'pilot'.

It may be relevant that the Latin term 'to steer' comes from the word *stare*, which means to stand, with derivative meanings 'place or thing which is standing'. The past participle of the Latin word produces 'status', 'state', 'institute', 'statue', 'static', 'statistics', 'prostitute', 'restitute', 'constitute'.

Example of governing or steersman behaviour

A helicopter lands at the SAC base. It is carrying two high status officials of the government. They carry institutional briefcases and standard, serious, worried looks. They are furious. It seems that 25 per cent of the captains in silos refused to launch without human confirmation. The government response to this independence of judgment by individuals is predictably institutional.

'Get the persons out of the loop.'

They introduce WHOPPER, a totally obedient Artificial Intelligence system guaranteed to follow government orders and to be free of the subjective, (PUNK) human unreliability factor.

Cyberpunk/pilots replace governetics/controllers

The word 'cybernetics' was coined by Norbert Wiener (1948), who wrote, 'We have decided to call the entire field of control and communication theory, whether in the machine or in the animal, by the name of Cybernetics, which we form from the Greek word for steersman [*sic*].' The word 'cyber' has been redefined (in the *American Heritage Dictionary*) as 'the theoretical study of control processes in electronic, mechanical, and biological systems, especially the flow of information in such systems'. The derivative word *cybernate* means 'to control automatically by computer or to be so controlled'.

An even more ominous interpretation defines cybernetics as 'the study of human control mechanisms and their replacement by mechanical or electronic systems'.

Note how Wiener and the Romanesque engineers have corrupted the meaning of cyber. The Greek word 'pilot' becomes 'governor or director'; the word 'to steer' becomes 'to control'.

We are liberating the term, teasing it free from serfdom to represent the auto-poetic, self-directed principle of organization which arises in the universe in many systems of widely varying sizes. In people, societies and atoms.

Charles Augustus Lindbergh: cyber-politician

Charles Lindbergh was a Republican congressman from Minnesota who first attained national prominence when he attacked industrial and commercial trusts, denounced pro-military propaganda and war profits. His courageous and skillful maverick attitude culminated in his active opposition to the First World War in 1917. These acts of independent thinking destroyed his governmental career.

He was the father of Charles Augustus Lindbergh, Lucky Lindy, the Lone Eagle, who attained fame as sky pilot, philosopher, ecologist.

Our oppressive birthright: the politics of literacy

The etymological distinctions between Greek and Roman terms are quite relevant to the pragmatics of the culture surrounding their usage. French philosophy, for example, has recently stressed the importance of language and semiotics in determining human behaviour and social structures. Michel Foucault's classic studies of linguistic politics and mind control led to him to believe that

> human consciousness – as expressed in speech and images, in self-definition and mutual designation . . . is the authentic locale of the determinant politics of being . . . What men and women are born into is only superficially this or that social, legislative, and executive system. Their ambiguous, oppressive birthright is the language, the conceptual categories, the conventions of identification and perception which have evolved and, very largely, atrophied up to the time of their personal and social existence. It is the established but customarily subconscious, unargued constraints of awareness that enslave.

Orwell and Wittgenstein both agree. To remove the means of expressing dissent is to remove the possibility of dissent. 'Whereof one cannot speak, thereof one must remain silent.' In this light, the difference between the Greek word 'pilot' and the Roman translation 'governor' becomes a most significant semantic manipulation. And the flexibility granted to symbol systems of all kinds by their representation in digital computers becomes very dramatic.

Several questions arise. Do we, for example, pride ourselves for becoming ingenious 'pilots' or 'dutiful controllers'?

Who, what, and why is governetics?

> Damn the torpedoes, full speed ahead.
>> (Captain David Glasgow Farragut's order to his steersman
>>> at the Battle of Mobile Bay, 5 August 1864)

> Aye, aye, sir!
>> (Unknown enlisted steersman at the
>> Battle of Mobile Bay, 5 August 1864).

The word governetics refers to an attitude of obedience-control in relationship to self or others.

Pilots, those who navigate on the seven seas or in the sky, have to devise and execute course changes continually in response to the changing environment. They respond continually to feedback, information about the environment. Dynamic. Alert. Alive.

The Latinate 'steersman', by contrast, is in the situation of following orders. The Romans, we recall, were great organizers, road builders, administrators. The galley ships, the chariots must be controlled. The legions of soldiers must be directed.

The Hellenic concept of the individual navigating his/her own course was an island of humanism in a sea of totalitarian empires. Athens was bounded on the East (the past) by the centralized, authoritarian kingdoms of the Middle East. The Governors of Iran, from Cyrus, the Persian emperor, to the recent Shah and Ayatollah, have exemplified the highest traditions of state control.

The Greeks were bounded on the other side, which we shall designate the West (or future) by a certain heavy concept called Rome. The caesars and popes of the Holy Roman Empire represented the next grand phase of institutional control. The governing hand on the wheel stands for stability, durability, continuity, permanence. Staying the course. Individual creativity, exploration and change are usually not encouraged.

Christopher Columbus: another example of cyberpunk behaviour

Christopher Columbus (1451–1506) was born in Genoa. At the age of twenty-five, he showed up in Lisbon and learned the craft of map-making. This was the golden era of Portuguese exploration. Many pilots and navigators were convinced that the earth was round and that the Indies and other unknown lands could be found by crossing the western seas. What was special about Columbus was his persistence and eloquence in support of the dream of discovery. For over ten years, he travelled the courts of Europe attempting to make 'the deal' to find backing for his 'enterprise of the Indies'.

According to the *Columbia Encyclopedia*: 'Historians have disputed for centuries his skill as a navigator, but it has been recently proved that with only dead-reckoning Columbus was unsurpassed in charting and finding his way about unknown seas.' Columbus was a most unsuccessful governor of the colonies he had discovered. He died in disgrace, his cyber-skills almost forgotten. (At least that's what they tell us in the authorized history books).

Cyberpunk: the pilots of the species

The winds and waves are always on the side of the ablest navigators.
(Edward Gibbon)

The word *cybernetic-person* or *cybernaut* returns us to the original meaning of 'pilot' and puts the self-reliant person back in the loop. The words *cybernetic-person*, *cybernaut*, and the more pop term *cyberpunk* refers to the personalization (and thus the popularization) of knowledge/information technology. Innovative thinking on the part of the individial.

According to Foucault, if you change the language you change the society. Following Foucault, we suggest that the term *cybernetic-person*, *cybernaut*, may describe a new model of human being and a new social order. *Cyberpunk* is, admittedly, a risky term. Like all

linguistic innovations, it must be used with a tolerant sense of high-tech humour. It's a stop gap, transitional meaning-grenade thrown over the language barricades to describe the resourceful, skillful individual who accesses and steers knowledge/communication technology towards his/her own private goals. For personal pleasure, profit, principle, or growth.

Cyberpunks are the inventors, innovative writers, techno-frontier artists, risk-taking film directors, icon-shifting composers, expressionist artists, free-agent scientists, innovative show-biz entrepreneurs, techno-creatives, computer visionaries, elegant hackers, bit-blipping *Prolog* adepts, special-effectives, video wizards, neurological test pilots, media explorers – all of those who boldly package and steer ideas out there where no thoughts have gone before.

Cyberpunks are sometimes authorized by the governors. They can, with sweet cynicism and patient humour, interface their singularity with institutions. They often work within 'the governing systems' on a temporary basis.

As often as not, they are unauthorized.

The legend of the Ronin

The following quotes come from *The Way of the Ronin* by Beverely Potter, '[T]he Ronin . . . has broken with the tradition of career feudalism. Guided by a personally defined code of adaptability, autonomy, and excellence, Ronin are employing career strategies grounded in a premise of rapid change.'

Ronin is used as a metaphor based on a Japanese word for a lordless samurai. As early as the eighth century, the word *ronin*, translated literally as 'wave people', was used in Japan to describe people who had left their allotted, slotted, caste-predetermined station in life. Samurai who had left the service of their feudal lords to become masterless.

> *Ronin* played a key role in Japan's abrupt translation from a feudal society to industrialism. Under feudal rule, warriors were not allowed to think freely or act according to their own will. On the other hand, having been forced by circumstances to develop independence, they took more readily to new ideas and technologies and became increasingly influential in the independent schools. These schools . . . were more liberal than were the official government schools, which taught only the traditional curriculum.

The West has many historical parallels to the *ronin* archetype. The term *free lance* has its origin in the period after the crusade when a large number of knights were separated from their lords. Many lived by the code of chivalry and became 'lances for hire'.

The American frontier was fertile ground for the *ronin* archetype. *Maverick*, derived from the Texan word for unbranded steer, is used to describe a free and self-directed individual.

> Although many of the Ronin's roots . . . are in the male culture, most career women are well acquainted with the Way of the Ronin. Career women have left their traditional stations and battled their way into the recesses of the male-dominated workplace. Most women's careers are characterized by a

multiplicity of experiences and back-and-forth moves between home, work, and school, causing them to confront the critics of self-direction. Like the Ronin who had no clan, professional women often feel excluded from the corporate cliques' inside tracks, without ally or mentor.

Shall we boot-up some examples of cyberpunk?

Carol Suen Rosin, proponent of non-militarized outer space, has become 'an honest broker' between the American and Soviet scientific groups.

Stanley Kubrick is the essence of cyberpunk.

Mary Ferguson, psyber-punk. Wrote *The Aquarian Conspiracy* and publishes the *Brain/Mind Bulletin*.

Steve Jobs and Steve Wozniak.

David Hockney.

Andy Warhol.

George Koopman.

William Gibson, Bruce Sterling, John Shirley, Rudy Rucker.

Charles Lindbergh: 'We (that's my ship and I) took off rather suddenly. We had a report somewhere around 4 o'clock in the afternoon before that the weather would be fine, so we thought we would try it.'

'I saw a fleet of fishing boats . . . I flew down almost touching the craft and yelled at them, asking if I was on the right road to Ireland. They just stared. Maybe they didn't hear me. Maybe I didn't hear them. Or maybe they thought I was a crazy fool. An hour later I saw land.'

In 1922, Lindbergh left a promising university career to study air navigation and flight. He was one of the first pilots to carry mail through the skies. On 21 May 1927, he made the first solo non-stop flight from the North American continent to the Eurasian continent. 'Lucky Lindy' immediately became a national hero.

In 1929, he married Anne Morrow, an intelligent, cultured author and woman of means. After the marriage, she became an accomplished pilot. The couple astonished the world by making several highly publicized flights together.

In 1936, Lindy (by then in exile) collaborated with Alex Carrel in developing an enhanced heart appliance to aid human circulation.

In 1938, after visiting the Eurasian continent, Lindbergh became convinced that America should stay out of the power struggle developing between the Axis and the Allies.[2]

The media widely publicized a motto/logo for Lindy: 'Smiling Through.'

Anne Morrow Lindbergh.

Mark Twain. He purchased the Remington-Type writer when it appeared in 1874 for $125. In 1875, he became the first author in history to submit a typewritten manuscript to a publisher. It was *The Adventures of Tom Sawyer*. 'This newfangled writing machine has several virtues. It piles an awful stack of words on one page. It don't muss things or scatter inkblots around. Of course it saves paper.'

Gertrude Stein.

Roy Walford.

Wilt Chamberlain.

Mathias (Rusty) Rust, age 19, a lanky, teenage loner from Hamburg, Germany, attained All-Star status as a cyberpunk when, on 28 May 1987, he flew a one-engine Cessna through the impenetrable Soviet air defences and landed in Moscow's Red Square. There were no gubernal or organizational motives. The technological adventure was a personal mission. Rusty just wanted to talk to some Russians. German newspapers celebrated the event, calling it 'the stuff of dreams' and comparing the youth to the Red Baron Manfred von Richthofen and Charles Lindbergh.

Stewart Brand, founder of *Co-evolution Quarterly*.

Bob Harris, the owner of a hardware store in Riverside, California, is an amateur glider pilot. On 17 February 1986, while soaring over the high desert north of Edwards Air Force Base, he caught the most beautiful 'mountain wave' he'd ever seen and rode it to a height of 49,000 feet. A world record. His celebration was rudely interrupted by the Federal Aviation Administration, who moved to revoke his pilot's licence. The charge: Pilot Harris had failed to get permission. The flight was unauthorized.

The cyber-flash kid: another example of innovative behaviour

The third scene in *WarGames* introduces us to the hero, Matthew Broderick. He is in a video arcade playing a space adventure game with poise and proficiency.

Get it? He's an Electron Jock. A Quantum Wizard. But is he a company man? Or a self-directed cyberpilot? Let's find out.

He is late for school. His autocratic biology teacher gives him a bad time. When the officious teacher asks about the origin of asexual reproduction, Matthew suggests, 'Your wife?'

Okay, we get it. Matthew is ungovernable. He's a cyberkid.

The teacher sends Matthew to the principal. While languishing in the governor's office, he obtains the code for the school's computer system. Back home, he uses his PC to access the school records. He changes the unfair grade to a passing level.

The cyberpunk code: TFYQA

The three scenes from *WarGames* present the cultural drama of the Roaring twentieth century. First we note that *WarGames* is an electronic quantum signal, a movie about high-tech computers and human evolution seen by millions, especially impressionable youngsters. The film illustrates and condemns the use of quantum/electronic knowledge technology by governates for control. The film celebrates the independence and skill of cyberpunks who think for themselves and innovate from within the static system. The captain and his wife use high-tech agricultural methods to enhance the potency of unauthorized botanical neuroactivators. The captain makes an unauthorized decision to abort Word War Three. In both instances, the captain follows the cyberpunk code: Think for Yourself, Question Authority (TFYQA). He pilots an independent course.

The cyberkid, Matthew Broderick, is equally courageous, outrageous, creative and bright. He is pulled into the classic confrontation: the Authoritarian Antique Teacher humiliates and punishes the Tom Sawyer kid. Matthew Thinks for Himself and Questions Authority. He rushes to the library and researches the life of Professor Falken, scans

scientific journals, scopes microfilm files – not to please the system but in pursuit of his own personal quest. Then he uses his Electron-skills in an unauthorized manner to pilot his own course.

Note that there is a new dimension of Electronic Ethics and Quantum Legality here. The captain and Matthew perform no act of physical violence, no theft of material goods. The captain processes some computer data and decides for himself. Matthew rearranges clusters of electrons stored on a chip.

They seek no control over others.

Cyberpunk as role model for the twenty-first century

The tradition of the 'Individual who Thinks for Him/Herself' extends to the beginnings of recorded human history. Indeed, the very label of our species, *homo sapiens*, defines us as the animals who think.

If our genetic function is *computare* (to think), then it follows that the ages and stages of human history, so far, have been larval or preparatory. Now, at the beginnings of the information age, are we ready to assume our genetic function? After the larval phases of submission to gene pools, the mature stage of the human life-cycle is the individual who thinks for him/herself.

Definitions of the word 'cyber'

The preceding pages have discussed the politics of knowledge in terms of the concept of 'cyber'.

Cyber means 'pilot'.

A *cyber-person* is one who pilots his/her own life. By definition, the cyber-person is fascinated by navigational information – expecially maps, charts, labels, guides, manuals, which help pilot one through life. The cyber-person continually searches for theories, models, paradigms, metaphors, images, icons which help chart and define the realities which we inhabit.

Cyber-tech refers to the tools, appliances, and methodologies of knowing and communicating. Linguistics. Philosophy. Semantics. Semiotics. Practical epistemologies. The ontologies of daily life. Words, icons, pencils, printing presses, screens, keyboards, computers, disks.

Cyber-politics introduces the Foucauldian notions of the use of language and linguistic-tech by the ruling classes in Feudal and Industrial societies to control children, the uneducated and powerless individuals.

The words *governor* or *steersman* or *G-man* are used to describe those who manipulate words and communication devices to control, to bolster authority – feudal, management, government. And to discourage innovative thought and free exchange.

We describe a person who relies on static, verbal abstractions, conformity to dogma, reliance on authority, as a vassal or G-Person or G-Man. From which we get G-think, G-text, G-babble, G-berish, vassaline, vassalize.

Originally published in L. McCaffery (ed.) (1991) *Storming the Reality Studio: A Casebook of Cyberpunk and Postmodern Fiction*, Durham: Duke University Press.
This essay has been edited for inclusion in the Reader.

Notes

1. Every gene pool develops its own name for Prometheus, the fearful genetic agent, Lucifer, who defies familial authority by introducing a new technology which empowers some members of the gene pool to leave the familiar cocoon. Each gene pool has a name for this ancestral state of security: 'Garden of Eden', 'Atlantis', 'Heaven', 'Home', etc.
2. The Axis included Germany, Italy, Spain, Austria, Japan, Czechoslovakia, Russia, and many East European, South American and Middle Eastern (Islamic) nations, and (later) Vichy France. The Allies included France, England and the British Commonwealth (Canada, Australia and South Africa). Among the countries that remained neutral during the Second World War were Switzerland, Ireland, Denmark and Sweden.

JENNIFER GONZÁLEZ

ENVISIONING CYBORG BODIES
Notes from current research

The truth of art lies in this: that the world really is as it appears in the work of art.

(Herbert Marcuse)

T HE CYBORG BODY IS THE body of an imagined cyberspatial existence. It is the site of possible being. In this sense it exists in excess of the real. But it is also imbedded within the real. The cyborg body is that which is already inhabited and through which the interface to a contemporary world is already made. Visual representations of cyborgs are thus not only utopian or dystopian prophesies, but are rather reflections of a contemporary state of being. The image of the cyborg body functions as a site of condensation and displacement. It contains on its surface and in its fundamental structure the multiple fears and desires of a culture caught in the process of transformation. Donna Haraway has written,

> A cyborg exists when two kinds of boundaries are simultaneously problem-
> atic: 1) that between animals (or other organisms) and humans, and 2) that
> between self-controlled, self-governing machines (automatons) and organ-
> isms, especially humans (models of autonomy). The cyborg is the figure born
> of the interface of automation and autonomy.[1]

Taking this as a working definition, one can consider any body a cyborg body that is both its own agent and subject to the power of other agencies. To keep to the spirit of this definition but to make it more specific, an *organic cyborg* can be defined as a monster of multiple species, whereas a *mechanical cyborg* can be considered a techno-human amalgamation. While images of *mechanical cyborgs* will be the focus of the short essays that follow, both types of cyborgs, which appear frequently in Western visual culture, are metaphors for a third kind of cyborg – a cyborg consciousness.[2] This last, is both manifest in all images included here, and is the invisible force driving their

production, what Michel Foucault might call a 'positive unconscious'.[3] This unconscious is reflected in the spatial and political agency implied by a given cyborg body. Unlike some of my contemporaries, I do not see the cyborg body as primarily a surface or simulacrum which signifies only itself; rather the cyborg is like a symptom – it represents that which cannot otherwise be represented.

Mechanical mistress

Flanked by rows of cypress, demurely poised with a hand on one hip, the other hand raised with a pendulous object hanging from plump and delicate fingers stands 'L'Horlogère' (The Mistress of Horology). From above her head stares the circular face of time, supported by a decorative frame through which her own face complacently gazes. Soft feminine shoulders descend into a tightly sculpted bust of metal. Clinched at the waist, her skirts flounce into a stiffly ornamental 'montre emboeté' which rests on dainty feet, toes curled up to create the base. An eighteenth-century engraving, this image by an unknown printer depicts what we today might call a *cyborg*. The body of the woman is not merely hidden inside the machine, nor is the organic body itself a mechanical replica. Rather the body and the machine are a singular entity. In contrast to, but within the context of, the popular depictions of entirely mechanical automata – the predecessors of our modern-day robots – this image represents an early conception of an ontological merging of 'cultural' and 'natural' artifacts.

Taken as a form of evidence, the representation of an amalgam such as this can be read as a symptom of the pre-industrial unconscious. *L'Horlogère* substantiates an ideology of order, precision and mechanization. French philosopher Julien Offray de La Mettrie, in his essay 'L'Homme machine' (1748) wrote, 'The human body is a machine which winds its own springs. It is the living image of perpetual movement.'[4] The beating hearts of many Europeans at this time no doubt sounded an apprehensive ticking. Wound up to serve the industrial impulse, the human model of perfection culminated in a mechanized identity. Variations of this ideal continued into the nineteenth century with the expansion of large-scale industrial production. Scholar Julie Wosk writes,

> artists' images of automatons became central metaphors for the dreams and nightmares of societies under-going rapid technological change. In a world where new labor-saving inventions were expanding human capabilities and where a growing number of people were employed in factory systems calling for rote actions and impersonal efficiency, nineteenth-century artists confronted one of the most profound issues raised by new technologies: the possibility that people's identities and emotional lives would take on the properties of machines.[5]

But was this not exactly what was desired by one part of the population – that another part of the population become mechanical? Was this not also exactly what was feared? The artists, depicting an experience already lived by a large portion of the population, were reflecting a situation in which the relation – and the distinction – between the machine and the human became a question of gender and class.

The pre-industrial representation of *L'Horlogère* thus functions as an early prototype of later conceptual models of the cyborg. The woman is a clock, the clock is a woman

– complex, mechanical, serviceable, decorative. Her history can be traced to automatic dolls with clockwork parts dating back to at least the fifteenth century in Europe[6] and much earlier in China, Egypt and Greece.[7] Of the examples which I have found of such automata, a decided majority represent female bodies providing some form of entertainment.

> The idea of automatons as useful servants and amusing toys continued in the designs of medieval and Renaissance clockmakers, whose figures, deriving their movements from clock mechanisms, struck the hours.[8]

The history of the automaton is thus imbedded in the mechanical innovations of keeping time, and *L'Horlogère* undoubtedly derives much of her status from this social context. She is clearly an embodied mechansim, but she has the privilege of her class. The imaginative engraver who produced this image undoubtedly wished to portray *L'Horlogère* as aristocratic; as one who could acquire, and therefore represent, the height of technological development. As machine, she displays the skill and artistry of the best engineers of her epoch. The fact that she represents a female body is indicative of the role she is meant to play as the objectification of cultural sophistication and sexuality. Her gender is consistent with the property status of an eighteenth-century decorative artifact.

L'Horlogère is not merely an automaton. As part human, she should have human agency, or some form of human being. Her implied space of agency is, nevertheless, tightly circumscribed. This cyborg appears more trapped by her mechanical parts than liberated through them. If a cyborg is 'the figure born of the interface of automaton and autonomy', then to what degree can this cyborg be read as a servant and toy, and to what degree an autonomous social agent? In order to determine the character of any given cyborg identity and the range of its power, one must be able to examine the *form* and not merely the *fact* of this interface between automaton and autonomy. For, despite the potentially progressive implications of a cyborg subject position,[9] the cyborg is not necessarily more likely to exist free of the social constraints which apply to humans and machines already. 'The machine is us, our processes, an aspect of our embodiment,'[10] writes Donna Haraway. It should therefore come as no surprise that the traditional, gendered roles of Euro-American culture are rarely challenged in the visual representations of cyborgs – a concept which itself arises from an industrially 'privileged' Euro-American perspective. Even the conceptual predecessors of the cyborg are firmly grounded in everyday social politics; 'Tradition has it that the golem first did housework but then became unmanageable.'[11] The image of *L'Horlogère* thus provides a useful ground and a visual tradition from which to explore and compare more contemporary examples of cyborg bodies.

Signs of changing consciousness

The image of the cyborg has historically recurred at moments of radical social and cultural change. From bestial monstrosities, to unlikely montages of body and machine parts, to electronic implants, imaginary representations of cyborgs take over when traditional bodies fail. In other words, when the current ontological model of human being does not fit a new paradigm, a hybrid model of existence is required to encompass a new, complex and contradictory lived experience. The cyborg body thus becomes the

historical record of changes in human perception. One such change may be reflected in the implied redefinition of the space the cyborg body inhabits.

Taking, for example, the 1920 photomontage by Hannah Höch entitled *Das schöne Mädchen* (The Beautiful Girl) it is possible to read its dynamic assemblage of images as an allegory of modernization. Allied with the Dadaists of the Weimar Republic, Höch provided a chaotic vision of the rapid social and cultural change that followed in the wake of the First World War. In *Das schöne Mädchen* the figure of a woman is set in the midst of a disjointed space of automobile and body parts. BMW logos, a severed hand holding a watch, a flying wig, a parasol, a hidden feminine face and a face-less boxer leaping through the tyre of a car surround the central figure whose head has been replaced with an incandescent light bulb – perhaps as the result or condition of her experience.

Many of Höch's early photomontages focus on what might be called the 'New Woman' in Weimar Germany. These images are not simply a celebration of new, 'eman-cipated' roles for women in a period of industrial and economic growth, they are also critical of the contradictory nature of this experience as depicted in the mass media. 'Mass culture became a site for the expression of anxieties, desires, fears and hopes about women's rapidly transforming identities,' writes Maude Lavin in her book *Cut With the Kitchen Knife: The Weimar Photomontages of Hannah Höch*.

'Stereotypes of the New Woman generated by the media could be complex and contradictory: messages of female empowerment and liberation were mixed with others of dependence, and the new consumer culture positioned women as both commodities and customers.'[12] Existing across several domains, the New Woman was forced to expe-rience space and presence in new and ambiguous ways. Travelling through and across this space could therefore be both physically and psychologically disorienting. The expe-rience of a disjointed modern space takes form in Höch's collage as a cyborg body suspended in chaotic perspective (the hand-held parasol in the image is reduced to one-tenth the size of the figure's floating hair), with body parts chopped off, and with new mechanical/electric parts added in their place (the missing hand severed at the figure's wrist reappears holding the watch in the foreground). It is impossible to tell exactly which spatial plane is occupied by the body and of what sort of perception this body is capable. Yet, despite her Dadaist affiliation, Höch's work tends not to be random. Her images produce a discordant but strikingly accurate appraisal of an early twentieth-century experience of modernism. Here, existence as a self-contained humanist subject is overcome by an experience of the body in pieces – a visual representation of an unconscious state of being that exceeds the space of the human body. Perception is aligned to coincide with the machine. The effects of such an alignment are made alarmingly transparent by Virginia Woolf in her 1928 novel *Orlando*. In her description of the uncanny event of experiencing the world from the perspective of the auto-mobile, her metaphor of torn scraps of paper is particularly appropriate to Höch's use of photomontage.

> After twenty minutes the body and mind were like scraps of torn paper tumbling from a sack, and indeed, the process of motoring fast out of London so much resembles the chopping up small body and mind, which precedes unconsciousness and perhaps death itself that it is an open question in what sense Orlando can be said to have existed at the present moment.[13]

The questionable existence of Orlando, Virginia Woolf's protagonist who changes gender and who adapts to social and cultural changes across many centuries and continents, is not unlike the questionable existence of the cyborg. It is the existence of a shifting consciousness that is made concrete only in moments of contradictory experience. The attempt to represent and reassemble – but not to repair – the multiple scraps of body and mind that are scattered at such historical junctures has, in fact, been a central activity of modernism.

Photomontage has served as a particularly appropriate medium for the visual exploration of cyborgs. It allows apparently 'real' or at least indexically grounded representations of body parts, objects and spaces to be rearranged and to function as fantastic environments or corporal mutations. Photographs seduce the viewer into an imaginary space of visually believable events, objects and characters. The same can be said of assemblage – the use of found or manufactured (often commonplace) objects to create a three-dimensional representational artifact. The common contemporary practice of representing a cyborg through photomontage or assemblage resembles the poetic use of everyday words: the discrete elements are familiar, though the total result is a new conceptual and ontological domain.

One of Höch's compatriots, Dadaist Raoul Hausmann, pictured this new ontological domain in several of his own photomontages and found-object assemblages. Unlike Höch's representations, however, Hausmann's images represent a more cerebral concept of the modern experience. Rather than a body in pieces, he depicts a mechanical mind. His assemblage *Tête méchanique* (Mechanical Head) is a particularly appropriate example of a cyborg mind. Also called 'The Spirit of Our Times', this assemblage consists of the wooden head of a mannequin to which are attached diverse cultural artifacts. A wallet is fixed to the back, a typographic cylinder in a small jewel box is on one side of the heard, a ruler attached with old camera parts is on the other side. The forehead is adorned with the interior of a watch, random numbers and a measuring tape, and a collapsible metal cup crowns the entire ensemble. Timothy O. Benson writes that this assemblage depicts a man imprisoned in an unsettling and enigmatic space, 'perceiving the world through a mask of arbitrary symbols'.[14] At the same time it functions as a hyper-historical[15] object collection; a testament to Hausmann's own contemporary material culture. The cyborg in this case is not without origins, though it is without origin myths. Donna Haraway contends that cyborgs have no natural history, no origin story, no Garden of Eden and thus no hope of, nor interest in, simplistic unity or purity. Nevertheless, given their multiple parts, and multiple identities, they will always be read in relation to a specific historical context. According to scholar Matthew Biro,

> by fashioning his cyborgs out of fragments of the new mass culture which he found all around him, Hausmann also believed he was fulfilling the primary positive or constructive function he could still ascribe to dada: namely, the material investigation of the signs and symbols bestowed on him by his historical present.[16]

Until the desire to define identities and the power to do so is lost or relinquished, even the most spontaneous cyborgs cannot float above the lingering, clinging past of differences, histories, stories, bodies, places. They will always function as evidence.

The new spatial relations of the human body are thus traced onto the cyborg body. Höch's figure is fragmentary and dispersed, floating in an untethered perspective.

Hausmann's figure implies a calculable context that is linear, a cerebral space of measurement and control. Each cyborg implies a new spatial configuration or territory – a habitat. For Höch's *Beautiful Girl*, the world is a space of multiple perspectives, consumer goods, lost identities and fleeting time. The world in which Hausmann's *Mechanical Head* operates is one that links identity to material objects, and is simultaneously an environment in which knowledge is the result of a random encounter with the world of things. Hausmann himself described this assemblage as representing an everyday man who 'has nothing but the capacities which chance has glued to his skull'.[17] Sense perception itself is accounted for only to the degree that appears in the image of the cyborg body. Sight, hearing and tactile senses can only be implied by the body's exterior devices. The *Mechanical Head*, for example, has no ears to 'hear' with, only a mechanical ruler and jewel case. *The Beautiful Girl* has neither eyes nor ears, nor mouth to speak with, only a light bulb for illumination. The human head which gazes from the corner of this image is at best the memory of what has been displaced. A new social space requires a new social being. A visual representation of this new being through an imaginary body provides a map of the layers and contradictions that make up a hyper-historical 'positive unconscious'. In other words, the cyborg body marks the boundaries of that which is the underlying but unrecognized structure of a given historical consciousness. It turns the inside out.

White collar epistemology

Turning the outside in, Phoenix Technologies Ltd produced an advertisement for their new Eclipse Fax in 1993. The advertisement's lead-in text reads: 'Eclipse Fax: if it were any faster, you'd have to send and receive your faxes internally.' The text floats over an image of a pale woman's head and shoulders. It is clear from the image that the woman is on her back as her long hair is splayed out around her head. Her shoulders are bare, implying that she is unclothed. Mechanical devices comprised of tubes, metal plugs, cables, hoses and canisters appear to be inserted into her ears, eye sockets and mouth. Two electrodes appear to be attached to the woman's forehead, with wires extending out to the sides, almost like the antennae of an insect. A futuristic Medusa's head of wires, blinded with technology, strapped to the ground with cables and hoses, penetrated at every orifice with the flow of information technologies, this is a subjugated cyborg. Her monstrous head is merely a crossroads. All human parts of the image are passive and receptive. Indeed it seems clear that the blind silence of this clearly female creature is the very condition for the possibility of information flow. This is not a cyborg of possibilities, it is a cyborg of slavery. The advertisement promises that the consumer will be able to send and receive faxes 'without being interrupted', and concludes that 'to fax any faster, you'd have to break a few laws. Of physics'. Here the new technology is not only seen as always available, but also as somehow pushing the boundaries of legality – even if only metaphorically – in the use of the body. This is the bad-boy fantasy prevalent in so many images of feminized cyborgs. The textual emphasis on speed in this advertisement is but a thin veil through which the underlying visual metaphor of information flow as sexual penetration bursts forth. For many, this is already an apt metaphor for cyborg body politics: knowledge as force-fed data.

What *are* the consequences of a montage of organic bodies and machines? Where do the unused parts go? What are the relations of power? Is power conserved? Is the loss of power in one physical domain the necessary gain of power for another? Who writes the laws for a cyborg bill of rights? Does everyone have the 'right' to become any kind of cyborg body? Or are these 'rights' economically determined? These are questions that arise in the attempt to figure a politics of cyborg bodies. A visualization of this hypothetical existence is all the more important for its reflection of an already current state of affairs.

The power of plenitude

Robert Longo's sculpture/installation entitled *All You Zombies: Truth before God*, stages the extreme manifestation of the body at war in the theatre of politics. The glow of many painted lights hang within the frame of a semicircular canvas – an opera house or concert hall – that surrounds a monstrous cyborg soldier who takes centre stage on a revolving platform. The chasm between the implied context of cultural refinement and the uncanny violence of a body that defies any and all such spaces, visually enunciates the collaboration that is always found between so-called civilization and its barbarous effects. The central figure is a cultural and semiotic nightmare of possibilities; an inhabitant of what Hal Foster has described as 'the war zone between schizoid obscenity and utopian hope'.[18] In a helmet adorned with diverse historical signs, the cyborg's double face with two vicious mouths snarls through a mask of metal bars and plastic hoses that penetrate the surface of the skin. One eye is blindly human, the other is a mechanical void. A feminine hand with razor sharp nails reaches out from the centre of the chest, as if to escape from within. With arms and legs covered in one-cent scales, clawed feet, legs with fins, knee joints like gaping jaws, serpents hanging from the neck, insects swarming at the genitals, hundreds of toy soldiers clinging to the entrails and ammunition slung across the body, this beast is a contemporary monster – what Longo has called 'American machismo'.[19] The cyborg might be what Robert Hughes saw in the Dadaist obsession with war cripples, 'the body re-formed by politics: part flesh, part machine'.[20] In this light, it may seem to embody the very 'illegitimate offspring of militarism and patriarchal capitalism' that Haraway problematizes in her 'Cyborg Manifesto'.[21] But in fact Longo's sculpture describes a rebellion against these institutions, who are better represented by the familiar corporate or government-owned, sterile, fantasy figures such as RoboCop.

Instead of an asexual automaton, Longo's creature represents a wild manifestation of human, animal and mechanical sexual potency and violence. With one artificially-rounded bare breast, and one arm raised, holding a torn flag to a broken pole, the figure is remarkably reminiscent of Delacroix's *Liberty Leading the People*. Her incongruous presence has the power to capture the imagination of the viewer through an embodiment of a maternal wrath and revolutionary zeal. At the same time the creature is not without his penis, protruding but protected in a sheath of its own armour (the wings of a powerful and no doubt stinging insect). Whether the cyborg is bisexual or not, it certainly has attributes of both human sexes. Interestingly, none of the three critics writing about this work in the exhibition catalogue mention this fact. Indeed, they all fail to acknowledge that the creature has any female attributes at all. Although the body overall has

a masculine feel of weight and muscular bulk, this is clearly not a single-sex being. It storms across several thresholds; that between male and female, life and death, human and beast, organic and inorganic, individual and collective. To a certain degree then, this might be considered a hybrid body; a body which 'rejoices' in the illegitimate fusions of animal and machine'.[22]

Historically, genetic engineering and cyborg bodies have produced similar fears about loss of human control – if there ever was such a thing – over the products of human creation. Barbara Stafford in her book *Body Criticism: Imagining the Unseen in Enlightenment Art and Medicine*, writes that in the eighteenth century,

> The hybrid posed a special problem for those who worried about purity of forms, interfertility, and unnatural mixtures. Both the plant and animal kingdoms were the site of forced breeding between species that did not amalgamate in the wild. The metaphysical and physical dangers thought to inhere in artificial grafts surfaced in threatening metaphors of infection, contamination, rape, and bastardy.[23]

Robert Longo's sculpture functions as an iconography of this metaphysics. It appears to be the very amalgamation of organic and inorganic elements that is the result of a dangerous and threatening mutation. But what makes this 'hybrid' fusion 'illegitimate'?

Fraught with many contradictory cultural connotations, the term 'hybrid' itself demands some explanation before it can be used in any casual way – as it has been – to describe a cyborg body. The term appears to have evolved out of an early seventeenth-century Latin usage of *hybrida* – a cross-bred animal.[24] Now the word has several meanings, among them: a person or group of persons reflecting the interaction of two unlike cultures, traditions, etc.; anything derived from heterogeneous sources or composed of elements of different or incongruous kinds; bred from two distinct races, breeds, varieties, species or genera. These definitions reveal a wide range of meaning, allowing for easy application, but little semantic substance. What makes the term controversial, of course, is that it appears to assume by definition the existence of a non-hybrid state – a pure state, a pure species, a pure race – with which it is contrasted. It is this notion of purity that must, in fact, be problematized. For if any progress is to be made in a politics of human or cyborg existence, heterogeneity must be taken as a given. It is therefore necessary to imagine a world of composite elements without the notion of purity. This, it seems, is the only useful way to employ the concept of the hybrid: as a combination of elements that, while not in themselves 'pure' nonetheless have characteristics that distinguish them from the other elements with which they are combined. Hybridity must not be tied to questions of legitimacy or the patriarchal lineage and system of property which it implies. Rather, it must be recognized that the world is comprised of hybrid encounters that refuse origin. Hybrid beings are what we have always been – regardless of our 'breeding'. The visual representation of a hybrid cyborg thus becomes a test site for possible ways of being in the world. Raging involuntarily even against its own existence, the hybrid figure in *All You Zombies: Truth before God*, stands as its own terrible witness of a militarized capitalist state. As a body of power, active within its multiple selves, though mercenary in its politics, this cyborg is as legitimate as any other.

Passing

When I began to explore visual representations of cyborg bodies, I was originally moti-
vated by a desire to unravel the relationship between representations of cyborgs and
representations of race and racial mixtures.[25] I was brought to this point by the obser-
vation that in many of the texts written about and around the concept of cyborgs the
term 'miscegenation' was employed. Not only that, there seemed to be a general
tendency to link the 'otherness' of machines with the otherness of racial and sexual
difference. I encountered statements such as the following:

> But by 1889 [the machine's] 'otherness' had waned, and the World's Fair
> audience tended to think of the machine as unqualifiedly good, strong, stupid
> and obedient. They thought of it as a giant slave, an untiring steel Negro
> controlled by Reason in a world of infinite resources.[26]
>
> Hence neither the identification of the feminine with the natural nor the
> identification of the feminine with the cultural, but instead, their uncertain
> mixture – *the miscegenation of the natural and the cultural* – is what incites, at
> once, panic and interest.[27]

The history of a word is significant. While the word 'hybrid' has come to have ambiguous
cultural connotations, words such as 'illegitimate' and 'miscegenation' are much
more problematic. The latter is believed to have been 'coined by US journalist David
Goodman Croly (1829–89) in a pamphlet published anonymously in 1864'.[28] 'Mis-
cegenated' unlike 'hybrid' was originally conceived as a pejorative description, and I
would agree with scholar Stephanie A. Smith that 'This term not only trails a violent
political history in the United States but is also dependent on a eugenicist, genocidal
concept of illegitimate matings.'[29] At the same time, this may be the very reason that
certain writers have employed the term – to point out the 'forbidden' nature of the
'coupling' of human and machine. (But, as others have made quite clear, this depen-
dence upon metaphors of sexual reproduction is a problem of, rather than the solution
to, conceptions of cyborg embodiment.) Lingering in the connotations of this usage are,
of course, references to racial difference.

While there are several images I have encountered of cyborgs that appear to be
racially 'marked' as not 'white' (*Cyborg* by Lynn Randolf being among the better known
and more optimistic of these images), none struck me as so emblematic of the issues
with which I was concerned as those found by my colleague Elena Tajima Creef in the
1991 Japanese comic book *Silent Möbius*.[30] In part one, issue six, there is the story of a
young woman of colour. (Her hair is green, and her face is structured along the lines
of a typical Euro-American comic-book beauty with big eyes – that not insignificantly
fluctuate between blue and brown – and a disappearing nose and mouth. Yet her skin
is a lovely chocolate brown. She is the only character of 'colour' in the entire issue and
she is clearly a 'hybrid'.) When we encounter her at the beginning of the story she is
identified as a member of a futuristic feminine police force who is rehabilitating in the
hospital. She is then seen racing off in a sporty jet vehicle after some dreaded foe. After
pages of combat with an enemy called 'Wire', it appears that she has won by default.
She then declares that she must expose something to her love interest, a white young
man with red hair. She disrobes, pulls out a weapon of some kind and proceeds to melt
off her beautiful skin (looking more and more like chocolate as it drips away from her

body), revealing to her incredulous and aroused audience that she is in fact a cyborg. Her gray body underneath looks almost white. She says, 'This is my body Ralph. Seventy percent of my body is bionic, covered with synth-flesh. Three years ago, after being cut to pieces, I was barely saved by a cyber-graft operation. But I had it changed to a combat graft.' 'Why?', Ralph asks. 'So I could become as strong as Wire, the thing that destroyed my life.' But she goes on to say, 'Eventually I started to hate this body. I wasn't femi-nine anymore. I was a super-human thing. I hated this body even though I wanted it. I didn't want to accept it. I kept feeling it wasn't the way I was supposed to be.' As she speaks the reader is given more views of her naked body with gray, cyborg parts laid bare beneath disappearing brown skin. In the end she says, 'I think I can finally live with what I have become.'[31]

'Kiddy', for that is her diminutive name, is typical of contemporary (mostly male-produced) cyborg fantasies: a powerful, yet vulnerable, combination of sex toy and techno-sophisticate – in many ways not unlike L'Horlogère. But she is not an awkward machine with tubes and prosthetics extending from joints and limbs. She is not wearing her power on the outside of her body, as does Robert Longo's sculpture, nor is she broken apart and reassembled into disproportionate pieces, as in the case of Hannah Höch's photomontage. Rather she is an 'exotic' and vindictive cyborg who passes – as simply human. It is when she removes her skin that she becomes the quintessential cyborg body. For in the Western imaginary, this body is all about revealing its internal mechanism. And Kiddy is all about the seduction of the striptease, the revelation of the truth, of her internal coherence; which, ultimately, is produced by the super-technicians of her time. Her 'real' identity lies beneath the camouflage of her dark skin – rather than on its surface.

'Passing' in this case has multiple and ominous meanings. Initially this cyborg body must pass for the human body it has been designed to replicate. At the same time, Kiddy must pass for the feminine self she felt she lost in the process of transformation. Staging the performance of 'true' identity, Kiddy raises certain questions of agency. Must she reveal the composition of her cyborg identity? Which seventy percent of her original self was lost? Which thirty percent was kept? Who is keeping track of percentages? What are the consequences of this kind of 'passing', especially when the body is so clearly marked with a sign – skin colour – of historical oppression in the West? Why does Kiddy feel her body is not the way it is 'supposed to be'? Has it been allowed unusual access to technological freedoms? Is the woman of colour necessarily a cyborg? Or is Kiddy also only 'passing' as a woman of colour? What are the possible conse-quences of this reading: I leave these questions open-ended.

From my encounter with the world of cyborgs, and any cyberspace that these bodies may inhabit, I have seen that the question of race is decidedly fraught. Some see cyborgs and cyberspace as a convenient site for the erasure of questions of racial identity – if signs of difference divide us, the logic goes, then the lack of these signs might create a utopian social-scape of equal representation. However, the problem with this kind of e-race-sure is that it assumes differences between individuals or groups to be primarily superficial – literally skin deep. It also assumes that the status quo is an adequate form of representation. Thus the question over which so much debate arises asks: are there important differences between people (and cyborgs), or are people (and cyborgs) in some necessary way the same? The answers to this two-part question must be yes, and yes. It is the frustration of living with this apparent contradiction that drives people to

look for convenient alternatives. As industrialized Western cultures become less homogeneous, this search intensifies. Cyborg bodies will not resolve this contradiction, nor do they – as yet – function as radical alternatives. It may be that the cyborg is now in a new and progressive phase, but its 'racial' body politics have a long way to go. At best, the configuration of the cyborg, which changes over time, will virtually chart human encounters with a contradictory, lived experience and continue to provide a vision of new ontological exploration.

Originally published in C. Gray (ed.) (1995) *The Cyborg Handbook*, London: Routledge. This essay has been edited for inclusion in the Reader.

Notes

Acknowledgements: I would like to thank all of the friends and colleagues who have helped, and continue to help, in my search for images of cyborg bodies, and who have pointed me in the direction of useful literature on the topic; especially Elena Tajima Creef, Joe Dumit, Douglas Fogle, Chris Hables Gray, Donna Haraway, Vivian Sobchack and the Narrative Intelligence reading group at the MIT Media Lab.

1. Donna Haraway, *Primate Visions: Gender, Race and Nature in the World of Modern Science* (New York: Routledge, 1989), p. 139.
2. Donna Haraway alludes to such a consciousness in her essay 'A Cyborg Manifesto,' in *Simians, Cyborgs, and Women: The Reinvention of Nature* (New York: Routledge, 1991).
3. Michel Foucault. *The Order of Things: An Archaeology of the Human Sciences* (New York: Vintage Books, 1973). Foucault explains his project in this text as significantly different from earlier histories and epistemologies of science by suggesting that he wishes to reveal a 'positive unconscious' of knowledge – 'a level that eludes the consciousness of the scientist and yet is part of scientific discourse'. (p. xi) This 'positive unconscious' can be thought of as 'rules of formation, which were never formulated in their own right, but are to be found only in widely differing theories, concepts, and objects of study.' (p. xi) One might also think of this notion as akin to certain definitions of ideology. It is useful for my purposes to the degree that it implies an unconscious but simultaneously proactive and wide-ranging discourse, in this case, of cyborg bodies.
4. Quoted in Julie Wosk, *Breaking Frame: Technology and the Visual Arts in the Nineteenth Century* (New Brunswick: Rutgers University Press, 1993), p.81.
5. Ibid. p. 79.
6. Ernst von Bassermann-Jordan, *The Book of Old Clocks and Watches*, trans. H. Alan Lloyd (London: George Allen & Unwin Ltd, 1964), p. 15.
7. 'The delight in automatons extended back even earlier to ancient Egyptian moving statuettes with articulated arms, and to the automatons of ancient Chinese, ancient Greek and medieval Arab artisans, as well as to European clockmakers of the medieval and Renaissance periods [. . .] Homer in *The Illiad* described two female automatons who aided the god Haphaestus, the craftsman of the gods. The women were "golden maidservants" who "looked like real girls and could not only speak and use their limbs but were endowed with intelligence and trained in handiwork by the immortal gods."' See Wosk, *Breaking Frame*, pp. 81–2.
8. Ibid. p. 82.
9. 'From another perspective, a cyborg world might be about lived social and bodily realities in which people are not afraid of their joint kinship with animals and machines, not afraid of permanently partial identities and contradictory standpoints [. . .] Cyborg unities are monstrous and illegitimate; in our present political circumstances, we could hardly hope for more potent myths for resistance and recoupling'. Haraway, 'A Cyborg manifesto', p. 154.
10. Ibid. p. 180.
11. Patricia S. Warrick, *The Cybernetic Imagination in Science Fiction*. Cambridge (MA: MIT Press, 1980), p. 32.

12. Maude Lavin, *Cut With a Kitchen Knife* (New Haven: Yale University Press, 1993), p. 2.

13. Virginia Woolf, *Orlando* (New York: Harcourt Brace Jovanovich Publishers, 1928), p. 307.

14. Timothy O. Benson, *Raoul Hausmann and Berlin Dada* (Ann Arbor: University of Michigan Research Press, 1987), p. 161.

15. I use the term hyper-historical to connote an object or existence that appears to be synchronous with a very specific moment in history, but that seems to have had not coherent evolutionary past, nor developing future. The concept was originally conceived in order to salvage the seemingly a-historical status of the cyborg in Donna Haraway's description of this term (see *Simians, Cyborgs, and Women: The Reinvention of Nature*). She writes that the cyborg has no myth of origin, but I do not think she means to imply that it has no historical presence. Rather it has a presence that is so entirely wrapped up in a state of contemporary and multiple being that it is an exceptionally clear marker of any given historical moment – even when it makes references to the past.

16. Matthew Biro, 'The Cyborg as New Man: Figures of Technology in Weimar and the Third Reich'. Unpublished manuscript delivered at the College Art Association Conference, New York 1994.

17. Benson, *Raoul Hausmann*, p. 161.

18. Hal Foster. 'Atrocity Exhibition,' in Howard N. Fox (ed.), *Robert Longo* (Los Angeles: Los Angeles County Museum of Art and New York: Rizzoli, 1989). 'It is in the war zone between schizoid obscenity and utopian hope that the art of Robert Longo is now to be found' (p. 61).

19. Howard N. Fox. 'In Civil War', in *Robert Longo*. 'Longo describes the monster as an image of "American machismo", a confusion of vitality and vigor with warlike destructiveness' (p. 43).

20. Robert Hughes, *The Shock of the New* (New York: Alfred A. Knopf Inc. 1980), p. 73.

21. Haraway. 'A Cyborg Manifesto', p. 151.

22. Ibid. p. 154.

23. Barbara Maria Stafford, *Body Criticism: Imagining the Unseen in Enlightenment Art and Medicine* (Cambridge, MA: The MIT Press, 1991), p. 264.

24. Random House Dictionary (Unabridged edition, 1993).

25. The term 'race' is itself problematic and relies upon a history of scientific and intellectual bias. I use it here because the term has come to have a common-usage definition referring to genetic phenotype. Regardless of my distaste for this usage, I nevertheless recognize the real relations of power that are structured around it. It would be naïve to ignore the ways in which this concept is employed and deployed. Here I try to point out the role of the idea of 'race' in the conception of cyborg bodies.

26. Hughes, *The Shock of the New*, p. 11.

27. Mark Seltzer, *Bodies and Machines* (New York: Routledge, 1992). p. 66.

28. Random House Dictionary (Unabridged edition, 1993).

29. Stephanie A. Smith, 'Morphing, Materialism and the Marketing of *Xenogenesis*', *Genders*, no. 18, winter 1993, p. 75.

30. Elena Tajima Creef is Assistant Professor of Women's Studies at Wellesley College. She discusses *Silent Möbius* in relation to issues of race and representation in, 'Towards a Genealogy of Staging Asian Difference', a chapter of her dissertation 'Re/orientations: The Politics of Japanese American Representation'.

31. Kia Asamiya, 'Silent Möbius', part 1, no. 6. trans. James D. Hudnall and Matt Thorn (Viz Communications Japan, Inc. 1991), pp. 34–6.

Post-(cyber)bodies

DAVID BELL

INTRODUCTION

THE TASK OF 'ENVISIONING CYBORG bodies', taken up by Jennifer González at the end of section six, returns in the essays which comprise this section of the Reader. As Mark Dery (1996: 292) writes, 'speculations about the fate of the body and debates over the promises and threats of posthumanism resound throughout cyberculture', and the six essays collected here under the heading 'post-(cyber)bodies' all make their own speculations and offer their own promises or threats. Each chapter deals with a particular vector of the debate on the human–machine interface in digital culture, and while not all of them explicitly discuss post-humanism, there is at least an implicit recognition that the future of the human body cannot be separated from the future of technology. In his book, *Escape Velocity*, Dery (1996) catalogues some of the scientific speculations about this growing human–machine intimacy, finding human immortality promised either through nanotechnological intervention or through the digitizing of human consciousness – and similar projections of cyborgian futures permeate the essays here: from Stelarc's manifesto for post-human evolution to Mike Featherstone's consideration of the liberatory potential of Virtual Reality (VR) for the elderly, and from Lisa Cartwright's exploration of the Visible Human Project to Susan Stryker's essay on the transsexual body *as* technology.

We begin the section with Stelarc's 'From psycho-body to cyber-systems', coupling this with Mark Dery's introduction to and commentary on Stelarc's work and ideas. Through performance art and through his manifestos, Stelarc is exploring the human–machine interface within the context of post-humanism (see the earlier discussion of post-humanism by Terranova in section three). Starting with perhaps his most famous provocation – that *the human body is obsolete* – Stelarc urges us to embrace new technologies, to welcome them into our bodies: 'the body must burst from its biological, cultural and planetary containment', he insists. He depicts the current human body as at an evolutionary dead-end, picking out its inefficiencies and frailties (this might

instructively be read alongside Featherstone's essay on aging), adding that 'the capabilities of being a body are constrained by having a body'. Mutation, symbiosis, incorporation; these are the next evolutionary steps for Stelarc, who once ingested a 'stomach sculpture', making his own insides into a gallery. His descriptions of performance pieces such as 'Amplified Body, Laser Eyes and Hand' and 'Virtual Body: Actuate/Rotate', which combine biomedical hardware, VR software and the artist's own wetware, show the ways Stelarc is trying to enact this cyborgization in his art; Dery's account of a Stelarc performance evokes the spectacle vividly. (See also Gromala's chapter in this section for another artist's work on the body in VR.)

Stelarc dismisses 'Frankensteinian fear of tampering with the body', finding in human–machine co-evolution instead 'an alien awareness – one that is posthistoric, transhuman and even extraterrestrial'. As Dery writes, Stelarc adopts and adapts Marshall McLuhan's idea that 'the vertiginous whirl of the information age has outpaced and overtaxed the nervous system'; his performances, then, are read by Dery as 'dress rehearsals for posthuman evolution'. However, Dery introduces a now-familiar dose of 'reality', asking 'Who builds these machines anyway? . . . [W]ho writes the code that creates the "high-fidelity illusion of tele-existence?" Who controls the remote controllers?' What this means, he says, is that we need a 'politics of posthumanism' (again, this echoes critiques of other technophiliacs such as the extropians; see Terranova). Against this, Stelarc refuses anything other than literal readings of his work, arguing that they are about 'ideas, not ideologies' – this is, of course, troubling for a cybercultural analysis which is aware of the structural contexts of new technology (see Escobar or Robins, for example).

A completely different take on the human–technology interface (though with some common motifs) is provided by Susan Stryker in 'Transsexuality: the postmodern body and/as technology'. Her essay begins allegorically, with the tale of 'Christine Jorgensen's atom bomb' (Jorgensen was a male-to-female [MTF] transsexual who, in the late 1940s, self-administered estrogen to 'technologize her becoming-woman', and whose sex-change surgery made front-page news); Stryker reads Jorgensen's story against the backdrop of atomic bomb testing, writing that 'the transsexual body, by corporealizing the transformation of a human existence through scientific technology . . . evoke[s] on a mass scale some of the same ambivalent fears inspired by the bomb'. While at one level both attest to scientific mastery, at another 'transsexual bodies and atomic bombs both confront the modern Western subject with the spectre of its own dissolution' (we could make a similar reading of Stelarc). Further, transsexuality rewrites the body as technology, as cyborgian (and maybe even as posthuman?): '[i]t provides a lesson in living as image, as object, as machine – even while offering active resistance to reductive definition by these terms'; it is a 'technologization of identity'.

While Stryker's initial focus is on the transsexual body-as-technology, and on photography as a technological practice intersecting with identity performance, in the second half of the essay she moves on to consider new media and communication technologies, raising some questions which resonate with many of the other essays written on the body in this Reader:

> What subjective qualities produced by the flesh persist in a technologized
> space that stages the body's absence? Do discourses like sex and race that

operate through the visual performativity of the flesh cease to matter in the new media domains, or do they just signify differently? How might flesh signify when it is not visually performative?

The experience of cyberspace, for Stryker, echoes the experience of transsexuality, of the body as technology: '[p]erformance extends easily from the warm thickness of meat into the attenuating pulse of electrons' (see also Foster, in section five). Against the post-human evolutionism of Stelarc, however, Stryker's body-as-technology does not negate being human: '[l]earning to live creatively with technology and as technology is not to abandon human subjectivity. ... Rather, it is to begin imagining new modes of subjectivity'.

The question of 'new modes of subjectivity' in cyberculture is also at the heart of Diana Gromala's 'Pain and subjectivity in virtual reality'. Her account begins with a useful reading of VR as 'a screen or mirror onto which we can project our deepest fears, hopes for utopia, cures for what ails us, or an escape from our current condition'. The substance of the essay concerns pain. Gromala recounts her first VR experience as in hospital, catching sight of the insides of her own body on a monitor, thrilling in 'the abject pleasure it produced'. Through a reading of Elaine Scarry's work on pain and subjectivity, Gromala theorizes VR as a 'problematic experience of the self and body' – a theorization which moves beyond many of those currently offered. Gromala's body-in-pain is analagous, in a way, to Stelarc's cyborg performance (indeed, her account of swallowing down a video camera resonates with Stelarc's 'Stomach Sculpture', while her interest in biomedical technologies clearly intersects with his work). Unlike Stelarc, however, structural questions remain prominent in Gromala's work: 'my body, through their tools and devices, is enhanced as a site through which social, political, economic and technological forces flow and collide' – these are evoked in VR installations drawing on a database of biomedical images of Gromala's body, such as 'Dancing with the Virtual Dervish: Virtual Bodies' (a useful comparison can likewise be made here with Cartwright's essay on the Visible Human Project).

'Dancing with the Virtual Dervish' draws on Scarry's discussion of pain's 'ability to destroy the language of the sufferer: one who experiences physical pain can neither have it confirmed nor denied' – this means than pain cannot be sharable (it is 'essentially subjective'), and thus blocks the projection of the self into the object world (which Scarry calls imagining). Gromala does not see VR as a way to share pain, but as an analagous experience of 'bodily disembodiment' (of simultaneously being in and not in the world; she suggests that similar 'boundary states' include *jouissance*, drug-taking and abjection – stages which also mess with embodiment and subjectivity; given Stryker's argument, we might add transsexuality to that list of boundary states). Theorizing VR experience in this way avoids the pitfalls of more simplistic arguments (that it simply means 'leaving the meat behind', for example).

Stelarc's pronouncements on the obsolescence of the human body resonate with Mike Featherstone's essay on aging and virtual reality. All the discussions of transgender, transsexual and transracial identity-play in cyberspace have tended to overlook the issue of age (reflecting, Featherstone suggests, the ageism of much cybertheory, which has focused on youthful cybercultures), yet the questions of embodiment, 'post-bodies' and identity-play all have potentially profound implications for the use of cyberspace by the

558 D A V I D B E L L

elderly. In addition, taking Stryker's body-as-technology alongside Stelarc's augmented post-human body, we can already note traces of the technologizing of the aging body in, among other things, pharmaceutical interventions (anti-aging creams, HRT, Viagra), surgical enhancements (facelifts, transplants) and prosthetic replacements (from false teeth and spectacles to pacemakers; remember R.U. Sirius' discussion of his mother as post-human in chapter 17 by Terranova). Adding in the possibilities of VR, Featherstone thus argues, 'could well have significant implications for the creation of a new set of images of what it means to be old':

> We could . . . argue here that what Haraway has done for feminism in terms
> of reconceptualizing the relationship between women, technology and the
> body, one could equally do for old age, through thinking through, in an
> equally radical manner, the potential for change.

There are, of course, broader structural questions concerning the position of the elderly in society to consider here – as well as questions of implications of the 'flight from aging' which dominates our ways of thinking about getting old. Is it possible to imagine uses of cyberspace by the elderly which aren't about prolonging 'midlifestyle', as Featherstone calls it? Empirical work with elderly users might usefully supplement Featherstone's speculative essay.

Of course, part of the 'flight from aging' is also a 'flight from death'. Post-humanist gurus promise immortality through technological enhancement or through digitizing memories, although some express a little ambivalence about this; Dery (1996: 294) quotes computer scientist Gerald Jay Sussman: 'I'm afraid, unfortunately, that I'm [part of] the last generation to die.' For some post-humans, of course, death is merely the first step in 'leaving the meat behind' – witness both Timothy Leary's on-line death, and the Heaven's Gate mass suicide. As with the prospect of uploading memory and conscious-ness, in these scenarios the body 'dies' but the 'mind' lives on. In the case of the Visible Human project (VHP), described in Lisa Cartwright's essay, the opposite occurs; as Catherine Waldby (1997: 13) writes, the VHP 'precisely reverses the relationship between obsolete body and recorded mind', since the VHP represents 'a recording of the flesh'. It is to the Visible Human Project, then, that our attention now turns.

Lisa Cartwright's 'The Visible Man: the male criminal subject as biomedical norm' presents the story of the VHP, in which the corpse of an executed Texan murderer, Joseph Paul Jernigan, has been digitized as 'one of biomedicine's prime models of normal human anatomy', made available on the World Wide Web, on CD-ROM and on video (the VHP also includes a female body, and awaits the addition of a foetus). Users can access different aspects of the bodies, roaming around and through them in cyber-space in almost infinite configurations, as the illustrations in Cartwright's essay indicate (the VHP has interesting links, then, to Gromala's 'Virtual Dervish', though with one fundamental difference: it lacks any agency on the part of the body opened up for an audience). Obviously, this digitized meat challenges us to think anew about questions of embodiment in cyberspace; similarly, the lifestory of the Visible Man raises questions about the criminal body and the state's power over that body and its postmortal uses. It is, in fact, a particularly profound site to rethink ownership of our bodies in life and in death, in the 'real world' and in the virtual.

Jernigan's execution, for example, seems like the obverse of post-human techno-logical augmentation (and can be read as a useful reminder that technology can have negative as well as positive impacts on the body): Jernigan was administered with a lethal injection that effectively made him 'forget to breathe' – as Cartwright puts it, a catheter fitted to his hand 'functioned as a kind of prosthetic disciplinary hand of the state of Texas, allowing prison officials chemically to reach into Jernigan's body and switch off the basic unconscious mechanism that regulated his breathing': biomedical technologies, held up by post-human gurus as offering the promise of immortality, can also bring about biologically premature mortality. While this death is recast in promo-tions of the VHP as eternal rebirth through simulation (the bodies can be animated to appear 'live'), Waldby (1997: 14) suggests that such a reanimated corpse is uncanny, Frankensteinian, ghost-like – it cannot escape its 'debt to mortality', and thus remains 'ghosted by the spectacle of death': Jernigan represents the digital undead. Further, Jernigan's live status as a criminal ward of state has, in Cartwright's analysis, bled over into his death and into his body's 'afterlife'; the privileges withheld from him in incar-ceration (including, crucially, the right to bodily privacy) will haunt his body forever: '[t]he universal biomedical subject is thus a subject stripped of his rights to privacy and bodily integrity, even after death'.

The future of the human body in digital culture is, therefore, full of either promises or threats, depending on which way you look at it. For Stelarc, as for other post-humanism advocates, new technologies offer new bodies, new modes of being (post-) human. Even in the more pragmatic analysis undertaken by Mike Featherstone, new technologies can reconfigure the biological processes of aging, potentially redefining the path of the lifecourse. However, the Visible Man raises questions about the status of the post-human, echoed in Mark Dery's questions about who is in control of the tech-nologies of the post-body; if, like Joseph Jernigan, our post-bodies are surrendered into the ether, to be manipulated by other users beyond our control, then post-humanism begins to look like eternal torment rather than Edenic digital immortality.

References

Dery, M. (1996) *Escape Velocity: Cyberculture at the End of the Century*, London: Hodder & Stoughton.
Waldby, C. (1997) 'Revenants: the Visible Human Project and the digital uncanny', *Body & Society* 3 (1): 1–16.

STELARC

FROM PSYCHO-BODY TO CYBER-SYSTEMS
Images as post-human entities

THE BODY NEEDS TO BE REPOSITIONED from the psycho realm of the biological to the cyber zone of the interface and extension – from genetic containment to electronic extrusion. Strategies toward the post-human are more about erasure, rather than affirmation – an obsession no longer with self but an analysis of structure. Notions of species evolution and gender distinction are remapped and reconfigured in alternate hybridities of human–machine. Outmoded metaphysical distinctions of soul–body or mind–brain are superseded by concerns of body–species split, as the body is redesigned – diversifying in form and functions. Cyborg bodies are not simply wired and extended but also enhanced with implanted components. Invading technology eliminates skin as a significant site, an adequate interface, or a barrier between public space and physiological tracts. The significance of the cyber may well reside in the act of the body shedding its skin. And as humans increasingly operate with surrogate bodies in remote spaces they function with increasingly intelligent and interactive images. The possibility of autonomous images generates an unexpected outcome of human–machine symbiosis. The post-human may well be manifested in the intelligent life form of autonomous images.

1. BEYOND AFFIRMATION INTO ERASURE: Can we re-evaluate the body without resorting to outmoded Platonic and Cartesian metaphysics? The old and often arbitrary psycho-analytical readings have been exhausted. Postmodern critiques generate a discourse of psycho-babble that not so much reveals but entraps the body in the *archetypical* and *allegorical*. The obsession with the self, sexual difference and the symbolic begins to subside in cyber-systems that *monitor*, *map* and *modify* the body. Increasing augmentation of the body and automation by transferring its functions to machines undermines notions of free agency and demystifies mind. CYBER-SYSTEMS SPAWN ALTERNATE, HYBRID AND SURROGATE BODIES.

2. The MYTH OF INFORMATION: The information explosion is indicative of an evolutionary dead end. It may be the height of human civilization, but it is also the

climax of its evolutionary experience. In our decadent biological phase, we indulge in information as if this compensates for our genetic inadequacies. The INFORMATION IS THE PROSTHESIS THAT PROPS UP THE OBSOLETE BODY. Information-gathering has become not only a meaningless ritual, but a deadly destructive paralyzing process, *preventing it from taking physical phylogenetic action*. Information-gathering satisfies the body's outmoded Pleistocence program. It is mentally seductive and seems biologically justified.

The cortex craves for information, but it can no longer contain and creatively process it all. How can a body subjectively and simultaneously grasp both nanoseconds and nebulae? THE CORTEX THAT CANNOT COPE RESORTS TO SPECIALIZATION. Specialization, once a manoeuvre methodically to collect information, now is a manifestation of information overloads. The role of information has changed. Once justified as a means of comprehending the world, it now generates a conflicting and contradictory, fleeting and fragmentary field of disconnected and undigested data. INFORMATION IS RADIATION. The most significant planetary pressure is no longer the *gravitational pull*, but the *information thrust*. The psycho-social flowering of the human species has withered. We are in the twilight of our cerebral fantasies. The symbol has lost all power. The accumulation of information has lost all puropse. Memory results in mimicry. Reflection will not suffice. THE BODY MUST BURST FROM ITS BIOLOGICAL, CULTURAL, AND PLANETARY CONTAINMENT.

3. FREEDOM OF FORM: In this age of information overloads, what is significant is no longer freedom of ideas but rather freedom of form – freedom to modify and mutate the body. The question is not whether society will allow people freedom of expression but whether the human species will allow the individuals to construct alternate genetic coding. THE FUNDAMENTAL FREEDOM IS FOR INDIVIDUALS TO DETERMINE THEIR OWN DNA DESTINY. Biological change becomes a matter of choice rather than chance. EVOLUTION BY THE INDIVIDUAL, FOR THE INDIVIDUAL. Medical technologies that monitor, map and modify the body also provide the means to manipulate the structure of the body. When we attach or implant prosthetic devices to prolong a person's life, we also create the potential to propel post-evolutionary development – PATCHED-UP PEOPLE ARE POST-EVOLUTIONARY EXPERIMENTS.

4. BIOTECH TERRAINS: The body now inhabits alien environments that conceal countless BODY PACEMAKERS – visual and acoustical cues that *alert, activate, condition and control the body*. Its circadian rhythms need to be augmented by artifical signals. Humans are now regulated in sync with swift, circulating rhythms of pulsing images. MORPHING IMAGES MAKE THE BODY OBSOLETE . . .

5. OBSOLETE BODY: It is time to question whether a bipedal, breathing body with binocular vision and a 1400cc brain is an adequate biological form. It cannot cope with the quantity, complexity and quality of information it has accumulated; it is intimidated by the precision, speed and power of technology and it is biologically ill-equipped to cope with its new extraterrestrial environment. The body is neither a very efficient nor a very durable structure. It malfunctions often and fatigues quickly; its performance is determined by its age. It is susceptible to disease and is doomed to a certain and early death. Its survival parameters are very slim. It can survive only weeks without food, days without water, and minutes without oxygen. The body's LACK OF MODULAR DESIGN and its overreactive immunological system make it difficult to

replace malfunctioning organs. It might be the height of technological folly to consider the body obsolete in form and function: yet it might be the highest of human realizations. For it is only when the body becomes aware of its present position that it can map its post-evolutionary strategies. It is no longer a matter of perpetuating the human species by REPRODUCTION, but of enhancing male/female intercourse by human–machine interface. THE BODY IS OBSOLETE. We are at the end of philosophy and human physiology. Human thought recedes into the human past.

6. ABSENT BODIES: We mostly operate as Absent Bodies. That is because A BODY IS DESIGNED TO INTERFACE WITH ITS ENVIRONMENT – its sensors are open-to-the-world (compared to its inadequate internal surveillance system). The body's mobility and navigation in the world require this outward orientation. Its absence is augmented by the fact that the body functions *habitually* and *automatically*. AWARENESS IS OFTEN THAT WHICH OCCURS WHEN THE BODY MALFUNCTIONS. Reinforced by Cartesian convention, personal convenience and neurophysiological design, people operate merely as minds, immersed in metaphysical fogs. The sociologist P. L. Berger made the distinction between 'having a body' and 'being a body'. AS SUPPOSED FREE AGENTS, THE CAPABILITIES OF BEING A BODY ARE CONSTRAINED BY HAVING A BODY. Our actions and ideas are essentially determined by our physiology. We are at the limits of philosophy, not only because we are at the limits of language. Philosophy is *fundamentally* grounded in our physiology . . .

7. REDESIGNING THE BODY/REDEFINING WHAT IS HUMAN. It is no longer meaningful to see the body as a site for the psyche or the social, but rather as a structure to be monitored and modified; the body not as a subject but as an object – NOT AS AN OBJECT OF DESIRE BUT AS AN OBJECT FOR DESIGNING. The psycho-social period was characterized by the body circling itself, *orbiting itself, illuminating and inspecting itself* by physical prodding and metaphysical contemplation. But having confronted its image of obsolescence, the body is traumatized to split from the realm of subjectivity and consider the necessity of re-examining and possibly redesigning its very structure. ALTERING THE ARCHITECTURE OF THE BODY RESULTS IN ADJUSTING AND EXTENDING ITS AWARENESS OF THE WORLD. As an object, the body can be amplified and accelerated, attaining planetary escape velocity. It becomes a post-evolutionary projectile, *departing and diversifying* in form and function.

8. EXTRA EAR: Having developed a Third Hand, consider the possibility of constructing an extra ear, *positioned next to the real ear*. A laser scan was done to create a 3D simulation of the Extra Ear in place. Although the chosen position is in front of and beside the right ear, *this may not be the surest and safest place anatomically to put it*. A balloon is inserted under the skin and is gradually inflated over a period of months until a bubble of stretched skin is formed. The balloon is then removed and a cartilage ear shape is pinned inside the bag of excess skin. A cosmetic surgeon would then need to cut and sew the skin over the cartilage structure. Rather than the hardware prosthesis of a mechanical hand, the Extra Ear would be a soft augmentation, mimicking the actual ear in shape and structure, but having different functions. IMAGINE AN EAR THAT CANNOT HEAR BUT RATHER CAN EMIT SOUNDS. Implanted with a sound chip and a proximity sensor, the ear would speak to anyone who would get close to it. Perhaps, the ultimate aim would be for the Extra Ear to whisper sweet nothings to the other ear. Or imagine the Extra Ear *as an Internet antenna* able to amplify RealAudio sounds to augment the local sounds heard by the actual ears. The Extra Ear would be a prosthesis made from its own skin. Why an

ear? An ear is a beautiful and complex structure. In acupuncture, the ear is the site for the stimulation of body organs. It not only hears but is also the organ of balance. To have an extra ear points to more than visual and *anatomical excess*.

9. SURFACE AND SELF: As surface, skin was once the beginning of the world and simultaneously the boundary of the self. As interface, it was once the site of the collapse of the personal and the political. But now *stretched* and *penetrated* by machines, SKIN IS NO LONGER THE SMOOTH SENSUOUS SURFACE OF A SITE OR A SCREEN. Skin no longer signifies closure. The rupture of surfaces and of skin means the *erasure* of inner and outer. As interface, the skin is inadequate.

10. THE INVASION OF TECHNOLOGY: Miniaturized and biocompatible, technology lands on the body. Although unheralded, it is one of the most important events in human history, focusing physical change on each individual. Technology is not only attached but is also implanted. ONCE A CONTAINER, TECHNOLOGY NOW BECOMES A COMPONENT OF THE BODY. As an instrument, technology fragmented and depersonalized experience – as a component it has the potential to SPLIT THE SPECIES. It is no longer of any advantage to either remain 'human' or evolve as a species. EVOLUTION ENDS WHEN THE TECHNOLOGY INVADES THE BODY. Once technology provides each person with the potential to progress individually in its development, the cohesiveness of the species is no longer distinction but the body–species split. The significance of technology may be that it culminates in alternate awareness – one that is POST-HISTORIC, TRANSHUMAN and even EXTRATERRESTRIAL (the first signs of an alien intelligence may well come from this planet).

11. AMPLIFIED BODY, LASER EYES AND HAND: If the earlier events can be characterized as probing and piercing the body (the three films of the inside of the stomach, lungs, and colon/the twenty-five body suspensions), determining the physical parameters and normal capabilities of the body, then the recent performances extend and enhance it visually and acoustically. Body processes amplified include brain waves (ECG), muscles (EMG), pulse (PLETHYSMOGRAM), and bloodflow (DOPPLER FLOW METER). Other transducers and sensors monitor limb motion and indicate body posture. The sound field is configured by buzzing, warbling, clicking, thumping, beeping, and whooshing sounds – of triggered, random, repetitive, and rhythmic signals. The artificial hand, attached to the right arm as an addition rather than a prosthetic replacement, is capable of independent motion, being activated by the EMG signals of the abdominal and leg muscles. It has a pinch-release, grasp-release, 270° wrist rotations (clock-wise and counterclock-wise), and a tactile feeback system for a rudimentary 'sense of touch'. While the body activates its extra manipulator, the real left arm is remote controlled – jerked into action by two muscle stimulators. Electrodes positioned on the flexor muscles and biceps curl the finger inward, bend the wrist, and thrust the arm upward. The triggering of the arm motion paces the performance and the stimulator signals are used as sound sources as is the motor sound of the Third Hand mechanism. The body performs in a structured and interactive lighting installation which flickers and flares, responding and reacting to the electrical discharges of the body – sometimes synchronizing, sometimes counterpointing. Light is not treated as an external illumination of the body but as a manifestation of the body rhythms. The performance is a choreography of controlled, constrained and involuntary motions – of internal rhythms and external gestures. It is an interplay between physiological control and electronic modulation, of human functions and machine enhancement.

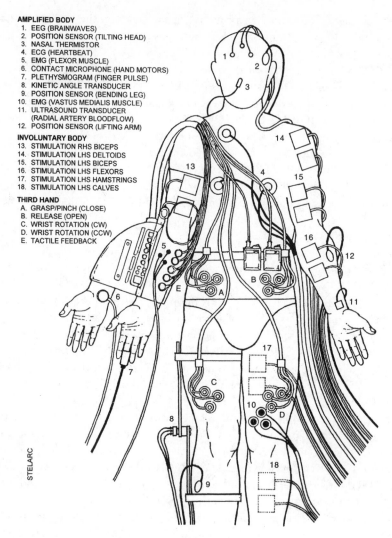

AMPLIFIED BODY
1. EEG (BRAINWAVES)
2. POSITION SENSOR (TILTING HEAD)
3. NASAL THERMISTOR
4. ECG (HEARTBEAT)
5. EMG (FLEXOR MUSCLE)
6. CONTACT MICROPHONE (HAND MOTORS)
7. PLETHYSMOGRAM (FINGER PULSE)
8. KINETIC ANGLE TRANSDUCER
9. POSITION SENSOR (BENDING LEG)
10. EMG (VASTUS MEDIALIS MUSCLE)
11. ULTRASOUND TRANSDUCER
 (RADIAL ARTERY BLOODFLOW)
12. POSITION SENSOR (LIFTING ARM)

INVOLUNTARY BODY
13. STIMULATION RHS BICEPS
14. STIMULATION LHS DELTOIDS
15. STIMULATION LHS BICEPS
16. STIMULATION LHS FLEXORS
17. STIMULATION LHS HAMSTRINGS
18. STIMULATION LHS CALVES

THIRD HAND
A. GRASP/PINCH (CLOSE)
B. RELEASE (OPEN)
C. WRIST ROTATION (CW)
D. WRIST ROTATION (CCW)
E. TACTILE FEEDBACK

Figure 1 *Involuntary Body/Third Hand* © Stelarc

12. THE SHEDDING OF SKIN: Off the Earth, the body's *complexity, softness and wetness* would be difficult to sustain. The strategy should be to HOLLOW, HARDEN and DEHYDRATE the body to make it more durable and less vulnerable. The present organization of the body is unnecessary. The solution to modifying the body is not to be found in its internal structure, but lies simply on its surface. The SOLUTION IS NO MORE THAN SKIN DEEP. The significant event in our evolutionary history was a change in the mode of locomotion. Future developments will occur with a *change of skin*. If we could engineer a SYNTHETIC SKIN which could absorb oxygen directly through its pores and could efficiently convert light into chemical nutrients, we could radically redesign the body, eliminating many of its redundant systems and malfunctioning organs, minimizing toxin build-up in its chemistry. THE HOLLOW BODY WOULD BE A BETTER HOST FOR TECHNOLOGICAL COMPONENTS.

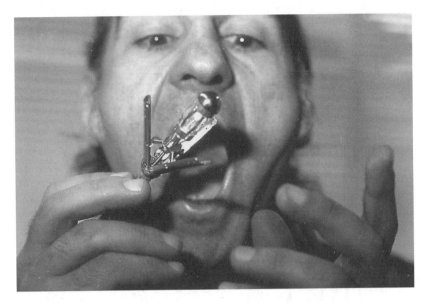

Figure 2 *Stomach Sculpture,* Fifth Australian Sculpture Triennale, 1996.
Photo: T. Figallo. © Stelarc

13. STOMACH SCULPTURE: HOLLOW BODY/HOST SPACE: The intention has been to design a sculpture for a distended stomach. The idea was to insert an art work into the body – *to situate the sculpture in an internal space.* The body becomes hollow with no meaningful distinctions between public, private and physiological spaces. TECHNOLOGY INVADES AND FUNCTIONS WITHIN THE BODY NOT AS A PROSTHETIC REPLACEMENT, BUT AS AN AESTHETIC ADORNMENT. The structure is collapsed into a capsule 50mm × 14mm, and tethered to its control box it is swallowed and inserted into the stomach. The stomach is *inflated* with air using an endoscope. A *logic circuit* board and a *servomotor* open the sculpture using a flexi-dive cable to 80mm × 50mm in size. A piezo-buzzer beeps in sync to a light globe blinking inside the stomach. The sculpture is an extending/retracting structure, sound-emitting and self-illuminating. (It is fabricated using implant-quality metals such as titanium, stainless steel, silver and gold.) The sculpture is retracted into its capsule form to be removed. As a body, one no longer looks at art, doesn't perform art, but contains art. THE HOLLOW BODY BECOMES A HOST, NOT FOR A SELF OR A SOUL, BUT SIMPLY FOR A SCULPTURE.

14. PAN-PLANETARY PHYSIOLOGY. Extraterrestrial environments amplify the body's obsolescence, intensifying pressures for its re-engineering. There is a necessity TO DESIGN A MORE SELF-CONTAINED, ENERGY-EFFICIENT BODY, WITH EXTENDED SENSORY ANTENNAE AND AUGMENTED CEREBRAL CAPACITY. Unplugged from this planet – from its complexity, interacting energy chain and protective biosphere – the body is biologically ill-equipped, not only in terms of its sheer survival, but also in its inability adequately to perceive and perform in the immensity of outer space. Rather than developing *specialist bodies for specific sites,* we should consider a pan-planetary physiology that is durable, flexible and capable of functioning in varying atmospheric conditions, gravitational pressures and electro-magnetic fields.

Figure 3 *Stomach Sculpture,* Fifth Australian Sculpture Triennale, 1996. © Stelarc

15. NO BIRTH/NO DEATH – THE HUM OF THE HYBRID: Technology trans-forms the nature of human existence, equalizing the physical potential of bodies and standardizing human sexuality. With fertilization now occurring outside the womb and the possibility of nurturing the foetus in an artificial support system THERE WILL TECHNICALLY BE NO BIRTH. And if the body can be redesigned in a modular fashion to facilitate the replacement of malfunctioning parts, then TECHNICALLY THERE WOULD BE NO REASON FOR DEATH – given the accessibility of replacements. Death does not authenticate existence. *It is an outmoded evolutionary strategy.* The body need no longer be repaired but simply have parts replaced. Extending life no longer means 'existing' but rather being 'operational'. Bodies need not age or deteriorate; they would not run down nor even fatigue; they would stall then start – possessing both the

potential for renewal and reactivation. In the extended space–time of extraterrestrial environments, THE BODY MUST BECOME IMMORTAL TO ADAPT. Utopian dreams become post-evolutionary imperatives. THIS IS NO MERE FAUSTIAN OPTION NOR SHOULD THERE BE ANY FRANKENSTEINIAN FEAR OF TAMPERING WITH THE BODY.

16. THE ANAESTHETIZED BODY: The importance of technology is not simply in the pure power it generates but in the *realm of abstraction* it produces through its *operational speed* and its development of *extended sense systems*. Technology pacifies the body and the world. It disconnects the body from many of its functions. DISTRAUGHT AND DISCONNECTED, THE BODY CAN ONLY RESORT TO INTERFACE AND SYMBIOSIS. The body may not yet surrender its autonomy but certainly its mobility. The body plugged into some machine network needs to be pacified. In fact, to function in the future and to achieve truly a hybrid symbiosis the body will need to be increasingly anaesthetized.

17. SPLIT BODY: VOLTAGE-IN/VOLTAGE-OUT: Given that a body is not in a hazardous location, there would be reasons to remote-actuate a person, or part of a person, rather than a robot. An activated arm would be connected to an intelligent mobile body with another free arm to augment its task! Technology now allows you to be physically moved by another mind. A computer interfaced MULTIPLE-MUSCLE STIMULATOR makes possible the complex programming of either in a local place or in a remote location. Part of your body would be moving; you've neither willed it to move, nor are you internally contracting your muscles to produce that movement. The issue would not be to automate a body's movement but rather the system would enable the displacement of a physical action from one body to another body in another place – for the on-line completion of a real-time task or the conditioning of a transmitted skill. There would be new interactive possibilities between bodies. A touch-screen interface would allow programming by *pressing* the muscle sites on the computer model and/or by retrieving and *pasting* from a library of gestures. Simulation of the movement can be examined before transmission and actuation. THE REMOTELY ACTUATED BODY WOULD BE SPLIT – on the one side voltage directed to the muscles via stimulator pads for involuntary movement, on the other side electrodes pick up internal signals, allowing the body to be interfaced to a Third Hand and other peripheral devices. THE BODY BECOMES A SITE BOTH FOR INPUT AND OUTPUT.

18. FRACTAL FLESH: Consider a body that can extrude its awareness and action into other bodies or bits of bodies in other places. An alternate operational entity that is spatially distributed but electronically connected. A movement that you initiate in Melbourne would be displaced and manifested in another body in Rotterdam. A shifting, sliding awareness that is *neither 'all-here' in this body nor 'all-there' in those bodies*. This is not about a fragmented body but a multiplicity of bodies and parts of bodies prompting and remotely guiding each other. This is not about master-slave control mechanisms but feedback-loops of ALTERNATE AWARENESS, agency and of split physiologies. Imagine one side of your body being remotely guided whilst the other side could collaborate with local agency. You watch a part of your body move but you have neither initiated it nor are you contracting your muscles to produce it. Imagine the consequences and advantages of being a split body with *voltage-in*, inducing the behaviour of a remote agent and *voltage-out* of your body to control peripheral devices. This would be a more complex and interesting body – not simply a single entity with one agency but one that

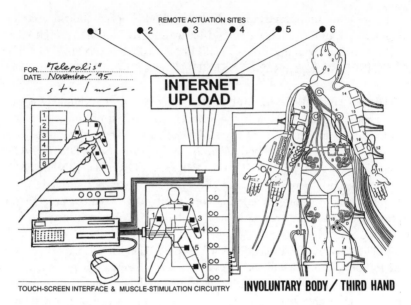

Figure 4 *Fractal Flesh: An Internet Body Upload Performance.* Luxembourg, 1995.
© Stelarc

would be A HOST FOR A MULTIPLICITY OF REMOTE AND ALIEN AGENTS. Of different physiologies and in varying locations. Certainly there may be justification, in some situations and for particular actions to tele-operate a human arm rather than a robot manipulater – for if the task is to be performed in a non-hazardous location, then it might be an advantage to use a remote human arm – as it would be attached to another arm and a mobile, intelligent body. Consider a task begun by a body in one place, completed by another body in another place. Or the transmission and conditioning of a skill. The body not as a site of inscription but as a medium for the manifestation of remote agents. This physically split body may have one arm gesturing involuntarily (remotely acutated by an unknown agent), whilst the other arm is enhanced by an exoskeleton prosthesis to perform with *exquisite skill and with extreme speed*. A body capable of incorporating movement that from moment to moment would be a pure machinic motion performed WITH NEITHER MEMORY NOR DESIRE.

19. STIMBOD: What makes this possible is a *touch-screen muscle stimulation system*. A method has been developed that enables the body's movements to be programmed by touching the muscle sites on the computer model. Orange flesh maps the possible stimulation sites whilst red flesh indicates the actuated muscle(s). The sequence of motions can be replayed continuously with its loop function. As well as choreography by pressing, it is possible to paste sequences together from a library of gesture icons. The system allows stimulation of the programmed movement for analysis and evaluation before transmission to actuate the body. At a lower stimulation level it is a body prompting system. At a higher stimulation level it is a body actuation system. This is not about remote-control of the body, but rather of CONSTRUCTING BODIES WITH SPLIT PHYSIOLOGIES, operating with multiple agency. Was it Wittgenstein who asked if in raising your arm you could remove the intention of raising it what would remain? Ordinarily, you would associate intention with action (except, perhaps in an instinctual

Figure 5 *Stimbod software*, Empire Ridge, Melbourne. © Stelarc

Figure 6 *Stimbod software*, Empire Ridge, Melbourne. © Stelarc

motion – or if you have a pathological condition like Parkinson's disease). With Stimbod, though, that intention would be transmitted from another body elsewhere. There would be actions without expectations. A two-way tele-Stimbod system would create a *possessed and possessing body* – a split physiology to collaborate and perform tasks remotely initated and locally completed – at the same time in the one physiology . . .

20. EXTREME ABSENCE AND THE EXPERIENCE OF THE ALIEN: Such a Stimbod would be hollow body, a host body for the *projection and performance of remote agents*. GLOVE ANAESTHESIA and ALIEN HAND are pathological conditions in which the patient experiences parts of their body as not there, as not their own, as not under their own control – an absence of physiology on the one hand and an absence of agency on the other. In a Stimbod not only would it possess a split physiology but it would experience parts of itself as automated, absent and alien. The problem would no longer be possessing a split personality, but rather a SPLIT PHYSICALITY. In our Platonic, Cartesian and Freudian pasts these might have been considered pathological and in our Foucauldian present we focus on inscription and control of the body. But in the terrain of cyber complexity that we now inhabit the inadequacy and the *obsolescence* of the ego-agent driven biological body cannot be more apparent. A transition from psycho-body to cybersystem becomes necessary to function effectively and intuitively in remote spaces, speeded-up situations and complex technological terrains. During a Sexuality and Medicine Seminar in Melbourne, Sandy Stone asked me what would be the cybersexual implications of the Stimbod system? Not having thought about it before I tried to explain what it might be like. If I was in Melbourne and Sandy was in New York, touching my chest would prompt her to caress her breast. Someone observing her there would see it as an act of self-gratification, as a masturbatory act. She would know though that her hand was remotely and perhaps even divinely guided! Given tactile and force-feedback, I would feel my touch through another person from another place as a secondary, additional and augmenting sensation. Or, by feeling my chest I can also feel her breast. An intimacy through interface, AN INTIMACY WITHOUT PROXIMITY. Remember that Stimbod is not merely a sensation of touch but an actuation system. Can a body cope with experiences of *extreme absence and alien action* without becoming overcome by outmoded metaphysical fears and obsessions of individuality and free agency? A Stimbod would thus need to experience its actuality neither all-present-in-this-body, nor all-present-in-that-body, *but partly-here and projected-partly-there*. An operational system of spatially distributed but electronically interfaced clusters of bodies ebbing and flowing in awareness, augmented by alternate and alien agency . . .

21. PING BODY/PROTO-PARASITE: In 1995 for Telepolis, people at the Pompidou Centre (Paris), the Media Lab (Helsinki) and the Doors of Perception conference (Amsterdam), were able to *remotely access and actuate* this body in Luxembourg, using the touch-screen interfaced muscle stimulation system. ISDN Picturetel links allowed the body to see the face of the person who was moving it whilst the programmers could observe their remote choreography. (Although people thought they were merely activating the body's limbs, they were inadvertently composing the sounds that were heard and the images of the body they were seeing – for the body had sensors, electrodes and transducers on its legs, arms and head that triggered sampled body signals and sounds and that also made the body a video switcher and mixer. And although people in other places were performing with the RHS of the body, it could respond by actuating its THIRD HAND, voltage-out from electrodes positioned on its abdominal and LHS leg muscles. This SPLIT BODY, then, was manifesting a combination of *involuntary, remotely guided, improvised* and EMG-muscle initiated motor motions.) In Ping Body – an Internet Actuated and Uploaded Performance (performed first for Digital Aesthetics in Sydney, but also for DEAF in Rotterdam in 1996), instead of the body being prompted by other bodies in other places, INTERNET ACTIVITY ITSELF

CHOREOGRAPHS AND COMPOSES THE PERFORMANCE. Random pinging to over 30 global Internet domains produce values from 0–2000 milliseconds that are mapped to the deltoid, bicepts, flexors, hamstring and calf muscles – 0–60 volts initiating involuntary movements. The movements of the body are amplified, with a midi interface measuring position, proximity and bending angle of limbs. Activated by Internet data the body is uploaded as info and images to a website to be viewed by other people elsewhere. The body is *telematically scaled-up, stimulated and stretched by reverberating signals* of an inflated spatial and electrical system. The usual relationship with the Internet is flipped – instead of the Internet being constructed by the input from people, the Internet constructs the activity of one body. The body becomes a nexus for Internet activity – its activity a statistical construct of computer networks.

22. PARASITE: EVENT FOR INVADED AND INVOLUNTARY BODY: A customized search engine has been constructed *that scans, selects and displays* images to the body – which functions in an interactive video field. Analyses of the JPEG files provide data that is mapped to the body via the muscle stimulation system. There is optical and electrical input into the body. THE IMAGES THAT YOU SEE ARE THE IMAGES THAT MOVE YOUR BODY. Consider the body's vision, *augmented and adjusted* to a parallel virtuality which increases in intensity to compensate for the twilight of the real world. Imagine the search engine selecting images of the body off the WWW, constructing a metabody that in turn moves the physical body. Representations of the body actuate the body's physiology. The resulting motion is mirrored in a VRML space at the performance site and also uploaded to a website as potential and recursive source images for body reactivation. RealAudio sound is inserted into sampled body signals and sounds generated by pressure, proximity, flexion and accelerometer sensors. The body's physicality provides feedback loops of interactive neurons, nerve endings, muscles, transducers and Third Hand mechanism. The system electronically extends the body's *optical and operational parameters* beyond its cyborg augmentation of the Third Hand and other peripheral devices. The prosthesis of the Third Hand is counterpointed by the PROSTHESIS OF THE SEARCH ENGINE SOFTWARE CODE. Plugged-in, the body becomes a parasite sustained by an extended, external and virtual nervous system. Parasite was first performed for Virtual World Orchestra in Glasgow. It has also been presented for The Studio for Creative Inquiry, Carnegie Mellon University at the Wood Street Galleries in Pittsburgh, Festival Atlantico in Lisbon, NTT-ICC in Tokyo, Ars Electronica in Linz and for the Fukui Biennale.

23. PSYCHO/CYBER: THE PSYCHOBODY is neither robust nor reliable. Its genetic code produces a body that malfunctions often and fatigues quickly, allowing only slim survival parameters and limiting its longevity. Its carbon chemistry GENERATES OUTMODED EMOTIONS. *The Psychobody is schizophrenic.* THE CYBERBODY is not a subject, but an object – not an object of envy but an object for engineering. THE Cyberbody bristles with electrodes and antennae, amplifying its capabilities and projecting its presence to remote locations and into virtual spaces. The Cyberbody becomes an extended system – not merely to sustain a self, but to enhance operation and initiate alternate intelligent systems.

24. HYBRID HUMAN–MACHINE SYSTEMS. The problem with space travel is no longer with the precision and reliability of technology but with the vulnerability and durability of the human body. In fact, it is now time to REDESIGN HUMANS, TO MAKE THEM MORE COMPATIBLE WITH THEIR MACHINES. It is not merely a

matter of 'mechanizing' the body. It becomes apparent that in the zero-G, frictionless, and oxygen-free environment of outer space technology is even more durable and functions more efficiently than on Earth. It is the human component that has to be sustained and also protected from small changes of pressure, temperature and radiation. The issue is HOW TO MAINTAIN HUMAN PERFORMANCE OVER EXTENDED PERIODS OF TIME. *Symbiotic systems* seem the best strategy; implanted components can energize and amplify developments; exoskeletons can power the body; robotic structures can become hosts for a body insert.

25. EXOSKELETON: A six-legged, *pneumatically-powered* walking machine has been constructed for the body. The locomotor, with either ripple or TRIPOD GAIT moves fowards, backwards, sideways and turns on the spot. It can also squat and lift by splaying or contracting its legs. The body is positioned on a rotating turn-table, actuating and controlling the machine legs by tilt sensors and micro-switches on an exoskeleton over the upper body and limbs. The left arm is AN EXTENDED ARM with pneumatic manipulator having 11 degrees-of-freedom. It is human-like in form but with additional functions. The fingers open and close, becoming multiple grippers. There is individual flexion of the fingers, with thumb and wrist rotation. The body actuates the walking machine by moving its arms. DIFFERENT GESTURES MAKE DIFFERENT MOTIONS. The body's arms guide the *choreography* of the locomotor's movements and thus *compose the cacophony* of pneumatic and mechanical sounds.

26. INTERNAL/INVISIBLE: It is time to recolonize the body with MICRO-MINIATURIZED ROBOTS to augment our bacterial population, to assist our immunological system and to monitor the capillary and internal tracts of the body. There is a necessity for the body to possess an INTERNAL SURVEILLANCE SYSTEM. Symptoms surface too late! The internal environment of the body would to a large extent contour the microbot's behaviour, thereby triggering particular tasks. Temperature, blood chemistry, the softness or hardness of tissue, and the presence of obstacles in tracts could all be primary indications of problems that would signal the microbots into action. *The biocompatibility of technology is no longer due to its substance but rather to its scale.* THE SPECK-SIZED ROBOTS ARE EASILY SWALLOWED, AND MAY NOT EVEN BE SENSED! At some nanotechnology level machines will inhabit cellular spaces and manipulate molecular structures . . . The trauma of repairing damaged bodies or even of redesigning bodies would be eliminated by a colony of nanobots delicately altering the body's architecture atoms-up, inside out.

27. TOWARD HIGH-FIDELITY ILLUSION: With teleoperation systems, it is possible to project human presence and perform physical actions in remote and extraterrestrial locations. A single operator could direct a colony of robots in different locations simultaneously or scattered human experts might collectively control a particular surrogate robot. Teleoperation systems would have to be more than hand-eye mechanisms. They would have to create kinesthetic feel, providing sensations of orientation, motion and body tension. Robots would have to be semi-autonomous, capable of 'intelligent disobedience'. With *Teleautomation* (Conway/Voz/Walker), forward simulation – with time and position clutches – assists in overcoming the problem of real time-delays, allowing prediction to improve performance. The experience of Telepresence (Minsky) becomes the high-fidelity illusion of *Tele-existence* (Tachi). ELECTRONIC SPACE BECOMES A MEDIUM OF ACTION RATHER THAN INFORMATION. It meshes the body with its machines in ever-increasing complexity and interactiveness. The body's

form is enhanced and its functions are extended. ITS PERFORMANCE PARAMETERS ARE LIMITED NEITHER BY ITS PHYSIOLOGY NOR BY THE LOCAL SPACE IT OCCUPIES.

28. PHANTOM LIMB/VIRTUAL ARM: Amputees often experience a phantom limb. It is now possible to have a phantom sensation of an additional arm – a virtual arm – albeit visual rather than visceral. The Virtual Arm is a computer-generated, human-like universal manipulator interactively controlled by VPL Virtual Reality equipment. Using data gloves with flexion and position-orientation sensors and a GESTURE-BASED COMMAND LANGUAGE allows real-time intuitive operation and additional extended capabilities. Functions are mapped to finger gestures, with parameters for each function, allowing elaboration. Some of the Virtual Arm's extended capabilities include *stretching* or telescoping of limb and finger segments, *grafting* of extra hands on the arm, and *cloning* or calling up an extra arm. The *record and playback* function allows the sampling and looping of motion sequences. A *clutch* command enables the operator to freeze the arm, disengaging the simulating hand. For teleoperation systems, features such as *locking* allow the fixing of the limb in position for PRECISE OPERATION WITH THE HAND. In *micro mode* complex commands can be generated with a single gesture, and in *fine control* delicate tasks can be completed by THE TRANSFORMATION OF LARGE OPERATOR MOVEMENTS TO SMALL MOVEMENTS OF THE VIRTUAL ARM.

29. IMAGES AS OPERATIONAL AGENTS: Plugged into Virtual Reality technology, physical bodies are transduced into phantom entities capable of performing within data and digitial spaces. The nature of both bodies and images has been significantly altered. IMAGES ARE NO LONGER ILLUSORY WHEN THEY BECOME INTER-ACTIVE. In fact, interactive images become operational and effective agents sustained in software and transmission systems. The body's representation becomes capable of response as images become imbued with intelligence. Sensors and trackers on the body make it a capture system for its image. The body is coupled to mobilize its phantom. A virtual or Phantom Body can be endowed with semi-autonomous abilities, enhanced functions, and artificial intelligence. Phantoms can manipulate data and perform with other phantoms in Cyberspace. PHYSICAL BODIES HAVE ORGANS. PHANTOM BODIES ARE HOLLOW. Physical bodies are ponderous and particular. Phantom bodies are flexible and fluid. Phantoms project and power the body.

30. VIRTUAL BODY: ACTUATE/ROTATE: Your virtual surrogate would not merely mimic the physical body's movements. A complex choreography is achieved by mapping virtual camera views to limb position/orientation. The involuntary jerking up and down of the left arm tumbles the virtual body while sweeping the right arm 90° produces a 360° virtual camera scan – visually rotating the virtual body around its vertical axis. The form of the virtual body can be configured acoustically – pulsing in phases with breathing sounds. This BREATH WARPING subtly and structurally connects the physical body with its virtual other. And by using DEPTH CUE – defining the operational virtual space as shallow – stepping and swaying forwards and backwards makes the virtual body appear and disappear in its video/virtual environment. The resulting interaction between the physical body and its phantom form becomes a more complex combination of kinestheic and kinematic choreography. In recent performances the *involuntary body* is actuating a *virtual body* while simultaneously avoiding a *programmed robot* within its task envelope . . .

31. MOVATAR – AN INVERSE MOTION CAPTURE SYSTEM: Motion Capture allows a body to animate a 3D computer-generated virtual body to perform in

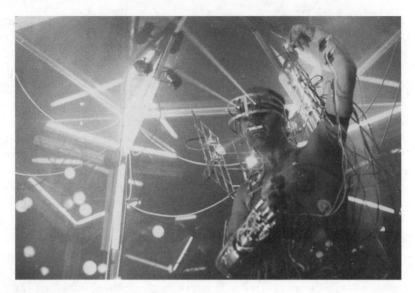

Figure 7 *Remote: Event for Laser Eye and Involuntary Arm*, Melbourne International Festival, Australia. Photo: T. Figallo. © Stelarc

computerspace or cyberspace. This is usually done by either markers on the body tracked by cameras, analysed by a computer and the motion mapped onto the virtual actor. Or it can be done using electromagnetic sensors (like Polhemus or Flock-of-Birds) that indicate position/orientation of limbs and head. Consider though a virtual body or an avatar that can access a physical body, actuating it to perform in the real world. If the avatar is *imbued with an artificial intelligence, becoming increasingly autonomous* and unpredictable, then it would be an AL (Artificial Life) entity performing with a human body in physical space. With an appropriate visual software interface and muscle stimulation system this would be possible. The avatar would become a Movatar. Its repertoire of behaviour could be modulated continously by Ping signals and might evolve using genetic algorithms. And with appropriate feedback loops from the real world it would be able to respond and perform in more *complex and compelling* ways. The Movatar would be able not only to act, but also to express its emotions by appropriating the facial muscles of its physical body. As a VRML ENTITY it could be logged-into from anywhere – to allow your body to be *accessed and acted upon*. Or, from its perspective, the Movatar could perform anywhere in the real world, at anytime with as many physical bodies in diverse and spatially separated locations . . .

32. REMOTE AGENTS AND COLLECTIVE STRATEGIES: Previously connection and communication with other bodies on the Internet was only textual, with an *acute absence* of physical presence. This was not the experience of authentic evolved absence that results in an effectively operating body in the real word – absence of the body on the Internet is an absence of inadequacy, that is an inadequacy of appropriate feedback-loops. As we hard-wire more high-fidelity image, sound, tactile and force-feedback sensation between bodies then we begin to generate powerful PHANTOM PRESENCES – *not phantom as in phantasmagorical, but phantom as in phantom limb sensation*. The sensation of the remote body sucked onto your skin and nerve endings, collapsing the psychological and spatial distance between bodies on the Net. Just as in the experience of a

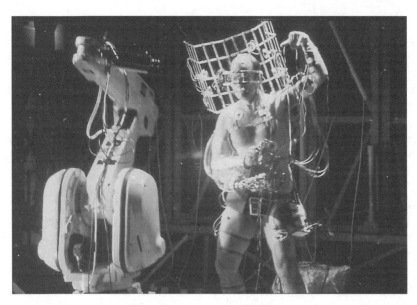

Figure 8 *Scanning Robot/Automatic Arm*, T.I.S.E.A., Museum of Contemporary Art, Sydney. Photo: T. Figallo. © Stelarc

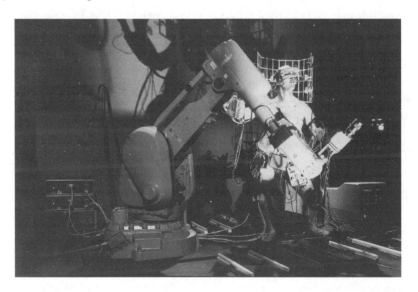

Figure 9 *Scanning Robot/Involuntary Arm*, Edge Biennale, London. Photo: M. Burton. © Stelarc

Phantom Limb with the amputee, bodies will generate phantom partners, not because of a lack, but as extending and enhancing addition to their physiology. *Your aura will not be your own.* It will only be through the construction of phantoms that the equivalent of our evolved absence will be experienced, as we function increasingly powerfully and with speed and intuition (a successful body operates automatically). Bodies must now perform in techno-terrains and data-structures beyond the human-scale where intention

and action collapse into accelerated responses. BODIES ACTING WITHOUT EXPEC-
TATION, PRODUCING MOVEMENTS WITHOUT MEMORY. Can a body act
without emotion? Must a body continuously affirm its emotional, social and biological
status quo? Or perhaps what is necessary is electronic erasure with new intimate, inter-
nalized interfaces to allow for the design of a body with more adequate inputs and
outputs for performance and *awareness augmented by search engines*. Imagine a body
remapped and reconfigured – not in genetic memory but rather in electronic circuitry.
What of a body that is intimately interfaced to the WWW – and that is stirred and is
startled by distant whispers and remote promptings of other bodies in other places. A
body that is informed by spiders, knowbots and phantoms . . .

33. PHANTOM BODY/FLUID SELF: Technologies are becoming better life-
support systems for our images than for our bodies. IMAGES ARE IMMORTAL. BODIES
ARE EPHEMERAL. The body finds it increasingly difficult to match the expectations
of its images. In the realm of multiplying and morphing images, the physical body's
impotence is apparent. THE BODY NOW PERFORMS BEST AS ITS IMAGE. Virtual
Reality technology allows a transgression of boundaries between male/female, human/
machine, time/space. The self becomes situated beyond the skin. This is not discon-
necting or a splitting but an EXTRUDING OF AWARENESS. What it means to be
human is no longer being immersed in genetic memory but in being reconfigured in the
electromagnetic field of the circuit IN THE REALM OF THE IMAGE.

34. ARTIFICIAL INTELLIGENCE/ALTERNATE EXISTENCE: The first signs of
artificial life may well come from this planet in the guise of images. ARTIFICIAL INTEL-
LIGENCE WILL NO LONGER MEAN EXPERT SYSTEMS OPERATING WITHIN
SPECIFIC TASK DOMAINS. Electronic space generates intelligent and autonomous
images that extend and enhance the body's operational parameters beyond its mere phys-
iology and the local space it occupies. What results is a meshing of the body with its
images and machines in ever-increasing complexity. The significance of interfacing with
images is that they culminate in an ALTERNATE AWARENESS THAT IS PAN-
HISTORIC AND POST-HUMAN.

Originally published in J. Broadhurst Dixon and E. Cassidy (eds) (1998) *Virtual Futures: Cyberotics,
Technology and Post-human Pragmatism*. London: Routledge (revised by the author 1999).

Notes

Stimbod was developed with the assistance of Troy Innocent at Empire Ridge in Melbourne. The
Muscle Stimulation System circuitry was designed by Bio-Electronics, Logitronics and Rainer Linz in
Melbourne with the box fabricated with the assistance of Jason Patterson. Tele-Stimbod, Ping Body
and Parasite software was developed by Jeffrey Cook, Sam de Silva, Gary Zebbington and Dimitri
Aronov from the Merlin group in Sydney. Kampnagel in Hamburg is funding the 6-Legged Locomotor
project.

MARK DERY

RITUAL MECHANICS
Cybernetic body art

Stelarc: I sing the body obsolete

> Knowledge is power! Do you suppose that fragile little form of your – your
> primitive legs, your ludicrous arms and hands, your tiny, scarcely wrinkled
> brain – can *contain* all that power? Certainly not! Already your race is flying
> to pieces under the impact of your own expertise. The original human form
> is becoming obsolete.[1]

YAWNING WITH YOUR MOUTH SEWN shut isn't easy, as Stelarc
discovered during his 1979 *Event for Support Structure*. The Australian performance
artist spent three days in Tokyo's Tamura Gallery, sandwiched between planks suspended
from a tepee-like arrangement of poles, his mouth and eyelids stitched tight with surgical
thread. At night, he slept on the gallery floor.

'Interestingly enough,' he recounts, 'it wasn't so much the painfulness of the stitching
. . . or the compression of the body between two pieces of wood but rather the diffi-
culty in yawning . . . that presented a problem.' His deep-toned, diabolical laugh bounces
off the walls. 'This is something I hadn't considered.'[2]

Stelarc (born Stelios Arcadiou) is the foremost exponent of cybernetic body art.
Decades before virtual reality went pop, he experimented with jerry-built simulation
technology at the Caulfield Institute of Technology and, later, at the Royal Melbourne
Institute of Technology (RMIT). From 1968 through 1970, he constructed a series
of enclosures called Sensory Compartments in which the user was 'assaulted by
lights, motion, sound' and fabricated helmets fitted with goggles that split the wearer's
binocular vision, immersing him or her in a fun-house-mirror world of superimposed
images. The artist, a confirmed McLuhanite, describes these devices as the product
of a 'realization . . . that it was the body's physiological hardware that determined its
intelligence, its awareness, and that if you alter this [hardware], you're going to present

an alternate perception'. This is a reiteration, in so many words, of McLuhan's assertion that

> [t]he extension of any one sense alters the way we think and act – the way we perceive the world. When these ratios change, men change.[3]

Proceeding from that proposition, Stelarc has evolved an aesthetic of prosthetics in which 'the artist [is] an evolutionary guide, extrapolating new trajectories . . . a genetic sculptor, restructuring and hypersensitizing the human body; an architect of internal body spaces; a primal surgeon, implanting dreams, transplanting desires; an evolutionary alchemist, triggering mutation, transforming the human landscape.'[4]

His nearly naked body plastered with electrodes and trailing wires, the artist in performance bears a striking resemblance to a Borg, one of the implacable cyborg villains in *Star Trek: The Next Generation*. With his Amplified Body, Laser Eyes, Third Hand, Automatic Arm and Video Shadow, he bodies forth the human–machine hybrid all of us are metaphorically becoming. Less a man than the organic nerve centre of a cybernetic system, he literalizes our vision of ourselves as terminal beings, inextricably entangled in the global telecommunications web. In that sense, he is a postmodern incarnation of the archetypal image of Man the microcosm – a naked man, spread-eagled inside a pentagram, which according to J. E. Cirlot is emblematic not only of the analogical relationship between the individual and the cosmos but of 'the human tendency towards ascendance and evolution'.[5]

'All the signposts direct us to him,' declares John Shirley, in an essay that theorizes Stelarc as the embodiment of cyberpunk's post-human yearnings, 'a chimera grafted together of horror and grace, the synthesis of erstwhile humanity and tomorrow's humanity struggling to be born.'[6] Positioning the artist alongside Survival Research Laboratories as a cultural mutagen 'doing the work of science fiction outside the genre', Shirley draws parallels between Stelarc's preoccupation with techno-evolution and the themes of cyborged or genetically engineered body modification treated in SF novels such as Bruce Sterling's *Schismatrix* and Samuel R. Delany's *Nova*.[7]

Stelarc has performed with hulking, industrial robot arms, dodging their potentially bone-shattering swipes. On occasion, his events take place in the midst of sculptural installations of glass tubes crawling with plasma discharges or flashing and flickering in response to signals sent by his body. A cage-like structure perched on the artist's shoulders emits argon-laser pulses. Synchronized to throb in time to his heartbeat, the beams are made, through eyeblinks, facial twitches and head movements, to scribble curlicues in the air. 'Video shadows' – images captured by video cameras positioned above and around him and projected on large screens – are frozen, superimposed, or juxtaposed in split-screen configurations.

A welter of *thrrrups*, squeals, creaks and *cricks*, most of them originating in Stelarc's body, whooshes around the performance space. The artist's heartbeat, amplified by means of an ECG (electrocardiograph) monitor, marks time with a muffled, metronomic thump. The opening and closing of heart valves, the slap and slosh of blood are captured by Doppler ultrasonic sound transducers, enabling Stelarc to 'play' his body. For example, one transducer is fastened to his wrist. 'By constricting the radial artery of the wrist,' he informs, 'the sound varies from the normal repetitive "whooshing" to a "clicking" as the blood is dammed, with a flooding rush of sound as the wrist is relaxed.'[8] A kinetic-angle transducer converts the bending of his right knee into avalanches of

sound; a microphone, placed over the larynx, picks up swallowing and other throat noises; and a plethysmogram amplifies finger pulse. From time to time, an electronic keening splits the air, wobbling on a single pitch, then zigzagging suddenly upward into a ragged whoop. It is produced by analogue synthesizers triggered by 'control voltages' – electrical signals modulated by the artist's heartbeat, muscles and brain waves (translated into EEG, or electroencephalogram, readouts).

Attached to an acrylic sleeve on the artist's right arm, the Third Hand chirrs frantically, its stainless steel fingers clutching at nothingness. Custom-made by a Japanese manufacturer, the Hand is a dexterous robotic manipulator than can be actuated by EMG (electromyogram) signals from the muscles in Stelarc's abdomen and thighs. It can pinch, grasp, release and rotate its wrist 290 degrees in either direction, and has a tactile feedback system that provides a rudimentary sense of touch by stimulating electrodes affixed to the artist's arm. Stelarc's left arm, meanwhile, is robotized – jerkily animated by intermittent jolts of electricity from a pair of muscle stimulators. 'Voltage is applied to the flexor and biceps muscles,' notes Stelarc, 'bending the wrist, curling the fingers and jerking the arm up and down involuntarily.'[9]

In recent performances, Stelarc has reached into cyberspace with his Virtual Arm. Developed at RMIT's Advanced Computer Graphics Centre, the Arm is a computer-generated 'universal manipulator' – a digital cartoon of a humanoid limb – controlled by gestures from a CyberGlove. The Arm can rotate its wrist and fingers continuously; stretch from here to externity; sprout extra hands or clone an octopuslike tangle of arms; draw lines with its fingertips or shoot spheres out of them.

In *Actuate/Rotate: Event for Virtual Body* (1993), Stelarc took the next step up the techno-evolutionary ladder. Donning a Polhemus magnetic tracking system whose sensors were attached to his head, torso and extremities, he interacted with a digital *doppelgänger* that mirrored his every move. The double appeared, alternately, as a wire-frame skeleton or a fleshed-out mannequin on a video display monitor. Simultaneously, video cameras fed live images of Stelarc's physical body into the system, and the computer-generated point of view – the virtual camera – was choreographed by his gestures, generating montages of fleshy and ghostly bodies.

Stelarc's performances are pure cyberpunk. Slowly contorting his body in a series of cyborg mudras, he unleashes an inhuman bedlam that sounds like a brawl between a shortwave radio and a Geiger counter. The twin beams of his 'laser eyes' stab into the dark; tendrils of electricity writhe, like living things, inside the sculptural installation's glass tubes; and 'video shadows' flit across monitors, now freezing, now stuttering stroboscopically. His arm is yanked upwards, puppet-like, by a burst of electricity while his Third Hand scrabbles at the air. In Stelarc's cybernetic synergism, the distinction between controller and controlled is blurred; he is simultaneously extended by, and an extension of, his high-tech system.

For Stelarc, the writing is literally on the wall. In his 1982 performance *Handswriting*, the artist laboriously coordinated pens held in both hands with the marker-wielding Third Hand to scrawl a single word on paper taped to a gallery wall: EVOLUTION.

Stelarc embodies McLuhan's declaration that with the advent of cyberculture 'man is beginning to wear his brain outside his skull and his nerves outside his skin; new technology breeds new man'.[10] McLuhan's technodeterministic reading of history rests on the assumption that

All media are extensions of some human faculty – psychic or physical. The wheel . . . is an extension of the foot. The book is an extension of the eye . . . clothing, an extension of the skin.[11]

According to McLuhan, all such extensive or 'autoamputative' strategies are the overstimulated nervous system's response the cultural catalysts such as 'the acceleration of pace and increase of load', themselves technological in origin.[12] Further, he argues, each autoamputation results in a numbing of that part of the nervous system associated with the now technologized and therefore traumatically amplified function.

To McLuhan, the metaphoric extrusion of the central nervous system ('that electric network that coordinates the various media of our senses') in the form of global telecommunications networks and other cybernetic technologies represents a survival mechanism, triggered by 'the successive mechanizations of the various physical organs since the invention of printing [that] have made too violent and superstimulated a social experience for the nervous system to endure'.[13]

Adopting McLuhan's premise that the vertiginous whirl of the information age has outpaced and overtaxed the nervous system, Stelarc argues that humanity is superannuated, its biological hardware unadapted to the infosphere. In his essay 'Prosthetics, Robotics and Remote Existence: Postevolutionary Strategies', he declares,

> It is time to question whether a bipedal, breathing body with binocular vision and a 1,400-cc brain is an adequate biological form. It cannot cope with the quantity, complexity and quality of information it has accumulated. . . . The most significant planetary pressure is no longer the gravitational pull but rather the information thrust. Gravity has molded the evolved body in shape and structure and contained it on the planet. Information propels the body beyond itself and its biosphere. Information fashions the form and function of the postevolutionary body.[14]

Like McLuhan, who couched his fundamental insight in the catchy maxim 'THE MEDIUM IS THE MESSAGE', Stelarc has condensed his theories into a single, mediagenic aphorism: 'THE BODY IS OBSOLETE'. Stelarc's cybernetic events are dress rehearsals for post-human evolution. High-tech prostheses and medical technologies for monitoring and mapping the body hold forth the promise, Stelarc maintains, of self-directed evolution – the result not of incremental mutation over generations but of somatic change brought about through technology. 'Patched-up people,' he writes, 'are evolutionary experiments'.[15] According to Stelarc, miniaturized, biocompatible technologies will one day make each individual a species unto him or herself.

> EVOLUTION ENDS WHEN TECHNOLOGY INVADES THE BODY. Once technology provides each person with the potential to progress individually in its [sic] development, the cohesiveness of the species is no longer important.[16]

The artist's philosophy of transcendence through technology is hitched to a space-age teleology: for Stelarc, our Manifest Destiny lies in the stars. If it is to attain 'planetary escape velocity', he reasons, the body must first be objectified:

> It is no longer meaningful to see the body as a *site* for the psyche or the social but rather as a *structure* to be monitored and modified. The body not

as a subject but as an object – NOT AS AN OBJECT OF DESIRE BUT AS AN OBJECT FOR DESIGNING.[17]

Reconceived as an 'it' rather than an 'I', the body may be subjected to ballistic streamlining, 'amplified and accelerated' into a 'postevolutionary projectile'. Humans embarked on an extraterrestrial odyssey would find the body's 'complexity, softness, and wetness . . . hard to sustain,' predicts Stelarc.[18] The body must be hollowed, hardened, and dehydrated, its inessential innards scooped out so that it may be 'a better host for technology', its skin peeled off and replaced by a synthetic dermis capable of converting light into chemical nutrients and absorbing all oxygen necessary to sustain life through its pores.[19] An internal early warning system would monitor what few organs remain, and 'micro-miniaturized robots', or nanomachines, would 'colonize the surface and internal tracts to augment the bacterial populations – to probe, monitor and protect the body'.[20]

Eviscerated and stuffed with modular components that can be easily replaced; armoured and endowed with pile-driver brawn by a robotic exoskeleton; fitted with an array of antennae to amplify its sight and hearing; and implanted with a brain chip or genetically engineered to expand its cortical capacity to supercomputer proportions, Stelarc's post-human being would inhabit a 'pan-planetary physiology that is durable, flexible and capable of functioning in varying atmospheric conditions, gravitational pressures and electromagnetic fields'.[21] Such creatures might resemble one of Sterling's 'Lobsters' – Borg-like post-humans sealed in 'skin-tight life-support systems, flanged here and there with engines and input-output jacks' whose

> greatest pleasure was to . . . open their amplified senses to the depths of space, watching stars past the limits of ultraviolet and infrared . . . or just sitting and soaking in watts of solar energy through their skins while they listened with wired ears to the warbling of Van Allen belts and the musical tick of pulsars.[22]

Entities such as these might choose to become 'reengineered extraterrestrial explorers', the artist speculates.[23] But in the scenario sketched in most of Stelarc's published essays and public lecturers, the mutant, transmigrant remains of the human race come to rest in virtual reality, in a 'high-fidelity illusion of tele-existence' wherein their 'performance parameters [would be] limited neither by . . . mere physiology nor the local space [they occupy]'.[24] In a 1993 lecture at the Manhattan artspace, the Kitchen, he argued

> If the . . . sensory feedback loops between the robot and the human operator are of a high enough quantity and quality, then there's a collapse of the psychological distance between the operator and the robot; in other words, if the robot does what the human commands and the human perceives what the robot perceives, the human-machine system [effectively] collapses into one operational unit.[25]

Immobilized in cybernetic networks and immortalized by means of replacement parts, Stelarc's post-human teleoperators would reach across solar systems to sift alien sands through robotic fingers – fingers sophisticated enough to reproduce reality with a fidelity indistinguishable from embodied experience. A post-evolutionary strategy that

began with bodies redesigned not to accommodate airflow but rather the torque of McLuhan's 'electric vortex' ends in a hyperreality that has become 'a medium of action rather than information'.[26]

Meanwhile, back in the present, Dr Richard Restak raises doubts about the nuts-and-bolts feasibility of the cyborg upgrades proposed by Stelarc. A neuropsychiatrist, professor of neurology at George Washington University, and the author of the *New York Times* best-seller *The Brain*, Restak takes issue with Stelarc's post-evolutionary scenario on medical as well as psychological grounds.

'It's essentially science fiction,' he contends, 'a kind of a postmodernist view of what the future person is going to be. In postmodern philosophy you can say, 'Why take anything for granted? Let's question the most basic elements – our very biology, for instance.' Of course, at the outer limits of this ideology, you come up against biology, which is where Stelarc's weakness lies.

'For example, I don't know how you would decide what innards are inessential because such things as the immune system are housed in some fairly unprepossessing organs, such as the thymus. You might be able to replace the liver and the kidneys but you'd have to keep some type of immune system. At the same time, the immune system is going to wreak havoc on any foreign object you put into the body. That's going to be your biggest problem: What would keep the body from rejecting these implants while it's in the process of this transmogrification? The immune system would have be suppressed but then of course you're open to viruses and bacteria. Furthermore, once you peel off the skin, before anything else can be put over it, your infection possibilities are just astronomical. There's no way that I could imagine that you could get from a human being to something like this, not only because of the technical hurdles but more specifically because of the biological ones.

'Moreover, who would want to live like this, out there among the stars? I've written on brain and body prostheses and they've done some wonderful things, but I look upon Stelarc's fantasies as pathological; they're in the general genre of world destruction fantasies – extreme, narcissistic fantasies of complete isolation. This creature's out there by itself, it doesn't need anybody because its brain has been amplified with a chip or genetically engineered, which I think implies an involutional process whereby it's just occupied with its own internal processing.

'Fantasies such as this represent a distorted Cartesianism. We're so locked into the Cartesian idea that we're a mind and the body is an it and we treat is as an it (the analogy is usually to a machine), whereas in fact we are embodied. I think there's a lot of self-hate in this objectification of the body, a lot of estrangement.'

Stelarc's essay 'Prosthetics, Robotics and Remote Existence: Post-evolutionary Strategies' ends with the assurance that, in tele-existence, '[t]he body's form is enhanced and its functions are extended . . . electronic space restructures the body's architecture and multiplies its operational possibilities.'[27] But beneath this tantalizing vision of the body apotheosized (albeit in a fashion that accommodates the contrary notion of human potential unbounded by physicality) lies an almost sadomasochistic subtext: the body, 'traumatized' by its objectification, is 'distraught and disconnected' from its functions by technological mediation and has no recourse but 'interface and symbiosis'. Here is McLuhan's traumatic autoamputation come back to haunt us, attended by his 'Narcissus Narcosis', the body's self-protective mechanism against the shock of being flayed alive. 'We have to numb our central nervous system when it is extended and exposed,' argues

McLuhan, 'or we will die'.[28] Stelarc likewise insists that '[t]he body plugged into the machine network needs to be pacified. In fact, to . . . truly achieve a hybrid symbiosis the body will need to be increasingly anesthetized'.[29]

As well, it must be skinned and gutted, 'eliminating many of its malfunctioning organs and systems, minimizing toxin build-up in its chemistry'.[30] Awash in toxic waste and always on the brink of collapse, Stelarc's body is indistinguishable from Foucault's ideal subject of power, the analysable, manipulable 'docile body', available to be subjected, used, transformed and improved.'[31]

Oddly, issues of power are absent from Stelarc's post-evolutionary schematic, as they inevitably are in McLuhan's writings; technology intersects with the body but never collides with social or economic issues. *Who builds these machines, anyway?* Sheathed in an impregnable exoskeleton, the Stelarcian cyborg is powerful but not empowered, a pharaonic monument to the mummy-like body withering inside it. Its mind, meanwhile, is elsewhere; most post-humans are, after all, 'mere manipulators of machine images' who live out eternity by proxy, directing robot colonies on distant planets.[32] But who writes the code that creates the 'high-fidelity illusion of tele-existence'? Who controls the remote controllers? What is needed here is a politics of post-humanism. Stelarc's art and thought do not exist, as he would have it, in the value-free cultural vacuum traditionally reserved for science. His science fiction dream of a body that is no longer 'a *site* for . . . the social' is hemmed in on all sides by feminist body criticism, the ongoing debate over the ethics of human biotechnology, and green critiques of capitalism's litanies of technological progress and unchecked expansion.

Stelarc seems unaware that his discourse is caught in the cross fire of the culture wars. 'The events are to do with ideas, not ideologies,' he insists. 'The artist refrains from the politics of power not through a naïvety of the implications and issues, but because the focus is on the imaginative post-evolutionary possibilities'.[33] His speculations 'emanate from the events', he argues, and are 'not meant to be a balanced and comprehensive theory'; they are 'about the business of being poetic rather than . . . politically persuasive'.

By retaining the poetic licence of the artist, he exempts himself from the scientific requirement that theories be unified. Simultaneously, and contrarily, he sanctions only literal interpretations of his work; figurative readings are dismissed as dependent on the very context – the realm of 'the psyche [and] the social' – from which post-evolutionary strategies are meant to map an escape route. Accordingly, he invokes a scientific objectivity that forecloses social or political readings of his work. 'Suspicious of subjective reporting', 'sceptical about statements of memory which are often very loose, inexact and difficult to evaluate', and wary 'of romanticizing and exaggerating past actions', he legitimates his post-humanist pronouncements and McLuhanesque epigrams with technical terminology and a dispassionate tone.[34]

But the very notion of ideation unperturbed by ideology, of a social space in which the collision of bodies and machines takes place outside 'the politics of power', is science fiction. The idea that truth is as much socially constructed as discovered – that is, that even avowedly value-neutral discourses are coloured by cultural assumptions – is the keynote of recent critiques of science. Science and technology 'are not isolated from ideological influence but are "part and parcel, woof and warp, of the social orders from which they emerge and which support them"', argues the cultural critic Claudia Springer.[35]

It is his embrace of a 'context-free' scientific objectivity that prevents Stelarc from seeing the correspondence between his cybernetic spectacles and what he terms the 'new mysticism' of a culture dazzled by a 'bewildering array of disconnected data'.[36] Stelarc has called his events 'sci-fi scenarious for human–machine symbiosis . . . performance as simulation rather than ritual'.[37] But the distinction may be semantic; computer simulations may *be* the rituals of cyberculture.

Fakir Musafar questions Stelarc's privileging of science fictions over 'cultural rituals that have long outlived their purposes'. A Silicon Valley advertising executive-turned-'modern primitive', Musafar has attained altered states through piercing, binding, suspension by hooks through his flesh, and other forms of what he calls 'body play'; modern primitives, he holds, constitute a cultural vanguard showing '[a] way out of the Middle Ages and European culture and a fusion of science and magic'.[38]

> Where I think Stelarc is missing the point is that . . . [w]e've gotten to the point where we can synthesize magic, technology and science. You listen to the babblings of the best physicists we have today, [and] they . . . sound like the alchemists used to.[39]

Additionally, there are correlations between Stelarc's work and Judeo-Christian symbolism. The artist's declaration that '[t]echnology, which shatters the body's subjective totality of reality, now returns to reintegrate its fragmented experience' – a restatement, in all the essentials, of McLuhan's claim that '[a]fter three thousand years of explosion, by means of fragmentary and mechanical technologies, the Western world is imploding' – invites interpretation as an allegorical return to a paradisal state, to a time before the rupture between self and Other, culture and nature.[40]

Rachel Rosenthal, a feminist performance artist whose works often address the politics of the body, theorizes Stelarc's cyber-body events as '[n]ostalgia for undifferentiation'. In her essay 'Stelarc, Performance and Masochism,' she writes,

> We are so isolated from the [O]ther, so lonely. Self-penetration, physical and violent, is a metaphysical response to this despair of ever connecting deeply. So we . . . pierce the separating membrane. We explode the integrity of form.[41]

For McLuhan, the invention of the written word was the 'separating membrane', dividing the 'I' from the 'all-that-is-not-I' and casting Western civilization into the post-lapsarian world of isolation, objectivity and rationality. His limning of this event sounds unmistakably like the biblical allegory of the fall:

> The whole man became fragmented man; the alphabet shattered the charmed circle and resonating magic of the tribal world, exploding man into an agglomeration of specialized and psychically impoverished individuals, or units, functioning in a world of linear time and Euclidean space.[42]

By extension, McLuhan's conviction that '[w]e have begun again to structure the primordial feeling, the tribal emotions from which a few centuries of literacy divorced us' equates the preliterate with the prelapsarian, the supposedly holistic worldview of pretechnological civilizations with an Edenic state of grace.[43]

Stelarc vehemently rejects such analyses. 'Can strategies be evaluated without resorting to convenient myths, metaphors and religious symbolism?' he demands.[44] To

which one might well respond, 'Can poetic extrapolations based on technological modernity – science fictions, by any other name – be disentangled from the meshwork of shared references that links all texts, religious myths among them?'

A sworn atheist, Stelarc discourages quests for mythic resonances in his rhetoric. But his post-evolutionary strategies spring from McLuhan, whose later thought is inflected by a Teilhardian scientific humanism; can a post-humanism so deeply indebted to an analysis of electronic culture that borders on the mystical expunge every last trace of that mysticism? As the noted historian of religion Mircea Eliade points out, 'It is interesting to observe to what extent the scenarios of initiation still persist in many of the acts and gestures of contemporary nonreligious man.'[45] Viewed as mythopoeia, Stelarc's dream of the end of limits ('the body must burst from its biological, cultural and planetary containment') is easily recast as an ascension rite for cyberculture, a vertical movement from the mundane to the 'high-fidelity illusion of tele-existence'. It is Jacob's ladder reimagined for an age of 'patched-up' – and patched-in – people. The artist's speculation that self-engineered evolution may result 'in an *alien awareness* – one that is posthistoric, transhuman and even extraterrestrial' calls to mind Eliade's assertion that

> [t]he 'most high' is a dimension inaccessible to man as man; it belongs to superhuman forces and beings. He who ascends by mounting the steps of a sanctuary or the ritual ladder that leads to the sky ceases to be a man; in one way or another, he shares in the divine condition.[46]

On a lighter note, Stelarc's cyborg myth dovetails with Roland Barthes' playful essay on the French superhero the jet-man, a post-human pilot whose helmet and antigravity suit ('*a novel type of skin* in which "even his mother would not known him"') signal a 'metamorphosis of species', the coming of 'jet-mankind'.[47] He writes, 'Everything concurs, in the mythology of the jet-man, to make manifest the plasticity of the flesh.'[48] Barthes sees in the jet-man's impersonal, asexual uniform and 'abstention and withdrawal from pleasures' a monastic regimen, a mortification of the flesh whose endpoint is 'the glamorous singularity of an inhuman condition'.[49] The myth of the jet-man, he emphasizes, is no less a religious allegory for its *Rocketeer* gadgetry. '[I]n spite of the scientific garb of this new mythology,' notes Barthes, 'there has merely been a displacement of the sacred.'[50]

Originally published in M. Dery (1996) *Escape Velocity: Cyberculture at the End of the Century*, London: Hodder and Stoughton.
This essay has been edited for inclusion in the Reader.

Notes

1. Bruce Sterling, *Crystal Express* (New York: Ace Books, 1990), p. 25.
2. Quoted from an archival videotape of Stelarc's lecture 'Remote gestures/obsolete desires', at the Kitchen Center for Video, Music, Dance, Performance, Film and Literature, New York, 9 March 1993.
3. Marshall McLuhan and Quentin Fiore, *The Medium Is the Massage: An Inventory of Effects* (New York: Bantam, 1967), p. 41.
4. Stelarc, 'Strategies and trajectories', in J. D. Pabbarth (with Stelarc) (ed.), *Obsolete Body/ Suspensions/Stelarc.* (Davis, Calif.: JP Publications, 1984), p. 76.
5. J. E. Cirlot, *A Dictionary of Symbols*, trans. Jack Sage, 2d ed. (New York: Dorset Press, 1971), p. 199.

6. John Shirley, 'SF alternatives, part one: Stelarc and the new reality', *Science Fiction Eye* 1, no. 2 (August 1987), pp. 57, 61.
7. Ibid., p. 59.
8. Stelarc, 'Beyond the body: amplified body, laser eyes & third hand', undated essay accompanying a performance at the Yokohama International School in Japan, p. 28.
9. Stelarc, press release for a performance of 'Remote gestures/obsolete desires: event for amplified body, involuntary arm, and third hand', at the Kitchen, New York, 12 and 13 March 1993.
10. '*Playboy* interview: Marshall McLuhan', March 1969, p. 74.
11. McLuhan and Fiore, *Medium Is the Massage*, p. 26–39.
12. Marshall McLuhan, *Understanding Media: The Extensions of Man* (New York: Signet, 1964), p. 52.
13. Ibid., p. 53.
14. Stelarc, 'Prosthetics, robotics and remote existence: postevolutionary strategies', *Leonardo* 24, no. 5 (1991), pp. 591, 594.
15. Stelarc, 'Redesigning the human body', an essay delivered at the Stanford University conference on design, 21–23 July 1983.
16. Stelarc, 'Prosthetics, robotics and remote existence', p. 591.
17. Ibid.
18. Stelarc, 'Redesigning the body', *Whole Earth Review*, summer 1989, p. 21.
19. Ibid.
20. Stelarc, 'Prosthetics, robotics and remote existence', p. 594.
21. Ibid., p. 593.
22. Sterling, 'Cicada Queen', *Crystal Express*, p. 76.
23. Stelarc, fax to the author, 1 December 1993.
24. Stelarc, 'Prosthetics, robotics and remote existence', p. 594.
25. Stelarc, Kitchen videotape, 9 March 1993.
26. '*Playboy* interview: Marshall McLuhan', p. 66; Stelarc, 'Prosthetics, robotics and remote existence', p. 594.
27. Stelarc, 'Prosthetics, robotics and remote existence', p. 594.
28. McLuhan, *Understanding Media*, p. 56.
29. Stelarc, 'Prosthetics, robotics and remote existence', p. 593.
30. Stelarc, 'Redesigning the body', p. 21.
31. Michel Foucault, *Discipline and Punish: The Birth of the Prison*, trans. Alan Sheridan (New York: Vintage, 1979), p. 136.
32. Stelarc, 'Prosthetics, robotics and remote existence', p. 594.
33. All quotes in this paragraph are from Stelarc's fax to the author, 1 December 1993.
34. Ibid.
35. Claudia Springer, 'Sex, memories, angry women', in Mark Dery (ed.) *Flame Wars: The Discourse of Cyberculture/South Atlantic Quarterly*, vol. 92, no. 4 (fall 1993), p. 714.
36. Stelarc, 'The myth of information', *Obsolete Body/Suspensions/Stelarc*, p. 24.
37. Stelarc, 'Detached breath/spinning retina', *High Performance*, nos. 41–2, (spring/summer 1988), p.70.
38. Kristine Ambrosia and Joseph Lanz, 'Fakir Musafar interview', in Adam Parfrey (ed.) *Apocalypse Culture* (New York: Amok Press, 1987), p. 111.
39. Ibid., p. 114.
40. Stelarc, 'Triggering an evolutionary dialectic', in *Obsolete Body/Suspensions/Stelarc*, p. 52; McLuhan, *Understanding Media*, p. 19.
41. *Obsolete Body/Suspensions/Stelarc*, p. 71.
42. '*Playboy* interview: Marshall McLuhan', p. 59.
43. McLuhan and Fiore, *The Medium Is the Massage*, pp. 63, 114.
44. Stelarc, fax to the author, 1 December 1993.
45. Mircea Eliade, *The Sacred & The Profane: The Nature of Religion* (New York: Harcourt, Brace and World, 1959), p. 207.
46. Stelarc, 'Prosthetics, robotics and remote existence', p. 591; Mircea Eliade, *The Sacred & the Profane*, pp. 118–19.

47. Roland Barthes, *Mythologies*, trans. Annette Lavers (New York: Noonday Press, 1972), p. 72. The italics are mine.
48. Ibid.
49. Ibid.
50. Ibid.

SUSAN STRYKER

TRANSSEXUALITY
The postmodern body and/as technology

Another Manhattan project: Christine Jorgensen's atom bomb

ONE AFTERNOON IN THE CLOSING months of 1949, the person who was becoming Christine Jorgensen stepped up to the counter of a drugstore in New York City.[1] At that moment she still answered to the name 'George' and was a rather shy young man, an aspiring film-maker with a rather indeterminate sense of self. She was not yet the woman who would make 'transsexual' a household word, though she was now taking the first practical step in the long process of realizing herself. In doing so, she began to engage with a set of issues that remain quite current – issues about gender, embodiment, technology and visual intelligibility. Examining the intersection of these concerns in the subject of transsexuality provides a point of departure for a much broader discussion of interest in the visual arts.

Jorgensen happened to be attending medical technicians' school in 1949, and had recently discovered endocrinology – then a relatively new and poorly understood branch of biological science. She read with fascination about the structural similarities of testosterone and estrogen, the hormones whose effects on bodily morphology and moods we have learned to interpret as signs of the masculine and the feminine. A difference of only 'four atoms of hydrogen and one atom of carbon' in each hormone, Jorgensen learned, was all that distinguished one chemical from the other, and thus – according to the logic of an essentializing biological determinism – all that separated men from women. Surely, she reasoned, 'there must be times when one could be so close to that physical dividing line that it would be difficult to determine on which side of the male-female line he belonged. There was an answer – somewhere'.

The 'somewhere' Jorgensen arrived at to begin her journey 'elsewhere' was a place of no particular significance – a drugstore chosen more or less at random where she could make an anonymous purchase. The 'answer' she chose to the question of gender identity – ethinyl estradiol, a recently synthesized version of estrogen – was similarly

random. Neither identity nor gender, after all, can be located in any substance, and other answers would undoubtedly have sufficed in other situations. But using estradiol to technologize her becoming-woman proved quite significant, given modern Western culture's scientific faith in materiality as the bedrock of epistemology. By altering certain qualities of the flesh, Jorgensen discovered that – at least in her day and age, and in her part of the world – hormones in fact possessed the power to contribute to a culturally intelligible process of changing sex.

On that afternoon in New York in 1949, Jorgensen realized she couldn't easily buy hormones without a prescription, but thought any doctor would consider her insane for wanting to experiment with estradiol's effects on her male body. She herself had no idea what the chemical would do to her if she ingested it, but was compelled to find out – and thereby a plan was hatched. Jorgensen had driven around in her car until she found a pharmacy in a strange section of the city. According to her own autobiograph-ical account, she approached the unsuspecting clerk, adopted a tone of voice 'designed to covey my familiarity with things medical', ordered several unremarkable items, and then asked nonchalantly for 'some high-potency estradiol'.

> 'That's a pretty strong chemical', the clerk replied. 'We're not supposed to sell it without a prescription.'
> 'Well, I guess I could have gotten a prescription, but just didn't think of it. You see, I'm at a medical technicians' school, and we're working on an idea of growth stimulation in animals through the use of hormones.'
> The clerk hesitated. 'Oh, well, in that case I guess it's okay.'

Soon thereafter Jorgensen was sitting in her car again, somewhat stunned by the ease with which she had accomplished a feat with such vast implications for her future. She unwrapped the package eagerly.

> There at last, the small bottle lay in my hand. How strange it seemed to me that the whole answer might lie in the particular combination of atoms contained in those tiny, aspirin-like tablets. As recently a few years before, science had split some of those atoms and unleashed a giant force. There in my hand lay another series of atoms, which in their way might set off another explosion.

Jorgensen had little idea how big that 'other explosion' would be until 1952, when she awoke in a Danish hospital to discover that news of her just-completed genital recon-struction surgery had been trumpeted to the four corners of the earth. 'It seems to me now a shocking commentary on the press of our time,' she recalled in her memoirs, 'that I pushed the hydrogen-bomb tests on Eniwetock right off the front pages.' Nevertheless, in the headlines of newspapers around the world, the spectacle of trans-sexuality erupted into public consciousness during the early days of the Cold War with all the force of white hot wind roaring out of Hiroshima. Transsexuality was nothing short of an atomic blast to the gender system, and Jorgensen found herself at ground zero.

Pomo euro techno anxiety

Because the bomb functioned as a master symbol for post-Second World War anxieties about the exigencies of human existence in relation to scientific technology, it is hardly surprising that Jorgensen turned to the bomb in her attempt to bring into language her own transformative experience with a new technology. Nor is it surprising that the transsexual body, by corporealizing the transformation of a human existence through scientific technology, should evoke on a mass scale some of the same ambivalent hopes and fears inspired by the bomb. I want to point out these associations by conflating transsexual and nuclear technologies in the fanciful notion of Christine Jorgensen's Atom Bomb — a metaphor for suggesting that the marginalized topic of transsexuality is deeply connected with some of the most pressing issues of the present era. Indeed, in Christine Jorgensen's transition from male to female we can discern one of those increasingly common moments in which some cultural critics see an end to the dominant modes of modern Western historical consciousness, meaning construction, and representational practice — an instance of ecstatic passage into the hyperreality of the postmodern condition.

The transsexual body is a symbol for our times as powerful as an atom bomb, a device that literalizes the collapse of the modern Western epistime: one end of history can in fact be found in a mushroom cloud. Meaning evaporates there. Time and space lose all referentiality in the atom blast, where ground zero and the year zero collide to mark the spot where reality implodes into elsewhere. The bomb and the transsexual body are similarly ambivalent figures. On one hand, they offer peculiarly pacifying images that collude with the fantasies driving contemporary culture, supplying evidence to modern Western subjects that their scientific world-view triumphs over all. Anything from cold hard matter to the ineffable essence of a human identity can be engineered into or out of existence. Like the processes through which uranium was manipulated to set off a chain reaction of explosive changes at the atomic level, transsexual surgical and hormonal transformations represent a desire for technical mastery over the material world. Metaphysical fantasies of transcendent power, like the old alchemical dream of turning lead into gold, apparently have been realized in nuclear technologies that can turn matter into energy, as well as in transsexual technologies that seemingly turn men into women (or women into men).

On the other hand, the fantasy of total power precipitates its own inevitable crisis according to the deconstructive potential of all binary oppositions. A logical extension of the domination of external objects that sustains subject-centred consciousness, the fantasy of total power spells the empowered subject's doom, rendering it instead a powerless object. The need to control becomes the necessity of being controlled; the ability to create becomes the prospect of being destroyed; the knower becomes the known. Thus, by attesting to a previously unimaginable potential for disrupting and refashioning the most fundamental attributes of existence, transsexual bodies and atomic bombs both confront the modern Western subject with the spectre of its own dissolution. They are two of the most compelling signs that Western culture has arrived at the Apocalypse it has long imagined.

Although neither she nor her doctors would have understood her transformative process in these terms, I want to suggest that Christine Jorgensen's change of sex instrumentalized the effective and visual effects produced by hormones, as well as the

morphological changes accomplished by surgery. She technologized her identification with a symbolic position (i.e. woman) in a such a manner that this identification became intelligible in terms of the code for everyday reality that she shared with the intended audience of her gender performance. By doing so, she began to signify her body in a new manner, literalizing metaphor as metamorphosis, replacing representation with presentation itself, and disrupting symbolic order to enter another realm – a meta-morphic space where image conforms to the expression of desire and the phantasmatic basks beneath the same sun that warms the surface of the skin.[2]

The transsexual body can thus be read as an avatar of postmodernity. It is one of Donna Haraway's cyborgs. If we live in a period characterized by increasing specular-ization, as Guy Debord and others claim, then the transsexual body most fully materializes the tendency toward visual spectacle; it is the most tangible realization of body as image.[3] If we are experiencing the commodification of everything, the transsexual body is the one that is literally purchased. It exemplifies the process that Jean Baudrillard has termed 'becoming-object'; indeed, in his more recent work Baudrillard explicitly discusses transsexuality as one of the central tendencies of postmodernity.[4] If, as Teresa Brennan suggests, we live in an era in which a collective social psychosis is sustained by a technology capable of producing as reality the foundational fantasies upon which the contemporary Western subject depends, then the male-to-female transsexual body in particular accomplishes by scientific means the psychical fantasy of Woman.[5] If we follow Jean-François Lyotard in conceptualizing postmodernity as a condition within the paramount virtue is performativity – where all knowledge converts to operational codes designed to increase efficiency, control and predictability – then transsexuality can be considered the encoding and instrumentalization of the means through which the meaning of the gendered body is discursively produced.[6] While this instrumentalization of the flesh certainly makes the transsexual body less 'natural,' it certainly makes it more 'postmodern'.

What interests me most about transsexuality in the context of postmodernity is not the tired question of whether it is good or evil. Like the postmodern condition itself, transsexuality is inescapably both. It is simultaneously an elaborately articulated medico-juridical discourse imposed on particular forms of deviant subjectivity, and a radical practice that promises to explode dominant constructions of self and society. It is a ground for many struggles rather than a side in any particular struggle. Most impor-tantly, I think, it is a place to engage with the reconstruction of subjectivity during a period when changing technologies, environmental factors, and political and social considerations make it imperative to critically assess the modern Western concept of proper personhood. While I believe that the contemporary Western subject needs to be reinvented in the name of our continued survival, this is not the same thing as saying that subjectivity itself is an outmoded condition. Unseating one's historically and cultur-ally specific mode of subjectivity from its position of privilege does not entail abandoning all subject positions, however mobile, multiple and strategic such positions might neces-sarily become.[7] Transsexuality is one practice among others that offers a means for mobilizing and reconfiguring the subject.

Transsexuality does not simply transgress and contest the reigning Law of proper subjectivity; rather, it begins playing a new game whose rules are still being formulated. Transsexuality intrigues me as a subjective practice of identification and embodiment that is pragmatically engaged with a set of concerns about biomedical technology and

the role of the visible surface body in the production and communication of meaning. It usefully unsettles received categories of being and doing, and promises productive 'monstrosities'.[8] Transsexuality is not just about gender; it is a harbinger of what future scenes of agency and intersubjective exchange might come to look like if current trends toward objectification and spectacularization persist. It provides a lesson in living as image, as object, as machine – even while offering active resistance to reductive definition by these terms.

Female-to-male transsexual photographer Loren Cameron expresses this sense of transsexuality's pedagogical potential in a discussion of his self-portraits. After describing the affective qualities he associates with making a transsexual identification, Cameron says:

> [T]he best way I could figure out to make these interior experiences perceptible was to literally wrap my external image in other people's words. I encircled pictures of myself with strings of comments that have actually been directed at me, and let my facial expressions and body language communicate how it feels to be the target of those remarks. The words act as mirrors. They reflect back on to nontranssexual viewers things they are likely to have thought before about people like me. The grammatical construction of these comments creates a further mirror-like reversal, putting the reader in 'my' place. The self-portraits then act as a visual reference that interprets this unfamiliar position for the viewer. They displace and reposition their audience.[9]

Cameron's work suggest that looking at the transsexual body requires a frank investigation of the particularities of one's embodiment, and how embodiment works to discursively position the embodied subject.[10] Photography is an art particularly well suited to this task. Since the technical studies of bodies in motion by Edward Muybridge and others in the nineteenth century, the camera has been the definitive tool for the scientific and aesthetic mapping of the body's temporal performativity. It is the machine best able to reproduce what many critical theories of the subject tell us is the psychological process through which we construct a sense of time and space as a sequence of images, and situate ourselves in these dimensions. The transsexual body as cyborg, as a technologization of identity, presents critical opportunities similar to those offered by the camera. Just as the camera offers a means for externalizing and examining a particular way of constructing time and space, the transsexual body – in the process of its transition from one sex to another – renders visible the culturally specific mechanisms of achieving gendered embodiment. It becomes paradigmatic of the gendering process, functioning, in Sandy Stone's words, as 'a meaning machine for the production of ideal type'.[11]

Judith Butler's now-familiar elaboration of the concept of gender performativity helps articulate the way in which I see the camera and the transsexual body as two similar technologies for the presentation of gender effects in the visual realm. Butler uses 'performativity' differently than does Lyotard, above, to refer to the temporal reiteration of signs that spatialize their effects on the surface of the body in order to produce the appearance of a gender identity.[12] Many of the most socially significant performative gestures of gender are visual – clothing, jewellery, stylized ways of holding and moving the body. However, by emphasizing these 'drag' aspects of gender performance,

much of the recent inquiry into the visual performativity of gender has neglected the extent to which flesh itself performs visually. The appearance of the skin, the distribution of hair, the fatty contours of body, the shape of the genitals – all signify gender visually.[13] According to the epistemological conventions of the contemporary West, these corporeal signs are precisely those that produce 'reality' as their visual effect.[14] Accordingly, these are the signs through which transsexuals instrumentalize gender in order to perform the reality of their subjective identifications.

Gender in the Butlerian paradigm is strikingly cinematic – any stability of gender identity's visual image is due solely to the incessant, unvarying repetition of its chosen signs over time. In this context, the critical importance of transgender phenomena becomes apparent; to account for movements in the (only apparent) stability of gender's image we necessarily confront the mechanisms through which that stability is produced as an effect. Signs of gender that we change relatively effortlessly like our clothes or relatively painlessly like the length of our hair have received the bulk of critical attention simply because they are more easily mobilised, their capacity for movement more readily perceived. The more sessile signs of the flesh are not qualitatively different, however, only less volatile. The effects they produce have a longer duration and greater stability simply because the signs are more difficult to manipulate. Unless it, too, attracts attention through some visible change, the flesh can be all too easily perceived as part of the fixed landscape against which gender performs itself, rather than as part of the performance itself.

Transsexuality offers a dramatic instance of the temporal instability of the flesh. It sets embodiment in motion. Transsexual embodiment practices offer a means of creatively tampering with the corporeal spatialization of gender's temporal performativity, while photography offers a similar means of playing with the temporal aspects of gender's visual performativity. This is no less true of still photography than motion pictures. The still camera frames a moment of the temporal stream of visual signification and freezes it into a static image. The ability to manipulate time and space through the lens enables the critical work of analysing the effects of gender and simultaneously expands the means for engaging with gender to invent new possibilities for being human. Work such as Loren Cameron's, which manipulates the body from both sides of the lens, contributes to the vital task of opening up greater opportunities for using the body-in-flux as a site of new cultural production.

Locating the postmodern body

One of the most trenchant critiques of postmodern and post-structuralist theory is that it tends to erase the body.[15] 'If the body is a metaphor for our locatedness in space and time,' Susan Bordo contends, 'then the postmodern body is no body at all.'[16] Postmodernism, in her view, continues to enact the philosophical fantasy of transcending the body, though through an error diametrically opposed to the error of modernism in regard to embodiment. Rather than attempting to deny the specificities of the flesh in the name of a universal human subject whose perspective is a 'God's-eye view from nowhere', postmodern thought tends to render bodily difference insignificant through mobility – it dreams of the ability to be everywhere, dancing from location to location and refusing to accept responsibility for being in a certain place, of a certain shape.

'What sort of body is it that is free to change its shape and location?' she asks rhetorically — and answers, 'no body at all.'

It seems to me that 'the transsexual body' would be a better response. The critical investigation of transsexual embodiment makes obvious some crucial distinctions between 'nowhere', 'everywhere', and 'anywhere'. While the first two terms do resist being located, 'anywhere' is always somewhere, though its location is not stable. 'Anywhere' — a term Bordo does not employ — best captures the sense of mobility that postmodern theory seeks to address, without arriving at an old utopian dream by a new route. Transsexual embodiment demonstrates that bodies can indeed be repositioned through the technical manipulation of the signs of the flesh that discourse fastens upon to situate the body in the first place. It does not, however, accomplish any sort of transcendence — either of the material specificity of the flesh or of the discourses through which the body is stabilized. It suggests that bodily relocations along discursive axes other than sex/gender are possible. Sites of identification certainly seem to be proliferating, and relocational technologies such as plastic surgery and gene therapy, technologies that alter the physical substance of the body, are becoming more powerful. But the postmodern body — however peripatetic — is never off the map. Its location at any moment can always be described by the intersection of some significant lines of cultural determination.

If we take seriously the structuralist and post-structuralist notion that situation and context determine meaning, as well as the Foucauldian notion that power is productive, then we need to start thinking about 'location' as a verb and not just a noun. If 'body' is the metaphor for our situation in time, space, language and culture, then how is that situation discursively produced and maintained through the flesh? This is the problem Judith Butler addresses with the concept of 'materialization', her term for the processes through which gender, race and other shaping discourses actively place, or locate, the body.[17] What has yet to be adequately theorized is the extent to which these discourses ground themselves in the flesh through the field of vision. Aspects of gender or racial identity that are not visually intelligible simply don't 'matter' in the same way as those that are visually significant — as any pretransitional transsexual or light-skinned person of colour can attest.

So much of what matters about a person is what we see of their body, that the need to attend to the social, political and economic consequences of the visual performativity of the flesh in the day-to-day world is not likely to vanish any time soon. And yet, opportunities for intersubjective exchanges in which bodies are not in evidence — or where the evidence of bodies must be called into question — are rapidly increasing as new communications and media technologies emerge. How are we to orient ourselves and make sense of our interactions with others on the Internet, for example, where the visual realm is compressed and encoded as optically-read text and we have no clues about the person's sex or race? As new digital imaging technologies emerge for creating pictures that can produce 'reality' as an effect and yet refer back to no material object, what happens to the modern West's visually-anchored epistemology? What happens when the dominant culture can't trust in the veracity of its own most compelling truth practices?[18]

I recently had an opportunity to explore questions of the body's relation to new technologies as part of a panel discussion conducted in the *alt.arts.nomad* newsgroup on the Internet, and down-loaded for 'Persistent Dispositions/Technotronic Identities', a multi-media event at the California Institute of the Arts. Flesh is not often visually

performative in cyberspace, and yet the subjects communicating there are inextricably caught up in other interactive webs where flesh matters a great deal – kinship systems, sexuality-based communities, cities, racial formations, educational institutions. What subjective qualities produced by the flesh persist in a technologized space that stages the body's absence? Do discourses like sex and race that operate through the visual performativity of the flesh cease to matter in the new media domains, or do they just signify differently? How might flesh signify when it is not visually performative?

I am quite a novice with electronic communications technologies, and one thing struck me forcefully – I began to have trouble telling where my boundaries were when I was on-line. Because subject and body are neither separable nor coterminous, using an unfamiliar means of communicating one's self can produce a powerful sense of disembodiment, heightening the subjective awareness of that lack of congruity. The more I tried to conceptualize the problem of where 'I' stopped and 'my' communicative tools started, the more trouble I had. I found it increasingly necessary to think in terms not of 'body and technology' but 'body as technology'. My hands and the keyboard, my eyes and the screen, seemed no longer meaningfully distinct; all were part of the same means of instrumentalizing a certain desire to communicate an intent.

Thinking about the question in this manner, however, I found myself on familiar ground again, for 'body as technology' is a condition I have become comfortable with as a transsexual. It is a postulate that follows easily enough from the principle of performativity. Flesh is a medium, a means of an identity performance. If we accept the psychoanalytic notion that what works itself out through the flesh is a set of desires and identifications, what Laplanche and Pontalis have termed the 'structuring fantasy' of the subject, then transgendered people are no different than any others – all subjects are strung from similar frameworks. Any number of cultural mechanisms attempt to secure the subject in certain historically determined relations between particular forms of the body and particular patterns of identification and desire. However, there is no necessary connection between one's psychical identifications and one's anatomy (that is, there is no intrinsic reason that someone born with a vulva and vagina cannot identify with the symbolic position 'he').

Any particular subject always negotiates the radical divide between me/not me in the process of organizing an identity, for the site of identification is always external to the I. All identifications are thus technologized – accomplished by some means designed to secure the subject in relation to something other than itself. The transgendered subject – the one who defies the historical association of genders and genitals – who desires to communicate the reality of its identifications needs to bring its corporeal signification into accord with fantasy that structures it. This is a difficult task because the signification of the body is determined by discursive formations that are always already prior to the subject. It requires the instrumental manipulation of the flesh, for flesh is the medium that generates the specific effects that have acquired special ontological status in the reigning episteme. What distinguishes the transsexual body from the nontranssexual body is not that it has been instrumentalized in the service of identification, however, but the means through which the instrumentalization takes place. Nontranssexual means of embodiment disappear into the fiction of a natural fact, while transsexuality foregrounds the necessity of instrumentalization through its blatant unnaturalness.

The location of the body, I want to suggest, lies somewhere between subjective identification and such cultural discourses as sex and race. It is indistinguishable from

technology, from instrumentalized means. To think about the body in this way challenges the metaphysical assumption of modern Western science that material substance is the source of meaning. Material embodiment is inescapable, but its meaning derives from elsewhere. On the one hand, the body is a technology for performing subjective identifications and desires, and the performance doesn't stop at what seems to be the body's outer limit. Performance extends easily from the warm thickness of meat into the attenuated pulse of electrons. On the other hand, the body is a technology for locating the subject. Its flesh generates effects that discourses take up as signs, discourses that pre-exist any individual subject and work to situate and shape its desires and identifications. It does not exit these shaping discourses simply because it enters another performative space. The body, then, is always the body-in-flux, an unstable field rather than fixed entity, a vacillation, a contested site for the production of new meaning. It is tenuous matter, caught between the energetic poles of subject and culture, constantly engaged in transformation.

Which brings us back by a circuitous path to Christine Jorgensen and her atom bomb. As I suggested at the outset of this chapter, the bomb and the transsexual body both stage anxieties about the relationship between the subject and technology, and literalize the collapse of the modern Western episteme. They both abolish materiality as the stable ground of meaning, and cause all that seems solid to melt into air. New media and communications technologies can evoke the same fears, by similarly calling into question the foundational premises that undergird contemporary subjectivity. In part, I want to suggest, this is due to the manner in which the subject engaged with an unfamiliar means of technologizing subjectivity crashes headlong through the metaphysical assumptions that sustain it and confronts the fictionality of its particular constructions. As painful and disorienting as such realizations can be, they are not without virtue. Learning to live creatively within technology and as technology is not to abandon human subjectivity, for human subjectivity is always instrumentalized through something other than itself. Rather, it is to begin imagining new modes of subjectivity. We have all learned to live under the shadow of a mushroom cloud. Some of us are happily transsexual. Many of us make art at the site of our intersection with machines. These all seem like hopeful tokens of an inhabitable future beyond the Apocalypse of the modern Western subject.

Originally published in *Exposure* 30 (1–2) (1995).
This essay has been edited for inclusion in the Reader.

Notes

1. The portions of this article dealing with Christine Jorgensen are drawn from the introduction to my book-length work in progress, *A Critical Gender: Autobiographical Perspectives on Transsexuality*. The following anecdotes about Jorgensen's transition are drawn from Christine Jorgensen, *Christine Jorgensen: A Personal Autobiography* (New York: Bantam Books, 1968; orig. pub. New York: Paul Eriksson, 1967), pp. 77–78, 130.
2. Jean Baudrillard, 'Forget Baudrillard', in *Forget Foucault* (New York: Semiotext(e), 1987), pp. 75, 95, discusses metaphor and metamorphosis. See also Judith Butler, *Bodies That Matter: On the Discursive Limits of 'Sex'* (New York: Routledge, 1993), particularly her discussions of phantasmatic identification and the relations between the Symbolic and Imaginary registers on pp. 65–6 and 138–40.

3. Guy Debord, *Society of the Spectacle* (Detroit: Black and Red, 1983; orig pub. 1967).

4. Jean Baudrillard, 'Forget Baudrillard', in *Forget Foucault* (New York: Semiotext(e), 1987), pp. 96–8; *The Transparancy of Evil: Essays on Extreme Phenomena* (London: Verso, 1993), pp. 20–6.

5. Teresa Brennan, *History After Lacan* (London: Routledge, 1993), pp. 3–4, 62–73, 114–17.

6. Jean-Françoise Lyotard, *The Postmodern Condition: A Report on Knowledge* (Mineapolis: University of Minnesota Press, 1984), p. 47.

7. For a related discussion see Jane Flax, *Disputed Subjects: Essays on Psychoanalysis, Politics, and Philosophy* (New York: Routledge, 1993), pp. 100–2.

8. I am thinking here not only of Donna Haraway's 'The promises of monsters: reproductive politics for inappropriate/d others', in Larry Grossberg, Cary Nelson and Paula Triechler (eds) *Cultural Studies* (New York: Routledge, 1992), pp. 295–337, but also my own discussion of monstrosity in 'My words to Victor Frankenstein above the village of Chamounix: performing transgender rage', *GLQ: A Journal of Lesbian and Gay Studies* 1:3 (Fall, 1993), pp. 237–54.

9. Loren Cameron, Barbara de Genevieve and Susan Stryker, 'Transpositions: an introduction to the art of transsexuality', forthcoming in Loren Cameron, *Our Vision, Our Voices: Transsexual Portraits and Nudes* (unpublished manuscript). Given the oppositional stance I have taken *vis-à-vis* Baudrillard in this essay, it is instructive to compare his notion of the proper subject of photography with Cameron's remarks: 'as soon as the subject begins to collude with the lens, and the photographer becomes too subjective, the "great game" of photography is over. Exoticism is dead. Today it is very hard indeed to find a subject – or even an object – that does not collude with the camera lens', *The Transparancy of Evil*, p. 152.

10. Cameron's one-man show, 'Our Vision, Our Voices', opened at 848 Community Art Space in San Francisco in May 1994, and at Highways Performance Gallery in Santa Monica in October 1994. Many of the images in the show were of surgically altered genitals – the first time such material had appeared in an artistic context rather than in medical textbooks. Barbara de Genevieve, in 'Letting us look: scandalous genders or blur baby blur', *Camerawork* (October 1994), says of Cameron's work that 'the desire and the necessity to see these particular bodies is the desire and the necessity to see the future: the cyborg body presents very "different political possibilities and limits from those proposed by the mundane fiction of Man and Woman"' (citing Donna Haraway, *Simians, Cyborgs, and Women: The Reinvention of Nature*, New York: Routledge, 1991, p. 180).

11. Sandy Stone, 'The empire strikes back: a posttranssexual manifesto', in Julia Epstein and Kristina Straub, *Body Guards: The Cultural Politics of Embodiment* (New York: Routledge, 1991), p. 294.

12. Judith Butler, *Gender Trouble: Feminism and the Subversion of Identity* (New York: Routledge, 1990), pp. 136–40.

13. This is not to deny that these bodily attributes also produce tactile, aural and olfactory effects, but rather to assert that in most interactions with others the visual effects are of primary importance. We usually see more of others than we feel, hear or smell of them.

14. In failing to adequately address the performativity of flesh, current gender theory often unwittingly reproduces the distinction between the 'real' and the merely 'performed' that it ostensibly seeks to break down.

15. Thomas Laqueur, *Making Sex: Body and Gender From the Greeks to Freud* (Cambridge: Harvard UP, 1990), p.12.

16. Susan Bordo, 'Feminism, postmodernism, and gender-skepticism', in Linda Nicholson (ed.) *Feminism/Postmodernism* (New York: Routledge, 1990), p. 145.

17. Judith Butler, *Bodies That Matter: On the Discursive Limits of 'Sex'* (New York: Routledge, 1993).

18. William Mitchell suggests some answers to these questions in *The Reconfigured Eye: Visual Truth in the Post-Photographic Era* (Cambridge: MIT Press, 1992).

DIANA GROMALA

PAIN AND SUBJECTIVITY IN
VIRTUAL REALITY

VIRTUAL REALITY (VR) EXISTS AS a mythopoeic cultural pheno-
menon and as an experience through which notions of subjectivity flow and collide.
Subjectivity – constituted and reconfigured through experiential aspects of VR and the
larger cultural domain within which it resides and operates – is befuddled: the experi-
ence is irreducible to subject/object, inside/outside, mind/body, and VR/'real' world
oppositions. Perhaps the most troubling aspect of VR is the consciousness-altering bodily
experience, generally and problematically termed disembodiment. The term itself reveals
the difficulty of linguistic or textual description and can be related to conditions of
jouissance, Avital Ronell's notion of drugs, and Julia Kristeva's exploration of the abject
(I/not I). Just where are the self and the body in relation to this disconcerting and
simultaneous experience of being in and not in the virtual world, and how do they
constitute each other? Elaine Scarry's conceptualization of pain and imagining provides
productive strategies to employ in exploring how the body and self extend agency and
how they constitute each other through the prostheses of VR.

Situated bodies, situated selves

Deeply implicated in the cultural production of so-called VR technologies, I often witness
and swallow the many paradoxes it creates. Highly regarded scientists, for example,
legitimize research directions in scholarly symposia, while at dinner they speak in hushed
tones, comparing VR experiences to transcendent spiritual states, drug trips, and 'd.t.'s'
or residual effects of extensive exposure. Respectable professors dream of 'downloading
"pure" consciousness'. Others thrill in the sensation of 'disembodiment' and the ecstasy
of 'leaving the meat behind'. Subjective states, such as a sense of 'immersion' or 'pres-
ence', are often measured by purportedly objective, empirical means. The user's body
stands woefully constricted and tethered, straining to clumsily adapt to the alleged limit-

lessness of VR – one can experience the ability to fly, as long as the three-foot sensor range is not exceeded. Such presuppositions also rely on a socioeconomic status of relative privilege, as well as the culturally determined ability to comprehend the symbolic languages or orders of VR. One of the most significant paradoxes is that VR is more widely discussed than actually experienced, yet the experiential component is what is found to be most compelling.

VR is frequently conflated with the larger existent or projected cultural processes referred to as cyberspace. In addition, future possibilities of VR technologies are often confused with actual current capabilities. This may help explain why VR, in a brief but frenzied moment during the last several years, enjoyed widespread attention in literature, film, the arts, the media, and other cultural forms, and why it has assumed mythopoeic dimensions in our cultural imagination. Though the technology is still in its infancy and has often not lived up to the urgent expectations created around it, much like artificial intelligence in previous decades, it none the less persists as both a troubling and potentially redemptive phenomenon.

Although VR is often depicted as if it lacked a history or a cultural context, its historical precedents can be traced through intertwining threads of mechanical developments, computational evolution, and the fantastical worlds elicited through mimetic simulations of ritual, dioramas, art, literature and theatre, and some may claim, medieval cathedrals. What these examples hold in common is the evocation and perception of a shareable but otherworldly place in which humans extend and project their agency – the ability to act upon, within, and through the world – and where subjectivity is problematized. The history of VR is in many ways the history of the conditions and construction of selfhood through projecting one's self and one's agency into the 'real' or object world and attendant virtual and fictional worlds.

In its contemporary manifestations, VR can be understood in a multiplicity of ways in relation to the experience and perceptions of the subject, as well as the informing context within which subjectivity and VR are situated. One is a deterministic view of VR which places its development as increasingly removed from human control, somehow taking on a 'nature' of its own, an essentialized apostasy. Here it is rendered in cautionary tales that stir our mythopoeic imagination in an animistic or fetishistic sense, as a phenomenon that takes on a monstrous life of its own, often turning against us in a threat to ultimately destroy us. These cautionary tales remind us that the extension and projection of human agency can be dangerous, whether the projection is indirect, through a robot or the automata described by the early Greeks and Chinese for example, or direct, through prostheses in contact with the body, as in VR. When human agency is externalized, projected through indirect means and expressed as embodied, an essentialized Other emerges. It becomes progressively further removed from direct human contact and can no longer be controlled by its human creator. This can be seen in a thread connecting golem in sixteenth-century Prague to Frankenstein, the feminine robot in *Metropolis*, the replicant Roy in *Blade Runner*, the T-1000 in *Terminator 2* and the biologic cells in *Blood Music*. The results are just as disastrous, however, when the projection is more intimately tied to a direct prosthetic interface with the body, such as current VR apparatuses of head-mounted displays, data gloves and body suits. In these instances, the technology, though not externalized as an entity, none the less reveals its ability to create a fertile framework or condition for human self-destruction. In *Lawnmower Man* and *Until the End of the World*, users are 'taken over' by something inherent in their own

consciousness, whether it is an escalating greed for power or a profound addiction to their dreams and desires. In either case of externalized entities or direct bodily experience, the technology grows disconnected from human agency.

However, these totalizing myths of a demonized technological Other, as well as the converse utopian rhetoric, reify cultural hegemony in the construction of subjectivity. By relying upon a totalizing view of technology, especially as a seemingly autonomous Other, most of reality is omitted.[1] Further, by not questioning or considering the instrumental forces, conditions, processes and power relations of a technology implicit in the cultural realm, we can unproblematically distance ourselves from our own implicit role and responsibility in these processes. This unquestioning acceptance works at the level of ideology or 'common sense'; thus, unequal power relations remain invisible.

Subjectivity in relation to VR can also be understood in terms of a problematic relation to the symbolic realm, implicated in the much wider, everyday cultural experience of hyperreality described by Jean Baudrillard[2] and Paul Virilio.[3] In a hyperreal cultural context, symbols no longer maintain a referent or are preferred over the thing they originally represented. In this view, the phenomenon of VR can be seen as a simple distraction to or instance of the much wider everyday cultural experience of hyperreality, an experience that in turn problematizes subjectivity in the schizophrenic terms of Fredric Jameson,[4] Gilles Deleuze, and Felix Guattari.[5] The schizophrenic subject, constituted through this realm, is no longer a unified entity, but a free-floating, fragmented being. Deleuze and Guatarri celebrated this construction or reconstitution of a schizophrenic subject as a strategy for survival in a Western world of late capitalism, characterized by processes of the hyperreal brought about in part by technology.

The experiential dimensions of VR provoke further confusion in the relationship between bodily experience and subjectivity in the symbolic realm. An indeterminate subjectivity embedded in this context of hyperreality not only experiences disconcerting shifts in the time/space continuum and free-floating signifiers on the level of the everyday, but in some way can seem to bodily inhabit or occupy the symbolic realm of VR. Because the technologically enhanced body, or human sensorium, is 'joined in a sensory feedback loop with the simulacrum that lives in RAM, it is impossible to locate an originary source for experience and sensation'.[6] Thus, the body is experienced as more viscerally 'present' than it is in other fictive realms and is therefore seen to somehow circumvent our subjective relation to the symbolic. According to Jaron Lanier, for example, VR abrogates the process of entry into the symbolic realm, what he terms 'postsymbolic communication'.[7] Resulting attempts to describe this VR experience as disembodiment, however, only serve to reify a mind/body split. A schizophrenic subjectivity might provide an alternative to the Cartesian dualism by nomadically embracing shifting and contingent experiences.

In the view of Jean-François Lyotard,[8] the experience of VR can be seen as an instantiation of the instrumentality of technology in a postmodernist context. Lyotard describes technology as a language game, extending while reconfiguring the modernist myths or metanarratives of mastery and progress, while the state maintains domination by escalating the rate of technological change to an ever-increasing frequency. Implicit in this technological landscape, the phenomenon and experience of VR reflect and are co-opted by instrumental forces of domination. Here, the self dissolves into a host of networks and relations of contradictory codes and interfering messages, which he, like Deleuze and Guattari, valorizes. Likewise, as Donna Haraway would have it, the phenomenon

and experience of VR are related to larger sites or processes of domination. VR rein-
forces but could also simultaneously disrupt those very structures through emerging
contingent and hybrid subjectivities. Rather than adhering to a demonization of tech-
nology or reacting to it by developing another, oppositional and totalizing theory,
Haraway enjoins us to embrace 'the skilful task of reconstructing the boundaries of daily
life, in partial connection to others, in communication with all of our parts'.[9]

As a cultural artifact, VR can be seen as a diagnostic tool or an expression of our
millennialist angst. Like artifical intelligence and a broad range of new technologies,
from the printing press to the telephone and television before it, VR functions as a
screen or mirror upon which we can project our deepest fears, hopes for utopia, cures
for what ails us, or an escape from our current condition, expressed in relation to our
notions of subjectivity and the body. However, VR differs from the evocation of imag-
inary spaces, such as the suspension of disbelief that happens in the theatre, in part
because of the seemingly more direct and visceral implication of our bodily responses
in the feedback loop with VR technologies. The Lacanian mirror of mis-recognition
seemingly becomes a mirror we can literally walk into, or, in N. Katherine Hayles'
terms, becomes a second mirror stage – the Mirror of the Cyborg, one which accounts
for a subjectivity not reliant upon physical boundaries.[10]

Most frequently, VR is understood in terms of the experiential, inevitably referred
to as the sensation of so-called disembodiment. By implication, traditional notions of
subjectivity are disturbed by the inexplicable quality and effects of VR-induced sensa-
tions. The fascination with the sensation of disembodiment belies the most outstanding
characteristic of VR: the profound experiential dimension that seems to resist linguistic
or textual description and that confounds binary oppositions of mind/body and
self/other. 'Boundary states' of subjectivity that cannot be reduced to binary opposi-
tions provide useful models for the examination of the sensation of so-called
disembodiment and its effect on subjectivity. These are Avital Ronell's notions of
narcotics, and Julia Kristeva's notion of the abject (I/not I) – the problematic projec-
tion of the self into the object world. However, Elaine Scarry's conceptualization of
pain provides perhaps the most useful strategy for examining sensation and subjectivity,
since it necessarily implicates the body and self as inextricably bound.

As an experience of embodied imaginary space, VR is often compared to altered
states of consciousness, such as those provoked by narcotics or hallucinogenic drugs.
Rather than considering a drug-enhanced state of consciousness as a search for an exterior,
transcendental dimension in a dualism of interior/exterior, or mind/body, Avital Ronell
views the desire for a 'chemical prosthesis' of drugs, or a technological prosthesis of
virtual reality, as a desire to explore 'fractal interiorities'. Again, subjectivity is decen-
tred. The chemical prostheses provide an experience in which the 'distinction between
interiority and exteriority is radically suspended, and where this phantasmic opposition
is opened up'.[11] Kristeva's concept of the abject can be seen as another type of boundary
state in relation to the body and its social construction. 'The abject is what of the body
falls away from it while remaining irreducible to the subject/object and inside/outside
oppositions. The abject necessarily partakes of both polarized terms but cannot be clearly
identified with either'.[12] We are repulsed by but at some level desire and claim these
abject products of bodily fluids and 'wastes' as a part of the self. Perhaps this is akin to
the sensations provoked by VR: desire and anxiety (or unrecognized revulsion) simul-
taneously emerge as our body responds to the feedback loop and disrupt traditionally

sacrosanct notions of body and self. Such boundary states assume that a certain degree of self has already been constructed, whether it is understood to be whole and intact, or contingent and partial. However, other boundary states that occur prior to an infant's construction of self or separation from its mother, such as Lacan's 'imaginary' and Kristeva's view of *jouissance*, also serve to elide and disrupt oppositions of self and Other, inside and outside. An unconscious desire to return to this intensely pleasurable state of *jouissance* may be proffered to explain one of the reasons for VR's popularity.

Pain's remains

Though I was only 13, I mourned the loss of my kidney the night before they cut it from my body, 'removed' the dysfunctional organ. What seemed curious to me was that I wasn't allowed to keep it, vitiating the traditions of my family. My people are 'of the earth' types from isolated areas of the Carpathian Mountains, people whose traditions are rarely mentioned by anthropologists. They collect and save their body parts in yellowed glass jars sealed with wax which reside in medicine cabinets, hope chests, and potato cellars worthy of Dr Caligari. They save their protein excrement, their hair, and bury their body parts along with the soil of their birthplace in some sort of shamanistic hangover. Only after unseemly insistence was I allowed to see what my ambitious surgeon said would make me famous in the *New England Journal of Medicine:* a calculus the size of Montana, attended by a complete lack of evidence of the horrendous pain physicians associate with this disease. He felt that the kidney itself, the meat, would be too upsetting for me to see, but somehow the stone would not. *Medusa from the inside* I thought as I snatched it and held its smooth, foetal shape. But holding it was strictly forbidden because I might have somehow damaged what rightfully belonged to science, to pathology – I had violated the protocols of medical science. Never would I be buried with all of my bodily creations. In contrast, a few years later, the reverse was true: now I experienced inexplicable pain, which could not be readily substantiated by physical evidence. My subjective experience of pain seemed to defy verification by the objective, scientific measures insisted upon by Western medicine. Thus I came to my first virtual reality experience in a research hospital, subversively catching glimpses of the interior of my body. There, in an attempt to substantiate and objectify my emerging pain, physicians used microvideography to explore my viscera, projecting it on televisions and larger screens to other physicians and interns. Drugged but conscious, I was nonetheless consistently and vehemently discouraged from viewing my own body, though I thrilled in the abject pleasure it produced when I caught glimpses of its enormous and animate projections.

In her book, *The Body in Pain: The Making and Unmaking of the World*, Scarry defines pain by the manner in which it implies a split between one's sense of one's own reality and the reality of others. An essentially subjective state, pain cannot be denied or confirmed. Scarry outlines the exceptional character of pain when compared to all other interior states: 'We do not simply have feelings, but have feelings for somebody or something: love is love of x, fear is fear of y, ambivalence is ambivalence about z. Pain has no referential content, it takes no object, and more than any other phenomenon, resists objectification in language'.[13] She discusses pain through the metaphor of three concentric but permeable circles: the innermost, the difficulty of expressing pain; next,

the political and perceptual complications that result because of that difficulty; and finally, the nature of both material and verbal expressibility, that is, the nature of human creation.

Scarry's analysis of pain provides useful methods for understanding the experiential aspects of VR. This experience – what I term the transformative state of consciousness provoked by sensorial experiences of the body *and* inexorably bound to them in simultaneity – is a projection of the self into the object world; in this case the object world is VR. Though Scarry's analysis appears to be somewhat problematic in her distinction of physical pain, implying a mind/body split, her framework does allow for a semipermeability that both partakes of and denies strict binary oppositions. It is thus valuable in the examination of the experience of VR in two ways. First, by focusing on the projection of a sentient being into the object world, what Scarry refers to as 'imagining', the mind/body duality becomes permeable and allows for the consideration of simultaneous experiences. Second, Scarry outlines this projection and ultimate reformation as transformative. Again, this condition allows for semipermeability, or a continuous feedback loop between the sentient being and the object world.

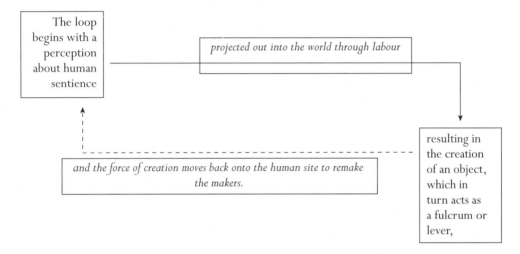

Scarry's use of the term 'sentient' is crucial here, in that it refers to consciousness inextricably bound to sensation; hence, the conscious 'mind' is one with perception through the bodily senses. Further, in her definition of the effect of pain as a splitting of one's own sense of reality from others', which resides within the larger frame of the processes of pain and imagining, Scarry accounts for both the irreducible material fact of the body as well as subjective experience without falling into a solipsistic subjectivity. By extension, this frame of self-objectification, termed imagining, allows for the consideration of the simultaneous experiences offered in VR. This represents a significant opportunity in discourses surrounding VR,[14] which otherwise tend to deny the body as somehow separate from the mind and expendable. In these discourses, the sensation of disembodiment is generally proffered as adhering to the well-worn Cartesian split. It is possible and liberatory, as some would have it, to escape from the body, or at least from the aversive aspects of the body, that is, pain. The dream here is to download pure consciousness (mind) and leave the problematic meat (body) behind. The assumptions underlying this stance reify the position that the mind and body are separable, that experience can

be unproblematically compartmentalized, and further serve to limit the conscious experience of VR to, again, an either/or experience. This reasoning assumes that one experiences VR, say, in the ability to 'fly' in the simulation, without simultaneously experiencing the irreducible physical limitations of the material body and its dissonant inputs. A reluctant acknowledgement of simultaneity of experience gets a nod, albeit one in terms of disease, from the observation of 'sim-sickness'. Sim-sickness (or simulation sickness) refers to the proprioceptive determinations of the body receiving two sets of signals at odds with each other, one originating from the 'real' world, say, gravity, the other from visual cues in the simulation that can produce the sensation of flying. The result is nausea, though the body usually adapts through habituation. Describing this in terms of a disease reveals the tendency to desire an escape from the problematic meat, rather than reincorporating it in simultaneous experiences, which phenomena of adaptability like habituation serve to accomplish.

However, rather than considering the sensation experienced in VR as a denial or escape from the material body, I would instead argue that this experiential component of VR can be viewed more productively when focused on Scarry's description of imagining – the projection of the sentient being into the object world – in this case through technological prosthesis, a move associated with pleasure. By focusing on the projection, the fiduciary subject[15] – that is, the body as the privileged site of geopolitical instrumental forces within systems of domination and the irreducible material fact of the body – is not disavowed. The meat remains, and remains connected to a multiplicity of simultaneous experience.

Scarry posits the following: 'Pain and imagining' constitute extreme conditions of, on the one hand, intentionality as a state and, on the other, intentionality as self-objectification; and between these two boundary conditions all the other more familiar binary acts-and-objects are located. That is, pain and imagining are the 'framing events' within whose boundaries all other perceptual, somatic, and emotional events occur; thus, between the two extremes can be mapped the whole terrain of the human psyche'.[16]

According to Scarry, pain serves to split one's own sense of reality from others', while imagining allows the subject – unified in subjectivity, or decentred and schizophrenic – to project, to participate in a shared reality. The experience of VR seems to manage both. The user of VR, partially cut off from participation in the real world by a head-mounted display, can be observed to be thrashing about, simultaneously and partially functioning in another world. Semi-immersed in the VR world, this user can communicate with other users who are 'telepresent' through similar technological prostheses and representations. However, if a user spills virtual coffee on another user in VR, the person may react as if liquid burned their flesh; but, simultaneously, in the material world, her pants are not wet – the liquid does not fully translate. Yet if one user scares another user in VR and that person is heavily invested in the simulation, he could perhaps suffer a very real heart attack. The realities are multiple and simultaneous, only partially shared, not reducible to the VR world or the real world, yet necessarily implicated in both. Mythopoeic examples often employ the trope of a shock to the body, a visible instance of a sign of pain, before the subject experientially 'enters' VR. This is not unlike shamanistic practices of inducing pain as a signal that many anthropologists interpret as 'a little death' of the body necessary to signal a rebirth of a reconstituted self.[17] These can both be read as a denial of the flesh, but read another way, they can signal the disconcerting experience of simultaneous presence – the

irreducible material aspect of the body is in the VR world and in the real world, just as the reconfigured shaman, even renamed, returns to the same body through which the transcendental state was induced.

The nature and the process of imagining and creation described by Scarry provides useful insights in examining subjectivity in VR. The sentient being projects into the object world and is in turn transformed in the process:

> Imagining works this way. We begin with a perception about human sentience. It is projected out into the object world through labor and results in the creation of an object (in this case, a VR object/experience). This object in turn acts as a fulcrum or lever, which the force of creation moves back onto the human site to remake the makers. To repeat, there is a reciprocal consequence at the human site.[18]

Scarry goes on to say that imagining works either directly, by 'extending its powers and acuity (poem, telescope)', or indirectly, 'by eliminating aversiveness (chair, vaccine)'. Like imagining, VR seems to work in both ways. Indirectly, the user, the sentient being in VR, projects and extends agency in a multiplicity of ways. The users, or sentient beings, can extend their ability to interact and effect change simultaneously in the simulation and in the 'material' world by remote manipulations of robotic arms in space, or by remote surgery. They can interact with other users who, though physically remote, are none the less 'telepresent', and can share and communicate in a common simulation. Certain qualities of a VR simulation do not strictly reproduce what is possible outside of the simulation, such as the six degrees of freedom which produce the illusion that users can fly. Indirectly the experience of VR can simultaneously eliminate aversiveness, for example, in providing surgeons, pilots and astronauts an opportunity to refine skills and habituate themselves to unfamiliar experiences. The temporary 'escape' into a fictive world eliminates the aversiveness of the real world. In some instances, VR works directly and indirectly, simultaneously. In using robotic arms to manipulate dangerous materials, users directly extend their agency to remote sites and simultaneously eliminate aversiveness by remaining at a safe distance.

In the feedback loop of Scarry's process of imagining, subjectivity can be seen to be continuously and dynamically influenced. This feedback loop begins with a perception about human sentience and an intentionality, as stated earlier, as self-objectification. What drives this intentionality in relation to VR? Perhaps it is alluded to in Ronell's discussion of drugs: 'Much like the paradigms installed by the discovery of endorphins, being-on-drugs indicates that a structure is already in place, prior to the production of the materiality we call drugs, including virtual reality or cyberprojections.'[19] We do not reproduce that which is ultimately outside of our perceptions, that which influences our subjectivity, including experiences of so-called disembodiment. In situating VR as the object/experience, subjectivity is dynamically influenced by the partial shareability of a VR experience, and by a simultaneous experience of being within and outside of VR.

In terms of the theorists mentioned in the introduction, Scarry can be considered to be adhering to binary oppositions and a tendency toward a totalizing discourse. What is at issue is the shareability of a reality on an ontological level, technologically mediated or not. A decentred and contingent subjectivity, by definition, must share, or partially share, a reality. Scarry's positing of permeability allows for the attenuation of strict splits between binary oppositions.

Virtual bodies

Some time ago, I was in a semi-contorted position, trying to watch the interior of my stomach lining, in real time. Swallowing, incorporating the video camera elicited pain, as did the torturous nerve conduction studies that were required, again, in an effort to substantiate my subjective experience of chronic pain through 'objective' tests. Although the suggestion would be anathema to Western physicians, it seemed not unlike the home-opathic magic practised by my herbalist grandfather: provoke pain to cure one of it. My grandfather taught me what Western medicine could not: how to cope with ever-present pain. In essence, I deal with chronic physical pain in part by re-experiencing it, simul-taneously, as pleasurable. In many non-Western methods of meditation, this involves not an escape from the body, but rather, a reinhabitation of its inward enormity, or an erasure of the distinction between interior and exterior, a certain sense of an expansion and simultaneous loss of self, perhaps not unrelated to *jouissance*.

I had long since insisted on my place in both the subject and object position of this medicinal discourse. A voyeur of the wonders of medical imaging, I collect and person-ally finance, with the help of my insurance companies, all sorts of 'objective' and 'scientific' visualizations of my body. What fascinates me is the spectral and sensuous quality of these representations, images of bone and viscera, fluid and sound, movement and depth. Here my body, through their tools and devices, is enhanced as a site through which social, political, economic and technological forces flow and collide, often with very real and tangible effect. Here I become a cyborg, both theoretically and as a result of the way technology alters my material being. The idea of a cyborg tweaked my throb-bing interest, not only in the liberatory possibilities outlined by Haraway,[20] but also because, quite literally, I have devices, or what belongs to the object world within my interior being.

I was interested in bringing my experience of chronic pain into the object realm, as Scarry suggests, in order to make it shareable. In order to produce art, that is, to hopefully invite or induce an insight, revelation, or state of altered consciousness, I was interested in exploring the experiential aspect, the sensation of disembodiment of VR, to reflect that double move of conflating pain with pleasure. Further, I was looking at these visualizations of my body as sites of contestation and negotiation among social, political and economic forces that had a direct result on my subjectivity and material body. In doing so, I wanted to reappropriate these visualizations, digital data obtained from technologies that are able to extend our perception to apprehend previously inac-cessible properties of bodies, from x-rays, MRIs, and sonograms to electron microscopy, invasive microvideography, and algorithmic interpretations, which transform data from bodily sounds, heat and 'measurable' pain sensitivities into malleable visual and aural forms.

Thus, a cyborg materially as well as theoretically, I explored these issues in the creation of *Dancing with the Virtual Dervish: Virtual Bodies*, a work in virtual environments. Through the beneficence of the Canadian government's Department of Communications and the Banff Centre for the Arts, I engaged in a three-year process of creating an immersive virtual environment which has since been performed at various venues. With a choreographer and computer scientists,[21] this immersive, interactive virtual environ-ment was constructed from the database of visualizations of my body. This virtual body is of enormous scale and exists in a state of constant decay and reformation. The virtual

body becomes a 'book' as it is overwritten with texts of desire, Battaille-inspired reem-bodiments of Eros and Thanatos swirling about splintered and reconfigured forms, textual encryptions of a body in pain, a body in confluence with materiality, the immaterial, and dematerialized notions of corporeal transcendence, of corporeal reinhabitation.

Conclusion

My first-hand experience with pain illustrates Scarry's description of its ability to destroy the language of the sufferer: one who experiences physical pain can neither have it confirmed or denied. The effect of pain is that it prevents the projection of self into the object world (imagining) to make pain sharable. Yet, my artistic goal of *Dancing with the Virtual Dervish: Virtual Bodies* was not to replicate the experience of pain but to create a virtual environment which elicits a reinhabitation of the body, one which conflates pain with pleasure and unknowable states of death. To quote Scarry, 'That pain is so frequently used as a symbolic substitute for death in the initiation rites of many tribes is surely attributable to an intuitive human recognition that pain is the equivalent in felt-experience of what is unfeelable in death'.[22] I linked this strategy of reinhabitation to the consciousness-influencing bodily experience of disembodiment of VR. Both states strongly decentre our culturally specific emphasis on certain senses (the visual, sonic) above others (haptic, kinesthetic, visceral, emotional) and provoke profound visceral responses which seem to defy textual description. The experience of VR, understood in its mythopoeic cultural forms as a problematic experience of the self and body, has an ability to throw assumptions of subjectivity into disarray.

Underlying discourses that strive to redefine relationships between technology and subjectivity assume that a stable subjectivity exists intact, prior to experiences of fluid and mutable disembodiment, an assumption that post-structuralist theorists call into question. The disembodied experience, combined with qualities of VR that seemingly do not replicate 'reality', serves to upset notions in our relationship to the symbolic realm, as well as binary mind/body, subject/object, and material/immaterial distinc-tions. Other boundary states which do not allow for strict binary oppositions include *jouissance*, drugs and the abject. While they provide useful analogies in the exploration of subjectivity in VR, Elaine Scarry's conceptualization of pain provides productive strate-gies to employ in exploring how the body and self extend agency and how they constitute each other through the prostheses of VR precisely because what is at stake is our human ability to make our world shareable with others.

Originally published in L. Hershman Leeson (ed.) (1996) *Clicking In: Hot Links to a Digital Culture*,
Seattle: Bay Press.

Notes

1. Donna J. Haraway, 'A cyborg manifesto: science, technology, and socialist-feminism in the late twentieth century', in *Simians, Cyborgs, and Women* (New York: Routledge, 1991).
2. Jean Baudrillard, *Simulations*, trans. Paul Foss, Paul Patton and Philip Beitchman (New York: Semiotext(e), 1983).
3. Paul Virilio, *The Vision Machine* (London: British Film Institute and Bloomington and Indianapolis: Indiana University Press, 1994).

4. Fredric Jameson, 'Postmodernism and consumer society', in Hal Foster (ed.), *The Anti-Aesthetic: Essays on Postmodern Culture* (Seattle: Bay Press, 1983).

5. Gilles Deleuze and Felix Guattari, *A Thousand Plateaus*, trans. Brian Massumi (Minneapolis and London: University of Minnesota Press, 1987).

6. N. Katherine Hayles, 'The Seductions of Cyberspace', in Verena Andermatt Conley (ed.) *Rethinking Technologies* (Minneapolis and London: University of Minnesota Press, 1993), p. 174.

7. As Katherine Hayles reminds us, Jaron Lanier's view that VR will supplant language denies the underlying assembly language of VR computation, as well as the formation of our sensibilities through language. Because our sensibilities are formed through language, Hayles continues, language pervades even nonlinguisitc domains. Ibid., 190, n. 38.

8. Jean-François Lyotard, *The Postmodern Condition: A Report on Knowledge* (Minneapolis: The University of Minnesota Press, 1988).

9. Haraway, 'A cyborg manifesto', p. 181.

10. Hayles, 'The seductions of cyberspace', pp. 186–8.

11. Avital Ronell, 'Our narcotic modernity', in *Rethinking Technologies*, 61.

12. Elizabeth Grosz, *Volatile Bodies* (Bloomington and Indianapolis: Indiana University Press, 1994), p. 192. See also Julia Kristeva, *Powers of Horror: An Essay on Abjection*, trans. Leon Roudiez (New York: Columbia University Press, 1982).

13. Elaine Scarry, *The Body in Pain: The Making and Unmaking of the World* (New York and Oxford: Oxford University Press, 1985; rpt. 1987), p. 5.

14. The discourses to which I refer include those proffered by such authors as William Gibson, O. B. Hardison, Jr. And Hans Moravec, among others. Many media representations of VR are similarly described in these terms. However, significant scholarship calls such a view into question, particularly the work of N. Katherine Hayles, Allucquere Rosanne Stone and Anne Balsalmo.

15. Allucquere Rosanne Stone, 'Virtual systems', in Jonathan Crary and Sanford Kwinter (eds) *Incorporations* (New York: Zone Books, 1992; distributed by MIT Press).

16. Scarry, *The Body in Pain*, p. 165.

17. Mircea Eliade, *Shamanism: Archaic Techniques of Ecstasy*, tran. Willard R. Trask (Princeton: Princeton University Press, 1964; rpt. 1972).

18. Scarry, *The Body in Pain*, p. 307.

19. Ronell, 'Our narcotic modernity', p. 62.

20. Haraway, 'A cyborg manifesto'.

21. *Dancing with the Virtual Dervish: Virtual Bodies* was a project in Virtual Environments created by artist Diana Gromala and choreographer Yacov Sharir. It was funded by a major grant from the Canadian Government's Department of Communications and the Banff Centre for the Arts. The author wishes to recognize the computer scientists and engineers who collaborated: John Harrison, Glen Frazier, Graham Lindgren and Chris Shaw, as well as Raonull Conover, computer artist. *Dancing with the Virtual Dervish: Virtual Bodies* has been performed at numerous international venues, including the Fifth Cyberspace Conference, the Art and Virtual Environments Symposium, the Second Biennial Conference on Art and Technology, and the International Society for Electronic Arts (ISEA).

22. Scarry, *The Body in Pain*, p. 31.

MIKE FEATHERSTONE

POST-BODIES, AGING AND VIRTUAL REALITY

Print and radio tell; stage and film show; cyberspace embodies.
(Howard Rheingold 1992: 192)

Essentially from a virtual reality perspective, the definition of the body is that part which you can move as fast as you can think.
(Jaron Lanier, quoted in Lanier and Biocca 1992: 162)

When sense ratios change, men change.
(Marshall McLuhan [after Blake] 1962: 265).

WHEN WE EXAMINE POPULAR CULTURAL representations of old age in contemporary Western societies we tend to find two sets of images. In the first place there are the 'heroes of aging', those who adopt a positive attitude towards the aging process and seem to remain 'forever youthful' in their work habits, bodily posture, facial expressions and general demeanour. The second refers to those individuals who experience severe bodily decline through disabling illness to the extent that the outer body is seen as misrepresenting and imprisoning the inner self, something we have referred to as 'the mask of aging' (Featherstone and Hepworth 1991a; 1995).

It can be argued that within consumer culture the first category is dominant and we are provided with a constant series of heroic images of active old people, many of them stars and celebrities. The second category provides glimpses of the hidden and more disagreeable aspects of the aging process, the voyeuristic fascination with the decrepit elderly represented as abominations of human nature. Such representations challenge our existing modes of classification and capacity to empathize with those whose bodies have so clearly betrayed them. These images of the elderly as subhuman or para-human beings comprise a suppressed minor strand within consumer culture; they form part of the repertoire of the pornography of old age.

But what of the future? Is this opposition fixed, or can it be transcended? What is the potential for progressive technological solutions to these problems? With regard to the first category, consumer culture already promotes solutions which draw upon medical and technical expertise in featuring active youthful elderly men and women engaged in diet, health fitness regimes, or undergoing cosmetic surgery and other longevity-inducing techniques and therapies (see Hepworth and Featherstone 1982; Featherstone and Hepworth 1982; Featherstone 1991a, 1991b). These can be regarded as a continuation of the long-established tradition of interest in rejuvenation and longevity which has more recently managed to divest itself of many of the religious prohibitions (against vanity, hedonism, self-expression, self-love etc.), which denigrated the body in favour of the cultivation of the spirit (Gruman 1966). From this perspective the malfunctioning body can be repaired and the ravages which time has wrought eliminated, or held at bay. Both the surface of the body and face (the outer body) can be refurbished, and its capacity to function smoothly in order to provide an enabling, and preferably effortless and painless, platform from which to engage in life's full range of activities (the inner body), repaired or enhanced. The various regimes and techniques of body maintenance coupled with increasingly sophisticated medical technology offer the prospect, for those who possess the necessary financial resources, of holding at bay the mask of aging and turning old age into an extended active phase of 'midlifestyle' (Featherstone and Hepworth 1991b).

For those, however, who suffer disabling or degenerative illnesses in old age, for whom the body cannot be repaired, the metaphor of the mask of aging, or that of the body as a prison, can be more readily applied. One possible strategy here is to seek to escape the pain and discomfort of a body which no longer functions as an adequate base for interpersonal communication and self-expression, through leaving the body to venture into other worlds. Here we can think of the world of fantasy and day-dreams.[1] Yet for many people this does not represent a viable means of escape from the here-and-now embodiment of the everyday world. The degree of realism and capacity to suspend doubt, or the 'believability' of the experience, may be relatively low.

A further possibility is vicarious escape through watching situations, interactions, people, places and dramas on television, film or videotape. Here it is possible to move over into the 'epoch' of this other world and suspend doubt. The drawback with this medium is that it relies solely on two of the human senses: seeing and hearing. It is also a non-interactive medium: one can switch on or off, fast-forward or rewind. There are, however, signs that this situation could be about to change through the development of new information technology. Strong claims are currently being made that virtual reality can offer highly realistic out-of-body experiences and the impression that one is able to move and interact with other beings in a parallel universe, with the potential to utilize the full range of human senses. Yet for its advocates virtual reality promises much more: virtual reality is seized on by some as something new and exciting which will open up new dimensions of human, or post-human existence.

Yet in all the dazzling descriptions of virtual reality that I have read there is no mention made of the elderly. This is strange, for it is well known that the elderly contains a high proportion of the disabled, as well as those who are dissatisfied with their physical appearance and have low self-esteem. Research on virtual reality clearly has some very important implications for our notions of embodiment, the structure and ordering of social encounters and out-of-body experiences. It therefore could

well have significant implications for the creation of a new set of images of what it is to be old.

Electronically mediated communication can be used to transmit a variety of different types of information, ranging from: highly-coded relatively unambiguous data (such as flows of money and financial market indices), to written or printed texts (requiring different degrees of interpretation in order to clarify context), to speech (apparently less ambiguous), to visual models (which can take the form of short-hand representations of complex symbolic information, such as models and maps), and photographic representations of human beings and their surrounding world (such representations in the form of photographs, film or television which are taken to provide a high degree of immediacy, an 'illusion of presence' and indexicality (see Falk 1993)).

How does this relate to our discussion of the disempowerment which follows from the onset of old age, especially the visibility of the ravages which time has worked on the appearance of the body and face? In the first place it could be argued that by separating the speaking, or message-sending body from the listening, or message-receiving body in time and space and using electronic transfers of written information, the elderly person could benefit from the lack of co-presence and the invisibility of his or her body. While some may be quick to condemn such abstract exchanges as depersonalizing, it can be argued that it enables the avoidance of being identified as an elderly person. In addition it provides a degree of control over the flow of the interchange in the response time and form taken to make a reply, something which can conceal impaired direct embodied communicative capacity (for example, cueing, response time, mishearing etc.). In effect, in addressing a fax, letter or electronic mail transfer into one's personal computer, the oft-cited usual range of stigmatizing social inequality (gender, ethnicity, age, class etc.) while by no means eliminated, are not as immediately obvious as in the case of direct face-to-face encounters.

Yet while some may revel in the freedom emanating from loss of the face-to-face embodied encounters and the capacity to escape from the host of judgements about a person's habitus, status, capital and empowerment, there is always the danger of disclosure, or meeting the 'real' embodied person behind the text or voice. Stone (1992: 82ff; and see also chapter 31, this volume) recounts the case of Julie, a totally disabled older woman, who could only push the keys of her computer with a headstick. She established close contact with a number of other women on the 'net', and offered them advice about their deepest troubles. After a number of years it was revealed that 'Julie' did not exist: in fact, she was a middle-aged male psychiatrist, who claims to have been mistaken for another woman the first time he logged in, and because he liked the intimacy, vulnerability, and depth he found in conversations between women, he decided to continue with the deception by elaborating the persona of a totally disabled, single, older woman. The deception worked for years, until one of Julie's admirers determined to meet her, finally tracked her down. When the news hit the network some women were outraged. One said 'I felt raped. I felt that my deepest secrets had been violated' (Stone 1992: 83). Julie was an early case of 'computer cross-dressing' which gives an indication of the new range of modes of interaction and identity explorations which are becoming possible through computer networks.

In summary, we can make a number of points. First, the capacity to develop new technology to facilitate modes of information exchange which enable communication to take place over distance, is increasing. Such modes as the telephone and Bulletin Board

System (BBS) computer networks facilitate simultaneous interchanges based upon the voice and text which are disembodied modes of interaction. Second, disembodiment need not be regarded as a drawback, for some it is grasped as a benefit, as it facilitates anonymous interactions with strange others whom one has not met, or whom one would not seek to meet. Third, this facilitates the development of shared 'nonplace' worlds whereby simulated environments can be created in order to provide spaces for disembodied interactions which facilitate the expression of a range of playful or fantasy-based interactions. Fourth, rather than abstract technological modes of interchange being regarded as 'de-humanizing' in a negative sense through the loss of visibility, tactility and the alleged warmth of 'full-blooded' face-to-face encounters, they may open up new possibilities for intimacy and self-expression. Fifth, this may lead to a series of experiences which are vivid, yet fragmented in the sense that they do not involve the whole body or self, in which the boundaries between reality and fantasy, body and technology, the organic and cybernetic, closeness and distance, intimacy and anonymity, primary and secondary relationships, become destabilized. Sixth, while the majority of people interested in disembodied interactions by telephone or computer network are the young, such interactions would seem to be ideally suited to the needs of the elderly faced with restricted mobility, impaired communicative competence and other 'bodily betrayals'. We will now turn to an examination of virtual reality with its potential to extend these developments into new dimensions.

Virtual reality

The technological potential of virtual reality research has a number of potential implications for the aging body and future images of old age.

First, as Jaron Lanier has pointed out, in virtual reality it becomes difficult to define where the boundary of the body is (Lanier and Biocca 1992: 162; see also Stone 1992: 99ff). The body can effectively move as fast as the user can think, it can fly, walk, maintain a form near that of our normal body, or become something completely different such as another human being or animal, the body can merge with other bodies and exchange sense data in intimate situations instead of bodily fluids.

Even in the case of severe disability of the real body, it is possible for the user's virtual body to engage in mobility and sensory exploration. All it needs is for some limited sensory input into the computer, which can be taught to read a limited repertoire of bodily movements which can operate switches, conventions, keyboards in the virtual space, as well as enabling a range of movements and interactional possibilities for the virtual body. For example, cerebral palsied patients could use tongue-steered virtual reality. For those who suffer from near total paralysis of the body, technically it is possible for a camera to read small lip movements, or even eye movements, or tilts of the head, which once a set of conventions have been agreed can be digitally inputted into the computer via a camera to produce mobility and operative capacity for the user within a virtual world. There is also the capacity to artificially augment or extend the senses and develop cross-syntheses of the senses to help, for example, the deaf and the blind. In addition there is the potential for enhanced opportunities for those with physical and learning disabilities in 'virtual classrooms', or 'virtual rehabilitation centres' in which users operate specialist systems which use the potential for freedom, movement

and absorption of attention span, as well as the technical capacity for rapid input and output integration, of virtual worlds to design new learning techniques. There would seem to be a good deal of potential here to develop systems to deal with a wide range of disabilities, which of course are disproportionately concentrated in the elderly, such as strokes.[2]

With regard to disability it is important to emphasize that virtual reality's sole function need not be to provide a sense of escape from the 'body as prison', to generate an experience of freedom and mobility in sensorily exciting worlds, such as simulated mountain climbing. Rather, it can have a much more prosaic function in its capacity to externalize and mobilize surrogate devices to carry out the full range of tasks which a fully operative normal body does in everyday life, through the manipulation of operative systems and recording of bodily movements which occur in the virtual world. In effect, virtual reality can be used as a command system with which to control the everyday environment. The user possesses a series of technological devices which act as a surrogate externalized functioning body, which he/she manipulates through operating a simulation of a free-moving body in virtual space through a very restricted and limited repertoire of sensory/bodily movements inputted from the disabled body. This would mean that for disabled people to operate their everyday environments, or escape into alternative worlds, they would have to spend a good part of their everyday lives in virtual reality. Indeed some commentators envisage the virtual reality user as akin to a scuba diver, who surfaces into the real world from time to time to refuel (to ingest and expel necessary bodily fluids) and then re-enters the virtual medium.

A second range of possibilities for the body relate to interaction with other human beings in virtual worlds. In virtual reality conferences an accurate three-dimensional simulation of the interactants' bodies relate to each other in a virtual room. Here one would expect that a series of conventions on body formatting, modes of presentation and respect of body space (whether flying around the room is permissible) would emerge in order for the interaction to proceed smoothly and cost-efficiently. Yet while there are strategic imperatives for business and organizational modes of communication, this need not be the case with other leisure virtual reality interactions. For example, one would assume that the businessman would seek some guarantee, equivalent to a fingerprint or DNA-print, that the virtual body of the person he interacts with is bona fide. At the same time there may well be all sorts of pressures to steal a march by upgrading or enhancing the beauty and expressive capacity of the virtual face and body. Likewise there might also be pressures to retain last year's simulation – or even one from the last decade. The pressures for such conventions and how they would be monitored and a body of law developed (does a deal conducted with an alternative body in virtual reality carry the legality as that between real persons?) and enforcement agencies instructed to deal with offenders, is an interesting subject for speculation.

With regard to leisure interactions, there exists a whole range of potential games involving different modes of interaction and the merging of bodies. One form which has attracted a good deal of interest is 'teledildonics'. This offers the potential to take on and 'inhabit' a range of different bodies for sexual encounters. Within the confines of the virtual world everyone can potentially look as youthful, fit and beautiful as everyone else, provided they purchase or design the necessary simulation. For those who have bodies which do not match up to the cultural ideals, or are disabled or old, entering into a virtual reality 'teledildonic' network may offer a new range of opportunity

structures, forms of intimacy and emotional attachments. Whether or not, as Rheingold (1992: 352) remarks, 'the physical comingling of genital sensations will come to be regarded as a less intimate act than sharing the data structures of your innermost self-representations', remains to be seen. There would therefore seem to be potential for greater tolerance of the possibilities of inhabiting, co-habiting (dwelling inside another's body) and merging (being co-wired in series with another's body in which senses are coupled together and a single body exists in the virtual world).

There is an argument, often associated with postmodernism, that we are currently about to enter a post-literate era as we move from a print culture whose dominant form was reading, into an image culture where information is conveyed through visual images such as film, television and video (Meyrowitz 1985: Featherstone 1991a). Virtual reality (VR) commentators take this a step further by suggesting that the VR medium is ideally suited for new forms of interpersonal communication which are more graphic and mimetic than spoken or written language, and potentially more economical. Jaron Lanier, for example, refers to this future computer-augmented metalanguage as 'post-symbolic communication', and argues that we will soon be able to communicate by exchanging images, sounds and dynamic models. In effect we will not write, but send a simulation, a miniature reality or virtual world, which the receiver will be able to enter, explore and understand.[3]

It is this potential for a range of new out-of-body experiences and the development of post-symbolic communication which has captured the imagination of a new generation of technophiliacs. The new cyberpunk literature has already been fed back into virtual reality design and theory: fiction and research are interacting and chasing each other in what some would see as a typically postmodern fashion. There is not the space here to refer to the growing literature on cyberspace which has been largely prompted by William Gibson's (1984) novel *Neuromancer* save to mention that Gibson's fiction gives us a world which has a massive range of para-bodies, meta-bodies and post-bodied forms: bodies are wired to computers, artificial intelligences assume human form, and those who move around at street level can purchase prosthetic aids to upgrade the human body and its sensorium.

Cyborgs, experience and memory

The fictional accounts of cyberspace provide a dystopian corrective to some of the more utopian excesses of the advocates of virtual reality. With regard to the position of the elderly does this merely mean that we have come back to square one, to a world in which the possibilities of leaving behind a decrepit and betraying body as prison for the freedom of virtual reality is really a sham because new forms of power relationships and interdependencies will necessarily emerge? Will the contingencies of power games in the virtual world continue to reward those who have 'an edge', and penalize those whose bodies or post-bodied sensori are deficient? Of course, the elderly will have increased possibilities of disguise, of adopting off-the-peg virtual bodies, or having their own body surfaces reinscribed and inner functions restructured and upgraded. Yet, it can be argued, the practical imperatives of recognition, of needing to make a judgement about the other, as to whether he/she/it is potentially dangerous, friendly or indifferent, is something all living entities need to do, whether in material everyday life

or in a virtual world. The elderly will only be able to participate fully in the new virtual world, to the extent to which they possess the power resources to be able to purchase the technological upgrades necessary to achieve and maintain a competitive edge.

The alternative is to write off participation in the new emerging public world of the matrix, with all its dangers and excitement, in favour of the potentially more controllable private world of leisure and fantasy. Here one could experience exhilarating directed-dreaming in which one summons up a world. It would even be technically possible to create beings with which one could interact in that world, who were granted a degree of autonomy. Or alternatively one may wish to preserve in that world simulations of one's friends, relatives or partners. Hence it may be possible for the elderly to relive and re-experience previous moments with simulations of former partners, and enjoy intimacy and shared sensory encounters. Where genuine interaction with others is concerned and the space becomes more public (or quasi- or para-public), the problems of risk and empowerment will emerge. For example, Jaron Lanier's discussion of the potential capacity to show our emotions by bodily transfiguration – turning into a red lobster when one wishes to express anger – may work, or be retained within certain contexts. Yet as in all types of communication it is to be expected that forms and conventions will emerge which provide the equivalents of everyday face-to-face cueing devices, turn-taking in conversations, body language etc. which are driven by the economizing imperative of being understood which, while operating most strongly in purposive work contexts, cannot be divorced entirely from apparently freer and more meandering, playful forms of sociability.

Yet it can be argued that the appeal of disembodied forms of experience, which are coupled into real risks and power games, may also appeal to the elderly. In *Neuromancer* we are given a sense that cyberspace is a place of rapture and erotic intensity (Heim 1992). The loss of the capacity to re-enter this world, to remain confined in the 'body as prison', is a daunting threat for those who live for the exhilaration of cyberspace. This occurs in the book when the central character, Case, has his immune and nervous system tampered with and slowed down as a punishment for double-crossing a former employer:

> For Case, who'd lived for the bodiless exultation of cyberspace, it was the Fall. In the bars he'd frequented as a cowboy hotshot, the elite stance involved a certain relaxed contempt for the flesh. The body was meat. Case fell into the prison of his own flesh.
>
> (Gibson 1984: 6).

What is the status of this experience and how do we evaluate it? For those who would view it from the perspective of a nostalgia for the real, the cyberspace experience would fall into the sector of intense, tactile, fragmented experiences which provide a series of shocks: the machine pleasures of speed, vertigo and immersion; something to contrast with 'genuine' experiences arrived at and articulated in collective situations, which reinforce the social bond and generate a sense of the sacred. Such experiences are held to feed the collective memory and generate lasting emotionally meaningful relations between people, which can be relived through rituals.

On the one side we can place Donna Haraway, who argues for the liberatory potential of the new technology to alter the bodily infrastructure of human beings. Haraway celebrates the cyborg as a sign of hope for women to escape from the conceptual dualisms

of culture/nature and mind/body which help confine women to a rigid view of their gendered nature, and instead explore the ways to reinvent and reconfigure a host of new post-gendered possibilities. Hence her oft-quoted remark: 'I'd rather be a cyborg than a goddess' (Haraway 1991). We could equally argue here that what Haraway has done for feminism in terms of reconceptualizing the relationship between women, technology and the body, one could equally do for old age, through thinking through, in an equally radical manner, the potential for change.

On the other side we have figures such as Heidegger, whose opposition to technology is well known and influential. For Heidegger (1978) such experiences as those we have described in virtual reality would be opposite of 'dwelling': being able to build a meaningful relationship to the world. Walter Benjamin could be placed on either side, for at different places in his writings he actively supports the potential of the shocks and fragmentation of the new technologically-induced experiences, yet in other places he seeks to bemoan the shallowness of such transacted experiences (*Erlebnis*) and argue for the importance of experiences which have been grounded and sedimented into collective memory (*Erfahrung*) which provide continuity (see Benjamin 1973). One could continue this argument, as many have done before and make a strong plea for the importance of a sense of place, tradition and continuity for the elderly, whose position in the life course necessarily means they will look backwards and need to have their past experiences validated to retain a sense of self-worth. But this argument holds if the elderly can only look back to remember the past and are not granted a future. The speculative technological developments we have spoken of certainly contain a range of possible future modes of bodied and disembodied experiences and empowerment for various groups of the elderly. Given this, it is difficult to see why such experiences could not generate new forms of sociation, rituals, the sacred and liminoid repertoires (see Tomas 1992; Heim 1992). If this is the case, then virtual reality could not just be regarded as another distraction of the young, but as containing possibilities of extended hope and development, with all their associated excitement, risk and dangers.

Originally published in M. Featherstone and A. Wernick (eds) (1995) *Images of Aging: Cultural Representations of Later Life*, London: Routledge.
This essay has been edited for inclusion in the Reader.

Notes

I would like to thank Roger Burrows, Mike Hepworth, Britt Robillard, Kevin Robins, Chris Rojek, Michael Schapiro, Ralph Shroeder, John Tulloch and Andy Wernick for numerous suggestions which were helpful in writing and revising this paper. Earlier versions of this paper were presented at the Second Images of Aging Conference, University of Geneva, Sierre, Switzerland, July 1993, the Department of Comparative Literature at the University of Hong Kong in November 1993, and The Center for the Body, Deakin University in February 1994.

1. See Schutz (1962) on the worlds of fantasy and day-dreams as separate 'finite provinces of meaning' which require a different natural attitude to that found in the paramount reality of everyday life. He also refers to the world of dreams (see also Halton 1992). There is a considerable literature, much of it fictional, on the subject of dream-travel, in which trained subjects

can consciously guide their movements around the world while in a dream-sleep. For fictional accounts see the Lobsang-Rampa autobiographical novels on Tibetan monks trained for adastral travel and Dennis Wheatley's novel *The Ka of Griffith Hillary*.

2. The film *The Lawnmower Man* (Brett Leonard, 1993), described as 'The UK's first virtual reality film', focuses on the way in which Joe Smith, 'a simple gardener', who is an educationally subnormal young man, is introduced to virtual reality learning systems and rapidly 'increases his brain power by 400%' with dramatic and spectacular consequences.

3. One potential implication here is the capacity to simulate environments in every country in the world, or indeed from past ages, which the virtual reality user can enter and explore. If such a system was perfected this would, it has been argued, mean the end of tourism and travel. For a humorous account of this future situation in the twenty-first century see Penley (1992).

References

Baudrillard, J. (1993) *Symbolic Exchange and Death*, London: Sage.
Benjamin, W. (1973) *Charles Baudelaire*, London: New Left Books.
Biocca, F. (1992) 'Virtual reality technology: a tutorial', *Journal of Communication* 42(4).
Falk, P. (1993) 'The representation of presense: outlining an anti-aesthetics of pornography', *Theory, Culture & Society* 10(2).
Featherstone, M. (1991a) *Consumer Culture and Postmoderism*, London: Sage.
—— (1991b) 'The body in consumer culture', in M. Featherstone, M. Hepworth and Bryan S. Turner (eds) *The Body*, London: Sage.
Featherstone, M. and Hepworth, M. (1982) 'Ageing and inequality: consumer culture and the new middle age', in D. Robbins *et al.* (eds) *Rethinking Inequality*, Aldershot: Gower Press.
—— (1991a) 'The mask of ageing', in M. Featherstone, M. Hepworth and Bryan S. Turner (eds) *The Body*, London: Sage.
—— (1991b) 'The midlifestyle of George and Lynne', in M. Featherstone, M. Hepworth and Bryan S. Turner (eds) *The Body*, London: Sage.
—— (1995) *The Mask of Ageing*, London: Sage.
Finkelstein, J. (1991) *The Fashioned Self*, Oxford: Polity Press.
Fjellman, S. (1992) *Vinyl Leaves: Walt Disney World and America*, Boulder: Westview Press.
Gane, M. (1991) *Baudrillard: Critical and Fatal Theory*, London: Routledge.
Gibson, W. (1986) [1984] *Neuromancer*, New York: Fantasia Press.
Gruman, G.J. (1966) 'A history of ideas about the prolongation of life', Philadelphia: *American Philosophical Society Transactions* 56(9).
Halton, E. (1992) 'The reality of dreaming', *Theory, Culture & Society* 9(4).
Haraway, D. (1991) *Symians, Cyborgs and Women. The Reinvention of Nature*, London: Free Association Books.
Heidegger, M. (1978) 'Building, dwelling, thinking', D. F. Krell (ed.) *Basic Writings*, London: Routledge.
Heim, M. (1992) 'The erotic ontology of cyberspace', in M. Benedikt (ed.) *Cyberspace: First Steps*, Cambridge, Mass.: MIT Press.
Hepworth, M. and Featherstone, M. (1982) *Surviving Middle Age*, Oxford: Blackwell.
King, R. (1992) 'The siren scream of telesex: speech, seduction and simulation', mimeo.
Lanier, J. and Biocca, F. (1992) 'An insider's view of the future of virtual reality', *Journal of Communication* 42(4).
McLuhan, M. (1962) *Guttenberg Galaxy: the Making of Typographical Man*, Toronto: Toronto University Press.
Meyrowitz, J. (1985) *No Sense of Place*, Oxford: Oxford Univerity Press.
Penley, C. (1992) 'Future travel: anthropology and cultural distance in an age of virtual reality: or a past seen from a possible future', *Visual Anthropology Review* 8(1).
Rheingold, H. (1992) *Virtual Reality*, New York: Simon & Schuster.
Rojeck, C. (1993) *Ways of Escape*, London: Macmillan.

Schutz, Alfred (1962) 'On multiple realities', in *Collected Papers Volume 1*, The Hague: Nijhoff.

Steuer, J. (1992) 'Defining virtual reality: dimensions determining telepresence', *Journal of Communication* 42(4).

Stone, A. R. (1992) 'Will the real body please stand up? Boundary stories about virtual cultures', in M. Benedikt (ed.) *Cyberspace: First Steps*, Cambridge, Mass.: MIT Press.

Tomas, D. (1992) 'Old rituals for new space', in M. Benedikt (ed.) *Cyberspace: First Steps*, Cambridge, Mass.: MIT Press.

Wiley, J. (1995) 'No body's doing it', *Body & Society* 1(1).

Zijderveld, A. (1971) *The Abstract Society*, Harmondsworth: Allen Lane.

LISA CARTWRIGHT

THE VISIBLE MAN
The male criminal subject as biomedical norm

I RECENTLY OVERHEAD A CONVERSATION in which it was related that, demographically speaking, American men with the highest sperm count are those incarcerated in prisons. I wasn't prepared to approach the person relating this perplexing piece of biomedical gossip to enquire about her source. Whether or not the prison population is in fact the most potent of the American male population, the claim speaks volumes about the contemporary fantasies of medical science and the US public regarding the bodies of prisoners, masculine virility and biomedical norms. It suggests that the criminal body, historically associated with pathology and abnormality, may now symbolize the apex of virility and health in the national imagination.

In the late 1990s, we are witnessing a conjuncture of popular and scientific interest in the criminal body and its functions in life and in death. This fascination recalls the last century's public interest in criminal anatomy. As John Tagg and Allan Sekula have demonstrated, functionaries of late nineteenth-century institutions of law and social service regarded the structure and surface markings of the criminal body as a visual indicator of mental pathology.[1] This precedent suggests a model of criminality that doesn't quite match up with the criminal as the embodiment of potency described by my anonymous source. The anecdote I relate, along with recent representations of the criminal body including the one discussed at length below, suggest that cultural critics need to reconsider the new kinds of investments being made by science and by the media public in those bodies that are regarded as charges of the state.

This chapter really begins with another more familiar media tale about the male criminal body as a model of health: the story of Texan Joseph Paul Jernigan, an executed murderer whose body has become one of biomedicine's prime models of normal human anatomy. Jernigan's white male body was posthumously selected from numerous cadavers circulating in the public domain to serve as the raw material for an anatomical compendium of the male body that is currently available on the World Wide Web, in CD-ROM, and on video as the Visible Man. This virtual body was joined recently

(in November 1995) by a counterpart, the Visible Woman. Together, they form the nucleus of a kind of virtual family conceived by the National Library of Medicine and collaborating contractors, a digital family of anatomical models slated to be completed with the inclusion of the bodies of a younger woman and a foetus. As the first member of this family to be made available to the public, Jernigan's body has spent the past year at the locus of numerous private and federal projects devoted to establishing the most intricately detailed and yet universally standardized compendium of the normal male body to date. In effect, Jernigan's body has become the gold standard of human anatomy.[2]

The widespread public acceptance of Jernigan's transformation from convict to model of health is indicated in a 1996 *Chronicle of Higher Education* article wherein it is suggested that the late felon's posthumous service to the public is a form of absolution, earning him the title of 'Internet angel'. 'In his life,' author David L. Wheeler writes, 'he took a life. In his death, he may end up saving a few.'[3] The identity of the Visible Woman remains virtually anonymous: she is typically described as a 59-year-old resident of Maryland who died of a heart attack – a housewife who, according to her husband, was 'never sick a day in her life' and hence wanted to leave her unscathed body to science.[4] The Visible Man occupies a different place in the public eye: he is imbued with a name, an identity, and a personal history – more specifically, a narrative of moral corruption in life and redemption after death. Since early 1995, Jernigan and the Visible Human Project have been the focus of a surfeit of media coverage ranging from science and medicine journal reports to World Wide Web sites to broadcasting features on venues such as National Public Radio and network news shows. Much of this coverage features not only the status of the Visible Man as a remarkable achievement of medical technology, but also the intimate details of Jernigan's criminal past.

Cultural critics would do well to consider the broader implications of the public narrative linking the Visible Human Project to Jernigan's public exoneration through his service-in-death to medical science and to public health culture. We might ask why it is that at this point in history the white male criminal charge of the state is the subject placed at the locus of a new and highly public biomedical norm. Whereas so far the Visible Woman more often has been at the centre of gender-specific projects like a proposed prototype and virtual reality training programme in gynecological and reproductive health care,[5] the Virtual Man more often has served as a gender-neutral model of human anatomical form and function. How did the federal government and their state university contractors justify this use of Jernigan's body? Moreover, how did the American public come to find compelling this story of the transformation of the criminal subject from public offender to public icon of physical health, embracing the media's rendering of the details of Jernigan's litigious and moral history, along with science's public rendering of his physical body? The Visible Human Project's display and dissemination of Jernigan's fragmented body is also a display of the often less overt politics of health and representation: by occupying a place in the public eye, the Project brings to the fore questions of gender, class, cultural identity, as well as questions of service to medicine 'for the good of mankind' – the latter a set of questions more often negotiated behind closed doors, within medical profession settings, and not in the public media.

Jernigan's institutional journey

In 1981, Jernigan was caught by surprise in the midst of a home burglary. He stabbed and shot the homeowner dead. Texas courts found Jernigan guilty of murder and sentenced him to death by lethal injection. Twelve years after the crime, prison workers attached an IV catheter to Jernigan's left hand and administered a drug that effectively suppressed the brain functions which regulate breathing. As journalist David Ellison has put it, the drug made Jernigan forget how to breathe.[5]

Jernigan's story is already a tale about the conjuncture of state and medical technologies of bodily regulation and control. The IV catheter attached to his hand functioned as a kind of prosthetic disciplinary hand of the state of Texas, allowing prison officials chemically to reach into Jernigan's body and switch off the basic unconscious mechanism that regulated his breathing. But the story of state prosthetics and technological regulation doesn't end there: Jernigan's body, unlike most of the bodies that make it to the end of Death Row, was not buried and forgotten.

Jernigan may have led a life of crime, but on at least one count he was a model citizen: he had signed a donor consent authorizing medical and scientific use of his body upon death. Initially, Jernigan's generous intentions were thwarted by the fact that the cause of his death was lethal injection, a process that left his organs tainted – poisoned – and hence useless for transplant into another (living) body. However, his age (he was 39), body type and health condition suited perfectly the needs of a rather different sort of medical team scouting the market for cadavers: a team of researchers from the University of Colorado at Boulder who had won a public competition mounted by the National Library of Medicine (NLM), a contest wherein contractors ranging from university science centres to graphic arts firms could submit plans for rendering the male and female virtual bodies which would constitute the core of the federal Visible Human Project. This team formed the Center for Human Simulation, describing itself as 'a new entity emerging for the synthesis of three-dimensional imaging and human anatomy' whose general purpose is to 'develop interactions with computerized anatomy in virtual space' among collaborating team of anatomists, radiologists, computer scientists, bioengineers, physicians, anthropologists and educators.

The visible human project

In 1986, a long-range planning committee of the NLM, a division of the National Institutes of Health, had determined that electronic images would play an increasingly important role in clinical and biomedical research. They speculated about a coming era in which the NLM's widely used bibliographic and factual database services would be complemented by libraries of digital images, distributed over high-speed computer networks and by high-capacity physical media. The committee encouraged the NLM to 'thoroughly and systematically investigate the technical requirements for and feasibility of a biomedical images library'. In 1989, a Planning Panel on Electronic Image Libraries was formed under the Library's Board of Regents. This panel proposed the title and basic ground plan for

> a first project building a digital image library of volumetric data representing a complete, normal adult male and female. This Visible Human Project will

include digitized photographic images for cryosectioning, digital images derived from computerized tomography, and digital magnetic resonance images of cadavers.[7]

Michael J. Ackerman, the head of the University of Colorado team that won the NLM contract, notes that 'so much of medicine is what a doctor sees, but most of medicine is written in books'.[8] Certainly there is no shortage of medical atlases and anatomical compendia – books offering images and dimensional models featuring CT scans, MR images and PET scans, as well as radiographs, photographs, drawings, and diagrams of bodily organs, systems, and sections. The NLM's database would break new ground not by representing the body according to the techniques of more recent biomedical imaging, but by making these images available in a highly public venue (the Internet), and by actively making it available to the medical layperson (e.g. the science teacher, the graphic artist) as well as to the specialist. Further, the Visible Human Project would make easily reproducible and highly malleable the relatively fixed renderings of more conventional (book-format) atlases. Those paying the fee for a licence agreement to download and use the data sets that comprise the Project can optically move through the body via hypermedia links, three-dimensional reconstructions, and even a specialized walk-through program that allows the user to simulate spatial passage through the tissue of the body from any perspective – in Wheeler's words, as if one were 'like a wall moving through a ghost'.[9] Finally, whereas book atlases tend to focus on discrete bodily parts or systems, the Visible Human Project incorporates the entire body, its physical mass sliced into relatively equitable, almost arbitrary slabs, like a length of salami. Discrimination among parts thus becomes a cataloguer's nightmare. As Ackerman puts it, 'For a librarian, this is very unsettling. It's like having books lying all over the place not indexed or cataloged.'[10]

The Colorado team aimed to work with a completely intact human body that had died while young and in good health – a tall order for the medical cadaver marketplace. They waited two-and-a-half years for the right body to materialize. According to Wheeler, Jernigan's life of crime was of no concern to the team.[11] Less than two days after Jernigan's execution, the dead felon's body was encased in a special gelatin solution and deep-frozen to minus 160 degrees Fahrenheit at the Colorado Health Sciences Center. The frozen corpse was later chopped into four segments, and each was passed through computed tomography (CT) and magnetic resonance (MR) scanners – the same equipment used in medical diagnosis – to optically render Jernigan's body into a series of planar images.

The segmentation of Jernigan's body was not limited to the realm of optics. Each frozen body-segment was passed through a cryogenic macrotome – a kind of high-tech meat-slicer that physically segmented all four blocks of the body into a total of 1,871 one-millimetre-thin slices. In the words of a project overview, this phase of the process '[revealed] slice-by-slice the beauty and detail within'.[12] After each pass, colour photographs were taken of the face of the remaining block. Each of these 1,878 photographs was numbered in succession, then scanned into a computer animation program that would allow its users to restack, dissemble and volume-render discrete body parts, yielding the first digital series representing an entire human body. Users of this program can travel the entire length of vertical structures such as the spinal cord, the trachea, the esophagus, long bones, muscles and major blood vessels. Thus segmented

into a pancake-like stack of planar units, Jernigan was rendered a virtual laminated man, each black-and-white or colourized layer of which could be viewed on the NLM database individually, in succession, or in reconstructed stacks.

The idea of segmenting human tissue into planar sections for photograph and projection is not new. Earlier in the century, a few scientists dabbled in this realm, slicing small body parts into ultra-thin slices and affixing these slices onto successive frames of a strip of motion picture film, then projecting these films for a cinematic tour through dense body tissue.[13] What is different about the Visible Human Project is its physical scope (an entire human body is segmented) as well as the scope of its projected use. As Wheeler notes, images from the Project have appeared in a gallery in Japan alongside body renderings by Leonardo da Vinci. The US Army is using the Project to simulate the passage of shrapnel through flesh and bone. And a State University of New York at Stony Brook team has created interactive fly-through animations of the human colon on the basis of a set of the Jernigan images.[14] Furthermore, video, CD-ROM, and interactive videodisc programs based on the Visible Man are now being marketed through websites and advertisements in journals ranging from *Science* to *Wired*.

I've noted that Jernigan's body was selected for the Visible Human Project on the basis of its ostensible typicality. But what constituted typicality, what constituted health for the NLM and the Colorado Health Sciences Center? Jernigan was white, weighed 199 pounds, and stood at 5-foot 11-inches. As recently as early in this century, his status as a criminal almost certainly would have marked his visage and his physique for close critical scrutiny. His low forehead and his close-set eyes, for example, might have been interpreted as signs of mental incompetence. However, Jernigan's form instead allows him to qualify for the role of biomedicine's model male citizen. The criminal body, ironically, becomes the prototype for the healthy male body.

The Colorado team that selected the body for the Visible Man project claims not to have learned of the identity and source of Jernigan's body until after its selection. I would argue, though, that this fact is not highly significant to my discussion. More important is the fact that Jernigan's body would never have come up for review by the team had Jernigan not been an anonymous and marketable cadaver, a subject whose status as a live ward of the state rendered him in death a subject stripped of his rights to certain privileges of citizenry – most notably, the right of bodily privacy. What is significant is not that Jernigan's identity initially was not known, but that it did become known – moreover, become publicly renowned – at the time that the Visible Man went on-line. It is precisely because of Jernigan's status as less than a private citizen, as a subject stripped of certain rights under the auspices of the state, that he qualified as a universal biomedical subject, and as a public icon of physical health. The universal biomedical subject is thus a subject stripped of his rights to privacy and bodily integrity, even after death.

Originally published in J. Terry and M. Calvert (eds) (1997) *Processed Lives: Gender and Technology in Everyday Life*, London: Routledge.
This essay has been edited for inclusion in the Reader.

Notes

1. See John Tagg, *The Burden of Representation: Essays on Photographies and Histories* (Minneapolis and London: University of Minnesota Press, 1993); Allan Sekula, 'The body in the archive', *October* 39 (1986), pp. 1–64.

2. Web page address for Visible Man Human Project, Mallinckrodt Institute of Radiology, Bill Lorensen, 'Marching through the visible man' paper: *http://www.nlm.nih.gov/research/visible/visible_human.html*

3. David L. Wheeler, 'Creating a body of knowledge', *Chronicle of Higher Education*, 2 February 1996, A6, A7 and A14. Quotation from page A14.

4. For information about the Visible Woman, see Jacqueline Stenson, '"Visible Woman" makes debut on the Internet', *Medical Tribune News Service*, 28 November 1995; '"Visible Woman" news brief from National Library of medicine', *Gratefully Yours* (a newsletter published by the NLM), September/October 1995; and Bill Lorensen, 'Marching through the visible woman', *http://www.nlm.nih.gov/research/visible/visible_human.html*

6. David Ellison, Anatomy of a murderer', *21-C Scanning the Future*, March 1994, pp. 20–5.

7. National Library of Medicine (US) Board of Regents, 'Electronic Imaging Report of the Board of Regents', US Department of Health and Human Services, Public Health Service, National Institutes of Health, 1990. NIH Publication 90–2197.

8. Quoted in Wheeler, 'Creating a body of knowledge', p. A6.

9. Ibid., p. A14.

10. Ibid.

11. Ibid., p. A7.

12. The Visible Human Project, Project Overview, *http://www.nlm.nih.gov/research/visible/visible_human.html*

13. See the discussion of serial section films in Lisa Cartwright, *Screening the body: Tracing Medicine's Visual Culture* (Minneapolis and London: University of Minnesota Press), pp. 96–7.

14. Wheeler, 'Creating a body of knowledge', p. A7. The SUNY Stony Brook project was created jointly by the Departments of Radiology and Computer Science.

Scaling cyberspaces

DAVID BELL

INTRODUCTION

DISCUSSIONS OF CYBERCULTURE TEND TO focus on particular spatial
scales; at one end, the scale of the body (as previous sections in this Reader have
demonstrated) and at the other end, the scale of the global (see the next section). We
are reminded by geographer Neil Smith (1993) that a whole host of other spatial scales
exist in between them. His typology of spatial scales runs *body, home, community, city,*
region, nation, global, and in this section we look at four scales that lie between the
poles of the body and the global: the scale of home, the scale of community, the scale
of city, and the scale of nation. We have a number of questions to ask about each;
among the most crucial are: what kinds of virtual geographies exist at these scales?
How has cyberspace redefined what these spaces mean? How do these virtual spaces
map onto their 'real life' equivalents? As Randal Woodland's discussion of queer world-
making in cyberspace shows, there is a particular spatial imaginary at work in virtual
realms, which both shapes and is shaped by the forms of interaction that take place
there. A geographical twist is thus added to cybercultural analysis here, in order to
understand what we might rather clumsily call *the spaces of cyber*.

We begin with the scale of home; with Susan Leigh Star's 'From Hestia to home
page', a (cyber)feminist analysis of the shifting meanings of home in the digital age.
Star's essay combines the concrete impacts of new technologies on the home (telecom-
muting, for example), with an allegorical perspective drawing on Ancient Greek and
Roman domestic goddesses (inspired, of course, by Donna Haraway's slogan 'I'd rather
be a cyborg than a goddess'). This moves Star into a discussion of women's taken-
for-grantedness and 'invisible labour', questioning the discourses of time-saving and
labour-saving through which new technologies are so often sold. Also important is women's
limited access to new 'liberating' forms of technology (a point made by Susan Clerc in
section three in her discussion of women's under-representation in on-line fandom) and
the problems that electronic communications bring, for example to home-workers. Star

also casts a critical eye over the metaphor of nomadism or homelessness – used in cyber-space in a positive sense:

> there is a big push, so multifaceted and overdetermined that the world's largest conspiracy theory couldn't hold it, to make us live our lives on line, to abandon living and working in a particular locale. At times this has made me apply to myself the term 'homeless' or 'nomad'. On reflection, this is both true and untrue; certainly the mark of a privileged speaker.

So, while Star might be a 'virtual nomad', her off-line life is as *homed*; she lists the assumptions about 'home' that go unnoticed unless one has to do without them. To be 'homed' in cyberspace – through, for example, having a home page – also carries impor-tant assumptions, such as having access to the technologies (not just hard- and software, but also literacy), the supporting technical and social infrastructure, and the money and time to keep everything going – all of which are unequally distributed, of course. Thinking much more critically about 'homed-ness' and homelessness in cyberspace, Star concludes, is necessary in order to 'modify some of the hype about "the Net" with a deeper and subtler politics'.

While the scale of home has been relatively neglected in cybercultural work, the scale of community has attracted a lot of attention, as we have already seen. The debate about what 'virtual community' means has been particularly protracted, and we have chosen to represent that debate with Michele Willson's thoughtful essay 'Community in the abstract'. Willson summarizes the ways in which 'community' is rewritten in cyber-space by theorists who stress 'equality, liberty and fraternity', and offers a nuanced critique of these claims which draws on debates about the status of community off-line as well as on-line. En route, Willson also makes some interventions in cybercultural theory more generally, such as her stress on the Internet as a kind of database which then questions liberatory arguments by adding the twist of surveillance. She similarly moves through a number of supposedly positive characteristics of virtual community, subjecting them to equally rigorous critique: the hyping of anonymity, for example, which is set against the need for accountability (see also Ostwald on the virtual city Habitat). Importantly, Willson argues the need to approach the question of virtual community on two fronts: 'an analysis of the potentialities of the technology that enable virtual commu-nities to exist in their present form; and an analysis of the specific form of each virtual community'.

In many ways, theories of identity- and community-formation in cyberspace are seen to mirror processes observed more broadly in 'postmodern' times – the decentring of the subject, fluidity and fragmentation in social arrangements, reflexivity and so on. In place of nostalgized 'real' community life (integrated, deep community) is matrixial, instrumental association (fragmentary, shallow 'pseudocommunity'). More problematic is the substitution of on-line community for off-line participation; Willson cites an example, from Turkle's *Life on the Screen* (1995), of someone 'actively involved in the political machinations of his cybersociety but also completely apathetic about and disen-gaged from the political situation surrounding him in his "offline" life'.

Willson's theorization of virtual community draws on philosopher Jean-Luc Nancy's work on community as the '*incomplete* sharing of the relation between beings', stressing

the *relation* rather than the subject; virtual communitarians, as Willson dubs them, tend to stress only the impacts of on-line community membership to individuals:

> In virtual communities, we are presented with the description of community where participants appear autonomus, self-indulgent and seeking self-satisfaction. Free-floating beings, whose encounters with others may be formative, are depicted; but these relations are not elaborated sufficiently ... [I]t is the ability for interactivity that is being celebrated and on which meaning is founded for its participants. Yet the celebration is expressed in terms of the possibilities for the subject of these relations.

Virtual communities, then, are upheld as sites of 'multiple, liberating, equalizing' association, yet a closer reading of the activities and motivations of members reveals a 'thinning' of the connections and complexities of community; they work to focus on the self at the expense of 'embodied relations' between beings.

The potential 'retreat from the real' into virtual communities also runs as a motif through Michael Ostwald's discussion of 'Virtual urban futures', and in a sense what Ostwald is often describing is the enactment of community in the context of the city; the breakdown of community is linked to urban decay, and the virtual city thus stands as a surrogate for the demoralized and degraded urban landscape. Ostwald locates a general trend towards the simulation of cityspace – which involves certain processes such as sanitization, homogenization, privatization, zoning and theming – as occurring outside the virtual realm, too; in a sense, all cityscapes are becoming virtual, and his reading of West Edmonton Mall shows how processes of urban restructuring are changing both the forms and the meanings of the city (see, for example, Sorkin 1992). As many commentators have noted, one outcome of this restructuring is the loss of urban communal space (eroded by privatization and replaced by 'pseudo-public space') – and it is this lost aspect of the city which, some argue, has been replaced by cyberspace's 'virtual public sphere' (see, for example, Poster 1997).

Ostwald draws on the concept of the agora, found in cities of Ancient Rome and Greece; space of mixed use, free exchange and communication, and minimal regulation: '[t]he agora provided a space through which cultures and languages could mix, a place where produce was bartered and tales were told'. Is such a heterogeneous place of meeting a useful analogy for the 'virtual city'? Ostwald goes in search of the agora, finding its faint traces in the shopping mall and in cyberspace. As we have already noted, he argues that malls are already virtual urban spaces; his second search takes him to Lucasfilm's Habitat, a computer-mediated virtual city (or, perhaps more accurately, a virtual urban community). Habitat was established as a graphical, electronic urban environment featuring a rudimentary cityscape populated by avatars (cartoon-renderings of its inhabitants), and Ostwald provides a vivid description of the virtual city thus created. More interesting is the story of the evolving social relations of Habitat-dwellers – from the establishment of currency to outbursts of crime and the constitution of elected governing bodies (we could read this alongside Tomas' discussion of imagined future cities in William Gibson's writing; see section two). Although a long way from the fully realized virtual city – the *City of Bits*, to use Mitchell's (1996) term – Habitat lets us catch a glimpse of one virtual urban future, even if it was, in Ostwald's opinion, a

degraded one: 'Habitat degenerated into the simulation of some idealized place' in much the same way that shopping malls simulate a particular (nostalgic and/or utopian) urban form.

Just as cities are constituted as much by their inhabitants as by their built (or virtual) fabric, so it is pertinent to think of nations, in Benedict Anderson's (1983) well-known phrase, as *imagined communities*. Ananda Mitra's essay 'Virtual common-ality' draws on Anderson's notion to explore the kinds of nations imagined in cyberspace. As we shall also see in the next section, the nation is reconstituted through CMC (computer-mediated communication) in a number of important ways – some of which are seen to threaten the integrity of national boundaries. There are links, then, between what Mitra has to say about the 'virtual nation' and the previous two chapters; as he says, '[w]ith the growth of CMC, particularly from the use of the Internet, a new set of possibilities for community and nation formation have emerged'. To track this re-imagining of the nation in cyberspace, Mitra looks at what we might call the 'digital diaspora' – people physically, spatially separated, but who are making connections and finding commonalities across the Internet (and on bulletin boards specifically). For this digital diaspora, 'electronic space is the only common space that they can occupy', meaning that it provides an important cultural resource. His essay draws empirical material from Indian subgroups on Usenet's *soc.culture* BBS in order to 'look for India on the Internet', taking a 'snapshot' of all discussions on a single day as well as observing (in a less comprehensive way) subsequent discussions which have emerged.

A phenomenon which particularly interests Mitra is the evolving 'national critical discourse' within the newsgroup *soc.culture.indian*, and he plots the discursive inter-changes around particular issues, showing both the mobility and the multiplicity of 'national images' evoked in postings. A second feature of newsgroups that Mitra focuses on is cross-posting – when a message is widely disseminated across groups. This obvi-ously disrupts the internal discourses within groups, and can lead to heated, even abusive outbursts. Further, while discussions in *soc.culture.indian* can be polarized and adver-sarial, they can also express much more commonly-held opinions; the example Mitra gives is of discussions of the image of Indians in American popular culture. As he concludes, 'these discussions attempt to negotiate the diasporic identity and often hold the community together while the discussions about India tend to split the community'. Of course, as Mitra makes clear, the constantly shifting emphases and multiple discur-sive threads on a site like *soc.culture.indian* mean that the image of India produced there is unstable, contested and ephemeral.

What the four chapters in this section all suggest, ultimately, is that cyberspace is reshaping geography across all spatial scales and in a multitude of ways (see also Crang, Crang and May 1999). We stay with these questions in section nine, which begins with an essay exploring the transnational traffic through cyberspace, and attempts to regu-late such flows and shore up national boundaries, and then moves on to consider how cyberspace is conceived within discussions of globalization.

References

Anderson, B. (1983) *Imagined Communities: Reflections on the Origin and Spread of Nationalism*, London: Verso.

Crang, M., Crang, P. and May, J. (eds) (1999) *Virtual Geographies: Bodies, Space and Relations*, London: Routledge.

Mitchell, W. (1996) *City of Bits: Space, Place, and the Infobahn*, Cambridge: MIT.

Poster, M. (1997) 'Cyberdemocracy: the internet and the public sphere', in D. Holmes (ed.) *Virtual Politics: Identity and Community in Cyberspace*, London: Sage.

Smith, N. (1993) 'Homeless/global: scaling places', in J. Bird, B. Curtis, T. Putnam, G. Robertson and L. Tickner (eds) *Mapping the Futures: Local Cultures, Global Change*, London: Routledge.

Sorkin, M. (ed.) (1992) *Variations on a Theme Park: The New American City and the End of Public Space*, New York: Noonday.

Turkle, S. (1995) *Life on the Screen: Identity in the Age of the Internet*, London: Weidenfeld and Nicolson.

SUSAN LEIGH STAR

FROM HESTIA TO HOME PAGE
Feminism and the concept of home in cyberspace

DIRECTLY OR INDIRECTLY, LARGE-SCALE electronic communi-
cations media are changing our working and leisure lives.[1] The pace of work, its
location and distribution, and the nature of play (what sort and with whom) are changing,
from electronic banking to virtual sex. One effect, which I address in this chapter, is
to blur physical and geographic boundaries around the questions: Where is home; where
do I live? Because I may communicate frequently over a great geographical distances,
and collaborate on work and continue friendships electronically, the question is compli-
cated. In this chapter, I begin with an exploration of Ancient Greco-Roman concepts
of home and its associated deities and discuss how these act as useful metaphors to begin
feminist questioning of how home has changed in 'cyberspace'.

The conceptions of Ancient Greek and Roman domestic goddesses (and a few gods)
offer some provocative metaphors for thinking about home, cyberspace and feminism.
Vesta (Roman) or Hestia (Greek) was unique among deities for having no personification:

> Her State worship (*Vesta publica populi Romani Quiritium*) should not be in a
> temple but in a round building near the Regia, doubtless an imitation in
> stone of the ancient round hut . . . This contained no image but a fire which
> was never let out.
>
> (*Oxford Classical Dictionary* 1992: 1116)

> (The fire) seems to have been considered in some sense the life of the people
> . . . Hence the cult of the communal or sacred hearth was apparently
> universal, but the goddess never developed, hardly even achieving anthro-
> pomorphisation. She therefore has next to no mythology.
>
> (*Oxford Classical Dictionary* 1992: 511)

Newborn Greek children were carried around the hearth at the age of five days;
Hestia's name was invoked in swearing, in prayer and at the beginning of a meal. In

contrast to this non-personified, omnipresent fire energy are other forms of household worship of particular gods, including one, Zeus Ktesios, 'who is hardly more than a deified storejar in origin' (*Oxford Classical Dictionary* 1992: 1140), and worship of the spirit of the storage cupboards where the household food was kept (*Oxford Classical Dictionary* 1992: 1140).

The (in)famous vestal virgins were a Roman innovation to the worship of Hestia as she became Vesta. These were the sacred keepers of Vesta's flame, selected from virgin girls of between five and ten years of age, who served for most of their lives to keep the communal hearth fire constantly alive. This was a position of some responsibility (especially for a child) – should the fire go out, the girl or woman could be entombed alive as punishment!

These three aspects of domestic goddesses and gods suggest three modes of approaching the idea of home:

1. That which is omnipresent, taken-for-granted and which enlivens the rest of life in a background fashion.
2. That which rests comfortably in particular locales (such as jars and cupboards), embodying a place to be secure and fed.
3. That which must be defended and tended, often in a very public fashion, under the rule of the State and Church.

All three of these senses are important for understanding gender, home and cyberspace from a feminist perspective.

Fire and the eternal flame as the taken-for-granted: invisible work and 'easiness'

Historian Randi Markussen argues that the notion of 'easiness' as applied to information systems is particularly insidious for those who are used to being 'on call', at the service of others (often, in these times, women) (Markussen 1995). Easiness, as historically equated with progress, is presented as being ready-to-hand, convenient, an improvement on the nuisances of daily life. However, it is inextricably interlinked with someone's 'being available' or 'on call', as well as with a developed cultural understanding of how complex technologies work:

> Technology is not only equated with labour-saving; it also means timesaving. Time saved is not regarded as a useless emptying of time. Time saved is time that opens up for new options and possibilities. The ability to organize time and space is an important aspect of power in both its enabling and restraining capabilities. What does it imply if this is primarily understood and legitimated by linking easier with better? Is power really the same as leisure, ease, free time – all for discretionary use? . . . how can we apply a historical perspective that goes beyond easiness?
>
> (Markussen 1995: 160).

Markussen reminds us of the feminist disputes about domestic technology and how the promises of easiness, of more free time, are highly problematic for women in the context of shifting labour values (Leto 1988). Cowan's *More Work for Mother* (1983) says

it all in the title: having dozens of labour-saving household devices only raises expectations of cleanliness and gourmet meals. In fact, historically such devices have robbed women both of free time and of communal activities such as washing, isolating us in single family homes. Both observations are problematic, of course, in any individual instance (who really wants to go back to pounding out clothes on the river bank once one has had a washing machine in the home?). Nevertheless, the structural and collective effect of 'time savers' for women always presents serious dilemmas for feminists. Markussen notes: 'The introduction of the electronic text may open a space for renegotiating the meaning of work, but there are dilemmas inherent in this from the perspective of women' (Markussen 1995: 170).

We have all had the experience of being *too* available, *too* taken for granted, in situations where we disproportionately take on the conversation work, the nurturing and listening work. We are in this sense the eternal hearth flame. In the home as conceived under patriarchy, this meant being the always-available 'mum'; but, in these times, that burden of work exists also electronically and in other workplaces. Cheris Kramarae quotes a respondent:

> If women are supposed to take care of making everyone easy in social situations, how come we're not given tax breaks for cars and gasoline to scoot around helping people out? And how come we're not given training in microphone use, and special classes to help us take care of crowds? What about giving us special phones with cross-country network connections so we can keep in touch and know who needs help and where? How are we supposed to exercise these 'nice' social skills we're supposed to have without some help here?
>
> (Kramarae 1988: 1)

Many people in information systems are interested in modelling or 'capturing' forms of invisible labour, such as the management of real-time contingencies, which sociologists call 'articulation work' (Schmidt and Bannon 1992). Yet the problems with this for those who are disempowered may mean a further reification and disproportionate burdens, as we have seen in the case of women's work (Star 1991a and 1991b).

Gods of the jars and cupboards: situated locales, exclusions, RL and F-t-F

The flip side of being omnipresent and always available/invisible is to be contained in a little jar, a ghetto; to be excluded from participation. Markussen notes that if you are outside the hermeneutic of the instruction manual, the means to program the video recorder, the logging-on instructions for the computer, then *any* labour-saving device is not easy at all: 'Technologies have been assimilated in ways that have isolated women in performing work that previously had a social and communicative significance' (Markussen 1995: 168).

There are two senses in which we are placed in jars and cupboards electronically. The first, which has begun to be analysed by feminist scholars, is the exclusion of women's voices from electronic networks and other technological work (Taylor, Kramarae and Ebben 1993; Hacker 1990). This occurs through lack of training and

socialization, but also through the reproduction of violence against women in cyber-space. We have known for a long time that home can be either a safe haven or the most dangerous place for a women to be (statistically, it is the most likely place for a woman to meet a violent death).

The blurring of boundaries between on-line and off-line is the second sense in which we are implicated in the 'jar and cupboard' aspect of cyberspace goddesses/gods. By this I mean that the ubiquitous talk which blurs the distinctions between electronic trans-actions conducted via keyboard, video or other electronic devices, and unmediated interactions hold some particular dangers for those who have been either barred from electronic participation or who face dangers such as rape and sexual harassment there. Again, this has often been women, although Sherry Turkle has recently written a fasci-nating account of how gender itself is blurred and even 'cycled through' in fantasy games (Turkle 1994).

The expanding and nearly ubiquitous presence of networked information technolo-gies of all sorts has raised serious questions about where one lives and works. It is possible for some to 'telecommute' from terminals or computers at home, if their work involves data entry, writing or technical tasks that can be so handled. Furthermore, it is possible to teach (at least some of the time) via bulletin board, video relays and confer-encing systems, and other software and hardware configurations (see, for example, Riel 1995), thus blurring the traditional classroom boundaries.[2] In high-tech work, the process of production may be spread across continents as specifications are shipped from one site to another and parts configured according to global economies of scale. Mitter has pointed out how such 'global factories' are especially problematic for women in less developed nations:

> A growing discrepancy in the wages and working conditions of core and flex-ible workers characterizes the current restructuring of manufacturing jobs. In a polarised labour market, women predominate in the vulnerable, invis-ible or marginalised work.
>
> (Mitter 1991: 61)

As many have noted, the combining of telecommuting with the global factory has proved a dreadful development for women in general: we become isolated in 'the elec-tronic cottage', miss promotion and social aspects of the job, and often are expected to do finicky tasks such as data entry along with full-time child care. At first heralded as the liberation of working mothers (sound familiar?), the installation of terminals in homes to allow for 'home work' via telecommuting proved over time to be disadvantageous for most home-workers. It can be an easy way for a corporation to engage in 'union busting' and bypass any particular state's labour regulations.

It is also of concern that the blurring of on-line and off-line lives contains dangers for all of us; we stand to lose track of our bodies, the good side of our 'jars and cupboards', and the many mundane physical tasks that go into maintaining a home or a workplace. Some lines from a poem describe this tension:

> oh seductive metaphor
> network flung over reality
> filaments spun from the body
> connections of magic

extend
extend
extend

who will see the spaces between?

the thread trails in front of me
imagine a network with no spaces between
fat as air
 as talk

this morning in the cold Illinois winter sun
an old man, or perhaps not so old
made his way in front of a bus his aluminum canes inviting
spider thoughts
 a slow, a pregnant spider
 the bus lumbering stopped

and in the warm cafe I read of networks and cyborgs
 the clean highways of data
 the swift sure knowing
 that comes with power

who will smell the factory
will measure the crossroads
will lift his heavy coat from his shoulders
 will he sit before
 the terminal

(Star 1995a: 31)

One macabre aspect of the separation of physical and electronically mediated communications has already occured in the coining of new categories to mark that which occurs 'off-line' as a special form of life. Computer developers and those writing to each other over the news boards on the networks speak of 'RL' and 'F-t-F" (Face-to-Face) as special categories. What does it mean that RL is now a marked category? What does it imply about what we are doing in cyberspace: is it 'UL' (unreal life)? And who will benefit from the blurred boundaries; who will suffer?[3]

Electronic vestals: the web and the state

The final metaphoric thread from our goddesses concerns the relationship between the state and the individual, the public and the private. The panopticon surveillance possibilities of electronic communication indeed force us to create a new politics concerning the public and the private. A number of groups, including Computer Professionals for Social Responsibility (CPSR) in the US, and Computers and Social Responsibility (CSR) in Britain, have been very concerned about invasions of privacy and surveillance by electronic means. Star describes several experiences in this domain:

I visited a state park near San Juan Capistrano. All around were signs, 'Warning: Wild Mountain Lions Loose in Vicinity.' Having never encoun-

tered a mountain lion, I pulled up at the entrance gate to ask the ranger what I should do if I met one, and how many there were. 'Well, they're not actually on the loose. What that means is that a mother has had two cubs, and we haven't had time to tag them yet.'

(Star 1995b: 1)

It seems that all the mountain lions in the park were fitted with encoded sensors, which for ecological data-collection purposes allow the park service to keep track of them. The two as-yet-untagged cubs represented a kind of wildness about which the public must be informed.

'But what should I DO if I meet them?' I persisted. 'Well,' said the ranger, 'I couldn't answer that, because if I told you in my official capacity, and then you did it, and got injured, you could sue me or the park system.' I looked at him. 'Could I tell you in my unofficial capacity, just off the record?' 'Sure,' I said, trying not to laugh, 'That would be fine.' 'Well, my advice there would be just to act really weird. Jump up and down and make funny noises and flap your arms in the air. If the animal can't figure out what you are, she won't chase after you, but just walk away.'

(Star 1995b: 2)

A similar incident occurred some years later in Champaign, Illinois. A man was arrested for stealing a television, his second offence. He broke into a friend's home, using a back-garden window, and took the television. He then picked up the car keys lying on the kitchen counter and helped himself to the family car. The car was abandoned and the man apprehended whilst trying to sell the television to a shop. The man is not considered dangerous, and jails in America are crowded. He does have a job (at a fast-food chain), and jailing him would force him to lose that work.

The judge decides that he is a good candidate for the town's new electronic jail program. The man will wear an electronic ankle bracelet that is attached to a sensor in his house. He may go to work but must be inside his house from 6pm to 8am. The sensor will record his movements, and if he deviates from them, he will be put in a physical jail instead of a virtual one. The same technology is being used to monitor the whereabouts of frail elders or those with Alzheimer's, allowing them to stay in their own homes longer, and not have to go to nursing homes.

(Star 1995b: 2)

I love the idea of being a kind of residual category for a mountain lion. I find it ironic that it is not wild animals but the non-computerized lions which put fear in the hearts of tourists. I am grateful for the complicated heterogeneous networks that bear news of safety and danger, such as receiving email about friends caught in the San Francisco earthquake of 1989, when the telephone lines were not working. If I were old and frail, or fearful, I might welcome the reassurance provided by the electronic sensor; if I had to choose between jail and virtual house arrest, I would certainly choose the latter. There is a lot of fun to be had in 'surfing the Net' and communicating at long distance with old friends. At the same time, these links crisscrossing the world, these rearrangements of work and play, do shake up my sense of freedom, privacy and naturalness in

often frightening fashions. Having destroyed the habitat of the mountain lion, we now track its every move and redefine wildness as that which gives us no information — that which is outside the Net.

Even so simple an act as giving a password on your computer (just like using a key in your door at home) means participating in a particular cultural definition of public and private, home and state. It indicates that you have an electronic 'territory' which is your private property; it also acquiesces in the notion that only some people ('registered users') should be allowed on the network or computer in question.[4] How many of us think of this act in this way? What other specific cultural practices are related to home and work, public and private, state and individual, 'over the Net' and in cyberspace?

Home ↔ homing; homeless ↔ homed

For the very privileged, 'navigating the Net' is now a viable option, where one can obtain electronic addresses on, for instance, the World Wide Web and communicate with, obtain papers and images from millions of others via programs such as Mosaic and Netscape.[5] It is interesting to note that this convergence of technologies has simultaneously given rise to much hyperbole about global citizenship. For example, a 'Netizen' was defined in a 6 July 1993 post to The Daily News Usenet as follows:

> Welcome to the 21st Century. You are a Netizen (Net Citizen), and you exist as a citizen of the world thanks to the global connectivity that the Net gives you. You physically live in one country but you are in contact with much of the world via the global computer network. Virtually you live next door to every other single Netizen in the world. Geographical separation is replaced by existence in the same virtual space . . . We are seeing [the] revitalization of society. The frameworks are being redesigned from the bottom up. A new more democratic world is becoming possible . . . According to one user the Net has 'immeasurably increased the quality of my life.' The Net seems to open a new lease on life for people. Social connections which never before were possible are now much more accessible . . . Information, and thus people, are coming alive.
>
> (Posted by Michael Hauben)

Yet, as I discussed above, such accessibility is two-edged, especially for those overburdened with care-giving, as we women have been.

One important lesson from the convergence of feminism and other social justice movements with poststructuralist theory in recent years is the concept that every marked category implies its opposite. So, men 'have gender' too (that is, there are historically specific practices associated with becoming a man in any culture, which differ across times and places) — it is not just women who are gendered. Whites are 'ethnic' and 'have race' too, not just blacks, Hispanics or Asians. Furthermore, all designations such as male or female, black or white, rich or poor, can be seen in verbal terms, not just as nouns. So, in addition to being relational as marked-unmarked (everyone has race, not just so-called 'minorities'), such categories are also achievements — something done, not given. So we can talk about the ways in which boys and girls undergo and produce

'gendering'; Toni Morrison (1992) has used the term 're-racing' to describe racial atti-
tudes in the Clarence Thomas–Anita Hill hearing of a couple of years ago.[6] Following
this lead, we can problematize the word 'home', and begin to think about *homing*. In
writing this chapter, I have thought a lot about the marked category 'homeless', and
about how homing is an achievement.

As I do much of my work and communication with friends by email, I often find
myself feeling lonely and isolated. In a way this is paradoxical. Just this month, three
old friends with whom I had lost touch a decade ago found my address on the Net and
wrote to re-make contact. I have more to say on email to my sister in the course of a
week than we have said over the phone in a year. At the same time, I have moved
ten times over this decade, and travel extensively to see old friends, feel a hug, a 'catch
up' in a way that the electronic medium does not allow. Part of the moving goes
with being an American academic (it is very common, especially for politically
active scholars!). But another part derives from the illusion that I could live anywhere
and still 'be in touch'. This becomes clear during the weekends, when I have vowed
for my sanity not to log on to email – and there is a silence around me. Those elec-
tronic friends can't come to the movies with me, can't go for hikes in the woods, can't
cook together.

Of course, it is only a communication medium. Yet, on another level, there is a
big push, so multifaceted and overdetermined that the world's largest conspiracy theory
couldn't hold it, to make us live our lives on-line, to abandon living and working in a
particular locale. At times this has made me apply to myself the term 'homeless' or
'nomad'. On reflection, this is both true and untrue; certainly the mark of a privileged
speaker.

Two researchers at the University of Illinois, Casey Condon and Dave Schwein-
gruber, have recently carried out an extended ethnography in a local shelter for homeless
men (Condon and Sweingruber 1994). They define 'homeless' as being unable to obtain
permanent shelter and a job – what the shelter calls a PLA: permanent living arrange-
ment. They have made a very interesting case that this sort of homelessness is imbricated
with questions of time and morality. The men are treated as if they are incarcerated;
they must be inside the shelter from 7pm until 9am; they must be working on their
'problem', looking for a PLA; they may not stay for more than thirty days if they are
not working on their problem. Of course, different residents have different relation-
ships to this puritan morality and conception of time and progress.

The US, as Britain, presents a country of great opulence populated with rising
numbers of homeless people. The streets of every major city are filled with mini-cities
made of cardboard boxes and shopping carts; a walk down the street involves numerous
encounters with people asking for money. Rich people find this disturbing and unsightly.
In 1988, New York mayor Ed Koch ordered that people living on the street be exam-
ined by mental-health workers, and if 'found deficient', forcibly hospitalized (Deutsche
1990: 111). Deutsche says of these politics that:

> The presence in public places of the homeless – the very group which Koch
> invokes – represents the most acute symptom of a massive and disputed
> transformation in the uses of the broader city . . . this reorganization is deter-
> mined in all its facets by prevailing power relations.
>
> (Deutsche 1990: 110)

She goes on to specify these power relations as embodied in land-development politics and commodification, and in the job losses that have resulted from the internationalization of large corporations.

So, in a very important sense, the homeless are the canaries in the mines for those of us breathing globalized electronic air. I am a *homed person*, by analogy with marking other unmarked categories. That is, I have always had the means to put a roof over my head and bread in my stomach. I do not have to wash myself in public toilets, house-sit for others in order to have a chance to repair my clothes or cook a meal, as does a heroine in Marge Piercy's remarkable new novel, *Longings of Women* (Piercy 1994). But that does not get at the feeling of the marked/unmarked, since it is so easy for me to say. Peggy McIntosh's thoughtful article on being white described white privilege as being 'like an invisible weightless knapsack of special provisions, assurances, tools, maps, guides, codebooks, passports, visas, clothes, compass, emergency gear, and blank checks' (McIntosh 1992: 71). She lists forty-six assumptions associated with being white, including activities such as going into a bookshop and finding writing of and about one's race represented, being late to a meeting without people thinking that somehow reflects on her race, and so on. Following her lead, I can come up with the following assumptions about home:

- Being homed means that I have an ordered supply of food, clothes and tools upon which to draw without having to think about it at the moment; in planning and ensuring the supply, I know that I have a place to put them.
- Being homed means that I can pass through the innumerable interactions that complex state bureaucracy requires; giving my name, address and social security number, without being ashamed.
- Being homed means that I do not risk arrest in the process of conducting my bodily functions (eating, sleeping, passing waste).
- Being homed means that I can unproblematically link my supplies with my social life and my working life, in a manner more or less chosen by me.
- Being homed means that I may come and go, and during my absences my supplies and address will remain more or less constant; and that I may return and leave at will without threat of the law or negotiations with others who live around me.

Yet in this complex freedom, there is, too, a sense – in the words of the song – of having 'nothing left to lose'. There is a sense in which the traditional axis of homed–homeless has been torqued by the global electronic network – primarily for those of us who are home, but not exclusively. For example, many of those who work with the homeless have instituted voice-mail centres, so that prospective employers may call and not realize that the person does not have a fixed abode. Such passing behaviour is made possible by new electronic technologies – and in ways that are very problematic from a feminist perspective. We know what passing does to the soul, and we also see that this is a convenient way for the homed to ignore the problems that gave rise to the homelessness in the first place.

The axis along home–homing is also torqued. Do I really 'live on the Net'? Do *I* have a fixed abode, or a PLA? Of course, and of course not. I do, however, have a 'Home Page' on the World Wide Web, which I am constantly building up and playing with. This is a document which holds my picture, a couple of articles and bibliography, and has an address which may be accessed from a computer anywhere in the world.

Any part of that document can be hypertext-linked to any other one I know about on the World Wide Web; and, after it's set up, I can click on those links and travel to places far away. I think about my Home Page quite frequently (possibly because I just learned how to programme one), envisioning future links and additions. It is a new addition to the way I think about myself and my sense of home. At the same time, I miss going to the movies with my friends whose bodies usually inhabit San Francisco ... To be homed in cyberspace, therefore, has a double-edged meaning: to be both homed and homeless in some sense. Living on top of the earlier sense of physically homed, to be homed in cyberspace means:

1. I have enough money to buy the basic setup of a terminal, keyboard and modem, and I have a traditional home with telephone wires over which to run the device (or I work for an institution which provides them for me).
2. I have access to maintenance people who can answer questions for me and help me plug into the larger infrastructure.
3. I am literate and can either type, see and sit up, or have special support (for example, a Braille terminal or voice recognition) to help me carry out the equivalent of these tasks.
4. I have a job which allows me an electronic-mail address and does not monitor my communications (such monitoring does occur in the US, especially in large corporations).
5. I have time and inclination, and a wide enough social network, to have others to write to and read.

I would hope that a feminist vision of homed-ness and homelessness in cyberspace would build on this list and modify some of the hype about 'the Net' with a deeper and subtler politics.

Conclusion

Donna Haraway (1985) concludes her now classic article 'A manifesto for cyborgs' with the phrase 'I'd rather by a cyborg than a goddess'. I see no reason why goddesses are not also cyborgs, although I take her point that a misplaced naturalistic romanticism/essentialism is not the answer to living in the high-tech world, so heterogeneously composed of human, technology, text, culture and nature (Latour 1992).

One of the difficulties in analysing the changes wrought by the information revolution is the combination of hype, hope and rationalistic processes, such as business process re-engineering, entailed by it. Feminism has a long tradition of thoughtful critique of such complex changes, calling attention to the mingling of the personal and the political, the domestic and the workplace, and to the hidden assumptions embedded in central or 'master' narratives. We have both this critique to offer to the changes in the world today and an imaginative narrative tradition that speaks to the importance of each person's and each community's experience.

The very interesting combination of eternal flame, mundane little pot and vestal virgin point to an enduring set of questions about the meaning of home, the hearth and the relationship between women, the public and the private. As a feminist, I have no

wish to contribute to homelessness in cyberspace; as a goddess and a cyborg, I insist
on it.

Originally published in N. Lykke and R. Braidotti (eds) (1996) *Between Monsters, Goddesses and Cyborgs: Feminist Confrontations with Science, Medicine and Cyberspace*, London: Zed Books. This essay has been edited for inclusion in the Reader.

Notes

1. Thanks to Geof Bowker, Cheris Kramarae, Jeanie Taylor and the women of WITS (Women, Information Technology and Scholarship) at the University of Illinois for insights and support. Nick Burbules and Casey Condon provided detailed comments, which I gratefully acknowledge. An earlier version of this chapter was presented at the conference 'Between Mother Goddesses, Monsters and Cyborgs: Feminist Perspectives on Science, Technology and Health Care', Odense University, Denmark, 2–5 November 1994. I thank the participants for helpful comments.
2. Such blurring of physical boundaries has of course arguably occurred since the inception of writing. In education, correspondence courses and television teaching such as that used by the British Open University have 'stretched' the notion of classroom. But real-time, interactive use makes a qualitative leap over such asynchronous methods.
3. Nick Burbules points out that there is a further pun on the term 'URL', which is the name given to a location on the World Wide Web. Is that 'unreal life?', he asks, half in jest (personal communication, 27 February 1995).
4. Casey Condon points out the similarity here with the electronic trading of stocks on Wall Street and elsewhere; he notes that people unfamiliar with the process could not fathom out those sorts of exchanges and their relation to labour (personal communication, April 1995).
5. This software, developed by the National Center for Supercomputing Applications (NCSA) at the University of Illinois, Urbana-Champaign, allows decentralized multi-media access to documents, photographs, sound and movies. Users number in the many millions worldwide.
6. Thomas, a US Supreme Court judge and an African-American, is married to a white woman, and during his appointment hearing was accused by Anita Hill, an African-American, of sexual harassment. Morrison contends that the public process took Thomas from his token position as 'white' and 're-raced' him with the stereotyped American black man (Morrison 1992).

References

Bjerknes, G. and T. Bratteteig (1987) 'Florence in wonderland: system development with nurses', in G. Bjerknes, P. Ehn and M. Kyng (eds) *Computers and Democracy: A Scandinavian Challenge*, Avebury: Aldershot, pp. 281–95.
Bowker, G., S. Timmermans and S.L. Star (1995) 'Infrastructure and organizational transformation: classifying nurses' work', in W. Orlikowski, G. Walsham, M. Jones and F. DeGross (eds) *Information Technology and Changes in Organizational Work* (proceedings of IFIP WG8.2 conference, Cambridge), Chapman & Hall, London, pp. 344–70.
Condon, M. C. And D. Schweingruber (1994) 'The morality of time and the organization of a men's emergency shelter', unpublished manuscript, Department of Sociology, University of Illinois, Urbana-Champaign.
Cowan, R. Schwartz (1983) *More Work for Mother*, Basic Books, New York.
Deutsche, R. (1990) 'Uneven development: public art in New York City', in R. Ferguson, M. Gever, T. T. Minh-ha and C. West (eds) *Out There: Marginalization and Contemporary Cultures*, MIT Press, Cambridge, Mass., pp. 107–30.
Dibbell, J. (1993) 'A rape in cyberspace, or, how an evil clown, a Haitian trickster spirit, two wizards, and a cast of dozens turned a database into a society', *Village Voice*, 21 December 1993.

Hacker, S. (1990) *Doing It the Hard Way: Investigations of Gender and Technology*, Unwin Hyman, Boston, Mass.

Kramarae, C. (1988) 'Gotta go Myrtle, technology's at the door', in Cheris Kramarae (ed.) *Technology and Women's Voices: Keeping in Touch*, Routledge & Kegan Paul, New York, pp. 1–14.

Haraway, D. (1985) 'A manifesto for cyborgs: science, technology, and socialist feminism in the 1980s', *Socialist Review*, vol. 15, pp. 65–107.

Latour, B. (1992) *We Have Never Been Modern*, Harvard University Press, Cambridge, Mass.

Leto, V. (1988) 'Washing, seems it's all we do', in Cheris Kramarae (ed.) *Technology and Women's Voice: Keeping in Touch*, Routledge & Kegan Paul, New York, pp. 161–79.

McIntosh, P. (1992) 'White privilege and male privilege: a personal account of coming to see correspondences through work in women's studies', in M. L. Anderson and P. Hill Collins (eds) *Race, Class and Gender: An Anthology*. Wadsworth, Belmont, Calif., p. 70–81.

Markussen, R. (1995) 'Constructing easiness – Historical perspectives on work, computerization, and women', in S. L. Star (ed.) *The Cultures of Computing*, Sociological Review Monograph Series, Basil Blackwell, Oxford, pp. 158–80.

Mitter, S. (1991) 'Computer-aided manufacturing and women's employment: a global critique of post-Fordism', in I. V. Eriksson, B. A. Kitchenham and K. G. Tijdens (eds) *Women, Work and Computerization*, North-Holland, Amsterdam, pp. 53–65.

Morrison, T. (ed.) (1992) *Race-ing Justice, En-Gendering Power: Essays On Anita Hill, Clarence Thomas, and the Construction of Social Reality*, Pantheon Books, New York.

Oxford Classical Dictionary, second edition (1992) edited by N. G. L. Hammond and H. H. Scullard, Oxford University Press, Oxford.

Piercy, M. (1994) *The Longings of Women*, Fawcett Columbine, New York.

Riel, M. (1995) 'Cross-classroom collaboration in global learning circles', in S. L. Star (ed.) *The Cultures of Computing*, Sociological Review Monograph Series, Basil Blackwell, Oxford, pp. 219–43.

Schmidt, K. and L. Bannon (1992) 'Taking CSCW seriously: supporting articulation work', *Computer Supported Cooperative Work: An International Journal*, vol. 1. pp. 7–40.

Star, S. L. (1991a) 'Invisible work and silenced dialogues in representing knowledge', in I. V. Eriksson, B. A. Kitchenham and K. G. Tijdens (eds) *Women, Work and Computerization: Understanding and Overcoming Bias in Work and Education*, North-Holland, Amsterdam, pp. 81–92.

—— (1991b) 'Power, technology and the phenomenology of conventions: on being allergic to onions', in J. Law (ed.) *A Sociology of Monsters: Essays on Power, Technology and Domination*, Routledge, London, pp. 26–56.

—— (1995a) *Ecologies of Knowledge: Work and Politics in Science and Technology*, SUNY Press, Albany, N.Y.

—— (ed.) (1995b) *The Cultures of Computing*, Sociological Review Monograph Series, Basil Blackwell, Oxford.

Taylor, H. J., C. Kramarae and M. Ebben (eds) (1993) *Women, Information Technology and Scholarship*, Center for Advanced Study, Urbana, Ill.

Turkle, S. (1994) 'Constructions and reconstructions of self in virtual reality: playing in the MUDs', *Mind, Culture and Activity*, vol. 1, pp. 158–67.

Wagner, I. (1993) 'Women's voices: the case of nursing information systems', *AI and Society*, vol. 7, pp. 295–310.

MICHELE WILLSON

COMMUNITY IN THE ABSTRACT
A political and ethical dilemma?

> On each side of the political spectrum today we see a fear of social disintegration and a call for the revival of community.
>
> (Giddens 1994: 124)

IN AN AGE WHEN PEOPLE have more capacity – through technologically aided communication – to be interconnected across space and time than at any other point in history, the postmodern individual in contemporary Western society is paradoxically feeling increasingly isolated and is searching for new ways to understand and experience meaningful togetherness.[1] Nostalgia contributes to this search. Re-presented memories of 1950s-style communities where moral, social and public order 'flourished' are contrasted with present social forms, which are portrayed as chaotic, morally impoverished and narcissistic. However, and at least in theory, there is also a desire to formulate more enriching ways of experiencing ourselves 'in relation' which escape the difficulties of earlier, restrictive forms of community.

Many are looking for a form of 'being together' which can be seen as valued and, indeed, necessary. In turning to technology, we are presented with the possibility of virtual communities as a potential solution. Virtual communities – or communities experienced through technological mediation over the Internet and possibly enhanced in the future by virtual reality technologies – are represented by some as a form of postmodern community. These virtual communities are depicted as the answer to the theorist's search for a less exclusionary or repressive experience of community. Perhaps this will prove to be the case. But other theorists are uneasy about whether the unique, 'liberatory' and interconnective potential of the virtual will provide a vision for future communities. This is not to claim that celebrations of such a form of community are positing it as the only form to be practised or experienced, since to some degree 'earlier' forms will still continue to exist. How the relations between old and new forms are modelled requires further elaboration and critical attention.

In view of society's reliance on technology to solve its problems, both scepticism and a further examination of the claims surrounding virtual communities are required. It seems plausible that the hunger for community that is evident in postmodernity is in fact partly driven by the experience and ramifications of being an 'individual' within a technologically organized and aided society.[2] As such, it is interesting that there are similarities between the directions taken by theories of community formulated both within and outside the technological arena. If some see the solution as technological and others, while equally concerned with the issue of more meaningful community, avoid the topic of technology altogether, the same kind of question needs to be asked: namely, whether, in facing the difficulties presented by prior formulations of community, theorists are stripping the complex notion of community down to a superficial, one-dimensional understanding of human interaction. What I want to suggest is that, through the withdrawal of community from an embodied, political and social arena – either to lodge within a philosophical abstraction or to become a disembodied, technologically enabled interaction – an ethical or political concern for the Other is rendered impotent and unrealizable. 'Community' is then produced as an ideal rather than as a reality, or else it is abandoned altogether.

Technologies of individuation

This chapter investigates the political and ethical implications of the rise of cultures of disembodiment. To do that requires separating the applications of information and communication technologies into the areas of administration, surveillance and communications. There is, of course, significant overlap between these areas. For the sake of simplicity I shall be referring to two 'types' of computer technology: the system technologies or databases used by the public and private sectors, and the Internet.[3]

Databases are used by institutions to accumulate, combine and create information on all facets of life (including people's personal lives). These systems operate from diverse, decentred locations, often with different intentions or orientations. Database systems are becoming increasingly interconnected and sophisticated, taking on the form of a global information system capable of infinite analysis, profiling and information combinations. This has consequences for the subjectivity of social actors through the creation of a technologized Panopticon.[4] The Western individual increasingly experiences her/his life as monitored by technology: being caught on speed camera; captured on video while shopping; monitored for work efficiency by technological surveillance techniques; and taking a loan which is recorded, linked with other financial transactions and purchasing practices, and related to demographic statistics. These are just a few examples of contemporary surveillance. The continuous but often unverifiable surveillance has implications, as Foucault (1977) notes in Discipline and Punish, for the instigation of normalization practices. The power of normalization refers to the process by which a subject self-imposes or interiorizes particular norms and behaviours to conform to a self-perceived (but socially constructed) understanding of normality. This process is accentuated by the subject's own perception of the depth and pervasive nature of her/his visibility. Databases extend the gaze through disciplinary space, enabling a more pervasive and more widespread surveillance of each and every subject than previously possible. The subject of surveillance is universalized in that s/he is reduced to one file among

many, but also individuated through being personally identifiable, trapped within time and space by the continual visibility provided by the database/s. Files can be called up at any time with a simple command typed into a computer terminal. This has the potential to 'compartmentalize' the individual, separating her/him from others through the isolating qualities of the gaze.

Databases are perceived as a means to assist the surveyor. Given that the surveyor is usually an institution of some description, viewing those outside (or working within) its system, images of Orwell's Big Brother – or many 'little brothers' – are ominously invoked. The technology is oriented towards attaining control through information storage and analysis. Within the data field, information itself becomes an entity. Detached from its referent subject, it is able to be moved, manipulated and transformed.

The Internet also enables information to be moved, transformed and manipulated, bringing into question the issues of authorship and authenticity of material. In contrast to system databases, however, the Internet is depicted as a liberating technology. Its information is accessible to many users and it is interactive in form. The Internet enables the extension of many everyday activities. It is utilized for information collection, discussion of both academic and social topics, dissemination of views and undertaking financial transactions. Like databases, the Internet is unimpeded by state boundaries and is increasingly accessible on a global scale.[5] It is a diverse, decentred communications system with unlimited input – in as much as anybody who is connected to a network can participate in the system – resulting in seemingly uncontrolled and unpredictable development. This is viewed by some institutions as potentially threatening, leading to media exposure of 'illegitimate' or socially destructive activities on the Internet, and attempts by politicians to grapple with this issue through discussions of censorship and guidelines.[6] Yet these institutions also seek a greater involvement in the technology, devising ways through which Internet users can unwittingly provide information about themselves or their practices, and thus contribute to their own surveillance. Howard Rheingold raises the conceivable scenario of those who are information-poor, or have limited access to the technology, being offered 'free time' in exchange for the relinquishing of some personal privacy or control over private information (Rheingold 1993: 293–4). Technological constructs, such as artificial search engines, are increasing in both ability and number. These may well be able to create profiles and records on individuals' activities and their behaviour within virtual communities. In such a situation, the Internet also operates as a database.

Highlighting in this way the similarities between the Internet – in terms not only of its potential but also of its current capacity – and databases suggests that the application to the technology of such terms as *controlling* or *liberating* is arbitrary. Obviously, the technology itself is neither controlling nor liberating, but the social and cultural uses to which it is put may well be. In so far as the Internet operates as an interconnected database, it has as much potential for bringing about panoptical kinds of recognition relations as it has for enhancing an experience of freedom and mobility. The Internet is therefore also a powerful form of technology of individuation. It connects and disconnects individuals at the same time. As a paradox of 'connectivity', of participation with others in a virtual space, the technology disconnects the individual from the embodied interactions surrounding her/him. Although it may not individualize through the operation of the gaze to the same extent as presently available through databases, interaction through the Internet still heightens the solitary nature of participation, an activity both singular and universalized.

Equality, fraternity and liberty in a virtual community?

Virtual communities are formed and function within cyberspace – the space that exists within the connections and networks of communication technologies. They are presented by growing numbers of writers as exciting new forms of community which *liberate* the individual from the social constraints of embodied identity and from the restrictions of geographically embodied space; which *equalize* through the removal of embodied hierarchical structures; and which promote a sense of connectedness (or *fraternity*) among interactive participants. They are thereby posited as the epitome of a form of postmodern community within which multiplicity of self is enhanced and difference proliferates uninhibited by external, social structures.

Virtual communities exist within bulletin boards, conference groups, MUDS, MOOs and other interactive networks. Interaction is conducted predominantly through textual means. Descriptions, actions and locations are all communicated textually, produced by a keyboard. This will surely change over time with the increasing sophistication of virtual reality technology and the continued enhancement of graphic and video technologies (such as video conferencing). However, while visual information is limited to text-based description, and auditory or other sensory information is excluded from the interaction, the 'player' or community member is able to depict her/himself in whatever shape, form or gender s/he desires. Participants in virtual communities can thus escape their own embodied identities and accordingly can also escape any social inequities and attitudes relating to various forms of embodiment. Race, gender or physical disability is indiscernible over the Internet. Any basis for enacting embodied discrimination is removed, freeing access to participation and granting each participant equal status within the network.

Liberation may also be achieved from the constraints of geographical space in so far as the physical location of the 'body' of the player is overcome through the extension of interaction in cyberspace, compressing into a readily transversible medium. Thus virtual communities are also seen as a way of overcoming the inherent isolation of contemporary life where people do not know their physical neighbours, are not involved in their local township decisions and possibly work from home. This 'solution' overlooks the physically isolated nature of participation, where only the mind is extended into the mutual interaction. It is worth noting that virtual community participants often feel the need to reinforce/complement their disembodied relations by simulating, at the level of ritual, more embodied or sensorial contacts. For example, participants on the WELL – a virtual community on the Internet – have regular face-to-face picnics and social gatherings. The participants develop a more complete understanding of each other at such gatherings.

The perception of anonymity is presented as a further 'plus' by proponents of virtual community. Liberated from the normative gaze of both institutions and society, identity cannot be verified and attached to the embodied user and behaviour is not constrained by 'real space' norms and values.[7] The degree of anonymity actually achieved is questionable, and will prove increasingly so as information providers and commercial interests devise more effective means of accumulating information about network users. Additionally, the chaos within some communities – as a consequence of anonymity being equated with a lack of accountability – has led them to require participants to provide stable identification. On the WELL, for example, participants are obliged to link all

presentations of self with an unchanging referent user-ID, thus enabling identities to be verified (Rheingold 1993). The need for a kind of order within community interaction has prompted such communities to sacrifice liberatory aspects of anonymity in favour of accountability. The recording and archiving of interactions also creates the 'historical trace' of a character, decreasing the ability for that character to interact unidentified by past behaviours or statements.

Normative guidelines exist within those communities and the gaze – although in a modified form – applies. Marc Smith writes that, as in 'real space' communities, virtual communities must invoke and maintain the commitment of their members; monitor and sanction behaviour; and carry out the production and distribution of essential resources (HREF 1). There are specific rules attached to each community, which participants must agree to follow in order to maintain participatory rights. Many of these rules are fashioned either by the participants themselves or, more frequently, by the person/s who originally constructed the community space. For example, in conference groups the 'host' has control over the topics discussed and the behaviour permitted by conference participants, to the extent that certain topics or users may be banned if necessary.[8]

The question of ethics, or a notion of the common good, within virtual communities themselves (or even within the notion of virtual communities) is related to the existence of the kind of normative guidelines I have been outlining. Communitarian theorists such as Sandel, Taylor and MacIntyre have concentrated on the importance of a certain notion of the common good for 'real space' communities. They examine the incorporation of ethics and norms by the institutions, and within the practices, of such communities.

Something akin to spiritual enlightenment is commercially marketed as attainable with the use of information technologies. The recent television advertising campaign by IBM, 'Solutions for a Small Planet™', demonstrates an attempt to link their technologies to the ethos driving current New Age spirituality movements. Two messages are conveyed through these advertisements – one using nuns and another monks, so excited by the computer's capabilities that it interrupts, or even takes the place of, their spiritual contemplations. Firstly, the advertisements suggest the possible realization of a spiritual experience, as religious contemplation comes to stand for or is even replaced by experiencing the technology. Secondly, the very term 'Small Planet' carries with it the possibilities of universal interconnectivity and accessibility. With this technology, the viewer can readily infer, it is easy to be connected with everyone rather than to be lost in a sea of isolation and alienation: a variation on the cliché 'it's a small world' as a response to meeting someone familiar in an unlikely place. It emphasizes the transversality and compression of space into a more manageable concept/experience. A similar kind of suggestion links the communitarian emphasis of interactive technologies. By using these technologies, it is implied, the global can become as manageable and as familiar as your local community (the community that you have, nostalgically, lost).

This message of manageability and familiarity appears to be carried uncritically by all virtual community enthusiasts. They see the good life as achievable through the opportunities of flexible, disembodied identities unconstrained by geographical time and space, and no longer dependent on 'meaningful' others. Which means that it is the *forms* of participation that result in meaningful experiences for participants. Emphasizing multiplicity and choice stresses procedural measures, where the ability to choose identities and location is celebrated, but does not explain the nature of the good life itself.

However, virtual communities must also be understood as multiple and different, making it impossible here to delineate the qualities or understandings of each within one encompassing generalization. Any analysis of virtual community needs to proceed on two different though ultimately related levels: an analysis of the potentialities of the technology that enable virtual communities to exist in their present form; and an analysis of the specific form of each virtual community. The first helps to identify the capabilities and means of all communities within virtual space, allowing certain generalizations; while the second focuses on the specificity of each virtual community, with its own particular norms and regulations.

What is promoted as part of the good life, enabled by the capabilities of the technology, is the accentuation of choice. Within a virtual community individuals are able to choose the level or degree of interaction. They can choose when to participate, they can choose their degree of involvement with others – as long as those with whom they wish to be involved agree.[9] Marriages take place, 'sexual' relationships are formed and hierarchical or administrative relations created. As Sherry Turkle notes: 'Women and men tell me that the rooms and mazes on MUDs are safer than city streets, virtual sex is safer than sex anywhere, MUD friendships are more intense than real ones, and *when things don't work out you can always leave*' (1995: 244; my emphasis). Relationships can be 'broken' at any stage by the simple withdrawal of the character/identity, leaving one to wonder at the level and depth of commitment or investment in these relationships.

Individuals can also choose to have several characters within a community, or to belong to several communities, at any one time. As such they continually 'flit' between one character and another, and between communities. This ability has led observers to analogize the activities of 'character building' and 'flitting' as the concrete depiction of postmodern theory with its emphasis on multiplicity and the navigating of surfaces (Turkle 1995: 44–5). Nor is it so different from the multiple memberships, social roles and thus identities that individuals hold in modem society, although the rate of transition between these is not as instantaneous as in cyberspace. Such instantaneity accelerates the transformative skills needed to assimilate rapidly into the 'clothes' of each character and may indeed affect a person's experience and means of relating to the world. Parallels can be drawn between this flitting and television 'channel surfing' in the constant search for more rewarding stimuli. Jonathan Crary notes that 'in fundamental ways, we're being drilled to accept as "natural" the idea of switching our attention rapidly from one thing to another' (1995: 66). One wonders whether we are becoming sensory junkies perpetually in search of new experiences; that is, whether this searching for constant yet apparently superficial stimulation is leading to the promotion of instant gratification at the expense of more involved, complex, meaningful investigation and understanding.

In terms of interaction within a virtual community, the emphasis is on fluidity and choice of associations in a social space. Interaction is abstracted from more concrete and embodied particularities and takes place within an environment shaped by the actors themselves. A 'loosening' of connections may appear liberating. But such an understanding devalues many of the positive and ontologically important aspects of those very connections. It appears, for example, contradictory to elevate the enriching aspects of virtual communities while at the same time devaluing or ignoring relations such as those that exist between parent and child, which many theorists would see as fundamental for the basis of any community. As David Holmes (1997) has so aptly analogized, the

participants of virtual community are like messages in bottles, floating randomly in the oceans waiting to be picked up – a notion connected to the postmodern depiction of the multiplicity of selves in present society (Holmes 1997: 37–8). That there are no bonds or connections 'between' these bottles, apart from communication around a certain interest, is not an anxiety within virtual communities.

Instead, liberatory and postmodern claims about virtual communities are precisely based on the promotion of an anonymity which enables flexible, multiple and anonymous identity construction, and the alteration of spatial and time experiences. What is described in such utopian formulations is the ability to 'play' with identity and to promote communication and information collection. I would suggest that the dissolution or fragmentation of the subject and the instantaneous, transient nature of all communication disconnect or abstract the individual from physical action and a sense of social and personal responsibility to others. A fairly superficial example can be drawn from Sherry Turkle's book *Life on the Screen*. Turkle describes a virtual community participant actively involved in the political machinations of his cybersociety but also completely apathetic about and disengaged from the political situation surrounding him in his 'off-line' life (or embodied location), to the extent that he is not interested in participating in a local senate election (Turkle 1995: 242).

Blanchot makes a similar point about the disembodied experiences of the broadcast media:

> The whole world is offered to us, but by way of a gaze. . . . Why take part in a street demonstration if at the same moment, secure and at rest, we are at the demonstration [manifestation] itself thanks to a television set.
>
> (1993: 240)

Yet the experiential quality of actually attending a demonstration and being surrounded by activity, and the noise and smells of crowd contagion, is a more complex, more involving experience than that achieved via the medium of a television screen. While virtual communities may be interactive, they do not require either physical commitment (other than working with a keyboard) or moral, political or social extension beyond the network. Of those who use the Internet and virtual communities, only a small percentage actively participates. The rest operate from a voyeuristic or 'viewer' position similar to that practised in television viewing.[10]

Since other peripheral distractions are filtered out by the reliance on text-based descriptions, the nature of the interaction becomes intensely focused. Attention is solely placed on the act of communication as perceived through the visual interpretation of text.[11] Such a focus leads to claims that relations on the Internet are more intense than those in real space. In some ways, this view of interaction within a virtual community could be compared to the idea of the singles bar, with the singularity of purpose that this might suggest. Such a singular intention does not equate well with the complex experience of intimacy. And in any case, a very different analogy about interaction with a singular purpose, with a very different result, might just as easily be drawn using Blanchot's example of the street demonstration.

Anthony Giddens writes: 'Intimacy . . . is not, as some have suggested, a substitute for community, or a degenerate form of it; it is the very medium whereby a sense of the communal is generated and continued' (1994: 127). The question is whether intimacy can be achieved in such a public domain as the Internet, with only text-based

representation and the imagination. It is necessary to ask if 'community' can be suffi-ciently defined by the machinations of thin/emptied-out selves interacting via text through cyberspace;[12] or whether, by removing the difficulties and limitations of more traditional communities, we are also stripping away many of the factors that 'make' community meaningful for its participants.

In addressing these issues, it is instructive also to consult the recent work of commu-nity theorists working outside the technological debate. To this end, the contemporary thought of Jean-Luc Nancy, when extended to the analysis of virtual communities, enables certain useful analogies and observations.[13] As I want to show, there are similarities between the culture of virtual communities and Nancy's theoretical emphases. Both stress the multiplicity of experience and the dangers of prescribing particular forms of community and identity. Both can also be seen to encounter difficulties in enacting a political ethics concerned with the Other.

The community of Jean-Luc Nancy and the virtual community: a comparison

While the notion of *community* is experiencing a resurgence of interest, many theorists nevertheless overlook the implications of living and experiencing ourselves within a world increasingly reliant on technology. Albert Borgmann explains that society's reliance on, and everyday use of technology becomes a normalized pattern:

> *When the pattern is so firmly established, it also tends to become invisible.* There are fewer and fewer contrasts against which it is set off; and meeting us in objective correlates, it attains an objective and impersonal force.
>
> (1984: 104; my emphasis)

The technological paradigm has become naturalized and so pervasive that it appears invisible or, at the very least, inevitable. But technological capabilities and uses impact on the subjectivity of the Western individual. Failure to consider the effects here has consequences for the adequacy of some community theories. Yet, despite overlooking technological influences, the formulations advanced by some community theorists reveal similarities in direction to those of virtual community proponents. It will become apparent that both technological and non-technological understandings of community have been abstracted from a 'realizable' embodied form of community, either to an ontological schema (as is the case with Nancy), or to an on-line network experience in the form of virtual communities.

Nancy rejects the traditional conception of community as a grouping or coalescing around a fixed essence and identity. Community represented this way becomes 'commu-nity as communion' (Nancy 1991: 15). Such a form of community constrains a group of people to a monolithic form of identity, suppressing difference and promoting exclu-sionary practices. Nancy argues instead for community to be understood as the *incomplete* sharing of the relation between beings. For him, being is not common because it differs with each experience of existence, but being is *in* common: it is the *in* where commu-nity 'resides'. Community is to be 'found' at the limit where singular beings meet. The danger is in prescribing or categorizing an essence or form for both community and the beings that it involves.

Some similarities can be drawn between Nancy's theoretical manoeuvres and those celebrating virtual communities.[14] Nancy's discussion emphasizes the fluidity and singularity of being and the importance of the relations between beings. The emphasis on the absence of bonds or ties between these beings allows a non-prescriptive form of relations. Similarly, the virtual communitarians argue for multiplicity, difference and fluidity of experience, although they posit this argument within the notion of multiple, self-constituted selves/identities. They argue for a multiplicity of forms of community existent within the technology, whereby the multiple selves of a subject can belong to one community or to many communities and can freely move between all or any of these. As such, like Nancy, they wish to avoid prescribing particular forms of community and identity. Both orientations understand and encourage a concept of community which promotes relations free from constraint. Yet it appears there are also important differences and these deserve further elaboration.

Nancy would not accept the virtual community argument that a multiplicity of identities within a multiplicity of communities enables a more fruitful experience of community. Instead, identity would be seen to be more in the nature of work, or of a 'fixing' imposed on singular beings. It would therefore be open to the dangers of totalitarianism, oppression and the death/reduction of community (Nancy 1991). This is similar to the argument in Georgio Agamben's *The Coming Community*. Agamben attempts an understanding of community which does not rely on an idea of identity nor on members belonging to any particularity. Identity involves the accentuation of particular characteristics and the suppression of other characteristics. Instead, Agamben uses the term 'whatever singularity' to emphasize the unique and multiple characteristics of each being. 'Whatever singularity' does not belong to a particular group, nor even to a linguistic designation (Agamben 1993). Nancy's work carries a similar intention of avoiding the prescription of an essence for his singular beings or their communities.

Nancy asserts that a focus on the subject destroys any conceptualization of community.[15] He draws attention to the significance of the relation *between* beings, rather than to the beings themselves. Singular beings are not fixed totalities: they exist in and through their relations with other singular beings. Indeed, the use of the term 'singular beings' emphasizes these beings' difference, their multiplicity and their relations. A singular being 'ends' at the point where it is exposed to another singular being (or beings) (Nancy 1991: 27). This is the *limit* where there is a possibility of one singular being and another being existing simultaneously. It is where a consciousness of both separation and togetherness exists at the same time. Nancy's use of these concepts in discussing community and his denunciation of the existence of the 'individual' as an absolute totality without relations intend to highlight the relations between beings. For him, the focus of community is on the relational: the ontological necessity of the relational and, at the same time, the difference in each presentation or experience of the relational. Thus, he claims, we can never lose community despite fears to the contrary.

Such an assertion recognizes the uniqueness of other beings and imposes an implicit ethical responsibility to allow and respect differences. To ignore these differences or attempt to consume them within a totalized whole is to destroy the experience of community. It is precisely this focus on relationships and an ethical consideration for the Other which lacks adequate development in virtual community analyses. If the emphasis of community analysis is on the individual and the effects on/for the individual,

then the Other is objectified, becoming a utilitarian instrument for the achievement of the individual's own ends. Understanding the relationship in that way fails to recognize the importance of the Other for self-constitution, and the importance of relations between self and Other for the functioning of community. Any possibility of an ethical responsibility towards the Other encountered by the self (where that self undergoes as a result a formative or boundary experience) is neglected. And the failure to delineate the possibility of an ethics can only accentuate further the compartmentalization and totalization of the individual, despite the potential for fluidity and multiplicity opened by the technology.

In light of the awareness that postmodern theory raises about the suppression of difference and the Other, this is an important point. In virtual communities, we are presented with the description of community where participants appear autonomous, self-indulgent and seeking self-satisfaction. Free-floating beings, whose encounters with others may be formative, are depicted; but these relations are not elaborated sufficiently. Obviously there is a need for other characters to exist to enable interaction within these communities. Indeed, it is the ability for interactivity that is being celebrated and on which meaning is founded for its participants. Yet the celebration is expressed in terms of the possibilities for the subject of these relations. This concentration can be attributed in part to a reluctance to describe or prescribe a particular form of relations and, in that sense, it leaves the way open for multiple, varying experiences of the relational. In turn, it may explain why theorists, even as they concern themselves with an idea of virtual community, are more willing to focus on the potentialities enabled by the technology than on the relations of community.

A further difference between Nancy and the virtual communitarians occurs in the kind of attention paid to notions of subjectivity. Despite a certain ambiguity around his conception of singular beings, Nancy posits his analysis as ontological. Indeed his singular beings could be described as essentialized and ahistorical. Historical and cultural forces are not attributed a formative influence on singular beings. At the same time, an essence is not ascribed to these beings, since each being experiences itself differently. Such an understanding, while devoid of generalizations and oppressive classifications, makes any critique of singularity and community extremely difficult. It also renders any historically situated analysis of community redundant since community is assumed to be impervious to such influences. The virtual communitarians, on the other hand, direct their view to the subjective effects of the discourses and practices enabled through technological application. For writers like Turkle and Poster, there is an emphasis on multiple subjectivities or selves where different experiences, social roles and interactions (languages/ discourses) result in the experience of different identities. These selves could be described as more situated and non-essential than the beings depicted by Nancy. However, such a portrayal of multiple selves is reductionist. It removes the complexity and depth from the process of self-constitution by limiting perceived influences on this process to singular events/experiences and the possibility of infinite (unrelated) multiplicity. It also fails to explain adequately the possible implications to the decentred subject of multiple selves of cultural and historical change. Thus, while the approach taken can be clearly distinguished from Nancy's, the criticism of ahistoricism might also be levelled here.

Relations between the various selves of the virtual community member require further elaboration, as does the question of how they are integrated (if at all). Integration need not imply centralization. It is simply an assertion against the insularity of these

selves, and thus a recognition of their effect – in whatever degree – on the Other/others.
As Marc Smith explains:

> Despite the unique qualities of the social spaces to be found in virtual worlds,
> people do not enter new terrains empty-handed. We carry with us the sum-
> total of our experiences and expectations generated in more familiar social
> spaces.
>
> (HREF 1: 138)

New experiences and understandings may be generated in virtual space, leading to the
possibility – or expectation – that these new understandings will affect other selves (or,
as it might be interpreted, other aspects of the self). It seems a persuasive argument
that each self existing 'within' a subject (decentred or otherwise) must impact on the
other selves, forcing some self-compromise and modification. Contradictory practices
must be self-justified – possibly unconsciously – and relegated to a particular sphere or
presentation of the self. For example, the way a person behaves when performing a
particular social role may be deemed acceptable only while carrying out that role.
Nevertheless, some behaviour required for the role may also be completely contradic-
tory to, and irreconcilable with, the expectations and behaviours of other roles in the
person's life. Failure to reconcile these selves in some way would seemingly result in
confusion and disorientation. Jane Flax argues that this is indeed the case. She suggests
that schizoid and borderline individuals, for example, do not have the subjective fluidity
to enable reconciliation and modification of selves to take place, hence their difficulties
in functioning within society (Flax 1993).

Some level of cohesion among selves or, alternatively, a fluid – although sometimes
contradictory – unitary subjectivity can be argued. Anthony Cascardi writes that: 'contra-
dictions within modernity are lodged within the divided subject, who may act in different
functional roles and as a member of various social groups and who may speak in different
voices when in pursuit of different ends or when making different value claims' (1992:
7). This division of the subject is extended through the possibilities produced by medi-
ation in virtual environments. But the virtual communitarians need to elaborate the
relationship between, and the influences on, their multiple selves for their position to
be convincing.

Attitudes towards the deliberate construction of community uncover other differ-
ences between the two theoretical orientations. For Nancy, community cannot be 'made'.
It exists at an ontological level within the relation between beings. To attempt to create
community is to make it into work, actively constraining the relation between beings
by ascribing particular qualities or restrictions, and thus undermining community. For
Nancy, the task is to understand the experience of community rather than to describe
or create community. Such an orientation is open to the criticism of being politically
disengaged and apathetic; of being so careful in avoiding description that the theory
disempowers political direction or incentive. It mobilizes a withdrawal from the polit-
ical arena and thus disregards the possibilities for realizing actual practical benefits or
change. Virtual communities, on the other hand, are undeniably 'made', in the sense
that the illusion of space is created for the production and operation of community
within a humanly crafted technology. Yet this does not mean that interaction will auto-
matically take place, nor that a community will be formed, since people cannot be
forced to participate. There must be something which compels or invites their partici-

pation. And we would need to reiterate the observation that has already been made: the distancing that occurs through the disembodied processes of participation in a virtual community does not encourage embodied political activity, nor does it draw attention to political activity outside that community.[16]

Both theoretical interpretations of community rely on a tendency towards realization of community in the abstract: a removal of community from the embodied political sphere either to an ontological condition which would not appear to require action, or to a phenomenological experience which engages our minds and not our bodies. Both understandings are ahistorical in orientation; and fail to explain adequately where their notions of community are situated and how those notions can be extended and integrated into a physical realization of community.

Conclusion

Virtual communities are celebrated as providing a space and form for a new experience of community. This experience is depicted as multiple, liberating, equalizing and thus providing a richer experience of togetherness. However, a critical examination of these understandings reveals, paradoxically, a 'thinning' of the complexities of human engagement to the level of one-dimensional transactions and a detaching of the user from the political and social responsibilities of the 'real space' environment. This tendency towards a withdrawal from the active political sphere of real space, or the withdrawal from attempts to realize an embodied form of community, is mirrored in the works of other contemporary community theorists such as Jean-Luc Nancy.

In their desire to avoid placing restrictive or totalizing tendencies on the experience or understanding of community, theorists of both technological and non-technological orientation have removed community from a tangible, embodied or concrete possibility, relegating it either to the sphere of ontological, pre-political, pre-historical existence; or to an experiential existence within the nodes of a computer network system. This general movement towards a separation or abstraction of community from the political possibilities of real space removes any necessity for direct, embodied, political action. The depth of commitment to others within a community also declines, questioning the possibility of responsibility for the Other. As Nancy emphasizes, a concern for the Other is vital for any valid experience of community. But in the case of virtual communities such an ethic is far from apparent.

The growth of virtual culture and technosociality in everyday life carries with it contradictory implications for identity and community. Virtual communities enrich or 'round out' the use of technology by encouraging communication and creative imagination. Children growing up using the medium will see it as an extension of their world, including their relationship base. This in itself will have ramifications for the ways they experience themselves and their interpersonal relations. But we need to be careful in the claims we make about, and the hopes we invest in, virtual communities. By relying on understandings of community which paradoxically work to concentrate our attention on our selves while distancing us from our embodied relations, we may be accentuating the very compartmentalization against which we could be striving.

Originally published in D. Holmes (ed.) (1997) *Virtual Politics: Identity and Community in Cyberspace*, London: Sage.
This essay has been edited for inclusion in the Reader.

Notes

I would like to thank Paul James, Michael Janover and David Downes for their suggestions and assistance with this chapter.

1. The idea of 'community' is experiencing a resurgence in interest among both theorists and society at large. America has seen the growth of a self-named 'Responsive Community' movement which has emphasized the way in which the community has suffered through the privileging of individual rights and concerns. There has also been an increase in the rhetoric of community employed by politicians like Bill Clinton and Tony Blair (see Willson 1995).
2. This is not to argue for technological determinism. That is, I am not saying that the technology alone produces specific, unavoidable subjective practices or outlooks. Rather, I am arguing that the uses to which the technology is applied by the society/culture; the modes of thought which are accentuated by technological applications; and the practices that are enabled or increased through the technological capabilities available, all have consequences for the experience of subjectivity. Technological capabilities which enable practices otherwise impossible for the society to perform unassisted must, of course, also be granted the potential for subjective effect.
3. The broadcast media would also be situated here and are important because of their cultural and political impact. For more elaboration on broadcast media see McCoy (1993), and David Holmes (1997).
4. See Foucault (1977) and Poster (1990) for further elaboration on the effects and potential of the Panopticon (as modelled on Jeremy Bentham's construction of a prison). Poster refers to this phenomenon as a Superpanopticon. However, he does not emphasize the role of the gaze, or visibility, in the application and self-imposition of a subject's normalization processes. Databases enable an extension of that visibility into abstracted space, producing a more pervasive and intrusive gaze than that achievable without technological extension.
5. This is not to be trapped within the debate over the universality of access and participation on the Internet while its participants are primarily white male, middle-class English speakers from Western industrialized countries.
6. For example, President Clinton signed the Communications Decency Act, which authorizes the censoring and monitoring of objectionable material on the Internet. China has begun to restrict Internet access, and Victoria, Australia, has already instigated its own on-line censorship provisions. See van Niekerk (1996: D1).
7. Some difficulty arose in deciding what term to use in describing interaction and experiences outside cyberspace. 'Real life' is problematic as it places a distinction between embodied experience as being real and interaction via technology as not real. Participants in virtual communities would obviously wish to contest the 'unreality' of their interaction, which may well play a very 'real' part in their lives. It also fails to take into account the constructed or perceptual aspects of our interpretations of reality in embodied or real space. 'Embodied space' indicates the realm of face-to-face contact alone, and is therefore also problematic. It is also more unwieldy. The term 'real space' – while still not entirely appropriate – is more suitable.
8. This is a fairly drastic step and usually requires certain consultation with others before action is taken (HREF 1: 29).
9. In the few cases where mutual agreement has not been involved, there has been tremendous discussion around the issue. Virtual rape has provoked significant concern and debate about the impact of text-based acts of violence.
10. Statistics show that 50 per cent of postings on the WELL were contributed by only 1 per cent of users (HREF 1: 96).
11. Although now graphics and sound are being gradually incorporated.
12. 'Whether virtual systems can sustain the depth and complexity necessary for durable social structures that can withstand time and disruptive circumstances as yet unknown, remains to be seen' (Stone 1992: 620).
13. I have taken some liberties with the extension and application of Nancy's theory to allow discussions of virtual communities. According to Poster, Nancy denies the applicability of his

theoretical endeavour to technological mediation and indeed elsewhere writes that technolog-
ical and capitalistic economies work to undermine experiences of community. However, the
theory is still useful to elaborate on, and provide a contrast with, aspects of theorizing around
virtual communities.

14. Here I am focusing my analysis and assumptions primarily on the work on virtual communi-
ties undertaken by Rheingold, Poster and Turkle. Although they have different understandings
of subjectivity and also different expectations for these communities, there is sufficient common-
ality to justify such an approach.

15. Nancy claims that those analyses that focus on the subject, thus ignoring these relations, will
fail to understand adequately experiences of community: 'this limit is itself the paradox: namely,
the paradox of thinking magnetically attracted toward community and yet governed by the
theme of the sovereignty of a subject. For Bataille, as for us all, a thinking of the subject
thwarts a thinking of community' (Nancy 1991: 23).

16. This is not to assert that political activity oriented toward off-line situations does not take place
through computer networks. However, in such a situation, the user entering or participating
in on-line dialogue is usually applying the technology as a tool to spread political information
rather than accessing a social space.

References

Agamben, G. (1993) *The Coming Community*, trans. Michael Hardt, Minneapolis, MN: University of
Minnesota Press.
Blanchot, M. (1993) *The Infinite Conversation*, trans. Susan Hanson, Minneapolis, MN: University of
Minnesota Press.
Borgmann, A. (1984) *Technology and the Character of Contemporary Life: A Philosophical Inquiry*, Chicago:
University of Chicago Press.
Cascardi, A. (1992) *The Subject of Modernity*, Cambridge: Cambridge University Press.
Crary, J. (1995) 'Interzone', *World Art: The Magazine of Contemporary Visual Arts*, 4: 65–6.
Flax, J. (1993) 'Multiples: on the contemporary politics of subjectivity', *Human Studies*, 16: 33–49.
Foucault, M. (1977) *Discipline and Punish: The Birth of the Prison*, trans. Alan Sheridan, London: Allen
Lane/Penguin Books.
Giddens, A. (1991) *Modernity and Self-Identity: Self and Society in the Late Modern Age*, Stanford, CA:
Stanford University Press.
Giddens, A. (1994) *Beyond Left and Right: The Future of Radical Politics*. Cambridge: Polity.
Holmes, D. (ed.) (1997) *Virtual Politics: Identity and Community in Cyberspace*, London: Sage.
HREF 1. *Http://www.sscnet.ucla.edu/soc/csoc* Smith, M. (1992) 'Voices from the WELL: the logic of
virtual commons'.
McCoy, T. S. (1993) *Voices of Difference: Studies in Critical Philosophy and Mass Communication*, Creskill,
NJ: Hampton Press.
MacIntyre, A. (1981) *After Virtue: A Study in Moral Theory*, London: Duckworth.
Nancy, J.-L. (1991) *The Inoperative Community*, ed. Peter Connor; trans. Peter Connor, Lisa Garbus,
Michael Holland and Simona Sawhney, Minneapolis, MN: University of Minnesota Press.
Poster, M. (1990) *The Mode of Information: Poststructuralism and Social Context*, Oxford: Polity.
Poster, M. (1995) *The Second Media Age*, Cambridge: Polity.
Rheingold, H. (1993) *The Virtual Community: Homesteading on the Electronic Frontier*, Reading, MA:
Addison-Wesley.
Stone, A. R. (1992) 'Virtual systems', in Jonathan Crary and Sanford Kwinter (eds), *Incorporations:
Zone 6*, New York: Zone, pp. 609–21.
Turkle, S. (1995) *Life on the Screen: Identity in the Age of the Internet*, New York: Simon and Schuster.
van Niekerk, M. (1996) 'Censor moves to shackle Net', *The Age* (Melbourne), 13 February, p. D1.
Willson, M. (1995) 'Community: a compelling solution?' *Arena*, 15, February/March: 25–7.

MICHAEL OSTWALD

VIRTUAL URBAN FUTURES

Changing spatial perceptions

WHEN, SOME TIME IN THE late 1980s, the technologies associated with virtual reality first entered the collective consciousness of the popular media, they were frequently presented as aberrant and potentially destructive. Many early newspaper articles and television documentaries focused exclusively on the idea of the 'hacker' or the 'cyberpunk' as embodiment of the social cost of virtual technologies (Chesterman and Lipman 1988; Sterling 1992). In such programmes and texts, the dishevelled and socially inept computer nerd was frequently depicted as the most benign expression of the advent of computer-simulated space. However, it was argued that the line between the computer nerd and the criminal hacker was a fine one because the criminal of the 1980s did not break in through the bedroom window but through the computer screen (Hafner and Markoff 1991). Significantly, while the flat monitor of the computer was regarded as an open window inviting crime, the almost identical screen of the television was somehow seen as more secure because it lacked the two-way interaction that characterized the computer interface. Despite this difference, the computer, like the television before it, was viewed as an active agent of social disintegration. The computer screen was a potential portal into the backstreets and ghettos of the city; a window through which drugs, pornography and violence could exert an influence on the home. Overt virtual technologies, including the Internet, were blamed, like television before them, for the breakdown in the family unit, the rise in street crime and the decay of conventional Cartesian urban spaces.[1] The fear and loathing that suffused popular perceptions of the new technology were not implicitly Luddite but were aligned to the ability of the technology to accelerate the ongoing process of moral, social and urban decline.

By 1993 a significant shift had taken place in the media: the virtual technologies were no longer to be feared but to be tamed and welcomed (Chapman 1994). The advent of the new technosciences, metaphorically embodied in the concepts of virtual

reality and cyberspace, was heralded as a potentially new way of reinstating democracy, reforming the community and redistributing the populace so that urban ghettos could be invigorated with new life (Lénárd et al. 1996; Mitchell 1995). The rise in popularity of previously underground magazines such as *Mondo 2000* and *Wired* was accompanied by new publications including *21·C* and Internet supplements in the *Financial Review*, the *New York Times* and the *Sydney Morning Herald*. Both television programmes and the popular press provided glossaries of terms to allow the average viewer and reader to be carried away in veneration of the virtual technologies. And, at that moment when major companies started to advertise their World Wide Web addresses on television, the virtual landscape of the Net became accepted as an extension of the 'real' world. Virtual technologies were no longer suspected of destroying community and urban space.

While it cannot be denied that the same period, the early 1990s, saw a global outcry against pornography on the Internet, this debate was frequently couched in terms of the problems of greater political freedom or the potential for new software to lock away such sites. Regardless of which side of the argument the media and politicians chose, the debate concerning virtual technologies was argued on social grounds not on technological ones. Significantly, the positive and negative effects of the new virtual realm were seen to impact not only on the community but on the spaces that people inhabit. In the 1980s the computer screen was the unlocked window, the site of paranoid fears of invasion; but by the 1990s software 'locks', 'net-nannies' and 'guard-dog' programs had been developed to secure this so-called window. If, in the 1980s, virtual technologies had been linked to the breakdown in community and, through this connection, to the destruction of urban form, in the 1990s they were seen as the saviour of community life. It did not matter whether the arguments were for or against the virtual technologies, it seemed that no case could be made without referring to both the social consequences of the technologies and their impact on the public spaces of the city. This realization leads to the thought that the rise in virtual technologies had somehow become bound tightly with the decline in amenity of urban communal space.

Also bound up in the complex relationship between virtual technologies and communal spaces is the reason for the rapid shift in media support for the new technology in the early 1990s. Virtual technologies did not, and could not, arise overnight. Virtual technologies and spaces had been slowly and imperceptibly developing for many years in parallel with the decline in popularity of conventional urban spaces in most major Western cities. By the early 1990s, the physical world had already become so virtual that when the new technologies finally impacted on the populace they seemed to be a natural extension of the artificial and temporal spaces that already existed. In a world saturated with television, radio, video, portable stereos and mobile telephones the virtual technologies had already infiltrated society and prepared the ground for their acceptance. By 1990, telecommuting had become popular, distance learning was back in vogue and it was becoming increasingly difficult to find a real bank in the inner city as they were rapidly being replaced with autotellers, alcoves which served as displaced extensions of the banking world (Mitchell 1995; Nixon 1996).

All these technological changes have resulted in a widespread change in perception. The human mind can now perceive a new spatial form, one which derives from the television and computer screen but which has expanded outside the 'thin', 'nonreflecting' surface. Baudrillard's assumption that the 'flat screen' may replace the 'real scene' posits the key to understanding the surrogate urban landscape of the late

1980s and the connection between virtual technologies and Cartesian urban space. The perception of spatiality is becoming increasingly dependent on simulation of an environment which is 'other' to the natural; and, because of this simulation, the new space is inherently unstable. Instability and impermanence have meant that not only is the new spatiality simulated, it is also temporal. Like a ROM chip, once it is without power the memory fades and waits to be replaced with a new vision.[2] The new space, like the television, simulates something that is *other than the real space* and, also like the television, is impermanent.

The artificial environments created through virtual technologies, like televised space, are not only perfect simulations of 'other' space, they are also dynamic environments wherein cultural and social values become fluid. Yet these twin characteristics of simulation and temporality may be found in the marginal areas of urban society as well as in the environments created by virtual technologies. For this reason, those environments in the real world, where falsification is normal, change is inevitable and there is semblance of community, may be called virtual urban spaces. Virtual urban space, however, is not to be found in the parks, streets and gardens of the city, rather it may be seen most clearly in the shopping malls and the theme parks of the urban fringe (Ostwald 1996b). However, in order to find urban space which is both temporal and simulated, electronic space must be entered. The virtual electronic matrix of primitive cyberspace already exists and communities have formed in large numbers in cities which cannot be located in conventional Cartesian space. In both the mall and the primitive Matrix, the existing derivation of Gibson's literary cyberspace, the virtuality of urban space may be clearly distinguished.

The rise in virtual technologies is a natural extension of the way in which twentieth-century urban communal spaces already constitute virtual environments. The mall and the primitive Matrix are environments in which sensorial perception has been eroded and the space thus created may only be described as virtual. Such spaces are linked and defined not through technology but through the way that communities form and interact in them. This chapter is concerned with the spaces that promote and define community interaction at the boundary between the Cartesian world and the virtual world. It deals not with high technology but with the interface between physical architecture and virtual architecture: between the most virtual of physical urban spaces and the most prosaic of electronic urban spaces. I will begin with an analysis of the connection between conventional urban spaces and virtual urban spaces, and the communities forming in each. This is followed by a brief review of current theories linking the rise in virtual technology to the decline in urban communal space and an examination of a historical model of urban form, the agora, which embodies that relationship. Finally, I want to consider two contemporaneous examples of virtual urban space, one from the margins of conventional urban space (West Edmonton Mall) and the other from the electronic networks (Lucasfilm's Habitat). Through this analysis we can establish that there is often little or no gap between the so-called 'real world' and the 'virtual world'. With such a realization comes the understanding that conventional means of analysing the city are no longer adequate. There is a strong and growing need to consider that zone where the boundaries between the physical and the virtual are completely blurred.

The changing nature of urban space

The urban centre (in its modern incarnation: the metropolis) has been the focus of intense discussion and theoretical debate since the Renaissance. By the Victorian era massive social and technological changes had caused cities to grow at unprecedented rates until the first urban sprawls developed. However, it is in the last decade that the most striking changes have occurred in the ways in which space and community are perceived. Cities are growing globally and the population explosion has placed pressure on already overcrowded urban spaces. The technological revolution is changing how information is used and global communications networks have reduced the perceived effect of spatial displacement. Moreover, through global money markets all countries are interdependently linked. The modern city is beset with the problems of overpopulation, crime and pollution. Urban public spaces, once the site for recreational activities, have frequently degenerated into wastelands roamed by street gangs and ruled by violence. The nature of urban public space is changing and the ensuing cultural change is not a localized event, although it may not be occurring either simultaneously nor at the same rate in all cities. This change is most apparent in the urban centres of the US, South America, Australia and Asia, while in Europe the overwhelming weight of historical precedence has provided a slightly different form of cultural and spatial change.

That 'nostalgia is [still] the hegemonic discourse of urbanism' is a major factor influencing the postmodern cityscape (Sorkin in Hennessey et al. 1992: 19). The postmodern solution to urban decay was often the gentrification of depressed regions and communities. For this reason Virilio maintains that the cities of today are monuments to a fictionalized past:

> Neo-geological, the 'Monument Valley' of some pseudolithic era, today's metropolis is a phantom landscape, the fossil of past societies whose technologies were intimately aligned with the visible transformation of matter, a project from which the sciences have increasingly turned away.
>
> (1991: 27)

Virilio argues that the cities of today are still too closely aligned with the sciences, transport systems and communications networks of the past, and for this reason they are incapable of reacting to the changes taking place. In a discussion of the new spatial forms that are impacting on architecture and urbanism, Krewani and Thomson question the nature of the city in a tone which closely mirrors Virilio's. They ask whether at 'this point one should stop and ask how real our city experience is and whether our daily city experience has not long since come to resemble its fictitious representation' (Krewani and Thomson 1992: 124). This tendency for cities to become simulated in non-virtual space is a common component of postmodern urban form and has been widely recognized. Christine Boyer (1994, 1996) has argued that the cities of the 1990s are becoming fictional as they start to represent the collective, mediatized memory of the populace. Michael Sorkin, in *Variations on a Theme Park* (1992), has suggested that the postmodern city is prone to Disneyfication (the concatenation of simulation and artifice) and Deyan Sudjic (1993) has noticed the way in which major international cities are starting to resemble one another through the erasure of difference.

Virilio is also concerned with the dislocations in time perception caused by the same changes in urban space identified by Boyer, Sorkin and Sudjic. 'Unity of place without

unity of time,' he says, 'makes the city disappear into the heterogeneity of advanced technology's temporal regime' (1986: 19). Through its contact with electronic networks, rapid transit centres and international money markets, the postmodern cityscape is gradually becoming more and more reliant on systems which are both simulated and transient. The idea that technology is erasing the perceived distance between points and the relationship between time and space is not unfamiliar. Cultural critics have often commented on the 'changing pace of life' and 'the shrinking globe'. Both are phenomena related to the advent of technologies which reduce the perceived distance between locations and eliminate the time-lag conventionally associated with all communication (Harvey 1990). In *The Lost Dimension*, Virilio develops this idea of space–time displacement for the city:

> From here on, urban architecture has to work with the opening of a new 'technological space-time.' . . . Instead of operating in the space of a constructed social fabric, the intersecting and connecting grid of highway and service systems now occurs in the sequences of an imperceptible organization of time in which the man/machine interface replaces the façades of buildings as the surfaces of property allotments.
>
> (1991: 13–14)

Advances in technology have impacted on the perceived space–time relationship through the creation of a phenomenological space. The ability to make phone calls to other countries is now an accepted fact of life and this has contributed to the development of a global telephone culture which negates distance. Similarly the television provides an 'eye to the world', and simulates a global space within the flat screen. While the impact on spatial perception is reasonably clear, Virilio has linked the perception of space closely to the formation of community, as outlined in his theory of the 'third window'.

Virilio posits three symbolic types of 'window', using the term to imply a physical interface between interior and exterior. Historically, the first and most primitive type of window was used to enter and exit a space; in modern times this window has become known as a door. The second window is linked to both community and amenity; it is needed to allow other people to be viewed and communicated with – it provides visual stimulation without the requirement for ease of passage. The original needs for light and air that the second window answered are rapidly fading as modern technologies replace this function. Virilio's third window is the flat screen of the television. All these 'windows' provide a communal and spatial extension of the house. In the case of the third window, the television or computer screen, this extension is like the space just outside the physical window: it is a perceived space, one which the senses identify as being present. The third window is the most stimulating of all three because it represents a constantly changing space (since it is both temporal and simulated). As the third window slowly supplants the significance of the first two, the manner in which people, and especially urban people, experience the city will change. Virilio's third window may well be seen as more than television and as all aspects of time- and space-altering technology.

Sobchack and Baudrillard have both studied the spatial characteristics of the flat screen. Their findings, like Virilio's, suggest that the need for communal urban space has, at least partially, been provided through the surrogate media of the television and the computer network. For Baudrillard, 'the scene and mirror no longer exist; instead there is a screen and a network'; the third window becomes the 'smooth operational

surface of communication' (1987: 126–7). Sobchack calls the realization that the flat screen may represent a perceptible space 'the inflation of space' (1991: 255).

Virilio's third window provides a starting point for an understanding of the connection between space and community, and how it is possible for virtual space and virtual community to exist as a natural extension of the physical world. As already noted, the urban spaces of the physical world and the virtual world are intricately connected through the notion of community interaction and social formation. Allucquere Rosanne Stone supports this by suggesting that communities may exist in non-Cartesian space. She refers to such societies as 'virtual communities' because they exist within the virtual space of personal perception, like an extension of Virilio's third window. Stone's argument calls for the understanding of the phenomenological view of the spatial and the experiential. She identifies four epochs of virtual communities, all of which have spatial connotations. Each epoch is defined by the communication technology around which the communities have been based (Stone 1991, 1995).

Stone's first epoch identifies studies of scholarly publication. The first virtual communities of this type were made up of 'like minded gentlemen of science' whose researches were painstakingly recorded and circulated for discussion among fellow scientists. The modern incarnation of this community, perpetuated through the medium of the journal and the research paper, still exists in academia. In this sense, the academic journal may be seen as a textual community comprising people separated by displacements in time and space but linked through their interest in a certain topic. Moreover, the academic community of the journal has, like any other community, strict laws and customs. Communications between members of the community may be rigidly ordered to meet accepted forms of language, referencing and format.

The second epoch of virtual communities has grown from the media. In this epoch, the virtual spatiality of radio and television connect people together through perceived experiences and the illusion of participation. Like the academic community spatialized within the journal or paper, the televisual community creates its own particular variations of language and presentation. Also like the journal, the virtual community of the media is capable of creating its own outcasts by forming and directing public opinion. However, the most interesting virtual communities, which most clearly display urban spatial properties, are in the third and fourth epochs.

Stone suggests that the third epoch commenced in May 1978 when Communitree went on-line. Communitree acted as a bulletin board service, an electronic pin-board on which notices could be left. Theoretically, through such bulletin board services, people from all parts of the world were able to leave messages and conduct conversations from their computer terminals. With the emergence of the first electronic bulletin board the presence of virtual links increased rapidly. Communitree was a rudimentary precursor to the global news-nets where hundreds of thousands converse daily and exchange data in a free-flowing system.

Epoch four in Stone's virtual community is based around Gibson's visions of the Matrix, a form of cyberspace. Novak describes cyberspace as a 'completely spatialized visualization of all information in global information processing systems, along pathways provided by present and future communications networks, enabling full copresence and interaction of multiple users allowing input and output . . . and total integration and intercommunication with a full range of intelligent products and environments in real space' (1991: 225). For the novelist Gibson, cyberspace is a 'consensual hallucination';

a 'graphic representation of data abstracted from the banks of every computer in the human system'. In appearance, cyberspace is like 'lines of light ranged in the nonspace of the mind', it is reminiscent of 'clusters and constellations of data', of 'city lights receding' into the distance along endless highways (1986: 67). Stone's fourth epoch is a projection of the future of virtual space into cyberspace communities. Virtual reality on a small scale already exists in a few research centres around the world and in even fewer private organizations; and the people who have inhabited virtual space simultaneously number only in the low hundreds. Benedikt claims that cyberspace is more than the popular model of virtual reality outlined by Rheingold (1991) or Krueger's 'artificial reality' (1991). Benedikt sees the critical component of any definition of cyberspace as the element of community. A single person does not exist in cyberspace, but in virtual reality. A city may exist in cyberspace, but only as a function of the actions of its inhabitants (see Benedikt 1991).

The agora: cultural seepage in the physical and virtual environments

Each of Stone's definitions of community has embodied within it the concept of new customs, rules and cultural formations. The textual community of the journal has strict customs which militate against the individual's regional, cultural and political tendencies. In the same way, the televisual community propagates the formation of a global language of consumer logos, slogans and imagery. Global recognition of any product name, regardless of the dominant culture and ideology of the region, is the aim of widespread television advertising. In modern critical theory, the television's role in neutralizing and fragmenting culture is well known. Advertisements and products are increasingly multicultural and multilingual in nature. As a technological device the television is the catalyst for both virtualization and cultural neutralization.

The World Wide Web is the latest extension of the physical world into a medium where advertising competes constantly for high-profile sections of homepages. The language of the Internet is a *mélange* of words which originate in disparate sources: technical jargon, cult television lore and keyboard graphics all combine freely in the patois of the cyberpunk or hacker. Internet terms such as 'spamming', which originated in British comedy in the early 1970s, are now part of a global language despite the fact that in many parts of the world the comedy series that spawned this usage is completely unknown. Netiquette and net slang in the late 1980s were almost entirely derived from British, North American and Japanese cultures. The literary and televisual predilections of the early denizens of electronic bulletin boards thus became the basis for the language of the nets, while those cultures that entered electronic space in the years that followed had to adapt and change. At the 1994 cyberspace conference in Canada, local indigenous communities petitioned the organizers of the conference to leave them out of the event, and indeed out of cyberspace, until their native culture was sufficiently robust to withstand the overpowering influences present in the Internet (Stone et al. 1995). In all Stone's epochs it is clear that as each and every community is constructed, the particular spatial systems they are forming within (be they text, audio, video or virtual world) impact on the way in which cultural and social systems are formed. For example, the cultural and social systems forming in the Internet have certain emotional signs and cues

– such as : -), the sideways 'smiley' face signifying humour – primarily because they are limited visually and must often derive emphasis from keyboard notations. For this reason, such cultural cues and signs are frequently unable to be translated into conventional urban space and, in this way, may seem to undermine or at least defy Cartesian social systems. Thus the spatial and communicative medium does influence the intermixing or erasing of social and political systems.

Historically, certain city spaces have been linked to the loss or dilution of social and cultural mores. The city, and any urban space, has as a central function social and cultural orientation. Elizabeth Grosz has even defined the function of the city in terms of its capacity to 'orient sensory' and perceptual information, in so far as it helps to produce specific conceptions of spatiality' (1992: 250). Specifically, she sees the spatiality of the city as fundamental to providing the principles that organize 'family, sexual, and social relations'. Importantly, the form and structure of the city 'provide the context in which social rules and expectations are internalized or habituated in order to ensure social conformity' (Grosz 1992: 250). Seen in this way the spatial form of the Cartesian city, like the virtual environment, influences regional, cultural and social stability. An historical example of this concept is the agora.

In post-Homeric Greece the agora was an urban space separated from the temple precinct because of theological and ontological differences. Spatially, in the cities of ancient Greece and Rome, the agora was defined by an exclusion from the city grid signifying that it occupied a zone outside the order of the city. The architectural and urban historian Lewis Mumford notes that the agora was primarily 'an open space, publicly held and occupiable for public purposes', it was 'open to the passer-by' and contained 'temporary stalls or stands' (1991: 176). Pierre von Meiss records that in the 'regular grid layout of Priene, a colonial town of antiquity, the status of exception' to the rule of the town 'is reserved for the agora, the sanctuary and the theatre' (von Meiss 1992: 54). This formal exclusion from the city grid, while common in modern cites, had strong symbolic meanings for the inhabitants of an ancient Greek or Roman town. The major cross streets that defined an ancient Roman town frequently passed beside or through the agora so that travellers from other regions would be drawn into the central, non-town space. In this way, such travellers and the cultures they carried with them would tend to reach the agora before being encouraged to remain or depart. The agora was often spatially bounded by street walls and contained (under the eye of the city watch), but within the space it was allowed to change as frequently as required.

Spaces of exclusion like the agora were not only public spaces but also spaces where messages were posted, or chalked on walls, and where news was spread by word of mouth. At that time there was 'probably no urban market-place where the interchange of news and opinions did not . . . play almost as important a part as the interchange of goods' (Mumford 1991: 176). The agora in this sense functioned as a centre for the passage of information and for free communication; and for this reason it has been linked to the rise in politics and the Greek democratic tradition. In the *Iliad*, the agora is described as a 'place of meeting', although the modern translation has been stripped of much of its original meaning. The agora, in a quotidian sense, fulfilled the ancient Greek requirements for commerce and communication. On one level it was a form of marketplace but the original translation, a 'place of meeting', was far more accurate. The agora provided a space through which cultures and languages could mix, a place where produce was bartered and tales were told. It was the site for the intermixing and changing of

culture, acting simultaneously as 'market, as place of assembly, and as festival place' (Mumford 1991: 176). The dimension that controlled this change in culture was anthropocentric, given the necessary dependence on speech. As word of a merchant's travels spread from the agora, the inhabitants of the city were slowly altered by the influx of non-Greek or non-Roman cultures. In Mumford's terminology the agora was a site of 'cultural seepage' where social, political and communal change occurred (1991: 121).

The agora model is still highly relevant to studies of urban social formations. Similarly the complex interplay of communal, spatial, cultural and political forces at work in the agora renders it an appropriate model with which to consider critically those spaces formed through the agency of virtual technologies. The most recent incarnation of the agora is contained in two spatial devices: the shopping mall for commerce and the computer for communication. Mumford has traced the agora and its functions ostensibly to the modern shopping mall:

> Not indeed until the automatism and the impersonality of the supermarket were introduced in the United States in the mid twentieth century were the functions of the market as a centre of personal transactions and social entertainment entirely lost. And even here that social loss has been only partly offset by the development of the larger shopping centre where, in the characteristic style of our over-mechanized age, various media of mass communication at least serve as a vicarious substitute – under the sly control of the guardians of the market.
>
> (1991: 176)

Since Mumford shows the historical agora to have been a simulated and temporal space, it can be seen as a precursor to the shopping mall. Similarly the agora model is fitting for analysis of primitive electronic communities since, as Mumford says, if the Greek 'acropolis represents the city in depth . . . the agora represents it in extension, reaching out beyond its visible spatial limits' (1991: 190). Like the Internet, the agora 'expressed no unity' and 'almost any function might be performed there' (ibid.: 190). The agora is a worthy model for virtual urban space because it encapsulates the concepts of spatial extension, cultural neutralization, community formation and temporality. We can now consider two examples of spaces which are simulated, temporal and, like the agora, sites of 'cultural seepage' – a shopping mall and an electronic environment.

The mall: simulated and temporal urban space

Any introduction to West Edmonton Mall (WEM) reeks of hyperbole, but it is worth the exercise if only to explain the magnitude of it all. WEM is 'larger than a hundred football fields', 353,000 square metres of retail space comprising seven major department stores, 41 large stores, 110 restaurants, 13 night clubs, 20 movie theatres, an interdenominational chapel and approximately 700 other assorted shops.[3] WEM is the epitome of Rabelaisian consumerism, it is the ultimate shopping venue where almost any legal commodity may be found. But, for the developers, the mall's 'shop and buy' nature is secondary to its experiential nature. WEM has grown with a degree of hyperactive Disneyfication which rivals any centre of commerce in the world. Within the vast, architecturally uninspiring, vaulted atrium exists a *mélange* of visions,

a concatenation of history and fantasy, each parasitically growing into the other until quotidian boundaries of sense and relationship are diminished. The simulated settings that inhabit WEM are seemingly more important than the shops themselves. The ersatz reality may provoke a carnivalesque nature to the space but the simulation of fantasy is the most noteworthy feature of the mall.

WEM contains a full-size ice skating rink with the potential for spectator seating and a full-size replica of the *Santa Maria* floats in an artificial lagoon. This lagoon is so extensive that a fleet of submarines spiral through floodlit plastic seaweed carrying shoppers on small-scale sanitized adventures to stimulate their leisure time. The lagoon is itself a strange mixture of reality and fantasy – real penguins interact with mechanical sharks and real fish live in plastic caves and eat specially provided food (the plastic seaweed being inedible). A mock Victorian iron bridge carries 'tourists' from cinema to amusement centre by way of a small water-front café where an automaton band plays loud jazz, challenging the surrounding muzak. In another area, the lagoon flows into a beach, the gloomy sun high above WEM is supplemented with artificial sunlight, mechanical waves break on the beach and a few hardy bathers frolic in the specially imported sand. Elsewhere, Siberian tigers (real), Parisian art deco signs (fake), Ching dynasty vases (real) and Doric columns (fake) compete for attention. However, the widespread simulation of history and geography in the shopping mall is not the only example of excessive artifice. Above the mall is a 360-room motel, themed in case the endless kaleidoscopic experiences below are not enough for the most jaded of tastes. Horse-drawn carriages may pick up the visitor and deposit him/her near the medieval English suite with its false timber and stone walls, electric fireplace and flushing toilets. The real medieval is not sanitized enough for WEM. Hollywood-themed rooms are also available, with adjacent suites offering ancient Greek and Roman decor or the Wild West. Nowhere is the degree of fantasy more evident than in the 'Polynesian rooms where the bed floats in a warrior catamaran under full sail while a volcano erupts behind a waterfall which fills a lava rock jacuzzi pool' (Maitland 1990: 147). On opening the mall, one of the developers proudly announced that 'What we have done means you don't have to go to New York or Paris or Disneyland or Hawaii. We have it all here for you in one place, in Edmonton, Alberta, Canada' (Henry 1986: 60). Why go to Paris when WEM can provide a simulacrum of the boulevards right here in Edmonton?

Viewed from above, the main structure of the mall stretches in an east–west direction for almost two kilometres. Inside, a central 'street' runs through a series of spaces and at right angles to this main street are a series of corridors which stretch up to 700 metres in length. These corridors pantomime historical streets: a nineteenth-century Parisian boulevard, Victorian courts and New Orlean's Bourbon Street. Bourbon Street WEM is a whimsical spatial narrative derived from a spurious historical syntax of forms. It is a veritable forest of pediments, balconies, Moorish arches, caryatides and dormer windows. WEM provides a fictional image of the past; a fantasy, no doubt, but one allowing the modern shopper to travel to distant places. The setting has been dislocated through time and space, its relevance is lost, the people are gone and the freestyle interpretation has impoverished the original. Yet, for the viewer of WEM's fictional places – even while recognizing that a copy is being experienced – the copy itself has become transposed onto the signified meaning of the space and has erased the original. The Bourbon Street in WEM is *the Bourbon Street* for most of its visitors; there is no other.

In the modern memory, which is palimpsestically erased but imperfectly rewritten, the new urban space becomes a reality even though it is simulated and tainted with hyper-reality.

The spatial form portrayed within the mall may be one of fragmented images, distorted vistas and shattered reflections, but this superficial chaos possesses an underlying order and design. The mall is a collage of 'psycho-graphics' designed to suit the specific socioeconomic values of the desired shoppers. The 'white noise' that fills mall space, combined with the muzak, dulls the auditory experience and distorts the shopper's sense of time and place. The more heavy-handed visual subliminals, by distracting the senses, alter perception and further exacerbate the already poor definition of space. The outcome of all this altered perception is what William Kowinski names as *mal de mall*: 'a perceptual paradox' which influences the shopper through the layering of 'stimulation and sedation'; a condition which is 'characterized by disorientation, anxiety, and apathy' (Crawford 1992: 14). And at the same time the mall, through the blurred spatial perceptions, is also a depersonalizing experience. Joan Didion describes the mall as an environment where 'one moves for a while in an aqueous suspension' which militates against informed choice and retention of 'personality' (1979: 183). The mall is a space characterized by a proliferation of conflicting signs and images. These signs interfere with perception and the recorded memory of spatial identity rendering the modern shopping mall intensely virtual.

As malls develop and grow, they have been aiming towards seemingly utopian visions of space and recreation. As Frieden and Sagalyn note in *Downtown Inc*, by 'providing safe, comfortable spaces open long hours, developers made their retail centres inviting to a broad cross section of the population' (1991: 68). Developers made their malls inviting by offering a completely controlled environment. At WEM the entire mall is internalized; someone's work, recreation, indeed life, might all take place inside its walls. Malls have their own generators, water supplies and, in some cases, law-enforcement agencies. They are in effect private cities, places where the inhabitants can escape into simulated comfort and forget about the homeless, the poor and the unemployed. The implications of private space and privately owned cities are far reaching. Social ideologies aside, one of the fundamental characteristics of the mall is the presence of an authoritarian set of controls. Surveillance cameras watch over every space in WEM; it is a price the shopper or tourist must pay to exist in this sanitized new urban space. Moreover, in WEM the visions recorded on the security cameras may be replayed on public display screens, while in shop windows video camera displays simultaneously record and play footage of shoppers as they look into the cameras. In a mall, all activities become both displayed and virtual because everyone is recorded and replayed from multiple angles and in reverse, until even the original shopper is hard to distinguish from the recorded and simulated image.

The spatial reality of the shopping mall is also temporal in nature, being governed by economics and the mathematical mapping of value to topography. Pure topography, in a geographic sense, is not enough to map the ideal location of a shopping mall. It must be combined with demographic and economic data as well as estimates of time and speed of travel. In combination, these factors form coordinates which may be used to map illusory, virtual terrain. This form of mapping, which over-writes the physical world, is known as econotopography. The concept of economic topographies is not new. The idea of mapping land values to sites has been previously studied in major cities and

is also seen most clearly to be analogous to spatial mapping in cities such as New York. This mapping technique is simple to visualize in that the higher the land value, the higher the representation of the bar on the econotopographic map. However, the economic significance of the shopping mall may be mapped onto the landscape even more comprehensively than by land value topographies. The mall, like a river, must have a catchment area which may be marked on a conventional map but which is governed by non-topographic factors. This is the region from which the mall may expect to attract the largest proportion of its customers. The more affluent the region, or the better the public transport, the wider the catchment area.

In WEM, the regularly changing socio-econotopographic mix of the community can be seen. There is a constant instability in the number of stores in WEM at any given moment; the exact mix of shopping is in constant change to meet supply and demand. As the surrounding economic and demographic systems change, they send complex ripples through the econotopographic map until the system settles towards equilibrium and the surety of economic returns reduces. The solution to this problem is to rebuild, revitalize and refurbish. A regional shopping centre in the US, Canada or Australia may have a life span of between seven and ten years before it needs cosmetic surgery, either major or minor. Unless a new image has been proposed and a new lease of life granted to the ageing shopping centre, equilibrium will change arithmetically into decline and, thence, geometrically into receivership. Thus the econotopographic space of the mall is in cyclical change, and for this reason WEM has a limited life span in its current form. The side-effect of the cyclical nature of the shopping mall is that all of the space it defines is, by virtue of the cycle, completely temporal. Bourbon Street (WEM) has a distinct life span before it will be removed and replaced by some other simulation. The identity of the space will change and, even though the Cartesian relationship between space and location is not varied, the signified presence of new space will erase and then rewrite the new over the old.

Simulation, temporality and the associated transient spatiality are characteristics of the virtuality of urban futures. Space is no longer a constant; the perception of space and time is deconstructed through the synchronous application of simulation and temporality. The space is related to the physical presence of site, but it is even more strongly related to the virtual space of the econotopographic map (and the simulated spatiality of the mall interiors). This is a virtual mapping of space and time derived from the topographic renderings of economic geometries. The shopping mall is the consummate virtual urban space. It is both simulated and temporal. It represents an extant virtual environment present at the boundaries of conventional urban space.

Habitat: simulated and temporal electronic space

Since the late 1980s, a new pattern of communal city has come into existence in electronic space. Perhaps the earliest and most well-documented example of a virtual urban space in an electronic environment is Habitat. While, in once sense, Habitat existed originally as a 35-foot-long mural on the wall of a building in California, this was merely a representation. On-line through the electronic networks, 'each area of the mural represents an entirely expandable area in the cyberspace, be it a forest, a plain or a city' (Stone 1991: 94). Habitat is a virtual urban city which transcends common

spatial boundaries. Moreover, Habitat offers a very rare model of a community forming and stabilizing, the interactions of its people, their relationships and commerce. Yet Habitat could never be considered a space in any conventional sense.

In 1986 Lucasfilm and Quantum Computer Services produced Habitat, a graphical computer environment where people could interact and see representations of them-selves in virtual space. By 1987 Habitat was the world's first electronic urban environment, a true virtual space both simulated and temporal. In the words of its creators, Morningstar and Farmer:

> The system we developed can support a population of thousands of users in a single shared cyberspace. Habitat presents its users with a real time animated view into an on-line simulated world in which users can communicate, play games, go on adventures, fall in love, get married, get divorced, wage wars, protest against them and experiment with self government.
>
> (1991: 273)

Habitat could be accessed through a personal computer with a modem connection allowing for up to 20,000 computers to access the central mainframe simultaneously. Similarly the Habitat world was broken up into 'a large number of discrete locations' called 'regions' and at its height 'Habitat consisted of 20,000 of them' (Morningstar and Farmer 1991: 276). A person existed in Habitat as a 'toon' – people were depicted as blocky images of colour surrounded by jagged black lines. Each Avatar, as they were called, had a recognizable torso, legs, arms and head. Avatars could walk, turn in a choice of four directions, pick up and use objects, and had a few variations on body position (standing, walking and dead). The bodies were positioned by using a joystick and were viewed in elevation as flat two-dimensional figures. The background land-scapes were dominated by primitive child-like renditions of houses with pitched roofs, protruding chimneys, virulent green grass and a vibrant blue sky. Each Avatar could move from one region to another, the scenery changing as the Avatar walked through city and country and forest. As the Avatars moved they could encounter others, and therein lay the interest. When another Avatar was encountered it could be addressed by typing on the keyboard. Above the first Avatar's head would appear a balloon which would stretch to fit the sentences being typed. The second, in real time and on his/her own computer screen somewhere else in the real world, could read what was being typed and reply in turn. This interaction rapidly stripped the basic cartoon images of their perceived simplicity. Habitat became more than a poorly rendered computer game, it was an interactive environment, a place with its own currency, news-paper and traditions.

Morningstar and Farmer produced only the elementary environment and a few simple activities within that environment. Originally, they had attempted to plan the communities themselves but quickly ran into difficulty as 'a virtual world such as Habitat needs to scale with its population' and for 20,000 Avatars they 'needed 20,000 "houses", organized into towns and cities with associated traffic arteries and shopping and recreational areas' (Morningstar and Farmer 1991: 286). In early 1987, with the activities that had been designed failing to attract the envisaged interest and with the towns still only half developed, it was feared that within weeks of going on-line the community would fail. Yet, for those inhabiting the virtual urban space, the activities were mere sidelines to a far more interesting pastime – setting up a virtual community

and political system. Avatars quickly became involved in initiating trade: money, called tokens, could be accrued through interest in the bank and items could be bought, used and sold. Communities developed around the initial cities as Habitat money bought land and developed the sites. Societies grew up and meetings were held with Avatars voting on the naming of the first Habitat city. Habitat became a model urban community with hundreds and eventually thousands of people participating.

Habitat had not been on-line for long, when the first of a series of disquieting events took place. As in the real world, crime sullied the new electronic community. It was discovered that objects currently 'in hand' had a degree of instability, and when one Avatar met another it was possible to take whatever the stationary Avatar was holding and run away with it. Electronic purse snatching soon grew into a major crime-wave. The gods of Habitat, the programmers Morningstar and Farmer, were soon petitioned to stop crime but they were adamant that it was not their business. So the people of Habitat lived in fear for a few weeks as crime escalated further. Because Habitat was originally designed as an adventuring environment, a form of extension of the computer gaming and role-playing market, it was assumed necessary to permit the purchasing of weapons from electronic stores in the Habitat world. These guns and magic wands, orig- inally intended to allow Avatars to fight fantasy monsters, were soon employed for other purposes. An unfortunate young Avatar couple walking hand in hand across the woods found themselves ambushed, killed and looted. Being killed was not as final as it sounds since the next day they were resurrected, but they had lost all their possessions and some of their money. Soon battles broke out and marauding gangs roamed the forests. Back in town, the urban Avatars arranged a meeting of all interested people and called for ideas on what to do about the 'murderers'. It was eventually decided to elect a sheriff and to ask the gods to limit the effectiveness of the guns. Morningstar and Farmer agreed in the face of public pressure; henceforth guns would not function in the city areas and the sheriff would have the power to charge and fine Avatars caught breaking the newly defined laws.

It is interesting to note the parallels between WEM and Habitat. It is also ironic that some of the first locations designed in Habitat were for 'shopping' malls. Both places, by challenging traditional laws regarding public space, have brought to light instances when existing laws might need to be revised. Frieden and Sagalyn have analysed the way in which public laws may not be appropriate for private urban environments such as the mall and private political systems. The realization was only gradual that new laws might be needed to govern the rise in privately owned public space (Frieden and Sagalyn 1991). But consider Habitat. What if the death of a personal Avatar brought on a real heart-attack in the owner deeply involved in their on-line existence? Is the Habitat assassin with the fixed cartoon grin now a murderer in the real world? Such violent crimes were more noticeable in the early days of Habitat, but a number of other significant incidents occurred. A church was formed dedicated to non-violence and allowing all Avatars to live in virtual peace. A newspaper was circulated daily listing recent events and unsafe areas, and recording the views of the more urban Avatars. Some other enterprising Avatars formed political parties and ran for government. In time, as Avatars made money and started to enter into the development of communi- ties, the land stabilized, the bandits still thrived in the forests but they would not attack well-armed parties, and then, before the next phase of expansion could occur, Habitat was shut down.

While various incarnations of Habitat continue to operate to this day, Habitat itself fell victim to a combination of circumstances, all of which were largely peripheral to the myriad events which occurred there. Two factors which were certainly instrumental in its demise were the reliance of Habitat on the Commodore 64 computer (which was steadily losing market share) and the widespread growth of the Internet. As is so often the case, commercial not social factors finally determined when it was time to erase the town and move on.

Virtual urban futures

When Habitat started, it was the first electronic communal space ever realized on such a scale; now there are hundreds of similar communities operating on the Internet. Like WEM, Habitat was an internally inconsistent environment in that it relied on fabrication and proved to be dramatically temporal when it was finally shut down. The mall is also erased when it undergoes the endless and inevitable process of refurbishment: Bourbon Street will be replaced with the ubiquitous 'Main Street', the submarines will become dinosaurs and before long no one will be able to remember whether the penguins were real or not. The spatiality of the mall derives its character from both simulation and transience, producing an environment which is as virtual as Habitat. Both Habitat and WEM also relied on a form of omniscient surveillance system to ensure that their urban spaces were safe yet, paradoxically, this also meant that any communities thus formed were a shallow imitation of the social patterns of the outside world. It was outside these isolated conclaves, in the forests of Habitat and in the endless car parks of WEM, that the real world of crime and violence continued to exist largely unperturbed. The virtual space of the mall provides a perfectly sanitized setting, devoid of social problems and controlled by technology to ensure that the sordid realities of the outside world do not intrude. Habitat also attempted to create an ideal world by breaking universal laws: by allowing 'people' to be resurrected and to live without food, water and sickness. Habitat relied on two all-knowing and all-seeing gods, the programmers Morningstar and Farmer, to keep them safe and to control the environment. In both cases the environments became like the panopticon prisons Foucault argued were the ultimate means and form of dehumanization. The panoptic environment, which inscribes spatially the power of the viewer into the body of the prisoner, the shopper or the Avatar, is emphatically not a communal environment.

The agora, like WEM and Habitat, was a place of commerce and communication, a place for mixing cultures and experiences, but the similarities end there. The modern shopping mall is a subversive simulated space, it is a heavily controlled and mediated environment where any semblance of physical or political freedom is illusory. The mall does not encourage 'cultural seepage', rather it actively discourages any cultural and spatial forms which it has not already assimilated. In this sense, it superficially possesses characteristics of urban space but it has little or no capacity to encourage community formation. Like the agora, Habitat sought to provide 'an indiscriminate container' which could be filled with interaction, communication and commerce (Mumford 1991: 177). Yet the community that formed in electronic space was at best a parody and, instead of fulfilling the agora's role as site of political freedom, Habitat degenerated into the simulation of some idealized place. Like Disneyland's Main Street, with its colourful

town hall, church and picket fences, Habitat's community was no more than a shallow façade. Whether or not this situation would have been remedied if the environment had been allowed to continue remains unknown. The possibility of real political and social freedom in Habitat was ignored in favour of commerce and consumption. Although more successful than WEM, the virtual urban space of Habitat was still a poor catalyst for social, political and cultural interaction.

Both Habitat and WEM possess many similarities and strongly support the contentions of this chapter that marginal urban spaces in the real world already constitute virtual environments and that the same characteristics are now being transplanted into the virtual realm. However, these examples offer no strong evidence that genuine communities will form in virtual urban spaces in either the Cartesian or the electronic world. The most recent incarnation of the agora is neither the shopping mall nor the closed electronic environment, but may just be the Internet itself. The agora does not necessarily provide a sense of place, rather it provides a sense of passage, translation and personal freedom. If the Internet can achieve the right balance of interaction, leisure and commerce it may in time develop into a genuine community space. While it continues to mirror the malls, theme parks and office buildings of the Cartesian world it will never become the mythical 'place of meeting' described by Homer in the *Iliad*.

Originally published in D. Holmes (ed.) (1997) *Virtual Politics: Identity and Communication in Cybersociety*, London: Sage.

Notes

This chapter has been developed from ideas published in the journal *Transition* (Ostwald 1993) and in the book *Architecture, Post Modernity and Difference* (Ostwald 1996a). I also wish to thank Barry Maitland and Sandy Stone and for drawing my attention to WEM and Habitat respectively.

1. In this chapter the term 'Cartesian space' is occasionally used to refer to the 'physical' or 'real' world. Given that the aim of the chapter is to remove the boundaries that separate the 'physical' from the 'virtual', it is doubly ironic that such ambiguous terms must first be created and then used alongside the equally ambiguous terms 'physical', 'virtual' and 'real'.

2. One of the essences of virtual space is that it is phenomenological – it is based on perception. Cartesian experiential space is temporal in that it is limited to a particular time-frame. For example, a house may exist at a given moment in time and may be experienced through direct sensorial perception but if the house is demolished the spatial identity is erased. 'Real' space is therefore also temporal, based on a time-frame relative to our perceptions. Virtual space is no different, but its time-frame is not necessarily relative to our own. The perception of a distinct virtual spatial form is derived from secondary sensorial stimulation, which means that not only is the exact identity of the space widely different from one person to another, but the same virtual space may be perceived differently each time it is experienced. Virtual space is highly temporal: 'real' space is also temporal but to a lesser degree.

3. In terms of size, in 1992 the *Guinness Book of Records* listed WEM as the world's largest shopping mall, more than double the size of its nearest rival. WEM also held three other records in 1991: the world's largest indoor amusement park, the world's largest indoor water park and the world's largest parking lot. Despite all of this, the Bloomington 'Mall of America' in Minnesota surpassed WEM in size in 1994. In terms of content, the exact mix of shops in WEM has been listed with many variations in a number of sources. Any discrepancies between these sources relate to the constantly changing mix of shops and attractions present in WEM. The major sources for all of the information on WEM used in this chapter are Maitland (1990), Jackson and Johnson (1991) and Crawford (1992).

References

Benedikt, M. (1991) 'Cyberspace: some proposals', in Michael Benedikt (ed.), *Cyberspace: First Steps*, Cambridge, MA: MIT Press, pp. 119–224.

Baudrillard, J. (1987) *Simulations* (trans. Paul Foss, Paul Patton and Philip Beitchman), New York: Semiotext(e).

Boyer, M. C. (1994) *The City of Collective Memory: Its Historical Imagery and Architectural Enhancements*, Cambridge, MA: MIT Press.

Boyer, M. C. (1996) *Cybercities: Visual Perception in the Age of Electronic Communication*, New York: Princeton Architectural.

Chapman, G. (1994) 'Taming the computer', in Mark Dery (ed.), *Flame Wars: The Discourse of Cyberculture. South Atlantic Quarterly*, Special Issue, 92 (4): 297–319.

Chesterman, J. and Lipman, A. (1988) *The Electronic Pirates*, London: Routledge.

Crawford, M. (1992) 'The world in a shopping mall', in Michael Sorkin (ed.), *Variations on a Theme Park: The New American City and the End of Public Space*, New York: Noonday, pp. 3–30.

Didion, J. (1979) *The White Notebook*, New York: Simon and Schuster.

Frieden, B. J. and Sagalyn, L. B. (1991) *Downtown Inc.: How America Rebuilds Cities*, Cambridge, MA: MIT Press.

Gibson, W. (1986) *Neuromancer*, London: Grafton.

Grosz, E. (1992) 'Bodies-cities', in Beatriz Colomina, (ed.), *Sexuality and Space*, New York: Princeton Architectural Press, pp. 241–53.

Hafner, K. and Markoff, J. (1991) *Cyberpunk, Outlaws and Hackers on the Computer Frontier*, New York: Simon and Schuster.

Harvey, D. (1990) *The Condition of Postmodernity*, Oxford: Basil Blackwell.

Hennessey, P., Mitsogianni, V. and Morgan, P. (1992) 'Interview with Michael Sorkin', *Transition*, 39: 19–27.

Henry, G. M. (1986) 'Welcome to the pleasure dome', *Time*, October 27: 60.

Jackson, E. L. and Johnson, D. B. (1991) 'Feature issue, the West Edmonton Mall and megamalls', *The Canadian Geographer*, 35: 3.

Krewani, A. and Thomson, C. W. (1992) 'Virtual realities', *Diadalos*, 41: 118–35.

Krueger, M. R. (1991) *Artificial Reality II*, New York: Addison-Wesley.

Lénárd, I., Oosterhuis, K. and Rubbens, M. (1996) *Sculpture City: The Electronic Fusion of Art and Architecture*, Rotterdam: 010.

Maitland, B. (1990) *The New Architecture of the Retail Mall*, London: Architecture Design and Technology.

Mitchell, W. J. (1995) *City of Bits*, Cambridge, MA: MIT Press.

Morningstar, C. and Farmer, F. R. (1991) 'The lessons of Lucasfilm's Habitat', in Michael Benedikt (ed.), *Cyberspace: First Steps*, Cambridge, MA: MIT Press, pp. 273–301.

Mumford, L. (1991) *The City in History: Its Origins, Transformations and its Prospects*, London: Penguin.

Nixon, M. (1996) 'De recombinant architectura', *21·C*, 1: 40–5.

Novak, M. (1991) 'Liquid architectures in cyberspace', in Michael Benedikt (ed.), *Cyberspace: First Steps*, Cambridge, MA: MIT Press, pp. 255–71.

Ostwald, M. J. (1993) 'Virtual urban space: field theory (allegorical textuality) and the search for a new spatial typology', *Transition*, 43: 4–24.

—— (1996a) 'Virtual urban futures: the (post) twentieth century city as cybernetic circus', in Wong Chong Thai and Güsüm Nalbanoglu (eds), *Architecture, Post Modernity and Difference*, Singapore: National University of Singapore, pp. 111–32.

—— (1996b) 'Understanding cyberspace: learning from Luna Park', *Architecture Australia*, 85 (2): 84–7.

Rheingold, H. (1991) *Virtual Reality*, London: Secker and Warburg.

Sobchack, V. (1991) *Screening Space: The American Science Fiction Film*, New York: Ungar.

Sorkin, M. (1992) 'See you in Disneyland', in Michael Sorkin (ed.), *Variations on a Theme Park: The New American City and the End of Public Space*, New York: Noonday, pp. 205–32.

Sterling, B. (1992) *The Hacker Crackdown*, New York: Bantam.

Stone, A. R. (1991) 'Will the real body please stand up? Boundary stories about virtual cultures', in Michael Benedikt (ed.), *Cyberspace: First Steps*, Cambridge, MA: MIT Press, pp. 81–118.

—— (1995) *The War of Desire and Technology at the Close of the Mechanical Age*, Cambridge, MA: MIT Press.

Stone, A. R., Ostwald, M. J. and Duget, A.-M. (1995) *Technology and the Second Hand Experience: Cyberspace Forum for the Sydney Biennale*, Sydney: Powerhouse Museum (25 July 1995).

Sudjic, D. (1993) *The 100 Mile City*, London: Flamingo.

Virilio, P. (1986) 'The overexposed city', in Jonathan Crary, Michel Feher, Hal Foster and Sanford Kwinter (eds), *Zone 1/2*, New York: Zone, pp. 14–38.

—— (1991) *The Lost Dimension* (trans. D. Moshenberg). New York: Semiotext(e).

von Meiss, P. (1992) *Elements of Architecture: From Form to Place*, New York: Van Nostrand Reinhold.

ANANDA MITRA

VIRTUAL COMMONALITY
Looking for India on the Internet

THE NOTION OF COMMUNITY HAS become a central construct in
thinking about the way in which humans organize their lives. In the electronic age,
particularly in the age of the Internet, this organization of human activities has become
more complex with the availability of fast, efficient and powerful means of communi-
cation that can have a significant impact on the way we organize the communities we
live in and interact with. Moreover, that effect need not be restricted to specific
geographic spaces but can be widespread as the tentacles of computer-mediated com-
munication (CMC) reach across the globe. It is thus 'important to reconceptualize
the 'community' as a construct that helps us understand the organization of human
activities.

To a certain degree a general and abstract concept of communities can be found in
the work of Benedict Anderson (1983), who suggested that communities and nations
could be imagined around shared cultural practices. This made it possible to think of
them in a structural way, going beyond a historical and geographic characterization.[1]
The 'imagined community' argument proposed by Anderson rested on the premise that
shared practices provided a focus around which communities could be imagined. The
notion of 'imagination' and 'imaging' were closely tied to each other in this construc-
tion. In this chapter, the terms 'imaging' and 'imagination' are used precisely in this
manner — to indicate the ways in which a community, albeit electronic, can textually
produce itself, thus imagine itself — as well as present itself to the outside world, and
thus produce an image. Within this framework, the development of language, and later
the printed word, offered the centres around which communities and nations could be
imaged, providing the foundation to think of communities and nations built around
residual and emergent cultural formations and practices.[2]

In a more traditional sense, however, the notion of community has been tied to
physical proximity. In a critique of the discussions of virtual communities, one commen-
tator said,

A community is more than a bunch of people distributed in all 24 time zones, sitting in their dens and pounding away on keyboards about the latest news in *alt.music.indigo-girls*. That's not a community; it's a fan club. Newsgroups, mailing lists, chat rooms – call them what you will – the Internet's virtual communities are not communities in almost any sense of the word. A community is people who have greater things in common than a fascination with a narrowly defined topic.

(Snyder 1996: 92)

It is such critiques that make the question of the Internet community so troublesome. While Anderson could have argued for the Internet to be a forum for the production of community, many others would be hard-pressed to agree, since by the very nature of the technology, the use of a computer monitor and a keyboard, participation through the Internet becomes an individualized activity where the 'human touch' is often lacking. Indeed it can be argued that such humanization would detract from the notion of community because it is antithetical to the way we have been naturalized to think of communities. These arguments are central to technophobes who have argued that technology is dehumanizing and consequently the application of technology would transform the culture and everyday life of people (see, for example, the arguments of Neil Postman 1993). However, it is also true that every technological invention and adaptation, from fire to the Internet, has transformed the way in which humans relate to each other and form communities. Consequently, it is relatively difficult (and perhaps fruitless) to arrive at a definitive description of community because that itself is a provisional construct changing in meaning as new technologies of communication evolve. This chapter is an attempt to rethink the notion of community in the face of the use of the Internet. What remains constant, however, is the notion that communities require interaction and involve people.

With the emergence of media technologies, nations and communities could be imagined around other central popular cultural formations, for instance those of broadcast media and film. Often nations are produced and represented by media and there emerge specific media formations which can be called 'national media' because they represent the principal cultural practices of the nation (see, for example, Elsaesser 1989; Hay 1987; Turner 1988). It can thus be argued that particular communities and nations are symbolically and representationally produced around specific popular cultural practices like those of language and media.

With the growth of CMC, particularly from use of the Internet, a new set of possibilities for community and nation formation have emerged. Unlike the distributed system of mass communication, with a central agency producing the media messages, the computer system could be used as a more 'democratic' apparatus where access is broadly distributed and brings with it the option of interaction, offering new possibilities of community formation. For instance, Jones (1995) and Baym (1995) have argued that the new CMC technologies have produced the opportunity and the possibility for the creation of electronic communities where a set of shared practices help to produce the conditions that are similar to traditional communities outside of the realm of computers and virtual spaces defined by the 'bit'-based technology of computers (see, for example, the work of Negroponte 1995).

To think of community in the electronic age, the construct of commonality becomes central because the technology has now provided the ability to communicate across the

boundaries and limitations that the traditional community imposed. Carey has (1989) pointed out a fundamental perspective that addresses the issue: 'Communication under a ritual view is the sacred ceremony that draws persons together in fellowship and commonality' (7). It is precisely this question of commonality and fellowship that becomes the critical issue in the context of this analysis. Indeed, what produces community in the era of the Internet are the shared systems of culture, language and beliefs that are spread across large distances and consequently the opportunities for community formation *vis-à-vis* the Internet have broadened in scope and possibilities.

This broadening of the horizons has happened in the last couple of decades, which have seen significant steps in the development of CMC in the production of interpersonal and group relationships; this period has also witnessed the emergence of new social blocs whose communal, tribal and national roots have been disrupted by voluntary and involuntary migration and immigration, with the consequent production of atomized individuals who find themselves spatially removed from the people with whom they have been historically affiliated. The movement of people across geographic borders and the emergence of diasporic immigrant communities across the globe, particularly in Western Europe and America, have now produced a large group of people whose places of origin are far removed from their current location. Instances of such groups abound as Census in America reports the increasing presence of immigrants and permanent residents.[3] These are people who are also playing a pivotal role in the culture, politics and economics of the West. Along with this development has come increasing tension about the presence of such immigrants, as evidenced in the enactment of laws that curb the freedom of immigrants, exemplified in the 1994 passage of Proposition 187b in California, which denies access to public service for specific classes of immigrants.

Immigrants are usually not geographically close to each other (barring the instances of 'Korea-towns', 'little-Indias', and other groupings of sociologically and ethnically similar people in large urban areas of the West). Unlike the earlier immigrants who set up home in the boroughs of New York and neighbourhoods of Chicago, producing Italian, Polish and other ethnic enclaves in metropolitan areas, with a shared language and often shared common work-areas, the new immigrants, particularly the well-educated, professional Asian immigrants, do not share the same geographic spaces. They are often scattered across the Western hemisphere, working in similar professions but spatially distanced from each other. This has produced an increasing need for alternative means of community formation, and I believe that one of the many ways in which such groups are being formed is with the use of electronic communication systems.[4] This is more and more evident in the growth of electronic 'newsgroups' which are earmarked for specific nationalities and communities within nations. I will elaborate later, but suffice it to say these diasporic people, geographically displaced and distributed across large areas, are gaining access to CMC technologies and are increasingly using these technologies to re-create a sense of virtual community through a rediscovery of their commonality. Through this process, new images of community and nation are emerging by the discursive activity of creating and exchanging messages on electronic bulletin boards.[5]

The conditions of existence of the diasporic individuals and their need to form community cannot be understood in traditional terms where spatial proximity was a necessity. It is only when one can move the discussion of community to the more abstract level of shared practices and experiences such as those of language and media that it is

possible to begin to understand how a shared system of communication such as CMC, with its shared language and systems of meaning, can be used to produce communities that do not need geographic closeness. This is precisely why the construct of the 'imagined' community becomes powerful in thinking of the communities being formed in the electronic forum. The electronic communities produced by the diasporic people are indeed imagined connections that are articulated over the medium of the Internet, where the only tangible connection with the community is through the computer, a tool to image and imagine the group affiliation.

The Internet communities and nations

The collective thinking that is possible on the Internet happens in a virtual space that is accessible to anyone with a computer, a modem and an 'account' on a computer system that is networked. There are minimal technological barriers to using this entire unlimited virtual space to send a message. However, the user-audiences of this space have attempted to contain the potential anarchy of unlimited postings by artificially subdividing the space into many spaces which, in the Internet vocabulary, are called 'subgroups'.

For the purpose of this analysis I focus on the subdivisions within the '*soc.culture*' Usenet group. There are numerous subgroups within the hierarchy of *soc.culture*. These represent nations, communities, tribes, cultures and ways of life from Afghanistan to Zimbabwe. The nationality of a subgroup is indicated by a third element to the name. There are thus groups such as *soc.culture.indian*, *soc.culture.korean*, etc. For the purpose of this analysis, the Indian subgroups are selected for critical review. However, the analysis considers other subgroups that also play a role in producing the national image. Currently there are a large number of subgroups across which cross-posting occurs to produce images of India and the subcontinent. These are subcategories of the general Indian subgroups, but this analysis will also make reference to other groups, particularly *soc.culture.bengali*, *soc.culture.pakistani* and *soc.culture.bangladesh*, since the image is the product of discourses that occur across all these groups.

Looking for India on the Internet

For the purpose of this study a listing of all the postings on 25 March 1995 was obtained from the *soc.culture.indian* (*sci*) group. A total of 1,287 postings were identified. Subsequently the newsgroups were observed on a random basis to explore emergent issues that appear in the virtual space. The identification of the large number of postings on a specific day works as a 'freeze frame' of the thousands of postings that appear on the bulletin board and disappear as they are read and responded to, while the regular visits represent the way in which the community grows or deals with the issues that are important to their members. These postings represented members of the community who are actively participating in producing discourse by reading and responding to the texts that appear on the Internet space. However, there is a larger group of users who are only reading the posts and not necessarily adding to them, but are nevertheless an audience for the discussions continuing on the network (these people are often called

'lurkers'). The period covered in the analysis includes the postings that appeared in the weeks preceding 25 March 1995.

As a starting point it is possible to explore the nomenclature of the postings to put a framework around the specific text being observed. The changing nature of the community and the images that are produced can be illustrated by the way in which the postings are named. Each message contains author information and a subject line that summarizes the theme of the posting. Based on these it is possible to identify how the discussions proceed through a discursive process in which authors interact with each other, contributing opinions about issues, and collectively producing a portrait of the virtual community. The subject line helps to identify the themes of the discussions and, based on these, it is possible to classify the messages into a set of categories. It is important, too, to note a characteristic of the Internet called 'cross-posting', which is an increasingly popular practice of newsgroup posters, and to note that when reading the postings, it is possible to instruct the newsreader software to sort these according to specific themes based on the subject of the post.

In the context of building national and tribal communities the issue of 'cross-posting' takes on a particularly important role. Given the open nature of the medium it is possible for a user to post a message to multiple bulletin boards or parts of the Internet at the same time. It is thus possible to send a message to appear in the Indian newsgroup as well as the Hawaii group, the Pakistani group, and the group representing Bangladesh.

Cross-posting is particularly important in the current context since this is partly how the national image is produced. When postings are restricted to a particular group, there is little opportunity of exposure to members from other communities. Given the organization of the Internet space, and the conventions that have evolved over time, there is little evidence to suggest that members who are regular readers of *soc.culture.indian* spend much time in reading *soc.culture.hawaii* (see, for example, McLaughlin, Osborne, and Smith 1995). The space is almost always organized like ethnic neighbourhoods in large metropolitan areas where outsiders often are unwelcome and feel uncomfortable. However, since the organization of the seamless space of the Internet is artificial and virtual, the process of cross-posting makes it much easier to violate the conventions of 'neighbourhoods', and users can, with great ease, cross into areas where they simply do not belong. While in traditional spatially organized community there were places that were physically 'off-limits' (for instance, consider the effects of racial segregation), in the electronic community there are no technological barriers to posting a note to any newsgroup one desires. There are no 'Internet police' who determine who can go where and what can be said where. Indeed this is a limitless space where the poster has free access to all the different communities and often uses that power. Moreover, it is this power that makes it important to begin to understand how individuals can produce images of people and places through the use of the Internet. Thus the image of India produced solely within the Indian newsgroup would be of little consequence since that image is available only to the predominantly Indian users who would inhabit that particular space. But, when the postings are distributed across a large number of groups, the image is produced across a much larger audience. Cross-posting takes on particular significance in the Indian subgroups because of the divisive forces in the subcontinent and the way in which multiple subgroups have appeared representing secessionist tendencies and remaining in constant conflict with each other with rampant cross-posting.

Analysing the postings, a set of categories of messages can be identified. The first and most common category can be called the *general postings*, which are primarily informational. A majority of these are 'introduction' or 'looking for' messages in which a user announces his or her presence on the network, or uses the network to try to find someone who they expect is also a member of the community. Although these messages do not address specific issues, they affirm the communal assumptions that implicate the way in which *sci* has evolved. There is a presupposition that most members of the Indian community would access the network and would chance upon these general messages and thus re-establish contacts with people they might have known before. This signifies that the community produced by, and around, *sci* is a representation of the allegiances that existed before the diasporic experience occurred. For instance, when one encounters a message that refers back to a college in India there is an effort to find, in the virtual community, familiar relationships that have been severed by the process of geographic movement but can now be re-established in the virtual space of the Internet. This particular use of the network is a common practice across a large number of groups. Baym (1995) points to this in calling it the 'external contexts' that influence the way in which CMC proceeds. These are the past identities that are brought to the network which help the users find their network identity by seeking the congruences that existed prior to entry into the virtual space. However, the identity that emerges on the network is a synthesis of the prior affiliations and allegiances and the new one that is found in the new space. This synthesis actually runs against the grain of many of the 'impersonal' arguments about CMC that have been proposed (for example, the work of Baron 1984; Kiesler, Siegel and McGuire 1984; Rice 1984; Sproul and Kiesler 1991; Walther and Burgoon 1992). What these postings indicate is that there is a strong tendency among the subcontinental users to try to find 'similar' people who share the histories and practices that produce the communal identity of the users as they exist outside of the network.

Such postings also become an indicator of the community of people who are active and passive users of the network. A majority of these users are in the US, with a handful in Western Europe and still fewer in India. These are people who have chosen or been forced to move to a new geographic space where they are attempting to negotiate their dual identity as an immigrant and as a member of a place of origin, an amalgam which now becomes discursively produced in their postings. These users enter into an exchange of ideas and opinions which collectively represent their new identities in the West while also producing their own images of the West and India.

These images are produced within a second thematic area that can be called *national critical discourse*. These are postings that address the issue of religion, and the tensions around the practices of religion that produce the contemporary national identity of India and its relation with other nations of the world. Postings with subject headings such as 'BURN KORAN IF BOY DIES' and 'STOP BASHING OUR PRIESTS' attempt to produce an image of India rooted in a rediscovered allegiance to the Hindu religion. The theme is developed through a process of exchange. The themes also mutate as new postings appear, so what could start as a discussion about religion could easily transform into a discussion about politics, culture and language. For instance, the following exchange responded to recent regional polls and the victory of a self-professed Hindu party in a Western state of India (Maharashtra):

On 25 March 1995 'kulbir' wrote:
The new premier of Maharashtra, a Western Hindustani province belongs to
Shiv Sena whose head is Mr. Bal Thakre. Mr. Thakre is a controversial charis-
matic right wing leader of Hindus. He is on record saying that if he becomes
the PM of Hindustan he will give Muslims 48 hours to leave India.
To this, 'Dr Jai Maharaj' responded on 26 March 1995 with the following:
Is it possible for you to substantiate your claim above with a reference to a
published source?
On the same day 'Rohan Oberoi' quoted both the above posters and wrote:
I can give reference for this one. The interview was published in TIME,
January 25, 1993. Asked 'But Muslims are beginning to flee Bombay,' Thakre
replied 'If they are going, let them go. If they are not going, kick them out.'
Told that 'Muslims are beginning to feel like Jews in Nazi Germany,' he
replied, 'Have they behaved like the Jews in Nazi Germany? If so, there is
nothing wrong if they are treated as Jews were in Nazi Germany.'
This is from memory, so I may have the wording wrong here and there, but
you're welcome to look up the interview.

This exchange illustrates several aspects of the way in which opinions are developed and
disseminated on *sci* as claims are made, refuted and substantiated by members of the
network. Interestingly, the initial claim made by 'kulbir' is later substantiated not by
the same person but by a different member of the community who offers the citation
from the popular news magazine. In addition, the entire exchange produces a polariza-
tion in the community as there are clearly two schools of thought concerning this
politician and consequently the way in which India can be imagined on the network.
Moreover, all three of the posters are outside of India and are using the *sci* space not
for any specific political activism but only as a forum where conflicting opinions can be
aired, and through such discourse a national image can be produced. This exchange
also highlights the textuality of the Internet, its constantly shifting foci of discussions,
and the empowerment of the user-audiences, all of which are the unique characteristics
of the network.

Other subject headings also produce similar polarizations and national images. While
the above exchange was going on, members of the *sci* group were also participating in
discussions of another topic area of critical national importance. Given the early 1995
victory of the party led by the politician referred to above, the other theme also dealt
with the issue of religion, culture and politics. The connection between themes, world-
views and authors become apparent in the following exchange between 'Jai Maharaj'
and a set of other participants. The theme of this exchange is the debate that has erupted
in India over the renaming of the commercial centre of Bombay (the capital city of the
state of Maharashtra) to its pre-British name of Mumbai. The following exchange lays
out the connections that are being drawn between this event and other themes that are
popular on *sci*:

On 25 March, 1995 'Krishanan' posted the following:
I realize that the Shiv Sena is changing the name because it the name BOMBAY
was christened by foreigners. But the implications are too expensive. All the
airlines have to change the name from Bombay to Mumbai. . . . And all of
this for what, it is not going to benefit anybody for changing the name, bcoz

[*sic*] the British do not feel slighted by this act, except it might just elicit a few laughs at this jingoistic and brash act.

In response 'Dr. Jai Maharaj' wrote:

Send the bill to London. Also, enclose a demand for the return of the Koh-i-noor diamond, all other stolen riches, and just compensation to all victims and their descendants for the British atrocities on the people of Bharat and south Asia.

The piece is signed off with the Hindu greeting 'Om Shanti', which translates to 'Hail Peace'.

This exchange demonstrates the way in which particular posters align themselves with specific images of India. Marahaj claims that India is better called 'Bharat', the ancient Hindu name for the geographic space, while the other poster offers a more pragmatic analysis of the consequences of the change of name.

Connected with this polarization is the way in which the Indian national image is juxtaposed with its relationship to Pakistan. Given the strong Hindu-centric tendencies seen in the newsgroup, and the cross-posting that continues constantly, exchanges such as the following become commonplace and reproduce the antagonism between the nations:

On 3 April 1995 a member of the Pakastani newsgroups responded with the following to an earlier cross-post:

You damned Sikhs/Hindus you are right, you do not level up to Pakistanis. So do not bother comparing your lowly selves to us. We will f*** the Hindus in Kashmir and use the Sikh bastereds [*sic*] in Punjab to f*** the Hindus even more.

Get out of *soc.culture.pakistan* you Indian trash and by the way do not threaten us with violence we are fully aware of our physical superiority. Most of which is evident in our Cricket, Squash, and Hockey players who represent the best in the world.

So F*** Sikhs and F*** Hindus and most of all F*** India

To this a member of the Indian newsgroup responded as follows:

and I suppose you were going to use Cricket bats and Hockey sticks to defend Lahore when Indian army was about to reach their [*sic*] during the last war!: -) Try Hans Raj Mahajan hockey stick, they are excellent!:)

This exchange illustrates the animosity that exists between the members, as demonstrated in the intensity of the first post and the ridicule employed in response. Such exchanges have become commonplace on this shared space, where the arguments begin to lose any rational basis and the debate is often reduced to a series of harangues and name-calling that express deep antagonisms. More important, such exchanges often cross the national newsgroup boundaries and enter into areas that have little involvement with the issues, leading to even more textually violent reactions and the exposure of deeply felt images and beliefs about the subcontinent. The following post on *sci* on 5 April 1995 from an anonymous member of a nonsub-continental newsgroup helps to illustrate the point and expose the consequences of rampant cross-posting:

YOU ARE ALL THE SAME SHIT. AS FAR AS I AM CONCERNED, YOU ALL PEOPLE (SUBCONTINENT) ARE FILTHY AND 'SEWAGE RATES'

> [sic] WHY DO WE CARE YOUR F***ING CENTURIES OLD ANIMOSITY
> BETWEEN YOU? PAKISTANIS, INDIANS, SIKHS ARE ALL THE SAME.
> STOP CROSS_POSTING AND KEEP YOU [sic] BIGOTRY INTO [sic]
> YOURSELVES. MR. HOT SHOT, YOU AIN'T SHIT BUT A PIECE OF
> SCUM YOURSELF. CLEAN YOURSELF OUT BEFORE BAD-MOUTHING
> SOME [sic] ELSE. HAVE YOU EVER HEAR [sic] 'CHARITY STARTS AT
> HOME'? TAKE CARE OF YOURSELF FIRST..BITCH!!! AND TELL YOUR
> PAKISTANIS [sic] BROTHERS TO STOP CROSS-POSTING OUR NEWS
> [sic] GROUPS. WE'RE SICK OF YOU MOTHERF***.

The expletives expose not only the possible consequences of cross-posting but also the image that is circulating in the network about India, Pakistan and other parts of the subcontinent. The intensity of the feeling is further amplified by the use of all-caps in the post, which is the equivalent of shouting over the Internet. Needless to say, this also exposes the ease with which opinionated bigots are able to utilize the resources of the Internet to produce and circulate weak arguments based on crude rhetoric.

Yet another theme that recurs in these discussions is the way in which the image of India and the identity as Indians in the West is constantly negotiated by entering into dialogues about the role that India and Indians play in the culture, society and politics of the West – particularly in America. These exchanges work to bring the community together just when the discussions about India tend to split the group apart. These also become indicators of the way in which the new immigrant identity is being negotiated in the Internet space. Among the messages collected for this study, several different topic areas addressed the issue of identity in the West, including discussions about the merit of the Indian movie-maker Satyajit Ray over the Japanese film-maker Kurosawa. Among the various discussions on this topic an anonymous poster wrote on 5 April 1995:

> I think the Americans are more interested in Japanese culture for purely
> political, financial and historical reasons. Being popular in America does not
> mean much though in terms of one's artistic talents.

This short statement becomes a commentary on the way the diasporic people see their position in the West, particularly in terms of other nations which have contributed to the immigrant groups in America. If Kurosawa can be considered a Japanese icon, then Ray is certainly an Indian one, and the American preference of one icon over another, and the discussion of that on the Internet space, becomes a reaffirmation of the identity crisis that the Indians negotiate in their everyday life in the new land. This is further illustrated in other discussions that were going on at the same time, such as the one titled 'Why no Oscars award for Indian movies'. In some instances the precarious nature of one's immigrant identity and status also becomes the focus of discussion, as demonstrated in themes that dealt with the proposition in California to deny public services to illegal immigrants, the portrayal of an Indian rapist in the popular television show *NYPD Blue*, and the discussions about the way in which Christian channels on television talk about the 'pagan' Hindu religion. All of these discussions attempt to negotiate the diasporic identity and often hold the community together while the discussions about India tend to split the community.

The debate is made more powerful by the constant cross-posting that attempts to tease out the most flammable remarks from members of other groups who would be

particularly offended by a posting. This is a deliberate process of inciting conflict on the Internet where the members of specific groups often want the other community members to react to their postings in order to create a lively and often heated discourse. Yet, it is this discourse that produces images and often points out the representations that are available on the Internet. As illustrated in the earlier posting, the way in which a series of posts appeared in several different newsgroups led to responses and comments that ultimately produced a particular image of the subcontinent.

This image has several components. First, the nation appears to be divisive and ridden with internal contradictions that concern questions of religion, gender and political affiliation. The sentiments run strong where members of the network want to produce a specific religion-centric image of India around the trappings of an ancient Hindu base, while others would argue that such a fundamentalist approach towards nation-building is flawed and unproductive. Connected with the Hindu base are associated concerns about the role of women in Indian society, where, too, there is continuing debate over the appropriate 'place' for women in India and their specific insertion in the social fabric.

Also connected with this religious and nationalistic image is the strong antagonism that is expressed towards Pakistan and Bangladesh. Indeed, it would appear that many members of the group would just as well 'nuke' Pakistan and remove it from the face of the earth. When such messages are cross-posted in the Pakistani newsgroups there is certainly a groundswell of reactions and the virtual conflict becomes even more pronounced. This image of the struggle is manifest in a variety of contexts that deal with the issues in Kashmir, terrorism in Punjab, the general Hindu revival, and anti-Islamic feelings in India.

Connected with this image is a picture of internal dissent that is not only manifest in the debates about politics in India but is also represented in the number of subgroups that have emerged out of the *sci* parent group. The fact that there are separate groups for Tamils, Bengalis and Punjabis becomes a representation of the irreconcilable differences that exist between the 'tribes' within India. The notion of a 'tribe' on the Internet has been suggested by Rheingold (1993), who considers the various parts of the WELL as tribes, while as a post-national formation the concept of the ethnic tribes has been suggested by Appadurai (1993), who argues that there is an increasing emergence of the trope of the tribe as media, such as the Internet, are being mobilized by the diasporic communities to rediscover their fundamental affiliations and allegiances. It is this tendency that is represented on the Net as well, but now a large number of people can obtain this image by following the discourses on the Net.

Finally, the network image of India is produced by the discourses of a limited set of people who have taken the initiative to wield their electronic strength, and it is these voices that are heard over and over again as they attempt to establish a particular dominant image of India. There has been a certain degree of debate about the identity of these users as well. As illustrated in the earlier examples, in the period considered here, perhaps one of the most vocal members of *sci* has been the character called 'Dr Jai Maharaj'. This user had been cross-posting in a variety of newsgroups and maintains a strong Hindu/Indian stance that supports the creation of a Hindu state and the resurrection of 'Bharat', an historical name associated with a re-imaging of the subcontinent around its Hindu orientation. His posts have also included arguments about the need for vegetarianism and the connection between vegetarianism and Hinduism. He became known

primarily because of his rampant cross-posting, which angered members of newsgroups who felt that their spaces were being violated by a person with whom they felt no need to communicate. This process has led to a large degree of animosity towards the poster and a consequent curiosity about his or her origins.[6] The name would suggest an Indian of Hindu origin but that itself is debatable, as the following exchanges would show:

> In response to the question: 'Who is Jai Maharaj?' a user wrote the following on 20 March 1995:
>
> You have asked the $64,000 question. I have watched and sometimes posted in ACH [alt.culture.hawaii] for about 2 months. Jai has never responded to any questions regarding his background. The closest information comes from the ACH Lynch Mob. From what I can gather the Lynch Mob was a bunch of people who were becoming iirateat [sic] Jai's constant cross posting of articles into unrelated newsgroups [spamming]. When these people became vocal, he called them a Lynch Mob.
>
> Well maybe you will succeed where many have failed in answering the question 'What is Jai Maharaj?'
>
> 'Good Luck'
>
> Ken

This note shows how one user can generate confusion and interest and create specific images of the people he represents. This is the way in which images on the Internet begin to form and emerge. Needless to say, with time, *sci* users recognized that the poster was unreliable and often abusive. However, an outsider entering *sci* and encountering the postings of Maharaj might perceive a specific image of India.

Based on these postings it is possible to claim that the image of India that emerges on the Internet through the various postings and cross-postings arises from issues that are predominantly negative and produce a particularly dismal picture of divisions and differences, ones that are now being translated to the virtual space of international electronic networks. Needless to say, some of the discourse can be ignored as trivial drivel between people who are engaging in unproductive and abusive arguments. Yet, it is through this discourse that the diasporic community is reimagining itself as well as presenting an outside 'face'. Clearly these examples, and continuing responses to cross-posting, show that the Indian 'face' that is being presented is being despised by many of the users of the Net. Yet the ones who are disgusted with the divisionary image of India are not necessarily the ones who can offer an alternative voice of unity or sobriety. The only argument has appeared in the form of further inflammatory remarks, as illustrated earlier where the members of other forums are being equally bigoted in 'screaming' out at the Indians and asking them to keep their troubles to themselves without 'polluting' various newsgroups. This is a matter of concern because this can ultimately hurt the way the Indian communities in the West want to create a collective memory of themselves in the space of the Internet.

Significance of the image

Groups such as *sci* emerge as electronic communities where many of the traditional aspects of community are reproduced in a textual format. Thus when a user posts about

his or her college affiliation and attempts to find an old acquaintance on the Internet the fundamental communal assumptions of a common fraternity are mobilized. Moreover, when such a poster gets a response from a member of the group new connections and networks are produced. The national newsgroups become particularly important in this respect since the electronic community is produced in the same way that Anderson's imagined community becomes a nation. The 'imagination' that binds the members of the electronic group is the common memory of the same putative place of origin from which most of the posters came. The sense of community is based on an original home where everyone belonged, as well as a sense of a new space where the question of belonging is always problematized. Since the original home is now inaccessible, the Internet space is co-opted to find the same companionship that was available in that original place of residence.

However, if the postings were restricted to the space of *sci* alone some of this purpose would be lost. The electronic system offers the opportunity to cast a large 'Net' and this is done through the process of cross-posting. Yet it is this mechanism that also allows for the construction of an electronic national image that is available widely and easily. Consequently, irresponsible postings, and postings that are often sent to incite attack, not only fuel debate but also lead to the production of the national image. Here the metonymy between the organization of the Internet space and the way ethnicity is spatially organized becomes remarkable. The fact that the diasporic Indians now occupy a new space – in America and Western Europe – demands the production of a specific 'face'. This is the product of a variety of everyday practices from the performance of religious rituals to the Independence Day parades in New York. Increasingly, as the Internet becomes a part of these practices, the way in which posters send messages to the common and shared spaces of the Internet will determine what 'electronic face' that community produces for themselves and for their country of origin.

The reorganization of space and the dissolution of boundaries is one of the more important elements of the virtual communality that the newsgroup produces. With the increasing immigration and emigration of people, who once shared a sense of traditional community with spatial commonality in colleges, workplaces and towns and cities in India, the rediscovery of the commonality on the seamless and virtual space of the Internet becomes an important aspect. Indeed the lack of the 'human touch' that has been argued to be one of the drawbacks of the electronic community is restored through the Internet for the immigrants whose spatial orientation has been disrupted. As a matter of fact, for this virtual community, the electronic space is the only common space that they can occupy. Consequently, the traffic of communication on the newsgroup (as in other national newsgroups) is often far larger than in other groups, which often operate as fan clubs, as Snyder (1996) suggests. Thus negotiated here is the lost space of a nation, community or tribe which is being re-created and reinvented on the other Internet space. Therefore, for the immigrant newsgroups the question of space is critical and the loss of geographic proximity is the *raison d'être* for the mobilization of the Internet space.

Another unique feature is drawn from this particular face that is produced by an electronic community such as *sci*. Here the texts and discourses that make up the substance of the community become representations of a range of deep structural contradictions that become a defining characteristic of the country being imaged. The image of a country can be thought of in two ways. One is the public image that is produced by organized sources such as national media, international news flow, and

other mediated forums where a monolithic image is constructed for specific political and ideological purposes. On the other hand, there are the non-naturalized images that are shared by the people most involved with the consequences of the image. These are the immigrants who have to constantly negotiate their existence based on the public memory of the country they come from. The electronic medium now offers an opportunity to develop discourses that provide this internally contradictory democratically produced image that is open for debate and reimaging as new debates emerge on the Internet. This becomes particularly true for India and the *sci* group, which is constantly concerned with the contradictions that mark contemporary India. Consequently, the large range of discussions about the merits of Hinduism, the problems with Pakistan and the support or criticism of the newly emerging Hindu party in India all become manifestations and concretizations of the fundamental contradictions between the different social, cultural and political blocs that make up post-Independence India. This post-colonial national formation is the product of the people who make up the electronic community, and given the wide range of opinions and worldviews proposed on the Internet, the image of India that is produced on *sci* for its users is replete with the contradictions that are a mainstay of everyday life in the South Asian country. While the community here does not have any geographic connections with the national space, all the cultural, religious and political baggage carried by the members of the electronic community become evident in the discussions on the Internet space which provides a relatively 'safer' environment for the debates and arguments than the riot-torn streets of Bombay. The struggle that is commonplace in India now becomes a struggle over meaning in the space of the Internet, albeit in languages and styles that are often bigoted, suggestive of violence and sometimes low-level harangues.

Finally, no particularly new directions of thinking that would provide alternatives to the traditional structural contradictions are emerging on the Internet space. For instance, in the exchange cited earlier, Jai Maharaj wants the Bombay name-change proposition to be sent to London. This is yet another throwback to the colonial past and the continuing struggles over identity in a post-colonial era. In this manner, and through similar such exchanges, *sci* is becoming a site for the reproduction of the conventional struggles, issues and contradictions that have been a natural part of India for too long. All other mediated images of India have also reproduced the opposition between the Hindus and Muslims, the higher and lower castes and people of different languages as the primary defining characteristics of the country and the Internet space has to a large degree circulated the same image. This becomes a reconfirmation of the fact that the users of the Internet are indeed products of an ideological system where they have been subjected to accepting certain aspects of India as fundamental and 'natural' without having the ideological option of questioning or challenging their assumptions. Consequently, a user who once made an argument about the precariousness of the Indian Republic as a union of various states was quieted quickly as that position was found to be far too 'unnatural' and potentially disruptive.

This tendency toward segmentation is balanced only by the precariousness of the immigrant identity, in as much as most members of the community need to negotiate their existence in a society where they feel marginalized. This paradoxical phenomenon is evident in the postings that tend to bind the community together around a sense of national pride and a challenging of the mainstream Western way of depicting India. Consequently, when users question headline stories and the practices of the media

industry, not only does an image of their original country emerge but their user iden-
tity as immigrants is also being exposed and discussed. These discussions often serve as
the glue that holds the community together in the electronic space as the members
continue to discuss the issues that divide them around their differential images of India.

Conclusion

There are two forces at work that implicate the dynamics of the way a nation can be
imaged in Internet space. On the one hand there are the centralizing tendencies through
which members of the virtual community use the electronic space to develop a certain
fraternity around the place of origin and their identities in the New World. Because the
Internet space is divided as it is, any community can feel cohesive by the fact that they
are distinct from other electronic groups. Consequently the *sci* group members can feel
a sense of community in knowing that they all have a common place of origin in India,
and thus their legitimacy and claim to the *sci* group. Along with that legitimacy comes
the feeling of distinctiveness from other groups such as *soc.culture.pakistan* or any of
the various other national discussion groups on the Internet. While cross-posting is
common, it is recognized as an aberrant phenomenon, and the fact that it invites wrath
and flaming is a further underscoring of the fact that the members of the groups do
indeed feel a centralizing and 'parochial' force where the intrusions of cross-posting are
accepted but unloved.

On the other hand, there is a strong segmenting force that constantly tests the glue
that holds the community together – its place of origin. The centrifugal forces gener-
ated by the variety of discourses that image India always expose the differences between
the members of the community and can often lead to the disruption of the community.
This is most evident in the way in which the space is constantly carved up into smaller
slices as specific 'tribes' demand their own space and forum. Thus the creation of groups
which have an additional defining characteristic such as Indian-American, Indian-Bengali
and so forth. However, such segmentation does not undermine the fundamental central-
izing forces, because very often the users of these subgroups would also pay attention
to the 'parent' group (although there is no technical hierarchical organization of the
groups). This attention is manifest in reading the articles on *sci* and posting articles to
sci as well as the subgroup that they feel closer to. Ultimately what the centralizing and
the segmenting forces accomplish is the production of a large set of debates and discus-
sions that not only help to create the image of India but also question and reflect on
the segmentation that continues for the Indian network groups.

Such dialogue is possible because the space cannot be co-opted by any particular
point of view. The power and the uniqueness of the dynamics of the electronic commu-
nity lie precisely in the absence of restrictions and controls on anyone's voice. This is
indeed a forum where everyone who is able to access the space is also able to speak
within the space. Everyone has a 'voice' in this space. This has far-reaching conse-
quences, particularly in the way the space can be utilized to produce national images.
In other kinds of traditional public spaces, such as those created by broadcast media or
film, the question of empowerment becomes much more diffuse than in the case of the
Internet. The arguments of hegemony and the existence of a dominant ideology that
serves the needs of the leading social bloc become particularly generative in thinking of

the ways in which mediated national images are produced, because very often the central-
izing tendencies of media texts ignore the segmenting tendencies of an increasingly
diversified audience. For instance, it has been argued that television has played a focal
and centripetal role in the resurgence of Hindu fundamentalism in India (Mitra 1993),
but it becomes much more difficult to propose the same argument in the case of the
Internet since it is much more difficult to locate the dominant in the virtual space.

The Internet space is indeed a cacophony of voices, all of whom feel empowered,
and the traditional definition of dominance becomes nearly inapplicable to this commu-
nity. Gramsci's fundamental proposition that hegemony is produced by gaining consent
of the masses often provides the backbone for the arguments about media dominance
(see, for instance, the vast literature on media and critical/cultural studies). However,
using the same notion of hegemony, it becomes clear that the question of gaining consent
becomes unimportant in the electronic space because the traditional centres disappear
on the Internet. Here power of any nature, be it coercive or non-coercive, is only mani-
fest in the texts that are produced by its users.[7] This is a space where power is manifest
in discursive capital, and, given the varieties of ideological positions that find voice on
the electronic space, there is no single dominant ideology that can be identified.

This, too, is the primary strength of the Internet space, because it provides a forum
where there is no ideological closure, which accompanies most centralizing forces. As
evidenced in the case of the debate over the naming of Bombay, or the fate of the
Muslims in India, the debate never ends because no single argument appears to be
convincing and persuasive enough to attract consent from all members of the Net. And
this multiplicity of voices is only possible because of the way the Internet space is organ-
ized, with minor checks and balances, and with no tangible 'control' on how the space
is utilized.[8] While in some respects this could have negative outcomes, in the case of
imaging a nation this 'freedom' certainly provides for ongoing and necessary debate.
No grand narratives about India emerge on the Internet space. Unlike broadcast media,
no one is in 'control' of the space and the images of the nation that evolve are constantly
metamorphosing. The notion of permanence of image is subverted by the ongoing
discourses on the space and nationhood and nationalism become constantly contested
and discursively produced. Moreover, in most public discourse there is a need to find
closure because, as in movies, television and other forms of mass media, there is always
a point of view that is preferred and is more 'natural'. Given the fact that such mass
media are produced by groups with specific interests, there is some ideological work to
be done and the hegemonic tendency is to produce one particular closure over others.
As my work on Indian television (Mitra 1993) has demonstrated, the Indian state-owned
television system had a particular Hindu image that it was trying to portray through an
array of texts. In a similar fashion it is possible to identify a specific colonial/oriental/neo-
colonial image that has been produced in literary texts and movies of the West (see,
for example, Mitra 1996; Said 1993). However, these are organized sources and far
different in character from the discourses on the Internet, where the nature of the texts
does not require closure. Narrative analysis of literature, movie and television presup-
poses the notion of narrative closure, which is tied to, and implicated by, ideological
closure, but the ongoing heteroglossic discourse of the Internet neither requires nor
produces such closure because it is an ongoing process.

My approach to the Internet emphasizes the textuality of the system of messages
that are exchanged. These are texts produced by the users, who are constantly

accentuating the texts with their ideologies and worldviews. This calls for a theoretical foundation that sees the process of language as non-singular and non-monolithic. Bakhtin/Volosinov (1981/1973) provide this argument and also go on to suggest that language is indeed ideological. Consequently the way the image of the nation and the identity scripts are produced by these texts needs to be examined in terms of their ideological implications. While this analysis is a step in that direction, plenty of research still needs to be done with these texts to arrive at convincing images of nations that are obtained from them.

Foucault argues the same in saying that the 'social' is produced in the network of discourses and discursive practices, and the Internet messages become an example of the phenomenon where heteroglossic language constantly produces the Internet version of the social. However, Foucault becomes problematic in relation to the Internet, since it is difficult to make the connections between power and discourse that he would want to draw. Indeed, as exposed in this analysis, the very nature of the Internet precludes any discussion of power since there is no specific repressive power that sets boundaries, or productive power that produces any grand narrative or preferred discourse. The only form of control lies in the boundaries that are produced by the discourse and the members who produce the discourse. In Foucault's thinking these can be considered to be the only form of control of discourse, as in his words:

> There is a raefication [sic], this time, of the speaking subjects; none shall enter the order of discourse if he does not satisfy certain requirements or if he is not, from the outset, qualified to do so. To be more precise: not all regions of discourse are equally open and penetrable; some of them are largely forbidden (they are differentiated and differentiating), while others seem to be almost open to all winds and put at the disposal of every speaking subject, without prior restrictions.
>
> (Foucault 1989: 221)

This to a large degree captures the situation with the Internet, where the forces of inclusion constantly struggle with the forces which throw open the virtual discursive space to 'every speaking subject without prior restrictions', except in the form of creation of subspaces.

Yet because of the lack of restrictions and the particularly 'fluid' nature of the system there arise two additional concerns. First, the image of a nation that is produced is indeed transient and ephemeral. True to its postmodern form, the discourses constantly regress and no centre emerges that is constant and permanent. While permanence of an image is a strongly debated issue within postmodern scholarship, the Internet poses a new condition since every single posting changes the image to some degree and this change is a continuing process since the postings never stop. Even as this chapter is being written, and when ultimately it is read, the Indian image on the Internet will have changed somewhat. However, the emphasis is really on the 'somewhat', because just as political and cultural changes do not occur rapidly, the general image on the Internet does not change very quickly. What does alter rapidly is the nature of the discourse on which the image is based. New and fresh voices appear much more easily and expediently than in any other form of mediated communication. This, too, sets the system apart from other forms of communication. This uniqueness is certainly connected with the empowerment that the Internet provides, and the users can perhaps feel that

their single contribution, while not 'singular', is a significant part of the metamorphosing image.

The second issue connected with the process of metamorphosis is the problematization of the research of the Internet text. When approached from the perspective of content and theme, as in this case, it is customary in other forms of media research that an 'end' of the text is clearly defined (barring the case of soap operas, this is true for most television programme episodes and certainly true for cinema). This closure provides an anchor for the analysis. Additionally, a reading of the closure provides insights into the ideological, cultural and political arguments implicating a particular narrative. Moreover, the closure in the text provides a certain degree of finality to the analysis as well. Consequently, independent of the fact of how a text is analysed, it is expected that any particular analysis will provide a unique perspective on the text, while the text remains static and unchanging. In the case of Internet texts this fundamental assumption simply does not hold true. At best it is possible to identify a period in time and obtain a snap-shot of the image being produced and circulated. That conclusion is neither binding nor exhaustive since, ever-metamorphosing and ever-growing, the 'nature of the Internet beast' continues to change every minute (literally), undermining any claims of authenticity that researchers can have of their reading of the network discourse. Researchers need to be aware of this, and thus be cautious and prepared to accept the fact that the image is indeed transitional and is bound to change with time and the appearance of new community members. Consequently, in this space every textual utterance is open to challenge and questioning and ultimately no dominant, unquestioned national image emerges because the very nature of the Internet space does not allow for permanence of images.

Originally published in S. Jones (ed.) *Virtual Culture: Identity and Communication in Cybersociety*, London: Sage.
This essay has been edited for inclusion in the Reader.

Notes

1. The concept of the 'nation' has been contested from Deutsch and Foltz's (1966) notion of the nation as a geographic construction, to Gramsci's (1971) idea of the nation as civil society to Anderson's (1983) proposition of nations as imagined communities. More recently the issue of the nation has been debated by other authors, such as Appadurai (1993) and Buscombe (1993), who have argued for the erosion of the nation-state and the emergence of post-nations that do not have well-defined and naturalized boundaries.

2. Here the notion of residual and emergent is a reference to Raymond Williams' (1961) proposition that at any moment in time there are in all cultures elements that are reminiscent of the history of the culture while there also are elements that are emerging as new elements in the culture. This is important to the argument proposed in this chapter, because the key struggle discussed here is between the residual constructs of nation as geographical entities and the emergent proposition that nations can be constructed around emergent elements of culture – in this case electronic communication systems.

3. The 25 September 1995 issue of *US News and World Report* reports a steady growth, from a little over 4 per cent in 1970 to a little over 8 per cent in 1994, of foreign-born residents as a share of the US population.

4. Other forms of community formation include the emergence of ethnic media such as Chinese television channels, Indian newspapers and ethnic community centres and schools.

5. The issue of diaspora and the emergence of diasporic communities has now been discussed and debated from several perspectives. Some of the critical discussions and examples of community

formation by diasporic people have appeared in *Public Culture*. There have been discussions about the Cuban diaspora (Campa 1994), the production and implications of the Korean community in America (Palumbo-Liu 1994), and fundamental discussions of the new diasporic condition (Appadurai 1993). These discussions point out that immigrant and displaced communities are constantly struggling to produce new identities and are using different means to achieve this; I argue that the electronic communication systems offer such an opportunity.

6. This is perhaps one of the most powerful aspects of Internet communication: the identity of the poster can be successfully hidden from public scrutiny. It is often impossible to recognize gender, national origin and ethnicity if the poster chooses to use a well-hidden pseudo-name. To a large degree Dr Maharaj has been successful in doing that.

7. The way in which power is exercised is through the process of 'flaming', where the errant voices are 'burnt out' and subdued and quieted. Yet that works only because the errant members choose to keep quiet and not due to any other reasons (see the work of Siegel, Dubrovsky, Kiesler and McGuire 1986).

8. The only control is exercised by system administrators and network moderators who can review articles before they are posted. However, groups such as *sci* are often unmoderated, thus eliminating even this minimal control. Only when an exchange might violate the 'netiquette' of language and decorum could it be brought to the attention of the system administrator of the poster's computer, leading to some repercussions to the user.

References

Allor, M. (1988) Relocating the site of the audience, *Critical Studies in Mass Communication*, 5, 217–33.

Althusser, L. (1971) *Lenin and Philosophy and Other Essays*, New York: Monthly Review Press.

—— (1986) 'Ideology and ideological state apparatuses', in G. Hanhardt (ed.), *Video Culture* (pp. 56–95), Rochester, NY: Visual Studies Workshop, Inc.

Anderson, B. (1983) *Imagined Communities: Reflections on the Origins and Spread of Nationalism*, London: Verso.

Appadurai, A. (1993) 'Patriotism and its futures', *Public Culture*, 5, 411–29.

Badgett, T. and Sandler, C. (1993) *Welcome to Internet: From Mystery to Mastery*, New York: MIS Press.

Bakhtin, M. M. (1981) *The Dialogic Imagination: Four Essays*, (trans. M. Hoquist and C. Emerson), Austin: University of Texas Press.

Baron, N. S. (1984) 'Computer-mediated communication as a force in language change' *Visible Language*, 18 (2), 118–141.

Baym, N. K. (1995) 'The emergence of community in computer-mediated communication', in S. G, Jones (ed.), *CyberSociety: Computer-mediated Communication and Community* (pp. 138–63). Thousand Oaks, CA: Sage.

Beniger, J. (1987) 'Personalization of the mass media and the growth of pseudo-community'. *Communication Research*, 14 (3), 352–71.

Braun, E. (1994) *The Internet Directory*, New York: Fawcett Columbine.

Buscombe, E. (1993) 'Nationhood, culture and media boundaries: Britain', *Quarterly Review of Film and Video*, 14 (3), 25–34.

Campa, R. (1994) 'The Latino diaspora in the United States: sojourns from a Cuban past'. *Public Culture*, 13, 293–319.

Carey, J. (1989) *Communication and Culture*, Boston: Unwin-Hyman.

de Certeau, M. (1984) *The Practice of Everyday Life*, Berkeley: University of California Press.

Dery, M. (1993) 'Flame wars'. *South Atlantic Quarterly*, 92, 559–68.

Deutsch, K. W. and Foltz, W. J. (1966) *Nation Building*, New York: Atherton Press.

Dubrovsky, V. J., Kiesler, S. and Sethna, B. N. (1991) 'The equalization phenomenon: status effects in computer-mediated or face-to-face decision-making groups'. *Human–Computer Interaction*, 6, 119–46.

Elsaesser, T. (1989) *New German Cinema: A History*, London: British Film Institute.

Foucault, M. (1989) 'From the "Order of discourse"', in P. Rice and P. Waugh (eds), *Modern Literary Theory* (pp. 221–33), New York: Edward Arnold.

Glistner, P. (1993) *The Internet Navigator*, New York: John Wiley.

Gramsci, A. (1971) *Selections From the Prison Notebooks* (Q. Hoare and G.N. Smith, eds), New York: International Publishers.

Hall, S. (1980) 'Encoding/decoding', in S. Hall, D. Hobson, A. Lowe and P. Willis (eds), *Culture, Media, Language* (pp. 128–39), London: Hutchinson.

—— (1986) 'On postmodernism and articulation', *Journal of Communication Enquiry*, 10 (2), 45–60.

Hay, J. (1987) *Popular Film Culture in Fascist Italy*, Bloomington: Indiana University Press.

Hiltz, S. R., Turoff, M. and Johnson, K. (1989) 'Experiments in group decision making, 3: disinhibition, deindividuation, and group process in pen name and real name computer conferences', *Decision Support Systems*, 5, 217–32.

Jones, S. G. (1995) 'Understanding community in the information age', in S. G. Jones (ed.), *CyberSociety: Computer-mediated Communication and Community* (pp. 10–35), Thousand Oaks, CA: Sage.

Kiesler, S., Siegel, J. and McGuire, T. W. (1984) 'Social psychological aspects of computer-mediated communication'. *American Psychologist*, 39 (10), 1123–34.

Krol, E. (1992) *The Whole Internet*, New York: O'Reilly and Associates.

LaQuey, T. (1993) *The Internet Companion*. Reading, MA: Addison-Wesley.

McLaughlin, M. L., Osborne, K. K. and Smith, C. B. (1995) 'Standards of conduct on Usenet', in S. G. Jones (ed.), *CyberSociety: Computer-mediated Communication and Community* (pp. 90–111), Thousand Oaks, CA: Sage.

Mitra, A. (1993) *Television and Popular Culture in India*, New Delhi: Sage.

—— (1996, August) 'Images of South Asia on film', paper presented at the Film, Culture, History: International Conference, Aberdeen, Scotland.

Negroponte, N. (1995) *Being Digital*, New York: Knopf.

Palumbo-Liu, D. (1994) 'Los Angeles, Asians, and perverse ventriloquism: on the functions of Asian Americans in recent American imagery'. *Public Culture*, 13, 365–85.

Peck, M. S. (1987) *The Different Drum: Community Making and Peace*, New York: Simon and Schuster.

Poole, M. S. and DeSanctis, G. (1987) *Group Decision Making and Group Decision Support Systems: A 3-Year Plan for the GDSS Research Project*. Working paper, Minneapolis, MIS Research Center, University of Minnesota.

Postman, N. (1993) *Technopoly: The Surrender of Culture to Technology*, New York: Vintage Books.

Rheingold, H. (1993) *The Virtual Community: Homesteading on the Electronic Frontier*, Reading, MA: Addison-Wesley.

Rice, R. E. (1984) *The New Media: Communication, Research and Technology*, Beverley Hills, CA: Sage.

Said, E. (1993) *Orientalism*, New York: Vintage Books.

Siegel, J. M., Dubrovsky, V. M., Kiesler, S. and McGuire, T. W. (1986) 'Group process in computer-mediated communication'. *Organizational Behavior and Human Decision Processes*, 37, 157–87.

Smolensky, M. W., Carmody, M. A. and Halcomb, C. G. (1990) 'The influence of task type, group structure and extraversion on uninhibited speech in computer-mediated communication'. *Computers in Human Behavior*, 6, 261–72.

Snyder, J. (1996) 'Get real'. *Internet World*, 7 (2), 92–4.

Sproul, L. and Kiesler, S. (1991) *Connections: New Ways of Working in the Networked Organization*, Cambridge, MA: MIT Press.

Thompson, P. A. and Ahn, D. (1992) 'To be or not to be: an exploration of E-prime, copula deletion, and flaming in electronic mail'. *ETC: A Review of General Semantics*, 49, 146–97.

Turner, G. (1988) *Film as Social Practice*, London: Routledge.

Volosinov, V. N. (1973) *Marxism and the Philosophy of Language* (trans. L. Matejka and I. R. Titunik), London: Seminar Press.

Walther, J. B. (1992) 'Interpersonal effects in computer-mediated interaction: a relational perspective'. *Communication Research*, 19, 52–90.

—— (1993) Impression development in computer-mediated interaction'. *Western Journal of Communication*. 57, 381–98.

—— (1994) 'Anticipated ongoing interaction versus channel effects on relational communication in computer-mediated interaction', *Human Communication Research*, 20, 473–501.

Walther, J. B. and Burgoon, J. K. (1992) 'Relational communication in computer-mediated interaction,' *Human Communication Research*, 19, 50–88.

Williams, R. (1961) *Marxism and Literature*, Oxford: Oxford University Press.

Cybercolonization

DAVID BELL

INTRODUCTION

Cyberspace, then, is the 'American dream' writ large; it marks the dawn of a new 'American civilisation'. White man's burden shifts from its moral obligation to civilise, democratise, urbanise and colonise non-Western cultures, to the colonisation of cyberspace.

(Ziauddin Sardar)

WE HAVE CHOSEN TO CLOSE *The Cybercultures Reader* with four essays which all address the globalizing tendencies of cyberspace, asking questions about the impacts these will have on 'the world we live in', to borrow Kevin Robins' phrase. The essays share a critical stance which seeks to think cyberspace as a mode of colonization, reflecting (and countering) prominent popular discourses of virtual 'frontiers' to be settled and uncharted territories to discover and explore (see, for example, Rheingold 1993). We are, then, working at the scale of the transnational or global here, looking at attempts to locate cyberspace within a history of discovery, exploration, colonization and exploitation.

Graham Barwell and Kate Bowles' essay concerns attempts to regulate border traffic in cyberspace. As the Internet goes global, important questions arise, such as:

how will this disruption to the previously distinct hierarchies of here and there, self and Other, centre and margin, West and Orient, impact upon . . . routines of national self-identification . . .? What is the future of cultural nationalism in the age of global storytelling? . . . And if cultural difference is to be erased, whose cultures precisely will be lost?

In order to explore these questions, Barwell and Bowles discuss Canada's attempts to prohibit cross-border transmission of material relating to a high-profile court case. First, however, they introduce responses to homogenizing tendencies in cyberculture, looking

briefly at French and Japanese policies read in the light of the perceived Americanization threatened by the Internet (cyberspace in its current forms is here seen as essentially an American cultural form, something which even some US users express unease about). These cases (and that of Australia) all suggest to Barwell and Bowles that 'the selective global spread of the Internet appears to jeopardize the smooth operation of the nation state at many levels: economic, cultural, legal'. While advocates see this as liberation from the tyranny (or the mere inconvenience) of national boundaries, Barwell and Bowles argue, through their reading of the Homolka Case, that such attempts to control border traffic provide 'a useful illustration not only of the dislocation of neo-colonization which the medium represents, but also of the perils of uncritical acceptance of such apparent post-nationalism'.

The details of the Homolka Case are well covered in their chapter, and need not detain us here (though we might want to note the increasing use of the Internet as a site for opinion and discussion of high-profile court cases – the Louise Woodward case being a prominent recent example). The most interesting feature is Canada's attempts to suppress information about the case from becoming public, so as not to prejudice proceedings. Reporters were banned from attending, therefore, and the news media were denied access to the courtroom. This silence inevitably propagated myths and rumours about the details of the case, and the Internet soon became the medium through which these – and discussions of the media ban – began to be circulated. In a process analogous to that discussed by Richard Thieme on the 'UFO meme' in section four, these rumours took on a life of their own, multiplying and diffusing, while the US media attempted to breach the ban (which had become absorbed into much broader cultural border-disputes with Canada). Faced with this new medium of transmission, the Canadian government had to redefine its ban in an attempt to silence cyberspace – again, causing outrage among libertarian Internet advocates in the US. A series of what Barwell and Bowles call transnational 'moral clusters' can thus be traced in cyberspace – of which those disputing the info-ban around the Homolka Case can be included – whose opposition to state regulation and ability to mobilize globally offers a counter to simplistic 'cultural imperialism' arguments about the Internet. Finally, Barwell and Bowles conclude that the Internet is showing the transitional nature of borders and nations, although this in itself raises some challenges both for forms of identification in cyberspace, and perhaps more crucially, for those denied access to it. These issues resound through all the essays in this section.

The question of cybercolonization is approached from a different angle by Lisa Nakamura, in her discussion of 'identity tourism' in LambdaMOO. Returning to themes already discussed in the Reader – such as identity-play and performativity in cyberspace – Nakamura discusses the phenomenon of 'racial passing' on MOOs. Early on in the essay she notes the contested and marginalized figuring of 'race' in LambdaMOO:

> Players who elect to describe themselves in racial terms, as Asian, African American, Latino, or others members of oppressed and marginalized minorities, are often seen as engaging in a form of hostile performance, since they introduce what many consider a real life 'divisive issue' into the phantasmic world of cybernetic textual interaction. The borders and frontiers of cyber-

space take on a keen sharpness when the enunciation of racial otherness is put into play as performance.

Crucially, in LambdaMOO, writing one's race is offered as a choice (whereas, for example, one must designate a gender in order to play) – so anyone choosing to visibilize their race is seen as threatening the social harmony of the game; unless, that is, their racial identification plays on racial stereotypes, as Nakamura's discussion of Asian perform-ance in LambdaMOO shows. Stereotyped Asian identities are paraded on the site in a form of Orientalist 'identity tourism'. For these tourists, Nakamura argues, LambdaMOO 'represents a phantasmic imperial space' (drawing on Said's [1987] discussions of racial passing as imperial 'wish-fantasy' and 'adventure') – a cybercultural version of the TV series *Fantasy Island*. The stereotypes of Asianness deployed in LambdaMOO are either martial arts experts and Samurai, or sexualized, docile, submissive Geishas.

Nakamura's essay approaches the questions raised by Barwell and Bowles: 'the trope of the cyber frontier ... connotes a conflict on the level of cultural self definition', she writes, adding that 'the figuration of cyberspace as the most recent representation of the frontier sets the stage for border skirmishes in the realm of cultural representations of the Other'. Race is therefore either erased or exoticized in LambdaMOO, and can find no discursive space outside those two options. Nakamura suggests, in a way similar to Andrew Ross' redefining of hacking (see section three), that a critical way forward might be to think of on-line discourses about race as a kind of cybercultural bug in the system, undermining 'cybersocial hygiene': '[t]he "unexpected occurrence" of race has the potential, by its very unexpectedness, to sabotage [or jam] the ideology-machine's routines.'

The last two chapters in the section both address the globalizing impulses of cyber-space. Jon Stratton links cyberspace to previous communications technologies which have contributed towards time–space compression, and which he sees as 'transport systems' of capitalist expansion (for a similar historicizing of cyberspace, see Thrift 1996). With the growing importance of the 'non-place' that is cyberspace, we are entering the era of virtual capitalism: '[t]he opening up of cyberspace begins a new movement of hyper-deterritorialization, this time within the exchange system of capi-talism' (see also Luke 1999; Sassen 1999). Cyberspace must therefore be written into Arjun Appadurai's famous roster of disjunctive global flows – in fact, it impacts on all the existing flows (of people, money, media, technologies and ideologies) (Appadurai 1990). As Stratton writes, these global flows 'are a consequence of the capitalist dynamics of nation-states but, at the same time, place the old spatial verities of the nation-state under pressure. Nowhere is this more obvious than on the Internet'. Increasingly, as we have already seen, cyberspace crosses national borders and 'moral clusters' and other groupings form transnationally. While at present the Internet is inscribed by American hegemony (Stratton quotes Vice President Al Gore's enthusiastic promoting of the 'global information infrastructure' or GII, envisaging the information superhighway as, in Stratton's words, 'a global interactive commodity-delivery system'; see also Ross 1996), the growing use by non-Americans and non-English speakers will inevitably undermine that hegemony (see also Barwell and Bowles, this section).

One dimension which Stratton usefully adds to his discussion is the way in which the 'imagined community' thesis depends on 'the construction of [the nation's] members

as an audience' – the mass media are thus central to national definition. The Internet complicates this, since it blurs distinctions between information and opinion; attempts such as Gore's, to redefine the Internet as the *Information* Superhighway, are thus read as trying to reconfigure the Internet as a mass media delivery system (while also making it a medium for consumption). However, against this impulse, the presence of 'minority' groups voicing opinions in cyberspace undermines its role in reproducing a coherent nation-state or imagined community. As Stratton concludes, 'it will remain to be seen whether the American capitalist dominance of hyperspace will continue, or whether more space can be produced in which other languages, other cultures, and non-economic concerns can all have a space'.

The final chapter of this section is unapologetically polemical; for Ziauddin Sardar, cyberspace represents 'the darker side of the West'. In effect, Sardar's critique of cyberspace brings together the themes covered in the essays by Barwell and Bowles, Nakamura, and Stratton, presenting a history of Western colonialism into which cyberspace is slotted. The sum of Sardar's position is laid out early in the essay, where he writes that cyberspace is 'a conscious reflection of the deepest desires, aspirations, experiential yearning and spiritual *Angst* of Western man', adding that it is 'resolutely being designed as a new market' and that it is 'an emphatic product of the culture, world-view and technology of Western civilisation'. In a broad-ranging and staunchly critical overview, Sardar unpicks the mythologies of cyberspace, echoing the stance of writers like Kevin Robins (see section one) that the hype needs countering with a 'dose of reality'. He describes the Internet, for example, as a 'grotesque soup of information', a babble: '[a] great deal of this stuff is obscene; much of it is local; most of it is deafening noise'. Further, he never lets us forget the origins of cyberspace, virtual reality and the Internet in the military-industrial complex, while he characterizes Internet users as belonging to one of two groups of white, middle-class, male Americans: either college students or a ragbag of psychotics, fanatics and perverts, unleashing their 'darker sides' into cyberspace.

The diversity of 'real life' is occluded by 'on-line monoculture', Sardar writes, ending with the pronouncement that '[c]yberspace, with its techno-Utopian ideology, is an instrument for distracting Western society from its increasing spiritual poverty, utter meaningless and [the] grinding misery and inhumanity of everyday lives'. This is cybercritique at its most intense; cybercultural flaming that lets no one off the hook, and leaves no aspect of the hype of cyberspace unscrutinized (cybergurus get an especially vigorous working-over). Even the subversive potentials noted by Barwell and Bowles, Nakamura, and Stratton, which might undermine the hegemonic bloc at cyberspace's core, or subcultural work within cyberspace, which might eat away at it, cannot be separated out from the overarching logic of domination in Sardar's eyes. Intimately and irredeemably tied to the West's history of colonization, exploitation and annihilation, cyberspace offers no 'solutions for a small planet'.

References

Appadurai, A. (1990) 'Disjuncture and difference in the global cultural economy', in M. Featherstone (ed.) *Global Culture*, London: Sage.

Luke, T. (1999) 'Simulated sovereignty, telematic territoriality: the political economy of cyberspace', in M. Featherstone and S. Lash (eds) *Spaces of Culture: City, Nation, World*, London: Sage.

Rheingold, H. (1993) *The Virtual Community: Homesteading on the Electronic Frontier*, Reading: Addison-Wesley.

Ross, A. (1996) 'Earth to Gore, Earth to Gore', in S. Aronowitz, B. Martinson and M. Menser (eds) *Technoscience and Cyberculture*, London: Routledge.

Said, E. (1987) 'Introduction', in R. Kipling, *Kim*, New York: Penguin.

Sassen, S. (1999) 'Digital networks and power', in M. Featherstone and S. Lash (eds) *Spaces of Culture: City, Nation, World*, London: Sage.

Thrift, N. (1996) 'Old technological fears and new urban eras: reconfiguring the goodwill of electronic things', *Urban Studies* 33 (8) 1463–93.

GRAHAM BARWELL AND KATE BOWLES

BORDER CROSSINGS
The Internet and the dislocation of citizenship

I N A COMMERCIAL SHOWN ON US television in 1993, MCI Communications described the information superhighway as a road connecting all points: 'There will be no more there. We will all only be here.' Even though the nature of this communications phenomenon is such that greater numbers are still experiencing its effects via these discursive speculations rather than by an actual encounter with the network, it is none the less the case that the proposed collapsing of the tyranny of distances (both social and geographical) requires some careful thought. It is our purpose to ask: how will this disruption to the previously distinct hierarchies of here and there, self and Other, centre and margin, West and Orient, impact upon the routines of national self-identification with which Australia and Canada are especially preoccupied? What is the future of cultural nationalism in the age of global storytelling? Can we continue to distinguish between the global and the universal? And if cultural difference is to be erased, whose cultures precisely will be lost?

The Internet is non-hierarchical and not controlled by any one organization. But this does not mean it is not subject to regulation. Access to it was first restricted to those engaged in US Defense Department research and it was to be used for military purposes only.[1] As the Internet expanded in the US with the help of Federal Funds through the National Science Foundation (NSF) and other agencies, regulations were introduced to control the use of the part of the network provided by the NSF, particularly to prevent its exploitation for commercial purposes. Corporations could join but could not use it for advertising since they had not funded it. As personal computers and modems became widely available, individuals who had set up their own mini-networks accessible to anyone with the appropriate equipment and the right phone number became of increasing interest to the US Secret Service, because of fears that they were disseminating illegal information on computer hacking. More recently, attention in Britain and the US has been focused on reputed on-line activity by organized groups of paedophiles; and attempts have been made to monitor various channels of communication in order

to apply the same restrictions on the electronic exchange of sexually explicit or libellous material as are exerted over the more established technologies of representation: print, video, photography.

The actions of government authorities and the police against these loose coalitions of private individuals and ad hoc on-line communities, whose ethical bias was towards self-regulation rather than censorship, caused concern. This was the impetus for the foundation of a number of electronic civil liberties groups, the most prominent of which is probably the Electronic Frontier Foundation (EFF), established in the States in 1991 by John Barlow, an ex-lyricist for the rock group The Grateful Dead and now a computer expert, and Mitchell Kapor, the co-founder of Lotus Development Corporation and co-designer of the program, Lotus 1–2–3. Supported by endowments from other like-minded individuals well-placed in the American computer industry, the foundation aims to develop public awareness of civil liberties and legal issues, to encourage educational activities and support easy access to computing and telecommunications. The EFF has sponsored groups in a number of other countries including both Canada (EFC) and Australia (EFA).[2] The Australian group, established in 1993, is concerned to support, educate, research and advise, especially on legal issues.

The Internet and nationalism

The concept of the Internet as the frontier, which attracted scorn from some quarters when first proposed, is based on the notion that, in the words of the EFF mission statement, the new forms of digital 'communities without a single, fixed geographical location comprise the first settlements on an electronic frontier'. The concept of communities settled along an electronic frontier is extended in the way similar groups which share its aims are termed 'outposts'. It is perhaps not surprising that one of the EFF founders lives on a property in Wyoming.

The American origin of the Internet means that great emphasis is placed on its potential for the promotion of democratic ideals and free trade. A current guidebook notes that in education the availability of access to the network has a 'democratic effect . . . on what is communicated. A student can exchange ideas with a leading authority as a peer.'[3] The NSFNet Acceptable Use Policy, cited by another guidebook as an example of the kinds of regulation applying to some parts of the Internet, specifies that communication with foreign users is acceptable, provided that 'any network . . . the foreign user employs . . . provides reciprocal access to US researchers and educators'.[4] Ironically, the American Government also argues that for American users transmission of computer messages overseas is subject to the Department of Commerce's export restrictions. The older civil liberties groups are particularly concerned to see that rights enshrined under US law are not infringed. Thus the EFF declares in its mission statement it will '[s]upport litigation in the public interest to preserve, protect, and extend First Amendment rights within the realm of computing and telecommunications technology' and speaks of ensuring the 'civil liberties guaranteed in the Constitution and the Bill of Rights are applied'. An American commentator notes in connection with network ethics that the two overriding premises are that individualism is honoured and fostered, and that the network is good and must be protected. He adds, '[n]otice these are very close to the frontier ethics of the West, where individualism

and preservation of lifestyle were paramount'.[5] The founding ethic could not be more explicitly nationalized.

As the Net spread beyond the US, the combination of this original bias with America's reputation for media colonization (the Coca-Colonization effect) caused concern. In Europe, where the Internet protocols for communication between computers were regarded as 'a cultural threat akin to EuroDisney',[6] the French introduced in the early 1980s their own national network, not connected to the Internet, the Minitel system, which was widely used and very successful by the mid-1980s. But the consequence of this success, if the national network is updated and linked internationally, is that it runs the risk of importing into French culture precisely the kinds of influence the Academie Française is supposed to resist.

In Japan, participation in the early development of the Internet had been similarly limited by government policies. The use of a modem was illegal until 1985 and Internet accounts were difficult to get. Users were strongly influenced by America. For example, in the case of TWICS, a conferencing system in Tokyo which joined the Internet in 1986, the co-founders were an American English teacher and a 'Japanese with the sensibilities of an American teenager',[7] and the language used is English. Japanese participation in on-line culture had also been hampered by a written language based on ideographs rather than an alphabet, as well as certain cultural norms, such as social formalities that can define and limit the terms of argumentative debate. While the telecommunications companies are committed to linking every Japanese home to a fibre-optic network by 2015, the potential for a clash between Japanese and American cultural values is plain. The awkward metaphor for a Japanese virtual community called Beejima reveals the tensions as the national culture tries to accommodate the foreign: 'The image of Beejima was a friendly little island community in the electronic seas of Japan, close to Tokyo but accessible from anywhere, a Japanese system modeled on Japanese context, with an international and multicultural outlook.'[8] In the US itself some of the dedicatedly non-hierarchical groups have recognized the potential for cultural domination inherent in the notion of the US nation as the centre. Thus in April 1994 EFF offered a defensive clarification of the term 'outpost', to the effect that the 'EFF considers itself as much of an outpost, a pioneer in a new, uncharted territory, as even the smallest local activist'.[9] In other words, the outposts are not to be considered as franchises – but the metaphor remains explicitly American.

The reaction of the Australian government to the Internet suggests that while it recognizes, like the French and the Japanese, that the globalization of the Internet may be a form of colonization, or at least a manifestation of America's cultural expansionism, it nevertheless is responding with a nationalist discourse which may well be both outdated and unsustainable. Thus, the then Prime Minister Paul Keating's 1994 address to the Labour Party National Conference spoke of the information superhighway purely in terms of the necessity of providing Australian content, following the model of the television industry, while the Senate Select Committee on Community Standards Relevant to Telecommunications, which was established in 1991, has looked only at telephone, videotext and Pay-TV services, though it noted in its most recent report that the transmission of 'pornography and violent material from computer bulletin boards and personal computers is a matter of increasing public concern'.[10] A Federal Government task force has recently recommended an amendment to the Commonwealth Crimes Act to ban the transmission of offensive material on computers. While such actions aimed at content,

whether Australian or pornographic (the terms are not mutually exclusive), presumably reflect community concerns and are certainly in keeping with the Australian legal system, they fail to recognize that the Internet, developed in the US and deeply encoded with the legal principles and ethics of that country, may pose a more complex problem for Australian culture.

How do we locate this problem within a discussion of post-coloniality? Certainly the selective global spread of the Internet appears to jeopardize the smooth operation of the nation state at many levels: economic, cultural, legal. Just as certainly, the disembodiment of the Internet citizen complicates our understanding of the everyday performance of nationality, as one factor among a number which are similarly complicated: gender, ethnicity, sexuality, class, all appear to disappear along with the power axis of centre and margin. According to the tenets of terminal connectedness, there *is* no more here or there, or, to reframe the magical effect, 'on the Internet, no one knows you're a dog'.

And yet, in one sense it is appropriate to draw attention to the demographics and ethical preferences of the Internet community as American. The purpose of this is not to regress into conspiracy theories of media imperialism, or to agonize over whether or not, as one posting to USENet put it, 'national borders are speed bumps on the information superhighway', but to examine the more complicated challenge to the workings of the nation state that occurs wherever the new community represents itself as supranational or as 'global'. One particular Canadian case, which we have also examined elsewhere,[11] highlights the potential of the Internet for violating the priorities and privileges of non-US national authorities in the control of sensitive information, without necessarily acting in the interests of the US Government. It is a useful illustration not only of the dislocation of neo-colonization which the medium represents, but also of the perils of uncritical acceptance of such apparent post-nationalism.

The Homolka case

In June 1993, Justice Francis Kovacs of the Ontario Court of Justice consented to the imposition of a publication ban on the details of the manslaughter trial of Karla Homolka, a young Canadian woman who had been arrested and charged, along with her husband Paul Bernardo, in connection with the kidnapping, sexual assault and murder of two local schoolgirls, Leslie Mahaffy and Kristen French. Excessive public interest in the case was anticipated due to the nature of the crimes, and the rumoured wealth of grisly detail which could emerge. In the interests of preserving a viable trial environment for the second of the defendants, Paul Bernardo, Justice Kovacs deployed the ban mechanism as a means of curbing that potential public and media attention.

In the text of the ban, subsequently made available via the Internet, Justice Kovacs considered the question of the likely American media interest in the trial, particularly given that the murders had occurred in a region close to the Canadian/American border. A Canadian court has no control over media in the US, obviously, and in his decision therefore to ban foreign reporters from the trial – the only remaining option – Justice Kovacs cited Justice Thorson in the 1984 case of Global Communication Ltd and the Attorney General of Canada, in which it was observed that the 'widest possible latitude' given to media reporting of trials in the US is offset by a much more rigorously

investigative approach to jury selection – which itself of course becomes part of the media narrative, as we saw during 1995 in the infamous O. J. Simpson trial – and by the sequestration of the jury during the trial. In Canada, by contrast, the individual's right to privacy mitigates against such searching personal investigation, and jury sequestration is rare. In that case, Justice Thorson had concluded:

> I offer no comment on the relative merits of the two different approaches, except to say that each shares the common objective of seeking to ensure a fair trial but comes at that objective from a different tradition of legal history.[12]

Accordingly, all foreign media and members of the general public were banned from the courtroom, and only accredited Canadian media, and members of the Mahaffy, French and Homolka families were permitted to attend, bound by the Crown's prohibition on their reporting anything other than the charge and the sentence. Karla Homolka was found guilty of manslaughter, and was sentenced to two concurrent twelve-year terms. In not imposing life sentences, Kovacs acknowledged her cooperation with the police, but concluded:

> No sentence I can impose would adequately reflect the revulsion of the community for the deaths of two innocent young girls who lived their lives without reproach in the eyes of the community.[13]

The Canadian media appealed against the ban but did not violate it, a response which itself caused comment in the US press. The *Washington Post*, for example, subsequently argued that to Canadians, 'censorship at the edges is an acceptable trade-off for social order', and quoted Rowland Lorimer of the Canadian Center for Studies in Publishing as saying that 'If anything, Canada defines itself against the United States by its lack of libertarianism. We have a positive attitude toward public enterprise. We believe the state can act on behalf of society as a whole.' The article further quoted Stuart Adam, Dean of the Arts Faculty at Carleton University in Ottawa as saying that 'The United States can look anarchic to Canadians. It's impossible to watch the Mike Tyson case, or the Rodney King case, or the William Kennedy Smith case, from the outside and remain confident that they were born in justice'.[14]

There was, however, a significant element of debate in Canada regarding the ban, contextualized within Canada's long history of cultural dispute with the US. It quickly became clear that the scant details surrounding the case were in themselves so provocative as to generate unprecedented public interest in the trial, on both sides of the border.[15] The few known facts included the bodies having been dismembered before discovery and the charge of 'offering an indignity to the body of the deceased'. The textual silence at the centre of this hysterical reaction immediately created a blank prescription on which the worst fears of the community, the most graphic of urban legends, could be inscribed. All that was missing was a forum in which these fears could be articulated, collated and revised.

Rumours had been posted and discussed electronically from the outset, principally in the USENet newsgroups *soc.culture.canada* and *ont.general*. In July 1993, two students from the University of Toronto and the University of Western Ontario formed a new USENet newsgroup named *alt.fan.karla-homolka* to host the discussion, and to provide a location for banned material. This use of *alt.fan* as a semi-ironic designation is a regular USENet practice, as is the formation of sites for the discussion of informa-

tion broadcast on television, particularly in court trials. In this case, however, the news-group provided an address in cyberspace where information subject to a media ban could collect, immediately challenging the definition of 'publication' on which the ban rested.

Rumours from anonymous respondents with alleged contacts among the sixty journalists who had attended the trial formed the basis of the newsgroup's earliest content. Comments were typically prefigured by 'I'll say right now that this is hearsay but fairly reliable since I am sixth removed . . .' or 'What I'm about to write may be true, and it certainly is sick . . .'. By the time media attention was drawn to the Internet itself as a source of information, the group's coalition of editors had assembled these rumours into a Frequently Asked Questions list (or FAQ), in accordance with USENet practice, the contents of which were indisputably grisly but only disputably grounded in fact.

The Internet's role in mediating or fabricating culturally potent indices of 'the unspeakable' is made clear in the original FAQ details regarding the performance of the crimes themselves. Images of stalking, sexual torture, voyeurism, lesbianism, bondage, live dismemberment and, finally, necrophilia combine in this lurid but increasingly coherent paranoid narrative. Inevitably, rumours included the existence of snuff movies, which sat alongside the home movies of the victims used by the television news programme *A Current Affair* in its two reports about the crime; a poignant detail added later was the rumour that Paul Bernardo had had the foresight to tape episodes of *The Simpsons* over this incriminating evidence. As the loose collage of speculations cohered into a narrative, these overlaps and interactions with television, video and other mediations or simulacra took on an appearance which could best be described as postmodern.

Sustaining this definition is the fact that the media's appropriation of the principal speculations in the FAQ, in the absence of other hard information, was initially extensive. Indeed, one version of the FAQ claims that the Canadian press suppressed the name of '*alt.fan.karla-homolka* 'for fear their US counterparts would print scoops from it before they did'. The migration of rumour outwards from the FAQ into the media, and thence back into the FAQ, has some significant nodal points. On 19 September 1993, the British tabloid newspaper the *Sunday Mirror* ran a story under the headline 'Killer Ken and Barbie's Video of Horror', filed by their correspondent in New York. Comparing Karla and Paul to British serial killers Ian Brady and Myra Hindley, figures with a high media profile, the article hinted at 'lesbian sex orgies' and videotapes, and plagiarized Canadian reports of the trial, embellishing where necessary. Canadian distributors of the paper were immediately warned by the Ontario Attorney General, Marion Boyd, that they would be subject to a contempt order if copies were distributed to Canadian news-stands, drawing attention to the fact that a ban on publication logically extends from the production to the distribution of information.

This was a problem also being considered in the broadcast media. Canadian cable company Rogers Cablevision was faced with a contempt order if it conveyed Buffalo TV News from across the border, but protested that monitoring its ten US channels eighteen hours per day in case banned details were mentioned was simply unfeasible. When on 26 October 1993 *A Current Affair* ran a segment on the case, screens across Canada were blacked out by the cable providers. The producers claimed in the segment that their decision to put the story to air had 'almost caused an international incident'

708 GRAHAM BARWELL AND KATE BOWLES

and included a quote from Marion Boyd clearly intended to be construed as a Canadian Government threat to an American media provider.

The most significant US media intervention came on 23 November 1993 when the *Washington Post* ran a story from its Toronto correspondent, Anne Swardson, titled 'Unspeakable Crimes: This Story Can't be Told in Canada. And So All Canada is Talking About It', including most of the banned information, and appearing to be sourced in the FAQ. This encouraged other American newspapers in the border region, who had previously observed at least the spirit of the ban. Newspapers in Buffalo and Detroit reprinted the *Post* story, and although the *Buffalo News* substituted a 'story about dolphins' in its overseas edition, Canadians living near the border simply drove across to bring back copies of the US version. Newspaper stands sprang up near border crossings, and customs officers were left with the somewhat ludicrous option of limiting each returning Canadian to one copy, confiscating the rest, in a move reminiscent of the distinction between personal use and intent to sell in anti-drugs legislation. American magazines and periodicals covering the emerging story, in which the ban had replaced the crime as the centre of the controversy, offered special editions to Canada, and US television programmes were blacked out from Canadian screens. Despite this apparent sensitivity, however, the US media increasingly tended to represent itself as a kind of resistance movement servicing news-starved Canadian citizens, in an almost parodic reversal of the refuge Canada had offered to US draft dodgers during the Vietnam war.

While media attention intensified, and the intervenors (now including Rogers Cablevision) returned unsuccessfully to the Appeal Court to protest that the ban was unenforceable, journals dealing specifically with new information technologies began to debate the role the Internet had played in making the banned information available. The situation regarding production and distribution of information was no clearer there, and both Internet providers and their consumers had attracted the hostile attention of the Ontario police. In its April 1994 edition, the US publication *Wired* magazine included a story containing a number of factual errors regarding the creation of *alt.fan.karla-homolka*, but including one item of banned information, the details of Karla Homolka's plea. The hard-copy was therefore banned in Canada, prompting a *Wired* press release titled 'Cyberspace Cannot Be Censored', denying that the ban had even been breached, and taking the opportunity to advertise *Wired*'s on-line availability in the guise of a defence of freedom of speech. In addition, the magazine's publisher Louis Rossetto was quoted as saying 'Banning of publications is behaviour we normally associate with Third World dictatorships'.

This comment was then seized upon by Toronto free newspaper *eye WEEKLY*, also available on-line. *eye* called *Wired* to confirm that they had equated Canada with a Third World dictatorship, to query their description of the banning of *Wired* as 'utterly chilling', and to confirm their suspicion that *Wired* had not acquainted itself with the details of the ban, including the fact that the plea itself was banned material. When this turned out to be the case, *eye* concluded scathingly that all that was chilling was 'what a terrible time an American publication is having understanding this story'. Anyone who has seen a hard copy of *Wired* will have no trouble at all understanding the David and Goliath aspect of this encounter between a free street-newspaper and the giant of the cyberspace magazine trade.

A strange twist then occurred in April 1994 with the production of a press release from the so-called 'Citizens Coalition for Responsible Government' based in Buffalo.

Attacking the 'socialist' Ontario Government, extensively plagiarizing the *Washington Post* article and using absolutely unsubstantiated material from the FAQ, the Coalition offered a 'detailed info pack' for the sum of US$20, the money to contribute to a mass mailing campaign. This finally prompted some Canadian journalists to break their silence, at least to the extent that they denied that the evidence at Homolka's trial had included information on snuff movies. 'Most of it is fabrication – 99 per cent untrue', said one television reporter who had attended the trial. 'None of what we heard was grisly, or what I would describe as grisly.' Another agreed: 'What I heard in court was certainly nothing like that.'

Internet citizens and national government

In part, the case of Karla Homolka and the Internet hinges on questions of the authority which we attribute to printed material. It is this authority which supports the application of a ban on publication, even as the definitions of publication begin to unravel. The mode of production of electronic texts operates to erase the differences in status between types of information: transcripts of television shows, private correspondence, conversational expletives, unsubstantiated rumours and explorations of the sadistic imagination, all sit alongside electronically scanned articles from the print media, and legal texts which argue against the publication of all the other texts. No one appears to profit.

In addition, with the unravelling of socio-geographic notions of distance, coalitions of concerned citizens of one country can appear to be located in another simply by logging in to an overseas mailserver: one of the FAQ's original authors has been electronically located in Finland and Texas, all the while remaining corporeally in Toronto. It is precisely this seeming dislocation of citizenship which complicates any notion of legal 'rights' in such cases. While the office of the Ontario Attorney General, the Ontario Police Department, and other agencies whose conceptualization of national borders is obliged to remain concrete, have made strenuous efforts to limit the transnational spread of electronic transmissions of banned information, it is clear that the Internet gives its citizens both the means and the inclination to resist nationalist efforts at censorship.

The fact that those citizens are also congregating *across* national boundaries in what we may call moral clusters (those for or against gun control, those who oppose the availability of unrestricted sexually explicit material, homosexual lobby groups and far-right militia organizations, to name but a few), many of whom are united in their opposition to governments of any national hue attempting to control the technology, undermines any reading of Internet history as a history of simple imperialism. If no one profits from its valueless circulation of information, then that economic motive for classical imperialism, which extends to other contemporary media such as film and television, is removed, leaving a kind of disembodied but undeniably moral imperative: the mode of colonial discourse without the motive. Ironically, this creates the impression that what has been effected is precisely that model of cultural diversity, on a global scale, to which the Australian Government has committed itself at the national level.

Has the Internet redistributed the means of power and cultural production sufficiently that it becomes appropriate to talk of postcolonialism in this context? How clear is the connection between diversity and hybridity, and how significant is that aura of the postmodern that surrounds its eclectic and egalitarian patterns of information

gathering? Without resorting to the neo-imperialist thesis, we would none the less argue that the Internet is far from attaining that utopian status where the politics of class, gender and national identities have become redundant. A survey conducted and published on USENet recently commented that among its respondents 80 per cent were male, 80 per cent were white, and the median age was 31 years; 85 per cent claimed post-secondary education, and 29 per cent had completed a postgraduate programme of studies; 82 per cent described their location as urban or suburban. Although the authors acknowledge that 32 per cent of their respondents were non-American, the untranslatable specificities within this group regarding the significance of, say, urban versus rural locations, are smoothed into the demographics for the sample as a whole. This manoeuvre appears as evidence of the global dislocation of the Internet community precisely as it subsumes the particular identities of the minority groups into that of the largest population, the white American college-educated male.

The cultural presumption behind this elision of difference is a characteristic of the Internet which we cannot afford to ignore. Although the net defence against accusations of imperialism is that if there is no more 'here', there can be no more colonizing of 'there', the risk is that the American-dominated English-speaking communications revolution is merely absorbing 'there' into 'here' in a classic faux pluralist manoeuvre. The equal and opposite risk is that second-world Governments of settler colonies such as Australia and Canada, who have often found themselves to be neither unequivocally here nor there along the moral continuum of colonial to postcolonial discourse, will resort to an unsustainable and outdated model of cultural nationalism in order to manage the new medium. If there is no here or there, then to steer a course between the two we need a new metaphor: to say that 'we will all only be here' remains in the same metaphorical territory, mistaking those of us who *are* here for all of us ('Who's "we", paleface?'), and thus losing the inadequate but useful accounts of identity on which theories of postcolonial subjectivity rest.

Until such a metaphor is devised, the most practical descriptive recourse is the embrace of contradiction, acknowledging that borders, and thus nations, are in a transitional phase, both existing and not existing, and that the political significance of both conditions to the Internet and its citizens must be taken into account. This relationship of this paradigmatic instance of dual but simultaneous identity – not quite hybridity – to either postmodernism or to postcolonialism is yet to be fully developed.

Originally published in S. Murray (ed.) *Not on Any Map: Essays on Postcoloniality and Cultural Nationalism*, Exeter: Exeter University Press.
This essay has been edited for inclusion in the Reader.

Notes

1. The SF-Lovers list on ARPANet ran into trouble because it was considered an inappropriate use.
2. Information about the EFF, including its mission statement, is readily available from its ftp site at *eff.org* Information about its offshoots is held at the same site under/*pub*/*groups*/[Canada, Australia, etc.]. A listing of all (not just EFF-affiliated) groups supporting the on-line community is available under /*pub*/*groups*/*outposts.faq*
3. Richard J. Smith and Mark Gibbs, *Navigating the Internet* (Carmel, Ind.: SAMS-Prentice Hall, 1993), p. 17.

4. Ed Krol, *The Whole Internet: User's Guide and Catalog*, (2nd edn.), Nutshell Handbooks (Sebastapol, Cal.: OUReilly, 1994), pp. 495–6. Krol discusses export restrictions on page 37. The NSF policy is available by ftp from *nic.merit.edu* under */nsfnet/acceptable.use.policies/nsfnet.txt*.

5. Ibid., p. 40.

6. Ibid., p. 18.

7. Rheingold, *The Virtual Community*, (London: Secker and Warburg, 1991) p. 215. Our account of developments in France and Japan derives from chapters 7–8 of Rheingold's valuable book.

8. Ibid., p. 216.

9. Electronic Frontier Foundation and Stanton McCandlish, 'International, National, Regional and Local Groups Supporting the On-line Community', version 3.13 (8 April 1994). Available by ftp from *eff.org under pub/groups/outposts.faq*.

10. Senate Select Committee on Community Standards Relevant to the Supply of Services Utilizing Telecommunications Technologies, *Report* (Canberra: Parliament House, May 1993) p. 30.

11. 'A case of violation: Karla Homolka, the Internet and the presentation of the unspeakable', paper presented at the Law and Literature of Australia Annual Conference, Queensland University of Technology, 30 September–2 October 1994. There is a full discussion of the case by Frank Davey in *Karla's Web: A Cultural Investigation of the Mahaffy–French Murders* (Toronto: Viking–Penguin, 1994).

12. Quoted in R. v. Bernardo, (1993) O. J. no. 2047, Action no. 125/93, Media Ban, paragraph 117. The text of the ban, divided into numbered paragraphs, is available through the Internet from a web server in Indiana at URL *http://www.cs.indiana.edu/canada/karla.html*. This site also has other material relating to the case.

13. Quoted in D'Arcy Jenish, 'Unspeakable Crimes', *Maclean's* 19 July 1993, p. 4.

14. Charles Trueheart, 'Canadians Debate New Curbs on Speech, Press', *Washington Post*, 31 January 1994.

15. As at least one American news editor commented, the geographical proximity of his readership to the region patrolled by Homolka and her husband required that he publish the banned information (whatever the quality of his sources); if details leaked into Canada, this would be regrettable but could not be a primary consideration.

LISA NAKAMURA

RACE IN/FOR CYBERSPACE
Identity tourism and racial passing on the Internet

M Y STUDY, WHICH I WOULD characterize as ethnographic, with certain important reservations, focuses on the ways in which race is 'written' in the cyberspace locus called LambdaMOO, as well as the ways it is read by other players, the conditions under which it is enunciated, contested, and ultimately erased and suppressed, and the ideological implications of these performative acts of writing and reading otherness. What does the way race is written in LambdaMOO reveal about the enunciation of difference in new electronic media? Have the rules of the game changed, and if so, how?

Role-playing sites on the Internet like LambdaMOO offer their participants programming features such as the ability to physically 'set' one's gender, race and physical appearance, through which they can, indeed are required to, project a version of the self which is inherently theatrical. Since the 'real' identities of the interlocutors at Lambda are unverifiable (except by crackers and hackers, whose outlaw manipulations of code are unanimously construed by the Internet's citizens as a violation of both privacy and personal freedom) it can be said that everyone who participates is 'passing', as it is impossible to tell if a character's description matches a player's physical characteristics. Some of the uses to which this infixed theatricality are put are benign and even funny – descriptions of self as a human-size pickle or pot-bellied pig are not uncommon, and generally are received in a positive, amused, tolerant way by other players. Players who elect to describe themselves in racial terms, as Asian, African American, Latino, or other members of oppressed and marginalized minorities, are often seen as engaging in a form of hostile performance, since they introduce what many consider a real life 'divisive issue' into the phantasmatic world of cybernetic textual interaction. The borders and frontiers of cyberspace which had previously seemed so amorphous take on a keen sharpness when the enunciation of racial otherness is put into play as performance. While everyone is 'passing', some forms of racial passing are condoned and practised since they do not threaten the integrity of a national sense of self which is defined as white.

The first act a participant in LambdaMOO performs is that of writing a self description — it is the primal scene of cybernetic identity, a postmodern performance of the mirror stage:

> Identity is the first thing you create in a MUD. You have to decide the name of your alternate identity — what MUDders call your character. And you have to describe who this character is, for the benefit of the other people who inhabit the same MUD. By creating your identity, you help create a world. Your character's role and the roles of the others who play with you are part of the architecture of belief that upholds for everybody in the MUD the illusion of being a wizard in a castle or a navigator aboard a starship: the roles give people new stages on which to exercise new identities, and their new identities affirm the reality of the scenario.
>
> (Rheingold 1993)

In LambdaMOO it is required that one choose a gender; though two of the choices are variations on the theme of 'neuter', the choice cannot be deferred because the programming code requires it. It is impossible to receive authorization to create a character without making this choice. Race is not only not a required choice, it is not even on the menu.[1] Players are given as many lines of text as they like to write any sort of textual description of themselves that they want. The 'architecture of belief' which underpins social interaction in the MOO, that is, the belief that your interlocutors possess distinctive human identities which coalesce through and vivify the glowing letters scrolling down the computer screen, is itself built upon this form of fantastic autobiographical writing called the self-description. The majority of players in LambdaMOO do not mention race at all in their self-description, though most do include eye and hair colour, build, age, and the pronouns which indicate a male or a female gender.[2] In these cases when race is not mentioned as such, but hair and eye colour is, race is still being evoked — a character with blue eyes and blonde hair will be assumed to be white. Yet while the textual conditions of self-definition and self-performance would seem to permit players total freedom, within the boundaries of the written word, to describe themselves in any way they choose, this choice is actually an illusion. This is because the choice not to mention race does in fact constitute a choice — in the absence of racial description, all players are assumed to be white. This is partly due to the demographics of Internet users — most are white, male, highly educated and middle class. It is also due to the utopian belief-system prevalent in the MOO. This system, which claims that the MOO should be a free space for play, strives towards policing and regulating racial discourse in the interest of social harmony. This system of regulation does permit racial role-playing when it fits within familiar discourses of racial stereotyping, and thus perpetuates these discourses. I shall focus on the deployment of Asian performance within the MOO because Asian personae are by far the most common non-white ones chosen by players and offer the most examples for study.

The vast majority of male Asian characters deployed in the MOO fit into familiar stereotypes from popular electronic media such as video games, television and film, and popular literary genres such as science fiction and historical romance. Characters named Mr Sulu, Chun Li, Hua Ling, Anjin San, Musashi, Bruce Lee, Little Dragon, Nunchaku, Hiroko, Miura Tetsuo and Akira invoke their counterparts in the world of popular media; Mr Sulu is the token 'Oriental' in the television show *Star Trek*, Hua Ling and

Hiroko are characters in the science fiction novels *Eon* and *Red Mars*, Chun Li and Liu Kang are characters from the video games *Street Fighter* and *Mortal Kombat*, the movie star Bruce Lee was nicknamed 'Little Dragon', Miura Tetsuo and Anjin San are characters in James Clavell's popular novel and mini-series *Shogun*, Musashi is a medieval Japanese folklore hero, and Akira is the title of a Japanese animated film of the genre called *anime*. The name Nunchaku refers to a weapon, as do, in a more oblique way, all of the names listed above. These names all adapt the samurai warrior fantasy to cyberdiscursive role-playing, and permit their users to perform a notion of the Oriental warrior adopted from popular media. This is an example of the crossing over effect of popular media into cyberspace, which is, as the latest comer to the array of electronic entertainment media, a bricolage of figurations and simulations. The Orientalized male persona, complete with sword, confirms the idea of the male Oriental as potent, antique, exotic and anachronistic.

This type of Orientalized theatricality is a form of identity tourism; players who choose to perform this type of racial play are almost always white, and their appropriation of stereotyped male Asiatic samurai figures allows them to indulge in a dream of crossing over racial boundaries temporarily and recreationally. Choosing these stereotypes tips their interlocutors off to the fact that they are not 'really' Asian; they are instead 'playing' in an already familiar type of performance. Thus, the Orient is brought into the discourse, but only as a token or 'type'. The idea of a non-stereotyped Asian male identity is so seldom enacted in LambdaMOO that its absence can only be read as a symptom of a suppression.

Tourism is a particularly apt metaphor to describe the activity of racial identity appropriation, or 'passing' in cyberspace. The activity of 'surfing' (an activity already associated with tourism in the mind of most Americans) the Internet not only reinforces the idea that cyberspace is not only a place where travel and mobility are featured attractions, but also figures it as a form of travel which is inherently recreational, exotic and exiting, like surfing. The choice to enact oneself as a samurai warrior in LambdaMOO constitutes a form of identity tourism which allows a player to appropriate an Asian racial identity without any of the risks associated with being a racial minority in real life. While this might seem to offer a promising venue for non-Asian characters to see through the eyes of the Other by performing themselves as Asian through on-line textual interaction, the fact that the personae chosen are overwhelmingly Asian stereotypes blocks this possibility by reinforcing these stereotypes.

This theatrical fantasy of passing as a form of identity tourism has deep roots in colonial fiction, such as Kipling's *Kim* and T.E. Lawrence's *The Seven Pillars of Wisdom*, and Sir Richard Burton's writings. The Irish orphan and spy Kim, who uses disguise to pass as Hindu, Muslim and other varieties of Indian natives, experiences the pleasures and dangers of cross-cultural performance. Said's (1987) insightful reading of the nature of Kim's adventures in cross-cultural passing contrasts the possibilities for play and pleasure for white travellers in an imperialistic world controlled by the European empire with the relatively constrained plot resolutions offered that same boy back home. 'For what one cannot do in one's own Western environment, where to try to live out the grand dream of a successful quest is only to keep coming up against one's own mediocrity and the world's corruption and degradation, one can do abroad. Isn't it possible in India to do everything, be anything, go anywhere with impunity?' (1987: 42). To practitioners of identity tourism as I have described it above, LambdaMOO represents

a phantasmatic imperial space, much like Kipling's Anglo-India, which supplies a stage upon which the 'grand dream of a successful quest' can be enacted.

Since the incorporation of the computer into the white-collar workplace, the line which divides work from play has become increasingly fluid. It is difficult for employers and indeed, for employees, to always differentiate between doing 'research' on the Internet and 'playing': exchanging email, checking library catalogues, interacting with friends and colleagues through synchronous media-like 'talk' sessions, and video conferencing offer enhanced opportunities for gossip, jokes and other distractions under the guise of work.[3] Time spent on the Internet is a hiatus from 'RL' (or real life, as it is called by most participants in virtual social spaces like LambdaMOO), and when that time is spent in a role-playing space such as Lambda, devoted only to social interaction and the creation and maintenance of a convincingly 'real' milieu modelled after an 'international community', that hiatus becomes a full-fledged vacation. The fact that Lambda offers players the ability to write their own descriptions, as well as the fact that players often utilize this programming feature to write stereotyped Asian personae for themselves, reveal that attractions lie not only in being able to 'go' to exotic spaces,[4] but to co-opt the exotic and attach it to oneself. The appropriation of racial identity becomes a form of recreation, a vacation from fixed identities and locales.

This vacation offers the satisfaction of a desire to fix the boundaries of cultural identity and exploit them for recreational purposes. As Said puts it, the tourist who passes as the marginalized Other during his travels partakes of a fantasy of social control, one which depends upon and fixes the familiar contours of racial power relations.

> It is the wish-fantasy of someone who would like to think that everything is possible, that one can go anywhere and be anything. T.E. Lawrence in *The Seven Pillars of Wisdom* expresses this fantasy over and over, as he reminds us how he – a blond and blue-eyed Englishman – moved among the desert Arabs as if he were one of them. I call this a fantasy because, as both Kipling and Lawrence endlessly remind us, no one – least of all actual whites and non-whites in the colonies – ever forgets that 'going native' or playing the Great Game are facts based on rock-like foundations, those of European power. Was there ever a native fooled by the blue or green-eyed Kims and Lawrences who passed among the inferior races as agent adventurers? I doubt it.
>
> (Said 1987: 44)

As Donna Haraway notes, high technologies 'promise ultimate mobility and perfect exchange – and incidentally enable tourism, that perfect practice of mobility and exchange, to emerge as one of the world's largest single industries' (1991: 168). Identity tourism in cyberspaces like LambdaMOO functions as a fascinating example of the promise of high-technology to enhance travel opportunities by redefining what constitutes travel – logging on to a phantasmatic space where one can appropriate exotic identities means that one need never cross a physical border or even leave one's armchair to go on vacation. This 'promise' of 'ultimate mobility and perfect exchange' is not, however, fulfilled for everyone in LambdaMOO. The suppression of racial discourse which does not conform to familiar stereotypes, and the enactment of notions of the Oriental which do conform to them, extends the promise of mobility and exchange only to those who wish to change their identities to fit accepted norms.

Performances of Asian female personae in LambdaMOO are doubly repressive because they enact a variety of identity tourism which cuts across the axes of gender and race, linking them in a powerful mix which brings together virtual sex, Orientalist stereotyping and performance. A listing of some of the names and descriptions chosen by players who masquerade as 'Asian' 'females' at LambdaMOO include: AsianDoll, Miss_Saigon, Bisexual_Asian_Guest, Michelle_Chang, Geisha_Guest, and Maiden_Taiwan. They describe themselves as, for example, a 'mystical Oriental beauty, drawn from the pages of a Nagel calendar', or, in the case of the Geisha_Guest, a character owned by a white American man living in Japan:

> a petite Japanese girl in her twenties. She has devoted her entire life to the perfecting of the tea ceremony and mastering the art of lovemaking. She is multi-orgasmic. She is wearing a pastel kimono, 3 under-kimonos in pink and white. She is not wearing panties, and that would not be appropriate for a geisha. She has spent her entire life in the pursuit of erotic experiences.

Now, it is commonly known that the relative dearth of women in cyberspace results in a great deal of 'computer cross-dressing', or men masquerading as women. Men who do this are generally seeking sexual interaction, or 'netsex' from other players of both genders. When the performance is doubly layered, and a user extends his identity tourism across both race and gender, it is possible to observe a double appropriation or objectification which uses the 'Oriental' as part of a sexual lure, thus exploiting and reifying through performance notions of the Asian female as submissive, docile, a sexual plaything.

The fetishization of the Asian female extends beyond LambdaMOO into other parts of the Internet. There is a Usenet newsgroup called *alt.sex.fetish.orientals* which is extremely active – it is also the only one of the infamous *alt.sex* newsgroups which overtly focuses upon race as an adjunct to sexuality.

Cyberspace is the newest incarnation of the idea of national boundaries. It is a phenomenon more abstract yet at the same time more 'real' than outer space, since millions of participants deploy and immerse themselves within it daily, while space travel has been experienced by only a few people. The term 'cyberspace' participates in a topographical trope which, as Stone (1994) points out, defines the activity of on-line interaction as a taking place within a locus, a space, a 'world' unto itself. This second 'world', like carnival, possesses constantly fluctuating boundaries, frontiers and dividing lines which separate it from both the realm of the 'real' (that which takes place off-line) and its corollary, the world of the physical body which gets projected, manipulated and performed via on-line interaction. The title of the *Time* magazine cover story for 25 July 1994, 'The Strange New World of Internet: Battles on the Frontiers of Cyberspace', is typical of the popular media's depictions of the Internet as a world unto itself with shifting frontiers and borders which are contested in the same way that national borders are. The 'battle' over borders takes place on several levels which have been well documented elsewhere, such as the battle over encryption and the conflict between the rights of the private individual to transmit and receive information freely and the rights of government to monitor potentially dangerous, subversive or obscene material which crosses state lines over telephone wires. These contests concern the distinction between public and private. It is, however, seldom acknowledged that the trope of the battle on the cyber frontier also connotes a conflict on the level of cultural self definition.

If, as Chris Chesher notes, 'the frontier has been used since as a metaphor for freedom and progress, and . . . space exploration, especially, in the 1950s and 1960s was often called the "new frontier"', (1995: 18), the figuration of cyberspace as the most recent representation of the frontier sets the stage for border skirmishes in the realm of cultural representations of the Other. The discourse of space travel during this period solidified the American identity by limning out the contours of a cosmic, or 'last' frontier.[5] The 'race for space', or the race to stake out a border to be defended against both the non-human (aliens) and the non-American (the Soviets) translates into an obsession with race and a fear of racial contamination, always one of the distinctive features of the imperialist project. In such films as *Alien*, the integrity and solidarity of the American body is threatened on two fronts – both the anti-human (the alien) and the passing-as-human (the cyborg) seek to gain entry and colonize Ripley's human body. Narratives which locate the source of contaminating elements within a deceitful and uncanny technologically-enabled theatricality – the ability to pass as human – depict performance as an occupational hazard of the colonization of any space. New and futuristic technologies call into question the integrity of categories of the human since they enable the non-human to assume a human face and identity.

Recently, a character on Lambda named 'Tapu' proposed a piece of legislation to the Lambda community in the form of petition. This petition, entitled 'Hate-Crime', was intended to impose penalties upon characters who harassed other characters on the basis of race. The players' publicly posted response to this petition, which failed by a narrow margin, reveals a great deal about the particular variety of utopianism common to real-time textual on-line social interaction. The petition's detractors argued that legislation or discourse designed to prevent or penalize racist 'hate speech' were unnecessary since those offended in this way had the option to 'hide' their race by removing it from their descriptions. A character named 'Taffy' writes, 'Well, who knows my race unless I tell them? If race isn't important then why mention it? If you want to get in somebody's face with your race then perhaps you deserve a bit of flak. Either way I don't see why we need extra rules to deal with this.' 'Taffy', who signs himself 'proud to be a sort of greyish pinky color with bloches' [sic] recommends a strategy of both blaming the victim and suppressing race, an issue which 'isn't important' and shouldn't be mentioned because doing so gets in 'somebody's face'. The fear of the 'flak' supposedly generated by player's decisions to include race in their descriptions of self is echoed in another post to the same group by 'Nougat', who points out that 'how is someone to know what race you are a part of? If [sic] this bill is meant to combat comments towards people of different races, or just any comments whatsoever? Seems to me, if you include your race in your description, you are making yourself the sacrificial lamb. I don't include "caucasian" in my description, simply because I think it is unnecessary. And thusly, I don't think I've ever been called "honkey"'. Both of these posts emphasize that race is not, should not be, 'necessary' to social interaction on LambdaMOO. The punishment for introducing this extraneous and divisive issue into the MOO, which represents a vacation space, a Fantasy Island of sorts, for its users, is to become a 'sacrificial lamb'. The attraction of Fantasy Island lay in its ability to provide scenarios for the fantasies of privileged individuals. And the maintenance of this fantasy, that of a race-free society, can only occur by suppressing forbidden identity choices.

While many of the members of social on-line communities like LambdaMOO are stubbornly utopian in their attitudes towards the power dynamics and flows of

information within the technologically mediated social spaces they inhabit, most of the theorists are pessimistic. Andrew Ross and Constance Penley introduce the essays in their collection *Technoculture* by asserting that 'the odds are firmly stacked against the efforts of those committed to creating technological counter-cultures' (1991: iii). Chesher concedes that 'In spite of the claims that everyone is the same in virtual worlds, access to technology and necessary skills will effectively replicate class divisions of the rest of reality in the virtual spaces' (1994: 28) and 'will tend to reinforce existing inequalities, and propagate already dominant ideologies' (ibid.: 29). Indeed, the cost of Net access does contribute towards class divisions as well as racial ones; the vast majority of the Internet's users are white and middle class. One of the dangers of identity tourism is that it takes this restriction across the axes of race/class in the 'real world' to an even more subtle and complex degree by reducing non-white identity positions to part of a costume or masquerade to be used by curious vacationers in cyberspace. Asianness is co-opted as a 'passing' fancy, an identity-prosthesis which signifies sex, the exotic, passivity when female, and anachronistic dreams of combat in its male manifestation. 'Passing' as a samurai or geisha is diverting, reversible, and a privilege mainly used by white men. The paradigm of Asian passing masquerades on LambdaMOO itself works to suppress racial difference by setting the tone of the discourse in racist contours, which inevitably discourage 'real-life' Asian men and women from textual performance in that space, effectively driving race underground. As a result, a default 'whiteness' covers the entire social space of LambdaMOO – race is 'whited out' in the name of cybersocial hygiene.

The dream of a new technology has always contained within it the fear of total control, and the accompanying loss of individual autonomy. Perhaps the best way to subvert the hegemony of cybersocial hygiene is to use its own metaphors against itself. Racial and racist discourse in the MOO is the unique product of a machine and an ideology. Looking at discourse about race in cyberspace as a computer bug or ghost in the machine permits insight into the ways that it subverts that machine. A bug interrupts a program's regular commands and routines, causing it to behave unpredictably. 'Bugs are mistakes, or unexpected occurrences, as opposed to things that are intentional' (Aker 1987: 12). Programmers routinely debug their work because they desire complete control over the way their program functions, just as Taffy and Nougat would like to debug LambdaMOO of its 'sacrificial lambs', those who insist on introducing new expressions of race into their world. Discourse about race in cyberspace is conceptualized as a bug, something which an efficient computer user would eradicate since it contaminates their work/play. The 'unexpected occurrence' of race has the potential, by its very unexpectedness, to sabotage the ideology-machine's routines. Therefore, its articulation is critical, as is the ongoing examination of the dynamics of this articulation. As Judith Butler puts it:

> Doubtlessly crucial is the ability to wield the signs of subordinated identity in a public domain that constitutes its own homophobic and racist hegemonies through the erasure or domestication of culturally and politically constituted identities. And insofar as it is imperative that we insist upon those specificities in order to expose the fictions of an imperialist humanism that works through unmarked privilege, there remains the risk that we will make the articulation of ever more specified identities into the aim of political

activism. Thus every insistence on identity must at some point lead to a taking stock of the constitutive exclusions that reconsolidate hegemonic power differentials.

(1993: 118)

The erasure and domestication of Asianness on LambdaMOO perpetuates an Orientalist myth of social control and order. As Cornell West puts it, as Judith Butler puts it, 'race matters', and 'bodies matter'. Programming language and Internet connectivity have made it possible for people to interact without putting into play any bodies but the ones they write for themselves. The temporary divorce which cyberdiscourse grants the mind from the body and the text from the body also separates race and the body. Player scripts which eschew repressive versions of the Oriental in favour of critical rearticulations and recombinations of race, gender and class, and which also call the fixedness of these categories into question have the power to turn the theatricality characteristic of MOOspace into a truly innovative form of play, rather than a tired reiteration and reinstatement of old hierarchies. Role-playing is a feature of the MOO, not a bug, and it would be absurd to ask that everyone who plays within it hew literally to the 'RL' gender, race or condition of life. A diversification of the roles which get played, which are permitted to be played, can enable a thought-provoking detachment of race from the body, and an accompanying questioning of the essentialness of race as a category. Performing alternative versions of self and race jams the ideology-machine, and facilitates a desirable opening up of what Judith Butler calls 'the difficult future terrain of community' in cyberspace (1993: 242).

Originally published in *Works and Days* 13 (1–2) (1995).
This essay has been edited for inclusion in the Reader.

Notes

1. Some MUDS such as Diku and Phoenix require players to select races. These MUDS are patterned after the role-playing game Dungeons and Dragons and unlike Lambda, which exists to provide a forum for social interaction and chatting, focus primarily on virtual combat and the accumulation of game points. The races available to players (orc, elf, dwarf, human, etc.) are familiar to readers of the 'sword and sorcery' genre of science fiction, and determine what sort of combat 'attributes' a player can exploit. The combat metaphor which is a part of this genre of role-playing reinforces the notion of racial difference.

2. Most players do not choose either spivak or neuter as their gender; perhaps because this type of choice is seen as a non-choice. Spivaks and neuters are often asked to 'set gender' by other players; they are seen as having deferred a choice rather than having made an unpopular one. Perhaps this is an example of the 'informatics of domination' which Haraway (1991) describes.

3. Computer users who were using their machines to play games at work realized that it was possible for their employers and co-workers to spy on them while walking nearby and notice that they were slacking – hence, they developed screen savers which, at a keystroke, can instantly cover their 'play' with a convincingly 'work-like' image, such as a spreadsheet or business letter.

4. Microsoft's recent television and print media advertising campaign markets access to both personal computing and networking by promoting these activities as a form of travel; the ads ask the prospective consumer, 'where do you want to go today?' Microsoft's promise to transport the user to new spaces where desire can be fulfilled is enticing in its very vagueness, offering an open-ended invitation for travel and novel experiences.

5. The political action group devoted to defending the right to free speech in cyberspace against governmental control calls itself 'The Electronic Frontier Foundation'; this is another example of the metaphorization of cyberspace as a colony to be defended against hostile takeovers.

References

Aker, S. et al. (1987–91) *Macintosh Bible* 3rd edition, Berkeley: Goldstein and Blair.

Butler, J. (1993) *Bodies that Matter: On the Discursive Limits of 'Sex'*, New York: Routledge.

Chesher, C. (1994) 'Colonizing virtual reality: construction of the discourse of virtual reality, 1984–1992', *Cultronix*, vol. 1, issue 1, Summer 1994. *The English Server*. On-line, 16 May 1995.

Elmer, D. P. (1994) 'Battle for the soul of the Internet', *Time*, 25 July.

Haraway, D. (1991) *Simians, Cyborgs, and Women*, New York: Routledge.

Penley, C. and Ross, R. (1991) *Technoculture*, Minneapolis: University of Minnesota Press.

Rheingold, H. (1993) *The Virtual Community*, New York: HarperPerennial. *The Well*. On-line, 16 May 1995.

Stone, A. R. (1994) 'Will the real body please stand up?: boundary stories about virtual cultures', in Michael Benedikt (ed.) *Cyberspace: First Steps*, Cambridge: MIT Press.

Said, E. (1987) Introduction. *Kim*, by Rudyard Kipling, New York: Penguin, pp. 7–46.

Chapter 47

JON STRATTON

CYBERSPACE AND THE
GLOBALIZATION OF CULTURE

I N HIS 1984 NOVEL *NEUROMANCER*, William Gibson introduces the
idea of 'cyberspace' to describe a fundamental transformation in human–machine
relations mediated by a massive interlinking web of computer networks. As Robert
Adrian puts it:

> In Gibson's *Neuromancer* the protagonist 'jacks in' to the net. He is not a
> user, he is not at the wheel of his datamobile speeding down the Infobahn
> – he simply disappears into the net and becomes a part of the data-flow.[1]

Gibson's imagery is saturated through with an anxiety over gender relations and the loss
of the body as a site of the construction of identity. The cowboys and jockeys who jack
into the network, or 'matrix', as Gibson calls it, are male. As its name suggests, the
matrix itself is female. It is simultaneously mother and lover. In the image, womb and
vagina are conflated and the male who disappears into the matrix, leaving his body
behind, succeeds in fulfilling the desire that, Freud argues, makes the woman's genitals
uncanny: he returns 'home'. The price of this fulfilment is the loss of the body. As we
shall see, repressed in this image is the recognition of the pleasures and anxieties that
are associated with the (relatively) new bodiless virtual identity of Internet users.

There is, however, another theme suppressed in this image of cyberspace as a
mother/lover. The matrix is a site of reproduction, but of what? The short answer is
capitalism, but it is more complicated than this. In the *Grundrisse*, Marx explains that
'Circulation time . . . appears as a barrier to the productivity of labour' and goes on:

> [capital] strives . . . to annihilate this space [of circulation] with time, i.e. to
> reduce to a minimum the time spent in motion from one place to another.
> The more developed the capital, therefore, the more extensive the market
> over which it circulates, which forms the spatial orbit of its circulation, the
> more does it strive simultaneously for an even greater extension of the market
> and for the greater annihilation of space by time.[2]

The alternative to decreasing circulation time is what Harvey has succinctly called 'the spatial fix'; in short, the expansion of the capitalist economic order to new geographical spaces in order to find raw materials, new, cheap sources of labour and new markets.[3] Cyberspace, I want to suggest, did not simply appear fully formed at a point in the second half of the 1980s. Rather, it has its origins in nineteenth-century attempts to speed up circulation time, and has taken on a new importance with the globalization of consumption-oriented capitalism and the ending of the possibility of the spatial fix.

The most fruitful place to look for a beginning to cyberspace is with the invention of the telegraph in the first half of the nineteenth century. In what has become a celebrated insight, James Carey has noted that, 'The simplest and most important point about the telegraph is that it marked the decisive separation of "transportation" and "communication"'.[4] It is, I would argue, not the introduction of computers that marks the beginning of the production of cyberspace, but the increase in the speed of communication over distance to a point where the time taken for a message to traverse that distance reduces to a period experienced by the receiver, and sender, as negligible. In metaphorical terms, we could say that as the time taken to cross the geographical space decreases, that space is decontextualized and replaced by a distinctly non-geographical hyperspace. In such a space, as Carey explains, 'symbols move independently of geography and independently of and faster than transport'[5] – precisely the precondition, in other words, for the reification of information we have come to take for granted in the computer age.

There is one more aspect of the introduction of the telegraph which we need to explore here. Carey argues that:

> The effect of the telegraph is a simple one: it evens out markets in space. The telegraph puts everyone in the same place for purposes of trade; it makes geography irrelevant. The telegraph brings the conditions of supply and demand in all markets to bear on the determination of a price. Except for the marginal exception here and there, it eliminates opportunities for arbitrage by realizing the classical assumption of perfect information.[6]

Here Carey is thinking of the telegraph in the service of capitalist exchange. If, as Marx argues, money is a universal solvent, because it enables the exchange value of all commodities to be compared when they have been priced, so the telegraph begins the process of dissolving all markets into one hypermarket, because information in all local markets can be communicated to all other local markets. Where arbitrage is an effect of the inability to transfer information across geographical space, the instantaneous media of communication produce a homogenized hypermarket in hyperspace.

This hyperspatial market is ideal for dealing in money itself – as money, too, has become reified into a commodity during the second half of the twentieth century, especially since the early 1970s. This process is materially associated with the global movement away from the gold standard, but it is most clearly expressed in the increasing importance of finance capital. This money is not tied directly to production and is used to make more money by playing the (world) stock exchanges, gambling on exchange rate shifts or seeking-out high interest rates. Harvey describes the new situation like this:

> What does seem special about the period since 1972 is the extraordinary efflorescence and transformation in finance markets. There have been phases

of capitalist history – from 1890 to 1929 for example – when finance capital (however defined) seemed to occupy a position of paramount importance within capitalism, only to lose that position in the speculative crashes that followed. In the present phase, however, it is not so much the concentration of power in financial institutions that matters, as the explosion in new financial instruments and markets, coupled with the rise of highly sophisticated systems of financial co-ordination on a global scale.[7]

What has enabled these highly sophisticated global systems to flourish has been the development of increasingly complex computers and their coupling with an automated and digitalized telecommunications system linking points not only nationally but internationally. The reification of money, like that of information, leads us back to the reconstitution of communication media as transport systems. These new commodities are being transported through a hyperspace in which distance does not exist, and place and extension are replaced by pure movement.

Where geographical space was colonized and transformed into a site of production (and consumption) within the capitalist exchange system, hyperspace is, itself, a product of communication technologies developed in the context of capitalism. The terrain of cyberspace is fundamentally deterritorialized. In *Anti-Oedipus*, Gilles Deleuze and Felix Guattari have constructed a history of place that describes how capitalism deterritorializes and reterritorializes. Robert Young has usefully summed up this part of their argument:

> The reduction of everything, including production and labour, to the abstract value of money enables [capitalism] to decode flows and 'deterritorialize' the socius. Having achieved a universal form of exchange, it then reterritorializes – 'institutes or restores all sorts of residual and artificial, imaginary, or symbolic territorialities' such as states, nations or families.[8]

Young goes on to quote from *Anti-Oedipus*:

> There is a two-fold movement of decoding or deterritorializing flows on the one hand, and their violent and artificial reterritorialization on the other. The more the capitalist machine deterritorializes, decoding and axiomatizing flows in order to extract surplus values from them, the more its ancillary apparatuses, such as government bureaucracies and the forces of law and order, do their utmost to reterritorialize, absorbing in the process a larger and larger share of surplus value.[9]

Young points out that this description not only fits the 'Western' history of industrialization, but also the 'Western' process of colonization. Capitalist exchange produces a new organization of space, one bound together by exchange and organized according to a perspectival and panoptic understanding. As Jean Baudrillard has noted, 'We are witnessing the end of perspective and panoptic space (which remains a moral hypothesis bound up with every classical analysis of the "objective" essence of power), and hence the *very abolition of the spectacular*'.[10] Although announcing the end of the world of spectacle is hyperbole, nevertheless, as we shall see, the attempt to reconceptualize cyberspace as an information superhighway evidences a nostalgia for linkages between capital, communication media and the nation-state. The equivalence between a democracy of

citizen voters and a 'passive' mass audience which operates in modern democratic nation-states as a consequence of the rise of traditional mass media is broken down in the proliferating interactivity of the Internet.

The opening up of cyberspace begins a new movement of hyper-deterritorialization, this time within the exchange system of capitalism. From this point of view the Internet, the day-to-day expression of cyberspace, might best be understood as a vector in McKenzie Wark's sense of the term:

> Both capital and the military command space with vectors – technologies that traverse and thereby abstract space and time from the specificities of locality, culture, terrain and tradition. It is no accident that accelerated development of the vector is synonymous with modernity, and has been jointly sponsored by military and corporate interests.[11]

Within the post-Second World War history of economic internationalization, this new form of electronic hyper-deterritorialization can be read as a further spatial fix to capitalism's globalization. As Arjun Appadurai argues, 'The new global cultural economy has to be understood as a complex, disjunctive order, which cannot any longer be understood in terms of existing center-periphery models (even those that might account for multiple centers and peripheries)'.[12] Appadurai's point is that global capitalism needs to be thought of in terms of flows rather than binary positionalities. He proposes a framework which identifies five dimensions of the 'global cultural flow' – ethnoscapes, mediascapes, technoscapes, finanscapes and ideoscapes. He argues, using the same term as Deleuze and Guattari but in a different way, that these flows drive an increasing deterritorialization of people, images, commodities, money and ideas, or what I have been calling hyper-deterritorialization. While recognizing the crucial limits on connection to the Internet – out of an estimated 30 million users in 1994, roughly 25 million are American, and all require access to a computer, a phone line and a provider – it is, nevertheless, a significant vector in the reinforcement of the global flows which Appadurai describes.

Appadurai's centre-periphery metaphor expresses well the global order which developed from the seventeenth-century spread of colonialism. It opposes a Euro-American core made up, ultimately, of 'developed' modern nation-states with a periphery of the rest of the world whose relation to the 'West' is primarily as a source of surplus value. The concept of the nation-state has been one of the most successful of the exports of 'Western' modernity. Important to centre-periphery models is the idea of emplaced relations, relations which were, in fact, focused in and through the nation-state. Appadurai has signalled how these relations have been transformed:

> The globalization of culture is not the same as its homogenization, but globalization involves the use of a variety of instruments of homogenization (armaments, advertising techniques, language hegemonies, clothing styles and the like), which are absorbed into local political and cultural economies, only to be repatriated as heterogeneous dialogues of national sovereignty, free enterprise, fundamentalism, etc. in which the state plays an increasingly delicate role: too much openness to global flows and the nation-state is threatened by revolt – the China syndrome; too little, and the state exits the national stage, as Burma, Albania and North Korea, in various ways have done.[13]

The reorganization of global capitalism, which is expressed through the change in metaphor, has altered the experience of the nation-state. The world which was organized along centre-periphery lines was dominated by space, in particular a geographical space organized into nation-states and their colonial adjuncts.

Global flows are a consequence of the capitalist dynamics of nation-states but, at the same time, place the old spatial verities of the nation-state under pressure. Nowhere is this more obvious than in the Internet. The instantaneity of communication with the telegraph and the telephone helped to bind the nation-state together for two reasons. First, they were used within the context of the homogenizing ideology of the nation-state. This process was reinforced by the use the state made of these technologies in its bureaucratic and administrative systems, both in direct relation to the citizenry and in the increased centralization of power they allowed over the forces of control – the armed forces and the police. Second, they were used primarily within the nation-state. However, by the 1970s the new telecommunications technologies – including, for example, the use of satellites – made international telephone calls easier to make, cheaper and, above all for the citizen user, clearer. Reworking Carey's point, Wark comments that, 'Together with the railroad, the vectors of the telegraph and telephone largely created the possibility of extensive interstate communications'.[14] Carey notes that, 'In a sense the railroad and the canal regionalized markets; the telegraph nationalized them'.[15] In this way these technologies pursued one of the main themes of the modern nation-state, the movement towards internal homogenization. The user's perception of hyperspace as a static, emplaced space is a function of the instantaneity of communication. In the vectorial space of the Internet the special quality of both information and money – that unlike other commodities they have no use value in their own right but only as items of exchange – is naturalized. More and more it became the case that talking to someone 'on the other side of the world', most importantly for this argument in another nation-state, sounded just as if they were 'just down the road'.

Nation-states seek to homogenize and define themselves as different from other nation-states. In the last instance this difference is defined spatially, expressed in the material and cultural environment within the nation-state's borders and delimited by those borders. The separation of communication from transport meant that, when the new communication media were used internationally, people's sense of the nation-state as expressed in a distinctive geographical spatiality diminished. From this perspective, the hyperspace of the Internet elides the geographical spatial formations of nation-states which underpin their claims to a national culture. It is for this general reason that many nation-states, such as Japan and Singapore, have been hesitant about enabling their citizens to connect to the Internet at all.[16] While most nation-states were prepared to tolerate the lack of control over the one-to-one interaction of international telephone calls – except, maybe, in times of internal revolt – the Internet offers a qualitative increase in communicative possibilities. It is therefore logical that those nation-states whose citizens at present dominate the Internet will tend to feel less threatened by the technology, while conversely, those which sense that such dominance threatens their own cultural integrity will show a more hostile reaction. This would be a consequence not only of the prevalence of English and the use of the Roman alphabet, but also of the kinds of information available and the culturally specific modes of interaction which predominate in cyberspace: the very rhetoric, for example, of freedom, censorship and human rights which are central to discussion of these issues.

American dominance in the direction of the global flow in the Internet, however, need not necessarily continue. Here, indeed, lies an irony – for what Marx would have described as a contradiction in capitalism. At present the US is taking the lead in the construction of a 'global information infrastructure' (GII), a project which has taken on the aura of a humanitarian mission. In a 1994 address in Kyoto, Japan, American Vice President Al Gore said:

> The effort to build the GII provides us with an opportunity to reach beyond ideology to forge a common goal of providing an infrastructure that will benefit all the citizens of our nations. We will use this infrastructure to help our respective economies and to promote health, education, environmental protection and democracy.[17]

Sandwiching health, education and the environment is, significantly, the dual emphasis on economic and political goals. Gore no doubt intends that the 'freedom' of information access offered by the Internet will correlate with a movement within authoritarian nation-states towards democracy. The US, in other words, is promoting and underwriting the GII for its own economic – and ideological – advantage, but as more non-Americans and non-English speakers come on-line the American hegemony over the use of the Internet will become harder to sustain.

The connection between the economic order and the Internet is reinforced in the five principles that the International Telecommunication Union has adopted for a GII: 'Private investment. Market-driven competition. Flexible regulatory systems. Non-discriminatory access. And universal service'.[18] The first three of these principles emphasize a capitalist form for the building, ownership and running of the GII, including what it is used for. The last two are about audience. The idea – or, given its utopian quality, the ideal – is to constitute the entire global population as an audience. In order to understand fully what is being promoted here we need to remember Gore's rhetorical shift from talking about the Internet to the Information Superhighway. Making this connection, we can see that the building of the GII provides the basis for a global interactive commodity-delivery system for vastly expanded media companies.

How, precisely, is this marketer's dream to be achieved? Wark describes how, in military and corporate terms, 'ever faster, cheaper, more flexible and higher bandwidth vectors arm those who have access to them with strategic advantages'.[19] Adrian, noting the limited prospects for the growth of value-added services for the telephone, also sees the answer in increased bandwidth:

> Increased bandwidth allows telephone space to be appropriated for commercial propaganda; occupied by infotainment commodities; turned into a shopping mall. . . . What these corporations really want is interactive cable TV – with the interactivity restricted to on-line shopping, video games and pay-to-view movies with the telephone thrown in as a give-away because it requires almost no space on the cable. The Infobahn in this definition is little more than a catalogue of products, services, information and entertainment that can be ordered or purchased and consumed on-line.[20]

The point here is in the recognition that the corporations would like, ideally, to limit interactivity. The extraordinary thing about the telephone, as compared to radio and television, is that it did not develop as a mass communication medium. It is non-centralized

and interactive. Based on the same telecommunications technology, the Internet offers the one-to-one interaction of email or 'talk' as well as a wide variety of one-to-many inter-actions from Usenet to LISTSERV lists and the instantaneous multiple interaction of IRC. All this in contrast to the functional complicity in the way radio and television techno-logies developed with the organization of the modern nation-state.

In a now justly celebrated image, Benedict Anderson has described the nation as an imagined community.[21] His idea is that a sense of nationhood is produced out of the sharing of a range of myths and knowledge. He argues that the newspaper started as one means through which such sharing could take place. Writing about South America, Anderson describes the gazette, which he views as the antecedent to the newspaper, as containing:

> aside from news about the metropole – commercial news (when ships would arrive and depart, what prices were current for what commodities in what ports), as well as colonial political appointments, marriages of the wealthy and so forth. In other words, what brought together, on the same page, *this* marriage with *that* ship, *this* price with *that* bishop, was the very structure of the colonial administration and market system itself. In this way, the news-paper of Caracas quite naturally, and even apolitically, created an imagined community among a specific assemblage of fellow-readers, to whom these ships, brides, bishops, and prices belonged.

As the 'news' aspect of the newspaper developed, Anderson points out how 'the very conception of the newspaper implies the refraction of even "world events" into a specific imagined world of vernacular readers'.[22] In this connection between the 'invention' of the newspaper and the rise of the nation-state we find two other developments: the formation of a modern public sphere, and the formation of the mass audience.

In his influential discussion of the rise of the modern public sphere, Jürgen Habermas argues that it evolved as a bourgeois development that took place in the context of the spread of the capitalist market. He views it as a key component in the functioning of democracy, suggesting that 'the public sphere as a functional element in the political realm was given the normative status of an organ for the self-articulation of civil society with a state authority corresponding to its needs'.[23] Based in print culture and espe-cially that of newspapers, the public sphere, for Habermas, is the site of the political debate central to democratic society. Newspapers, in this view, serve primarily to stim-ulate and aid informed debate. There is another side, however, to their role. As we have seen, Anderson argues that newspapers help to produce the imagined community of the nation-state by imparting information to an audience. The point here is that, like the later mass media of radio and television, newspapers are not interactive. Their production of a national imagined community takes place through the construction of a silenced mass audience. John Hartley, taking this approach a step further, emphasizes this somewhat more cynical view of the mass media's role in the construction of the public sphere. Comparing the modern situation with that of ancient Greece and Rome, Hartley writes,

> nowadays there is no physical public domain, and politics is not 'of the popu-lace.' Contemporary politics are *representative* in both senses of the term; citizens are represented by a chosen few, and politics is represented to the

public via the various media of communication. Representative political space is literally made of pictures – they *constitute* the public domain.[24]

There is no need to limit the constitution of the public sphere to pictures. It includes both print (as in newspapers) and voice (as in radio). In order to understand how this has come about, Hartley goes back to the first attempt to theorize a modern political state, that of Thomas Hobbes in *Leviathan* (1651), and shows how, when

> Leviathan is given life by completely taking over the powers of those repre-sented, leaving nothing behind. . . . [a]ny henceforth exercised by civil subjects (private individuals) are those that Leviathan 'authorizes' or devolves back onto them. In short, the public transfers its sovereign powers to Leviathan, and Leviathan is thence *author* of the public.

Now, 'the strong state, Leviathan, which has often been equated with *absolute monarchy*, becomes the polity under which *democracy* is possible. This is because political *participa-tion* has transformed into *representation* on the abolition of the public'.[25] The public, in other words, has been transformed into an audience.

Ien Ang, in discussing the discursive construction of the mass television audience, distinguishes between two basic audience constructs reflecting the division of television into commercial and public service forms, namely, audience-as-market and audience-as-public. Though they differ in substantial ways, 'both kinds of institution,' she notes, 'inevitably foster an instrumental view of the audience as an object to be conquered . . . in both cases the audience is structurally placed at the receiving end of a linear, one-way process'.[26] This overarching discursive construct of the audience forms it as attentive, massified and passive. While Ang is writing about television in particular, the understanding of the audience that she elaborates is a general characteristic of the public sphere in the modern nation-state.

Anderson describes how the creation of a nation depends, in large part, on the construction of its members as an audience who can be transformed into an imagined community. Hartley shows a similar process in operation with the democratic state. Whereas for Habermas there is a discontinuity between the roles of newspapers and of the new audio and visual mass media, the latter corresponding to a degradation of the public sphere, Hartley sees these media as continuing the same process of which the newspaper has always been a part. Following Hartley's argument, we are now in a posi-tion to understand why radio and television developed as centralized communication delivery systems. In short, the nation-state's imagined community, its public sphere and its audience are, ideally, coterminous. In this context, the generalized interactivity of the Internet, along with the ability of anyone with access to put forward their own views in any of a range of forums, poses a threat to the distinction between public information – epitomized in the notion of journalistic objectivity – and personal opinion, a distinction central to the formation of the imagined community of the democratic nation-state.

Over the last few years, however, there have been two tendencies in media devel-opment that have begun to restructure the mass media/audience formation. The first is the move to multiple channels made possible by the spread of cable television. This has led to narrow-casting and to a general problematization of the category of the 'mass media'. The second is the move towards greater interactivity. This ranges from the use

of VCRs to pay-per-view and, eventually, the ability to order the programmes one wants to watch. In terms of both these developments the Internet marks a qualitative shift. In the case of the Internet the passive media audience described by Ang becomes (inter)active, participating fully in the production of the media product. It is the attempt to 'reform' the Internet into yet another mass media delivery system which is at the heart of the rhetorical shift towards the notion of an 'Information Superhighway'. Where the traditional mass media audience consumes images, the scarcely veiled aim of the Information Superhighway is to transform the passive, receiving audience of the mass media into an active, consuming audience, now consuming, however, not just images but also – for a fee – the entire range of commercial goods and services which are becoming available on-line.

In *The Practice of Everyday Life*, his radical account of the active role citizen populations play in the production of an everyday life apparently determined by the material and disciplinary expressions of the nation-state, Michel de Certeau claims, 'Marginality is today no longer limited to minority groups, but is rather massive and pervasive'. He goes on to assert that, 'Marginality is becoming universal. A marginal group has now become a silent majority'.[27] What he is describing is the very success of the processes described by Anderson, Hartley and Ang, a success threatened by the demassification and interactivity, here to be understood as the 'public' speaking out by those previously silenced by the mass media, that is central to the access structure of the Internet in its current form. When minority, silenced groups, such as the Chiapas Amerindians in Mexico can speak out on the Internet and when anybody can voice their opinions on a newsgroup, not only the organization of the media and the construct of the audience, but also the formation of a unified and distinct imagined community – a disciplined and disciplinary public sphere – and the very understanding of the nation-state itself are transformed. The Internet is one more vector in the global flows that have shifted nation-state rhetoric from homogeneity to multiculturalism, and nation-state politics from a class basis to an interest basis. We can now appreciate that there is a second reason, of necessity deeply imbricated with the first, for Gore's concern to shift the rhetoric – and the material form – of the Internet towards the Information Superhighway. In addition to economic considerations, the latter would reconstitute the Internet as something much more approaching the modern mass media, and as such would be less threatening to the established form of the nation-state.

We must distinguish carefully between the idea of a radically new public sphere in which the old 'audience' can be active in the presentation of their views and the idea of community. Particularly in American discussions of the Internet there is a tendency for these two concepts to merge. At its most basic the modern idea of a public sphere depends on a distinction between private and public life. The public sphere, the realm of public life, has been, in the modern world, the space of shared knowledge and of politics. Anderson and Hartley would agree that the traditional mix of information in newspapers expresses well the form of the modern public sphere that has been developing since the eighteenth century.[28]

Previously I have suggested that the citizen-audience is silenced in the modern public sphere. The situation is actually a little more complicated. From the eighteenth-century coffee houses of London to today's discussions during office teabreaks there is consideration of issues. However, this consideration is limited to the information presented by the mass media, and the structure of the media-audience relation allows almost no

response or other opportunity for expression within the organization of the media beyond letters to the editor and talk radio. As we have seen, the suggestion is that the Internet provides a new forum where the audience can express itself. In his article 'Old freedoms and new technologies: the evolution of community networking', Jay Weston is very clear about this potential:

> The Internet is mostly about people finding their voice, speaking for themselves in a public way, and the content that carries this relationship is of separate, even secondary, importance. . . . Mass media do not confirm [personal] existence, and cannot. The market audience exists, but the reader, listener or viewer does not.[29]

As the title of this article indicates, Weston believes that the citizen's ability to speak out in the public sphere is an 'old freedom' which has been limited by the development of the mass media. My point has been that this is not an old freedom at all, but that, in fact, democracy as it exists in the modern state is built on the illusion that freedom exists.

The discourse of community appears to coincide with that of the modern public sphere in the notion of interactive communication – people talking to one another. But in the modern West, 'community' carries an additional nostalgic connotation. It refers to a mythic understanding of the essential 'sharedness' of a way of life before the fragmentation of interpersonal interaction and the loss of a taken-for-granted moral order brought about by the founding modern changes – secularization, urbanization, capitalism, industrialization and, of course, the emergence of the nation-state.

As I have remarked before, there are, as yet, no American complaints about the Internet's threat to American culture; the naïve perception, and one hidden in Gore's pronouncements about the GII, is that American ideology, founded on European Enlightenment values, will form the homogenizing basis for the Internet community. These values, such as human rights, individualism and democracy, go hand-in-hand with Gore's other concern, the spread of capitalism. The determination to transform the Internet into the Information Superhighway would counter the 'problems' of minority access, by returning to the modern mass media relation, metamorphosing the current access to public speaking into a limited, interactive choice among different purchasable commodities and, in the process, slowing down the reconstitution of the nation-state. In the end, however, it will remain to be seen whether the American capitalist dominance of hyperspace will continue, or whether more space can be produced in which other languages, other cultures, and non-economic concerns can all have a space.

Originally published in D. Porter (ed.) (1997) *Internet Culture*, London: Routledge.
This essay has been edited for inclusion in the Reader.

Notes

1. Robert Adrian, 'Infobahn blues', *CTHEORY*, article 21 (1995). Available by contacting ctheory@concordia.ca; William Gibson, *Neuromancer* (New York: Ace Books, 1984).
2. Karl Marx, *Grundrisse*, (London: New Left Review, 1973), p. 539.
3. David Harvey, *The Limits to Capital* (Oxford: Basil Blackwell, 1982).
4. James Carey, *Communication as Culture: Essays on Media and Society* (Boston: Unwin Hyman, 1988), p. 213.

5. Ibid., p. 213.
6. Ibid., p. 217.
7. David Harvey, *The Condition of Postmodernity: An Enquiry into the Origins of Cultural Change* (Oxford: Basil Blackwell, 1989), pp. 192–4.
8. Robert Young, *Colonial Desire: Hybridity in Theory, Culture and Race* (London: Routledge, 1995), p. 169.
9. Gilles Deleuze and Felix Guattari, *Anti-Oedipus: Capitalism and Schizophrenia* (London: Athlone, 1984), pp. 34–5.
10. Jean Baudrillard, *Simulations* (New York: Semiotexte, 1983), p. 54.
11. McKenzie Wark, 'What does capital want? corporate desire and the Infobahn fantasy', *Media Information Australia* 74 (November 1994), 18. In *The Virtual Community. Homesteading on the Electronic Frontier* (Reading, Mass.: Addison-Wesley, 1993). Howard Rheingold provides a technological history of the Internet locating it as an outgrowth of the US Department of Defence Advanced Research Project Agency during the 1960s and 1970s (67).
12. Arjun Appadurai, 'Difference in the global cultural economy', in Mike Featherstone (ed.) *Global Culture: Nationalism, Globalization and Modernity* (London: Sage, 1990), p. 296.
13. Ibid., p. 307.
14. Wark, 'What does capital want', p. 19.
15. Carey, *Communication as Culture*, p. 217.
16. In Japan the concern seems to have been that the Internet would increase foreign influences on Japanese culture. In 'Wiring Japan', *Wired* 2.2 (February 1994), pp. 38–42, Bob Johnstone describes Japan's tardiness in connecting to the Internet as the effect of a 'head-on collision of two cultures: the freewheeling, democratic style of the Internet has run smack into traditional Japan at its most authoritarian'. In Singapore, after much initial official hesitation, the population is now being encouraged to access the Internet as a part of Singapore's modernization drive. At the same time, there remains some concern over the effects on 'Asian' morality of 'Western' depravity.
17. Remarks (as delivered) by Vice President Al Gore via satellite to the International Telecommunication Union Plenipotentiary Conference Kyoto, Japan; 22 September 1994. Taken, here, from the LISTSERV CPSR-GLOBAL.
18. Ibid.
19. Wark, 'What does capital want', p. 18.
20. Adrian, 'Infobahn blues'.
21. Benedict Anderson, *Imagined Communities: Reflections on the Origin and Spread of Nationalism* (London: Verso, 1983).
22. Ibid., pp. 62–3.
23. Jürgen Habermas, *The Structural Transformation of the Public Sphere: An Inquiry into a Category of Bourgeois Society* (Cambridge, Mass.: MIT Press, 1989): p. 74.
24. John Hartley, *The Politics of Pictures: The Creation of the Public in the Age of Popular Media* (London: Routledge, 1992), p. 35.
25. Ibid., pp. 124–5.
26. Ien Ang, *Desperately Seeking the Audience* (London: Routledge, 1990), pp. 31–2.
27. Michel de Certeau, *The Practice of Everyday Life* (Berkeley: University of California Press, 1984), p. xvii.
28. See, for example, Richard Sennett, *The Fall of Public Man* (Cambridge: Cambridge University Press, 1977).
29. Jay Weston, 'Old freedoms and new technologies: the evolution of community networking', electronically published in cyberjournal@Sunnyside.Com, 22 December 1994.

ZIAUDDIN SARDAR

ALT.CIVILIZATIONS.FAQ
Cyberspace as the darker side of the west

RICHARD PEPIN'S *HOLOGRAM MAN* IS a third-grade film with a first-class insight into Western psychosis. It exhibits and plays with all that Western man desires, all that lies buried deep in his consciousness and all that is steaming his restless soul. The story is one-dimensional. A rookie cop, Decoda, arrests a psychotic terrorist, Slash Gallagher, after a bloody encounter. In his own evil way, Slash just wants the world to be a better place and free of the Corporation that rules it; and in his own legal way, Decoda too just wants the world to be a better place and doesn't really care for the Corporation that sustains him. Slash is sentenced to the worst form of imprisonment that the future can offer: holographic stasis. His body is turned into a hologram, while his brain and soul are stored in a computer to be reprogrammed. Slash's multicultural gang (this is a politically correct film) manage to free their leader, hacking his mind and soul out of the computer, but his body is destroyed in the attempt. Slash pours an artificial skin on himself and walks the earth as an electromagnetic hologram: walking through walls, changing his physical identity at will, a mind, a soul, free from the limitations of physical existence he is invincible, a man turned into god by virtual reality. As is usual with such narratives, Decoda too turns into a hologram to defeat and capture his foe. Even though he is not as strong as Slash, Decoda is smarter. In the final encounter, Decoda not only kills Slash but also takes care of the equally evil chairman of the Corporation.

The tone of *Hologram Man* is set within the first ten minutes of the film: grand spectacle wrapped in grotesque violence and graphic sex. Its origins in computer games like *Doom 21* and *Mortal Kombat* are evident, as is its love affair with digital technology, which played no small part in its production, and virtual reality. Such combinations of violence, advanced technology and sex are not only used to sell films and video games (they are the *raison d'être* of *Hologram Man* and numerous other similar films like *Digital Man*, *Brain Scan*, *Videodrome* and *Lawnmower Man*), they also come in rather useful in shaping civilizations. Violence, advanced technology and sex have been the containers – vats – within

which the West has existed for much of the second half of the millennium. In the normal course of events, the West has used these barrels to capture non-Western civilizations and cultures and then projected its own darker side on to them, portraying and describing – and therefore containing – them in terms of violence, sex and primitive technology. At the end of the second millennium, however, the standard grand narrative appears to be going through a new and interesting twist: the darker side of the West is bouncing back on itself. The very materials with which the West painted all Other civilizations is now acquiring a life of its own and is threatening to recast the projected image as well as the self-perception of the West. As the body of Western civilization gradually dissolves into digital technology, it is slowly being replaced, just like those of Slash and Decoda in *Hologram Man*, with a transparent virtual skin that reveals the true darkness that lies underneath: in the mind and soul of the West. Decoda and Slash are the two Janus-like faces of Western civilization: one, the projected innocence, standard-bearer of civilization, the enforcer of universal law and morals; the other, pathologically untamed, the psychotic inner reality. To look at the inner reality of the West, the darker side it projects on to Other cultural and mental landscapes, we must look at the West's latest conquest, the new domain that it has colonized: cyberspace.

The allure of the Colon

Western civilization has always been obsessed with new territories to conquer. The narratives of these conquests, on the whole, have followed a basic linear pattern. The hunger for new conquests stems from the insatiable desire to acquire new wealth and riches which in turn provides impetus for the development of new technologies of subjugation which are then employed to bring new territories under the servitude of the West. Once a new territory has been colonized, it is handed over to business interests to loot; and the worst elements of the West are posted there to administer and civilize the natives. The natives themselves are rendered non-people by framing them with the images of all that the West fears about itself. Cristobal Colon's (aka Columbus) voyage to the 'New World', for example, was a product of the quest for wealth and riches, what in contemporary parlance we would call 'new markets'. Colon and those who followed him, adventurers and perverts, rampaged what they discovered and butchered the natives they encountered. The West's conquest and colonization of the Muslim world was motivated by its image of the Orient where unfathomable riches existed and cruel and barbaric scenes were staged. Once colonized, Islam was projected as evil and depraved, licentious and barbaric, ignorant and stupid, monstrous and ugly, fanatic and violent: the very traits of those who went to the Muslim world to rule it, civilize it, and strip it of its wealth and power. The English and Dutch East India Companies went to India and Indonesia looking for new markets and, with the aid of advanced military technology, enslaved their cultures and turned these countries into gold mines for the homeland. The conquest of the American West was spurred by the Gold Rush, the desire of the settlers for absolute freedom, and ended with the almost total annihilation of the native Americans. When the West ran out of physical landscapes to conquer, it moved into mental territories. Colonization paved the way for modernity. During the second half of this century, modernity relentlessly conquered almost every culture and every mind. Under colonization, the basic weapon was the brute force of military

technology; modernity combines military technology with communication technology, Western cultural products and instrumental rationality. The 'civilizing mission' gives way to 'progress' and 'modernization' and produces the same effect: cultures are decimated, bulldozed, 'globalized' with barbaric abandon. When mental and cultural territories are exhausted, the West moves on to conquer the reality of Other people. The end of modernity ushers in the all-embracing totality of postmodernism. In Other peoples' reality, Other ways of knowing and being, Other identities, postmodernism has discovered new spaces to conquer and subdue. Here 'progress', 'modernization' and instrumental rationality are replaced with relativism, real human beings are filtered through electronic screens to render them into virtual images – all the better to exploit them and butcher them without feeling real emotions.[1] Virtual persons bleed virtual blood – just like so many computer games, including that simulation of the real thing, 'War in the Gulf'.[2]

Beyond postmodernism's subjugation of the realities, modes of knowing and actual being of Other cultures, the West urgently needs new spaces to conquer. The moon and the inner planets are ruled out for the time being given the cost of colonizing them. The outer space is a domain best left, for the time being, to Star Trek. For the conquest to continue unabated, new terrestrial territories have to be found; and where they don't actually exist, they must be created. Enter, cyberspace.

Like most new technologies, cyberspace did not appear, to use the words of Chris Chesher, 'from nowhere as a mystical spark of inspiration from the mind of one individual'.[3] It is a conscious reflection of the deepest desires, aspirations, experiential yearning and spiritual Angst of Western man. It is resolutely being designed as a new market and it is an emphatic product of the culture, world-view and technology of Western civilization. That it is a 'new frontier', a 'new continent', being reclaimed from some unknown wilderness by heroic figures not unlike Cristobal Colon, is quite evident from how the conquest of cyberspace is described by many of its champions. Analogies to colonization abound. The September 1990 edition of the cyberpunk magazine, Mondo 2000, carries the cover line: 'The Rush Is On! Colonizing Cyberspace'.[4] Ivan Pope, editor of the British cyberspace magazine 3W, describes it as 'one of those mythical places, like the American West or the African Interior, that excites the passions of explorers and carpetbaggers in equal measures'.[5] Howard Rheingold, a guru of the movement, describes his own flirtations with cyberspace as 'my own odyssey to the outposts of a new scientific frontier . . . and an advanced glimpse of a possible new world in which reality itself might become a manufactured and metered commodity'.[6] Many computer games, like Super Mario Brothers, Civilization, Death Gate, Merchant Colony and Big Red Adventure are little more than updated versions of the great European voyages of discovery. These are not just games but worlds, constructed Western utopias, where all history can be revised and rewritten, all non-Western people forgotten, in the whirl of the spectacle. It is hardly surprising that Mary Fuller and Henry Jenkins have found direct parallels between many Nintendo games and New World documents like Columbus' Diario (1492–93), Walter Raleigh's Discoveries of the Large, Rich and Beautiful Empire of Guiana (1596) and John Smith's True Relation of Such Occurrences and Accidents of Noate as Hath Hapned in Virginia (1608). The theme is reflected in more serious documents. 'Cyberspace and the American dream: A Magna Carta for the Knowledge Age', a document that 'represents the cumulative wisdom and innovation of many dozens of people' including Alvin Toffler, prepared for the right-wing The Progress and Freedom

Foundation, states that 'the bioelectronic frontier is an appropriate metaphor for what is happening in cyberspace, calling in mind as it does the spirit of invention and discovery that led the ancient mariners to explore the world, generations of pioneers to tame the American continent and, more recently, to man's first exploration of outer space'.[7] We are not told what the voyages of discovery did to the indigenous populations; nor that they were motivated as much by greed as the so-called 'spirit of adventure'.[8] Unlike the original Magna Carta, which concerned itself with mundane political and civil liberties granted by King John at Runnymede on 15 June 1215, 'A Magna Carta for the Knowledge Age' places cyberspace at the zenith of civilization: it represents 'civilization's truest, highest calling' and would lead to unparalleled 'demassification, customization, individuality, freedom', providing the main form of 'glue holding together an increasingly free and diverse society'.

Cyberspace, then, is the 'American dream' writ large; it marks the dawn of a new 'American civilization'. White man's burden shifts from its moral obligation to civilize, democratize, urbanize and colonize non-Western cultures, to the colonization of cyberspace. Those engaged in constructing the new cybercivilization often see their heroic efforts in terms of 'a moral responsibility to fulfil an historic destiny, comparing themselves with historical precedents, like the original White colonizers of North America'.[9]

The 'frontier' was, of course, an invented concept which recapitulated an experience that had already passed. The frontier exists in the mind, it operates as a myth only after the process of control has been established. The fate of the American West was already determined before the idea of the frontier could be effective as the means for its dominated integration within the praxis of American citizenry.[10] As an idea, the frontier is a tool of domination that arises from the certainty that one already has total control. As an instrument, the function of the frontier is to pass the routine practice of domination into the hands of the populace, to give them the illusion of freedom while they merely act out the actual effective control that is already predetermined, scrutinized and seen to be good by those with power. The frontier is the agency through which power élites get everyone to do their work while thinking they are acting on their own volition. Cyberspace frontier is no different. It has already been controlled; the populace are now being motivated to explore and settle in the new frontier. The ideologically constructed anarchy of cyberspace reflects the drive of the early settlers who colonized the territory like free agents, but only as the free agents of the evolving concept of a particular civilization. What the frontier gives is the liberty to indulge licence within the brief of the civilizational stage directions, 'to do', as John Wayne apocryphally termed it, 'what a man's got to do'. What such men did turned out to be only what was in the self-interest of the civilization they represented, and what characterized the doing was brutality to Others.

What the cyberspace 'frontier' is doing as a first step is rewriting history: an exercise in catharsis to release the guilt of wiping out numerous indigenous cultures from the face of the earth, the colonization of two-thirds of the world and the continuous degradation of life in the Third World that the West has engendered. Why else have these colonial metaphors of discovery been adopted by champions of cyberspace – particularly, as Mary Fuller and Henry Jenkins note, when these

> metaphors are undergoing sustained critique in other areas of the culture, a critique that hardly anyone can be unaware of in the year after the quincentenary of Columbus's first American landfall. When John Barlow (1990)

writes that 'Columbus was probably the last person to behold so much usable and unclaimed real estate (or unreal estate) as these cybernauts have discovered' (p. 37), the comparison to cyberspace drains out the materiality of the place Columbus discovered, and the nonvirtual bodies of the pre-Columbian inhabitants who did, in fact, claim it, however unsuccessfully. I would speculate that part of the drive behind the rhetoric of virtual reality as a New World or new frontier is the desire to recreate the Renaissance encounter with America without guilt: this time, if there are others present, they really won't be human (in the case of Nintendo characters), or if they are, they will be other players like ourselves, whose bodies are not jeopardized by the virtual weapons we wield.[11]

But, of course, cyberspace does have real victims. The rewriting of colonial history has a direct impact on the lives of those whose history is being denied and whose historic identity is distorted. It leads to blaming the victims for the misery of their current reality. If Colon, Drake and other swashbuckling heroes of Western civilization were no worse than pioneers of cyberspace, then they must have been a good thing; and colonized people should be thankful for the civilization and new technology they brought and the new markets they opened up! Western revisionist writers and thinkers never tire of making such claims, as William A. Henry III's reinterpretation of American history in his *In Defense of Elitism* illustrates so well.[12] Cyberspace is particularly geared towards the erasure of all non-Western histories. Once a culture has been 'stored' and 'preserved' in digital forms, opened up to anybody who wants to explore it from the comfort of their armchair, then it becomes more real than the real thing. Who needs the arcane and esoteric real thing anyway? In the postmodern world where things have systematically become monuments, nature has been transformed into 'reserve', knowledge is giving way to information and data, it is only a matter of time before Other people and their cultures become 'models', so many zeros and ones in cyberspace, exotic examples for scholars, voyeurs and other interested parties to load on their machine and look at. Cyberspace is a giant step forward towards museumization of the world: where anything remotely different from Western culture will exist only in digital form. And in digital form, not only their past but also their present and potential futures can be manipulated: 'We can run a simulation and show you what are your best options for survival.' But non-Western history is being sanitized not just by the metaphors of cyberspace, numerous computer and video games, advertisements for software, but also by a host of new CD-ROM encyclopedias like *Microsoft Encarta*, the *Compton Interactive Encyclopedia* where *Star Trek*'s Captain Picard is your tour guide, and *The Story of Civilization* by Will and Ariel Durant. The great explosion of information on CD-ROMs is an old West-is-Great paradigm repackaged for a new generation and extending the dominance of the old academy. The hard won new spaces and discourses of Third World perspectives created in conventional fields now disappear into the oblivion of cyberspace: we thus return to square one, the beginning. The Other is once again the virgin land waiting passively to be dominated by the latest territory controlled by the West. Even the documentary evidences of history are oxidized in the way they are 'preserved' in cyberspace:

> The Archivo General de Indias in Seville harbours hundreds of thousands of historical sources, in the form of decrees, instructions, letters, regulations,

case records, maps, petitions from Indian chiefs, etc. which refer to the
historical ties between Spain and its former colonies in Latin America. The
whole archive is now being digitalised. The manuscripts are being recorded
on interactive, optical video disc, not only to protect the original collection·
[*to preserve the past for posterity – the present is once again discarded*], but also to
increase their accessibility for the researcher: the documents, discoloured
by time, can be 'cleaned' on the screen via the computer (stains can be
removed, creases smoothed out, colours changed, letters enlarged or reduced,
etc. . . .). In a way, a 'contaminated' and guilt-laden episode of history is
being relieved of its blood, sweat and tears, and being given a false air of
innocence. In the unbearable lightness of the realm of data, things are being
relieved of their stoutness and weightiness: as 'bits' and 'bytes' they all look
the same. It is not about whether the originals speak the truth, but about
their disappearance into a retouchable 'image': the act of copying makes the
originals artificial, too. At the same time, the 'real thing', having become
inaccessible, is entrenched in secrecy for fear that it will be touched by life,
so that its existence becomes insignificant.[13]

But cyberspace not only kills history, it kills people too. The dress rehearsal for the
smart bombs that so consistently missed their targets in the Gulf War was carried out
in cyberspace. Cyberspace, like Teflon and mini hi-fi and so much of modern advanced
technology, has its origins in the military. The Internet was developed as a foolproof
mode of communication in case of a nuclear war and expanded as a computer network
that linked university research centres with the defence departments. Virtual reality (VR)
first emerged as a safe and inexpensive way of training pilots to fly advanced military
planes. Indeed, the US military has been testing equipment and operators using VR tech-
nology for some time. The origins of the term 'information superhighway' can be traced
back to that other highway, also a product of military concerns, which emerged at the
end of the Second World War: the grand American interstate highway system (the Al
Gores have been involved in both: Al Gore Sr played an instrumental part in the devel-
opment of the federal highway system; Al Gore Jr has been instrumental in placing the
information superhighway on the American political agenda). The software games market
is saturated with 'shoot-em-up' games and flight simulators, involving flying jet fighters,
shooting and bombing targets, not simply because people like playing such games, but
because weapons guidance and tracking research for military use has filtered down into
video games. Virtual reality has now moved on to the 'entertainment' arena largely
because the US defence industry wants a return on its investment by finding other uses
for the technology it originally developed.[14]

Not surprisingly, the first major commercial application of VR betrays its military
origins. Battle Tech, one of the earliest commercial uses of VR, is a game based on
networked military tank simulators. At Chicago's North Pier, where a Battle Tech Center
opened in 1990,

> Players pay and sign in at the front desk and are matched up with others to
> make teams. The teams play in a room decorated as the war room of a star-
> ship, with TV monitors filling up a wall. Each player gets a Battle Tech
> console, which is steered like a battle tank, with floor pedals and throttle.
> Speakers around supply the sounds of machinery and battle. The joystick has

triggers and buttons for controlling weapons systems. The idea is not to beat the machine but to beat the enemy either individually or in teams. As one report states, 'what gives realism and challenge to the Battle Tech experience is the fact that you play against living opponents rather than the algorithms of a computer's program'.[15]

Once the military has opened up the new frontier, the settlers can move in to play their games, to explore, colonize and exploit the new territory taking us back to mythic times when there were other worlds (Islam, China, India, Africa, America) with resources beyond imagination and riches without limits.

Since its genesis as a military research project, the Internet has been managed by the government-funded National Science Foundation (NSF). The NSF has now handed over the managerial reins to three commercial carriers, Sprint, Ameritech and Pacific Bell. These multinational, modern equivalents of the East India Company will become the principal providers of access to the Internet. The many networks that make the Internet, the network of all computer networks, are interlinked in a rough hierarchy: the bigger the network the higher up the ladder of hierarchy it sits. Thus the big multinational corporations will dominate cyberspace. And, whereas government-funded network providers offered free access, commercial providers are in the market to make profits. If cyberspace is the new gold mine, it will be exploited to the full with trade organizations dictating and shaping cyberpolicies.

Already, the really big thing on cyberspace is business: foreign trade, trillions of dollars swashing around in a hyper-paranoia of electronic transfer, chasing profit in the 24-hour global market. The Internet is becoming more and more inviting to business interests and within a few years it will become the vehicle for shopping and other forms of consumerism. Today, one can't log on to a commercial network like Compuserve without receiving an invitation to visit the 'Shopping Mall'. Soon, in the not too distant future, we will all be as the family Robinson: the bank, the post office, shopping centre, library, job centre, video store and newspapers will disappear into cyberspace and the computer, telephone, TV, VCR and stereo will all be replaced by a magic box in our living rooms. We will be logged on, tuned in and staying at home and shopping to our heart's content. Life, as they say, will never be the same again. Indeed, cyberspace has done much to boost business – trade is growing twice as fast, and foreign direct investment four times as fast as national economies. But privatization and deregulation means that cyberspace is a space without rules; where it can promote business, it can also advance crime.[16] Cybercrime is going to be *the* crime of the future. Organized crime is a $750-billion-a-year enterprise, the drug trafficking generates revenues of $400 billion to $500 billion; much of this money finds its way into cyberspace, where it is totally out of governments' control, where it can lose itself in split-second deals, and where it is legitimized by the international movement of more than $1 trillion a day. Within ten years it will become well nigh impossible to trace ill-gotten revenues, giving organized crime an unparalleled boost. 'Currency collapse' from dirty cybermoney is something that even gives that gung-ho bible of cyberspace, *Wired*, the 'creeps'. It is one of the ten technological developments on 'The Wired Scared Shitlist': 'corrupted currency destroys global markets'.[17]

Cyberspace frontier, then, is set to follow the patterns of the old West. And like the old West, it is a terrain where marshalls and lawmen roam freely bringing order

and justice whenever and wherever they can. The lawmen of cyberspace and the new heroes of the West are hackers, whiz-kids who break into computers, punish those who break the code of 'Netiquette' and terrorize other users. While hackers are lonely and social inadequates who can relate only to computers,[18] films like *Sneakers* and *Hackers* have turned them into champions of the electronic frontier. 'A Magna Carta for the Knowledge Age' describes them as heroic individuals 'who ignored every social pressure and violated every rule to develop a set of skills through an early and intense exposure to low-cost, ubiquitous computing' (so did Billy the Kid, but in his days the new technology came in the form of repeater revolvers) and who created 'new wealth in the form of the baby business that has given America the lead in cyberspatial exploration and settlement'. But not all hackers have created wealth; quite a few have created crime and have led the way for total demolition of privacy. Cellular phone (which give off signals even when they are switched off) hackers can tap into any conversation and trace anyone almost anywhere. But with or without cellular phones, soon there will be 'nowhere to hide'.[19]

Almost every computer transaction would be hacked, every conversation amenable to tapping, and mountains of personal data about individuals routinely collected, such as medical history and financial records, would be available to anyone who wants it. On-line terrorism is not too far away and most of the early proponents of this sick art are hackers.[20] While some hackers will be causing increasing havoc, other hackers will be tracking them down.

The Others are on the other side of (actual) reality

One of the most pernicious myths about the Internet is that it provides free access to all the information about everything to everybody everywhere at any time. To begin with, access to the Internet is not free. Individuals working in organizations, universities and research institutions have 'free' access because their institutions pay. For individuals without institutional support, Internet access is an expensive luxury: there is the cost of the computer and necessary peripherals (£2000/$3200, recurring every two years as both the hardware and software become useless within that period); payment to the Internet provider (£180/$300 per year) and the telephone bills (around £500/$800 a year). One can feed a family of four in Bangladesh for a whole year for that sort of money. Thus the Internet is only available to those who can afford a computer and the connection and telephone charges that go with it. In the West, this means educated households with incomes in the upper brackets. In the US, for example, households with incomes above $75,000 are three times more likely to own a computer than households with incomes between $25,000 and $30,000.[21] That leaves most of the households of minorities in the cold. (But Asian and Pacific Islanders are more likely than whites to own a home computer and therefore have access to the Internet.) In the Third World – that is, countries *with* telecommunication infrastructures – only the reasonably well-off can afford access to the Internet. That leaves most of humanity at the mercy of real reality.[22] Contrary to popular belief, computers are not becoming cheaper. It is true that the price of computing power falls by half every two years. But as soon as the price of a model falls, its production is discontinued and manufacturers move to higher specification machines to keep their profits growing. In any case, new

software does not run on the cheaper (lower specification) models; consumers have no option but to upgrade. So the presumption that the average citizen can purchase increasingly sophisticated computers at a decreasing price is a gigantic myth. Neither is information on the Net free. Much of it, really useful stuff from the Pentagon to research on advanced commercial technologies is encoded. Not all the information in the world is on the Net (thank God for that); and unless all the world's cultures are willing to be digitized, it will never be so. The Net, in fact, provides us with a grotesque soup of information: statistics, data and chatter from the military, academia, research institutions, purveyors of pornography, addicts of Western pop music and culture, right-wing extremists, lunatics who go on about aliens, paedophiles and all those contemplating sex with a donkey. A great deal of this stuff is obscene; much of it is local; most of it is deafening noise. Our attention is constantly being attracted by someone trying to sell us something we don't want, some pervert exhibiting his perversion, groups of cyber-freaks giggling in the corner, while giant corporations trade gigabytes of information about money and death.

So most of the people on the Internet are white, upper- and middle-class Americans and Europeans; and most of them, are men. Indeed, women are conspicuous largely by their absence: less than one per cent of the people on-line are women. This is not surprising: cyberspace, like earthspace, has not really been developed with women in mind. The binary coding of cyberspace carries with it another type of encoding: that of gender relations. Most video games are designed with a very white, Western male view of what children find interesting: killing, shooting and blowing things up. In games like *Mortal Kombat* and *Comanche Maximum Overkill*, which contain horrific scenes of violence, the object is simply to kill or hunt your opponent; *Doom* and its various sequels involve nothing more than relentless and perpetual digital killing. The women in these games, if there are any, are either simply cyberbimbos, electronic renderings of Barbie dolls, or are as psychotic as the male characters. In most cases, however, female characters are as absent from these narratives as women from the Internet; at best, they are there to be rescued from evil villains, as in *Prince of Persia* and its sequel. Given this background, it is not surprising that women have not taken to cyberspace.

The cyberspace is inhabited not just by the white, middle-class male, but a *particular* type of white, middle-class male – or more appropriately two main types of white, middle-class males. The first and the most predominant type of male on cyberspace is the college student.[23] Seven out of ten institutes of higher learning in the US provide free Internet access to their students. Apart from spending most of their time 'netsurfing', game-playing, chatting on-line, these students also create 'home pages' as advertisements for themselves. There are countless such home pages on the World Wide Web containing 'information' on what they eat and excrete, what they would look like if they were Martians, and their musings on God, Hegel, Chicago Bears and the Grateful Dead. When they get bored they create such home pages as 'Nymphomania' (brainchild of a Duke University freshman) or simply put pornographic pictures on their servers. When they get really bored, they write stories: the case of Joe Baker, a 21-year-old sophomore at the University of Michigan's College of Literature, Science and Arts, is only one example – the Net is full of them. In February 1995, Baker posted a story to the Usenet newsgroup *alt.sex.stories* in which he graphically described kidnapping and torturing one of his fellow students. In a later email correspondence, Baker even described how he was going to carry out his fantasy.[24] This group of Internet users has the same demographic

profile as *Playboy* readers: that is, both groups are aged 18 to 35, 80 to 90 per cent are male, they are well-educated and have a higher than average income.[25]

The 10 to 20 per cent of white, male Internet users that fall outside the *Playboy* demographic profile – they have just as high levels of income but are, perhaps, not that well-educated – are the kind of individuals who, in the days of the Empire, were rounded up and shipped off to Australia, the 'New World' or some other part of 'the colonies' to murder, rape, sodomize or otherwise tame and civilize the natives. In the new frontier that is cyberspace, these people are forging digital colonies on behalf of the Western civilization. Frankly, many of these individuals are genuinely psychotic; real projections of the holographic Slash Gallagher, they live on various home pages maintained by numerous right-wing militia groups or belong to newsgroups like *alt.sex.amputee* and *alt.sex.nasal hair*. These are the kind of individuals who, hours after the recent bombing in Oklahoma City, posted diagrams explaining how to make bombs similar to the lethal mixture that blew up the Alfred Murrah federal building, with the message: 'There you go . . . Thought that might help some of you'. Or the kind of individuals who regularly post 'stories' that explain the best way of kidnapping children and how to torture, mutilate and sodomize them, and the best way of 'snuffing' (murdering) them. There is an abundance of this kind of stuff on some 60 Internet newsgroups whose titles begin with *alt.sex.* and literally thousands of privately run bulletin boards which pander to such horrors in the name of freedom of expression.

One of the oldest and best-known bulletin boards is the Well, which was established by the founders of the 'hippie' journal *Whole Earth Review* (formerly, *Co-Evolution Quarterly*). Here's a subscriber to the 'Well community' giving his reasons for resigning his membership:

> Racism, sexism and pedophilia are alive and vigorously protected by the subscribers. 'Jokes' about sex with 3- and 8-year-old children are available to anyone who cares to log on the Well – including your children. When I asked that such graffiti be placed in a less public conference, the outrage came in surprising salvos, including from Howard (Rheingold), who went on to discuss 'First Amendment Rights' – and to leave the 'jokes' on-line, no restrictions. It was explained to me that, 'after all, the material was labeled "Sick and Disgusting"' – I had been warned. From his safely isolated keyboard another told me, 'if you can't take a joke then FUCK YOU!' . . . I try to imagine what a battered woman or a victim of sexual abuse feels when such material scrolls into view. I prefer bigots face-to-face as opposed to some computer-hooded adolescent scribbling on cyberspace toilet walls.[26]

The problem is that that half of cyberspace which is not commercial is largely 'toilet wall'. On *alt.sex.stories*, for example, you can read stories about how infant girls have their nipples cut and throats slashed; tales of fathers sodomizing their baby daughters; mothers performing fellatio on their juvenile sons. Even in the less psychotic arena of the *alt.sex* colony, sex is just another blood sport, like killing Nazi Germans in *Doom* or shooting hostile aliens in *Daedalus Encounter*. It has nothing to do with intimacy, tenderness or any other human emotion. Just what is going on in the mind of the individual who wants to place digitized sound samples of his sexual encounter on the Internet? Or what kind of humanity is embodied in a person who provides an informed description, on *alt.sex.bestiality*, of how to mount a horse? Unfortunately, there *are* a lot of

these people on the Internet — a hyper-ventilating, hyper-abusing, hyper-self-abusing, sitting alone in front of their computer screens 'chatting' to people they have never met and are unlikely ever to meet, projecting their darker side on the hypertext world of cyberspace.

Give me nothing, or give me something else

Hypertext is becoming the norm in cyberspace from 'edutainment' CD-ROMs like Microsoft's *Ancient Lands* to tax-preparation programmes to the multimedia tours of DNA and dinosaurs (as, for example, on the Field Museum of Natural History's Home Page) on the World Wide Web. One can log on to the Web and cruise for hours, jumping from page to page, subject to subject, country to country, computer to computer — 'surfin' the Net' in a frenzied journey to nowhere. It is important to appreciate that surfing is the essential metaphor here: one does not stop anywhere, one carries on at the speed of light. This is totally different from looking for information. When you need information you go directly to it; and if you do not know where it is, you use a whole array of excellent tools on the Net that can take you where the information you want resides. No, this is not about information retrieval, nor learning: one can't learn simply by perusing information, one learns by digesting it, reflecting on it, critically assimi-lating it; nor indeed about education. It's about boredom.

Boredom is a cultural phenomenon unique to Western culture (but now, unfortu-nately, being spread like a virus to non-Western cultures). Bedouins, for example, can sit for hours in the desert, feeling the ripples of time, without being bored. Traditional societies know nothing of boredom. Traditional life is a goal-orientated existence where the goals are deeply embedded in the world-view of the tradition and have real meaning for those who imbibe the tradition. It is enriched by countless face-to-face, intimate relationships, based both on extended families and communal life; personal relationships in traditional societies tend to be shared, close and intimate, leading to a host of duties and responsibilities that give orientation and meaning to individual lives. In most Third World societies, individuals and communities are normally too busy trying to survive to be bored. Boredom is a product of culture where individual and communal goals have lost all their significance and meanings, where an individual's attention span is no longer than a single frame in an MTV video: five seconds. In such a culture, one needs something different to do, something different to see, some new excitement and spec-tacle every other moment. Netsurfing provides just that: the exhilaration of a joyride, the spectacle of visual and audio inputs, a relief from boredom and an illusion of God-like omniscience as an added extra. But, of course, travel at such a high speed has a price. Hypertext generates hyper-individuals: rootless, without a real identity, perpetually looking for the next fix, hoping that the next page on the Web will take them to nirvana. The individual himself is reduced to hypertext: a code of information. And this process seems to be accelerating. The more we come to rely on computers, the more we use them for work, education, entertainment, communication, the more we become an extension of cyberspace. Our concerns are largely limited to discrete data or information at best. Knowledge in its true sense, let alone wisdom, never really enters the equation. We are constantly moving towards the left of the axis: discrete data — information — knowledge — wisdom.

In the continuous tracking of cyberspace, the mind loses all sense of assimilation and synthesis as discrete data jump out at us from one page to the next, from one hyper-link to another; often without logical sequence. Human perception itself becomes discrete as we jump from page to page, here taking in a text, there listening to that sound, and over there looking at a video; everything occurring at the click of the mouse, with the speed of intuition. The individual's self is reduced to discrete bits of binary code, our humanity is digested by cyberspace.

The loss of humanity is quite evident in how the rhetoric of cyberspace is being used to give new definitions to community and identity. Cyberspace, it is argued, will provide through electronic pathways what cement roads were unable to do: connect us rather than atomize us. 'Cyberspace,' says 'A Magna Carta for the Knowledge Age', 'will play an important role in knitting together the diverse communities of tomorrow, facilitating the creation of 'electronic neighbourhoods' bound together not by geography but by shared interests.' Virtual communities, the mind-numbing cyber forecaster Howard Rheingold[27] announces, will bloom like wild flowers in the future and every individual will be able to choose the community or communities they want to belong to. 'You want identity?' scream Usenet groups and countless bulletin boards. 'Select from the menu and sign on!' 'Or start your own community. Create a new confer-ence!' Cyberspace, then, is the place to discover what has escaped Western man in mundane reality: community and identity, the two prerequisites for being human. Computer networks provide the ability to transcend geography, time zones and social status and develop relationships on 'forums' and 'newsgroups'. Conferences, on-line chats, bulletin boards are supposed to overcome the atomism of society and lead the individual to develop the multiple bonds that urban life denies. For, out there in the real world, communities have broken down, social institutions lie derelict, family has come to mean a collection of atomized individuals thrown temporarily together by the accident of birth, cities are little more than alienating perpendicular tangles, inner cities resemble bomb sites and fear and loathing stalk the streets. But belonging and posting to a Usenet group, or logging on to a bulletin board community, confirms no more an identity than belonging to a stamp collecting club or a Morris dancing society. And what responsibilities does the 'electronic neighbourhood' place on its members? Can one simply resign one's membership from a community? And is identity simply a matter of which electronic newsgroup one belongs to? Communities are shaped by a sense of belonging to a place, a geographical location, by shared values, by common struggles, by tradition and history of a location – not by joining a group of people with common interests. On this logic, the accountants of the world will instantly be trans-formed into a community the moment they start a newsgroup: *alt.accounts* (with *alt. accounts.spreadsheets* constituting a sub-community). John Gray:

> We are who we are because of the places in which we grow up, the accents and friends we acquire by chance, the burdens we have not chosen but somehow learn to cope with. Real communities are always local – places in which people have put down roots and are willing to put up with the burdens of living together. The fantasy of virtual community is that we can enjoy the benefits of community without its burdens, without the daily effort to keep delicate human connections intact. Real communities can bear these burdens because they are embedded in particular places and evoke enduring

loyalties. In cyberspace, however, there is nowhere that a sense of place can grow, and no way in which the solidarities that sustain human beings through difficult times can be forged.[28]

Real community creates context. It generates issues which arise with relations to time and space, history and contemporary circumstances, and require responsible judgement – which is why so many issues are difficult, they require balancing of opposing pressures. A cyberspace community is self-selecting, exactly what a real community is not; it is contingent and transient, depending on a shared interest of those with the attention span of a thirty-second soundbite. The essence of real community is its presumptive perpetuity – you have to worry about other people because they will always be there. In a cyberspace community you can shut people off at the click of a mouse and go elsewhere. One has therefore no responsibility of any kind. Where community has come to mean not knowing that your old neighbour has died until his or her body begins to rot and driving for miles to go to a shopping mall for essential groceries, cyberspace provides an easy simulation for the sweaty hard work required for building real communities. But virtual communities serve another purpose: they protect from the race and gender mix of real community, from the contamination of pluralism. Even when ethnic and race user groups establish themselves on the Internet, they are invisible, accessed only by others from the same backgrounds and interests. Thus the totalizing on-line character of cyberspace ensures that the marginalized stay marginalized: the external racism of Western society is echoed in cyberspace as on-line monoculture. Cyberspace provides an escape from the inescapable reality of diversity in the actual world. Moreover, it fulfils the desire of community by the neat trick of labelling users with communal tags. 'In the midst of desire,' writes Joe Lockard, 'we sometimes function under the conceit that if we name an object after our desire, the object is what we name it. Hard-up men buy large blow-up figures of women and hump desperately, admiring the femininity of their "girlfriends" and groaning women's names over them. But whatever their imagination, it's rubberized plastic, not a woman. Likewise, cyberspace is to community as Rubber Rita is to woman.'[29] In fact, desire is being ideologically manipulated to engender familiarity and acceptance of the hardware and software that goes to make cyberspace.

Let alone generate community, cyberspace does not even enhance communication. Listen to a newsgroup or a bulletin board conference: are people *talking* to each other, is there real communication that transforms both the sender and the recipient, what sorts of relationships are really being forged? Is it 'discussion', or is it people shouting at each other across a crowded bazaar, or simply gang warfare?[30] Everyone on the newsgroups or bulletin boards seems to be looking for something or someone: a particular bit of information, clients, files, 'how do I do that?' or, much more frequently, 'hot' sex – 'are there any girls on this thing?' When they are not looking for something, correspondents are usually abusing each other; even serious, research-orientated newsgroups appear to be burning with 'flame' (abuse) wars. This is hardly surprising: how is it possible for people who can't even say hello to each other as the door shuts on an elevator to discuss the meaning of life over a modem with complete strangers? Just what is going on in terms of the very best in electronic communication is represented in Mark Taylor and Esa Saarinan's *Imagologies*[31] which comes complete with glowing recommendations from the high and mighty of cyber- and other intellectual spaces. A sample:

'Creates new ideas and vocabulary' says the virtual reality pioneer, Jaron Lanier; a 'profound and prescient book', declares Cornel West, the black scholar and activist; 'If you want to get a headstart on the twenty-first century, *Imagologies* is required reading', announces Terry Semel, President of Warner Brothers. Taylor and Saarinan claim that they wrote their book 'for an age in which people do not have the time to write or read books' (presumably because they are too busy flaming each other on the Internet) via email between the US and Finland. Their aim is to produce a new form of 'media philosophy' for the postmodern age. The book thus has no logical structure, it simply strings together musings and reflections on such topics as style, speed, virtuality, cyborgs, pedagogies and other concerns of cyber freaks in a haphazard and panicky manner. We are treated to such gems of wisdom as 'in simcult, excess becomes excessive'; 'the play of surfaces exposes depth as another surface'; 'the televisual reflects the presence of absence that is the absence of presence'; 'reality is only skin deep'; 'electricity is an occult force that is the light of the world' and 'philosophy lacks the courage to be superficial'. This is what two serious analytical philosophers were communicating to each other via email, for God's sake. One liners, sub-Forest Gump textual debris, amounting to some 300 pages, all in the pretence of inventing a new paradigm for cyberspace communication. One gets better graffiti at the public convenience in Oxford Street. Is it really possible to believe that communities could grow out of such breathtaking banality? To a more discerning eye, 'electronic communities' that exist on the Internet consist of millions of isolated, insatiable, individual desires feeding blindly upon each other's dismal projections.

Apart from promoting community, cyberspace is also projected as a panacea for most of our political problems. All the problems of representative democracy are going to be solved, we are told, when everyone gets on-line and starts voting on everything.[32] In cyber-led society, citizens will not only be better informed but will also be able to side-step varieties of pressure groups to participate directly in decision making. For Democrat Vice-President Al Gore, the information superhighway is required 'to promote, to protect and to preserve freedom and democracy'. Speaker of the House, the arch-Republican Newt Gingrich, sees in cyberspace the beginnings of a 'virtual Congress' in which power is transferred electronically 'towards the citizens out of the Washington Beltway'.[33] 'A Magna Carta for the Knowledge Age' also presents a vision of cyberspace, 'the latest American frontier': it will empower American people through unhindered access to information. The problem with this vision is that it does not actually change the system which in fact constitutes *the* problem – it simply places its faith in information technology to make the system run more smoothly. Most democratically elected governments do what they, often ideologically, have decided to do. If cyberdemocracy could get governments to change their minds, if 'push-button voting' in 'electronic townhalls' – to use the terms of Ross Perot – could force elected representatives to listen to their constituencies, then opinion polls would be just as effective. The Western democracies are not lacking public feedback; what people lack is faith in politics, politicians and political institutions. Would electronic democracy make politicians more upright, more moral, more conscientious, more responsible? Would cyberdemocracy make the Pentagon more open and accountable to the public? Would CIA operations be open to public scrutiny? What electronic democracy offers is more of the same: more instantaneously mushrooming pressure groups, more fragmented politics, more corrupt public life. As *Time* magazine notes:

Some of the information technologies that so pervade Washington life have not only failed to cure America's ills but actually seem to have made them worse. Intensely felt public opinion leads to the impulsive passage of dubious laws; and meanwhile, the same force fosters the gridlock that keeps the nation from balancing its budget, among other things, as a host of groups clamor to protect their benefits. In both cases, the problem is that the emerging cyberdemocracy amounts to a kind of 'hyper-democracy': a nation that, contrary to all Beltway-related stereotypes, is thoroughly plugged in to Washington – too plugged in for its own good.[34]

Citizens become no more responsible simply because they give instant opinion through cyberspace than when they decide to join a lynch mob. Cyberdemocracy is lynch law. It fosters the delusion of the frontier that you can get the laws you want – but laws are not products of individual clamour but of collective and consultative acts that have to reflect the balance of the community. To be humane, just and protective of all segments of society, laws need the context of discussion, information and testing against the needs of all – the very things you can't get from an instant reflex in cyberspace. Instant decision by cyberpolls obviates the need to understand and consider, thereby taking us further and further on the march from knowledge and wisdom.

The romantic, liberating notion of information technologies draws our attention away from its more real potential: to enslave us in its totality. Beyond the rapture of free access to unlimited information and the dream of controlling all human knowledge, lies the reciprocal threat of total organization. All newsgroups, bulletin boards, Web pages – well, everything in cyberspace – are managed by invisible system operators (sysops) who ensure that the system runs smoothly and who hold unrestricted power to deny entry, cut, delete or censor any communication, and who observe all that is going on their system. On bigger networks, Big Sysops can not only monitor what is going on but also have the ability to intercept communications, read them and re-route them in different directions. Private email is not really all that private. Those who control the system, economically, technically and politically, have access to everything on the system. Absolute Sysop holds infinite invisible power. Underneath the fabricated tranquillity of cyberspace lies the possibility of surveillance by the all-knowing, all-seeing, central network system operator. Who can handle so much power without being corrupted? The monopolistic tendencies of those who control cyberspace reflect the ethos of the East India Companies. Just like the Imperial Companies, the access providers, like Sprint and Pacific Bell, are monopolies licensed by central government with the mandate to chart new territories and are working to promote a particular world-view. And just like the companies, the access providers seek total dominion over the 'New World'. Soon, 'common carriage', the public-policy means by which free-speech principles are safeguarded, may not be all that common: privately owned carriers are not too concerned about free speech[35] – just as imperial companies were not too concerned about the rights of those they colonized. We are thus set to move from the physical colonization of the Other to virtual colonization of everything by virtual capitalism. Virtual capitalism is not just about profitability, it is about cynical power: *vide* Microsoft's Bill Gates' megalomaniac obsession with absolute power.[36] Virtual colonization is the new dimension of European colonialism: 'A reinvigorated recolonization of planetary reality that reduces human and non-human matter to a spreading wake of a cosmic dust-

trail in the deepest space of the blazing comet of virtual capitalism.'[37] One of the worst nightmares of *Wired* foretells of a possible future to come:

> Redmond, Wash., Noon: Jan. 20, 2001 (via *Microsoft Network*) – During swearing-in ceremonies held today on the step of Whitehouse 97 (formerly building no. 9), Microsoft Chairman Bill Gates shocked the business world by announcing a hostile takeover of every company listed on the New York and Nasdaq stock exchanges minutes before taking the oath of office as 44th President of the United States.[38]

Suicidal twin kills brother by mistake

If cyberspace is the newly discovered Other of Western civilization, then its colonization would not be complete without the projection of Western man's repressed sexuality and spiritual yearning on to the 'new continent'. The notion of 'free cyberspace' is nothing more than the 'virgin land' concept of the original explorers of the New World. In the days of the Empire, the colonies provided the white man with an arena to live out its wildest sexual fantasies, unrestrained and uncontrolled by the mores of European social behaviour. These fantasies were projected on the natives themselves in, for example, numerous colonial fictional and travel narratives, and generated, in the words of Rana Kabbani, a 'sense of reality in the midst of unreality'.[39] The first pictorial representations of America are of a passive female virgin figure. Eastern mysticism had an equal seductiveness – it provided an answer to arid Christianity and Western man's spiritual *Angst*. Cyberspace provides both: an arena for the projection of erotic fantasies as well as a gnostic trip.

The potential for sexual union and spiritual high is best manifested in virtual reality (VR) technologies. Virtual reality is nothing more than computer-generated, three-dimensional, simulated worlds in which individuals, geared up with suitable apparatus, can project themselves, move around, and interact directly by means of the senses. Virtual reality is a product of the collective consciousness of Western culture: it has its roots in the military, space programme, computer industry, science fiction, the arts, cyperpunk and computer hacker culture. The counter-culture played a major part in its evolution and embraced it as its own; during the 1980s, cyberpunk magazine *Mondo 2000* became the main platform for VR. The old-hippie-acid gurus, like Timothy Leary, see VR as a new form of electronic LSD. Jaron Lanier (he who provided zealous endorsement for the dumbfoundly ignorant and crude tome, *Imagologies*), sees VR as the answer to 'the American stupor' or moral and spiritual crisis of Western civilization; 'Virtual reality is the first medium to come along which doesn't narrow the human spirit' and 'all you can do is be creative in Virtual reality', he declares.[40] A blind man leading so many blind moths towards a lamp that gives no light.

What we are actually being sold by cyberpunks, the computer and entertainment industry, magazines like *Wired* and mindless hype of books like *Being Digital* by the information revolution guru Nicholas Negroponte,[41] is a designer techno utopia. And it is a utopia that delivers what capitalism has always promised: a world where everything is nothing more than the total embodiment of one's reflected desires. When morality and politics become meaningless, when social, cultural and environmental problems seem

totally insurmountable, when injustices and oppression in actual reality become unbearable, then the seduction of the magical power of technology becomes all embracing. Cyberpunks are latterday utopians, the counterpart of Sir Thomas Moore, Francis Bacon, Tommaso Campanella and other European utopians who cannibalized the ideas and cultures of the 'New Worlds' to construct their redeeming fantasies. As a subculture, the merging of bohemia with information technology, cyberpunk first appeared in the 1980s; it is basically a mutant of the drug and hippie culture of the 1960s. Just as classical utopians envisaged that the encounter with the people of the New Worlds could produce a better society in Europe, cyberpunks believe that virtual reality will lead us to a better human understanding. And just as sixteenth- and seventeenth-century utopians saw the indigenous communities of America and elsewhere as a source for discovering new styles of communal living, the cyberpunks see virtually reality as a new well of social awareness, freedom, love and spiritual enlightenment. From reshaping the realities of Others to suit Europeans, we move to a new form of technological utopianism geared to shaping the reality inside a computer.

The fascination with virtual reality is not simply functional or even aesthetic; it is, for want of a better word, tantric. In the first instance it is purely carnal; but beyond that virtual reality holds the promise of magical sex leading to mystical rapture. Western society has always considered the body to be little more than a machine, so it is hardly surprising that it is so ready to extend its limitations by merging it with other machines. When reality becomes indistinguishable from binary code in virtual reality, then even sex and mysticism are reduced to binary communication. After all, what is sex? A simple exchange of signal blips between two genetic machines. And what is mysticism? The dance of binary codes in virtual space:

> Two men are staring into a computer screen at Apple's research and development branch. While the first, a computer nerd straight out of Central Casting, mans the keyboard, beside him sits the other, John Barlow, lyricist for the Grateful Dead, psychedelics explorer, and Wyoming rancher. They watch the colorful paisley patterns representing fractual equations swirl like the aftervisions of a psychedelic hallucination, tiny Martian colonies forming on an eerie continental coastline. The computer operator magnifies one tiny piece of the pattern, and the detail expands to occupy the entire screen. Dancing microorganisms cling to a blue coral reef. The new patterns reflect the shape of the original picture. He zooms in again and the shapes are seen again and again. A supernova explodes into weather system, then spirals back down to the pods on the leaf of a fern plant. The two men witness the creation and recreation of universes. Barlow scratches his whiskers and tips his cowboy hat. 'It's like looking at the mind of God.' The nerd corrects him: 'It is the mind of God.'[42]

The mysticisms of the Mandelbrot sets are perplexed wonders for those who have lost all connection with the natural world and spirituality, who are used to thinking of the world as a machine and have no idea what is the function of a soul. The tantric dimension of cyberspace is well captured by William Gibson, who first described the term cyberspace as a 'consensual hallucination', in his seminal novel, *Neuromancer*.[43] Case, the burnt-out, suicidal protagonist of the novel, has an intense relationship with cyberspace. For him, it is a place of ecstasy and sexual intensity, of uncontrollable desire

and total submission. Ordinary experience is boring and artificial by comparison. He despairs at not being able to get back into cyberspace, of being trapped in the meat that was his body; it would amount to the Fall. Again and again, the computer wizard is obsessively driven back to the information network. He desires nothing less than to become one with cyberspace.

In direct opposition to non-Western cultures, which enhance body awareness by directing the mind towards the body in such systems as Tai chi, Yoga, Tantra and acupuncture, Western culture seeks liberation from the body by dissolving into the machine. To escape his utter loneliness, his inability to relate meaningfully to nature or other cultures, even his own society, Western man seeks union with the only thing that he sees as redemptive: technology. Postmodern relativism provides no other root for escape. Only total dissolution in his own products, in the will of his technology, can bring relief from his all-embracing solitude. This is like *fana* – the total annihilation of one's ego and self in the Will of God. 'Who are you?,' they asked the Muslim Sufi al-Hallaj, when he reached the state of *fana*. 'I am the Truth,' he replied. For Western man the Truth lies in the projection of his desires that shapes his technology and constitutes cyberspace. Whereas al-Hallaj sought liberation from desire, the Western man seeks enslavement to desire; whereas Western man seeks release from tradition, disciplined experiential knowledge and pursues short cuts to nirvana via drugs, borrowed gnosis and redemptive technology, al-Hallaj laboured long and hard, within tradition and disciplined experiential enquiry to reach his desired goal; whereas al-Hallaj sought annihilation of his self in a higher Being, Western man wants experiential knowledge and hence salvation through his own gadgets. Just as Western man seeks community without the burdens of belonging ('community at zero cost'), instant identity without the confinements of tradition or history, and spiritual enlightenment without the troublesome bother of believing in any thing higher than himself or his technology, he seeks sex without responsibility. The quest for absolute freedom, without any responsibilities, duties or burdens, is central to Western man's being. Cybersex promises intimacy without the necessity or even desirability of giving to another. It is a one-way street: in cyberspace you enter the simulant of your desires, you feel what she (it?) feels, she is yours but you don't belong to her, while she is your puppet you are totally free. Cybersex CD-ROMS, like *Virtual Valerie*, already offer this scenario. Soon there will be full-scale interactive movies offering totally immersive experiences.

One potential of virtual reality is that it could make actors totally redundant; if virtual images of a herd of dinosaurs can be made to stampede across a movie screen, what barriers are there to synthesizing human actors digitally as well? When the actor Brandon Lee died during the shooting of *The Crow*, the producers continued with the picture by pasting digitized images of the actor into unfinished scenes. In *In the Line of Fire*, digital sequences of Clint Eastwood (playing a CIA agent trying to protect the president) were pasted on to an old newsreel of a George Bush motorcade; in *Forest Gump*, Tom Hanks pops up digitally in a whole range of historical footage. Not just that real actors can be replaced with their virtual counterparts, but the movie itself can become an interactive experience. Interactive games like *Under the Killing Moon*, which combine live and digitized action show the future possibilities. Within a decade, one will be able to shoot/dine/sleep with Julia Roberts and/or Sylvester Stallone and have virtual reality software that allows you to design your own mate and have your way with them any way you wish.

Beyond that lies the possibility of a whole new breed of 'human': in the first instance it will be more like *Digital Man* than *Hologram Man*. Once the processor circuitry minia-turizes enough, it could be put inside a tiny rice-shaped piece of biocompatible material and placed under the skin. This is happening now to identify lost cats and dogs. Soon, criminals may be tagged like that. Then children – so that those kidnapped can be traced. Then everyone. In less then a decade, nanotechnology will make it possible for micro-machines to be connected directly to our body tissues, even to our brains – and cyborgs, 'the ultimate transhuman, who can choose the design, form, and substance of his/her own body', will walk the earth.[44] But holographic man is not too far off, either. Real-time holo-graphic videos of full-colour, shaded images, which float freely in space, have already been developed 'about the size and shape of a teacup or a dumpy-looking Princess Leia'.[45] In less than 20 years, Princess Leia will grow up into a fully developed hologram person.

As they enter the virtual reality of cyberspace and become a mere extension of the machine, what still continues to be human about humans? What humanity is there in a digitalized tantric trance? How dispensable is the human in cyberspace? As the Sufi agitator and anarchist guru, Hakim Bey, argues, information-induced 'gnostic Trace accumulates very gradually (like mercury poisoning) till eventually it turns pathological'.[46] What emerges out of virtual reality is Slash Gallagher, a hologram with a body, a disturbed mind trapped in an agitated soul. Cyberspace is not a new, unknown territory; it is an artificial creation where the creator(s) and the computer already know everything – every nook and cranny, every secret behind every door. 'Remove the hidden recesses, the lure of the unknown,' writes Michael Heim, 'and you also destroy the erotic urge to uncover and reach further; you destroy the source of yearning. Set up a synthetic reality, place your-self in a computer-simulated environment, and you undermine the human craving to pen-etrate what radically eludes you, what is novel and unpredictable. The computer God's-eye view robs you of your freedom to be fully human.'[47]

Friends, what country is this?

The digital quest for absolute freedom ends with information, the strings of ones and zeros, taking the form of physical entity. But the personal and social relationships engen-dered by this entity have already been engineered by those who make the machine that makes information so palpable and those who write the software that gives it its phys-ical attributes. Cyberspace is social engineering of the worst kind. Those who have made cyberspace inevitable have shaped its datascape with their subconscious perceptions and prejudices, conscious fantasies and fears – all of them pulled out from the dark well of colonial projections. The frontier, as Frederick Jackson Turner recast it in writings dating from 1893,[48] was merely a trick of the light to make people perceive similarity and continuity as development and change, the delusion that they had indeed a new iden-tity. Turner's raw material was the same substance that Cristobal Colon brought to the New World, Vasco de Gama took to the East, and various colonial corporations took to India and South East Asia. The goal of getting to India and fulfilling Colon's dream was a notion alive in the minds of the founding fathers of the American Republic. The frontier was a merchant venture, just like the opening of the New World, and now cyberspace. But this venture cannot be envisioned without the context of an ideology and the mechanism of control. These, whether it be 'discovery' of the New World, the

spice empires, settling the American West or cyberspace, are all the same: white supremacism, the West as the yardstick of civilization, the divine right stuff and military force from armed galleons to the Seventh cavalry to the armed citizenry with their right to bear arms and vote through the computer terminal. The supposed democracy of cyberspace only hands control more effectively back to a centralized élite, the ideology of the free citizen making everyone oblivious to the more enduring deep structures of control. Decentralized domination solves two problems simultaneously: it makes the new territory manageable and submissive to the structures of control while keeping the citizens happy by giving them a sense of their importance as they are being used. Thus the mythic notion of the frontier is constructed to bring the past into an organized, reinterpreted unity whose main function is to give new interpretative emphasis to desired aspects of how the dominated territory is to be controlled in the future and establish that 'progress' has been achieved.

William Gibson describes cyberspace as 'an infinite cage'.[49] The cage is the contours of the colonial history within which the darker side of the West is given an infinite reign. Manufacturing fantasies that provide escape from the injustices of the mundane world is so much easier than dealing directly with real people, with real lives, real histories and real emotions, living in their own non-programmed, real communities. Under colonialism, these fantasies framed and controlled non-Western cultures of the world. In the new colony of cyberspace, they bounce right back to surround Western man in the darkness of his own projections. Cyberspace, with its techno-utopian ideology, is an instrument for distracting Western society from its increasing spiritual poverty, utter meaninglessness and grinding misery and inhumanity of everyday lives.

Prepare for holographic Slashers to break out of *alt.sex.stories* and stalk the earth.

Originally published in Z. Sardar and J. Ravetz (eds) (1996) *Cyberfutures: Culture and Politics on the Information Superhighway*, London: Pluto.

Notes

1. For a discussion of the relationship between colonization, modernity and postmodernism, see Ziaudduin Sardar, 'Do not adjust your mind: post-modernism, reality and the Other', *Futures*, 25 (8), October 1993, pp. 877–93.
2. 'War in the Gulf', from Empire Software, begins with the wonderful words, 'lets go kick some ass'.
3. Chris Chesher, 'Colonizing virtual reality: construction of the discourse of virtual reality 1984–1992', *Cultronix*, vol. 1, no. 1. On-line journal available from: *http: //english-www.hss.emu.edu/cultronix.*
4. *Mondo 2000*, Summer 1990, no. 2, cover.
5. Ivan Pope, 'Public domain: cruising the wires', *The Idler*, issue 4, April–May 1994.
6. Howard Rheingold, *Virtual Reality* (New York, Summit, 1991), p. 17.
7. Progress and Freedom Foundation, 'Cyberspace and the American Dream: A Magna Carta for the Knowledge Age', available on the World Wide Web: *http: //www.pff.org/.*
8. For the impact of 'voyages of discovery' on Other cultures, see Zia Sardar, Merryl Wyn Davies and Ashis Nandy, *Barbaric Others: A Manifesto on Western Racism* (London, Pluto Press, 1993).
9. Chesher, 'Colonizing virtual reality'.
10. See the seminal work by Henry Nash Smith, *Virgin Lands: The American West as Symbol and Myth* (Cambridge, Harvard University Press, 1978).
11. Mary Fuller and Henry Jenkins, 'Nintendo and New World travel writing: a dialogue', in Steven G. Jones (ed.), *Cybersociety: Computer-Mediated Communication and Community* (London, Sage, 1995), p. 59.

12. William A. Henry III, *In Defense of Elitism* (New York, Doubleday, 1994). For a critique of Henry, see Ziauddin Sardar, 'Other futures: non-Western cultures in futures studies', in Richard A. Slaughter (ed.), *The Knowledge Base of Future Studies*, DDM Media Group, Hawthorn (1996).

13. Jorinde Seijdel, 'Operation re-store world', *Mediamatic*, 8 (1), pp. 1862–9.

14. Harvey P. Newquist III, 'Virtual reality's commercial reality', *Computerworld*, 26 (13), pp. 93–5 (1993).

15. Cheris Kramarae, 'A backstage critique of virtual reality', in Steven G. Jones, *Cybersociety*, p. 39.

16. Jessica Matthews, 'Dirty money is way out of control in cyberspace', *International Herald Tribune*, 26 April 1995.

17. The Wired Scared Shitlist', *Wired*, 3 (1), pp. 110–15 (January 1995).

18. See Bruce Sterling, *Hacker Crackdown* (New York, Bantum, 1992).

19. Richard Lacayo, 'Individual rights: nowhere to hide', *Time*, 11 November 1991, pp. 30–3.

20. Mary Ellen Mark, 'Terror on-line', *Vogue*, January 1995 (American edition).

21. Ken Cottrill, 'Poverty of resources', The *Guardian*, On-Line Section, 30 March 1995.

22. See *The Internet and the South: Superhighway or Dirt-Track?* A Report by the Panos Institute, London, 1995.

23. Fern Shen, 'America's newest student craze? It's the Internet', *International Herald Tribune*, 27 April 1995.

24. Gilbert Yap, 'Tension on the frontier', *The Star* (Kuala Lumpur), In-Tech Section, 2 May 1995.

25. 'Playboy set to snare Internet riches', *The Independent*, 17 May 1995.

26. Letter in *Utne Reader*, no. 69, May–June 1995, p. 5.

27. Howard Rheingold, *The Virtual Community* (New York, HarperPerennial, 1993).

28. John Gray, 'The sad side of cyberspace', The *Guardian*, 10 April 1995.

29. Joe Lockard, *Bad Subjects*, 18 February 1995. On-line journal available from: *http: //english-server.hss.cmu.edu/bs*.

30. For an interesting account of on-line gang warfare, see Michelle Slatalla and Joshua Quitner, *Masters of Deception: The Gang That Ruled Cyberspace* (New York, Harper-Collins, 1995).

31. Marck C. Taylor and Esa Saarinen, *Imagologies: Media Philosophy* (London, Routledge, 1994).

32. See, for example, James H. Snider, 'Democracy on-line: tomorrow's electronic electorate', *The Futurist*, September/October 1994, pp. 15–19.

33. Robert Wright,'Hyper democracy', *Time*, 23 January 1995, pp. 51–6.

34. Ibid., p. 52.

35. See Eli Noam, 'Beyond liberalisation II: the impending doom of the common carriage', *Telecommunication Policy*, 18 (6), August 1994, pp. 435–52.

36. For an antithesis to William Henry Gates' vision, see Gar Alperovitz, 'Distributing our technological inheritance', *Technological Review*, October 1994, pp. 31–6.

37. Arthur Kroker and Michael A. Weinstein, 'The political economy of virtual reality: pan-capitalism', *Ctheory*, 17 (1–2), 1994. On-line journal available from: *http: //english-server.hss.cmu.edu/ctheory*.

38. 'The Wired Scared Shitlist', *Wired* 3.

39. Rana Kabbani, *Europe's Myths of the Orient: Devise and Rule* (London, Macmillan, 1986), p. 29.

40. Quoted by Chris Chesher, 'Colonizing virtual reality'.

41. Nicholas Negroponte, *Being Digital* (London, Hodder and Stoughton, 1995).

42. Douglas Rushkoff, *Cyberia: Life in the Trenches of Hyperspace* (San Francisco, Harper, 1994), p. 26.

43. William Gibson, *Neuromancer* (London, HarperCollins, 1984).

44. Wes Thomas, 'Nanocyborgs', *Mondo 2000*, issue 12, pp. 19–25 (there's no date on this issue; I presume cyberpunks are not too concerned about time!).

45. Negroponte, *Being Digital*, p. 125.

46. Hakim Bey, 'The information war', *Ctheory*, 18 (1), 1995. See reference 37.

47. Michael Heim, *The Metaphysics of Virtual Reality* (Oxford, Oxford University Press, 1993), p. 105.

48. Frederick Jackson Turner, *The Significance of the Frontier in American History*, 1893.

49. William Gibson, *Mona Lisa Overdrive* (New York, Bantam, 1988), p. 49.

Index

Baudry, J. 193
Bauer, J. A. 234
Baym, N. K. 409, 677, 681
Bazin, A. 151, 162, 171
Bec, L. 7
Bechdel, S. 407
Beck, U. 485
Bell, D. 1–11, 205–9, 391–5, 555–9, 627–30, 697–700
Bell, M. 25–8
Benedikt, M. 25–43, 71, 80, 86, 664
Benjamin, W. 130, 164, 170, 194, 616
Benson, T. O. 544
Berlant, L. 442, 445, 449
Berlet, C. 433
Berman, B. 480
Bernado, P. 705, 707
Bertleson, D. R. 242
Betsky, A. 40
Bey, H. 750
Binnie, J. 392
Biocca, F. 609
biosociality 57, 67
biotechnoeroticism 111
biotechnology 57, 67–8
Biro, M. 544
birth 566–7
Black, E. 243
Blade Runner 109, 124, 126, 127, 129–32, 157, 162, 191, 192, 197–9, 313, 341
Blanchot, M. 650
blasphemy 291
blip culture 155
Blumberg, R. L. 306
Blumer, H. 193–4
Boas 71
bodies 108; boundaries 306, 517; cyber 560–76; cyborg 540–51; in different realities 497–8; on the electronic frontier 489–503; legible 524; male criminal 619–23; obsolete 561–2, 580; post-modern 593–6; privatized 516–17; redesigned 562; role of 14; split 567; technophilic 111, 176–9; virtual 573, 579
Boehmer, E. 242
Bolter, J. D. 338, 418
Bolyai 41
bomb metaphor 588–90
Bordo, S. 472, 593
boredom 742

Borgmann, A. 651
Bornstein, K. 408, 440, 445, 451–2
boundaries 20, 292, 474; blurred 361–3; bodily 306, 517; conditions 302; human/animal 293, 361; and narrative 161; national 697–8, 716–17; nature/culture 62–3, 473, 523; on- and off-line 635–6; physical/non-physical 294; real/virtual world 98; self 362; social/cultural 66; technology/nature 517–18; transgressed 293, 295, *see also* electronic frontier; interface
Bourdieu 65
Bowie, D. 18
Bowles, K. 697–700, 702–10
Boyd, M. 707–8
Boyer, C. 661
Boyle, R. 507, 517, 524
Bozeman, J. 209
Brady, I. 707
Brail, S. 353
Brakhage, S. 162
Brancusi 166
Brand, B. 537
Brand, S. 427, 515
Branwyn, G. 145, 391–2, 394, 396–402
Braun, D. 245, 252
Brennan, S. 514
Brennan, T. 591
Brenner, E. 238
Breuer, J. 331
Bricken, W. 515
Bromley, H. 412
Bronson, C. 124
Brooks, F. 514
Brosnan, P. 13
Browning, F. 430
Bruno, G. 197
Bukatman, S. 17, 108, 110, 149–74
Bulletin Board Systems (BBS) 397, 403–15, 432–8, 474, 508–11; guides 398–9; rooms 397–9, 417
Bullock, S. 4
bunkering in 27, 96–7, 100
Burdi, G. 247
Burgoon, J. K. 681
Burning Chrome 175
Burroughs, W. 139, 152, 427, 466, 490
Burton, R. 714
Bush, G. 749
business, on cyberspace 738